2007

Artist's &
Graphic Designer's
Market.

Mary Cox, Editor

Michael Schweer, Assistant Editor

WRITER'S DIGEST BOOKS
CINCINNATI, OH

If you are an editor, art director, creative director, art publisher or gallery director and would like to be considered for a listing in the next edition of *Artist's & Graphic Designer's Market*, send your request for a questionnaire to *Artist's & Graphic Designer's Market*—QR, 4700 East Galbraith Road, Cincinnati, Ohio 45236, or e-mail artdesign@fwpubs.com.

Editorial Director, Writer's Digest Books: Jane Friedman
Managing Editor, Writer's Digest Market Books: Alice Pope
Writer's Market Web site: www.writersmarket.com
Writer's Digest Books Web site: www.writersdigest.com

2007 Artist's & Graphic Designer's Market. Copyright © 2006 by Writer's Digest Books. Published by F + W Publications, 4700 East Galbraith Road, Cincinnati, Ohio 45236. Printed and bound in the United States of America. All rights reserved. No part of this book may be reproduced in any form or by any electronic or mechanical means including information storage and retrieval systems without written permission from the publisher, except by reviewers who may quote brief passages to be printed in a magazine or newspaper.

Distributed in Canada by Fraser Direct
100 Armstrong Avenue
Georgetown, ON, Canada L7G 5S4
Tel: (905) 877-4411

Distributed in the U.K. and Europe by David & Charles
Brunel House, Newton Abbot, Devon, TQ12 4PU, England
Tel: (+44) 1626 323200, Fax: (+44) 1626 323319
E-mail: postmaster@davidandcharles.co.uk

Distributed in Australia by Capricorn Link
P.O. Box 704, Windsor, NSW 2756 Australia
Tel: (02) 4577-3555

ISSN: 1075-0894
ISBN-13: 978-1-58297-429-3
ISBN-10: 1-58297-429-2

Cover design by Kelly Kofron/Claudean Wheeler
Interior design by Clare Finney
Production coordinated by Robin Richie and Kristen Heller

Attention Booksellers: This is an annual directory of F + W Publications.
Return deadline for this edition is December 31, 2007.

Contents

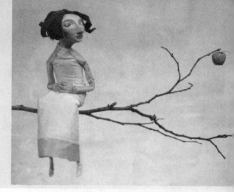

© 2006 Red Nose Studio

MARKETS

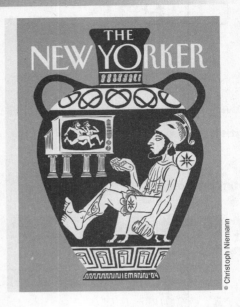

© Christoph Niemann

© 2006 Zach Trenholm

RESOURCES

INDEXES

Spider-Man: ™ and © 2006 Marvel Characters, Inc. Used with permission.

From the Editor

Weave Your Web

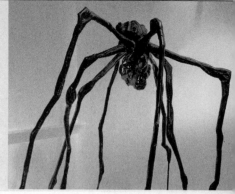

Several years ago while balancing a plate of brie and strawberries at a museum opening, an eerie sensation crept over me. Something caused me to glance upwards. High above me, eight feet tall at least, exquisitely balanced on spindly legs, was the biggest spider I had ever seen. Without realizing it, I had walked under a sculpture by renowned artist Louise Bourgeois. This huge bronze was beautiful, powerful and scary, yet gentle and protective at the same time. I was in awe. It made me feel as small as, well, a spider—or heaven forbid, a fly. I cannot explain the experience without reverting to one of those fancy words art critics use—"visceral." For indeed it was. Now, years later, I am honored to feature that spider's creator in this book. (See Louise Bourgeois: The Courage to Create on page 12).

The morning I edited the Bourgeois interview, I had been startled earlier by a spider of a different color. More butterscotch than bronze, this one was appropriately itsy-bitsy—but just as heart-stopping. There she sat proudly holding court in the center of one of those gloriously round *Charlotte's Web*-like structures, blissfully unaware that the cornerstone she so carefully chose to anchor her masterpiece was the door-handle on the passenger's side of our vintage Buick. What to do? Call the office and say "I can't come in because a spider web is attached to our car?" Luckily, the driver for the morning commute is a sculptor who knows a work of art when he sees one. After a little prodding, the reluctant arachnid went scurrying up the nearest branch, her beautiful home flying in the wind. On the drive to work, we comforted ourselves in the knowledge that the spider will create again, as she was born to do.

Several other coincidences cropped up as we pulled together this edition. For example, three of the artists talked about creating art on rooftops. Two created portraits of Edgar Allan Poe. Two are members of rock bands—and on and on.

I'm not surprised at all the commonalities. Though artists exhibit varying styles and subject matter, they are very much alike at heart. The main thread I follow again and again in their stories is the inexplicable need to make art—and the willingness to work hard.

Like the spider, you were born to create. Take inspiration from the artists in this book who scribble fantastical ideas on the subway, sculpt eccentric characters or animate Web sites. Use the ,2000 listings with advice from the many helpful articles in this book to find venues and clients and contact them professionally. But most importantly, be true to yourself. In the words of Louise Bourgeois: "If the artwork is true, then it will communicate and have value to others."

Mary Cox

Mary Cox
artdesign@fwpubs.com
www.artists-market.com

How to Use This Book

To Sell Your Work

I f you are picking up this book for the first time, you might not know quite how to start using it. Your first impulse might be to flip through and quickly make a mailing list, submitting to everyone with hopes that someone might like your work. Resist that urge.

First you have to narrow down the names in this book to those who need your particular art style. That's what this book is all about. We provide the names and addresses of art buyers along with plenty of marketing tips. You provide the hard work, creativity and patience necessary to hang in there until work starts coming your way.

What you'll find in this book

The book is divided into five parts:

1. Business articles and interviews
2. Section introductions
3. Listings of companies and galleries
4. Insider Reports
5. Indexes

Listings: the heart of this book

This book is divided into market sections, from greeting card companies to design firms. (See Table of Contents for complete list.) Each section begins with an introduction containing information and advice to help you break into the specific market.

Listings are the life's blood of this book. In a nutshell listings are names, addresses and contact information for places that buy or commission artwork, along with a description of the type of art they need and their submission preferences.

Articles and Interviews

Throughout this book you will find helpful articles and interviews with working artists and experts from the art world. These articles give you a richer understanding of the marketplace by sharing the featured artists' personal experiences and insights. Their stories, and the lessons you can learn from other artists' feats and follies, give you an important edge over artists who skip the articles.

HOW *AGDM* WORKS

Following the instructions in the listings, we suggest you send samples of your work (not originals) to a dozen (or more) targeted listings. The more listings you send to, the greater

your chances. Establish a tracking system to keep track of who you submit your work to and send follow-up mailings to your target markets at least twice a year.

How to read listings

Each listing contains a description of the artwork and/or services it prefers. The information often reveals how much freelance artwork they use, whether computer skills are needed and which software programs are preferred.

In some sections, additional subheads help you identify potential markets. Magazine listings specify needs for cartoons and illustrations. Galleries specify media and style.

Editorial comments, denoted by bullets (•), give you extra information about markets, such as company awards, mergers and insight into a listing's staff or procedures.

It takes a while to get accustomed to the layout and language in the listings. In the beginning, you will encounter some terms and symbols that might be unfamiliar to you. Refer to the Glossary on page 608 to help you with terms you don't understand.

Listings are often preceded by symbols, which help lead the way to new listings **N** and other information. When you encounter these symbols, refer to the inside covers of this book for a complete list of their meanings.

Working with listings

1. Read the entire listing to decide whether to submit your samples. Do *not* use this book simply as a mailing list of names and addresses. Reading listings helps you narrow your mailing list and submit appropriate material.

2. Read the description of the company or gallery in the first paragraph of the listing. Then jump to the **Needs** heading to find out what type of artwork the listing prefers. Is it the type of artwork you create? This is the first step to narrowing your target market. You should only send your samples to listings that need the kind of work you create.

3. Send appropriate submissions. It seems like common sense to research what kind of samples a listing wants before sending off just any artwork you have on hand. But believe it or not, some artists skip this step. Many art directors have pulled their listings from *AGDM* because they've received too many inappropriate submissions. Look under the **First Contact & Terms** heading to find out how to contact the listing. Some companies and publishers are very picky about what kind of samples they like to see; others are more flexible.

What's an inappropriate submission? I'll give you an example. Suppose you want to be a children's book illustrator. Don't send your sample of puppies and kittens to *Business Law Today* magazine—they would rather see law-related subjects. Instead use the Niche Marketing Index on page 615 to find listings that take children's illustrations. You'd be surprised how many illustrators waste their postage sending the wrong samples. And boy, does that alienate art directors. Make sure all your mailings are *appropriate* ones.

4. Consider your competition. Under the **Needs** heading, compare the number of freelancers who contact the listing with the number they actually work with. You'll have a better chance with listings that use a lot of artwork or work with many artists.

5. Look for what they pay. In most sections, you can find this information under **First Contact & Terms**. Book publishers list pay rates under headings pertaining to the type of work you do, such as **Text Illustration** or **Book Design**.

At first, try not to be too picky about how much a listing pays. After you have a couple of assignments under your belt, you might decide to only send samples to medium- or high-paying markets.

6. Be sure to read the Tips! Artists say the information within the **Tips** helps them get a feel for what a company might be like to work for.

These steps are just the beginning. As you become accustomed to reading listings, you

will think of more ways to mine this book for your potential clients. Some of our readers tell us they peruse listings to find the speed at which a magazine pays its freelancers. In publishing, it's often a long wait until an edition or book is actually published, but if you are paid "on acceptance" you'll get a check soon after you complete the assignment and it is approved by the Art Director.

When looking for galleries, savvy artists often check to see how many square feet of space is available and what hours the gallery is open. These details all factor in when narrowing down your search for target markets.

Pay attention to copyright information

It's also important to consider what **rights** listings buy. It is preferable to work with listings that buy first or one-time rights. If you see a listing that buys "all rights," be aware you may be giving up the right to sell that particular artwork in the future. See Copyright Basics on page 51.

Look for specialties and niche markets

Read listings closely. Most describe their specialties, clients and products within the first paragraph of the listing. If you hope to design restaurant menus, for example, target agencies that have restaurants for clients. But if you don't like to draw food-related illustration and prefer illustrating people, you might target ad agencies whose clients are hospitals or financial institutions. If you like to draw cars, look for agencies with clients in the automotive industry, and so on. Many book publishers specialize, too. Look for a publisher who specializes in children's books if that's the type of work you'd like to do. The Niche Marketing Index on page 615 lists possible opportunities for specialization.

Read listings for ideas

You'd be surprised how many artists found new niches they hadn't thought of by browsing the listings. One greeting card artist read about a company that produces mugs. Inspiration struck. Now this artist has added mugs to her repertoire, along with paper plates, figurines and rubber stamps—all because she browsed the listings for ideas!

Sending out samples

Once you narrow down some target markets, the next step is sending them samples of your work. As you create your samples and submission packets, be aware your package or postcard has to look professional. It must be up to the standards art directors and gallery dealers expect. See Promoting Your Work: Let Your Artwork Work for You, on page 56 for a look at some great samples sent out by other artists. Make sure your samples rise to that standard of professionalism.

See you next year!

Use this book for one year. Highlight listings, make notes in the margins, fill it full of Post-it notes. In November of 2007, our next edition—the 2008 *Artist's & Graphic Designer's Market*—starts arriving in bookstores. By then, we'll have collected hundreds of new listings and changes in contact information. It is a career investment to buy the new edition every year. (And it's deductible! See The Business of Art on page 42.)

Join a professional organization

Artists who have the most success using this book are those who take the time to read the articles to learn about the bigger picture. In our interviews and Insider Reports, you'll learn

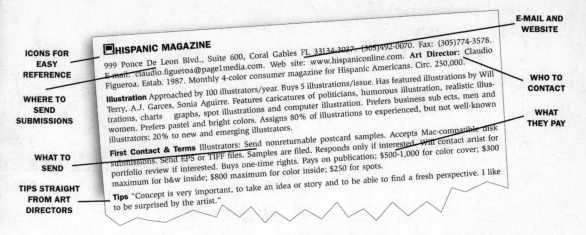

ICONS FOR
EASY
REFERENCE

WHERE TO
SEND
SUBMISSIONS

WHAT TO
SEND

TIPS STRAIGHT
FROM ART
DIRECTORS

E-MAIL AND
WEBSITE

WHO TO
CONTACT

WHAT
THEY PAY

▣HISPANIC MAGAZINE
999 Ponce De Leon Blvd., Suite 600, Coral Gables FL 33134-3037. (305)492-0070. Fax: (305)774-3578. E-mail: claudio.figueroa@page1media.com. Web site: www.hispaniconline.com. **Art Director:** Claudio Figueroa. Estab. 1987. Monthly 4-color consumer magazine for Hispanic Americans. Circ. 250,000.
Illustration Approached by 100 illustrators/year. Buys 5 illustrations/issue. Has featured illustrations by Will Terry, A.J. Garces, Sonia Aguirre. Features caricatures of politicians, humorous illustration, realistic illustrations, charts graphs, spot illustrations and computer illustration. Prefers business sub ects, men and women. Prefers pastel and bright colors. Assigns 80% of illustrations to experienced, but not well-known illustrators; 20% to new and emerging illustrators.
First Contact & Terms Illustrators: Send nonreturnable postcard samples. Accepts Mac-compatible disk submissions. Send EPS or TIFF files. Samples are filed. Responds only if interested. Will contact artist for portfolio review if interested. Buys one-time rights. Pays on publication; $500-1,000 for color cover; $300 maximum for b&w inside; $800 maximum for color inside; $250 for spots.
Tips "Concept is very important, to take an idea or story and to be able to find a fresh perspective. I like to be surprised by the artist."

what has worked for other artists and what kind of work impresses art directors and gallery dealers.

You'll find out how joining professional organizations such as the Graphic Artists Guild (www.gag.org) or the American Institute of Graphic Arts (www.aiga.org) and the Society of Children's Writers and Illustrators (www.scbwi.org) can jump start your career. You'll find out the importance of reading trade magazines such as *HOW* (www.howdesign.com), *Print*, (www.printmag.com) and *Greetings etc.* (www.greetingsmagazine.com) to learn more about the industries you hope to approach. You'll learn about trade shows, portfolio days, Web sites, art reps, shipping, billing, working with vendors, networking, self-promotion and hundreds of other details it would take years to find out about on your own. Perhaps most importantly, you'll read about how successful artists overcame rejection through persistence.

Hang in there!

Being professional doesn't happen overnight. It's a gradual process. I would venture to say that only after two or three years of using each successive year's edition of this book will you have garnered enough information and experience to be a true professional in your field. So if you really want to be a professional artist, hang in there. Before long, you'll feel that heady feeling that comes from selling your work or seeing your illustrations on a greeting card or in a magazine. If you really want it and you're willing to work for it, it *will* happen.

Christoph Niemann

The Thinking Man's (and Woman's) Illustrator

© Jason Fulford

by Steven Heller

Since moving to New York City eight years ago from Ludwigsburg, Germany, Christoph Niemann has become one of the chief go-to illustrators for art directors seeking to clarify the complexities inherent in subjects such as gun control, trade deficits and black holes. Niemann's wit, irony, and minimalist style have made him a favorite with such major magazines and newspapers as *The New York Times*, *The New Yorker*, *Men's Health*, *Esquire*, *Popular Science* and international publications such as the German business weekly, *WirtschaftsWoche*.

Niemann's brain seems to be wired for thinking metaphorically. In Niemann's world, donuts explain black holes and pink toothpaste succinctly sums up romantic obsession.

Every solution begins as a series of doodles Niemann comes up with on the subway ride from his Brooklyn home into Manhattan. He likes to have a couple backups (or 10), just to prove he's nailed the problem. He also maintains bulging binders of rejected sketches every bit as smart as those that make it to print. "The good stuff never comes easy—it's like weightlifting," says Niemann, who confesses he draws every day because it feels good to look at the pile of work.

As one of the art directors who calls on him regularly for tricky assignments, I recently had the opportunity to quiz him about his work. Here, Niemann speaks on his process, his clients, and avoiding distraction.

When and why did you decide to become an illustrator?

As far as I remember I knew I wanted to be an illustrator when I was maybe 13 or 14. Thinking illustration would be an insane career choice, I briefly considered becoming an architect. But my dad told me that this would involve building little models. I happen to be the most inept man on the face of the earth when it comes to building little models of anything, so I decided to abandon that idea very quickly.

Were you always a good drawer? Or did you really study hard to do what you do?

My brother was the effortlessly talented one. He did these insane portraits of my parents when we were little (3 or 4) whereas I was pretty much doing predictable kids art, maybe a bit better than average. But I always enjoyed drawing enough that I kept at it, and guess I always was the best draftsman in class. Then again, the competition wasn't that hard. I always felt I had to achieve my skills through hard practice, Thankfully I seem to have a masochistic streak that makes me enjoy hard practice.

STEVEN HELLER is an art director at *The New York Times* and the author of more than 100 books and articles on design.

Why did you decide to immigrate to America from Germany? Wasn't there enough work to keep you going? Didn't you like the beer and schnitzel?

When I was I student I spent two consecutive summers as an intern in New York (with Paul Davis in '95 and with Paula Scher at Pentagram in '96), so I was already infected with the New York virus. When I finished my degree in '97 I decided to just give it a shot for a year to see whether it works, knowing that once I would have settled in Berlin or Hamburg it would have been much harder to leave everything behind and do such a crazy move. So I have never really tried to work in Germany (though I have a lot of clients there who I enjoy working for a lot). On top of that, you can actually find very decent schnitzel here in New York.

Let's talk struggle. Did you ever? Did you ever have to sell yourself? Or did America just open its wide arms and take you in like so many cheap computer chips?

When I came here I was only worried about whether I would get enough jobs, but luckily I pretty much had enough work right from the start.

The struggles happened at other fronts. For about six months I was living and working in a loft on lower Broadway that I shared with three other people. My roommates were nice and easy going (one of them started smoking his first gigantic joint at 8 in the morning). My desk was a little chest with drawers, so I had to basically work sitting sideways. On top of two Multiplex-style television sets that were acoustically competing with two insane dogs, an Irish folk-band was rehearsing about five feet from me rather frequently. I concluded my stay at this joint being carried out on a stretcher followed by a bumpy ride in an ambulance to Beth Israel, where I got treated for a slipped disc and a wicked blood infection. When I came back to pick up my stuff the dogs had eaten my portfolio.

Decades before you brought your signature brand of conceptual illustration to these shores, Eastern Europeans—from Rumania, Poland, Hungary, and Czechoslovakia—had introduced symbolic and surreal conceptual illustration to American editorial art. Do you think you have a German sensibility that has somehow influenced American illustration? Or have you been influenced by American art?

My greatest influences as far as American illustrators go were always very New York related (Saul Steinberg, Milton Glaser, Seymour Chwast, Brad Holland), and I always felt that New York Design had a very central/eastern European feel. When I was looking at illustration or design yearbooks in school, I always felt I understood New York design much better than anything from London, for example. I am still stunned by the fact that people here got almost every single metaphor in my book when I first came to the city, even though I hadn't done any of that work having an American audience in mind. And from my experiences since, I doubt it would have been that easy if I had started out in Paris, London or California for that matter.

Have you ever attempted to create a more American style with American art directors in mind? Do you think of your work as American?

Other than some strange metaphors that I had to learn first (e.g. golden nest eggs), I never felt I had to adjust. Since I spent almost my entire professional career here my work probably qualifies as American (to the degree that New York qualifies as American . . .)

You're faster than a speeding bullet, and more powerful (in your conceptual acumen) than a locomotive. How did you become such an illustrative Superman?

Ha! What a nice question, if only I could agree with you. One of my ultimate career goals is to always be the one person with the most accurate knowledge of my weaknesses, which is

why I won't use this answer to dwell on my multiple insecurities. There are three things that I think work to my advantage. First, I think a lot about technology and how I can use it to streamline my work progress without compromising the results (whether I succeed in that is another question). The second one is working without music (I really think that makes a big difference). The third is coffee.

Why don't you like to listen to music while you work? Did you overturn a bottle of ink while dancing to Shakira?

Music or no music, I think I spill about half a gallon of ink per year.

I simply can't focus enough if music is playing in the background. Thinking of ideas and especially drawing require so much concentration that I have to minimize any sensual distraction.

Getting back to those insecurities. Just give me one biggie.

I keep reading all these interviews with all those famous designers who keep fighting for their vision, against all odds and despite an audience that "isn't ready for it." Of course I do

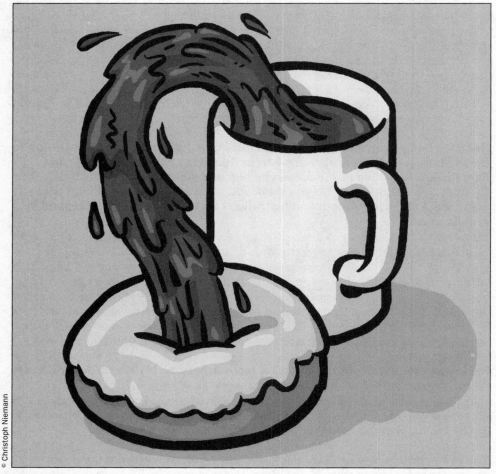

© Christoph Niemann

One of the most creative minds of his time, illustrator Christoph Niemann is sought out by magazines for his ability to visually explain difficult concepts by transforming everyday objects into surreal icons. What better way to illustrate a complex article about black holes for *Popular Science* than with a simple coffee and donut?

fight for an idea that I think works or against a stupid suggestion that would compromise the quality of a concept.

But at the end of the day, if I come up with something, be it a single idea, or a new style or some strange theory and I can't get anybody really excited about it very quickly, I usually lose my enthusiasm and abandon that direction very swiftly. I guess that streak actually helps me professionally, but I wonder often whether I am to be too dependent on other people's opinion.

Let's get down and dirty. What is your process? How do you make illusionary magic on the page or screen?

All the good and special solutions come from god-knows-where, and involve the unfortunate but unavoidable sweat, tears and desperation. But I certainly have a work process for the ''everyday'' illustration that I have perfected enough that I know will allow me to do an un-embarrassing solution in a fairly short time. I doodle on 8½ by 11 paper and run through the entire list of possible metaphors for a topic and while drawing see if there is a slightly-less-than-predictable twist with which I can turn it into an interesting image. Once (or while) I do that I think about how to render that Idea (do I want to draw the character as a bubble nosed cartoon man or a super stylized bathroom icon, etc.).

What stimulus (or stimulants in addition to coffee) do you require to make the perfect image? Does it matter if the manuscript is good or bad?

Actually, the more bland or irrelevant the story, the easier it is to come up with a funny idea for it. The worst possible assignment would be a real news story about aliens landing on earth. I don't think that there is any illustration that could come even close to the most blurry photograph. This may sound like a stupid example, but it is a similar problem to illustrate a story about a ground-breaking invention or a charismatic person.

What are those bland stories?

Stories on ''why your eight-year-old doesn't like broccoli'' give you much more opportunities to come up with a surprise.

I'm not letting you off the hook about stimulants . . .

As far as stimulants go, I barely ever do any research once I get an assignment. I rather try to practice preemptive research, meaning I try to read a lot of newspapers, magazines and Web sites in order to get a fairly broad sense of what is going on out there. Hoping that once I get an article, I already know what the discussion is all about. If I get assignments about fly-fishing, ice skating or car races, I have a real problem, because I have no interest (and knowledge) about them and therefore have a much harder time coming up with an image that a possible reader can relate to.

Art directors—especially editorial ones like me—rely on you for ideas we couldn't think of in a hundred years. That makes you an invaluable commodity. What does it mean to you?

I like—and thrive on—the collaboration with art directors, but that doesn't make me any less insecure about people (especially readers) actually getting my jokes. Once I have finished a drawing I feel pretty confident, but in the work process, that doesn't help me much because until I have that idea that does get approved, I do feel like *this* will be the job that will simply not work out.

Do you reject clichés or reinvent them?

In general all clichés are my friends. Some clichés are so over-used though, that they turn into illustration clichés themselves that then can be quoted. (At this point a piggy bank is

The Art of Business

not a metaphor for finance, but a metaphor for a metaphor for finance.) Of course it is always a huge relief when a fresh image comes around. I remember around 1999 it became okay to use a shopping cart for *any* kind of shopping (probably because of amazon.com—before that it only said "supermarket"). And all of a sudden you have a great new and very versatile image that can be abused in a million different ways.

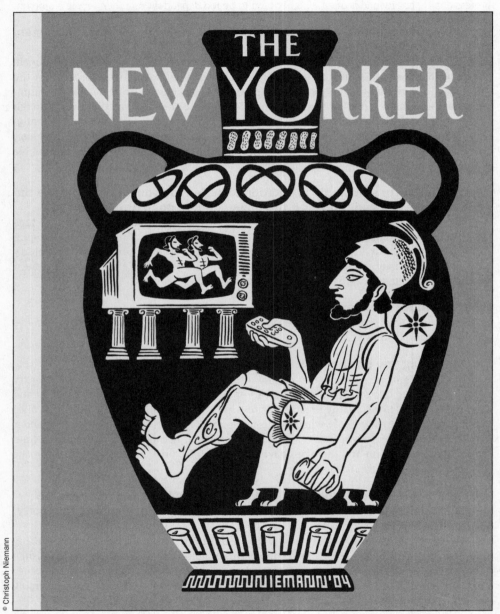

Christoph Niemann's work is regularly showcased on the cover of *The New Yorker*. There's a lot going on in Niemann's witty turn on his own ode to a Grecian urn. The idea alone is enough to cause a double take, but it's details like the pretzels, peanuts and beer decorative borders that say "this has got to be a Christoph Niemann cover!"

What does style mean to you? Your own is rather economical; witty, though not slapstick. You reduce your images to clear simple linear forms. Is this style one of compromise or is it truly the way you see and feel your ideas?

I actually have to disagree. Even though I am drawn to simple linear solutions, I use fairly baroque solutions quite often. It all depends on the idea. A lot of the very conceptual ideas work best when the drawing is subdued and impersonal, but there are some ideas that need a lot of technique to carry you over the finish line. I did a drawing about the gay marriage discussion on Adam and Adam in paradise. And the only way it worked was as a crazily detailed Dürer rip-off ink drawing.

What is the best kind of job and why?

The one that makes everybody involved happy. Unfortunately I only know that when the job is over.

Okay, then conversely, what is the worst job, and when do you know its time to give up?

I think I have gotten much better at smelling trouble before it turns into a disaster. Two big red flags are: The client doesn't really know what they want and even though they pretend to hire you for a real job, they just need your art to make up their minds on where they want to take the project. I have often worked with concepts that were given to me by the client (especially in advertising, this is unavoidable). But over the years I have gotten pretty good at knowing what kind of concept will graphically work and what doesn't. Knowing that they will blame me if their incomprehensible idea won't work on paper, I try to politely run away as fast as I can.

I know that you keep a book filled with "idears" as you call them in your quaint accent. Do you physically review them when you have a problem to solve?

I have tried so often to bring a killed idea back to life but unfortunately they all seem to be cursed. That's why these books are unfortunately only good for impressing students (and occasionally design writers).

Getting back to style for a moment. You have two or three basic approaches— linear stick figure, more rendered line, and a sketchier modeled approach (either flat or rendered color). Do you ever change your approach in mid- drawing? Do you ever surprise your client by changing your style unexpectedly?

I know how tense the work process is for most art directors, so I usually stay away from stylistic surprises in the middle of the game. But there are a very small number of art directors that I have such good relationships with that I constantly alter the approach, even when it is getting very close to the deadline.

Is illustration a satisfying enough endeavor for you?

It is, and especially when you look at the giants like Steinberg, Chwast, Holland or Heinz Edelmann you can see that you can spend a lifetime doing it without ceasing to reinvent yourself and keeping things interesting. The question is if the way I do illustrations today remains a viable profession, or whether it will morph into a less "artistic" and isolated field. If there are no more 4×4 spot illustrations to be done I will have to use my skills differently and I am young and stupid enough to hope that I will enjoy whatever that may be as much as I what I am doing now.

Louise Bourgeois

The Courage to Create

Photo: Nanda Lanfranco

by Elizabeth Exler

There must be at least one thing that every artist could learn or be inspired by when hearing Louise Bourgeois' phenomenal success story. At 94, she's America's oldest—and most famous—controversial artist. Bourgeois may be looking a little more delicate these days and getting about with the use of a walker, but that quintessential Mona Lisa smile remains and she's still going strong artwise.

Major museums worldwide vie to exhibit Bourgeois' sculpture, and she continues producing new work. Her upcoming list of exhibitions includes a retrospective at the Tate Modern in London, which will travel to the Centre Georges Pompidou, Paris, followed by the Guggenheim in New York and the Museum of Contemporary Art, LA.

As a young artist, Bourgeois had to navigate between exiled European artists and the New York School of which she was a founding member. She married the American art historian, Robert Goldwater, and together they shared friendships with such luminaries as Miro (a close friend) and Duchamp, who she knew in Paris. She later met Abstract Expressionists Franz Kline and deKooning. She fully experienced the difficulties of being a woman artist, but continued to perservere.

Bourgeois has never remained static. Early on she was constantly redefining her work. In the early 1960 she moved from the rigidity of carving wood to creating labyrinthine spirals and lairs in plaster and latex. Her courage to maintain an ongoing process of self-discovery—that has often hinged on less-than-popular themes and imagery—is a monumental reason why her vision has never gone out of style. Although she has become a kind of surrogate mentor to generations of younger artists, Bourgeois says, "I'm neither a preacher nor a teacher."

Could you give us the short version of Louise Bourgeois' early years?

I was born in Paris in 1911. My parents were in the business of tapestry restoration. At an early age I began to draw in the missing parts of the tapestry to be rewoven. My father wanted me to continue in the family business, but my mother was a feminist and wanted me to become educated. All of the women in my family were hard workers. When my mother was ill, I took care of her. It was after she died, that I abandoned mathematics and philosophy and began to study art at various academies.

ELIZABETH EXLER is a painter/printmaker, teacher and art materials researcher who writes for several art publications.

How did you get into art?

In Paris, my teachers offered me the possibility of a world outside the family business. My father was not happy with my pursuit of art. He played the tough love card. I needed to support myself to study. My father thought artists were parasites and were seducing everyone. He wanted me to get married. My inability to deal with the death of my mother

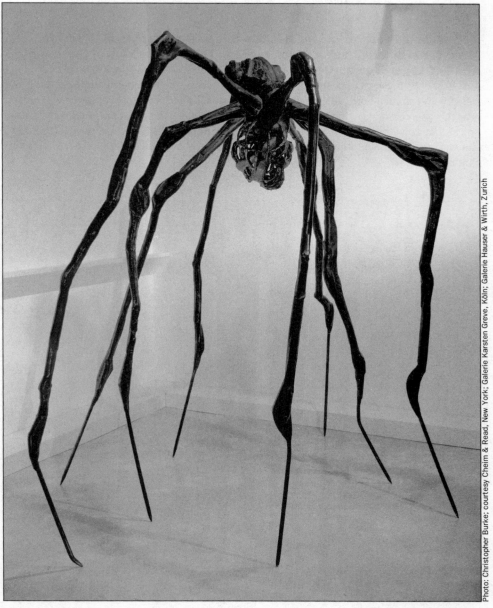

The Art of Business

Spider, 1997, bronze, 94×96×84″. Louise Bourgeois' monumental bronze spiders are public art at its best—accessible and yet profound. This work is one of Bourgeois's arachnoid series, which has enchanted art lovers in museums in the United States, Ireland, Japan, Australia and France.

had everything to do with me running from art school to art school. I was fighting for my survival. That's how deep the trauma was.

Your work is famous or notorious for probing the painful, hidden agendas of the psyche.

My art is my form of psychoanalysis. I was able to exorcise my demons through art.

So you defied your father and decided to apprentice yourself to several teachers in different schools and ateliers. The most famous of these was Fernand Leger. You bartered tuition fees by working as his assistant.

I have always loved my teachers, such as Yves Brayer at the Grande-Chaumiere. But it was Leger who I studied with, who pushed me in the direction of sculpture. In Leger's class there was this exercise of drawing a spiraled pencil shaving. It was in the way I was rendering this spiral that Leger sensed my relationship with three-dimensional form. I needed the three-dimensional form. Sculpture involves the body and it also establishes distance. This is very important to me.

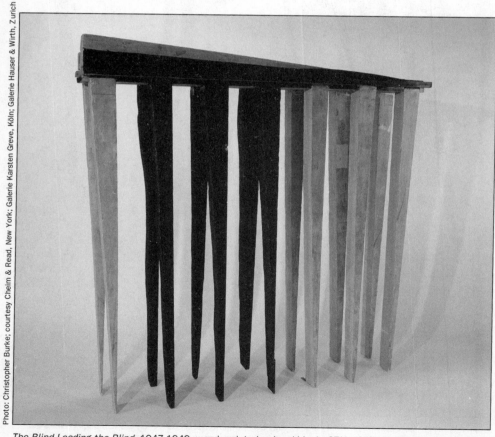

The Blind Leading the Blind, 1947-1949, wood, painted red and black, 67⅛×64¾×16¼". Bourgeois' first monumental sculpture is considered one of her most famous works.

You were very patient about waiting for your chance to show. However, not only did you remain friendly with former Surrealist protégés, but also formed new liaisons with the American Modernists and then the Abstract Expressionists.

I had my first solo show in 1945, which was of paintings. My sculpture took a long time to develop. At that time I had three children to take care of and space in the apartment was also an issue. It was only when I discovered the roof that I started to focus on making sculpture. Though I made paintings, I always considered myself a sculptor. The roof was not my studio, but having access to it allowed me the opportunity to experience the sculptures while I was working on them. I was able to set them up and move them around. The beauty of the roof was that it was a totally isolated and silent place. That was important.

> ''If the artwork is true, then it will communicate and have value to others.''

How did you view the politics of the American art world and what were a few of your most important breakthroughs or shows?

The making of art is one thing and the art world is another. Art is one thing and art history another. There are artists whose work remains in the world of ideas, I am interested in the world of emotions. In 1951, Alfred Barr bought my ''Sleeping Figure'' for the Museum of Modern Art; in 1982, Deborah Wye organized my retrospective there. I've been showing with Cheim & Read gallery in New York since 1997 and in Europe, I'm represented by Galerie Karsten Greve and Galerie Hauser & Wirth. I like my dealers; they are my friends.

I think you didn't need to promote yourself because you seem to enjoy an emotional bond with other artists, dealers and other art world personalities, almost like an extended family.

I didn't know how to promote myself. You wouldn't know it from my work, but I am shy. I didn't work for anyone but myself. My work is pure self-expression. I have nothing to sell. I knew that making art made me less anxious. I was never concerned with the art market and am still not. I believe what I make is true. If the artwork is true, it will communicate to others, and it will have value to others.

What is your advice to emerging artists?

Trust yourself. In your art you must tell your own story and if you tell your own story, you will be interesting. Don't tell somebody else's story and don't get the green disease of envy.

What would be the highlight of your career?

My favorite piece is always the one I'm working on now. At this time, I'm focused on a sculpture that is a fountain for a park in Seattle. The sculpture is called, ''Father and Son,'' and consists of two figures cast in stainless steel. The water is used to hide and reveal these figures alternatively. The work is about miscommunication. The figures' hands are reaching out towards each other in attempt and a desire to communicate, but the endeavor is doomed.

Creating Bookcovers

How to Get an Art Director's Attention

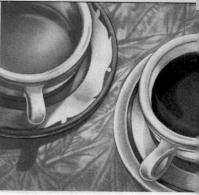

by Carol Pinchefsky

If the eyes are the window to the soul, a book cover is the window to the soul of a book. No one knows this better than an art director for a publishing company. Although the author has written that book, the art director is responsible for giving the book its outward appearance: Art directors must determine the concept of the cover, so that it stands out on the shelf while at the same time remaining within the expectations of its genre. Without authors, books would not be written—but without the art directors' vision to entice a reader into purchasing them, books wouldn't sell.

Art directors do not work in a vacuum. They rely on a stable of freelancers who can supply them with fresh ideas and who can bring their own unique perspective to a project. Art directors look for people with talent who are willing to work as creative partners; artists must be able to accommodate the changes made by the director, and more frequently, the marketers who sell the book.

Creating book covers is a difficult field to break into, but art directors reward their freelancers with repeat business and stellar references. Consequently, cover artists with rigid design ethics who skip deadlines will not find themselves employed for long.

Here, three hardworking art directors from major publishers discuss what they look for in a freelance artist. **Richard Aquan** is an art director with HarperCollins. **Vivian Ducas** is an art director with Harlequin. **Susan Mitchell** is an art director with Farrar, Straus & Giroux.

What kind of promo samples really prompt you to take a chance on an illustrator you've never worked with before?

Richard Aquan: I look at consistency when I'm looking at the work. I don't want to see one good piece, I want to see 10 good pieces. I gotta know the guy's consistent, and unfortunately I pretty much only use the top guys.

It's the person's work: If I like the work, I use it.

But the important thing when you assign something is finding the right person for the right book. If you're doing a romance book you want a romance illustrator, because if you give somebody inappropriate subject matter to paint or design, you're not going to get a good job. That's the most important part about art direction.

CAROL PINCHEFSKY has written for *Novel & Short Story Writer's Market* and is currently writing a graphic novel.

Vivian Ducas: It all depends on the freelancer. I have worked with freelancers who I've never worked with before who found my name through *Artist's & Graphic Designer's Market*. One of the designers was very consistent: every couple of weeks, she sent me a postcard, and I could tell she geared it toward the book publishing business. When I finally contacted her, she offered to go through a little bit of a test. I then referred her back to our Web site to look at some books and give me three examples of covers she thought she could do better and why. She took the initiative to understand our product and took the creative initiative to approach it three different ways, not just one way. She was able to discuss it and rationalize and learn from it, so it gave me the confidence to know she is someone I can collaborate with. Another fellow wouldn't do the test. I don't know what's become of him.

Susan Mitchell: "If I really liked a sample I would want to see more; I don't think one sample is enough to prove anything. I do not hire an illustrator because of their previous work in terms of content, I want them to give me something that doesn't look like what they've done, something that shows fresh thinking. I don't want people to repeat themselves, but I want the quality that they're known for.

Susan Mitchell

Describe your ideal freelancer.

Aquan: A good freelancer is somebody who will work with you and adapt to all the changes. There are a lot of changes in this business: the editors ask for one thing and when they see it they change their minds. It's really hard on designers and illustrators.

If you're in the art world, you live and die by the deadline, and if you don't make the deadline you don't get used again. We take this pretty seriously. I'd say that unless the person's really that damn good I won't use them again—but it rarely happens, because everybody I work with is a professional.

Ducas: Capable and terrific at what you do—that's what makes it fun. There's room for all kinds of personalities. As long as you collaborate, you like what you do, you deliver on time, and you want to do it again, that's good stuff. There's room for all personalities.

Show that you're dependable and that you deliver on time—that's a big one because if you're an art director inside a large company, you may be gathering 12 very important people together for a meeting based on something that the freelancer provided. If you're not delivering on time, then you've disappointed the art director, the marketing team, editors, designers, production people and so on. The art director will think twice before calling that freelancer for the next assignment.

Mitchell: They don't get locked into a box. They have the flexibility to work with an art director. I need to work with somebody who is going to work with me to maintain quality but is able to make changes as need to.

What are your pet peeves about freelance artists?

Aquan: I don't like needy freelancers. I give you the details, but if I have to explain myself repeatedly or do this stuff for you, why am I hiring you? Then there's always the passive aggressive, who'll add this subtle change that gets me mad. I'm the type of person who'll get the files and change it back myself.

The Art of Business

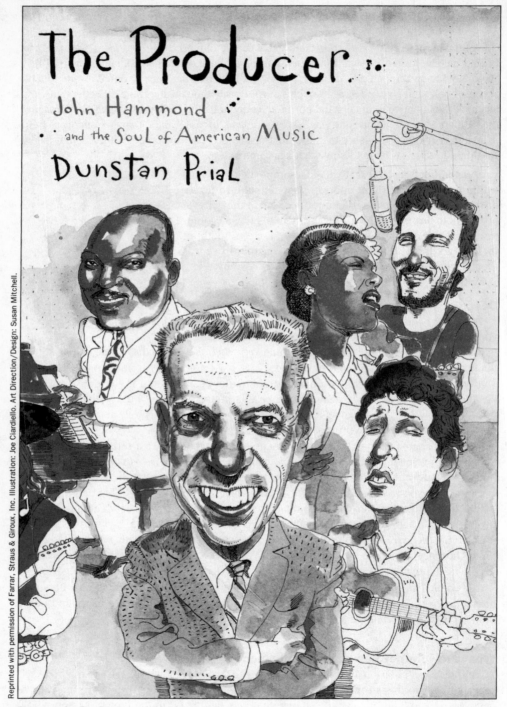

The cover for *The Producer: John Hammond and the Soul of American Music* was very much a group effort, says Art Director Susan Mitchell. "My editor, Paul Elie, and I went over piles of photos but there was not one of Hammond in the same room with the performers he produced." Joe Ciardiello's spirited watercolor caricatures provided both a solution and a memorable cover.

Ducas: It's that lonely little HR-type letterhead on 8½ by 11 that says "Hello, you don't know me, my name is, and I'd really love to . . ." They don't work. They just look so lonely. I don't' mind a cover letter, I know it's professional. But there's a lot of artists who rely on the cover letter, and that's not enough. If you're in the graphic arts business, use the graphic arts medium.

Mitchell: I work with many freelancers, and my only pet peeve is when they're rigid, there's only their way. There are some extremely talented people who are intractable and do fabulous work, but I can't work with them because they don't have flexibility.

Vivian Ducas

© Natasha Nicholson

I don't go out on a limb unless I have a good feeling about working with a person and I'm confident we're going to be able to work together. That confidence comes through phone calls and talking face to face.

Where do you find illustrators?

Aquan: It depends. If I'm looking for a certain style for a cover, I know certain reps who I call and ask for samples. I usually go through Spectrum (www.spectrumfantasticart.com) and the Society of Illustrators Annual of American Illustration (www.societyillustrators.org) books to find somebody I like.

Ducas: Everywhere. I look at magazines, reference award show books, source books, Web sites. . . . I'll look to a referral from another art director. Some freelancers find the art director—it's not uncommon to be sent printed samples or brochures.

I look to source books that showcase portfolio samples of freelance illustrators and photographers like Workbook (www.workbook.com) and Black Book (www.blackbook.com). Other sources include annual books, like the Society of Illustrators Annual of American Illustration.

Mitchell: I talk to my coworkers and my peer group: I'm in touch with all the art directors in the book industry, and I will find time to talk with an artist based on a personal recommendation. I do keep an eye on what's coming out of the art schools if they have a booklet of the students' work. I recently found an illustrator that way. I like to go into the year books, the American Illustration contest (www.ai-ap.com/cfe.html), the Communication Arts illustration contest (www.commarts.com) and see a smattering of what they selected. It's a great filtering process.

Do you like postcards for promotional samples? How often should freelancers send them?

Aquan: I get a ton of them, and I keep the ones I like. I probably get 50 a week easily. Freelancers need to send them as often as possible.

Ducas: I do. How often depends on how much they want to get noticed. Once is not enough: it's a start.

Mitchell: I do. I like to receive individual postcards. I look for quality, style, sophistication, something that looks fresh and appeals to my sensibilities. It's good to send a reminder card of your latest work—not the same thing over and over again. Artists should be aware that in New York all publishers have publishing schedules, and timing is everything.

Do you use art reps to find appropriate artists?

Aquan: I use art reps when I'm looking for something and I'm not sure what I can find. You call them up and they do the research for you. They have various illustrators in their

The Art of Business

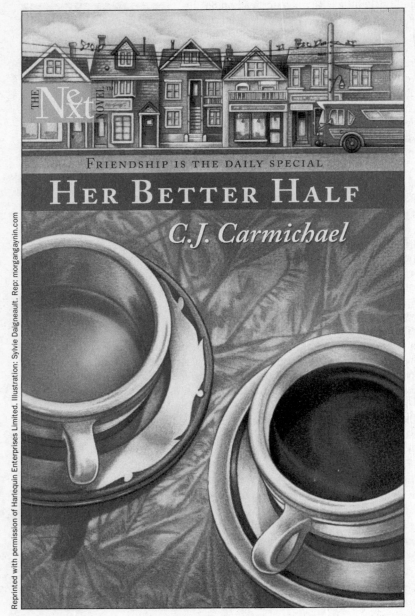

Reprinted with permission of Harlequin Enterprises Limited. Illustration: Sylvie Daigneault. Rep: morgangaynin.com

Harlequin covers are no longer typically the windswept couple embracing on a hilltop, or a swashbuckling pirate staring down his object of desire. The publisher has changed and so has the art they choose for covers. In the Harlequin® NEXT™ series, a quiet image of two coffee cups evokes a relationship. Sylvie Daigneault's illustration sets the stage for *Her Better Half* and invites us into the characters' inner lives. Art Director Vivian Ducas appreciated the artist's portrayal of the setting in the street scene details and many nuances.

stables with various styles, and they'll send over samples, so I don't necessarily have to go digging through a whole drawer of my samples.

Ducas: Absolutely. They organize their stable of artists so I can just phone up the rep and say this is what I'm looking for, got any suggestions, anyone new that you haven't put up on your Web site yet that might want to take a chance?

Mitchell: Rarely. In the past they were known as "reptiles." Back in the day they got in the way of your work with the artist.

Do you ever use art that already exists?

Aquan: Lots of times. I call certain photographers and illustrators and ask if they have stock. I sometimes have photo researchers find art for me. When we're picking up a book that's done in the UK, if we like it we'll buy it and pick up the rights from the illustrator.

Ducas: We do at times. The industry is changing, and stock images have become a resource. I think the creative goal is to do something with it, so that you can own the final idea. It's how you use a stock image, as a starting point rather than the end.

Mitchell: I use some photography. A funny thing: We always like people's personal work—as opposed to their assignment work—because it's a little more humanistic, and it comes from their heart and has a quality that doesn't seem pat or uniform or contrived. When I've tried to hire that same person to do an original assignment, very often it doesn't work out because deadline makes them freeze. I like to use stock work because it's bird in hand.

Do you read the book you're designing the cover for?

Aquan: Some people do read them. I don't have time. I'm not a fast reader. I do 160 books a year, of which time I have allotted to design is usually eight to 10 weeks, 12 weeks tops, to make it for the catalogue. I rely heavily on the editor to give me a synopsis of the book to work on it. They have to present an idea, and from that I'll design a cover based upon what they tell me they want.

On the science fiction list, we'll call the author, and say we need a scene for the cover. They will give us an outline and tell us what they want—a cathedral and a winged guy—and I'll work with that. I'll send that to the illustrator, and the illustrator will then do sketches. I'll look at it, suggest changes if needed, and once we get a revision, back it goes to the editor and the author for a second pass before we go for a finish.

If the artist wants to read the book I'll send it to them. Unfortunately most of them are busy, and they like a synopsis.

Ducas: We work either six months or a year in advance so you quite often can't read the book. We have a synopsis to work with and to discuss with the editors and marketing people.

The art directors do more than "chose" art for covers. Art directors work closely with the editors and marketing people. They are responsible for the total package so art directors collaborate with talented and skilled designers, typographers as well as illustrators and photographers. Some are in-house, some are freelance. Check out the exciting work we do at http://design.harlequin.ca.

Mitchell: I can't speak for anybody else, but as for the people that work with me, they must read their books. We still value originality, and the artist is going to find a different take from that author's text. The author's words are going to bring the artist to a different place. If you're working at a company whose writers are great, which ours are, the artists find inspiration in the authors' words, and it's going to guarantee you something fresh and original.

The Art of Business

Is there a difference in the look of paper back and hard cover books?

Aquan: There's a tremendous difference between hard cover, mass market and trade paperback. Each one is designed to a certain need and you can't just design them the same. The trade paperbacks tend to be more highbrow, more literary. The mass markets have to be big, hit-em-over-the-head type, big author, big title, and they use more illustrations. The

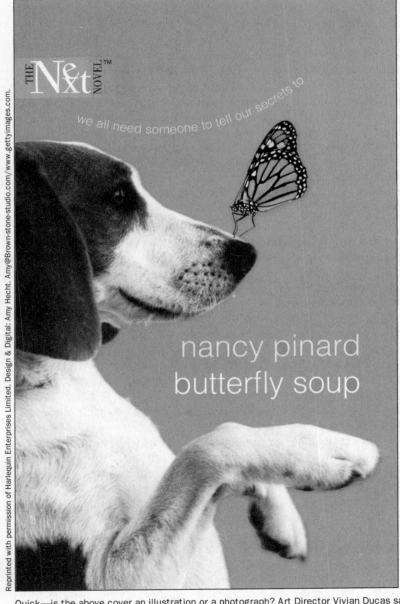

THE Next NOVEL™

we all need someone to tell our secrets to

nancy pinard
butterfly soup

Quick—is the above cover an illustration or a photograph? Art Director Vivian Ducas says it is both. These days, she explains, artist's manipulate photos into covers that can be playful, somber or serious. Designer/ digital artist Amy Hecht contacted Ducas through Harlequin's listing in *Artist's & Graphic Designer's Market*.

hardcovers tend to use more photography. The bottom line is you still have to know the marketing of publishing books.

Mitchell: I think the form changes the look: if you take a cover and wrap it around a hardcover book with a spine and a flap, then you trim it and fold it around a paperback, you have a different look because of the physical properties of each.

The distinction is changing and evolving. There are mass market books now that have a trade look to them, a little more sophisticated, a little finer typography, simpler, cleaner, more tasteful looking.

Where is book cover art heading in the future?

Aquan: That's a tough thing to say, because things that artists like are different from what the market wants to buy; we speak a higher visual language. Where the books will go is more about marketing trends.

But history repeats itself: everything you can think of has been done before. You just have to find a new way of inventing and repackaging it. Foil has been around for years, but only in mass market books. Now hard covers use it all the time.''

Ducas: ''Trends'' is a funny word. I just know that readers are very visually literate and sophisticated now, and we're just doing it for them. That's where freelancers come in, because they're out there, discovering new looks and different styles. The art director make the connection with that perfect illustrator, typographer, and/or photographer and can take your look or your style and apply it. Collaboration is really the fun part of the job.

Mitchell: This a complicated answer. You can be too far ahead of the curve and miss the market, but if you don't push that envelope a little bit, you're caught in Tiredland. I think book cover art is in a decline right now, if I may be honest. The form is being challenged by the agent, author, bookseller,

I wonder where it's going. I feel the market is driving a lot of what is done. The people in charge are not the people who should be calling the shots; they're making covers uniform. I don't try to write the copy! I'm a not a writer, but I am a reader, but do I offer my opinion? Mutual respect is very hard to find right now, yet it's essential to the process of growing.

The Art of Business

Success Stories

*Small Steps Lead to Giant
Leaps for Freelancers*

by Donya Dickerson

The world is alive with art—in books, magazines, murals, ads, calendars, greeting cards, Web sites, stationery—essentially everywhere you look. And, as an artist, you probably wonder, what's the story behind all those published pieces of art? Who are the illustrators? And, most importantly, what's the secret to their success?

For many artists, this secret is actually very straightforward. Success means being dedicated to your art, persistent in contacting markets for your work, and professional in all your interactions. But although it's straightforward, it's never simple. Attracting the attention of markets can take a lot of work and understanding the ins and outs of the graphic design and illustration business can be tricky and even a little intimidating.

All of the artists in this piece—Stephanie Rodriguez, Thom Glick, and Susie Ghahremani—have effectively navigated their own freelance careers. Along the way, they've come up with their own secrets for success, which they share here. The good news, they all say, is that there are markets everywhere—1,800 in this book—that are hungry for submissions from talented artists. Take a moment and learn their valuable insights into what it takes to make it in the art world. Then, use *AGDM* to create your own success story.

Stephanie Rodriguez

For Stephanie Rodriguez, success as an artist has meant more than just getting her work published. Instead, she says "freelancing for me has been such a rewarding experience because I have had the opportunity to work with people from all over the world as well as work on many different kinds of projects."

Throughout her career doing interior and cover illustrations for books, magazines and catalogs, she's worked with companies such as Plank Road Publishing, *newWitch, Apex Sci-Fi Horror Digest, Cemetery Dance, Brutarian, Strange Horizons, Aurealis, Australian Science Fiction*, and more.

Stephanie Rodriguez

Rodriguez first started sending out her work when she was a senior at The Fashion Institute of Technology, where a professor introduced her to *Artist's & Graphic Designer's Market*. As she explains, "*AGDM* opened my eyes to all the different markets where I could submit my work. It not only helped me target specific companies, but

DONYA DICKERSON is an editor and freelance writer who frequently writes for *Writer's Market*.

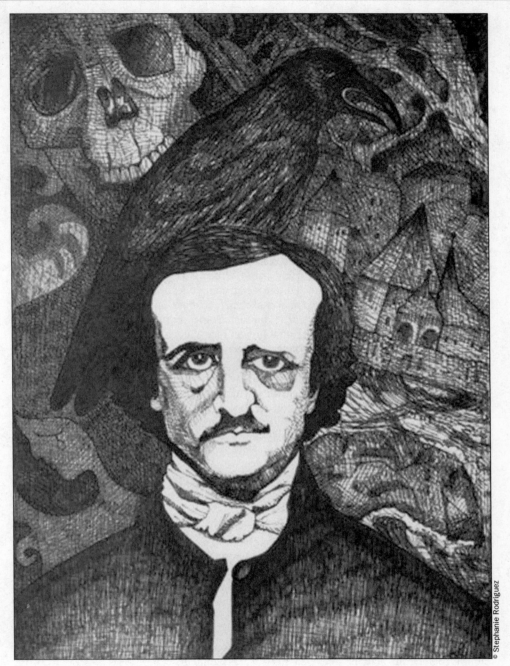

Stephanie Rodriguez's work is graphic and bold, and her subjects are drawn from literature, music and the people in her life. Her mysterious tribute to Poe, "Memories of Edgar" graced the cover of *Whistling Shade*'s Winter 2005 issue. Her work has appeared in *BIGnews*, *newWitch* and *Rivet*. To see more, and to keep up with Rodriguez's journey, visit her Web site at www.stephanierodriguez.artroof.com.

The Art of Business

it also aided me in deciding where and when to send my work, how to personalize cover letters and postcards. I used *AGDM* to focus in on the markets I thought would best suit my illustration style."

Her initial mailing didn't elicit the response that she'd hoped for. "When I first started submitting my work to art directors, the response varied. Some responded within a month, others took almost a year to respond and some not at all. It was very frustrating for me to receive rejection letters."

Instead of letting this discourage her, she became even more "determined to follow my dream of becoming a professional illustrator," she says. "I started to e-mail art directors and send out more packages and postcards. I would mail these out relentlessly until I got responses. I also created postcards to send as follow-ups to the art directors that answered me back saying they would keep me on file and later contact me when they had an assignment available that would best suit my style."

She began to get responses and soon had her first professional job, with *Whistling Shade*, a quarterly literary journal from St. Paul, Minnesota. "The assignment," she says, "was to create a pen and ink cover illustration of Edgar Allan Poe for their 'Mystery and Crime' issue."

In addition to helping her find more markets for her work, *AGDM* also showed her how to navigate through the often confusing world of being a freelancer, teaching her "about contracts and other legal issues related to specific companies." For example, one key lesson she learned is to never "start working on sketches or ideas until you have received some confirmation from the art director for a contract. Something unpredictable could happen, and you might find yourself working on a project that will never happen."

Rodriguez also learned the importance of always acting professionally. She believes this has been the key to getting repeat assignments from the people she's worked with. "Once I find a client," she explains, "I do my best to show an interest in working with them continuously. If there is a client that pays well who I enjoy working with, I ensure that the work is in as soon as possible. You must be conscientious and always be on time with deadlines. This will help you keep the clientele you have as well as gain new ones."

For anyone trying to make it as an artist, Rodriguez believes that one of the most important secrets to success is to have patience. "Remember, it takes years for anyone to mature and develop themselves as a professional in any field. Above all, if you are sincere, love your work and have confidence in yourself, you will find the energy to pursue this profession."

Thom Glick

Artist Thom Glick's first success as a magazine illustrator happened while he was a student at Columbus College of Art and Design—and *AGDM* played a key role in this initial achievement. "I used *AGDM* to research what markets were available to me, as well as the best methods to approach those markets," he says.

After sending out a mailing to the targeted list of markets he found in *AGDM*, Glick says, "I immediately got responses to my postcards and follow-ups." Nevertheless, it took a few months before he actually received his first assignment. "*Cleveland Magazine* contacted me wanting three spots to

Thom Glick

accompany an article about the upcoming baseball season, he says. They pretty much knew what they wanted in each of the images, so it wasn't a real complicated assignment. It gave me an opportunity to concentrate on my technique and my voice. Over all the experience was great and highly addictive; I couldn't wait to get my next assignment."

Clearly, Glick was hooked, and through hard work and dedication, he's built an impressive

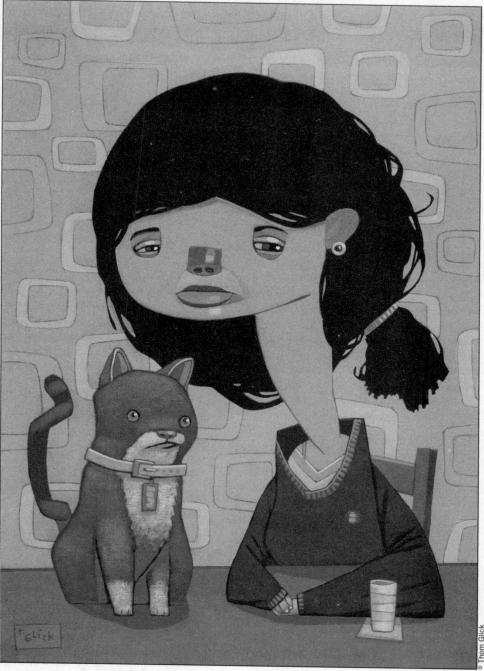

Thom Glick's print *Roger and Zuzka* originally appeared in *Cat Fancy* magazine. Glick makes every one of his illustration assignments stand as a work of art on its own, beyond the initial assignment. He later offers these works of art for sale through his Web site, www.thomglick.com/shop.html. His online shop is ready for business, working for him at all hours of the day and night, nationally and internationally. Visit his Web site and take in his amazing Phobia series and a portrait of Trent Reznor of Nine Inch Nails.

client list that includes *The Washington City Paper, Cat Fancy* and more. "The bulk of my work so far," says Glick, "has been in the editorial market, most specifically for alternative newsweeklies. I really enjoy the challenge that editorial work presents with its quick turn-arounds and continual need for new and inventive visual solutions."

But Glick hasn't limited himself to illustrating editorial pieces. He's also had great success obtaining work in numerous other markets. "Other assignments I've done," he says, "have included graphics for T-shirts, logos, caricatures, portraits, Web site design, picture book illustration, advertising page layout, interior retail rendering, some minor production management, gallery work, and some instructional and demonstrational work." He also painted a mural for the Trader Joe's grocery store in Columbus, Ohio.

For Glick, the key to success is "to be patient and persistent but also constant and relentless." As he explains, "I always keep in mind the very relevant saying: It's the squeaky wheel that gets the grease. Art directors and editors are constantly flooded with artists trying to break into the market, so don't get discouraged if it takes a few tries to get noticed."

To ensure he's constantly getting his name in front of key decision makers, Glick has a very organized mailing system in place. "I use the AGDM to compile contact lists and mailing lists. After I send out the postcards I typically wait a week and then follow up with an e-mail or phone call. I do my best to update my Web site often and I try to send out a new postcard a few times a year." And his Web site, www.thomglick.com, has played an important role in his success. "With how quick today's markets work, it is very helpful to have a portfolio out there that can be easily accessed any time of the day anywhere in the world."

Glick also makes sure that his mailings incorporate everything that an art director would need. "I make sure to include my contact information and my Web address," he says, "so that potential clients can see more of my work. I also try to include one color piece and one black and white piece so that I can use one postcard design for a variety of clients."

For anyone who is ready to send out a mailing, Glick recommends that "if you are using *AGDM* as a source for finding potential clients, make sure to pay attention to what kind of art the client is looking for as well as their preferred method for receiving samples or mailers. It can be a huge waste of time for both you and a potential client if the samples you send are irrelevant or in the wrong format. I once missed some details in a description and sent a black and white publication a color postcard, when they only used black and white art and they preferred to receive a packet of hard copy samples rather than a postcard."

He also advises that "anyone who is interested in getting involved in any art-related market shouldn't be afraid to ask for help or advice. There are an abundance of resources, literature, as well as organizations, out there for artists, to keep them informed on everything from copyright issues to pricing to standard business practices. It's always better to think preventively rather than reactionary."

Glick's final advice for artists is to remember that there are countless markets out there looking for talented new artists. "A lot of people are afraid that the editorial illustration is disappearing, but I think that this market will always exist. There's a definite and constant need for editorial art. If you love making art there's an outlet somewhere out there for you. All you need is passion and perseverance."

Susie Ghahremani

When Susie Ghahremani first started submitting her work, she learned several lessons the hard way. "I thought if I sent a postcard with my Web site on it to magazines, they would go to the trouble of looking up my full portfolio and contact

Susie Ghahremani

info." She then proceeded to create "a stack of very amateur promotional postcards, bought about 300 postcard stamps, and just started sending them out. It was disorganized, expensive and ridiculous."

Today, Ghahremani's whimsical illustrations have been published in an impressive list of national publications that includes *The New York Times*, *The Washington Post*, *Shape*, and *Child*. In addition, she has exhibited her paintings in galleries across the country, including Giant Robot (LA, NYC, San Francisco), The Front Room (Brooklyn) and Motel Gallery (Portland).

From those first tough steps to her now flourishing freelance career, she's learned several valuable lessons that have contributed to her success. First, she found that it's crucial to investigate the markets before she submits to them. When she first started submitting her work, she says, she "contacted magazines without considering their content and if my work was appropriate for them. That was totally a waste of time and money! The response and non-response I received really forced me to learn quickly."

While she recognizes that "getting to know your illustration market is time consuming," this important step "will really help you connect with the right outlets for your work." Taking the time to know the specific tastes of different markets has really paid off for Ghahremani. "I've found 50% of my work through the combination of *AGDM* and research online and on the magazine stands," she says.

Once she assembled a list of markets that were strong fits for her work, Ghahremani sent out carefully targeted promotional postcards. When it comes to that initial contact with Art Directors, she recommends that "your promo should be the absolute most representative image(s) of your work you can find." In addition to being an example of your own illustration

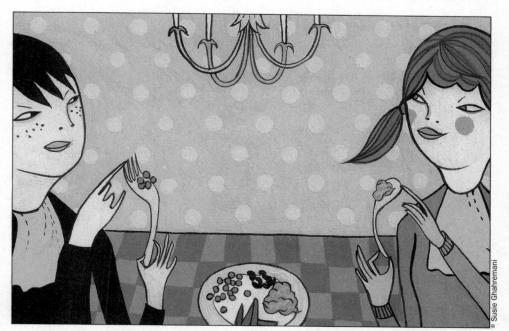

© Susie Ghahremani

Susie Ghahremani may be from the smallest state, Rhode Island, but she lives life in a big way and her art makes a big impact. She's a singer with her own one-woman band, Snoozer, and is a non-stop illustrator with a unique style. The above illustration is titled *Food Fight*—more of her work can be viewed on her Web site www.boygirlparty.com, which offers notecards, t-shirts and more featuring Ghahremani's work. You can also hear her sing!

The Art of Business

style, a promo card must also honestly represent your illustration skills. Your promo, says Ghahremani, "could be your best painting ever, just make sure you can achieve the same quality of work again and that your work is consistent."

After learning the right way to approach markets, Ghahremani had immediate success. "I got my first call from a prestigious client regarding my first promo the day after I put it in the mail!" While exciting, this call actually provided another important learning opportunity for her. As she explains, "They wanted to review 'my book.' I didn't even know what that meant at the time. Your 'book' is your tangible portfolio. I didn't have one! I was terrified. I stayed up all night professionally printing samples and arranging their presentation and overnighted them the next morning. Miraculously, they hired me, and I had a deadline the following week."

When it comes to putting together your work to send to markets, Ghahremani advises that "your portfolio should be cohesive. I think my first portfolio had about 10 different styles and techniques in it. A disjointed portfolio confuses art directors about what to expect from you." For anyone having trouble assembling a portfolio, she recommends "exercises like www.illustrationfriday.com or taking articles from magazines you already like and re-illustrating the articles as if they had hired you."

Ultimately, Ghahremani believes that the secret to success is to "keep trying! The more work you do, the better and more refined your work will get. The more work you do, the more art directors will see you, too. Don't feel disappointed if you don't achieve what you hoped to right away. Keep up your energy and enthusiasm, and don't let making art stop being fun!"

Ghahremani's final advice is "love what you do! There are a lot of ups and downs in a career as an illustrator, a lot of hard work, lulls and times when you're completely swamped and overwhelmed, but enjoying your work is the best reward. I wouldn't trade it in for anything." That's a sure sign of success.

Chris Sickels

In Praise of Awkward Grace

© Jennifer Sickels

by Megan Lane Patrick

Drive far enough down State Route 9 in Greenfield, Indiana, and you find Chris Sickels in his studio, a two-story red garage behind his green house. But he's not alone—there are the puppets. Four long shelves, packed with puppets, run across the entire length of the long back wall. Looking into all the carefully sculpted faces, you start to hear them chatter in your mind: A red-haired woman is yelling at the top of her lungs, calling her children home for dinner. A slick businessman in a suit tries to sell you a nice piece of real estate in Florida. "Damp? Well, just a little," he says. A Gypsy fortune-teller whispers, "I see . . . I see a bright future for you."

Once Sickels creates and dresses his puppets, he sets up scenes with props and backgrounds fashioned from a variety of materials and found objects, which he then photographs. His 3-D illustrations have appeared in magazines, newspapers and animation for clients like *HOW*, *Los Angeles Times*, *Business Week* and Spike TV. You can see examples of his work at www.rednosestudio.com.

When Sickels first began getting illustration jobs, he had only been out of college for three years and was working part-time doing construction, installing and tearing down shows for museums in Cincinnati, while pursuing a freelance career on the side. Today, Sickels is worlds away from where he started. "When I was first looking into colleges, I knew I wanted to go to art school, but I didn't know about illustration," he says. "I also didn't know people created things for magazines. I grew up on a farm, and we didn't have subscriptions to magazines. So, when I went to school, I figured I'd have to design shampoo bottles for Procter & Gamble or draw logos."

And he probably would have forged a fine career doing just that if it hadn't been for a couple of influential people who steered him in a different creative direction. "During my sophomore year in college, I met a student, Sean Wallace, who was kind of nontraditional," Sickels recalls. "He'd been a Marine, and he came back and was studying illustration. He basically took me to a newsstand and showed me magazines and how these guys could create work to fit stories and work with writers."

Another big influence was Susan Curtis, an illustration instructor at the Art Academy of Cincinnati who helped Sickels find his own style. "My first few years in college, I was really inspired by Norman Rockwell, N.C. Wyeth and C.F. Payne," he says. "But there was an instructor who taught an advanced illustration class, and she took me to the downtown

MEGAN LANE PATRICK is a senior editor for *HOW* magazine and books. This article first appeared in *HOW*.

library and showed me books of illustrators who created their own worlds and their own characters, and the work wasn't based on models or shots of people in certain environments. She said that illustration can be more you and less based on real life. So, she taught me to play and just have fun in my sketchbooks.''

In those sketchbooks, Sickels' characters first came to life, but as his career grew, the sketchbooks became more personal. "I don't do job sketches in them," he say. "I just carry

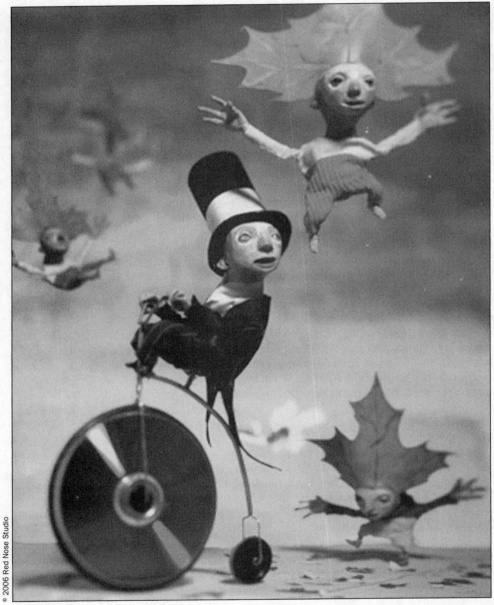

© 2006 Red Nose Studio

When Chris Sickels gets an assignment, he starts with sketches, "just playing," then narrows it down to three strongest concepts. Once the sketches are OK'd by the art director he sets about building the objects in 3-D, using the sketch as a blueprint. Read more about his process on his Web site, www.rednosestudio.com.

them with me. They're like little security blankets, so if I'm waiting someplace, I'll draw. Sometimes I'll draw people or I'll just draw out of my head.

"Usually, I try to do two or three sketchbooks a year where I just play," he continues. "Ninety-five percent of the drawings are horrible. I mean they're really just bad. But every now and then, there's this little gem that pops out or a character that really seems to say something. In the past, I'd always kept it personal, and just recently, I started to see that there's a lot of good material in those books and that I can really let those characters translate into the work I'm doing now."

Sickels also realized that the ideas in his sketchbooks had been popping up in his work subconsciously. "Like the guy sitting on the roof with the DVD cases," he says, referring to a project he worked on for *The New York Times*. "There was this sketch I did the summer before—I sat up on the roof watching a nighthawk and I did a drawing of it. Then I realized that that drawing was the seed for this idea, even though it was done eight months before."

It's the little things, like watching birds or rummaging through junk shops, that fuel Sickels' creativity. "There's a lot of stupid stuff that I like to look at," he says. "Living on State Route 9, there are all kinds of semis that come through, and they shake the whole house and they shake the studio, but they'll be carrying the weirdest things, anything from half of a house to a big shrink-wrapped yacht, to pieces of industrial equipment like big furnaces or parts of big wind harvesters like they have out West. There'll be two 60- or 80-foot propellers on a semi. And the machine or generator part is the size of a large dump truck. Stuff like that . . . I don't know if it's the scale, but it makes you feel like you're just a little part in this whole world."

Scale plays a pivotal role in Sickels' work. As he's discussing a new assignment with an art director, he'll make sketches and notations about what kinds of objects he might use to create a backdrop or props for the puppets. Anything is fair game for these creations. For one illustration, Sickels constructed an old-fashioned canister vacuum from a hodgepodge of materials including a garlic press, a tire gauge and the cord from an old electric skillet. "You kind of visualize it three-dimensionally or visualize the kind of objects that will be integrated into the piece," he says.

Sometimes these found objects decide the size of the puppets, which are usually 6 to 8 inches tall. "The objects take the pieces in different directions," Sickels says. "It's not always in your complete control. So you have to work with the objects instead of trying to bend the objects to fit your idea."

For a piece where the environment of the illustration is more important than the characters, Sickels starts with the background and uses existing puppets to work out the details. "If it's more about the puppet itself, then usually the head will kind of start it, because that head is the emotion," he explains. "In a lot of my pieces, the characteristics in the face are the soul of it. So the face is usually one of the first things to get done."

Sickles shapes the heads from Sculpey, a flesh-colored clay that can be hardened in the oven. The bodies are wire armatures covered with foam. And the fabric clothing is sewn right onto the puppets. "I'm always looking for fabric with a small weave for scale," he says. Despite these simple materials, the puppets are able to express a wide range of emotions.

"The sculptures sometimes look pretty crude, or the stitching is really rough, or the buildings are painted really sloppily," Sickels says. And that's where the camera comes in. "It hides so much. You throw something a little bit out of focus and it looks more detailed. So I try to use that illusion of the camera to its full advantage, especially with editorial timelines. You know, you may only have three days to do a piece."

Part of what inspired Sickels to move from drawing and painting his characters to creating them in 3-D was the challenge of learning how to use the camera. (He shoots with a couple of old 4×5 cameras and occasionally with a digital camera for small pieces.)

"Brian Steege shot a few pieces for me in the beginning, as well as another photographer in Cincinnati, Steve Paszt, and they were excited enough about the puppets that they let me come in on a slow day or after hours and they'd play around shooting the sets," he says. "I got to watch how they handled lights and how they handled the camera and even the test exposures. And then it was just trial and error."

When Sickels moved to Los Angeles for 18 months, he bought a camera of his own. He'd call his photographer friends for advice. "I had this little notebook, and I'd keep notes of each shot, so if I needed to replicate the lighting, I'd know what I did," he says. "Now I'm to the point where I'm a little better at playing things by ear. But it's taken about five years to get the photography under a little bit of control. I still don't know how to do it."

But, of course, he does. And it shows in his finished pieces, which is just fine with Sickels. He's the first to admit that he's happy to have his work speak for him. He says he's also grateful for the agent he found just before leaving Los Angeles.

"It was really interesting trying to find a rep; a lot of them were like used-car salesmen," he says. "You know they can sell your work to anybody, but do you really want to be doing work for cigarette companies or alcohol companies? And a lot of reps will have 50 different illustrators and cover everything from fluffy teddy bears to sweaty girls with beer bottles."

Then he found Chrystal Falcioni of Magnet Reps. "I think she has 10 or 11 illustrators, and they're very personal to how she works," he says. "She was an art director for about 10 years, so she has a keen sense of the industry. She's passionate about what she does and about her illustrators. It's worked out to be a good relationship. But that was hard to find.

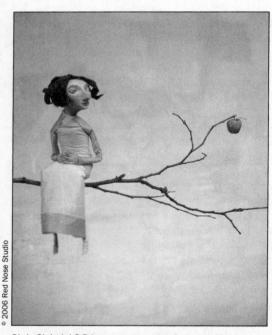

Chris Sickels' 3-D images are a cross between illustration, fine art, sculpture, set design and puppetry. This piece is a photograph of an actual figure sitting on a real tree limb. Photographed in front of Sickels' pale blue water color backdrop, the scene takes on a life of its own. The piece was originally created to illustrate an article on eating disorders in *AARP* magazine but has since been exhibited in galleries.

At that time, I was doing both the painting and 3-D work, and there were a ton of reps who couldn't see the practicality of the puppets. They were like, 'You gotta do paintings, people won't buy the 3-D stuff.' " But Falcioni was willing to take that chance.

And it's people like her who really boost Sickels' confidence. "The coolest thing for me is when an art director says, 'I don't have any brilliant ideas, but I trust you and I know you'll solve it,' " he says. "When they instill that little bit of confidence, it makes such a difference because I'm still at a stage where I consider myself pretty green. I think it's just part of me. I've never been a really outgoing, confident kind of guy. I think it takes a special art director to be able to do that. In a way, it makes their job easier and it makes the illustrator's job easier."

But Sickels is the last person to take it easy on himself. For the past few years, he's been teaching himself to make stop-motion animated shorts starring his puppets. And the most recent challenge he's set for himself is to become a better storyteller. "I'm pretty

happy with how I can do an image or a sequence of images,'' he says, ''but creating a story that progresses over time and has a conflict and a resolution—I haven't been able to wrap my head around it yet.''

The closest he's come is the work he did for The Red Thread Project, a collaboration with a local design firm and printer that's won three *HOW* design awards and several nods from printing competitions. ''I would walk around the house saying these stupid limericks, then I started putting drawings to them,'' he explains. ''They're not poetic, there's no rhythm to them, there's no math to them like a good poem. But that's how my work is. It isn't really graceful. It's usually pretty awkward—like if the puppet moved, he'd fall off or he'd trip or he'd run into a wall. It's a bit of beauty and a bit of awkwardness. And I think that's kind of how I am.''

The Art of Business

Craig Thompson

Chunky Rice *and* Blankets:
Cure for Ailing Comics Image

© Greg Preston

by Lauren Mosko

When Craig Thompson was in high school, he refused to set foot in a comic book store. "I loved comics as a kid, but then I fell out of love with the medium. I wanted to stop being as much of a nerd and grow up a bit and have girls like me," he laughs. "I had friends who were always trying to sell me on comics or take me to a comics store, but it always made me uncomfortable."

It wasn't that he didn't appreciate sequential art; it was the *image* of comic books that turned him off. "For one thing, I didn't think it should be a primarily masculine adolescent form," Thompson explains. "The stories you can tell [with the medium] could be much more quiet and sensitive and intimate than these terrible superhero and science fiction/fantasy stories."

He also felt the traditional saddle-stitched binding of comics and the way they were treated contributed to the notion that the material was insubstantial. "I like having books; I like having something with a spine that you can put on a bookshelf," Thompson says. "That whole collector market of people putting little comic books in plastic bags and keeping them in boxes in their dens, I found really repulsive. I just wanted to break out of that [mentality] and get back to the medium itself."

Thompson was convinced comics had the potential to reach a much broader audience. He issued a challenge to himself and re-entered the world of comics, with the intent to bend and/ or break all preconceptions about the form. He answered his own call to arms with the critically acclaimed and commercially successful graphic novels *Goodbye, Chunky Rice* (Top Shelf, 2000) and *Blankets* (2003) and the travelogue *Carnet de Voyage* (2004), which have earned not only Harvey, Eisner and Ignatz awards but also quite a devoted following among avid comics consumers. In interview after interview, however, Thompson reiterates that it's really new readers— those more reluctant or skeptical about the medium—he's trying to appeal to with his work because he remembers that time when he counted himself among them.

Here, Thompson shares his own thoughts on his work, on the comics medium and where it's headed, and on the sacrifices necessary to create art.

Please talk about your creative process. Has it changed significantly from book to book?

Well, *Chunky Rice*, being my first book, was just made up as I went along. It was page by page, and I probably got 20 or 30 pages in when it was pointed out to me that the story didn't

LAUREN MOSKO is the editor of *Novel & Short Story Writer's Market* and a newly anointed comics geek.

have a beginning or an end. It was just floating in the middle of nowhere. So that's when I went back and I thumbnailed—did like a sketchy version—of a beginning and an end. And that was kind of like a revelation.

I didn't write out a script or screenplay but drew the first draft in comics form, albeit rough thumbnails. I remember the process being really quick with *Chunky*. Maybe there was a week when I sat down and was able to thumbnail the rest of the book out. And then things made sense and flowed better for me while drawing, and I was confident about what was coming next.

I spent almost a year thumbnailing *Blankets*, and when I reached the end, it felt like an end of the book, but it didn't feel like "the" end of the book. But because things were tied up enough I went ahead and started drawing the book, and when I reached the last chapter I totally reconfigured and rewrote it. I was kind of experiencing it in real time; my life was more directly influencing what I drew and wrote.

With the new book, I'm using that same method of thumbnailing everything ahead of time, but it's kind of driving me crazy. I'm still not drawing the final artwork and I've been working a year and a half or so on the thumbnails. Just editing and redrawing and reworking everything, taking out characters and adding new ones. I haven't even gotten to the true image-making of the book. Unlike *Blankets*, which I tried to make more sparse and breathable, the new book is just a lot more dense. It's taking a long time for some legitimate reasons and some stupid reasons. I think initially I had a good flow when I was writing it, but then I hit a big creative block. I had an epiphany about restructuring the whole narrative in a nonlinear way that kind of salvaged me from that block but it also complicated the whole process. I'd written like 400 pages and then kind of made a mess out of it.

I think *Carnet* was very refreshing because there was zero editing. It is my diary, straight to paper. In fact, I sent it to press while I was still on the trip. It was back from the press before I got back to the States. And there's something really fulfilling about the instantaneous aspect of that.

In your Fear of Speed interview, you were talking about *Blankets* and you said, "When I was writing it, that was me. Now that it's written, it's a character." That's some fascinating psychology. Can you talk a little bit more about that idea?

When I was writing *Blankets*, I was working so hard to relive those experiences and pin them down on paper, and ultimately I think I failed because the book isn't those moments. It's like a paper-and-ink reenactment from watered-down memories. It's not a reproduction. But at the same time, something new is born, something that has its own life. Some readers who meet me think they can identify with me because they know this character on the pages of my book, which is not really me. It's the part of myself I choose to depict; sometimes I flatter myself, sometimes I deprecate myself. In the end, anyway, it's just these clunky drawings.

Any kind of documentation is an abstraction from the reality. Everyone who keeps a diary talks about the fact that they tend to only journal during negative moments, when they're trying to work things out. When they look back they're like, that doesn't really represent my life at all. As soon as you try to pin something down in words or drawings, you're changing it—you *have to*. That's sort of the perpetual frustration of artists. In a way, it's better to do fantasy work like I'm doing now, because it doesn't have the pretense of being reality, and in some ways it's more honest.

Talk a little more about your upcoming graphic novel, *Habibi*. You're obviously pushing yourself again narratively—moving out of your own experience and into the realm of Arabian folk tale. What's your vision for the final artwork?

One of the things about making comics—and it must apply to lots of mediums, but for me personally—after I've spent 100 . . . 200 . . . 600 pages drawing something, I'm pretty sick

of it. That happened with *Chunky Rice*, where I was sick of the cute little animals with round heads and the slick brush line. I knew with my next book I wanted to do something a little more visually organic, like a looser brush line, and with human beings and with an environment that was more real to me.

But then I went crazy doing that with *Blankets*. I'd drawn 600 pages of myself as a character and of these mundane Midwestern landscapes, like pick-up trucks and these terrible ranch-style houses and cubicle-style churches. And so with the next book I wanted to do something big and fantastical and epic and outside of myself.

Actually I think I was throwing back and forth two notions of it either being this elaborate, fantastical, make-everything-up, crazy world or do something more socially and politically relevant, à la Joe Sacco. I do think *Habibi* is kind of a compromise using this Arabian Nights genre. It's fantastical but it can't escape the obvious Middle Eastern trappings. It can't avoid having certain social and political implications. And I think growing up with Biblical stories helps me write things allegorically.

Did you do photo research on the Middle East or will you draw from imagination?
It will be a combination. I definitely got really caught up in Islamic architecture and art, especially calligraphy. I think that was part of the core. There's something I'd read about beautiful Arabic calligraphy being the music of words and that echoed my own notion of comics being a music of drawings.

Reprinted with permission from Top Shelf.

Blankets, Craig Thompson's brutally honest yet tender graphic novel has been described as "achingly beautiful" by *TIME* magazine. Visit www.doot dootgarden.com to read more about Thompson's books and view his online portfolio.

All I hear is how impossible it is to break into comics/graphic novels. Please talk about your dues-paying experience. How did you come to work with Top Shelf?
I don't know if it's incredibly hard to break into graphic novels. A lot of people will send me mail asking how to become a graphic novelist, how to get published, how to get someone to pay you to work on your graphic novel, but basically you just have to make the comics yourself and start shopping it around to publishers. And some of them pay advances and most of them don't, so even then you're dependent on if the book sells, then you'll make some money from royalties.

I became acquainted with Top Shelf when they were just starting out as a company too. I did the dues paying thing when I was kind of like their little grunt. (laughs) They had a Kinko's connection and could get free photocopies, so the publisher Brett Warnock and I would go there after midnight and stay until five in the morning making photocopies and binding comics together. It was a really lo-fi sort of outfit back then.

I worked as a designer for them for a while, designing other cartoonists' books. And they'd pay me a token $50 here and there; I was definitely laboring towards getting my own book published. With *Chunky Rice*, there

was a tiny advance and the book started to do well and make royalties, but it still wasn't very significant financially. I paid for *Blankets* by working as an illustrator for three and a half years. And that's what paid the bills—*Nickelodeon* magazine.

How did you originally get the gig making copies for Top Shelf? Did you just send them a résumé and say, hey I want to help you guys out?

When I was living in Wisconsin, I was working a bunch of terrible jobs but making my own photocopied mini-comics. I was fortunate to have a great distribution connection through this other cartoonist, John Porcellino, who has been doing mini-comics for a long time, 10-15 years, and had a distribution company called Spit and a Half. And so my little mini-comics were able to get all around the state.

Brett Warnock, who started Top Shelf, sent me a letter while I was still in Wisconsin asking if I would be a part of this anthology that he did. I remember the anthology was a real mixed bag; some of it was great and some of it was awful. So I didn't respond to his letter until I ended up in Portland myself and I didn't have any friends. I dug up his info and gave him a call. At first he disregarded my call, because apparently he was getting calls all the time from young hopefuls wanting to get their foot in the door. But then he remembered who I was and that he'd actually sent me a letter and we started hanging out. It was a very young time in the company. They hadn't done any graphic novels; they were

Carnet de Voyage is Craig Thompson's sketch-book-journal of his two-month journey through Africa and Europe.

mainly doing an anthology. It was really just Brett in his living room. At the beginning of the next year, he joined up with Chris Staros. That's also when I was signed on.

Did they know you had book aspirations at the time?

Right away when I met Brett, I showed him my work. Of the handful of pages I had, he actually liked Chunky Rice, the turtle character, more than my other work. He kind of pointed out, "Oh I like this guy; if you do a whole book of him, I'll publish it." So I had that incentive. It was just going to be a pamphlet-style comic book of 60 pages or so but it kept growing and growing, especially after I sat and wrote out the rest of it. It ended up being a book, and it was one of their first books with a spine.

Why did you decide to get an agent?

Much of that was motivated by trying to figure out what to do with my next book—if I really wanted to do it with Top Shelf or with someone else—and I was also really overwhelmed with all the business distractions. All the constant interviews and business travel, people needing this or that, tons of e-mails—and so I was asking around like, what do I *do*? I was getting all kinds of suggestions, and I think it was a writer friend who first said, you need an agent.

When I talked with other cartoonists, they said, no you don't need an agent, they're just going to take some of your money. When I talked to people in the writing world, writers and authors would say, you need an agent; that's a no-brainer. (laughs) So I went through this long

phase of interviewing a lot of agents and trying to figure out if I really needed one.

It's kind of a new concept to the world of comics. I'm really happy with my decision. PJ [Mark] has helped me a lot. I'd talked to a number of people and some that were really nice but [I chose him because] he was familiar with my work and was a fan. It was nice; he said he'd be happy to help me verbally in any way, whether I chose him as an agent or not.

Are there many agents who represent cartoonists? How did you find PJ Mark?

I already had some connections with book publishers and had done a little bit of the ground-work myself, feeling out if they were interested in publishing me, but I still didn't know how I would go about negotiating a contract or how I would compare one publisher to the other. The editors I was talking to were very helpful. PJ's name came from two entirely different publishers. There were maybe two or three other names that also came up when I was asking around, because they had represented a number of cartoonists.

In your ADDTF interview, you were talking with Sean Collins about fighting pressure to serialize *Blankets*. You said, "I guess other cartoonists have a point that they have to make a living, but they're artists, godammit. They have to make some sacrifices for their art." I was struck by the passion in your comment, and so I have to ask: What sacrifices do you feel you have made for your own art?

Well (laughs), there was a lot of starvation in those last six years. When I first moved to Portland, I worked some really bad jobs while working on my comics. There was a time when I'd go to Taco Bell and wait for people to abandon unwrapped tacos on their plate. That's what I was living off of, surviving on. After *Chunky Rice* was out and had some success, I'd get my free copies from the printer and take them straight to the used bookstore and sell all of them so I could have groceries for that week.

Just last night I was with a friend and walking by this apartment I used to live in and it was terrible *terrible*, like ghetto-style. I lived there for five years. That's where I drew *Blankets*. It was just this really trashy, noisy, chaotic place. So that's what I traded to get my work done—a lot of creature comforts.

I expect to be poor again. I feel like I'm in a good upswing right now. Graphic novel is a huge buzzword in the literary industry; I don't know how long that's going to last. I expect there to be dry spells again.

There are a lot of things we don't have access to when we're artists. But that's not our world, that's not our calling. We're not in the world of material goods and that sort of success. It kind of reminds me of my parents' Christian upbringing, like you're laboring for something spiritual.

Even though you work as a full-time illustrator, do you think, with three illustrated novels and another on the way, that you've finally found your true calling—as a novelist? Do you even feel comfortable thinking of yourself as a novelist?

I usually just use the term cartoonist, which is an admittedly broad term. It could be a Disney animator, or someone who draws political cartoons for a newspaper, or someone who draws caricatures at the circus. But it has a certain old-fashioned sensibility to it that I like, sort of like a working-class draftsman.

Novelist still sounds a bit pretentious. I feel like I've labored so hard against the format that comics were known for and wanted them to be book form and novel-length comics. I was really troubled by the trappings of comic books, pamphlet form. But beyond that now, I'm comfortable again just calling them comics. At the time I thought it was important to say "illustrated novel" and separate it from all the preconceived notions of the medium.

Do you reject the term "illustrated novel" now? What will the cover of *Habibi* say: "a very long comic"?

(laughs) I think *Habibi* won't say anything. I don't regret it. I think the whole debate is a little bit boring and silly. It goes on a lot in the comics community. People are always trying to define the label. But I feel like I can justify my decision to put that on the book; I guess I could have put "a comic book" on the cover and that alone, [being] a huge book, would have challenged preconceptions. But I didn't want to use it at the time; I just felt there was too much of a negative connotation to the term "comic book."

But I think that's starting to change. And graphic novel is just like a hip catch phrase, it seems. I was at the Frankfurt book fair with my agent and we saw an advertisement for Chicken Soup for the Soul Graphic Novel. We thought that was pretty hilarious. That someone is very proud of themselves for fusing the two (laughs) into *an amazing new form*.

You said earlier that you expect to be poor again. Do you think graphic novels are around for a little while or do you think they're cooling off? I mean, don't things stop being cool when you get Chicken Soup for the Graphic Soul or whatever? Do you think the market is a little saturated already?

There's definitely room to grow. That won't be a problem. And it will be good because out of this explosion, there will come a handful of books that will stick around for a while. For a long time, all we've had is Art Spiegelman's *Maus* as something like a literary graphic novel, and that list has already grown pretty dramatically over the last 10 years. It will continue to grow at some kind of slow rate but there will be probably a saturation point. A lot of book publishers just want to publish graphic novels now and they're not really discerning what's good and what's not.

Comic books are ultimately books, and the book market—it's kind of unfathomable that it's still alive. People say every year, this is it, publishing is over, but it's still going on. And sometimes things come along and revitalize the literary world for a bit. But it's definitely an old-fashioned medium. We've got the Internet and video games now.

So I think it's past its heyday to some extent. But maybe it will exist in different formats. Maybe it will crossover to more digital comics. Most people I know still love handling an object in their hands, the smell of ink on paper, and again the quietness of the medium. They like that they can let their computers go to sleep and go read a book. So I think that will go on for a bit.

Again, going back to growing up Christian, my parents always had a very apocalyptic view that the world was going to end any day now, and to some extent that kind of feeling persists in me. Every time I hear jet planes going overhead, I'm like, oh here it is. And I'm kind of comfortable with that, to some extent. So I'll be surprised if the world even keeps going long enough for (laughs) books to be eliminated entirely.

What's the most important thing you've learned as your writing career evolved?

That it doesn't get any easier. Definitely when you're a young cartoonist—even before you're a cartoonist—you have to come to the realization that no matter what kind of crap job you're working or if you're going to school or paying school loans, you can't let those be excuses. You have to just start drawing. And that's the first big revelation you have and progress you make towards being a cartoonist, just not letting all those excuses get in the way.

I think I still held on to a notion that with more economic freedom, the creative parts would flow even easier. That's not really the case, or it hasn't been. There's still plenty of distractions and excuses you can make for not getting work done. I guess it goes back to that core thing I learned: You can't make excuses. (laughs) You can *always* make excuses, but you've just got to draw.

The Business of Art

How to Stay on Track and Get Paid

As you launch your artistic career, be aware that you are actually starting a small business. It is crucial that you keep track of the details, or your business will not last very long. The most important rule of all is to find a system to keep your business organized and stick with it.

YOUR DAILY RECORD-KEEPING SYSTEM

Every artist needs to keep a daily record of art-making and marketing activities. Before you do anything else, visit an office supply store and pick out the following items (or your own variations of these items). Keep it simple so you can remember your system and use it on automatic pilot whenever you make a business transaction.

What you'll need:

- A packet of colorful file folders or a basic Personal Information Manager on your computer or Palm Pilot.
- A notebook or legal pads to serve as a log or journal to keep track of your daily art-making and art marketing activities.
- A small pocket notebook to keep in your car to track mileage and gas expenses.

How to start your system

- Designate a permanent location in your studio or home office for two file folders and your notebook.
- Label one red file folder "Expenses."
- Label one green file folder "Income."
- Write in your daily log book each and every day.

Every time you purchase anything for your business, such as envelopes or art supplies, place the receipt in your red Expenses folder. When you receive payment for an assignment or painting, photocopy the check or place the receipt in your green Income folder. That's all there is to it.

Job jackets keep assignments on track

Whether you are an illustrator or fine artist, you should devise a system for keeping track of assignments and artworks. Most illustrators assign job numbers to each assignment they receive and create job jacket or file folders for each job. Some file these folders by client

name; others keep them in numerical order. The important thing is to keep all correspondence for each assignment in a spot where you can easily find it.

Pricing illustration and design

One of the hardest things to master is what to charge for your work. It's difficult to make blanket statements on this topic. Every slice of the market is somewhat different. Nevertheless, there is one recurring pattern: Hourly rates are generally only paid to designers working

Pricing Your Fine Art

Tips

There are no hard-and-fast rules for pricing your fine artwork. Most artists and galleries base prices on market value—what the buying public is currently paying for similar work. Learn the market value by visiting galleries and checking prices of works similar to yours. When you are starting out, don't compare your prices to established artists but to emerging talent in your region. Consider these when determining price:

- **Medium.** Oils and acrylics cost more than watercolors by the same artist. Price paintings higher than drawings.

- **Expense of materials.** Charge more for work done on expensive paper than for work of a similar size on a lesser grade paper.

- **Size.** Though a large work isn't necessarily better than a small one, as a rule of thumb you can charge more for the larger work.

- **Scarcity.** Charge more for one-of-a-kind works like paintings and drawings, than for limited editions such as lithographs and woodcuts.

- **Status of artist.** Established artists can charge more than lesser-known artists.

- **Status of gallery.** Prestigious galleries can charge higher prices.

- **Region.** Works usually sell for more in larger cities like New York and Chicago.

- **Gallery commission.** The gallery will charge from 30 to 50 percent commission. Your cut must cover the cost of materials, studio space, taxes and perhaps shipping and insurance, and enough extra to make a profit. If materials for a painting cost $25, matting and framing cost $37 and you spent five hours working on it, make sure you get at least the cost of material and labor back before the gallery takes their share. Once you set your price, stick to the same price structure wherever you show your work. A $500 painting by you should cost $500 whether it is bought in a gallery or directly from you. To do otherwise is not fair to the gallery and devalues your work.

As you establish a reputation, begin to raise your prices—but do so cautiously. Each time you graduate to a new price level, it becomes more difficult to come back down.

in house on a client's equipment. Freelance illustrators working out of their own studios are almost always paid a flat fee or an advance against royalties.

If you don't know what to charge, begin by devising an hourly rate, taking into consideration the cost of materials and overhead and what you think your time is worth. If you are a designer, determine what the average salary would be for a full-time employee doing the same job. Then estimate how many hours the job will take and quote a flat fee based on these calculations.

There is a distinct difference between giving the client a job estimate and a job quote. An estimate is a ballpark figure of what the job will cost but is subject to change. A quote is a set fee which, once agreed upon, is pretty much carved in stone. Make sure the client understands which you are negotiating. Estimates are often used as a preliminary step in itemizing costs for a combination of design services such as concepting, typesetting and printing. Flat quotes are usually used by illustrators, as there are fewer factors involved in arriving at fees.

For recommended fees for different services, refer to *Graphic Designer's Guide to Pricing, Estimating & Budgeting,* by Theo Stephan Williams and the *Graphic Artist's Guild's Handbook of Pricing & Ethical Guidelines,* 11th edition. Many artists' organizations have hotlines you can call to find out standard payment for the job you're doing.

As you set fees, certain stipulations call for higher rates. Consider these bargaining points:

- **Usage (rights).** The more rights purchased, the more you can charge. For example, if the client asks for a "buyout" (to buy all rights), you can charge more, because by relinquishing all rights to future use of your work, you will be losing out on resale potential.
- **Turnaround time.** If you are asked to turn the job around quickly, charge more.
- **Budget.** Don't be afraid to ask a project's budget before offering a quote. You won't want to charge $500 for a print ad illustration if the ad agency has a budget of $40,000 for that ad. If the budget is that big, ask for higher payment.
- **Reputation.** The more well known you are, the more you can charge. As you become established, periodically raise your rates (in small steps) and see what happens.

What goes in a contract?

Contracts are simply business tools to make sure everyone is in agreement. Ask for one any time you enter into a business agreement. Be sure to arrange for the specifics in writing or provide your own. A letter stating the terms of agreement signed by both parties can serve as an informal contract. Several excellent books, such as *Legal Guide for the Visual Artist* (Fourth Edition) and *Business and Legal Forms for Illustrators,* both by Tad Crawford (Allworth Press), contain negotiation checklists and tear-out forms and provide sample contracts you can copy. The sample contracts in these books cover practically any situation you might run into.

The items specified in your contract will vary according to the market you are dealing with and the complexity of the project. Nevertheless, here are some basic points you'll want to cover:

Commercial contracts

- **A description of the service you are providing.**
- **Deadlines for finished work.**
- **Rights sold.**
- **Your fee.** Hourly rate, flat fee or royalty.
- **Kill fee.** Compensatory payment received by you if the project is cancelled.
- **Changes fees.** Penalty fees to be paid by the client for last-minute changes.
- **Advances.** Any funds paid to you before you begin working on the project.

- **Payment schedule.** When and how often you will be paid for the assignment.
- **Statement regarding return of original art.** Unless you are doing work for hire, your artwork should always be returned to you.

Gallery contracts

- **Terms of acquisition or representation.** Will the work be handled on consignment? What is the gallery's commission?
- **Nature of the show(s).** Will the work be exhibited in group or solo shows or both?
- **Time frames.** At what point will the gallery return unsold works to you? When will the contract cease to be in effect? If a work is sold, when will you be paid?
- **Promotion.** Who will coordinate and pay for promotion? What does promotion entail? Who pays for printing and mailing of invitations? If costs are shared, what is the breakdown?
- **Insurance.** Will the gallery insure the work while it is being exhibited?
- **Shipping.** Who will pay for shipping costs to and from the gallery?
- **Geographic restrictions.** If you sign with this gallery, will you relinquish the rights to show your work elsewhere in a specified area? If so, what are the boundaries of this area?

© 2006 Zach Trenholm

Staying current on today's celebrities can be a marketable strategy if you are skilled at getting a likeness of popular personalities. Zach Trenholm's award-winning portrait caricatures have appeared in *TIME*, *Newsweek*, *US News & World Report* and *Fortune*. See more of Trenholm's work at www.zachtrenholm.com.

How to send invoices

If you are a designer or illustrator, you will be responsible for sending invoices for your services. Clients generally will not issue checks without them, so mail or fax an invoice as soon as you've completed the assignment. Illustrators are generally paid in full either upon receipt of illustration or on publication. Most graphic designers arrange to be paid in thirds, billing the first third before starting the project, the second after the client approves the initial roughs and the third upon completion of the project.

Standard invoice forms allow you to itemize your services. The more you spell out the charges, the easier it will be for your clients to understand what they are paying for. Most freelancers charge extra for changes made after approval of the initial layout. Keep a separate form for change orders and attach it to your invoice.

If you are an illustrator, your invoice can be much simpler, as you'll generally be charging a flat fee. It's helpful, in determining your quoted fee, to itemize charges according to time, materials and expenses. (The client need not see this itemization; it is for your own purposes.)

Most businesses require your social security number or tax ID number before they can cut a check, so include this information in your bill. Be sure to put a due date on each invoice; include the phrase ''payable within 30 days'' (or other preferred time frame) directly on your invoice. Most freelancers ask for payment within 10-30 days.

Sample invoices are featured in *Business and Legal Forms for Illustrators* and *Business and Legal Forms for Graphic Designers*, by Tad Crawford (Allworth Press).

If you are working with a gallery, you will not need to send invoices. The gallery should send you a check each time one of your pieces is sold (generally within 30 days). To ensure that you are paid promptly, call the gallery periodically to touch base. Let the director or business manager know that you are keeping an eye on your work. When selling work independently of a gallery, give receipts to buyers and keep copies for your records.

Take advantage of tax deductions

You have the right to deduct legitimate business expenses from your taxable income. Art supplies, studio rent, printing costs and other business expenses are deductible against your gross art-related income. It is imperative to seek the help of an accountant or tax preparation service in filing your return. In the event your deductions exceed profits, the loss will lower your taxable income from other sources.

To guard against taxpayers fraudulently claiming hobby expenses as business losses, the IRS requires taxpayers demonstrate a ''profit motive.'' As a general rule, you must show a profit three out of five years to retain a business status. If you are audited, the burden of proof will be on you to demonstrate your work is a business and not a hobby.

The nine criteria the IRS uses to distinguish a business from a hobby are:

- the manner in which you conduct your business
- expertise
- amount of time and effort put into your work
- expectation of future profits
- success in similar ventures
- history of profit and losses
- amount of occasional profits
- financial status
- element of personal pleasure or recreation

If the IRS rules that you paint for pure enjoyment rather than profit, they will consider you a hobbyist. Complete and accurate records will demonstrate to the IRS that you take your business seriously.

Can I Deduct My Home Studio?

Important

If you freelance full time from your home and devote a separate area to your business, you may qualify for a home office deduction. If eligible, you can deduct a percentage of your rent or mortgage and utilities and expenses like office supplies and business-related telephone calls.

The IRS does not allow deductions if the space is used for reasons other than business. A studio or office in your home must meet three criteria:

- The space must be used exclusively for your business.

- The space must be used regularly as a place of business.

- The space must be your principle place of business.

The IRS might question a home office deduction if you are employed full time elsewhere and freelance from home. If you do claim a home office, the area must be clearly divided from your living area. A desk in your bedroom will not qualify. To figure out the percentage of your home used for business, divide the total square footage of your home by the total square footage of your office. This will give you a percentage to work with when figuring deductions. If the home office is 10% of the square footage of your home, deduct 10% of expenses such as rent, heat and air conditioning.

The total home office deduction cannot exceed the gross income you derive from its business use. You cannot take a net business loss resulting from a home office deduction. Your business must be profitable three out of five years. Otherwise, you will be classified as a hobbyist and will not be entitled to this deduction.

Consult a tax advisor before attempting to take this deduction, since its interpretations frequently change.

For additional information, refer to IRS Publication 587, Business Use of Your Home, which can be downloaded at www.irs.gov or ordered by calling (800)829-3676.

The Art of Business

Even if you are a "hobbyist," you can deduct expenses such as supplies on a Schedule A, but you can only take art-related deductions equal to art-related income. If you sold two $500 paintings, you can deduct expenses such as art supplies, art books and seminars only up to $1,000. Itemize deductions only if your total itemized deductions exceed your standard deduction. You will not be allowed to deduct a loss from other sources of income.

How to fill out a Schedule C

To deduct business expenses, you or your accountant will fill out a 1040 tax form (not 1040EZ) and prepare a Schedule C. Schedule C is a separate form used to calculate profit or loss from your business. The income (or loss) from Schedule C is then reported on the 1040 form. In regard to business expenses, the standard deduction does not come into play as it would for a hobbyist. The total of your business expenses need not exceed the standard deduction.

There is a shorter form called Schedule C-EZ for self-employed people in service industries.

It can be applicable to illustrators and designers who have receipts of $25,000 or less and deductible expenses of $2,000 or less. Check with your accountant to see if you qualify.

Deductible expenses include advertising costs, brochures, business cards, professional group dues, subscriptions to trade journals and arts magazines, legal and professional services, leased office equipment, office supplies, business travel expenses, etc. Your accountant can give you a list of all 100 percent and 50 percent deductible expenses (such as entertainment). And don't forget to deduct the cost of this book.

As a self-employed ''sole proprieter,'' there is no employer regularly taking tax out of your paycheck. Your accountant will help you put money away to meet your tax obligations and may advise you to estimate your tax and file quarterly returns.

Your accountant also will be knowledgeable about another annual tax called the Social Security Self-Employment tax. You must pay this tax if your net freelance income is $400 or more.

The fees of tax professionals are relatively low, and they are deductible. To find a good accountant, ask colleagues for recommendations, look for advertisements in trade publications or ask your local Small Business Association.

Whenever possible, retain your independent contractor status

Some clients automatically classify freelancers as employees and require them to file Form W-4. If you are placed on employee status, you may be entitled to certain benefits but a portion of your earnings will be withheld by the client until the end of the tax year and you could forfeit certain deductions. In short, you may end up taking home less than you would if you were classified as an independent contractor.

The IRS uses a list of 20 factors to determine whether a person should be classified as an independent contractor or an employee. This list can be found in the IRS Publication 937. Note, however, that your client will be the first to decide how you will be classified.

Report all income to Uncle Sam

Don't be tempted to sell artwork without reporting it on your income tax. You may think this saves money, but it can do real damage to your career and credibility—even if you are never audited by the IRS. Unless you report your income, the IRS will not categorize you as a professional, and you won't be able to deduct expenses. And don't think you won't get caught if you neglect to report income. If you bill any client in excess of $600, the IRS requires the client to provide you with a form 1099 at the end of the year. Your client must send one copy to the IRS and a copy to you to attach to your income tax return. Likewise, if you pay a freelancer over $600, you must issue a 1099 form. This procedure is one way the IRS cuts down on unreported income.

Register with the state sales tax department

Most states require a two to seven percent sales tax on artwork you sell directly from your studio or at art fairs or on work created for a client. You must register with the state sales tax department, which will issue you a sales permit or a resale number and send you appropriate forms and instructions for collecting the tax. Getting a sales permit usually involves filling out a form and paying a small fee. Reporting sales tax is a relatively simple procedure. Record all sales taxes on invoices and in your sales journal. Every three months, total the taxes collected and send it to the state sales tax department.

In most states, if you sell to a customer outside of your sales tax area, you do not have to collect sales tax. However, this may not hold true for your state. You may also need a business license or permit. Call your state tax office to find out what is required.

Helpful Resources

For More Info

Most IRS offices have walk-in centers open year-round and offer over 90 free IRS publications to help taxpayers. Some helpful booklets include Publication 334—Tax Guide for Small Business; Publication 505—Tax Withholding and Estimated Tax; and Publication 533—Self Employment Tax. Order by phone at (800)829-3676.

There's plenty of great advice on the Internet, too. Check out the official IRS Web site: www.irs.gov. Fun graphics lead you to information, and you can even download tax forms.

If you don't have access to the Web, the booklet that comes with your tax return forms contains addresses of regional Forms Distribution Centers you can write to for information.

The U.S. Small Business Administration offers seminars and publications to help you launch your business. Check out their extensive Web site at www.sba.gov.

Arts organizations hold many workshops covering business management, often including detailed tax information. Inquire at your local arts council, arts organization or university to see if a workshop is scheduled.

The Service Corp of Retired Executives (SCORE) offers free business counseling via e-mail at their Web site at www.score.org.

Save money on art supply sales tax

As long as you have the above sales permit number, you can buy art supplies without paying sales tax. You will probably have to fill out a tax-exempt form with your permit number at the sales desk where you buy materials. The reason you do not have to pay sales tax on art supplies is that sales tax is only charged on the final product. However, you must then add the cost of materials into the cost of your finished painting or the final artwork for your client. Keep all receipts in case of a tax audit. If the state discovers that you have not collected sales tax, you will be liable for tax and penalties.

If you sell all your work through galleries, they will charge sales tax, but you still need a tax exempt number to get a tax exemption on supplies.

Some states claim "creativity" is a non-taxable service, while others view it as a product and therefore taxable. Be certain you understand the sales tax laws to avoid being held liable for uncollected money at tax time. Contact your state auditor for sales tax information.

Save money on postage

When you send out postcard samples or invitations to openings, you can save big bucks by mailing bulk. Fine artists should send submissions via first class mail for quicker service and better handling. Package flat work between heavy cardboard or foam core, or roll it in a cardboard tube. Include your business card or a label with your name and address on the outside of the packaging material in case the outer wrapper becomes separated from the inner packing in transit.

Protect larger works—particularly those that are matted or framed—with a strong outer surface, such as laminated cardboard, masonite or light plywood. Wrap the work in polyfoam, heavy cloth or bubble wrap and cushion it against the outer container with spacers to keep

from moving. Whenever possible, ship work before it is glassed. If the glass breaks en route, it may destroy your original image. If you are shipping large framed work, contact a museum in your area for more suggestions on packaging.

The U.S. Postal Service will not automatically insure your work, but you can purchase up to $600 worth of coverage. Artworks exceeding this value should be sent by registered mail. Certified packages travel a little slower but are easier to track.

Consider special services offered by the post office, such as Priority Mail, Express Mail Next Day Service and Special Delivery. For overnight delivery, check to see which air freight services are available in your area. Federal Express automatically insures packages for $100 and will ship art valued up to $500. Their 24-hour computer tracking system enables you to locate your package at any time.

UPS automatically insures work for $100, but you can purchase additional insurance for work valued as high as $25,000 for items shipped by air (there is no limit for items sent on the ground). UPS cannot guarantee arrival dates but will track lost packages. It also offers Two-Day Blue Label Air Service within the U.S. and Next Day Service in specific zip code zones.

Before sending any original work, make sure you have a copy (photocopy, slide or transparency) in your files. Always make a quick address check by phone before putting your package in the mail.

Send us your business tips!

If you've discovered a business strategy we've missed, please write to *Artist's & Graphic Designer's Market*, 4700 East Galbraith Road, Cincinnati OH 45236 or e-mail us at artdesign@f wpubs.com. A free copy of the 2008 edition goes to the best five suggestions.

Copyright Basics

What You Need to Know

As creator of your artwork, you have certain inherent rights over your work and can control how each one of your artworks is used, until you sell your rights to someone else.

The legal term for these rights is called **copyright**. Technically, any original artwork you produce is automatically copyrighted as soon as you put it in tangible form.

To be automatically copyrighted, your artwork must fall within these guidelines:

- **It must be your *original* creation.** It cannot be a *copy* of somebody else's work.
- **It must be "pictorial, graphic, or sculptural."** Utilitarian objects, such as lamps or toasters, are not covered, although you can copyright an illustration featured on a lamp or toaster.
- **It must be fixed in "any tangible medium, now known or later developed."** Your work, or at least a representation of a planned work, must be created in or on a medium you can see or touch, such as paper, canvas, clay, a sketch pad or even a website. It can't just be an idea in your head. An idea cannot be copyrighted.

Copyright lasts for your lifetime plus seventy years

Copyright is *exclusive*. When you create a work, the rights automatically belong to you and nobody else but you until you sell those rights to someone else.

Works of art created on or after January 1978 are protected for your lifetime plus 70 years.

The artist's bundle of rights

One of the most important things you need to know about copyright is that it is not just a *singular* right. It is a *bundle* of rights you enjoy as creator of your artwork. Let's take a look at the five major categories in your bundle of rights and examine them individually:

- **Reproduction right.** You have the right to make copies of the original work.
- **Modification right.** You have the right to create derivative works based on the original work.
- **Distribution rights.** You have the right to sell, rent or lease copies of your work.
- **Public performance right.** The right to play, recite or otherwise perform a work. (This right is more applicable to written or musical art forms than visual art.)
- **Public display right.** You have the right to display your work in a public place.

This bundle of rights can be divided up in a number of ways, so that you can sell all or part of any of those exclusive rights to one or more parties. The system of selling parts of

your copyright bundle is sometimes referred to as **"divisible" copyright**. Just as a land owner could divide up his property and sell it to many different people, the artist can divide up his rights to an artwork and sell portions of those rights to different buyers.

Divisible copyright: Divide and conquer

Why is this so important? Because dividing up your bundle and selling parts of it to different buyers will help you get the most payment from each of your artworks. For any one of your artworks, you can sell your entire bundle of rights at one time (not advisable!) or divide and sell each bundle pertaining to that work into smaller portions and make more money as a result. You can grant one party the right to use your work on a greeting card and sell another party the right to print that same work on T-shirts.

Clients tend to use legal jargon to specify the rights they want to buy. The terms below are commonly used in contracts to specify portions of your bundle of rights. Some terms are vague or general, such as "all rights"; others are more specific, such as "first North American rights." Make sure you know what each term means.

Divisible copyright terms

- **One-time rights.** Your client buys the right to use or publish your artwork or illustration on a one-time basis. One fee is paid for one use. Most magazine and bookcover assignments fall under this category.
- **First rights.** This is almost the same as purchase of one-time rights, except that the buyer is also paying for the privilege of being the first to use your image. He may use it only once unless the other rights are negotiated.

 Sometimes first rights can be further broken down geographically when a contract is drawn up. The buyer might ask to buy **first North American rights,** meaning he would have the right to be the first to publish the work in North America.
- **Exclusive rights.** This guarantees the buyer's exclusive right to use the artwork in his particular market or for a particular product. Exclusive rights are frequently negotiated by greeting card and gift companies. One company might purchase the exclusive right to use your work as a greeting card, leaving you free to sell the exclusive rights to produce the image on a mug to another company.
- **Promotion rights.** These rights allow a publisher to use an artwork for promotion of a publication in which the artwork appeared. For example, if *The New Yorker* bought promotional rights to your cartoon, they could also use it in a direct mail promotion.
- **Electronic rights.** These rights allow a buyer to place your work on electronic media such as websites. Often these rights are requested with print rights.
- **Work for hire.** Under the Copyright Act of 1976, section 101, a "work for hire" is defined as "(1) a work prepared by an employee within the scope of his or her employment; or (2) a work . . . specially ordered or commissioned for use as a contribution to a collective, as part of a motion picture or audiovisual work or as a supplementary work . . . if the parties expressly agree in a written instrument signed by them that the work shall be considered a work made for hire." When the agreement is "work for hire," you surrender all rights to the image and can never resell that particular image again. If you agree to the terms, make sure the money you receive makes it well worth the arrangement.
- **All rights.** Again, be very aware that this phrase means you will relinquish your right to a specific artwork. Before agreeing to the terms, make sure this is an arrangement you can live with. At the very least, arrange for the contract to expire after a specified date. Terms for all rights—including time period for usage and compensation—should be confirmed in a written agreement with the client.

Since legally your artwork is your property, when you create an illustration for a magazine you are, in effect, temporarily "leasing" your work to the client for publication. Chances are you'll never hear an art director ask to lease or license your illustration, and he may not even realize he is leasing, not buying, your work. But most art directors know that once the magazine is published, the art director has no further claims to your work and the rights revert back to you. If the art director wants to use your work a second or third time, he must ask permission and negotiate with you to determine any additional fees you want to charge. You are free to take that same artwork and sell it to another buyer.

However, had the art director bought "all rights," you could not legally offer that same image to another client. If you agreed to create the artwork as "work for hire," you relinquished your rights entirely.

What licensing agents know

The practice of leasing parts or groups of an artist's bundle of rights is often referred to as **"licensing,"** because (legally) the artist is granting someone a "license" to use his work for a limited time for a specific reason. As licensing agents have come to realize, it is the exclusivity of the rights and the ability to divide and sell them that make them valuable. Knowing exactly what rights you own, which you can sell, and in what combinations will help you negotiate with your clients.

Don't sell conflicting rights to different clients

You also have to make sure the rights you sell to one client don't conflict with any of the rights sold to other clients. For example, you can't sell the exclusive right to use your image on greeting cards to two separate greeting card companies. You *can* sell the exclusive greeting card rights to one card company and the exclusive rights to use your artwork on mugs to a separate gift company. It's always good to get such agreements in writing and to let both companies know your work will appear on other products.

When to use the Copyright © and credit lines

A copyright notice consists of the word "Copyright" or its symbol ©, the year the work was created or first published and the full name of the copyright owner. It should be placed where it can easily be seen, on the front or back of an illustration or artwork. It's also common to print your copyright notice on slide mounts or onto labels on the back of photographs.

Under today's laws, placing the copyright symbol on your work isn't absolutely necessary to claim copyright infringement and take a plagiarist to court if he steals your work. If you browse through magazines, you will often see the illustrator's name in small print near the illustration, *without* the Copyright ©. This is common practice in the magazine industry. Even though the © is not printed, the illustrator still owns the copyright unless the magazine purchased all rights to the work. Just make sure the art director gives you a credit line near the illustration.

Usually you will not see the artist's name or credit line alongside advertisements for products. Advertising agencies often purchase all rights to the work for a specified time. They usually pay the artist generously for this privilege and spell out the terms clearly in the artist's contract.

How to register a copyright

To register your work with the U.S. Copyright Office, call the Copyright Form Hotline at (202) 707-9100 and ask for package 115 and circulars 40 and 40A. Cartoonists should ask for package 111 and circular 44. You can also write to the Copyright Office, Library of Congress,

The Art of Business

101 Independence Ave. SE, Washington DC 20559, Attn: Information Publications, Section LM0455.

You can also download forms from the Copyright Office website at www.copyright.gov. Whether you call or write, they will send you a package containing Form VA (for visual artists). Registering your work costs $30.

After you fill out the form, return it to the Copyright Office with a check or money order for $30, a deposit copy or copies of the work and a cover letter explaining your request. For almost all artistic work, deposits consist of transparencies (35mm or $2^1/_4 \times 2^1/_4$) or photographic prints (preferably $8^1/_2 \times 10$). Send one copy for unpublished works; two copies for published works.

You can register an entire collection of your work rather than one work at a time. That way you will only have to pay one $30 fee for an unlimited number of works. For example if you have created a hundred works between 2003 and 2004, you can send a copyright form VA to register "the collected work of Jane Smith, 2003-2004." But you will have to send either slides or photocopies of each of those works.

Why register?

It seems like a lot of time and trouble to send in the paperwork to register copyrights for all your artworks. It may not be necessary or worth it to you to register every artwork you create. After all, a work is copyrighted the moment it's created anyway, right?

The benefits of registering are basically to give you additional clout in case an infringement occurs and you decide to take the offender to court. Without a copyright registration, it probably wouldn't be economically feasible to file suit, because you'd be only entitled to your damages and the infringer's profits, which might not equal the cost of litigating the case. Had the works been registered with the U.S. Copyright office, it would be easier to prove your case and get reimbursed for your court costs.

Likewise, the big advantage of using the copyright © also comes when and if you ever have to take an infringer to court. Since the copyright © is the most clear warning to potential plagiarizers, it is easier to collect damages if the © is in plain sight.

Register with the U.S. Copyright Office those works you fear are likely to be plagiarized before or shortly after they have been exhibited or published. That way, if anyone uses your work without permission, you can take action.

Deal swiftly with plagiarists

If you suspect your work has been plagiarized and you have not already registered it with the Copyright Office, register it immediately. You have to wait until it is registered before you can take legal action against the infringer.

Before taking the matter to court, however, your first course of action might be a well-phrased letter from your lawyer telling the offender to "cease and desist" using your work, because you have a registered copyright. Such a warning (especially if printed on your lawyer's letterhead) is often enough to get the offender to stop using your work.

Don't sell your rights too cheaply

Recently a controversy has been raging about whether or not artists should sell the rights to their work to stock illustration agencies. Many illustrators strongly believe selling rights to stock agencies hurts the illustration profession. They say artists who deal with stock agencies, especially those who sell royalty-free art, are giving up the rights to their work too cheaply.

Another pressing copyright concern is the issue of electronic rights. As technology makes it easier to download images, it is more important than ever for artists to protect their work against infringement.

Copyright Resources

For More Info

The U.S. Copyright Website (www.copyright.gov), the official site of the U.S. Copyright Office, is very helpful and will answer just about any question you can think of. Information is also available by phone at (202) 707-3000. Another great site, called The Copyright Website, is located at http://benedict.com.

A few great books on the subject are *Legal Guide for the Visual Artist*, by Tad Crawford (Allworth Press); *The Rights of Authors, Artists, and other Creative People*, by Kenneth P. Norwick and Jerry Simon Chasen (Southern Illinois University Press); *Electronic Highway Robbery: An Artist's Guide to Copyrights in the Digital Era*, by Mary E. Carter (Peachpit Press). *The Business of Being an Artist*, by Daniel Grant (Allworth Press), contains a section on obtaining copyright/trademark protection on the Internet.

Log on to www.theispot.com and discuss copyright issues with your fellow artists. Join organizations that crusade for artists' rights, such as the Graphic Artist's Guild (www.gag.org) or The American Institute of Graphic Arts (www.aiga.org). Volunteer Lawyers for the Arts (www.vlany.org) is a national network of lawyers who volunteer free legal services to artists who can't afford legal advice. A quick search of the Web will help you locate a branch in your state. Most branches offer workshops and consultations.

The Art of Business

Promoting Your Work

Let Your Artwork Work for You

So you're ready to launch your freelance art or gallery career. How do you let people know about your talent? One way is by introducing yourself to them by sending promotional samples. Samples are your most important sales tool so put a lot of thought into what you send. Your ultimate success depends largely on the impression they make.

We divided this article into three sections, so whether you are a fine artist, illustrator or designer, check the appropriate heading for guidelines. Read individual listings and section introductions thoroughly for more specific instructions.

As you read the listings, you'll see the term SASE, short for self-addressed, stamped envelope. Enclose a SASE with your submissions if you want your material returned. If you send postcards or tearsheets, no return envelope is necessary. Many art directors only want nonreturnable samples. More and more, busy art directors do not have time to return samples, even with SASEs. So read listings carefully and save stamps.

ILLUSTRATORS AND CARTOONISTS

You will have several choices when submitting to magazines, book publishers and other illustration and cartoon markets. Many freelancers send a cover letter and one or two samples in initial mailings. Others prefer a simple postcard showing their illustrations. Here are a few of your options:

Postcard. Choose one (or more) of your illustrations or cartoons that is representative of your style, then have the image printed on postcards. Have your name, address, phone number, e-mail and Web site printed on the front of the postcard or in the return address corner. Somewhere on the card should be printed the word "Illustrator" or "Cartoonist." If you use one or two colors, you can keep the cost below $200. Art directors like postcards because they are easy to file or tack on a bulletin board. If the art director likes what she sees, she can always call you for more samples. For more on postcard mailings see Postcards on page 47.

Promotional sheet. If you want to show more of your work, you can opt for an 8½×11 color or black and white photocopy of your work. No matter what size sample you send, never fold the page. It is more professional to send them flat, in a 9×12 envelope, along with a typed query letter, preferably on your own professional stationery.

Tearsheets. After you complete assignments, acquire copies of any printed pages on which your illustrations appear. Tearsheets impress art directors because they are proof that you are experienced and have met deadlines on previous projects.

Photographs. Some illustrators have been successful sending photographs, but printed or photocopied samples are preferred by most art directors. It is probably not practical or effective to send slides.

Rebecca Hahn's promotional postcard broadcasts both her unique style and her Web site's URL to art directors. The above postcard garnered assignments with *Bitch* (three illustrations), *Vim & Vigor* (two illustrations), *Girlfriends* (one illustration) and *Delaware Bride* (two illustrations) for a total of more than $1,700. Visit her Web site at www.rebeccahahn.com to see more of her work.

Query or cover letter. A query letter is a nice way to introduce yourself to an art director for the first time. One or two paragraphs stating you are available for freelance work is all you need. Include your phone number, samples or tearsheets.

E-mail submissions. E-mail is another great way to introduce your work to potential clients. When sending e-mails, provide a link to your Web site or JPEGs of your best work.

DESIGNERS AND COMPUTER ARTISTS

Plan and create your submission package as if it were a paying assignment from a client. Your submission piece should show your skill as a designer. Include one or both of the following:

Cover letter. This is your opportunity to show you can design a beautiful, simple logo or letterhead for your own business card, stationery and envelopes. Have these all-important pieces printed on excellent quality bond paper. Then write a simple cover letter stating your experience and skills.

Sample. Your sample can be a copy of an assignment you have done for another client or a clever self-promotional piece. Design a great piece to show off your capabilities. For ideas and inspiration, browse through *Designers' Self-Promotion: How Designers and Design Companies Attract Attention to Themselves*, by Roger Walton (HBI).

STAND OUT FROM THE CROWD

You may only have a few seconds to grab art directors' attention as they make their way through the ''slush'' pile (an industry term for unsolicited submissions). Make yourself stand out in simple, effective ways:

Tie in your cover letter with your sample. When sending an initial mailing to a potential client, include a cover letter of introduction with your sample. Type it on a great-looking letterhead of your own design. Make your sample tie in with your cover letter by repeating a design element from your sample onto your letterhead. List some of your past clients within your letter.

Send artful invoices. After you complete assignments, a well-designed invoice (with one of your illustrations or designs strategically placed on it, of course) will make you look professional and help art directors remember you—and hopefully, think of you for another assignment.

Print and Mail Through the USPS

Tip

If you're looking for a convenient, timesaving and versatile service for printing and mailing promotional postcards consider the U.S. Postal Service. USPS offers a postcard service through their Web site. You can have promotional postcards printed either on 4×6 or 6×9 glossy cardstock and buy as many or as little as you need. Premium Postcards™ cost 84 cents for 4×6 and $1.32 for 6×9—which includes the cost of postage.

One drawback of going through the USPS is that you can't order a certain amount of postcards to keep on hand—cards must be addressed through the Web site and are mailed out for you automatically. But you can essentially create a personal database and simply click on an address and mail a promo card whenever needed. You can upload different images to the site, www.usps.com, and create postcards that are geared to specific companies. (When you visit the site, click on ''Send Cards, Letters & Flyers'' in the Mailing Tools box.)

Follow up with seasonal promotions. Many illustrators regularly send out holiday-themed promo cards. Holiday promotions build relationships while reminding past and potential clients of your services. It's a good idea to get out your calendar at the beginning of each year and plan some special promos for the year's holidays.

ARE PORTFOLIOS NECESSARY?

You do not need to send a portfolio when you first contact a market. But after buyers see your samples they may want to see more, so have a portfolio ready to show.

Many successful illustrators started their careers by making appointments to show their portfolios. But it is often enough for art directors to see your samples.

Some markets in this book have drop-off policies, accepting portfolios one or two days a

© 2005 Lynn Jeffery

Lynn Jeffery's "Click and Pick" postcards really piqued art directors' curiosity and garnered 10 assignments from new clients. The card lured art directors to go online and choose outfits for one of Jeffery's whimsical characters. Once they played with the animated paperdoll on Jeffery's Web site, art directors viewed the rest of her online portfolio. Check out www.lynnjeffery.com where you can view more illustrations and animation.

week. You will not be present for the review and can pick up the work a few days later, after they've had a chance to look at it. Since things can get lost, include only duplicates that can be insured at a reasonable cost. Only show originals when you can be present for the review. Label your portfolio with your name, address and phone number.

PORTFOLIO POINTERS

The overall appearance of your portfolio affects your professional presentation. It need not be made of high-grade leather to leave a good impression. Neatness and careful organization are essential whether you are using a three-ring binder or a leather case. The most popular portfolios are simulated leather with puncture-proof sides that allow the inclusion of loose samples. Choose a size that can be handled easily. Avoid the large, "student" size books which are too big to fit easily on an art director's desk. Most artists choose 11×14 or 18×24. If you are a fine artist and your work is too large for a portfolio, bring your slides and a few small samples.

- **Don't include everything you've done in your portfolio.** Select only your best work and choose pieces germane to the company or gallery you are approaching. If you're showing your book to an ad agency, for example, don't include greeting card illustrations.
- **Show progressives.** In reviewing portfolios, art directors look for consistency of style and skill. They sometimes like to see work in different stages (roughs, comps and finished pieces) to see the progression of ideas and how you handle certain problems.
- **Allow your work to speak for itself when presenting your portfolio.** It's best to keep explanations to a minimum and be available for questions if asked. Prepare for the review by taking along notes on each piece. If the buyer asks a question, take the opportunity to talk a little bit about the piece in question. Mention the budget, time frame and any problems you faced and solved. If you are a fine artist, talk about how the piece fits into the evolution of a concept and how it relates to other pieces you've shown.
- **Leave a business card.** Don't ever walk out of a portfolio review without leaving the buyer a sample to remember you by. A few weeks after your review, follow up by sending a small promo postcard or other sample as a reminder.

GUIDELINES FOR FINE ARTISTS

Send a 9×12 envelope containing material galleries request in their listings. Usually that means a query letter, slides and résumé, but check each listing. Some galleries like to see more. Here's an overview of the various components you can include:

- **Slides.** Send 8-12 slides of similar work in a plastic slide sleeve (available at art supply stores). To protect slides from being damaged, insert slide sheets between two pieces of cardboard. Ideally, slides should be taken by a professional photographer, but if you must take your own slides, refer to *The Quick & Easy Guide to Photographing Your Artwork*, by Roger Saddington (North Light Books), or *Photographing Your Artwork*, by Russell Hart and Nan Star (Amherst Media). Label each slide with your name, the title of the work, media and dimensions of the work and an arrow indicating the top of the slide. Include a list of titles and suggested prices they can refer to as they review slides. Make sure the list is in the same order as the slides. Type your name, address, phone number, e-mail and Web site at the top of the list. Don't send a variety of unrelated work. Send work that shows one style or direction.
- **Query letter or cover letter.** Type one or two paragraphs expressing your interest in showing at the gallery, and include a date and time when you will follow up.
- **Résumé or bio.** Your résumé should concentrate on your art-related experience. List

any shows your work has been included in and the dates. A bio is a paragraph describing where you were born, your education, the work you do and where you have shown in the past.

- **Artist's statement.** Some galleries require a short statement about your work and the themes you are exploring. Your statement should show you have a sense of vision. It should also explain what you hope to convey in your work.
- **Portfolios.** Gallery directors sometimes ask to see your portfolio, but they can usually judge from your slides whether your work would be appropriate for their galleries. Never visit a gallery to show your portfolio without first setting up an appointment.
- **SASE.** If you need material back, don't forget to include a SASE.

Greeting Cards, Gifts & Products

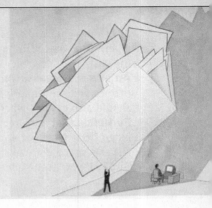

The companies listed here contain some great potential clients for you. Although greeting card publishers make up the bulk of the listings, you'll also find hundreds of other opportunities. The businesses in this section need images for all kinds of other products: paper plates, napkins, banners, shopping bags, T-shirts, school supplies, personal checks, calendars—you name it. We've included manufacturers of everyday items, like mugs, as well as companies looking for fine art for limited edition collectibles.

THE BEST WAY TO ENTER THE MARKET

1. Read the listings carefully to learn exactly what products each company makes and the specific styles and subject matter they use.

2. Visit stores. Browse store shelves to see what's out there. Take a notebook and jot down the types of cards and products you see. If you want to illustrate greeting cards, familiarize yourself with the various categories of cards and note which images tend to appear again and again in each category.

3. Track down trends. Pay attention to the larger trends in society. Society's move toward diversity, openness and acceptance is reflected in the cards we buy. There has also been a return to patriotism. Fads such as reality TV, as well as popular celebrities, often show up in images on cards and gifts. Trends can also be spotted in movies, national magazines and on Web sites.

WHAT TO SUBMIT

- Do *not* send originals. Companies want to see photographs, photocopies, printed samples, computer printouts, slides or tearsheets.
- Before you make copies of your sample, render the original artwork in watercolor or gouache in the standard industry size, $4^{5}/_{8} \times 7^{1}/_{2}$ inches.
- Artwork should be upbeat, brightly colored and appropriate to one of the major categories or niches popular in the industry.
- When creating greeting card art, leave some space at the top or bottom of the artwork, because cards often feature lettering there. Check stores to see how much space to leave. It is not necessary to add lettering, because companies often prefer to use staff artists to create lettering.
- Have color photocopies or slides made of your completed artwork. (See listings for specific instructions.)
- Make sure each sample is labeled with your name, address, phone number, e-mail address and Web site.

Insider Tips You Can Use

Tips

Linda King Davey spent 10 years at Paramount Cards as a creative planner, humor manager and creative director and served as creative vice president at Marian Heath for five years. Now she's working as a freelance illustrator, editor and art director. Here, she gives her observations on how to increase your salability in a changing market.

1 Due to increased belt tightening, greeting card companies have fewer in-house artists, or else they've eliminated them entirely. This is good news for freelancers. More companies are buying freelance versus internally generated art.

2 Art directors want to identify an artist with one specific look. The ability to do various styles of illustration was once thought to increase an artist's marketability, but having multiple styles in your portfolio is not as highly regarded these days and can possibly be a drawback.

3 In recent years, consumer acceptance of contemporary looks has grown. The demand for creative, unique and innovative techniques is great.

4 Art directors typically have difficulty finding designs for specific categories, such as Wedding Congratulations, First Communion, Graduation and so on. You may want to consider doing speculative designs in these areas.

5 Create designs that utilize popular greeting card finishes like foil, emboss, glitter and virko (raised, plastic coating). Art directors will appreciate having these processes considered as an integral part of the design.

6 When sending a portfolio, make it clear what you want returned and what the art director can keep on file. Always include samples or photocopies that can be kept on file with your name, phone and e-mail address on each piece.

—Cindy Duesing

- Send three to five appropriate samples of your work to the contact person named in the listing. Include a brief (one to two paragraph) cover letter with your initial mailing.
- Enclose a self-addressed stamped envelope if you need your samples back.
- Within six months, follow up with another mailing to the same listings and additional companies you have researched.

Submitting to gift & product companies

Send samples similar to those you would send to greeting card companies, only don't be concerned with leaving room at the top of the artwork for a greeting. Some companies prefer you send postcard samples or color photocopies. Check the listings for specifics.

Greeting Card Basics

Important

- **Approximately 7 billion** greeting cards are purchased annually, generating more than $7.5 billion in retail sales.

- **Women** buy 85 to 90% of all cards.

- **The average person** receives eight birthday cards a year.

- **Seasonal cards** express greetings for more than 20 different holidays, including Christmas, Easter and Valentine's Day.

- **Everyday cards** express nonholiday sentiments. The "everyday" category includes get well cards, thank you cards, sympathy cards, and a growing number of person-to-person greetings. There are cards of encouragement that say "Hang in there!" and cards to congratulate couples on staying together, or even getting divorced! There are cards from "the gang at the office" and cards to beloved pets. Check the rows and rows of cards in store racks to note the many "everyday" occasions.

- **Birthday cards** are the most popular everyday cards, accounting for 60% of sales of everyday cards.

- **Categories** are further broken down into the following areas: **traditional**, **humorous** and "**alternative**" cards. "Alternative" cards feature quirky, sophisticated or offbeat humor.

- **The most popular card-sending holidays,** according to the Greeting Card Association, are (in order):

1. Christmas
2. Valentine's Day
3. Mother's Day
4. Easter
5. Father's Day
6. Thanksgiving
7. Halloween
8. St. Patrick's Day
9. Jewish New Year
10. Hannukkah
11. Grandparent's Day
12. Sweetest Day
13. Passover
14. Secretary's Day
15. National Boss's Day
16. April Fool's Day
17. Nurses' Day

Payment and royalties

Most card and product companies pay set fees or royalty rates for design and illustration. Card companies almost always purchase full rights to work, but some are willing to negotiate for other arrangements, such as greeting card rights only. If the company has ancillary plans in mind for your work (calendars, stationery, party supplies or toys), they will probably want to buy all rights. In such cases, you may be able to bargain for higher payment. For more tips, see Copyright Basics on page 51.

Don't overlook the collectibles market

Limited edition collectibles—everything from Dale Earnhardt collector plates to *Wizard of Oz* ornaments—appeal to a wide audience and are a lucrative niche for artists. To do well in this field, you have to be flexible enough to take suggestions. Companies test market to find

out which images will sell the best, so they will guide you in the creative process. For a collectible plate, for example, your work must fit into a circular format or you'll be asked to extend the painting out to the edge of the plate.

Popular themes for collectibles include patriotic images, Native American, wildlife, animals (especially kittens and puppies), children, religious (including madonnas and angels), stuffed animals, dolls, TV nostalgia, gardening, culinary and sports images.

E-cards

If you are at all familiar with the Internet, you know that electronic greeting cards are everywhere. Many can be sent for free, but they drive people to Web sites so they are a big bonus for Web sites to offer visitors. The most popular e-cards are animated, and there is an increasing need for artists who can animate their own designs for the Web, using Flash animation. To look at the range in electronic greeting cards, visit a few sites, such as www.hallmark.com, www.bluemountain.com, and www.americangreetings.com, and do a few Web searches. Companies often post their design needs on their Web sites.

Helpful Resources

For More Info

Greetings etc. (www.greetingsmagazine.com) is the official publication of the Greeting Card Association (www.greetingcard.org). Subscriptions are reasonably priced. To subscribe call (973)252-0100 or subscribe online (and while you're there, sign up for their monthly e-newsletter).

Party & Paper is a trade magazine focusing on the party niche. Visit their website at www.partypaper.com for industry news and subscription information.

The National Stationery Show, the "main event" of the greeting card industry, is held each May at New York City's Jacob K. Javits Center. Visit www.nationalstationeryshow.com to learn more about that important event. Other industry events are held across the country each year. For upcoming trade show dates, check *Greetings etc.* or *Party & Paper.*

ALASKA MOMMA, INC.

303 Fifth Ave., New York NY 10016. (212)679-4404. Fax: (212)696-1340. E-mail: licensing@alaskamomma.com. **President, licensing:** Shirley Henschel. "We are a licensing company representing artists, illustrators, designers and established characters. We ourselves do not buy artwork. We act as a licensing agent for the artist. We license artwork and design concepts such as wildlife, florals, art deco and tropical to toy, clothing, giftware, textiles, stationery and housewares manufacturers and publishers."

Needs "We are looking for people whose work can be developed into dimensional products. An artist must have a distinctive and unique style that a manufacturer can't get from his own art department. We need art that can be applied to products such as posters, cards, puzzles, albums, bath accessories, figurines, calendars, etc. No cartoon art, no abstract art, no b&w art."

First Contact & Terms "Artists may submit work in any form as long as it is a fair representation of their style." Prefers to see several multiple color samples in a mailable size. No originals. "We are interested in artists whose work is suitable for a licensing program. We do not want to see b&w art drawings. What we need to see are transparencies or color photographs or color photocopies of finished art. We need to see a consistent style in a fairly extensive package of art. Otherwise, we don't really have a feeling for what the artist can do. The artist should think about products and determine if the submitted material is suitable for licensed products. Please send SASE so the samples can be returned. We work on royalties that run from 5-10% from our licensees. We require an advance against royalties from all customers. Earned royalties depend on whether the products sell."

Tips "Publishers of greeting cards and paper products have become interested in more traditional and conservative styles. There is less of a market for novelty and cartoon art. We need artists more than ever as we especially need fresh talent in a difficult market. Look at product! Know what companies are willing to license."

ALEF JUDAICA, INC.

8440 Warner Dr., Culver City CA 90232. (310)202-0024. Fax: (310)202-0940. E-mail: alon@alefjudaica.com. **President:** Alon Rozov. Estab. 1979. Manufacturer and distributor of a full line of Judaica, including menorahs, Kiddush cups, greeting cards, giftwrap, tableware, etc.

Needs Approached by 15 freelancers/year. Works with 10 freelancers/year. Buys 75-100 freelance designs and illustrations/year. Prefers local freelancers with experience. Works on assignment only. Uses freelancers for new designs in Judaica gifts (menorahs, etc.) and ceramic Judaica. Also for calligraphy, pasteup and mechanicals. All designs should be upper scale Judaica.

First Contact & Terms Mail brochure, photographs of final art samples. Art director will contact artist for portfolio review if interested, or portfolios may be dropped off every Friday. Sometimes requests work on spec before assigning a job. Pays $300 for illustration/design; pays royalties of 10%. Considers buying second rights (reprint rights) to previously published work.

ALLPORT EDITIONS

2337 NW York, Portland OR 97210-2112. (503)223-7268. Fax: (503)223-9182. E-mail: info@allport.com. Web site: www.allport.com. **Contact:** Creative Director. Estab. 1983. Produces greeting cards and stationery. Specializes in greeting cards fine art, humor, florals, animals and collage.

Needs Approached by 200 freelancers/year. Works with 5-10 freelancers/year. Buys 80 freelance designs and illustrations/year. Art guidelines available on Web site. Uses freelancers mainly for art for cards. Prefers art scaleable to card size. Produces material for all holidays and seasons, birthdays and everyday. Submit seasonal material 1 year in advance.

First Contact & Terms Illustrators/Artists: Send query letter with photocopies or photographs and SASE. Accepts submissions on disk compatible with PC-formatted TIFF or JPEG files with Illustrator, Photoshop or Quark document. Samples are filed or returned by SASE. Responds in 3 months. Portfolio review not required. Rights purchased vary according to project. All contracts on royalty basis. Pays for illustration by the project. Finds freelancers through artists' submissions and stationery show in New York.

Tips "Submit enough samples for us to get a feel for your style/collection. Two is probably too few, 40 is too many."

AMCAL, INC., MeadWestvaco Consumer and Office Products

Courthouse Plaza NE, Dayton OH 45463. (937)495-3046 or (800)798-6323. Fax: (937)495-3192. E-mail: calendars@meadwestvaco.com. Web site: www.amcalart.com or www.meadwestvaco.com. Publishes calendars, note cards, Christmas cards and other books and stationery items. "Markets to a broad distribution channel, including better gifts, books, department stores and larger chains throughout U.S. Some sales to Europe, Canada and Japan. We look for illustration and design that can be used many ways: calendars, note cards, address books and more, so we can develop a collection. We license art that appeals to a widely female audience." No gag humor or cartoons.

Needs Prefers work in horizontal format. Art guidelines for SASE with first-class postage, on our Web site or "you can call and request."

First Contact & Terms Illustrators: Send query letter with brochure, résumé, photographs, SASE, slides, tear-sheets and transparencies. Include a SASE for return of submission. Responds within 6 weeks. Will contact artist for portfolio review if interested. Pays for illustration by the project, advance against royalty.

Tips "Research what is selling and what's not. Go to gift shows and visit lots of stationery stores. Read all the trade magazines. Talk to store owners."

AMERICAN GREETINGS CORPORATION
One American Rd., Cleveland OH 44144. (216)252-7300. E-mail: jim.hicks@amgreetings.com. Web site: www.amgreetings.com. **Director of Creative Recruitment:** James E. Hicks. Estab. 1906. Produces greeting cards, stationery, calendars, paper tableware products, giftwrap and ornaments "a complete line of social expressions products." Also recruiting for AG Interactive. Also looking for skills in Flash, Photoshop, strong drawing skills and animation.

Needs Prefers artists with experience in illustration, decorative design and calligraphy. Usually works from a list of 100 active freelancers. Guidelines available for SASE.

First Contact & Terms Send query letter with résumé. "Do not send samples." Pays $200 and up based on complexity of design. Does not offer royalties.

Tips "Get a BFA in Graphic Design with a strong emphasis on typography."

AMSCAN INC.
80 Grasslands Rd., Elmsford NY 10523. (914)345-2020. Fax: (914)345-8431. **Contact:** Erika Pozzuto. Estab. 1954. Designs and manufactures paper party goods. Extensive line includes paper tableware, invitations, giftwrap and bags, decorations. Complete range of party themes for all ages, all seasons and all holidays. Features a gift line which includes baby hard and soft goods, wedding giftware, and home decorative and tabletop products. Seasonal giftware also included.

Needs "Ever-expanding department with incredible appetite for fresh design and illustration. Subject matter varies from baby, juvenile, floral, type-driven and graphics. Designing is accomplished both in the traditional way by hand (i.e., painting) or on the computer using a variety of programs like FreeHand, Illustrator, Painter and Photoshop."

First Contact & Terms "Send samples or copies of artwork to show us range of illustration styles. If artwork is appropriate, we will pursue." Pays by the project $300-3,500 for illustration and design.

ANW CRESTWOOD/THE PAPER COMPANY/PAPER ADVENTURES
(formerly Leader Paper Products/Paper Adventures), 501 Ryerson Road, Lincoln Park NJ 07035. (973)406-5000. Fax: (973)709-9494. E-mail: katey@anwcrestwood.com. Web site: www.anwcrestwood.com. **Creative Department Contact:** Katey Franceschini. Estab. 1901. Company produces stationery, scrapbook and paper crafting. Specializes in stationery, patterned papers, stickers and related paper products.

Needs Approached by 100 freelancers/year. Works with 20 freelancers/year. Buys or licenses 150 freelance illustrations and design pieces/year. Prefers freelancers with experience in illustration/fine art, stationery design/surface design. Works on assignment only. Considers any medium that can be scanned.

First Contact & Terms Freelancers send or e-mail nonreturnable color samples. Company will call if there is a current or future project that is relative. Accepts Mac-compatible disk and e-mail submissions. Samples are filed for future projects. Will contact artist for more samples and to discuss project. Pays for illustration by the project, $100 and up. Also considers licensing for complete product collections. Finds freelancers through tradeshows and *Artist's & Graphic Designer's Market.*

Tips "Research the craft and stationery market and send only appropriate samples for scrapbooking, cardcrafting and stationery applications. Send lots of samples, showing your best, neatest and cleanest work with a clear concept."

APPLEJACK ART PARTNERS
(formerly Applejack Licensing International), Box 1527, Historic Route 7A, Manchester Center VT 05255. (802)362-3662. Fax: (802)362-3286. E-mail: jess@applejackart.com. Web site: www.applejackart.com. **Contact:** Jess Rogers, manager of art sourcing and artist support. Licenses art for balloons, bookmarks, calendars, CD-ROMs, collectible figurines, decorative housewares, decorations, games, giftbags, gifts, giftwrap, greeting cards, limited edition plates, mugs, ornaments, paper tableware, party supplies, personal checks, posters, prints, school supplies, stationery, T-shirts, textiles, toys, wallpaper, etc.

Needs Extensive artwork for use on wide cross section of product categories. Looking for variety of styles and subject matter. Art guidelines free for SASE with first class postage. Considers all media and all styles. Prefers

final art under 24×36, but not required. Produces material for all holidays. Submit seasonal material 6 months in advance.
First Contact & Terms Artists: Send brochure, photocopies, photographs, slides, tearsheets, transparencies, CD-ROM and SASE. Illustrators: Send query letter with photocopies, photographs, photostats, transparencies, tearsheets, résumé and SASE. No e-mail submissions. Accepts disk submissions compatible with Photoshop, Quark or Illustrator. Samples are filed or returned by SASE. Responds in 1 month. Will contact artist for portfolio review if interested. Portfolio should include color final art, photographs, photostats, roughs, slides, tearsheets.

AR-EN PARTY PRINTERS, INC.
8225 N. Christiana Ave., Skokie IL 60076. (847)673-7390. Fax: (847)673-7379. E-mail: info@ar-en.net. Web site: ar-en.com. **Owner:** Gary Morrison. Estab. 1978. Produces stationery and paper tableware products. Makes personalized party accessories for weddings and all other affairs and special events.
Needs Works with 1-2 freelancers/year. Buys 10 freelance designs and illustrations/year. Art guidelines not available. Works on assignment only. Uses freelancers mainly for new designs. Also for calligraphy. Looking for contemporary and stylish designs, especially b&w line art, no gray scale, to use for hot stamping dyes. Prefers small (2×2) format.
First Contact & Terms Send query letter with brochure, résumé and SASE. Samples are filed or returned by SASE if requested by artist. Responds in 2 weeks. Company will contact artist for portfolio review if interested. Rights purchased vary according to project. Pays by the hour, $40 minimum; by the project, $750 minimum.
Tips "My best new ideas always evolve from something I see that turns me on. Do you have an idea/style that you love? Market it. Someone out there needs it."

ART LICENSING INTERNATIONAL INC.
7350 So. Tamiami Trail #227, Sarasota FL 34231. (941)966-8912. Fax: (941)966-8914. E-mail: artlicensing@comcast.net. Web site: www.artlicensinginc.com. **Contact:** Michael Woodward, president. Licenses art and photography for fine art prints, calendars, decorative housewares, gifts, greeting cards, jigsaw puzzles, etc.
 • Please see listing in Artists' Reps section.

ARTFUL GREETINGS
P.O. Box 52428, Durham NC 27717. (919)598-7599. Fax: (919)598-8909. E-mail: myw@artfulgreetings.com. Web site: www.artfulgreetings.com. **Vice President of Operations:** Marian Whittedalderman. Estab. 1990. Produces bookmarks, greeting cards, T-shirts and magnetic notepads. Specializes in multicultural subject matter, all ages.
Needs Approached by 200 freelancers/year. Works with 10 freelancers/year. Buys 20 freelance designs and illustrations/year. No b&w art. Pastel chalk media does not reproduce as bright enough color for us. Uses freelancers mainly for cards. Considers bright color art, no photographs. Looking for art depicting people of all races. Prefers a multiple of 2 sizes 5×7 and 5½×8. Produces material for Christmas, Mother's Day, Father's Day, graduation, Kwanzaa, Valentine's Day, birthdays, everyday, sympathy, get well, romantic, thank you, woman-to-woman and multicultural. Submit seasonal material 1 year in advance.
First Contact & Terms Designers: Send photocopies, SASE, slides, transparencies (call first). Illustrators: Send photocopies (call first). May send samples and queries by e-mail. Samples are filed. Artist should follow up with call or letter after initial query. Will contact for portfolio review of color slides and transparencies if interested. Negotiates rights purchased. Pays for illustration by the project $50-100. Finds freelancers through word of mouth, NY Stationery Show.
Tips "Don't sell your one, recognizable style to all the multicultural card companies."

ARTVISIONS
Licensing agency. E-mail: see Web site. Web site: www.artvisions.com. Estab. 1993. "Not currently seeking new talent. However, we are always willing to view the work of top-notch established artists. For details and contact information, please see our listing in the Artists' Reps section."

THE ASHTON-DRAKE GALLERIES
9200 N. Maryland Ave., Niles IL 60714. E-mail: adartist@ashtondrake.com. Web site: www.collectiblestoday.com. Estab. 1985. Direct response marketer of collectible dolls, ornaments and figurines. Clients consumers, mostly women of all age groups.
Needs Approached by 300 freelance artists/year. Works with 250 freelance doll artists, sculptors, costume designers and illustrators/year. Works on assignment only. Uses freelancers for illustration, wigmaking, porcelain decorating, shoemaking, costuming and prop making. Prior experience in giftware design and doll design a plus. Subject matter includes babies, toddlers, children, brides and fashion. Prefers "cute, realistic and natural human features."

First Contact & Terms Send or e-mail query letter with résumé and copies of samples to be kept on file. Prefers photographs, tearsheets or photostats as samples. Samples not filed are returned. Responds in 1 month. Compensation by project varies. Concept illustrations are done "on spec." Sculptors receive contract for length of series on royalty basis with guaranteed advances.

Tips "Please make sure we're appropriate for you. Visit our Web site before sending samples!"

BARTON-COTTON INC.

1405 Parker Rd., Baltimore MD 21227. (410)247-4800. Fax: (410)247-3681. E-mail: carol.bell@bartoncotton.com. **Contact:** Carol Bell, art buyer. Produces religious greeting cards, commercial all-occasion, Christmas cards, wildlife designs and spring note cards. Licenses wildlife art, photography, traditional Christmas art for note cards, Christmas cards, calendars and all-occasion cards.

Needs Buys 150-200 freelance illustrations/year. Submit seasonal work any time. Free art guidelines for SASE with first-class postage and sample cards; specify area of interest (religious, Christmas, spring, etc.).

First Contact & Terms Send query letter with résumé, tearsheets, photocopies or slides. Submit full-color work only (watercolor, gouache, pastel, oil and acrylic). Previously published work and simultaneous submissions accepted. Responds in 1 month. Pays by the project. Pays on acceptance.

Tips "Good draftsmanship is a must. Spend some time studying current market trends in the greeting-card industry. There is an increased need for creative ways to paint traditional Christmas scenes with up-to-date styles and techniques."

FREDERICK BECK ORIGINALS

51 Bartlett Ave., Pittsfield MA 01201. (413)443-0973. Fax: (413)445-5014. **Art Director:** Mark Brown. Estab. 1953. Produces silk screen printed Christmas cards, traditional to contemporary.

- This company is under the same umbrella as Editions Limited and Gene Bliley Stationery. One submission will be seen by all companies, so there is no need to send three mailings. Frederick Beck and Editions Limited designs are a little more high end than Gene Bliley designs. The cards are sold through stationery and party stores, where the customer browses through thick binders to order cards, stationery or invitations imprinted with customer's name. Though some of the same cards are repeated or rotated each year, all companies are always looking for fresh images. Frederick Beck and Gene Bliley's sales offices are still in North Hollywood, CA, but art director works from Pittsfield office.

BEISTLE COMPANY

1 Beistle Plaza, Shippensburg PA 17257-9623. (717)532-2131. Fax: (717)532-7789. E-mail: beistle@cvn.net. Web site: www.beistle.com. Art Director: Rick Buterbaugh. Estab. 1900. Manufacturer of paper and plastic decorations, party goods, gift items, tableware and greeting cards. Targets general public, home consumers through P-O-P displays, specialty advertising, school market and other party good suppliers.

Needs Approached by 250-300 freelancers/year. Works with 50 freelancers/year. Prefers artists with experience in designer gouache illustration. Also needs digital art (Macintosh platform or compatible). Art guidelines available. Looks for full-color, camera-ready artwork for separation and offset reproduction. Works on assignment only. Uses freelance artists mainly for product rendering and brochure design and layout. Prefers digital art using various styles and techniques. 50% of freelance design and 50% of illustration demand knowledge of QuarkXPress, Illustrator, Photoshop or Painter.

First Contact & Terms Send query letter with résumé and color reproductions with SASE. Samples are filed or returned by SASE. Art director will contact artist for portfolio review if interested. Sometimes requests work on spec before assigning a job. Pays by the project. Considers buying second rights (reprint rights) to previously published work. Finds artists through word of mouth, magazines, submissions/self-promotions, sourcebooks, agents, visiting artists' exhibitions, art fairs and artists' reps.

Tips "Our primary interest is in illustration; often we receive freelance propositions for graphic designbrochures, logos, catalogs, etc. These are not of interest to us as we are manufacturers of printed decorations. Send color samples rather than b&w."

BEPUZZLED/UNIVERSITY GAMES

2030 Harrison St., San Francisco CA 94110. (415)503-1600. Fax: (415)503-0085. **Creative Services Manager:** Susan King. Estab. 1986. Produces games and puzzles for children and adults. "Bepuzzled mystery jigsaw games challenge players to solve an original whodunit thriller by matching clues in the mystery with visual clues revealed in the puzzle."

Needs Works with 20 freelance artists/year. Buys 20-40 designs and illustrations/year. Prefers local artists with experience in children's book and adult book illustration. Uses freelancers mainly for box cover art, puzzle images and character portraits. All illustrations are done to spec. Considers many media.

First Contact & Terms Send query letter with brochure, résumé, tearsheets or other nonreturnable samples.

Samples are filed. Art director will contact artist for portfolio review if interested. Portfolio should include original/final art and photographs. Original artwork is returned at the job's completion. Sometimes requests work on spec before assigning a job. Pays by the project, $300-3,000. Finds artists through word of mouth, magazines, submissions, sourcebooks, agents, galleries, reps, etc.

BERGQUIST IMPORTS, INC.

1412 Hwy. 33 S., Cloquet MN 55720. (218)879-3343. Fax: (218)879-0010. E-mail: bbergqu106@aol.com. Web site: www.bergquistimports.com. **President:** Barry Bergquist. Estab. 1948. Produces paper napkins, mugs and tile. Wholesaler of mugs, decorator tile, plates and dinnerware.

Needs Approached by 25 freelancers/year. Works with 5 freelancers/year. Buys 50 designs and illustrations/year. Prefers freelancers with experience in Scandinavian designs. Works on assignment only. Also uses freelancers for calligraphy. Produces material for Christmas, Valentine's Day and everyday. Submit seasonal material 6-8 months in advance.

First Contact & Terms Send query letter with brochure, tearsheets and photographs. Samples are not filed and are returned. Responds in 2 months. Request portfolio review in original query. Artist should follow up with a letter after initial query. Portfolio should include roughs, color tearsheets and photographs. Rights purchased vary according to project. Originals are returned at job's completion. Requests work on spec before assigning a job. Pays by the project, $50-300; average flat fee of $100 for illustration/design; or royalties of 5%. Finds artists through word of mouth, submissions/self-promotions and art fairs.

GENE BLILEY STATIONERY

51 Bartlett Ave., Pittsfield MA 01201-0989. (413)443-0973. Fax: (413)445-5014. **Art Director:** Mark Brown. General Manager: Gary Lainer. Sales Manager: Ron Pardo. Estab. 1967. Produces stationery, family-oriented birth announcements and invitations for most events and Christmas cards.

● This company also owns Editions Limited and Frederick Beck Originals. One submission will be seen by both companies. See listing for Editions Limited/Frederick Beck.

BLOOMIN' FLOWER CARDS

4734 Pearl St., Boulder CO 80301. (800)894-9185. Fax: (303)545-5273. E-mail: don@bloomin.com. Web site: http://bloomin.com. **President:** Don Martin. Estab. 1995. Produces greeting cards, stationery and gift tags—all embedded with seeds.

Needs Approached by 100 freelancers/year. Works with 5-8 freelancers/year. Buys 5-8 freelance designs and illustrations/year. Art guidelines available. Uses freelancers mainly for card images. Considers all media. Looking for florals, garden scenes, holiday florals, birds, and butterflies—bright colors, no photography. Produces material for Christmas, Easter, Mother's Day, Father's Day, Valentine's Day, Earth Day, birthdays, everyday, get well, romantic and thank you. Submit seasonal material 8 months in advance.

First Contact & Terms Designers: Send query letter with color photocopies and SASE or electronic files. Illustrators: Send postcard sample of work, color photocopies or e-mail. Samples are filed or returned with letter if not interested. Responds if interested. Portfolio review not required. Rights purchased vary according to project. Pays royalties for design. Pays by the project or royalties for illustration. Finds freelancers through word of mouth, submissions, and local artists' guild.

Tips "All submissions MUST be relevant to flowers and gardening."

BLUE MOUNTAIN ARTS

P.O. Box 1007, Boulder CO 80306. (303)417-6513. Fax: (303)447-0939. E-mail: jkauflin@sps.com. Web site: www.sps.com. **Contact:** Jody Kauflin, art director. Estab. 1970. Produces books, bookmarks, calendars, greeting cards, mugs and prints. Specializes in handmade looking greeting cards, calendars and books with inspirational or whimsical messages accompanied by colorful hand-painted illustrations.

Needs Art guidelines free with SASE and first-class postage or on Web site. Uses freelancers mainly for hand-painted illustrations. Considers all media. Product categories include alternative cards, alternative/humor, conventional, cute, inspirational and teen. Submit seasonal material 10 months in advance. Art size should be 5×7 vertical format for greeting cards.

First Contact & Terms Send query letter with photocopies, photographs, SASE and tearsheets. Send no more than 5 illustrations initially. No phone calls, faxes or e-mails. Samples are filed or are returned by SASE. Responds in 2 months. Portfolio not required. Buys all rights. Pays freelancers flat rate; $150-250/illustration if chosen. Finds freelancers through artists' submissions and word of mouth.

Tips "We are an innovative company, always looking for fresh and unique art styles to accompany our sensitive or whimsical messages. We also welcome illustrated cards accompanied with your own editorial content. We strive for a hand-made look. We love color! We don't want photography! We don't want slick computer art! Do in-store research to get a feel for the look and content of our products. We want illustrations for printed

cards, NOT E-CARDS! We want to see illustrations that fit with our existing looks and we also want fresh, new and exciting styles and concepts. Remember that people buy cards for what they say. The illustration is a beautiful backdrop for the message.''

BLUE MOUNTAIN WALLCOVERINGS

(formerly Imperial Home Decor Group), 15 Akron Rd., Toronto ON M8W 1T3 Canada. (416)251-1678. Fax: (416)251-8968. Web site: www.blmtn.com. **Contact:** Dan Scott. Produces wallpaper.

Needs Works with 20-50 freelancers/year. Prefers local designers/illustrators with experience in wallpaper. Art guidelines available. Product categories include conventional, country, juvenile and teen. 5% of freelance work demands knowledge of Photoshop.

- Blue Mountain Wallcoverings acquired Imperial Home Decor Group, Inc. (IHDG) in February 2004, creating one of the largest manufacturers and distributors of wallcoverings in the world.

First Contact & Terms Send brochure, photocopies and photographs. Samples are filed. Responds only if interested. Company will contact artist for portfolio review of color, finished art, original art, photographs, transparencies if interested. Buys rights for wallpaper and/or all rights. Pays freelancers by the project. Finds freelancers through agents, artists' submissions and word of mouth.

BLUE SKY PUBLISHING

6595 Odell Place, Suite C, Boulder CO 80301. (303)530-4654. E-mail: bspinfo@blueskypublishing.net. Web site: www.blueskypublishing.net. **Contact:** Robert Marqueen. Estab. 1989. Produces greeting cards. ''At Blue Sky Publishing, we are committed to producing contemporary fine art greeting cards that communicate reverence for nature and all creatures of the earth, that express the powerful life-affirming themes of love, nurturing and healing, and that share different cultural perspectives and traditions, while maintaining the integrity of our artists' work. Our mainstay is our photographic card line of Winter in the West and other breathtaking natural scenes. We use well known landmarks in Arizona, New Mexico, Colorado and Utah that businesses in the West purchase as their corporate holiday greeting cards.''

Needs Approached by 500 freelancers/year. Works with 3 freelancers/year. Licenses 10 fine art pieces/year. Works with freelancers from all over US. Prefers freelancers with experience in fine art media oils, oil pastels, acrylics, calligraphy, vibrant watercolor and fine art photography. Art guidelines available for SASE. ''We primarily license existing pieces of art or photography. We rarely commission work.'' Looking for colorful, contemporary images with strong emotional impact. Art guidelines for SASE with first-class postage. Produces cards for all occasions. Submit seasonal material 1 year in advance.

First Contact & Terms Send query letter with SASE, slides or transparencies. Samples are filed or returned if SASE is provided. Responds in 4 months if interested. Transparencies are returned at job's completion. Pays royalties of 3% with a $150 advance against royalties. Buys greeting card rights for 5 years (standard contract; sometimes negotiated).

Tips ''We're interested in seeing artwork with strong emotional impact. Holiday cards are what we produce in biggest volume. We are looking for joyful images, cards dealing with relationships, especially between men and women, with pets, with Mother Nature and folk art. Vibrant colors are important.''

THE BRADFORD EXCHANGE

9333 Milwaukee Ave., Niles IL 60714. (847)581-8217. Fax: (847)581-8221. E-mail: squigley@bradfordexchange. com. Web site: www.collectiblestoday.com. **Artist Relations:** Suzanne Quigley. Estab. 1973. Produces and markets collectible products, including collector plates, ornaments, music boxes, cottages and figurines.

Needs Approached by thousands of freelancers/year. ''We're seeking talented freelance designers, illustrators and artists to work with our product development teams.'' Prefers artists with experience in rendering painterly, realistic, ''finished'' scenes. Uses freelancers for all work including concept sketching, border designs, sculpture. Traditional representational style is best, depicting children, pets, wildlife, homes, religious subjects, fantasy art, animation, celebrities, florals or songbirds in idealized settings.

First Contact & Terms Prefers designers send color references or samples of work you have done or a CD, along with a résumé and additional information. Please do not send original work or items that are one of a kind. Samples are filed in our Artist Resource file and are reviewed by product development team members as concepts are created that would be appropriate for your work. Art Director will contact artist only if interested. ''We offer competitive compensation.''

BRISTOL GIFT CO., INC.

P.O. Box 425, 6 North St., Washingtonville NY 10992. (845)496-2821. Fax: (845)496-2859. E-mail: bristol6@fron tiernet.net. Web site: www.bristolgift.net. **President:** Matt Ropiecki. Estab. 1988. Produces framed pictures for inspiration and religious markets.

Needs Approached by 5-10 freelancers/year. Art guidelines available for SASE. Works with 2 freelancers/year.

Buys 15-30 freelance designs and illustrations/year. Works on assignment only. Uses freelancers mainly for design. Also for calligraphy, P-O-P displays, Web design and mechanicals. Prefers 16×20 or smaller. 10% of design and 60% of illustration require knowledge of PageMaker or Illustrator. Produces material for Christmas, Mother's Day, Father's Day and graduation. Submit seasonal material 6 months in advance.

First Contact & Terms Send query letter with brochure and photocopies. Samples are filed or are returned. Responds in 2 weeks. Company will contact artist for portfolio review if interested. Portfolio should include roughs. Requests work on spec before assigning a job. Originals are not returned. Pays by the project $30-50 or royalties of 5-10%. Rights purchased vary according to project. Interested in buying second rights (reprint rights) to previously published artwork.

BRUSH DANCE INC.

165 N. Redwood Dr. Ste. 200, San Rafael CA 94903. (800)531-7445. Fax: (415)491-4938. E-mail: lkalloch@brush dance.com. Web site: www.brushdance.com. **Contact:** Liz Kalloch, art director. Estab. 1989. Produces greeting cards, blank journals, illustrated journals, gift books, boxed notes, calendars and magnets. "The line of Brush Dance products is inspired by the interplay of art and words. We develop products that combine powerful and playful words and images that act as daily reminders that inspire, connect, challenge and support."

Needs Approached by 200 freelancers/year. Works with 3-5 freelancers/year. Uses freelancers for illustration and calligraphy. Looking for nontraditional work conveying emotion or message. We are also interested in artists who are using both images and original words in their work.

First Contact & Terms Check our Web site for artist guidelines. Send query letter and tearsheets or color copies of your work. *Please don't send us transparencies, and never send originals.* Samples are filed or returned by SASE. Pays on a royalty basis with percentage depending on product. Finds artists through word of mouth, submissions, art shows.

Tips *"Please* do your research, and look at our Web site to be sure your work will fit into our line of products."

CAN CREATIONS, INC.

Box 848576, Pembroke Pines FL 33084. (954)581-3312. E-mail: judy@cancreations.com. Web site: www.cancre ations.com. **President:** Judy Rappoport. Estab. 1984. Manufacturer of Cello wrap.

Needs Approached by 8-10 freelance artists/year. Works with 2-3 freelance designers/year. Assigns 5 freelance jobs/year. Prefers local artists only. Works on assignment only. Uses freelance artists mainly for "design work for cello wrap." Also uses artists for advertising design, illustration and layout; brochure design; posters; signage; magazine illustration and layout. "We are not looking for illustrators at the present time. Most designs we need are graphic and we also need designs which are geared toward trends in the gift industry. Looking for a graphic Web site designer for graphics on Web site only."

First Contact & Terms Send query letter with tearsheets and photostats. Samples are not filed and are returned by SASE only if requested by artist. Responds in 2 weeks. Call or write to schedule an appointment to show a portfolio, which should include roughs and b&w tearsheets and photostats. Pays for design by the project, $75 minimum. Pays for illustration by the project, $150 minimum. Considers client's budget and how work will be used when establishing payment. Negotiates rights purchased.

Tips "We are looking for simple designs geared to a high-end market."

CANETTI DESIGN GROUP INC.

P.O. Box 57, Pleasantville NY 10570. (914)238-3159. Fax: (914)238-0106. E-mail: info@canettidesigngroup.com. **Marketing Vice President:** M. Berger. Estab. 1982. Produces photo frames, writing instruments, kitchen accessories and product design.

Needs Approached by 50 freelancers/year. Works with 10 freelancers/year. Works on assignment only. Uses freelancers mainly for illustration/computer. Also for calligraphy and mechanicals. Considers all media. Looking for contemporary style. Needs computer-literate freelancers for illustration and production. 80% of freelance work demands knowledge of Illustrator, Photoshop, Quark.

First Contact & Terms Send postcard-size sample of work and query letter with brochure. Samples are not filed. Portfolio review not required. Buys all rights. Originals are not returned. Pays by the hour. Finds artists through agents, sourcebooks, magazines, word of mouth and artists' submissions.

CAPE SHORE, INC.

Division of Downeast Concepts, 86 Downeast Dr., Yarmouth ME 04096. (207)846-3726. Fax: (207)846-1019. E-mail: capeshore@downeastconcepts.com. Web site: www.downeastconcepts.com. **Contact:** Melody Martin-Robie, creative director. Estab. 1947. "Cape Shore is concerned with seeking, manufacturing and distributing a quality line of gifts and stationery for the souvenir and gift market." Licenses art by noted illustrators with a track record for paper products and giftware. Guidelines available on Web site.

Needs Approached by 100 freelancers/year. Works with 50 freelancers/year. Buys 400 freelance designs and

illustrations/year. Prefers artists and product designers with experience in gift product, hanging ornament and stationery markets. Art guidelines available free for SASE. Uses freelance illustration for boxed note cards, Christmas cards, ornaments, home accessories, ceramics and other paper products. Considers all media. Looking for skilled wood carvers with a warm, endearing folk art style for holiday gift products.

First Contact & Terms "Do not telephone; no exceptions." Send query letter with color copies. Samples are filed or are returned by SASE. Art director will contact artist for portfolio review if interested. Portfolio should include finished samples, printed samples. Pays for design by the project, advance on royalties or negotiable flat fee. Buys varying rights according to project.

Tips "Cape Shore is looking for realistic detail, good technique, and traditional themes or very high quality contemporary looks for coastal as well as inland markets. We will sometimes buy art for a full line of products, or we may buy art for a single note or gift item. Proven success in the giftware field a plus, but will consider new talent and exceptional unpublished illustrators."

CARDMAKERS
Box 236, High Bridge Rd., Lyme NH 03768. Phone/fax: (603)795-4422. E-mail: info@cardmakers.com. Web site: www.cardmakers.com. **Principal:** Peter Diebold. Estab. 1978. Produces greeting cards. "We produce special cards for special interests and greeting cards for businesses—primarily Christmas. We also publish everyday cards for stockbrokers and boaters."

• Cardmakers requests if you send submissions via e-mail, please keep files small. When sending snail mail, please be aware they will only respond if SASE is included.

Needs Approached by more than 300 freelancers/year. Works with 5-10 freelancers/year. Buys 20-40 designs and illustrations/year. Prefers professional-caliber artists. Art guidelines available on Web site only. Please do not e-mail us for same. Works on assignment only. Uses freelancers mainly for greeting card design and calligraphy. Considers all media. "We market 5×7 cards designed to appeal to individual's specific interest—boating, building, cycling, stocks and bonds, etc." Prefers an upscale look. Submit seasonal ideas 6-9 months in advance.

First Contact & Terms Designers: Send brief sample of work. Illustrators: Send postcard sample or query letter with brief sample of work. "One good sample of work is enough for us. A return postcard with boxes to check off is wonderful. Phone calls are out; fax is a bad idea." Samples are filed. Responds only if interested. Portfolio review not required. Pays flat fee of $100-300 depending on many variables. Rights purchased vary according to project. Interested in buying second rights (reprint rights) to previously published work, if not previously used for greeting cards. Finds artists through word of mouth, exhibitions and *Artist's & Graphic Designer's Market* submissions.

Tips "We like to see new work in the early part of the year. It's important that you show us samples *before* requesting submission requirements. Getting published and gaining experience should be the main objective of freelancers entering the field. We favor fresh talent (but do also feature seasoned talent). PLEASE be patient waiting to hear from us! Make sure your work is equal to or better than that which is commonly found in use presently. Go to a large greeting card store. If you think you're as good or better than the artists there, continue!"

CASE STATIONERY CO., INC.
179 Saw Mill River Rd., Yonkers NY 10701-6616. (914)965-5100. Fax: (914)965-2362. E-mail: case@casestationery.com. Web site: www.casestationery.com. **President:** Jerome Sudnow. Vice President: Joyce Blackwood. Estab. 1954. Produces stationery, notes, memo pads and tins for mass merchandisers in stationery and housewares departments.

Needs Approached by 10 freelancers/year. Buys 50 designs from freelancers/year. Works on assignment only. Buys design and/or illustration mainly for stationery products. Uses freelancers for mechanicals and ideas. Produces materials for Christmas; submit 6 months in advance. Likes to see youthful and traditional styles, as well as English and French country themes. 10% of freelance work requires computer skills.

First Contact & Terms Send query letter with résumé and tearsheets, photostats, photocopies, slides and photographs. Samples not filed are returned. Responds ASAP. Call or write for appointment to show a portfolio. Original artwork is not returned. Pays by the project. Buys first rights or one-time rights.

Tips "Find out what we do. Get to know us. We are creative and know how to sell a product."

CASPARI, INC.
116 E. 27th St., New York NY 10016. (212)685-9798. Fax: (212)685-9401. E-mail: info@hgcaspari.com. Web site: www.hgcaspari.com. **Contact:** Lucille Andriola. Publishes greeting cards, Christmas cards, invitations, giftwrap and paper napkins. "The line maintains a very traditional theme."

Needs Buys 80-100 illustrations/year. Prefers watercolor, gouache, acrylics and other color media. Produces seasonal material for Christmas, Mother's Day, Father's Day, Easter and Valentine's Day. Also for life events such as moving, new house, wedding, birthday, graduation, baby, get well, sympathy.

First Contact & Terms Send samples to Lucille Andriola to review. Prefers unpublished original illustrations,

slides or transparencies. Art director will contact artist for portfolio review if interested. **Pays on acceptance**; negotiable. Pays flat fee of $400 for design. Finds artists through word of mouth, magazines, submissions/self-promotions, sourcebooks, agents, visiting artist's exhibitions, art fairs and artists' reps.

Tips "Caspari and many other small companies rely on freelance artists to give the line a fresh, overall style rather than relying on one artist. We feel this is a strong point of our company. Please do not send verses."

CENTRIC CORP.

6712 Melrose Ave., Los Angeles CA 90038. (323)936-2100. Fax: (323)936-2101. E-mail: centric@juno.com. Web site: www.centriccorp.com. **President:** Sammy Okdot. Estab. 1986. Produces celebrity licensed products such as watches, clocks, mugs, frames, pens and T-shirts for ages 15-45.

Needs Freelancers who know Photoshop, Quark, Illustrator well. Send samples of your work and rate range. Pays when project is completed.

Tips "Search the demographics of buyers who purchase Elvis, Lucy, Marilyn Monroe, James Dean, Betty Boop, and Bettie Page to know how to 'communicate a message' to the buyer."

CHARTPAK/FRANCES MEYER, INC.

1 River Road, Leeds MA 01053. (800)628-1910. Fax: (800)762-7918. E-mail: info@chartpak.com. Web site: www.chartpak.com. **Contact:** Robin Campion, creative director. Estab. 1979. Produces scrapbooking products, stickers and stationery.

- Frances Meyer was acquired by Chartpak in 2003. Product lines will retain the Frances Meyer look, but company moved from Savannah, Georgia to Leeds, Massachusetts.

Needs Works with 5-6 freelance artists/year. Art guidelines available free for SASE. Commissions 100 freelance illustrations and designs/year. Works on assignment only. "Most of our artists work in either watercolor or acrylic. We are open, however, to artists who work in other media." Looking for "everything from upscale and sophisticated adult theme-oriented paper items, to fun, youthful designs for birth announcements, baby and youth products. Diversity of style, originality of work, as well as technical skills are a few of our basic needs." Produces material for Christmas, graduation, Thanksgiving (fall), New Year's, Halloween, birthdays, everyday, weddings, showers, new baby, etc. Submit seasonal material 6-12 months in advance.

First Contact & Terms Send query letter with tearsheets, SASE, photocopies, transparencies (no originals) and "as much information as is necessary to show diversity of style and creativity. No response or return of samples by Frances Meyer, Inc. *without SASE!*" Responds in 2-3 months. Company will contact artist for portfolio review if interested. Originals are returned at job's completion. Pays royalty (varies).

Tips "Generally, we are looking to work with a few talented and committed artists for an extended period of time. We do not 'clean out' our line on an annual basis just to introduce new product. If an item sells, it will remain in the line. Punctuality concerning deadlines is a necessity."

CITY MERCHANDISE INC.

241 41st St., P.O. Box 320081, Brooklyn NY 11232. (718)832-2931. Fax: (718)832-2939. E-mail: citymdse@aol.com. **Executive Assistant:** Martina Santoli. Produces calendars, collectible figurines, gifts, mugs, souvenirs of New York.

Needs Works with 6-10 freelancers/year. Buys 50-100 freelance designs and illustrations/year. "We buy sculptures for our casting business." Prefers freelancers with experience in graphic design. Works on assignment only. Uses freelancers for most projects. Considers all media. 50% of design and 80% of illustration demand knowledge of Photoshop, QuarkXPress, Illustrator. Does not produce holiday material.

First Contact & Terms Designers: Send query letter with brochure, photocopies, résumé. Illustrators and/or cartoonists: Send postcard sample of work only. Sculptors: Send résumé and slides, photos or photocopies of their work. Samples are filed. Include SASE for return of samples. Responds in 2 weeks. Portfolios required for sculptors only if interested in artist's work. Buys all rights. Pays by project.

CLARKE AMERICAN

P.O. Box 460, San Antonio TX 78292-0460. (210)697-1375. Fax: (210)558-7045. E-mail: linda_m_roothame@clarkeamerican.com. Web site: www.clarkeamerican.com. **Product Marketing Specialist:** Ashley Collins. Estab. 1874. Produces checks and other products and services sold through financial institutions. "We're a national printer seeking original works for check series, consisting of five, three, or one scene. Looking for a variety of themes, media, and subjects for a wide market appeal."

Needs Uses freelancers mainly for illustration and design of personal checks. Considers all media and a range of styles. Prefers art twice standard check size.

First Contact & Terms Send postcard sample or query letter with brochure and résumé. "Indicate whether the work is available; do not send original art." Samples are filed and are not returned. Responds only if interested. Rights purchased vary according to project. Payment for illustration varies by the project.

Tips "Keep red and black in the illustration to a minimum for image processing."

CLEO, INC.

4025 Viscount Ave., Memphis TN 38118. (901)369-6657 or (800)289-2536. Fax: (901)369-6376. E-mail: cpatat@ cleowrap.com. Web site: www.cleowrap.com. **Senior Director of Creative Resources:** Claude Patat. Estab. 1953. Produces giftwrap and gift bags. "Cleo is the world's largest Christmas giftwrap manufacturer. Other product categories include some seasonal product. Mass market for all age groups."

Needs Approached by 25 freelancers/year. Works with 40-50 freelancers/year. Buys more than 200 freelance designs and illustrations/year. Uses freelancers mainly for giftwrap and gift bags (designs). Also for calligraphy. Considers most any media. Looking for fresh, imaginative as well as classic quality designs for Christmas. 30" repeat for giftwrap. Art guidelines available. Submit seasonal material at least a year in advance.

First Contact & Terms Send query letter with slides, SASE, photocopies, transparencies and speculative art. Accepts submissions on disk. Samples are filed if interested or returned by SASE if requested by artist. Responds only if interested. Rights purchased vary according to project; usually buys all rights. Pays flat fee. Also needs package/product designers, pay rate negotiable. Finds artists through agents, sourcebooks, magazines, word of mouth and submissions.

Tips "Understand the needs of the particular market to which you submit your work."

COMSTOCK CARDS, INC.

600 S. Rock Blvd., Suite 15, Reno NV 89502. (775)856-9400. Fax: (775)856-9406. e-mail submissions@comstockcards.com. Web site: www.comstockcards.com. **Production Manager:** Cindy Thomas. Estab. 1987. Produces greeting cards, giftbags and invitations. Styles include alternative and adult humor, outrageous and shocking themes; specializes in fat, age and funny situations. No animals or landscapes. Target market predominately professional females, ages 25-55.

Needs Approached by 250-350 freelancers/year. Works with 30-35 freelancers/year. "Especially seeking artists able to produce outrageous adult-oriented cartoons." Uses freelancers mainly for cartoon greeting cards. Art guidelines for SASE with first-class postage. No verse or prose. Gaglines must be brief. Prefers 5×7 final art. Produces material for all occasions. Submit holiday concepts 6 months in advance.

First Contact & Terms Send query letter with SASE, tearsheets or photocopies. Samples are not usually filed and are returned by SASE if requested. Responds only if interested. Portfolio review not required. Originals are not returned. Pays royalties of 5%. Pays by project, $50-150 minimum; may negotiate other arrangements. Buys all rights.

Tips "Make submissions outrageous and funny prose. Outrageous humor is what we look for—risqué OK, mild risqué best."

CONCORD LITHO

92 Old Turnpike Rd., Concord NH 03301. (603)225-3328. Fax: (603)225-6120. E-mail: info@concordlitho.com. Web site: www.concordlitho.com. **Contact:** Art Librarian. Estab. 1958. Produces greeting cards, stationery, posters, giftwrap, specialty paper products for direct marketing. Provide a range of print goods for commercial markets but also supplies high-quality paper products used for direct mail fundraising.

Needs Buys 100 designs and illustrations/year. Works on assignment only but will consider available work also. Uses freelancers mainly for greeting cards, wrap and calendars. Also for calligraphy and computer-generated art. Considers all media but prefers watercolor. Art guidelines available for SASE with first-class postage. Art needs range from generic seasonal and holiday greeting cards to religious subjects, wildlife, florals, nature, scenics, cute and whimsical art and inspirational vignettes. "We prefer more traditional designs with occasional contemporary needs. Always looking for traditional religious art." Prefers digitial art. Produces material for all holidays and seasons Christmas, Valentine's Day, Mother's Day, Father's Day, Easter, Thanksgiving, New Year, birthdays, everyday and other religious dates. Submit seasonal material 6 months in advance.

First Contact & Terms Send introductory letter with with nonreturnable photographs, samples, or photocopies of work. Indicate whether work is for style only and if it is available. Accepts submissions on disk. Responds in 3 months. Portfolio review not required. Rights purchased vary according to project. Pays by the project, $200-800. No phone calls, please.

Tips Send quality samples or copies.

COURAGE CENTER

3915 Golden Valley Road, Minneapolis, MN 55422. (888)413-3323. E-mail: artsearch@courage.org. Web site: www.couragecards.org. **Art and Production Manager:** Laura Brooks. Estab. 1970. "Courage Cards are holiday cards that are produced to support the programs of Courage Center, a nonprofit provider of rehabilitation services that helps people with disabilities live more independently."

Needs Holiday art appropriate for greeting cards: including traditional, winter, nostalgic, religious, ethnic and world peace designs. Features artists with disabilities, but all artists are encouraged to enter the annual Courage Card Art Search. Art guidelines available on company's Web site.

First Contact & Terms Call or e-mail name and address to receive Art Search guidelines, which are mailed in January for the July 31 entry deadline. Artist retains ownership of the art. Pays $400 licensing fee in addition to nationwide recognition through distribution of more than 500,000 catalogs and promotional pieces, Internet, TV, radio and print advertising.

Tips "Do not send originals. Entries should arrive as a result of the Art Search. The Selection Committee chooses art that will reproduce well as a card. We need colorful contemporary and traditional images for holiday greetings. Participation in the Courage Cards Art Search is a wonderful way to share your talents and help people live more independently."

CREATIF LICENSING

31 Old Town Crossing, Mt. Kisco NY 10549. (914)241-6211. E-mail: info@creatifusa.com. Web site: www.creatif usa.com. **Licensing Contact:** Marcie Silverman. Estab. 1975. "Creatif is a licensing agency that represents artists and brands." Licensing art for commercial applications on consumer products in the gift, stationery and home furnishings industries.

Needs Looking for unique art styles and/or concepts that are applicable to multiple products and categories.

First Contact & Terms Send query letter with photocopies, photographs, SASE or tearsheets. Does not accept e-mail attachments but will review Web site links. Responds in 2 months. Samples are returned with SASE. Creatif will obtain licensing agreements on behalf of the artists, negotiate and manage the licensing programs and pay royalties. Artists are responsible for filing all copyright and trademark. Requires exclusive representation of artists.

Tips "We are looking to license talented and committed artists. It is important to understand current trends, and design with specific products in mind."

☒ CREEGAN CO., INC.

The Creegan Animation Factory, 510 Washington St., Steubenville OH 43952. (740)283-3708. Fax: (740)283-4117. E-mail: creegans@weir.net. Web site: www.creegans.com. **President:** Dr. G. Creegan. Estab. 1961. "The Creegan Company designs and manufactures animated characters, costume characters and life-size audio animatronic air-driven characters. All products are custom made from beginning to end."

 • Recently seen on the Travel Channel and Made in America with John Ratzenberger.

Needs Prefers local artists with experience in sculpting, latex, oil paint, molding, etc. Artists sometimes work on assignment basis. Uses freelancers mainly for design comps. Also for mechanicals. Produces material for all holidays and seasons, Christmas, Valentine's Day, Easter, Thanksgiving, Halloween and everyday. Submit seasonal material 3 months in advance.

First Contact & Terms Send query letter with résumé and nonreturnable photos or other samples. Samples are filed. Responds. Write for appointment to show portfolio of final art, photographs. Originals returned. Rights purchased vary according to project.

SUZANNE CRUISE CREATIVE SERVICES, INC.

7199 W. 98th Terrace, #110, Overland Park KS 66212. (913)648-2190. Fax: (913)648-2110. E-mail: artagent@crui secreative.com. Web site: www.cruisecreative.com. **President:** Suzanne Cruise. Estab. 1990. "Art agent representing artists for licensing on to categories such as: calendars, craft papers, decorative housewares, fabric giftbags, gifts, giftwrap, greeting cards, home decor, keychains, mugs, ornaments, prints, scrap booking, stickers, tabletop, and textiles. "We are a full-service licensing agency, as well as a full-service creative agency representing both licensed artists and freelance artists. Our services include, but are not limited to, screening manufacturers for quality and distribution, negotiating rights, overseeing contracts and payments, sending artists' samples to manufacturers for review, and exhibiting artists' work at major trade shows annually." Art guidelines on the Web site.

Needs Seeks established and emerging artists with distinctive styles suitable for the ever-changing consumer market. Looking for artists that manufacturers cannot find in their own art staff or in the freelance market, or who have a style that has the potential to become a classic license. "We represent a wide variety of freelance artists, and a few select licensed artists, offering their work to manufacturers of goods such as gifts, textiles, home furnishings, bedding, book publishing, social expression, puzzles, rubber stamps, etc. We look for art that has popular appeal. It can be traditional, whimsical, cute, humorous, seasonal or everyday, as long as it is not 'dated'."

First Contact & Terms Send query letter with color photocopies, tearsheets or samples. No originals. Samples are returned only if accompanied by SASE. Responds only if interested. Portfolio required. Request portfolio review in original query.

Tips "Walk a few trade shows and familiarize yourself with the industries you want your work to be in. Attend a few of the panel discussions that are put on during the shows to get to know the business a little better."

CUSTOM STUDIOS INC.

4353 N. Lincoln Ave., Chicago IL 60618. (773)665-2226. Fax: (773)665-2228. E-mail: customstudios123@yahoo. com. Web site: www.custom-studios.com. **President:** Gary Wing. Estab. 1966. ''We specialize in designing and screen printing custom T-shirts for schools, business promotions, fundraising and for our own line of stock.'' Also manufacture coffee mugs, bumper stickers, balloons and over 1,000 other products.

Needs Works with 7 freelance illustrators/year. Assigns 10 freelance jobs/year. Needs b&w illustrations (some original and some from customer's sketch). Uses artists for direct mail and brochures/fliers, but mostly for custom and stock T-shirt designs, we are open to new stock design ideas the artist may have.

First Contact & Terms Send query letter with résumé, photostats, photocopies or tearsheets. ''We will not return originals or samples.'' Responds in 1 month. Mail b&w or color tearsheets to be kept on file. Pays for design and illustration by the hour, $15-35; by the project, $50-150. Considers turnaround time and rights purchased when establishing payment. For designs submitted to be used as stock T-shirt designs, pays 5-10% royalty. Rights purchased vary according to project.

Tips ''Send 5-10 good copies of your best work. We would like to see more illustrations or copies, not originals. Do not get discouraged if your first designs sent are not accepted.''

N DALOIA DESIGN

100 Norwich E, West Palm Beach FL 33417. (561)697-4739. E-mail: daloiades@aol.com. **Owner/Designer:** Peter Daloia. Estab. 1983. Produces art for stationery and gift products such as magnets, photo frames, coasters, bookmarks, home decor, etc.

Needs Approached by 20-30 freelancers/year. Uses freelancers for product art. Freelancers must know software appropriate for project, including PageMaker, Photoshop, QuarkXPress, Illustrator or ''whatever is necessary.''

First Contact & Terms Artists send samples of your work. Samples are filed and are **not returned.** Responds only if interested. Payment ''depends on project and use.'' Negotiates rights purchased.

Tips ''Keep an open mind, strive for excellence, push limitations.''

DIMENSIONS, INC.

1801 N 12th St., Reading PA 19604. (610)939-9900. Fax: (610)939-9666. E-mail: pam.keller@dimensions-crafts. com. Web site: www.dimensions-crafts.com. **Designer Relations Coordinator:** Pamela Keller. Produces craft kits including but not limited to needlework, stained glass, paint-by-number, kids bead crafts and memory products. ''We are a craft manufacturer with emphasis on sophisticated artwork and talented designers. Products include needlecraft kits, paint-by-number, and baby products. Primary market is anyone who does crafts.''

Needs Approached by 50-100 freelancers/year. Works with 200 freelancers/year. Develops more than 400 freelance designs and illustrations/year. Uses freelancers mainly for the original artwork for each product. Art guidelines for SASE with first-class postage. In-house art staff adapts for needlecraft. Considers all media. Looking for fine art, realistic representation, good composition, more complex designs than some greeting card art; fairly tight illustration with good definition; also whimsical, fun characters. Produces material for Christmas, everyday, birth, wedding and anniversary records. Majority of products are everyday decorative designs for the home.

First Contact & Terms Send cover letter with color brochure, tearsheets, photographs or photocopies. Samples are filed ''if artwork has potential for our market.'' Samples are returned by SASE only if requested by artist. Responds in 1 month. Portfolio review not required. Originals are returned at job's completion. Pays by project, royalties of 2-5%; sometimes purchases outright. Finds artists through magazines, trade shows, word of mouth, licensors/reps.

Tips ''Current popular subjects in our industry florals, wildlife, garden themes, ocean themes, celestial, cats, birds, Southwest/Native American, juvenile/baby and whimsical.''

DLM STUDIO

2563 Princeton Rd., Cleveland Heights OH 44118. (216)881-8888. Fax: (216)274-9308. E-mail: pat@dlmstudio.c om. Web site: www.dlmstudio.com. **Vice President:** Pat Walker. Estab. 1984. Produces fabrics/packaging/ wallpaper. Specializes in wallcovering, border and mural design, entire package with fabrics, also ultra-wide ''mural'' borders. Also licenses artwork for wall murals.

Needs Approached by 40-80 freelancers/year. Works with 20-40 freelancers/year. Buys hundreds of freelance designs and illustrations/year. Art guidelines free for SASE with first-class postage. Works on assignment and some licensing. Uses freelancers mainly for designs, color work. Looking for traditional, country, floral, texture, woven, menswear, children's and novelty styles. 50% of freelance design work demands computer skills. Wallcovering CAD experience a plus. Produces material for everyday.

First Contact & Terms Illustrators: Send query letter with photocopies, examples of work, résumé and SASE. Accepts disk submissions compatible with Illustrator or Photoshop files (Mac), SyQuest, also accepts digital files on CD or DVD. Samples are filed or returned by SASE on request. Responds in 1 month. Request portfolio

review of color photographs and slides in original query, follow-up with letter after initial query. Rights purchased vary according to project. Pays by the project, $500-1,500, "but it varies." Finds freelancers through agents and local ads, word of mouth.

Tips "Send great samples, especially childrens and novelty patterns. Novelty and special interest also strong, and digital files are very helpful. Study the market closely; do very detailed artwork."

EDITIONS LIMITED/FREDERICK BECK

51 Bartlett Ave., Pittsfield MA 01201. (413)443-0973. Fax: (413)445-5014. E-mail: mark@chatsworthcollection.com. Web site: www.chatsworthcollection.com. **Art Director:** Mark Brown. Estab. 1958. Produces holiday greeting cards, personalized and box stock and stationery.

- Editions Limited joined forces with Frederick Beck Originals. The company also runs Gene Bliley Stationery. See editorial comment under Frederick Beck Originals for further information. Mark Brown is the art director for all three divisions.

Needs Approached by 100 freelancers/year. Works with 20 freelancers/year. Buys 50-100 freelance designs and illustrations/year. Prefers freelancers with experience in silkscreen. Art guidelines available. Uses freelancers mainly for silkscreen greeting cards. Also for separations and design. Considers offset, silkscreen, thermography, foil stamp. Looking for traditional holiday, a little whimsy, contemporary designs. Size varies. Produces material for Christmas, graduation, Hannukkah, New Year, Rosh Hashanah and Valentine's Day. Submit seasonal material 15 months in advance.

First Contact & Terms Designers: Send query letter with brochure, photocopies, photographs, résumé, tearsheets. Samples are filed. Responds in 1 month. Will contact artist for portfolio review of b&w, color, final art, photographs, photostats, roughs if interested. Buys all rights. Pays $150-300/design. Finds freelancers through word of mouth, past history.

EISENHART WALLCOVERINGS CO.

400 Pine St., Hanover PA 17331. (717)632-5918. Fax: (717)632-2321. Web site: www.eisenhartwallcoverings.com. **Co-Design Center Administrators:** Gen Huston and Teresa Schnetzka. Licensing: Joanne Berwager. Estab. 1940. Produces custom and residential wallpaper, borders, murals and coordinating fabrics. Licenses various types of artwork for wall coverings. Manufactures and imports residential and architectural wallcovering under the Ashford House®, Eisenhart® and Color Tree® collections.

Needs Works with 10-20 freelancers/year. Buys 25-50 freelance designs and illustrations/year. Prefers freelancers with experience in wallcovering design, experience with Photoshop helpful. Uses freelancers mainly for wallpaper design/color. Also for P-O-P. Looking for traditional as well as novelty designs.

First Contact & Terms Designers should contact by e-mail. Illustrators: Send query letter with color copies. Samples are filed. Samples are returned by SASE if requested. Responds in 2 weeks. Artist should contact after 2 weeks. Will contact for portfolio review if interested. Buys all rights. Pays by design, varies. Finds freelancers through artists' submissions.

KRISTIN ELLIOTT, INC.

10 Industrial Way, Amesbury, MA 01913. (978)526-7126. Fax: (978) 834- 0700. E-mail: kedesignstudio@verizon.net. Web site: www.kristinelliott.com. **Creative Director:** Barbara Elliott. Publishes greeting cards and stationery products.

Needs Works with 25 freelance artists/year. Uses illustrations and graphic design. Prefers watercolor and gouache. Produces Christmas and everyday stationery products, including boxed notes, imprintables and photo cards.

First Contact & Terms Send published samples, color copies, tearsheets or photos. Include SASE for return of materials. Payment negotiable.

Tips Crisp, clean colors preferred. Best submission time is May through August.

ENCORE STUDIOS, INC.

17 Industrial West, Clifton NJ 07012. (800)526-0497. E-mail: artdept@encorestudios.com. Web site: www.encorestudios.com. Estab. 1979. Produces personalized wedding, bar/bat mitzvah, party and engraved invitations, birth announcements, stationery, and holiday cards.

Needs Approached by 50-75 freelance designers/year. Works with 20 freelancers/year. Prefers freelancers with experience in creating concepts for holiday cards, invitations, announcements and stationery. "We are interested in designs for any category in our line. Looking for unique type layouts, textile designs and initial monograms for stationery and weddings, holiday logos, Hebrew monograms for our bar/bat mitzvah line, and religious art for Bar/Bat Mitzvah." Considers b&w or full-color art. Looking for "elegant, graphic, sophisticated contemporary designs." 50% of freelance work demands knowledge of Macintosh, Illustrator, Photoshop, Quark XPress. Submit seasonal material all year.

First Contact & Terms Send e-mail with Jpg. or Pdf. attachments or send query letter with brochure, résumé, SASE, tearsheets, photographs, photocopies or slides. Samples are filed or are returned by SASE if requested by artist. Responds in 2 weeks only if interested. Write for appointment to show portfolio, or mail appropriate materials. Portfolio should include roughs, finished art samples, b&w photographs or slides. Pays by the project. Negotiates rights purchased.

ENESCO GROUP INC.

225 Windsor Dr., Itasca IL 60143-1225. (630)875-5300. Fax: (630)875-5350. Web site: www.enesco.com. **Contact:** New Submissions/Licensing. Producer and importer of fine gifts, home decor and collectibles, such as resin, porcelain bisque and earthenware figurines, plates, hanging ornaments, bells, picture frames, decorative housewares. Clients gift stores, card shops and department stores.

Needs Works with multiple freelance artists/year. Prefers artists with experience in gift product and packaging development. Uses freelancers for rendering, illustration and sculpture. 50% of freelance work demands knowledge of Photoshop, QuarkXPress or Illustrator.

First Contact & Terms Send query letter with résumé, tearsheets and/or photographs. Samples are filed or are returned. Responds in 2 weeks. Pays by the project. Submittor may be required to sign a submission agreement.

Tips "Contact by mail only. It is better to send samples and/or photocopies of work instead of original art. All will be reviewed by Senior Creative Director, Executive Vice President and Licensing Director. If your talent is a good match to Enesco's product development, we will contact you to discuss further arrangements. Please do not send slides. Have a well-thought-out concept that relates to gift products before mailing your submissions."

EVERYTHING METAL IMAGINABLE, INC. (E.M.I.)

401 E. Cypress, Visalia CA 93277. (559)732-8126 or (800)777-8126. Fax: (559)732-5961. Web site: www.artbronze.com. **Artists' Liaison:** Renee Robbins. Estab. 1967. Wholesale manufacturer. "We manufacture lost wax bronze sculpture." Clients: wholesalers, premium incentive consumers, retailers, auctioneers, corporations.

Needs Approached by 10 freelance artists/year. Works with 20 freelance designers/year. Assigns 5-10 jobs to freelance artists/year. Prefers artists that understand centrifugal casting, bronze casting and the principles of mold-making. Uses artists for figurine sculpture and model-making.

First Contact & Terms Send query letter with brochure or résumé, tearsheets, photostats, photocopies and slides. Samples not filed are returned only if requested. Responds only if interested. Call for appointment to show portfolio of original/final art and photographs "or any samples." Pays for design by the project, $500-20,000. Buys all rights.

Tips "Artists must be conscious of detail in their work, be able to work expediently and under time pressure and be able to accept criticism of work from client. Price of program must include completing work to satisfaction of customers. Trends include children at play."

FANTAZIA MARKETING CORP.

65 N. Chicopee St., Chicopee MA 01020. (413)534-7323. Fax: (413)534-4572. E-mail: fantazia@charter.net. Web site: www.fantaziamarketing.com. **President:** Joel Nulman. Estab. 1979. Produces toys and high-end novelty products. Produces novelty, lamps, banks and stationery items in over-sized form.

Needs Not limited. Will review anything. Prefers artists with experience in product development. "We're looking to increase our molded products." Uses freelancers for P-O-P displays, paste-up, mechanicals, product concepts. 50% of design requires computer skills.

First Contact & Terms Send query letter with résumé. Samples are filed. Responds in 2 weeks. Call for appointment to show portfolio. Portfolio should include roughs and dummies. Rights purchased vary according to project. Originals not returned. Pays by project. Royalties negotiable.

FENTON ART GLASS COMPANY

700 Elizabeth St., Williamstown WV 26187. (304)375-6122. Fax: (304)375-7833. E-mail: AskFenton@FentonArtGlass.com. Web site: www.Fentonartglass.com. **Design Director:** Nancy Fenton. Estab. 1905. Produces collectible figurines, gifts. Largest manufacturer of handmade colored glass in the US.

● Design Director Nancy Fenton says this company rarely uses freelancers because they have their own staff of artisans. "Glass molds aren't very forgiving," says Fenton. Consequently it's a difficult medium to work with. There have been exceptions. "We were really taken with Linda Higdon's work," says Fenton, who worked with Higdon on a line of historical dresses.

Needs Uses freelancers mainly for sculpture and ceramic projects that can be translated into glass collectibles. Considers clay, ceramics, porcelain figurines. Looking for traditional artwork appealing to collectibles market.

First Contact & Terms Send query letter with brochure, photocopies, photographs, résumé and SASE. Samples are filed. Responds only if interested. Negotiates rights purchased. Pays for design by the project; negotiable.

FIDDLER'S ELBOW

(formerly The Toy Works, Inc.), 101 Fiddler's Elbow Rd., Middle Falls NY 12848. (518)692-9665. Fax: (518)692-9186. E-mail: info@fiddlerselbow.com. Web site: www.fiddlerselbow.com. **Art and Licensing Coordinator:** Christy Phelan. Estab. 1974. Produces decorative housewares, gifts, pillows, totes, soft sculpture, flags and doormats.

Needs Works with 5 freelancers/year. Art guidelines available free for SASE. Buys 50 freelance designs and illustrations/year. Uses freelancers mainly for design and illustration. Looking for traditional, floral, adult contemporary, and pet themes. 50% of freelance design demands knowledge of Photoshop, Illustrator and QuarkXPress, however computer knowledge is not a must. Produces material for everyday home decor.

First Contact & Terms Designers and Illustrators: Send query letter with photostats, résumé, photocopies, photographs. Accepts disk submissions compatible with Postscript. Samples are filed or returned. Responds in 4 months. No phone calls! Portfolio review not required. Rights purchased vary according to project.

Tips When approaching a manufacturer, send color comps or prototypes with the type of art you create. It is much easier for manufacturers to understand your art if they see it on their product.

FISHER-PRICE

636 Girard Ave., E. Aurora NY 14052. (716)687-3983. Fax: (716)687-5281. Web site: www.fisher-price.com. **Director of Product Art:** Henry Schmidt. Estab. 1931. Manufacturer of toys and other children's products.

Needs Approached by 10-15 freelance artists/year. Works with 25-30 freelance illustrators and sculptors and 15-20 freelance graphic designers/year. Assigns 100-150 jobs to freelancers/year. Prefers artists with experience in children's style illustration and graphics. Works on assignment only. Uses freelancers mainly for product decoration (label art). Prefers all media and styles except loose watercolor. Also uses sculptors. 25% of work demands knowledge of FreeHand, Illustrator, Photoshop and FreeForm (sculptors).

- This company has two separate art departments Advertising and Packaging, which does catalogs and promotional materials, and Product Art, which designs decorations for actual toys. Be sure to specify your intent when submitting material for consideration. Art director told *AGDM* he has been receiving more e-mail and disk samples. He says it's a convenient way for him or his staff to look at work.

First Contact & Terms Send query letter with nonreturnable samples showing art style or photographs. Samples are filed. Responds only if interested. Call to schedule an appointment to show a portfolio. Portfolio should include original, final art and color photographs and transparencies. Pays for design and illustration by the hour, $25-50. Buys all rights.

FOTOFOLIO, INC.

561 Broadway, New York NY 10012. (212)226-0923. Fax: (212)226-0072. e-mail submissions@fotofolio.com. Web site: www.fotofolio.com. Estab. 1976. Publishes art and photographic postcards, greeting cards, notecards, books, t-shirts and postcards books.

Needs Buys 60-120 freelance designs and illustrations/year. Reproduces existing works. Primarily interested in photography and contemporary art. Produces material for Christmas, Valentine's Day, birthday and everyday. Submit seasonal material 8 months in advance. Art guidelines for SASE with first-class postage.

First Contact & Terms Send query letter with SASE % Editorial Dept. Samples are filed or are returned by SASE if requested by artist. Editorial Coordinator will contact artist for portfolio review if interested. Originals are returned at job's completion. Pays by the project, 7½-15% royalties. Rights purchased vary according to project. Finds artists through word of mouth, magazines, submissions/self-promotions, sourcebooks, agents, visiting artist's exhibitions, art fairs and artists' reps.

Tips "When submitting materials, present a variety of your work (no more than 40 images) rather than one subject/genre."

THE FRANKLIN MINT

Franklin Center PA 19091-0001. (610)459-7975. Fax: (610)459-6463. Web site: www.franklinmint.com. **Artist Relations Manager:** Cathy La Spada. Estab. 1964. Direct response marketing of high-quality collectibles. Produces collectible porcelain plates, prints, porcelain and coldcast sculpture, figurines, fashion and traditional jewelry, ornaments, precision diecast model cars, luxury board games, engineered products, heirloom dolls and plush, home decor items and unique gifts. Clients general public worldwide, proprietary houselist of 8 million collectors and 55 owned-and-operated retail stores. Markets products in countries worldwide, including USA, Canada, United Kingdom and Japan.

Needs Approached by 3,000 freelance artists/year. Contracts 500 artists/sculptors per year to work on 7,000-8,000 projects. Uses freelancers mainly for illustration and sculpture. Considers all media. Considers all styles. 80% of freelance design and 50% of illustration demand knowledge of PageMaker, FreeHand, Photoshop, Illustrator, QuarkXPress and 3D Studio Eclipse (2D). Accepts work in SGI format. Produces material for Christmas and everyday.

First Contact & Terms Send query letter, résumé, SASE and samples (clear, professional full-color photographs, transparencies, slides, greeting cards and/or brochures and tearsheets). Sculptors send photographic portfolios. Do not send original artwork. Samples are filed or returned by SASE. Responds in 2 months. Portfolio review required for illustrators and sculptors. Company gives feedback on all portfolios submitted. Payment varies.
Tips "In search of artists and sculptors capable of producing high quality work. Those willing to take art direction and to make revisions to their work are encouraged to submit their portfolios."

GAGNÉ WALLCOVERING, INC.

1771 N. Hercules Ave., Clearwater FL 33765. (727)461-1812. Fax: (727)447-6277. **Contact:** Linda Vierk, studio director. Estab. 1977. Produces wall murals and wallpaper. Specializes in residential and commercial wallcoverings, borders and murals encompassing a broad range of styles and themes for all age groups.
Needs Approached by 12-20 freelancers/year. Works with 20 freelancers/year. Buys 150 freelance designs and/or illustrations/year. Considers oils, watercolors, pastels, colored pencil, gouache, acrylic—just about anything two dimensional. Artists should check current wallcovering collections to see the most common techniques and media used.
First Contact & Terms Send brochure, color photocopies, photographs, slides, tearsheets, actual painted or printed sample of artist's hand if possible. Samples are filed. Responds only if interested. Portfolio not required. "We usually buy all rights to a design, but occasionally consider other arrangements." Pays freelancers by the project $500-1,200. Finds freelancers through magazines, licensing agencies, trade shows and word of mouth.
Tips "We are usually looking for traditional florals, country/folkart, juvenile and novelty designs. We do many borders and are always interested in fine representational art. Panoramic borders and murals are also a special interest. Be aware of interior design trends, both in style and color. Visit a wallcovering store and see what is currently being sold. Send us a few samples of your best quality, well-painted, detailed work.

GALISON BOOKS/MUDPUPPY PRESS

28 W. 44th St., New York NY 10036. (212)354-8840. Fax: (212)391-4037. E-mail: Lorena@galison.com. Web site: www.galison.com. **Creative Director:** Lorena Siminovich. Estab. 1978. Produces boxed greeting cards, puzzles, address books and specialty journals. Many projects are done in collaboration with museums around the world.
Needs Works with 10-15 freelancers/year. Buys 20 designs and illustrations/year. Works on assignment only. Uses freelancers mainly for illustration. Considers all media. Also produces material for Christmas and New Year. Submit seasonal material 1 year in advance.
First Contact & Terms Send postcard sample, photocopies, résumé and tearsheets (no unsolicited original artwork) and SASE. Accepts submissions on disk compatible with Photoshop, Illustrator or QuarkXPress (but not preferred). Samples are filed. Responds only if interested. Request portfolio review in original query. Creative Director will contact artist for portfolio review if interested. Portfolio should include color photostats, slides, tearsheets and dummies. Originals are returned at job's completion. Pays by project. Rights purchased vary according to project. Finds artists through word of mouth, magazines and artists' reps.
Tips "Looking for great presentation and artwork we think will sell and be competitive within the gift market."

GALLANT GREETINGS CORP.

P.O. Box 308, Franklin Park IL 60131. (847)671-6500. Fax: (847)233-2499. E-mail: joanlackouitz@gallantgreetings.com. Web site: www.gallantgreetings.com. **Vice President Product Development:** Joan Lackouitz. Estab. 1966. Creator and publisher of seasonal and everyday greeting cards, gift wrap and gift bags as well as stationery products.
First Contact & Terms Samples are filed or returned. Will respond within 3 weeks if interested. Do not send originals.

GALLERY GRAPHICS, INC.

P.O. Box 502, Noel MO 64854. (417)475-6191. Fax: (417)475-6494. E-mail: info@gallerygraphics.com. Web site: gallerygraphics.com. **Art Director:** Olivia Jacob. Estab. 1979. Produces calendars, gifts, greeting cards, stationery, prints, notepads, notecards. Gift company specializing primarily in nostalgic, country and other traditional designs.
Needs Approached by 100 freelancers/year. Works with 10 freelancers/year. Buys 100 freelance illustrations/year. Art guidelines free for SASE with first-class postage. Uses freelancers mainly for illustration. Considers any 2-dimensional media. Looking for country, teddy bears, florals, traditional. Prefers 16×20 maximum. Produces material for Christmas, Valentine's Day, birthdays, sympathy, get well, thank you. Submit seasonal material 8 months in advance.
First Contact & Terms Accepts printed samples or Photoshop files. Send TIFF or EPS files. Samples are filed or returned by SASE. Will contact artist for portfolio review of color photographs, photostats, slides, tearsheets,

transparencies if interested. Payment negotiable. Finds freelancers through submissions and word of mouth. **Tips** "Be flexible and open to suggestions."

GLITTERWRAP, INC.

701 Ford Rd., Rockaway NJ 07866. (973)625-4200, ext. 265. Fax: (973)625-0399. **Creative Director:** Melissa Camacho. Estab. 1987. Produces giftwrap, gift totes and allied accessories. Also photo albums, diaries and stationery items for all ages—party and special occasion market.

Needs Approached by 50-100 freelance artists/year. Works with 10-15 artists/year. Buys 10-30 designs and illustrations/year. Art guidelines available. Prefers artists with experience in textile design who are knowledgeable in repeat patterns or surface, or designers who have experience with the gift industry. Uses freelancers mainly for occasional on-site Mac production at hourly rate of $15-25. Freelance work demands knowledge of QuarkXPress, Illustrator and Photoshop. Considers many styles and mediums. Style varies with season and year. Consider trends and designs already in line, as well as up and coming motifs in gift market. Produces material for baby, wedding and shower, florals, masculine, Christmas, graduation, birthdays, Valentine's Day, Hanukkah and everyday. Submit seasonal material 6-8 months in advance.

First Contact & Terms Send query letter with brochure, tearsheets, or color copies of work. Do not send original art, photographs, transparencies or oversized samples. Samples are not returned. Responds in 3 weeks. "To request our submission guidelines send SASE with request letter. To request catalogs send 11×14 SASE with $3.50 postage. Catalogs are given out on a limited basis." Rights purchased vary according to project.

Tips "Giftwrap generally follows the fashion industry lead with respect to color and design. Adult birthday and baby shower/birth are fast-growing categories. There is a need for good/fresh/fun typographic birthday general designs in both adult and juvenile categories."

N GOES LITHOGRAPHING COMPANY SINCE 1879

42 W. 61st St., Chicago IL 60621-3999. (773)684-6700. Fax: (773)684-2065. E-mail: goeslitho@ameritech.net. Web site: www.goeslitho.com. **Contact:** Eric Goes. Estab. 1879. Produces stationery/letterheads, custom calendars to sell to printers and office product stores.

Needs Approached by 5-10 freelance artists/year. Works with 2-3 freelance artists/year. Buys 4-30 freelance designs and illustrations/year. Art guidelines for SASE with first-class postage. Uses freelance artists mainly for designing holiday letterheads. Considers pen & ink, color, acrylic, watercolor. Prefers final art 17×22, CMYK color compatible. Produces material for Christmas, Halloween and Thanksgiving.

First Contact & Terms "Send non-returnable examples for your ideas." Responds in 1-2 months if interested. Pays $100-200 on final acceptance. Buys first rights and reprint rights.

Tips "Keep your art fresh and be aggressive with submissions."

GRAHAM & BROWN

3 Corporate Dr., Cranbury NJ 08512. (609)395-9200. Fax: (609)395-9676. E-mail: ncaucino@grahambrownusa.com. Web site: www.grahambrown.com. Estab. 1946. Produces residential wall coverings and home decor products.

Needs Prefers freelancers for designs. Also for artwork. Produces material for everyday.

First Contact & Terms Designers: Send query letter with photographs. Illustrators: Send postcard sample of work only to the attention of Nicole Caucino. Samples are filed or returned. Responds only if interested. Buys all rights. For illustration pays a variable flat fee.

GREAT AMERICAN PUZZLE FACTORY INC.

16 S. Main St., South Norwalk CT 06854. (203)838-4240. Fax: (203)838-2065. E-mail: pduncan@greatamericanpuzzle.com. Web site: www.greatamericanpuzzle.com. **President:** Pat Duncan. Licensing: Patricia Duncan. Estab. 1975. Produces jigsaw puzzles and games for adults and children. Licenses various illustrations for puzzles (children's and adults').

Needs Approached by 150 freelancers/year. Works with 80 freelancers/year. Buys 70 designs and illustrations/year. Uses freelancers mainly for puzzle material. Looking for "fun, busy and colorful" work. 100% of graphic design requires knowledge of QuarkXPress, Illustrator or Photoshop.

First Contact & Terms Send postcard sample and/or 3 representative samples via e-mail. Do not send seasonal material. Also accepts e-mail submissions. Do not send originals or transparencies. Samples are filed or are returned. Art director will contact artist for portfolio review if interested. Original artwork is returned at job's completion. Pays flat fee of $600-1,000, work for hire. Royalties of 5-6% for licensed art (existing art only). Interested in buying second rights (reprint rights) to previously published work.

Tips "All artwork should be *bright*, cheerful and eye-catching. 'Subtle' is not an appropriate look for our market. Go to a toy store and look at what is out there. Do your homework! Send a professional-looking package to appropriate potential clients. Presentation means a lot. We get a lot of totally inappropriate submissions."

GREAT ARROW GRAPHICS

2495 Main St., Suite 457, Buffalo NY 14214. (716)836-0408. Fax: (716)836-0702. E-mail: design@greatarrow.com. Web site: www.greatarrow.com. **Art Director:** Lisa Samar. Estab. 1981. Produces greeting cards and stationery. ''We produce silkscreened greeting cards—seasonal and everyday—to a high-end design-conscious market.''

Needs Approached by 150 freelancers/year. Works with 75 freelancers/year. Buys 350-500 images/year. Art guidelines can be downloaded at www.greatarrow.com/guidelines.asp. Prefers freelancers with experience in silkscreen printing process. Uses freelancers for greeting card design only. Considers all 2-dimensional media. Looking for sophisticated, classic, contemporary or cutting edge styles. Requires knowledge of Illustrator or Photoshop. Produces material for all holidays and seasons. Submit seasonal material 1 year in advance.

First Contact & Terms Send query letter with photocopies. Accepts submissions on disk compatible with

© Great Arrow Graphics/Massimo Friedman Inc.

If you study Greeting Card companies and keep an eye out for their cards when you shop, you'll soon discover each has its own look. Great Arrow Graphics' hand silkscreened cards are bold and bright. They prefer designs that are spare, but not cold, possessing a quiet charm that separates them from cards found in mass market outlets. Designing a Great Arrow card is not as simple as it sounds. Sold in boutiques and bookstores, the cards are virtually cliché free. Vela Tuohy (Little Star Soup) shows a bride walking down the aisle, but seen from the back. Julie Zack's ''Bébé'' is refreshingly sophisticated for a baby shower card yet still touches the heart. More examples can be found at www.great arrow.com.

Illustrator or Photoshop or e-mail jpegs. Samples will not be returned, do not send originals until the images are accepted. Responds in 6 weeks if we are interested. Art director will contact artist for portfolio review if interested. Portfolio should include color roughs, final art, photographs and transparencies. Originals are returned at job's completion. Pays royalties of 5% of net sales. Rights purchased vary according to project.

Tips "We are interested in artists familiar with the assets and limitations of screenprinting, but we are always looking for fun new ideas and are willing to give help and guidance in the silkscreen process. Be original, be complete with ideas. Don't be afraid to be different . . . forget the trends . . . do what you want. Make your work as complete as possible at first submission. The National Stationery Show in New York City is a great place to make contacts."

HALLMARK CARDS, INC.

P.O. Box 419580, Kansas City MO 64141-6580. Web site: www.hallmark.com. Estab. 1931.

- Because of Hallmark's large creative staff of full-time employees and their established base of freelance talent capable of fulfilling their product needs, they do not accept unsolicited freelance submissions.

🛉 HAMPSHIRE PEWTER COMPANY

43 Mill St., Wolfeboro NH 03894-1570. (603)569-4944. Fax: (603)569-4524. E-mail: gifts@hampshirepewter.com. Web site: www.hampshirepewter.com. **President:** Abe Neudorf. Estab. 1974. Manufacturer of handcast pewter tableware, accessories and Christmas ornaments. Clients jewelry stores, department stores, executive gift buyers, tabletop and pewter specialty stores, churches and private consumers.

Needs Works with 3-4 freelance artists/year. "Prefers New-England based artists." Works on assignment only. Uses freelancers mainly for illustration and models. Also for brochure and catalog design, product design, illustration on product and model-making.

First Contact & Terms Send query letter with photocopies. Samples are not filed and are returned only if requested. Call for appointment to show portfolio, or mail b&w roughs and photographs. Pays for design and sculpture by the hour or project. Considers complexity of project, client's budget and rights purchased when determining payment. Buys all rights.

Tips "Inform us of your capabilities. For artists who are seeking a manufacturing source, we will be happy to bid on manufacturing of designs under private license to the artists, all of whose design rights are protected. If we commission a project, we intend to have exclusive rights to the designs by contract as defined in the Copyright Law, and we intend to protect those rights."

MARIAN HEATH GREETING CARDS, LCC

9 Kendrick Rd., Wareham MA 02571. (508)291-0766. Fax: (508)295-5992. E-mail: marianheath@marianheath.com. Web site: www.marianheath.com. **Creative Director:** Molly DelMastro. Estab. 1950. Produces greeting cards, giftbags, giftwrap, stationery and ancillary products. Greeting card company supporting independent card and gift shop retailers.

Needs Approached by 100 freelancers/year. Works with 35-45 freelancers/year. Buys 500 freelance designs and illustrations/year. Prefers freelancers with experience in social expression. Art guidelines free for SASE with first-class postage or e-mail requesting guidelines. Uses freelancers mainly for greeting cards. Considers all media and styles. Generally $5\frac{1}{4} \times 7\frac{1}{4}$ unless otherwise directed. Will accept various sizes due to digital production, manipulation. 30% of freelance design and illustration work demands knowledge of Photoshop, Illustrator, QuarkXPress. Produces material for all holidays and seasons and everyday. Submit seasonal material 1 year in advance.

First Contact & Terms Designers: Send query letter with photocopies, résumé and SASE. OK to send slides, tearsheets and transparencies if necessary. Illustrators: Send query letter with photocopies, résumé, tearsheets and SASE. Accepts Mac-formatted JPEG disk submissions. Samples are filed or returned by SASE. Responds within 1-3 month. Will contact artist for portfolio review of color, final art, slides, tearsheets and transparencies. Pays for illustration by the project; flat fee, or royalties; varies per project. Finds freelancers through agents, artists' rep, artist's submission, licensing and design houses.

HIGH RANGE DESIGNS

P.O. Box 346, Victor ID 83455-0346. (208)787-2277. Fax: (208)787-2276. E-mail: hmiller@highrangedesigns.com. **President:** Hondo Miller. Estab. 1989. Produces T-shirts. "We produce screen-printed garments for recreational sport-oriented markets and resort markets, which includes national parks. Subject matter includes, but is not limited to, skiing, climbing, hiking, biking, fly fishing, mountains, out-of-doors, nature, canoeing and river rafting, Native American, wildlife and humorous sayings that are text only or a combination of text and art. Our resort market customers are men, women and kids looking to buy a souvenir of their vacation experience or activity. People want to identify with the message and/or the art on the T-shirt."

• According to High Range Designs art guidelines, it is easiest to break into HRD with designs related to fly fishing, downhill skiing, snowboarding or river rafting. The guidelines suggest that your first submission cover one or more of these topics. The art guidelines for this company are detailed and include suggestions on where to place design on the garment.

Needs Approached by 20 freelancers/year. Works with 3-8 freelancers/year. Buys 10-20 designs and illustration/year. Prefers artists with experience in screen printing. Uses freelancers mainly for T-shirt ideas, artwork and color separations.

First Contact & Terms Send query letter with résumé, SASE and photocopies. Accepts submissions on disk compatible with FreeHand 8.0 and Illustrator 8.0. Samples are filed or are returned by SASE if requested by artist. Responds in 6 months. Company will contact artist for portfolio review if interested. Portfolio should include b&w thumbnails, roughs and final art. Originals are returned at job's completion. Pays by the project, royalties of 5% based on actual sales. Buys garment rights.

Tips "Familiarize yourself with screen printing and T-shirt art that sells. Must have knowledge of color separations process. We look for creative design styles and interesting color applications. Artists need to be able to incorporate the colors of the garments as part of their design thinking, as well as utilize the screen-printing medium to produce interesting effects and textures. However, sometimes simple is best. Four-color process will be considered if highly marketable. Be willing to work with us on design changes to get the most marketable product. Know the industry. Art that works on paper will not necessarily work on garments. No cartoons please."

HOFFMASTER SOLO CUP COMPANY

2920 N. Main St., Oshkosh WI 54903. (920)235-9330. Fax: (920)235-1642. **Art and Marketing Services Manager:** Paul Zuehlke. Produces decorative paper tableware, placemats, plates, tablecloths and napkins for institutional and consumer markets. Printing includes up to 6-color flexographic napkin printing.

Needs Approached by 20-30 freelancers/year. Works with 5-10 freelancers/year. Prefers freelancers with experience in paper tableware products. Art guidelines and specific design needs based on current market are available from Creative Managers. Looking for trends and traditional styles. Prefers 9" round artwork with coodinating 6.5" square image. Produces material for all holidays and seasons and everyday. Special need for seasonal material.

First Contact & Terms Send query letter with photocopies, résumé, appropriate samples by mail or fax only. Ideas may be sent in a color rough sketch. Accepts disk submissions compatible with Illustrator and FreeHand. Samples are filed or returned by SASE if requested by artist. Responds in 90 days only if interested. "Will provide feedback to artists whose designs could be adapted but are not currently acceptable for use without additional work and a resubmission." Creative Manager will contact artist for portfolio review if interested. Portfolio should include thumbnails, roughs, finished art samples, color photostats, tearsheets, photographs and dummies. Prefers to buy artwork outright. Rights purchased vary according to project. Pays by the project $350-1,500. Amounts vary according to project. May work on a royalty arrangement for recognized properties. Finds freelancers through art fairs and artists' reps.

Tips Looking for new trends and designs appropriate for plates and napkins.

IGPC

460 W. 34th St., 10th Floor, New York NY 10001. (212)629-7979. Fax: (212)629-3350. E-mail: artdept@igpc.net. Web site: www.igpc.net. **Art Director:** Aviva Darab. Agent to foreign governments. "We produce postage stamps and related items on behalf of 40 different foreign governments."

Needs Approached by 50 freelance artists/year. Works with 10 freelance illustrators and designers/year. Assigns several hundred jobs to freelancers/year. Prefers artists within metropolitan New York or tri-state area. Must have extremely sophisticated computer, design and composition skills and a working knowledge of graphic design (mechanicals). Artist's research ability a plus. Artwork must be focused and alive (4-color). Artist's pricing needs to be competitive. Works on assignment only. Uses artists for postage stamp art. Prefers airbrush, acrylic and gouache (some watercolor and oil OK). Must have reasonable knowledge of Photoshop and Quark.

First Contact & Terms Send samples showing illustrative skills. Doesn't need to be precious high quality. Color copies are fine. Responds in 5 weeks. Art Director will contact artist for portfolio review if interested. Portfolio should contain "4-color illustrations of realistic, tight flora, fauna, technical subjects, autos or ships. Also include reduced samples of original artwork." Sometimes requests work on spec before assigning a job. Pays by the project. Consider government allowance per project when establishing payment.

Tips "Artists considering working with IGPC must have excellent drawing abilities in general or specific topics, i.e., flora, fauna, transport, famous people, etc.; sufficient design skills to arrange for and position type; the ability to create artwork with clarity and perfection. Familiarity with printing process and print call-outs a plus. Generally, the work we require is realistic art. In some cases, we supply the basic layout and reference material;

however, we appreciate an artist who knows where to find references and can present new and interesting concepts. Initial contact should be made by appointment. Have fun!''

THE IMAGINATION ASSOCIATION/THE FUNNY APRON COMPANY

P.O. Box 1780, Lake Dallas TX 75065-1780. (940)498-3308. Fax: (940)498-1596. E-mail: ellice@funnyaprons.com. Web site: www.funnyaprons.com. **Creative Director:** Ellice Lovelady. Estab. 1992. Our primary focus is now on our subdivision, The Funny Apron Company, that manufactures humorous culinary-themed aprons and T-shirts for the gourmet marketplace.''

Needs Works with 12 freelancers/year. Artists must be fax/e-mail accessible and able to work on fast turn-around. Check Web site to determine if your style fits our art direction. 100% of freelance work DEMANDS knowledge of Illustrator, Corel Draw, or programs with ability to electronically send vector-based artwork. (Photoshop alone is not sufficient.)

First Contact & Terms Send query letter with brochure, photographs, SASE and photocopies. E-mail inquiries must include a LINK to a Web site to view artwork. We will NOT open unsolicited attachments. Samples are filed or returned by SASE if requested by artist. Company will contact artist if interested. Negotiates rights and payment terms. Finds artists via word of mouth from other freelancers or referrals from publishers.

Tips Looking for artist ''with a style we feel we can work with and a professional attitude. Understand that sometimes we require several revisions before final art, and all under tight deadlines. Even if we can't use your style, be persistent! Stay true to your creative vision and don't give up!''

INKADINKADO, INC.

1801 North 12th St., Reading PA 19604. (610)939-9900 or (800)523-8452. Fax: (610)939-9666. E-mail: customer.service@inkadinkado.com. Web site: www.inkadinkado.com. **Creative Director:** Mark Nelson, licensing contact. Pamela Keller, designer relations coordinator. Estab. 1978. Creates artistic rubber stamps, craft kits, and craft accessories. Also offers licenses to illustrators depending upon number of designs interested in producing and range of style by artist. Distributes to craft, gift and toy stores and specialty catalogs.

Needs Works with 12 illustrators and 6 designers/year. Uses freelancers mainly for illustration, lettering, line drawing, type design. Considers pen & ink. Themes include animals, education, holidays and nature. Prefers small; about 2×3. 50% of design and illustration work demands knowledge of Photoshop, QuarkXPress, Illustrator. Produces material for all holidays and seasons. Submit seasonal material 6-8 months in advance.

First Contact & Terms Designers and Illustrators: Send query letter with 6 nonreturnable samples. Accepts submissions on disk. Samples are filed and not returned. Responds only if interested. Company will contact artist for portfolio review of b&w and final art if interested. Pays for illustration by the project, $100-250/piece. Rights purchased vary according to project. Also needs calligraphers for greeting cards and stamps, pays $50-100/project.

Tips ''Work small. The average size of an art rubber stamp is 3×3.''

INSPIRATIONS UNLIMITED

P.O. Box 5097, Crestine CA 92325. (909)338-6758 or (800)337-6758. Fax: (909)338-2907. Web site: www.inspirationalgreetingcards.org. **Owner:** John Wiedefeld. Estab. 1983. Produces greeting cards, gift enclosures, note cards and stationery.

Needs Approached by 15 freelancers/year. Works with 4 freelancers/year. Buys 48 freelance designs and illustrations/year. Uses freelancers mainly for greeting cards. Will consider all media, all styles. Prefers 5×7 vertical only. Produces material for Christmas, Mother's Day, graduation, Valentine's Day, birthdays, everyday, sympathy, get well, romantic, thank you, serious illness. Submit seasonal material 1 year in advance.

First Contact & Terms Designers and Illustrators: Send photocopies and photographs. Samples are filed and are not returned. Responds in 1 week. Company will contact artist for portfolio review if interested. Buys reprint rights; rights purchased vary according to project. Pays $100/piece of art. Also needs calligraphers, pays $25/hour. Finds freelancers through artists' submissions, art galleries and shows.

Tips ''Send color copies of your artwork for review with a self-addressed envelope.''

INTERCONTINENTAL GREETINGS LTD.

176 Madison Ave., New York NY 10016. (212)683-5830. Fax: (212)779-8564. E-mail: intertg@intercontinental-ltd.com. **Creative Director:** Thea Groene. Estab. 1967. Sells reproduction rights of designs to manufacturers of multiple products around the world. Reps artists in 50 different countries, with clients specializing in greeting cards, giftware, giftwrap, calendars, postcards, prints, posters, stationery, paper goods, food tins, playing cards, tabletop, bath and service ware and much more. (Prefer artwork previously made with few or no rights pending.)

Needs Approached by several hundred artists/year. Seeking creative decorative art in traditional and computer media (Photoshop preferred; some Illustrator work accepted). Graphics, sports, occasions (i.e., Christmas, baby, birthday, wedding), humorous, ''soft touch,'' romantic themes, animals. Accepts seasonal/holiday material any

time. Prefer artists/designers experienced in greeting cards, paper products, tabletop and giftware.

First Contact & Terms Query with samples. Send unsolicited color copies or CDs by mail with return SASE for consideration. Upon request, submit portfolio for review. Provide résumé, business card, brochure, flier, tearsheets or slides to be kept on file for possible future assignments. "Once your art is accepted, we use" original color art; Photoshop files on disk, TIFF, Mac, 300 dpi; 4×5, 8×10 transparencies and 35mm slides. Responds only if interested (will send back nonaccepted in SASE if given). Pays on publication. No credit line given. Offers advance when appropriate. Sells one-time rights and exclusive product rights. Simultaneous submissions and previously published work OK. Please state reserved rights if any.

Tips Recommends the annual New York Surtex and Licensing shows. In portfolio samples, wants to see "a neat presentation, thematic in arrangement, a series of interrelated images (at least six). In addition to having good drawing/painting/designing skills, artists should be aware of market needs."

THE INTERMARKETING GROUP

29 Holt Rd., Amherst NH 03031. (603)672-0499. **President:** Linda L. Gerson. Estab. 1985. Licensing agent for all categories of consumer goods including greeting cards, stationery, calendars, posters, paper tableware products, tabletop, dinnerware, giftwrap, eurobags, giftware, toys, needle crafts. The Intermarketing Group is a full-service art licensing agency representing artists' works for licensing with companies in consumer goods products, including the home furnishings, paper product, greeting card, giftware, toy, housewares, needlecraft and apparel industries.

Needs Approached by 100 freelancers/year. Works with 6 freelancers/year. Licenses work as developed by clients. Prefers freelancers with experience in full-color illustration. Uses freelancers mainly for tabletop, cards, giftware, calendars, paper tableware, toys, bookmarks, needlecraft, apparel, housewares. Will consider all media forms. "My firm generally represents illustrated works and illustrations for direct product applications. All works are themed." Prefers 5×7 or 8×10 final art. Produces material for all holidays and seasons and everyday. Submit seasonal material 6 months in advance.

First Contact & Terms Send query letter with brochure, tearsheets, résumé, slides, SASE or color copies. Samples are not filed and are returned by SASE. Responds in 3 weeks. Originals are returned at job's completion. Requests work on spec before assigning a job. Pays royalties of 2-7% plus advance against royalties. Buys all rights. Considers buying second rights (reprint rights) to previously published work. Finds new artists "mostly by referrals and via artist submissions. I do review trade magazines, attend art shows and other exhibits to locate suitable clients."

Tips "Companies today seem to be leaning towards a fresh, trendy look in the art approach. Companies are selective in their licenses. A well-organized presentation is very helpful. Be aware of the market. See what is selling in stores and focus on specific products that would incorporate your art well. Get educated on market conditions and trends."

KALAN LP

97 S. Union Ave., Lansdowne PA 19050. (610)623-1900 ext. 341. Fax: (610)623-0366. E-mail: klangrock@kalanlp.com. Web site: www.kalanlp.com. **Art Director:** Chris Wiemer. Copywriter: Katie Langrock. Estab. 1973. Produces giftbags, greeting cards, school supplies, stationery and novelty items such as keyrings, mouse pads, shot glasses and magnets.

Needs Approached by 50-80 freelancers/year. Buys 100 freelance designs and illustrations/year. Art guidelines are available. Uses freelancers mainly for fresh ideas, illustration and design. Considers all media and styles. Some illustration demands knowledge of Photoshop 7.0 and Illustrator 10. Produces material for major holidays such as Christmas, Mother's Day, Valentine's Day; plus birthdays and everyday. Submit seasonal material 9-10 months in advance.

First Contact & Terms Designers: Send query letter with photocopies, photostats and résumé. Illustrators and cartoonists: Send query letter with photocopies and résumé. Accepts disk submissions compatible with Illustrator 10 or Photoshop 7.0. Send EPS files. Samples are filed. Responds in 1 month if interested in artist's work. Will contact artist for portfolio review of final art if interested. Buys first rights. Pays by the project, $75 and up. Finds freelancers through submissions and newspaper ads.

KEMSE AND COMPANY

P.O. Box 14334, Arlington TX 76094. (888)656-1452. Fax: (817)446-9986. E-mail: kim@kemseandcompany.com. Web site: www.kemseandcompany.com. **Contact:** Kimberly See. Estab. 2003. Produces stationery. Specializes in multicultural stationery and invitations.

Needs Approached by 10-12 freelancers/year. Works with 5-6 freelancers/year. Buys 15-20 freelance designs and/or illustrations/year. Considers all media. Product categories include African American and Hispanic. Produces material for all holidays and seasons, birthday, graduation and woman-to-woman. Submit seasonal material 8 months in advance. Art size varies, please discuss with contact. 75% of freelance work demands knowledge of FreeHand, Illustrator, QuarkXPress and Photoshop.

Ellice Lovelady

Spicing up the kitchen with artsy fun

When she quit her vegetarian diet 14 years ago, former greeting card creative director Ellice Lovelady had no idea she would get the inspiration for an entirely new and successful business concept—funny aprons. After "falling off the wagon and finding herself in the gutter with Whopper wrappers," Lovelady was compelled to make an apron that confessed, "Recovering Vegetarian" with a bloody butcher knife on the front. Irony comes naturally to Lovelady, whose second apron design featured a fat grandmother and read, "Honorary Poster-Child for the American Cholesterol Association." Now Lovelady produces a full line of aprons with themes ranging from cooking and wine to sports, through her business The Imagination Association/The Funny Apron Company (www.funnyaprons.com).

Lovelady admits that she is not an artist, but that her specialty is in conceptual work. Her background in the greeting card industry and in T-shirt design was as a creative direct or. Unsure of where to go with her avant-garde apron ideas, Lovelady formed a focus group of former colleagues and friends, asking point-blank—If I put one of these designs on an apron, would you buy it? She then needed to test out her product, which required her to invest her own savings and take a financial risk. She found a T-shirt rep to man a booth featuring her aprons at a local show, but this still was much too small a venue with too few designs for Lovelady to determine if she was heading in the right direction.

This was when she had to really put her money where her mouth was. She began asking former artists she'd worked with in greeting cards if they would be willing to illustrate any of her designs. By word of mouth, her concept branched out to other artists who were interested in her aprons. She paid for all the materials up front, had no money to pay the artists but they agreed to do the work on spec earning any future royalties. "This was literally a grassroots organization," she admits. "And it took perseverance."

Now 14 years later, Lovelady laughs about the stacks of rejection letters she received from every mail order catalog that turned her down. Whether it was clairvoyance or her acute sense of irony, she kept every last "thank you, but no thank you" letter and now finds herself working with every single one of those catalogs today.

Having worked on both the artistic and manufacturing sides of the business, Lovelady has a unique perspective on how artists should approach today's market and effective suggestions on how to make it in industry that she knows can be brutal. In addition to the age-old advice that artists must be willing to accept multiple rejections and that they are not alone in having stacks of disappointing letters, Lovelady also has worked with a slew of different artists, some whom she would call again in a heartbeat and others whom she has chosen not to work with again.

"I adore artists who not only have great talent, but who have professionalism. In order

to work with me, you need to be quick and upfront when communicating about when you can reasonably meet deadlines. For long term projects, I need a timeline and artists need to deliver accordingly.'' Unfortunately, Lovelady has found many artists whose designs she loves but who she will not do business with because they fail to work in a timely manner.

Another problem she has faced with many talented artists is their lack of technical skills. Today's industry has changed drastically in the past 10 years, according to Lovelady, and the demands on artists are even higher. Computer-illiteracy just won't cut it today, she insists. ''Adobe Photoshop works great for greeting cards, but it won't get you anywhere if you branch out to other print mediums.'' Knowledge and fluency in Vector-based artwork for screen printing is now a minimum that Lovelady requires from artists who work with

© Megacolor

''People love funny aprons'' says Ellice Lovelady, and apparently they also love buying them as gifts. That's the winning formula behind Lovelady's The Funny Apron Company. ''Although the line is 100% slogan driven, I like to add a little pizzazz, that, as Emeril would say, kicks it up a notch,'' says Lovelady. The pizzazz often takes the form of a whimsical graphic provided by freelancers such as Charles Somerville of Who Else? Enterprises. Somerville created ''Real Men Fry Turkeys'' and ''Born to Golf,'' while the ''Sophisticated Apron'' (center, worn by Lovelady, and her firm's best seller to date) was created in-house.

her. "It makes me so sad to think about the number of artists I've had to stop working with whose designs were exquisite, but they were costing me too much money because they hadn't educated themselves on the latest technology."

Companies, particularly smaller ones like The Funny Apron Company, no longer have an in-house art department that will take your art in any form and cut it up so that it will work across different mediums. "It is no longer cost effective," insists Lovelady. "Chopping up a design to make it work in the correct format is just too expensive." Lovelady remembers several artists who resisted technology kicking and screaming, and she herself felt this way until she realized the transition was not an option. Luckily, Lovelady has been able to continue to work with many of the same artists over the years because they have made this necessary transition and adjusted to the changing industry.

Another change Lovelady has noticed within her apron/culinary niche is the tendency of buyers to prefer more text and less design. As an art-lover, this devastates her. But as a business woman who doesn't just want The Funny Apron Company to be a hobby, she has redirected her line to be more text-driven with less intricate designs. Fourteen years ago, her audience went crazy over the beautiful artwork, but sales are showing that today people are looking for the joke.

If interested in sending her work, Lovelady prefers artists send a portfolio, though she occasion ally receives work on spec. Given the number of portfolios she sees, she strongly recommends that for their own protection artists always document who they are sending work to and what they are sending. "Don't expect confidentiality agreements," advises Lovelady. "You don't know what's already in the pipeline and the manufacturers do, so they rarely agree to them. It is a matter of trust which is why it is so important to document."

Lovelady also advises artists to recognize that when a manufacturer invests time and money in promoting their work and making brochures, they are making a commitment. "I am humbled thinking back to when I would try and insist on big checks up front from a company as a sign of dedication to my work. Being on the other side of the business, I see how much money is spent promoting an artist's work and *that* in itself is a commitment."

In terms of licensing, Lovelady tends to accept artists on a work-for-hire basis and typically buys all rights. She prefers this over licensing, because then she and the artist can work together during every step of the process. "Most artists tend to prefer it too because they don't know if their design will be very lucrative or pay pennies in royalty checks. This way they know in advance how much money they will make for a project." Although she can't speak for other companies, Lovelady does little licensing now and when she does license, she typically asks only for the right of first refusal if the artist were to try to sell the design to work on a mug, magnet, or any other subsidiary that her company may branch into in the future.

Currently, The Funny Apron Company is sticking to aprons, "but I am always looking," Lovel ady admits. "There is just such a wide market out there." Never imagining that her apron idea would take off so successfully, Lovelady can't help but envision the endless possibilities that exist for someone who loves art and is willing to learn the business.

—*Rebecca Chrysler*

First Contact & Terms Send query letter with photocopies, résumé and SASE. Accepts e-mail submissions with image file. Prefers Windows-compatible, JPEG files. Samples are filed. Responds only if interested. Company will contact artist for portfolio review if interested. Portfolio should include color, finished art, roughs and thumbnails. Buys all rights and reprint rights. Pays freelancers by the project. Finds freelancers through artists' submissions.

KENZIG KARDS, INC.
2300 Julia Goldbach Ave., Ronkonkoma NY 11779-6317. (631)737-1584. Fax: (631)737-8341. E-mail: kenzigkard s@aol.com. **Contact:** Jerry Kenzig, president. Estab. 1999. Produces greeting cards and stationery. Specializes in greeting cards (seasonal and everyday) for a high-end, design-conscious market (all ages).
Needs Approached by 75 freelancers/year. Works with 3 freelancers/year. Prefers local designers/illustrators, however, we will consider freelancers working anywhere in US. Art guidelines free with SAE and first-class postage. Uses freelancers mainly for greeting cards/design and calligraphy. Considers watercolor, colored pencils; most media. Product categories include alternative/humor, business and cute. Produces material for baby congrats, birthday, cards for pets, Christmas, congratulations, everyday, get-well/sympathy, Valentine's Day and wedding/anniversary. Submit seasonal material 6 months in advance. Art size should be 5×7 or $5^{3}/_{4} \times 5^{3}/_{4}$ square. 20% of freelance work demands knowledge of Illustrator, QuarkXPress and Photoshop.
First Contact & Terms Send query letter with brochure, résumé and tearsheets. After introductory mailing, send follow-up postcard sample every 6 months. Samples are filed. Responds in 2 weeks. Company will contact artist for portfolio review if interested. Portfolio should include color, original art, roughs and tearsheets. Buys one-time rights and reprint rights for cards and mugs. Negotiates rights purchased. Pays freelancers by the project, $150-350; royalties (subject to negotiation). Finds freelancers through industry contacts (Kenzig Kards, Inc. is a regular member of the Greeting Card Association [GCA]), artist's submissions and word of mouth.
Tips ''We are open to new ideas and different approaches within our niche (i.e. dog- and cat-themed designs, watercolor florals, etc.) Looking for bright colors and cute, whimsical art. Floral designs require crisp colors.''

KID STUFF
University Blvd. at Essex Entrance, Topeka KS 66619-0235. (785)862-3707. Fax: (785)862-1424. E-mail: michael @kidstuff.com. Web site: www.kidstuff.com. **Contact:** Michael Oden, Sr. Director of Creative. Estab. 1982. Produces collectible figurines, toys, kids' meal sacks, edutainment activities and cartons for restaurants worldwide.
Needs Approached by 30 freelancers/year. Works with 10 freelancers/year. Buys 30-50 freelance designs and illustrations/year. Works on assignment only. Uses freelancers mainly for illustration, activity or game development and sculpting toys. Considers all media. Looking for humorous, child-related styles. Freelance illustrators should be familiar with Photoshop, Illustrator, FreeHand and QuarkXPress. Produces material for Christmas, Easter, Halloween, Thanksgiving, Valentine's Day and everyday. Submit seasonal material 3 months in advance.
First Contact & Terms Illustrators and Cartoonists: Send query letter with photocopies or e-mail JPEG files. Sculptors, calligraphers: Send photocopies. Samples are filed or returned by SASE. Responds only if interested. Portfolio review not required. Pays by the project, $250-2,000 for illustration. Finds freelancers through word of mouth and artists' submissions.

THE LANG COMPANIES, LCC.
514 Wells St., Delafield WI 53018. (262)646-3399. Web site: www.lang.com. **Product Development Coordinator:** Yvonne Moroni (product development and art submissions). Estab. 1982. Produces high quality linen-embossed greeting cards, stationery, calendars, boxes, and gift items.
Needs Approached by 300 freelance artists/year. Art guidelines available, SASE. Works with 40 freelance artists/year. Uses freelancers mainly for card and calendar illustrations. Considers all media and styles. Looking for traditional and nonabstract country-inspired, folk, contemporary and fine art styles. Produces material for Christmas, birthdays and everyday. Submit seasonal material 6 months in advance.
First Contact & Terms Send query letter with SASE and brochure, tearsheets, photostats, photographs, slides, photocopies or transparencies. Samples are returned by SASE if requested by artist. Responds in 6 weeks. Pays royalties based on net wholesale sales. Rights purchased vary according to project.
Tips ''Research the company and submit compatible art. Be patient awaiting a response.''

THE LOLO COMPANY
6755 Mira Mesa Blvd., Suite 123-410, San Diego, CA 92121. (800)760-9930. Fax: (800)234-6540. E-mail: products @lolofun.com. Web site: www.lolofun.com. **Creative Director:** Robert C. Paul. Estab. 1995. Publishes board games. Prefers humorous work. Uses freelancers mainly for product design and packaging. Recent games include ''Bucket Blast,'' ''It da gan,'' ''Run Around Fractions'' and ''You're It.''
Needs Approached by 1 illustrator and 1 designer/year. Works with 2 illustrator and 2 designer/year. 100% of freelance design and illustration demands knowledge of Illustrator, Photoshop and QuarkXPress.

First Contact & Terms Preferred submission package is self-promotional postcard sample. Send 5 printed samples or photographs. Accepts disk submissions in Windows format; send via Zip as EPS. Samples are filed. Will contact artist for portfolio review if interested. Portfolios should include artwork of characters in sequence, color photocopies, photographs, transparencies of final art and roughs. Rights purchased vary according to project. Finds freelancers through word of mouth and Internet.

LPG GREETINGS, INC.
4000 Porett Dr., Gurnee IL 60031. (847)244-4414. Fax: (847)244-0188. E-mail: judy@lpggreetings.com. Web site: www.lpggreetings.com. **Creative Director:** Judy Cecchi. Estab. 1992. Produces greeting cards. Specializes in boxed Christmas cards.

Needs Approached by 50-100 freelancers/year. Works with 20 freelancers/year. Buys 70 freelance designs and illustrations/year. Art guidelines free for SASE with first-class postage. Uses freelancers mainly for original artwork for Christmas cards. Considers any media. Looking for traditional and humorous Christmas. Greeting cards can be vertical or horizontal; 5×7 or 6×8. Usually prefers 5×7. Submit seasonal material 1 year in advance.

First Contact & Terms Send query letter with photocopies. Samples are filed if interested or returned by SASE. Portfolio review not required. Will contact artist for portfolio if interested. Rights purchased vary according to project. Pays for design by the project. For illustration: pays flat fee. Finds freelancers through word of mouth and artists' submissions. Please do not send unsolicited samples via e-mail; they will not be considered.

Tips "Be creative with fresh new ideas."

LUNT SILVERSMITHS
298 Federal St., P.O. Box 1010, Greenfield MA 01302-1010. (413)774-2774. Fax: (413)774-4393. E-mail: alunt@luntsilver.com. Web site: www.luntsilver.com. **Director of Design:** Alexander C. Lunt. Estab. 1902. Produces collectibles, gifts, Christmas ornaments, babyware, tabletop products, sterling and steel flatware.

Needs Approached by 1-2 freelancers/year. Works with 1-2 freelancers/year. Contracts 35 product models/year. Prefers freelancers with experience in tabletop product, model-making. Uses freelancers mainly for model-making, prototypes and cad engineering. Also for mechanicals. Considers clay, plastaline, resins, hard models. Looking for traditional, florals, sentimental, contemporary. 50% of freelance design work demands knowledge of Photoshop, Illustrator, Cad. Produces material for all holidays and seasons, Christmas, Valentine's Day, everyday.

First Contact & Terms Designers and sculptors should send query letter with brochure, photocopies, photographs, résumé. Sculptors should also send résumé and photos. Accepts disk submissions created digitally. Samples are filed or returned by SASE. Responds in 1 week only if interested. Will contact for portfolio review if interested. Portfolio should include photographs, slides. Rights purchased vary according to project. Pays for design, illustration and sculpture according to project.

MADISON PARK GREETINGS
1407 11th Ave., Seattle WA 98122-3901. (206)324-5711. Fax: (206)324-5822. E-mail: info@madpark.com. Web site: www.madisonparkgreetings.com. **Art Director:** Glen Biely. Estab. 1977. Produces greeting cards, stationery, notepads, frames.

Needs Approached by 250 freelancers/year. Works with 15 freelancers/year. Buys 200 freelance designs and illustrations/year. Art guidelines available free for SASE. Works on assignment only. Uses freelancers mainly for greeting cards. Also for calligraphy, reflective art. Considers all paper-related media. Produces material for Christmas, Easter, Mother's Day, Father's Day, graduation, New Year, Valentine's Day, birthdays, everyday, sympathy, get well, anniversary, baby congratulations, wedding, thank you, expecting, friendship. "We are interested in floral and whimsical imagery, as well as humor." Submit seasonal material 10 months in advance.

First Contact & Terms Designers: Send photocopies, slides or transparencies. Illustrators: Send postcard sample or photocopies. Accepts submissions on disk. Send EPS files. "Good samples are filed; rest are returned." Please enclose SASE. Company will contact artist for portfolio review of color, final art, roughs if interested. Rights purchased and royalty vary according to project.

MILLIMAC LICENSING CO.
188 Michael Way, Santa Clara CA 95051. (408)984-0700. Fax: (408)984-7456. E-mail: bruce@clamkinman.com or clamkinman@comcast.net. Web site: www.clamkinman.com. **Owner:** Bruce Ingrassia. Estab. 1978. Produces collectible figurines, mugs, T-shirts and textiles. Produces a line of cartoon characters called the Clamkin® Family directed towards "children and adults young at heart."

Needs Approached by 10 freelancers/year. Works with 2-3 freelancers/year. Buys 30-40 freelance designs and illustrations/year. Prefers freelancers with experience in cartooning. Works on assignment only. Uses freelancers mainly for line art, color separation, Mac computer assignments. Considers computer, pen & ink. Looking for humorous, clever, "off the wall," cute animals. 50% of freelance design/illustration demands knowledge of Photo-

shop, Illustrator, FreeHand (pencil roughs OK). "Computer must be Mac or PC." Produces material for everyday.
First Contact & Terms Designers/Cartoonists: Send query letter with photocopies. Sculptors send photos of work. Accepts disk submissions compatible with Mac Adobe Illustrator files. Samples are filed. Will contact artist for portfolio review if interested. Rights purchased and pay rates vary according to project. Finds freelancers through submissions. "I also find a lot of talent around town at fairs, art shows, carnivals, students—I'm always on the lookout."
Tips "Get a computer—learn Adobe Illustrator, Photoshop. Be clever, creative, open minded and responsible and never give up. Quitters never get there."

MIXEDBLESSING

P.O. Box 97212, Raleigh NC 27624-7212. (919)847-7944. Fax: (919)847-6429. E-mail: mixedblessing@earthlink.com. Web site: www.mixedblessing.com. **President:** Elise Okrend. Licensing: Philip Okrend. Estab. 1990. Produces interfaith greeting cards combining Jewish and Christian as well as multicultural images for all ages. Licenses holiday artwork for wrapping paper, tote bags, clothing, paper goods and greeting cards.
Needs Approached by 10 freelance artists/year. Works with 10 freelancers/year. Buys 20 designs and illustrations/year. Provides samples of preferred styles upon request. Works on assignment only. Uses freelancers mainly for card illustration. Considers watercolor, pen & ink and pastel. Prefers final art 5×7. Produces material for Christmas and Hanukkah. Submit seasonal material 10 months in advance.
First Contact & Terms Send nonreturnable samples for review. Samples are filed. Responds only if interested. Originals are returned at job's completion. Sometimes requests work on spec before assigning a job. Pays flat fee of $125-500 for illustration/design. Buys all rights. Finds artists through visiting art schools.
Tips "I see growth ahead for the industry. Go to and participate in the National Stationery Show."

NALPAC, LTD.

1111 E. Eight Mile Rd., Ferndale MI 48220. (248)541-1140. Fax: (248)544-9126. E-mail: ralph@nalpac.com. **President, licensing:** Ralph Caplan. Estab. 1971. Produces coffee mugs gift bags, trendy gift and novelty items, and T-shirts for gift and mass merchandise markets. Licenses all kinds of artwork for T-shirts, mugs and gifts.
Needs Approached by 10-15 freelancers/year. Works with 2-3 freelancers/year. Buys 70 designs and illustrations/year. Works on assignment only. Considers all media. Needs computer-literate freelancers for design, illustration and production. 60% of freelance work demands computer skills.
First Contact & Terms Send query letter with brochure, résumé, SASE, photographs, photocopies, slides and transparencies. Samples are filed or are returned by SASE if requested by artist. Responds in 1 month. Call for appointment to show portfolio. Usually buys all rights, but rights purchased may vary according to project. Also needs package/product designers, pay rate varies. Pays for design and illustration by the hour $10-25; or by the project $40-500, or offers royalties of 4-10%.

NCE, NEW CREATIVE ENTERPRISES, INC.

401 Milford Pkwy., Milford OH 45150. (800)435-1000. Fax: (513)248-3156. E-mail: mhaas@ncegifts.com. Web site: www.ncegifts.com. **Contact:** Mark Haas, creative director. Estab. 1979. Produces low-medium priced giftware and decorative accessories. "We sell a wide variety of items ranging from home decor to decorative flags. Our typical retail-level buyer is female, age 30-50."
Needs Approached by 5-10 freelancers/year. Works with 2-5 freelancers/year. Buys 10-50 designs and illustrations/year. Prefers freelancers with experience in textiles. Most often needs ink or marker illustration. Seeks heart-warming and whimsical designs and illustrations using popular (Santa, Easter Bunny, etc.) or unique characters. Final art must be mailable size. Needs computer-literate freelancers for design, illustration and production. 50% of freelance work demands knowledge of Illustrator. Produces material for Christmas, Valentine's Day, Easter, Thanksgiving and Halloween. Submit seasonal material 1 year in advance.
First Contact & Terms Send query letter with tearsheets, photographs, photocopies, photostats, slides and transparencies. Samples are filed and are returned by SASE if requested by artist. Responds in 1 week. Director will contact artists for portfolio review if interested. Portfolio should include thumbnails, roughs, finished art samples, b&w and color tearsheets, photographs, slides and dummies. Originals are returned at job's completion. Rights purchased vary according to project.
Tips "If you want the artwork back please send a SASE with it."

NEW DECO, INC.

23123 Sunfield Dr., Boca Raton FL 33433. (800)543-3326. Fax: (561)488-9743. E-mail: newdeco@mindspring.com. Web site: newdeco.com. **President:** Brad Hugh Morris. Estab. 1984. Produces greeting cards, posters, fine art prints and original paintings.
Needs Specializing in pool and billiard artwork only. Works with 5-10 freelancers/year. Buys 8-10 designs and

5-10 illustrations/year. Uses artwork for original paintings, limited edition graphics, greeting cards, giftwrap, calendars, paper tableware, poster prints, etc. Licenses artwork for posters and prints.

First Contact & Terms Send query letter with brochure, résumé, tearsheets, slides and SASE. Samples not filed are returned by SASE. Responds in 10 days only if interested. To show portfolio, send e-mail. Pays royalties of 5-10%. Negotiates rights purchased.

Tips "Do not send original art at first." Contact only if you have an original image relating to Pool and Billiards.

NOBLE WORKS

123 Grand St., P.O. Box 1275, Hoboken NJ 07030. (201)420-0095. Fax: (201)420-0679. Web site: www.noblewor ksinc.com. **Contact:** Art Department. Estab. 1981. Produces greeting cards, notepads, gift bags and gift products. Produces "modern cards for modern people." Trend oriented, hip urban greeting cards.

Needs Approached by 100-200 freelancers/year. Works with 50 freelancers/year. Buys 250 freelance designs and illustrations/year. Prefers freelancers with experience in illustration. Art guidelines on Web site or available for SASE with first-class postage. We purchase "secondary rights" to illustration. Considers illustration, electronic art. Looking for humorous, "off-the-wall" adult contemporary and editorial illustration. Produces material for Christmas, Mother's Day, Father's Day, graduation, Halloween, Valentine's Day, birthdays, thank you, anniversary, get well, astrology, sympathy, etc. Submit seasonal material 18 months in advance.

First Contact & Terms Designers: Send query letter with photocopies, SASE, tearsheets, transparencies. Illustrators and Cartoonists: Send query letter with photocopies, tearsheets, SASE. After introductory mailing send follow-up postcard sample every 8 months. Responds in 1 month. Buys reprint rights. Pays for design and illustration by the project. Finds freelancers through sourcebooks, illustration annuals, referrals.

NORTHERN CARDS

5694 Ambler Dr., Mississauga ON L4W 2K9 Canada. (905)625-4944. Fax: (905)625-5995. E-mail: ggarbacki@nor therncards.com. Web site: northerncards.com. **Product Coordinator:** Greg Garbacki. Estab. 1992. Produces 3 brands of greeting cards.

Needs Approached by 200 freelancers/year. Works with 25 freelancers/year. Buys 75 freelance designs and illustrations/year. Uses freelancers for "camera-ready artwork and lettering." Art guidelines for SASE with first-class postage. Looking for traditional, sentimental, floral and humorous styles. Prefers $5\frac{1}{2} \times 7\frac{3}{4}$ or 5×7. Produces material for Christmas, Easter, Mother's Day, Father's Day, graduation, Valentine's Day, birthdays and everyday. Also sympathy, get well, someone special, thank you, friendship, new baby, good-bye and sorry. Submit seasonal material 6 months in advance.

First Contact & Terms Designers: Send query letter with brochure, photocopies, slides, résumé and SASE. Illustrators and Cartoonists: Send photocopies, tearsheets, résumé and SASE. Lettering artists send samples. Samples are filed or returned by SASE. Responds only if interested. Pays flat fee, $200 (CDN). Finds freelancers through newspaper ads, gallery shows and Internet.

Tips "Research your field and the company you're submitting to. Send appropriate work only."

NOVO CARD PUBLISHERS INC.

3630 W. Pratt Ave., Lincolnwood IL 60712. (847)763-0077. Fax: (847)763-0022. E-mail: art@novocard.net. Web site: www.novocard.net. Estab. 1927. Produces all categories of greeting cards.

Needs Approached by 200 freelancers/year. Works with 30 freelancers/year. Buys 300 or 400 pieces/year from freelance artists. Art guidelines free for SASE with first-class postage. Uses freelancers mainly for illustration and text. Also for calligraphy. Considers all media. Prefers crop size $5 \times 7\frac{3}{4}$, bleed $5\frac{1}{4} \times 8$. Knowledge of Photoshop, Illustrator and QuarkXPress helpful. Produces material for all holidays and seasons and everyday. Submit seasonal material 8 months in advance.

First Contact & Terms Designers: Send brochure, photocopies, photographs and SASE. Illustrators and Cartoonists: Send photocopies, photographs, tearsheets and SASE. Calligraphers: Send b&w copies. Accepts disk submissions compatible with Macintosh QuarkXPress 4.0 and Windows 95. Art samples are not filed and are returned by SASE only. Written samples retained on file for future assignment with writer's permission. Responds in 2 months. Pays for design and illustration by the project, $75-200.

OATMEAL STUDIOS

Box 138, Rochester VT 05767. (802)767-3171. Fax: (802)767-9890. **Creative Director:** Helene Lehrer Siobhan. Estab. 1979. Publishes humorous greeting cards and notepads, creative ideas for everyday cards and holidays.

Needs Approached by approximately 300 freelancers/year. Buys 100-150 freelance designs and illustrations/year. Art guidelines for SASE with first-class postage. Considers all media. Produces seasonal material for Christmas, Mother's Day, Father's Day, Easter, Valentine's Day and Hanukkah. Submit art year-round for all major holidays.

First Contact & Terms Send query letter with slides, roughs, printed pieces or brochure/flyer to be kept on file; write for artists' guidelines. "If brochure/flyer is not available, we ask to keep one slide or printed piece;

color or b&w photocopies also acceptable for our files." Samples returned by SASE. Responds in 6 weeks. No portfolio reviews. Negotiates payment.

Tips "We're looking for exciting and creative, humorous (not cutesy) illustrations and single panel cartoons. If you can write copy and have a humorous cartoon style all your own, send us your ideas! We do accept work without copy too. Our seasonal card line includes traditional illustrations, so we do have a need for non-humorous illustrations as well."

THE OCCASIONS GROUP

(formerly Blue Sheet Marketing) 1710 Roe Crest Dr., North Mankato MN 56003. Fax: (507)625-3388. E-mail: dknutson@theoccasionsgroup.com. Web site: www.executive-greetings.com. **Creative Director:** Deb Knutson. Produces calendars, greeting cards, stationery, posters, memo pads, advertising specialties. Specializes in Christmas, everyday, dental, healthcare greeting cards and postcards, and calendars for businesses and professionals. **Needs** Art guidelines available free for SASE. Works with 20-30 freelancers/year. Buys approximately 300 freelance designs and illustrations/year. Prefers freelancers with experience in greeting cards. Works on assignment only. Uses freelancers mainly for illustration, calligraphy, lettering, humorous writing, cartoons. Prefers traditional Christmas and contemporary and conservative cartoons. Some design work demands knowledge of Photoshop, Illustrator, QuarkXPress abd InDesign. Produces material for Christmas, Thanksgiving, birthdays, everyday.

First Contact & Terms Designers: send brochure, résumé, tearsheets. Illustrators and cartoonists: send tearsheets. After introductory mailing, send follow-up postcard sample every 6 months. Calligraphers: send photocopies of their work. Accepts Mac-compatible disk submissions. Samples are filed. Buys one-time or all rights. Pays for illustration by the project, $250-500. Finds freelancers through agents, other professional contacts, submissions and recommendations.

OFFRAY

Rt. 24 Box 601, Chester NJ 07930. (908)879-3135. Fax: (908)879-8588. E-mail: pattijo.smith@berwickoffray.com. **Contact:** Patti Jo Smith, business unit manager of design and new product. Estab. 1900. Produces ribbons. "We're a ribbon company—for ribbon designs we look to the textile design studios and textile-oriented people; children's designs, craft motifs, fabric trend designs, floral designs, Christmas designs, bridal ideas, etc. Our range of needs is wide, so we need various looks."

Needs Approached by 8-10 freelancers/year. Works with 5-6 freelancers/year. Buys 8-10 freelance designs and illustrations/year. Artists must be able to work from pencils to finish, various styleswork is small and tight. Works on assignment only. Uses freelancers mainly for printed artwork on ribbons. Looking for artists able to translate a trend or design idea into a $1\frac{1}{2}$ to 2-inch space on a ribbon. Produces material for Christmas, everyday. Submit seasonal material 6 months in advance.

First Contact & Terms Send postcard sample or query letter with résumé or call. Samples are filed. Responds only if interested. Portfolio should include color final art. Rights purchased vary according to project. Pays by the project.

OUT OF THE BLUE

7350 So. Tamiami Trial #227, Sarasota FL 34231. (941)966-4042. Fax: (941)966-8914. E-mail: outoftheblue.us@mac.com. Web site: www.out-of-the-blue.us. **President:** Michael Woodward. Creative Director: Maureen May. "Out of the Blue specializes in creating 'Art Brands.' We are looking for fine art, decorative art, photography or character concepts that we can license for product categories such as posters and prints, greeting cards, calendars, stationery, gift products and the home decor market. We specialize particulary in the fine art print/poster market."

Needs Collections of art, illustrations or photography which have wide consumer appeal. CD presentation preferred, but photocopies/flyers are acceptable. If submitting character concepts, include a style guide showing all the characters and a synopsis with storylines.

First Contact & Terms Send samples on CD (JPEG files), short bio, color photocopies and SASE. E-mail presentations also accepted. Terms 50/50 with no expense to artist as long as artist can provide high-res scans if we agree on representation.

Tips "Pay attention to trends and color palettes. Artists need to consider actual products when creating new art. Look at products in retail outlets and get a feel for what is selling well. Get to know the markets you want to sell your work to."

PAINTED HEARTS

1222 N. Fair Oaks Ave., Pasadena CA 91103. (626)798-3633. Fax: (626)296-8890. E-mail: richard@paintedhearts.com. Web site: www.paintedhearts.com. **Sales Manager:** Richard Crawford. President: Susan Kinney. Estab. 1988. Produces greeting cards, stationery, invitations and note cards.

Needs Approached by 75 freelance artists/year. Works with 6 freelancers/year. Art guidelines free for SASE

with first-class postage or by e-mail. Works on assignment only. Uses freelancers mainly for design. Produces material for all holidays and seasons, birthdays and everyday. Submit seasonal material 1 year in advance.

First Contact & Terms Send art submissions and writers submissions Attn: Richard Crawford or use e-mail. Send query letter with résumé, SASE and color photocopies. Samples are returned with SASE. Responds only if interested. Write for appointment to show portfolio, which should include original and published work. Rights purchased vary according to project. Originals returned at job's completion. Pays royalties of 5%.

Tips "Familiarize yourself with our card line." This company is seeking "young artists (in spirit!) looking to develop a line of cards. We're looking for work that is compatible but adds to our look, which is bright, clean watercolors. We need images that go beyond just florals to illustrate and express the occasion."

PAPER MAGIC GROUP INC.

401 Adams Ave., Scranton PA 18510. (570)961-3863. Fax: (570)348-8389. **Creative Director:** Don French. Estab. 1984. Produces greeting cards, stickers, vinyl wall decorations, 3-D paper decorations. "We publish seasonal cards and decorations for the mass market. We use a wide variety of design styles."

Needs Works with 60 freelance artists/year. Prefers artists with experience in greeting cards. Work is by assignment or send submissions on spec. Designs products for Christmas and Valentine's Day. Also uses freelancers for lettering and art direction.

First Contact & Terms Send query letter with résumé, samples and SASE to the attention of Lisa Spencer. Color photocopies are acceptable samples. Samples are filed or are returned by SASE only if requested by artist. Responds in 2 months. Originals not returned. Pays by the project, $350-2,000 average. Buys all rights.

Tips "Please, experienced illustrators only."

PAPER MOON GRAPHICS, INC.

Box 34672, Los Angeles CA 90034. (310)287-3949. Fax: (310)287-2588. E-mail: moonguys@aol.com. Web site: www.papermoon.com. **Contact:** Creative Director. Estab. 1977. Produces greeting cards and stationery. "We publish greeting cards with a friendly, humorous approach—dealing with contemporary issues."

• Paper Moon is a contemporary, alternative card company. Traditional art is not appropriate for this company.

Needs Works with 40 artists/year. Buys 200 designs/illustrations/year. Buys illustrations mainly for greeting cards and stationery. Art guidelines for SASE with first-class postage. Produces material for everyday, holidays and birthdays. Submit seasonal material 6 months in advance.

First Contact & Terms Send query letter with brochure, tearsheets, photostats, photocopies, slides and SASE. Samples are filed or are returned only if requested by artist and accompanied by SASE. Responds in 10 weeks. To show a portfolio, mail color roughs, slides and tearsheets. Original artwork is returned to the artist after job's completion. Pays average flat fee of $350/design; $350/illustration. Negotiates rights purchased.

Tips "We're looking for bright, fun style with a contemporary look. Artwork should have a young 20s and 30s appeal." A mistake freelance artists make is that they "don't know our product. They send inappropriate submissions, not professionally presented and with no SASE."

PAPERPRODUCTS DESIGN U.S. INC.

60 Galli Dr., Suite 1, Novato CA 94949. (415)883-1888. Fax: (415)883-1999. E-mail: carol@paperproductdesign.com. Web site: www.paperproductsdesign.com. **President:** Carol Florsheim. Estab. 1990. Produces paper napkins, plates, designer tissue, giftbags and giftwrap, porcelain accessories. Specializes in high-end design, fashionable designs.

Needs Approached by 50-100 freelancers/year. Buys multiple freelance designs and illustrations/year. Artists do not need to write for guidelines. They may send samples to the attention of Carol Florsheim at any time. Uses freelancers mainly for designer paper napkins. Looking for very stylized/clean designs and illustrations. Prefers $6^{1}/_{2} \times 6^{1}/_{2}$. Produces seasonal and everyday material. Submit seasonal material 9 months in advance.

First Contact & Terms Designers: Send brochure, photocopies, photographs, tearsheets. Samples are not filed and are returned if requested with SASE. Responds in 6 weeks. Request portfolio review of color, final art, photostats in original query. Rights purchased vary according to project. Pays for design and illustration by the project in advances and royalties. Finds freelancers through agents, *Workbook*.

Tips "Shop the stores, study decorative accessories, fashion clothing. Read European magazines. We are a design house."

PARAMOUNT CARDS INC.

400 Pine St., Pawtucket RI 02860. (401)726-0800, ext. 2182. Fax: (401)727-3890. Web site: www.paramountcards.com. **Contact:** Freelance Art Coordinator. Estab. 1906. Publishes greeting cards. "We produce an extensive line of seasonal and everyday greeting cards which range from very traditional to whimsical to humorous. Almost all artwork is assigned." Art guidelines on Web site.

Needs Works with 50-80 freelancers/year. Uses freelancers mainly for finished art. Also for calligraphy. Consid-

ers watercolor, gouache, airbrush and acrylic. Prefers $5^{1}/_2 \times 8^5/_{16}$. Produces material for all holidays and seasons. Submit seasonal holiday material 1 year in advance.

First Contact & Terms Send query letter, résumé, SASE (important), color photocopies, slides, photos, transparencies (35mm, 4×5 and 8×10), CDs (no zip disks please) and printed card samples. Label all your pieces with your name, address and telephone number. Send duplicates and copies only! "If you send originals, it is at your own risk. Paramount Cards will not be held responsible for lost and damaged submissions." Samples are filed only if interested or returned by SASE if requested by artist. Responds in up to 4 months if interested. If your style is of interest, company may contact you for a larger selection. Pays by the project, $200-450. Finds artists through word of mouth and submissions.

Tips "Send a complete, professional package. Only include your best work; you don't want us to remember you from one bad piece. Always include SASE with proper postage and *never* send original art; color photocopies are enough for us to see what you can do. Label all your pieces with your name, address and phone number. Limit your submission to no more than 25 images (10-12 editorial samples) that will best demonstrate the range and variety of your work. Allow up to 4 months for a response. No submission will be returned without an appropriate sized SASE. No phone calls please."

MARC POLISH ASSOCIATES
P.O. Box 3434, Margate NJ 08402. (609)823-7661. E-mail: mpolish@verizon.net. Web site: www.justtoiletpaper. com. **President:** Marc Polish. Estab. 1972. Produces T-shirts and sweatshirts. "We specialize in printed T-shirts, sweatshirts, printed bathroom tissue, paper towels and coasters. Our market is the gift and mail order industry, resort shops and college bookstores."

Needs Works with 6 freelancers/year. Designs must be convertible to screenprinting. Produces material for Christmas, Valentine's Day, Mother's Day, Father's Day, Hanukkah, graduation, Halloween, birthdays and everyday.

First Contact & Terms Send query letter with brochure, tearsheets, photographs, photocopies, photostats and slides. Samples are filed or are returned. Responds in 2 weeks. To show portfolio, mail anything to show concept. Originals returned at job's completion. Pays royalties of 6-10%. Negotiates rights purchased.

Tips "We like to laugh. Humor sells. See what is selling in the local mall or department store. Submit anything suitable for T-shirts. Do not give up. No idea is a bad idea. It sometimes might have to be changed slightly to fit into a marketplace."

THE POPCORN FACTORY
13970 W. Laurel Dr., Lake Forest IL 60045. E-mail: abromley@thepopcornfactory.com. Web site: www.thepopc ornfactory.com. **Director of Merchandising:** Ann Bromley. Estab. 1979. Manufacturer of popcorn packed in exclusive designed cans and other gift items sold via catalog for Christmas, Halloween, Valentine's Day, Easter and year-round gift giving needs.

Needs Works with 6 freelance artists/year. Assigns up to 20 freelance jobs/year. Works on assignment only. Uses freelancers mainly for cover illustration. Occasionally uses artists for advertising, brochure and catalog design and illustration. 100% of freelance catalog work requires knowledge of QuarkXPress and Photoshop.

First Contact & Terms Send query letter with photocopies, photographs or tearsheets. Samples are filed. Responds in 1 month. Write for appointment to show portfolio, or mail finished art samples and photographs. Pays for design by the hour, $50 minimum. Pays for catalog design by the page. Pays for illustration by project, $250-2,000. Considers complexity of project, skill and experience of artist, and turnaround time when establishing payment. Buys all rights.

Tips "Send classic illustration, graphic designs or a mix of photography/illustration. We can work from b&w concepts—then develop to full 4-color when selected. *Do not send art samples via e-mail.*"

PORTAL PUBLICATIONS, LTD.
201 Alameda del Prado, Suite 200, Novato CA 94949. (415)884-6200. Fax: (415)382-3377. E-mail: artsub@portal pub.com. Web site: www.portalpub.com. **Cards and Stationery:** Gary Higgins, creative director. Calendars, posters, prints (wall decor): Bette Trono, VP of Wall Decor. Estab. 1954. Produces calendars, cards, stationery, posters and prints and other decorative art. "All Portal products are image-driven, with emphasis on unique styles of photography and illustration. All age groups are covered in each product category, although the prime market is female, ages 18 to 45."

Needs Approached by more than 1,000 freelancers (includes photographers and illustrators)/year. Freelance designs and illustrations purchased per year varies, more than 12 calligraphy projects/year. Prefers freelancers with experience in "our product categories." Art guidelines free for SASE with first-class postage or via Web site. Works on assignment only. Uses freelancers mainly for primary image, photoshop work and calligraphy. Considers any media. Looking for "beautiful, charming, provocative, humorous images of all kinds." 90% of freelance design demands knowledge of the most recent versions of Illustrator, QuarkXPress and Photoshop. Submit seasonal material 12 months in advance.

First Contact & Terms Send query letter with photocopies and SASE and follow-up postcard every 6 months. Prefers color copies to disk submissions. Samples are filed and not returned. Responds only if interested. Will contact for portfolio review of b&w, color and final art if interested. Rights purchased vary according to project. **Tips** ''Send color copies of your work that we can keep in our files—also, know our product lines.''

PORTERFIELD'S FINE ART LICENSING

5 Mountain Rd., Concord NH 03301-5479. (800)660-8345 or (603)228-1864. Fax: (603)228-1888. E-mail: informa tion@porterfieldsfineart.com. Web site: www.porterfieldsfineart.com. **President:** Lance J. Klass. Licenses representational, holiday, seasonal, Americana, and many other subjects. ''We're a full-service licensing agency.'' Estab. 1994. Functions as a full-service licensing representative for individual artists wishing to license their work into a wide range of consumer-oriented products. ''We have one of the fastest growing art licensing agencies in North America, as well as the best-known art licensing site on the Internet, rated #1 in art licensing by Google for almost 6 years. Stop by our site for more information about how to become a Porterfield's artist and have us represent you and your work for licenses in wall and home decor, home fabrics, stationery and all paper products, crafts, giftware and many other fields.''

Needs Approached by more than 400 artists/year. Licenses many designs and illustrations/year. Prefers commercially oriented artists ''who can create beautiful pieces of art that people want to look at again and again, and that will help sell products to the core consumer, that is, women over 30 who purchase 85% of all consumer goods in America.'' Art guidelines listed on its Internet site. Considers existing works first. Considers any media—oil, pastel, watercolor, acrylics. ''We are seeking artists who have exceptional artistic ability and commercial savvy, who study the market for trends and who would like to have their art and their talents introduced to the broad public. Artists must be willing to work hard to produce art for the market.''

First Contact & Terms E-mail JPEG files or your site address, or send query letter with tearsheets, photographs, photocopies. SASE required for return of materials. Responds in several weeks. Will contact for further portfolio review if interested. Licenses primarily on a royalty basis.

Tips ''We are impressed first and foremost by level of ability, even if the subject matter is not something we would use. Thus a demonstration of competence is the first step; hopefully the second would be that demonstration using subject matter that we believe would be commercially marketable onto a wide and diverse array of consumer products. We work with artists to help them with the composition of their pieces for particular media. We treat artists well, and actively represent them to potential licensees. Instead of trying to reinvent the wheel yourself and contact everyone 'cold,' we suggest you look at getting a licensing agent or rep whose particular abilities complement your art. We specialize in the application of art to home decor and accessories, prints and wall decor, and also to print media such as cards, stationery, calendars, prints, lithographs and home fabrics. The trick is to find the right rep whom you feel you can work with, who really loves your art whatever it is, who is interested in investing financially in promoting your work, and whose specific contacts and abilities can help further your art in the marketplace.''

PRATT & AUSTIN COMPANY, INC.

1 Cabot St., Holyoke MA 01040. (800)848-8020, ext. 577. E-mail: bruce@specialtyll.com. **Contact:** Bruce Pratt. Estab. 1931. Produces envelopes, tablets, invitations, scrap book pages, stationery, greeting cards, three ring binders, clip boards, game boards, and calendars. Does not produce greeting cards. ''Our market is the modern woman at all ages. Design must be bright, cute, busy and elicit a positive response.''

● Now a division of Specialty Loose Leaf Inc.

Needs Approached by 100-200 freelancers/year. Works with 10 freelancers/year. Buys 50-100 designs and illustrations/year. Art guidelines available. Uses freelancers mainly for concept and finished art. Also for calligraphy.

First Contact & Terms Send nonreturnable samples, such as postcard or color copies. Samples are filed or are returned by SASE if requested. Will contact for portfolio review if interested. Portfolio should include thumbnails, roughs, color tearsheets and slides. Pays flat fee. Rights purchased vary. Interested in buying second rights (reprint rights) to previously published work. Finds artists through submissions and agents.

THE PRINTERY HOUSE OF CONCEPTION ABBEY

P.O. Box 12, Conception MO 64433. (660)944-3110. Fax: (660)944-3116. E-mail: art@printeryhouse.org. Web site: www.printeryhouse.org. **Art Director:** Brother Michael Marcotte, O.S.B. Creative Director: Ms. Lee Coats. Estab. 1950. Publishes religious greeting cards. Licenses art for greeting cards and wall prints. Specializes in religious Christmas and all-occasion themes for people interested in religious, yet contemporary, expressions of faith. Card designs are meant to speak to the heart. They feature strong graphics, calligraphy and other appropriate styles.

Needs Approached by 100 freelancers/year. Works with 40 freelancers/year. Art guidelines and technical specifications available on Web site. Uses freelancers for product illustration and lettering. Looking for dignified

styles and solid religious themes. Has preference for high quality broad edged pen lettering with simple back-grounds/illustrations. Produces seasonal material for Christmas and Easter as well as the religious birthday, get well, sympathy, thank you, etc. Digital work is accepted in Photoshop or Illustrator format.

First Contact & Terms Send query letter with résumé, photocopies, CDs, photographs, slides or tearsheets. Calligraphers send samples of printed or finished work. Nonreturnable samples preferred or else samples with SASE. Accepts disk submissions compatible with Photoshop or Illustrator. Send TIFF or EPS files. Usually responds within 3-4 weeks. To show portfolio, mail appropriate materials only after query has been answered. "Generally, we continue to work with artists once we have accepted their work." Pays flat fee of $300-$500 for illustration/design, and $100-$200 for calligraphy. Usually buys exclusive reproduction rights for a specified format, but artist retains copyright for any other usage.

Tips "Remember that our greeting cards need to have a definite Christian/religious dimension but not overly sentimental. It must be good quality artwork. We sell mostly via catalogs so artwork has to reduce well for catalog."

PRISMATIX, INC.

324 Railroad Ave., Hackensack NJ 07601. (201)525-2800 or (800)222-9662. Fax: (201)525-2828. E-mail: prismatix@optonline.net. **Vice President:** Miriam Salomon. Estab. 1977. Produces novelty humor programs. "We manufacture screen-printed novelties to be sold in the retail market."

Needs Works with 3-4 freelancers/year. Buys 100 freelance designs and illustrations/year. Works on assignment only. 90% of freelance work demands computer skills.

First Contact & Terms Send query letter with brochure, résumé. Samples are filed. Responds only if interested. Portfolio should include color thumbnails, roughs, final art. Payment negotiable.

PRIZM INC.

P.O. Box 1106, Manhattan KS 66505-1106. (785)776-1613. Fax: (785)776-6550. E-mail: michele@prizm-inc.com. **President of Product Development:** Michele Johnson. Produces and markets figurines, decorative house-wares, gifts, and ornaments. Manufacturer of exclusive figurine lines.

Needs Approached by 20 freelancers/year. Art guidelines free for SASE with first-class postage. Works on assignment only. Uses freelancers mainly for figurines, home decor items. Also for calligraphy. Considers all media. Looking for traditional, old world style, sentimental, folkart. Produces material for Christmas, Mother's Day, everyday. Submit seasonal material 1 year in advance.

First Contact & Terms Send query letter with photocopies, résumé, SASE, slides, tearsheets. Samples are filed. Responds in 2 months if SASE is included. Will contact for portfolio review of color, final art, slides. Rights purchased vary according to project. Pays royalties plus payment advance; negotiable. Finds freelancers through artist submissions, decorative painting industry.

Tips "People seem to be more family oriented—therefore more wholesome and positive images are important. We are interested in looking for new artists and lines to develop. Send a few copies of your work with a concept."

RAINBOW CREATIONS, INC.

216 Industrial Dr., Ridgeland MS 39157. (601)856-2158. Fax: (601)856-5809. E-mail: phillip@rainbowcreations.net. Web site: www.rainbowcreations.net. **President:** Steve Thomas. Art Director: Phillip McDaniel. Estab. 1976. Produces wallpaper. Primarily designs wall coverings, boarders and murals for the contract wallcovering market.

Needs Approached by 10 freelancers/year. Works with 5 freelancers/year. Buys 45 freelance designs and illustrations/year. Prefers freelancers with experience in Illustrator and Photoshop. Art guidelines available on individual project basis. Works on assignment only. Uses freelancers mainly for images that are enlarged into murals. Also for setting designs in repeat. Considers Mac and hand-painted media. 50% of freelance design work demands knowledge of Photoshop and Illustrator. Produces material for everyday.

First Contact & Terms Designers: Send query letter with photocopies, photographs and résumé. "We will accept disk submissions if compatible with Illustrator or Photoshop." Samples are returned. Responds in 7 days. Buys all rights. Pays for design and illustration by the project. Payment based on the complexity of design.

RECO INTERNATIONAL CORPORATION

706 Woodlawn Ave., Cambridge OH 43725. (740)432-8800. Fax: (740)432-8811. E-mail: hreich@reco.com. Web site: www.reco.com. Manufacturer/distributor of limited editions, collector's plates, 3-dimensional plaques, lithographs and figurines. Sells through retail stores and direct marketing firms.

Needs Works with freelance and contract artists. Uses freelancers under contract for plate and figurine design, home decor and giftware. Prefers romantic and realistic styles.

First Contact & Terms Send query letter and brochure to be filed. Write for appointment to show portfolio. Art director will contact artist for portfolio review if interested. Negotiates payment. Considers buying second rights (reprint rights) to previously published work or royalties.

Tips "Have several portfolios available. We are very interested in new artists. We go to shows and galleries, and receive recommendations from artists we work with."

RECYCLED PAPER GREETINGS INC.

3636 N. Broadway, Chicago IL 60613. (773)348-6410. Fax: (773)281-1697. Web site: www.recycled.com. **Art Directors:** Gretchen Hoffman, John LeMoine. Publishes greeting cards, adhesive notes and imprintable stationery.
Needs Buys 1,000-2,000 freelance designs and illustrations. Considers b&w line art and color—"no real restrictions." Looking for "great ideas done in your own style with messages that reflect your own slant on the world." Prefers 5×7 vertical format for cards. "Our primary interest is greeting cards." Produces seasonal material for all major and minor holidays including Jewish holidays. Submit seasonal material 18 months in advance; everyday cards are reviewed throughout the year.
First Contact & Terms Send SASE to the Art Department or view Web site for artist's guidelines. "Please do not send slides, CD's or tearsheets. We're looking for work done specifically for greeting cards."Responds in 2 months. Portfolio review not required. Originals returned at job's completion. Sometimes requests work on spec before assigning a job. Pays average flat fee of $250 for illustration/design with copy. Some royalty contracts. Buys card rights.
Tips "Remember that a greeting card is primarily a message sent from one person to another. The art must catch the customer's attention, and the words must deliver what the front promises. We are looking for unique points of view and manners of expression. Our artists must be able to work with a minimum of direction and meet deadlines. There is a renewed interest in the use of recycled paper; we have been the industry leader in this for over three decades."

REEDPRODUCTIONS

100 Ebbtide Ave., Suite 100, Sausalito CA 94965. (415)331-2694. Fax: (415)331-3690. E-mail: reedpro@earthlink .net. **Owner/Art Director:** Susie Reed. Estab. 1978. Produces general stationery and gift items including greeting cards, magnets and address books. Special emphasis on nature.
Needs Approached by 20 freelancers/year. Works with few freelancers/year. Art guidelines are not available. Works on assignment only. Artwork used for paper, gift, and novelty items. Prefers color or b&w photo realist illustrations of nature images (plants and landscapes, not animals).
First Contact & Terms Send query letter with brochure or résumé, tearsheets, photocopies or slides. Samples are filed or are returned upon request if sent with a SASE. Art Director will contact artist for portfolio review if interested. Portfolio should include color or b&w final art, final reproduction/product, slides, tearsheets and photographs. Originals are returned at job's completion. Payment negotiated at time of purchase. Considers buying second rights (reprint rights) to previously published work.

RIGHTS INTERNATIONAL GROUP, LLC

453 First St., Hoboken NJ 07030. (201)239-8118. Fax: (201)222-0694. E-mail: rhazaga@rightsinternational.com. Web site: www.rightsinternational.com. **Contact:** Robert Hazaga. Estab. 1996. Agency for cross licensing. Licenses images for manufacturers of giftware, stationery, posters, home furnishing.
 • This company also has a listing in the Posters & Prints section.
Needs Approached by 50 freelancers/year. Uses freelancers mainly for creative, decorative art for the commercial and designer market. Also for textile art. Considers oil, acrylic, watercolor, mixed media, pastels and photography.
First Contact & Terms Send brochure, photocopies, photographs, SASE, slides, tearsheets or transparencies. Accepts disk submissions compatible with PC format. Responds in 1 month. Will contact for portfolio review if interested. Negotiates rights purchased and payment.

RITE LITE LTD./THE JACOB ROSENTHAL JUDAICA-COLLECTION

333 Stanley Ave., Brooklyn NY 11207. (718)498-1700. Fax: (718)498-1251. E-mail: alex@riteliteltd.com. Estab. 1948. Manufacturer and distributor of a full range of Judaica. Clients include department stores, galleries, gift shops, museum shops and jewelry stores.
 • Company is looking for new menorahs, mezuzahs, children's Judaica, Passover and matza plates.
Needs Art guidelines not available. Works on assignment only. Must be familiar with Jewish ceremonial objects or design. Also uses artists for brochure and catalog design, illustration and layout mechanicals, and product design. Most of freelance work requires knowledge of Illustrator and Photoshop. Produces material for Hannukkah, Passover and other Jewish Holidays. Submit seasonal material 1 year in advance.
First Contact & Terms Designers: Send query letter with brochure or résumé and photographs. Illustrators: Send photocopies. Do not send originals. Samples are filed. Responds in 1 month only if interested. Portfolio review not required. Art Director will contact for portfolio review if interested. Portfolio should include color tearsheets, photographs and slides. Pays flat fee per design. Buys all rights. Finds artists through word of mouth.

Tips "Be open to the desires of the consumers. Don't force your preconceived notions on them through the manufacturers. Know that there is one retail price, one wholesale price and one distributor price."

ROCKSHOTS GREETING CARDS

20 Vandam St., 4th Floor, New York NY 10013-1274. (212)243-9661. Fax: (212)604-9060. **Editor:** Bob Vesce. Estab. 1979. Produces calendars, giftbags, giftwrap, greeting cards, mugs. "Rockshots is an outrageous, sometimes adult, always hilarious card company. Our themes are sex, birthdays, sex, holiday, sex, all occasion and sex. Our images are mainly photographic, but we also seek out cartoonists and illustrators."

Needs Approached by 10-20 freelancers/year. Works with 5-6 freelancers/year. Buys 10 freelance designs and illustrations/year. Art guidelines free for SASE with first-class postage. "We like a line that has many different facets to it, encompassing a wide range of looks and styles. We are outrageous, adult, witty, off-the-wall, contemporary and sometimes shocking." Prefers any size that can be scaled on a greeting card to 5 inches by 7 inches. 10% of freelance illustration demands computer skills. Produces material for Christmas, New Year, Valentine's Day, birthdays, everyday, get well, woman to woman ("some male bashing allowed") and all adult themes.

First Contact & Terms Illustrators and/or cartoonists send photocopies, photographs and photostats. Samples are filed. Responds only if interested. Portfolio review not required. Buys first rights. Pays per image.

Tips "As far as trends go in the greeting card industry, we've noticed that 'retro' refuses to die. Vintage looking cards and images still sell very well. People find comfort in the nostalgic look of yesterday. Sex also is a huge seller. Rockshots is looking for illustrators that can come up with something a little out of mainstream. Our look is outrageous, witty, adult and sometimes shocking. Our range of style starts at cute and whimsical and runs the gamut all the way to totally wacky and unbelievable. Rockshots cards definitely stand out from the competition. For our line of illustrations, we look for a style that can convey a message, whether through a detailed elaborate colorful piece of art or a simple 'gesture' drawing. Characters work well, such as the ever-present wisecracking granny to the nerdy 'everyman' guy. It's always good to mix sex and humor, as sex always sells. As you can guess, we do not shy away from much. Be creative, be imaginative, be funny, but most of all, be different."

ROMAN, INC.

880 S. Rohlwing Rd., Addison IL 60101-4218. (630)705-4500. Fax: (630)705-4601. E-mail: dswetz@roman.com. Web site: www.roman.com. **Vice President:** Julie Puntch. Estab. 1963. Produces collectible figurines, decorative housewares, decorations, gifts, limited edition plates, ornaments. Specializes in collectibles and giftware to celebrate special occasions.

Needs Approached by 25-30 freelancers/year. Works with 3-5 freelancers/year. Uses freelancers mainly for graphic packaging design, illustration. Also for a variety of services. Considers variety of media. Looking for traditional-based design. Roman also has an inspirational niche. 80% of freelance design and illustration demands knowledge of Photoshop, QuarkXPress, Illustrator. Produces material for Christmas, Mother's Day, graduation, Thanksgiving, birthdays, everyday. Submit seasonal material 1 year in advance.

First Contact & Terms Send query letter with photocopies. Samples are filed or returned by SASE. Responds in 2 months if artist requests a reply. Portfolio review not required. Pays by the project, varies. Finds freelancers through word of mouth, artists' submissions.

RUBBERSTAMPEDE

2690 Pellisier Place, City of Industry CA 90601. (562)695-7969. Fax: (800)546-6888. E-mail: psmith@deltacreative.com. Web site: www.deltacreative.com. **Director of Marketing:** Peggy Smith. Estab. 1978. Produces art and novelty rubber stamps, kits, glitter pens, ink pads, papers, stickers, scrapbooking products.

Needs Approached by 30 freelance artists/year. Works with 10-20 freelance artists/year. Buys 200-300 freelance designs and illustrations/year. Uses freelance artists for calligraphy, P-O-P displays, and original art for rubber stamps. Considers pen & ink. Looks for whimsical, feminine style and fashion trends. Produces seasonal material Christmas, Valentine's Day, Easter, Hanukkah, Thanksgiving, Halloween, birthdays and everyday (includes wedding, baby, travel, and other life events). Submit seasonal material 9 months in advance.

First Contact & Terms Send nonreturnable samples. Samples are filed. Responds only if interested. Pays by the hour, $15-50; by the project, $50-1,000. Rights purchased vary according to project. Originals are not returned.

RUSS BERRIE AND COMPANY

111 Bauer Dr., Oakland NJ 07436. (800)631-8465. **Director Paper Goods:** Penny Shaw. Produces greeting cards, bookmarks and calendars. Manufacturer of impulse gifts for all age groups.

• This company is no longer taking unsolicited submissions.

SANGRAY GIFTS BY PDI.

(formerly Sangray Corporation) 2828 Granada Blvd., Pueblo CO 81005. (719)564-3408. Fax: (719)564-0956. E-mail: sales@pdipueblo.com. Web site: www.sangray.com. **Licensing:** Thomas Luchin. Licenses art for gift and

novelty. Estab. 1971. Produces refrigerator magnets and additional gift products all using full color art. Art guidelines for SASE with first-class postage.

Needs Approached by 30-40 freelancers/year. Works indirectly with 6-7 freelancers/year. Buys 25-30 freelance designs and illustrations/year. Open to all themes and styles. Uses freelancers mainly for fine art for products. Considers all media. Prefers 7×7 or digital. Submit seasonal material 10 months in advance.

First Contact & Terms Send query letter with examples of work in any media. Samples are filed. Responds in 1 month. Company will contact artist for portfolio review if interested. Buys first rights. Originals are returned at job's completion. Pays by the project or royalty. Finds artists through submissions and design studios.

Tips "Try to get a catalog of the company products and send art that closely fits the style the company tends to use."

THE SARUT GROUP

P.O. Box 110495, Brooklyn NY 11211. (718)387-7484. Fax: (718)387-7467. E-mail: far@sarut.com. Web site: www.thesarutgroup.com. **Vice President Marketing:** Frederic Rambaud. Estab. 1979. Produces museum quality science and nature gifts. "Marketing firm with 20 employees. 36 trade shows a year. No reps. All products are exclusive. Medium- to high-end market."

Needs Approached by 4-5 freelancers/year. Works with 4 freelancers/year. Uses freelancers mainly for new products. Seeks contemporary designs. Produces material for all holidays and seasons.

First Contact & Terms Samples are returned. Responds in 2 weeks. Write for appointment to show portfolio. Rights purchased vary according to project.

Tips "We are looking for concepts; products, not automatically graphics."

SEABROOK WALLCOVERINGS, INC.

1325 Farmville Rd., Memphis TN 38122. (901)320-3500. Fax: (901)320-3675. Web site: www.seabrookwallpape r.com. **Director of Product Development:** Suzanne Ashley. Estab. 1910. Developer and distributor of wallcovering, coordinating fabric and accessories for all age groups and styles.

Needs Approached by 10-15 freelancers/year. Works with approximately 6 freelancers/year. Buys approximately 200 freelance designs and illustrations/year. Prefers freelancers with experience in wall coverings. Works on assignment only. Uses freelancers mainly for designing and styling wallcovering collections. Considers gouache, oil, watercolor, etc. Prefers 20½×20½. Produces material for everyday, residential.

First Contact & Terms Designers: Send query letter with color photocopies, photographs, résumé, slides, transparencies and sample of artists' "hand." Illustrators send query letter with color photocopies, photographs and résumé. Samples are filed or returned. Responds in 2 weeks. Company will contact artist for portfolio review of final art, roughs, transparencies and color copies if interested. Buys all rights. Pays for design by the project. Finds freelancers through word of mouth, submissions, trade shows.

Tips "Attend trade shows pertaining to trends in wall covering. Be familiar with wallcovering design repeats."

SOURIRE

P.O. Box 1659, Old Chelsea Station, New York NY 10113. (718)573-4624. E-mail: greetings@cardsorbust.com. Web site: www.cardsorbust.com. **Contact:** Submissions. Estab. 1998. Produces giftbags, giftwrap/wrapping paper, greeting cards, stationery, T-shirts. Specializes in exclusive designs for cultural holidays and occasions. Target market is Black American and multi-ethnic men and women between ages 20 and 60.

Needs Approached by 50 freelancers/year. Licenses up to 20 freelance designs and/or illustrations/year. Art guidelines free with SASE and first-class postage. Uses freelancers mainly for graphics, paintings, illustrations. Considers all media. Product categories include wedding, women, babies, historical, handcrafted. Produces material for all cultured holidays and occasions. Submit material 6 months in advance.

First Contact & Terms Send query letter with brochure, postcard sample, photocopies, SASE, tearsheets, URL. Samples are returned by SASE or else discarded. Responds in 3 months. Portfolio not required. Rights purchased vary according to licensing contract. Pays freelancers by royalties or flat fee. Finds freelancers through artists' submissions and word of mouth.

SPARROW & JACOBS

6701 Concord Park Dr., Houston TX 77040. (713)329-9400. Fax: (713)744-3898. E-mail: sparrowart@gabp.com. **Contact:** Product Merchandiser. Estab. 1986. Produces calendars, greeting cards, postcards and other products for the real estate industry.

Needs Buys many freelance designs and illustrations/year for postcards and greeting cards. Considers all media. Looking for new product ideas featuring flowers, landscapes, animals, holiday themes, seasonal art (spring/ summer and fall/winter) and much more. "Our products range from, but are not limited to, humourous illustrations and comical cartoons to classical drawings and unique paintings." Produce material for Christmas, Easter,

Mother's Day, Father's Day, Halloween, New Year, Thanksgiving, Valentine's Day, birthdays, everyday, time change. Submit seasonal material 1 year in advance.

First Contact & Terms Send query letter with color photocopies, photographs or tearsheets. We also accept e-mail submissions of low-resolution images. If sending slides, do not send originals. We are not responsible for slides lost or damaged in the mail. Samples are filed or returned in your SASE.

SPENCER GIFTS, LLC

6826 Black Horse Pike, Egg Harbor Twp. NJ 08234-4197. (609)645-5526. Fax: (609)645-5797. E-mail: james.stevenson@spencergifts.com. Web site: wwwspencergifts.com. **Contact:** James Stevenson. Licensing: Carl Franke. Estab. 1965. Retail gift chain located in approximately 750 stores in 43 states including Hawaii and Canada. Includes new retail chain stores named Spirit Halloween Superstores.

• Products offered by store chain include posters, T-shirts, games, mugs, novelty items, cards, 14K jewelry, neon art, novelty stationery. Spencer's is moving into a lot of different product lines, such as custom lava lights and Halloween costumes and products. Visit a store if you can to get a sense of what they offer.

Needs Assigns 10-15 freelance jobs/year. Prefers artists with professional experience in advertising design. Uses artists for illustration (hard line art, fashion illustration, airbrush). Also needs product and fashion photography (primarily jewelry), as well as stock photography. Uses a lot of freelance computer art. 50% of freelance work demands knowledge of FreeHand, Illustrator, Photoshop and QuarkXPress. Also needs color separators, production and packaging people. ''You don't necessarily have to be local for freelance production.''

First Contact & Terms Send postcard sample or query letter with *nonreturnable* brochure, résumé and photocopies, including phone number where you can be reached during business hours. Accepts submissions on disk. James Stevenson will contact artist for portfolio review if interested. Will contact only upon job need. Considers buying second rights (reprint rights) to previously published work. Finds artists through sourcebooks.

Tips ''Become proficient in as many computer programs as possible.''

STOTTER & NORSE

1000 S. Second St., Plainfield NJ 07063. (908)754-6330. Fax: (908)757-5241. E-mail: sales@stotternorse.com. Web site: www.stotternorse.com. **V.P. of Sales:** Larry Speichler. Estab. 1979. Produces barware, serveware, placemats and a broad range of tabletop products.

Needs Buys 20 designs and illustrations/year. Art guidelines not available. Works on assignment only. Uses freelancers mainly for product design. Seeking trendy styles. Final art should be actual size. Produces material for all seasons. Submit seasonal material 6 months in advance.

First Contact and Terms Send query letter with brochure and résumé. Samples are filed. Responds in 1 month or does not reply, in which case the artist should call. Call for appointment to show portfolio. Negotiates rights purchased. Originals returned at job's completion if requested. Pays flat fee and royalties; negotiable.

SUNSHINE ART STUDIOS, INC.

270 Main St., Agawam MA 01001. (413)82-8700. Fax: (413)821-8701. E-mail: aorsi@sunshinecards.com. Web site: sunshinecards.com. **Contact:** Alicia Orsi, art director. Estab. 1921. Produces greeting cards, stationery and calendars that are sold in own catalog, appealing to all age groups.

Needs Works with 50 freelance artists/year. Buys 100 freelance designs and illustrations/year. Prefers artists with experience in greeting cards. Art guidelines available for SASE with first-class postage. Works on assignment only. Uses freelancers for greeting cards, stationery and gift items. Also for calligraphy. Considers all media. Looking for traditional or humorous look. Prefers art $4\frac{1}{2} \times 6\frac{1}{2}$ or 5×7. Produces material for Christmas, birthdays and everyday. Submit seasonal material 6-8 months in advance.

First Contact & Terms Send query letter with brochure, résumé, SASE, tearsheets and slides. Samples are filed or are returned by SASE if requested by artist. Responds only if interested. Portfolio should include finished art samples and color tearsheets and slides. Originals not returned. Pays by the project, $450-700. Pays $100-150/piece for calligraphy and lettering. Buys all rights.

SYRACUSE CULTURAL WORKERS

Box 6367, Syracuse NY 13217. (315)474-1132. Fax: (877)265-5399. E-mail: scw@syrculturalworkers.com. Web site: www.syrculturalworkers.com. **Art Director:** Karen Kerney. Estab. 1982. Syracuse Cultural Workers publishes and distributes peace and justice resources through their Tools For Change catalog. Produces posters, note cards, postcards, greeting cards, T-shirts and calendars that are feminist, progressive, radical, multicultural, lesbian/gay allied, racially inclusive and honoring of elders and children.

• SCW is specifically seeking artwork celebrating peace-making diverstiy, people's history and community building. Our mission is to help sustain a culture that honors diversity and celebrates community; that inspires and nurtures justice, equality and freedom; that respects our fragile Earth and all its beings; that

encourages and supports all forms of creative expression. Themes include environment, positive parenting, positive gay and lesbian images, multiculturalism and cross-cultural adoption.

Needs Approached by many freelancers/year. Works with 50 freelancers/year. Buys 40-50 freelance fine art images and illustrations/year. Considers all media (in slide form). Art guidelines available on Web site or free for SASE with first-class postage. Looking for progressive, feminist, liberating, vital, people- and earth-centered themes. ''December and January are major art selection months.''

First Contact & Terms Send query letter with slides, brochures, photocopies, photographs, SASE, tearsheets and transparencies. Samples are filed or returned by SASE. Responds in 1 month with SASE. Will contact for portfolio review if interested. Buys one-time rights. Pays flat fee of $85-450; royalties of 4-6% gross sales. Finds artists through word of mouth, our own artist list and submissions.

Tips ''Please do NOT send original art or slides. Rather, send photocopies, printed samples or duplicate slides. Also, one postcard sample is not enough for us to judge whether your work is right for us. Include return postage if you would like your artwork/slides returned.''

TALICOR, INC.

901 Lincoln Parkway, Plainwell MI 49080. (269)685-2345. E-mail: nikkih@talicor.com. Web site: www.talicor.com. **President:** Nicole Hancock. Estab. 1971. Manufacturer and distributor of educational and entertainment games and toys. Clients chain toy stores, department stores, specialty stores and Christian bookstores.

Needs Works with 4-6 freelance illustrators and designers/year. Prefers local freelancers. Works on assignment only. Uses freelancers mainly for game design. Also for advertising, brochure and catalog design, illustration and layout; product design; illustration on product; P-O-P displays; posters and magazine design.

First Contact & Terms Send query letter with tearsheets, samples or postcards. Samples are not filed and are returned only if requested. Responds only if interested. Call or write for appointment to show portfolio. Pays for design and illustration by the project, $100-3,000. Negotiates rights purchased. Accepts digital submissions via e-mail.

TJ'S CHRISTMAS

14855 W. 95th St., Lenexa KS 66215. (913)888-8338. Fax: (913)888-8350. E-mail: ed@imitchell.com. Web site: www.imitchell.com. **Creative Coordinator:** Edward Mitchell. Estab. 1983. Produces figurines, decorative accessories, ornaments and other Christmas adornments. Primarily manufactures and imports Christmas ornaments, figurines and accessories. Also deals in some Halloween, Thanksgiving, gardening, 3-D art (woodcarving and sculptures) and everyday home decor items. Clients higher-end floral, garden, gift and department stores.

Needs Uses freelancers mainly for unique and innovative designs. Considers most media. ''Our products are often nostalgic, bringing back childhood memories. They also should bring a smile to your face. We are looking for traditional designs that fit with our motto, 'Cherish the Memories.' '' Produces material for Christmas, Halloween, Thanksgiving and everyday. Submit seasonal material 18 months in advance.

First Contact & Terms Send query letter with résumé, SASE and photographs. Will accept work on disk. Portfolios may be dropped off Monday-Friday. Samples are not filed and are returned by SASE. Responds in 1 month. Negotiates rights purchased. Pays advance on royalties of 5%. Terms are negotiated. Finds freelancers through magazines, word of mouth and artists' reps.

Tips ''We typically stay away from selling mass markets. To succeed requires something different and better. Try richer color combinations and new twists on traditional concepts. Inspirational and humorous wording can help differentiate product, too!.''

VAGABOND CREATIONS INC.

2560 Lance Dr., Dayton OH 45409. (937)298-1124. E-mail: sales@vagabondcreatoions.net. Web site: www.vagabondcreations.net. **Art Director:** George F. Stanley, Jr. Publishes stationery and greeting cards with contemporary humor. 99% of artwork used in the line is provided by staff artists working with the company.

• Vagabond Creations Inc. now publishes a line of coloring books.

Needs Works with 3 freelancers/year. Buys 6 finished illustrations/year. Seeking line drawings, washes and color separations. Material should fit in standard-size envelope.

First Contact & Terms Query. Samples are returned by SASE. Responds in 2 weeks. Submit Christmas, Valentine's Day, everyday and graduation material at any time. Originals are returned only upon request. Payment negotiated.

Tips ''Important! Currently we are *not* looking for additional freelance artists because we are very satisfied with the work submitted by those individuals working directly with us. We do not in any way wish to offer false hope to anyone, but it would be foolish on our part not to give consideration. Our current artists are very experienced and have been associated with us in some cases for over 30 years.''

VERMONT T'S

354 Elm St., Chester VT 05143. (802)875-2091. Fax: (802)875-4480. E-mail: vtts@vermontel.net. **President:** Thomas Bock. Commercial screenprinter, specializing in T-shirts and sweatshirts. Vermont T's produces custom as well as tourist-oriented silkscreened sportswear. Does promotional work for businesses, ski-resorts, tourist attractions and events.

Needs Works with 3-5 freelance artists/year. Uses artists for graphic designs for T-shirt silkscreening. Prefers pen & ink, calligraphy and computer illustration.

First Contact & Terms Send query letter with brochure. Samples are filed or are returned only if requested. Responds in 10 days. To show portfolio, mail photostats. Pays for design by the project, $400-1,200. Negotiates rights purchased. Finds most artists through portfolio reviews and samples.

Tips "Have samples showing rough through completion. Understand the type of linework needed for silkscreening."

CAROL WILSON FINE ARTS, INC.

Box 17394, Portland OR 97217. (503)261-1860. E-mail: info@carolwilsonfinearts.com. Web site: www.carolwils onfinearts.com. **Contact:** Gary Spector. Estab. 1983. Produces greeting cards and fine stationery products.

Needs Romantic floral and nostalgic images. "We look for artists with high levels of training, creativity and ability."

First Contact & Terms Write or call for art guidelines. No original artwork on initial inquiry. Samples not filed are returned by SASE.

Tips "We are seeing an increased interest in romantic fine arts cards and very elegant products featuring foil, embossing and die-cuts."

Magazines

Magazines are a major market for freelance illustrators. The best proof of this fact is as close as your nearest newsstand. The colorful publications competing for your attention are chock-full of interesting illustrations, cartoons and caricatures. Since magazines are generally published on a monthly or bimonthly basis, art directors look for dependable artists who can deliver on deadline and produce quality artwork with a particular style and focus.

Art that illustrates a story in a magazine or newspaper is called editorial illustration. You'll notice that term as you browse through the listings. Art directors look for the best visual element to hook the reader into the story. In some cases this is a photograph, but often, especially in stories dealing with abstract ideas or difficult concepts, an illustration makes the story more compelling. A whimsical illustration can set the tone for a humorous article, for example, or an edgy caricature of movie stars in boxing gloves might work for an article describing conflicts within a film's cast. Flip through a dozen magazines in your local drugstore and you will quickly see that each illustration conveys the tone and content of articles while fitting in with the magazine's "personality."

The key to success in the magazine arena is matching your style to appropriate publications. Art directors work to achieve a synergy between art and text, making sure the artwork and editorial content complement each other.

TARGET YOUR MARKETS

Read each listing carefully. Within each listing are valuable clues. Knowing how many artists approach each magazine will help you understand how stiff your competition is. (At first, you might do better submitting to art directors who aren't swamped with submissions.) Look at the preferred subject matter to make sure your artwork fits the magazine's needs. Note the submission requirements and develop a mailing list of markets you want to approach.

Visit newsstands and bookstores. Look for magazines not listed in *Artist's & Graphic Designer's Market*. Check the cover and interior. If illustrations are used, flip to the masthead (usually a box in one of the beginning pages) and note the art director's name. The circulation figure is relevant too. As a rule of thumb, the higher the circulation, the higher the art director's budget. When art directors have a good budget, they tend to hire more illustrators and pay higher fees. Look at the illustrations and check the illustrator's name in the credit line in small print to the side of the illustration. Notice which illustrators are used often in the publications you wish to work with. You will notice that each illustrator they chose has a very definite style. After you have studied the illustrations in dozens of magazines, you will understand what types of illustrations are marketable.

Although many magazines can be found at a newsstand or library, some of your best markets may not be readily available on newsstands. If you can't find a magazine, check the listing in *Artist & Graphic Designer's Market* to see if sample copies are available. Keep in mind that many magazines also provide artists' guidelines on their Web sites.

CREATE A PROMO SAMPLE

Focus on one or two *consistent* styles to present to art directors in sample mailings. See if you can come up with a style that is different from every other illustrator's style, if only slightly. No matter how versatile you may be, limit styles you market to one or two. That way, you'll be more memorable to art directors. Pick a style or styles you enjoy and can work in relatively quickly. Art directors don't like surprises. If your sample shows a line drawing, they expect you to work in that style when they give you an assignment. It's fairly standard practice to mail nonreturnable samples: either postcard-size reproductions of your work, photocopies or whatever is requested in the listing. Some art directors like to see a résumé; some don't.

MORE MARKETING TIPS

- **Don't overlook trade magazines and regional publications.** While they may not be as glamorous as national consumer magazines, some trade and regional publications are just as lavishly produced. Most pay fairly well and the competition is not as fierce. Until you can get some of the higher circulation magazines to notice you, take assignments from smaller magazines, too. Alternative weeklies are great markets as well. Despite their modest payment, there are many advantages in working with them. You learn how to communicate with art directors, develop your signature style and learn how to work quickly to meet deadlines. Once the assignments are done, the tearsheets become valuable samples to send to other magazines.
- **Develop a spot illustration style in addition to your regular style.** ''Spots''—illustrations that are half-page or smaller—are used in magazine layouts as interesting visual cues to lead readers through large articles or to make filler articles more appealing. Though the fee for one spot is less than for a full layout, art directors often assign five or six spots within the same issue to the same artist. Because spots are small in size, they must be all the more compelling. So send art directors a sample showing several power-packed small pieces along with your regular style.
- **Invest in a fax machine, e-mail and graphics software.** Art directors like to work with illustrators with fax machines and e-mail, because they can quickly fax or e-mail a layout with a suggestion. The artist can send back a preliminary sketch or ''rough'' the art director can OK. Also they will appreciate it if you can e-mail TIFF, EPS or JPEG files of your work.
- **Get your work into competition annuals and sourcebooks.** The term ''sourcebook'' refers to the creative directories published annually showcasing the work of freelancers. Art directors consult these publications when looking for new styles. If an art director uses creative directories, we often include that information in the listings to help you understand your competition. Some directories like *Black Book*, *The American Showcase* and *RSVP* carry paid advertisements costing several thousand dollars per page. Other annuals, like the *Print Regional Design Annual* or *Communication Art Illustration Annual* feature award winners of various competitions. An entry fee and some great work can put your work in a competition directory and in front of art directors across the country.

- **Consider hiring a rep.** If after working successfully on several assignments you decide to make magazine illustration your career, consider hiring an artists' representative to market your work for you. (See the Artists' Reps section, page 585.)

Helpful Resources

For More Info

- A great source for new magazine leads is in the business section of your local library. Ask the librarian to point out the business and consumer editions of the *Standard Rate and Data Service (SRDS)* and *Bacon's Magazine Directory*. These huge directories list thousands of magazines and will give you an idea of the magnitude of magazines published today. Another good source is a yearly directory called *Samir Husni's Guide to New Consumer Magazines* also available in the business section of the public library and online at www.mrmagazine.com. Also read *Folio* magazine to find out about new magazine launches and redesigns.

- Each year the Society of Publication Designers sponsors a juried competition, the winners of which are featured in a prestigious exhibition. For information about the annual competition, contact the Society of Publication Designers at (212)223-3332 or visit their Web site at www.spd.org.

- Networking with fellow artists and art directors will help you find additional success strategies. The Graphic Artist's Guild (www.gag.org), The American Institute of Graphic Artists (AIGA; www.aiga.org), your city's Art Directors Club (www.adcglobal.org) or branch of the Society of Illustrators (www.societyofillustrators.org) holds lectures and networking functions. Attend one event sponsored by each organization in your city to find a group you are comfortable with. Then join and become an active member.

N A. & U. MAGAZINE, America's Aids Magazine

25 Monroe St., Suite 205, Albany NY 12210-2729. (518)426-9010. Fax: (518)436-5354. E-mail: mark@aumag.o rg. Web site: www.aumag.org. **Art Director:** Mark Crescent. Estab. 1991. Monthly 4-color literary magazine. *A.&U.*is an AIDS publication our audience is everyone affected by the AIDS crisis. Circ. 180,000. Art guidelines are free for #10 SASE with first-class postage.

Cartoons Approached by 10 cartoonists/year. Buys 1 cartoon/year. Prefers work relating to HIV/AIDS disease. Prefers single panel, double panel or multiple panel humorous, b&w washes, color washes or line drawings.

Illustration Approached by 15 illustrators/year. Buys 5 illustrations/issue. Features humorous illustration, real-istic illustrations, charts & graphs, informational graphics, medical illustration, spot illustrations and computer illustration of all subjects affected by HIV/AIDS. Prefers all styles and media. Assigns 50% of illustrations to well-known or "name" illustrators; 25% to experienced, but not well-known illustrators; 25% to new and emerging illustrators. 50% of freelance illustration demands knowledge of Adobe Illustrator or Photoshop.

First Contact & Terms Cartoonists: Send query letter with b&w photocopies, color photocopies, samples and SASE. Illustrators: Send query letter with printed samples, photocopies and SASE. Accepts Mac-compatible disk submissions. Samples are not filed and are returned by SASE. Responds within 1 month only if interested. Will contact artist for portfolio review if interested. Buys first North American serial rights. **Pays on acceptance,** $500 maximum. Finds freelancers through artists promotional samples.

Tips We would like to get cutting-edge and unique illustrations or cartoons about the HIV/AIDS crisis, they can be humorous or nonhumorous.

A.T. JOURNEYS: The Magazine of the Appalachian Trail Conservancy

P.O. Box 807, Harpers Ferry WV 25425. (304)535-6331. Fax: (304)535-2667. **Editor:** Martin A. Bartels. Member-ship publication focuses on the stories of people who experience and support the Appalachian Trail, as well as conservation-oriented stories related to the Appalachian Mountain region. Circ. 37,000. Published 6 times/year. Sometimes accepts previously published material. Returns original artwork after publication. Sample copy and art guidelines available for legitimate queries.

Illustration Buys 8-12 illustrations/issue. Accepts all styles and media; computer generated (identified as such) or manual. Original artwork should be directly related to the Appalachian Trail.

First Contact & Terms Illustrators: Send query letter with samples to be kept on file. Prefers nonreturnable postcards, photocopies or tearsheets as samples. Samples not filed are returned by SASE. Responds in 2 months. Negotiates rights purchased. **Pays on acceptance;** $25-$250 for b&w, color. Finds most artists through refer-ences, word of mouth and samples received through the mail.

AARP THE MAGAZINE

601 E Street NW, Washington DC 20049. (202)434-2277. Fax: (202)434-6451. Web site: www.aarpmagazine.org. **Design Director:** Eric Seidman. Art Director: Courtney Murphy-Price. Estab. 2002. Bimonthly 4-color magazine emphasizing health, lifestyles, travel, sports, finance and contemporary activities for members 50 years and over. Circ. 21 million. Originals are returned after publication.

Illustration Approached by 200 illustrators/year. Buys 30 freelance illustrations/issue. Assigns 60% of illustra-tions to well-known or "name" illustrators; 30% to experienced but not well-known illustrators; 10% to new and emerging illustrators. Works on assignment only. Considers digital, watercolor, collage, oil, mixed media and pastel.

First Contact & Terms Samples are filed "if I can use the work." Do not send portfolio unless requested. Portfolio can include original/final art, tearsheets, slides and photocopies and samples to keep. Buys first rights. Pays on completion of project; $700-3,500.

Tips "We generally use people with strong conceptual abilities. I request samples when viewing portfolios."

N ABSOLUTE MAGNITUDE, SF

DNA Publications, P.O. Box 2988, Radford VA 24143-2988. E-mail: dnapublications@iinanie.com. **Art Director:** Warren Lapine. Estab. 1993. Quarterly 4-color cover, b&w interior literary magazine featuring science fiction. Circ. 9,000.

Illustration Approached by 20 illustrators/year. Buys 7 illustrations/issue. Has featured illustrations by Bob Eggleton, Kelly Frease. Features illustrations for fiction. Prefers bright covers, pen & ink interiors. Assigns 25% of illustrations to well-known or "name" illustrators; 50% to experienced, but not well-known illustrators; 25% to new and emerging illustrators.

First Contact & Terms Illustrators: Send query letter with photocopies. Samples are filed. Responds in 60 days. Will contact artist for portfolio review if interested. Pays $100-400 for color cover; $50-75 for b&w inside. Finds illustrators through samples.

Tips "We assume that you are only as good as your weakest portfolio piece."

⊕ ACTIVE LIFE

LexiCon, 1st Floor, London EC1M 5PA United Kingdom. (020)7253 5775. Fax: (020)7253 5676. E-mail: activelife @lexicon-uk.com. Web site: www.activelifemag.co.uk. **Managing Editor:** Helene Hodge. Editor's Assistant: Katy Morrison. Estab. 1990. Bimonthly lively lifestyle consumer magazine for the over 50s. Circ. 240,000.

Illustration Approached by 200 illustrators/year. Buys 12 illustration/issue. Features humorous illustration. Preferred subject families. Target group 50+. Prefers pastel and bright colors. Assigns 20% of illustration to well-known or "name" illustrators; 60% to experienced, but not well-known illustrators; 20% to new and emerging illustrators.

First Contact & Terms Illustrators: Send nonreturnable samples. Accepts Mac-compatible disk submissions. Samples are filed. Responds within 1 month. Will contact artist for portfolio review if interested. Buys all rights. Pays on publication. Finds illustrators through promotional samples.

Tips We use all styles, but more often "traditional" images.

AD ASTRA

1620 I St. NW, Suite 615, Washington DC 20006. (202)429-1600. Fax: (202)463-8497. E-mail: aduignan@nss.o rg. Web site: www.nss.org. **Editor-in-Chief:** Anthony Duignan Cabrera. Estab. 1989. Circ: 25,000. Quarterly feature magazine popularizing and advancing space exploration and development for the general public interested in all aspects of the space program.

Illustration Works with 40 freelancers/year. Uses freelancers for magazine illustration. Buys 10 illustrations/ year. "We are looking for original artwork on space themes, either conceptual or representing specific designs, events, etc." Prefers acrylics, then oils and collage.

Design Needs freelancers for multimedia design. 100% of freelance work requires knowledge of Photoshop, QuarkXPress and Illustrator.

First Contact & Terms Illustrators: Send postcard sample or slides. "Color slides are best." Designers: Send query letter with brochure and photographs. Samples not filed are returned by SASE. Responds in 6 weeks. Pays $100-300 color cover; $25-100 color inside. "We do commission original art from time to time." Fees are for one-time reproduction of existing artwork. Considers rights purchased when establishing payment. Pays designers by the project.

Tips "Show a set of slides showing planetary art, spacecraft and people working in space. I do not want to see 'science-fiction' art. Label each slide with name and phone number. Understand the freelance assignments are usually made far in advance of magazine deadline."

ADVANSTAR LIFE SCIENCES

Five Paragon Dr., 2nd Floor, Montvale NJ 07645. (973)944-7777. E-mail: mec.art@advanstar.com. Web site: www.advanstar.com. Estab. 1909. Publishes 8 health-related publications and special products. Interested in all media, including electronic and traditional illustrations. Accepts previously published material. Originals are returned at job's completion. Uses freelance artists for "most editorial illustration in the magazines."

Cartoons Prefers general humor topics workspace, family, seasonal; also medically related themes. Prefers single panel b&w drawings and washes with gagline.

Illustration Prefers all media including 3-D illustration. Needs editorial and medical illustration that varies "but is mostly on the conservative side." Works on assignment only.

First Contact & Terms Cartoonists: Send unpublished cartoons only with SASE to Jeanne Sabatie, cartoon editor. Pays $115. Buys first world publication rights. Illustrators: Send samples to Sindi Price. Samples are filed. Responds only if interested. Write for portfolio review. Buys nonexclusive worldwide rights. Pays $1,000-1,500 for color cover; $200-600 for b&w, $250-800 for color inside.

ADVENTURE CYCLIST

150 E. Pine St., Missoula MT 59802. (406)721-1776. Fax: (406)721-8754. E-mail: gsiple@adventurecycling.org. Web site: www.adventurecycling.org. **Art Director:** Greg Siple. Estab. 1974. Published 9 times/year. A journal of adventure travel by bicycle. Circ. 43,000. Originals returned at job's completion. Sample copies available.

Illustration Buys 1 illustration/issue. Has featured illustrations by Margie Fullmer, Ludmilla Tomova and Anita Dufalla. Works on assignment only.

First Contact & Terms Illustrators: Send printed samples. Samples are filed. Publication will contact artist for portfolio review if interested. Pays on publication, $50-350. Buys one-time rights.

THE ADVOCATE

6922 Hollywood Blvd., Suite 1000, Los Angeles CA 90028-5148. (323)871-1225. Fax: (323)467-6805. E-mail: gstoll@advocate.com. Web site: www.advocate.com. **Art Director:** George Stoll. Estab. 1967. Biweekly. National gay and lesbian 4-color consumer news magazine.

Illustration Approached by 20 illustrators/year. Buys 1-2 illustrations/issue. Has featured illustrations by Alex-

ander Munn, Sylvie Bourbonniere and Tom Nick Cocotos. Features caricatures of celebrities and politicians, computer illustration, realistic illustration and medical illustration. Preferred subjects men, women, gay and lesbian topics. Considers all media. Assigns 90% of illustrations to experienced, but not well-known illustrators; 10% to new and emerging illustrators.

First Contact & Terms Send postcard sample or nonreturnable samples. Accepts disk submissions. Art guidelines available on Web site. Samples are filed. Responds only if interested. Portfolio review not required. Buys one-time rights. Pays on publication.

Tips "We are happy to consider unsolicited illustration submissions to use as a reference for making possible assignments to you in the future. Before making any submissions to us, please familiarize yourself with our magazine. Keep in mind that *The Advocate* is a news magazine. As such, we publish items of interest to the gay and lesbian community based on their newsworthiness and timeliness. We do not publish unsolicited illustrations or portfolios of individual artists. Any illustration appearing in *The Advocate* was assigned by us to an artist to illustrate a specific article."

AGING TODAY

833 Market St., San Francisco CA 94103. (415)974-9619. Fax: (415)974-0300. Web site: www.asaging.org. **Editor:** Paul Kleyman. Estab. 1979. "*Aging Today* is the bimonthly black & white newspaper of The American Society on Aging. It covers news, public policy issues, applied research and developments/trends in aging." Circ. 10,000. Accepts previously published artwork. Originals returned at job's completion if requested. Sample copies available for SASE with 77¢ postage.

Cartoons Approached by 50 cartoonists/year. Buys 1-2 cartoons/issue. Prefers political and social satire cartoons; single, double or multiple panel with or without gagline, b&w line drawings. Samples returned by SASE. Responds only if interested. Buys one-time rights.

Illustration Approached by 50 illustrators/year. Buys 1 illustration/issue. Works on assignment only. Prefers b&w line drawings and some washes. Considers pen & ink. Needs editorial illustration.

First Contact & Terms Cartoonists: Send query letter with brochure and roughs. Illustrators: Send query letter with brochure, SASE and photocopies. Pays cartoonists $25, with fees for illustrations, $25-50 for b&w covers or inside drawings. Samples are not filed and are returned by SASE. Responds only if interested. To show portfolio, artist should follow up with call and/or letter after initial query. Buys one-time rights.

Tips "Send brief letter with two or three applicable samples. Don't send hackneyed cartoons that perpetuate ageist stereotypes."

AGONYINBLACK, VARIOUS COMIC BOOKS

E-mail: editor@chantingmonks.com. Web site: www.chantingmonks.com. **Editor:** Pamela Hazelton. Estab. 1994. Bimonthly "illustrated magazine of horror" for mature readers. Circ. 4-6,000. Art guidelines for #10 SASE with first-class postage.

Illustration Approached by 200-300 illustrators/year. Buys 5 illustrations/issue. Has featured illustrations by Bernie Wrightson, Louis Small and Ken Meyer. Features realistic and spot illustration. Assigns 50% of illustrations to well-known or "name" illustrators; 30% to experienced but not well-known illustrators; 20% to new and emerging illustrators. Prefers horror, disturbing truth. Considers all media.

First Contact & Terms Illustrators: Send query letter with printed samples, photocopies, SASE or tearsheets. Send follow-up samples every 3 months. Accepts disk submissions compatible with Photoshop, PageMaker files only or TIFFs, GIFs, JPG; no e-mail uploads. Samples are filed. Responds in 9 weeks. Buys first North American serial rights. Pays on publication; $50-300 for b&w cover; $25-50 maximum for spots. Will discuss payment for spots. Finds illustrators through conventions and referrals.

Tips "We publish comic books and occasionally pinup books. We mostly look for panel and sequential art. Please have a concept of sequential art. Please inquire via e-mail for all submissions."

AIM

P.O. Box 1174, Maywood IL 60153. (708)344-4414. Fax: (206) 543-2746. Web site: www.aimmagazine.org. **Editor-in-Chief:** Ruth Apilado. Managing Editor: Dr. Myron Apilado. Estab. 1973. 8½×11. Circ: 7,000. b+w quarterly with 2-color cover. Readers are those "wanting to eliminate bigotry and desiring a world without inequalities in education, housing, etc." Circ. 7,000. Responds in 3 weeks. Accepts previously published, photocopied and simultaneous submissions. Sample copy $5; artist's guidelines for SASE.

Cartoons Approached by 12 cartoonists/week. Buys 10-15 cartoons/year. Uses 1-2 cartoons/issue. Prefers education, environment, family life, humor in youth, politics and retirement; single panel with gagline. Especially needs "cartoons about the stupidity of racism."

Illustration Approached by 4 illustrators/week. Uses 4-5 illustrations/issue; half from freelancers. Prefers pen & ink. Prefers current events, education, environment, humor in youth, politics and retirement.

First Contact & Terms Cartoonists: Send samples with SASE. Illustrators: Provide brochure to be kept on file

for future assignments. Samples not returned. Responds in 1 month. Prefers b&w for cover and inside art. Buys all rights on a work-for-hire basis. Pays on publication. Pays cartoonists $5-15 for b&w line drawings. Pays illustrators $25 for b&w cover illustrations.

Tips ''We could use more illustrations and cartoons with people from all ethnic and racial backgrounds in them. We also use material of general interest. Artists should show a representative sampling of their work and target the magazine's specific needs. Nothing on religion.''

ALASKA BUSINESS MONTHLY

P.O. Box 241288, Anchorage AK 99524-1288. (907)276-4373. Fax: (907)279-2900. E-mail: editor@akbizmag.com. **Editor:** Debbie Cutler. Estab. 1985. Monthly business magazine. ''*Alaska Business Monthly* magazine is written, edited and published by Alaskans for Alaskans and other U.S. and international audiences interested in business affairs of the 49th state. Its goal is to promote economic growth in the state by providing thorough and objective discussion and analyses of the issues and trends affecting Alaska's business sector and by featuring stories on the individuals, organizations and companies that shape the Alaskan economy.'' Circ. 11,000. Accepts previously published artwork. Originals returned at job's completion if requested. Sample copies available for SASE with 3 first-class stamps.

First Contact & Terms Rights purchased vary according to project. Pays on publication; $300-500 for color cover; $50-250 for b&w inside and $25-300 for color inside.

Tips ''We usually use local photographers for photos and employees for illustrations. Read the magazine before submitting anything.''

ALASKA MAGAZINE

301 Arctic Slope Ave., Suite 300, Anchorage AK 99518-3035. (907)272-6070. Fax: (907)275-2117. E-mail: webmaster@alaskamagazine.com. Web site: www.alaskamagazine.com. **Art Director:** Tim Blum. Estab. 1935. Monthly 4-color regional consumer magazine featuring Alaskan issues, stories and profiles exclusively. Circ. 200,000.

Illustration Approached by 200 illustrators/year. Buys 1-4 illustration/issue. Has featured illustrations by Bob Crofut, Chris Ware, Victor Juhaz, Bob Parsons. Features humorous and realistic illustrations. On assignment only. Assigns 50% to new and emerging illustrators. 50% of freelance illustration demands knowledge of Illustrator, Photoshop and QuarkXPress.

First Contact & Terms Send postcard or other nonreturnable samples. Accepts Mac-compatible disk submissions. Samples are not returned. Responds only if interested. Will contact artist for portfolio review if interested. Buys first North American serial rights and electronic rights or rights purchased vary according to project. Pays on publication. Pays illustrators $125-300 for color inside; $400-600 for 2-page spreads; $125 for spots.

Tips ''We work with illustrators who grasp the visual in a story quickly and can create quality pieces on tight deadlines.''

ALTERNATIVE THERAPIES IN HEALTH AND MEDICINE

169 Saxony Rd., Suite 103, Encinitas CA 92024-6779. (760)633-3910. Fax: (760)633-3918. Web site: www.alternative-therapies.com. **Creative Art Director:** Lee Dixson. Estab. 1995. Bimonthly trade journal. ''*Alternative Therapies* is a peer-reviewed medical journal established to promote integration between alternative and cross-cultural medicine with conventional medical traditions.'' Circ. 20,000. Accepts previously published artwork. Originals returned at job's completion. Sample copies available.

Illustration Buys 6 illustrations/year. ''We purchase fine art for the covers, not graphic art.''

First Contact & Terms Illustrators: Send query letter with slides. Samples are filed. Responds in 10 days. Publication will contact artist for portfolio review if interested. Portfolio should include photographs and slides. Buys one-time and reprint rights. Pays on publication; negotiable. Finds artists through agents, sourcebooks and word of mouth.

AMERICA

106 W. 56th St., New York NY 10019. (212)581-1909. Fax: (212)399-3596. Web site: www.americamagazine.org. **Associate Editor:** James Martin. Estab. 1904. Weekly Catholic national magazine published by US Jesuits. Circ. 46,000.

Illustration Buys 3-5 illustrations/issue. Has featured illustrations by Michael O'Neill McGrath, William Hart McNichols, Tim Foley, Stephanie Dalton Cowan. Features realistic illustration and spot illustration. Assigns 45% of illustrations to new and emerging illustrators. Considers all media.

First Contact & Terms Illustrators: Send printed samples and tearsheets. Buys first rights. Pays on publication; $300 for color cover; $150 for color inside.

Tips ''We look for illustrators who can do imaginative work for religious, educational or topical articles. We will discuss the article with the artist and usually need finished work in two to three weeks. A fast turnaround is extremely valuable.''

AMERICA WEST AIRLINES MAGAZINE

4636 E. Elwood St., Suite 5, Phoenix AZ 85040-1963. (602) 997-7200 Fax: (602) 997-9875. E-mail: matt@skywor d.com. Web site: www.skyword.com. **Art Director:** Matt Nielsen. Estab. 1986. Monthly inflight magazine for national airline; 4-color, "conservative design. Appeals to an upscale audience of travelers reflecting a wide variety of interests and tastes." Circ. 125,000. Accepts previously published artwork. Original artwork is returned after publication. Sample copy $3. Art guidelines for SASE with first-class postage. Needs computer-literate illustrators familiar with Photoshop, Illustrator, QuarkXPress and FreeHand.

Illustration Approached by 100 illustrators/year. Buys 5 illustrations/issue from freelancers. Has featured illustrations by Pepper Tharp, John Nelson, Shelly Bartek, Tim Yearington. Assigns 95% of illustrations to experienced but not well-known illustrators. Buys illustrations mainly for spots, columns and feature spreads. Uses freelancers mainly for features and columns. Works on assignment only. Prefers editorial illustration in airbrush, mixed media, colored pencil, watercolor, acrylic, oil, pastel, collage and calligraphy.

First Contact & Terms Illustrators: Send query letter with color brochure showing art style and tearsheets. Looks for the "ability to intelligently grasp idea behind story and illustrate it. Likes crisp, clean colorful styles." Accepts disk submissions. Send EPS files. Samples are filed. Does not report back. Will contact for portfolio review if interested. Sometimes requests work on spec. Buys one-time rights. Pays on publication. "Send lots of good-looking color tearsheets that we can keep on hand for reference. If your work interests us we will contact you."

Tips "In your portfolio show examples of editorial illustration for other magazines, good conceptual illustrations and a variety of subject matter. Often artists don't send enough of a variety of illustrations; it's much easier to determine if an illustrator is right for an assignment if we have a complete grasp of the full range of abilities. Send high-quality illustrations and show specific interest in our publication."

N AMERICAN AIRLINES NEXOS

4333 Amon Creek Blvd., Ft. Worth TX 76155-2664. (817)963-5378. Fax: (817) 931-5782. E-mail: marco.rosales@ aa.com. Web site: www.nexosmag.com. **Art Director:** Marcos Rosales. Bimonthly bilingual publication for Latin American passengers of American Airlines. Circ. 236,000.

Illustration Approached by 300 illustrators/year. Buys 50 illustrations/year. Features humorous and spot illustrations of business and families.

First Contact & Terms Illustrators: Send postcard sample. After introductory mailing, send follow-up postcard sample every 6 months. Pays illustrators $100-250 for color inside. Pays on publication. Buys one-time rights. Finds freelancers through artists' submissions.

AMERICAN BANKERS ASSOCIATION-BANKING JOURNAL

345 Hudson St., 12th Floor, New York NY 10014-4502. (212)620-7256. Fax: (212)633-1165. E-mail: wwilliams@s bpub.com. Web site: www.ababj.com. **Creative Director:** Wendy Williams. Associate Creative Director: Phil Desiere. Estab. 1908. 4-color; contemporary design. Emphasizes banking for middle and upper level banking executives and managers. Monthly. Circ. 31,440. Accepts previously published material. Returns original artwork after publication.

Illustration Buys 4-5 illustrations/issue from freelancers. Features charts & graphs, computer, humorous and spot illustration. Assigns 20% of illustrations to new and emerging illustrators. Themes relate to stories, primarily financial, from the banking industry's point of view; styles vary, realistic, surreal. Uses full-color illustrations. Works on assignment only.

First Contact & Terms Illustrators: Send finance-related postcard sample and follow-up samples every few months. To send a portfolio, send query letter with brochure and tearsheets, promotional samples or photographs. Negotiates rights purchased. **Pays on acceptance**; $250-950 for color cover; $250-450 for color inside; $250-450 for spots.

Tips Must have experience illustrating for business or financial publications.

AMERICAN FITNESS

15250 Ventura Blvd., Suite 200, Sherman Oaks CA 91403. (818)905-0040, ext. 200. Fax: (818)990-5468. E-mail: americanfitness@afaa.com. Web site: www.afaa.com. **Editor-in Chief:**Meg Jordan. Bimonthly magazine for fitness and health professionals. Circ. 42,900. Accepts previously published material. Original artwork returned after publication.

Illustration Approached by 12 illustrators/month. Assigns 2 illustrations/issue. Works on assignment only. Prefers "very sophisticated" 4-color line drawings.

First Contact & Terms Illustrators: Send postcard promotional sample. Acquires one-time rights.

Tips "Excellent source for never-before-published illustrators who are eager to supply full-page lead artwork."

THE AMERICAN GARDENER

7931 E. Boulevard Dr., Alexandria VA 22308. (703)768-5700. Fax: (703)768-7533. E-mail: editor@ahs.org. Web site: www.ahs.org. **Editor:** David J. Ellis. Managing Editor: Mary Yee. Estab. 1922. Consumer magazine for

advanced and amateur gardeners and horticultural professionals who are members of the American Horticultural Society. Bimonthly, 4-color magazine. Circ. 35,000. Original artwork is returned at job's completion. Sample copies for $5.

Illustration Rarely uses illustrations. Works on assignment only. "Botanical accuracy is important for some assignments. All media used; digital media welcome."

First Contact & Terms Illustrators: Send query letter with résumé, tearsheets, slides and photocopies. Samples are filed. "We will call artist if their style matches our need." To show a portfolio, mail b&w and color tearsheets and slides. Buys one-time rights. Pays $150-300 color inside; on publication.

Tips "Prefers art samples depicting plants and gardens or gardening."

THE AMERICAN LEGION MAGAZINE

P.O. Box 1055, Indianapolis IN 46206. E-mail: Magazine@Legion.org. (317)630-1298. Fax: (317)630-1280. E-mail: mgrills@legion.org. Web site: www.legion.org. **Cartoon Editor:** Matt Grills. Art Director: Holly Soria. Circ. 2,550,000. Emphasizes the development of the world at present and milestones of history; 4-color general-interest magazine for veterans and their families. Monthly. Original artwork not returned after publication.

Cartoons Uses 3 freelance cartoons/issue. Receives 150 freelance submissions/month. "Experience level does not matter and does not enter into selection process." Especially needs general humor in good taste. "Generally interested in cartoons with broad appeal. Those that attract the reader and lead us to read the caption rate the highest attention. Because of tight space, we're not in the market for spread or multipanel cartoons but use both vertical and horizontal single-panel cartoons. Themes should be home life, business, sports and everyday Americana. Cartoons that pertain only to one branch of the service may be too restricted for this magazine. Service-type gags should be recognized and appreciated by any ex-service man or woman. Cartoons that may offend the reader are not accepted. Liquor, sex, religion and racial differences are taboo.

First Contact & Terms Cartoonists: "No roughs. Send final product for consideration." Usually responds within 1 month. Buys first rights. **Pays on acceptance;** $150.

Tips "Artists should submit their work as we are always seeking new slant and more timely humor. Black & white submissions are acceptable, but we purchase only color cartoons. Want good, clean humor—something that might wind up on the refrigerator door. Consider the audience!"

AMERICAN LIBRARIES

50 E. Huron St., Chicago IL 60611-2795. (312)280-4216. Fax: (312)440-0901. E-mail: americanlibraries@ala.org. Web site: www.ala.org/alonline. **Editor:** Leonard Kniffel. Estab. 1907. Monthly professional 4-color journal of the American Library Association for its members, providing independent coverage of news and major developments in and related to the library field. Circ. 58,000. Sample copy $6. Art guidelines available with SASE and first-class postage.

Cartoons Approached by 15 cartoonists/year. Buys no more than 1 cartoon/issue. Themes related to libraries only. Average payment $50.

Illustration Approached by 20 illustrators/year. Buys 1-2 illustrations/issue. Assigns 25% of illustrations to new and emerging illustrators. Works on assignment only.

First Contact & Terms Cartoonists: Send query letter with brochure and finished cartoons. Illustrators: Send query letter with brochure, tearsheets and résumé. Samples are filed. Does not respond to submissions. To show a portfolio, mail tearsheets, photographs and photocopies. Portfolio should include broad sampling of typical work with tearsheets of both b&w and color. Buys first rights. **Pays on acceptance.** Pays cartoonists $35-50 for b&w. Pays illustrators $75-150 for b&w and $250-300 for color cover; $150-250 for color inside.

Tips "I suggest inquirer go to a library and take a look at the magazine first." Sees trend toward "more contemporary look, simpler, more classical, returning to fewer elements."

AMERICAN MEDICAL NEWS

515 N. State, Chicago IL 60610. (312)464-4432. Fax: (312)464-4445. E-mail: Jef_Capaldi@ama-assn.org. Web site: www.amednews.com. **Art Director:** Jef Capaldi. Assistant Art Director: Casey Braun. Estab. 1958. Weekly trade journal. "We're the nation's most widely circulated publication covering socioeconomic issues in medicine." Circ. 250,000. Originals returned at job's completion. Sample copies available. 10% of freelance work demands knowledge of Photoshop and FreeHand.

Illustration Approached by 250 freelancers/year. Buys 2-3 illustrations/issue. Works on assignment only. Considers mixed media, collage, watercolor, acrylic and oil.

First Contact & Terms Send postcard samples. Samples are filed. Will contact for portfolio review if interested. Buys first rights. **Pays on acceptance.** Pays $300-500 for b&w, $500-850 for color inside. Pays $200-400 for spots. Finds artists through illustration contest annuals, word of mouth and submissions.

Tips "Illustrations need to convey a strong, clever concept."

AMERICAN MUSCLE MAGAZINE

P.O. Box 6100, Rosemead CA 91770. **Art Director:** Michael Harding. Monthly 4-color magazine emphasizing bodybuilding, exercise and professional fitness. Features general interest, historical, how-to, inspirational, interview/profile, personal experience, travel articles and experimental fiction (all sports-related). Circ. 457,611. Accepts previously published material. Original artwork returned after publication.
Illustration Buys 5 illustrations/issue.
First Contact & Terms Illustrators: Send query letter with résumé, tearsheets, slides and photographs. Samples are filed or are returned. Responds in 1 week. Buys first rights, one-time rights, reprint rights or all rights. **Pays on acceptance.**
Tips "Be consistent in style and quality."

AMERICAN MUSIC TEACHER

441 Vine St. Suite 505, Cincinnati OH 45202-2811. (513)421-1420. Fax: (513)421-2503. Web site: www.mtna.org. **Art Director:** Brian Pieper. Estab. 1951. Bimonthly 4-color trade journal emphasizing music teaching. Features historical and how-to articles. "*AMT* promotes excellence in music teaching and keeps music teachers informed. It is the official journal of the Music Teachers National Association, an organization which includes concert artists, independent music teachers and faculty members of educational institutions." Circ. 26,424. Accepts previously published material. Original artwork returned after publication. Sample copies available.
Illustration Buys 1 illustration/issue. Uses freelancers mainly for diagrams and illustrations. Prefers musical theme. "No interest in cartoon illustration."
First Contact & Terms Illustrators: Send query letter with brochure or résumé, tearsheets, slides and photographs. Samples are filed or are returned only if requested with SASE. Responds in 3 months. To show a portfolio, mail printed samples, color and b&w tearsheets, photographs and slides. Buys one-time rights. Pays on publication; $50-150 for b&w and color, cover and inside.

AMERICAN SCHOOL BOARD JOURNAL

1680 Duke St., Alexandria VA 22314-3474. (703)838-6722. Fax: (703)549-6719. E-mail: msabatier@nsba.org. Web site: www.asbj.com. **Production Manager/Art Director:** Michele Sabatier Mann. Estab. 1891. National monthly magazine for school board members and school administrators. Circ. 36,000. Sample copies available.
Illustration Buys 40-50 illustrations/year. Considers all media. Send postcard sample.
First Contact & Terms Illustrators: Send follow-up postcard sample every 3 months. Will not accept samples as e-mail attachment. Please send URL. Responds only if interested. Art director will contact artist for portfolio review of tearsheets if interested. Buys one-time rights. **Pays on acceptance.** Pays $1,200 maximum for color cover; $250-350 for b&w, $300-600 for color inside. Finds illustrators through agents, sourcebooks, online services, magazines, word of mouth and artist's submissions.
Tips "We're looking for new ways of seeing old subjects—children, education, management. We also write a great deal about technology and love high-tech, very sophisticated mediums. We prefer concept over narrative styles."

ANALOG

475 Park Ave. S., New York NY 10016. (212)686-7188. Fax: (212)686-7414. **Senior Art Director:** Victoria Green. Associate Art Director: June Levine. All submissions should be sent to June Levine, associate art director. Estab. 1930. Monthly consumer magazine. Circ. 80,000. Art guidelines free for #10 SASE with first-class postage.
Cartoons Prefers single panel cartoons.
Illustration Buys 4 illustrations/issue. Prefers science fiction, hardware, robots, aliens and creatures. Considers all media.
First Contact & Terms Cartoonists: Send query letter with photocopies and/or tearsheets and SASE. Samples are not filed and are returned by SASE. Illustrators: Send query letter with printed samples or tearsheets and SASE. Send follow-up postcard sample every 4 months. Accepts disk submissions compatible with QuarkXPress 7.5/version 3.3. Send EPS files. Files samples of interest, others are returned by SASE. Responds only if interested. "No phone calls." Portfolios may be dropped off every Tuesday and should include b&w and color tearsheets and transparencies. "No original art please, especially oversized." Buys one-time rights. **Pays on acceptance.** Pays cartoonists $35 minimum for b&w cartoons. Pays illustrators $1,200 for color cover; $125 minimum for b&w inside; $35-50 for spots. Finds illustrators through *Black Book*, *LA Workbook*, *American Showcase* and other reference books.

ANTHOLOGY

P.O. Box 4411, Mesa AZ 85211-4411. (602)461-8200. E-mail: info@anthology.org. Web site: www.anthology.org. **Contact:** Ann Loring, art editor. Executive Editor: Sharon Skinner. Estab. 1991. Bimonthly b&w literary

magazine featuring poetry, prose and artwork. Circ. 2,000. Sample copies for $3.95. Art guidelines free for #10 SASE with first-class postage.

Illustration Approached by 40-50 illustrators/year. Acquires 6-10 illustrations/issue. Has featured illustrations by Ed Fillmore, Curtis Broadway, Ronit Glazer and Roxell Edward Karr. Features humorous, realistic and spot illustrations of sci-fi, fantasy objects. Prefers b&w ink. Assigns 100% of illustrations to new and emerging illustrators. 100% of freelance illustration demands knowledge of PageMaker or Corel Draw.

First Contact & Terms Illustrators: Send query letter with photocopies and SASE. Accepts Window-compatible disk submissions. Send TIFF, BMP, PCX or GIF files. Samples are not filed, returned by SASE. Responds in 3 months. Buys one-time rights. Pays in complimentary copies and ad space. Finds illustrators through word of mouth.

Tips "Illustration is a valuable yet overlooked area for many literary magazines. The best chance illustrators have is to show the publication how their work will enrich its pages."

AQUARIUM FISH MAGAZINE

P.O. Box 6050, Mission Viejo CA 92690. (949)855-8822. Fax: (949)855-3045. E-mail: aquariumfish@fancypubs.c om. Web site: www.aquariumfish.com. **Editor:** Russ Case. Estab. 1988. Monthly magazine covering fresh and marine aquariums and garden ponds. Photo guidelines for SASE with first-class postage or on Web site.

Cartoons Approached by 30 cartoonists/year. Themes should relate to aquariums and ponds.

First Contact & Terms Cartoonists: Cartoon guidelines for SASE with first-class postage. Buys one-time rights. Pays $35 for b&w and color cartoons.

ARMY MAGAZINE

2425 Wilson Blvd., Arlington VA 22201. (703)841-4300. Web site: www.ausa.org. **Art Director:** Paul Bartels. Estab. 1950. Monthly trade journal dealing with current and historical military affairs. Also covers military doctrine, theory, technology and current affairs from a military perspective. Circ. 115,000. Originals returned at job's completion. Sample copies available for $3.00. Art guidelines available.

Cartoons Approached by 5 cartoonists/year. Buys 1 cartoon/issue. Prefers military, political and humorous cartoons; single or double panel, b&w washes and line drawings with gaglines.

Illustration Approached by 1 illustrator/year. Buys 1 illustration/issue. Works on assignment only. Prefers military, historical or political themes. Considers pen & ink, airbrush, acrylic, marker, charcoal and mixed media. "Can accept artwork done with Illustrator or Photoshop for Macintosh."

First Contact & Terms Cartoonists: Send query letter with brochure and finished cartoons. Responds to the artist only if interested. Illustrators: Send query letter with brochure, résumé, tearsheets, photocopies and photostats. Samples are filed or are returned by SASE if requested by artist. Publication will contact artist for portfolio review if interested. Portfolio should include b&w and color tearsheets, photocopies and photographs. Buys one-time rights. Pays on publication. Pays cartoonists $50 for b&w. Pays illustrators $300 minimum for b&w cover; $500 minimum for color cover; $50 for b&w inside; $75 for color inside; $35-50 for spots.

ART:MAG

P.O. Box 70896, Las Vegas NV 89170-0896. (702)734-8121. E-mail: magman@iopener.net. **Art Director:** Peter Magliocco. Contributing Artist-at-Large: Bill Chown. Art Editor: "The Mag Man." Estab. 1984. Yearly b&w small press literary arts zine. Circ. 100. Art guidelines for #10 SASE with first-class postage.

Cartoons Approached by 5-10 cartoonists/year. Buys 5 cartoons/year. Prefers single panel, political, humorous and satirical b&w line drawings.

Illustration Approached by 5-10 illustrators/year. Buys 3-5 illustrations/year. Has featured illustrations by Guy R. Beining and M. Wakefield/George Coston. Features caricatures of celebrities and politicians and spot illustrations. Preferred subjects art, literature and politics. Prefers realism, hip, culturally literate collages and b&w line drawings. Assigns 30% of illustrations to new and emerging illustrators.

First Contact & Terms Cartoonists: Send query letter with b&w photocopies, samples, tearsheets and SASE. Samples are filed. Rights purchased vary according to project. Illustrators: Send query letter with photocopies, SASE. Responds in 3 months. Portfolio review not required. Buys one-time rights. Pays on publication. Pays cartoonists/illustrators 1 contributor's copy. Finds illustrators through magazines, word of mouth.

Tips "Art:Mag is basically for new or amateur artists with unique vision and iconoclastic abilities whose work is unacceptable to slick mainstream magazines. Don't be conventional, be idea-oriented."

ARTHRITIS TODAY MAGAZINE

1330 W. Peachtree St., Atlanta GA 30309-2922. (404)872-7100. Fax: (404)872-9559. E-mail: atmail@arthritis.o rg. Web site: www.arthritis.org. **Art Director:** Susan Siracusa. Estab. 1987. Bimonthly consumer magazine. "*Arthritis Today* is the official magazine of the Arthritis Foundation. The award-winning publication is more than the most comprehensive and reliable source of information about arthritis research, care and treatment.

It is a magazine for the whole person—from their lifestyles to their relationships. It is written both for people with arthritis and those who care about them.'' Circ. 700,000. Originals returned at job's completion. Sample copies available. 20% of freelance work demands knowledge of Illustrator, QuarkXPress or Photoshop.

Illustration Approached by over 100 illustrators/year. Buys 5-10 illustrations/issue. Works on assignment only; stock images used in addition to original art.

First Contact & Terms Illustrators: Send query letter with brochure, tearsheets, photostats, slides (optional) and transparencies (optional). Samples are filed. Publication will contact artist for portfolio review if interested. Portfolio should include color tearsheets, photostats, photocopies, final art and photographs. Buys first-time North American serial rights. Other usage negotiated. **Pays on acceptance.** Finds artists through sourcebooks, Internet, other publications, word of mouth, submissions.

Tips ''No limits on areas of the magazine open to freelancers. Two to three departments in each issue use spot illustrations. Submit tearsheets for consideration. No cartoons.''

THE ARTIST'S MAGAZINE

4700 E. Galbraith Rd., Cincinnati OH 45236. E-mail: tamedit@fwpubs.com. Web site: www.artistsmagazine.c om. **Art Director:** Daniel Pessell. Magazine published 10 times a year. 4-color magazine emphasizing the techniques of working artists for the serious beginning, amateur and professional artist. Circ. 180,000. Occasionally accepts previously published material. Returns original artwork after publication. Sample copy $4.99 US, $7.99 Canadian or international; remit in US funds.

• Sponsors annual contest. Send SASE for more information.

Cartoons Buys 3-4 cartoons/year. Must be related to art and artists.

Illustration Buys 2-3 illustrations/year. Has featured illustrations by Susan Blubaugh, Sean Kane, Jamie Hogan, Steve Dininno, Kathryn Adams. Features humorous and realistic illustration. Works on assignment only.

First Contact & Terms Cartoonists: Contact Cartoon Editor. Send query letter with brochure, photocopies, photographs and tearsheets to be kept on file. Prefers photostats or tearsheets as samples. Samples not filed are returned by SASE. Buys first rights. **Pays on acceptance.** Pays cartoonists $65 on acceptance for first-time rights. Pays illustrators $350-1,000 for color inside; $100-500 for spots.

Tips ''Research past issues of publication and send samples that fit the subject matter and style of target publication.''

ASCENT MAGAZINE

837 Rue Gilford, Montreal ON H2J 1P1 Canada. (514)499-3999. Fax: (514)499-3904. E-mail: info@ascentmagazi ne.com. Web site: www.ascentmagazine.com. **Contact:** Joe Ollmann, designer. Estab. 1999. Quarterly consumer magazine focusing on yoga and engaged spirituality. Circ. 7,500. Sample copies are available for $7. Art guidelines available on Web site or e-mail design@ascentmagazine.com.

Illustration Approached by 20-40 illustrators/year. Prefers b&w. Assigns 50% to new and emerging illustrators. 50% of freelance illustration demands knowledge of Illustrator, InDesign and Photoshop.

First Contact & Terms Send postcard sample or query letter with b&w photocopies, samples, URL. Accepts e-mail submissions with link to Web site or image file. Prefers Mac-compatible, TIFF files. Samples are filed. Responds in 2 months. Company will contact artist for portfolio review if interested. Portfolio should include b&w and color, finished art, photographs and tearsheets. Pays illustrators $300-800 for color cover; $50-300 for b&w inside; $150-500 for 2-page spreads. Pays on publication. Buys first rights, electronic rights. Finds freelancers through agents, artists' submissions, magazines and word of mouth.

Tips ''Please be familiar with our magazine. Be open to working with specifications we want (artistic and technical).''

ISAAC ASIMOV'S SCIENCE FICTION MAGAZINE

475 Park Ave. S., New York NY 10016. (212)686-7188. Fax: (212)686-7414. **Senior Art Director:** Victoria Green. All submissions should be sent to June Levine, associate art director. Estab. 1977. Monthly b&w with 4-color cover magazine of science fiction and fantasy. Circ. 61,000. Accepts previously published artwork. Original artwork returned at job's completion. Art guidelines available for #10 SASE with first-class postage.

Cartoons Approached by 20 cartoonists/year. Buys 10 cartoons/year. Two covers commissioned/year. The rest are second-time rights or stock images. Prefers single panel, b&w washes or line drawings with and without gagline. Address cartoons to Brian Bieniowski, editor.

Illustration No longer buys interior illustration.

First Contact & Terms Cartoonists: Send query letter with printed samples, photocopies and/or tearsheets and SASE. Accepts disk submissions compatible with QuarkXPress version 3.3. Send EPS files. Accepts illustrations done with Illustrator and Photoshop. Samples are filed or returned by SASE. Responds only if interested. Portfolios may be dropped off every Tuesday and should include b&w and color tearsheets. Buys one-time and

reprint rights. **Pays on acceptance.** Pays cartoonists $35 minimum. Pays illustrators $600-1,200 for color cover.
Tips No comic book artists. Realistic work only, with science fiction/fantasy themes. Show characters with a background environment.

ASPEN MAGAZINE
720 E. Durant Ave., Suite E8, Aspen CO 81611. (970)920-4040. Fax: (970)920-4044. E-mail: production@aspenm agazine.com. Web site: www.aspenmagazine.com. **Art Director:** Britta Gustafson. Bimonthly 4-color city magazine with the emphasis on Aspen and the valley. Circ. 18,300. Accepts previously published artwork. Original artwork returned at job's completion. Sample copies and art guidelines available.
Illustration Approached by 15 illustrators/year. Buys 2 illustrations/issue. Themes and styles should be appropriate for editorial content. Considers all media. Send query letter with tearsheets, photostats, photographs, slides, photocopies and transparencies. Samples are filed. Responds only if interested. Call for appointment to show a portfolio, which should include thumbnails, roughs, tearsheets, slides and photographs. Buys first, one-time or reprint rights. Pays on publication.

ASSOCIATION OF BREWERS
P.O. Box 1679, Boulder CO 80306. Web site: www.beertown.org. **Magazine Art Director:** Kelli McPhail. Estab. 1978. "Our nonprofit organization hires illustrators for two magazines, *Zymurgy* and *The New Brewer*, each published bimonthly. *Zymurgy* is a journal of the American Homebrewers Association. The goal of the AHA division is to promote public awareness and appreciation of the quality and variety of beer through education, research and the collection and dissemination of information." Circ. 10,000. "*The New Brewer* is a journal of the Institute for Brewing Studies. The goal of the IBS division is to serve as a forum for the technical aspects of brewing and to seek ways to help maintain quality in the production and distribution of beer." Circ. 3,000.
Illustration Approached by 50 illustrators/year. Buys 3-6 illustrations/year. Prefers beer and homebrewing themes. Considers all media.
Design Prefers local design freelancers only with experience in Photoshop, QuarkXPress, Illustrator.
First Contact & Terms Illustrators: Send postcard sample or query letter with printed samples, photocopies, tearsheets; follow-up sample every 3 months. Accepts disk submissions with EPS, TIFF or JPEG files. "We prefer samples we can keep." No originals accepted; samples are filed. Responds only if interested. Art director will contact artist for portfolio review of b&w, color, final art, photographs, photostats, roughs, slides, tearsheets, thumbnails, transparencies; whatever media best represents art. Buys one-time rights. Pays 60 day net on acceptance. Pays illustrators $700-800 for color cover; $200-300 for b&w inside; $200-400 for color inside. Pays $150-300 for spots. Finds artists through agents, sourcebooks (Society of Illustrators, *Graphis*, *Print*, *Colorado Creative*), mags, word of mouth, submissions. Designers: Send query letter with printed samples, photocopies, tearsheets.
Tips "Keep sending promotional material for our files. Anything beer-related for subject matter is a plus. We look at all styles."

ASSOCIATION OF COLLEGE UNIONS INTERNATIONAL
One City Centre, 120 W. Seventh St., Suite 200, Bloomington IN 47404-3925. (812)855-8550. Fax: (812)855-0162. Web site: www.acuiweb.org. **Contact:** Andrea Langerveld. Estab. 1914. Professional higher education association magazine covering "multicultural issues, creating community on campus, union and activities programming, managing staff, union operation, professional development and student development."
 • Also publishes hardcover and trade paperback originals. See listing in the Book Publishers section for more information.
Illustration Works on assignment only. Considers all kinds of illustration.
Design Needs designers for production.
First Contact & Terms Illustrators: Send query letter with résumé, photocopies, tearsheets, photographs, Web sites or color transparencies of college student union activities. Designers: Send query letter with résumé and samples. Samples are filed. Responds only if interested. Negotiates rights purchased. Pays by project.
Tips "We are a volunteer-driven association. Most people submit work on that basis. We are on a limited budget."

ASTRONOMY
21027 Crossroads Circle, Waukesha WI 53186-4055. (262)796-8776. Fax: (262)796-6468. E-mail: onlineeditor@a stronomy.com. Web site: www.astronomy.com. **Art Director:** Carole Ross. Estab. 1973. Monthly consumer magazine emphasizing the study and hobby of astronomy. Circ. 200,000.
 • Published by Kalmbach Publishing. Also see listings for *Classic Toy Trains*, *Finescale Modeler*, *Model Railroader*, *Model Retailer*, *Bead and Button*, *Birder's World*, *Trains*, *The Writer* and *Dollhouse Miniatures*.
Illustration Approached by 20 illustrators/year. Buys 2 illustrations/issue. Has featured illustrations by James

Yang, Gary Baseman. Considers all media. 10% of freelance illustration demands knowledge of Photoshop, Illustrator, QuarkXPress.
First Contact & Terms Illustrators: Send query letter with duplicate slides. Do not send originals. Accepts submissions on disk compatible with above software. Samples are filed and not returned. Buys one-time rights. Finds illustrators through word of mouth and submissions.

ATLANTA MAGAZINE

260 W. Peachtree St. NW, Suite 300, Atlanta GA 30303-1202. (404)527-5500. Fax: (404)527-5575. E-mail: sbogle @atlantamag.emmis.com. Web site: www.atlantamagazine.com. **Contact:** Susan L. Bogle, design director. Associate Art Director: Alice Lynn McMichael. Estab. 1961. Monthly 4-color consumer magazine. Circ. 66,000.
Illustration Buys 3 illustrations/issue. Has featured illustrations by Fred Harper, Harry Campbell, Jane Sanders, various illustrators repped by Wanda Nowak, various illustrators repped by Gerald & Cullen Rapp, Inc. Features caricatures of celebrities, fashion illustration, humorous illustration and spot illustrations. Prefers a wide variety of subjects. Style and media depend on the story. Assigns 60% of illustrations to well-known or ''name'' illustrators; 30% to experienced but not well-known illustrators; 10% to new and emerging illustrators.
First Contact & Terms Illustrators: Send nonreturnable postcard sample. Samples are filed. Will contact artist for portfolio review if interested. Buys first rights. **Pays on acceptance.** Finds freelancers through promotional samples, artists' reps, *The Alternative Pick*.

AUTHORSHIP

10940 S. Parker Rd., Parker CO 80134-7440. (303)841-0246. Fax: (303)841-2607. Web site: www.nationalwriters .com. **Executive Director:** Sandy Whelchel. Estab. 1937. Quarterly magazine. ''Our publication is for our 3,000 members and is cover-to-cover about writing.''
First Contact & Terms Cartoonists: Samples are returned. Responds in 4 months. Buys first North American serial and reprint rights. **Pays on acceptance.** Pays cartoonists $25 minimum for b&w. Illustrators: Accepts disk submissions. Send TIFF or JPEG files.
Tips ''We only take cartoons slanted to writers.''

AUTO RESTORER

P.O. Box 6050, Mission Viejo CA 92690. (949)855-8822, ext. 412. Fax: (949)855-3045. E-mail: tkade@fancypubs. com. Web site: www.autorestorermagazine.com. **Editor:** Ted Kade. Estab. 1989. Monthly b&w consumer magazine with focus on collecting, restoring and enjoying classic cars and trucks. Circ. 75,000. Originals returned at job's completion. Sample copies available for $5.50.
Illustration Approached by 5-10 illustrators/year. Buys 1 illustration/issue. Prefers technical illustrations and cutaways of classic/collectible automobiles through 1979. Considers pen & ink, watercolor, airbrush, acrylic, marker, colored pencil, oil, charcoal, mixed media and pastel.
First Contact & Terms Illustrators: Send query letter with SASE, slides, photographs and photocopies. Samples are filed or returned by SASE if requested by artist. Responds to the artist only if interested. Buys one-time rights. Pays on publication; technical illustrations negotiable. Finds artists through submissions.
Tips Areas most open to freelance work are technical illustrations for feature articles and renderings of classic cars for various sections.

AUTOMOBILE MAGAZINE

Dept. AGDM, 120 E. Liberty, Ann Arbor MI 48104. (313)994-3500. Web site: www.automobilemag.com. **Art Director:** Molly Jean. Estab. 1986. Monthly 4-color ''automobile magazine for upscale lifestyles.'' Traditional, ''imaginative'' design. Circ. 650,000. Original artwork is returned after publication. *Art guidelines specific for each project*.
Illustration Buys illustrations mainly for spots and feature spreads. Works with 5-10 illustrators/year. Buys 2-5 illustrations/issue. Works on assignment only. Considers airbrush, mixed media, colored pencil, watercolor, acrylic, oil, pastel and collage. Needs editorial and technical illustrations.
First Contact & Terms Illustrators: Send query letter with brochure showing art style, résumé, tearsheets, slides, photographs or transparencies. Show automobiles in various styles and media. ''This is a full-color magazine, illustrations of cars and people must be accurate.'' Samples are returned only if requested. ''I would like to keep something in my file.'' Responds to queries/submissions only if interested. Request portfolio review in original query. Portfolio should include final art, color tearsheets, slides and transparencies. Buys first rights and one-time rights. Pays $200 and up for color inside. Pays $2,000 maximum depending on size of illustration. Finds artists through mailed samples.
Tips ''Send samples that show cars drawn accurately with a unique style and imaginative use of medium.''

BABYBUG

315 Fifth St., Peru IL 61354-0300. (815)223-2520. Fax: (815)224-6675. **Art Director:** Suzanne Beck. Estab. 1994. Magazine published every six weeks "for children six months to two years." Circ. 44,588. Sample copy for $4.95 plus 10% of total order ($4 minimum) for shipping and handling; art guidelines for SASE.

Illustration Approached by about 85 illustrators/month. Buys 23 illustrations/issue. Considers all media.

First Contact & Terms Illustrators: Send query letter with printed samples, photocopies and tearsheets. Samples are filed or returned if postage is sent. Responds in 45 days. Buys all rights. Pays 45 days after acceptance. Pays $500 minimum for color cover; $250 minimum per page inside. Finds illustrators through agents, *Creative Black Book*, magazines, word of mouth, artist's submissions and printed children's books.

BACKPACKER MAGAZINE

Rodale, 33 E. Minor St., Emmaus PA 18098-0001. (610)967-5171. Fax: (610)967-8181. E-mail: mbates@backpac ker.com. Web site: www.backpacker.com. **Art Director:** Matthew Bates. Estab. 1973. Consumer magazine covering nonmotorized wilderness travel. Circ. 306,500.

Illustration Approached by 200-300 illustrators/year. Buys 10 illustrations/issue. Considers all media. 60% of freelance illustration demands knowledge of FreeHand, Photoshop, Illustrator, QuarkXPress.

First Contact & Terms Illustrators: Send query letter with printed samples, photocopies and/or tearsheets. Send follow-up postcard sample every 6 months. Accepts disk submissions compatible with QuarkXPress, Illustrator and Photoshop. Samples are filed and are not returned. Art director will contact artist for portfolio review of color photographs, slides, tearsheets and/or transparencies if interested. Buys first rights or reprint rights. Pays on publication. Finds artists through submissions and other printed media.

Tips *Backpacker* does not buy cartoons. "Know the subject matter, and know *Backpacker Magazine*."

BALTIMORE JEWISH TIMES

1040 Park Ave., Suite 200, Baltimore MD 21218. (410)752-3504. Fax: (443)451-0702. E-mail: artdirector@jewish times.com. Web site: www.jewishtimes.com. **Art Director:** Tracie Restauro. Weekly b&w tabloid with 4-color cover emphasizing special interests to the Jewish community for largely local readership. Circ. 20,000. Accepts previously published artwork. Returns original artwork after publication, if requested. Sample copy available.

- This publisher also publishes *Style Magazine*, a Baltimore lifestyle magazine, and *Chesapeake Life*, covering lifestyle topics in southern Maryland and the Eastern Shore.

Illustration Approached by 50 illustrators/year. Buys 4-6 illustrations/year. Works on assignment only. Prefers high-contrast, b&w illustrations.

First Contact & Terms Illustrators: Send query letter with brochure showing art style or tearsheets and photocopies. Samples not filed are returned by SASE. Responds if interested. To show a portfolio, mail appropriate materials or write/call to schedule an appointment. Portfolio should include original/final art, final reproduction/product and color tearsheets and photostats. Buys first rights. Pays on publication; $200 for b&w cover and $300 for color cover; $50-100 for b&w inside.

Tips Finds artists through word of mouth, self-promotion and sourcebooks. Sees trend toward "more freedom of design integrating visual and verbal."

BALTIMORE MAGAZINE

1000 Lancaster St., Suite 400, Baltimore MD 21202-4382. (410)752-4200. Fax: (410)625-0280. E-mail: wamanda @baltimoremag.com. Web site: www.baltimoremagazine.net. **Art Director:** Amanda White-Iseli. Editorial Design Assistant: Kathryn Swartz. Estab. 1908. Monthly city magazine featuring news, profiles and service articles. Circ. 57,000. Originals returned at job's completion. Sample copies available for $2.50/copy. 10% of freelance work demands knowledge of QuarkXPress, FreeHand, Illustrator or Photoshop or any other program that is saved as a TIFF or PICT file.

Illustration Approached by 60 illustrators/year. Buys 4 illustrations/issue. Works on assignment only. Considers all media, depending on assignment.

First Contact & Terms Illustrators: Send postcard sample. Accepts disk submissions. Samples are filed. Will contact for portfolio review if interested. Buys one-time rights. Pays on publication; $250-600 for color insides; 60 days after invoice. Finds artists through sourcebooks, publications, word of mouth, submissions.

Tips All art is freelance—humorous front pieces, feature illustrations, etc. Does not use cartoons.

BARTENDER MAGAZINE

P.O. Box 158, Liberty Corner NJ 07938-0158. (908)766-6006. Fax: (908)766-6607. E-mail: barmag@aol.com. Web site: www.bartender.com. **Editor:** Jackie Foley. Art Director: Todd Thomas. Estab. 1979. Quarterly 4-color trade journal emphasizing restaurants, taverns, bars, bartenders, bar managers, owners, etc. Circ. 150,000.

Cartoons Approached by 10 cartoonists/year. Buys 3 cartoons/issue. Prefers bar themes; single panel.

Illustration Approached by 5 illustrators/year. Buys 1 illustration/issue. Works on assignment only. Prefers bar themes. Considers any media.

First Contact & Terms Cartoonists: Send query letter with finished cartoons. Buys first rights. Illustrators: Send query letter with brochure. Samples are filed. Negotiates rights purchased. Pays on publication. Pays cartoonists $50 for b&w and $100 for color inside. Pays illustrators $500 for color cover.

Ⓝ BASELINE

28 E. 28th St., New York NY 10016-7939. (212)503-5424. Fax: (212)503-5454. E-mail: baseline@ziffdavis.com. Web site: www.baselinemag.com. **Art Director:** Nicole White. Estab. 2001. Monthly publication for senior IT and corporate management business leaders. Circ. 125,100.

Illustrators Features business humorous, informational and spot illustrations of technology. Assigns 50% to new and emerging illustrators.

First Contact & Terms Illustrators: Send postcard sample, photocopies or tearsheets. After introductory mailing, send follow-up postcard sample every 6 months. Accepts e-mail submissions with link to Web site. Responds only if interested. Pays illustrators $100 for color inside. Buys one-time rights. Finds freelancers through artists' submissions.

Ⓝ BAY WINDOWS

631 Tremont St., Boston MA 02118-2034. (617)266-6670. Fax: (617)266-5973. E-mail: jepperly@baywindows.com. Web site: www.baywindows.com. **Editorial Art Director**: Matt McGuire. Estab. 1983. A weekly newspaper ''targeted to politically-aware lesbians, gay men and other political allies publishing non-erotic news and features''; b&w with 2-color cover. Circ. 60,000. Accepts previously published artwork. Original artwork returned after publication. Sample copies available. Needs computer illustrators familiar with Illustrator or FreeHand.

Cartoons Approached by 25 freelance cartoonists/year. Buys 1-2 freelance cartoons/issue. Buys 50 freelance cartoons/year. Preferred themes include politics and life-styles. Prefers double and multiple panel, political and editorial cartoons with gagline, b&w line drawings.

Illustration Approached by 60 freelance illustrators/year. Buys 1 freelance illustration/issue. Buys 50 freelance illustrations/year. Artists work on assignment only. Preferred themes include politics ''humor is a plus.'' Considers pen & ink and marker drawings.

First Contact & Terms Cartoonists: Send query letter with roughs. Samples are returned by SASE if requested by artist. Illustrators: Send query letter with photostats and SASE. Samples are filed. Responds in six weeks only if interested. Portfolio review not required. Rights purchased vary according to project. Pays on publication. Pays cartoonists $50-100 for b&w only. Pays illustrators $100-125 for cover; $75-100 for b&w inside; $75 for spots.

◪ BC OUTDOORS, HUNTING AND SHOOTING

1080 Howe St., Suite 900, Vancouver BC V6Z-2T1 Canada. (604)606-4644. Fax: (604)687-1925. E-mail: sswanson@oppublishing.com. Web site: www.bcosportfishing.com. **Art Director:** Shannon Swanson. Biannual 4-color magazine, emphasizing fishing, hunting, camping, wildlife/conservation in British Columbia. Circ. 30,000. Original artwork returned after publication unless bought outright.

Illustration Approached by more than 10 illustrators/year. Has featured illustrations by Ian Forbes, Brad Nickason and Michael McKinell. Buys 4-6 illustrations/year. Prefers local artists. Interested in outdoors, wildlife (BC species only) and activities as stories require. Format b&w line drawings and washes for inside and color washes for inside.

First Contact & Terms Works on assignment only. Samples returned by SAE (nonresidents include IRC). Reports back on future assignment possibilities. Arrange personal appointment to show portfolio or send samples of style. Subject matter and the art's quality must fit with publication. Buys first North American serial rights or all rights on a work-for-hire basis. Pays on publication; $40 minimum for spots.

Tips ''Send us material on fishing and hunting. We generally just send back nonrelated work.''

THE BEAR DELUXE

P.O. Box 10342, Portland OR 97296. (503)242-1047. E-mail: bear@orlo.org. Web site: www.orlo.org. **Contact:** Kristin Rogers, art director. Editor-in-Chief: Tom Webb. Estab. 1993. Quarterly 4-color, b&w consumer magazine emphasizing environmental writing and visual art. Circ. 20,000. Sample copies for $3. Art guidelines for SASE with first-class postage.

Cartoons Approached by 50 cartoonists/year. Buys 5 cartoons/issue. Prefers work related to environmental, outdoor, media, arts. Prefers single panel, political, humorous, b&w line drawings.

Illustration Approached by 50 illustrators/year. Has featured illustrations by Matt Wuerker, Ed Fella, Eunice Moyle and Ben Rosenberg. Caricature of politicians, charts & graphs, natural history and spot illustration.

Bear Deluxe has been receiving attention from the design world, even making *Print*'s regional annual three years running. The above cover was designed and illustrated by Thomas Cobb.

© Thomas Cobb

Assigns 30% of illustrations to new and emerging illustrators. 30% of freelance illustration demands knowledge of Illustrator, Photoshop and FreeHand.

First Contact & Terms Cartoonists: Send query letter with b&w photocopies and SASE. Samples are filed or returned by SASE. Responds in 4 months. Illustrators: Send postcard sample and nonreturnable samples. Accepts Mac-compatible disk submissions. Send EPS or Tiff files. Samples are filed or returned by SASE. Responds only if interested. Portfolios may be dropped off by appointment. Buys first rights. Pays on publication. Pays cartoonists $10-50 for b&w. Pays illustrators $200 b&w or color cover; $15-75 for b&w or color inside; $15-75 for 2-page spreads; $20 for spots. Finds illustrators through word of mouth, gallery visits and promotional samples.

Tips "We are actively seeking new illustrators and visual artists, and we encourage people to send samples. Most of our work (besides cartoons) is assigned out as editorial illustration or independent art. Indicate whether an assignment is possible for you. Indicate your fastest turn-around time. We sometimes need people who can work with 2-3 week turn-around or faster."

N BEARS MAGAZINE

P.O. Box 88, Tremonton UT 84337-0088. (801)257-3634. Fax: (801)257-7341. Web site: www.bearsmag.com. **Contact:** Brad Garfield. Estab. 1995. Quarterly magazine. Circ. 15,000.

Illustration 100% of freelance illustration demands knowledge of Photoshop, Illustrator and QuarkXPress.

First Contact & Terms Illustrators: Send postcard sample, query letter or call. Samples are filed and are not returned. Responds only if interested. Artist should follow-up with call or letter after initial query. Portfolio should include b&w or color photographs, slides and tearsheets. Buys one-time rights. Pays on publication; $100-200 for color cover; $25-50 for b&w, $25-50 for color inside. Finds illustrators through word of mouth.

Tips "Browse our magazine; read it, and then contact us for any questions or ideas you might have to improve *Bears Magazine.*"

BETTER HEALTH MAGAZINE

1450 Chapel St., New Haven CT 06511-4405. (203)789-3972. Fax: (203)789-4053. Web site: www.srhs.org/betterhealth.asp. **Editor/Publishing Director:** Cynthia Wolfe Boynton. Estab. 1979. Bimonthly, 4-color "consumer health magazine." Circ. 149,000. Accepts previously published artwork. Original artwork returned at job's completion. Sample copies available for $2.50. Some freelance work demands knowledge of Photoshop, QuarkXPress or Illustrator.

Illustration Approached by 100 illustrators/year. Buys 2-4 illustrations/issue. Works on assignment only. Considers watercolor, collage, airbrush, acrylic, colored pencil, oil, mixed media, pastel and computer illustration.

First Contact & Terms Illustrators: Send query letter with tearsheets. Accepts disk submissions compatible with Mac, Illustrator or Photoshop. Samples are filed. Responds only if interested. Mail postcard samples, photostats, photographs and photocopies. Portfolio should include rough, original/final art, color tearsheets, photostats, photographs and photocopies. Buys first rights. **Pays on acceptance**; $600 for color cover; $400 for color inside.

BIRD WATCHER'S DIGEST

149 Acme St., Marietta OH 45750. (740)373-5285. Fax: (740)373-8443. E-mail: editor@birdwatchersdigest.com. Web site: www.birdwatchersdigest.com. **Editor:** William H. Thompson III. Bimonthly magazine covering birds and bird watching for "bird watchers and birders (backyard and field; veteran and novice)." Circ. 90,000. Art guidelines available on Web site or free for SASE. Previously published material OK. Original work returned after publication. Sample copy $3.99.

Illustration Buys 1-2 illustrations/issue. Has featured illustrations by Julie Zickefoose, Tom Hirata, Kevin Pope and Jim Turanchik. Assigns 15% of illustrations to new and emerging illustrators.

First Contact & Terms Illustrators: Send samples or tearsheets. Responds in 2 months. Buys one-time rights. Pays $50 minimum for b&w; $100 minimum for color.

BIRMINGHAM PARENT, EVANS PUBLISHING LLC

3584 Hwy. 31 S. #324, Pelham AL 35124. (205)663-5070. Fax: (205)621-3983. E-mail: carol@birminghamparent. com. Web site: www.birminghamparent.com. Estab. 2004. Monthly. We serve parents of families in Central Alabama/Birmingham with news pertinent to them. Circ. 40,000+. Art guidelines free with SASE or on Web site.

Cartoons Approached by 2-3 cartoonists/year. Buys 12 cartoons/year. Prefers fun, parenting issues, nothing controversial. Format: single panel. Humorous. Media: color washes.

Illustration Approached by 2 illustrators/year. Buys 0 illustrations/year. Has featured illustrations by only our art director at this time. Preferred color schemes, styles and/or media: see magazine. Assigns 5% of illustrations to new and emerging illustrators; 95% of freelance work demands computer skills. Freelancers should be familiar with InDesign, QuarkXPress, Photoshop. E-mail submissions accepted with link to Web site. Windows-compatible. Prefers JPEG, PDF. Samples are not filed. If not filed, samples are returned by SASE; not returned. Portfolio not required. Pays cartoonists $0-25 for b&w cartoons, $0-25 for color cartoons. Pays on publication. Buys electronic rights, first North American serial rights.

Tips "We do very little freelance artwork. We are still a small publication and don't have space or funds for it. Our art director provides the bulk of our needs. It would have to be outstanding for us to consider purchasing such right now."

N BLACK BEAR PUBLICATIONS/BLACK BEAR REVIEW

1916 Lincoln St., Croydon PA 19021-8026. E-mail: bbreview@earthlink.net. Web site: www.BlackBearReview.c om. **Editor:** Ave Jeanne. Estab. 1984. Publishes award-winning, semiannual b&w magazine emphasizing social, political, ecological and environmental subjects "for mostly well-educated adults." Circ. 500. Also publishes chapbooks. Accepts previously published artwork. Art guidelines for SASE with first-class postage or visit our Web site. Current copy $6 postpaid in U.S., $9 overseas.

Illustration Works with 20 illustrators/year. Buys 10 illustrations/issue. Has featured the illustrations of Marcus Gorenstein, Jessica Freeman, Hailey Parnell, Durlabh Singh, Amy Chace and Miles Histand. Prefers collage, woodcut, pen & ink.

First Contact & Terms Illustrators: Send camera-ready pieces with SASE. Artwork sent on disk or via e-mail must be in one of the following Microsoft Windows formats BMP, GIF or JPG. Samples not filed are returned by SASE. Portfolio review not required. Responds to e-mail submissions in 1 week. Acquires one-time rights or reprint rights. Pays on publication with sample copy for the magazine and $510-20 for cover illustration work. Pays cash on acceptance for chapbook illustrators. Chapbook illustrators are contacted for assignments. Average pay for chapbook illustrators is $20-50 for one-time rights. Does not use illustrations over 4×6. Finds artists through word of mouth, submissions and on the Internet. Seeks submissions for print format and for our Web site.

Tips "Read our listing carefully. Be familiar with our needs and our tastes in previously published illustrations. We can't judge you by your résumé—send copies of b&w artwork. Include title and medium. Send pieces that reflect social concern. No humor please. If we are interested, we won't let you know without a SASE. Artwork may be sent via e-mail. Illustrations may be color for use on our Web site. If you direct us to see samples on your home page, give us time to visit and reply."

BLACK ENTERPRISE

130 Fifth Ave., 10th Floor, New York NY 10011-4306. (212)242-8000. Web site: www.blackenterprise.com. **Contact:** Terence K. Saulsby, art director. Estab. 1970. Monthly 4-color consumer magazine targeting African Americans and emphasizing personal finance, careers and entrepreneurship. Circ. 450,000.

Illustration Approached by over 100 illustrators/year. Buys 10 illustrations/issue. Has featured illustrations by Ray Alma, Cecil G. Rice, Peter Fasolino. Features humorous and spot illustrations, charts & graphs, computer illustration on business subjects. Assigns 10% of illustrations to new and emerging illustrators. 50% of freelance illustration demands knowledge of Illustrator and Photoshop.

First Contact & Terms Illustrators: Send postcard sample. Samples are filed. After introductory mailing, send follow-up postcard every 3 months. Responds only if interested. Portfolios may be dropped off Monday-Friday and should include color finished, original art and tearsheets. Buys first rights. **Pays on acceptance**; $200-800 for color inside; $800-1,000 for 2-page spreads. Finds illustrators through agents, artist's submissions and *Directory of Illustration*.

BODY + SOUL

42 Pleasant St., Watertown MA 02472-2335. (617)926-0200, ext. 348. Fax: (617) 926-5021. E-mail: rgbarnes@bo dyandsoulmag.com. Web site: www.bodyandsoulmag.com. **Art Director:** Robin Gilmore-Barnes. Emphasizes

alternative lifestyles, holistic health, ecology, personal growth, human potential, planetary survival. Bimonthly. Circ. 242,000. Accepts previously published material and simultaneous submissions. Originals are returned after publication by request. Sample copy $3.
Illustration Buys 60-90 illustrations/year. Works on assignment only.
First Contact & Terms Illustrators: Send tearsheets, slides or promo pieces. Samples returned by SASE if not kept on file. Portfolio may be dropped off. Pays $1,000 for color cover; $400 for color inside.
Tips Finds artists through sourcebooks and reps. "I prefer to see tearsheets or printed samples."

BOSTONIA MAGAZINE
10 Lenox St., Brookline MA 02446-4042. (617)353-3081. Fax: (617)353-6488. E-mail: bostonia@bu.edu. Web site: www.bu.edu/alumni/bostonia. **Art Director:** Kim Han. Estab. 1900. Quarterly 4-color alumni magazine of Boston University. Audience is "highly educated." Circ. 230,000. Sample copies free for #10 SASE with first-class postage. Art guidelines not available.
Illustration Approached by 500 illustrators/year. We buy 3 illustrations/issue. Features humorous and realistic illustration, medical, computer and spot illustration. Assigns 10% of illustrations to well-known or "name" illustrators; 50% experienced but not well-known illustrators; 40% to new and emerging illustrators. Considers all media. Works on assignment only.
First Contact & Terms Illustrators: Send query letter with photocopies, printed samples and tearsheets. Samples are filed and not returned. Responds within weeks only if interested. Will contact for portfolio review if interested. Portfolio should include color and b&w roughs, final art and tearsheets. Buys first North American serial rights. "Payment depends on final use and size." **Pays on acceptance.** Payment varies for cover and inside; pays $200-400 for spots. "Liberal number of tearsheets available at no cost." Finds artists through magazines, word of mouth and submissions.
Tips "Portfolio should include plenty of tearsheets/photocopies as handouts. Don't phone; it disturbs flow of work in office. No sloppy presentations. Show intelligence and uniqueness of style."

BOTH SIDES NOW
10547 State Hwy. 110 N., Tyler TX 75704-3731. (903)592-4263. E-mail: bothsidesnow@prodigy.net. Web site: www.bothsidesnow.info. **Editor/Publisher:** Elihu Edelson. Alternative zine covering the interface between spirituality and politics from a New Age perspective. Quarterly, computer printed publication. Circ. 200. Accepts previously published material. Original artwork returned by SASE. Sample copy $2.
Cartoons Buys various number of cartoons/issue. Prefers fantasy, political satire, spirituality, religion and exposes of hypocrisy as themes. Prefers single or multipanel b&w line drawings.
Illustration Buys variable amount of illustrations/issue. Prefers fantasy, surrealism, spirituality and realism as themes. Black & white only.
First Contact & Terms Cartoonists: Send query letter or e-mail with typical examples. Illustrators: Send query letter or e-mail with résumé and examples. Samples not filed are returned by SASE. Responds in 3 months. Pays cartoonists/illustrators on publication in copies and subscription.
Tips "Pay close attention to listing and Web site FAQ page. Do not send color or angst-laden downers, please."

N BOULDER MAGAZINE
1919 14th St., Suite 709, Boulder CO 80302-5326. (303)443-0600. Fax: (303)443-6627. E-mail: lindalee@brockpub.com. Web site: www.getboulder.com. **Art Director:** Lindalee Schwinnen. City magazine published 3 times/year for residents of Boulder, featuring articles about local personalities and area businesses. Circ.: 60,000.
Illustration Features caricatures of local celebrities/politicians, humorous illustration.
First Contact & Terms Illustrators: Send non-returnable postcard sample or photocopies. After introductory mailing, send follow-up postcard sample every 6 months. Samples are filed. Portfolio not required. Company will contact artist for portfolio review if interested. Pays illustrators $100 minimum. Buys one-time rights. Finds freelancers through artists' submissions.

BOW & ARROW HUNTING MAGAZINE
265 S. Anita Dr., #120, Orange CA 92868-3343. (714)939-9991. Fax: (714)939-9909. E-mail: editorial@bowandarrowhunting.com. Web site: www.bowandarrowhunting.com. **Editor:** Joe Bell. Emphasizes the sport of bowhunting. Circ. 97,000. Published 9 times per year. Art guidelines free for SASE with first-class postage. Original artwork returned after publication.
Cartoons Buys occasional cartoon. Prefers single panel with gag line; b&w line drawings.
Illustration Buys 2-6 illustrations/issue; all from freelancers. Has featured illustrations by Tes Jolly and Cisco Monthay. Assigns 25% of illustrations to new and emerging illustrators. Prefers live animals/game as themes.
First Contact & Terms Cartoonists: Send finished cartoons. Illustrators: Send samples. Prefers photographs or original work as samples. Especially looks for perspective, unique or accurate use of color and shading, and

an ability to clearly express a thought, emotion or event. Samples returned by SASE. Responds in 2 months. Portfolio review not required. Buys first rights. Pays on publication; $500 for color cover; $100 for color inside; $50-100 for b&w inside.

BOYS' QUEST

P.O. Box 227, Bluffton OH 45817. (419)358-4610. Fax: (419)358-5027. Web site: www.boysquest.com. **Assistant Editor:** Diane Winebar. Estab. 1995. Bimonthly consumer magazine "geared for elementary boys." Circ. 10,000. Sample copies $5 each, $6.50 outside of US; art guidelines for SASE with first-class postage.

Cartoons Buys 1-3 cartoons/issue. Prefers wholesome children themes. Prefers single or double panel, humorous, b&w line drawings with gagline.

Illustration Approached by 100 illustrators/year. Buys 6 illustrations/issue. Has featured illustrations by Chris Sabatino, Gail Roth and Pamela Harden. Features humorous illustration; realistic and spot illustration. Assigns 40% of illustrations to new and emerging illustrators. Prefers childhood themes. Considers all media.

First Contact & Terms Cartoonists: Send finished cartoons. Illustrators: Send query letter with printed samples. Samples are filed or returned by SASE. Responds in 2 months. To arrange portfolio review of b&w work, artist should follow up with call or letter after initial query. Buys first rights. Pays on publication. Pays cartoonists $5-25 for b&w. Pays illustrators $200-250 for color cover; $25-35 for b&w inside; $50-70 for 2-page spreads; $10-25 for spots. Finds illustrators through artist's submissions.

Tips "Read our magazine. Send in a few samples of work in pen & ink. Everything revolves around a theme; the theme list is available with SASE."

BRIDE'S MAGAZINE

750 Third Ave., New York NY 10017. (212)630-4371. Fax: (212)630-5894. Web site: www.brides.com. **Art Director:** Donna Agajanian. Estab. 1934. Bimonthly 4-color; "classic, clean, sophisticated design style." Circ. 336,598. Original artwork is returned after publication.

Illustration Buys illustrations mainly for spots and feature spreads. Buys 5-10 illustrations/issue. Works on assignment only. Considers pen & ink, airbrush, mixed media, colored pencil, watercolor, acrylic, collage and calligraphy. Needs editorial illustrations.

First Contact & Terms Illustrators: Send postcard sample. In samples or portfolio, looks for "graphic quality, conceptual skill, good 'people' style; lively, young but sophisticated work." Samples are filed. Will contact for portfolio review if interested. Portfolios may be dropped off every Monday-Thursday and should include color and b&w final art, tearsheets, photographs and transparencies. Buys one-time rights or negotiates rights purchased. Pays on publication; $250-350 for b&w or color inside; $250 minimum for spots. Finds artists through word of mouth, magazines, submissions/self-promotions, sourcebooks, artists' agents and reps, attending art exhibitions.

BRUTARIAN

9405 Ulysses Court, Burke VA 22015. E-mail: art@brutarian.com. Web site: www.brutarian.com. **Publisher:** Dominick J. Salemi. Estab. 1991. Quarterly magazine. Circ. 5,000.

Illustration Approached by 100 illustrators/year. Buys 5 illustrations/issue. "We want artwork that is original, stylistically distinct and has impact. We have several avenues to display artwork, both in our published magazine and on our Web site."

First Contact & Terms "The original artwork may be in any medium, but submissions must be in electronic format or a photocopy. Electronic submissions must be 300 dpi or better and sent in separate e-mails to the address above. Artists may also send a direct link to specific pieces of art on their Web site (preferred method). Photocopies may be color or b&w. It is recommended that artists send several representative samples of their work. Along with your submission, please indicate if you're interested in doing on-demand illustration. Pay is $100/cover art, $50/full-page illustration and $25/filler art. We purchase print rights for the current issue and ongoing non-exclusive electronic rights for our Web site, artist gallery and archive. Payment is on or slightly after publication. Response time will vary. We typically respond within a month but recommend that you contact us if you have not heard from us after two months."

BUGLE: JOURNAL OF ELK AND THE HUNT

5705 Grant Creek Road, Missoula MT 59808. (406)523-4523. Fax: (406)523-4550. E-mail: rmysse@rmef.org. Web site: www.elkfoundation.org. **Art Director:** Randi Mysse. Estab. 1984. Bimonthly 4-color outdoor conservation and hunting magazine for a nonprofit organization. Circ. 150,000.

Illustration Approached by 10-15 illustrators/year. Buys 3-4 illustrations/issue. Has featured illustrations by Pat Daugherty, Cynthie Fisher, Joanna Yardley and Bill Gamradt. Features natural history illustration, humorous illustration, realistic illustrations and maps. Preferred subjects wildlife and nature. "Open to all styles." Assigns

60% of illustrations to well-known or "name" illustrators; 20% to experienced but not well-known illustrators; 20% to new and emerging illustrators. **First Contact & Terms** Illustrators: E-mail with query letter and pdf of samples or link to portfolio. Will contact artist for portfolio review if interested. **Pays on acceptance**; $250-400 for b&w, $250-400 for color cover; $100-150 for b&w, $100-200 for color inside; $150-300 for 2-page spreads; $50 for spots. Finds illustrators through existing contacts and magazines.
Tips "We are looking for elk, other wildlife and habitat. Attention to accuracy and realism."

BUILDINGS MAGAZINE

615 Fifth St. SE, Cedar Rapids IA 52401-2158. (319)364-6167. Fax: (319)364-4278. E-mail: info@buildings.com. Web site: www.buildings.com. **Art Director:** Elisa Geneser. Estab. 1906. Monthly trade magazine featuring "information related to current approaches, technologies and products involved in large commercial facilities." Circ. 72,000. Original artwork returned at job's completion.
Illustration Works on assignment only. Considers all media, themes and styles.
First Contact & Terms Illustrators: Send postcard sample. Designers: Send query letter with brochure, photocopies and tearsheets. Accepts submissions on disk compatible with Macintosh. Will contact for portfolio review if interested. Portfolio should include thumbnails, b&w/color tearsheets. Rights purchased vary. **Pays on acceptance.** Pays illustrators $250-500 for b&w, $500-1,500 for color cover; $50-200 for b&w inside; $100-350 for color inside; $30-100 for spots. Pays designers by the project. Finds artists through recommendations and submissions.
Tips "Send postcards with samples of your work printed on them. Show us a variety of work (styles), if available. Send only artwork that follows our subject matter—commercial buildings, products and processes, and facility management."

BULLETIN OF THE ATOMIC SCIENTISTS

6042 S. Kimbark Ave., Chicago IL 60637-2898. (773)702-2555. Fax: (773)702-0725. E-mail: bulletin@thebulletin.org. Web site: www.thebulletin.org. **Managing Editor:** Catherine Auer. Art Director: Joy Olivia Miller. Estab. 1945. Bimonthly magazine of international affairs and nuclear security. Circ. 15,000. Sample copies available.
Cartoons Approached by 15-30 cartoonists/year. Buys 3-5 cartoons/issue. Prefers single panel, humor related to global security, b&w/color washes and line drawings.
Illustration Approached by 30-40 illustrators/year. Buys 2-3 illustrations/issue.
First Contact & Terms Send postcard sample and photocopies. Buys one-time and digital rights. Responds only if interested. **Pays on acceptance.** Pays cartoonists $60 for b&w. Pays illustrators $300-500 for color cover; $100-300 for color inside. Publishes illustrators with a variety of experience.
Tips "We're eager to see cartoons that relate to our editorial content, so it's important to take a look at the magazine before submitting items."

BUSINESS & COMMERCIAL AVIATION

6 International Dr., Suite 310, Rye Brook NY 10573. (914)939-0300. Fax: (914)939-1283. E-mail: william_garvey @aviationnow.com. Web site: www.aviationnow.com/bca. **Art Direction:** Ringston Media. Editor-in-Chief: William Garvey. Monthly technical publication for corporate pilots and owners of business aircraft. 4-color; "contemporary design." Circ. 55,000.
Illustration Works with 12 illustrators/year. Buys 12 editorial and technical illustrations/year. Uses artists mainly for editorials and some covers. Especially needs full-page and spot art of a business-aviation nature. "We generally only use artists with a fairly realistic style. This is a serious business publication and graphically conservative. Need artists who can work on short deadline time." 70% of freelance work demands knowledge of Photoshop, Illustrator, QuarkXPress and FreeHand.
First Contact & Terms Illustrators: Query with samples and SASE. Responds in 1 month. Photocopies OK. Buys all rights, but may reassign rights to artist after publication. Negotiates payment. **Pays on acceptance.**$400 for color; $175-250 for spots.

N. BUSINESS 2.0

1 California St., 29th Flr., San Francisco CA 94111-5401. (415)293-4800. Fax: (415)293-5910. Web site: www.business2.com. **Art Director:** Eric Siry. Monthly business publication written for business people working in online and traditional companies. Publication highlights new ideas and technology in practical terms. Circ. 612,900.
Illustration Approach by 200 illustrators/year. Buys 120 illustrations/year. Has featured illustrations by Randy Pollak, Zohar Lazar. Features business celebrities, charts & graphs, humorous, informational, realistic and spot illustrations of business technology subjects. Assign 10% to new and emerging illustrators. 10% of freelance illustration demand knowledge of Photoshop.
First Contact & Terms Illustrators: Send postcard sample of photocopies or tearsheets. After introductory

mailing, send follow-up postcard sample every 3 months. Responds only if interested. Company will contact artist for portfolio review if interested. Portfolios should include roughs and finished art. Pays illustrators $1,000-2,000 for color cover; $250-1,000 for color inside. Pays on publication. Buys one-time rights. Finds freelancers through artists' submissions and sourcebooks.

BUSINESS LAW TODAY

321 N. Clark St., 20th Floor, Chicago IL 60610. (312)988-5000. Fax: (312)988-5444. E-mail: tedhamsj@staff.aban et.org. Web site: www.abanet.org/buslaw/blt. **Art Director:** Jill Tedhams. Estab. 1992. Bimonthly magazine covering business law. Circ. 60,291. Art guidelines not available.

Cartoons Buys 20-24 cartoons/year. Prefers business law and business lawyers themes. Prefers single panel, humorous, b&w line drawings with gaglines.

Illustration Buys 6-9 illustrations/issue. Has featured illustrations by Sean Kane, Max Licht and Jim Starr. Features whimsical, realistic and computer illustrations. Assigns 10% of illustrations to new and emerging illustrators. Prefers editorial illustration. Considers all media. 10% of freelance illustration demands knowledge of Photoshop, Illustrator and QuarkXPress.

First Contact & Terms Cartoonists: Send photocopies and SASE to the attention of Ray DeLong. Samples are not filed and are returned by SASE. Responds in several days. Illustrators: "We will accept work compatible with QuarkXPress version 4.04. Send EPS or TIFF files." Samples are filed and are not returned. Responds only if interested. Buys one-time rights. Pays on publication. Pays cartoonists $150 minimum for b&w. Pays illustrators $850 for color cover; $520 for b&w inside; $650 for color inside; $175 for b&w spots.

Tips "Although our payment may not be the highest, accepting jobs from us could lead to other projects, since we produce many publications at the ABA. Sending samples (three to four pieces) works best to get a sense of your style; that way I can keep them on file."

BUSINESS LONDON MAGAZINE

P.O. Box 7400, London N5Y 4X3 United Kingdom. (519)471-2907. Fax: (519)473-7859. E-mail: design@business london.ca. Web site: www.businesslondon.ca. **Art Director:** Rob Rodenhuis. Monthly magazine "covering London and area businesses, entrepreneurs, building better businesses." Circ. 14,000. Sample copies not available; art guidelines not available.

Cartoons Approached by 2 cartoonists/year. Buys 1 cartoon/issue. Prefers business-related line art. Prefers single panel, humorous b&w washes and line drawings without gagline.

Illustration Approached by 5 illustrators/year. Buys 2 illustrations/issue. Has featured illustrations by Nigel Lewis and Scott Finch. Features humorous and realistic illustration; informational graphics and spot illustration. Assigns 50% of illustrations to experienced but not well-known illustrators; 50% to new and emerging illustrators. Prefers business issues. Considers all media. 10% of freelance illustration demands knowledge of Photoshop 3, Illustrator 5.5, QuarkXPress 3.2.

First Contact & Terms Send query letter with roughs and printed samples. Accepts disk submissions compatible with QuarkXPress 7/version 3.3, Illustrator 5.5, Photoshop 3, TIFFs or EPS files. Samples are filed and are not returned. Responds only if interested. Art director will contact artist for portfolio review of b&w, color, final art, photographs, slides and thumbnails if interested. Pays on publication. Pays cartoonists $25-50 for b&w, $50-100 for color. Pays illustrators $125 maximum for cover; $25 minimum for b&w inside. Buys first rights. Finds illustrators through artist's submissions.

Tips "Arrange personal meetings, provide vibrant, interesting samples, start out cheap! Quick turnaround is a must."

BUSINESS TENNESSEE

2817 West End Ave., Suite 216, Nashville TN 37203. (615)843-8000. Fax: (615)843-4300. E-mail: finney@busine sstn.com. Web site: www.businesstn.com. **Creative Director:** Lauren Finney. Estab. 1993. Monthly statewide business magazine. Circ. 45,000.

• A publication of the Decision Media, Inc. (www.businesstn.com).

Cartoons Approached by many cartoonists/year. Buys 2-3 cartoons/year. Prefers whimsical single panel, political color washes and b&w line drawings. Responds only if interested.

Illustration Approached by many illustrators/year. Buys 2-3 illustrations/issue. Has featured illustrations by Lori Bilter, Pashur, Mike Harris, Dar Maleki, Kurt Lightner, Peter Ferfuson, Phil Flanders, Travis Foster, Tim Williams. Features caricatures of celebrities and politicians; charts & graphs; computer and spot illustrations of business subjects and country music celebs. Prefers bright colors and pastels, "all styles welcome except 'grunge.'" Assigns 50% of illustrations to experienced but not well-known illustrators; 50% to new and emerging illustrators. 10% of freelance illustration demands knowledge of Illustrator, Photoshop, FreeHand, QuarkXPress.

First Contact & Terms Send query letter with samples. Accepts Mac-compatible disk submissions. Send EPS files. Samples are filed and are not returned. Will contact artist for portfolio review if interested. Rights purchased

Tim Williams

Bringing a magazine cover to life

Tim Williams is a multi-Addy award-winner who's been a working illustrator for more than 20 years. Williams started his career by designing billboards in the Atlanta area for Ted Turner Billboards and parlayed that job into steady work at a successful illustration studio. From the contacts made through his studio work, Williams was able to strike out on his own—he currently runs his own illustration studio in Cummings, Georgia. Over the years he's worked for *Entertainment Weekly*, *Disney Adventures*, the Atlanta Braves, Turner Broadcasting, the NBA, *Focus on the Family* and LeapFrog. Here he discusses the steps taken to bring a cover to life for *Business TN* magazine.

How did you get the opportunity to work with *Business TN*?
It's kind of an interesting little story. I use to live in Nashville when I was a teenager. A friend of mine from high school owns an insurance company in that area and he contacted me—probably the first time I heard from him in 30 years. During the course of us exchanging e-mails he told me about *Business TN*—by this time he knew I was an illustrator. He said you ought to send them some stuff. So I started peppering them with samples. And after about six months of hitting them pretty hard I got a call from the Art Director Lauren Finney. I did a few spot illustrations for them first and then a couple of features. I think the Dolly cover was my third cover for them.

What went into the decision to make the Dolly Parton cover in this particular style? It is a timeless, dignified image of her as opposed to the usual colorful larger-than-life pictures. Walk me through the process of the idea/creation behind the cover.
They had a pretty good idea of they wanted. Michael Burgin, the Managing Editor at *Business TN*, made it clear to me that they wanted avoid the caricature image. They wanted to make it look almost like a Greek statue. They wanted that dignity to it because that is the thing they were promoting in the text of the article: Dolly Parton as the icon. And to be honest with you I had some trouble coming up with the illustration at first. The first couple set of sketches I did, they weren't pleased with, and I wasn't pleased with them either. By this time I had bought a Dolly Parton book and was just immersing myself in reference, and I found the perfect photograph of her. If I remember right it was of her taking an instrumental break during a concert, and the tilt of head, everything about the photograph, was perfect. I based my illustration on that photo.

What was your deadline like when they gave you the assignment?
I had approximately 10 days—two business weeks. Included in the assignment was an inside illustration where we did Dolly full-body and three little icons logo illustrations to

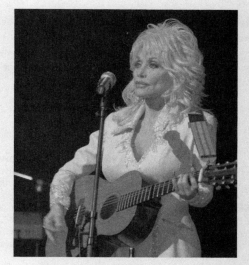

When Tim Williams was commissioned to create a Dolly Parton cover illustration for *Business TN* magazine, the Art Director stressed the importance of capturing her icon status. The frames above show Williams' process in creating the cover. He began with a rough sketch of Parton. Unsatisfied with the initial image, he discovered a photograph of her by Chris Barnes and used it as a reference. This photo captures the dignified portrayal of Parton Williams was looking for. Using the photo as a jumping off point, Williams was able to create a classic statuesque cover image for *Business TN*.

accompany the article. So there was some inside work to be done as well as the cover during the two-week period.

What was the reaction to the piece?

I haven't had a chance to send it out yet to prospective clients, but I heard from Lauren that there has been a positive reaction. And that it was kind of unusual cover for them to do also, so all of us were sort of taking a chance with it. One of the things I heard is that they are doing a ton of reprints on it—that is a good thing.

—*Michael Schweer*

vary according to project. **Pays on publication.** Pays cartoonists $50-150 for b&w; $60-200 for color cartoons. Pays illustrators $200-1,000 for color cover; $50-300 for b&w inside; $60-500 for color inside; $150-800 for 2-page spreads; $30 for spots. Finds freelancers through other publications.

Ⓝ BUSINESSWEEK

1221 Ave. of the Americas, 3rd Floor, New York NY 10020-1001. (212)512-2511. Fax: (212)512-4938. E-mail: malcom_frouman@businessweek.com. Web site: www.businessweek.com. **Art Director:** Malcolm Frouman. Weekly business magazine to keep readers informed on important news that affects the business community in the U.S. and abroad. Circ. 985,025.
Illustration Approached by hundreds of illustrators/year. Buys 50 illustrations/year. Has featured illustrations by Steven Brodner. Features caricatures of politicians, charts & graphs, humorous, informational and spot illustrations of business. Assigns 5% to new and emerging illustrators. 10% of freelance illustration demands knowledge of Illustrator and QuarkXPress.
First Contact & Terms Illustrators: Send postcard sample with URL. After introductory mailing, send follow-up postcard sample every 3 months. Samples are filed. Responds only if interested. Portfolio not required. Pays illustrators $1,000-2,000 for color cover; $450-1,000 for color inside. Pays on publication. Negotiates rights purchased. Finds freelancers through artists' submissions and sourcebooks.

Ⓝ BUST

78 5th Avenue, 5th floor, New York NY 10011-8000. (212)675-1707. Fax: (212)924-5492. E-mail: tegan@bust.com; laurie@bust.com. Web site: www.bust.com. **Art Directors:** Tracie Egan, Laurie Henzel. Estab. 1993. Bimonthly magazine for smart, young women as a hip, humorous alternative to the mainstream. Features interviews with artists, authors, and musicians, along with features on fashion and beauty. Circ. 100,000.
Cartoons Approached by 100 cartoonists/year. Buys 5 cartoons/year. Prefers single panel, women, feminist, dating, men, jobs.
Illustration Approached by 100 freelancers/year. Buys 10 illustrations/year. Features caricatures of authors and musicians, humorous and spot illustrations of feminist career issues, fashion, music. Assigns 50% to new and emerging illustrators.
First Contact & Terms Cartoonists: Send query letter with photocopies. Illustrators: Send postcard sample. After introductory mailing, send follow-up postcard every 6 months. Responds only if interested. Pays cartoonists $100 for color cartoons. Pays illustrators $100-200 for b&w inside. Buys one-time rights.

CALIFORNIA HOME & DESIGN

618 Santa Cruz Ave., Menlo Park CA 94025. (650)324-1818. Fax: (415)324-1888. E-mail: edit@18media.com. Web site: www.18media.com. **Art Director:** Lisa Druri. Estab. 1994. Bimonthly magazine of Northern California lifestyle. Circ. 52,500. Sample copy free for 9×10 SASE and first-class postage.
Cartoons Approached by 200 cartoonists/year. Buys 4 cartoons/year. Prefers financial themes. Prefers single panel, humorous, color washes, without gagline.
Illustration Approached by 100 illustrators/year. Buys 6 illustrations/year. Prefers financial, fashion. Considers all media. 50% of freelance illustration demands knowledge of Photoshop, Illustrator, QuarkXPress.
Design Needs freelancers for design and production. Prefers local design freelancers. 100% of freelance work demands knowledge of Photoshop, Illustrator, QuarkXPress.
First Contact & Terms Cartoonists: Send photocopies. Illustrators: Send postcard sample, query letter with printed samples. Accepts disk submissions compatible with QuarkXPress (EPS files). Designers: Send printed samples. Samples are filed. Responds only if interested. Buys one-time rights. Pays on publication. Pays cartoon-

apists $50-100 for b&w; $75-200 for color. Pays illustrators $100-250 for spots. Finds illustrators through artist's submissions.

Tips "Read our magazine."

CALIFORNIA LAWYER

44 Montgomery St., Suite 250, San Francisco CA 94104. (415)296-2473. Fax: (415)296-2440. E-mail: jake_flaherty@dailyjournal.com. **Creative Director:** Jake Flaherty. Art Director: Marsh Sessa.

Illustration Approached by 100 illustrators/year. Buys 24-30 illustrations/year. Has featured illustrations by Dav Bordeleau, Grady McFerrin, Doug Fraser, Red Nose Studio, Richard Borge, Jack Black, Jonathan Carlson, Dan Page, Asaf Hanuka. Features caricatures of celebrities/politicians, realistic illustration, charts & graphs, humorous illustration, computer illustration, informational graphics, spot illustrations. Preferred subjects: business, politics, law. e-mail submissions accepted with link to Web site, accepted with image file at 72 dpi. Prefers JPEG. If not filed, samples are not returned. Request portfolio review in original query. Artist should follow up with call.

First Contact & Terms Cartoonists: Send postcard sample, URL. After introductory mailing, send follow-up postcard every 2 or 3 months.

⚡ CANADIAN BUSINESS

One Mount Pleasant Rd., 11th Floor, Toronto ON M4Y 2Y5 Canada. (416)596-5100. Fax: (416)596-5155. E-mail: tdavin@canadianbusiness.com. Web site: www.canadianbusiness.com. **Art Director:** Tim Davin. Associate Art Director: John Montgomery. Biweekly 4-color business magazine focusing on Canadian management and entrepreneurs. Circ. 85,000.

Illustration Approached by 200 illustrators/year. Buys 5-10 illustrations/issue. Has featured illustrations by Gerard Dubois, Joe Morse, Seth, Gary Taxali, Dan Page. Features conceptual illustrations, portraits, caricatures and infographics of business subjects. Assigns 70% of illustrations to well-known or "name" illustrators; 30% to new and emerging illustrators. 50% of freelance illustration demands knowledge of Illustrator and Photoshop.

First Contact & Terms Illustrators: Send postcard sample, printed samples and photocopies. Accepts Mac-compatible disk submissions. Responds only if interested. Will contact artist for portfolio review if interested. **Pays on acceptance**; $1,000-2,000 for color cover; $300-1,500 for color inside; $300 for spots. Finds illustrators through magazines, word of mouth and samples.

⚡ CANADIAN DIMENSION (CD)

91 Albert St., Room 2-B, Winnipeg MB R3B 1G5 Canada. (204)957-1519. Fax: (204)943-4617. E-mail: info@canadiandimension.mb.ca. Web site: www.canadiandimension.mb.ca. **Art Director:** Jessica Koroscil. Estab. 1963. Bimonthly consumer magazine published "by, for and about activists in the struggle for a better world, covering women's issues, aboriginal issues, the enrivonment, labour, etc." Circ. 3,100. Accepts previously published artwork. Originals returned at job's completion. Sample copies available for $2. Art guidelines available for SASE with first-class postage.

Illustrators Approached by 20 illustrators/year. Has featured illustrations by Kenneth Vincent, Darcy Muenchrath and Stephen King. Buys 20 illustrations/year.

First Contact & Terms Illustrators: Send query letter with brochure and SASE. Samples are filed or returned by SASE if requested by artist. Publication will contact artist for portfolio review if interested. Buys one-time rights. Pays on publication; $100 for b&w cover; $50 for b&w inside and spots. Finds artists through word of mouth and artists' submissions. E-mail inquiries, samples or URLs welcome.

⚡ CANADIAN GARDENING

25 Sheppard Ave. West, Suite 100, Toronto ON M2N 6S7 Canada. (416)733-7600. E-mail: mailbox@canadiangardening.com. Web site: www.canadiangardening.com. **Art Director:** Bonnie Summerfeldt. Estab. 1990. Special interest magazine published 8 times/year. "A down-to-earth, indispensable magazine for Canadians who love to garden." Circ. 152,000.

Illustration Approached by 50 illustrators/year. Prefers using Canadian artists. Buys 2 illustrations/issue. Considers all media. 50% of freelance illustration demands knowledge of Photoshop, Illustrator and InDesign.

First Contact & Terms Illustrators: Send query letter with tearsheets. Accepts disk submissions compatible with Slide Show, InDesign, Illustrator or Photoshop (Mac). Samples are filed and are not returned. Responds only if interested. Buys first rights. Pays within 45 days, $50-250 (CDN) for spots.

⚡ CANADIAN HOME WORKSHOP

340 Ferrier St., Suite 210, Markham ON L3R 2Z5 Canada. (905)475-8440. Fax: (905)475-9560. Web site: www.canadianhomeworkshop.com. **Contact:** Amy McCleverty, art director. Estab. 1977. "The Do-it-Yourself" magazine published 10 times/year, which "includes instructions and plans for woodworking projects and step-by-

step home improvement articles along with tips from the pros." Circ. 120,000. Sample copies are available on request. Art guidelines available.

Illustration Approached by several freelancers each year. Buys 20 illustrations/year. Has featured illustrations by Jason Schneider, Paul Perreault and Len Churchill. Features computer, humorous, realistic and spot illustration. Assigns 10% of illustrations to new and emerging illustrators. 90% of freelance illustration demands knowledge of Illustrator, Photoshop and QuarkXPress.

First Contact & Terms Send postcard sample or query letter with brochure, photocopies, photographs, samples and tearsheets. Send follow-up postcard every 6 months. Accepts e-mail submissions with link to Web site or image file. Prefers Mac-compatible TIFF, JPEG, GIF or EPS files. Samples are filed and not returned. Responds only if interested. Company will contact for portfolio review if interested. Portfolio should include color finished art, photographs and tearsheets. Pays illustrators $150-800 for color inside; $600-1,200 for 2-page spreads. **Pays on acceptance.** Buys first rights, electronic rights. Finds freelancers through agents, artists' submissions and word of mouth.

CAREER FOCUS

7300 W. 110th St., 7th Floor, Overland Park KS 66210-2330. (913)317-2888. E-mail: editorial@careerfocusmagaz ine.net. Web site: www.careerfocusmagazine.net. **Contact:** Executive Editor. Estab. 1985. Bimonthly educational, career development magazine. "A motivational periodical designed for Black and Hispanic college graduates who seek career development information." Circ. 250,000. Accepts previously published artwork. Originals are returned at job's completion.

• *Career Focus* is published by CPG Communications Inc. (Career Publishing Group) which also publishes *Direct Aim, College Preview, Focus Kansas City* and *First Opportunity.* These magazines have similar needs for illustration as *Career Focus.*

Illustration Buys 1 illustration/issue.

First Contact & Terms Illustrators: Send query letter with samples as attachments via e-mail. Any correspondence should be conducted via e-mail. Samples are filed. Responds only if interested. Buys one-time rights. Pays on publication; $20 for b&w, $25 for color.

CAT FANCY

Bowtie, Inc., 3 Burroughs, Irvine CA 92618. (949)855-8822. e-mail query@catfancy.com. Web site: www.catcha nnel.com. **Contact:** Sandy Meyer. Monthly 4-color magazine for cat lovers; contemporary, colorful and conservative. Readers are interested in all phases of cat ownership. Circ. 290,000. No simultaneous submissions. Check Web site for artist guidlines. Sample copy $5.50; artist's guidelines for SASE.

Illustration Needs editorial, medical and technical illustration and images of cats.

First Contact & Terms Cartoonists: Send query letter with photostats or photocopies as samples and SASE. Illustrators: Send query letter with brochure, high-quality photocopies (preferably color), SASE and tearsheets. Article illustrations assigned. Portfolio review not required. Responds in 3 months. Buys first rights. Pays on publication. Pays cartoonists $35 for b&w line drawings. Pays illustrators $20-35 for spots; $50-300 for color insides; more for packages of multiple illustrations.

Tips "Seeking creative and innovative illustrators that lend a modern feel to our magazine. Please review a sample copy of the magazine before submitting your work to us."

N: CATALINA

1230 Ave. of the Americas 7th Flr., New York NY 10020-1513. (212)745-1363. Fax: (212)202-7608. E-mail: cathy@catalinamagazine.com. Web site: www.catalinamagazine.com. **Conatct:** Art Director. Estab. 1996. Bimonthly consumer magazine for Hispanic women between 24 and 54 focusing on careers, beauty, food, parenting, relationships, health and travel. Circ.: 510,821.

Illustration Approached by 100 illustrators/year. Buys 10 illustrations/year. Preferred subjects: families, Hispanic women, fashion, health, career.

First Contact & Terms Illustrators: Send postcard sample. After introductory mailing, send follow-up postcard sample every 6 months. Responds only if interested. Pays illustrators $100-200 for color inside. Buys one-time rights.

CATHOLIC FORESTER

P.O. Box 3012, Naperville IL 60566-7012. (630)983-4900. Fax: (630)983-4057. E-mail: magazine@catholicforester.c om. Web site: www.catholicforester.com. **Contact:** Art Director. Estab. 1883. "We are a fraternal insurance company but use general-interest articles, art and photos. Audience is middle-class, many small town as well as big-city readers, patriotic, Catholic and traditionally conservative." National quarterly 4-color magazine. Circ. under 100,000. Accepts previously published material. Sample copy for 9×12 SASE with 3 first-class stamps.

Illustration Buys and commissions editorial illustration.

First Contact & Terms Cartoonists: Material returned by SASE. Responds in about 2 months. Illustrators: Will contact for portfolio review if interested. Requests work on spec before assigning job. Buys one-time rights, North American serial rights or reprint rights. Pays on publication. Pays cartoonists $30 for b&w. Pays illustrators $30-100 for b&w, $75-300 for color inside.

Tips "Know the audience you're drawing for; always read the article and don't be afraid to ask questions. Pick the art director's brain for ideas and be timely."

CED

P.O. Box 266007, Highlands Ranch CO 80163-6007. (303)470-4800. Fax: (303)470-4890. E-mail: druth@reedbusi ness.com. Web site: www.cedmagazine.com. **Art Director:** Don Ruth. Estab. 1978. Monthly trade journal dealing with "the engineering aspects of the technology in Cable TV. We try to publish both views on subjects." Circ. 22,815. Accepts previously published work. Original artwork not returned at job's completion. Sample copies and art guidelines available.

Illustration Buys 1 illustration/issue. Works on assignment only. Features caricatures of celebrities; realistic illustration; charts and graphs; informational graphics and computer illustrations. Assigns 10% of illustrations to new and emerging illustrators. Prefers cable TV-industry themes. Considers watercolor, airbrush, acrylic, colored pencil, oil, charcoal, mixed media, pastel, computer disk formatted in Photoshop, Illustrator or FreeHand.

First Contact & Terms Contact only through artist rep. Samples are filed. Call for appointment to show portfolio. Portfolio should include final art, b&w/color tearsheets, photostats, photographs and slides. Rights purchased vary according to project. **Pays on acceptance.** Pays illustrators $400-800 for color cover; $125-400 for b&w and color inside; $250-500 for 2-page spreads; $75-175 for spots.

Tips "Be persistent; come in person if possible. Be willing to change in mid course; be willing to have finished work rejected. Make sure you can draw and work fast."

CHARLESTON MAGAZINE, CHARLESTON HOME, CHARLESTON WEDDINGS

782 Johnnie Dodds Blvd., Suite C, Mt. Pleasant SC 29464. (843)971-9811. Fax: (843)971-0121. E-mail: mmonk@ charlestonmag.com. Web site: www.charlestonmag.com. **Art Director:** Melinda Smith Monk. Editor: Darcy Shankland. Estab. 1973. Monthly 4-color consumer magazine. *Charleston Home* is quarterly, *CharlestonWeddings* is two times a year with a more regional and national distribution. "Indispensible resource for information about modern-day Charleston SC, addresses issues of relevance and appeals to both visitors and residents." Circ. 20,000. Art guidelines are free for #10 SASE with first-class postage.

Illustration Approached by 35 illustrators/year. Buys 1 illustration/issue. Has featured illustrations by Tate Nation, Nancy Rodden, Paige Johnson, Emily Thompson and local artists. Features realistic illustrations, informational graphics, spot illustrations, computer illustration. Prefers business subjects, children, families, men, pets, women and teens. Assigns 10% of illustrations to well-known or "name" illustrators; 30% to experienced but not well-known illustrators; 60% to new and emerging illustrators. 35% of freelance illustration demands knowledge of Illustrator, Photoshop, FreeHand, PageMaker, QuarkXPress.

First Contact & Terms Illustrators: Send postcard sample and follow-up postcard every month or send query letter with printed samples. Accepts Mac-compatible disk submissions. Samples are filed or returned by SASE. Responds only if interested. Will contact artist for portfolio review if interested. Rights purchased vary according to project. Pays 30 days after publication; $175 for b&w, $200 for color cover; $100-400 for 2-page spreads; $50 for spots. Finds illustrators through sourcebooks, artists' promo samples, word of mouth.

Tips "Our magazine has won several design awards and is a good place for artists to showcase their talent in print. We welcome letters of interest from artists interested in semester-long, unpaid internships-at-large. If selected, artist would provide 4-5 illustrations for publication in return for masthead recognition and sample tearsheets. Staff internships (unpaid) also available on-site in Charleston SC. Send letter of interest and samples of work to Art Director."

CHARLOTTE MAGAZINE

127 W. Worthington Ave., Suite 208, Charlotte NC 28203-4474. (704)335-7181. Fax: (704)335-3739. E-mail: erin.potter@charlottemagazine.com. Web site: www.charlottemag.com. **Art Director:** Erin Potter. Estab. 1995. Monthly 4-color city-based consumer magazine for Charlotte and surrounding areas. Circ. 30,000. Sample copies free for #10 SAE with first-class postage.

Illustration Approached by many illustrators/year. Buys 1-5 illustrations/issue. Features caricatures of celebrities and politicians; computer illustration; humorous illustration; natural history, realistic and spot illustration. Prefers wide range of media/conceptual styles. Assigns 20% of illustrations to new and emerging illustrators.

First Contact & Terms Illustrators: Send postcard sample and follow-up postcard every 6 months. Send non-returnable samples. Accepts e-mail submissions. Send EPS or TIFF files. Samples are filed. Responds only if interested. Portfolio review not required. Finds illustrators through artist promotional samples and sourcebooks.

Tips "We are looking for diverse and unique approaches to illustration. Highly creative and conceptual styles are greatly needed. If you are trying to get your name out there, we are a great avenue for you."

◪ Ⓝ CHATELAINE

One Mount Pleasant Rd. 8th Flr., Toronto ON M4Y 2Y5. (416)764-2879. Fax: (416)764-2431. E-mail: caren.watki ns@chatelaine.rogers.com. Web site: www.chatelaine.com. **Art Director:** Caren Watkins. Monthly consumer magazine for contemporary Canadian woman, focusing on health, fashion, beauty, home decorating and trend. Circ. 675,016. Also publishes French edition. Address: 1200 Ave. McGill College, bureau 800, Montreal PQ H3B 4G7. **Art Director:** Ilana Shamir. Circ.: 200,000.

Illustration Features caricatures of celebrities/politicians, fashion, humorous and spot illustrations of business, children, families and women.

First Contact & Terms Illustrators: Send postcard sample with link to Web site. After introductory mailing, send follow-up postcard sample every 6 months. Responds only if interested. Buys one-time rights.

Ⓝ CHEF

20 W. Kinzie St. 12th Flr. #1200, Chicago IL 60610-6392. (312)849-2220. Fax: (312)849-2174. E-mail: cmacavoy @talcott.com. Web site: www.chefmagazine.com. **Art Director:** Camri MacAvoy. Trade publication for chefs who manage commercial and non-commercial kitchens, catering firms, restaurants, hotels/resorts/casinos, culinary schools, country clubs, universities, health care facilities. Reports on latest food service tools, food safety issues, and profiles on chefs. Circ.: 38,900.

Cartoons Approached by 50 cartoonists/year. Buys 2 cartoons/year. Prefers cooking/chef related themes. Prefers single panel and humorous.

Illustration Approached by 100 illustrators/year. Buys 5 illustrations/year. Features cooking, catering and cafeterias. Assigns 50% to new and emerging illustrators.

First Contact & Terms Cartoonists: Send 2-3 photocopies with link to Web site. Illustrators: Send postcard sample. After introductory mailing, send follow-up postcard every 6 months. Responds only if interested. Pays cartoonists $50 for cartoons. Pays illustrators $100 for b&w inside. Buys one-time rights. Finds freelancers through artists' submissions.

Tips "Only interested in work related to cooking, kitchens, chefs and catering."

CHEMICAL WEEK

110 William St., 11th Floor, New York NY 10038. (212)621-4900. Fax: (212)621-4950. E-mail: msotolongo@che mweek.com. Web site: www.chemweek.com. **Director:** Mario Sotolongo. Estab. 1908. Bimonthly, 4-color trade publication emphasizing commercial developments in specialty chemical markets. Circ. 23,000.

Illustration Features charts and graphs, computer illustration, informational graphics, natural history illustration, realistic illustrations, medical illustration of business subjects. Prefers bright colors and clean look. Assigns 100% of illustrations to experienced but not well-known illustrators. 100% of freelance illustration demands knowledge of Illustrator, Photoshop, QuarkXPress.

First Contact & Terms Illustrators: Send nonreturnable postcard sample and follow-up postcard every 6 months. Accepts Mac-compatible disk submissions. Send EPS or TIFF files. Samples are filed and are not returned. Responds only if interested. Portfolio review not required. Rights purchased vary according to project. Pays on publication; $500-800 for color.

Tips "Freelancers should be reliable and produce quality work. Promptness and the ability to meet deadlines are most important."

CHESAPEAKE BAY MAGAZINE

1819 Bay Ridge Ave., Annapolis MD 21403. (410)263-2662. Fax: (410)267-6924. E-mail: kashley@cbmmag.net. Web site: www.cbmmag.net. **Art Director:** Karen Ashley. Estab. 1972. Monthly 4-color magazine focusing on the boating environment of the Chesapeake Bay—including its history, people, places and ecology. Circ. 45,000. Original artwork returned after publication upon request. Sample copies free for SASE with first-class postage. Art guidelines available.

Illustration Approached by 12 illustrators/year. Buys 2-3 technical and editorial illustrations/issue. Has featured illustrations by Jim Paterson, Kim Harroll, Jan Adkins, Tamzin C. Biles, Marcy Ramsey, Peter Bono, Stephanie Carter and James Yang. Assigns 50% of illustrations to new and emerging illustrators. Considers pen & ink, watercolor, collage, acrylic, marker, colored pencil, oil, charcoal, mixed media and pastel. Usually prefers watercolor or acrylic for 4-color editorial illustration. "Style and tone are determined by the artist after he/she reads the story."

First Contact & Terms Illustrators: Send query letter with résumé, tearsheets and photographs. Samples are filed. Make sure to include contact information on each sample. Responds only if interested. Publication will contact artist for portfolio review if interested. Portfolio should include "anything you've got." No b&w photo-

copies. Buys one-time rights. "Price decided when contracted." Pays illustrators $100-300 for quarter-page or spot illustrations; up to $1,200 for spreads—four-color inside.

Tips "Our magazine design is relaxed, fun, oriented toward people having fun on the water. Style seems to be loosening up. Boating interests remain the same. But for the Chesapeake Baywater, quality and the environment are more important to our readers now than in the past. Colors brighter. We like to see samples that show the artist can draw boats and understands our market environment. Send tearsheets or send Web site information. We're always looking. Artist should have some familiarity with the appearance of different types of boats, boating gear and equipment."

▣ CHESS LIFE

137 Obrien Dr. Crossville TN 38555. (931)787-1234. Fax: (931)787-1200. Web site: www.uschess.org. **Editor:** Dan Lucas. Estab. 1939. Official publication of the United States Chess Federation. Contains news of major chess events with special emphasis on American players, plus columns of instruction, general features, historical articles, personality profiles, tournament reports, cartoons, quizzes, humor and short stories. Monthly b&w with 4-color cover. Design is "text-heavy with chess games." Circ. 70,000/month. Accepts previously published material and simultaneous submissions. Sample copy for SASE with 6 first-class stamps; art guidelines for SASE with first-class postage.

• Also publishes children's magazine, *Chess Life For Kids* every other month. Same submission guidelines apply.

Cartoons Approached by 200-250 cartoonists/year. Buys 10-20 cartoons/year. All cartoons must be chess related. Prefers single panel with gagline; b&w line drawings.

Illustration Approached by 100-150 illustrators/year. Works with 4-5 illustrators/year from freelancers. Buys 8-10 illustrations/year. Uses artists mainly for cartoons and covers. All must have a chess motif. Works on assignment, but will also consider unsolicited work.

First Contact & Terms Cartoonists: Send query letter with brochure showing art style. Material kept on file or returned by SASE. Illustrators: Send query letter with samples or e-mail Dan Lucas at dlucas@uschess.org. Responds in 2 months. Negotiates rights purchased. Pays on publication. Pays cartoonists $25. Pays illustrators $150, b&w cover; $300, color cover; $25 inside.

CHILD LIFE

Children's Better Health Institute, P.O. Box 567, Indianapolis IN 46206. (317)634-1100. Fax: (317)684-8094. Web site: www.childlifemag.org. **Art Director:** Rob Falco. Estab. 1921. 4-color magazine for children 9-11. Bimonthly. Circ. 30,000. Sample copy $2.95. Art guidelines for SASE with first-class postage.

• We are not accepting freelance illustrations at this time.

Ⓝ CHILDREN'S BUSINESS

7 W. 34th St. 4th Flr., New York NY 10001-8100. (212)630-3659. Fax: (212)630-4580. E-mail: amadorl@fairchild pub.com. Web site: www.childrensbusiness.com. **Art Director:** Luzmery Amador. Estab. 1985. Monthly trade publication for professionals in the children's fashion and consumer industry, provides information on new products and line launches. Circ.: 12,626.

Cartoons Approached by 100 cartoonists/year. Buys 2 cartoons/year. Prefer kid's fashion.

Illustration Approached by 200 illustrators/year. Buys 10 illustrations/year. Prefers children, toddlers and kids fashion. Assigns 50% to new and emerging illustrators.

First Contact & Terms Cartoonists: Send query letter with photocopies. Illustrators: Send postcard sample with URL. After introductory mailing, send follow-up postcard sample every 6 months. Responds only if interested. Pays cartoonists $50 for color cartoons. Pays illustrators $100 for b&w inside. Buys one-time rights. Finds freelancers through artists' submissions.

CHILDREN'S DIGEST

Children's Better Health Institute, P.O. Box 567, Indianapolis IN 46202. (317)636-8881. Fax: (317)684-8094. Web site: www.childrensdigestmag.org. **Art Director:** Henry Deng. 4-color magazine with special emphasis on book reviews, health, nutrition, safety and exercise for preteens. Published 8 times/year. Circ. 106,000. Sample copy $1.25; art guidelines for SASE.

• Also publishes *Child Life, Children's Playmate, Humpty Dumpty's Magazine, Jack and Jill, Turtle Magazine* and *UKids Weekly Reader Magazine.*

Illustration Approached by 200 illustrators/year. Works with 2 illustrators/year. Buys 2 illustrations/year. Has featured illustrations by Len Ebert, Tim Ellis and Kathryn Mitter. Features humorous, realistic, medical, computer and spot illustrations. Assigns 90% of illustrations to experienced but not well-known illustrators; 10% to new and emerging illustrators. Uses freelance art mainly with stories, articles, poems and recipes. Works on assignment only.

First Contact & Terms Illustrators: Send query letter with brochure, résumé, samples and tearsheets to be kept

on file. "Send samples with comment card and SASE." Portfolio review not required. Prefers photostats, slides and good photocopies as samples. Samples returned by SASE if not kept on file. Responds in 2 months. Buys all rights. Pays $275 for color cover; $35-90 for b&w inside; $60-120 for 2-color inside; $70-155 for 4-color inside; $35-70 for spots. Pays within 3 weeks prior to publication date. "All artwork is considered work for hire." Finds artists through submissions and sourcebooks.

Tips Likes to see situation and storytelling illustrations with more than 1 figure. When reviewing samples, especially looks for artist's ability to bring a story to life with illustrations and to draw well consistently. No advertising work, cartoon styles or portraits of children. Needs realistic styles and animals.

CHILDREN'S PLAYMATE

Children's Better Health Institute, P.O. Box 567, Indianapolis IN 46206. (317)636-8881. Fax: (317)684-8094. Web site: www.childrensplaymatemag.org. **Art Director:** Rob Falco. 4-color magazine for ages 6-8. Special emphasis on entertaining fiction, games, activities, fitness, health, nutrition and sports. Published 8 times/year. Circ. 78,000. Original art becomes property of the magazine and will not be returned. Sample copy $1.25.
- Also publishes *Child Life, Children's Digest, UKids Weekly Reader Magazine, Humpty Dumpty's Magazine, Jack and Jill* and *Turtle Magazine.*

Illustration Uses 8-12 illustrations/issue; buys 6-8 from freelancers. Interested in editorial, medical, stylized, humorous or realistic themes; also food, nature and health. Considers pen & ink, airbrush, charcoal/pencil, colored pencil, watercolor, acrylic, oil, pastel, collage, multimedia and computer illustration. Works on assignment only.

First Contact & Terms Illustrators: Send sample of style; include illustrations of children, families, animals—targeted to children. Provide brochure, tearsheet, stats or good photocopies of sample art to be kept on file. Samples returned by SASE if not filed. Artist should follow up with call or letter. Also considers b&w camera-ready art for puzzles, such as dot-to-dot, hidden pictures, crosswords, etc. Buys all rights on a work-for-hire basis. Payment varies. Pays $275 for color cover; up to $155 for color and $90 for b&w inside, per page. Finds artists through artists' submissions/self-promotions.

Tips "Become familiar with our magazine before sending anything. Don't send just two or three samples. I need to see a minimum of eight pieces to determine that the artist fits our needs. Looking for samples displaying the artist's ability to interpret text, especially in fiction for ages 6-8. Illustrators must be able to do their own layout with a minimum of direction."

CHRISTIAN HOME & SCHOOL

3350 E. Paris Ave. SE, Grand Rapids MI 49512. (616)957-1070. Fax: (616)957-5022. E-mail: rogers@csionline.org. Web site: www.CSIonline.org. **Senior Editor:** Roger W. Schmurr. Emphasizes current, crucial issues affecting the Christian home for parents who support Christian education. 4-color magazine; 4-color cover; published 4 times/year. Circ. 66,000. Sample copy for 9×12 SASE with 4 first-class stamps; art guidelines for SASE with first-class postage.

Cartoons Prefers family and school themes.

Illustration Buys approximately 2 illustrations/issue. Has featured illustrations by Patrick Kelley, Rich Bishop and Pete Sutton. Features humorous, realistic and computer illustration. Assigns 75% of illustrations to experienced but not well-known illustrators; 25% to new and emerging illustrators. Prefers pen & ink, charcoal/pencil, colored pencil, watercolor, collage, marker and mixed media. Prefers family or school life themes. Works on assignment only.

First Contact & Terms Illustrators: Send query letter with résumé, tearsheets, photocopies or photographs. Show a representative sampling of work. Samples returned by SASE, or "send one or two samples art director can keep on file." Will contact if interested in portfolio review. Buys first rights. Pays on publication. Pays cartoonists $75 for b&w. Pays illustrators $300 for 4-color full-page inside. Finds most artists through references, portfolio reviews, samples received through the mail and artist reps.

CHRISTIAN RESEARCH JOURNAL

30162 Tomas, Suite 101, Rancho Santa Margarita CA 92688-2124. (949)858-6100. Fax: (949)858-6111. E-mail: response@equip.org. Web site: www.equip.org. **Contact:** Dwayne Cogdill, art director. Contact by e-mail only at dwayne@cognitiondesign.com. Estab. 1977. Quarterly religion and theology journal that probes "today's religious movements, promoting doctrinal discernment and critical thinking, and providing reason for Christian faith and ethics." Circ. 20,000. Art guidelines not available.

Illustration Has featured illustrations by Tom Fluharty, Phillip Burke, Tim O'Brian. Features caricatures of celebrities/politicians, realistic illustrations of men and women and related to subjects of articles. Assigns 5% of illustrations to new and emerging illustrators.

First Contact & Terms Cartoonists/illustrators: Send postcard sample. Accepts e-mail submissions with link to Web site. Prefers JPEG files. Responds only if interested. Company will contact artist for portfolio

review if interested. Pays on completion of assignment. Buys first rights. Finds freelancers through artists' submissions, word of mouth and illustrator reps.

CHRISTIANITY TODAY

465 Gundersen Dr., Carol Stream IL 60188. (630)260-6200. Fax: (630)260-0114. Web site: www.christianitytoday.com/ctmag/. **Design Director:** Gary Gnidovic; assistant designer: Alicia Sharp. Estab. 1956. Monthly magazine "of thoughtful essays and news reporting on the evangelical Christians around the world." Circ. 170,000.
Cartoons Approached by 50 cartoonists/year. Buys 1 cartoon/issue. Prefers pen & ink; "must have an understanding of our subculture (evangelical Christian)." Prefers single panel b&w drawings with gagline.
Illustration Approached by 100s of illustrators/year. Buys 1-4 illustrations/issue. Considers all media. 5% of freelance illustration demands computer knowledge.
First Contact & Terms Send query letter with printed samples or photocopies and SASE. Samples are filed or returned by SASE. Responds only if interested. Art director will contact artist for portfolio review if interested. Buys first North American serial rights. **Pays on acceptance.** Pays cartoonists $25-100 for b&w. Pays illustrators $500-1,000 for color cover; $200-450 for b&w, $300-700 for color inside; $100-250 for spots.
Tips "Though it is not necessary to be a Christian, it's very helpful if artists understand our subculture. I look for conceptual artists."

THE CHURCH HERALD

4500 60th St. SE, Grand Rapids MI 49512-9642. (616)698-7071. Fax: (616)698-6606. E-mail: herald@rca.org. Web site: www.herald.rca.org. **Editor:** Christina Van Eyl. Estab. 1837. Monthly magazine. "The official denominational magazine of the Reformed Church in America." Circ. 95,000. Accepts previously published artwork. Originals returned at job's completion. Sample copies available for $2. Open to computer-literate freelancers for illustration.
Illustration Buys up to 2 illustrations/issue. Works on assignment only. Considers pen & ink, watercolor, collage, marker and pastel.
First Contact & Terms Illustrators: Send postcard sample with brochure. Accepts disk submissions compatible with QuarkXPress, InDesign, Photoshop, Illustrator. Also may submit via e-mail. Samples are filed. Responds to the artist only if interested. Portfolio review not required. Buys one-time rights. Pays on publication; $300 for color cover; $200 for color inside.

CICADA

315 Fifth St., Peru IL 61354. Web site: www.cricketmag.com. **Senior Art Editor:** Ron McCutchan. Estab. 1998. Bimonthly literary magazine for young adults (senior high-early college). Limited illustration (spots and frontis pieces). Black & white interior with full-color cover. Circ. 18,000. Original artwork returned after publication. Sample copy $7.95 plus 10% of total order ($4 minimum) for shipping and handling; art guidelines available on Web site or for SASE with first-class postage.
Illustration Works with 30-40 illustrators a year. Buys 120 illustrations/year. Has featured illustrations by Erik Blegvad, Victor Ambrus, Ted Rall and Whitney Sherman. Has a strong need for good figurative art with teen appeal, but also uses looser/more graphic/conceptual styles and photo illustrations. Works on assignment only.
First Contact & Terms Illustrators: Send query letter and 4-6 samples to be kept on file "if I like it." Prefers photocopies and tearsheets as samples. Do not send original art work. Samples not kept on file are returned by SASE only. Responds in 6 weeks. Pays 45 days from receipt of final art; $750 for color cover, $50-150 for b&w inside. Buys all rights.

CINCINNATI CITYBEAT

811 Race St., 5th Floor, Cincinnati OH 45202. (513)665-4700. Fax: (513)665-4369. Web site: www.citybeat.com. **Art Director:** Sean Hughes. Estab. 1994. Weekly alternative newspaper emphasizing issues, arts and events. Circ. 50,000.
● Please research alternative weeklies before contacting this art director. He reports receiving far too many inappropriate submissions.
Cartoons Approached by 30 cartoonists/year. Buys 1 cartoon/year.
Illustration Buys 1-3 illustrations/issue. Has featured illustrations by Ryan Greis, Woodrow J. Hinton III and Jerry Dowling. Features caricatures of celebrities and politicians, computer and humorous illustration. Prefers work with a lot of contrast. Assigns 40% of illustrations to new and emerging illustrators. 10% of freelance illustration demands knowledge of Illustrator, Photoshop, FreeHand, QuarkXPress.
First Contact & Terms Cartoonists: Send query letter with samples. Illustrators: Send postcard sample or query letter with printed samples and follow-up postcard every 4 months. Accepts Mac-compatible disk submissions. Send EPS, TIFF or PDF files. Samples are filed. Responds in 2 weeks only if interested. Buys one-time rights. Pays on publication. Pays cartoonists $10-100 for b&w, $30-100 for color cartoons, $10-35 for comic strips.

Pays illustrators $75-150 for b&w cover, $150-250 for color cover; $10-50 for b&w inside, $50-75 for color inside, $75-150 for 2-page spreads. Finds illustrators through word of mouth and artist samples.

CINCINNATI MAGAZINE

705 Central Ave., Suite 175, Cincinnati OH 45202. (513)421-4300. Fax: (513)562-2746. E-mail: nstetler@cintima g.emmis.com. **Art Director:** Nancy Stetler. Estab. 1960. Monthly 4-color lifestyle magazine for the city of Cincinnati. Circ. 30,000. Accepts previously published artwork. Original artwork returned at job's completion. **Illustration** Approached by 200 illustrators/year. Has featured illustrations by Robert de Michiel and C.F. Payne. Works on assignment only.

First Contact & Terms Send samples. Samples are filed or returned by SASE. Responds only if interested. Buys one-time rights or reprint rights. Pays on publication; $500-800 for features; $200-450 for spots.

Tips Prefers traditional media with an interpretive approach. No cartoons or mass-market computer art, please.

CIRCLE K MAGAZINE

3636 Woodview Trace, Indianapolis IN 46268. (317)875-8755. Fax: (317)879-0204. E-mail: magazine@kiwanis. org. Web site: www.circlek.org. **Art Director:** Maria Malandrakis. Estab. 1968. Kiwanis International's youth magazine for college-age students emphasizing service, leadership, etc. Published 3 times/year. Circ. 12,000. Originals and sample copies returned to artist at job's completion.

 • This organization also publishes *Kiwanis* magazine and *Keynoter.*

Illustration Approached by more than 30 illustrators/year. Buys 1-2 illustrations/issue. Works on assignment only. Needs editorial illustration. "We look for variety."

First Contact & Terms Send query letter with photocopies, photographs, tearsheets and SASE. Samples are filed. Will contact for portfolio review if interested. Portfolio should include tearsheets and slides. **Pays on acceptance.**$100 for b&w cover; $250 for color cover; $50 for b&w inside; $150 for color inside.

CITY & SHORE MAGAZINE

200 E. Las Olas Blvd., Ft. Lauderdale FL 33301-2299. (954)356-4685. Fax: (954)356-4612. E-mail: gcarannante@ sun-sentinel.com. Web site: www.cityandshore.com. **Contact:** Greg Carannante, art director. Estab. 2000. Bi-monthly "luxury lifestyle magazine published for readers in South Florida." Circ. 42,000. Sample copies available for $4.95.

Illustration "Rarely uses illustrations, but when we do, we prefer sophisticated, colorful styles, with lifestyle-oriented subject matter."

First Contact & Terms Accepts e-mail submissions with image file.

CITY LIMITS

120 Wall St., 20th Floor, New York NY 10005. (212)479-3344. Fax: (212)344-6457. E-mail: editor@citylimits.org. Web site: www.citylimits.org. **Art Director:** Tracie McMillan. Estab. 1976. Monthly urban affairs magazine covering issues important to New York City's low- and moderate-income neighborhoods, including housing, community development, the urban environment, crime, public health and labor. Circ. 10,000. Originals returned at job's completion. Sample copies for 9×12 SASE and 4 first-class stamps.

Cartoons Buys 5 cartoons/year. Prefers N.Y.C. urban affairs—social policy, health care, environment and economic development. Prefers political cartoons; single, double or multiple panel b&w washes and line drawings without gaglines.

Illustration Buys 2-3 illustrations/issue. Has featured illustrations by Noah Scalin. Must address urban affairs and social policy issues, affecting low- and moderate-income neighborhoods, primarily in New York City. Considers pen & ink, watercolor, collage, airbrush, mixed media and anything that works in b&w.

First Contact & Terms Cartoonists: Send query letter with finished cartoons and tearsheets. Buys first rights and reprint rights. Illustrators: Send postcard sample or query letter with tearsheets, photocopies, photographs and SASE. Samples are filed. Responds in 1 month. Request portfolio review in original query. Buys first rights. Pays on publication. Pays cartoonists $50 for b&w. Pays illustrators $50-100 for b&w cover; $50 for b&w inside; $25-50 for spots. "Our production schedule is tight, so publication is generally within two weeks of acceptance, as is payment." Finds artists through other publications, word of mouth and submissions.

Tips "Our niche is fairly specific." Freelancers "are welcome to call and talk."

CLARETIAN PUBLICATIONS

205 W. Monroe, Chicago IL 60606. (312)236-8682. Fax: (312)236-8207. E-mail: wrightt@uscatholic.org. **Art Director:** Tom Wright. Estab. 1960. Monthly magazine "covering the Catholic family experience and social justice." Circ. 40,000. Sample copies and art guidelines available.

Illustration Approached by 20 illustrators/year. Buys 4 illustrations/issue. Considers all media.

First Contact & Terms Illustrators: Send postcard sample and query letter with printed samples and photocopies

or e-mail with an attached Web site to visit. Accepts disk submissions compatible with EPS or TIFF. Samples are filed. Responds only if interested. Art director will contact artist for portfolio review if interested. Negotiates rights purchased. **Pays on acceptance.** $100-400 for color inside.

Tips "We like to employ humor in our illustrations and often use clichés with a twist and appreciate getting art in digital form."

CLEANING BUSINESS

P.O. Box 1273, Seattle WA 98111. (206)622-4241. Fax: (206)622-6876. E-mail: wgriffin@cleaningconsultants.com. Web site: www.cleaningbusiness.com. **Publisher:** Bill Griffin. Submissions Editor: Bill S. Quarterly e-magazine with technical, management and human relations emphasis for self-employed cleaning and maintenance service contractors and workers. Internet publication. Prefers to purchase all rights. Simultaneous submissions OK "if sent to noncompeting publications." Original artwork returned after publication if requested by SASE.

Cartoons Buys 1-2 cartoons/issue. Must be relevant to magazine's readership. Prefers b&w line drawings.

Illustration Buys approximately 12 illustrations/year including some humorous and cartoon-style illustrations.

First Contact & Terms Illustrators: Send query letter with samples. "*Don't* send samples unless they relate specifically to our market." Samples returned by SASE. Buys all rights. Responds only if interested. Pays for illustration by project $3-15. Pays on publication.

Tips "Our budget is limited. Those who require high fees are wasting their time. We are interested in people with talent and ability who seek exposure and publication. Our readership is people who work for and own businesses in the cleaning industry, such as maid services; janitorial contractors; carpet, upholstery and drapery cleaners; fire, odor and water damage restoration contractors; etc. If you have material relevant to this specific audience, we would definitely be interested in hearing from you. We are also looking for books, games, videos, software, jokes and reports related to the cleaning industry."

THE CLERGY JOURNAL

6160 Carmen Ave. E., Inver Grove Heights MN 55076-4422. (800)328-0200. Fax: (888)852-5524. E-mail: sfirle@logostaff.com. Web site: www.logosproductions.com. **Editor:** Sharon Firle. Magazine for professional clergy and church business administrators; 2-color with 4-color cover. Monthly (except June, August and December). Circ. 4,000. Original artwork returned after publication if requested.

● This publication is one of many published by Logos Productions and Woodlake Books.

Cartoons Buys 4 single panel cartoons/issue from freelancers on religious themes.

First Contact & Terms Cartoonists: Send SASE. Responds in 1 month. Pays $25 on publication.

CLEVELAND MAGAZINE

1422 Euclid Ave., Suite 730, Cleveland OH 44115. (216)771-2833. Fax: (216)781-6318. E-mail: sluzewski@clevelandmagazine.com. **Contact:** Gary Sluzewski. Monthly city magazine, b&w with 4-color cover, emphasizing local news and information. Circ. 45,000.

Illustration Approached by 100 illustrators/year. Buys 3-4 editorial illustrations/issue on assigned themes. Sometimes uses humorous illustrations. 40% of freelance work demands knowledge of InDesign, Ilustrator or Photoshop.

First Contact & Terms Illustrators: Send postcard sample with brochure or tearsheets. e-mail submissions must include sample. Accepts disk submissions. Please include application software. Call or write for appointment to show portfolio of printed samples, final reproduction/product, color tearsheets and photographs. Pays $100-700 for color cover; $75-300 for b&w inside; $150-400 for color inside; $75-350 for spots.

Tips "Artists are used on the basis of talent. We use many talented college graduates just starting out in the field. We do not publish gag cartoons but do print editorial illustrations with a humorous twist. Full-page editorial illustrations usually deal with local politics, personalities and stories of general interest. Generally, we are seeing more intelligent solutions to illustration problems and better techniques. The economy has drastically affected our budgets; we pick up existing work as well as commissioning illustrations."

COBBLESTONE, DISCOVER AMERICAN HISTORY

Cobblestone Publishing, Inc., 30 Grove St., Suite C, Peterborough NH 03458-1438. (603)924-7209. Fax: (603)924-7380. E-mail: anndillon@yahoo.com. Web site: www.cobblestonepub.com. **Art Director:** Ann Dillon. Monthly magazine emphasizing American history; features nonfiction, supplemental nonfiction, fiction, biographies, plays, activities and poetry for children ages 8-14. Circ. 38,000. Accepts previously published material and simultaneous submissions. Sample copy $4.95 with 8×10 SASE; art guidelines on Web site. Material must relate to theme of issue; subjects and topics published in guidelines for SASE. Freelance work demands knowledge of Illustrator, Photoshop and QuarkXPress.

● Other magazines published by Cobblestone include *Calliope* (world history), *Dig* (archaeology for kids), *Faces* (cultural anthropology), *Odyssey* (science), all for kids ages 8-15, and *Appleseeds* (social studies), for ages 7-9.

Illustration Buys 2-5 illustrations/issue. Prefers historical theme as it pertains to a specific feature. Works on assignment only. Has featured illustrations by Annette Cate, Beth Stover, David Kooharian. Features caricatures of celebrities and politicians, humorous, realistic illustration, informational graphics, computer and spot illustration. Assigns 15% of illustrations to new and emerging illustrators.

First Contact & Terms Illustrators: Send query letter with brochure, résumé, business card and b&w photocopies or tearsheets to be kept on file or returned by SASE. Write for appointment to show portfolio. Buys all rights. Pays on publication; $20-125 for b&w inside; $40-225 for color inside. Artists should request illustration guidelines.

Tips "Study issues of the magazine for style used. Send update samples once or twice a year to help keep your name and work fresh in our minds. Send nonreturnable samples we can keep on file; we're always interested in widening our horizons."

⚅ COLLEGE PARENT MAGAZINE

PO Box 888, Liberty Corner NJ 07938-0888. (908)580-1271. Fax: (908)580-0761. E-mail: kbruzenak@collegeparentmagazine.com. Web site: www.collegeparentmagazine.com. **Art Director:** Ken Bruzenak. Estab. 2003. Bimonthly consumer magazine written by parents of college and college-bound students. Circ.: 100,000. Guidelines available on Web site.

Cartoons Approached by 100 cartoonists/year. Buys 10 cartoons/year. Prefer college and single panel.

Illustration Approached by 100 illustrators/year. Buys 20 illustrations/year. Features teens, college students and parents caricatures of celebrities/politicians, humorous illustration and spot illustrations. Assigns 10% to new and emerging illustrators.

First Contact & Terms Cartoonists: Send photocopies. Illustrators: Send postcard sample with URL. Responds only if interested. Pays cartoonists $50-100 for b&w. Pays illustrators $100-200 for color inside. Pays on publication. Buys one-time rights. Finds freelancers through artists' submissions.

⚅ COLLEGE PLANNING & MANAGEMENT

2621 Dryden Rd. #300, Dayton OH 45439-1600. (800)523-4625. Fax: (937)293-1310. E-mail: jgunderman@peterli.com. Web site: www.peterli.com. **Contact:** Jeff Gunderman. Estab. 1970. Monthly trade publication for presidents, chief administrators and purchasing directors of junior colleges, colleges and universities. Circ.: 30,000.

Illustration Prefers college students and campus.

First Contact & Terms Illustrators: Send postcard sample. After introductory mailing, send follow-up postcard sample every 6 months. Responds only if interested. Pays illustrators $150-250 for color inside. Buys one-time rights. Find freelancers through artists' submissions.

COMMONWEAL

475 Riverside Dr., Suite 405, New York NY 10115. (212)662-4200. Fax: (212)662-4183. E-mail: editors@commonwealmagazine.org. Web site: www.commonwealmagazine.org. **Editor:** Paul Baumann. Estab. 1924. Public affairs journal. "Journal of opinion edited by Catholic lay people concerning public affairs, religion, literature and all the arts"; b&w with 4-color cover. Biweekly. Circ. 20,000. Sample copies for SASE with first-class postage. Guidelines for SASE with first-class postage.

Cartoons Approached by 20-40 cartoonists/year. Buys 3-4 cartoons/issue from freelancers. Prefers simple lines and high-contrast styles. Prefers single panel, with or without gagline; b&w line drawings.

Illustration Approached by 20 illustrators/year. Buys 3-4 illustrations/issue, 60/year from freelancers. Has featured illustrations by Baloo. Assigns 10% of illustrations to new and emerging illustrators. Prefers high-contrast illustrations that "speak for themselves." Prefers pen & ink and marker.

First Contact & Terms Cartoonists: Send query letter with finished cartoons. Illustrators: Send query letter with tearsheets, photographs, SASE and photocopies to Tiina Aleman, production editor. Samples are filed or returned by SASE if requested by artist. Responds in 2 weeks. To show a portfolio, mail b&w tearsheets, photographs and photocopies. Buys non-exclusive rights. Pays cartoonists $15 for b&w. Pays illustrators $15 for b&w inside. Pays on publication.

Tips "Be familiar with publication before mailing submissions."

COMMUNITY BANKER

900 19th St. NW, Washington DC 20006. (202)857-3100. Fax: (202)857-5581. E-mail: jbock@acbankers.org. Web site: www.americascommunitybankers.com. **Art Director:** Jon C. Bock. Estab. 1993. Monthly trade journal targeting senior executives of high tech community banks. Circ. 12,000. Accepts previously published artwork. Originals returned at job's completion.

Illustration Approached by 200 illustrators/year. Buys 2 illustrations/issue. Has featured illustrations by Michael

Gibbs, Kevin Rechin, Jay Montgomery and Matthew Trueman. Features humorous illustration, informational graphics, spot illustrations, computer illustration. Preferred subjects business subjects. Prefers pen & ink with color wash, bright colors, painterly. Works on assignment only.

First Contact & Terms Illustrators: Send query letter, nonreturnable postcard samples and tearsheets. Accepts Mac-compatible disk submissions. Send TIFF files. Samples are filed. Responds only if interested. "Artists should be patient and continue to update our files with future mailings. We will contact artist when the right story comes along." Publication will contact artist for portfolio review if interested. Portfolio should include mostly finished work, some sketches. Buys first North American serial rights. Pays on publication; $1,200-2,000 for color cover; $800-1,200 for color inside; $250-300 for spots. Finds artists primarily through word of mouth and sourcebooks—*Directory of Illustration* and *Illustration Work Book.*

Tips "Looking for high tech/technology in banking; quick turnaround; and new approaches to illustration."

CONFRONTATION: A LITERARY JOURNAL

English Department, C.W. Post, Brookville NY 11548. (516)299-2720. Fax: (516)299-2735. E-mail: martin.tucker @liu.edu. **Editor:** Martin Tucker. Estab. 1968. Semiannual literary magazine devoted to the short story and poem, for a literate audience open to all forms, new and traditional. Circ. 2,000. Sample copies available for $3. 20% of freelance work demands computer skills.

● *Confrontation* has won a long list of honors and awards from CCLM (now the Council of Literary Magazines and Presses) and NEA grants.

Illustration Approached by 10-15 illustrators/year. Buys 2-3 illustrations/issue. Works on assignment only. Considers pen & ink and collage.

First Contact & Terms Illustrators: Send query letter with SASE and photocopies. Samples are not filed and are returned by SASE. Responds in 2 months only if interested. Rights purchased vary according to project. Pays on publication; $50-100 for b&w, $100-250 for color cover; $25-50 for b&w, $50-75 for color inside; $25-75 for spots.

CONSUMERS DIGEST

8001 N. Lincoln Ave., 6th Floor, Skokie IL 60077. (847)763-9200. Fax: (847)763-0200. E-mail: lrutstein@consum ersdigest.com. Web site: www.consumersdigest.com. **Art Director:** Lori Rutstein. Estab. 1961. Bimonthly consumer magazine offering "practical advice, specific recommendations and evaluations to help people spend wisely." Circ. 1,250,250. Art guidelines available.

Illustration 75% of freelance illustration demands knowledge of FreeHand, Photoshop, Illustrator.

First Contact & Terms Illustrators: Send postcard sample or query letter with printed samples, tearsheets. Accepts disk submissions compatible with Macintosh System 8.0. Samples are filed or are returned by SASE. Responds only if interested. Portfolio dropoffs are departmentally reviewed on the second Monday of each month and returned in the same week. Buys first rights. **Pays on acceptance**, $400 minimum for b&w inside; $300-1,000 for color inside; $300-400 for spots. Finds illustrators through *American Showcase* and *Workbook*, submissions and other magazines.

COOK COMMUNICATIONS MINISTRIES

4050 Lee Vance View, Colorado Springs CO 80918-7100. (719)536-0100. Web site: www.cookministries.org. **Creative Director:** Randy Maid. Publisher of teaching booklets, books, take home papers for Christian market, "all age groups." Art guidelines available for SASE with first-class postage only. No samples returned without SASE.

Illustration Buys about 10 full-color illustrations/month. Has featured illustrations by Richard Williams, Chuck Hamrick, Ron Diciani. Assigns 5% of illustrations to new and emerging illustrators. Features realistic illustration; Bible illustration; computer and spot illustration.

First Contact & Terms Illustrators: Send tearsheets, color photocopies of previously published work; include self-promo pieces. No samples returned unless requested and accompanied by SASE. Work on assignment only. **Pays on acceptance**; $400-700 for color cover; $150-250 for b&w inside; $250-400 for color inside; $500-800 for 2-page spreads; $50-75 for spots. Considers complexity of project, skill and experience of artist and turn-around time when establishing payment. Buys all rights.

Tips "We do not buy illustrations or cartoons on speculation. Do *not* send book proposals. We welcome those just beginning their careers, but it helps if the samples are presented in a neat and professional manner. Our deadlines are generous but must be met. Fresh, dynamic, the highest of quality is our goal; art that appeals to everyone from preschoolers to senior citizens; realistic to humorous, all media."

COPING WITH CANCER

P.O. Box 682268, Franklin TN 37068. (615)790-2400. Fax: (615)794-0179. E-mail: editor@copingmag.com. Web site: www.copingmag.com. **Editor:** Julie McKenna. Estab. 1987. "*Coping with Cancer* is a bimonthly, nationally-

distributed consumer magazine dedicated to providing the latest oncology news and information of greatest interest and use to its readers. Readers are cancer survivors, their loved ones, support group leaders, oncologists, oncology nurses and other allied health professionals. The style is very conversational and, considering its sometimes technical subject matter, quite comprehensive to the layman. The tone is upbeat and generally positive, clever and even humorous when appropriate, and very credible." Circ. 90,000. Sample copy available for $3. Art guidelines for SASE with first-class postage.

COSMO GIRL

224 W. 57th St., 3rd Floor, New York NY 10019-3212. (212)649-3852. Fax: (212)489-9664. Web site: www.cosm ogirl.com. **Contact:** Art Department. Estab. 1996. Monthly 4-color consumer magazine designed as a cutting-edge lifestyle publication exclusively for teenage girls. Circ. 1.5 million.

Illustration Approached by 350 illustrators/year. Buys 6-10 illustrations/issue. Has featured illustrations by Annabelle Verhoye, Kareem Iliya, Balla Pilar, Berto Martinez, Marc Stuwe, Chuck Gonzales and Marie Perron. Features caricatures of celebrities and music groups, fashion, humorous and spot illustration. Preferred subjects teens. Assigns 10% of illustrations to well-known or "name" illustrators; 80% to experienced but not well-known illustrators; 10% to new and emerging illustrators.

First Contact & Terms Illustrators: Send postcard sample and follow-up postcard every 6 months. Samples are filed. Responds only if interested. Buys first rights. **Pays on acceptance.** Pay varies. Finds illustrators through sourcebooks and samples.

COSMOPOLITAN

The Hearst Corp., 224 W. 57th St., New York NY 10019-3299. (212)649-3570. Fax: (212)581-6792. E-mail: jlanuza@hearst.com. Web site: www.cosmopolitan.com. **Art Director:** John Lanuza. Associate Art Director: Theresa Izzilo. Estab. 1886. Monthly 4-color consumer magazine for contemporary women covering a broad range of topics including beauty, health, fitness, fashion, relationships and careers. Circ. 3,021,720.

Illustration Approached by 300 illustrators/year. Buys 10-12 illustrations/issue. Has featured illustrations by Marcin Baranski and Aimee Levy. Features beauty, humorous and spot illustration. Preferred subjects women and couples. Prefers trendy fashion palette. Assigns 5% of illustrations to new and emerging illustrators.

First Contact & Terms Illustrators: Send postcard sample and follow-up postcard every 4 months. Samples are filed. Responds only if interested. Buys first North American serial rights. **Pays on acceptance**; $1,000 minimum for 2-page spreads; $450-650 for spots. Finds illustrators through sourcebooks and artists' promotional samples.

COUNTRY FOLK MAGAZINE

HC 77 Box 580, Pittsburg MO 65724. Web site: www.countryfolkmag.com. **Managing Editor:** Susan Salaki. Estab. 1994. Magazine "capturing the history of the Ozark region of Missouri." Circ. 5,000. Sample copies available for $4.25. Art guidelines available for SASE with first-class postage or on our Web site.

Cartoons Buys 1 cartoon/issue. All cartoons should reflect the theme of "Life in the Ozarks" or "country life." Prefers single panel b&w line drawings with gagline.

First Contact & Terms Cartoonists: Send photocopies only. Responds in 1 week. Buys one-time rights. Pays up to $5 for quality cartoons.

Tips "Most of the work we publish is written by older men and women who have heard stories from their parents and grandparents about how the Ozark region was settled in the 1800s. Our readers are country people-not hillbillies. Cartoons should reflect that difference. We never purchase cartoons that ridicule anyone or any type of person."

CRICKET

Box 300, Peru IL 61354-0300. Web site: www.cricketmag.com. **Senior Art Director:** Ron McCutchan. Estab. 1973. Monthly magazine emphasizes children's literature for children ages 10-14. Design is fairly basic and illustration-driven; full-color with 2 basic text styles. Circ. 65,000. Original artwork returned after publication. Sample copy $4.95 plus 10% of total order ($4 minimum) for shipping and handling; art guidelines available on Web site or for SASE with first-class postage.

Cartoons "We rarely run cartoons."

Illustration Approached by 800-1,000 illustrators/year. Works with 75 illustrators/year. Buys 600 illustrations/year. Has featured illustrations by Trina Schart Hyman, Kevin Hawkes and Deborah Nourse Lattimore. Assigns 25% to new and emerging illustrators. Uses artists mainly for cover and interior illustration. Prefers realistic styles (animal or human figure), but "we're also looking for humorous, folkloric and nontraditional styles." Works on assignment only.

First Contact & Terms Illustrators: Send query letter with SASE and samples to be kept on file, "if I like it." Prefers photocopies and tearsheets as samples. Samples not kept on file are returned by SASE. Responds in 6 weeks. Does not want to see "overly slick, cute commercial art (i.e., licensed characters and overly sentimental

greeting cards).'' Buys all rights. Pays 45 days from receipt of final art; $750 for color cover; $50-150 for b&w inside; $75-250 for color inside; $250-350 for 2-page spreads; $50-75 for spots.

Tips ''We are trying to focus *Cricket* at a slightly older, preteen market. Therefore we are looking for art that is less sweet and more edgy and funky. Since a large proportion of the stories we publish involve people, particularly children, *please* try to include several samples with *faces* and full figures in an initial submission (that is, if you are an artist who can draw the human figure comfortably). It's also helpful to remember that most children's publishers need artists who can draw children from many different racial and ethnic backgrounds. Know how to draw the human figure from all angles, in every position. Send samples that tell a story (even if there is no story); art should be intriguing.''

CSI MEDIA CORP.

(Parent company of *Magical Blend*), P .O . Box 600, Chico CA 95927. (530)893-9037. Fax: (530)893-9076. E-mail: artdept@magicalblend.com. Web site: www.magicalblend.com. **Art Director:** Lee Elsmore. Estab. 1980. Bimonthly 4-color magazine emphasizing spiritual exploration, transformation and New Age themes. Circ. 100,000. Original artwork returned after publication. Sample copy orders and art guidelines on Web site.

Illustration Works with 5-10 illustrators/year. Uses 23-35 illustrations/year. Has featured illustrations by Gage Taylor and Alex Grey. Assigns 30% of illustrations to new and emerging illustrators. ''We keep samples on file and work by editorial fit according to the artist's style and content. Be patient; we have used art that's been on file for 5 years—when it fits, we go for it. We prefer eye-friendly and well-executed color work. We look for pieces with a positive, inspiring, uplifting feeling.''

First Contact & Terms Illustrators: Prefer e-mail contact or mailed samples. NO ORIGINALS! Responds only if interested. Buys first North American serial rights. Pays in copies, subscriptions and possibly ad space. Will print contact information with artwork if desired by artist.

Tips ''We want work that is energetic and thoughtful that has a hopeful outlook on the future. We like to print quality art by people who have talent but don't fit into any category and are usually unpublished. Have technical skill, be unique, show a range of styles; don't expect to get rich from us, 'cuz we sure aren't!''

DAKOTA COUNTRY

P.O. Box 2714, Bismark ND 58502. (701)255-3031. Fax: (701)255-5038. E-mail: dcmag@btinet.net. Web site: www.dakotacountrymagazine.com. **Publisher:** Bill Mitzel. Estab. 1979. *Dakota Country* is a monthly hunting and fishing magazine with readership in North and South Dakota. Features stories on all game animals and fish and outdoors. Basic 3-column format, full-color throughout magazine, 4-color cover, feature layout. Circ. 14,200. Accepts previously published artwork. Original artwork is returned after publication. Sample copies for $2; art guidelines for SASE with first-class postage.

Cartoons Likes to buy cartoons in volume. Prefers outdoor themes, hunting and fishing. Prefers multiple or single panel cartoon with gagline; b&w line drawings.

Illustration Features humorous and realistic illustration of the outdoors. Portfolio review not required.

First Contact & Terms Send query letter with samples of style. Samples not filed are returned by SASE. Responds to queries/submissions within 2 weeks. Negotiates rights purchased. **Pays on acceptance.** Pays cartoonists $10-20, b&w. Pays illustrators $20-25 for b&w inside; $12-30 for spots.

Tips ''Always need good-quality hunting and fishing line art and cartoons.''

DAKOTA OUTDOORS

P.O. Box 669, Pierre SD 57501-0669. (605)224-7301. Fax: (605)224-9210. E-mail: dakotaoutdoors@capjournal.com. **Editor:** Lee Harstad. Estab. 1978. Monthly outdoor magazine covering hunting, fishing and outdoor pursuits in the Dakotas. Circ. 7,500. Accepts previously published artwork. Original artwork is returned at job's completion. Sample copies and art guidelines for SASE with first-class postage.

Cartoons Approached by 10 cartoonists/year. Buys 1-2 cartoons/issue. Prefers outdoor, hunting and fishing themes. Prefers cartoons with gagline.

Illustration Approached by 2-10 illustrators/year. Buys 1 illustration/issue. Features spot illustration. Prefers outdoor, hunting/fishing themes, depictions of animals and fish native to the Dakotas. Prefers pen & ink. Accepts submissions on disk compatible with Macintosh in Illustrator, FreeHand and Photoshop. Send TIFF, EPS and PICT files.

First Contact & Terms Cartoonists: Send query letter with appropriate samples and SASE. Illustrators: Send postcard sample or query letter with tearsheets, SASE and copies of line drawings. Samples are not filed and are returned by SASE. Responds in 2 months. To show a portfolio, mail ''high-quality line art drawings.'' Rights purchased vary according to project. Pays on publication. Pays cartoonists $5 for b&w. Pays illustrators $5-50 for b&w inside; $5-25 for spots.

Tips ''We especially need line-art renderings of fish, such as the walleye.''

DC COMICS

AOL-Time Warner, Dept. AGDM, 1700 Broadway, 5th Floor, New York NY 10019. (212)636-5990. Fax: (212)636-5977. Web site: www.dccomics.com. **Vice President Design and Retail Product Development:** Georg Brewer. Monthly 4-color comic books for ages 7-25. Circ. 6,000,000. Original artwork is returned after publication.

- See DC Comics's listing in Book Publishers section. *DC Comics* does not read or accept unsolicited submissions of ideas, stories or artwork.

DECORATIVE ARTIST'S WORKBOOK

4700 E. Galbraith Rd., Cincinnati OH 45236. E-mail: joan.heiob@fwpubs.com. **Contact:** Joan Heiob, art director. Estab. 1987. "A step-by-step bimonthly decorative painting workbook. The audience is primarily female; slant is how-to." Circ. 89,000. Does not accept previously published artwork. Original artwork is returned at job's completion. Sample copy available for $4.65; art guidelines not available.

Illustration Buys occasional illustration; 1/year. Works on assignment only. Features humorous, realistic and spot illustration. Assigns 50% of illustrations to experienced but not well-known illustrators; 50% to new and emerging illustrators. Prefers realistic styles. Prefers pen & ink, watercolor, airbrush, acrylic, colored pencil, mixed media, pastel and digital art.

First Contact & Terms Send postcard sample or query letter with tearsheets. Accepts disk submissions compatible with the major programs. Send EPS or TIFF files. Samples are filed. Responds only if interested. Buys first or one-time rights. Pays on publication; $50-100 for b&w inside; $100-350 for color inside.

DELAWARE TODAY MAGAZINE

3301 Lancaster Pike, Suite 5C, Wilmington DE 19805-1436. (302)656-1809. Fax: (302)656-5843. E-mail: kcarter @delawaretoday.com. Web site: www.delawaretoday.com. **Creative Director:** Kelly Carter. Monthly 4-color magazine emphasizing regional interest in and around Delaware. Features general interest, historical, humorous, interview/profile, personal experience and travel articles. "The stories we have are about people and happenings in and around Delaware. Our audience is middle-aged (40-45) people with incomes around $79,000, mostly educated. We try to be trendy in a conservative state." Circ. 25,000. Needs computer-literate freelancers for illustration.

Cartoons Works on assignment only.

Illustration Buys approximately 1-2 illustrations/issue. Has featured illustrations by Nancy Harrison, Tom Deja, Wendi Koontz, Craig LaRontonda and Jacqui Oakley. "I'm looking for different styles and techniques of editorial illustration!" Works on assignment only. Open to all styles.

First Contact & Terms Cartoonists: Do not send gaglines. Do not send folders of pre-drawn cartoons. Illustrators: Send postcard sample. "Will accept work compatible with QuarkXPress 7.5/version 4.0. Send EPS or TIFF files (RGB)." Send printed color promos. Samples are filed. Responds only if interested. Publication will contact artist for portfolio review if interested. Portfolio should include printed samples, color or b&w tearsheets and final reproduction/product. Pays on publication; $200-400 for cover; $100-150 for inside. Buys first rights or one-time rights. Finds artists through submissions and self-promotions.

Tips "Be conceptual, consistent and flexible."

DERMASCOPE

Geneva Corporation, 2611 N. Belt Line Rd., Suite 101, Sunnyvale TX 75182. (972)226-2309. Fax: (972)226-2339. E-mail: saundra@dermascope.com. Web site: www.dermascope.com. **Production Manager:** Saundra Brown. Estab. 1978. Monthly magazine/trade journal, 128-page magazine for aestheticians, plastic surgeons and stylists. Circ. 15,000. Sample copies and art guidelines available.

Illustration Approached by 5 illustrators/year. Prefers illustrations of "how-to" demonstrations. Considers all media. 100% of freelance illustration demands knowledge of Photoshop, Illustrator, QuarkXPress, Fractil Painter.

First Contact & Terms Accepts disk submissions. Samples are not filed. Responds only if interested. Rights purchased vary according to project. Pays on publication.

THE EAST BAY MONTHLY

1301 59th St., Emeryville CA 94608. (510)658-9811. Fax: (510)658-9902. E-mail: artdirector@themonthly.com. **Art Director:** Andreas Jones. Estab. 1970. Consumer monthly tabloid; b&w with 4-color cover. Editorial features are general interests (art, entertainment, business owner profiles) for an upscale audience. Circ. 80,000. Accepts previously published artwork. Originals returned at job's completion. Sample copy and guidelines for SASE with 5 oz. first-class postage. No nature or architectural illustrations.

Cartoons Approached by 75-100 cartoonists/year. Buys 3 cartoons/issue. Prefers single panel, b&w line drawings; "any style, extreme humor."

Illustration Approached by 150-200 illustrators/year. Buys 2 illustrations/issue. Prefers pen & ink, watercolor, acrylic, colored pencil, oil, charcoal, mixed media and pastel.
Design Occasionally needs freelancers for design and production. 100% of freelance design requires knowledge of PageMaker, Macromedia FreeHand, Photoshop, QuarkXPress, Illustrator and InDesign.
First Contact & Terms Cartoonists: Send query letter with finished cartoons. Illustrators: Send postcard sample or query letter with tearsheets and photocopies. Designers: Send query letter with résumé, photocopies or tearsheets. Accepts submissions on disk, Mac compatible with Macromedia FreeHand, Illustrator, Photoshop, PageMaker, QuarkXPress or InDesign. Samples are filed or returned by SASE. Responds only if interested. Write for appointment to show portfolio of thumbnails, roughs, b&w tearsheets and slides. Buys one-time rights. Pays cartoonists $35 for b&w. Pays illustrators $100-200 for b&w inside; $25-50 for spots. Pays 15 days after publication. Pays for design by project.

ELECTRICAL APPARATUS
Barks Publications, Inc., Chicago IL 60611-4198. (312)321-9440. Fax: (312)321-1288. E-mail: eamagazine@aol.com. Web site: www.eamagazine.com. **Senior Editor:** Kevin Jones. Estab. 1948. Monthly 4-color trade journal emphasizing industrial electrical/mechanical maintenance. Circ. 16,000. Original artwork not returned at job's completion. Sample copy $5.
Cartoons Approached by several cartoonists/year. Buys 3-4 cartoons/issue. Has featured illustrations by Joe Buresch, Martin Filchock, James Estes, John Paine, Bernie White and Mark Ziemann. Prefers themes relevant to magazine content; with gagline. "Captions are edited in our style."
Illustration "We have staff artists, so there is little opportunity for freelance illustrators, but we are always glad to hear from anyone who believes he or she has something relevant to contribute."
First Contact & Terms Cartoonists: Send query letter with roughs and finished cartoons. "Anything we don't use is returned." Responds in 3 weeks. Buys all rights. Pays $15-20 for b&w and color.
Tips "We prefer single-panel cartoons that portray an industrial setting, ideally with an electrical bent. We also use cartoons with more generic settings and tailor the gaglines to our needs."

[N] ELECTRONIC MUSICIAN
6400 Hollis St., Emeryville CA 94608. (510)985-3205. Fax: (510)653-5142. Web site: www.emusician.com. **Art Director:** Laura Williams. Estab. 1986. Bimonthly consumer magazine for music how-to. Circ. 64,000. Sample copies and art guidelines available on request.
Cartoons Approached by 100 cartoonist/year. Buys 12 cartoons/year. Prefers humorous.
Illustration Approached by 500 illustrators/year. Buys 12 illustrations/year. Has featured Colin Johnson, Kitty Meek. Prefers computer and realistic illustrations of music. Assigns 80% to new and emerging illustrators. 50% of freelance illustrations demands knowledge of whatever software they do best.
First Contact & Terms Cartoonists/Illustrators: Send postcard sample with samples and tearsheets. After introducing mailing, send follow-up postcard sampled every 6 months. Accepts e-mail submissions with link to Web site. Prefers Mac-compatible, JPEG files. Samples are filed. Company will contact artist for portfolio review if interested. Portfolio should include finished art. Pays cartoonists $100-400 for b&w. Pays illustrators $800-1,200 for color cover. Pays on publication. Buys one-time rights. Finds freelancers through artists' submissions.

ESQUIRE
300 W. 57th St. 21st Fl. Broadway, New York NY 10019. (212)649-4020. Fax: (212)649-4305. Web site: www.esquire.com. **Contact:** Design Director. Contemporary culture magazine for men ages 28-40 focusing on current events, living trends, career, politics and the media. Estab. 1933. Circ. 750,000.
First Contact & Terms Illustrators: Send postcard mailers. Drop off portfolio on Wednesdays for review.

[N] ETCETERA
P.O. Box 8543, New Haven CT 06531. E-mail: iedit4you@aol.com. **Art Director:** Mindi Englart. Estab. 1996. 2 times/year b&w literary magazine. Circ 500. Sample copies available for $3. Art guidelines free for #10 SASE with first-class postage.
Cartoons Prefers single, double or multiple panel humorous b&w washes and line art.
Illustration Approached by 20 illustrators/year. Buys 3-8 illustrations/issue. Has featured illustrations by Barbara Kagan, Jonathan Talbot and Michael McCurdy. Features fine art illustration and comics. Prefers b&w only. Assigns 33% of illustrations to well-known or "name" illustrators; 33% to experienced, but not well-known illustrators; 33% to new and emerging illustrators.
First Contact & Terms Cartoonists: Send query letter with b&w photocopied samples and SASE. Illustrators: Send postcard sample or send query letter with printed samples, photocopies, tearsheets and SASE ("no originals, please"). Accepts Mac-compatible disk submissions. Send EPS or JPEG files. Samples are filed or are returned by SASE. Responds in 5 months. Will contact artist for portfolio review if interested. Buys one-time

rights. Pays on publication. Pays cartoonists/illustrators 1 issue plus a 1-year subscription. Finds illustrators through the Internet and word of mouth.

Tips "We're always open to new talent. Professional, clean quality black & white work. We are open to many forms including collage, abstract, line drawings, prints, woodcuts, images that incorporate text, avant garde. Want stark, humorous, funky, understandable work that will reproduce well via offset printing."

⬛ EVENT

Douglas College, New Westminster BC V3L 5B2 Canada. (604)527-5293. Fax: (604)527-5095. E-mail: event@do uglas.bc.ca. Web site: event.douglas.bc.ca. **Editor:** Cathy Stonehouse. Assistant Editor: Ian Cockfield. Estab. 1971. For "those interested in literature and writing"; b&w with 4- or 2-color cover. Published 3 times/year. Circ. 1,300. Art guidelines available free for SASE (Canadian postage/IRCs only). Slides/negatives of artwork returned after publication. Sample back issue for $5. Current issue for $8.

Illustration Buys approximately 3 illustrations/year. Has featured illustrations by Sharalee Regehr, Michael Downs and Jesus Romeo Galdamez. Assigns 50% of illustrations to new and emerging illustrators. Uses freelancers mainly for covers. "Interested in drawings and prints, b&w line drawings, photographs and lithographs for cover, and thematic or stylistic series of 3 works. SASE (Canadian postage or IRCs).

First Contact & Terms Reponse time varies; generally 4 months. Buys first North American serial rights. Pays on publication, $150 for color cover, 2 free copies plus 10 extra covers.

EXECUTIVE FEMALE

60 East 42nd St., Suit 2700, New York NY 10165. (212)351-6450. Fax: (212)351-6486. E-mail: nafe@nafe.com. Web site: www.nafe.com. **Contact:** Art Director. Estab. 1972. Association magazine for National Association for Female Executives, 4-color. "Get-ahead guide for women executives, which includes articles on managing employees, personal finance, starting and running a business." Circ. 125,000. Accepts previously published artwork. Original artwork is returned after publication.

Illustration Buys illustrations mainly for spots and feature spreads. Buys 7 illustrations/issue. Works on assignment only. Send samples (not returnable).

First Contact & Terms Samples are filed. Responds only if interested. Buys first or reprint rights. Pays on publication; $100-800.

FAMILY CIRCLE

Dept. AGDM, 375 Lexington Ave., New York NY 10017-5514. (212)499-2000. Web site: www.familycircle.com. **Art Director:** David Wolf. Circ. 7,000,000. Supermarket-distributed publication for women/homemakers covering areas of food, home, beauty, health, child care and careers. 17 issues/year. Does not accept previously published material. Original artwork returned after publication.

Illustration Buys 2-3 illustrations/issue. Works on assignment only.

First Contact & Terms Provide query letter with nonreturnable samples or postcard sample to be kept on file for future assignments. Do not send original work. Prefers transparencies, postcards or tearsheets as samples. Responds only if interested. Prefers to see finished art in portfolio. Submit portfolio by appointment. All art is commissioned for specific magazine articles. Negotiates rights. **Pays on acceptance.**

FAMILY TIMES PUBLICATIONS

P.O. Box 16422, St. Louis Park MN 55416. (952)922-6186. Fax: (952)922-3637. E-mail: aobrien@familytimesinc. com. Web site: www.familytimesinc.com. **Editor/Art Director:** Annie O'Brien. Estab. 1991. Bimonthly tabloid. Circ. 60,000. Sample copies available with SASE. Art guidelines available—call for guidelines.

● Publishes *Family, Senior, Grandparent* and *Baby Times*.

Illustration Approached by 6 illustrators/year. Buys 33 illustrations/year. Has featured illustrations by primarily local illustrators. Preferred subjects: children, families, teen. Preferred all media. Assigns 2% of illustrations to new and emerging illustrators. Freelancers should be familiar with Illustrator, Photoshop. E-mail submissions accepted with link to Web site, accepted with image file at 72 dpi. Mac-compatible. Prefers JPEG. Samples are filed. Responds only if interested. Portfolio not required. Company will contact artist for portfolio review if interested. Pays illustrators $300 for color cover, $100 for b&w inside, $225 for color inside. Pays on publication. Buys one-time rights, electronic rights. Finds freelancers through artists' submissions, sourcebooks, online.

First Contact & Terms Illustrators: Send query letter with b&w/color photocopies or e-mail.

Tips "Looking for fresh, family friendly styles and creative sense of interpretation of editorial."

⬛ FANTAGRAPHICS BOOKS

7563 Lake City Way NE, Seattle WA 98115. (206)524-1967. Fax: (206)524-2104. **Contact:** Gary Groth or Kim Thompson. Monthly and bimonthly comic books and graphic novels. Titles include *Love and Rockets, Hate,*

Eightball, The Acme Novelty Library, Black Hole, Blab, Frank and *Penny Century*. All genres except superheroes. Circ. 8,000-30,000. Sample copy $3; catalog $2.

Cartoons Approached by 500 cartoonists/year. "Fantagraphics is looking for artists who can create an entire product or who can work as part of an established team." Most of the titles are b&w.

First Contact & Terms Cartoonists : Send query letter with photocopies which display storytelling capabilities, or submit a complete package. All artwork is creator-owned. Buys one-time rights usually. Payment terms vary. Creator receives an advance upon acceptance and then royalties after publication.

Tips "We prefer not to see illustration work unless there is some accompanying comics work. We also do not want to see unillustrated scripts. Be sure to include basic information like name, address, phone number, etc. Also include SASE. In comics, I see a trend toward more personal styles. In illustration in general, I see more and more illustrators who got their starts in comics appearing in national magazines."

FASHION ACCESSORIES

P.O. Box 859, Mahwah NJ 07430. (201)684-9222. Fax: (201)684-9228. **Publisher:** Sam Mendelson. Estab. 1951. Monthly trade journal; tabloid; emphasizing costume jewelry and accessories. Publishes both 4-color and b&w. Circ. 9,500. Accepts previously published artwork. Original artwork is returned to the artist at the job's completion. Sample copies for $3.

Illustration Works on assignment only. Needs editorial illustration. Prefers mixed media. Freelance work demands knowledge of QuarkXPress.

First Contact & Terms Illustrators: Send query letter with brochure and photocopies. Samples are filed. Responds in 1 month. Portfolio review not required. Rights purchased vary according to project. **Pays on acceptance**; $50-100 for b&w cover; $100-150 for color cover; $50-100 for b&w inside; $100-150 for color inside.

FAST COMPANY

375 Lexington Ave., 8th Floor, New York NY 10017-5644. (212)499-2000. Fax: (212)389-5496. E-mail: rrees@fastcompany.com. Web site: www.fastcompany.com. **Art Director:** Dean Markadakis. Deputy Art Director: Lisa Kelsey. Estab. 1996. Monthly cutting edge business publication supplying readers with tools and strategies for business today. Circ. 734,500.

Illustration Approached by "tons" of illustrators/year. Buys approximately 20 illustrations/issue. Has used illustrations by Bill Mayer, Ward Sutton and David Cowles. Considers all media.

First Contact & Terms Illustrators: Send postcard sample or printed samples, photocopies. Accepts disk submissions compatible with QuarkXPress for Mac. Send EPS files. Send all samples to the attention of Julia Moburg. Samples are filed and not returned. Responds only if interested. Rights purchased vary according to project. **Pays on acceptance**, $300-1,000 for color inside; $300-500 for spots. Finds illustrators through submissions, illustration annuals, *Workbook* and *Alternative Pick*.

▣ FAULTLINE

Department of English and Comparative Literature, Irvine CA 92697-2650. E-mail: faultline@uci.edu. Web site: www.humanities.uci.edu/faultline. **Creative Director:** Sara Joyce Robinson and Lisa P. Sutton (2004-05 rotating director).

• Even though this is not a paying market, this high-quality literary magazine would be an excellent place for fine artists to gain exposure. Postcard samples with a Web site address are the best way to show us your work.

FIFTY SOMETHING MAGAZINE

1168 Beachview, Willoughby OH 44094. (440)951-2468. Fax: (440)951-1015. **Editor:** Linda L. Lindeman-DeCarlo. Estab. 1990. Quarterly magazine; 4-color. "We cater to the fifty-plus age group with upbeat information, feature stories, travel, romance, finance and nostalgia." Circ. 25,000. Accepts previously published artwork. Original artwork is returned at the job's completion. Sample copies for SASE, 10×12, with $1.37 postage.

Cartoons Approached by 50 cartoonists/year. Buys 3 cartoons/issue. Prefers funny issues on aging. Prefers single panel b&w line drawings with gagline.

Illustration Approached by 50 illustrators/year. Buys 2 illustrations/issue. Prefers old-fashioned, nostalgia. Considers all media.

First Contact & Terms Cartoonists: Send query letter with brochure, roughs and finished cartoons. Illustrators: Send query letter with brochure, photographs, photostats, slides and transparencies. Samples are filed. Responds only if interested. To show a portfolio, mail thumbnails, printed samples, b&w photographs, slides and photocopies. Buys one-time rights. Pays on publication. Pays cartoonists $10, b&w and color. Pays illustrators $25 for b&w, $100 for color cover; $25 for b&w, $75 for color inside.

FILIPINAS MAGAZINE

1580 Bryant St., Daly City CA 94015. (650)985-2535. Fax: (650)985-2532. E-mail: r.virata@filipinasmag.com. Web site: www.filipinasmag.com. **Art Director:** Raymond Virata. Estab. 1992. Monthly magazine "covering

issues of interest to Filipino Americans and Filipino immigrants.'' Circ. 30,000. Sample copies free for 9×12 SASE and $1.70. Contact Art Director for information.

Cartoons Buys 1 cartoon/issue. Prefers work related to Filipino/Filipino-American experience. Prefers single panel, humorous, b&w washes and line drawings with or without gagline.

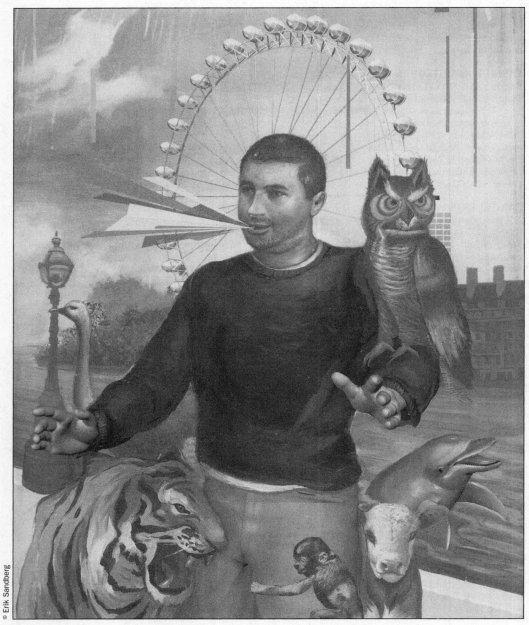

This illustration was commissioned by *Fast Company* for an article entitled "Prophet Among Pinstripes". Erik Sanberg really went the extra mile with the detail and symbolism within the illustration. See more of Sandberg's work at www.eriksandberg.net.

Illustration Approached by 5 illustrators/year. Buys 1-3 illustrations/issue. Considers all media.
First Contact & Terms Cartoonists/Illustrators: Send query letter with photocopies. Accepts disk submissions compatible with Mac, QuarkXPress 4.1, Photoshop 6, Illustrator 7; include any attached image files (TIFF or EPS) or fonts. Samples are filed. Responds only if interested. Pays on publication. Pays cartoonists $25 minimum. Pays illustrators $100 minimum for cover; $25 minimum for inside. Buys all rights.
Tips "Read our magazine."

FIRST FOR WOMEN

270 Sylvan Ave., Englewood Cliffs NJ 07632. (201)569-6699. Fax: (201)569-6264. E-mail: dearpage@firstforwo men.com. Web site: www.firstforwomen.com. **Art Director:** Francois Baron. Estab. 1988. Mass market consumer magazine for the younger woman published every 3 weeks. Circ. 1.4 million. Originals returned at job's completion. Sample copies and art guidelines available upon request.
Cartoons Buys 10 cartoons/issue. Prefers women's issues. Prefers humorous cartoons; single panel b&w washes and line drawings.
Illustration Approached by 100 illustrators/year. Buys 1 illustration/issue. Works on assignment only. Preferred themes are humorous, sophisticated women's issues. Considers all media.
First Contact & Terms Cartoonists: Send query letter with photocopies. Illustrators: Send query letter with any sample or promo we can keep. Samples are filed. Responds only if interested. Publication will contact artist for portfolio review if interested. Buys one-time rights. **Pays on acceptance.** Pays cartoonists $150 for b&w. Pays illustrators $200 for b&w, $300 for color inside. Finds artists through promo mailers and sourcebooks.
Tips Uses humorous or conceptual illustration for articles where photography won't work. "Use the mail—no phone calls please."

FIRST HAND MAGAZINE

P.O. Box 1314, Teaneck NJ 07666. (201)836-9177. Fax (201)836-5055. E-mail: editor@firsthandmag.com. Estab. 1980. Monthly consumer magazine emphasizing gay erotica. Circ. 60,000. Sample copies available for $5. Art guidelines for SASE with first-class postage.
Cartoons Approached by 10 cartoonists/year. Buys 5 cartoons/issue. Prefers gay male themes—erotica; humorous; single panel b&w line drawings with gagline.
Illustration Approached by 30 illustrators/year. Buys 12 illustrations/issue. Prefers gay male erotica. Considers pen & ink, airbrush, marker, colored pencil and charcoal.
First Contact & Terms Cartoonists: Send query letter with finished cartoons. Illustrators: Send query letter with photostats. Samples are not filed and are returned by SASE. Responds in 6 weeks. Portfolio review not required. Buys all rights. Pays on publication. Pays cartoonists $20 for b&w. Pays illustrators $50 for b&w inside.

N FLORIDA LEADER MAGAZINE

Oxendine Publishing, P.O. Box 14081, Gainesville FL 32604-2081. (352)373-6907. Fax: (352)373-8120. E-mail: jeff@studentleader.com. Web site: www.floridaleader.com. **Art Director:** Jeff Riemersma. Estab. 1983. 4-color magazine for college and high school students. Publishes 6 issues/year. Circ. 23,000. Sample copies for $8\frac{1}{2} \times 11$ SASE and 4 first-class stamps. Art guidelines for #10 SASE with first-class postage.
 • Oxendine Publishing also publishes *Student Leader Magazine* (www.studentleader.com); same art director.
Illustration Approached by hundreds of illustrators/year. Buys 4 illustrations/issue. Has featured illustrations by Tim Foley, Jackie Pittman, Greta Buchart and Dan Miller. Assigns 33% of illustrations to well-known or "name" illustrators; 33% to experienced, but not well-known illustrators; 33% to new and emerging illustrators. Considers all media. 50% of freelance illustration demands computer skills.
First Contact & Terms Illustrators: Send postcard sample. Disk submissions must be PC-based TIF or EPS images. Samples are filed and are not returned. Responds only if interested. Rights purchased vary according to project. Pays on publication; $100 for color inside. Finds illustrators through sourcebooks and artist's submissions.
Tips "We need responsible artists who complete projects on time and have a great imagination. Also must work within budget."

N FLORIDA REALTOR

7025 Augusta National Dr., Orlando FL 32822-5017. (407)438-1400. Fax: (407)438-1411. E-mail: traceyc@far.o rg. Web site: www.floridarealtormagazine.com. **Art Director:** Tracey Calvet. Estab. 1925. Monthly trade publication covers news and issues of the Florida real estate industry, including sales, market trends, legislation and legal matters. Circ.: 117,572.
Illustration Approached by 100 illustrators/year. Buys 25 illustrations/issue. Features homes, office of realtor and commercial building.

First Contact & Terms Cartoonists: Send query letter with photocopies and URL. Illustrators: Send postcard samples with URL. After introductory mailing, send follow-up postcard sample every 6 months. Pays illustrators $100 for color inside. Pays on publication. Buys one-time rights. Finds freelancers through artists' submissions.

🔊 FLY FISHERMAN MAGAZINE

Primedia Inc., 6405 Flank Dr., Harrisburg PA 17112. (717)657-9555. Fax: (717)657-9552. E-mail: david.siegfried @primedia.com. Web site: www.flyfisherman.com. **Art Director:** David Siegfried. Estab. 1969. Bimonthly magazine covering all aspects of fly fishing including how to, where to, new products, wildlife and habitat conservation, and travel through top-of-the-line photography and artwork; 4-color. In-depth editorial. Readers are upper middle class subscribers. Circ. 150,000. Sample copies for SASE with first-class postage. Art guidelines for SASE with first-class postage.

Cartoons Buys 1 cartoon/issue, 6-10 cartoons/year from freelancers. Prefers fly fishing related themes only. Prefers single panel with or without gagline; b&w line drawings and washes.

Illustration Buys illustrations to illustrate fishing techniques and for spots. Buys 4-10 illustrations/issue, 50 illustrations/year. Buys 2-3 map illustrations/issue. Prefers digital or electronic files. Considers airbrush, mixed media, watercolor, acrylic, pastel, pen and ink and charcoal pencil. Needs computer-literate illustrators familiar with Adobe Illustrator, Photoshop and Macromedia FreeHand.

First Contact & Terms Cartoonists: Send query letter with samples of style. Illustrators: Send query letter with brochure showing art style, résumé and appropriate samples, excluding originals. Samples are filed or returned by SASE. Responds to queries/submissions within 3 weeks. Call or write to schedule an appointment to show a portfolio or mail appropriate materials. Buys one-time rights and occasionally all rights. Pays on publication.

Tips Spot art for front and back of magazine is most open to illustrators.

FOCUS ON THE FAMILY

8605 Explorer Dr., Colorado Springs CO 80920-1051. (719)531-3400. Fax: (719)531-3499. Web site: www.family. org. **Senior Art Director:** Mike Harrigan. Estab. 1977. Publishes magazines. Specializes in religious-Christian. Circ. 2,700,000. Publishes 9 titles/year.

Needs Approached by 100 illustrators and 12 designers/year. Works with illustrators from around the US. Prefers designers experienced in Macintosh. Uses designers mainly for periodicals, publication design/production. 100% of design and 20% illustration demands knowledge of FreeHand, Photoshop, Illustrator and QuarkXPress.

First Contact & Terms Send query letter with photocopies, printed samples, résumé, SASE and tearsheets portraying family themes. Send follow-up postcard every year. Samples are filed. Responds in 2 weeks. Will contact artist for portfolio review of photocopies of artwork portraying family themes if interested. Buys first, one-time or reprint rights. Finds freelancers through agents, sourcebooks and submissions.

Text Illustration Assigns 150 illustration jobs/year. Pays by project. Prefers realistic, abstract, cartoony styles.

FOLIO: MAGAZINE

Red 7 Media, LLC, 33 South Main St., Norwalk CT 06854. (203)854-6730. Fax: (203)854-6735. Web site: www.fol iomag.com. **Managing Editor:** Matt Kinsmar. Trade magazine covering the magazine publishing industry. Circ. 9,380. Sample copies for SASE with first-class postage.

Illustration Approached by 200 illustrators/year. Buys 150-200 illustrations/year. Works on assignment only. Artists' online galleries welcome in lieu of portfolio.

First Contact & Terms Illustrators: Send postcard samples and/or photocopies or other appropriate samples. No originals. Samples are filed and returned by SASE if requested by artist. Responds only if interested. Call for appointment to show portfolio of tearsheets, slides, final art, photographs and transparencies. Buys one-time rights. Pays by the project.

Tips "Art director likes to see printed 4-color and b&w sample illustrations. Do not send originals unless requested. Computer-generated illustrations are used but not always necessary. Charts and graphs must be Macintosh-generated."

🔊 FOODSERVICE AND HOSPITALITY

Kostuch Publications Limited, 23 Lesmill Rd., #101, Don Mills ON M3B 3P6 Canada. (416)447-0888. Fax: (416)447-5333. E-mail: mhewis@foodservice.ca. Web site: www.foodserviceworld.com. **Art Director:** David Heath. Estab. 1973. Monthly business magazine for foodservice industry/operators. Circ. 25,000. Sample copies available. Art guidelines available.

• Also publishes *Hotel Executive Magazine*.

Illustration Approached by 30 illustrators/year. Buys 1 illustration/issue. Prefers serious/businessy/stylized art for *Hotel Executive Magazine*; casual free and fun style for *Foodservice and Hospitality*. Considers all media.

First Contact & Terms Illustrators: Send query letter with printed samples and tearsheets or postcards. Samples

are filed. Responds only if interested. Art director will contact artist for portfolio review of final art and tearsheets if interested. Portfolios may be dropped off every Monday and Tuesday. Buys one-time rights. Pays on publication; $500 minimum for color cover; $300 minimum for color inside. Finds illustrators through sourcebooks, word of mouth, artist's submissions.

FORBES MAGAZINE

60 Fifth Ave., New York NY 10011. (212)620-2200. E-mail: bmansfield@forbes.com. **Art Director:** Robert Mansfield. Five associate art directors. Established 1917. Biweekly business magazine read by company executives and those who are interested in business and investing. Circ. 950,000. Art guidelines not available.

Illustration Assigns 20% of illustrations to new and emerging illustrators.

First Contact & Terms "Assignments are made by one of the art directors. We do not use, nor are we liable for, ideas or work that a Forbes art director didn't assign. We prefer contemporary illustrations that are lucid and convey an unmistakable idea with wit and intelligence. No cartoons please. Illustration art must be rendered on a material and size that can be separated on a drum scanner or submitted digitally. We are prepared to receive art on zip, scitex, CD, floppy disk, or downloaded via e-mail. Discuss the specifications and the fee before you accept the assignment. **Pays on acceptance** whether reproduced or not. Pays up to $3,000 for a cover assignment and an average of $450 to $700 for an inside illustration depending on complexity, time and the printed space rate. Dropping a portfolio off is encouraged. Deliver portfolios by 11 a.m. and plan to leave your portfolio for a few hours or overnight. Call first to make sure an art director is available. Address the label to the attention of the Forbes Art Department and the individual you want to reach. Attach your name and local phone number to the outside of the portfolio. Include a note stating when you need it. Robin Regensberg, the art traffic coordinator, will make every effort to call you to arrange for your pickup. Samples: Do not mail original artwork. Send printed samples, scanned samples or photocopies of samples. Include enough samples as you can spare in a portfolio for each person on our staff. If interested, we'll file them. Otherwise they are discarded. Samples are returned only if requested."

Tips "Look at the magazine to determine if your style and thinking are suitable. The art director and associate art directors are listed on the masthead, located within the first ten pages of an issue. The art directors make assignments for illustration. However, it is important that you include Robert Mansfield in your mailings and portfolio review. We get a large number of requests for portfolio reviews and many mailed promotions daily. This may explain why, when you follow up with a call, we may not be able to acknowledge receipt of your samples. If the work is memorable and we think we can use your style, we'll file samples for future consideration."

FOREIGN SERVICE JOURNAL

2101 E St. NW, Washington DC 20037. (202)338-4045. Fax: (202) 338-6820. E-mail: journal@afsa.org. Web site: www.fsjournal.org. **Art Director:** Caryn Suko Smith. Estab. 1924. Monthly magazine emphasizing foreign policy for foreign service employees; 4-color with design in "Harpers' style." Circ. 16,000. Returns original artwork after publication. Art guidelines available.

Illustration Works with 11 illustrators/year. Buys 35 illustrations/year. Needs editorial illustration. Uses artists mainly for covers and article illustration. Works on assignment only.

First Contact & Terms Illustrators Send postcard samples. Accepts disk submissions. "Mail in samples for our files." Publication will contact artist for portfolio review if interested. Buys first rights. Pays on publication; $1,000 for color cover; $100 and up for color inside. Finds artists through sourcebooks.

⚄ Ⓝ FOREVER YOUNG

467 Speers Rd., Oakville ON L6K 3S4 Canada. (905)815-0017. Fax: (905)337-5571. Web site: www.foreveryoung news.com. **Art Director.** Estab. 1980. Monthly consumer magazine provides information on travel, health, food, housing and finance for people 50 or older. Circ.: 525,000.

Cartoons Approached by 100 cartoonists/year. Buys 5 cartoons/year. Prefer people over 50, couples, vacations and single panel.

Illustration Approached by 50 illustrators/year. Buys 10 illustrations/year. Features children, families, pets, men and women, 50 or older, humorous illustration and spot illustrations. Assigns 10% to new and emerging illustrators.

First Contact & Terms Cartoonists: Send query letter with photocopies. Illustrators: Send postcard sample with URL. After introductory mailing, send follow-up postcard sample every 6 months. Responds only if interested. Pays cartoonists $50-100 for b&w. Pays illustrators $75-250 for color inside. Pays on publication. Buys one-time rights. Find freelancers through artists' submissions.

FOUNDATION NEWS & COMMENTARY

Council on Foundations, 1828 L St. NW, Washington DC 20036. (202)466-6512. Fax: (202)785-3926. Web site: www.foundationnews.org. **Executive Editor:** Allan R. Clyde. Estab. 1959. Bimonthly 4-color nonprofit

association magazine that "covers news and trends in the nonprofit sector, with an emphasis on foundation grantmaking and grant-funded projects." Circ. 10,440. Original artwork returned after publication. Sample copy available.

Illustration Approached by 50 illustrators/year. Buys 3 illustrations/issue. Considers all formats.

First Contact & Terms Send query letter with tearsheets, photostats, slides and photocopies. Samples are filed "if good"; none are returned. Buys first rights. **Pays on acceptance.**

Tips The magazine is "clean, uncluttered, sophisticated, simple but attractive. Its content is somewhat abstract and is therefore more visually conceptual than literal."

▣ FUGUE LITERARY MAGAZINE

200 Brink Hall, University of Idaho, P.O. Box 441102, Moscow ID 83843. (208)885-6156. E-mail: fugue@uidaho. edu. Web site: www.class.uidaho.edu/english/fugue. Estab. 1990. Biannual literary magazine. Circ. 500. Sample copies available for $6. Art guidelines available with SASE.

Illustration Approached by 10 illustrators/year. Buys 1-2 illustrations/year. Has featured illustrations by Sarah Wichlucz, Cori Flowers. Features graphic art. Prefers any color scheme; preferably paintings (in slide form). Freelance illustration demands knowledge of PageMaker and Photoshop.

First Contact & Terms Cartoonists/Illustrators: Send query letter with b&w photocopies, photographs, résumé, SASE and slides. Accepts e-mail submissions with link to Web site. Prefers Windows-compatible, TIFF or JPEG files. Samples are not filed but are returned by SASE. Responds in 4 months. Company will contact artist for portfolio review if interested. Portfolio should include b&w original art, photographs, slides and thumbnails. **Pays on acceptance.** Buys first North American serial rights.

THE FUTURIST

7910 Woodmont Ave., Suite 450, Bethesda MD 20814. (301)656-8274. Fax: (301)951-0394. Web site: www.wfs.o rg. **Art Director:** Lisa Mathias. Emphasizes all aspects of the future for a well-educated, general audience. Bimonthly b&w and color magazine with 4-color cover; "fairly conservative design with lots of text." Circ. 30,000. Accepts simultaneous submissions and previously published work. Return of original artwork following publication depends on individual agreement.

Illustration Approached by 50-100 illustrators/year. Buys fewer than 10 illustrations/year. Needs editorial illustration. Uses a variety of themes and styles "usually b&w drawings. We like an artist who can read an article and deal with the concepts and ideas." Works on assignment only.

First Contact & Terms Illustrators: Send samples or tearsheets to be kept on file. Accepts disk submissions compatible with QuarkXPress or Photoshop on a Mac platform. Send EPS files. Will contact for portfolio review if interested. Rights purchased negotiable. **Pays on acceptance**; $500-750 for color cover; $75-350 for b&w, $200-400 for color inside; $100-125 for spots.

Tips "Send samples that are strong conceptually with skilled execution. When a sample package is poorly organized, poorly presented—it says a lot about how the artists feel about their work." This publication does not use cartoons.

⬚ GALLERY MAGAZINE

Dept. AGDM, 401 Park Ave. S., New York NY 10016-8808. (212)779-8900. Fax: (212)725-7215. Web site: www.gallerymagazine.com. **Creative Director:** Mark DeMaio. Emphasizes "sophisticated men's entertainment for the upper middle-class, collegiate male; monthly 4-color with flexible format, conceptual and sophisticated design." Circ. 375,000.

Cartoons Approached by 100 cartoonists/year. Buys 3-8 cartoons/issue. Interested in sexy humor; single, double or multiple panel, color and b&w washes, b&w line drawings with or without gagline.
Responds in 1 month.

Illustration Approached by 300 illustrators/year. Buys 30 illustrations/year. Works on assignment only. Needs editorial illustrations. Interested in the "highest creative and technical styles." Especially needs slick, high-quality, 4-color work. 100% of freelance work demands knowledge of QuarkXPress and Illustrator.

Design Needs freelancers for design and production. 100% of freelance work demands knowledge of Photoshop, Illustrator, QuarkXPress. Prefers local freelancers only.

First Contact & Terms Cartoonists: Send finished cartoons. Enclose SASE. Contact J. Linden. Illustrators: Send flier, samples or tearsheets to be kept on file for possible future assignments. Prefers prints over transparencies. Designers: Send query letter with résumé, SASE and tearsheets. Samples returned by SASE. Publication will contact artist for portfolio review if interested. Negotiates rights purchased. Pays on publication. Pays illustrators $350 for b&w inside; $250-1,000 for color inside; $250-500 for spots. Pays designers by the hour, $25. Finds artists through submissions and sourcebooks.

Tips A common mistake freelancers make is that "often there are too many samples of literal translations of the subject. There should also be some conceptual pieces."

GAME & FISH

2250 Newmarket Pkwy., Suite 110, Marietta GA 30067. (770)953-9222. Fax: (770)933-9510. Web site: www.gam eandfish.about.com. **Graphic Artist:** Allen Hansen. Estab. 1975. Monthly b&w with 4-color cover. Circ. 575,000 for 30 state-specific magazines. Original artwork is returned after publication. Sample copies available.

Illustration Approached by 50 illustrators/year. Buys illustrations mainly for spots and feature spreads. Buys 1-5 illustrations/issue. Considers pen & ink, watercolor, acrylic and oil.

First Contact & Terms Illustrators: Send query letter with photocopies. "We look for an artist's ability to realistically depict North American game animals and game fish or hunting and fishing scenes." Samples are filed or returned only if requested. Responds only if interested. Portfolio review not required. Buys first rights. Pays 2½ months prior to publication; $25 minimum for b&w inside; $75-100 for color inside.

Tips "We do not publish cartoons, but we do use some cartoon-like illustrations which we assign to artists to accompany specific humor stories. Send us some samples of your work, showing as broad a range as possible, and let us hold on to them for future reference. Being willing to complete an assigned illustration in a 4-6 week period and providing what we request will make you a candidate for working with us."

GEORGIA MAGAZINE

P.O. Box 1707, Tucker GA 30085-1707. (770)270-6950. Fax: (770)270-6995. E-mail: ann.orowski@georgiaemc.c om. Web site: www.georgiamagazine.org. **Editor:** Ann Orowski. Estab. 1945. Monthly consumer magazine promoting electric co-ops (largest read publication by Georgians for Georgians). Circ. 460,000 members.

Cartoons Approached by 10 cartoonists/year. Buys 2 cartoons/year. Prefers electric industry theme. Prefers single panel, humorous, b&w washes and line drawings.

Illustration Approached by 10 illustrators/year. Prefers electric industry theme. Considers all media. 50% of freelance illustration demands knowledge of Illustrator and QuarkXPress.

Design Uses freelancers for design and production. Prefers local designers with magazine experience. 80% of design demands knowledge of Photoshop, Illustrator, QuarkXPress and InDesign.

First Contact & Terms Cartoonists: Send query letter with photocopies. Samples are filed and not returned. Illustrators: Send postcard sample or query letter with photocopies. Designers: Send query letter with printed samples and photocopies. Accepts disk submissions compatible with QuarkXPress 7.5. Samples are filed or returned by SASE. Responds in 2 months if interested. Rights purchased vary according to project. **Pays on acceptance.** Pays cartoonists $50 for b&w, $50-100 for color. Pays illustrators $50-100 for b&w, $50-200 for color. Finds illustrators through word of mouth and artist's submissions.

GIRLFRIENDS MAGAZINE

3415 Cesar Chavez, #101, San Francisco CA 94110. (415)648-9464. Fax: (415)648-4705. E-mail: ethan@girlfrien dsmag.com. Web site: www.girlfriendsmag.com. **Art Director:** Ethan Duran. Estab. 1994. Monthly lesbian magazine. Circ. 30,000. Sample copies available for $4.95. Art guidelines for #10 SASE with first-class postage.

Illustration Approached by 50 illustrators/year. Buys 3-4 illustrations/issue. Features caricatures of celebrities and realistic, computer and spot illustration. Assigns 40% of illustrations to new and emerging illustrators. Prefers any style. Considers all media. 10% of freelance illustration demands knowledge of Illustrator, QuarkXPress.

First Contact & Terms Illustrators: Send query letter with printed samples, tearsheets, résumé, SASE and color copies. Accepts disk submissions compatible with QuarkXPress (JPEG files). Samples are filed or returned by SASE on request. Responds in 2 months. To show portfolio, artist should follow up with call and/or letter after initial query. Portfolio should include color, final art, tearsheets, transparencies. Rights purchased vary according to project. Pays on publication; $50-200 for color inside; $150-300 for 2-page spreads; $50-75 for spots. Finds illustrators through word of mouth and submissions.

Tips "Read the magazine first; we like colorful work; ability to turn around in two weeks."

GIRLS' LIFE

4517 Hartford Rd., Baltimore MD 21214-3122. (410)426-9600. Fax: (410)254-0991. Web site: www.girlslife.com. **Art Director:** Chun Kim. Estab. 1994. Bimonthly consumer magazine for 8- to 15-year-old girls. Originals sometimes returned at job's completion. Sample copies available for $5 on back order or on newsstands. Art guidelines not available. Sometimes needs computer literate freelancers for illustration. 20% of freelance work demands computer knowledge of Illustrator, QuarkXPress or Photoshop. Circ. 363,000.

Illustration Prefers anything pertaining to girls 8-15 years-old. Assigns 60% of illustrations to experienced but not well-known illustrators; 10% to new and emerging illustrators. Considers pen & ink, watercolor, airbrush, acrylic and mixed media.

First Contact & Terms Illustrators: Send query letter with SASE, tearsheets, photographs, photocopies, photo-stats, slides and transparencies. Samples are filed or are returned by SASE if requested by artist. Publication will contact artist for portfolio review if interested. Portfolio should include tearsheets, slides, photostats, photo-

copies, final art and photographs. Buys first rights. Pays on publication. Finds artists through artists' submissions.

Tips "Send work pertaining to our market."

GLAMOUR

4 Times Square, 16th Floor, New York NY 10036. (212)286-2860. Fax: (212)286-8336. Web site: www.glamour.com. **Art Director:** Cynthia Harris. Deputy Art Director: Peter Hemmel. Monthly magazine. Covers fashion and issues concerning working women (ages 20-35). Circ. 2 million. Originals returned at job's completion. Sample copies available on request. 5% of freelance work demands knowledge of Illustrator, QuarkXPress, Photoshop and FreeHand.

Cartoons Buys 1 cartoon/issue.

Illustration Buys 1 illustration/issue. Works on assignment only. Considers all media.

First Contact & Terms Illustrators: Send postcard-size sample. Samples are filed and not returned. Publication will contact artist for portfolio review if interested. Rights purchased vary according to project. Pays on publication.

N GLAMOUR LATINOAMERICA

1101 Brickell Ave. 15th Flr., Miami FL 33131-3105. (305)371-9393. Fax: (305)371-9392. Web site: www.condenast.com. **Art Director:** Teresita Perera. Estab. 1998. Monthly consumer magazine for the contemporary Hispanic woman. Covers the latest trends in fashion and beauty, health, relationships, careers and entertainment. Circ.: 406,760.

Illustration Approached by 100 illustrators/year. Buys 40 illustrations/year. Features fashion caricatures of celebrities, fashion illustration and spot illustrations. Assigns 10% to new and emerging illustrators. Illustrators: Send postcard sample with link to Web site. After introductory mailing, send follow-up postcard sample every 6 months. Responds only if interested.

First Contact & Terms Illustrators: $150-400 for color inside. Buys one-time rights. Finds freelancers through submissions.

GLASS FACTORY DIRECTORY

Box 2267, Hempstead NY 11551. (516)481-2188. E-mail: manager@glassfactorydir.com. Web site: www.glassfactorydir.com. **Manager:** Liz Scott. Annual listing of glass manufacturers in US, Canada and Mexico.

Cartoons Receives an average of 1 submission/week. Buys 5-10 cartoons/issue. Cartoons should pertain to glass manufacturing (flat glass, fiberglass, bottles and containers; no mirrors). Prefers single and multiple panel b&w line drawings with gagline. Prefers roughs or finished cartoons. "We do not assign illustrations. We buy from submissions only."

First Contact & Terms Send SASE. Usually gets a review and any offer back to you within a month. Buys all rights. **Pays on acceptance**; $30.

Tips "We don't carry cartoons about broken glass, future, past or present. We can't use stained glass cartoons—there is a stained glass magazine. We will not use any cartoons with any religious theme. Since our directory is sold world-wide, caption references should consider that we do have a international readership."

GOLF TIPS MAGAZINE

12121 Wilshire Blvd., Suite 1200, Los Angeles CA 90025-1123. (310)820-1500. Fax: (310)820-2793. Web site: www.golftipsmag.com. **Art Director:** Warren Keating. Estab. 1986. Monthly 4-color consumer magazine featuring golf instruction articles. Circ. 300,000.

Illustration Approached by 100 illustrators/year. Buys 3 illustrations/issue. Has featured illustrations by Phil Franke, Scott Matthews, Ed Wexler. Features charts & graphs, humorous illustration, informational graphics, realistic and medical illustration. Preferred subjects men and women. Prefers realism or expressive, painterly editorial style or graphic humorous style. Assigns 30% of illustrations to well-known or "name" illustrators; 50% to experienced but not well-known illustrators; 20% to new and emerging illustrators. 15% of freelance illustration demands knowledge of Illustrator, Photoshop and FreeHand.

First Contact & Terms Illustrators: Send postcard or other nonreturnable samples. Accepts Mac-compatible disk submissions. Send EPS or TIFF files. Samples are filed. Will contact artist for portfolio review if interested. Rights purchased vary according to project. Pays on publication; $500-700 for color cover; $100-200 for b&w inside; $250-500 for color inside; $500-700 for 2-page spreads. Finds illustrators through *LA Workbook, Creative Black Book* and promotional samples.

Tips "Look at our magazine and you will see straightforward, realistic illustration, but I am also open to semi-abstract, graphic humorous illustration, gritty, painterly, editorial style, or loose pen & ink and watercolor humorous style."

THE GOLFER

551 Fifth Ave., Suite 3010, New York NY 10176. (212)867-7070. Fax: (212)867-8550. E-mail: thegolfer@thegolfer mag.com. Web site: www.thegolfermag.com. **Contact:** Andrea Darif, art director. Estab. 1994. Published 6 times/year "sophisticated golf magazine with an emphasis on travel and lifestyle." Circ. 254,865.

Illustration Approached by 200 illustrators/year. Buys 6 illustrations/issue. Considers all media.

First Contact & Terms Illustrators: Send postcard sample. "We will accept work compatible with QuarkXPress 3.3. Send EPS files." Samples are not filed and are not returned. Responds only if interested. Rights purchased vary according to project. Pays on publication. Payment to be negotiated.

Tips "I like sophisticated, edgy, imaginative work. We're looking for people to interpret sport, not draw a picture of someone hitting a ball."

[N] GOLFWEEK

1500 Park Center Dr., Orlando FL 32835. Fax: (407)563-7077. E-mail: smiller@golfweek.com. Web site: www.go lfweek.com. **Art Director:** Scott Miller. Weekly golf magazine for the accomplished golfer. Covers the latest golfing news and all levels of competitive golf from amateur and collegiate to juniors and professionals. Includes articles on golf course architecture as well as the latest equipment and apparel. Circ. 119,000.

Illustration Approached by 200 illustrators/year. Buys 20 illustrations/year. Has featured illustrations by Roger Schillerstrom. Features caricatures of golfers and humorous illustration of golf courses and golfers. Assigns 20% to new and emerging illustrators. 5% of freelance illustration demands knowledge of Photoshop.

First Contact & Terms Illustrators: Send postcard sample. After introductory mailing, send follow-up postcard sample every 3-6 months. Accepts e-mail submissions with link to Web site. Prefers JPEG files. Samples are filed. Responds only if interested. Portfolios not required. Pays illustrators $400-1,000 for color cover; $400-500 for color inside. Pays on publication. Buys one-time rights. Finds freelancers through artists' submissions and sourcebooks.

Tips "Look at our magazine. Know golf."

GOVERNING

1100 Connecticut Ave. NW, Suite 1300, Washington DC 20036-4109. (202)862-8802. Fax: (202)862-0032. E-mail: rsteadham@governing.com. Web site: www.governing.com. **Art Director:** Richard Steadham. Estab. 1987. Monthly magazine. "Our readers are executives of state and local governments nationwide. They include governors, mayors, state legislators, county executives, etc." Circ. 86,284.

Illustration Approached by hundreds of illustrators/year. Buys 2-3 illustrations/issue. Prefers conceptual editorial illustration dealing with public policy issues. Considers all media. 10% of freelance illustration demands knowledge of Photoshop, Illustrator, FreeHand.

First Contact & Terms Send postcard sample with printed samples, photocopies and tearsheets. Send follow-up postcard sample every 3 months. "No phone calls please. We work in QuarkXPress, so we accept any format that can be imported into that program." Samples are filed. Responds only if interested. Art director will contact artist for portfolio review if interested. Buys one-time rights. Pays on publication; $700-1,200 for cover; $350-700 for inside; $350 for spots. Finds illustrators through *Blackbook*, *LA Workbook*, online services, magazines, word of mouth, submissions.

Tips "We are not interested in working with artists who can't take direction. If you can collaborate with us in communicating our words visually, then we can do business. Also, please don't call asking if we have any work for you. When I'm ready to use you, I'll call you."

GRAND RAPIDS MAGAZINE

Gemini Publications, 549 Ottawa Ave., Grand Rapids MI 49503. (616)459-4545. Fax: (616)459-4800. E-mail: info@geminipub.com. Web site: www.geminipub.com. **Editor:** Carole Valade. Monthly for greater Grand Rapids residents. Circ. 20,000. Original artwork returned after publication. Local artists only.

Cartoons Buys 2-3 cartoons/issue. Prefers Michigan, Western Michigan, Lake Michigan, city, issue, consumer/household, fashion, lifestyle, fitness and travel themes.

Illustration Buys 2-3 illustrations/issue. Prefers Michigan, Western Michigan, Lake Michigan, city, issue, consumer/household, fashion, lifestyle, fitness and travel themes.

First Contact & Terms Cartoonists/Illustrators: Send query letter with samples. Samples not filed are returned by SASE. Responds in 1 month. To show a portfolio, mail printed samples and final reproduction/product or call for an appointment. Buys all rights. Pays on publication. Pays cartoonists $35-50 for b&w. Pays illustrators $200 minimum for color cover; $40 minimum for b&w inside; $40 minimum for color inside.

Tips "Particular interest in those who are able to capture the urban lifestyle."

GRAPHIC ARTS MONTHLY

2000 Clearwater Drive, Oak Brook IL 60523. (630)288-8565. Fax: (630)288-8540. E-mail: tntovas@reedbusiness. com. Web site: www.gammag.com/. **Senior Art Director:** Mrs. Terry Ntovas. Estab. 1930. Monthly 4-color

trade magazine for management and production personnel in commercial and specialty printing plants and allied crafts. Design is "direct, crisp and modern." Circ. 70,000. Accepts previously published artwork. Originals returned at job's completion. Needs computer-literate freelancers for illustration.

Illustration Approached by 150 illustrators/year. Buys 6 illustrations/issue. Works on assignment only. Considers all media, including computer.

First Contact & Terms Illustrators: Send postcard-sized sample to be filed. No phone calls please. Accepts disk submissions compatible with Photoshop, Illustrator or JPEG files. Will contact for portfolio review if interested. Portfolio should include final art, photographs, tearsheets. Buys one-time and reprint rights. **Pays on acceptance;** $750-1200 for color cover; $250-350 for color inside; $250 for spots. Finds artists through submissions.

N GRAY AREAS

P.O. Box 808, Broomall PA 19008-0808. E-mail: grayarea@mod.net. Web site: www.grayarea.com/gray2.htm. **Publisher:** Netta Gilboa. Estab. 1991. Magazine examining gray areas of law and morality in the fields of music, law, technology and popular culture. Accepts previously published artwork. Originals not returned. Sample copies available for $8; art guidelines not available.

Cartoons Approached by 15 cartoonists/year. Buys 2-5 cartoons/issue. Prefers "illegal subject matter" humorous cartoons; single, double or multiple panel b&w line drawings.

Illustration Works on assignment only. Has featured illustrations by Dennis Preston, Jeff Wampler and Wes Wilson. Assigns 5% of illustrations to well-known or "name" illustrators; 35% to experienced, but not well-known illustrators; 60% to new and emerging illustrators. Features humorous and computer illustration. Assigns 50% of illustrations to experienced, but not well-known illustrators; 50% to new and emerging illustrators. Prefers "illegal subject matter like sex, drugs, computer criminals." Considers "any media that can be scanned by a computer, up to $8\frac{1}{2} \times 11$ inches." 50% of freelance work demands knowledge of PageMaker 6.0 or CorelDraw 6.0.

Design Needs freelancers for design. 50% of freelance work demands knowledge of PageMaker 6.0, FreeHand 5.0 or CorelDraw 6.0.

First Contact & Terms Cartoonists: Send query letter with brochure, roughs, photocopies or finished cartoons. Illustrators: Send postcard sample or query letter with SASE and photocopies. Designers: Send query letter with photocopies. Accepts disk submissions compatible with IBM/PC. Samples are filed. Responds in 1 week only if SASE enclosed. Portfolio review not required. Buys one-time rights. Pays on publication. Pays illustrators $500 for color cover; negotiable b&w. Pays designers by project. Pays 5 copies of issue and masthead listing for spots.

Tips "Most of the artists we use have approached us after seeing the magazine. All sections are open to artists. We are only interested in art which deals with our unique subject matter. Please do not submit without having seen the magazine. We have a strong 1960s style. Our favorite artists include Robert Crumb and Rick Griffin. We accept all points of view in art, but only if it addresses the subject we cover. Don't send us animals, statues or scenery."

N THE GREEN MAGAZINE

226 W. 37th St. 9th Flr., New York NY 10018-6605. (212)629-4920. Fax: (212)629-4932. E-mail: hlee@thegreenm agazine.com. Web site: www.thegreenmagazine.com. **Art Director:** Helen Lee. Estab. 2002. Bimonthly consumer magazine for the affluent minority golf enthusiast featuring articles on personalities, travel and leisure, business and etiquette. Circ.: 150,000.

Illustration Approached by 350 illustrators/year. Buys 30 illustrations/year. Features minority golfers and golf courses caricatures of celebrities/politicians, humorous illustration and spot illustrations. Assigns 5% to new and emerging illustrators.

First Contact & Terms Illustrators: Send postcard sample or photocopies. After mailing introductory mailing, send follow-up postcard sample every 2-3 months. Company will contact artist for portfolio review if interested. Pays illustrators $100-350 for color inside. Buys one-time rights. Finds freelancers through artists' submissions.

GREENPRINTS

P.O. Box 1355, Fairview NC 28730. (828)628-1902. E-mail: patstone@atlantic.net. Web site: www.greenprints.c om. **Editor:** Pat Stone. Estab. 1990. Quarterly magazine "that covers the personal, not the how-to, side of gardening." Circ. 13,000. Sample copy for $5; art guidelines available on Web site or free for #10 SASE with first-class postage.

Illustration Approached by 46 illustrators/year. Works with 15 illustrators/issue. Has featured illustrations by Claudia McGehee, P. Savage, Marilynne Roach and Jean Jenkins. Assigns 30% of illustrations to emerging and 5% to new illustrators. Prefers plants and people. Considers b&w only.

First Contact & Terms Illustrators: Send query letter with photocopies, SASE and tearsheets. Samples accepted by US mail only. Accepts e-mail queries without attachments. Samples are filed or returned by SASE. Responds

in 2 months. Buys first North American serial rights. Pays on publication; $250 maximum for color cover; $100-125 for b&w inside; $25 for spots. Finds illustrators through word of mouth, artist's submissions.

Tips "Read our magazine and study the style of art we use. Can you do both plants and people? Can you interpret as well as illustrate a story?"

GROUP PUBLISHING—MAGAZINE DIVISION

P.O. Box 481, Loveland CO 80539. (970)669-3836. Fax: (970)292-4372. E-mail: info@group.com. Web site: www.group.com. Publishes *Group Magazine*, **Art Director:** Rebecca Parrott (6 issues/year; circ. 50,000; 4-color); *Children's Ministry Magazine*, **Art Director:** RoseAnne Sather (6 issues/year; circ. 65,000; 4-color), for adult leaders who work with kids from birth to 6th grade; *Rev. Magazine*, **Art Director:** Jeff Spencer (6 issues; 4-color), an interdenominational magazine which provides innovative and practical ideas for pastors. Previously published, photocopied and simultaneous submissions OK. Original artwork returned after publication. Sample copy $2 with 9×12 SAE.

 • This company also produces books. See listing in Book Publishers section.

Illustration Buys 2-10 illustrations/issue. Has featured illustrations by Matt Wood, Chris Dean, Dave Klug and Otto Pfandschmidt.

First Contact & Terms Illustrators: Send postcard samples, SASE, tearsheets to be kept on file for future assignments. Accepts disk submissions compatible with Mac. Send EPS files. Responds only if interested. **Pays on acceptance.** Pays illustrators $125-1,000, from b&w/spot illustrations (line drawings and washes) to full-page color illustrations inside. Buys first publication rights and occasional reprint rights.

Tips "We prefer contemporary, nontraditional (not churchy), well-developed styles that are appropriate for our innovative, youth-oriented publications. We appreciate artists who can conceptualize well and approach difficult and sensitive subjects creatively."

▣ GUIDEPOSTS PUBLICATIONS

16 E. 34th St., New York NY 10016. Fax: (212)684-1311. Web site: www.guidepostsmag.com. **Design Director:** Francesca Messina. Mangaging Art Director: Donald Partyka. Estab. 1995. Bimonthly magazine featuring true stories of angel encounters and angelic behavior. Circ. 1,000,000. Art guidelines posted on Web site.

 • Publishes 4 titles out of New York office: *Guideposts*, a monthly magazine with a circulation of 2.6 million; *Angels On Earth*, a bi-monthly magazine with a circulation of 500,000; *Sweet 16*, a magazine for teenage girls with a circulation of 200,000; and a new start-up lifestyle and spirituality magazine, *Positive Thinking*.

Illustration Approached by 500 illustrators/year. Buys 5-10 illustrations/issue. Has featured illustrations by Kinuko Craft, Gary Kelley, Rafal Olbinski. Features computer, whimsical, reportorial, humorous, conceptual, realistic and spot illustration. Assigns 40% of illustrations to well-known or "name" illustrators; 40% to experienced but not well-known illustrators; 20% to new and emerging illustrators. Prefers conceptual/realistic, "soft" styles. Considers all media.

First Contact & Terms Illustrators: Please send nonreturnable promotional materials, slides or tearsheets. Accepts disk submissions compatible with Photoshop, Illustrator. Samples are filed. Send *only* nonreturnable samples. Art director will contact artist for portfolio review of color slides and transparencies if interested. Rights purchased vary. **Pays on acceptance**; $500-2,500 for color cover; $500-2,000 2-page spreads; $300-500 for spots. For more information, see Web site. Finds artists through reps, *American Showcase*, *Society of Illustrators Annual*, submissions and artist's Web sites.

Tips "Please study our magazine and be familiar with the content presented."

HADASSAH MAGAZINE

50 W. 58th St., New York NY 10019. (212)451-6289. Fax: (212)451-6257. E-mail: egoldberg@hadassah.org. Web site: www.hadassah.org. **Art Director:** Jodie Rossi. Estab. 1914. Consumer magazine. *Hadassah Magazine* is a monthly magazine chiefly for Jewish interests—both here and in Israel. Circ. 250,000.

Illustration Approached by 50 freelance illustrators/year. Works on assignment only. Features humorous, realistic, computer and spot illustration. Prefers themes of news, Jewish/family, Israeli issues, holidays.

First Contact & Terms Cartoonists: Send postcard sample or query letter with tearsheets. Samples are filed or are returned by SASE. Write for appointment to show portfolio of original/final art, tearsheets and slides. Buys first rights. Pays on publication. Pays illustrators $400-600 for color cover; $100-200 for b&w inside; $200-250 for color inside; $75-100 for spots.

▣ HARDWOOD MATTERS

National Hardwood Lumber Association, P.O. Box 34518, Memphis TN 38184-0518. (901)377-1818. Fax: (901)382-6419. E-mail: t.bullard@nhla.com. Web site: www.nhla.com. **Editor:** Tim Bullard. Estab. 1989. Monthly magazine for trade association. Publication covers "forest products industry, government affairs and environmental issues. Audience is forest products members, Congress, natural resource users. Our magazine

is pro-resource use, *no preservationist slant* (we fight to be able to use our private property and natural resources)." Accepts previously published artwork. Art guidelines not available.

- This publication buys one cartoon/issue at $20 (b&w). Send query letter with finished cartoons (single, double or multi-panel).

Illustration Buys 6 illustrations/year. Prefers forestry, environment, legislative, legal themes. Considers pen & ink.

First Contact & Terms Illustrators: Send query letter with résumé, photocopies of pen & ink work. Rights purchased vary according to project. Pays up to $200 for b&w inside.

Tips "Our publication covers all aspects of the forest industry, and we consider ourselves good stewards of the land and manage our forestlands in a responsible, sustainable way—submissions should follow this guideline."

HARPER'S MAGAZINE

666 Broadway, 11th Floor, New York NY 10012. (212)420-5720. Fax: (212)228-5889. E-mail: stacey@harpers.o rg. **Art Director:** Stacey D. Clarkson. Estab. 1850. Monthly 4-color literary magazine covering fiction, criticism, essays, social commentary and humor.

Illustration Approached by 250 illustrators/year. Buys 5-10 illustrations/issue. Has featured illustrations by Ray Bartkus, Steve Brodner, Tavis Coburn, Hadley Hooper, Ralph Steadman, Raymond Verdaguer, Andrew Zbihlyj, Danijel Zezelj. Features intelligent concept-oriented illustration. Preferred subjects literary, artistic, social, fiction-related. Prefers intelligent, original thought and imagery in any media. Assigns 25% of illustrations to new and emerging illustrators. 10% of freelance illustration demands knowledge of Photoshop.

First Contact & Terms Illustrators: Send nonreturnable samples. Accepts Mac-compatible disk submissions. Samples are filed and are not returned. Will contact artist for portfolio review if interested. Portfolios may be dropped off for review the last Wednesday of any month. Buys first North American serial rights. Pays on publication; $250-400 for b&w inside; $450-1,000 for color inside; $450 for spots. Finds illustrators through samples, annuals, reps, other publications.

Tips "Intelligence, originality and beauty in execution are what we seek. A wide range of styles is appropriate; what counts most is content."

HEARTLAND BOATING MAGAZINE

319 N. 4th St., #650, St. Louis MO 63102. (314)241-4310. Fax: (314)241-4207. Web site: www.Heartlandboating. com. **Art Director:** John R. Cassady II. Estab. 1989. Specialty magazine published 9 times per year devoted to power (cruisers, houseboats) and sail boating enthusiasts throughout middle America. The content is both humorous and informative and reflects "the challenge, joy and excitement of boating on America's inland waterways." Circ. 14,000. Originals are returned at job's completion. Sample copies available for $5. Art guidelines for SASE with first-class postage or check our Web site.

Cartoons On assignment.

Illustration Works on assignment only. Prefers boating-related themes. Considers pen & ink.

First Contact & Terms Illustrators: Send postcard sample or query letter with SASE, photocopies and tearsheets. Samples are filed or returned by SASE. Responds in 2 months. Portfolio review not required. First North American rights purchased. Pays on publication. Pay is negotiated. Finds artists through submissions.

HIGH COUNTRY NEWS

119 Grand Ave., P.O. Box 1090, Paonia CO 81428-1090. (970)527-4898. Fax: (970)527-4897. E-mail: cindy@hcn. org. Web site: www.hcn.org. **Art Director:** Cindy Wehling. Estab. 1970. Biweekly newspaper published by the nonprofit High Country Foundation. High Country News covers environmental, public lands and community issues in the 10 western states. Circ. 24,000. Art guidelines at www.hcn.org/about/guidelines.jep.

Cartoons Buys 1 editorial cartoon/issue. Only issues affecting Western environment. Prefers single panel, political, humorous on topics currently being covered in the paper. Color or b&w. Professional quality only.

Illustration Considers all media if reproducible.

First Contact & Terms Cartoonists: Send query letter with finished cartoons and photocopies. Illustrators: Send query letter with printed samples and photocopies. Accepts e-mail and disk submissions compatible with QuarkXPress and Photoshop. Samples are filed or returned by SASE. Responds only if interested. Rights purchsed vary according to project. Pays on publication. Pays cartoonists $35-100 depending on size used. Pays illustrators $100-200 for color cover; $35-100 for inside. Finds illustrators through magazines, newspapers and artist's submissions.

HIGHLIGHTS FOR CHILDREN

803 Church St., Honesdale PA 18431. (570)253-1080. Fax: (570)253-0179. Web site: www.highlights.com. **Art Director:** Cynthia Faber Smith. **Editor:** Christine French Clark. Monthly 4-color magazine for ages 2-12. Circ. 2 million plus. Art guidelines for SASE with first-class postage.

Cartoons Receives 20 submissions/week. Buys 2-4 cartoons/issue. Interested in upbeat, positive cartoons involving children, family life or animals; single or multiple panel. "One flaw in many submissions is that the concept or vocabulary is too adult or that the experience necessary for its appreciation is beyond our readers. Frequently, a wordless self-explanatory cartoon is best."

Illustration Buys 30 illustrations/issue. Works on assignment only. Prefers "realistic and stylized work; upbeat, fun, more graphic than cartoon." Pen & ink, colored pencil, watercolor, marker, cut paper and mixed media are all acceptable. Discourages work in fluorescent colors.

First Contact & Terms Cartoonists: Send roughs or finished cartoons and SASE. Illustrators: Send query letter with photocopies, SASE and tearsheets. Samples to be kept on file. Responds in 10 weeks. Buys all rights on a work-for-hire basis. **Pays on acceptance.** Pays cartoonists $20-40 for line drawings. Pays illustrators $1,200 for color front and back covers; $50-$700 for color inside. "We are always looking for good hidden pictures. We require a picture that is interesting in itself and has the objects well-hidden. Usually an artist submits pencil sketches. In no case do we pay for any preliminaries to the final hidden pictures." Hidden pictures should be submitted to Jody Taylor.

Tips "We have a wide variety of needs, so I would prefer to see a representative sample of an illustrator's style."

HISPANIC MAGAZINE

999 Ponce De Leon Blvd., Suite 600, Coral Gables FL 33134-3037. (305)492-0070. Fax: (305)774-3578. E-mail: claudio.figueroa@pagelmedia.com. Web site: www.hispaniconline.com. **Art Director:** Claudio Figueroa. Estab. 1987. Monthly 4-color consumer magazine for Hispanic Americans. Circ. 276,000.

Illustration Approached by 100 illustrators/year. Buys 5 illustrations/issue. Has featured illustrations by Will Terry, A.J. Garces, Sonia Aguirre. Features caricatures of politicians, humorous illustration, realistic illustrations, charts & graphs, spot illustrations and computer illustration. Prefers business subjects, men and women. Prefers pastel and bright colors. Assigns 80% of illustrations to experienced, but not well-known illustrators; 20% to new and emerging illustrators.

First Contact & Terms Illustrators: Send nonreturnable postcard samples. Accepts Mac-compatible disk submissions. Send EPS or TIFF files. Samples are filed. Responds only if interested. Will contact artist for portfolio review if interested. Buys one-time rights. Pays on publication; $500-1,000 for color cover; $300 maximum for b&w inside; $800 maximum for color inside; $250 for spots.

Tips "Concept is very important, to take a idea or story and to be able to find a fresh perspective. I like to be surprised by the artist."

ALFRED HITCHCOCK MAGAZINE

475 Park Ave. S., 11th Floor, New York NY 10016. (212)686-7188. Fax: (212)686-7414. **Contact:** June Levine, associate art director. Estab. 1956. Monthly b&w magazine with 4-color cover emphasizing mystery fiction. Circ. 202,470. Accepts previously published artwork. Original artwork returned at job's completion. Art guidelines available for #10 SASE with first-class postage.

Illustration Approached by 300 illustrators/year. Buys 2-3 illustrations/issue. Prefers semirealistic, realistic style. Works on assignment only. Considers pen & ink. Send query letter with printed samples, photocopies and/or tearsheets and SASE.

First Contact & Terms Illustrators: Send follow-up postcard sample every 3 months. Samples are filed or returned by SASE. Responds only if interested. "No phone calls." Portfolios may be dropped off every Tuesday and should include b&w and color tearsheets. "No original art please." Rights purchased vary according to project. **Pays on acceptance.** $1,000-1,200 for color cover; $100 for b&w inside; $35-50 for spots. Finds artists through submissions drop-offs, RSVP.

Tips "No close-up or montages. Show characters within a background environment."

HOME BUSINESS MAGAZINE

PMB 368, 9582 Hamilton, Suite 368, Huntington Beach CA 92646. (714)968-0331. Fax: (714)962-7722. E-mail: henderso@ix.netcom.com. Web site: www.homebusinessmag.com. **Contact:** Creative Director. Estab. 1992. Bimonthly consumer magazine. Circ. 110,000. Sample copies free for 10×13 SASE and $2.53 in first-class postage.

Illustration Approached by 100 illustrators/year. Buys several illustrations/issue. Features natural history illustration, realistic illustrations, charts & graphs, informational graphics, spot illustrations and computer illustration of business subjects, families, men and women. Prefers pastel and bright colors. Assigns 40% of illustrations to well-known or "name" illustrators; 40% to experienced but not well-known illustrators; 20% to new and emerging illustrators. 100% of freelance illustration demands knowledge of Illustrator and QuarkXPress.

First Contact & Terms Illustrators: Send query letter with printed samples, photocopies and SASE. Send elec-

tronically as JPEG files. Responds only if interested. Will contact artist for portfolio review if interested. Buys reprint rights. Negotiates rights purchased. Pays on publication. Finds illustrators through magazines, word of mouth or via Internet.

HOME EDUCATION MAGAZINE

P.O. Box 1083, Tonasket WA 98855. (509)486-1351. Fax: (509)486-2753. E-mail: edchief@homeedmag.com. Web site: www.homeedmag.com. **Managing Editor:** Helen Hegener. Estab. 1983. "We publish one of the largest magazines available for homeschooling families." Desktop bimonthly published in full color; 4-color glossy cover. Circ. 82,500. Original artwork is returned after publication upon request. Sample copy $6.50. Guidelines available via e-mail.

Cartoons Approached by 15-20 cartoonists/year. Buys 1-2/year. Style preferred is open, but theme must relate to home schooling. Prefers single, double or multiple panel b&w line drawings and washes with or without gagline.

Illustration Staff handles illustration.

Design Staff handles design.

First Contact & Terms Cartoonists: Send query letter with samples of style, roughs and finished cartoons, "any format is fine with us." Accepts disk submissions. "We're looking for originality, clarity, warmth. Children, families and parent-child situations are what we need." Samples are filed or are returned by SASE. Responds in 3 weeks. Will contact for portfolio review if interested. Buys one-time rights, reprint rights or negotiates rights purchased. **Pays on acceptance.** Pays cartoonists $10-20 for b&w.

Finds artists primarily through submissions and self-promotions.

Tips "Most of our artwork is produced by staff artists. We receive very few good cartoons. Study what we've done in the past, suggest how we might update or improve it."

N HOMEPC

600 Community Dr., Manhasset NY 11030. (516)562-5000. Fax: (516)562-7007. **Creative Director:** David Loewy. Estab. 1994. Monthly consumer magazine. A magazine for home computer users. Easy to read, non-technical; covering software and hardware, entertainment and personal products. Circ. 650,000. Originals are returned at job's completion. Sample copies available. 50% of freelance work demands knowledge of Photoshop.

Illustration Approached by 200 illustrators/year. Buys 15 illustrations/issue. Works on assignment only. Considers airbrush, colored pencil, mixed media, collage, acrylic, oil and computer illustration.

Design Needs freelancers for production. 100% of design work demands knowledge of FreeHand, Photoshop, QuarkXPress and Illustrator.

First Contact & Terms Illustrators: Send postcard sample with tearsheets. Designers: Send résumé and tear-sheets. Accepts Mac compatible disk submissions. Samples are filed and are not returned. Publication will contact artist for portfolio review if interested. Portfolio should include final art and tearsheets. Buys one-time and reprint rights; rights purchased vary according to project. **Pays on acceptance.** Pays illustrators $2,000-3,000 for color cover; $500-1,500 for color inside; $200-500 for spots. Pays designers by the hour, $15-25. Finds 75 percent of illustrators through sourcebooks; 25 percent through mailers and chance discovery.

HONOLULU MAGAZINE

1000 Bishop St., Honolulu HI 96813. (808)537-9500. Fax: (808)537-6455. E-mail: jaysonh@pacificbasin.net. Web site: www.honlulumagazine.com. **Art Director:** Jayson Harper. "Monthly 4-color city/regional magazine reporting on current affairs and issues, people profiles, lifestyle. Readership is generally upper income (based on subscription). Circ. 33,000. Contemporary, clean, colorful and reader-friendly" design. Original artwork is returned after publication. Sample copies for SASE with first-class postage. Art guidelines available free for SASE.

Illustration Buys illustrations mainly for spots and feature spreads. Buys 2-6 illustrations/issue. Has featured illustrations by Rob Barber, Dean Hayashi and Charlie Pedrina. Assigns 10% of illustrations to new and emerging illustrators. Works on assignment only. Considers any media but not pencil work.

First Contact & Terms Illustrators: Send postcard or published sample showing art style. Looks for local subjects, conceptual abilities for abstract subjects (editorial approach) likes a variety of techniques. Knowledge of Hawaii a must. Samples are filed or are returned only if requested with a SASE. Responds only if interested. Write to schedule an appointment to show a portfolio which should include original/final art and color and b&w tearsheets. Buys first rights or one-time rights. Pays 60 days after publication; $300-500 for cover; $100-350 for inside; $75-150 for spots. Finds artists through word of mouth, magazines, submissions, attending art exhibitions.

Tips "Needs both feature and department illustration—best way to break in is with small spot illustration. Prefers art on Zip disk or e-mail. Friendly and professional attitude is a must. Be a very good conceptual artist, professional, fast, and, of course, a sense of humor."

HOPSCOTCH, The Magazine for Girls

P.O. Box 164, Bluffton OH 45817. (419)358-4610. Fax: (419)358-5027. Web site: www.hopscotchmagazine.com. **Contact:** Marilyn Edwards. Estab. 1989. A bimonthly magazine for girls between the ages of 6 and 12; 2-color with 4-color cover; 52 pp.; 7×9 saddle-stapled. Circ. 15,000. Original artwork returned at job's completion. Sample copies available for $5; $6.50 outside US. Art guidelines for SASE with first-class postage. 20% of freelance work demands computer skills.

 • Also publishes *Boys' Quest* (www.boysquest.com) and *Fun For Kidz* (www.funforkidz.com).

Illustration Approached by 200-300 illustrators/year. Buys 6-7 freelance illustrations/issue. Has featured illustrations by Chris Sabatino, Pamela Harden and Donna Catanese. Features humorous, realistic and spot illustration. Assigns 40% of illustrations to new and emerging illustrators. Artists work mostly on assignment. Needs story illustration. Prefers traditional and humor; pen & ink.

First Contact & Terms Illustrators: Send query letter with photocopies of pen & ink samples. Samples are filed. Responds in 2 months. Buys first rights and reprint rights. **Pays on acceptance**; $200-250 for color cover; $25-35 for b&w inside; $50-70 for 2-page spreads; $10-25 for spots.

Tips "Read our magazine. Send a few samples of work in pen and ink. Everything revolves around a theme. Our theme list is available with SASE."

◨ HORSE ILLUSTRATED

Bowtie, Inc., 3 Burroughs, Irvine CA 92618. (949)855-8822. E-mail: horseillustrated@bowtieinc.com. Web site: www.horseillustrated.com. **Managing Editor:** Elizabeth Moyer. Editor: Moira C. Harris. Estab. 1976. Monthly consumer magazine providing "information for responsible horse owners." Circ. 220,000. Originals are returned after job's completion. Art guidelines on Web site.

Cartoons Approached by 200 cartoonists/year. Buys 1 or 2 cartoons/issue. Prefers satire on horse ownership ("without the trite cliches"); single panel b&w line drawings with gagline.

Illustration Approached by 60 illustrators/year. Buys 1 illustration/issue. Prefers realistic, mature line art, pen & ink spot illustrations of horses. Assigns 10% of illustrations to new and emerging illustrators. Considers pen & ink.

First Contact & Terms Cartoonists: Send query letter with brochure, roughs and finished cartoons. Illustrators: Send query letter with SASE and photographs. Samples are not filed and are returned by SASE. Responds in 6 weeks. Portfolio review not required. Buys first rights or one-time rights. Pays on publication. Pays cartoonists $40 for b&w. Finds artists through submissions.

Tips "We only use spot illustrations for breed directory and classified sections. We do not use much, but if your artwork is within our guidelines, we usually do repeat business. *Horse Illustrated* needs illustrators who know equine anatomy, as well as human anatomy with insight into the horse world."

HORTICULTURE MAGAZINE

98 N. Washington St., Boston MA 02114. (617)742-5600. Fax: (617)367-6364. E-mail: edit@hortmag.com. Web site: www.hortmag.com. **Contact:** Art Director. Estab. 1904. Monthly magazine for all levels of gardeners (beginners, intermediate, highly skilled). "*Horticulture* strives to inspire and instruct avid gardeners of every level." Circ. 300,000. Originals are returned at job's completion. Art guidelines are available.

Illustration Approached by 75 freelance illustrators/year. Buys 10 illustrations/issue. Works on assignment only. Features realistic illustration; informational graphics; spot illustration. Assigns 20% of illustrations to new and emerging illustrators. Prefers tight botanicals; garden scenes with a natural sense to the clustering of plants; people; hands and "how-to" illustrations. Considers all media.

First Contact & Terms Illustrators: Send query letter with brochure, résumé, SASE, tearsheets, slides. Samples are filed or returned by SASE. Publication will contact artist for portfolio review if interested. Buys one-time rights. Pays 1 month after project completed. Payment depends on complexity of piece; $800-1,200 for 2-page spreads; $150-250 for spots. Finds artists through word of mouth, magazines, artists' submissions/self-promotions, sourcebooks, artists' agents and reps, attending art exhibitions.

Tips "I always go through sourcebooks and request portfolio materials if a person's work seems appropriate and is impressive."

◨ HR MAGAZINE

1800 Duke St., Alexandria VA 22314. (703)535-6860. Fax: (703)548-9140. E-mail: janderson@shrm.org. Web site: www.shrm.org. **Art Director:** John Anderson Jr. Estab. 1948. Monthly trade journal dedicated to the field of human resource management. Circ. 165,000.

Illustration Approached by 70 illustrators/year. Buys 6-8 illustrations/issue. Prefers people, management and stylized art. Considers all media.

First Contact & Terms Illustrators: Send query letter with printed samples. Accepts disk submissions. Illustrations can be attached to e-mails. *HR Magazine* is Macintosh based. Samples are filed. Art director will contact

artist for portfolio review if interested. Rights purchased vary according to project. Requires artist to send invoice. Pays within 30 days. Pays $700-2,500 for color cover; $200-1,800 for color inside. Finds illustrators through sourcebooks, magazines, word of mouth and artist's submissions.

HUMPTY DUMPTY'S MAGAZINE

Children's Better Health Institute, Box 567, Indianapolis IN 46206. (317)636-8881. Fax: (317)684-8094. Web site: www.humptydumptymag.org. **Art Director:** Rob Falco. A health-oriented children's magazine for ages 4-7; 4-color; simple and direct design. Published 6 times/year. Circ. 264,000. Originals are not returned at job's completion. Sample copies available for $1.25; art guidelines for SASE with first-class postage.
- Also publishes *Child Life, Children's Digest, Children's Playmate, Jack and Jill, Turtle Magazine* and *U. Kids, A Weekly Reader Magazine*.

Illustration Approached by 300-400 illustrators/year. Buys 10-15 illustrations/issue. Has featured illustrations by John Nez, Kathryn Mitter, Alan MacBain, David Helton and Patti Goodnow. Features humorous, realistic, medical, computer and spot illustration. Assigns 10% of illustrations to new and emerging illustrators. Works on assignment only. Preferred styles are mostly cartoon and some realism. Considers any media as long as finish is done on scannable (bendable) surface.

First Contact & Terms Illustrators: Send query letter with photocopies, tearsheets and SASE. Samples are filed and are not returned. Responds only if interested. To show a portfolio, mail color tearsheets, digital files (Mac), photostats, photographs and photocopies. Buys all rights. Pays on publication; $275 for color cover; $35-90 for b&w inside; $70-155 for color inside; $210-310 for 2-page spreads; $35-80 for spots; additional payment for digital preseparated imagery $35 full; $15 half; $10 spot.

Tips "Please review our publications to see if your style is a match for our needs. Then you may send us very consistent styles of your abilities, along with a comment card and SASE for return."

IDEALS MAGAZINE

A division of Guideposts, 535 Metroplex Dr., Suite 250, Nashville TN 37211. (615)333-0478. Fax: (888)815-2759. Web site: www.idealspublications.com. **Editor:** Marjorie Lloyd. Estab. 1944. 4-color quarterly general interest magazine featuring poetry and text appropriate for the family. Circ. 200,000. Sample copy $4. Art guidelines free with #10 SASE with first-class postage or view on Web site.

Illustration Approached by 100 freelancers/year. Buys 4 or less illustrations/issue. Uses freelancers mainly for flowers, plant life, wildlife, realistic people illustrations and botanical (flower) spot art. Prefers seasonal themes. Prefers watercolors. Assigns 90% of illustrations to experienced illustrators; 10% to new and emerging illustrators. "We are not interested in computer generated art. No electronic submissions."

First Contact & Terms Illustrators: Send nonreturnable samples or tearsheets. Samples are filed. Responds only if interested. Do not send originals. Buys artwork "for hire." Pays on publication; payment negotiable.

Tips "In submissions, target our needs as far as style is concerned, but show representative subject matter. Artists are strongly advised to be familiar with our magazine before submitting samples of work."

IEEE SPECTRUM

3 Park Ave., 17th Floor, New York NY 10016-5902. (212)419-7555. Fax: (212)419-7570. Web site: www.spectrum.ieee.org. **Contact:** Mark Montgomery, senior art director. Estab. 1964. Monthly nonprofit trade magazine serving electrical and electronics engineers worldwide. Circ. 380,000.

Illustration Buys 5 illustrations/issue. Has featured illustrations by John Hersey, David Plunkert, Mick Wiggins. Features charts, graphs, computer illustration, informational graphics, realistic illustration and spot illustration. Preferred subjects business, technology, science. Assigns 25% to new and emerging illustrators. Considers all media.

First Contact & Terms Illustrators: Send postcard sample or query letter with printed samples and tearsheets. Samples are filed and are not returned. Responds only if interested. Art director will contact artist for portfolio review if interested. Do *not* send samples via e-mail. Portfolio should include color, final art and tearsheets. Buys first rights and one year's use on Web site. **Pays on acceptance**; $1,500 minimum for cover; $400 minimum for inside. Finds illustrators through *American Showcase, Workbook*.

Tips "Please visit our Web site and review *Spectrum* before submitting samples. Most of our illustration needs are with 3-D technical diagrams and a few editorial illustrations."

N ILLINOIS ENTERTAINER

124 W. Polk, #103, Chicago IL 60605. (312)922-9333. Fax: (312)922-9369. E-mail: ieeditors@aol.com. **Editor:** Michael C. Harris. Estab. 1974. Sleek consumer/trade-oriented monthly entertainment magazine focusing on local and national alternative music. Circ. 75,000. Accepts previously published artwork. Originals are not returned. Sample copies for SASE with first-class postage.

Illustration Approached by 10-20 freelance illustrators/year. Works on assignment only.

First Contact & Terms Illustrators: Send postcard sample or query letter with photocopies and photographs. Will contact for portfolio review if interested. Buys first rights. Pays on publication; $100-140 for color cover; $20-30 for b&w inside; $20-30 for color inside. Finds artists through word of mouth and submissions.
Tips "Send some clips and be patient."

IMPACT WEEKLY

322 S. Patterson Blvd., Dayton OH 45202. (937)222-8855. Fax: (937)222-6113. E-mail: contactus@impactweekly .com. **Design Coordinator:** Suji Allen. Estab. 1993. Alternative weekly focusing on local news, arts and culture, and music. 50,000 readership. Circ. 25,000. Sample copies free for 8×10 SAE and 5 first-class stamps. Art guidelines are free for #10 SAE with first-class postage.
Illustration Approached by 25 illustrators/year. Buys 30 illustrations/issue. Has featured illustrations by T.S. Hart and Steven Verriest. Features caricatures of celebrities, politicians; computer illustration; humorous, realistic and spot illustration. Preferred subjects. As needed for editorial assignments with strong concepts. Assigns 10% of illustrations to well-known or "name" illustrators; 60% to experienced, but not well-known illustrators; 30% to new and emerging illustrators. 50% of freelance illustration demands knowledge of Illustrator, Photoshop, QuarkXPress, and have scanning skills.
First Contact & Terms Illustrators: Send postcard sample and follow-up postcard every 6 months. Send nonreturnable samples. Accepts Mac-compatible disk submissions. Samples are filed. Responds only if interested. Buys first rights, reprint rights. Negotiates rights purchased. Pays $75-150 for color cover; $35 for b&w inside; $35 for color inside; $35 for spots. Finds illustrators through readers, word of mouth, promos from artists.
Tips "We're looking for freelancers with hip, edgy styles. Ability to meet or exceed deadlines is a *MUST*. Wired artists preferred. Strong conceptual skills required."

INCOME OPPORTUNITIES

5300 City Plex Tower, 2448 E. 81st St., Tulsa OK 74137-4207. (918)491-6100. Fax: (918)491-9424. E-mail: sbrown@natcom-publications.com. Web site: www.incomeops.com. **Contact:** Steven M. Brown. Estab. 1956. Monthly consumer magazine for home-based and small businesses. Circ. 300,000. Originals returned at job's completion. 5% of freelance work demands knowledge of Illustrator/Photoshop.
Illustration Approached by 10 illustrators/year. Buys 10 illustrations/issue. Works on assignment only. Considers watercolor and airbrush.
First Contact & Terms Send sample. Accepts disk submissions compatible with Illustrator 6.0. Samples are filed. Responds to the artist only if interested. To arrange portfolio review artist should follow up with call and letter after initial query. Portfolio should include tearsheets, final art and photographs. Buys one-time rights. Pays on publication; $400-900 for cover art; $350-500 color inside. Finds artists through sourcebooks like *American Showcase*, also through submissions.
Tips "Send mailing cards." Looking for "strong design skills with the experience of previous clients."

THE INDEPENDENT WEEKLY

P.O. Box 2690, Durham NC 27715. (919)286-1972. Fax: (919)286-4274. E-mail: mbshain@indyweek.com. Web site: www.indyweek.com. **Art Director:** Maria Bilinski Shain. Estab. 1982. Weekly b&w with 4-color cover tabloid; general interest alternative. Circ. 50,000. Original artwork is returned if requested. Sample copies and art guidelines for SASE with first-class postage.
Illustration Buys 10-15 illustrations/year. Prefers local (North Carolina) illustrators. Has featured illustrations by Shelton Bryant, V. Cullum Rogers, Nathan Golub. Works on assignment only. Considers pen & ink; b&w, computer generated art and color.
First Contact & Terms Samples are filed or are returned by SASE if requested. Responds only if interested. E-mail for appointment to show portfolio or mail tearsheets. Pays on publication; $150 for cover illustrations; $20 for inside illustrations.
Tips "Have a political and alternative 'point of view.' Understand the peculiarities of newsprint. Be easy to work with. No prima donnas."

INDUSTRYWEEK

1300 E. 9th St., Cleveland OH 44114-1501. (216)931-9488. Fax: (216)696-7670. E-mail: ndankovich@industrywe ek.com. Web site: www.industryweek.com. **Art Director:** Nick Dankovich. Estab. 1882. Weekly business magazine written for industry executives and key decision makers looking for insight into the latest business developments in the manufacturing world. Circ. 200,237.
Illustration Approached by 150 illustrators/year. Buys 75 illustrations/year. Has featured illustrations by Patrick Corrigan, Dave Joly, Vala Kondo. Features humorous, informational and spot illustrations of business. Assigns 10% to new and emerging illustrators. 10% of freelance illustration demands knowledge of Illustrator.
First Contact & Terms Illustrators: Send query letter with URL. After introductory mailing, send follow-up

postcard sample every 2-3 months. Accepts e-mail submissions with link to Web site. Prefers JPEG files. Samples are filed. Responds only if interested. Art Director will contact artist for portfolio review if interested. Pays illustrators $250-700 for color inside. Pays on publication. Buys one-time rights. Finds freelancers through artists' submissions.

INGRAMS MAGAZINE
2049 Wyandotte, Kansas City MO 64108. E-mail: msweeney@ingramsonline.com. Web site: www.ingramsonlin e.com. **Contact:** Michelle Sweeney. Monthly magazine covering business. Circ. 105,000. Art guidelines not available.

Illustration Buys 2 illustrations/issue. Features realistic illustration; charts & graphs and computer and spot illustration. Assigns 20% of illustrations to experienced, but not well-known illustrators; 80% to new and emerging illustrators. Considers all media. 50% of freelance illustration demands knowledge of Photoshop and QuarkXPress. Prefers local talent.

First Contact & Terms Illustrators: Send query letter with printed samples. Samples are filed. Responds only if interested. Art director will contact artist for portfolio review of b&w and color photographs and tearsheets if interested. Rights purchased include reprint rights and Web posting rights. Pays $50/image. Finds illustrators through magazines and artist's submissions.

Tips "Look through our magazine. If you're interested, send some samples. No phone calls please."

ISLANDS
460 N. Orlando Avenue, Suite 200, Winter Park FL 32789. (407)628-4802. Fax: (407)628-7061. E-mail: edito ria;@islands.com. Web site: www.islands.com. **Art Director:** Mike Bessire. Estab. 1981. Published 8 times a year. Magazine of "international travel exclusively about islands." 4-color with contemporary design. Circ. 225,000. Original artwork returned after publication. Sample copies available. Art guidelines for SASE with first-class postage. 100% of freelance work demands knowledge of QuarkXPress, FreeHand, Illustrator and Photoshop.

Illustration Approached by 20-30 illustrators/year. Buys 3-4 illustrations/issue. Needs editorial illustration. No theme or style preferred. Considers all media.

First Contact & Terms Illustrators: Send query letter with brochure, tearsheets, photographs and slides. "We prefer samples of previously published tearsheets." Samples are filed. Responds only if interested. Write for appointment to show portfolio or mail printed samples and color tearsheets. Buys first rights or one-time rights. **Pays on acceptance**; $500-750 for color cover; $100-400 per image inside.

Tips A common mistake freelancers make is that "they show too much, not focused enough. Specialize!" Notices "no real stylistic trends, but desktop publishing is affecting everything in terms of how a magazine is produced."

JACK AND JILL
Children's Better Health Institute, 1100 Waterway Blvd., Box 567, Indianapolis IN 46202. (317)636-8881. Fax: (317)684-8094. Web site: www.jackandjillmag.org. **Art Director:** Greg Vanzo. Emphasizes educational and entertaining articles focusing on health and fitness as well as developing the reading skills of the reader. For ages 7-10. Monthly except bimonthly January/February, April/May, July/August and October/November. Circ. 200,000. Magazine is 36 pages, 30 pages 4-color and 6 pages b&w. The editorial content is 50% artwork. Original artwork not returned after publication (except in case where artist wishes to exhibit the art; art must be available to us on request). Sample copy $1.25; art guidelines for SASE with first-class postage.

● Also publishes *Child Life, Children's Digest, Children's Playmate, Humpty Dumpty's Magazine* and *Turtle.*

Illustration Approached by more than 100 illustrators/year. Buys 25 illustrations/issue. Has featured illustrations by Alan MacBain, Phyllis Pollema-Cahill, George Sears and Mary Kurnick Maacs. Features humorous, realistic, medical, computer and spot illustration. Assigns 15% of illustrations to well-known or "name" illustrators; 70% to experienced but not well-known illustrators; 15% to new and emerging illustrators. Uses freelance artists mainly for cover art, story illustrations and activity pages. Interested in "stylized, realistic, humorous illustrations for mystery, adventure, science fiction, historical and also nature and health subjects. Works on assignment only. "Freelancers can work in FreeHand, Photoshop or Quark programs."

First Contact & Terms Illustrators: Send postcard sample to be kept on file. Accepts disk submissions. Publication will contact artist for portfolio review if interested. Portfolio should include printed samples, tearsheets, b&w and 2-color pre-separated art. Pays $275-335 for color cover; $90 maximum for b&w inside; $155-190 for color inside; $310-380 for 2-page spreads; $35-80 for spots. Company pays higher rates to artists who can provide color-separated art. Buys all rights on a work-for-hire basis. On publication date, each contributor is sent several copies of the issue containing his or her work. Finds artists through artists' submissions and self-promotion pieces.

Tips Portfolio should include "illustrations composed in a situation or storytelling way, to enhance the text

matter. Send samples of published story for which you did illustration work, samples of puzzles, hidden pictures, mazes and self-promotion art. Art should appeal to children first. Artwork should reflect the artist's skill regardless of techniques used. Fresh, inventive colors and characters a strong point. Research publications to find ones that produce the kind of work you can produce. Send several samples (published as well as self-promotion art). The style can vary if there is a consistent quality in the work.''

JACKSONVILLE

534 Lancaster St., Jacksonville FL 32204. (904)358-8330. Fax: (904)358-8668. E-mail: info@jacksonvillemag.c om. Web site: www.jacksonvillemag.com. **Creative Director:** Bronie Massey. Estab. 1983. City/regional lifestyle magazine covering Florida's First Coast. 12 times/yearly with 2 supplements. Circ. 25,000. Originals returned at job's completion. Sample copies available for $5 (includes postage).

Illustration Approached by 50 illustrators/year. Buys 1 illustration every 6 months. Has featured illustrations by Robert McMullen, Jennifer Kalis and Liz Burns. Assigns 75% of illustrations to local experienced but not well-known illustrators; 25% to new and emerging illustrators. Prefers editorial illustration with topical themes and sophisticated style.

First Contact & Terms Illustrators: Send tearsheets. Will accept computer-generated illustrations compatible with Macintosh programs Illustrator and Photoshop. Samples are filed and are returned by SASE if requested. Publication will contact artist for portfolio review if interested. Portfolio should include b&w and color tearsheets and slides. Buys one-time rights. Pays on publication; $600 for color cover; $150-400 for inside depending on scope.

JEWISH ACTION

11 Broadway, New York NY 10004. (212)613-8146. Fax: (212)613-0646. E-mail: ja@ou.org. Web site: www.ou. org/publications/ja/. **Editor:** Nechama Carmel. Art Director: Ed Hamway. Estab. 1986. Quarterly magazine ''published by Orthodox Union for members and subscribers. Orthodox Jewish contemporary issues.'' Circ. 25,000. Sample copies can be seen on Web site.

Cartoons Approached by 2 cartoonists/year. Prefers themes relevant to Jewish issues. Prefers single, double or multiple panel, political, humorous b&w washes and line drawings with or without gaglines.

Illustration Approached by 4-5 illustrators. Considers all media. Assigns 50% of illustrations to experienced but not well-known illustrators; 50% to new and emerging illustrators. Knowledge of Photoshop, Illustrator and QuarkXPress ''not absolutely necessary, but preferred.''

Design Needs freelancers for design and production. Prefers local design freelancers only.

First Contact & Terms Send query letter with photocopies and SASE. Accepts disk submissions. Prefer QuarkXPress TIFF or EPS files. Can send ZIP disk. Samples are not filed and are not returned. Responds only if interested. Art director will contact artist for portfolio review of photographs if interested. Buys one-time rights. Pays within 6 weeks of publication. Pays cartoonists $20-50 for b&w. Pays illustrators $25-75 for b&w, $50-300 for color cover; $50-200 for b&w, $25-150 for color inside. Finds illustrators through submissions.

Tips Looking for ''sensitivity to Orthodox Jewish traditions and symbols.''

JOURNAL OF ACCOUNTANCY

AICPA, Harborside 201 Plaza III, Jersey City NJ 07311. (201)938-3450. E-mail: jcostello@aicpa.org. **Art Director:** Jeryl Ann Costello. Monthly 4-color magazine emphasizing accounting for certified public accountants; corporate/business format. Circ. 400,000. Accepts previously published artwork. Original artwork returned after publication.

Illustration Approached by 200 illustrators/year. Buys 2-6 illustrations/issue. Prefers business, finance and law themes. Accepts mixed media, then pen & ink, airbrush, colored pencil, watercolor, acrylic, oil, pastel and digital. Works on assignment only. 35% of freelance work demands knowledge of Illustrator, QuarkXPress and FreeHand.

First Contact & Terms Illustrators: Send query letter with brochure showing art style. Samples not filed are returned by SASE. Portfolio should include printed samples, and tearsheets. Buys first rights. Pays on publication; $1,200 for color cover; $200-600 for color (depending on size) inside. Finds artists through submissions/self-promotions, sourcebooks and magazines.

Tips ''We look for indications that an artist can turn the ordinary into something extraordinary, whether it be through concept or style. In addition to illustrators, I also hire freelancers to do charts and graphs. In portfolios, I like to see tearsheets showing how the art and editorial worked together.''

JOURNAL OF ASIAN MARTIAL ARTS

821 W. 24th St., Erie PA 16502-2523. (814)455-9517. Fax: (814)455-2726. E-mail: info@goviamedia.com. Web site: www.goviamedia.com. **Publisher:** Michael A. DeMarco. Estab. 1991. Quarterly journal covering all historical and cultural aspects of Asian martial arts. Interdisciplinary approach. College-level audience. Circ. 10,000.

Accepts previously published artwork. Sample copies available for $10. Art guidelines for SASE with first-class postage.

Illustration Buys 60 illustrations/issue. Has featured illustrations by Oscar Ratti, Tony LaMotta and Michael Lane. Features realistic and medical illustration. Assigns 10% of illustrations to new and emerging illustrators. Prefers b&w wash; brush-like Oriental style; line. Considers pen & ink, watercolor, collage, airbrush, marker and charcoal.

First Contact & Terms Illustrators: Send query letter with brochure, résumé, SASE and photocopies. Accepts disk submissions compatible with PageMaker, QuarkXPress and Illustrator. Samples are filed. Responds in 6 weeks. Publication will contact artist for portfolio review if interested. Portfolio should include b&w roughs, photocopies and final art. Buys first rights and reprint rights. Pays on publication; $100-300 for color cover; $10-100 for b&w inside; $100-150 for 2-page spreads.

Tips "Usually artists hear about or see our journal. We can be found in bookstores, libraries or in listings of publications. Areas most open to freelancers are illustrations of historic warriors, weapons, castles, battles—any subject dealing with the martial arts of Asia. If artists appreciate aspects of Asian martial arts and/or Asian culture, we would appreciate seeing their work and discuss the possibilities of collaboration."

JUDICATURE

2700 University Ave., Des Moines IA 50311. E-mail: drichert@ajs.org. Web site: www.ajs.org. **Contact:** David Richert. Estab. 1917. Journal of the American Judicature Society. 4-color bimonthly publication. Circ. 6,000. Accepts previously published material and computer illustration. Original artwork returned after publication. Sample copy for SASE with $1.59 postage; art guidelines not available.

Cartoons Approached by 10 cartoonists/year. Buys 1-2 cartoons/issue. Interested in "sophisticated humor revealing a familiarity with legal issues, the courts and the administration of justice."

Illustration Approached by 20 illustrators/year. Buys 1-2 illustrations/issue. Has featured illustrations by Estelle Carol, Mary Chaney, Jerry Warshaw and Richard Laurent. Features humorous and realistic illustration; charts & graphs; computer and spot illustration. Works on assignment only. Interested in styles from "realism to light humor." Prefers subjects related to court organization, operations and personnel. Freelance work demands knowledge of Quark and FreeHand.

Design Needs freelancers for design. 100% of freelance work demands knowledge of Quark and FreeHand.

First Contact & Terms Cartoonists: Send query letter or e-mail with samples of style and SASE. Responds in 2 weeks. Illustrators: Send query letter, SASE, photocopies, tearsheets or brochure showing art style (can be sent electronically). Publication will contact artist for portfolio review if interested. Portfolio should include roughs and printed samples. Wants to see "black & white and color, along with the title and synopsis of editorial material the illustration accompanied." Buys one-time rights. Negotiates payment. Pays cartoonists $35 for unsolicited b&w cartoons. Pays illustrators $250-375 for 2-, 3- or 4-color cover; $250 for b&w full page, $175 for b&w half page inside; $75-100 for spots. Pays designers by the project.

Tips "Show a variety of samples, including printed pieces and roughs."

KALEIDOSCOPE: Exploring the Experience of Disability Through Literature and the Fine Arts

701 S. Main St., Akron OH 44311-1019. (330)762-9755. E-mail: mshiplett@udsakron.org. Web site: www.udsakron.org. **Editor-in-Chief:** Gail Willmott. Estab. 1979. Black & white with 4-color cover. Semiannual. "Elegant, straightforward design. Explores the experiences of disability through lens of the creative arts. Specifically seeking work by artists with disabilities. Work by artists without disabilities must have a disability focus." Circ. 1,500. Accepts previously published artwork. Sample copy $6; art guidelines for SASE with first-class postage.

Illustration Freelance art occasionally used with fiction pieces. More interested in publishing art that stands on its own as the focal point of an article. Approached by 15-20 artists/year. Has featured illustrations by Dennis J. Brizendine, Deborah Vidaver Cohen and Sandy Palmer. Features humorous, realistic and spot illustration.

First Contact & Terms Illustrators: Send query letter with résumé, photocopies, photographs, SASE and slides. Do not send originals. Prefers high contrast, b&w glossy photos, but will also review color photos or 35mm slides. Include sufficient postage for return of work. Samples are not filed. Publication will contact artist for portfolio review if interested. Acceptance or rejection may take up to a year. Pays $25-100 for color covers; $10-25 for b&w or color insides. Rights revert to artist upon publication. Finds artists through submissions/self-promotions and word of mouth.

Tips "Inquire about future themes of upcoming issues. Considers all mediums, from pastels to acrylics to sculpture. Must be high-quality art."

KANSAS CITY MAGAZINE

118 Southwest Blvd., 3rd Floor, Kansas City MO 64108. (816)421-4111. Fax: (816)221-8350. E-mail: akingsolver @abartapub.com. Web site: www.kcmag.com. **Contact:** Alice Kingsolver, art director. Estab. 1994. Monthly lifestyle-oriented magazine, celebrating living in Kansas City. "We try to look at things from a little different

angle (for added interest) and show the city through the eyes of the people." Circ. 27,000. Sample copies available for #10 SASE with first-class postage. Art guidelines not available.

Illustration Approached by 100-200 illustrators/year. Buys 3-5 illustrations/issue. Works on assignment only. Prefers conceptual editorial style. Considers all media. 25% of freelance illustration demands knowledge of Illustrator and Photoshop.

Design Needs freelancers for design and production. Prefers local freelancers only. 100% of freelance work demands knowledge of Photoshop, Illustrator and QuarkXPress.

First Contact & Terms Illustrators: Send postcard-size sample or query letter with tearsheets, photocopies and printed samples. Designers: Send query letter with printed samples, photocopies, SASE and tearsheets. Accepts disk submissions compatible with Macintosh files (EPS, TIFF, Photoshop, etc.). Samples are filed. Will contact artist for portfolio review if interested. Portfolio should include final art, photographs, tearsheets, photocopies and photostats. Buys reprint rights. **Pays on acceptance**; $500-800 for color cover; $50-200 for b&w, $150-300 for color inside. Pays $50-150 for spots. Finds artists through sourcebooks, word of mouth, submissions.

Tips "We have a high quality, clean, cultural, creative format. Look at magazine before you submit."

KASHRUS MAGAZINE—The Periodical for the Kosher Consumer

P.O. Box 204, Brooklyn NY 11204. (718)336-8544. Fax: (718)336-8550. E-mail: info@kashrusmagazine.com. Web site: www.kashrusmagazine.com. **Editor:** Rabbi Yosef Wikler. Estab. 1980. Bimonthly magazine with 4-color cover which updates consumer and trade on issues involving the kosher food industry, especially mislabeling, new products and food technology. Circ. 10,000. Accepts previously published artwork. Original artwork is returned after publication. Sample copy $2; art guidelines not available.

Cartoons Buys 2 cartoons/issue. Accepts color for cover or special pages. Seeks "kosher food and Jewish humor."

Illustration Buys illustrations mainly for covers. Works on assignment only. Has featured illustrations by R. Keith Rugg and Theresa McCracken. Features humorous, realistic and spot illustration. Assigns 30% of illustrations to new and emerging illustrators. Prefers pen & ink.

First Contact & Terms Send query letter with photocopies. Request portfolio review in original query. Portfolio should include tearsheets. Pays cartoonists $25-35 for b&w; payment is negotiated by project. Pays illustrators $100-200 for color cover; $25-75 for b&w inside; $75-150 for color inside; $25-35 for spots. Finds artists through submissions and self-promotions.

Tips "Send general food or Jewish food- and travel-related material. Do not send off-color material."

KENTUCKY LIVING

P.O. Box 32170, Louisville KY 40232. (502)451-2430. Fax: (502)459-1611. E-mail: e-mail@kentuckyliving.com. Web site: www.kentuckyliving.com. **Editor:** Paul Wesslund. 4-color monthly emphasizing Kentucky-related and general feature material for Kentuckians living outside metropolitan areas. Circ. 500,000. Accepts previously published material. Original artwork returned after publication if requested. Sample copy available.

Cartoons Approached by 10-12 cartoonists/year.

Illustration Buys occasional illustrations/issue. Works on assignment only. Prefers b&w line art.

First Contact & Terms Illustrators: Send query letter with résumé and samples. Samples not filed are returned only if requested. Buys one-time rights. **Pays on acceptance.** Pays cartoonists $30 for b&w. Pays illustrators $50 for b&w inside.

[N] THE KETC GUIDE

3655 Olive St., St. Louis MO 63108. (314)512-9000. Fax: (314)512-9005. Web site: www.ketc.org. **Manager of Art & Design:** Jennifer Snyder. Estab. 1991. Company magazine of KETC/Channel 9. Monthly 4-color cover, 2-color inside program guide going to over 44,000 members of Channel 9, a PBS station. Age group of members is over 25, with a household income of $50,000 average. Circ. 44,000. Accepts previously published artwork. Originals returned at job's completion. Sample copies available. 100% of freelance work demands knowledge of Illustrator, QuarkXPress or Photoshop.

Tips Send printed samples of work to art department manager. "There is no point in cold-calling if we have no visual reference of the work. We have a limited budget, but a high circulation. We offer longer deadlines, so we find many good illustrators will contribute."

KIPLINGER'S PERSONAL FINANCE

1729 H St. NW, Washington DC 20006. (202)887-6416. Fax: (202)331-1206. E-mail: ccurrie@kiplinger.com. Web site: www.kiplinger.com. **Art Director:** Cynthia L. Currie. Estab. 1947. A monthly 4-color magazine covering personal finance issues including investing, saving, housing, cars, health, retirement, taxes and insurance. Circ. 800,000. Originals are returned at job's completion.

Illustration Approached by 350 illustrators/year. Buys 4-6 illustrations/issue. Works on assignment only. Has

featured illustrations by Dan Adel, Tim Bower, Michael Paraskevas, Edwin Fotheringham. Features computer, conceptual editorial and spot illustration. Assigns 5% of illustrations to new and emerging illustrators. Interested in editorial illustration in new styles, including computer illustration.

First Contact & Terms Illustration: Send postcard samples. Accepts Mac-compatible CD submissions. Samples are filed or returned by SASE if requested by artist. Publication will contact artist for portfolio review if interested. Buys one-time rights. Pays on publication; $400-1,200 for color inside; $250-500 for spots. Finds illustrators through reps, online, magazines, *Workbook* and award books.

KIWANIS

3636 Woodview Trace, Indianapolis IN 46268. (317)875-8755. Fax: (317)879-0204. E-mail: magazine@kiwanis. org. Web site: www.kiwanis.org. **Art Director:** Maria Malandrakis. Estab. 1918. 4-color magazine emphasizing civic and social betterment, business, education and domestic affairs for business and professional persons. Published 6 times/year. Original artwork returned after publication by request. Circ. 240,000. Art guidelines available for SASE with first-class postage.

Illustration Buys 1-2 illustrations/issue. Assigns themes that correspond to themes of articles. Works on assignment only. Keeps material on file after in-person contact with artist.

First Contact & Terms Illustration: Include SASE. Responds in 2 weeks. To show a portfolio, mail appropriate materials (out of town/state) or call or write for appointment. Portfolio should include roughs, printed samples, final reproduction/product, color and b&w tearsheets, photostats and photographs. Buys first rights. **Pays on acceptance**; $600-1,000 for cover; $400-800 for inside; $50-75 for spots. Finds artists through talent sourcebooks, references/word of mouth and portfolio reviews.

Tips "We deal direct—no reps. Have plenty of samples, particularly those that can be left with us. Too many student or unassigned illustrations in many portfolios."

L.A. PARENT MAGAZINE

443 E. Irving Dr., Suite A, Burbank CA 91504-2447. (818)846-0400. Fax: (818)841-4964. E-mail: carolyn.graham @parenthood.com. Web site: www.laparent.com. **Editor:** Carolyn Graham. Estab. 1979. Magazine. A monthly regional magazine for parents. 4-color throughout; "bold graphics and lots of photos of kids and families." Circ. 120,000. Accepts previously published artwork. Originals are returned at job's completion.

Illustration Buys 2 freelance illustrations/issue. Assigns 50% of illustrations to experienced but not well-known illustrators; 50% to new and emerging illustrators. Works on assignment only. Send postcard sample. Accepts disk submissions compatible with Illustrator 5.0 and Photoshop 3.0. Samples are filed or returned by SASE. Responds in 2 months. To show a portfolio, mail thumbnails, tearsheets and photostats. Buys one-time rights or reprint rights. **Pays on publication**; $300 color cover; $75 for b&w inside; $50 for spots.

Tips "Show an understanding of our publication. Since we deal with parent/child relationships, we tend to use fairly straightforward work. Also looking for images and photographs that capture an L.A. feel. Read our magazine and find out what we're all about."

Ⓝ LADIES HOME JOURNAL

125 Park Ave. 20th Flr., New York NY 10017-8501. (212)455-1293. Fax: (212)455-1313. E-mail: support@lhj.c om. Web site: www.lhj.com. **Art Director:** Scott Yardley. Estab. 1883. Monthly consumer magazine celebrates the rich values of modern family life. Topics include beauty, fashion, nutrition, health, medicine, home decorating, parenting, self-help, personalities and current events. Circ.: 412,087. Art guidelines available on Web site.

Cartoons Prefer single panel, humorous and color washes.

Illustration Features caricatures of celebrities, humorous illustration and spot illustrations of families, women and pets.

First Contact & Terms Cartoonists: Send query letter with photocopies. Illustrators: Send postcard sample with URL. After introductory mailing, send follow-up postcard sample every 3-6 months. Samples are filed. Responds only if interested. Pays illustrators $200-500 for color inside. Buys one-time rights. Finds freelancers through artists' submissions and sourcebooks.

LADYBUG, the Magazine for Young Children

P.O. Box 300, Peru IL 61354. **Art Director:** Suzanne Beck. Estab. 1990. Monthly 4-color magazine emphasizing children's literature and activities for children, ages 2-6. Design is "geared toward maximum legibility of text and basically art-driven." Circ. 140,000. Accepts previously published material. Original artwork returned after publication. Sample copy $4.95 plus 10% of total order ($4 minimum) for shipping and handling; art guidelines for SASE with first-class postage.

Illustration Approached by 600-700 illustrators/year. Works with 40 illustrators/year. Buys 200 illustrations/ year. Has featured illustrations by Rosemary Wells, Tomie de Paola and Diane de Groat. Uses artists mainly

for cover and interior illustration. Prefers realistic styles (animal, wildlife or human figure); occasionally accepts caricature. Works on assignment only.
First Contact & Terms Illustrators: Send query letter with photocopies, photographs and tearsheets to be kept on file, "if I like it." Prefers photocopies and tearsheets as samples. Samples are returned by SASE if requested. Publication will contact artist for portfolio review if interested. Portfolio should show a strong personal style and include "several pieces that show an ability to tell a continuing story or narrative." Does not want to see "overly slick, cute commercial art (i.e., licensed characters and overly sentimental greeting cards)." Buys all rights. **Pays 45 days after acceptance**; $750 for color cover; $250 for color full page; $100 for color, $50 for b&w spots.
Tips "Has a need for artists who can accurately and attractively illustrate the movements for finger-rhymes and songs and basic informative features on nature and 'the world around you.' Multiethnic portrayal is also a *very* important factor in the art for *Ladybug*."

[N] LATINA
1500 Broadway #700, New York NY 10036-4055. (212)642-0200. Fax: (917)777-0861. E-mail: rgeorge@latina.com. Web site: www.latina.com. **Art Director:** Rob George. Estab. 1996. Monthly consumer magazine for Hispanic women living in the United States who has strong ties to her Latin roots. Features articles on successful Latina women, health, careers, family life, fitness, parenting, fashion, beauty and entertainment. Circ.: 397,447.
Illustration Approached by 100 illustrators/year. Buys 10-15 illustrations/year. Features caricatures of Hispanic celebrities, humorous illustration and spot illustrations of families and women. Assigns 25% to new and emerging illustrators.
First Contact & Terms Illustrators: Send postcard sample with URL. After introductory mailing, send follow-up postcard sample every 4-6 months. Responds only if interested. Pays illustrators $100-400 for color inside. Buys one-time rights. Find freelancers through artists' submissions.

LAW PRACTICE MANAGEMENT
24476 N. Echo Lake Rd., Hawthorn Woods IL 60047-9039. (847)550-9790. Fax: (847)550-9794. E-mail: mark@feldcomm.com. Web site: www.abanet.org/lpm. **Art Director:** Mark Feldman, Feldman Communications, Inc. 4-color trade journal for the practicing lawyer about "the business of practicing law." Estab. 1975. Published 8 times/year. Circ. 20,833.
Illustration Uses cover and inside feature illustrations. Uses all media, including computer graphics. Mostly 4-color artwork.
First Contact & Terms Illustrators: Send postcard sample or query letter with samples. Pays on publication. Very interested in high quality, previously published works. Pay rates $200-350/illustration. Original works negotiable. Cartoons very rarely used.
Tips "Topics focus on management, marketing, communications and technology."

LOG HOME LIVING
4125 Lafayette Center Dr., Suite 100, Chantilly VA 20151. (800)826-3893 or (703)222-9411. Fax: (703)222-3209. E-mail: ssilver@homebuyerpubs.com. Web site: www.loghomeliving.com. **Design Director:** Sylvia Silver. Estab. 1989. Monthly 4-color magazine "dealing with the aspects of buying, building and living in a log home. We emphasize upscale living (decorating, furniture, etc)." Circ. 108,000. Accepts previously published artwork. Sample copies not available. Art guidelines for SASE with first-class postage. 20% of freelance work demands knowledge of QuarkXPress, Illustrator and Photoshop.
• Also publishes *Timber Home Living*, *Log Home Design Ideas* and *Building Systems*.
Illustration Buys 2-4 illustrations/issue. Works on assignment only. Prefers editoral illustration with "a strong style—ability to show creative flair with not-so-creative a subject." Considers watercolor, airbrush, colored pencil, pastel and digital illustration.
Design Needs freelancers for design and production occasionally. 100% of freelance work demands knowledge of Photoshop, Illustrator, QuarkXPress and InDesign.
First Contact & Terms Illustrators: Send postcard sample. Designers: Send query letter with brochure, résumé, and samples. Accepts disk submissions compatible with Illustrator, Photoshop and QuarkXPress. Samples are filed. Publication will contact artist for portfolio review if interested. Portfolio should include thumbnails, roughs, printed samples or color tearsheets. Buys all rights. **Pays on acceptance**. Pays illustrators $100-200 for b&w inside; $250-800 for color inside; $100-250 for spots. Pays designers by the project. Finds artists through submissions/self-promotions, sourcebooks.

THE LOOKOUT
8121 Hamilton Ave., Cincinnati OH 45231. (513)728-6866. Fax: (513)931-0950. E-mail: lookout@standardpub.com. Web site: www.lookoutmag.com. **Administrative Assistant:** Sheryl Overstreet. Weekly 4-color magazine

for conservative Christian adults and young adults. Circ. 85,000. Sample copy available for $1.

Illustration Prefers both humorous and serious, stylish illustrations featuring Christian families. We no longer publish cartoons.

First Contact & Terms Illustrators: Send postcard or other nonreturnable samples.

Tips Do not send e-mail submissions.

LOS ANGELES MAGAZINE

5900 Wilshire Blvd., 10th Floor, Los Angeles CA 90036. (323)801-0075. Fax: (323)801-0106. Web site: www.losangelesmagazine.com. **Art Director:** Joe Kimberling. Monthly 4-color magazine with a contemporary, modern design, emphasizing lifestyles, cultural attractions, pleasures, problems and personalities of Los Angeles and the surrounding area. Circ. 170,000. Especially needs very localized contributors—custom projects needing person-to-person concepting and implementation. Previously published work OK. Sample copy $3.10% of freelance work demands knowledge of QuarkXPress, Illustrator and Photoshop.

Illustration Buys 10 illustrations/issue on assigned themes. Prefers general interest/lifestyle illustrations with urbane and contemporary tone. To show a portfolio, send or drop off samples showing art style (tearsheets, photostats, photocopies and dupe slides).

First Contact & Terms Pays on publication; negotiable.

Tips "Show work similar to that used in the magazine. Study a particular publication's content, style and format. Then proceed accordingly in submitting sample work. We initiate contact of new people per *Showcase* reference books or promo fliers sent to us. Portfolio viewing is all local."

N LUCKY

4 Times Square 8th Flr., New York NY 10036-6518. (212)286-2860. Fax: (212)286-8063. E-mail: jenifer_walter@condenast.com. Web site: www.luckymag.com. **Art Director:** Jenifer Walter. Estab. 2002. Monthly consumer magazine focusing on shopping, fashion, beauty, lifestyles. Provides upbeat, practical tips on shopping, latest fashion accessories and new items. Circ.: 1,024,000.

Illustration Approached by hundreds of illustrators/year. Buys 35 illustrations/year. Features fashion illustration, humorous illustration and spot illustrations of women.

First Contact & Terms Illustrators: Send postcard sample or e-mail with link to Web site. After introductory mailing, send follow-up postcard sample every 3-6 months. Samples are filed. Responds only if interested. Pays illustrators $200-500 for color inside. Buys one-time rights. Find freelancers through sourcebooks.

THE LUTHERAN

8765 W. Higgins Rd., Chicago IL 60631-4101. (773)380-2540. Fax: (773)380-2751. E-mail: lutheran@thelutheran.org. Web site: www.thelutheran.org. **Art Director:** Michael D. Watson. Estab. 1988. Monthly general interest magazine of the Evangelical Lutheran Church in America; 4-color, "contemporary" design. Circ. 400,000. Previously published work OK. Original artwork returned after publication on request. Free sample copy for 9×12 SASE and 5 first-class stamps. Freelancers should be familiar with Illustrator, QuarkXPress or Photoshop. Art guidelines available.

Cartoons Approached by 100 cartoonists/year. Buys 2 cartoons/issue from freelancers. Interested in humorous or thought-provoking cartoons on religion or about issues of concern to Christians; single panel b&w washes and line drawings with gaglines. Prefers finished cartoons.

Illustration Buys 6 illustrations/year from freelancers. Has featured illustrations by Rich Nelson, Jimmy Holder, Michael D. Watson. Assigns 30% of illustrations to well-known or "name" illustrators; 70% to experienced but not well-known illustrators. Works on assignment. Does not use spots.

First Contact & Terms Cartoonists: Send query letter with photocopies of cartoons and SASE. Illustrators: Send query letter with brochure and tearsheets to keep on file for future assignments. Buys one-time usage of art. Will return art if requested. Responds usually within 2 weeks. Accepts disk submississions compatible with Illustrator 5.0. Samples returned by SASE if requested. Portfolio review not required. Pays on publication. Pays cartoonists $50-100 for b&w line drawings and washes. Pays illustrators $600 for color cover; $150-350 for b&w, $500 for color inside. Finds artists mainly through submissions.

Tips "Include your phone number with submission. Send samples that can be retained for future reference. We are partial to computer illustrations. Would like to see samples of charts and graphs. Want professional looking work, contemporary, not too wild in style."

N MA: MANAGING AUTOMATION

5 Penn Plaza 9th Flr., New York NY 10001-1860. (212)629-1519. E-mail: rclark@thomaspublishing.com. Web site: www.managingautomation.com. **Art Director:** Robert Clark. Estab. 1986. Monthly business magazine written for personnel involved in computer integrated manufacturing. Covers technical, financial and organizational concerns. Circ. 100,115.

Illustrations Approached by 50 illustrators/year. Buys 10 illustrations/year. Features humorous, informational and spot illustrations of computers and business. Assigns 10% to new and emerging illustrators. 20% of freelance illustration demand knowledge of Illustrator and Photoshop.

First Contact & Terms Illustrators: Send postcard sample with URL. After introductory mailing, send followup postcard sample every 6 months. Accepts e-mail submissions with link to Web site. Prefers TIFF files. Samples are filed. Responds only if interested. Company will contact artist for portfolio review if interested. Pays $200-500 for color inside. Pays on publication. Buys one-time rights. Finds freelancers through artists' submissions.

MAD MAGAZINE/MAD KIDS

1700 Broadway, New York NY 10019. (212)506-4850. Fax: (212)506-4848. Web site: www.madmag.com. **Art Director:** Sam Viviano. Associate Art Directors: Nadina Simon, Patty Dwyer. Assistant Art Director: Ryan Flanders. Monthly irreverent humor, parody and satire magazine. Estab. 1952. Circ. 250,000.

Illustration Approached by 300 illustrators/year. Works with 50 illustrators/year. Has featured illustrations by Mort Drucker, All Jaffe, Sergio Aragones, Peter Kuper, Drew Friedman, Tom Richmond and Hermann Mejia. Features humor, realism, caricature.

First Contact & Terms Illustrators: Send query letter with tearsheets and SASE. Samples are filed. Buys all rights. Pays $2,000-$3,200 for color cover; $300-$800 for inside. Finds illustrators through direct mail, sourcebooks (all).

Design Uses local freelancers for design infrequently. 100% of freelance design demands knowledge of Illustrator, Photoshop and QuarkXPress.

Tips "Know what we do! *MAD* is very specific. Everyone wants to work for *MAD*, but few are right for what *MAD* needs! Understand reproduction process, as well as 'give-and-take' between artist and client."

MANAGED CARE

780 Township Line Rd., Yardley PA 19067. (267)685-2788. Fax: (267)685-2966. Web site: www.managedcarema g.com. **Art Director:** Philip Denlinger. Estab. 1992. Monthly trade publication for healthcare executives. Circ. 60,000.

Illustration Approached by 50 illustrators/year. Buys 3 illustrations/issue. Has featured illustrations by Theo Rudnak, David Wilcox, Gary Overacre, Roger Hill. Features informational graphics, realistic and spot illustration. Prefers business subjects. Assignments for illustrations divided equally between well-known or name illustrators; experienced, but not well-known, illustrators; and new and emerging illustrators.

First Contact & Terms Send postcard sample. Samples are filed. Will contact artist for portfolio review if interested. Rights purchased vary according to project. **Pays on acceptance**; $1,500-2,000 for color cover; $250-750 for color inside; $450 for spots. Finds illustrators through *American Showcase* and postcards.

MARKETING MAGAZINE

One Mount Pleasant Rd. 7th Flr., Toronto ON M4Y 2Y5. (416)764-2000. Fax: (416)764-1519. E-mail: peter.zaver @marketingmag.rogers.com. Web site: www.marketingmag.ca. **Art Director:** Peter Zaver. Estab. 1980. Weekly trade publication featuring news, commentary and articles on advertising, promotion, direct marketing, public relations and digital marketing in Canada. Circ.: 13,000. Sample copies available on request. Art guidelines available on Web site.

Illustration Approached by 150 illustrators/year. Buys 10 illustrations/year. Features humorous illustration and spot illustrations of business.

First Contact & Terms Illustrators: Send postcard sample with tearsheets. Responds only if interested. Pays illustrators $100-200 for inside. Buys one-time rights.

MBUSINESS

600 Harrison St., San Francisco CA 94107. (415)947-6212. Fax: (415)947-6029. E-mail: ptucker@cmp.com. Web site: www.mbusinessdaily.com. **Contact:** Peter Tucker, art director. Estab. 2000. Monthly trade publication bringing cutting-edge mobile news, analysis and trends to the mobile phone and handheld computer industry.

Illustration Has featured illustrations by Keith Negley, Eldon Doty, A.I. Garces and Regan Dunnick. Features humorous illustration and informational graphics. Preferred subjects business subjects, men and women. Assigns 90% to experienced, but not well-known illustrators; 10% to new and emerging illustrators.

First Contact & Terms Illustrators: Send postcard sample and nonreturnable samples. Buys one-time rights. Pays $200-450 for color inside; $100-300 for spots. Finds illustrators through *Creative Black Book* and artists promotional samples.

Ⓝ MEDICAL ECONOMICS—PRIMARY CARE EDITION

5 Paragon Dr., Montvale NJ 07645-1725. (973)847-5343. Fax: (973)847-5390. E-mail: rsiani@advanstar.com. Web site: www.memag.com. **Art Director:** Robert Siani. Cartoon Editor: Jeanne Sabatie. Semi-monthly trade publication for physicians in office, group and managed care practices. Circ.: 168,000.

Illustration Buys 10 illustrations/year. Features spot illustrations of families, doctors, nurses and assistants.

First Contact & Terms Cartoonists: Send b&w photocopies. Illustrators: Send postcard sample. After introductory mailing, send follow-up postcard sample every 6 months. Buys one-time rights. Finds freelancers through artists' submissions and sourcebooks.

MEN'S HEALTH

733 Third Ave., 15th Floor, New York NY 10017. (212)697-2040. Fax: (212)682-2273. Web site: www.menshealth.com. **Art Director:** George Karabotsos. Art guidelines not available.

Cartoons Buys 10 cartoons/year.

Illustration Buys 100 illustrations/year. Has featured illustrations by Daniel Adel, Gary Taxali, Eboy, Mirkoilic, Jonathon Carlson. Features caricatures of celebrities/politicians, realistic illustration, charts & graphs, humorous illustration, medical illustration, computer illustration, informational graphics, spot illustrations. Prefer subjects about men. 100% of freelance work demands computer skills. Freelancers should be familiar with InDesign, Illustrator, Photoshop. E-mail submissions accepted with link to Web site. Samples are not filed and are not returned. Portfolio not required.

METROKIDS

4623 S. Broad St., Philadelphia PA 19112. (215)291-5560. Fax: (215)291-5563. Web site: www.metrokids.com. **Art Director:** Tracy Rucher. Estab. 1990. Monthly parenting tabloid. Circ. 125,000. Accepts previously published artwork. Sample copy free for 3 first-class stamps. Art guidelines free for SASE with first-class postage. Needs computer-literate freelancers for illustration.

Cartoons Approached by 12 cartoonists/year. Buys 1 cartoon/issue. Prefers parenting issues or kids' themes; single panel b&w line drawings.

Illustration Approached by 50 illustrators/year. Buys 100/year. Prefers parenting issues or kids' themes. Considers pen & ink.

First Contact & Terms Send query letter with tearsheets, SASE and photocopies. Samples are filed or returned by SASE if requested by artist. Responds in 3 months. Portfolio review not required. Buys reprint rights. Pays on publication. Pays cartoonists $25 for b&w. Pays illustrators $50 for color cover; $25 for b&w inside.

Ⓝ METROSPORTS MAGAZINE

1450 Randolph, Chicago IL 60607-1414. (312)421-1551. Fax: (312)421-1454. E-mail: Rsedge@windycitysportsmag.com. Web site: www.metrosports.com. **Art Director:** Stacey Edge. Estab. 1986. Monthly tabloid, b&w with 4-color cover and center. Features multiple recreational sports coverage New York metro, Boston, Washington, Philadelphia and Connecticut markets in separate editions. Circ. 200,000. Accepts previously published artwork. Originals are returned at job's completion. Art guidelines for SASE with first-class postage. Needs computer-literate freelancers for design.

Cartoons Approached by 300 cartoonists/year. Preferred theme is recreational (not team) sports.

Illustration Approached by 600 illustrators/year. Prefers line drawings, pen & ink and marker.

First Contact & Terms Cartoonists: Send query letter with brochure and roughs. Negotiates rights purchased. Illustrators: Send query letter with photographs or photocopies. Samples are filed. Responds only if interested. To show portfolio, mail photocopies. Buys one-time rights. Pays on publication.

Tips "We look for contemporary and original look."

MGW MAGAZINE

(formerly Mom Guess What Magazine) 1103 T. St., Sacramento CA 95814. (916)441-6397. Fax: (916)441-6422. E-mail: info@mgwnews.com. Web site: www.mgwnews.com. **Publisher/Editor:** Linda Birner. Estab. 1978. Semi-monthly newspaper "for gays/lesbians." Circ. 21,000. Sample copies for 10×13 SASE and 4 first-class stamps. Art guidelines for #10 SASE with first-class postage.

Cartoons Approached by 15 cartoonists/year. Buys 5 cartoons/issue. Prefers gay/lesbian themes. Prefers single and multiple panel political, humorous b&w line drawings with gagline.

Pays cartoonists $5-50 for b&w.

Illustration Approached by 10 illustrators/year. Buys 3 illustrations/issue. Has featured illustrations by Andy Markley and Tim Brown. Features caricatures of celebrities; humorous, realistic and spot illustration. Assigns 50% of illustration to new and emerging illustrators. Prefers gay/lesbian themes. Considers pen & ink. 50% of freelance illustration demands knowledge of PageMaker.

Design Needs freelancers for design and production. Prefers local design freelancers. 100% of freelance work demands knowledge of PageMaker 6.5, QuarkXPress, Photoshop, Freehand, InDesign.

First Contact & Terms Cartoonists: Send query letter with photocopies and SASE. Illustrators: Send query letter with photocopies. Art director will contact artist for portfolio review of b&w photostats if interested. Rights purchased vary according to project. Pays on publication; $100 for b&w or color cover; $10-100 for b&w or color inside; $300 for 2-page spreads; $25 for spots. Finds illustrators through word or mouth and artist's submissions.

Tips "Send us copies of your ideas that relate to gay/lesbian issues, serious and humorous."

MICHIGAN OUT OF DOORS

P.O. Box 30235, Lansing MI 48909. (517)371-1041. Fax: (517)371-1505. E-mail: magazine@mucc.org. Web site: www.mucc.org. **Contact:** Tony Hansen. 4-color magazine emphasizing outdoor recreation, especially hunting and fishing, conservation and environmental affairs. Circ. 80,000. "Conventional" design. Art guidelines available free for SASE. Sample copy $3.50.

Illustration "Following the various hunting and fishing seasons, we have a limited need for illustration material; we consider submissions 6-8 months in advance." Has featured illustrations by Ed Sutton and Nick Van Frankenhuyzen. Assigns 10% of illustrations to new and emerging illustrators.

First Contact & Terms Responds as soon as possible. **Pays on acceptance**; $30 for pen & ink illustrations in a vertical treatment.

MID-AMERICAN REVIEW

English Dept., Bowling Green State University, Bowling Green OH 43403. (419)372-2725. Web site: www.bgsu. edu/midamericanreview. **Contact:** Editor-in-Chief. Estab. 1980. Semiannual literary magazine publishing "the best contemporary poetry, fiction, essays, and work in translation we can find. Each issue includes poems in their original language and in English." Circ. 700. Originals are returned at job's completion. Sample copies available for $5.

Illustration Approached by 10-20 illustrators/year. Buys 1 illustration/issue.

First Contact & Terms Send query letter with brochure, SASE, tearsheets, photographs and photocopies. Samples are filed or are returned by SASE if requested by artist. Responds in 3 months. Buys first rights. Pays on publication. Pays $50 when funding permits. Also pays in copies, up to 20.

Tips "*MAR* only publishes artwork on its cover. We like to use the same artist for one volume (two issues). We are looking for full-color artwork for a front-to-back, full bleed effect. Visit our Web site!"

Ｎ THE MILITARY OFFICER

201 N. Washington St., Alexandria VA 22314. (703)549-2311. Web site: www.moaa.org. **Art Director:**Debbie Pickering. Estab. 1945. Four-color magazine for retired and active duty military officers of the uniformed services; concerns current military/political affairs; recent military history, especially Vietnam, Korea and Iraq; holiday anecdotes; travel; human interest; humor; hobbies; second-career job opportunities and military family lifestyle.

Illustration Works with 9-10 illustrators/year. Buys 15-20 illustrations/year. Buys illustrations on assigned themes. Uses freelancers mainly for features and covers.

First Contact & Terms Send samples.

Tips "We look for artists who can take a concept and amplify it editorially."

Ｎ MODEL RAILROADER

P.O. Box 1612, 21027 Crossroads Circle, Waukesha WI 53187. (414)786-8776. Fax: (414)796-1778. E-mail: tlund@kalmbach.com. Web site: www.modelrailroader.com. **Art Director:** Thomas Danneman. Monthly magazine for hobbyists, rail fans. Circ. 230,000. Sample copies available for 9×12 SASE with first-class postage. Art guidelines available.

- Published by Kalmbach Publishing. Also publishes *Classic Toy Trains*, *Astronomy*, *Finescale Modeler*, *Model Retailer*, *Nutshell News* and *Trains*.

Cartoons Prefers railroading themes. Prefers b&w line drawings with gagline.

Illustration Prefers railroading, construction, how-to. Considers all media. 90% of freelance illustration demands knowledge of Photoshop 3.0, Illustrator 6.0, FreeHand 3.0, QuarkXPress 3.31 and Fractal Painter.

First Contact & Terms Cartoonists: Send photocopies and tearsheets. Responds only if interested. Buys one-time rights. **Pays on acceptance**; $30 for b&w cartoons. Illustrators: Send query letter with printed samples, photocopies, SASE and tearsheets. Accepts disk submissions compatible with QuarkXPress 5.5. (Send EPS files.)

Call first. Samples are filed and are not returned. Will contact for portfolio review of final art, photographs and thumbnails if interested. Buys all rights. Pays on publication; negotiable.

ℕ MODERN REFORMATION MAGAZINE

1716 Spruce St., Philadelphia PA 19103. (215)546-3696. Fax: (215)735-5133. E-mail: modref@alliancenet.org. Web site: www.modernreformation.org. **Design and Layout:** Lori Cook. Managing Editor: Eric Candry. Estab. 1991. Bimonthly b&w theological magazine from a reformational perspective. Circ. 10,000. Sample copies and art guidelines for 9×12 SASE and 5 first-class stamps.

Illustration Buys 5 illustrations/issue. Has featured illustrations by Corey Wilkinson. Features charts & graphs, realistic, religious and spot illustration. Preferred subjects religious. Prefers scratchboard, pen & ink, realism. Assigns 75% of illustrations to new and emerging illustrators; 25% to experienced, but not well-known illustrators. 25% of freelance illustration demands knowledge of Illustrator, Photoshop and QuarkXPress.

First Contact & Terms Illustrators: Send query letter with photocopies. Accepts Mac-compatible disk submissions. Samples are filed. Will contact artist for portfolio review if interested. Buys one-time rights. **Pays on acceptance.**$150 minimum for b&w inside. Finds illustrators through artists' promo samples.

Tips ''Knowledge of theological issues helpful; quick turnaround and reliability a must.''

MOMENT

4710 41st St. NW, Washington DC 20016-1706. (202)364-3300. Fax: (202)364-2636. Web site: www.moment mag.com. **Contact:** Josh Rolnick, associate editor. Art Directors: Ron Mele and Daryl Wakeley. Estab. 1973. Bimonthly Jewish magazine, featuring articles on religion, politics, culture and Israel. Circ. 65,000. Accepts previously published artwork. Originals returned at job's completion. Sample copies available for $4.50.

Cartoons Uses reprints and originals. Prefers political themes relating to Middle East, Israel and contemporary Jewish life.

Illustration Buys 5-10 illustrations/year. Works on assignment only.

First Contact & Terms Send query letter. Samples are filed. Responds only if interested. Rights purchased vary according to project. Pays cartoonists minimum of $30 for ¼ page, b&w and color. Pays illustrators $30 for b&w, $225 for color cover; $30 for color inside (¼ page or less).

Tips ''We look for specific work or style to illustrate themes in our articles. Please know the magazine— read back issues!''

MONEY

Time & Life Bldg. Rockefeller Cntr., New York NY 10020-1393. (212)522-0930. Fax: (212)522-1796. Web site: www.money.com. **Contact:** Syndi Becker, art director. Deputy Art Director: Mary Ann Salvato Jones. Estab. 1972. Monthly 4-color consumer magazine. Circ. 1,000,000.

Illustration Approached by tons of illustrators/year. Buys 34 illustrations/issue. Features caricatures of business people, CEOs of visible companies, charts & graphs, humorous and spot illustrations of men and women. Assigns 10% of illustrations to well-known or ''name'' illustrators; 90% to experienced, but not well-known illustrators.

First Contact & Terms Illustrators: Send query letter with 5 or 6 printed samples. Samples are not returned. Responds only if interested. Will contact artist for portfolio review if interested. Buys one-time rights. Pays $250-750 for spots. Finds illustrators through *Creative Black Book*, *LA Workbook*, artists' promotional samples.

Tips Because our publication is photo-driven, we don't use as much illustration as we'd like—but we love illustration. The trouble with some beginning illustrators is that they do not yet have the consistency of style that's so important in editorial work. I'll get a sample I love, ask to see more, and the illustrator shows work that's all over the place in terms of style. And I'll think ''Oh, this isn't anything I like, the sample I liked,'' and won't hire that illustrator. Make sure your samples show that there is consistency in your work.

MONTANA MAGAZINE

P.O. Box 5630, Helena MT 59604. (406)444-5100. Fax: (406)443-5480. Web site: www.montanamagazine.com. **Editor:** Beverly R. Magley. Estab. 1970. Bimonthly magazine covering Montana recreation, history, people, wildlife. Geared to Montanans. Circ. 40,000.

Illustration Approached by 15-20 illustrators/year. Buys 1-2 illustrations/year. Prefers outdoors. Considers all media. Knowledge of Quark, Photoshop, Illustrator helpful but not required. Send query letter with photocopies. Accepts disk submissions compatible with Quark.

First Contact & Terms Illustrators: Send EPS files. Samples are filed and are not returned. Buys one-time rights. Pays on publication; $50-125 for color. Pays $35-50 for spots. Finds illustrators through submissions, word of mouth.

Tips ''We work with local artists usually because of convenience and turnaround.'' No cartoons.

MORE

125 Park Ave. 25th Flr., New York NY 10017-5529. (212)557-6600. Fax: (212)455-1313. E-mail: more@mdp.com. Web site: www.more.com. **Creative Director:** Maxine Davidowitz. Estab. 1998. Monthly publication focuses on the smart and sophisticated women addressing real life concerns, such as changing role of women in society with advice on self-improvement, health, fashion and style. Art guidelines available on Web site.

Illustration Buys 20 illustrations/year. Features fashion and humorous illustration of men and women, health, relationships, office, politics and the sophisticated look.

First Contact & Terms Illustrators: Send postcard sample. After introductory mailing, send follow-up postcard sample every 6 months. Accepts e-mail submission with link to Web site. Samples are filed. Responds only if interested. Company will contact artist for portfolio review if interested. Pays illustrators $200 for spot illustrations. Finds freelancers through artists' submissions and sourcebooks.

THE MORGAN HORSE

122 Bostwick Rd., Shelburne VT 05482. (802)985-4944. Fax: (802)985-8897. Web site: www.morganhorse.com. **Contact:** Art Director. Emphasizes all aspects of Morgan horse breed including educating Morgan owners, trainers and enthusiasts on breeding and training programs; the true type of the Morgan breed; techniques on promoting the breed; how-to articles; as well as preserving the history of the breed. Monthly. Circ. 4,500. Accepts previously published material, simultaneous submissions. Original artwork returned after publication. Sample copy $4.

Illustration Approached by 10 illustrators/year. Uses artists mainly for editorial illustration and mechanical production. "Line drawings are most useful for magazine work. We also purchase art for promotional projects dealing with the Morgan horse; horses must look like *Morgans*."

First Contact & Terms Illustrators: Send query letter with samples and tearsheets. Accepts "anything that clearly shows the artist's style and craftsmanship" as samples. Buys all rights or negotiates rights purchased. **Pays on acceptance**; $25-100 for b&w; $100-300 for color inside.

Tips As trend sees "more of an effort on the part of art directors to use a broader style. Magazines seem to be moving toward more interesting graphic design. Our magazine design is a sophisticated blend of conservative and tasteful contemporary design. While style varies, the horses in our illustrations must be unmistakably Morgans."

MOTHER JONES

731 Market St., Suite 600, San Francisco CA 94103. (415)665-6637. Fax: (415)665-6696. Web site: www.motherjones.com. **Design Director:** Jane Palecek. Estab. 1976. Bimonthly magazine. Focuses on investigative journalism, progressive politics and exposes. Circ. 201,233. Accepts previously published artwork. Originals returned at job's completion. Sample copies available.

Cartoons Approached by 25 cartoonists/year. Prints one cartoon/issue (6/year). Prefers full page, multiple-frame color drawings. Works on assignment only.

Illustration Approached by hundreds of illustrators/year. Has featured illustrations by Gary Baseman, Chris Ware, Juliette Borda and Gary Panter. Assigns 90% of illustrations to well-known or "name" illustrators; 5% to experienced but not well-known illustrators; 5% to new and emerging illustrators. Works on assignment only. Considers all media.

First Contact & Terms Cartoonists: Send query letter with postcard-size sample or finished cartoons. Illustrators: Send postcard-size sample or query letter with samples. Samples are filed or returned by SASE. Responds to the artist only if interested. Portfolio should include photographs, slides and tearsheets. Buys first rights. Pays on publication; payment varies widely. Finds artists through illustration books, other magazines, word of mouth.

MOTHERING MAGAZINE

P.O. Box 1690, Santa Fe NM 85504. (505)984-6287. E-mail: laurat@mothering.com. Web site: www.mothering.com. **Contact:** Laura Egley Taylor, art director. Estab. 1976. Consumer magazine focusing on natural family living and natural/alternative practices in parenting. Circ. 80,000. Sample copies and art guidelines available.

Illustration Send query letter and/or postcard sample. Works on assignment only. Media and styles vary.

First Contact & Terms Illustrators: Send query with postcard samples or send EPS, JPEG or PDF files. Director will contact for portfolio review if interested. Portfolio should include color tearsheets, photostats, photographs, slides and color photocopies. Samples are filed. Responds only if interested. Buys first rights. Pays on publication; $500 maximum for cover; $275-450 for inside. Payment for spots depends on size. Finds illustrators through submissions, sourcebooks, magazines, word of mouth.

Tips "Become familiar with tone and subject matter (mothers and babies) of our magazine."

MS. MAGAZINE

20 Exchange Place, 22nd Floor, New York NY 10005. (212)509-2092. Fax: (212)509-2407. Web site: www.msma gazine.com. **Art Department:** Francine Romeo. Estab. 1972. Bimonthly consumer magazine emphasizing feminist news, essays, arts. Circ. 150,000. Originals returned at job's completion. Art guidelines not available.

Cartoons Approached by 50 cartoonists/year. Buys 10 cartoons/issue. Prefers women's issues. Prefers political and humorous work.

Illustration Approached by hundreds of illustrators/year. Buys 10 illustrations/issue. Works on assignment only. Considers all media.

First Contact & Terms Cartoonists: Send query letter with photocopied finished cartoons. "Never send originals." Illustrators Send postcard-size sample or color copies. Samples sometimes filed and are not returned. Does not reply. Portfolio review by ms request only. Buys one time rights. Pays on publication. Pays cartoonists $100 and up for b&w. Finds artists through word of mouth, submissions and sourcebooks. "Absolutely no calls."

◨ MUSCLEMAG INTERNATIONAL

5775 McLaughlin Rd., Mississauga ON L5R 3P7 Canada. (905)507-3545. E-mail: editorial@emusclemag.com. Web site: www.emusclemag.com. **Contact:** Robert Kennedy. Estab. 1974. Monthly consumer magazine. Magazine emphasizes bodybuilding for men and women. Circ. 300,000. Originals not returned at job's completion. Sample copies available for $5; art guidelines not available.

Illustration Approached by 200 illustrators/year. Buys 130 illustrations/year. Has featured illustrations by Eric Blais , Mark Collins, and Gino Edwards. Features caricatures of celebrities; charts & graphs; humorous, medical and computer illustrations. Assigns 20% of illustrations to new and emerging illustrators. Prefers bodybuilding themes. Considers all media.

First Contact & Terms Cartoonists: Send photocopy of your work. Illustrators: Send query letter with photocopies. Samples are filed. Responds in 1 month. Portfolio review not required. Buys all rights. **Pays on acceptance.** Pays cartoonists $50-100. Pays illustrators $100-150 for b&w inside; $250-1,000 for color inside. "Higher pay for high-quality work." Finds artists through "submissions from artists who see our magazine."

Tips Needs line drawings of bodybuilders exercising. "Study the publication. Work to improve by studying others. Don't send out poor quality stuff. It wastes editor's time."

MY FRIEND: THE CATHOLIC MAGAZINE FOR KIDS

50 Saint Pauls Avenue, Boston MA 02130-3491. (617)522-8911. Fax: (617)541-9805. E-mail: myfriend@pauline media. com. Web site: www.myfriendmagazine.org. **Contact:** Sister Maria Grace Dateno, editor. Estab. 1979. Monthly Catholic magazine for kids, 4-color cover, containing information, entertainment and Christian information for young people ages 7-12. Circ. 8,000. Art guidelines available for SASE with $1.35 postage.

Illustration Approached by 150 illustrators/year. Buys 6 illustrations/issue; 60/year. Works on assignment only. Has featured illustrations by Chuck Galey, Brenda Gilliam, Julie Olson, and Bob Berry. Features realistic illustration; spot illustration. Assigns 10% of illustrations to new and emerging illustrators. Prefers humorous, realistic portrayals of children. Considers pen & ink, watercolor, airbrush, acrylic, marker, colored pencil, oil, charcoal, mixed media, pastel and computer-generated art.

Design Done in-house.

First Contact & Terms Illustrators: Send query letter with résumé, SASE, tearsheets, photocopies. Designers: Send query letter with résumé, photocopies and tearsheets. Accepts dis k submissions compatible with Windows/Mac OS, PageMaker 6.5, Illustrator, Photoshop. Send TIFF or EPS files. Samples are filed. Responds within 2 months only if interested. Portfolio review not required. Rights purchased vary according to project. Pays on publication; $250 for color 3-page spread; $200 for color single-page spread.

NA'AMAT WOMAN

350 Fifth Ave., Suite 4700, New York NY 10118. (212)563-5222. Fax: (212)563-5710. E-mail: judith@naamat.o rg. **Editor:** Judith Sokoloff. Estab. 1926. Jewish women's magazine published 4 times yearly, covering a wide variety of topics that are of interest to the Jewish community, affiliated with NA'AMAT USA (a nonprofit organization). Originals are returned at job's completion. Sample copies available for $1.

Illustration Approached by 30 illustrators/year. Buys 2-3 illustrations/issue (b&w for inside; color cover). Has featured illustrations by Julie Delton, Ilene Winn-Lederer and Avi Katz.

First Contact & Terms Illustrators: Send query letter with tearsheets. Samples are filed or are returned by SASE if requested by artist. Responds to the artist only if interested. Publication will contact artist for portfolio review if interested. Portfolio should include b&w tearsheets and final art. Rights purchased vary according to project. Pays on publication. Pays illustrators $150-200 for cover; $75-100 for inside. Finds artists through sourcebooks, publications, word of mouth, submissions.

Tips "Give us a try! We're small, but nice."

NAILPRO

7628 Densmore Ave., Van Nuys CA 91406. (818)782-7328. Fax: (818)782-7450. E-mail: nailpro@creativeage.com. Web site: www.nailpro.com. **Creative Director:** Dawn Klugman. **Art Director:** Patty Quon-Sandberg. Monthly trade magazine for the nail and beauty industry audience nail technicians. Circ. 58,000. Sample copies available.

Cartoons Prefers subject matter related to nail industry. Prefers humorous color washes and b&w line drawings with or without gagline.

Illustration Approached by tons of illustrators. Buys 3-4 illustrations/issue. Has featured illustrations by Kelley Kennedy, Nick Bruel and Kathryn Adams. Assigns 20% of illustrations to well-known or "name" illustrators; 70% to experienced but not well-known illustrators; 10% to new and emerging illustrators. Prefers whimsical computer illustrations. Considers all media. 85% of freelance illustration demands knowledge of Photoshop 5.5, Illustrator 8.0 and QuarkXPress 4.04.

Design Needs freelancers for design, production and multimedia projects. Prefers local design freelancers only. 100% of freelance work demands knowledge of Photoshop 5.5, Illustrator 8.0 and QuarkXPress 4.04.

First Contact & Terms Cartoonists: Send query letter with samples. Responds only if interested. Rights purchased vary according to project. Illustrators: Send postcard sample. Designers: Send query letter with printed samples and tearsheets. Accepts disk submissions compatible with QuarkXPress 4.04, TIFFs, EPS files submitted on Zip, JAZ or CD (Mac format only). Send samples to Attn: Art Director. Samples are filed. Responds only if interested. Art director will contact artist for portfolio review of b&w, color, final art and tearsheets if interested. Buys first rights. Payment to cartoonists varies with projects. Pays on publication. Pays illustrators $350-400 for 2-page, full-color feature spread; $300 for 1-page; $250 for ½ page. Pays $50 for spots. Finds illustrators through *Workbook*, samples sent in the mail, magazines.

NAILS

3520 Challenger Street, Torrance CA 90503. (310)533-2400. Fax: (310)533-2504. E-mail: nailsmag@nailsmag.com. Web site: www.nailsmag.com. **Art Director:** Danielle Parisi. Estab. 1983. Monthly 4-color trade journal; "seeks to educate readers on new techniques and products, nail anatomy and health, customer relations, chemical safety, salon sanitation and business." Circ. 57,000. Originals can be returned at job's completion. Sample copies available. Art guidelines vary. Needs computer-literate freelancers for design, illustration and production. 100% of freelance work demands knowledge of QuarkXPress, Illustrator or Photoshop.

Illustration Buys 3 illustrations/issue. Works on assignment only. Needs editorial and technical illustration; charts and story art. Prefers "fashion-oriented styles." Interested in all media.

First Contact & Terms Illustrators: Send query letter with brochure and tearsheets. Samples are filed. Responds in 1 month or artist should follow up with call. Call for an appointment to show a portfolio of tearsheets and transparencies. Buys all rights. **Pays on acceptance**; $200-500 (depending on size of job) for b&w and color inside. Finds artists through self-promotion and word of mouth.

NATION'S RESTAURANT NEWS

425 Park Ave., 6th Floor, New York NY 10022-3506. (212)756-5000. Fax: (212)756-5215. E-mail: postoffice@nrn.com. Web site: www.nrn.com. **Art Director:** Joe Anderson. Assistant Art Director: Alexis Henry. Estab. 1967. Weekly 4-color trade publication/tabloid. Circ. 100,000.

Illustration Buys 15 illustrations/year. Features computer, humorous and spot illustrations of business subjects in the food service industry. Prefers pastel and bright colors. Assigns 5% of illustrations to well-known or "name" illustrators; 70% to experienced but not well-known illustrators; 25% to new and emerging illustrators. 20% of freelance illustration demands knowledge of Illustrator or Photoshop.

First Contact & Terms Illustrators: Send postcard sample or other nonreturnable samples, such as tearsheets. Accepts MAC-compatible disk submissions. Send EPS files. Samples are filed. Will contact artist for portfolio review if interested. Buys one-time rights. Pays on publication; $700-900 for b&w cover; $1,000-1,500 for color cover; $300-400 for b&w inside; $275-350 for color inside; $450-500 for spots. Finds illustrators through *Creative Black Book* and *LA Work Book*, *Directory of Illustration* and *Contact USA*.

THE NATION

33 Irving Pl., 8th Floor, New York NY 10003. (212)209-5400. Fax: (212)982-9000. E-mail: studio@stevenbrowerdesign.com. Web site: www.thenation.com. **Art Director:** Steven Brower. Estab. 1865. A weekly journal of "left/liberal political opinion, covering national and international affairs, literature and culture." Circ. 100,000. Originals are returned after publication upon request. Sample copies available. Art guidelines not available.

• *The Nation's* art director works out of his design studio at Steven Brower Design. You can send samples to *The Nation* and they will be forwarded.

Illustration Approached by 50 illustrators/year. Buys 3-4 illustrations/issue. Works with 25 illustrators/year. Has featured illustrations by Robert Grossman, Luba Lukora, Igor Kopelnitsky and Karen Caldecott. Buys illus-

trations mainly for spots and feature spreads. Works on assignment only. Considers pen & ink, airbrush, mixed media and charcoal pencil; b&w only.

First Contact & Terms Illustrators: Send query letter with tearsheets and photocopies. "On top of a defined style, artist must have a strong and original political sensibility." Samples are filed or are returned by SASE. Responds only if interested. Buys first rights. Pays $100-150 for b&w inside; $175 for color inside.

NATIONAL ENQUIRER

1000 American Media Way, Boca Raton FL 33464. (561)997-7733. Fax: (561)989-1373. E-mail: jcannatafox@nationalenquirer.com. **Editor:** Joan Cannata-Fox. A weekly tabloid. Circ. 2 million (readership 14 million). Originals are returned at job's completion.

Cartoons "We get 1,000-1,500 cartoons weekly." Buys 200 cartoons/year. Has featured cartoons by Norm Rockwell, Glenn Bernhardt, Earl Engelman, George Crenshaw, Mark Parisi, Marty Bucella and Yahan Shirvanian. Prefers animal, family, husband/wife and general themes. Nothing political or off-color. Prefers single panel b&w line drawings and washes with or without gagline. Computer-generated cartoons are not accepted. Prefers to do own coloration.

First Contact & Terms Cartoonists: Send query letter with good, clean, clear copies of finished cartoons. Samples are not returned. Buys first and one-time rights. Pays $200 for b&w plus $20 each additional panel. Editor will notify if cartoon is accepted.

Tips "Study several issues to get a solid grasp of what we buy. Gear your work accordingly."

NATIONAL GEOGRAPHIC

17th and M Streets NW, Washington DC 20036. (202)857-7000. Web site: www.nationalgeographic.com. **Art Director:** Chris Sloan. Estab. 1888. Monthly. Circ. 9 million. Original artwork returned 1 year after publication, but *National Geographic* owns the copyright.

• *National Geographic* receives up to 30 inquiries a day from freelancers. They report most are not appropriate to their needs. Please make sure you have studied several issues before you submit. They have a roster of artists they work with on a regular basis, and it's difficult to break in, but if they like your samples they will file them for consideration for future assignments.

Illustration Works with 20 illustrators/year. Contracts 50 illustrations/year. Interested in "full-color renderings of historical and scientific subjects. Nothing that can be photographed is illustrated by artwork. No decorative, design material. We want scientific geological cut-aways, maps, historical paintings, prehistoric scenes." Works on assignment only.

First Contact & Terms Illustrators: Send color copies, postcards, tearsheets, proofs or other appropriate samples. Art director will contact for portfolio review if interested. Samples are returned by SASE. **Pays on acceptance**: varies according to project.

Tips "Do your homework before submitting to any magazine. We only use historical and scientific illustrations, ones that are very informative and very accurate. No decorative, abstract or portraits."

THE NATIONAL NOTARY

P.O. Box 2402, Chatsworth CA 91313-2402. (818)739-4000. Fax: (818)700-1942 (Attn: Editorial Department). E-mail: publications@nationalnotary.org. Web site: www.nationalnotary.org. **Managing Editor:** Philip W. Browne. Editorial Supervisor: Consuelo Israelson. Emphasizes "notaries public and notarization—goal is to impart knowledge, understanding and unity among notaries nationwide and internationally." Readers are notaries of varying primary occupations (legal, government, real estate and financial), as well as state and federal officials and foreign notaries. Bimonthly. Circ. 300,000. Original artwork not returned after publication. Sample copy $5.

• Also publishes *Notary Bulletin*.

Cartoons Approached by 5-8 cartoonists/year. Cartoons "must have a notarial angle"; single or multiple panel with gagline, b&w line drawings.

Illustration Approached by 3-4 illustrators/year. Uses about 3 illustrations/issue; buys all from local freelancers. Works on assignment only. Themes vary, depending on subjects of articles. 100% of freelance work demands knowledge of Illustrator, QuarkXPress or FreeHand.

First Contact & Terms Cartoonists: Send samples of style. Illustrators: Send business card, samples and tearsheets to be kept on file. Samples not returned. Responds in 6 weeks. Call for appointment. Buys all rights. Negotiates pay.

Tips "We are very interested in experimenting with various styles of art in illustrating the magazine. We generally work with Southern California artists, as we prefer face-to-face dealings."

NATIONAL REVIEW

215 Lexington Ave., New York NY 10016. (212)679-7330. Web site: www.nationalreview.com. **Art Director:** Luba Myts. Emphasizes world events from a conservative viewpoint; bimonthly b&w with 4-color cover, design

is "straight forward—the creativity comes out in the illustrations used." Originals are returned after publication. Uses freelancers mainly for illustrations of articles and book reviews, also covers. Circ. 150,000+.

Cartoons Buys 6 cartoons/issue. Interested in "light political, social commentary on the conservative side."

Illustration Buys 6-7 illustrations/issue. Especially needs b&w ink illustration, portraits of political figures and conceptual editorial art (b&w line plus halftone work). "I look for a strong graphic style; well-developed ideas and well-executed drawings." Style of Tim Bower, Jennifer Lawson, Janet Hamlin, Alan Nahigian. Works on assignment only.

First Contact & Terms Cartoonists: Send appropriate samples and SASE. Responds in 2 weeks. Illustrators: Send query letter with brochure showing art style or tearsheets and photocopies. No samples returned. Responds to future assignment possibilities. Call for an appointment to show portfolio of final art, final reproduction/product and b&w tearsheets. Include SASE. Buys first North American serial rights. Pays on publication. Pays cartoonists $50 for b&w. Pays illustrators $100 for b&w inside; $750 for color cover.

Tips "Tearsheets and mailers are helpful in remembering an artist's work. Artists ought to make sure their work is professional in quality, idea and execution. Recent printed samples alongside originals help. Changes in art and design in our field include fine art influence and use of more halftone illustration." A common mistake freelancers make in presenting their work is "not having a distinct style, i.e., they have a cross sample of too many different approaches to rendering their work. This leaves me questioning what kind of artwork I am going to get when I assign a piece."

NATURAL LIFE

508-264 Queens Quay W, Toronto ON M5J 1B5 Canada. **Editor:** Wendy Priesnitz. Estab. 1976. Bimonthly magazine covering environment, sustainability, voluntary simplicity. Circ. 35,000. Sample copy for $ 4.95.

● *Natural Life* is not currently buying cartoons or other illustrations.

Tips "Read us first!"

NEW HAMPSHIRE MAGAZINE

150 Dow St., Manchester NH 03101. (603)624-1442. Fax: (603)624-1310. E-mail: slaughlin@nh.com. Web site: www.nhmagazine.com. **Creative Director:** Susan Laughlin. Estab. 1990. Monthly 4-color magazine emphasizing New Hampshire lifestyle and related content. Circ. 26,000. Monthly topics: Health & senior living.

Illustration Approached by 12 illustrators/year. Has featured illustrations by Brian Hubble and Stephen Sauer. Features lifestyle illustration, charts & graphs and spot illustration. Prefers illustrating concept of story. Assigns 50% to experienced but not well-known illustrators; 50% to new and emerging illustrators.

First Contact & Terms Illustrators: Send postcard sample and follow-up postcard every 3 months. Samples are filed. Portfolio review not required. Negotiates rights purchased. Pays on publication. Pays illustrators $75-250 for color inside; $150-500 for 2-page spreads; $125 for spots.

Tips "Lifestyle magazines want 'uplifting' lifestyle messages, not dark or disturbing images."

NEW JERSEY MONTHLY

55 Park Place, Morristown NJ 07693. (973)539-8230. Fax: (973)538-2953. E-mail: dpanagakos@njmonthly.com. Web site: www.njmonthly.com. **Art Director:** Donna Panagakos. Estab. 1984. Monthly city magazine focuses on topics related to the New Jersey regions, especially the New Jersey business community, political issues and human interest articles. Circ.: 94,100.

Illustration Features New Jersey caricatures of business leaders, celebrities/politicians and humorous illustration of business, families, pets, cooking and health. Assigns 50% to new and emerging illustrators.

First Contact & Terms Illustrators: Send postcard sample. After introductory mailing, send follow-up postcard sample every 3-6 months. Samples are filed. Responds only if interested. Pays illustrators $100 for color inside. Buys one-time rights.

Tips "Be familiar with New Jersey personalities and topics. Have a consistent style and professional presentation. Follow through with assignments. Be willing to take directions from art director."

NEW MEXICO MAGAZINE

495 Old Santa Fe Trail, Lew Wallace Bldg., Santa Fe NM 87501-2750. (505)827-7447. Fax: (505)827-6496. E-mail: ask@nmmagazine.com. Web site: www.nmmagazine.com. **Contact:** Art Director. Monthly regional magazine for residents and tourists to the state of New Mexico. Circ.: 117,000.

Illustration Buys 10 illustrations/year. Features spot illustrations. Assigns 5% to new and emerging illustrators.

First Contact & Terms Illustrators: Send postcard sample with URL. Responds only if interested. Pays illustrators $100 for color inside. Buys one-time rights. Find freelancers through artists' submissions.

NEW MOON: THE MAGAZINE FOR GIRLS AND THEIR DREAMS

34 E. Superior St., #200, Duluth MN 55802. (218)728-5507. Fax: (218)728-0314. E-mail: girl@newmoon.org. Web site: www.newmoon.org. **Managing Editor:** Kate Freeborn. Estab. 1992. Bimonthly 4-color cover, 4-color inside consumer magazine. Circ. 30,000. Sample copies are $7.00.

Illustration Buys 3-4 illustrations/issue. Has featured illustrations by Andrea Good, Liza Ferneyhough, Liza Wright. Features realistic illustrations, informational graphics and spot illustrations of children, women and girls. Prefers colored work. Assigns 30% of illustrations to new and emerging illustrators.

First Contact & Terms Illustrators: Send postcard sample or other nonreturnable samples. Final work can be submitted electronically or as original artwork. Send EPS files at 300 dpi or greater, hi-res. Samples are filed. Responds only if interested. Portfolio review not required. Buys one-time rights. Pays on publication; $400 maximum for color cover; $200 maximum for inside.

Tips "Be very familiar with the magazine and our mission. We are a magazine for girls ages 8-14 and look for illustrators who portray people of all different shapes, sizes and ethnicities in their work. Women and girl artists preferred. See cover art guidelines at www.newmoon.org."

NEW MYSTERY MAGAZINE

101 W. 23rd St., Penthouse 1, New York NY 10011. (212)353-3495. E-mail: mail@newmystery.org. Web site: newmystery.org. **Art Director:** Dana Irwin. Estab. 1989. Quarterly literary magazine—a collection of mystery, crime and suspense stories with b&w drawings, prints and various graphics. Circ. 100,000. Accepts previously published artwork. Originals are returned at job's completion. Sample copies available for $7 plus $1.24 postage and SASE; art guidelines for SASE with first-class postage.

Cartoons Approached by 100 cartoonists/year. Buys 1-3 cartoons/issue. Prefers themes relating to murder, heists, guns, knives, assault and various crimes; single or multiple panel, b&w line drawings.

Illustration Approached by 100 illustrators/year. Buys 12 illustrations/issue. Prefers themes surrounding crime, murder, suspense, noir. Considers pen & ink, watercolor and charcoal. Needs computer-literate freelancers for illustration.

Design Needs freelancers for multimedia. Freelance work demands knowledge of Photoshop and QuarkXPress.

First Contact & Terms Cartoonists: Send query letter with finished cartoon samples. Illustrators: Send postcard sample with SASE. Designers: Send query letter with SASE and tearsheets. Accepts disk submissions compatible with IBM. Send TIFF and GIF files. Samples are filed. Responds in 2 months. To show a portfolio, mail appropriate materials b&w photocopies and photographs. Rights purchased vary according to project. Pays on publication. Pays cartoonists $20-50 for b&w, $20-100 for color. Pays illustrators $100-200 for covers; $25-50 for insides; $10-25 for spots. Pays by the project, $100-200.

Tips "Study an issue and send right-on illustrations. Do not send originals. Keep copies of your work. *NMM* is not responsible for unsolicited materials."

THE NEW REPUBLIC

1331 H St. NW, Suite 700, Washington DC 20005. (202)508-4444. E-mail: jheroun@tnr.com. Web site: www.tnr. com. **Art Director:** Joe Heroun. Estab. 1914. Weekly political/literary magazine; political journalism, current events in the front section, book reviews and literary essays in the back; b&w with 4-color cover. Circ. 100,000. Original artwork returned after publication. Sample copy for $3.50. 50% of freelance work demands computer skills.

Illustration Approached by 400 illustrators/year. Buys up to 5 illustrations/issue. Uses freelancers mainly for cover art. Works on assignment only. Prefers caricatures, portraits, 4-color, "no cartoons." Style of Vint Lawrence.

First Contact & Terms Illustrators: Send query letter with tearsheets or postcard samples. Samples returned by SASE if requested. Publication will contact artist for portfolio review if interested. Portfolio should include color photocopies. Rights purchased vary according to project. Pays on publication; up to $600 for color cover; $250 for b&w and color inside.

NEW WRITER'S MAGAZINE

P.O. Box 5976, Sarasota FL 34277. Phone/fax: (941)953-7903. E-mail: newriters@aol.com. **Editor/Publisher:** George J. Haborak. Estab. 1986. Bimonthly b&w magazine. Forum "where all writers can exchange thoughts, ideas and their own writing. It is focused on the needs of the aspiring or new writer." Circ. 5,000. Rarely accepts previously published artwork. Original artwork returned after publication if requested. Sample copies for $3; art guidelines for SASE with first-class postage.

Cartoons Approached by 15 cartoonists/year. Buys 1-3 cartoons/issue. Features spot illustration. Assigns 80% of illustrations to new and emerging illustrators. Prefers cartoons "that reflect the joys or frustrations of being a writer/author"; single panel b&w line drawings with gagline.

Illustration Buys 1 illustration/issue. Works on assignment only. Prefers line drawings. Considers watercolor, mixed media, colored pencil and pastel.

First Contact & Terms Cartoonists: Send query letter with samples of style. Illustrators: Send postcard sample. Samples are filed or returned by SASE if requested. Responds in 1 month. To show portfolio, mail tearsheets. Buys first rights or negotiates rights purchased. Pays on publication. Payment negotiated.

NEW YORK MAGAZINE

444 Madison Ave., 14th Floor, New York NY 10022. (212)508-0700. **Design Director:** Luke Hayman. Art Director: Chris Dixon. Emphasizes New York City life; also covers all boroughs for New Yorkers with upper-middle income and business people interested in what's happening in the city. Weekly. Original artwork returned after publication.

Illustration Works on assignment only.

First Contact & Terms Illustrators: Send query letter with tearsheets to be kept on file. Prefers photostats as samples. Samples returned if requested. Call or write for appointment to show portfolio (drop-offs). Buys first rights. Pays $1,000 for b&w and color cover; $800 for 4-color, $400 for b&w full page inside; $225 for 4-color, $150 for b&w spot inside.

THE NEW YORKER

4 Times Square, New York NY 10036. (212)286-5400. Fax: (212)286-5735. E-mail: (cartoons) toon@cartoonbank.com. Web site: www.cartoonbank.com. Emphasizes news analysis and lifestyle features. Circ. 938,600.

Cartoons Buys b&w cartoons. Receives 3,000 cartoons/week. Cartoon editor is Bob Mankoff, who also runs Cartoon Bank, a stock cartoon agency that features *New Yorker* cartoons.

Illustration All illustrations are commissioned. Portfolios may be dropped off Wednesdays between 10-6 and picked up on Thursdays. Art director is Caroline Mailhot.

First Contact & Terms Cartoonists: Accepts unsolicited submissions only by mail. Reviews unsolicited submissions every 1-2 weeks. Photocopies only. Strict standards regarding style, technique, plausibility of drawing. Especially looks for originality. Pays $575 minimum for cartoons. Contact cartoon editor. Illustrators: Mail samples, no originals. "Because of volume of submissions we are unable to respond to all submissions." No calls please. Emphasis on portraiture. Contact illustration department.

Tips "Familiarize yourself with *The New Yorker*."

NEWSWEEK

251 W. 57th St., 15th Floor, New York NY 10019. (212)445-4000. Web site: www.newsweek.com. **Art Director:** Alexander Ha. Assistant Managing Editor/Design: Lynn Staley. Weekly news magazine. Circ. 3,180,000. Has featured illustrations by Daniel Adel and Zohar Lozar.

Illustration Prefers illustrations or situations in national and international news.

First Contact & Terms Illustrators: Send postcard samples or other nonreturnable samples. Portfolios may be dropped off at front desk Tuesday or Wednesday from 9 to 5. Call ahead.

NORTH AMERICAN HUNTERNORTH AMERICAN FISHERMAN

12301 Whitewater Dr., #260, Minnetonka MN 55343-4103. (952)936-9333. Fax: (952)352-7001. Web site: www.huntingclub.com. **Art Director:** Mark Simpson. Estab. 1978 (*N. Hunter*) and 1988 (*N. Fisherman*)Bimonthly consumer magazines. *North American Hunter* and *Fisherman* are the official publications of the North American Hunting Club and the North American Fishing Club. Circ. 700,000 and 500,000. Accepts previously published artwork. Originals are returned at job's completion. Sample copies available. Art guidelines for SASE with first-class postage. Needs computer-literate freelancers for illustration. 20% of freelance work demands computer knowledge of Illustrator, QuarkXPress, Photoshop or FreeHand.

- This publisher also publishes *Cooking Pleasures* (circ. 300,000), *Handy* (circ. 900,000), *PGA Partners* (circ. 600,000), *Health & Wellness* (circ. 300,000), *Creative Home Arts* (circ. 300,000), *History* (circ. 300,000), *Street Thunder* (circ. 200,000) and *Gardening How-To* (circ. 500,000).

Cartoons Approached by 20 cartoonists/year. Buys 3 cartoons/issue. Prefers humorous work portraying outdoorsmen in positive image; single panel b&w washes and line drawings with or without gagline.

Illustration Approached by 40 illustrators/year. Buys 3 illustrations/issue. Prefers illustrations that portray wildlife and hunting and fishing in an accurate and positive manner. Considers pen & ink, watercolor, airbrush, acrylic, colored pencil, oil, charcoal, mixed media, pastel and electronic renderings.

First Contact & Terms Cartoonists: Send query letter with brochure. Illustrators: Send query letter with brochure, tearsheets, résumé, photographs and slides. Samples are filed. Portfolio review not required. Rights purchased vary according to project. **Pays on acceptance.**

THE NORTH AMERICAN REVIEW

University of Northern Iowa, Cedar Falls IA 50614. (319)273-6455. Fax: (319)273-4326. Email: nar@2edu. Web site: webdelsol.com/NorthAmReview/NAR/. **Art Directors:** Roy R. Behrens and Gary Kelley. Estab. 1815. "General interest bimonthly, especially known for fiction (twice winner of National Magazine Award for fiction)." Accepts previously published work. Original artwork returned at job's completion. "Sample copies can be purchased on newsstand or examined in libraries."

• The NAR is the oldest literary magazine in America, and it continues to be one of the most respected. It's known for the creativity and excellence of its illustration and layouts.

Illustration Approached by 500 freelance artists/year. Buys 15 freelance illustrations/issue. Artists primarily work on assignment. Looks for "well-designed illustrations in any style. We prefer to use b&w media for illustrations reproduced in b&w and color for those reproduced in color. We prefer camera-ready line art for spot illustrations."

First Contact & Terms Illustrators: Send postcard samples, color photocopies or other nonreturnable samples. Please send no more than 5 pieces. Samples are filed if of interest or returned by SASE if requested by artist. Responds to the artist only if interested. No portfolio reviews. Buys one-time rights. Contributors receive 2 copies of the issue. Pays on publication $300 for color cover plus 50 tearsheets of cover only; $10 for b&w inside spot illustrations; $65 for b&w large illustration. No color inside.

Tips "Send b&w photocopies of spot illustrations (printed size about 2×2). For the most part, our color covers and major b&w inside illustrations are obtained by direct assignment from illustrators we contact, e.g., Gary Kelley, Chris Payne, Skip Liepke and others. Write for guidelines for annual cover competition."

NORTH AMERICAN WHITETAIL MAGAZINE

2250 Newmarket Pkwy., Suite 110, Marietta GA 30067. (770)953-9222. Fax: (770)933-9510. Web site: www.nort hamericanwhitetail.com. **Editorial Director:** Ken Dunwoody. Estab. 1982. Consumer magazine "designed for serious hunters who pursue whitetailed deer." 8 issues/year. Circ. 130,000. Accepts previously published artwork. Original artwork is returned at job's completion. Sample copies available for $3; art guidelines not available.

Illustration Approached by 30 freelance illustrators/year. Buys 6-8 freelance illustrations/year. Works on assignment only. Considers pen & ink, watercolor, acrylic and oil.

First Contact & Terms Illustrators: Send postcard sample and/or query letter with brochure and photocopies. Samples are filed or are returned by SASE if requested by artist. Responds only if interested. To show a portfolio, mail appropriate materials. Rights purchased vary according to project. Pays 10 weeks prior to publication; $25 minimum for b&w inside; $75 minimum for color inside.

▣ NORTH CAROLINA LITERARY REVIEW

English Dept., Greenville NC 27858-4353. E-mail: bauerm@mail.ecu.edu. **Editor:** Margaret Bauer. Estab. 1992. Annual literary magazine of art, literature, culture having to do with NC. Circ. 500. Samples available for $10 and $15; art guidelines for SASE with first-class postage or e-mail address. NC artists/art only.

Illustration Considers all media.

First Contact & Terms Illustrators: Send postcard sample or send query letter with printed samples, SASE and tearsheets. Send follow-up postcard sample every 2 months. Samples are not filed and are returned by SASE. Responds in 2 months. Art director will contact artist for portfolio review of b&w, color slides and transparencies if interested. Rights purchased vary according to projects. Pays on publication; $100-250 for cover; $50-250 for inside. Pays $25 for spots. Finds illustrators through magazines and word of mouth.

Tips "Read our magazine. Artists, photographers, and graphic designers have to have North Carolina connections."

NOTRE DAME MAGAZINE

535 Grace Hall, Notre Dame IN 46556. (574)631-4630. Web site: www.ND.EDU/ ~ NDMAG. **Art Director:** Don Nelson. Estab. 1971. Quarterly 4-color university magazine that publishes essays on cultural, spiritual and ethical topics, as well as news of the university for Notre Dame alumni and friends. Circ. 155,000. Accepts previously published artwork. Original artwork returned after publication.

Illustration Buys 5-8 illustrations/issue. Has featured illustrations by Ken Orvidas, Earl Keleny, Vivienne Fleshner, Darren Thompson and James O' Brien. Works on assignment only. Tearsheets, photographs, brochures and photocopies OK for samples. Samples are returned by SASE if requested. "Don't send submissions—only tearsheets or samples." Buys first rights.

Tips "Create images that can communicate ideas. Looking for noncommercial style editorial art by accomplished, experienced editorial artists. Conceptual imagery that reflects the artist's awareness of fine art ideas and methods is the kind of thing we use. Sports action illustrations not used. Cartoons not used."

NOW AND THEN

CASS/ETSU, Box 70556, Johnson City TN 37614-1707. (423)439-7865. Fax: (423)439-7870. E-mail: sauceman@ etsu.edu. Web site: www.etsu.edu/cass. **Editor:** Fred Sauceman. Estab. 1984. Magazine covering Appalachian issues and arts, published twice a year. Circ. 1,000. Accepts previously published artwork. Originals are returned at job's completion. Sample copies available for $8. Art guidelines free for SASE with first class postage or on Web site.

Cartoons Approached by 5 cartoonists/year. Prefers Appalachia issues, political and humorous cartoons; b&w washes and line drawings.

Illustration Approached by 3 illustrators/year. Buys 1-2 illustrations/issue. Has featured illustrations by Nancy Jane Earnest, David M. Simon and Anthony Feathers. Features natural history; humorous, realistic, computer and spot illustration. Assigns 100% of illustrations to experienced but not well-known illustrators. Prefers Appalachia, any style. Considers b&w or 2- or 4-color pen & ink, collage, airbrush, marker and charcoal. Freelancers should be familiar with FreeHand, PageMaker or Photoshop.

First Contact & Terms Cartoonists: Send query letter with brochure, roughs and finished cartoons. Illustrators: Send query letter with brochure, SASE and photocopies. Samples are filed or will be returned by SASE if requested by artist. Responds in 6 months. Publication will contact artist for portfolio review if interested. Portfolio should include b&w tearsheets, slides, final art and photographs. Buys one-time rights. Pays on publication. Pays cartoonists $25 for b&w. Pays illustrators $50-100 for color cover; $25 maximum for b&w inside.

Tips "We have special theme issues. Illustrations have to have something to do with theme. Write for guidelines, see the Web site, enclose SASE."

NURSEWEEK

6860 Santa Teresa Blvd., San Jose, CA 95119. (408)249-5877. Fax: (408)574-1207. E-mail: youngk@nurseweek.c om. Web site: www.nurseweek.com. **Art Director:** Young Kim. "*Nurseweek* is a biweekly 4-color tabloid mailed free to registered nurses nationwide. Combined circulation of all publications is over 1 million. *Nurseweek* provides readers with nursing-related news and features that encourage and enable them to excel in their work and that enhance the profession's image by highlighting the many diverse contributions nurses make. In order to provide a complete and useful package, the publication's article mix includes late-breaking news stories, news features with analysis (including in-depth bimonthly special reports), interviews with industry leaders and achievers, continuing education articles, career option pieces (Spotlight, Entrepreneur) and reader dialogue (Letters, Commentary, First Person)." Sample copy $3. Art guidelines not available. Needs computer-literate freelancers for production. 90% of freelance work demands knowledge of Quark, PhotoShop, Illustrator, Adobe Acrobat.

Illustration Approached by 10 illustrators/year. Buys 1 illustration/year. Prefers pen & ink, watercolor, airbrush, marker, colored pencil, mixed media and pastel. Needs medical illustration.

Design Needs freelancers for design. 90% of design demands knowledge of Photoshop CS, QuarkXPress 6.0. Prefers local freelancers. Send query letter with brochure, résumé, SASE and tearsheets.

First Contact & Terms Illustrators: Send query letter with brochure, tearsheets, photographs, photocopies, photostats, slides and transparencies. Samples are not filed and are returned by SASE if requested by artist. Publication will contact artist for portfolio review if interested. Portfolio should include final art samples, photographs. Buys all rights. Pays on publication; $150 for b&w, $250 for color cover; $100 for b&w, $175 for color inside. Finds artists through sourcebooks.

NUTRITION HEALTH REVIEW

Box #406, Haverford PA 19041. (610)896-1853. Fax: (610)896-1857. **Contact:** A. Rifkin, publisher. Estab. 1975. Quarterly newspaper covering nutrition, health and medical information for the consumer. Circ. 285,000. Sample copies available for $3. Art guidelines available.

Cartoons Prefers single panel, humorous, b&w drawings.

Illustration Features b&w humorous, medical and spot illustrations pertaining to health.

First Contact & Terms Cartoonists/Illustrators: Send query letter with b&w photocopies. After introductory mailing, send follow-up postcard every 3-6 months. Samples are filed or returned by SASE. Responds in 6 months. Company will contact artist for portfolio review if interested. Pays cartoonists $20 maximum for b&w. Pays illustrators $200 maximum for b&w cover; $30 maximum for b&w inside. **Pays on acceptance.** Buys first rights, one-time rights, reprint rights. Finds freelancers through agents, artists' submissions, sourcebooks.

O&A MARKETING NEWS

Kal Publications, 559 S. Harbor Blvd., Suite A, Anaheim CA 92805-4525. (714)563-9300. Fax: (714)563-9310. Web site: www.kalpub.com. **Editor:** Kathy Laderman. Estab. 1966. Bimonthly b&w trade publication about the service station/petroleum marketing industry. Circ. 8,000. Sample copies for 11×17 SASE with 10 first-class stamps.

Magazines

• This publisher also published *Automotive Booster*.

Cartoons Approached by 10 cartoonists/year. Buys 1-2 cartoons/issue. Prefers humor that relates to service station industry. Prefers single panel, humorous, b&w line drawings.

First Contact & Terms Cartoonists: Send b&w photocopies, roughs or samples and SASE. Samples are returned by SASE. Responds in 1 month. Buys one-time rights. **Pays on acceptance**; $10 for b&w.

Tips "We run a cartoon (at least one) in each issue of our trade magazine. We're looking for a humorous take on business—specifically the service station/petroleum marketing/carwash/quick lube industry that we cover."

OFF DUTY MAGAZINE

3505 Cadillac, Suite 0-105, Costa Mesa CA 92626. Fax: (714)549-4222. E-mail: odutyedit@aol.com. **Executive Editor:** Tom Graves. Estab. 1970. Consumer magazine published 8 times/year "for U.S. military community worldwide." Sample copy for 8½×11 SASE and 6 first-class stamps.

• There are three versions of *Off Duty Magazine* U.S., Europe and the Pacific.

Illustration Approached by 10-12 illustrators/year. Buys 2 illustrations/issue. Considers airbrush, colored pencil, marker, pastel, watercolor and computer art. Knowledge of Illustrator helpful but not required.

First Contact & Terms Illustrators: Send query letter with printed samples. Samples are filed. Does not reply. Artist should wait for call about an assignment. Buys one-time rights. **Pays on acceptance;** negotiable for cover; $200-300 for color inside. Finds illustrators through previous work and word of mouth.

Tips "We're looking for computer (Illustrator better than FreeHand, and/or Photoshop) illustrators for an occasional assignment."

OFF OUR BACKS, A WOMAN'S NEWS JOURNAL

2337B 18th St., NW, Washington DC 20009. (202)234-8072. Fax: (202)234-8092. E-mail: offourbacks@cs.com. Web site: www.offourbacks.org. **Managing Editors:** Jennie Ruby and Karla Mantilla. Estab. 1970. Bimonthly feminist news journal; magazine format; covers women's issues and the feminist movement. Circ. 15,000. Accepts previously published artwork. Original artwork is returned at the job's completion. Sample copies available; art guidelines free for SASE with first-class postage.

Cartoons Approached by 6 freelance cartoonists/year. Buys 2 freelance cartoons/issue. Prefers political, feminist themes.

Illustration Approached by 20 freelance illustrators/year. Prefers feminist, political themes. Considers pen & ink.

First Contact & Terms Cartoonists: Send query letter with roughs. Responds to the artist if interested within 2 months. Illustrators: Send query letter with photocopies. Samples are filed. Responds to the artist only if interested. To show a portfolio, mail appropriate materials.

Tips "Ask for a sample copy. Preference given to feminist, woman-centered, multicultural line drawings."

N: OHIO MAGAZINE

1422 Euclid Ave., Cleveland OH 44115. (216)771-2833 or (800)210-7293. Fax: (216)781-6318. E-mail: editorial@ ohiomagazine.com. Web site: www.ohiomagazine.com. **Art Director:** Rob McGarr. 12 issues/year emphasizing traveling in Ohio. Circ. 95,000. Previously published work OK. Original artwork returned after publication. Sample copy $2.50; art guidelines not available.

Illustration Approached by 70 illustrators/year. Buys 2 illustrations/issue. Works on assignment only. Has featured illustrations by David and Amy Butler and Chris O'Leary. Features charts & graphs; informational graphics; spot illustrations. Assigns 10% of illustrations to new and emerging illustrators. Considers pen & ink, watercolor, collage, acrylic, marker, colored pencil, oil, mixed media and pastel. 20% of freelance work demands knowledge of Illustrator, QuarkXPress, Photoshop or FreeHand.

Design Needs freelancers for design and production. 100% of freelance work demands knowledge of Photoshop and QuarkXPress.

First Contact & Terms Illustrators: Send postcard sample or brochure, SASE, tearsheets and slides. Designers: Send query letter with tearsheets. Accepts disk submissions. Send Mac EPS files. Samples are filed or are returned by SASE. Responds in 1 month. Request portfolio review in original query. Portfolio should include b&w and color tearsheets, slides, photocopies and final art. Buys one-time rights. **Pays on acceptance**; $250-500 for color cover; $50-400 for b&w inside; $50-500 for color inside; $100-800 for 2-page spreads; $50-125 for spots. Finds artists through submissions and gallery shows.

Tips "Please take time to look at the magazine if possible before submitting."

OKLAHOMA TODAY MAGAZINE

120 N. Robinson, Suite 600, Oklahoma City OK 73102. (405)230-8450. Fax: (405)230-8650. Web site: www.okla homatoday.com. **Editor:** Louisa McCune-Elmore. Associate Editor: Brooke Adcox. Estab. 1956. Bimonthly regional, upscale consumer magazine focusing on all things that define Oklahoma and interest Oklahomans.

Circ. 50,000. Accepts previously published artwork. Originals are returned at job's completion. Sample copies available with a SASE.

Illustration Approached by 24 illustrators/year. Buys 5-10 illustrations/year. Has featured illustrations by Rob Silvers, Tim Jessel, Steven Walker and Cecil Adams. Features caricatures of celebrities; natural history; realistic and spot illustration. Assigns 10% of illustrations to new and emerging illustrators. Considers pen & ink, watercolor, collage, airbrush, acrylic, marker, colored pencil, oil, charcoal and pastel. 20% of freelance work demands knowledge of PageMaker, Illustrator and Photoshop.

First Contact & Terms Illustrators: Send query letter with brochure, résumé, SASE, tearsheets and slides. Samples are filed. Responds in days if interested; months if not. Portfolio review required if interested in artist's work. Portfolio should include b&w and color thumbnails, tearsheets and slides. Buys one-time rights. Pays $200-500 for b&w cover; $200-750 for color cover; $50-500 for b&w inside; $75-750 for color inside. Finds artists through sourcebooks, other publications, word of mouth, submissions and artist reps.

Tips Illustrations to accompany short stories and features are most open to freelancers. "Read the magazine. Be willing to accept low fees at the beginning. We enjoy working with local artists or those with Oklahoma connections."

N OLD BIKE JOURNAL

1010 Summer St., Stamford CT 06905. (203)425-8777. Fax: (203)425-8775. **Art Director:** Jonas Land. Estab. 1989. Monthly international classic and collectible motorcycle magazine dedicated to classics of yesterday, today and tomorrow. Includes hundreds of classified ads for buying, selling or trading bikes and parts worldwide. Circ. under 100,000. Originals are returned at job's completion if requested. Sample copy $4 (US only). Art guidelines available. Computer-literate freelancers for illustration should be familiar with Photoshop, Illustrator or QuarkXPress.

Cartoons Approached by 12 cartoonists/year. Buys 1-2 cartoons/issue. Prefers vintage motorcycling and humorous themes; single panel, b&w line drawings.

Illustration Approached by 50-100 illustrators/year. Buys 1-5 illustrations/issue. Considers pen & ink, watercolor, airbrush, marker and colored pencil.

First Contact & Terms Cartoonists: Send query letter with copies of finished work. Illustrators: Send query letter with brochure, SASE, tearsheets, photographs, photocopies, photostats, slides and transparencies. Samples are filed or are returned by SASE if requested. Responds in 1 month. Call for appointment to show portfolio. Portfolio should include tearsheets, slides, photostats, photocopies and photographs. Buys one-time rights. Pays cartoonists $50 for b&w; $100 for color. Pays illustrators on publication; $25 for b&w; $100 for color.

Tips "Send copies or photos of final art pieces. If they seem fit for publication, the individual will be contacted and paid upon publication. If not, work will be returned with letter. Often, artists are contacted for more specifics as to what might be needed."

ON EARTH

40 W. 20th St., New York NY 10011. (212)727-2700. Fax: (212)727-1773. E-mail: onearthart@nrdc.org. Web site: www.nrdc.org. **Art Director:** Gail Ghezzi. Associate Art Director: Irene Huang. Estab. 1979. Quarterly "award-winning environmental magazine exploring politics, nature, wildlife, science and solutions to problems." Circ. 140,000.

Illustration Buys 4 illustrations/issue.

First Contact & Terms Illustrators: Send postcard sample. "We will accept work compatible with QuarkXPress, Illustrator 8.0, Photoshop 5.5 and below." Responds only if interested. Buys one-time rights. Also may ask for electronic rights. Pays $100-300 for b&w inside. Payment for spots varies. Finds artists through sourcebooks and submissions.

Tips "We prefer 4-color. Our illustrations are often conceptual, thought-provoking, challenging. We enjoy thinking artists, and we encourage ideas and exchange."

N ON INVESTING

731 Lexington Ave., New York NY 10022-1331. (609)705-5015. Fax: (646)268-5533. E-mail: oninvesting@bloomberg.com. Web site: www.schwab.com. **Art Director:** Evelyn Good. Quarterly personal finance magazine provides Schwab signature series services clients with information, strategies and analysis on their investment strategies. Circ.: 900,000.

Illustration Has featured Doug Ross, Steven Biver and Lisa Ferlic.

First Contact & Terms Illustrators: Send non-returnable postcard sample. After introductory mailing, send follow-up postcard sample every 6 months. Responds only if interested. Pays illustrators $100 for color inside. Buys one-time rights. Find freelancers through artists' submissions.

ⓝ ON WALL STREET

1 State St. Plaza 27th Flr., New York NY 10004-1505. (212)803-8576. Fax: (212)843-9606. E-mail: teresa.reinalda @sourcemedia.com. Web site: www.onwallstreet.com. **Art Director:** Teresa Reinalda. Estab. 1991. Monthly trade publication covering marketing, sales, practice management, investor psychology, news and opinions related to brokerage industry. Circ.: 91,200.

Illustration Approached by 100-200 illustrators/year. Buys 20 illustrations/year. Features charts & graphs and spot illustrations of business.

First Contact & Terms Illustrators: Send postcard sample with URL. After introductory mailing, send follow-up postcard sample every 6 months. Responds only if interested. Pays illustrators $100-250 for color inside. Buys one-time rights. Find freelancers through artists' submissions.

ⓝ OPEN YOUR EYES

6380 Wilshire Blvd. #113, Los Angeles CA 90048-5013. (323)924-9728. Fax: (323)924-5992. E-mail: jkim@oyem ag.com. Web site: www.oyemag.com. **Art Director:** June Kim. Estab. 2004. Bimonthly consumer magazine for U.S. Latino men interested in technology, fitness, women, fashion and entertainment. Circ.: 75,000.

Illustration Approached by 100 illustrators/year. Buys 10 illustrations/year. Features spot illustrations of technology and fitness. Assigns 20% to new and emerging illustrators.

First Contact & Terms Illustrators: Send postcard sample. After introductory mailing, send follow-up postcard sample every 6 months. Responds only if interested. Portfolio not required. Buys one-time rights. Finds freelancers through submissions and sourcebooks.

THE OPTIMIST

4494 Lindell Blvd., St. Louis MO 63108-2404. (314)371-6000. Fax: (314)371-6006. E-mail: nickrenta@optimist.o rg. Web site: www.optimist.org. **Graphic Designer:** Andrea Nickrent. 4-color magazine with 4-color cover that emphasizes activities relating to Optimist clubs in US and Canada (civic-service clubs). "Magazine is mailed to all members of Optimist clubs. Average age is 42; most are management level with some college education." Circ. 120,000. Sample copy for SASE; art guidelines not available.

Cartoons Buys 2 cartoons/issue. Has featured cartoons by Martin Bucella, Randy Glasbergen, Randy Bisson. Prefers themes of general interest family-orientation, sports, kids, civic clubs. Prefers color single panel with gagline. No washes.

First Contact & Terms Illustrators: Send query letter with samples. Send art on a disk if possible (Macintosh compatible). Submissions returned by SASE. Buys one-time rights. **Pays on acceptance:** $30 for b&w or color. **Tips** "Send clear cartoon submissions, not poorly photocopied copies."

ⓝ ORACLE MAGAZINE

500 Oracle Pkwy MS 10BP1, Redwood City CA 94065-1677. (650)506-7000. Fax: (650)633-2424. E-mail: rmercha n@oracle.com. Web site: www.otn.oracle.com/oraclemagazine. **Art Director:** Richard Merchan. Estab. 2000. Bimonthly trade publication for information managers, database administrators and Oracle users. Circ.: 524,000.

Illustration Approached by 200 illustrators/year. Buys 50 illustrations/year. Features informational graphics and spot illustrations of business and computers. Assigns 10% to new and emerging illustrators.

First Contact & Terms Illustrators: Send postcard sample with URL. After introductory mailing, send follow-up postcard sample every 3 months. Responds only if interested. Pays illustrators $250-1,000 for color inside. Pays on publication. Buys one-time rights. Finds freelancers through agents, artists' submissions, sourcebooks and word-of-mouth.

OREGON CATHOLIC PRESS

5536 NE Hassalo, Portland OR 97213-3638. E-mail: gust@ocp.org. Web site: www.ocp.org/. **Creative Director:** Gus Torres. Estab. 1988. Quarterly liturgical music planner in both Spanish and English with articles, photos and illustrations specifically for but not exclusive to the Roman Catholic market.

• See *OCP*'s listing in the Book Publishers section to learn about this publisher's products and needs.

Illustration Approached by 10 illustrators/year. Buys 20 illustrations/issue. Has featured illustrations by John August Swanson and Steve Erspamer. Assigns 50% of illustrations to new and emerging illustrators.

First Contact & Terms Illustrators: Send query letter with printed samples, photocopies, SASE. Does not return samples. Web site with samples preferred. Portfolio review not required. Rights purchased vary according to project. **Pays on acceptance.** $100-250 for color cover; $30-50 for b&w spot art or photo.

OREGON QUARTERLY

5228 University of Oregon, 130 Chapman Hall, Eugene OR 97403-5228. (541)346-5048. Fax: (541)346-5571. E-mail: quarterly@uoregon.edu. Web site: www.oregonquarterly.com. **Editor:** Guy Maynard. Estab. 1919. Quarterly 4-color alumni magazine. "The Northwest perspective. Regional issues and events as addressed by UO

faculty members and alumni.'' Circ. 91,000. Accepts previously published artwork. Originals are returned at job's completion. Sample copies available for SASE with first-class postage.

Illustration Approached by 25 illustrators/year. Buys 1 or 2 illustration/issue. Prefers story-related themes and styles. Interested in all media.

First Contact & Terms Illustrators: Send query letter with résumé, SASE and tearsheets. Samples are filed unless accompanied by SASE. Responds only if interested. Buys one-time rights. Portfolio review not required.

Pays on acceptance; $250 for b&w, $500 for color cover; $100 for b&w, $250 for color inside; $100 for spots.

Tips ''Send postcard or URL, not portfolio.''

ORLANDO MAGAZINE

801 N. Magnolia Ave., 201, Orlando FL 32803. (407)423-0618. Fax: (407)237-6258. E-mail: jason.jones@orlando magazine.com. Web site: www.orlandomagazine.com. **Art Director:** Jason Jones. Estab. 1946. ''We are a 4-color monthly city/regional magazine covering the Central Florida area—local issues, sports, home and garden, business, entertainment and dining.'' Circ. 30,000. Accepts previously published artwork. Originals are returned at job's completion. Sample copies available.

Illustration Buys 2-3 illustrations/issue. Has featured illustrations by T. Sirell, Rick Martin, Mike Wright, Jon Krause. Assigns 100% of illustrations to experienced, but not necessarily well-known illustrators. Works on assignment only. Needs editorial illustration.

Design Needs freelancers for design and production.

First Contact & Terms Illustrators: Send postcard, brochure or tearsheets. Samples are filed and are not returned. Responds only if interested with a specific job. Portfolio review not required. Buys first rights, one-time rights or all rights (rarely). Pays on publication; $400 for color cover; $200-250 for color inside. Pays for design by the project.

Tips ''Send appropriate samples. Most of my illustration hiring is via direct mail. The magazine field is still a great place for illustration. Have several ideas ready after reading editorial to add to or enhance our initial concept.''

OUR STATE: DOWN HOME IN NORTH CAROLINA

P.O. Box 4552, Greensboro NC 27404. (336)286-0600. Fax: (336)286-0100. E-mail: art_director@ourstate.com. Web site: www.ourstate.com. **Art Director:** Christine Xionis. Estab. 1933. Monthly 4-color consumer magazine featuring travel, history and culture of North Carolina. Circ. 130,000. Art guidelines are free for #10 SASE with first-class postage.

Illustration Approached by 6 illustrators/year. Buys 12 illustrations/issue. Features ''cartoon-y'' maps. Preferred subjects maps of towns in NC. ''Prefers watercolor, pastel and bright colors.'' Assigns 100% to new and emerging illustrators. 100% of freelance illustration demands knowledge of Illustrator.

First Contact & Terms Illustrators: Send postcard sample or nonreturnable samples. Samples are not filed and are not returned. Portfolio review not required. Buys one-time rights. Pays on publication; $400-600 for color cover; $75-350 for b&w inside; $75-350 for color inside; $350 for 2-page spreads. Finds illustrators through word of mouth.

OUR SUNDAY VISITOR

200 Noll Plaza, Huntington IN 46750. (260)356-8400. Fax: (260)356-8472. Web site: www.osv.com. **Contact:** Design Dept. Estab. 1912. Weekly magazine which focuses on Catholicism. Audience is mostly older, conservative; adheres to the teachings of the magisterium of the church. Circ. 85,000. Accepts previously published artwork. Originals are returned at job's completion. Sample copies available. Art guidelines not available.

Illustration Approached by 25-30 illustrators/year. Buys 100 illustrations/year. Works on assignment only. Preferred themes are religious and social issues. Considers all types of media and photographyboth traditional and digital.

First Contact & Terms Illustrators: Send query letter with photographs. Samples are filed. Portfolio review not required. Buys first rights. Pays on publication; $250 for b&w, $400 for color cover; $150 for b&w, $250 for color inside.

☑ ▣ OUTDOOR CANADA MAGAZINE

25 Sheppard Ave. W, Suite 100, Toronto ON M2N 6S7 Canada. E-mail: editorial@outdoorCanada.ca. Web site: www.outdoorcanada.ca. **Art Director:** Robert Biron. 4-color magazine for Canadian anglers and hunters, enthusiasts and their families. Stories on fishing, hunting and wildlife. Readers are 81% male. Publishes 8 regular issues/year. Circ. 95,000. Art guidelines are available.

Illustration Approached by 12-15 illustrators/year. Buys approximately 10 drawings/issue. Has featured illustrations by Malcolm Cullen, Stephen MacEachren and Jerzy Kolatch. Features humorous, computer and spot illustration. Assigns 90% to experienced, but not well-known illustrators; 10% to new and emerging illustrators.

Uses freelancers mainly for illustrating features and columns. Uses pen & ink, acrylic, oil and pastel.

Design Needs freelancers for multimedia. 20% of freelance work demands knowledge of Photoshop, Illustrator and QuarkXPress.

First Contact & Terms Illustrators: Send postcard sample or tearsheets. Designers: Send brochure, tearsheets and postcards. Accepts disk submissions compatible with Illustrator 7.0. Send EPS, TIFF and PICT files. Buys first rights. Pays illustrators $100-200 for small icon or diagram; $250-350 for maps; $350 for column spots and $750 for full page. Pays designers by the project. Artists should show a representative sampling of their work. Finds most artists through references/word of mouth.

Tips "Meet our deadlines and our budget. Know our product. Fishing and hunting knowledge an asset."

OUTDOOR LIFE MAGAZINE

Dept. AGDM, 2 Park Ave., New York NY 10016-5604. (212)779-5000. Fax: (212)779-5366. Web site: www.outdoorlife.com. **Art Director:** James M. Keleher. Assistant Art Directors: Margaret McKenna and Jason Beckstead. Estab. 1897. Monthly magazine geared toward hunting, fishing and outdoor activities. Circ. 900,000. Original artwork is returned at job's completion. Sample copies not available.

Illustration Works on assignment only.

First Contact & Terms Illustrators: Send nonreturnable postcard samples, tearsheets or brochures. Samples are filed. Rights purchased vary according to project. **Pays on acceptance.**

OUTER DARKNESS

1312 N. Delaware Place, Tulsa OK 74110. E-mail: odmagazine@aol.com. **Editor:** Dennis Kirk. Estab. 1994. Quarterly digest/zine of horror and science fiction, poetry and art. Circ. 500. Sample copy for $3.95 plus $1.00 postage. Sample illustrations free for 6×9 SASE and 2 first-class stamps. Art guidelines free for #10 SASE with first-class postage.

Cartoons Approached by 15-20 cartoonists/year. Buys 3-5 cartoons/year. Prefers horror/science fiction slant, but not necessary. Prefers single panel, humorous, b&w line drawings.

Illustration Approached by 60-70 illustrators/year. Buys 5-7 illustrations/issue. Has featured illustrations by Steve Rader, Popeye Wong, Bob Bryson, and Erika McGinnis. Features realistic science fiction and horror illustrations, b&w, pencil or ink. Assigns 20% of illustrations to new and emerging illustrators.

First Contact & Terms Cartoonists: Send query letter with b&w photocopies, samples, SASE. Samples are returned. Illustrators: Send query letter with photocopies, SASE. Responds in 2 weeks. Buys one-time rights. Pays on publication in contributor's copies. Finds illustrators through magazines and submissions.

Tips "Send samples of your work, along with a cover letter. Let me know a little about yourself. I enjoy learning about artists interested in *Outer Darkness*. *Outer Darkness* is continuing to grow at an incredible rate; it's presently available through both Project Pulp and Shocklines. It's also available in two out-of-state bookstores, and I'm working to get it in more."

OVER THE BACK FENCE

2947 Interstate Parkway, Brunswick OH 44212. (330)220-2483. Fax: (330)220-3083. E-mail: rockyA@LongPoint Media.com. Web site: www.backfencemagazine.com. **Creative Director:** Rocky Alten. Estab. 1994. Quarterly consumer magazine emphasizing southern Ohio topics. Circ. 15,000. Sample copies for $4; illustrator's guidelines can be found on the Web site.

Illustration Features humorous and realistic illustration; informational graphics and spot illustration. Assigns 50% of illustration to experienced but not well-known illustrators; 50% to new and emerging illustrators.

First Contact & Terms Illustrators: Send query letter with photocopies, SASE and tearsheets. See guidelines on Web site. Samples are occasionally filed or returned by SASE. Responds in 3 months. Creative director will contact artist for portfolio review if interested. Buys one-time rights. Pays $100 for b&w and color covers; $25-100 for b&w and color inside; $25-200 for 2-page spreads; $25-100 for spots. Finds illustrators through word of mouth and submissions.

Tips "Our readership enjoys our warm, friendly approach. The artwork we select will possess the same qualities."

OWL KIDS

(formerly Chickadee) Bayard Press Canada, 10 Lower Spadina Ave, Suite 200, Toronto ON M5V 2Z2 Canada. (416)340-2700. Fax: (416)340-9769. E-mail: chickadee@owl.on.ca. Web site: www.owlkids.com. **Creative Director:** Barb Kelly. Estab. 1979. 9 issues/year. Children's discovery magazine. Chickadee is a "hands-on" science, nature and discovery publication designed to entertain and educate 6-9 year-olds. Each issue contains photos, illustrations, an easy-to-read animal story, a craft project, fiction, puzzles, a science experiment and a pull-out poster. Circ. 150,000 in North America. Originals returned at job's completion. Sample copies available.

Uses all types of conventional methods of illustration. Digital illustrators should be familiar with Illustrator or Photoshop.

- The same company that publishes *Chickadee* now also publishes *Chirp*, a science, nature and discovery magazine for pre-schoolers two to six years old, and *OWL*, a similar publication for children over eight years old.

Illustration Approached by 500-750 illustrators/year. Buys 3-7 illustrations/issue. Works on assignment only. Prefers animals, children, situations and fiction. All styles, loaded with humor but not cartoons. Realistic depictions of animals and nature. Considers all media and computer art. No b&w illustrations.

First Contact & Terms Illustrators: Send postcard sample, photocopies and tearsheets. Accepts disk submissions compatible with Illustrator 8.0. Send EPS files. Samples are filed or returned by SASE. Will contact for portfolio review if interested. Portfolio should include final art, tearsheets and photocopies. Buys all rights. Pays within 30 days of invoice; $500 for color cover; $100-750 for color/inside; $100-300 for spots. Finds artists through sourcebooks, word of mouth, submissions as well as looking in other magazines to see who's doing what.

Tips "Please become familiar with the magazine before you submit. Ask yourself whether your style is appropriate before spending the money on your mailing. Magazines are ephemeral and topical. Ask yourself if your illustrations are editorial and contemporary. Some styles suit books or other forms better than magazines." Impress this art director by being "fantastic, enthusiastic and unique."

THE OXFORD AMERICAN

201 Donaghey Ave., Main 107, Conway AR 72035. (501)450-5376. E-mail: oamag@oxfordamericanmag.com. Web site: www.oxfordamericanmag.com. **Editor:** Marc Smirnoff. Estab. 1992. Quarterly literary magazine. "The Southern magazine of good writing." Circ. 33,000. Art guidelines on Web site.

- This award-winning magazine suspended publication in July 2003, but it relaunched in the fall of 2004 as a not-for-profit publication allied with the University of Central Arkansas. As *ADGM* goes to press, *OA* has not yet hired an art director. Check their Web site for updates.

Illustration Approached by many artists/year. Uses a varying number of illustrations/year. Considers all media.

First Contact & Terms Prefers digital submissions (attach JPEGs to e-mail) or include link to Web site. Also accepts printed tearsheets, photocopies or postcard sample of work. Samples are filed. Responds only if interested. To have materials returned, send SASE. Art director will contact artist for portfolio review of final art and roughs if interested. Buys one-time rights. Pays on publication. Finds artists through word of mouth and submissions.

Tips "See the magazine."

PACIFIC PRESS PUBLISHING ASSOCIATION

1350 North Kings Rd., Nampa ID 83687. (208)465-2500. **Contact:** Dennis Ferree, graphic designer. Art Designer, Textbooks: Eucaris Galicia. Art Designer, Spanish and French Magazines: Ariel Fuentealba. Art Designer, *Signs of the Times:* Merwin Stewart. Estab. 1875. Book and magazine publisher. Specializes in Christian lifestyles and Christian outreach.

- This association publishes magazines and books. Also see *Signs of the Times* listing for needs.

◼ PACIFIC YACHTING MAGAZINE

1080 Howe St., Suite 900, Vancouver BC V6Z 2T1 Canada. (604)606-4644. Fax: (604)687-1925. E-mail: editorial @pacificyachting.net. Web site: www.pacificyachting.com. **Editor:** Peter A. Robson. Estab. 1968. Monthly 4-color magazine focused on boating on the West Coast of Canada. Power/sail cruising only. Circ. 25,000. Accepts previously published artwork. Original artwork returned at job's completion. Sample copies available for $5.95 cover price. Art guidelines not available.

Cartoons Approached by 12-20 cartoonists/year. Buys 2-3 illustrations or cartoons/issue. Boating themes only; single panel b&w line drawings.

Illustration Approached by 25 illustrators/year. Buys 10-20 illustrations/year. Has featured illustrations by Dave Alavoine, Roger Jackson and Tom Shardlow. Boating themes only. Considers pen & ink, watercolor, airbrush, acrylic, colored pencil, oil and charcoal.

First Contact & Terms Cartoonists and Illustrators: Send query letter with brochure and roughs. "Will keep on file and contact if interested." Illustrators: Call for appointment to show portfolio of appropriate samples related to boating on the West Coast. Buys one-time rights. Pays on publication. Pays cartoonists $25-50 for b&w. Pays illustrators $300 for color cover; $50-100 for color inside; $25-50 for spots.

Tips "Know boats and how to draw them correctly. Know and love my magazine."

PAINT HORSE JOURNAL

P.O. Box 961023, Fort Worth TX 76161-0023. (817)834-2742. Fax: (817)222-8466. E-mail: pzinn@apha.com. Web site: www.painthorsejournal.com. **Art Director:** Paul Zinn. Monthly 4-color official publication of breed

registry of Paint horses for people who raise, breed and show Paint horses. Circ. 30,000. Original artwork returned after publication if requested. Sample copy for $4.50; artist's guidelines for SASE.

Illustration Buys a few illustrations each year.

First Contact & Terms Illustrators: Send business card and samples to be kept on file. Prefers snapshots of original art or photostats as samples. Samples returned by SASE if not filed. Responds in 1 month. Buys first rights but may wish to use small, filler art many times. Payment varies by project.

Tips "No matter what style of art you use, you must include Paint Horses with conformation acceptable (to the APHA). Horses of Arabian-type conformation or with markings not appropriate for Paint Horses will not be considered."

PARABOLA MAGAZINE

135 East 15th St., New York NY 10013. (212)505-9037. Fax: (212)979-7325. E-mail: editors@parabola.org. Web site: www.parabola.org. **Managing Editor:** Robert Doto. Art Director/Designer: Moulsari Jain. Estab. 1974. Quarterly magazine of world myth, religious traditions and arts/comparative religion. Circ. 40,000. Sample copies available. Art guidelines on Web site.

Illustration Approached by 20 illustrators/year. Buys 4-6 illustrations/issue. Prefers traditional b&w high contrast. Considers all media.

First Contact & Terms Illustrators: Send postcard or query letter with printed nonreturnable samples, photocopies and SASE. Accepts disk submissions. Samples are filed. Responds only if interested. Buys one-time rights. Pays on publication (kill fee given for commissioned artwork only); $300 maximum for cover; $150 maximum for b&w inside. Pays $50-100 for spots. Finds illustrators through sourcebooks, magazines, word of mouth and artist's submissions. "We rarely commission cover."

Tips "Familiarity with religious traditions and symbolism a plus. Timeless or classic look is preferred over trendy."

PASSPORT

6401 The Paseo, Kansas City MO 64131. (816)333-7000 ext. 2365. (816)333-4439. E-mail: kadams@nazarene.org. **Editor:** Ryan R. Pettit. Editorial Assistant: Kimberly Adams. Estab. 1992. "*Passport* is a weekly 8 page, color story paper that focuses on the interests and concerns of the preteen (11- to 12-year-old). We try to connect what they learn in Sunday School with their daily lives." Circ. 18,000. Originals are not returned. Sample copies free for SASE with first-class postage.

- Not accepting new submissions until 2007.

Cartoons Buys 1 cartoon/issue. Prefers humor for the preteen; single panel b&w line drawings with gagline.

First Contact & Terms Cartoonists: Send query letter with finished cartoon samples and SASE. Samples are filed or are returned by SASE if requested. Responds in 2 months. Buys multi-use rights. Pays $15 for b&w.

PC MAGAZINE

Ziff-Davis Media, 28 E. 28th St., 11th Floor, New York NY 10016. (212)503-3500. Fax: (212)503-5580. Web site: www.pcmag.com. **Art Director:** Richard Demler. Senior Associate Art Director: Michael St. George. Estab. 1983. Bimonthly consumer magazine featuring comparative lab-based reviews of current PC hardware and software. Circ. 750,000. Sample copies available.

Illustration Approached by 100 illustrators/year. Buys 5-10 illustrations/issue. Considers all media.

First Contact & Terms Illustrators: Send postcard sample and/or printed samples, photocopies, tearsheets. Accepts CD or e-mail submissions. Samples are filed. Portfolios may be dropped off and should include tearsheets and transparencies; art department keeps for one week to review. **Pays on acceptance.** Payment negotiable for cover and inside; $350 for spots.

PENNSYLVANIA LAWYER

Pennsylvania Bar Association, 100 South St., Harrisburg PA 17108-0186. (717)238-6715. E-mail: editor@pabar.org. Web site: www.pabar.org. **Editor:** Geoff Yuda. Bimonthly association magazine "featuring nuts and bolts articles and features of interest to lawyers." Circ. 30,000. Sample copies for #10 SASE with first-class postage. Art guidelines available.

Illustration Approached by 80 illustrators/year. Buys 2-3 illustrations/year. Considers all media.

First Contact & Terms Illustrators: Send query letter with samples. Samples are filed or returned by SASE. Art director will contact artist for portfolio review if interested. Negotiates rights purchased. **Pays on acceptance**; $300-500 for color cover; $100 for inside. Pays $25-50 for spots. Finds illustrators through word of mouth and artists' submissions.

Tips "Artists must be able to interpret legal subjects. Art must have fresh, contemporary look. Read articles you are illustrating, provide three or more roughs in timely fashion."

PERSIMMON HILL

Published by the National Cowboy & Western Heritage Museum, 1700 NE 63rd St., Oklahoma City OK 73111. (405)478-6404. Fax: (405)478-4714. E-mail: editor@nationalmuseum.org. Web site: www.nationalcowboymuseum.org. **Director of Publications:** M.J. Van Deventer. Estab. 1970. Quarterly 4-color journal of western heritage "focusing on both historical and contemporary themes. It features nonfiction articles on notable persons connected with pioneering the American West; art, rodeo, cowboys, floral and animal life; or other phenomena of the West of today or yesterday. Lively articles, well written, for a popular audience. Contemporary design follows style of *Architectural Digest* and *European Travel and Life*. Circ. 15,000. Original artwork returned after publication. Sample copy for $10.50.

Illustration Fine art only.

First Contact & Terms Send query letter with tearsheets, SASE, slides and transparencies. Samples are filed or returned by SASE if requested. Publication will contact artist for portfolio review if interested. Portfolio should include original/final art, photographs or slides. Buys first rights. Requests work on spec before assigning job. Payment varies. Finds artists through word of mouth and submissions.

Tips "We are a western museum publication. Most illustrations are used to accompany articles. Work with our writers, or suggest illustrations to the editor that can be the basis for a freelance article or a companion story. More interest in the West means we have to provide more contemporary photographs and articles about what people in the West are doing today. Study the magazine first at least four issues."

PEST CONTROL

7500 Old Oak Blvd., Cleveland OH 44130-3343. (440)891-2731. Fax: (440)891-2675. E-mail: lblake@questex.com. Web site: www.pestcontrolmag.com. **Art Director:** Laura Watilo Blake. Monthly trade publication for pest control specialists focusing on crawling and flying insect control, termite control, rodent and other pest control and public health issues. Circ.: 21,298.

Cartoons Approached by 50 cartoonists/year. Buys 1-2 cartoons/year. Prefer pest control, single panel and humorous.

Illustration Approached by 50 illustrators/year. Buys 3-5 illustrations/year. Prefers pest control. Assigns 50% to new and emerging illustrators.

First Contact & Terms Cartoonists/Illustrators: Send postcard sample with URL. After introductory mailing, send follow-up postcard sample every 6 months. Samples are filed. Responds only if interested. Buys one-time rights. Finds freelancers through artists' submissions.

PHI DELTA KAPPAN

P.O. Box 789, Bloomington IN 47402. (812)339-1156. Fax: (812)339-0018. Web site: www.pdkintl.org/kappan/kappan.htm. **Design Director:** Carol Bucheri. Emphasizes issues, policy, research findings and opinions in the field of education. For members of the educational organization Phi Delta Kappa and subscribers. Black & white with 4-color cover and "conservative, classic design." Published 10 times/year. Circ. 100,000. Include SASE. Responds in 2 months. "We return illustrations and cartoons after publication." Sample copy for $7 plus $5 S&H. "The journal is available in most public and college libraries."

Cartoons Approached by over 100 cartoonists/year. Looks for "finely drawn cartoons that reflect our multi-racial, multi-ethnic world." Cartoon content must be related to education.

Illustration Approached by over 100 illustrators/year. Uses one 4-color cover and spread/issue. Features serious conceptual art; humorous, realistic, computer and spot illustraion. Prefers style of John Berry, Brenda Grannan and Jem Sullivan. Most illustrations depict some aspect of the education process (from pre-kindergarten to university level), often including human figures.

First Contact & Terms Illustrators: Send postcard sample and include Web address to online portfolio. "We can accept computer illustrations that are Mac formatted (EPS or TIFF files; Photoshop 6.0 or Illustrator 9.0)." Buys one-time print and electronic rights. Payment varies.

Tips "We look for artists who can create a finely crafted image that holds up when translated onto the printed page. Our journal is edited for readers with master's or doctoral degrees, so we look for illustrators who can take abstract concepts and make them visual, often through the use of metaphor. Submission specifications online."

PHILADELPHIA WEEKLY

1500 Sansom St., 3rd Floor, Philadelphia PA 19102-2800. (215)563-7400. Fax: (215)563-0620. E-mail: jcox@philadelphiaweekly.com. Web site: www.philadelphiaweekly.com. **Art Director:** Jeffrey Cox. Estab. 1971. Alternative weekly, 4-color, tabloid focusing on news and opinion and arts and culture. Circ. 105,500.

Cartoons Approached by 25 cartoonists/year. Buys 0-1 cartoon/issue. Prefers single panel, multiple panel, political, humorous, b&w washes, b&w line drawings.

Illustration Approached by scores of illustrators/year. Buys 3-5 illustrations/issue. Has featured illustrations

by Brian Biggs, Jay Bevenour, James McHugh. Features caricatures of celebrities and politicians; humorous, realistic and spot illustrations. Considers a wide range of styles.
First Contact & Terms Cartoonists: Send query letter with b&w photocopies. Illustrators: Send postcard sample or query letter with printed samples and photocopies. Send nonreturnable samples. Samples are filed and are not returned. Responds only if interested. Buys one-time rights. Pays on publication; $300 for color cover; $75-150 for b&w inside; $100-250 for color inside; $75 for spots. Finds illustrators through promotional samples.

[N] PHOENIX MAGAZINE
8501-E Princess Dr. #190, Scottsdale AZ 85255-7818. (480)664-3960. Fax: (480)664-3961. Web site: www.phoenixmag.com. **Art Director:** Charmayne Glen. Monthly regional magazine for residents and visitors to Phoenix, Arizona covering local personality profiles, local culture and historical articles. Circ.: 63,000.
Illustration Features local caricatures of celebrities/politicians and humorous illustration of business and politics.
First Contact & Terms Illustrators: Send postcard sample with URL. Samples are filed. Responds only if interested. Pays illustrators $100-200 for color inside. Buys one-time rights. Finds freelancers through artists' submissions.

[N] PINK MAGAZINE
8 Puritan Mill, 916 Joseph E. Lowery Blvd., Atlanta GA 30318. E-mail: jtyson@pinkmagazine.com. Web site: www.pinkmagazine.com. **Art Director:** Jennifer Tyson. Estab. 2006. Bimonthly magazine for professional women. Circ.: 20,000.
Illustration Approached by 50 illustrators/year. Buys 100 illustrations/year. Has featured Mimi Mangrum. Features spot illustrations of business, families and women. Assigns 20% to new and emerging illustrators. 10% of freelance illustration demand knowledge of Photoshop.
First Contact & Terms Illustrators: Send postcard sample with URL. Send follow-up postcard sample every 4 months. Accepts e-mail submissions with link to Web site. Prefers JPEG files. Samples are filed and not returned. Responds only if interested. Art Director will contact artist for portfolio review if interested. Pays illustrators $250-900 for color inside. Pays on publication. Buys one-time rights. Finds freelancers through artists' submissions.

PLANNING
American Planning Association, 122 S. Michigan Ave., Suite 1600, Chicago IL 60603. (312)431-9100. Fax: (312)431-9985. Web site: www.planning.org. **Editor and Publisher:** Sylvia Lewis. Art Director: Richard Sessions. Monthly 4-color magazine for urban and regional planners interested in land use, housing, transportation and the environment. Circ. 38,000. Previously published work OK. Original artwork returned after publication, upon request. Free sample copy and artist's guidelines available. "Enclose $1 in postage for sample magazinestamps only, no cash or checks, please."
Cartoons Buys 2 cartoons/year on the environment, city/regional planning, energy, garbage, transportation, housing, power plants, agriculture and land use. Prefers single panel with gaglines ("provide outside of cartoon body if possible").
Illustration Buys 20 illustrations/year on the environment, city/regional planning, energy, garbage, transportation, housing, power plants, agriculture and land use.
First Contact & Terms Cartoonists: Include SASE. Illustrators: Send samples of style we can keep on file. If you want a response, enclose SASE. Responds in 2 weeks. Buys all rights. Pays on publication. Pays cartoonists $50 minimum for b&w line drawings. Pays illustrators $250 maximum for b&w cover drawings; $100 minimum for b&w line drawings inside.
Tips "Don't send portfolio. No corny cartoons. Don't try to figure out what's funny to planners. All attempts seen so far are way off base. Your best chance is to send samples of any type of illustration—cartoons or other—that we can keep on file. If we like your style we will commission work from you."

PLAYBOY MAGAZINE
680 N. Lakeshore Dr., Chicago IL 60611. (312)751-8000. Web site: www.playboy.com. **Art Director:** Tom Staebler. Estab. 1952. Monthly magazine. Circ. 3.5 million.
Cartoons Playboy Enterprises Inc., Cartoon Dept., 730 Fifth Ave., New York NY 10019.
Illustration Approached by 700 illustrators/year. Prefers "uncommercial looking" artwork. Considers all media.
First Contact & Terms Illustrators: Send postcard sample or query letter with slides and photocopies or other appropriate sample. Does not accept originals. Samples are filed or returned. Responds in 2 weeks. Buys all rights. **Pays on acceptance.**
Tips "No phone calls, only formal submissions of five pieces."

PN

(formerly Paraplegia News) 2111 E. Highland Ave., Suite 180, Phoenix AZ 85016-4702. (602)224-0500. Fax: (602)224-0507. E-mail: anngarvey@pnnews.com. Web site: www.pn-magazine.com. **Art Director:** Ann Garvey. Estab. 1947. Monthly 4-color magazine emphasizing wheelchair living for wheelchair users, rehabilitation specialists. Circ. 30,000. Accepts previously published artwork. Original artwork not returned after publication. Sample copy free for large-size SASE with $3 postage.

Cartoons Buys 3 cartoons/issue. Prefers line art with wheelchair theme. Prefers single panel b&w line drawings with or without gagline.

Illustration Prefers wheelchair living or medical and financial topics as themes. 50% of freelance work demands knowledge of QuarkXPress, Photoshop or Illustrator.

First Contact & Terms Cartoonists: Send query letter with finished cartoons to be kept on file. Responds only if interested. Buys all rights. **Pays on acceptance.** Illustrators: Send postcard sample. Accepts disk submissions compatible with Illustrator 10.0 or Photoshop 7.0. Send EPS, TIFF or JPEG files. Samples not filed are returned by SASE. Publication will contact artist for portfolio review if interested. Portfolio should include final reproduction/product, color and b&w tearsheets, photostats, photographs. Pays on publication. Pays cartoonists $10 for b&w. Pays illustrators $250 for color cover; $25 for b&w inside, $50 for color inside.

Tips "When sending samples, include something that shows a wheelchair user. We regularly purchase cartoons that depict wheelchair users."

POCKETS

P.O. Box 340004, 1908 Grand AV, Nashville TN 37203-0004. (615)340-7333. Fax: (615)340-7267. E-mail: pockets @upperroom.org. Web site: www.pockets.org. **Editor:** Lynn W. Gilliam. Devotional magazine for children 6-12. 4-color. Monthly except January/February. Circ. 100,000. Accepts one-time previously published material. Original artwork returned after publication. Sample copy for 9×12 or larger SASE with 4 first-class stamps.

Illustration Approached by 50-60 illustrators/year. Features humorous, realistic and spot illustration. Assigns 15% of illustrations to new and emerging illustrators. Uses variety of styles; 4-color, flapped art appropriate for children. Realistic, fable and cartoon styles.

First Contact & Terms Illustrators: Send postcard sample, brochure, photocopies, SASE and tearsheets. No fax submissions accepted. Also open to more unusual art forms cut paper, embroidery, etc. Samples not filed are returned by SASE. "No response without SASE." Responds only if interested. Buys one-time or reprint rights. **Pays on acceptance**; $600 flat fee for 4-color covers; $75-350 for color inside.

Tips "Decisions made in consultation with out-of-house designer. Send samples to our designer Chris Schechner, Schechner & Associates, 408 Inglewood Dr., Richardson, TX 75080."

POPULAR SCIENCE

Time 4 Media, 2 Park Ave., New York NY 10016. (212)779-5000. Fax: (212)481-8062. E-mail: dick.barnett@popsci.com. Web site: www.popsci.com. **Art Director:** Dick Barnett. "For the well-educated adult male, interested in science, technology, new products." Circ. 1,500,000. Original artwork returned after publication. Art guidelines available.

Illustration Uses 30-40 illustrations/issue. Has featured illustrations by Don Foley, P.J. Loughron, Andrew Grirds and Bill Duke. Assigns 50% of illustrations to well-known or "name" illustrators; 40% to experienced but not well-known illustrators; 10% to new and emerging illustrators. Works on assignment only. Interested in technical 4-color art and 2-color line art dealing with automotive or architectural subjects. Especially needs science and technological pieces as assigned per layout.

First Contact & Terms Illustrators: Send postcard sample, photocopies or other nonreturnable samples. Responds only if interested. Samples kept on file for future assignments. "After seeing portfolios, I photocopy or photostat those samples I feel are indicative of the art we might use." Reports whenever appropriate job is available. Buys first publishing rights.

Tips "More and more scientific magazines have entered the field. This has provided a larger base of technical artists for us. Be sure your samples relate to our subject matter, i.e., no rose etchings, and be sure to include a tearsheet for our files. I don't really need a high end, expensive sample. All I need is something that shows the type of work you do. Look at our magazine before you send samples. Our illustration style is very specific. If you think you fit into the look of our magazine, send a sample for our files."

THE PORTLAND REVIEW

P.O. Box 347, Portland OR 97207. (503)725-4533. Fax: (503)725-5860. E-mail: review@vanguard.vg.pdx.edu. Web site: www.portlandreview.org. **Contact:** Rebecca Rich Goldweber, editor. Estab. 1954. Quarterly student-run arts journal. Circ. 1,000. Sample copies available for $6. Art guidelines available free with SASE or on Web site.

Illustration Approached by 50 illustrators/year. We don't pay contributors. Features humorous and natural history illustration.

First Contact & Terms Cartoonists/Illustrators: Send postcard sample or query letter with b&w photocopies and SASE. Accepts e-mail submissions with link to Web site or with image file. Prefers Mac-compatible. Samples are not filed and not returned. Responds in 2 months. Portfolio not required.

PRAIRIE DOG

P.O. Box 470757, Aurora CO 80047-0757. (303)753-0956. Fax: (303)753-0956. E-mail: jrhart@isys.net. **Editor-in-Chief:** John R. Hart. Estab. 1995. Biannual literary magazine. Circ. 600. Sample copy available for $5.95 plus 4 first-class stamps. Art guidelines free for SASE with first-class postage.

Illustration Approached by 10 illustrators/year. Buys 20 illustrations/issue. Considers all media.

First Contact & Terms Illustrators: Send query letter with printed samples. Accepts disk submission in GIF, JPG, BMP, CDR, PCX or TIF files. Samples are filed. Responds in 6 months. Buys first-rights. Pays on publication, 1 copy of magazine.

Tips "Read our magazine."

PRAIRIE JOURNAL OF CANADIAN LITERATURE

P.O. Box 61203 Brentwood Postal Services, Calgary AB T2L 2K6 Canada. E-mail: prairiejournal@yahoo.com. Web site: www.geocities.com/prairiejournal. **Contact:** Editor (by mail). Estab. 1983. Biannual literary magazine. Circ. 600. Sample copies available for $6; art guidelines on Web site.

Illustration Approached by 25 illustrators/year. Buys 6 illustrations/year. Has featured illustrations by Hubert Lacey, Rita Diebolt, Lucie Chan. Considers artistic/experimental b&w line drawings or screened print.

First Contact & Terms Illustrators: Send postcard sample or query letter with b&w photocopies. Samples are filed. Responds only if interested. Portfolio review not required. Acquires one-time rights. Pays $50 maximum (Canadian) for b&w cover and $25 maximum for inside drawings. Pays on publication. Finds freelancers through unsolicited submissions and queries.

Tips "We are looking for black & white line drawings easily reproducable and camera-ready copy. Never send originals through the mail."

PRAIRIE SCHOONER

University of Nebraska, 201 Andrews Hall, Lincoln NE 68588-0334. (402)472-0911. Fax: (402)472-9771. E-mail: kgrey2@unlnotes.unl.edu. Web site: www.unl.edu/schooner/psmain.htm. **Contact:** Kelly Grey Carlisle, managing editor. Estab. 1926. Quarterly b&w literary magazine with full-color cover. "*Prairie Schooner*, now in its 80th year of continuous publication, is called 'one of the top literary magazines in America' by *Literary Magazine Review*. Each of the four issues contains short stories, poetry, book reviews, personal essays, interviews or some mix of these genres. Contributors are both established and beginning writers. Readers live in all states in the U.S. and in most countries outside the U.S." Circ. 2,800. Original artwork is returned after publication. "We rarely have the space or funds to reproduce artwork in the magazine but hope to do more in the future." Sample copies for $6.

Illustration Approached by 5-10 illustrators/year. Uses freelancers mainly for cover art.

First Contact & Terms "Before submitting, artist should be familiar with our cover and format, 6×9, vertical images work best; artist should look at previous issues of *Prairie Schooner*. Portfolio review not required. We are rarely able to pay for artwork; have paid $50 to $100."

Tips Finds artists through word of mouth.

THE PRESBYTERIAN RECORD

50 Wynford Dr., Toronto ON M3C 1J7 Canada. (416)441-1111. Fax: (416)441-2825. E-mail: pcrecord@presbyterian.ca. Web site: www.presbyterianrecord.ca. **Production and Design:** Samanta Edwards. Published 11 times/year. Deals with family-oriented religious themes. Circ. 50,000. Original artwork returned after publication. Simultaneous submissions and previously published work OK. Free sample copy and artists' guidelines for SASE with first-class postage.

Cartoons Approached by 12 cartoonists/year. Buys 1-2 cartoons/issue. Interested in some theme or connection to religion.

Illustration Approached by 6 illustrators/year. Buys 1 illustration/year on religion. Has featured illustrations by Ed Schnurr, Claudio Ghirardo and Chrissie Wysotski. Features humorous, realistic and spot illustration. Assigns 50% of illustrations to new and emerging illustrators. "We are interested in excellent color artwork for cover." Any line style acceptable—should reproduce well on newsprint. Works on assignment only.

First Contact & Terms Cartoonists: Send roughs and SAE (nonresidents include IRC). Illustrators: Send query letter with brochure showing art style or tearsheets, photocopies and photographs. Will accept computer illustrations compatible with QuarkXPress 4.1, Illustrator 8.0, Photoshop 6.0. Samples returned by SAE (nonresidents

include IRC). Responds in 1 month. To show a portfolio, mail final art and color and b&w tearsheets. Buys all rights on a work-for-hire basis. Pays on publication. Pays cartoonists $25-50 for b&w. Pays illustrators $50-100 for b&w cover; $100-300 for color cover; $25-80 for b&w inside; $25-60 for spots.

Tips "We don't want any 'cute' samples (in cartoons). Prefer some theological insight in cartoons; some comment on religious trends and practices."

PRESBYTERIANS TODAY

100 Witherspoon St., Louisville KY 40202. (502)569-5637. Fax: (502)569-8632. E-mail: today@pcusa.org. Web site: www.pcusa.org/today. **Art Director:** Linda Crittenden. Estab. 1830. 4-color; official church magazine emphasizing Presbyterian news and informative and inspirational features. Publishes 10 issues year. Circ. 58,000. Originals are returned after publication if requested. Some feature illustrations may appear on Web site. Sample copies for SASE with first-class postage.

Cartoons Approached by 20-30 cartoonists/year. Buys 1-2 freelance cartoons/issue. Prefers general religious material; single panel.

Illustration Approached by more than 50 illustrators/year. Buys 2-3 illustrations/issue, 30 illustrations/year from freelancers. Works on assignment only. Media varies according to need.

First Contact & Terms Cartoonists: Send roughs and/or finished cartoons. Responds in 1 month. Rights purchased vary according to project. Illustrators: Send query letter with tearsheets. Samples are filed and not returned. Responds only if interested. Buys one-time rights. Pays cartoonists $25, b&w. Pays illustrators $150-350, cover; $80-250, inside.

PREVENTION

400 S. 10th St., Emmaus PA 18098. (610)967-7548. Fax: (610)967-7654. E-mail: laura.baer@rodale.com. Web site: www.prevention.com. **Art Director:** Laura Baer. Estab. 1950. Monthly consumer magazine covering health and fitness, women readership. Circ. 3 million. Art guidelines available.

Illustration Approached by 500-750 illustrators/year. Buys 1-2 spot illustrations/issue. Considers all media.

First Contact & Terms Illustrators: Send postcard sample or query letter with photocopies, tearsheets, URL. Samples are filed. Responds only if interested. Art director will contact artist for portfolio review of b&w, color, photographs, tearsheets, transparencies if interested. Buys rights for all media. Finds illustrators through www.iSpot.com, magazines, submissions.

PRINT MAGAZINE

38 E. 29th St., 3rd Floor, New York NY 10016. (212)447-1400. Fax: (212)447-5231. E-mail: steven.brower@printmag.com. Web site: www.printmag.com. **Art Director:** Steven Brower. Estab. 1940. Bimonthly professional magazine for "art directors, designers and anybody else interested in graphic design." Circ. 55,000. Art guidelines available.

First Contact & Terms Illustrators/Designers: Send postcard sample, printed samples and tearsheets. Samples are filed. Responds only if interested. Art director will contact artist for portfolio review if interested. Portfolios may be dropped off every Monday, Tuesday, Wednesday, Thursday and Friday. Buys first rights. Pays on publication. Finds illustrators through agents, sourcebooks, word of mouth and artist's submissions.

Tips "Read the magazine: We show art and design and don't buy and commission much, but it does happen."

▨ PRISM INTERNATIONAL

Buch E462, 1866 Main Mall, Vancouver BC V6T 1Z1 Canada. (604)822-2514. Fax: (604)822-3616. E-mail: prism@interchange.ubc.ca. Web site: www.prism.arts.ubc.ca. Estab. 1959. Quarterly literary magazine. "We use cover art for each issue." Circ. 1,200. Original artwork is returned to the artist at the job's completion. Sample copies for $10, art guidelines for SASE with first-class Canadian postage.

Illustration Approached by 20 illustrators/year. Buys 1 cover illustration/issue. Has featured illustrations by Mark Ryden, Mark Mothersbaugh, Annette Allwood, The Clayton Brothers, Maria Capolongo, Mark Korn, Scott Bakal, Chris Woods, Kate Collie and Angela Grossman. Features representational and nonrepresentational fine art. Assigns 50% of illustrations to experienced but not well-known illustrators; 50% to new and emerging illustrators. "Most of our covers are full color artwork and sometimes photography; on occasion we feature black & white cover/year."

First Contact & Terms Illustrators: Send postcard sample. Accepts submissions on disk compatible with CorelDraw 5.0 (or lower) or other standard graphical formats. Most samples are filed. Those not filed are returned by SASE if requested by artist. Responds in 6 months. Portfolio review not required. Buys first rights. Pays on publication; $250 (Canadian) for b&w and color cover; $40 (Canadian) for b&w and color inside and 3 copies. Finds artists through word of mouth and going to local exhibits.

Tips "We are looking for fine art suitable for the cover of a literary magazine. Your work should be polished,

confident, cohesive and original. Please send postcard samples of your work. As with our literary contest, we will choose work which is exciting and which reflects the contemporary nature of the magazine.''

PRIVATE PILOT

265 S. Anita Dr., Suite 120, Orange CA 92868. (714)939-9991. Web site: www.privatepilotmag.com. **Editorial Director:** Bill Fedorko. Managing Editor: Kara Dodge. Art Director: Jerry Ford. Estab. 1965. Monthly magazine for owners/pilots of private aircraft, student pilots and others aspiring to attain additional ratings and experience. Circ. 105,000.

 • Also publishes *Custom Planes*, a monthly magazine for homebuilders and restorers. Same guidelines apply.

Illustration Works with 2 illustrators/year. Buys 10 illustrations/year. Uses artists mainly for spot art.

First Contact & Terms Illustrators: Send query letter with photocopies, tearsheets and SASE. Accepts submissions on disk (call first). Responds in 3 months. Pays $50-500 for color inside. ''We also use spot illustrations as column fillers.'' Buys 1-2 spot illustrations/issue. Pays $35/spot.

Tips ''Know the field you wish to represent; we specialize in general aviation aircraft, not jets, military or spacecraft.''

PROCEEDINGS

U. Naval Institute, 291 Wood Rd., Annapolis MD 21402-1254. (410)268-6110. Fax: (410)269-1049. Web site: www.navalinstitute.org. **Creative Director:** Karen Eskew. Monthly 4-color magazine emphasizing naval and maritime subjects. ''*Proceedings* is an independent forum for the sea services.'' Design is clean, uncluttered layout, ''sophisticated.'' Circ. 85,000. Accepts previously published material. Sample copies and art guidelines available.

Cartoons Buys 23 cartoons/year from freelancers. Prefers cartoons assigned to tie in with editorial topics.

Illustration Buys 1 illustration/issue. Works on assignment only. Has featured illustrations by Tom Freeman, R.G. Smith and Eric Smith. Features humorous and realistic illustration; charts & graphs; informational graphics; computer and spot illustration. Needs editorial and technical illustration. ''We like a variety of styles if possible. Do excellent illustrations and meet the requirement for military appeal.'' Prefers illustrations assigned to tie in with editorial topics.

First Contact & Terms Cartoonists: Send query letter with samples of style to be kept on file. Illustrators Send query letter with printed samples, tearsheets or photocopies. Accepts submissions on disk (call production manager for details). Samples are filed or are returned only if requested by artist. Responds only if interested. Publication will contact artist for portfolio review if interested. Negotiates rights purchased. Sometimes requests work on spec before assigning job. Pays cartoonists $25-50 for b&w, $50 for color. Pays illustrators $50 for b&w inside, $50-75 for color inside; $150-200 for color cover; $25 minimum for spots. ''Contact us first to see what our needs are.''

▨ PROFIT MAGAZINE

One Mount Pleasant Rd., 11th Floor, Toronto ON M4Y 2Y5 Canada. (416)764-1402. Fax: (416)764-1404. E-mail: jhull@profitmag.ca. Web site: www.profitguide.com. **Art Director:** John Hull. Estab. 1982. 4-color business magazine for Canadian entrepreneurs published 6 times/year. Circ. 102,000.

Illustration Buys 3-5 illustrations/issue. Has featured illustrations by Jerzy Kolacz, Jason Schneider, Ian Phillips. Features charts & graphs, computer, realistic and humorous illustration, informational graphics and spot illustrations of business subjects. Assigns 50% of illustrations to well-known or ''name'' illustrations; 50% to experienced but not well-known illustrators.

First Contact & Terms Illustrators: Send postcard or other nonreturnable samples. Accepts Mac-compatible disk submissions. Samples are not returned. Will contact artist for portfolio review if interested. Buys first rights. **Pays on acceptance**; $500-750 for color inside; $750-1,000 for 2-page spreads; $350 for spots. Pays in Canadian funds. Finds illustrators through promo pieces, other magazines.

PROGRESSIVE RENTALS

1504 Robin Hood Trail, Austin TX 78703. (512)794-0095. Fax: (512)794-0097. E-mail: nferguson@aprovision.org. Web site: www.rtohq.org. **Art Director:** Neil Ferguson. Estab. 1983. Bimonthly association publication for members of the Association of Progressive Rental Organizations, the national association of the rental-purchase industry. Circ. 6,000. Sample copies free for catalog-size SASE with first-class postage.

Illustration Buys 2-3 illustrations/issue. Has featured illustrations by Barry Fitzgerald, Aletha St. Romain, A.J. Garces, Edd Patton and Jane Marinsky. Features conceptual illustration. Assigns 15% of illustrations to new and emerging illustrators. Prefers cutting edge; nothing realistic; strong editorial qualities. Considers all media. ''Accepts computer-based illustrations (Photoshop, Illustrator).

First Contact & Terms Illustrators: Send postcard sample, query letter with printed samples, photocopies or tearsheets. Accepts disk submissions. (Must be Photoshop-accessible EPS high-resolution [300 dpi] files or

Illustrator files.) Samples are filed or returned by SASE. Responds in 1 month if interested. Rights purchased vary according to project. Pays on publication; $300-450 for color cover; $250-350 for color inside. Finds illustrators mostly through artist's submissions; some from other magazines.

Tips "Must have a strong conceptual ability—that is, they must be able to illustrate for editorial articles dealing with business/management issues. We are looking for cutting-edge styles and unique approaches to illustration. I am willing to work with new, lesser-known illustrators."

THE PROGRESSIVE

409 E. Main St., Madison WI 53703. (608)257-4626. Fax: (608)257-3373. Web site: www.progressive.org. **Art Director:** Nick Jehlen. Estab. 1909. Monthly b&w plus 4-color cover. Circ. 65,000. Originals returned at job's completion. Free sample copy and art guidelines.

Illustration Works with 50 illustrators/year. Buys 10 b&w illustrations/issue. Features humorous and political illustration. Has featured illustrations by Luba Lukova, Alex Nabaum and Seymour Chwast. Assigns 30% of illustrations to new and emerging illustrators. Needs editorial illustration that is "original, smart and bold." Works on assignment only.

First Contact & Terms Illustrators: Send query letter with tearsheets and/or photocopies. Samples returned by SASE. Responds in 6 weeks. Portfolio review not required. Pays $1,000 for b&w and color cover; $300 for b&w line or tone drawings/paintings/collage inside. Buys first rights. Do not send original art. Send samples, postcards or photocopies and appropriate postage for materials to be returned.

Tips Check out a copy of the magazine to see what kinds of art we've published in the past. A free sample copy is available by visiting our Web site.

PROTOONER

P.O. Box 2270, Daly City CA 94017-2270. Phone/fax: (650)755-4827. E-mail: protooner@earthlink.net. Web site: www.protooner.lookscool.com. **Editor:** Joyce Miller. Art Director: Ladd A. Miller. Estab. 1995. Monthly trade journal for the professional cartoonist and gagwriter. Circ. 1,300. Sample copy $6 US, $10 foreign. Art guidelines for #10 SASE with first-class postage.

Cartoons Approached by tons of cartoonists/year. Buys 5-6 cartoons plus cover cartoon/issue. Prefers good visual humorous impact. Prefers single panel, humorous, b&w line drawings, with or without gaglines.

Illustration Approached by 6-12 illustrators/year. Buys 3 illustrations/issue. Has featured illustrations by Brewster Allison, Thom Bluemel, Murray Mann, Bob Vojtko, and Earl Engleman. Assigns 20% of illustrations to new and emerging illustrators. Features humorous illustration; informational graphics; spot illustration. Prefers humorous, original. Avoid vulgarity. Considers pen & ink. 50% of freelance illustration demands computer knowledge. Query for programs.

First Contact & Terms Cartoonists: Send query letter with roughs, SASE, tearsheets. Illustrators: Send query letter with printed samples and SASE. Samples are filed. Responds in 1 month. Buys reprint rights. **Pays on acceptance.** "Pays cartoonists and illustrators $25/b&w front cover and $15/inside spot drawings. We assign illustrations to accompany articles, choosing from filed samples."

Tips "Pay attention to the magazine slant and SASE a must! Study sample copy before submitting. Request guidelines. Don't mail artwork not properly slanted!"

PSYCHOLOGY TODAY

115 E. 23rd St., 9th Floor, New York NY 10010. (212)260-7210. Fax: (212)260-7566. Web site: www.psychologytoday.com. **Art Director:** Philippe Garnier. Estab. 1991. Bimonthly consumer magazine for professionals and academics, men and women. Circ. 350,000. Accepts previously published artwork. Originals returned at job's completion.

Illustration Approached by 500 illustrators/year. Buys 5 illustrations/issue. Works on assignment only. Prefers psychological, humorous, interpersonal studies. Considers all media. Needs editorial, technical and medical illustration. 20% of freelance work demands knowledge of QuarkXPress or Photoshop.

First Contact & Terms Illustrators: Send query letter with brochure, photostats and photocopies. Samples are filed and are not returned. Responds only if interested. Buys one-time rights. Pays on publication; $200-500 for color inside; $50-350 for spots; cover negotiable.

PUBLIC CITIZEN NEWS

1600 20th St., NW, Washington DC 20009. (202)588-1000. Fax: (202)588-7799. E-mail: bguldin@citizen.org. Web site: www.citizen.org. **Editor:** Angela Bradbery. Bimonthly magazine emphasizing consumer issues for the membership of Public Citizen, a group founded by Ralph Nader in 1971. Circ. 90,000. Accepts previously published material. Sample copy available for 9×12 SASE with first-class postage.

Illustration Buys up to 2 illustrations/issue. Assigns 15% of illustrations to new and emerging illustrators. Prefers contemporary styles in pen & ink.

First Contact & Terms Illustrators: Send query letter with samples to be kept on file. Buys first rights or one-time rights. Pays on publication. Payment negotiable.

Tips "Send several keepable samples that show a range of styles and the ability to conceptualize. Want cartoons that lampoon policies and politicians, especially the Bush adminstration and on the far right of the political spectrum. Magazine was redesigned into a newspaper format in 1998."

PUBLISHERS WEEKLY

360 Park Avenue S., New York NY 10010. (646)746-6758. Fax: (646)746-6631. Web site: www.publishersweekly.com. **Art Director:** Clive Chiu. Weekly magazine emphasizing book publishing for "people involved in the creative or the technical side of publishing." Circ. 50,000. Original artwork is returned to the artist after publication.

Illustration Buys 75 illustrations/year. Works on assignment only. "Open to all styles."

First Contact & Terms Illustrators: Send postcard sample or query letter with brochure, tearsheets, photocopies. Samples are not returned. Responds only if interested. **Pays on acceptance**; $350-500 for color inside.

N QUE ONDA! SAN ANTONIA AND HOUSTON EDITIONS

1415 North Loop W #950, Houston TX 77008-5602. (713)880-1133. Fax: (713)880-2322. E-mail: jesus@queonda magazine.com. **Art Director:** Jesus Cota. Biweekly bilingual magazine providing news and entertainment source for Latino community in and around San Antonio and Houston areas. Focusing on local politics, area celebrities, health, sports and food. Circ.: 160,000.

Illustration Approached by 20 illustrators/year. Buys 10 illustrations/year. Features caricatures of local celebrities/politicians, Latino community, sports, health and local politics. Assigns 50% to new and emerging illustrators.

First Contact & Terms Illustrators: Send postcard sample. After introductory mailing, send follow-up postcard sample every 6 months. Responds only if interested. Buys one-time rights. Finds freelancers through artists' submissions.

QUEEN OF ALL HEARTS

26 S. Saxon Ave., Bay Shore NY 11706-8993. (631)665-0726. Fax: (631)665-4349. E-mail: montfort@optonline.n et. Web site: www.montfortmissionaries.com. **Managing Editor:** Rev. Roger Charest. Estab. 1950. Bimonthly Roman Catholic magazine on Marian theology and spirituality. Circ. 1,700. Accepts previously published artwork. Sample copy available.

Illustration Buys 1 or 2 illustrations/issue. Works on assignment only. Prefers religious. Considers pen & ink and charcoal.

First Contact & Terms Illustrators: Send postcard samples. Samples are not filed and are returned by SASE if requested by artist. Buys one-time rights. **Pays on acceptance.**$50 minimum for b&w inside.

Tips Area most open to freelancers is illustration for short stories. "Be familiar with our publication."

ELLERY QUEEN'S MYSTERY MAGAZINE

475 Park Ave. S., New York NY 10016. (212)686-7188. Fax: (212)686-7414. **Senior Art Director:** Victoria Green. Associate Art Director: June Levine. All submissions should be sent to June Levine, associate art director. Emphasizes mystery stories and reviews of mystery books. Art guidelines for SASE with first-class postage.

• Also publishes *Alfred Hitchcock Mystery Magazine, Analog* and *Isaac Asimov's Science Fiction Magazine.*

Cartoons "We are looking for cartoons with an emphasis on mystery, crime and suspense."

Illustration Prefers line drawings. All other artwork is done in house.

First Contact & Terms Cartoonists: Cartoons should be addressed to Lauren Kuczala, editor. Illustrators: Send SASE and tearsheets or transparencies. Accepts disk submissions. Responds in 3 months. **Pays on acceptance**; $1,200 for color covers; $125 for b&w interior art. Considers all media in b&w and halftones. Send SASE with tearsheets or photocopies and printed samples. Accepts finished art on disc.

Tips "Please see our magazine before submitting samples."

N QUICK & SIMPLE

114 W. 47th St. 22nd Flr., New York NY 10036-1510. (212)641-4000. Fax: (212)765-3528. E-mail: paarons@hear st.com. Web site: www.quickandsimple.com. **Art Director:** Paul Aarons. Estab. 2005. Weekly consumer magazine written for women interested in family, health, beauty and fashion. Offers upbeat tips, advice and solutions for everyday problems.

Cartoons Buys 10 cartoons/year. Prefers families, single panel, humorous.

Illustration Approached by 150 illustrators/year. Buys 10-15 illustrations/year. Features humorous illustration and spot illustrations of families.

First Contact & Terms Cartoonists: Send photocopies. Illustrators: Send postcard sample with URL. After introductory mailing, send follow-up postcard sample every 6 months. Accepts e-mail submissions with link to Web site. Responds only if interested. Buys one-time rights. Finds freelancers through artists' submissions.

⚎ QUILL & QUIRE

70 The Esplanade, #210, Toronto ON M5E 1R2 Canada. (416)360-0044. Fax: (416)955-0794. E-mail: info@quilla ndquire.com. Web site: www.quillandquire.com. **Editor:** Derek Weiler. Estab. 1935. 1/year trade journal of book news and reviews for booksellers, librarians, publishers, writers and educators. Circ. 6,000. Art guidelines not available.

Illustration Approached by 25 illustrators/year. Buys 3 illustrations/issue. Has featured illustrations by Barbara Spurll, Chum McLeod and Carl Wiens. Assigns 100% of illustrations to experienced but not well-known illustrators. Considers pen & ink and collage. 10% of freelance illustration requires knowledge of Photoshop, Illustrator and QuarkXPress.

First Contact & Terms Illustrators: Send postcard sample. Accepts disk submissions. Samples are filed. Responds only if interested. Negotiates rights purchased. **Pays on acceptance;** $200-300 for b&w and color cover; $100-200 for b&w and color inside. Finds illustrators through word of mouth, artist's submissions.

Tips "Read our magazine."

RANGER RICK

1100 Wildlife Center Dr., Reston VA 20190. (703)438-6000. Fax: (703)438-6094. Web site: www.nwf.org. **Art Director:** Donna D. Miller. Monthly 4-color children's magazine focusing on wildlife and conservation. Circ. 500,000. Art guidelines are free for #10 SASE with first-class postage.

Illustration Approached by 100-200 illustrators/year. Buys 4-6 illustrations/issue. Has featured illustrations by Danielle Jones, Jack Desrocher, John Dawson and Dave Clegg. Features computer, humorous, natural science and realistic illustrations. Preferred subjects children, wildlife and natural world. Assigns 1% of illustrations to new and emerging illustrators. 50% of freelance illustration demands knowledge of Illustrator, Photoshop.

First Contact & Terms Illustrators: Send query letter with printed samples, photocopies and SASE. Accepts Mac-compatible disk submissions. Samples are filed or returned by SASE. Responds in 3 months. Will contact artist for portfolio review if interested. Buys one-time rights. Pays on publication; $50-250 for b&w inside; $150-800 for color inside; $1,000-2,000 for 2-page spreads; $350-450 for full-color spots. Finds illustrators through promotional samples, books and other magazines.

Tips "Looking for new artists to draw animals using Illustrator, Photoshop and other computer drawing programs. Please read our magazine before submitting."

⚎ READER'S DIGEST

Reader's Digest Rd., Pleasantville NY 10570-7000. (914)238-1000. Fax: (914)238-4559. Web site: www.readersdi gest.com. **Art Director:** Hanu Laakso. Art Director: Dean Abatemarco. Estab. 1922. Monthly consumer magazine for the general interest reader. Content features articles from various sources on a wide range of topics published in 19 languages in more than 60 countries. Circ. 13,368,327 (U.S.) 25,000,000 worldwide.

Cartoons Approached by 500 cartoonists/year. Buys 30 cartoons/issue. Prefers single panel, b&w line drawings with or without color wash.

Illustration Approached by 500 illustrators/year. Buys 7-8 illustrations/issue. Has featured illustrations by Christoph Niemann, David Roth, Mirko Ilic, Natalie Ascencios, Ingo Fast and Andrea Ventura. Assigns 80% of illustrations to well-known or "name" illustrators; 15% to experienced, but not well-known illustrators; 5% to new and emerging illustrators.

First Contact & Terms Cartoonists: Send b&w or color photocopies. Illustrators: Send postcard sample, or small packet of 4-5 samples. Samples are filed. Responds only if interested. Will contact artist for portfolio review if interested. Buys one-time world rights for 1 year. **Pays on acceptance**; $750 minimum for color inside; $750 for spots. Finds illustrators through American Illustration, Society of Illustrators, *Workbook*, reps' Internet sites.

Tips More than anything else we're looking for a certain level of sophistication, whether that's in cartoon illustration or a Brad Holland-type illustration. That means excellence in concept and execution. There are a lot of artists who send samples but we look for that undefinable element that makes them stand out. Talent is talent. When you see someone with it, it's undeniable. Our job is to spot that talent, encourage it and use it.

⚎ REAL ESTATE MAGAZINE

50 Water St., Norwalk CT 06854-3061. (203)855-1234. Fax: (203)852-7208. E-mail: design@rismedia.com. Web site: www.rismedia.com. **Art Director:** Christy Lasalle. Monthly trade publication for real estate and relocation professionals. Circ.: 42,100.

Illustration Approached by 50 illustrators/year. Buys 10 illustrations/year. Features families, houses, real estate topics and relocation. Assigns 50% to new and emerging illustrators.

First Contact & Terms Cartoonists: Send 2-3 photocopies of cartoons of real estate topics. Illustrators: Send postcard sample. After introductory mailing, send follow-up postcard sample every 4-6 months. Samples are filed. Responds only if interested. Buys one-time rights. Finds freelancers through artists' submissions.

Ⓝ RED HAT SOCIETY LIFESTYLE

1900 International Park Dr. #50, Birmingham AL 35243-4244. (205)995-8860. Fax: (205)991-0071. E-mail: jdaniels@hoffmanmedia.com. Web site: www.redhatsociety.com. **Art Director:** Jodi Daniels. Bimonthly official publication of the Red Hat Society accentuating the need to play and enjoy life. Circ.: 26,000.

Cartoons Approached by 100 cartoonists/year. Buys 10 cartoons/year. Prefers themes about the Red Hat Ladies, whimsical, carefree notions, single panel, humorous.

Illustration Approached by 60 illustrators/year. Buys 20 illustrations/year. Features humorous illustration and spot illustrations of families, men, women and pets. Assigns 5% to new and emerging illustrators.

First Contact & Terms Cartoonists: Send query letter with photocopies. Illustrators: Send postcard sample with URL. After introductory mailing, send follow-up postcard sample every 4-6 months. Accepts e-mail submissions with link to Web site. Prefer JPEG files. Samples are filed. Responds only if interested. Portfolio not required. Buys one-time rights. Finds freelancers through artists' submissions.

REDBOOK

Redbook Art Dept., 224 W. 57th St., 6th Floor, New York NY 10019-3212. (212)649-2000. Fax: (212) 581-8114. Web site: www.redbookmag.com. **Art Directors:** Tracy Everding and Emily Furlani. Monthly magazine "written for young working women ages 23-40 who want to keep a balance between career and busy home lives. Offers information on fashion, food, beauty, nutrition, health, etc." Circ. 2,407,00. Accepts previously published artwork. Original artwork returned after publication with additional tearsheet if requested.

Illustration Buys 3-7 illustrations/issue. Illustrations can be in any medium. Accepts fashion illustrations for fashion page.

First Contact & Terms Send quarterly postcard. Art director will contact for more samples if interested. Portfolio drop off any day, pick up 2 days later. Buys reprint rights or negotiates rights.

Tips "We are absolutely open to seeing new stuff, but look at the magazine before you send anything, we might not be right for you. Generally, illustrations should look new, of the moment, fresh, intelligent and feminine. Keep in mind that our average reader is 30 years old, pretty, stylish (but not too 'fashion-y'). We do a lot of health pieces and many times artists don't think of health when sending samples to us—so keep that in mind too."

REFORM JUDAISM

633 Third Ave., 7th Floor, New York NY 10017-6778. (212)650-4240. Fax: (212)650-4249. E-mail: rjmagazine@urj.org. Web site: www.reformjudaismmag.org. **Managing Editor:** Joy Weinberg. Estab. 1972. Quarterly magazine. "The official magazine of the Reform Jewish movement. It covers developments within the movement and interprets world events and Jewish tradition from a Reform perspective." Circ. 310,000. Accepts previously published artwork. Originals returned at job's completion. Sample copies available for $3.50.

Cartoons Prefers political themes tying into editorial coverage.

Illustration Buys 8-10 illustrations/issue. Works on assignment. 10% of freelance work demands computer skills.

First Contact & Terms Cartoonists: Send query letter with finished cartoons. Illustrators: Send query letter with brochure, résumé, SASE and tearsheets. Samples are filed. Responds in 1 month. Publication will contact artist for portfolio review if interested. Portfolio should include tearsheets, slides and final art. Rights purchased vary according to project. **Pays on publication**; varies according to project. Finds artists through sourcebooks and artists' submissions.

Ⓝ REGISTERED REP

249 W. 17th St. 3rd Flr., New York NY 10011-5300. (212)462-3607. Fax: (212)206-3923. E-mail: jherr@primediabusiness.com. Web site: www.registeredrep.com. **Art Director:** John Herr. Estab. 1976. Monthly trade publication provides stockbrokers and investment advisors with industry news and financial trends. Circ.: 107,050.

Illustration Approached by 100 illustrators/year. Buys 10 illustrations/year. Features spot illustrations of business.

First Contact & Terms Illustrators: Send postcard sample. After introductory mailing, send follow-up postcard sample every 6 months. Responds only if interested. Company will contact artist for portfolio review if interested. Pays illustrators $200-500 for color inside. Pays on publication. Buys one-time rights. Finds freelancers through artists' submissions.

▣ RELIX MAGAZINE

104 W. 29th St., 11th Fl., New York NY 10001. (646)230-0100. Fax: (646)230-0200. Web site: www.relix.com. **Contact:** Red Hemns Design. Estab. 1974. Bimonthly consumer magazine emphasizing independent music and the jamband scene. Circ. 100,000.

First Contact & Terms Cartoonists: Send query letter with finished cartoons. Illustrators: Send query letter with

SASE and photocopies. Samples are not filed and are returned by SASE if requested by artist. Responds to the artist only if interested. Portfolio review not required. Buys first-time rights. Pays on publication. Finds artists through word of mouth.
Tips "Not looking for any skeleton artwork."

THE REPORTER

Women's American ORT, New York NY 10003. (212)505-7700. Fax: (212)674-3057. E-mail: afiedel@waort.org. Web site: www.waort.org. **Contact:** Amy Fiedel. Estab. 1966. Biannual organization magazine for Jewish women emphasizing Jewish and women's issues, lifestyle, education. *The Reporter* is the magazine of Women's American ORT, a membership organization supporting a worldwide network of technical and vocational schools. Circ. 50,000. Original artwork returned at job's completion. Sample copies for SASE with first-class postage.
Illustration Buys 4-8 illustrations/issue. Works on assignment only. Prefers contemporary art. Considers pen & ink, mixed media, watercolor, acrylic, oil, charcoal, airbrush, collage and marker.
First Contact & Terms Illustrators: Send postcard sample or query letter with brochure, SASE and photographs. Samples are filed. Responds to the artist only if interested. Rights purchased vary according to project. Pays on publication; $150 and up, depending on work.

RESIDENT AND STAFF PHYSICIAN

241 Forsgate Dr., Jamesburg NJ 08831-1385. (732)656-1140. Fax: (732)656-1955. E-mail: dbuffrey@mwc.com. Web site: www.mwc.com. **Editor:** Dalia Buffery. Monthly publication emphasizing hospital medical practice from clinical, educational, economic and human standpoints. For hospital physicians, interns and residents. Circ. 100,000.
Illustration "We commission qualified freelance medical illustrators to do covers and inside material. Artists should send sample work."
First Contact & Terms Illustrators: Send query letter with brochure showing art style or résumé, tearsheets, photostats, photocopies, slides and photographs. Call or write for appointment to show portfolio of color and b&w final reproduction/product and tearsheets. **Pays on acceptance**; $800 for color cover; payment varies for inside work.
Tips "We like to look at previous work to give us an idea of the artist's style. Since our publication is clinical, we require highly qualified technical artists who are very familiar with medical illustration. Sometimes we have use for nontechnical work. We like to look at everything. We need material from the *doctor's* point of view, *not* the patient's."

RESTAURANT HOSPITALITY

1300 E. Ninth St., Cleveland OH 44114. (216)931-9942. Fax: (216)696-0836. E-mail: croberto@penton.com. **Group Creative Director:** Christopher Roberto. Circ. 123,000. Estab. 1919. Monthly trade publication emphasizing restaurant management ideas, business strategies and industry trends. Readers are independent and chain restaurant operators, executives and chefs.
Illustration Approached by 150 illustrators/year. Buys 3-5 illustrations per issue (combined assigned and stock). Prefers food- and business-related illustration in a variety of styles. Has featured illustrations by Mark Shaver, Paul Watson and Brian Raszka. Assigns 10% of illustrations to well-known or "name" illustrators; 60% to experienced but not well-known illustrators; and 30% to new and emerging illustrators. Welcomes stock submissions.
First Contact & Terms Illustrators: Send postcard samples and follow-up card every 3-6 months. Buys one-time rights. **Pays on acceptance.** Payment range varies for full page or covers; $300-350 quarter-page; $250-350 for spots.
Tips "I like to work with illustrators who are trying new techniques—contemporary styles that work well to connect business ideas with restaurant and foodservice visuals. Please include a web address on your sample so I can view more of your work online."

RHODE ISLAND MONTHLY

280 Kinsley Ave., Providence RI 02903-4161. (401)277-8280. Fax: (401)277-8080. **Art Director:** Ellen Dessloch. Estab. 1988. Monthly 4-color magazine which focuses on life in Rhode Island. Provides the reader with in-depth reporting, service and entertainment features and dining and calendar listings. Circ. 40,000. Accepts previously published artwork. Art guidelines not available.
• Also publishes a bride magazine and tourism-related publications.
Illustration Approached by 200 freelance illustrators/year. Buys 2-4 illustrations/issue. Works on assignment. Considers all media.
First Contact & Terms Illustrators: Send self-promotion postcards or samples. Samples are filed and not re-

turned. Buys one-time rights. Pays on publication; $300 minimum for color inside, depending on the job. Pays $600-1,000 for features. Finds artists through submissions/self-promotions and sourcebooks.

Tips "Although we use a lot of photography, we are using more illustration, especially smaller, spot or quarter-page illustrations for our columns in the front of the magazine. If we see a postcard we like, we'll log on to the illustrator's Web site to see more work."

RICHMOND MAGAZINE

2201 W. Broad St., Suite 105, Richmond VA 23220. (804)355-0111. Fax: (804)355-5442. E-mail: steveh@richmag .com. Web site: www.richmag.com. **Creative Director:** Steve Hedberg. Estab. 1980. Monthly 4-color regional consumer magazine focusing on Richmond lifestyles. Circ. 35,000. Art guidelines available.

Illustration Approached by 30 illustrators/year. Buys 2-4 illustrations/issue. Has featured illustrations by Robert Megmack, Sterling Hundley, Ismael Roldan, and Doug Thompson. Features realistic, conceptional and spot illustrations. Assigns 25% of illustrations to new and emerging illustrators. Uses mostly Virginia-based illustrators.

First Contact & Terms Illustrators: Send postcard sample or query letter with photocopies, tearsheets or other nonreturnable samples. Send follow-up postcard every 3 months. Send JPEG files. Samples are not returned. Will contact artist for portfolio review if interested. Pays on publication. Pays $150-350 for color cover; $100-300 for color inside. Buys one-time rights. Finds illustrators through promo samples, word of mouth, regional sourcebooks.

Tips "Be dependable, on time and have strong concepts."

THE ROANOKER MAGAZINE

P.O. Box 21535, Roanoke VA 24018. (540)989-6138. E-mail: art@leisurepublishing.com. Web site: www.theroa noker.com. **Art Director:** William Alexander. Production Director: Patty Jackson. Estab. 1974. Bimonthly general interest magazine for the city of Roanoke, Virginia and the Roanoke valley. Circ. 10,000. Originals are returned. Art guidelines not available.

Illustration Approached by 20-25 freelance illustrators/year. Buys 2-5 illustrations/year. Works on assignment only.

First Contact & Terms Illustrators: Send query letter with brochure, tearsheets and photocopies. Samples are filed. Responds only if interested. No portfolio reviews. Buys one-time rights. Pays on publication; $100 for b&w or color cover; $75 for b&w or color inside.

Tips "Please *do not* call or send any material that needs to be returned."

ROBB REPORT

29160 Heathercliff Rd., Suite 200, Malibu CA 90265. (310)589-7700. Fax: (310)589-7701. **Design Director:** Russ Rocknak. Monthly 4-color consumer magazine "for the luxury lifestyle, featuring exotic cars, investment, entrepreneur, boats, etc." Circ. 150,000. Accepts previously published artwork. Original artwork is returned at job's completion. Sample copies not available; art guidelines for SASE with first-class postage.

ROLLING STONE MAGAZINE

1290 Avenue of the Americas, 2nd Floor, New York NY 10104-0298. (212)484-1616. Fax: (212)484-1664. Web site: www.rollingstone.com. **Art Director:** Amid Capeci. Deputy Art Directors: Matthew Cooley and Joe Newton. Associate Art Director: Martin Hoops. Assistant Art Director: Elizabeth Oh. Estab. 1967. Bimonthly magazine. Circ. 1.4 million. Originals returned at job's completion. 100% of freelance design work demands knowledge of Illustrator, QuarkXPress and Photoshop. (Computer skills not necessary for illustrators). Art guidelines on Web site.

Illustration Approached by "tons" of illustrators/year. Buys approximately 4 illustrations/issue. Works on assignment only. Considers all media.

First Contact & Terms Illustrators: Send postcard sample and/or query letter with tearsheets, photocopies or any appropriate sample. Samples are filed. Does not reply. Portfolios may be dropped off every Tuesday before 3 p.m. and should include final art and tearsheets. Portfolios may be picked back up on Thursday after 3 p.m. "Please make sure to include your name and address on the outside of your portfolio." Publication will contact artist for portfolio review if interested. Buys first and one-time rights. **Pays on acceptance**; payment for cover and inside illustration varies; pays $300-500 for spots. Finds artists through word of mouth, *American Illustration, Communication Arts*, mailed samples and drop-offs.

⬛ ROOM OF ONE'S OWN

P.O. Box 46160, Station D, Vancouver BC V6J 5G5 Canada. E-mail: info@roommagazine.com. Web site: www.r oommagazine.com. **Contact:** Editor. Estab. 1975. Quarterly literary journal. Emphasizes feminist literature for

women and libraries. Circ. 1,000. Original artwork returned after publication if requested. Sample copy for $7; art guidelines for SASE (nonresidents include 3 IRCs).

Illustration Buys 3-5 illustrations/issue from freelancers. Prefers good realistic illustrations of women and b&w line drawings. Prefers pen & ink, then charcoal/pencil and collage.

First Contact & Terms Illustrators: Send photographs, slides or original work as samples to be kept on file. Samples not kept on file are returned by SAE (nonresidents include IRC). Responds in 6 months. Buys first rights. Pays cartoonists $25 minimum for b&w and color. Pays illustrators $25-50, b&w, color. Pays on publication.

RUNNER'S WORLD

135 N. 6th St., Emmaus PA 18098. (610)967-5171. Fax: (610)967-8883. E-mail: rwedit@runnersworld.com. Web site: www.runnersworld.com. **Art Director:** Robert Festino. Director of Special Editorial Projects: Ken Kleppert. Estab. 1965. Monthly 4-color with a ''contemporary, clean'' design emphasizing serious, recreational running. Circ. 530,511. Accepts previously published artwork ''if appropriate.'' Returns original artwork after publication. Art guidelines not available.

Illustration Approached by hundreds of illustrators/year. Works with 50 illustrators/year. Buys average of 10 illustrations/issue. Has featured illustrations by Sam Hundley, Gil Eisner, Randall Enos and Katherine Adams. Features humorous and realistic illustration; charts & graphics; informational graphics; computer and spot illustration. Assigns 40% of illustrations to well-known or ''name'' illustrators; 40% to experienced but not well-known illustrators; 20% to new and emerging illustrators. Needs editorial, technical and medical illustrations. ''Styles include tightly rendered human athletes, graphic and cerebral interpretations of running themes. Also, *RW* uses medical illustration for features on biomechanics.'' No special preference regarding media but appreciates electronic transmission. ''No cartoons or originals larger than 11×14.'' Works on assignment only. 30% of freelance work demands knowledge of Illustrator, Photoshop or FreeHand.

First Contact & Terms Illustrators: Send postcard samples to be kept on file. Accepts submissions on disk compatible with Illustrator 5.0. Send EPS files. Publication will contact artist for portfolio review if interested. Buys one-time international rights. Pays $1,800 maximum for 2-page spreads; $400 maximum for spots. Finds artists through word of mouth, magazines, submissions/self-promotions, sourcebooks, artists' agents and reps and attending art exhibitions.

Tips Portfolio should include ''a maximum of 12 images. Show a clean presentation, lots of ideas and few samples. Don't show disorganized thinking. Portfolio samples should be uniform in size. Be patient!''

RURAL HERITAGE

Dept. AGDM, 281 Dean Ridge Lane, Gainesboro TN 38562-5039. (931)268-0655. Fax: (931)268-5884. E-mail: editor@ruralheritage.com. Web site: www.ruralheritage.com. **Editor:** Gail Damerow. Estab. 1976. Bimonthly farm magazine ''published in support of modern-day farming and logging with draft animals (horses, mules, oxen).'' Circ. 8,000. Sample copy for $8 postpaid; art guidelines not available.

- Editor stresses the importance of submitting cartoons that deal only with farming and logging using draft animals.

Cartoons Approached by ''not nearly enough'' cartoonists who understand our subject. Buys 2 or more cartoons/issue. Prefers bold, clean, minimalistic draft animals and their relationship with the teamster. ''No unrelated cartoons!'' Prefers single panel, humorous, b&w line drawings with or without gagline.

First Contact & Terms Cartoonists: Send query letter with finished cartoons and SASE. Samples accepted by US mail only. Samples are not filed (unless we plan to use them—then we keep them on file until used) and are returned by SASE. Responds in 2 months. Buys first North American serial rights or all rights rarely. Pays on publication; $10 for one-time rights; $20 for all rights.

Tips ''Know draft animals (horses, mules, oxen, etc.) well enough to recognize humorous situations intrinsic to their use or that arise in their relationship to the teamster. Our best contributors read *Rural Heritage* and get their ideas from the publication's content.''

SACRAMENTO MAGAZINE

706 56th St., Sacramento CA 95819. (916)452-6200. Fax: (916)498-6061. Web site: www.sacmag.com. **Art Director:** Debbie Hurst. Estab. 1975. Monthly consumer lifestyle magazine with emphasis on home and garden, women, health features and stories of local interest. Circ. 20,000. Accepts previously published artwork. Originals returned to artist at job's completion. Sample copies available.

Illustration Approached by 100 illustrators/year. Buys 5 illustrations/year. Works on assignment only. Considers pen & ink, collage, airbrush, acrylic, colored pencil, oil, marker and pastel.

First Contact & Terms Illustrators: Send postcard sample. Accepts disk submissions. Send EPS files. Samples are filed and are not returned. Publication will contact artist for portfolio review if interested. Portfolio should include b&w and color tearsheets and final art. Buys one-time rights. Pays on publication; $300-400 for color

cover; $200-500 for b&w or color inside; $100-200 for spots. Finds artists through submissions.
Tips Sections most open to freelancers are departments and some feature stories.

SACRAMENTO NEWS & REVIEW
1015 20th St., Sacramento CA 95814. (916)498-1234. Fax: (916)498-7920. E-mail: donb@newsreview.com. Web site: www.newsreview.com. **Art Director:** Don Button. Estab. 1989. ''An award-winning black & white with 4-color cover alternative newsweekly for the Sacramento area. We combine a commitment to investigative and interpretive journalism with coverage of our area's growing arts and entertainment scene.'' Circ. 90,000. Occasionally accepts previously published artwork. Originals returned at job's completion. Art guidelines not available.
 • Also publishes issues in Chico, CA and Reno, NV.
Illustration Approached by 50 illustrators/year. Buys 1 illustration/issue. Works on assignment only. Features caricatures of celebrities and politicans; humorous, realistic, computer and spot illustrations. Assigns 50% of illustrations to new and emerging illustrators. For cover art, needs themes that reflect content.
First Contact & Terms Illustrators: Contact via e-mail with link to portfolio Web site or PDF samples. Send postcard sample or query letter with photocopies, photographs, SASE, slides and tearsheets. Samples are filed. Publication will contact artist for portfolio review if interested. Buys first rights. **Pays on acceptance.** $75-150 for b&w cover; $150-300 for color cover; $20-75 for b&w inside; $10-40 for spots. Finds artists through submissions.
Tips ''Looking for colorful, progressive styles that jump off the page. Have a dramatic and unique style—not conventional or common.''

SAILING MAGAZINE
P.O. Box 249, Port Washington WI 53074-0249. (262)284-3494. Fax: (262)284-7764. E-mail: sailingmag@ameritech.net. Web site: www.sailingonline.com. **Editor:** Greta Schanen. Estab. 1966. Monthly 4-color literary magazine featuring sailing with a photography-oriented large format. Circ. 43,223.
Illustration Has featured illustrations by Marc Castelli. Features realistic illustrations, spot illustrations, map art and technical illustrations (sailboat plans). Preferred subjects nautical. Prefers pen & ink with color wash.
First Contact & Terms Illustrators: Send query letter with photocopies. Accepts Mac-compatible disk submissions. Send EPS, PDF or TIFF files. Samples are filed or returned by SASE. Responds within 2 months. Will contact artist for portfolio review if interested. Rights purchased vary according to project. Pays on publication; $25-100 for b&w inside, $25-100 for color inside, $200-500 for 2-page spreads, $25 for spots. ''Freelancers find us; we have no need to look for them.''
Tips ''Freelance art very rarely used.''

SALES & MARKETING MANAGEMENT MAGAZINE
770 Broadway, New York NY 10003. (646)654-7608. Fax: (646)654-7616. E-mail: abass@salesandmarketing.com. Web site: www.salesandmarketing.com. **Contact:** Andrew Bass, art director. Monthly trade magazine providing a much needed community for sales and marketing executives to get information on how to do their jobs with colleagues and receive exclusive research and tools that will help advance their careers. Circ. 65,000.
Illustration Approached by 250-350 illustrators/year. Buys over 1,200 illustrations/year. Has featured illustrations by Douglas Fraser, Murray Kimber, Chris Sickels. Illustration style ranges from realistic to humorous but not cartoonish. Prefers business subjects. 65% of freelance illustration demands knowledge of Illustrator or Photoshop.
First Contact & Terms Illustrators: Send promotional sample or postcard. Accepts Mac-compatible JPEG or EPS files, or link to Web site. Samples are filed. Will contact artist for portfolio review if interested. Portfolio should include tearsheets. Buys first North American serial rights or one-time rights. Finds illustrators through agents, artists' submissions, *WorkBook, Art Pick, American Showcase* and word of mouth.

SALT WATER SPORTSMAN
263 Summer St., Boston MA 02210. (617)303-3660. Fax: (617)303-3661. Web site: www.saltwatersportsman.com. **Art Director:** Chris Powers. Estab. 1939. Monthly consumer magazine describing the how-to and where-to of salt water sport fishing in the US, Caribbean and Central America. Circ. 163,369. Accepts previously published artwork. Originals returned at job's completion. Art guidelines available by e-mailing jason.wood@time4.com.
Illustration Buys 4-5 illustrations/issue. Works on assignment only. Considers pen & ink, watercolor, acrylic, charcoal and electronic art files.
Design Needs freelancers for design. 10% of freelance work demands knowledge of Photoshop, Illustrator, QuarkXPress.
First Contact & Terms Send query letter with tearsheets, photocopies, SASE and transparencies. Samples are

not filed and are returned by SASE if requested by artist. Publication will contact artist for portfolio review if interested. Portfolio should include b&w and color tearsheets and final art. Buys first rights. **Pays on acceptance.** Pays illustrators $500-1,000 for color cover; $50 for b&w inside; $100 for color inside. Pays designers by the project. Finds artists mostly through submissions.

Tips Areas most open to freelancers are how-to, semi-technical drawings for instructional features and columns; occasional artwork to represent fishing action or scenes. "Look the magazine over carefully to see the kind of art we run—focus on these styles."

SANTA BARBARA MAGAZINE

25 E. De La Guerra St., Santa Barbara CA 93101-2217. (805)965-5999. Fax: (805)965-7627. E-mail: editor@sbmag .com. Web site: www.sbmag.com. **Art Director:** Alisa Baur. Estab. 1975. Bimonthly 4-color magazine with classic design emphasizing Santa Barbara culture and community. Circ. 32,500. Original artwork returned after publication if requested. Sample copy for $3.50.

Illustration Approached by 20 illustrators/year. Works with 2-3 illustrators/year. Buys about 1-3 illustrations/ year. Uses freelance artwork mainly for departments. Works on assignment only.

First Contact & Terms Send postcard, tearsheets or photocopies. To show a portfolio, mail b&w and color art, final reproduction/product and tearsheets; will contact if interested. Buys first rights. **Pays on acceptance**; approximately $275 for color cover; $175 for color inside. "Payment varies."

Tips "Be familiar with our magazine."

THE SATURDAY EVENING POST

1100 Waterway Blvd., Indianapolis IN 46202. (317)634-1100. Fax: (317)637-0126. E-mail: johnson@satevepost. com. Web site: www.satevepost.org. **Contact:** Emily Johnson. Mail cartoon submissions to Post Toons, Box 567, Indianapolis IN 46202. Buys about 30 cartoons/issue. Uses freelance artwork mainly for humorous fiction. Prefers single panel with gaglines. Receives 100 batches of cartoons/week. "We look for cartoons with neat line or tone art. The content should be in good taste, suitable for a general-interest, family magazine. It must not be offensive while remaining entertaining. Review our guidelines online and then review recent issues. Political, violent or sexist cartoons are not used. Need all topics, but particularly medical, health, travel and financial."

Illustration Art Director: Chris Wilhoite. Uses average of 3 illustrations/issue. Send query letter with brochure showing art style or résumé and samples. To show a portfolio, mail final art. Buys all rights, "generally. All ideas, sketchwork and illustrative art are handled through commissions only and thereby controlled by art direction. Do not send original material (drawings, paintings, etc.) or 'facsimiles of' that you wish returned." Cannot assume any responsibility for loss or damage.

First Contact & Terms Cartoonists: SASE. Illustrators: "If you wish to show your artistic capabilities, please send nonreturnable, expendable/sampler material (slides, tearsheets, photocopies, etc.)." Responds in 2 months. Pays on publication. Pays cartoonists $125 for b&w line drawings and washes, no prescreened art. Pays illustrators $1,000 for color cover; $175 for b&w, $450 for color inside.

Tips "Send samples of work published in other publications. Do not send racy or too new-wave looks. Have a look at the magazine. It's clear that 50% of the new artists submitting material have not looked at the magazine."

THE SCHOOL ADMINISTRATOR

801 N. Quincy St., Suite 700, Arlington VA 22203-1730. (703)875-0753. Fax: (703)528-2146. E-mail: lgriffin@aas a.org. Web site: www.aasa.org. **Managing Editor:** Liz Griffin. Monthly association magazine focusing on education. Circ. 22,000.

Cartoons Approached by 75 editorial cartoonists/year. Buys 11 cartoons/year. Prefers editorial/humorous, b&w/color washes or b&w line drawings. "Humor should be appropriate to a CEO of a school system, not a classroom teacher."

Illustration Approached by 60 illustrators/year. Buys 2-3 illustrations/issue. Has featured illustrations by Ralph Butler, Paul Zwolak, Heidi Younger and Claudia Newell. Features spot and computer illustrations. Preferred subjects education K-12. Assigns 50% of illustrations to experienced but not well-known illustrators; 50% to well-known or "name" illustrators. Considers all media. "Prefers illustrators who can take a concept and translate it into a simple powerful image and who can deliver art in digital form."

First Contact & Terms Cartoonists: Send photocopies and SASE. Buys one-time rights. **Pays on acceptance.** Send nonreturnable samples. Samples are filed and not returned. Responds only if interested. Rights purchased vary according to project. Pays on publication. Pays illustrators $ 800 for color cover. Finds illustrators through word of mouth, stock illustration source and Creative Sourcebook.

Tips "Read our magazine. I like work that takes a concept and translates it into a simple, powerful image. Check out our Web site. Send art work to: Jeff Roberts, Auras Design, 8435 Georgia Ave., Silver Spring MD 20910."

SCIENTIFIC AMERICAN

415 Madison Ave., New York NY 10017-1111. (212)754-0550. Fax: (212)755-1976. Web site: www.sciam.com.
Contact: Jana Brenning, senior associate art director. Monthly 4-color consumer magazine emphasizing scientific information for educated readers, covering geology, astronomy, medicine, technology and innovations. Circ. 6 75,000 worldwide (20 international editions, some of whom create additional art).
Illustration Approached by 100+ illustrators/year. Buys 15-30 illustrations/issue, mostly science-related, but there are oppurtunities for editorial art in all media. Assigns illustrations to specialized science illustrators, to well-known editorial illustrators, and to relative newcomers in both areas.
First Contact & Terms Illustrators: Send postcard sample or e-mail with link to Web site; followup in 6 months. Responds only if interested. Portfolio reviews done as time allows. **Pays on acceptance**; $750-2,000 for color inside; $350-750 for spots.
Tips "We use all styles of illustration and you do not have to be an expert in science although some understanding certainly helps. The art directors at Scientific American are highly skilled at computer programs, have a broad-based knowledge of science, and closely guide the process. Editors are experts in their field and help with technical backup material. One caveat: content is heavily vetted here for accuracy, so a huge plus on the part of our illustrators is their ability to make changes and corrections cheerfully and in a timely fashion."

SCRAP

1325 G St. N.W., Suite 1000, Washington DC 20005-3104. (202)662-8547. Fax: (202)626-0947. E-mail: kentkiser @scrap.org. Web site: www.scrap.org. **Editor:** Kent Kiser. Estab. 1987. Bimonthly 4-color trade publication that covers all aspects of the scrap recycling industry. Circ. 11,300.
Cartoons "We occasionally run single-panel cartoons that focus on the recycling theme/business."
Illustration Approached by 100 illustrators/year. Buys 0-2 illustrations/issue. Features realistic illustrations, business/industrial/corporate illustrations and international/financial illustrations. Prefered subjects business subjects. Assigns 10% of illustrations to new and emerging illustrators.
First Contact & Terms Illustrators: Send postcard sample. Samples are filed. Responds in 2 weeks. Portfolio review not required. Buys first North American serial rights. **Pays on acceptance**; $1,200-2,000 for color cover; $300-1,000 for color inside. Finds illustrators through creative sourcebook, mailed submissions, referrals from other editors, and "direct calls to artists whose work I see and like."
Tips "We're always open to new talent and different styles. Our main requirement is the ability and willingness to take direction and make changes if necessary. No prima donnas, please. Send a postcard to let us see what you can do."

SEA MAGAZINE

17782 Cowan, Suite A, Irvine CA 92614. (949)660-6150. Fax: (949)660-6172. E-mail: editorial@goboating.com. Web site: www.goboating.com. **Art Director:** Julie Hogan. Estab. 1908. Monthly 4-color magazine emphasizing recreational boating for owners or users of recreational powerboats, primarily for cruising and general recreation; some interest in boating competition; regionally oriented to 13 Western states. Circ. 55,000. Accepts previously published artwork. Return of original artwork depends upon terms of purchase. Sample copy for SASE with first-class postage.
 ● Also publishes *Go Boating* magazine.
Illustration Approached by 20 illustators/year. Buys 10 illustrations/year mainly for editorial. Considers airbrush, watercolor, acrylic and calligraphy.
First Contact & Terms Illustrators: Send query letter with brochure showing art style. Samples are returned only if requested. Publication will contact artist for portfolio review if interested. Portfolio should include tearsheets and cover letter indicating price range. Negotiates rights purchased. Pays on publication; $50 for b&w; $250 for color inside (negotiable).
Tips "We will accept students for portfolio review with an eye to obtaining quality art at a reasonable price. We will help start career for illustrators and hope that they will remain loyal to our publication."

SEATTLE MAGAZINE

1505 Western Ave., Suite 500, Seattle WA 98101. Phone/fax: (206)284-1750. E-mail: sue.boylan@seattlemag.c om. Web site: www.seattlemag.com. **Art Director:** Sue Boylan. Estab. 1992. Monthly urban lifestyle magazine covering Seattle. Circ. 48,000. E-mail art director directly for art guidelines.
Illustration Approached by hundreds of illustrators/year. Buys 2 illustrations/issue. Considers all media. "We can scan any type of illustration."
First Contact & Terms Illustrators: Prefers e-mail submissions. Samples are filed. Responds only if interested. Art director will contact artist for portfolio review of color, final art and transparencies if interested. Buys one-time rights. Sends payment on 25th of month of publication. Pays on publication; $150-1,100 for color cover; $50-400 for b&w; $50-1,100 for color inside; $50-400 for spots. Finds illustrators through agents,

sourcebooks such as *Creative Black Book, LA Workbook*, online services, magazines, word of mouth, artist's submissions, etc.

Tips "Good conceptual skills are the most important quality that I look for in an illustrator as well as unique skills."

SEATTLE WEEKLY

1008 Western Ave., Suite 300, Seattle WA 98104. (206)623-0500. Fax: (206)467-4338. E-mail: ksteichen@seattle weekly.com. Web site: www.seattleweekly.com. **Contact:** Art Director. Estab. 1975. Weekly consumer magazine; tabloid format; news with emphasis on local and national issues and arts events. Circ. 102,000. Accepts previously published artwork. Original artwork can be returned at job's completion if requested, "but you can come and get them if you're local." Sample copies available for SASE with first-class postage. Art guidelines not available.

Illustration Approached by 30-50 freelance illustrators/year. Buys 3 freelance illustrations/issue. Works on assignment only. Prefers "sophisticated themes and styles."

First Contact & Terms Illustrators: Send query letter with tearsheets and photocopies. Samples are filed and are not returned. Does not reply, in which case the artists should "revise work and try again." To show a portfolio, mail b&w and color photocopies; "always leave us something to file." Buys first rights. Pays on publication; $200-250 for color cover; $60-75 for b&w inside.

Tips "Give us a sample we won't forget. A really beautiful mailer might even end up on our wall, and when we assign an illustration, you won't be forgotten. All artists used must sign contract. Feel free to e-mail for a copy."

THE SENSIBLE SOUND

403 Darwin Dr., Snyder NY 14226. (716)833-0930. Fax: (716)833-0929 (5 p.m.-9 a.m.). E-mail: sensisound@aol. com. **Publisher:** John A. Horan. Editor: Karl Nehring. Bimonthly publication emphasizing audio equipment for hobbyists. Circ. 13,600. Accepts previously published material and simultaneous submissions. Original artwork returned after publication. Sample copy for $3.

Cartoons Uses 4 cartoons/year. Prefers single panel, with or without gagline; b&w line drawings.

First Contact & Terms Will accept material on Mac-formatted disk or format via e-mail. Responds in 1 month. Negotiates rights purchased. Pays on publication; rate varies.

Tips "Audio hobbyist material only please. We receive all types of material but never anything appropriate."

▥ SHEEP MAGAZINE

W11564 Hwy. 64, Withee WI 54498. (715)785-7979. Fax: (715)785-7414. E-mail: csymag@tds.net. Web site: www.sheepmagazine.com. **Contact:** Anne-marie Tucker. Estab. 1980. A bimonthly publication covering sheep, wool and woolcrafts. Circ. 5,000. Accepts previously published work.

Cartoons Approached by 30 cartoonists/year. Buys 5 cartoons/year. Considers all themes and styles. Prefers single panel with gagline.

Illustration Approached by 10 illustrators/year. Buys 5 illustrations/year; no inside color. Considers pen & ink. Features charts & graphs, computer illustration, informational graphics, realistic, medical and spot illustrations. All art should be sheep related.

First Contact & Terms Cartoonists: Send query letter with brochure and finished cartoons. Illustrators: Send query letter with brochure, SASE and tearsheets. To show a portfolio, mail thumbnails and b&w tearsheets. Buys first rights or all rights. **Pays on acceptance.** Pays cartoonists $5-15 for b&w. Pays illustrators $75 minimum for b&w.

Tips "Demonstrate creativity and quality work."

SIERRA MAGAZINE

85 Second St., 2nd Floor, San Francisco CA 94105-3441. (415)977-5572. Fax: (415)977-5794. E-mail: sierra.letters @sierraclub.org. Web site: www.sierraclub.org. **Art Director:** Martha Geering. Bimonthly consumer magazine featuring environmental and general interest articles. Circ. 500,000.

Illustration Buys 8 illustrations/issue. Considers all media. 10% of freelance illustration demands computer skills.

First Contact & Terms Illustrators: Send postcard samples or printed samples, SASE and tearsheets. Samples are filed and are not returned. Responds only if interested. Call for specific time for drop off. Art director will contact artist for portfolio review if interested. Buys one-time rights. Finds illustrators through illustration and design annuals, illustration Web sites, sourcebooks, submissions, magazines, word of mouth.

SIGNS OF THE TIMES

1350 N. King's Rd., Nampa ID 83687. (208)465-2592. E-mail: pegpot@pacificpress.com. Web site: www.signtim es.com. **Art Director:** Peggy Pottle. A monthly Seventh-day Adventist 4-color publication that examines contem-

porary issues such as health, finances, diet, family issues, exercise, child development, spiritual growth and end-time events. "We attempt to show that Biblical principles are relevant to everyone." Circ. 200,000. Art guidelines available for SASE with first-class postage.

- They accept illustrations in electronic form provided to their FTP site by prior arrangement or sent as e-mail attachments.

Illustration Buys 6-10 illustrations/issue. Works on assignment only. Has featured illustrations by Ron Bell, Darren Thompson, Consuelo Udave and Lars Justinen. Features realistic illustration. Assigns 10% of illustrations to new and emerging illustrators. Prefers contemporary "realistic, stylistic, or humorous styles (but not cartoons)." Considers any media.

First Contact & Terms Send postcard sample, brochure, photographs, tearsheets or transparencies. Samples are not returned. "Tearsheets or color photos (prints) are best, although color slides are acceptable." Publication will contact artist for more samples of work if interested. Buys first-time North American publication rights. **Pays on acceptance** (30 days); $800 for color cover; $100-300 for b&w inside; $300-700 for color inside. Fees negotiable depending on needs and placement, size, etc. in magazine. Finds artists through submissions, sourcebooks and sometimes by referral from other art directors.

Tips "Most of the magazine illustrations feature people. Approximately 20 visual images (photography as well as artwork) are acquired for the production of each issue, half in black & white, half in color, and the customary working time frame is 3 weeks. Quality artwork and timely delivery are mandatory for continued assignments. It is customary for us to work with highly skilled and dependable illustrators for many years." Advice for artists "Invest in a good art school education, learn from working professionals within an internship, and draw from your surroundings at every opportunity. Get to know lots of people in the field where you want to market your work, and consistently provide samples of your work so they'll remember you. Then relax and enjoy the adventure of being creative."

[N] THE SILVER WEB

P.O. Box 38190, Tallahassee FL 32315. E-mail: annkl9@mail.idt.net. **Publisher/Editor:** Ann Kennedy. Estab. 1989. Semi-annual literary magazine. Subtitled "A Magazine of the Surreal." Circ. 2,000. Accepts previously published artwork. Originals returned at job's completion. Sample copies available for $7.20; art guidelines for SASE with first-class postage or via e-mail.

Illustration Approached by 50-100 illustrators/year. Buys 15-20 illustrations/issue. Has featured illustrations by Scott Eagle, David Walters, Alan Clark, Carlos Batts, Rodger Gerberding and Michael Shores. Assigns 60% of illustrations to experienced but not well-known illustrators; 40% to new and emerging illustrators. Prefers works of the surreal, horrific or bizarre but not traditional horror/fantasy (dragons or monsters are not desired). Considers pen & ink, collage, charcoal and mixed media.

First Contact & Terms Send query letter with samples and SASE. Samples are filed or are returned by SASE if requested by artist. Responds in 2 weeks. Publication will contact artist for portfolio review if interested. Rights purchased vary according to project. **Pays on acceptance**; $25-50 for color cover; $10-25 for b&w inside; $5-10 for spots.

Tips "I am more interested in what an artist creates because it is in his heart—rather than work done to illustrate a certain story. I want to see what you create because you want to create it."

SKI MAGAZINE

929 Pearl St., Suite 200, Boulder CO 80302. (303)448-7649. Fax: (303)448-7638. Web site: www.skimag.com. **Art Director:** Eleanor Williamson. Estab. 1936. Emphasizes instruction, resorts, equipment and personality profiles. For new, intermediate and expert skiers. Published 8 times/year. Circ. 450,000. Previously published work OK "if we're notified."

Illustration Approached by 30-40 freelance illustrators/year. Buys 25 illustrations/year.

First Contact & Terms Illustrators: Mail art and SASE. Responds immediately. Buys one-time rights. **Pays on acceptance**; $1,200 for color cover; $150-500 for color inside.

Tips "The best way to break in is an interview and a consistent style portfolio. Then, keep us on your mailing list."

SKILLSUSA CHAMPIONS

14001 James Monroe Hwy., Box 3000, Leesburg VA 20177. (703)777-8810. Fax: (703)777-8999. E-mail: tomhall @skillsusa. Web site: www.skillsusa.org. **Editor:** Tom Hall. Estab. 1965. Four-color quarterly magazine. "SkillsUSA Champions is primarily a features magazine that provides motivational content by focusing on successful members. SkillsUSA is an organization of 279,000 students and teachers in technical, skilled and service careers. Circ. 289,000. Accepts previously published artwork. Originals returned at job's completion (if requested). Sample copies available.

Illustration Approached by 4 illustrators/year. Works on assignment only. Prefers positive, youthful, innovative, action-oriented images. Considers pen & ink, watercolor, collage, airbrush and acrylic.

Design Needs freelancers for design. 100% freelance work demands knowledge of InDesign CS and FreeHand 5.0.

First Contact & Terms Illustrators: Send postcard sample. Designers: Send query letter with brochure. Accepts disks compatible with FreeHand 5.0, Illustrator 10, PageMaker 7.0 and InDesign CS. Send Illustrator, FreeHand and EPS files. Samples are filed. Portfolio should include printed samples, b&w and color tearsheets and photographs. Rights purchased vary according to project. **Pays on acceptance.** Pays illustrators $200-300 for color; $100-300 for spots. Pays designers by the project.

Tips ''Send samples or a brochure. These will be kept on file until illustrations are needed. Don't call! Fast turnaround helpful. Due to the unique nature of our audience, most illustrations are not re-usable; we prefer to keep art.''

SKIPPING STONES

P.O. Box 3939, Eugene OR 97403-0939. (541)342-4956. E-mail: editor@SkippingStones.org. Web site: www.Skip pingStones.org. **Editor** Arun Toke. Estab. 1988. Bimonthly b&w (with 4-color cover) consumer magazine. International nonprofit multicultural awareness and nature education magazine for today's youth. Circ. 2,000 (and on the web). Art guidelines are free for SASE with first-class postage. Sample copy available for $5.

Cartoons Prefers multicultural, social issues, nature/ecology themes. Requests b&w washes and line drawings. Featured cartoons by Lindy Wojcicki of Florida. Prefers cartoons by youth under age 19.

Illustration Approached by 100 illustrators/year. Buys 10-20 illustrations/year. Has featured illustrations by Sarah Solie, Wisconsin; Alvina Kong, California; Elizabeth Wilkinson, Vermont; Inna Svjatova, Russia; Jon Bush, Massachusetts. Features humorous illustration, informational graphics, natural history and realistic, authentic illustrations. Preferred subjects children and teens. Prefers pen & ink. Assigns 80% of work to new and emerging illustrators. Recent issues have featured Multicultural artists—their life and work.

First Contact & Terms Cartoonists: Send b&w photocopies and SASE. Illustrators: Send nonreturnable photocopies and SASE. Samples are filed or returned by SASE. Responds in 3 months if interested. Portfolio review not required. Buys first rights, reprint rights. Pays on publication 1-4 copies, NO $$s. Finds illustrators through word of mouth, artists' promo samples.

Tips ''We are a gentle, non-glossy, ad-free magazine not afraid to tackle hard issues. We are looking for work that challenges the mind, charms the spirit, warms the heart; handmade, nonviolent, global, for youth 8-15 with multicultural/nature content. Please, no aliens or unicorns. We are especially seeking work by young artists under 19 years of age! People of color and international artists are especially encouraged.''

SKYDIVING MAGAZINE

1725 N. Lexington Ave., DeLand FL 32724. (386)736-4793. Fax: (386)736-9786. E-mail: editor@skydivingmagaz ine.com. Web site: www.skydivingmagazine.com. **Editor:** Sue Clifton. Estab. 1979. ''Monthly magazine on the equipment, techniques, people, places and events of sport parachuting.'' Circ. 14,200. Originals returned at job's completion if requested. Sample copies available; art guidelines not available.

Cartoons Approached by 10 cartoonists/year. Buys 2 cartoons/issue. Has featured cartoons by Craig Robinson. Prefers skydiving themes; single panel, with gagline.

First Contact & Terms Cartoonists: Send query letter with roughs. Samples are filed. Responds in 2 weeks. Buys one-time rights. Pays $25 for b&w.

SMALL BUSINESS TIMES

1123 N. Water St., Milwaukee WI 53202. (414)277-8181. Fax: (414)277-8191. Web site: www.biztimes.com. **Art Director:** Shelly Paul. Estab. 1995. Biweekly newspaper/magazine business-to-business publication for southeast Wisconsin. Circ. 15,000.

Illustration Approached by 80 illustrators/year. Uses 3-5 illustrations/year. Has featured illustrations by Milan Zori, Marla Campbell, Dave Crosland. Features charts & graphs, computer, humorous illustration, informational graphics, realistic and b&w spot illustrations. Prefers business subjects in simpler styles that reproduce well on newsprint. Assigns 75% of work to new and emerging illustrators.

First Contact & Terms Illustrators: Send postcard sample and follow-up postcard every year. Accepts Mac-compatible disk submissions. Send EPS or TIFF files at 300dpi. Will contact artist for portfolio review if interested. Buys one-time rights. Pays illustrators $200-400 for color cover; $80-100 for inside. **Pays on acceptance.**

Tips ''Conceptual work wanted! Audience is business men and women in southeast Wisconsin. Need ideas relative to today's business issues/concerns (insurance, law, banking, commercial real estate, health care, manufacturing, finance, education, technology, retirement). One- to two-week turnaround.''

SMART MONEY

1755 Broadway, 2nd Floor, New York NY 10019. (212)830-9200. Fax: (212)830-9245. Web site: www.smartmoney.com. **Art Director:** Gretchen Smelter. Estab. 1992. Monthly consumer magazine. Circ. 760,369. Originals returned at job's completion. Sample copies available.

Illustration Approached by 200-300 illustrators/year. Buys 10 illustrations/issue. Works on assignment only. Considers pen & ink, airbrush, colored pencil, mixed media, collage, charcoal, watercolor, acrylic, oil, pastel and digital.

First Contact & Terms Illustrators: Send postcard-size sample. Samples are filed. Publication will contact artist for portfolio review if interested. Portfolio should include tearsheets and photocopies. Buys first and one-time rights. Pays 30 days from invoice; $1,500 for color cover; $400-700 for spots. Finds artists through sourcebooks and submissions.

SMITHSONIAN MAGAZINE

MRC 951, P.O. Box 37012, Washington DC 20013-7012. Web site: www.smithsonianmag.com. **Art Director:** Brian Noyes. Associate Art Director: Erik K. Washam. Monthly consumer magazine exploring lifestyles, cultures, environment, travel and the arts. Circ. 2,088,000.

Illustration Approached by hundreds of illustrators/year. Buys 1-3 illustrations/issue. Features charts & graphs, informational graphics, humorous, natural history, realistic and spot illustration.

First Contact & Terms Samples are filed. Responds only if interested. Will contact artist for portfolio review if interested. Buys first rights. **Pays on acceptance**; $350-$1,200 for color inside. Finds illustrators through agents and word of mouth.

SOAP OPERA DIGEST

261 Madison Ave., 10th Floor, New York NY 10016-2303. (212)716-2700. **Design Creative:** Virginia Bassett. Estab. 1976. Emphasizes soap opera and prime-time drama synopses and news. Weekly. Circ. 2 million. Accepts previously published material. Returns original artwork after publication upon request. Sample copy available for SASE.

Tips "Review the magazine before submitting work."

SOAP OPERA UPDATE MAGAZINE

270 Sylvan Ave., Englewood Cliffs NJ 07632. (201)569-6699, ext. 226. Fax: (201)569-2510. **Art Director:** Eric Savage. Estab. 1988. Biweekly consumer magazine geared toward fans of soap operas and the actors who work in soaps. It is "the only full-size, all color soap magazine in the industry." Circ. 700,000. Originals are not returned.

Illustration Approached by 100 illustrators/year. Works on assignment only. Prefers illustrations showing a likeness of an actor/actress in soap operas. Considers any and all media.

First Contact & Terms Illustrators: Send postcard sample. Samples are filed. Publication will contact artist for portfolio review if interested. Portfolio should include color tearsheets and final art. Buys all rights usually. Pays on publication; $50-200 maximum for color inside and/or spots. Finds artists through promo pieces.

Tips Needs caricatures of actors in storyline-related illustration. "Please send self-promotion cards along with a letter if you feel your work is consistent with what we publish."

SOAP OPERA WEEKLY

261 Madison Ave., New York NY 10016. (212)716-8400. **Art Director:** Susan Ryan. Estab. 1989. Weekly 4-color consumer magazine; tabloid format. Circ. 600,000-700,000. Original artwork returned at job's completion.

Illustration Approached by 50 freelance illustrators/year. Works on assignment only.

First Contact & Terms Illustrators: Send query letter with brochure and soap-related samples. Samples are filed. Request portfolio review in original query. Publication will contact artist for portfolio review if interested. Portfolio should include original/final art. Buys first rights. **Pays on acceptance**; $2,000 for color cover; $750 for color, full page.

SOLIDARITY MAGAZINE

Published by United Auto Workers, 8000 E. Jefferson, Detroit MI 48214. (313)926-5291. Fax: (313)331-1520. E-mail: uawsolidarity@uaw.net. Web site: www.uaw.org. **Editor:** Larry Gabriel. Four-color magazine for "1.3 million member trade union representing U.S., Canadian and Puerto Rican workers in auto, aerospace, agricultural-implement, public employment and other areas." Contemporary design.

Cartoons Carries "labor/political" cartoons. Payment varies.

Illustration Works with 10-12 illustrators/year for posters and magazine illustrations. Interested in graphic designs of publications, topical art for magazine covers with liberal-labor political slant. Looks for "ability to grasp our editorial slant."

First Contact & Terms Illustrators: Send postcard sample or tearsheets and SASE. Samples are filed. Pays $500-600 for color cover; $200-300 for b&w inside; $300-450 for color inside. Graphic Artists Guild members only.

▣ SOUTHERN ACCENTS MAGAZINE

2100 Lakeshore Dr., Birmingham AL 35209. (205)445-6000. Fax: (445)877-6990. Web site: www.southernaccents.com. **Art Director:** Ann M. Carothers. Estab. 1977. Bimonthly consumer magazine emphasizing fine Southern interiors and gardens. Circ. 400,000.

Ilustration Buys 25 illustrations/year. Considers color washes, colored pencil and watercolor.

First Contact & Terms Illustrators: Send postcard sample. Samples are returned. Responds only if interested. Art director will contact artist for portfolio of final art, photographs, slides and tearsheets if interested. Rights purchased vary according to project. Pays on publication; $100-800 for color inside. Finds artists through magazines, sourcebooks and submissions.

SPIDER

Carus Publishing Company, P.O. Box 300, Peru IL 61354. 815-224-5803. Web site: www.cricketmag.com. **Art Director:** Suzanne Beck. Monthly magazine. Estab. 1994. Circ. 70,000. *Spider* publishes high-quality literature for beginning readers, primarily ages 6-9.

Illustration Buys 20 illustrations/issue; 240 illustrations/year. Uses color artwork only. "Any medium—preferably one that can wrap on a laser scanner—no larger than 20×24. We use more realism than cartoon-style art." Works on assignment only. Reviews ms/illustration packages from artists. Illustrations only: Send promo sheet and tearsheets. Responds in 6 weeks. Samples returned with SASE; samples filed. Credit line given.

First Contact & Terms Send query letter with printed samples, photocopies, SASE and tearsheets. Send follow-up every 4 months. Samples are filed or are returned by SASE. Original artwork returned at job's completion. Responds in 6 weeks. Buys all rights. Pays 45 days after acceptance; $750 minimum for cover; $200-300 for color inside. Pays $50-150 for spots. Finds illustrators through artists who've published work in the children's field (books/magazines); artist's submissions.

Tips "Read our magazine; include samples showing children and animals; and put your name, address and phone number on every sample. It's helpful to include pieces that take the same character(s) through several actions/emotional states. It's also helpful to remember that most children's publishers need artists who can draw children from many different racial and ethnic backgrounds."

SPITBALL, THE LITERARY BASEBALL MAGAZINE

5560 Fox Rd., Cincinnati OH 45239. (513)385-2268. E-mail: spitball5@hotmail.com. Web site: www.angelfire.com/oh5/spitball. **Editor:** Mike Shannon. Quarterly 2-color magazine emphasizing baseball exclusively, for "well-educated, literate baseball fans." Sometimes prints color material in b&w on cover. Returns original artwork after publication if the work is donated; does not return if purchases work. Sample copy for $6.

Spitball has a regular column called "Brushes with Baseball" that features one artist and his work. Chooses artists for whom baseball is a major theme/subject. Prefers to buy at least one work from the artist to keep in its collection. *Spitball*'s editor, Mike Shannon, is organizing a national trading art show devoted to all-time baseball great Willie Mays. The show will celebrate Willie's 75th birthday, which occurs in May 2006. Artists interested in participating in the show should send Shannon a photo of baseball work of art completed by the artist and a SASE for more information. (This is not connected to *Spitball*.)

Cartoons Prefers single panel b&w line drawings with or without gagline. Prefers "old fashioned *Sport Magazine/New Yorker* type. Please, cartoonists . . . make them funny, or what's the point?"

Illustration "We need two types of art illustration (for a story, essay or poem) and filler. All work must be baseball-related; prefers pen & ink, airbrush, charcoal/pencil and collage. Interested artists should write to find out needs for specific illustration." Buys 3 or 4 illustrations/issue.

First Contact & Terms Cartoonists: Query with samples of style, roughs and finished cartoons. Illustrators: Send query letter with b&w illustrations or slides. Target samples to magazine's needs. Samples not filed are returned by SASE. Responds in 1 week. Negotiates rights purchased. **Pays on acceptance.** Pays cartoonists $10, minimum. Pays illustrators $20-40 b&w inside. Needs short story illustration.

Tips "Usually artists contact us and if we hit it off, we form a long-lasting mutual admiration society. Please, you cartoonists out there, drag your bats up to the *Spitball* plate! We like to use a variety of artists."

SPORTS 'N SPOKES

2111 E. Highland Ave., Suite 180, Phoenix AZ 85016-4702. (602)224-0500. Fax: (602)224-0507. E-mail: anngarvey@pnnews.com. Web site: www.sportsnspokes.com. **Art and Production Director:** Ann Garvey. Published 6 times a year. Consumer magazine with emphasis on sports and recreation for the wheelchair user. Circ. 15,000. Accepts previously published artwork. Sample copies for large SASE and $3.00 postage.

Cartoons Buys 3-5 cartoons/issue. Prefers humorous cartoons; single panel b&w line drawings with or without gagline. Must depict some aspect of wheelchair sport and/or recreation.

Illustration Works on assignment only. Considers pen & ink, watercolor and computer-generated art. 50% of freelance work demands knowledge of Illustrator, QuarkXPress or Photoshop.

First Contact & Terms Cartoonists: Send query letter with finished cartoons. Responds in 3 months. Buys all rights. **Pays on acceptance**; $10 for b&w. Illustrators: Send postcard sample or query letter with résumé and tearsheets. Accepts CD submissions compatible with Illustrator 10.0 or Photoshop 7.0. Send EPS, TIFF or JPEG files. Samples are filed or returned by SASE if requested by artist. Responds to the artist only if interested. Publication will contact artist for portfolio review if interested. Portfolio should include color tearsheets. Buys one-time rights and reprint rights. Pays on publication; $250 for color cover; $25 for b&w inside; $50 for color inside.

Tips "We have not purchased an illustration or used a freelance designer for many years. We regularly purchase cartoons with wheelchair sports/recreation theme."

SPORTS AFIELD

15621 Chemical Lane, Huntington Beach CA 92649. (714)373-4910. Fax: (714)894-4949. E-mail: artdirector@sportsafield.com. Web site: www.sportsafield.com. **Art Director:** Jerry Gutierrez. Estab. 1887. Monthly magazine. "*SA* is edited for hunting enthusiasts. We are the oldest outdoor magazine!." Circ. 50,000.

Illustration Hunting/wildlife themes only. Considers all media. Freelancers should be familiar with Photoshop, Illustrator, InDesign.

First Contact & Terms Illustrators: Send postcard sample or query letter with photocopies and tearsheets. Accepts disk submissions. Samples are filed. Responds only if interested. Will contact for portfolio of b&w or color photographs, slides, tearsheets and transparencies if interested. Buys first North American serial rights. Pays on publication; negotiable. Finds illustrators through *Black Book*, magazines, submissions.

☒ STANFORD MAGAZINE

Bowman Alumni House, Stanford CA 94305-4005. (415)725-1085. Fax: (415)725-8676. **Art Director:** Paul Carstensen. Estab. 1973. Consumer magazine, "geared toward the alumni of Stanford University. Articles vary from photo essays to fiction to academic subjects." Circ. 105,000. Accepts previously published artwork. Original artwork is returned at job's completion. Sample copies available.

Illustration Approached by 200-300 illustrators/year. Buys 4-6 illustrations/issue. Works on assignment only. Interested in all styles.

First Contact & Terms Send samples only. Call for appointment to show portfolio. Buys one-time rights. **Pays on acceptance.**

Tips "We're always looking for unique styles, as well as excellent traditional work. We like to give enough time for the artist to produce the piece."

STONE SOUP, The Magazine by Young Writers and Artists

P.O. Box 83, Santa Cruz CA 95063. (831)426-5557. E-mail: editor@stonesoup.com. Web site: www.stonesoup.com. **Editor:** Gerry Mandel. Quarterly 4-color magazine with "simple and conservative design" emphasizing writing and art by children. Features adventure, ethnic, experimental, fantasy, humorous and science fiction articles. "We only publish writing and art by children through age 13. We look for artwork that reveals that the artist is closely observing his or her world." Circ. 20,000. Sample copies available for $4. Art guidelines for SASE with first-class postage.

Illustration Buys 12 illustrations/issue. Prefers complete and detailed scenes from real life. All art must be by children ages 8-13.

First Contact & Terms Illustrators: Send query letter with photocopies. Samples are filed or are returned by SASE. Responds in 1 month. Buys all rights. Pays on publication; $75 for color cover; $25 for color inside; $25 for spots.

STRANG COMMUNICATIONS COMPANY

600 Rinehart Rd., Lake Mary FL 32746. Estab. 1975. (407)333-0600. Fax: (407)333-7100. E-mail: bill.johnson@strang.com. Web site: www.strang.com. **Contact:** Bill Johnson, marketing design director, or Joe Deleon, magazine design director. Estab. 1975. Publishes religious magazines and books for general readership. Illustrations used for text illustrations, promotional materials, book covers, children and gift books, dust jackets. Examples of recently published titles: *Charisma Magazine*; *New Man Magazine*; *Ministries Today Magazine*; Vida Cristiana (all editorial, cover). Illustration guidelines free with SASE.

Needs Works with 5-50 freelance illustrators annually. Needs illustrations of people, families, environmental portraits, situations. Model/property release preferred for all subjects.

First Contact & Terms Illustrators: Send nonreturnable promotional postcard, tearsheets, color copies or other

appropriate promotional material. Accepts digital submissions. Send query letter with samples. Provide résumé, business card, brochure, flier or tearsheets to be kept on file for possible future assignments. Works with freelancers on assignment only. Keeps samples on file. Simultaneous submissions and previously published work OK. Pays $5-75 for b&w; $50-550 for color spots; $100-550 for color covers. Payment negotiable. Pays on publication. Credit line given. Buys one-time, first-time, book, electronic and all rights; negotiable.

STRATEGIC FINANCE

10 Paragon Dr., Montvale NJ 07645. (800)638-4427. Fax: (201)474-1603. E-mail: mzisk@imanet.org. Web site: www.imanet.org and www.strategicfinancemag.com. **Editorial Director:** Kathy Williams. Art Director: Mary Zisk. Production Manager: Lisa Taylor. Estab. 1919. Monthly 4-color emphasizing management accounting for corporate accountants, controllers, chief financial officers, and treasurers. Circ. 65,000. Accepts simultaneous submissions. Originals are returned after publication.

Illustration Approached by 4 illustrators/day. Buys 3 illustrations/issue.

First Contact & Terms Illustrators: Send nonreturnable postcard samples. Prefers financial and corporate themes.

STUDENT LAWYER

321 N. Clark St., Chicago IL 60610. (312)988-6042. E-mail: kulcm@staff.abanet.org. **Art Director:** Mary Anne Kulchawik. Estab. 1972. Trade journal, 4-color, emphasizing legal education and social/legal issues. "*Student Lawyer* is a legal affairs magazine published by the Law Student Division of the American Bar Association. It is not a legal journal. It is a features magazine, competing for a share of law students' limited spare time—so the articles we publish must be informative, lively, good reads. We have no interest whatsoever in anything that resembles a footnoted, academic article. We are interested in professional and legal education issues, sociolegal phenomena, legal career features, and profiles of lawyers who are making an impact on the profession." Monthly (September-May). Circ. 35,000. Original artwork is returned to the artist after publication.

Illustration Approached by 20 illustrators/year. Buys 8 illustrations/issue. Has featured illustrations by Sean Kane and Jim Starr. Features realistic, computer and spot illustration. Assigns 50% of illustrations to experienced but not well-known illustrators; 50% to new and emerging illustrators. Needs editorial illustration with an 'innovative, intelligent style.' Works on assignment only. Needs computer-literate freelancers for illustration. No cartoons please.

First Contact & Terms Send postcard sample, brochure, tearsheets and printed sheet with a variety of art images (include name and phone number). Samples are filed. Call for appointment to show portfolio of final art and tearsheets. Buys one-time rights. **Pays on acceptance.** $500-800 for color cover; $450-650 for color inside; $150-350 for spots.

Tips "In your samples, show a variety of styles with an emphasis on editorial work."

☒ SUB-TERRAIN MAGAZINE

P.O. Box 3008, MPO, Vancouver BC V6B 3×5 Canada. (604)876-8710. Fax: (604)879-2667. E-mail: subter@portal.ca. Web site: www.subterrain.ca. **Editor:** Brian Kaufman. Estab. 1988. Quarterly partial full colour literary magazine featuring contemporary literature of all genres. Art guidelines for SASE with first-class postage.

Cartoons Prefers single panel cartoons.

Illustration Assigns 50% of illustrations to new and emerging illustrators.

First Contact & Terms Send query letter with photocopies. Samples are filed. Responds if interested. Portfolio review not required. Buys first rights, first North American serial rights, one-time rights or reprint rights. Pays $35-100 (Canadian), plus contributor copies.

Tips "Take the time to look at an issue of the magazine to get an idea of the kind of material we publish."

SUN VALLEY MAGAZINE

12 E. Bullion St., Suite B, Hailey ID 83333-8409. (208)788-0770. Fax: (208)788-3881. E-mail: art@sunvalleymag.com. Web site: www.sunvalleymag.com. **Art Director:** Mike Stevens. Estab. 1971. Consumer magazine published 3 times/year "highlighting the activities and lifestyles of people of the Wood River Valley." Circ. 17,000. Sample copies available. Art guidelines free for #10 SASE with first-class postage.

Illustration Approached by 10 illustrators/year. Buys 3 illustrations/issue. Prefers forward, cutting edge styles. Considers all media. 50% of freelance illustration demands knowledge of QuarkXPress.

First Contact & Terms Illustrators: Send query letter with SASE. Accepts disk submissions compatible with Macintosh, QuarkXPress 5.0 and/or InDesign. Send EPS files. Samples are filed. Does not report back. Artist should call. Art director will contact artist for portfolio review of b&w, color, final art, photostats, roughs, slides, tearsheets and thumbnails if interested. Buys first rights. **Pays on publication**; $350 cover; $80-240 inside.

Tips "Read our magazine. Send ideas for illustrations and examples."

SWEET 16

(formerly Guideposts for Teens), 1050 Broadway, Chesterton IN 46304. (219) 929-4429. Fax: (219)926-3839. Web site: www.guidepostssweet16mag.com. **Art Director:** Megan McPhail. Bimonthly magazine for teens 13-17 focusing on true teen stories, value centered. Estab. 1998. Circ. 200,000.

Illustration Approached by 100 illustrators per year. Buys 10 illustrations per issue. Considers all media but prefers electronic. Has featured illustrations by Cliff Nielsen, Jaques Barby, Donna Nelson, Sally Comport. Assigns 40% of illustrations to well-known or "name" illustrators; 70% to experienced, but not well-known illustrators; 50% to new and emerging illustrators.

First Contact & Terms Illustrators: Send postcard or tearsheets; "no large bundles, please. Disks welcome. Web sites will be visited." Samples are filed or returned by SASE if requested by artist. Responds only if interested. Art director will contact if more information is desired. Buys mostly first and reprint rights. Pays on invoice, net 30 days. Pays $700-900 single page; $1,200-1,800 per spread; $150-400 per color spot. Finds illustrators through submissions, reps and Internet.

Tips This art director loves "on the edge, funky, stylized nonadult, alternative styles. Traditional styles are sometimes used." Freelance graphic designers are used in 2 stories/issue.

T&D MAGAZINE

(formerly *Training & Development Magazine*), 1640 King St., Box 1443, Alexandria VA 22313-2043. (703)683-8146. Fax: (703)548-2383. E-mail: ljones@astd.org. **Art Director:** Elizabeth Z. Jones. Estab. 1945. Monthly trade journal magazine that covers training and development in all fields of business. Circ. 40,000. Accepts previously published artwork. Original artwork is returned at job's completion. Art guidelines not available.

Illustration Approached by 20 freelance illustrators/year. Buys a limited number of freelance illustrations per issue. Works on assignment only. Has featured illustrations by Alison Seiffer, James Yang and Riccardo Stampatori. Features humorous, realistic, computer and spot illustration. Assigns 10% of work to new and emerging illustrators. Prefers sophisticated business style. Considers collage, pen & ink, airbrush, acrylic, oil, mixed media, pastel.

First Contact & Terms Illustrators: Send postcard sample. Accepts disks compatible with Illustrator 9, FreeHand 5.0, Photoshop 5. Send EPS, JPEG or TIFF files. Use 4-color (process) settings only. Samples are filed. Responds to the artist only if interested. Write for appointment to show portfolio of tearsheets, slides. Buys one-time rights or reprint rights. Pays on publication; $700-1,200 for color cover; $350 for b&w inside; $350-800 for color inside; $800-1,000 for 2-page spreads; $100-300 for spots.

Tips "Send more than one image if possible. Do not keep sending the same image. Try to tailor your samples to the art director's needs if possible."

TAMPA BAY MAGAZINE

2531 Landmark Dr., Clearwater FL 33761. (727)791-4800. **Editor:** Aaron Fodiman. Estab. 1986. Bimonthly local lifestyle magazine with upscale readership. Circ. 40,000. Accepts previously published artwork. Sample copy available for $4.50. Art guidelines not available.

Cartoons Approached by 30 cartoonists/year. Buys 6 cartoons/issue. Prefers single-panel color washes with gagline.

Illustration Approached by 100 illustrators/year. Buys 5 illustrations/issue. Prefers happy, stylish themes. Considers watercolor, collage, airbrush, acrylic, marker, colored pencil, oil and mixed media.

First Contact & Terms Cartoonists: Send query letter with finished cartoon samples. Illustrators: Send query letter with photographs and transparencies. Samples are not filed and are returned by SASE if requested. To show a portfolio, mail color tearsheets, slides, photocopies, finished samples and photographs. Buys one-time rights. Pays on publication. Pays cartoonists $15 for b&w, $20 for color. Pays illustrators $150 for color cover; $75 for color inside.

▣ TECHNICAL ANALYSIS OF STOCKS & COMMODITIES

4757 California Ave. SW, Seattle WA 98116-4499. (206)938-0570. Fax: (206)938-1307. E-mail: cmorrison@traders.com. Web site: www.Traders.com. **Art Director:** Christine Morrison. Estab. 1982. Monthly traders' magazine for stocks, bonds, futures, commodities, options, mutual funds. Circ. 66,000. Accepts previously published artwork. Sample copies available for $5. Art guidelines on Web site.

● This magazine has received several awards including the Step by Step Design Annual, American Illustration IX, XXIII, XIV Society of American Illustration, New York. They also publish *Working Money*, a general interest financial magazine (has similar cartoon and illustration needs).

Cartoons Approached by 10 cartoonists/year. Buys 1-4 cartoons/issue. Prefers humorous cartoons, single panel b&w line drawings with gagline.

Illustration Approached by 100 illustrators/year. Buys 6 illustrations/issue. Works on assignment only. Features humorous, realistic, computer (occasionally) and spot illustrations.

First Contact & Terms Cartoonists: Send query letter with finished (non-returnable xeroxes only) cartoons. Illustrators: Send brochure, tearsheets, photographs, photocopies, photostats, slides. Accepts disk submissions compatible with any Adobe products on TIFF or EPS files. Samples are filed and are not returned. Publication will contact artist for portfolio review if interested. Portfolio should include b&w and color tearsheets, slides, photostats, photocopies, final art and photographs. Buys one-time rights and reprint rights. Pays on publication. Pays cartoonists $35 for b&w. Pays illustrators $135-350 for color cover; $165-213 for color inside; $105-133 for b&w inside.

Tips "Looking for creative, imaginative and conceptual types of illustration that relate to the article's concepts. Also caricatures with market charts and computers. Send a few copies of black & white and color work with cover letter. If I'm interested I will call."

ⓝ TEXAS MEDICINE

401 W. 15th St., Austin TX 78701. (512)476-7733. Fax: (512)370-1629. Web site: www.texmed.org. **Art Director:** Laura Levi. Monthly trade journal published by Texas Medical Association for the statewide Texas medical profession. Circ. 35,000. Sample copies and art guidelines available.

Illustrations Approached by 30-40 illustrators/year. Buys 4-6 illustrations/issue. Prefers medical themes. Considers all media.

First Contact & Terms Illustrators: Send postcard sample or query letter with photocopies. Accepts disk submissions of EPS or TIFF files for QuarkXPress 3.32. Samples are filed and are not returned. Responds only if interested. Art director will contact artist for portfolio review of b&w, color, final art, photographs, photostats, tearsheets or transparencies if interested. Rights purchased vary according to project. Pays on publication. Payment varies; $350 for spots. Finds artists through agents, magazines and submissions.

TEXAS MONTHLY

P.O. Box 1569, Austin TX 78767-1569. (512)320-6900. Fax: (512)476-9007. Web site: www.texasmonthly.com. **Art Director:** Scott Dadich. Estab. 1973. Monthly general interest magazine about Texas. Circ. 350,000. Accepts previously published artwork. Originals are returned to artist at job's completion.

Illustrations Approached by hundreds of illustrators/year. Works on assignment only. Considers all media.

First Contact & Terms Illustrators: Send postcard sample of work or send query letter with tearsheets, photographs, photocopies. Samples are filed "if I like them" or returned by SASE if requested by artist. Publication will contact artist for portfolio review if interested. Portfolio should include tearsheets, photographs, photocopies. Buys one-time rights. Pays on publication; $1,000 for color cover; $800-2,000 for color inside; $150-400 for spots.

▣ TEXAS PARKS & WILDLIFE

3000 S. IH 35, Suite 120, Austin TX 78704-6536. (512)912-7000. Fax: (512)707-1913. E-mail: magazine@tpwd.state.tx.us. Web site: www.tpwmagazine.com. **Art Director:** Mark Mahorsky. Estab. 1942. Monthly magazine "containing information on state parks, wildlife conservation, hunting and fishing, environmental awareness." Circ. 180,000. Sample copies for #10 SASE with first-class postage.

Illustration 100% of freelance illustration demands knowledge of QuarkXPress.

First Contact & Terms Illustrators: Send postcard sample. Samples are not filed and are not returned. Responds only if interested. Buys one-time rights. Pays on publication; negotiable. Finds illustrators through magazines, word of mouth, artist's submissions.

Tips "Read our magazine."

▣ THRASHER

1303 Underwood Ave., San Francisco CA 94124-3308. (415)822-3083. Fax: (415)822-8359. Web site: www.thrashermagazine.com. **Managing Editor:** Ryan Henry. Estab. 1981. Monthly 4-color magazine. "Thrasher is the dominant publication devoted to the latest in extreme youth lifestyle, focusing on skateboarding, snowboarding, new music, videogames, etc." Circ. 200,000. Originals returned at job's completion. Sample copies for SASE with first-class postage. Art guidelines not available. Needs computer-literate freelancers for illustration. Freelancers should be familiar with Illustrator or Photoshop.

Cartoons Approached by 100 cartoonists/year. Has featured illustrations by Mark Gonzales and Robert Williams. Prefers skateboard, snowboard, music, youth-oriented themes. Assigns 100% of illustrations to new and emerging illustrators.

Illustrations Approached by 100 illustrators/year. Prefers themes surrounding skateboarding/skateboarders, snowboard/music (rap, hip hop, metal) and characters and commentary of an extreme nature. Prefers pen & ink, collage, airbrush, marker, charcoal, mixed media and computer media (Mac format).

First Contact & Terms Cartoonists: Send query letter with brochure and roughs. Illustrators: Send query letter with brochure, résumé, SASE, tearsheets, photographs and photocopies. Publication will contact artist for

portfolio review if interested. Portfolio should include b&w and color tearsheets, photocopies and photographs. Rights purchased vary according to project. Negotiates payment for covers. Sometimes requests work on spec before assigning job. Pays on publication. Pays cartoonists $50 for b&w, $75 for color. Pays illustrators $75 for b&w, $100 for color inside.

Tips "Send finished quality examples of relevant work with a bio/intro/résumé that we can keep on file and update contact info. Artists sometimes make the mistake of submitting examples of work inappropriate to the content of the magazine. Buy/borrow/steal an issue and do a little research. Read it. Desktop publishing is now sophisticated enough to replace all high-end prepress systems. Buy a Mac. Use it. Live it."

▣ TIKKUN MAGAZINE

2342 Shattuck Ave., #1200, Berkeley CA 94704. (510)644-1200. Fax: (510)644-1255. E-mail: magazine@tikkun.org. Web site: www.tikkun.org. **Managing Editor:** Liz Winer. Estab. 1986. "A bimonthly Jewish critique of politics, culture and society. Includes articles regarding Jewish and non-Jewish issues, left-of-center politically." Circ. 70,000. Accepts previously published material. Original artwork returned after publication. Sample copies for $6 plus $2 postage.

Illustration Approached by 50-100 illustrators/year. Buys 10-12 illustrations/issue. Has featured illustrations by Julie Delton, David Ball, Jim Flynn. Features symbolic and realistic illustration. Assigns 90% of illustrations to experienced, but not well-known illustrators; 10% to new and emerging illustrators. Prefers line drawings.

First Contact & Terms Illustrators: Send brochure, résumé, tearsheets, photostats, photocopies. Slides and photographs for color artwork only. Buys one-time rights. Do not send originals; unsolicited artwork will not be returned. "Often we hold onto line drawings for last-minute use." Pays on publication; $150 for color cover; $50 for b&w inside.

Tips No "sculpture, heavy religious content. Read the magazine—send us a sample illustration of an article we've printed, showing how you would have illustrated it."

TIME

Attn: Art Dept., 1271 Avenue of the Americas, Rockefeller Center, New York NY 10020-1393. (212)522-1212. Fax: (212)522-0936. Web site: www.time.com. **Art Director:** Arthur Hochstein. Deputy Art Directors: Skye Gurney, Cynthia Hoffman, D.W. Pine. Estab. 1923. Weekly magazine covering breaking news, national and world affairs, business news, societal and lifestyle issues, culture and entertainment. Circ. 4,034,000.

Illustration Considers all media. Send postcard sample, printed samples, photocopies or other appropriate samples.

First Contact & Terms Illustrators: Accepts disk submissions. Samples are filed. Responds only if interested. Portfolios may be dropped off every Wednesday between 11 and 1. They are kept for one week and may be picked up the following Wednesday, between 11 and 1. Buys first North American serial rights. Payment is negotiable. Finds artists through sourcebooks and illustration annuals.

▣ THE TOASTMASTER

23182 Arroyo Vista, Rancho Santa Margarita CA 92688-2699. (949)858-8255. Fax: (949)858-1207. Web site: www.toastmasters.org. **Art Director:** Susan Campbell. Estab. 1924. Monthly trade journal for association members. "Language, public speaking, communication are our topics." Circ. 200,000. Accepts previously published artwork. Originals returned at job's completion. Sample copies available.

Illustration Buys 6 illustrations/issue. Works on assignment only. Prefers communications themes. Considers watercolor and collage.

First Contact & Terms Illustrators: Send postcard sample. Accepts disk submissions. Samples are filed or returned by SASE if requested by artist. Responds to the artist only if interested. Portfolio should include tearsheets and photocopies. Negotiates rights purchased. **Pays on acceptance**; $500 for color cover; $50-200 for b&w, $100-250 for color inside.

TODAY'S CHRISTIAN

465 Gundersen Dr., Carol Stream IL 60188. (630)260-6200. Fax: (630)480-2004. Web site: www.todays-christian.com. **Contact:** Phil Marcelo, art director. Estab. 1963. Bimonthly general interest magazine. "People of Faith. Stories of Hope." Circ. 145,000. Accepts previously published artwork. Originals returned at job's completion.

Illustration Works on assignment only. Has featured illustrations by Mary Chambers, Alain Massicotte, Rex Bohn, Ron Mazellan and Donna Kae Nelson. Features humorous, realistic and spot illustration. Prefers family, home and church life. Considers all media. Digital delivery preferred.

First Contact & Terms Illustrators: Samples are filed. Responds only if interested. To show a portfolio, mail appropriate materials. Buys one-time rights.

Tips "Send samples of your best work, in your best subject and best medium. We're interested in fresh and new approaches to traditional subjects and values."

TODAY'S CHRISTIAN WOMAN

465 Gundersen Dr., Carol Stream IL 60188. (630)260-6200. Fax: (630)260-0114. **Design Director:** Douglas A. Johnson. Estab. 1978. Bimonthly consumer magazine "for Christian women, covering all aspects of family, faith, church, marriage, friendship, career and physical, mental and emotional development from a Christian perspective." Circ. 250,000.

● This magazine is published by Christianity Today, Intl. which also publishes 11 other magazines.

Illustration Buys 6 illustrations/issue. Considers all media.

First Contact & Terms Illustrators: Send postcard sample or query letter with printed samples, photocopies, SASE and tearsheets. Samples are filed. Responds only if interested. Buys first rights. Pays $200-1,000 for color inside.

🖪 TODAY'S PARENT

One Mount Pleasant Rd., 8th Floor, Toronto ON M4Y 2Y5 Canada. (416)764-2883. Fax: (416)764-2801. Web site: www.todaysparent.com. **Art Director:** Jackie Shipley. Monthly parenting magazine. Circ. 175,000. Sample copies available.

Illustration Send query letter with printed samples, photocopies or tearsheets.

First Contact & Terms Illustrators: Send follow-up postcard sample every year. Accepts disk submissions. Art director will contact artist for portfolio review of b&w and color photographs, slides, tearsheets and transparencies if interested. Buys first rights. **Pays on acceptance**, $100-300 for b&w and $250-800 for color inside. Pays $400 for spots. Finds illustrators through magazines, submissions and word of mouth.

Tips Looks for "good conceptual skills and skill at sketching children and parents."

TRAVEL & LEISURE

1120 Sixth Ave., 10th Floor, New York NY 10036-6700. (212)382-5600. Fax: (212)382-5877. Web site: www.travelandleisure.com. **Contact:** David Heasty, creative director. Art Director: Nora Sheehan. Monthly magazine emphasizing travel, resorts, dining and entertainment. Circ. 1 million. Original artwork returned after publication. Art guidelines for SASE.

Illustration Approached by 250-350 illustrators/year. Buys 1-15 illustrations/issue. Interested in travel and leisure-related themes. "Illustrators are selected by excellence and relevance to the subject." Works on assignment only.

First Contact & Terms Provide samples and business card to be kept on file for future assignment. Responds only if interested.

Tips No cartoons.

🅽 TRAVEL IMPULSE

9336 117th Street, Delta BC V4C 6B8 Canada. (604)951-3238. Fax: (604)951-8732. E-mail: travimp@ibm.net. Web site: www.suntrackercafe.com. **Editor/Publisher:** Susan M. Boyce. Copy Editor: Kim Applegate. Graphics Consultant: Craig Stuckless. Estab. 1984 (under name of Travel & Courier News). Quarterly consumer magazine about travel. "Our readers love to travel, in fact, they find it irresistable. We publish unusual, quirky destinations plus tips on how to get there inexpensively." Circ. 1,000. Sample copies available for $5. Art guidelines free for SASE with first-class Canadian postage or IRC.

Illustration Buys 2-4 illustrations/issue. Features humorous illustration; charts & graphs. Assigns 25% of illustrations to new and emerging illustrators. Prefers "the allure of exotic destinations or the fun, playfulness of travel as themes." Considers all media especially charcoal, mixed media, pen & ink and photos.

First Contact & Terms Cartoonists: Send single panel only related to travel. Illustrators: Send postcard sample, photocopies or tearsheets. Submission/queries with U.S. postage cannot be acknowledged or returned. Accepts disk submissions compatible with PageMaker 6.5. Samples are filed. Buys first and reprint rights. Pays on publication; $30 minimum for b&w cover; $50 mimimum for color cover; $10 minimum for b&w inside.

Tips "Show us your playful side when submitting work."

TRAVEL NATURALLY

P.O. Box 317, Newfoundland NJ 07435. (973)697-3552. Fax: (973)697-8313. E-mail: naturally@internaturally.com. Web site: www.internaturally.com. **Publisher/Editor:** Bernard Loibl. Director of Operations: Brian J. Ballone. Estab. 1981. Quarterly magazine covering family nudism/naturism and nudist resorts and travel. Circ. 35,000. Sample copies for $8.50 and $4.50 postage; art guidelines for #10 SASE with first-class postage.

Cartoons Approached by 10 cartoonists/year. Buys approximately 3 cartoons/issue. Prefers nudism/naturism.

Illustration Approached by 10 illustrators/year. Buys approximately 3 illustrations/issue. Prefers nudism/naturism. Considers all media.

First Contact & Terms Cartoonists: Send query letter with finished cartoons. Illustrators: Contact directly. Accepts

all digital formats or hard copies. Samples are filed. Always responds. Buys one-time rights. Pays on publication. Pays cartoonists $20-80. Pays illustrators $200 for cover; $80/page inside. Fractional pages or fillers are prorated.

▣ TRIQUARTERLY
629 Noyes St., Evanston IL 60208-4302. (847)491-7614. Fax: (847)467-2096. Web site: www.triquarterly.org. **Editor:** Susan Firestone Hahn. Estab. 1964. *TriQuarterly* literary magazine is "dedicated to publishing writing and graphics which are fresh, adventurous, artistically challenging and never predictable." Circ. 5,000. Originals returned at job's completion.
Illustration Approached by 10-20 illustrators/year. Considers only work that can be reproduced in b&w as line art or screen for pages; all media; 4-color for cover.
First Contact & Terms Illustrators: Send query letter with SASE, tearsheets, photographs or photocopies. Samples are filed or are returned in 3 months (if SASE is supplied). Publication will contact artist if interested. Buys first rights. Pays on publication; $300 for b&w/color cover; $20 for b&w inside.

TURTLE MAGAZINE, FOR PRESCHOOL KIDS
Children's Better Health Institute, 1100 Waterway Blvd., Indianapolis IN 46202-0567. (317)636-8881. Fax: (317)684-8094. Web site: www.turtlemag.org. **Art Director:** Bart Rivers. Estab. 1979. Emphasizes health, nutrition, exercise and safety for children 2-5 years. Published 6 times/year; 4-color. Circ. 300,000. Original artwork not returned after publication. Sample copy for $1.75; art guidelines for SASE with first-class postage. Needs computer-literate freelancers familiar with Macromedia FreeHand and Photoshop for illustrations.
Illustration Approached by 100 illustrators/year. Works with 20 illustrators/year. Buys 15-30 illustrations/issue. Interested in "stylized, humorous, realistic and cartooned themes; also nature and health." Works on assignment only.
First Contact & Terms Illustrators: Send query letter with good photocopies and tearsheets. Accepts disk submissions. Samples are filed or are returned by SASE. Responds only if interested. Portfolio review not required. Buys all rights. Pays on publication: $275 for color cover, $35-90 for b&w inside, $70-155 for color inside, $35-70 for spots. Finds most artists through samples received in mail.
Tips "Familiarize yourself with our magazine and other children's publications before you submit any samples. The samples you send should demonstrate your ability to support a story with illustration."

TV GUIDE
1211 Sixth Ave., New York NY 10036. (212)852-7500. Fax: (212)852-7470. Web site: www.tvguide.com. **Art Director:** Theresa Griggs. Associate Art Director: Catherine Suhocki. Estab. 1953. Weekly consumer magazine for television viewers. Circ. 11,000,000. Has featured illustrations by Mike Tofanelli and Toni Persiani.
Illustration Approached by 200 illustrators/year. Buys 50 illustrations/year. Considers all media.
First Contact & Terms Illustrators: Send postcard sample. Samples are filed. Art director will contact artist for portfolio review of color tearsheets if interested. Negotiates rights purchased. **Pays on acceptance**; $1,500-4,000 for color cover; $1,000-2,000 for full page color inside; $200-500 for spots. Finds artists through sourcebooks, magazines, word of mouth, submissions.

U. THE NATIONAL COLLEGE MAGAZINE
12250 El Camino Real, Suite 104, San Diego CA 92130. (858)847-3350. Fax: (858)847-3340. E-mail: tony@colleges.com. Web site: www.colleges.com/umagazine.com. **Creative Art Director:** Tony Carrieri. Estab. 1986. Quarterly consumer magazine of news, lifestyle and entertainment geared to college students. Magazine is for college students by college students. Circ. 1 million. Sample copies and art guidelines available for SASE with first-class postage or on Web site. Do not submit unless you are a college student.
Cartoons Approached by 25 cartoonists/year. Buys 2 cartoons/issue. Prefers college-related themes. Prefers humorous color washes, single or multiple panel with gagline.
Illustration Approached by 100 illustrators/year. Buys 10-20 illustrations/issue. Features caricatures of celebrities; humorous illustration; informational graphics; computer and spot illustration. Assigns 100% of illustrations to new and emerging illustrators. Prefers bright, light, college-related, humorous, color only, no b&w. Considers collage, color washed, colored pencil, marker, mixed media, pastel, pen & ink or watercolor. 20% of freelance illustration demands knowledge of Photoshop, Illustrator and QuarkXPress.
First Contact & Terms Cartoonists: Send query letter with photocopies and tearsheets. Samples are filed and are not returned. Responds only if interested. Pays on publication. Pays cartoonists $25 for color. Pays illustrators $100 for color cover; $25 for color inside; $25 for spots. Finds illustrators through college campus newspapers and magazines.
Tips "We need light, bright, colorful art. We accept art from college students only."

U.S. LACROSSE MAGAZINE

113 W. University Pkwy., Baltimore MD 21210-3300. (410)235-6882. Fax: (410)366-6735. E-mail: cmenanteau@ uslacrosse.org. Web site: www.lacrosse.org. **Art Director:** Claudia Menanteau. Estab. 1978. "*Lacrosse Magazine* includes opinions, news, features, student pages, 'how-to's' for fans, players, coaches, etc. of all ages." Published 8 times/year. Circ. 80,000. Accepts previously published work. Sample copies available.

Cartoons Prefers ideas and issues related to lacrosse. Prefers single panel, b&w washes or b&w line drawings.

Illustration Approached by 12 freelance illustrators/year. Buys 3-4 illustrations/year. Works on assignment only. Prefers ideas and issues related to lacrosse. Considers pen & ink, collage, marker and charcoal. Freelancers should be familiar with Illustrator, FreeHand or QuarkXPress.

First Contact & Terms Cartoonists: Send query letter with finished cartoon samples. Illustrators: Send postcard sample or query letter with tearsheets or photocopies. Accepts disk submissions compatible with Mac. Samples are filed. Call for appointment to show portfolio of final art, b&w and color photocopies. Rights purchased vary according to project. Pays on publication. Pays cartoonists $40 for b&w. Pays illustrators $100 for b&w cover, $150 for color cover; $75 for b&w inside, $100 for color inside.

Tips "Learn/know as much as possible about the sport."

UNIQUE OPPORTUNITIES, The Physician's Resource

214 South 8th Street., Suite 502, Louisville KY 40202-2738. (502)589-8250. Fax: (502)587-0848. E-mail: barb@uo works.com. Web site: www.uoworks.com. **Publisher and Design Director:** Barbara Barry. Estab. 1991. Bimonthly trade journal. "Our audience is physicians who are looking for jobs. Editorial focus is on practice-related issues." Circ. 80,000. Originals returned at job's completion. Freelancers should be familiar with Illustrator, Photoshop and FreeHand.

Illustration Approached by 10 illustrators/year. Buys 1-2 illustrations/issue. Works on assignment only. Considers pen & ink, mixed media, collage, pastel and computer illustration. Prefers computer illustration.

First Contact & Terms Illustrators: Publication will contact artist for portfolio of final art, tearsheets, EPS files on a floppy disk if interested. Buys first or one-time rights. Pays 30 days after acceptance; $700 for color cover; $250 for spots. Finds artists through Internet only. Do not send samples in the mail.

UNMUZZLED OX

105 Hudson St., New York NY 10013. (212)226-7170. Fax: (718)448-3395. E-mail: MAndreOX@aol.com. **Editor:** Michael Andre. Emphasizes poetry, stories, some visual arts (graphics, drawings, photos) for poets, writers, artists, musicians and interested others; b&w with 2-color cover and "classy" design. Circ. varies depending on format (5,000-20,000). Return of original artwork after publication "depends on workartist should send SASE." Sample copy for $14 (book quality paperback form).

Illustration Uses "several" illustrations/issue. Themes vary according to issue.

First Contact & Terms Cartoonists: Send query letter with copies. No payment for cartoons. Illustrators: Send query letter and "anything you care to send" to be kept on file for possible future assignments. Responds in 10 weeks.

Tips Magazine readers and contributors are "highly sophisticated and educated"; artwork should be geared to this market. "Really, *Ox* is part of New York art world. We publish art, not 'illustration.' "

UROLOGY TIMES

7500 Old Oak Blvd., Cleveland OH 44130. (440)891-3108. Fax: (440)891-2735. E-mail: pseltzer@advanstar.com. Web site: www.urologytimes.com. **Art Director:** Peter Seltzer. Estab. 1972. Monthly trade publication. The leading news source for urgologists. Circ. 10,000. Art guidelines available.

Illustration Buys 6 illustrations/year. Has featured illustrations by DNA Illustrations, Inc. Assigns 25% of illustrations to new and emerging illustrators. 90% of freelance work demands computer skills. Freelancers should be familiar with Illustrator, Photoshop. E-mail submissions accepted with link to Web site. Prefers TIFF, JPEG, GIF, EPS. Samples are filed. Art director will contact artist for portfolio review if interested. Portfolio should include finished art and tearsheets. Pays on publication. Buys multiple rights. Finds freelancers through artists' submissions.

First Contact & Terms Illustrators: Send postcard sample with photocopies.

UTNE

1624 Harmon Place, Suite 330, Minneapolis MN 55403. (612)338-5040. Fax: (612)338-6043. Web site: www.utne .com. **Art Director:** Kristi Anderson. Associate Art Director: Stephanie Glaros. Estab. 1984. Bimonthly digest featuring articles and reviews from the best of alternative media; independently published magazines, newsletters, books, journals and Web sites. Topics covered include national and international news, history, art, music, literature, science, education, economics and psychology. Circ. 250,000.

● *Utne* seeks to present a lively diversity of illustration and photography "voices." We welcome artistic samples which exhibit a talent for interpreting editorial content.

Illustration Buys 10-15 illustrations per issue. Buys 60-day North American rights. Finds artists through submissions, annuals and sourcebooks.

First Contact & Terms Illustrators: Send single-sided postcards, color or b&w photocopies, printed agency/rep samples or small posters. We are unlikely to give an assignment based on only one sample, and we strongly prefer that you send several samples in one package rather than single pieces in separate mailings. Clearly mark your full name, address, phone number, fax number, and e-mail address on everything you send. Do not send electronic disks. Do not send original artwork of any kind. Samples cannot be returned.

VALLUM

P.O. Box 48003, Montreal QB H2V 4S8 Canada. E-mail: vallummag@sympatico.ca. Web site: www.vallummag.com. **Contact:** Joshua Auerbach or Eleni Auerbach, editors. Estab. 2001. Literary/fine arts magazine published twice yearly. Publishes exciting interplay of poets and artists. Circ. 3,200. Sample copies available for CDN $8.25/US $7. Art guidelines free with SASE or on Web site.

Illustration Buys 5 illustrations/year. Has featured illustrations by Danielle Borisoff, Allen Martian-Vandever, Barbara Legowski, Charles Weiss. Prefers art that is interesting visually, contemporary and fresh. Uses color for cover, inside of magazine uses b&w or color.

First Contact & Terms Illustrators: Send postcard sample or query letter with brochure, photographs, résumé, samples. After introductory mailing, send follow-up postcard every 6 months. Samples are not filed but are returned by SASE. Responds in 9-12 months. Payment varies. Pays on publication. Buys first North American rights.

VANCOUVER MAGAZINE

2608 Granville Street, Suite 560, Vancouver BC V6H 3V3 Canada. (604)877-7732. Fax: (604)877-4823. E-mail: rwatson@vancouvermagazine.com. Web site: www.vancouvermagazine.com. **Art Director:** Randall Watson. Monthly 4-color city magazine. Circ. 65,000.

Illustration Approached by 25 illustrators/year. Buys 8 illustrations/issue. Has featured illustrations by Maurice Vellecoup, Seth, Ken Steacy, Amanda Duffy. Features editorial and spot illustrations. Prefers conceptual, alternative, bright and graphic use of color and style. Assigns 10% of work to new and emerging illustrators.

First Contact & Terms Illustrators: Send postcard or other nonreturnable samples and follow-up samples every 3 months. Samples are filed. Responds only if interested. Portfolio may be dropped off every Tuesday and picked up the following day. Buys one-time and WWW rights. **Pays on acceptance**; negotiable. Finds illustrators through magazines, agents, *Showcase*.

Tips "We stick to tight deadlines. Aggressive, creative, alternative solutions encouraged. No phone calls please."

VANITY FAIR

4 Times Square, 22nd Floor, New York NY 10036. (212)286-8180. Fax: (212)286-6707. E-mail: vfmail@vf.com. Web site: www.vanityfair.com. **Deputy Art Director:** Julie Weiss. Design Director: David Harris. Estab. 1983. Monthly consumer magazine. Circ. 1.1 million. Does not use previously published artwork. Original artwork returned at job's completion. 100% of freelance design work demands knowledge of QuarkXPress and Photoshop.

Illustration Approached by "hundreds" of illustrators/year. Buys 3-4 illustrations/issue. Works on assignment only. "Mostly uses artists under contract."

VARBUSINESS

600 Community Dr., Manhasset NY 11030. (516)562-5000. E-mail: varbizart@cmp.com. Web site: www.varbusiness.com. **Senior Art Director:** Scott Gormely. Estab. 1985. Emphasizes computer business, for and about value added resellers. Biweekly 4-color magazine with an "innovative, contemporary, progressive, very creative" design. Circ. 107,000. Original artwork is returned to the artist after publication. Art guidelines not available.

Illustration Approached by more than 100 illustrators/year. Works with 30-50 illustrators/year. Buys 150 illustrations/year. Needs editorial illustrations. Open to all styles. Uses artists mainly for covers, full and single page spreads and spots. Works on assignment only. Prefers "digitally compiled, technically conceptual oriented art (all sorts of media)."

Design Also needs freelancers for design. 100% of design demands knowledge of Photoshop 4.0 and QuarkXPress 3.31.

First Contact & Terms Illustrators: Send postcard sample or query letter with tearsheets. Accepts e-mail submissions. Samples are filed. Responds only if interested. Call or write for appointment to show portfolio, which should include tearsheets, final reproduction/product and slides. Buys one-time rights. Pays on publication.

Pays $1,000-1,500 for b&w cover; $1,500-2,500 for color cover; $500-850 for b&w inside; $750-1,000 for color inside; pays $300-600 for spots.

Tips "Show printed pieces or suitable color reproductions. Concepts should be imaginative, not literal. Sense of humor sometimes important."

VEGETARIAN JOURNAL

P.O. Box 1463, Baltimore MD 21203-1463. (410)366-8343. E-mail: vrg@vrg.org. Web site: www.vrg.org. **Editor:** Debra Wasserman. Estab. 1982. Quarterly nonprofit vegetarian magazine that examines the health, ecological and ethical aspects of vegetarianism. "Highly educated audience including health professionals." Circ. 20,000. Accepts previously published artwork. Originals returned at job's completion upon request. Sample copies available for $3.

Cartoons Approached by 4 cartoonists/year. Buys 1 cartoon/issue. Prefers humorous cartoons with an obvious vegetarian theme; single panel b&w line drawings.

Illustration Approached by 20 illustrators/year. Buys 6 illustrations/issue. Works on assignment only. Prefers strict vegetarian food scenes (no animal products). Considers pen & ink, watercolor, collage, charcoal and mixed media.

First Contact & Terms Cartoonists: Send query letter with roughs. Illustrators: Send query letter with photostats. Samples are not filed and are returned by SASE if requested by artist. Responds in 2 weeks. Portfolio review not required. Rights purchased vary according to project. **Pays on acceptance.** Pays cartoonists $25 for b&w. Pays illustrators $25-50 for b&w/color inside. Finds artists through word of mouth and job listings in art schools.

Tips Areas most open to freelancers are recipe section and feature articles. "Review magazine first to learn our style. Send query letter with photocopy sample of line drawings of food."

VERMONT MAGAZINE

P.O. Box 800, Middlebury VT 05753-0800. (802)388-8480. Fax: (802)388-8485. E-mail: vtmag@sover.net. Web site: www.vermontmagazine.com. **Publisher:** Kate Fox. Estab. 1989. Bimonthly regional publication "aiming to explore what life in Vermont is like its politics, social issues and scenic beauty." Circ. 50,000. Accepts previously published artwork. Original artwork returned at job's completion. Sample copies and art guidelines for SASE with first-class postage.

Illustration Approached by 100-150 illustrators/year. Buys 2-3 illustrations/issue. Works on assignment only. Has featured illustrations by Chris Murphy. Features humorous, realistic, computer and spot illustration. Assigns 50% of illustrations to experienced but not well-known illustrators; 50% to new and emerging illustrators. "Particularly interested in creativity and uniqueness of approach." Considers pen & ink, watercolor, colored pencil, oil, charcoal, mixed media and pastel.

First Contact & Terms Illustrators: Send query letter with tearsheets, "something I can keep." Materials of interest are filed. Publication will contact artist for portfolio review if interested. Portfolio should include final art and tearsheets. Buys one-time rights. Considers buying second rights (reprint rights) to previously published work. Pays $400 maximum for color cover; $75-150 for b&w inside; $75-350 for color inside; $300-500 for 2-page spreads; $50-75 for spots. Finds artists mostly through submissions/self-promos and from other art directors.

VIBE

215 Lexington Ave., 6th Floor, New York NY 10016. (212)448-7300. Fax: (212)448-7377. E-mail: fbachleda@vib e.com. Web site: www.vibe.com. **Design Director:** Florian Bachleda. Estab. 1993. Monthly consumer magazine focused on music, urban culture. Circ. 800,000. Accepts previously published artwork. Originals returned at job's completion. Sample copies available.

Illustration Works on assignment only.

First Contact & Terms Cartoonists: Send postcard-size sample or query letter with brochure and finished cartoons. Responds to the artist only if interested. Illustrators: Send postcard-size sample or query letter with photocopies. Samples are filed. Publication will contact artist for portfolio review of roughs, final art and photocopies if interested. Buys one-time or all rights.

VIM & VIGOR

1010 E. Missouri Ave., Phoenix AZ 85014. (602)395-5850. Fax: (602)395-5853. **Senior Art Director:** Susan Knight. Creative Director: Randi Karabin. Estab. 1985. Quarterly consumer magazine focusing on health. Circ. 1.2 million. Originals returned at job's completion. Sample copies available. Art guidelines available.

• The company publishes many other titles as well.

Illustration Approached by 100 illustrators/year. Buys 10 illustrations/issue. Works on assignment only. Considers mixed media, collage, charcoal, acrylic, oil, pastel and computer.

First Contact & Terms Illustrators: Send postcard sample with tearsheets and online portfolio/Web site informa-

tion. Accepts disk submissions. Samples are filed. Rights purchased vary according to project. **Pays on acceptance.** Finds artists through agents, Web sourcebooks, word of mouth and submissions.

N VIRGINIA TOWN & CITY
P.O. Box 12164, Richmond VA 23241-0164. (804)649-8471. Fax: (804)343-3758. E-mail: vml@i2020.net. Web site: www.vml.org. **Editor:** David Parsons. Estab. 1965. Monthly b&w magazine with 4-color cover for Virginia local government officials (elected and appointed) published by nonprofit association. Circ. 5,000. Accepts previously published artwork. Originals returned at job's completion. Sample copies available. Art guidelines not available.

Cartoons "Currently none appear, but we would use cartoons focusing on local government problems and issues."

First Contact & Terms Publication will contact artist for portfolio review if interested. Rights purchased vary according to project. **Pays on acceptance.** Pays $25 for b&w. Pays illustrators $50-75 for b&w and $55 for color cover; $25-45 for b&w and $35 for color inside.

Tips "We occasionally need illustrations of local government services. For example, police, firefighters, education, transportation, public works, utilities, cable TV, meetings, personnel management, taxes, etc. Usually b&w. Illustrators who can afford to work or sell for our low fees, and who can provide rapid turnaround should send samples of their style and information on how we can contact them."

VOGUE PATTERNS
11 Penn Plaza, New York NY 10001. (212)465-6800. Fax: (212)465-6814. E-mail: mailbox@voguepatterns.com. Web site: www.voguepatterns.com. **Associate Art Director:** Christine Lipert. Manufacturer of clothing patterns with the Vogue label. Circ. 99,162. Uses freelance artists mainly for fashion illustration for the *Vogue Patterns* catalog and editorial illustration for *Vogue Patterns* magazine. "The nature of catalog illustration is specialized; every button, every piece of top-stitching has to be accurately represented. Editorial illustration assigned for our magazine should have a looser-editorial style. We are open to all media."

Illustration Approached by 50 freelancers. Works with 10-20 illustrators and 1-5 graphic designers/year. Assigns 18 editorial illustration jobs and 100-150 fashion illustration jobs/year. Looking for "sophisticated modern fashion and intelligent creative and fresh editorial."

First Contact & Terms Illustrators: Send query letter with résumé, tearsheets, slides or photographs. Samples not filed are returned by SASE. Call or write for appointment to drop-off portfolio. Pays for design by the hour, $15-25; for illustration by the project, $150-300.

Tips "Drop off comprehensive portfolio with a current business card and sample. Make sure name is on outside of portfolio. When a job becomes available, we will call illustrator to view portfolio again."

▣ WASHINGTON CITY PAPER
2390 Champlain St. N.W., Washington DC 20009. (202)332-2100. Fax: (202)332-8500. E-mail: mail@washcp.c om. Web site: www.washingtoncitypaper.com. **Art Director:** Pete Morelewicz. Estab. 1980. Weekly tabloid "distributed free in DC and vicinity. We focus on investigative reportage, arts, and general interest stories with a local slant." Circ. 95,000. Art guidelines not available.

Cartoons Only accepts weekly features, no spots or op-ed style work.

Illustration Approached by 100-200 illustrators/year. Buys 2-8 illustrations/issue. Has featured illustrations by Michael Kupperman, Peter Hoey, Greg Houston, Joe Rocco, Susie Ghahremani, and Robert Meganck. Features caricatures of politicians; humorous illustration; informational graphics; computer and spot illustration. Considers all media, if the results do well in b&w.

First Contact & Terms Illustrators: Send query letter with printed or e-mailed samples, photocopies or tearsheets. Art director will contact artist for more if interested. Buys first-rights. Pays on publication which is usually pretty quick. Pays cartoonists $25 minimum for b&w. Pays illustrators $110 minimum for b&w cover; $220 minimum for color cover; $85 minimum for inside. Finds illustrators mostly through submissions.

Tips "We are a good place for freelance illustrators, we use a wide variety of styles, and we're willing to work with beginning illustrators. We like illustrators who are good on concept and can work fast if needed. We avoid cliché DC imagery such as the capitol and monuments."

WASHINGTON FAMILY MAGAZINE
485 Spring Park Pl., Suite 550, Herndon VA 20170. (703)318-1385. Fax: (703)318-5509. E-mail: production@fam iliesmagazines.com. Web site: www.familiesmagazines.com. **Contact:** Kirsten Schneider. Estab. 1991. Monthly. Consumer magazine. Parenting magazine.Circ. 100,000. Art guidelines available by e-mail.

Illustration Approached by 100 illustrators/year. Features computer illustration. Preferred subjects: children, families, women. Prefers bright colors with process colors of no more than 2 color mixes. Freelancers should be familiar with PageMaker, Illustrator, Photoshop. E-mail submissions not accepted. Prefers JPEG, hi-res.

Samples are filed. Portfolio not required. Pays illustrators 100 for color cover. Pays on publication. Buys one-time rights. Finds freelancers through artists' submissions.
First Contact & Terms Illustrators: Send postcard sample, brochure, samples.

N THE WASHINGTON POST MAGAZINE
Dept. AM, 1150 15th St. NW, Washington DC 20071. (202)334-7585. Fax: (202)334-5693. **Art Director:** Brian Noyes. Estab. 1986. Weekly magazine; general interest. Circ. 1,200,000. Original artwork returned after publication.
Illustration Approached by 500 illustrators/year. Buys 3 illustrations/issue. Works on assignment only. Prefers any media.
First Contact & Terms Illustrators: Send query letter with tearsheets. Samples are filed. Does not report back. To show a portfolio, mail tearsheets and slides. Buys one-time rights. **Pays on acceptance**; $1,000 for color cover; $300 for color, "little pieces," inside.

WASHINGTONIAN MAGAZINE
1828 L St., NW, Suite 200, Washington DC 20036. (202)296-3600. E-mail: ecrowson@washingtonian.com. Web site: www.washingtonian.com. **Contact:** Eileen O'Tousa Crowson, design director. Estab. 1965. Monthly 4-color consumer lifestyle and service magazine. Circ. 185,000. Sample copies free for #10 SASE with first-class postage.
Illustration Approached by 200 illustrators/year. Buys 7-10 illustrations/issue. Has featured illustrations by Pat Oliphant, Chris Tayne and Richard Thompson. Features caricatures of celebrities, caricatures of politicians, humorous illustration, realistic illustrations, spot illustrations, computer illustrations and photo collage. Preferred subjects men, women and creative humorous illustration. Assigns 20% of illustrations to new and emerging illustrators. 20% of freelance illustration demands knowledge of Photoshop.
First Contact & Terms Illustrators: Send postcard sample and follow-up postcard every 6 months. Send nonreturnable samples. Send query letter with tearsheets. Accepts Mac-compatible submissions. Send EPS or TIFF files. Responds only if interested. Will contact artist for portfolio review if interested. Buys first rights. **Pays on acceptance**; $900-1,200 for color cover; $200-800 for b&w, $400-900 for color inside; $900-1,200 for 2-page spreads; $400 for spots. Finds illustrators through magazines, word of mouth, promotional samples, sourcebooks.
Tips "We like caricatures that are fun, not mean and ugly. Want a well-developed sense of color, not just primaries."

WEEKLY READER
Weekly Reader Corp., 200 First Stamford Place, Stamford CT 06912. (203)705-3500. Web site: www.weeklyreader.com. **Contact:** Amy Gery. Estab. 1928. Educational periodicals, posters and books. *Weekly Reader* teaches the news to kids pre-K through high school. The philosophy is to connect students to the world. Publications are 4-color. Accepts previously published artwork. Original artwork is returned at job's completion. Sample copies are available.
Illustration Needs editorial and technical illustration. Style should be "contemporary and age-level appropriate for the juvenile audience." Buys more than 50/week. Works on assignment only. Uses computer and reflective art.
First Contact & Terms Illustrators: Send brochure, tearsheets, SASE and photocopies. Samples are filed or are returned by SASE if requested by artist. Payment is usually made within 3 weeks of receiving the invoice. Finds artists through artists' submissions/self-promotions, sourcebooks, agents and reps. Some periodicals need quick turnarounds.
Tips "Our primary focus is the children's and young adult marketplace. Art should reflect creativity and knowledge of audience's needs. Our budgets are tight, and we have very little flexibility in our rates. We need artists who can work with our budgets. Avoid using fluorescent dyes. Use clear, bright colors. Work on flexible board."

⚡ WEST COAST LINE
2027 E. Academic Annex, Burnaby BC V5A 1S6 Canada. (604)291-4287. Fax: (604)291-4622. E-mail: wcl@sfu.ca. Web site: www.sfu.ca/west-coast-line. **Contact:** Managing Editor. Estab. 1990. Literary and visual arts journal published 3 times/year covering contemporary innovative writing and literary criticism/cultural studies by Canadians. Circ. 850. Art guidelines available free for SASE or send e-mail attachment/in body of message. Sample copies available.
First Contact & Terms Illustration: Send query letter with photocopies. Samples are filed and are returned by SASE (IRC for U.S. submissions). Responds in 3 months. Buys one-time rights. Pays on publication. Pays $150 for color cover; $25 minimum for b&w inside. Has featured illustrations by Laiwan, Christine Davis and Monique Mees.
Tips "Each issue features full-color cover of visual artist's work—photo, painting, collage, etc."

▣ WESTERN DAIRY BUSINESS

6437 Collamer Rd., E. Syracuse NY 13057. (315)703-7979. Fax: (315)703-7988. E-mail: mdbise@aol.com. Web site: www.dairybusiness.com. **Art Director:** Maria Bise. Estab. 1922. Monthly trade journal with audience comprised of "Western-based milk producers, herd size 100 and larger, all breeds of cows, covering the 13 Western states." Circ. 23,000. Accepts previously published artwork. Samples copies and art guidelines available.

Illustration Approached by 5 illustrators/year. Buys 1-4 illustrations/issue. Works on assignment only. Preferred themes "depend on editorial need." Considers 3-D and computer illustration.

First Contact & Terms Send query letter with brochure, tearsheets and résumé. Samples are filed or are returned by SASE if requested by artist. Responds in 2 weeks. Write for appointment to show portfolio of thumbnails, tearsheets and photographs. Buys all rights. Pays on publication; $100 for b&w, $200 for color cover; $50 for b&w, $100 for color inside.

Tips "We have a small staff. Be patient if we don't get back immediately. A follow-up letter helps. Being familiar with dairies doesn't hurt. Quick turnaround will put you on the 'A' list."

WESTWAYS

3333 Fairview Rd., A327, Costa Mesa CA 92808. (714)885-2396. Fax: (714)885-2335. E-mail: vaneyke.eric@aaa-calif.com. **Art Director:** Eric Van Eyke. Estab. 1918. A bimonthly lifestyle and travel magazine. Circ. 3,000,000. Original artwork returned at job's completion. Sample copies and art guidelines available for SASE.

Illustration Approached by 20 illustrators/year. Buys 2-6 illustrations/year. Works on assignment only. Preferred style is arty—tasteful, colorful. Considers pen & ink, watercolor, collage, airbrush, acrylic, colored pencil, oil, mixed media and pastel.

First Contact & Terms Illustrators: Send e-maill with link to Web site or query letter with brochure, tearsheets and samples. Samples are filed. Responds in 2 weeks only if interested. To show a portfolio, mail appropriate materials. Portfolio should include thumbnails, final art, b&w and color tearsheets. Buys first rights. Pays on publication; $250 minimum for color inside.

▣ Ⓝ WINDSOR REVIEW

Department of English, Windsor ON N9B 3P4 Canada. (519)253-4232, ext. 2290. Fax: (519)971-3676. E-mail: uwrevu@uwindsor.ca. **Art Editor:** Marty Gervais. Estab. 1966. Biannual 4-color literary magazine featuring poetry, short fiction and art. Circ. 400. Art guidelines free for #10 SASE with first-class postage.

Illustration Has featured illustrations and/or fine art by Eiichi Matsuhashi, Robbert Fortin, John Pufahl, Ellen Katterbach. Features computer, humorous and realistic illustration, fine art. Prefers "anything of quality and tasteintelligent, thought-provoking."

First Contact & Terms Accepts Windows-compatible disk submissions. Responds in 3 months. Buys all rights. Pays on publication.

Ⓝ WINDSURFING MAGAZINE

460 N. Orlando Ave., Winter Park FL 32789. (407)628-4802. Fax: (407)628-7061. E-mail: windsurf@gate.net. **Art Director:** Mike Bessire. Estab. 1981. Consumer magazine "for windsurfers and those interested in the sport. Audience is 30ish, mostly male and affluent." 8 issues/year. Circ. 75,000. Original artwork returned if requested at job's completion. One sample copy available to the artist. Art guidelines not available.

Illustration Approached by 1-2 illustrators/year. Buys 15-20 illustrations/year, mostly maps. Works on assignment only. Prefers "maps and a fun cartoon-like style." Considers airbrush, watercolor and collage.

First Contact & Terms Illustrators: Send query letter with SASE, "samples of various styles and short bio listing where published material has appeared." Samples are filed or are returned by SASE if requested by artist. Responds only if interested as need arises. "Please do not call." To show a portfolio, mail color tearsheets, photostats, photographs and photocopies. Rights purchased vary according to project. Pays on publication; $50-400 average for color inside.

Tips "Send a good selection of styles for us to review."

THE WITNESS

Episcopal Church Publishing Co., 1714 Franklin St., #100-139, Oakland CA 94612-3409. (510)428-1872. E-mail: editor@thewitness.org. Web site: www.thewitness.org. **Editor:** Sarah Dylan Breuer. Estab. 1917. Christian journal historically published in print, currently published only online but with goal to re-launch print production in 2007, "focusing on faith context for addressing social justice issues. Episcopal Anglican rootscontent is often serious yet occasionally quirky and irreverent." Readership 6,000.

Cartoons Buys 10-12 cartoons/year. Prefers single panel, political, b&w line drawings.

Illustration Has featured illustrations by Dierdre Luzwick, Betty LaDuke and Robert McGovern. Features humorous, realistic and spot illustration. "Themes social and economic justice, though we like to use art in unusual

and surprising combination with story topics. Style We appreciate work that is subtle, provocative, never sentimental."

First Contact & Terms Cartoonists: Send query letter with finished cartoons, photographs, photocopies, roughs or tearsheets. Illustrators: Send postcard sample or query letter with printed samples, photocopies and tearsheets. Accepts CD submissions in JPEG or GIF format. Samples are filed if suitable and are not returned. "We like to keep samples of artists' work on file, with permission to use in the magazine." Responds only if interested.

WOODENBOAT MAGAZINE

P.O. Box 78, Brooklin ME 04616-0078. (207)359-4651. Fax: (207)359-8920. E-mail: olga@woodenboat.com. Web site: www.woodenboat.com. **Art Director:** Olga Lange. Estab. 1974. Bimonthly magazine for wooden boat owners, builders and designers. Circ. 106,000. Previously published work OK. Sample copy for $6. Art guidelines free for SASE with first-class postage.

Illustration Approached by 10-20 illustrators/year. Buys 2-10 illustrations/issue on wooden boats or related items. Uses some illustration, usually by several regularly appearing artists, but occasionally featuring others.

Design Not currently using freelancers.

First Contact & Terms Illustrators: Send postcard sample or query letter with printed samples and tearsheets. Designers: Send query letter with tearsheets, résumé and slides. Samples are filed. Does not report back. Artist should follow up with call. Pays on publication. Pays illustrators $50-$400 for spots.

Tips "We work with several professionals on an assignment basis, but most of the illustrative material that we use in the magazine is submitted with a feature article. When we need additional material, however, we will try to contact a good freelancer in the appropriate geographic area."

WORKFORCE MANAGEMENT

4 Executive Circle, Suite 185, Irvine CA 92614. (949)255-5345. Fax: (949)221-8964. E-mail: dbloom@workforce. com. Web site: www.workforce.com. **Art Director:** David Bloom. Estab. 1922. Monthly trade journal for human resource business executives. Circ. 36,000. Sample copies available in libraries.

Illustration Approached by 100 illustrators/year. Buys 3-4 illustrations/issue. Prefers business themes. Considers all media. 40% of freelance illustration demands knowledge of Photoshop, QuarkXPress and Illustrator. Send postcard sample. Send follow-up postcard sample every 3 months. Samples are filed and are not returned. Does not reply, artist should call. Art director will contact for portfolio review if interested. Rights purchased vary according to project. **Pays on acceptance**; $350-500 for color cover; $100-400 for b&w and/or color inside; $75-150 for spots. Finds artists through agents, sourcebooks such as *LA Workbook*, magazines, word of mouth and submissions.

Tips "Read our magazine."

WORKSPAN

14040 N. Northsight Blvd., Scottsdale AZ 85260. (480)922-2063. Fax: (480)483-8352. E-mail: mmunoz@worldat work.org. Web site: www.worldatwork.org. **Contact:** Mark Anthony Munoz, art director. Estab. 2000. Monthly publication with a circulation of 26,000, targeting an audience which includes human resources, benefits, and compensation professionals. It serves as an informative resource with respect to practices, trends, knowledge and contemporary issues in the field. Sample copies available on request. Art guidelines are available by contacting the art director.

Illustration Approached by 500+ illustrators/year. Buys 20-25 illustrations/year. Has featured illustrations by Bill Mayer, Gerard DuBois, Curtis Parker, Charlie Hill, Adam Nikewicz, Doug Frasier, Tim Grasser. Features computer illustrations, realistic illustrations, spot illustrations or traditional illustrations of business. Prefers vibrant, rich, modern. Assigns 10% to new and emerging illustrators. 20% of freelance illustration demands knowledge of FreeHand, Illustrator, QuarkXPress and Photoshop.

First Contact & Terms Cartoonists/Illustrators: Send postcard samples with photocopies, samples, tearsheets, transparencies and URL. After introductory mailing, send follow-up postcard every 6 months. All samples are kept on file. Accepts e-mail submissions with link to Web site and e-mail submissions with image file. Prefers Mac-compatible TIFF and JPEG files. Samples are filed and returned by SASE. Responds only if interested. Portfolios may be dropped off every Monday. Company will contact artist for portfolio review if interested. Portfolio should include color photographs, tearsheets, thumbnails and film usage samples. Pays illustrators $1,500-3,000 for color cover, $900-2,000 for color inside; $1,000-2,000 for 2-page spreads. **Pays on acceptance.** Buys one-time rights, reprint rights (negotiated upon reprinting). Rights purchased vary according to project. Finds freelancers through agents, magazines, word of mouth, artists' submissions, sourcebooks, *Workbook*, GAD Directory, American Showcase and samples.

Tips "Research types of magazines that are appropriate before sending samples; although artwork may be exceptional, it may not fit our image guidelines. Also, any Web URLs should be tested before sending."

WORLD TRADE

23421 S. Pointe Dr., Suite 280, Laguna Hills CA 92653-1478. (949)830-1340. Fax: (949)830-1328. Web site: www.worldtrademag.com. **Art Director:** Mike Powell. Estab. 1988. Monthly 4-color consumer journal; "read by upper management, presidents and CEOs of companies with international sales." Circ. 83,000. Accepts previously published artwork. Original artwork is returned to artist at job's completion. Sample copies and art guidelines not available.

Cartoons Prefers business/social issues.

Illustration Approached by 15-20 illustrators/year. Buys 1-2 illustrations/issue. Works on assignment only. "We are open to all kinds of themes and styles." Considers pen & ink, colored pencil, mixed media and watercolor.

First Contact & Terms Illustrators: Send query letter with brochure and tearsheets. Samples are filed. Responds only if interested. Portfolio review not required. Buys first rights or reprint rights. Pays on publication; $800 for color cover; $275 for color inside.

Tips "Send an example of your work. We prefer previous work to be in business publications. Artists need to understand we work from a budget to produce the magazine, and budget controls and deadlines are closely watched."

Ⓝ YOUR HEALTH & FITNESS

900 Skokie Blvd., Suite 200, Northbrook IL 60062. (847)205-3000. Fax: (847)564-8197. **Supervisor of Art Direction:** Patricia Gager. Estab. 1978. Quarterly consumer and company magazine. "*Your Health & Fitness* is a magazine that allows clients to customize up to eight pages. Clients consist of hospitals, HMOs and corporations." Circ. 600,000. Accepts previously published artwork. Originals are returned at job's completion. Sample copies available. 70% of freelance work demands knowledge of Illustrator, QuarkXPress, Photoshop and FreeHand.

Illustration Approached by 200 illustrators/year. Buys 6 illustrations/issue. Works on assignment only. Prefers exercise, fitness, psychology, drug data, health cost, first aid, diseases, safety and nutrition themes; any style.

First Contact & Terms Illustrators: Send postcard sample and tearsheets. Accepts disk submissions compatible with Mac, Illustrator or Photoshop. Samples are filed or are returned. Responds only if interested. Publication will contact artist for portfolio review if interested. Portfolio should include b&w and color tearsheets and slides. Buys one-time or reprint rights. Pays on publication; $400-600 for color cover; $75-150 for b&w, $150-400 for color inside; $100-150 for spots. Finds artists through sourcebooks and submissions.

Design Needs freelancers for design. 100% of freelance work demands knowledge of Illustrator or QuarkXPress. Send query letter with tearsheets and résumé. Pays by the project.

Tips "Fast Facts" section of magazine is most open to freelancers; uses health- or fitness-related cartoons.

Posters & Prints

Have you ever noticed, perhaps at the opening of an exhibition or at an art fair, that though you have many paintings on display, everybody wants to buy the same one? Do friends, relatives and co-workers ask you to paint duplicates of work you already sold? Many artists turn to the print market because they find certain images have a wide appeal and will sell again and again. This section lists publishers and distributors who can publish and market your work as prints or posters. It is important to understand the difference between the terms "publisher" and "distributor" before you begin your research. Art *publishers* work with you to publish a piece of your work in print form. Art *distributors* assist you in marketing a pre-existing poster or print. Some companies function as both publisher and distributor. Look in the first paragraph of each listing to determine if the company is a publisher, distributor or both.

RESEARCH THE MARKET

Some listings in this section are fine art presses, others are more commercial. Read the listings carefully to determine if they create editions for the fine art market or for the decorative market. Visit galleries, frame shops, furniture stores and other retail outlets that carry prints to see where your art fits in. You may also want to visit designer showrooms and interior decoration outlets.

To further research this market, check each publisher's Web site or send for each publisher's catalog. Some publishers will not send their catalogs because they are too expensive, but you can often ask to see one at a local poster shop, print gallery, upscale furniture store or frame shop. Examine the colors in the catalogs to make sure the quality is high.

What to send

To approach a publisher, send a brief query letter, a short bio, a list of galleries that represent your work and five to 10 slides or whatever samples they specify in their listing. It helps to send printed pieces or tearsheets as samples, as these show publishers that your work reproduces well and that you have some understanding of the publication process. Most publishers will accept digital submissions via e-mail or CD.

Signing and numbering your editions

Before you enter the print arena, follow the standard method of signing and numbering your editions. You can observe how this is done by visiting galleries and museums and talking to fellow artists.

If you are creating a limited edition, with a specific set number of prints, all prints are

numbered, such as 35/100. The largest number is the total number of prints in the edition; the smaller number is the number of the print. Some artists hold out 10% as artist's proofs and number them separately with AP after the number (such as 5/100 AP). Many artists sign and number their prints in pencil.

Types of prints

Original prints. Original prints may be woodcuts, engravings, linocuts, mezzotints, etchings, lithographs or serigraphs. What distinguishes them is that they are produced by hand

Your Publishing Options

Important

1 **Working with a commercial poster manufacturer or art publisher.** If you don't mind creating commercial images and following current trends, the decorative market can be quite lucrative. On the other hand, if you work with a fine art publisher, you will have more control over the final image.

2 **Working with a fine art press.** Fine art presses differ from commercial presses in that press operators work side by side with you every step of the way, sharing their experience and knowledge of the printing process. You may be charged a fee for the time your work is on the press and for the expert advice of the printer.

3 **Working at a co-op press.** Instead of approaching an art publisher, you can learn to make your own hand-pulled original prints—such as lithographs, monoprints, etchings or silk-screens. If there is a co-op press in your city, you can rent time on a press and create your own editions. It is rewarding to learn printing skills and have the hands-on experience. You also gain total control of your work. The drawback is you have to market your images yourself by approaching galleries, distributors and other clients.

4 **Self-publishing with a printing company.** Several national printing concerns advertise heavily in artists' magazines, encouraging artists to publish their own work. If you are a savvy marketer who understands the ins and outs of trade shows and direct marketing, this is a viable option. However it takes a large investment up front. You could end up with a thousand prints taking up space in your basement, or if you are a good marketer, you could end up selling them all and making a much larger profit than if you had gone through an art publisher or poster company.

5 **Marketing through distributors.** If you choose the self-publishing route but don't have the resources to market your prints, distributors will market your work in exchange for a percentage of sales. Distributors have connections with all kinds of outlets like retail stores, print galleries, framers, college bookstores and museum shops.

by the artist (and consequently often referred to as hand-pulled prints). In a true original print the work is created specifically to be a print. Each print is considered an original because the artist creates the artwork directly on the plate, woodblock, etching stone or screen. Original prints are sold through specialized print galleries, frame shops and high-end decorating outlets, as well as fine art galleries.

Offset reproductions and posters. Offset reproductions, also known as posters and image prints, are reproduced by photochemical means. Since plates used in offset reproductions do not wear out, there are no physical limits on the number of prints made. Quantities, however, may still be limited by the publisher in order to add value to the edition.

Giclée prints. As color-copier technology matures, inkjet fine art prints, also called giclée prints, are gaining popularity. Iris prints, images that are scanned into a computer and output on oversized printers, are even showing up in museum collections.

Canvas transfers. Canvas transfers are becoming increasingly popular. Instead of, and often in addition to, printing an image on paper, the publisher transfers your image onto canvas so the work has the look and feel of a painting. Some publishers market limited editions of 750 prints on paper, along with a smaller edition of 100 of the same work on canvas. The edition on paper might sell for $150 per print, while the canvas transfer would be priced higher, perhaps selling for $395.

Pricing criteria for limited editions and posters

Because original prints are always sold in limited editions, they command higher prices than posters, which are not numbered. Since plates for original prints are made by hand, and as a result can only withstand a certain amount of use, the number of prints pulled is limited by the number of impressions that can be made before the plate wears out. Some publishers impose their own limits on the number of impressions to increase a print's value. These limits may be set as high as 700 to 1,000 impressions, but some prints are limited to just 250 to 500, making them highly prized by collectors.

A few publishers buy work outright for a flat fee, but most pay on a royalty basis. Royalties for handpulled prints are usually based on retail price and range from 5 to 20 percent, while percentages for posters and offset reproductions are lower (from $2\frac{1}{2}$ to 5 percent) and are based on the wholesale price. Be aware that some publishers may hold back royalties to cover promotion and production costs. This is not uncommon.

Prices for prints vary widely depending on the quantity available; the artist's reputation; the popularity of the image; the quality of the paper, ink and printing process. Since prices for posters are lower than for original prints, publishers tend to select images with high-volume sales potential.

Negotiating your contract

As in other business transactions, ask for a contract and make sure you understand and agree to all the terms before you sign. Make sure you approve the size, printing method, paper, number of images to be produced and royalties. Other things to watch for include insurance terms, marketing plans and a guarantee of a credit line or copyright notice.

Always retain ownership of your original work. Work out an arrangement in which you're selling publication rights only. You'll also want to sell rights only for a limited period of time. That way you can sell the image later as a reprint or license it for other use (for example as a calendar or note card). If you are a perfectionist about color, make sure your contract gives you final approval of your print. Stipulate that you'd like to inspect a press proof prior to the print run.

MORE INDUSTRY TIPS

Find a niche. Consider working within a specialized subject matter. Prints with Civil War themes, for example, are avidly collected by Civil War enthusiasts. But to appeal to Civil War buffs, every detail, from weapons and foliage in battlefields to uniform buttons, must be historically accurate. Signed limited editions are usually created in a print run of 950 or so and can average about $175-200; artist's proofs sell from between $195-250, with canvas transfers selling for $400-500. The original paintings from which images are taken often sell for thousands of dollars to avid collectors.

Sport art is another lucrative niche. There's a growing trend toward portraying sports figures from football, basketball and racing (both sports car and horse racing) in prints that include both the artist's and the athlete's signatures. Movie stars and musicians from the 1950s (such as James Dean, Marilyn Monroe and Elvis) are also cult favorites.

Work in a series. It is easier to market a series of small prints exploring a single theme than to market single images. A series of similar prints works well in long hospital corridors, office meeting rooms or restaurants. Also marketable are "paired" images. Hotels often purchase two similar prints for each of their rooms.

Study trends. If you hope to get published by a commercial art publisher or poster company, your work will have a greater chance of acceptance if you use popular colors and themes.

Attend trade shows. Many artists say it's the best way to research the market and make contacts. Increasingly it has become an important venue for self-published artists to market their work. Decor Expo is held each year in four cities: Atlanta, New York, Orlando and Los Angeles. For more information call (888)608-5300 or visit www.decor-expo.com.

Insider Tips

Tips

- Read industry publications, such as *Decor* magazine (www.decormagazine.com) and *Art Business News* (www.artbusinessnews.com), to get a sense of what sells.

- To find out what trade shows are coming up in your area, check the event calendars in industry trade publications. Many shows, such as the Decor Expo (www.decor-expo.com), coincide with annual stationery or gift shows, so if you work in both the print and greeting card markets, be sure to take that into consideration. Remember, traveling to trade shows is a deductible business expense, so don't forget to save your receipts!

- Consult *Business and Legal Forms for Fine Artists*, (3rd Edition), by Tad Crawford (Allworth Press) for sample contracts.

ACTION IMAGES INC.

7148 N. Ridgeway, Lincolnwood IL 60712. (847)763-9700. Fax: (847)763-9701. E-mail: actionim@aol.com. Web site: www.actionimagesinc.com. **President:** Tom Green. Estab. 1989. Art publisher of sport art. Publishes limited edition prints, open edition posters as well as direct printing on canvas. Specializes in sport art prints for events such as the Super Bowl, Final Four, Stanley Cup, etc. Clients include retailers, distributors, sales promotion agencies.

Needs Ideally seeking sport artists/illustrators who are accomplished in both traditional and computer generated artwork as our needs often include tight deadlines, exacting attention to detail and excellent quality. Primary work relates to posters & T-shirt artwork for retail and promotional material for sporting events. Considers all media. Artists represented include Cheri Wenner, Andy Wenner, Ken Call, Konrad Hack and Alan Studt. Approached by approximately 25 artists/year. Publishes the work of 1 emerging artist 2-3 years.

First Contact & Terms Send submissions on e-mail, JPEG, or PDF files or via mailed disk, compatible with Mac, + color printout. Samples are filed. Responds only if interested. If interested in samples, will ask to see more of artist's work. Pays flat fee $1,000-2,000. Buys exclusive reproduction rights. Rarely acquires original painting. Provides insurance while work is at firm and outbound in-transit insurance. Promotional services vary depending on project. Finds artists through recommendations from other artists, word of mouth and submissions.

Tips "If you're a talented artist/illustrator and know your PhotoShop/Illustrator software, you have great prospects."

AEROPRINT AND SPOFFORD HOUSE

South Shore Rd., Box 154, Spofford NH 03462. (603)363-4713. **Owner:** H. Westervelt. Estab. 1972. Art publisher/distributor handling limited editions and open editions of offset reproductions for galleries and collectors. Clients: aviation art collectors and history buffs.

Needs Artists represented include Merv Corning, Jo Kotula, Terry Ryan, Gil Cohen, James Deitz, Nixon Galloway, John Willis, Harley Copic, Robert Taylor, Nicholas Trudgian, Keith Ferris, William Phillips, John Shaw and Robert Bailey. Publishes the work of 8 established artists. Distributes the work of 32 established artists.

⚄ AFRICANARTSDIRECT

(formerly Ghwaco International) P.O. Box 8192, Station T, Ottawa ON K1G 3H7 Canada. (613)293-1011 or (888)769-ARTS. Fax: (613)824-9334 or (888)769-5505. E-mail: info@africanartsdirect.com. Web site: www.afric anartsdirect.com. **Product Development:** Dr. Kwasi Nyarko. Estab. 1994. Art publisher and distributor. Publishes/distributes limited edition, unlimited edition, canvas transfers and offset reproduction. Clients museum shops, galleries, gift shops, frame shops, distributors, bookstores and other buyers.

Needs Seeking contemporary African artists. Considers oil, acrylic and other media. Prefers works that contribute to emerging body of works that demonstrate excellence, talent, and vision. Artists represented include Wisdom Kudowor, Dr. Ablade Glover, Benjamin Offei-Nyako, Ben Agbee, Kofi Agorsor, Mark Buku, and John Mensah. Editions created working from an existing painting. Publishes work of emerging artists. Also needs freelancers for design.

First Contact & Terms Send query letter (e-mail) with samples of work. Samples are filed. Responds only if interested. Request portfolio review in original query. Company will contact artist for portfolio review if interested. Portfolio should include final art, photographs and slides. Pays royalties of up to 30% (net). Consignment basis firm receives 50% commission or negotiates payment. Offers no advance. Negotiates rights purchased. Requires exclusive representation of artist. Provides advertising, insurance while work is at firm, promotion, shipping from our firm and written contract. Finds artists through referrals, word of mouth and art fairs.

Tips "To create good works that are always trendy, do theme-based compositions. Artists should know what they want to achieve in both the long and short term. Overall theme of artist must contribute to the global melting pot of styles."

ALEXANDRE ENTERPRISES

P.O. Box 34, Upper Marlboro MD 20773. (301)627-5170. Fax: (301)627-5106. **Artistic Director:** Walter Mussienko. Estab. 1972. Art publisher and distributor. Publishes and distributes handpulled originals, limited editions and originals. Clients: retail art galleries, collectors and corporate accounts.

Needs Seeking creative and decorative art for the serious collector and designer market. Considers oil, watercolor, acrylic, pastel, ink, mixed media, original etchings and colored pencil. Prefers landscapes, wildlife, abstraction, realism and impressionism. Artists represented include Cantin and Gantner. Editions created by collaborating with the artist. Approached by 30 artists/year. Publishes the work of 2 emerging artists/year. Distributes the work of 2-4 emerging artists/year.

First Contact & Terms Send query letter with résumé, tearsheets and photographs. Samples are filed. Responds

in 6 weeks only if interested. Call to schedule an appointment to show a portfolio or mail photographs and original pencil sketches. Payment method is negotiated consignment and/or direct purchase. Offers an advance when appropriate. Negotiates rights purchased. Provides promotion, a written contract and shipping from firm. **Tips** "Artist must be properly trained in the basic and fundamental principles of art and have knowledge of art history. Have work examined by art instructors before attempting to market your work."

ARNOLD ART STORE & GALLERY

210 Thames St., Newport RI 02840. (401)847-2273 or (800)352-2234. Fax: (401)848-0156. E-mail: info@arnoldart.com. Web site: www.arnoldart.com. **Owner:** Bill Rommel. Estab. 1870. Poster company, art publisher, distributor, gallery specializing in marine art. Publishes/distributes limited and unlimited edition, fine art prints, offset reproduction and posters.

Needs Seeking creative, fashionable, decorative art for the serious collector, commercial and designer markets. Considers oil, acrylic, watercolor, mixed media, pastel, pen & ink, sculpture. Prefers sailing images—Americas Cup or other racing images. Artists represented include Kathy Bray, Thomas Buechner and James DeWitt. Editions created by working from an existing painting. Approached by 100 artists/year. Publishes/distributes the work of 10-15 established artists/year.

First Contact & Terms Send query letter with 4-5 photographs. Samples are filed or returned by SASE. Call to arrange portfolio review. Pays flat fee, royalties or consignment. Negotiates rights purchased; rights purchased vary according to project. Provides advertising and promotion. Finds artists through word of mouth.

HERBERT ARNOT, INC.

250 W. 57th St., New York NY 10107. (212)245-8287. E-mail: arnotart@aol.com. Web site: www.arnotart.com. **President:** Peter Arnot. Vice President: Vicki Arnot. Art dealer of original oil paintings. Clients: galleries, design firms.

Needs Seeking creative and decorative art for the serious collector and designer market. Considers oil and acrylic paintings. Has wide range of themes and styles "mostly traditional/impressionistic." Artists represented include Raymond Campbell, Christian Nesvadba, Gerhard Nesvadba and Malva. Distributes the work of 250 artists/year.

First Contact & Terms Send query letter with brochure, résumé, business card, slides or photographs to be kept on file. Samples are filed or are returned by SASE. Responds in 1 month. Portfolios may be dropped off every Monday-Friday or mailed. Provides promotion.

Tips "Artist should be professional."

ART BROKERS OF COLORADO

2419 W. Colorado Ave., Colorado Springs CO 80904. (719)520-9177. Fax: (719)633-5747. Web site: www.artbrokers.com. **Contact:** Nancy Stovall. Estab. 1991. Art publisher. Publishes limited and unlimited editions, posters and offset reproductions. Clients: galleries, decorators, frame shops.

Needs Seeking decorative art by established artists for the serious collector. Prefers oil, watercolor and acrylic. Prefers western theme. Editions created by collaborating with the artist. Approached by 20-40 artists/year. Publishes the work of 1-2 established artists/year.

First Contact & Terms Send query letter with photographs. Samples are not filed and are returned by SASE. Responds in 4-6 weeks. Company will contact artist for portfolio review of final art if interested. Pays royalties. Rights purchased vary according to project. Provides insurance while work is at firm.

Tips Advises artists to attend all the trade shows and to participate as often as possible.

ART DALLAS INC.

2325 Valdina St., Dallas TX 75207. (214)688-0244. Fax: (214)688-7758. E-mail: info@artdallas.com. Web site: www.artdallas.com. **President:** Judy Martin. Estab. 1988. Art distributor, gallery, framing and display company. Distributes handpulled originals, offset reproductions. Clients: designers, architects.

Needs Seeking creative art for the commercial and designer markets. Considers mixed media. Prefers abstract, landscapes. **First Contact & Terms** Send query letter with résumé, photocopies, slides, photographs and transparencies. Samples are filed or are returned. Responds in 2 weeks. Call for appointment to show portfolio of slides and photographs. Pays flat fee $50-5,000. Offers advance when appropriate. Negotiates rights purchased.

ART IMPRESSIONS, INC.

23586 Calabasas Rd., Suite 210, Calabasas CA 91302. (818)591-0105. Fax: (818)591-0106. E-mail: info@artimpressionsinc.com. Web site: www.artimpressionsinc.com. **Contact:** Jennifer Ward. Estab. 1990. Licensing agent. Clients: major manufacturers worldwide. Current clients include Warren Industries, Springs Industries, 3M, American Greetings, Portal Publications and Mead Westvaco.

Needs Seeking art for the commercial market. Considers oil, acrylic, mixed media, pastel and photography.

Prefers proven themes like children, domestic animals, fantasy/fairies, nostalgia. No abstract, nudes or "dark" themes. Artists represented include Schim Schimmel, Valerie Tabor-Smith, Celine Dion, Josephine Wall, Karla Dornacher and Seu Ereamer. Approached by over 70 artists/year.

First Contact & Terms Send query letter with photocopies, photographs, slides, transparencies or tearsheets and SASE. Accepts disk submissions. Samples are not filed and are returned by SASE. Responds in 2 months. Company will contact artist for portfolio review if interested. Artists are paid percentage of licensing revenues generated by their work. No advance. Requires exclusive representation of artist. Provides advertising, promotion, written contract and legal services. Finds artists through attending art exhibitions, word of mouth, publications and artists' submissions.

Tips "Artists should have at least 25 images available and be able to reproduce an equal number annually. Artwork must be available on disc or transparency, and be of reproduction quality."

ART LICENSING INTERNATIONAL INC.

7350 S. Tamiami Trail, #227, Sarasota FL 34231. (941)966-8912. Fax: (941)966-8914. E-mail: artlicensing@comcast.net. Web site: www.artlicensinginc.com. **Creative Director:** Michael Woodward. Estab. 1986. Licensing agency, which "represents artists who wish to establish a licensing program for their work."

- See listings in Greeting Cards, Gifts & Products and Artists' Rep sections of this book. This company licenses images internationally for a range of products including posters and prints, greeting cards, calendars, toys, etc.

First Contact & Terms Send a CD and photocopies or e-mail JPEGs or a link to your Web site. Send SASE for return of material. Commission rate is 50%.

Tips "Prints and posters should be in pairs or sets of 4 or more with regard for trends and color palettes related to the home decor market."

ART SOURCE

210 Cochrane, Suite 3, Markham ON L3R 8E6 Canada. (905)475-8181. Fax: (905)479-4966. E-mail: lou@artsource.ca. Web site: www.artsource.com. **President:** Lou Fenninger. Estab. 1979. Poster company and distributor. Publishes/distributes handpulled originals, limited editions, unlimited edition, canvas transfers, fine art prints, monoprints, monotypes, offset reproduction and posters. Clients galleries, decorators, frame shops, distributors, corporate curators, museum shops and giftshops.

Needs Seeking creative, fashionable and decorative art for the designer market. Considers oil, acrylic, watercolor, mixed media, pastel and pen & ink. Editions created by collaborating with the artist and by working from an existing painting. Approached by 50 artists/year. Publishes work of 5 emerging, 5 mid-career and 10 established artists/year. Distributes the work of 5 emerging, 5 mid-career and 10 established artists/year.

First Contact & Terms Send query letter with brochure, photocopies, photographs, photostats, résumé, SASE, slides, tearsheets and transparencies. Accepts low resolution submissions via e-mail. Please keep e-mail submissions to a maximum of 10 images. Responds in 2 weeks. Portfolios may be dropped off every Monday and Tuesday. Artist should follow-up with letter after initial query. Company will contact artist for portfolio review if interested. Portfolio should include color photographs, photostats, roughs, slides, tearsheets, thumbnails and transparencies. Pays royalties of 6-12%, flat fee is optional. Payment is negotiable. Offers advance when appropriate. Negotiates rights purchased. Rights purchased vary according to project. Sometimes requires exclusive representation of artist. Provide advertising, promotion and written contract.

ARTBEATS, INC.

129 Glover Ave., Norwalk CT 06850-1311. (800)677-6947. Fax: (203)846-2105. Web site: www.nygs.com. Estab. 2002. Art publisher. Publishes and distributes open edition posters and matted prints. Clients: retailers of fine wall decor. Current clients include Prints Plus, Hobby Lobby, and others. Member of New York Graphic Society Publishing Group.

Needs Seeking creative, fashionable and decorative art for the home design market. Art guidelines free for SASE with first-class postage. Artwork should be current, appropriate for home decor, professional and polished. Publishes approx. 400 new works each year.

First Contact & Terms Send query letter with résumé, color-correct photographs, transparencies or lasers. Samples are not filed and are returned by SASE if requested by artist. Responds in 3 months. Publisher will contact artist for portfolio review if interested. DO NOT SEND ORIGINALS, AND DO NOT CALL. Terms negotiated at time of contact. Provides written contract. Finds artists through art shows, licensing agents, exhibits, word of mouth and submissions.

ARTEFFECT DESIGNS & LICENSING

P.O. Box 370, 5800 AJ Venray, Netherlands. +31 627 421 344. **Manager:** William F. Cupp. Product development, art licensing and representation of European publishers.

Needs Seeking creative, decorative art for the commercial and designer markets. Considers oil, acrylic, mixed media. Interested in all types of design. Artists represented include Nathalie Boucher, James Demmick, M. Harris, Frans Nauts, Renee, Nancey Flores, Reint Withaar. Editions created by working from an existing painting.

First Contact & Terms Send brochure, photographs, slides. Responds only if interested. Company will contact artist for portfolio review of transparencies if interested. Pays flat fee or royalties. No advance. Rights purchased vary according to project. Provides advertising and representation at international trade shows.

ARTS UNIQ' INC.

1710 S. Jefferson Ave., P.O. Box 3085, Cookeville TN 38502. (800)833-0317. Fax: (931)528-8904. E-mail: LeeL@artsuniq.com. Web site: www.artsuniq.com. **Contact:** Lee Lindsey, sales director and licensing. 1985. Art publisher. Publishes limited and open editions. Licenses a variety of artwork for cards, throws, figurines, etc. Clients: art galleries, gift shops, furniture stores and department stores.

Needs Seeking creative and decorative art for the designer market. Considers all media. Artists represented include Jamie Carter, Lisa White, Judy Gibson and Carolyn Wright. Editions created by collaborating with the artist or by working from an existing painting.

First Contact & Terms Send query letter with slides or photographs. Samples are filed or are returned by request. Responds in 2 months. Pays royalties monthly. Requires exclusive representation rights. Provides promotion and shipping from firm.

ARTSOURCE INTERNATIONAL INC.

1081 E. Santa Anita Ave., Burbank CA 91501. (818)558-5200. Fax: (818)657-1414. E-mail: artsource_online@yahoo.com. Web site: www.artsource-online.com. **Contact:** Ripsime Marashian, managing editor. Estab. 1997. Art publisher of fine art and business management consultations. Handles fine art prints, unlimited edition, limited edition and posters. Clients: decorators, frame shops, distributors and galleries. Current clients include: art galleries, dealers, distributors, furniture stores and interior designers.

Needs Seeking decorative art for the commercial market and any art of exceptional quality. Considers acrylic, pastel and mixed media. "We prefer artwork with creative expression—figurative, landscapes, still lifes." Artists represented include Ruben Abovian, Carols and Alexander Sadoyan. Editions created by working from an existing painting. Approached by 20 artists/year. Works with 1-2 emerging artists/year.

First Contact & Terms Send query letter, brochure, SASE, photographs, tearsheets and résumé. Accepts e-mail submissions. Prefers JPEG. Samples are not filed. Samples returned by SASE. Responds only if interested. Company will contact artist for portfolio review if interested. Pays artists royalties of 10-15%. Negotiates payment. Our standard commission is 50% less 50% off retail. Offers advance when appropriate. Negotiates rights purchased according to project. Requires exclusive representation of artist. Provides advertising, written contract, promotion and exhibitions. Finds artists through submissions, art exhibits/fairs.

Tips "Provide a body of work along a certain theme to show a fully developed style that can be built upon. We offer services to artists who are serious about their career, individuals who want to become professional artist representatives, galleries and dealers who want to target new artists. For guidelines, go to Web site."

ARTVISIONS

Licensing agency. E-mail: see Web site. Web site: www.artvisions.com. Estab. 1993. "Not currently seeking new talent. However, we are always willing to view the work of top-notch established artists. For details and contact information, please see our listing in theh Artists' Reps section."

⬛ ASHLAND ART

1005 Highland Ave., Ashland KY 41102. Phone/fax: (606)325-1816. **Contact:** Bob Coffey, owner. Estab. 1974. Art publisher, distributor. Publishes/distributes hand-pulled originals, monoprints, monotypes, original art. Clients: art consultants, corporate curators, decorators, distributors, frame shops, galleries.

Needs Seeking decorative art for the commercial and designer markets. Considers acrylic, mixed media, oil, watercolor, serography, etchings. Editions created by collaborating with the artist and working with the needs of the customer. Approached by over 25 artists/year. Publishes work of 6-8 emerging artists/year. Distributes the work of over 60 emerging artists/year.

First Contact & Terms Send photographs, slides and transparencies. Samples are not filed but are returned. Responds in 2 weeks. Portfolios not required. Request portfolio review in original query. Company will contact artist for portfolio review if interested. Portfolio should include color art, in whatever presentation is easiest for artist. Pays on consignment basis. Firm receives variable commission. No advance. Rights purchased vary according to project. Requires regional exclusive representation of artist. Provides insurance while work is at firm, shipping from our firm, all sales expenses. Finds artists through artist's submissions, referrals.

AURA EDITIONS

4943 McConnell Ave., Suite J, Los Angeles CA 90066. (310)305-3900. Fax: (310)305-3960. **Art Director:** Curtis Moore. Estab. 2004. Art publisher, poster company and distributor. Publishes/distributes limited edition, unlimited edition and posters. Clients: frame shops, distributors, galleries, retail chain stores, O.E.M. framers.

Needs Seeking creative, fashionable and decorative art for the commercial and designer markets. Considers acrylic, pastel, watercolor, mixed media, photography and oil. Artists represented include Allayn Stevens, Inka Zlin and Peter Colvin. Editions created by collaborating with the artist or by working from an existing painting. Approached by 100 artists/year. Publishes work of 30 emerging, 15 mid-career and 10 established artists/year. Distributes the work of 5 emerging, 3 mid-career and 2 established artists/year.

First Contact & Terms Send query letter with brochure, photocopies, photographs and tearsheets. Samples are filed and are not returned. Responds in 6 months only if interested. Company will contact artist for portfolio review if interested. Portfolio should include photographs, slides and tearsheets. Royalties of 10%. Offers advance when appropriate. Negotiates rights purchased. Finds artists through sourcebooks, art fairs and word of mouth.

Tips "Follow catalog companies—colors/motifs."

BANKS FINE ART

1231 Dragon St., Dallas TX 75207. (214)352-1811. Fax: (214)352-6360. E-mail: mb@banksfineart.com. Web site: www.banksfineart.com. **Owner:** Bob Banks. Estab. 1980. Distributor, gallery of original oil paintings. Clients: galleries, decorators.

Needs Seeking decorative, traditional and impressionistic art for the serious collector and the commercial market. Considers oil, acrylic. Prefers traditional and impressionistic styles. Artists represented include Joe Sambataro, Jan Bain and Marcia Banks. Approached by 100 artists/year. Publishes/distributes the work of 2 emerging artists/year.

First Contact & Terms Send photographs. Samples are returned by SASE. Responds in 1 week. Offers advance. Rights purchased vary according to project. Provides advertising, in-transit insurance, insurance while work is at firm, promotion, shipping from firm, written contract.

Tips Needs Paris and Italy street scenes. Advises artists entering the poster and print fields to attend Art Expo, the industry's largest trade event, held in New York City every spring. Also recommends reading *Art Business News*.

BENJAMANS ART GALLERY

419 Elmwood Ave., Buffalo NY 14222. (716)886-0898. Fax: (716)886-0546. E-mail: eileen2134@aol.com. Web site: www.benartgallery.com. Licensing: Barry Johnson. Estab. 1970. Art publisher, distributor, gallery, frame shop and appraiser. Publishes and distributes handpulled originals, limited and unlimited editions, posters, offset reproductions and sculpture. Clients include P&B International.

Needs Seeking decorative art for the serious collector. Considers oil, watercolor, acrylic and sculpture. Prefers art deco and florals. Artists represented include Peter Max, Robert Blair, Joan Miro, Charles Birchfield, J.C. Litz, Jason Barr and Eric Dates. Editions created by collaborating with the artist. Approached by 20-30 artists/year. Publishes and distributes the work of 4 emerging, 2 mid-career and 1 established artists/year.

First Contact & Terms Send query letter with SASE, slides, photocopies, résumé, transparencies, tearsheets and/or photographs. Samples are filed or returned. Responds in 2 weeks. Company will contact artist for portfolio review if interested. Pays on consignment basis. Firm receives 30-50% commission. Offers advance when appropriate. Rights purchased vary according to project. Does not require exclusive representation of artist. Provides advertising, promotion, shipping to and from firm, written contract and insurance while work is at firm.

Tips "Keep trying to join a group of artists and try to develop a unique style."

BENTLEY PUBLISHING GROUP

1410 Lesnick Lane, Suite J, Walnut Creek CA 94597. (925)935-3186. Fax: (925)935-0213. E-mail: alp@bentleypublishinggroup.com. Web site: www.bentleypublishinggroup.com. **Product Development Coordinator:** Donovan Weaton. Estab. 1986. Art publisher of open and limited editions of offset reproductions and canvas replicas; also agency for licensing of artists' images worldwide. Licenses florals, teddy bear, landscapes, wildlife and Christmas images to appear on puzzles, tapestry products, doormats, stitchery kits, giftbags, greeting cards, mugs, tiles, wall coverings, resin and porcelain figurines, waterglobes and various other gift items. Clients: framers, galleries, distributors and framed picture manufacturers.

Needs Seeking decorative fine art for the designer, residential and commercial markets. Considers oil, watercolor, acrylic, pastel, mixed media and photography. Artists represented include Sherry Strickland, Lisa Chesaux and Andre Renoux. Editions created by collaborating with the artist or by working from an existing painting. Approached by 1,000 artists/year.

First Contact & Terms Submit JPEG images via e-mail or send query letter with brochure showing art style or résumé, advertisements, slides and photographs. Samples are filed or are returned by SASE if requested by artist. Responds in 6 weeks. Pays royalties of 10% net sales for prints monthly plus 50 artist proofs of each edition. Pays 40% monies received from licensing. Obtains all reproduction rights. Usually requires exclusive representation of artist. Provides national trade magazine promotion, a written contract, worldwide agent representation, 5 annual trade show presentations, insurance while work is at firm and shipping from firm.

Tips "Feel free to call and request guidelines. Bentley House is looking for experienced artists with images of universal appeal."

BERGQUIST IMPORTS INC.

1412 Hwy. 33 S., Cloquet MN 55720. (218)879-3343. Fax: (218)879-0010. E-mail: bbergqu106@aol.com. **President:** Barry Bergquist. Estab. 1948. Distributor. Distributes unlimited editions. Clients: gift shops.

Needs Seeking creative and decorative art for the commercial market. Considers oil, watercolor, mixed media and acrylic. Prefers Scandinavian or European styles. Artists represented include Jacky Briggs, Dona Douma and Suzanne Toftey. Editions created by collaborating with the artist or by working from an existing painting. Approached by 20 artists/year. Publishes the work of 2-3 emerging, 2-3 mid-career and 2 established artists/year. Distributes the work of 2-3 emerging, 2-3 mid-career and 2 established artists/year.

First Contact & Terms Send brochure, résumé and tearsheets. Samples are not filed and are returned. Responds in 2 months. Artist should follow up. Portfolio should include color thumbnails, final art, photostats, tearsheets and photographs. Pays flat fee $50-300, royalties of 5%. Offers advance when appropriate. Negotiates rights purchased. Provides advertising, promotion, shipping from firm and written contract. Finds artists through art fairs. Do not send art attached to e-mail. Will not download from unknown sources.

Tips Suggests artists read *Giftware News Magazine*.

BERKSHIRE ORIGINALS

2 Prospect Hill, Stockbridge MA 01263. (413)298-3691. Fax: (413)298-1293. E-mail: cparise@marian.org. Web site: www.marian.org. **Manager of Print Production:** Charlie Parise. Estab. 1991. Art publisher and distributor of offset reproductions and greeting cards.

Needs Seeking creative art for the commercial market. Considers oil, watercolor, acrylic, pastel and pen & ink. Prefers religious themes, but also considers florals, holiday and nature scenes, line art and border art.

First Contact & Terms Send query letter with brochure showing art style or other art samples. Samples are filed or are returned by SASE if requested by artist. Responds in 1 month. Write for appointment to show portfolio of slides, color tearsheets, transparencies, original/final art and photographs. Pays flat fee; $100-1,000. Buys all rights.

Tips "Good draftsmanship is a must, particularly with figures and faces. Colors must be harmonious and clearly executed."

BERNARD FINE ART

P.O. Box 1528, Manchester Center VT 05255. (802)362-0373. Fax: (802)362-1082. E-mail: Michael@applejackart .com. Web site: www.applejackart.com. **Managing Director:** Michael Katz. Art publisher. Publishes open edition prints and posters. Clients: picture frame manufacturers, distributors, manufacturers, galleries and frame shops. This company is a division of Applejack Art Partners, along with the high-end poster lines Hope Street Editions and Rose Selavy of Vermont. Applejack Licensing International, another division of Applejack Art Partners is an internationally known art licensing company.

Needs Seeking creative, fashionable, and decorative art and photography (b&w as well as color) for commercial and designer markets. Considers all media, including oil, watercolor, acrylic, pastel, mixed media and printmaking (all forms). Art guidelines free for SASE with first-class postage. Editions created by collaborating with the artist or by working from an existing painting. Some of the artists and photographers represented include Lisa Audit, Erin Dertner, Kevin Daniel, Valerie Wenk, Bill Bell, Harold Silverman, John Zaccheo, and Michael Harrison. Approached by hundreds of artists/year. Publishes the work of 8-10 emerging, 10-15 mid-career and 100-200 established artists.

First Contact and Terms Send query letter with brochure showing art style and/or résumé, tearsheets, photostats, photocopies, slides, photographs or transparencies, or e-mail with JPEGs. Samples are returned by SASE. Responds only if interested. Call or write for appointment to show portfolio of thumbnails, roughs, original/final art, b&w and color photostats, tearsheets, photographs, slides and transparencies. Pays royalty. Offers an advance when appropriate. Buys all rights. Usually requires exclusive representation of artist. Provides in-transit insurance, insurance while work is at firm, promotion, shipping from firm and a written contract. Finds artists through submissions, sourcebooks, agents, art shows, galleries and word of mouth.

Tips "We look for subjects with a universal appeal. Some subjects that would be appropriate are florals, still lifes,

wildlife, religious themes and landscapes and contemporary images/abstracts. Please send enough examples of your work so we can see a true representation of style and technique.''

TOM BINDER FINE ARTS

825 Wilshire Blvd., #708, Santa Monica CA 90401. (800)332-4278. Fax: (800)870-3770. E-mail: info@artman.n et. Web site: www.artman.net and www.alexanderchen.com. **Owner:** Tom Binder. Wholesaler of handpulled originals, limited editions and fine art prints. Clients: galleries and collectors.

Needs Seeking art for the commercial market. Considers acrylic, mixed media, giclee and pop art. Artists represented include Alexander Chen, Ken Shotwell and Elaine Binder. Editions created by working from an existing painting.

First Contact & Terms Send brochure, photographs, photostats, slides, transparencies and tearsheets. Accepts disk submissions if compatible with Illustrator 5.0. Samples are not filed and are returned by SASE. Does not reply; artist should contact. Offers advance when appropriate. Rights purchased vary according to project. Provides shipping. Finds artists through New York Art Expo and World Wide Web.

THE BLACKMAR COLLECTION

P.O. Box 537, Chester CT 06412. Phone/fax: (860)526-9303. Web site: www.theblackmarcollection.com. E-mail: carser@mindspring.com. Estab. 1992. Art publisher. Publishes offset reproduction and giclée prints. Clients: individual buyers.

Needs ''We are not actively recruiting at this time.'' Artists represented include DeLos Blackmar, Blair Hammond, Gladys Bates and Keith Murphey. Editions created by working from an existing painting. Approached by 24 artists/year. Publishes the work of 3 established artists/year. Provides advertising, in-transit insurance, insurance while work is at firm. Finds artists through personal contact. All sales have a buy back guarantee.

BON ART & ARTIQUE

Divisions of Art Resources International Ltd., 281 Fields Lane, Brewster NY 10509. (845)277-8888 or (800)228-2989. Fax: (845)277-8602. E-mail: sales@fineartpublishers.com. Web site: www.fineartpublishers.com. **Vice President:** Robin E. Bonnist. Estab. 1980. Art publisher. Publishes unlimited edition offset lithographs and posters. Does not distribute previously published work. Clients galleries, department stores, distributors, framers worldwide.

Needs Seeking creative and decorative art for the inernational fine art reproduction market. Considers oil, acrylic, giclée, watercolor and mixed media. Art guidelines free for SASE with first-class postage. Artists represented include Julia Hawkins, Claire Beaumont, Guido Borelli, Martin Wiscombe, Mid Gordon, Tina Chaden, Nicky Boehme, Jennifer Wiley, Claudine Hellmuth, Diane Knott, Joseph Kiley, Brenda Walton, Gretchen Shannon, Craig Biggs. Editions created by collaborating with the artist. Approached by hundreds of artists/year. Publishes the work of 15 emerging, 10 mid-career and 10 established artists/year.

First Contact & Terms E-mail or send query letter with photocopies, photographs, tearsheets, digital files on CD and photographs to be kept on file. Samples returned by SASE only if requested. Portfolio review not required. Prefers digital files on CD initially as samples, then reviews originals. Responds in 2 months. Appointments arranged only after work has been sent with SASE. Negotiates payment. Offers advance in some cases. Requires exclusive representation for prints/posters during period of contract. Provides advertising, in-transit insurance, insurance while work is at publisher, shipping from firm, promotion and a written contract. Artist owns original work. Finds artists through art and trade shows, magazines and submissions.

Tips ''Please submit decorative, fine quality artwork. We prefer to work with artists who are creative, professional and open to art direction.''

BRINTON LAKE EDITIONS

Box 888, Brinton Lake Rd., Concordville PA 19331-0888. (610)459-5252. Fax: (610)459-2180. E-mail: galleryone @mindspring.com. **President:** Lannette Badel. Estab. 1991. Art publisher, distributor, gallery. Publishes/distributes limited editions and canvas transfers. Clients: independent galleries and frame shops. Current clients include over 100 galleries, mostly East Coast.

Needs Seeking fashionable art. Considers oil, acrylic, watercolor, mixed media and pastel. Prefers realistic landscape and florals. Artists represented include Gary Armstrong and Lani Badel. Editions created by collaborating with the artist. Approached by 20 artists/year. Publishes/distributes the work of 1 emerging and 1 established artist/year.

First Contact & Terms Send query letter with samples. Samples are not filed and are returned. Responds in 2 months. Company will contact artist for portfolio review of final art, photographs, slides, tearsheets and transparencies if interested. Negotiates payment. Rights purchased vary according to project. Requires exclusive representation of artist.

Tips ''Artists submitting must have good drawing skills no matter what medium used.''

JOE BUCKALEW

1825 Annwicks Dr., Marietta GA 30062. (800)971-9530. Fax: (770)971-6582. E-mail: joesart@bellsouth.com. Web site: www.joebuckalew.com. **Contact:** Joe Buckalew. Estab. 1990. Distributor and publisher. Distributes limited editions, canvas transfers, fine art prints and posters. Clients: 600-800 frame shops and galleries.

Needs Seeking creative, fashionable, decorative art for the serious collector. Considers oil, acrylic and watercolor. Prefers florals, landscapes, Civil War and sports. Artists represented include B. Sumrall, R.C. Davis, F. Buckley, M. Ganeck, D. Finley, Dana Coleman, Jim Booth, Sandra Roper, Jill Strickland, Cherrie Nute and Steven Gunter. Approached by 25-30 artists/year. Distributes work of 10 emerging, 10 mid-career and 50 established artists/year. Art guidelines free for SASE with first-class postage.

First Contact & Terms Send sample prints. Accepts disk submissions. "Please call. Currently using a 460 commercial computer." Samples are filed or are returned. Does not reply. Artist should call. To show portfolio, artist should follow up with call after initial query. Portfolio should include sample prints. Pays on consignment basis. Firm receives 50% commission paid net 30 days. Provides advertising on Web site, shipping from firm and company catalog. Finds artists through ABC shows, regional art & craft shows, frame shops, other artists.

Tips "Paint your own style."

☑ CANADIAN ART PRINTS INC.

110-6311 Westminster Hwy., Richmond BC V7C 4V4 Canada. (800)663-1166 or (604)276-4551. Fax: (604)276-4552. E-mail: sales@canadianartprints.com. Web site: www.canadianartprints.com. **Creative Director:** Niki Krieger. Estab. 1965. Art publisher/distributor. Publishes or distributes unlimited edition, fine art prints, posters and art cards. Clients: galleries, decorators, frame shops, distributors, corporate curators, museum shops, giftshops and manufacturing framers. Licenses all subjects of open editions for wallpaper, writing paper, placemats, books, etc.

Needs Seeking fashionable and decorative art for the commercial and designer markets. Considers oil, acrylic, watercolor, mixed media, pastel. Prefers representational florals, landscapes, marine, decorative and street scenes. Artists represented include Linda Thompson, Jae Dougall, Philip Craig, Joyce Kamikura, Kiff Holland, Victor Santos, Dubravko Raos, Don Li-Leger, Michael O'Toole and Will Rafuse. Editions created by collaborating with the artist and working from an existing painting. Approached by 300-400 artists/year. Publishes/distributes the work of more than 150 artists/year.

First Contact & Terms Send query letter with photographs, SASE, slides, tearsheets, transparencies. Samples are not filed and are returned by SASE. Responds in 1 month. Will contact artist for portfolio review of photographs, slides or transparencies if interested. Pays range of royalties. Buys reprint rights or negotiates rights purchased. Provides advertising, in-transit insurance, insurance while work is at firm, promotion, shipping and contract. Finds artists through art exhibitions, art fairs, word of mouth, art reps, submissions.

Tips "Keep up with trends by following decorating magazines."

CARMEL FINE ART PRODUCTIONS, LTD.

3489 N. Shepard Ave., Milwaukee WI 53211. (414)967-4994. Fax (414)967-4995. E-mail: carmelfineart@sbcglobal.net. Web site: www.carmelprod.com. **Vice President Sales:** Louise Perrin. Estab. 1995. Art publisher/distributor. Publishes/distributes originals, limited and open edition fine art prints. Clients: galleries, corporate curators, distributors, frame shops, decorators.

Needs Seeking creative art for the serious collector, commercial and designer markets. Considers oil, acrylic, pastel. Prefers family-friendly abstract and figurative images. Artists represented include William Calhoun, Jon Jones, Okay Babs, G.L. Smothers, Anthony Armstrong, Woodrow Nash, Ted Ellis and Hector Anchundia. Editions created by collaborating with the artist and working from an existing painting. Approached by 10-20 artists/year. Publishes the work of 2-3 emerging, 1 mid-career and 2-3 established artists/year.

First Contact & Terms Send query letter with brochure, photographs. Samples are filed. Responds in 1 month. Will contact artist for portfolio review of final art, roughs if interested. Rights purchased vary according to project. Provides advertising, promotion, shipping from firm and contract. Finds artists through established networks.

Tips "Be true to your creative callings and keep the faith."

CARPENTREE, INC.

2724 N. Sheridan, Tulsa OK 74115. (918)582-3600. Fax: (918)587-4329. Web site: www.carpentree.com. **Contact:** Marj Miller, product development. Estab. 1976. Wholesale framed art manufacturer. Clients: decorators, frame shops, galleries, gift shops and museum shops.

Needs Seeking decorative art for the commercial market. Considers acrylic, mixed media, oil, pastel, pen & ink, sculpture, watercolor and photography. Prefers traditional, family-oriented, Biblical themes, landscapes. Editions created by collaborating with the artist and by working from an existing painting. Approached by 50 artists/year.

First Contact & Terms Send photographs, SASE and tearsheets. Accepts e-mail submissions with link to Web site and image file. Prefers Windows-compatible, JPEG files. Samples are not filed, returned by SASE. Responds in 2 months. Portfolio not required. Negotiates payment. No advance. Negotiates rights purchased. Requires exclusive regional representation of artist. Provides advertising, promotion and written contract. Finds artists through art exhibits/fairs and artist's submissions.

CHALK & VERMILION FINE ARTS

55 Old Post Rd., #2, Greenwich CT 06830. (203)869-9500. Fax: (203)869-9520. E-mail: mail@chalk-vermilion.com. Web site: www.chalk-vermilion.com. **Contact:** Artist Submission Department. Estab. 1976. Art publisher. Publishes original paintings, handpulled serigraphs and lithographs, posters, limited editions and offset reproductions. Clients: 4,000 galleries worldwide.

Needs Publishes decorative art for the serious collector and the commercial market. Considers oil, mixed media, acrylic and sculpture. Artists represented include Kerry Hallam, Philippe Bertho, Liudmila Kondakova, and Fanny Brennan. Editions created by collaboration. Approached by 350 artists/year.

First Contact & Terms Send query letter with résumé and/or biography, contact information and slides or photographs. Samples are filed or are returned by SASE if requested by artist. Responds in 3 months. Publisher will contact artist for portfolio review if interested. Payment "varies with artist, generally fees and royalties." Prefers exclusive representation of artist. Provides advertising, in-transit insurance, promotion, shipping to and from firm, insurance while work is at firm and written contract. Finds artists through exhibitions, trade publications, catalogs, submissions.

CIRRUS EDITIONS LTD.

542 S. Alameda St., Los Angeles CA 90013. (213)680-3473. Fax: (213)680-0930. E-mail: cirrus@cirrusgallery.com. Web site: www.cirrusgallery.com. **Owner:** Jean R. Milant. Produces limited edition handpulled originals. Clients: museums, galleries and private collectors.

Needs Seeking fine art for the serious collector and museums. Prefers abstract, conceptual work. Artists represented include Lari Pittman, Joan Nelson, John Millei, Jason Meadows, Edward Ruscha, and Bruce Nauman. Publishes and distributes the work of 6 emerging, 2 mid-career and 1 established artists/year.

First Contact & Terms Prefers CD or low resolution Jpegs. Samples are returned by SASE. No illustrators, graphic designers or commercial art submissions.

CLASSIC COLLECTIONS FINE ART

1 Bridge St., Irvington NY 10533. (914)591-4500. Fax: (914)591-4828. **Acquisition Manager:** Larry Tolchin. Estab. 1990. Art publisher. Publishes unlimited editions and offset reproductions. Clients: galleries, interior designers, hotels. Licenses florals, landscapes, animals for kitchen/bathroom.

Needs Seeking decorative art for the commercial and designer markets. Considers oil, acrylic, watercolor, mixed media and pastel. Prefers landscapes, still lifes, florals. Artists represented include Harrison Rucker, Henrietta Milan, Sid Willis, Charles Zhan and Henry Peeters. Editions created by collaborating with the artist and by working with existing painting. Approached by 100 artists/year. Publishes the work of 6 emerging, 6 mid-career and 6 established artists/year.

First Contact & Terms Send slides and transparencies. Samples are filed. Responds in 3 months. Company will contact artist for portfolio review if interested. Offers advance when appropriate. Buys first and reprint rights. Provides advertising; insurance while work is at firm; and written contract. Finds artists through art exhibitions, fairs and competitions.

◖ CLEARWATER PUBLISHING

161 MacEwan Ridge Circle NW, Calgary AB T3K 3W3 Canada. (403)295-8885. Fax: (403)295-8981. E-mail: clearwaterpublishing@shaw.ca. Web site: www.clearwater-publishing.com. **Contact:** Laura Skorodenski. Estab. 1989. Art publisher. Handles giclées, canvas transfers, fine art prints and offset reproduction. Clients: decorators, frame shops, gift shops, galleries and museum shops.

Needs Seeking artwork for the serious collector and commercial market. Considers acrylic, watercolor, mixed media and oil. Prefers largely high realism or impressionistic works. Artists represented can be seen on Web site.

First Contact & Terms Accepts e-mail submissions with link to Web site and image file. Windows-compatible. Prefers JPEG. Samples are not filed. Samples not returned. Responds only if interested. Company will contact artist for portfolio review if interested. Portfolios should include slides. No advance. Requires exclusive representation of artist.

THE COLONIAL ART CO.

1336 NW First St., Oklahoma City OK 73106. (405)232-5233. Fax: (405)232-6607. E-mail: info@colonialart.com. **Owner:** Willard Johnson. Estab. 1919. Publisher and distributor of offset reproductions for galleries. Clients: retail and wholesale. Current clients include Osburns, Grayhorse and Burlington.

Needs Artists represented include Felix Cole, Dennis Martin, John Walch and Leonard McMurry. Publishes the work of 2-3 emerging, 2-3 mid-career and 3-4 established artists/year. Distributes the work of 10-20 emerging, 30-40 mid-career and hundreds of established artists/year. Prefers realism and expressionism—emotional work.

First Contact & Terms Send sample prints. Samples not filed are returned only if requested by artist. Publisher/ distributor will contact artist for portfolio review if interested. Pays negotiated flat fee or royalties or on a consignment basis (firm receives 33% commission). Offers an advance when appropriate. Does not require exclusive representation of the artist. Considers buying second rights (reprint rights) to previously published work.

Tips "The current trend in art publishing is an emphasis on quality."

COLOR CIRCLE ART PUBLISHING, INC.

P.O. Box 190763, Boston MA 02119. (617)437-1260. Fax (617)437-9217. E-mail: color.circle@verizon.com. Web site: www.colorcircle.com. **Contact:** Bernice Robinson. Estab. 1991. Art publisher. Publishes limited editions, unlimited editions, fine art prints, offset reproductions, posters. Clients: galleries, art dealers, distributors, museum shops. Current clients include Deck the Walls, Things Graphics, Essence Art.

Needs Seeking creative, decorative art for the serious collector and the commercial market. Considers oil, acrylic, watercolor, mixed media, pastel, pen & ink. Prefers ethnic themes. Artists represented include Paul Goodnight. Editions created by collaborating with the artist or by working from an existing painting. Approached by 12-15 artists/year. Publishes the work of 2 emerging, 1 mid-career artists/year. Distributes the work of 4 emerging, 1 mid-career artists/year.

First Contact & Terms Send query letter with slides. Samples are filed or returned by SASE. Responds in 2 months. Negotiates payment. Rights purchased vary according to project. Provides advertising, insurance while work is at firm, promotion, shipping from our firm and written contract. Finds artists through submissions, trade shows and word of mouth.

Tips "We like to present at least two pieces by a new artist that are similar in theme, treatment or colors."

CRAZY HORSE PRINTS

23026 N. Main St., Prairie View IL 60069. (847)634-0963. **Owner:** Margaret Becker. Estab. 1976. Art publisher and gallery. Publishes limited editions, offset reproductions and greeting cards. Clients: Native American art collectors.

Needs "We publish only Indian-authored subjects." Considers oil, pen & ink and acrylic. Prefers nature themes. Editions created by working from an existing painting. Approached by 10 artists/year. Publishes the work of 2 and distributes the work of 20 established artists/year.

First Contact & Terms Send résumé and photographs. Samples are filed. Responds only if interested. Publisher will contact artist for portfolio review if interested. Portfolio should include photographs and bio. Pays flat fee $250-1,500 or royalties of 5%. Offers advance when appropriate. Buys all rights. Provides promotion and written contract. Finds artists through art shows and submissions.

CREATIF LICENSING CORP.

31 Old Town Crossing, Mt. Kisco NY 10549-4030. (914)241-6211. E-mail: info@creatifusa.com. Web site: www. creatifusa.com. **Contact:** Marcie Silverman. Estab. 1975. Art licensing agency. Clients: manufacturers of gifts, stationery, toys and home furnishings.

● Creatif posts submission guidelines on its Web page creatifusa.com/about_creatif/Creatif_Submission_Guide1.html.

DARE TO MOVE

1117 Broadway, Suite 301, Tacoma WA 98402. (253)284-0975. Fax: (253)284-0977. E-mail: daretomove@aol.com. Web site: www.daretomove.com. **President:** Steve W. Sherman. Estab. 1987. Art publisher, distributor. Publishes/distributes limited editions, unlimited editions, canvas transfers, fine art prints, offset reproductions. Licenses aviation and marine art for puzzles, note cards, book marks, coasters etc. Clients: art galleries, aviation museums, frame shops and interior decorators.

● This company has expanded from aviation-related artwork to work encompassing most civil service areas. Steve Sherman likes to work with artists who have been painting for 10-20 years. He usually starts off distributing self-published prints. If prints sell well, he will work with artist to publish new editions.

Needs Seeking naval, marine, firefighter, civil service and aviation-related art for the serious collector and commercial market. Considers oil and acrylic. Artists represented include John Young, Ross Buckland, Mike

Machat, James Dietz, Jack Fellows, William Ryan, Patrick Haskett. Editions created by collaborating with the artist or working from an existing painting. Approached by 15-20 artists/year. Publishes the work of 1 emerging, 2-3 mid-career and established artists/year. Distributes the work of 9 emerging and 2-3 established artists/year.
First Contact & Terms Send query letter with photographs, slides, tearsheets and transparencies. Samples are filed or sometimes returned by SASE. Artist should follow up with call. Portfolio should include color photographs, transparencies and final art. Pays royalties of 10% commission of wholesale price on limited editions and 5% commission of wholesale price on unlimited editions. Buys one-time or reprint rights. Provides advertising, in-transit insurance, insurance while work is at firm, promotion, shipping from firm and written contract.
Tips ''Present your best work—professionally.''

DELJOU ART GROUP, INC.
1616 Huber St., Atlanta GA 30318. (404)350-7190. Fax: (404)350-7195. E-mail: submit@deljouartgroup.com. **Contact:** Art Director. Estab. 1980. Art publisher, distributor and gallery of limited editions (maximum 250 prints), handpulled originals, monoprints/monotypes, sculpture, fine art photography, fine art prints and paintings on paper and canvas. Clients: galleries, designers, corporate buyers and architects. Current clients include Coca Cola, Xerox, Exxon, Marriott Hotels, General Electric, Charter Hospitals, AT&T and more than 3,000 galleries worldwide, ''forming a strong network throughout the world.''
Needs Seeking creative, fine and decorative art for the designer market and serious collectors. Considers oil, acrylic, pastel, sculpture and mixed media. Artists represented include Yunessi, T.L. Lange, Michael Emani, Vincent George, Nela Soloman, Alterra, Ivan Reyes, Mindeli, Sanford Wakeman, Niri Vessali, Lee White, Alexa Kelemen, Bika, Kamy, Craig Alan, Roya Azim, Jian Chang, Elya DeChino, Antonio Dojer and Mia Stone. Editions created by collaborating with the artist. Approached by 300 artists/year. Publishes the work of 10 emerging, 20 mid-career artists/year and 20 established artists/year.
First Contact & Terms Send query letter with photographs, slides, brochure, photocopies, tearsheets, SASE and transparencies. Prefers contact and samples via e-mail submit@deljouartgroup.com. Samples not filed are returned only by SASE. Responds in 6 months. Will contact artist for portfolio review if interested. Payment method is negotiated. Offers an advance when appropriate. Negotiates rights purchased. Requires exclusive representation. Provides promotion, a written contract and advertising. Finds artists through visiting galleries, art fairs, word of mouth, World Wide Web, art reps, submissions, art competitions and sourcebooks. Pays highest royalties in the industry.
Tips ''We need landscape artists, 3-D wall art (any media), strong figurative artists, sophisticated abstracts and soft-edge abstracts. We are also beginning to publish sculptures and are interested in seeing slides of such. We have had a record year in sales and have recently relocated again into a brand new gallery, framing and studio complex. We also have the largest gallery in the country. We have added a poster division and need images in different categories for our poster catalogue as well.''

DIRECTIONAL PUBLISHING, INC.
2812 Commerce Square E., Birmingham AL 35210. (205)951-1965. Fax: (205)951-3250. E-mail: customerservice @dp1.com. Web site: www.directionalart.com. **President:** Tony Murray. Estab. 1986. Art publisher. Publishes limited and unlimited editions, offset reproductions, contemporary and coastal. Clients: galleries, frame shops and picture manufacturers. Licenses decorative stationery, rugs, home products.
Needs Seeking decorative art for the designer market. Considers oil, watercolor, acrylic and pastel. Prefers casual designs in keeping with today's interiors. Artists represented include A. Kamelhair, H. Brown, R. Lewis, L. Brewer, S. Cairns, N. Strailey, D. Swartzendruber, D. Nichols, M.B. Zeitz and N. Raborn. Editions created by working from an existing painting. Approached by 50 artists/year. Publishes and distributes the work of 5-10 emerging, 5-10 mid-career and 3-5 established artists/year.
First Contact & Terms Send query letter with slides and photographs or digital disc. Samples are not filed and are returned by SASE. Responds in 3 months. Pays royalties. Buys all rights. Provides in-transit insurance, insurance while work is at firm, promotion, shipping from firm and written contract.
Tips ''Always include SASE. Do not follow up with phone calls. All work published is first of all *decorative*. The application of artist-designed borders to artwork can sometimes greatly improve the decorative presentation. We follow trends in the furniture/accessories market. Aged and antiqued looks are currently popular—be creative! Check out what's being sold in home stores for trends and colors.''

DODO GRAPHICS, INC.
145 Cornelia St., P.O. Box 585, Plattsburgh NY 12901. (518)561-7294. Fax: (518)561-6720. E-mail: dodographics @aol.com. **Manager:** Frank How. Art publisher of offset reproductions, posters and etchings for galleries and frame shops.
Needs Considers pastel, watercolor, tempera, mixed media, airbrush and photographs. Prefers contemporary themes and styles. Prefers individual works of art, 16×20 maximum. Publishes the work of 5 artists/year.

First Contact & Terms Send query letter with brochure showing art style or photographs, slides or CD ROM. Samples are filed or are returned by SASE. Responds in 3 months. Write for appointment to show portfolio of original/final art and slides. Payment method is negotiated. Offers an advance when appropriate. Buys all rights. Requires exclusive representation of the artist. Provides written contract.

Tips "Do not send any originals unless agreed upon by publisher."

DOLICE GRAPHICS

649 East 9th St., Suite C2, New York NY 10009. (212)529-2025. Fax: (212)260-9217. E-mail: joe@dolice.com. Web site: www.dolice.com. **Contact:** Joe Dolice, publisher. Estab. 1968. Art publisher. Publishes fine art prints, limited edition, offset reproduction, unlimited edition. Clients: architects, corporate curators, decorators, distributors, frame shops, galleries, gift shops and museum shops. Current clients include Bloomingdale's (Federated Dept. Stores).

Needs Seeking decorative, representational, antiquarian "type" art for the commercial and designer markets. Considers acrylic, mixed media, pastel, pen & ink, prints (intaglio, etc.) and watercolor. Prefers traditional, decorative, antiquarian type. Editions created by collaborating with the artist and working from an existing painting. Approached by 12-20 artists/year.

First Contact & Terms Send query letter with color photocopies, photographs, résumé, SASE, slides and transparencies. Samples are returned by SASE or not returned. Responds only if interested. Company will contact artist for portfolio review if interested. Negotiates payment. Buys all rights on contract work. Rights purchased vary according to project. Provides free Web site space and promotion and written contract. Finds artists through art reps and artist's submissions.

Tips "We publish replicas of antiquarian-type art prints for decorative arts markets and will commission artists to create "works for hire" in the style of pre-century artists and occasionally to color black & white engravings, etchings, etc. Artists interested should be well schooled and accomplished in traditional painting and printmaking techniques and should be able to show samples of this type of work if we contact them."

EDITIONS LIMITED GALLERIES, INC.

4090 Halleck St., Emeryville CA 94608. (510)923-9770. Fax: (510)923-9777. e-mail submissions@editionslimited.com. Web site: www.editionslimited.com. **Director:** Todd Haile. Art publisher and distributor of limited open edition prints and fine art posters. Clients: contract framers, galleries, framing stores, art consultants and interior designers.

Needs Seeking art for the original and designer markets. Considers oil, acrylic and watercolor painting, monoprint, monotype, photography and mixed media. Prefers landscape, floral and abstract imagery. Editions created by collaborating with the artist or by working from existing works.

First Contact & Terms Send query letter with résumé, slides and photographs or JPEG files (8" maximum at 72 dpi) via e-mail at Web site. Samples are filed or are returned by SASE. Responds in 2 months. Publisher/distributor will contact artist for portfolio review if interested. Payment method is negotiated. Negotiates rights purchased.

Tips "We deal both nationally and internationally, so we need art with wide appeal. When sending slides or photos, send at least six so we can get an overview of your work. We publish artists, not just images."

ENCORE GRAPHICS & FINE ART

P.O. Box 18846, Huntsville AL 35804. (800)248-9240. E-mail: jrandjr@hiwaay.net. Web site: www.egart.com. **President:** J. Rand Jr. Estab. 1995. Poster company, art publisher, distributor. Publishes/distributes limited edition, unlimited edition, fine art prints, offset reproduction, posters. Clients: galleries, frame shops, distributors.

Needs Creative art for the serious collector. Considers all media. Prefers African-American and abstract. Art guidelines available on company's Web site. Artists represented include Greg Gamble, Tod Fredericks, Tim Hinton, Mario Robinson, Lori Goodwin, Wyndall Coleman, T.H. Waldman, John Will Davis, Burl Washington, Henry Battle, Cisco Davis, Delbert Iron-Cloud, Gary Thomas and John Moore. Also Buffalo Soldier Prints and historical military themes. Editions created by working from an existing painting. Approached by 15 artists/year. Publishes the work of 3 emerging artists, 1 mid-career artist/year. Distributes the work of 3 emerging, 2 mid-career and 3 established artists/year.

First Contact & Terms Send photocopies, photographs, résumé, tearsheets. Samples are filed. Responds only if interested. Company will contact artist for portfolio review of color, photographs, tearsheets if interested. Negotiates payment. Offers advance when appropriate. Requires exclusive representation of artist. Provides advertising, in-transit insurance, insurance while work is at firm, promotion, shipping from firm, written contract. Finds artists through the World Wide Web and art exhibits.

Tips "Prints of African-Americans with religious themes or children are popular now. Paint from the heart."

⃞ ELEANOR ETTINGER INCORPORATED
119 Spring St., New York NY 10012. (212)925-7474. Fax: (212)925-7734. E-mail: eegallery@aol.com. Web site: www.eegallery.com. **President:** Eleanor Ettinger. Estab. 1975. Art dealer of limited edition lithographs, limited edition sculpture and unique works (oil, watercolor, drawings, etc.).
Needs Seeks classically inspired realistic work involving figurative, landscapes and still lifes for the serious collector. Considers oil, acrylic, mixed media. Prefers American realism.
First Contact & Terms Send query letter with visuals (slides, photographs, etc.), a brief biography, résumé (including a list of exhibitions and collections) and SASE for return of the materials. Responds in 3-4 weeks.

FAIRFIELD ART PUBLISHING
87 35th Street, 3rd Floor, Brooklyn NY 11232. (800)835-3539. Fax: (718) 832-8432. E-mail: cyclopete@aol.com.
Vice President: Peter Lowenkron. Estab. 1996. Art publisher. Publishes posters, unlimited editions and offset reproductions. Clients: galleries, frame shops, museum shops, decorators, corporate curators, giftshops, manufacturers and contract framers.
Needs Decorative art for the designer and commercial markets. Considers collage, oil, watercolor, pastel, pen & ink, acrylic. Some artists represented include Daniel Pollera, Roger Vilarchao, Yves Poinsot.
First Contact & Terms Send query letter with slides and brochure. Samples are returned by SASE if requested by artist. Responds only if interested. Pays flat fee, $400-2,500 maximum, or royalties of 7-15%. Offers advance when appropriate. Rights purchased vary according to project. Interested in buying second rights (reprint rights) to previously published artwork.

⃞ RUSSELL A. FINK GALLERY
Box 250, Lorton VA 22199. (703)550-9699. **Contact:** Russell A. Fink. Art publisher/dealer. Publishes offset reproductions using five-color offset lithography for galleries, individuals and framers.
Needs Seeking artwork with creative artistic expression for the serious collector. Considers oil, acrylic and watercolor. Prefers wildlife and sporting themes. Prefers individual works of art; framed. "Submit photos or slides of at least near-professional quality. Include size, price, media and other pertinent data regarding the artwork. Also send personal résumé and be courteous enough to include SASE for return of any material sent to me." Artists represented include Ray Harris-Ching, Ken Carlson, John Loren Head, Robert Abbett and Rod Crossman. Editions created by working from an existing painting. Publishes and distributes the works of 1 emerging artist and 1 mid-career artist/year. Publishes the work of 2 and distributes the work of 3 established artists/year.
First Contact & Terms Send query letter with slides or photographs to be kept on file. Call or write for appointment to show portfolio. Samples returned if not kept on file. Pays 10% royalties to artist or negotiates payment method. Negotiates rights purchased. Provides insurance while work is at publisher and promotion and shipping from publisher. Negotiates ownership of original art.
Tips "Looks for composition, style and technique in samples. Also how the artist views his own art. Mistakes artists make are arrogance, overpricing, explaining their art and underrating the role of the dealer."

FLYING COLORS, INC.
26943 Ruether Ave. Suite "S", San Clarita CA 91351. (661)424-0545. Fax: (661)299-5586. E-mail: joe@flying-colors.net. Web site: www.flying-colors.net. **Contact:** Joe McCormick, president. Estab. 1993. Poster company and art publisher. Publishes unlimited edition, fine art prints, posters. Clients: galleries, frame shops, distributors, museum shops, giftshops, mail order, end-users, retailers, chains, direct mail.
Needs Seeking decorative art for the commercial market. Considers oil, acrylic, watercolor, mixed media, pastel. Prefers multicultural, religious, inspirational wildlife, Amish, country, scenics, still life, American culture. Also needs freelancers for design. Prefers designers who own Mac computers. Artists represented include Greg Gorman, Deidre Madsen. Editions created by collaborating with the artist or by working from an existing painting. Approached by 200 artists/year. Publishes the work of 20 emerging, 5-10 mid-career, 1-2 established artists/year.
First Contact & Terms May contact via e-mail or send photocopies, photographs, SASE, slides, transparencies. Accepts disk submissions if compatible with SyQuest, Dat, Jazzy, ZIP, QuarkXPress, Illustrator, Photoshop or FreeHand. Samples are filed or returned by SASE. Responds only if interested. Artist should follow-up with call to show portfolio. Portfolio should include color, photographs, roughs, slides, transparencies. Negotiates payment. Offers advance when appropriate. Negotiates rights purchased, all rights preferred. Provides advertising, promotion, written contract. Finds artists through attending art exhibitions, art fairs, word of mouth, artists' submissions, clients, local advertisements.
Tips "Ethnic and inspirational/religious art is very strong. Watch the furniture industry. Come up with themes, sketches and series of at least two pieces. Art has to work on 8×10, 16×20, 22×28, 24×36, greeting cards and other possible mediums."

FORTUNE FINE ART

2908 Oregon Ct., #G3, Torrance CA 90503. (310)618-1231. Fax: (310)618-1232. E-mail: carolv@fortunefa.com. Web site: www.fortunefa.com. **Contact:** Carol J. Vidic, president. Licensing: Peter Iwasaki. Publishes fine art prints, hand-pulled serigraphs, originals, limited edition, offset reproduction, posters and unlimited edition. Clients: art galleries, dealers and designers.

Needs Seeking creative art for the serious collector. Considers oil on canvas, acrylic on canvas, mixed media on canvas and paper. Artists represented include John Powell, Daniel Gerhartz, Marilyn Simandle and Don Hatfield. Publishes and distributes the work of a varying number of emerging artists/year.

First Contact & Terms Send query letter with résumé, slides, photographs, transparencies, biography and SASE. Samples are not filed. Responds in 1 month. To show a portfolio, mail appropriate materials. Payment method and advances are negotiated. Prefers exclusive representation of artist. Provides in-transit insurance, insurance while work is at firm, promotion and written contract.

Tips ''Establish a unique style, look or concept before looking to be published.''

▣ FRONT LINE ART PUBLISHING

165 Chubb Ave., Lyndhurst NJ 07071. (201)842-8500. Fax: (201)842-8546. Web site: www.theartpublishinggroup.com. **Creative Director:** Rachael Cronin. Estab. 1981. Publisher of posters, prints, offset reproductions and limited editions. Clients: galleries, frame shops, gift shops and corporate curators.

Needs Seeking creative and decorative art reflecting popular trends for the commercial and designer markets. Considers oil, acrylic, pastel, pen & ink, watercolor and mixed media. Prefers contemporary interpretations of landscapes, seascapes, florals, abstracts and African-American subjects. Editions created by working from an existing painting or by collaborating with the artist. Approached by 300 artists/year. Publishes the work of 40 artists/year.

First Contact & Terms Send query letter with brochure, photocopies, photographs, tearsheets and slides. Samples not filed are returned by SASE. Responds in 1 month if interested. Company will contact artist for portfolio review of photographs and slides if interested. Payment method is negotiated; royalty based contracts. Requires exclusive representation of the artist. Provides advertising, promotion, written contract and insurance while work is at firm.

Tips ''Front Line Art Publishing is looking for artists who are flexible and willing to work to develop art that meets the specific needs of the print and poster marketplace. We actively seek out new art and artists on an ongoing basis.''

FUNDORA ART STUDIO

100 Bahama Rd., Key Largo FL 33047. (305)852-1516. E-mail: thomasfund@aol.com. **Director:** Thomas Fundora. Estab. 1987. Art publisher/distributor/gallery. Publishes limited edition fine art prints. Clients: galleries, decorators, frameshops. Current clients include Ocean Reef Club, Paul S. Ellison.

Needs Seeking creative and decorative art for the serious collector. Considers oil, watercolor, mixed media. Prefers nautical, maritime, tropical. Artists represented include Thomas Fundora, Gaspel, Juan A. Carballo, Carlos Sierra. Editions created by collaborating with the artist and working from an existing painting. Approached by 15 artists/year. Publishes/distributes the work of 2 emerging, 1 mid-career and 3 established artists/year.

First Contact & Terms Send query letter with brochure, photographs, slides or printed samples. Samples are filed. Will contact artist for portfolio review if interested. Pays royalties. Buys first rights. Requires exclusive representation of artist in US. Provides advertising and promotion. Also works with freelance designers.

Tips ''Trends to watch: tropical sea and landscapes.''

▣ G.C.W.A.P. INC.

12075 Marina Loop, W. Yellowstone MT 59758. (406)646-9551. **Executive Vice President:** Cindy Carter. Estab. 1980. Publishes limited edition art. Clients: galleries and individuals.

Needs Seeking art for the serious collector and commercial market. Considers oil and pastel. Prefers western, wildlife and train themes. Artists represented include Gary Carter, Arlene Hooker Fay, Jim Norton. Editions created by collaborating with the artist. Approached by 10-20 artists/year. Publishes/distributes the work of 3 established artists/year.

First Contact & Terms Send query letter with photographs, résumé and transparencies. Samples are returned. Responds in 1 month. Company will contact artists for portfolio review if interested. Negotiates payment. Buys reprint rights. Requires exclusive representation of artist. Provides advertising.

GALAXY OF GRAPHICS, LTD.

20 Murray Hill Pkwy., Suite 160, East Rutherford NJ 07073-2180. (201)806-2100. Fax: (201)806-2050. E-mail: christine.gaccione@kapgog.com. Web site: www.galaxyofgraphics.com. **Art Director:** Colleen Buchweitz. Estab. 1983. Art publisher and distributor of unlimited editions. Licensing handled by Christine Gaccione. Clients: galleries, distributors and picture frame manufacturers.

Needs Seeking creative, fashionable and decorative art for the commerical market. Artists represented include

Richard Henson, Betsy Brown, Elaine Lane, Charlene Olson, Vivian Flasch, Joyce Combs, Igor Lerashov, Ruane Manning and Carol Robinson. Editions created by collaborating with the artist or by working from an existing painting. Considers any media. "Any currently popular and generally accepted themes." Art guidelines free for SASE with first-class postage. Approached by several hundred artists/year. Publishes and distributes the work of 20 emerging and 20 mid-career and established artists/year.

First Contact & Terms Send query letter with résumé, tearsheets, slides, photographs and transparencies. Samples are not filed and are returned by SASE. Responds in 2 weeks. Call for appointment to show portfolio. Pays royalties of 10%. Offers advance. Buys rights only for prints and posters. Provides insurance while material is in-house and while in transit from publisher to artist/photographer. Provides written contract to each artist.

Tips "There is a trend of strong jewel-tone colors and spice-tone colors. African-American art very needed."

ROBERT GALITZ FINE ART & ACCENT ART

(formerly Robert Galitz Fine Art), 166 Hilltop Lane, Sleepy Hollow IL 60118-1816. (847)426-8842. Fax: (847)426-8846. Web site: www.galitzfineart.com. **Owner:** Robert Galitz. Estab. 1986. Distributor of fine art prints, hand-pulled originals, limited editions, monoprints, monotypes and sculpture. Clients: architects and galleries.

• See also listing in Galleries.

Needs Seeking creative, decorative art for the commercial and designer markets. Considers acrylic, mixed media, oil, sculpture and watercolor.

First Contact & Terms Send query letter with brochure, SASE, slides and photographs. Samples are not filed and are returned by SASE. Responds in 1 month. Company will contact artist for portfolio review if interested. Pays flat fee. No advance. Rights purchased vary according to project. Finds artists through art fairs and submissions.

GALLERY GRAPHICS

20136 St. Highway 59, Noel MO 64854. (417)475-6191. Fax: (417)475-3542. E-mail: info@gallerygraphics.com. Web site: www.gallerygraphics.com. Estab. 1980. Wholesale producer and distributor of prints, cards, sachets, stationery, calendars, framed art, stickers. Clients: frame shops, craft shops, florists, pharmacies and gift shops.

Needs Seeking art with nostalgic look, country, Victorian, children, angels, florals, landscapes, animals—nothing abstract or non-representational. Considers oil, watercolor, mixed media, pastel and pen & ink. 10% of editions created by collaborating with artist. 90% created by working from an existing painting. Artists include Barbara Mock, Glynda Turley, Sandra Kuck, Laurie Korsaden, Dana Gelsinger, and Angela Anderson.

First Contact & Terms Send query letter with brochure showing art style and tearsheets. Designers send photographs, photocopies and tearsheets. Accepts disk submissions compatible with IBM or Mac. Samples are filed or are returned by SASE. Responds in 2 months. To show portfolio, mail finished art samples, color tearsheets. Can buy all rights or pay royalties. Provides a written contract.

Tips " Please submit artwork on different subjects and styles. Some artists do certain subjects particularly well, but you don't know if they can do other subjects. Don't concentrate on just one area. Don't limit yourself, or you could be missing out on some great opportunities."

GANGO EDITIONS, INC.

2187 NW Reed, Portland OR 97210. (503)223-9694. Fax: (503)223-0925. E-mail: info@gangoeditions.com. Web site: www.gangoeditions.com. **Contact:** Robin Allen, art director. Estab. 1977. Art publisher/distributor. Publishes/distributes offset reproduction and posters. Clients: contract framers, architects, decorators, distributors, frame and gift shops, and galleries.

Needs Seeking decorative art for the commercial and designer markets. Considers oil, watercolor, acrylic, pastel, mixed media, and photography. Prefers art that follows current trends and colors. Artists represented include Amy Melious and Pamela Gladding. Editions created by working from an existing painting or other artwork and by collaborating with the artist. Publishes and distributes the work of 70 emerging artists/year.

First Contact & Terms Send query letter with slides, SASE, tearsheets, transparencies and/or photographs. E-mail submissions accepted with link to Web site or image file. Prefers Windows-compatible JPEG files. Samples returned by SASE. Artist is contacted by mail. Responds in 6 weeks. Company will contact artist for portfolio review if interested. Portfolio should include b&w and color finished, original art, photographs, slides or transparencies. Pays royalties of 10%. Requires exclusive representation of artist. Buys first rights and reprint rights. Provides advertising, in-transit insurance, insurance while work is at firm, promotion, shipping from our firm and written contract. Finds artists through art exhibits/fairs, art reps, artist's submissions, Internet and word of mouth.

Tips "We require work that can be done in pairs. Artist may submit a single but must have a mate available if piece is selected. To be a pair, the works must both be horizontal or vertical. Palette must be the same. Perspective the same. Content must coordinate."

GEME ART INC.

209 W. Sixth St., Vancouver WA 98660. (360)693-7772. Fax: (360)695-9795. E-mail: help@gemeart.com. **Art Director:** Jennifer Will. Estab. 1966. Art publisher. Publishes fine art prints and reproductions in unlimited and limited editions. Clients: galleries, frame shops, art museums. Licenses designs.

Needs Considers oil, acrylic, watercolor and mixed media. "We use a variety of styles from realistic to whimsical, catering to "Mid-America art market." Artists represented include Lois Thayer, Crystal Skelley, Steve Nelson.

First Contact & Terms Send color slides, photos or brochure. Include SASE. Publisher will contact artist for portfolio review if interested. Simultaneous submissions OK. Payment on a royalty basis. Purchases all rights. Provides promotion, shipping from publisher and contract.

Tips "We have added new sizes and more artists to our lines since last year."

GLEEDSVILLE ART PUBLISHERS

5 W. Loudoun St., Leesburg VA 20175. (703)771-8055. Fax: (703)771-0225. E-mail: buyart@gleedsvilleart.com. Web site: www.gleedsvilleart.com. **Contact:** Lawrence J. Thomas, president. Estab. 1999. Art publisher and gallery. Publishes and/or distributes fine art prints and limited edition. Clients: decorators, distributors, frame shops and galleries.

Needs Seeking decorative art for the serious collector, commercial and designer markets. Considers acrylic, mixed media, oil, pastel, pen & ink and watercolor. Prefers impressionist, landscapes, figuratives, city scenes, realistic and whimsical. Artists represented include Antony Andrews, Lillian D. August, Grant Hacking, and Bill Schmidt. Editions created by collaborating with the artist.

First Contact & Terms Send photographs, slides, tearsheets, transparencies and URL. Accepts e-mail submissions with link to Web site. Prefers Windows-compatible, JPEG files. Samples are filed or returned. Responds in 3 months. Company will contact artist for portfolio review if interested. Portfolio should include original art, slides, tearsheets, thumbnails and transparencies. Pays royalties. Negotiates rights purchased. Requires exclusive representation of artist. Provides advertising, promotion, shipping from our firm and written contract. Finds artists through art competitions, art exhibits/fairs, artist's submissions and word of mouth.

GRAPHIQUE DE FRANCE

9 State St., Woburn MA 01801. (781)935-3405. Fax: (781)935-5145. E-mail: artworksubmissions@graphiquedefrance.com. Web site: www.graphiquedefrance.com. **Contact:** Licensing Department. Estab. 1979. Manufacturer of fine art, photographic and illustrative greeting cards, notecard gift boxes, posters and calendars. Clients: galleries, foreign distributors, museum shops, high-end retailers, book trade, museum shops.

First Contact & Terms Prefers submissions made as JPEGS through Web site. Please do not send original artwork. Please allow 2 months for response. SASE is required for any submitted material to be returned.

Tips "It's best not to insist on speaking with someone at a targeted company prior to submitting work. Let the art speak for itself and follow up a few weeks after submitting."

RAYMOND L. GREENBERG ART PUBLISHING

116 Costa Rd. Highland NY 12528. (845)883-4220. Fax: (845)883-4122. E-mail: info@raymondlgreenberg.com. Web site: www.raymondlgreenberg.com. **Owner:** Ray Greenberg. Licensing: Ray Greenberg. Estab. 1995. Art publisher. Publishes unlimited edition fine art prints for major framers and plaque manufacturers. Licenses inspirational, ethnic, Victorian, kitchen and bath artwork for prints for wall decor. Clients include Crystal Art Galleries, North American Art.

Needs Black ethnic art and spiritual/yoga theme art. Artists represented include Nancy Van Kangegan, Jason DeLancy, Vrlin Kilgore. Editions created by collaborating with the artist and/or working from an existing painting. Approached by 35 artists/year. Publishes 1 emerging, 5 mid-career and 2 established artists/year.

First Contact & Terms Send query letter with photographs, slides, SASE; "any good, accurate representation of your work." Samples are filed or returned by SASE. Responds in 6 weeks. Company will contact artist for portfolio review if interested. Pays flat fee $50-200 or royalties of 5-7%. Offers advance against royalties when appropriate. Buys all rights. Prefers exclusive representation. Provides insurance, promotion, shipping from firm and contract. Finds artists through word of mouth.

Tips "Versatile artists who are willing to paint for the market can do very well with us. Be flexible and patient."

THE GREENWICH WORKSHOP, INC.

151 Main St., P.O. Box 231, Seymour CT 06483. Web site: www.greenwichworkshop.com. **Contact:** Artist Selection Committee. Art publisher and gallery. Publishes limited and open editions, offset reproductions, fine art lithographs, serigraphs, canvas reproductions and fine art porcelains and books. Clients: independent galleries in US, Canada and United Kingdom.

Needs Seeking creative, fashionable and decorative art for the serious collector, commercial and designer

markets. Considers oil, watercolor, mixed media, pastel and acrylic. Considers all but abstract. Artists represented include James C. Christensen, Howard Terpning, James Reynolds, James Bama, Bev Doolittle, Scott Gustafson, Braldt Bralds. Editions created by collaborating with the artist or by working from an existing painting. Approached by 100 artists/year. Publishes the work of 4-5 emerging, 15 mid-career and 25 established artists. Distributes the work of 4-5 emerging, 15 mid-career and 25 established artists/year.

First Contact & Terms Send query letter with brochure, slides, photographs, SASE and transparencies. Samples are not filed and are returned by SASE. Responds in 3 months. Publisher will contact artist for portfolio review if interested. Portfolio should include final art, tearsheets, photographs, slides and transparencies. Pays royalties. No advance. Rights purchased vary according to project. Requires exclusive representation of artist. Provides advertising, insurance while work is at firm, promotion, shipping to and from firm, and written contract. Finds artists through art exhibits, submissions and word of mouth.

GUILDHALL, INC.

P.O. Box 136550, Fort Worth TX 76136. (800)211-0305. Fax (817)236-0015. E-mail: westart@guildhall.com. Web site: www.guildhall.com. **President:** John M. Thompson III. Art publisher/distributor of limited and unlimited editions, offset reproductions and handpulled originals for galleries, decorators, offices and department stores. Current clients include over 500 galleries and collectors nationwide.

Needs Seeking creative art for the serious and commercial collector and designer market. Considers pen & ink, oil, acrylic, watercolor, and bronze and stone sculptures. *Prefers historical Native American, Western, equine, wildlife, landscapes and religious themes.* Prefers original works of art. Over past 25 years have represented over 50 artists in printing and licensing work. Editions created by collaborating with the artist and by working from existing art. Approached by 150 artists/year.

First Contact & Terms Send query letter with résumé, tearsheets, photographs, slides and 4×5 transparencies or electronic file, preferably cowboy art in photos or printouts. Samples are not filed and are returned only if requested. Responds in 1 month. Payment options include paying a flat fee for a single use; paying 10-20% royalties for multiple images; paying 35% commission on consignment. Negotiates rights purchased. Requires exclusive representation for contract artists. Provides insurance while work is at firm.

Tips "The new technologies in printing are changing the nature of publishing. Self-publishing artists have flooded the print market. Printing is the easy part. Selling it is another problem. Many artists, in order to sell their work, have to price it very low. In many markets this has caused a glut. Some art would be best served if it was only one of a kind. There is no substitute for scarcity and quality."

HADDAD'S FINE ARTS INC.

3855 E. Miraloma Ave., Anaheim CA 92806. (714)996-2100. Web site: www.haddadsfinearts.com. **President:** Paula Haddad. Art Director: Beth Hedstrom. Estab. 1953. Art publisher and distributor. Produces unlimited edition offset reproductions and posters. Clients: galleries, art stores, museum stores and manufacturers. Sells to the trade only—no retail.

Needs Seeking creative and decorative art for the commercial and designer markets. Seeks traditional/transitional scenes: landscapes, florals; decorative and abstract contemporary, and more—broad subject mix. Editions created by collaborating with the artist or by working from an existing painting. Approached by 200-300 artists/year. Publishes the work of 10-15 emerging artists/year. Also uses freelancers for design. 20% of projects require freelance design. Design demands knowledge of QuarkXPress and Illustrator.

First Contact & Terms Illustrators: Send query letter with brochure, transparencies, slides, photos representative of work for publication consideration. Include SASE. Designers: Send query letter explaining skills. Responds in 2-3 weeks. Publisher/distributor will contact artist for portfolio review if interested. Portfolio should include slides, roughs, final art, transparencies. Pays royalties quarterly, 10% of base net price. Rights purchased vary according to project. Provides advertising and written contract.

▣ HADLEY HOUSE PUBLISHING

1157 Valley Park Dr., Suite 130, Shakopee MN 55379. (952)943-8474. Fax: (952)943-8098. Web site: www.hadleylicensing.com.or www.hadleyhouse.com. **Vice President, Publishing/Licensing:** Deborah Borchard. Licensing: Gary Schmidt. Estab. 1974. Art publisher, distributor and 30 retail galleries. Publishes and distributes canvas transfers, fine art prints, giclées, limited and unlimited editions, offset reproductions and posters. Licenses all types of flat art. Clients: wholesale and retail.

Needs Seeking artwork with creative artistic expression and decorative appeal. Considers oil, watercolor, acrylic, pastel and mixed media. Prefers wildlife, florals, landscapes, figurative and nostalgic Americana themes and styles. Art guidelines free for SASE with first-class postage. Artists represented include Nancy Howe, Steve Hamrick, Cha Ilyong, Sueellen Ross, Larry Chandler, Collin Bogle, Lee Bogle, Adele Earnshaw and Bruce Miller. Editions created by collaborating with artist and by working from an existing painting. Approached by 200-300

artists/year. Publishes the work of 3-4 emerging, 15 mid-career and 8 established artists/year. Distributes the work of 1 emerging and 4 mid-career artists/year.

First Contact & Terms Send query letter with brochure showing art style or résumé and tearsheets, slides, photographs and transparencies. Samples are filed or are returned. Responds in 2 months. Call for appointment to show portfolio of slides, original final art and transparencies. Pays royalties. Requires exclusive representation of artist and/or art. Provides insurance while work is at firm, promotion, shipping from firm, a written contract and advertising through dealer showcase.

Tips "Build a market for your originals by affiliating with an art gallery or two. Never give away your copyrights! When you can no longer satisfy the overwhelming demand for your originals . . . *that* is when you can hope for success in the reproduction market."

IMAGE CONNECTION

456 Penn St., Yeadon PA 19050. (610)626-7770. Fax: (610)626-2778. e-mail submissions@imageconnection.biz. Web site: www.imageconnection.biz. **Contact:** Michael Markowica. Estab. 1988. Publishes and distributes limited editions and posters. Represents several European publishers.

Needs Seeking fashionable and decorative art for the commercial market. Considers oil, pen & ink, watercolor, acrylic, pastel and mixed media. Prefers contemporary and popular themes, realistic and abstract art. Editions created by collaborating with the artist and by working from an existing painting. Approached by 200 artists/year.

First Contact & Terms Send query letter with brochure showing art style or résumé, slides, photocopies, photographs, tearsheets and transparencies. Accepts e-mail submissions with link to Web site or Mac-compatible image file. Samples are not filed and are returned by SASE. Responds in 2 months. Company will contact artist for portfolio review if interested. Portfolio should include b&w and color finished, original art, photographs, slides, tearsheets and transparencies. Payment method is negotiated. Offers advance when appropriate. Negotiates rights purchased. Requires exclusive representation of artist for product. Finds artists through art competitions, exhibits/fairs, reps, submissions, Internet, sourcebooks and word of mouth.

IMAGE CONSCIOUS

1261 Howard St., San Francisco CA 94103. (415)626-1555. Fax: (415)626-2481. E-mail: cbardy@imageconscious.com. Web site: www.imageconscious.com. **Director of Product Development:** Cindy Bardy. Director of Licensing: Jennifer Reno. Estab. 1980. Art publisher and domestic and international distributor of offset and poster reproductions. Now licensing images as well. Clients: poster galleries, frame shops, department stores, design consultants, interior designers and gift stores. Current clients include Z Gallerie, Deck the Walls and Bed Bath & Beyond.

Needs Seeking creative and decorative art for the designer market. Considers oil, acrylic, pastel, watercolor, tempera, mixed media and photography. Prefers individual works of art, pairs or unframed series. Artists represented include Bill Brauer, Alan Blaustein, Monica Stewart, David Garibaldi, Eva Carter, Cynthia Markert and Haibin. Editions created by collaborating with the artist and by working from an existing painting or photograph. Approached by hundreds of artists/year. Publishes the work of 4-6 emerging, 4-6 mid-career and 8-10 established artists/year. Distributes the work of 50 emerging, 200 mid-career and 700 established artists/year.

First Contact & Terms Send query letter with brochure, résumé, tearsheets, photographs, slides and/or transparencies. Samples are filed or are returned by SASE. Accepts low res. e-mail submissions. Please limit initial submissions to 10 images. Responds in 1 month. Publisher/distributor will contact artist for portfolio review if interested. No original art. Payment method is negotiated. Negotiates rights purchased. Provides promotion, shipping from firm and a written contract.

Tips "Research the type of product currently in poster shops. Note colors, sizes and subject matter trends."

IMAGE SOURCE INTERNATIONAL

630 Belleville Ave., New Bedford MA 02745. (508)999-0090. Fax: (508)999-9499. E-mail: pdownes@isiposters.com. Web site: www.isiposters.com. **Contact:** Patrick Downes. Art Editor: Kevin Miller. Licensing: Patrick Downes. Art Diredtor: Bob Downs. Estab. 1992. Poster company, art publisher, distributor, foreign distributor. Publishes/distributes unlimited editions, fine art prints, offset reproductions, posters. Clients: galleries, decorators, frame shops, distributors, architects, corporate curators, museum shops, gift shops, foreign distributors (Germany, Holland, Asia, South America).

● Image Source International is one of America's fastest-growing publishers.

Needs Seeking fashionable, decorative art for the designer market. Considers oil, acrylic, pastel. Artists represented include Micarelli, Kim Anderson, Bertram Bahner, Juarez Machado, Anthony Watkins, Rob Brooks and Karyn Frances Gray. Editions created by collaborating with the artist or by working from an existing painting.

Approached by hundreds of artists/year. Publishes the work of 6 emerging, 2 mid-career and 2 established artists/year. Distributes the work of 50 emerging, 25 mid-career, 50 established artists/year.

First Contact & Terms Send query letter with brochure, photocopies, photographs, résumé, slides, tearsheets, transparencies, postcards. Samples are filed and are not returned. Responds only if interested. Company will contact artist for portfolio review if interested. Pays flat fee "that depends on artist and work and risk." Buys all rights. Requires exclusive representation of artist.

Tips Notes trends as sports art, neo-classical, nostalgic, oversize editions. "Think marketability. Watch the furniture market."

IMAGES OF AMERICA PUBLISHING COMPANY

P.O. Box 608, Jackson WY 83001. (800)451-2211. Fax: (307)739-1199. E-mail: info@artsfortheparks.com. Web site: www.artsfortheparks.com. Estab. 1986. Art publisher. Publishes limited editions, posters. Clients: galleries, frame shops, distributors, gift shops, national parks, natural history associations.

 • This company publishes the winning images in the Arts for the Parks competition which was created in 1986 by the National Park Academy of the Arts in cooperation with the National Park Foundation. The program's purpose is to celebrate representative artists and to enhance public awareness of the park system. The top 100 paintings tour the country and receive cash awards. Over $100,000 in prizes in all.

Needs Seeking national park images. Considers oil, acrylic, watercolor, mixed media, pastel, pen & ink. Prefers nature and wildlife images from one of the sites administered by the National Park Service. Art guidelines available on company's Web site. Artists represented include Jim Wilcox, Linda Tippetts, Howard Hanson, Dean Mitchell, Steve Hanks. Editions created by collaborating with the artist. Approached by over 2,000 artists/ year.

First Contact & Terms Submit by entering the Arts for the Parks contest for a $40 entry fee. Entry form and slides must be postmarked by June 1 each year. Send for prospectus before April 1st. Samples are filed. Portfolio review not required. Pays flat fee of $50-50,000. Buys one-time rights. Provides advertising.

Tips "All artwork selected must be representational of a National Park site."

INSPIRATIONART & SCRIPTURE, INC.

P.O. Box 5550, Cedar Rapids IA 52406. (319)365-4350. Fax: (319)861-2103. E-mail: charles@inspirationart.com. Web site: www.inspirationart.com. **Creative Director:** Charles R. Edwards. Estab. 1993 (incorporated 1996). Produces Christian poster prints. "We create and produce jumbo-sized (24×36) posters targeted at pre-teens (10-14), teens (15-18) and young adults (18-30). A Christian message is contained in every poster. Some are fine art and some are very commercial. We prefer very contemporary images."

Needs Approached by 150-200 freelance artists/year. Works with 10-15 freelancers/year. Buys 10-15 designs, photos, illustrations/year. Christian art only. Uses freelance artists for posters. Considers all media. Looking for "something contemporary or unusual that appeals to teens or young adults and communicates a Christian message." Art guidelines available via Web site or for SASE with first-class postage.

First Contact & Terms Send query letter with photographs, slides, SASE or transparencies. Accepts submissions on disk (call first). Samples are filed or are returned by SASE. Responds in 6 months. Company will contact artist for portfolio review if interested. Portfolio should include color roughs, final art, photographs and transparencies. "We need to see the artist's range. It is acceptable to submit 'secular' work, but we also need to see work that is Christian-inspired." Originals are returned at job's completion. Pays by the project, $50-250. Pays royalties of 5% "only if the artist has a body of work that we are interested in purchasing in the future." Rights purchased vary according to project.

Tips "The better the quality of the submission, the better we are able to determine if the work is suitable for our use (slides are best). The more complete the submission (i.e., design, art layout, scripture, copy), the more likely we are to see how it may fit into our poster line. We do accept traditional work but are looking for work that is more commercial and hip (think MTV with values). A poster needs to contain a Christian message that is relevant to teen and young adult issues and beliefs. Understand what we publish before submitting work. Visit our Web site to see what it is that we do. We are not simply looking for beautiful art, but rather we are looking for art that communicates a specific scriptural passage."

⊕ INTERNATIONAL GRAPHICS GMBH.

Junkersring 11, 76344, Eggenstein 011 Germany. 011(49)721-978-0620. Fax: 011(49)721-978-0651. E-mail: LW @ig-team.de. Web site: www.international-graphics.com. **President:** Lawrence Walmsley. Publishing Assistant: Anita Cieslar. Estab. 1981. Poster company/art publisher/distributor. Publishes/distributes limited edition monoprints, monotypes, offset reproduction, posters, original paintings and silkscreens. Clients: galleries, framers, department stores, gift shops, card shops and distributors. Current clients include Art.com, Windsor Art, Intercontinental Art and Balangier.

Needs Seeking creative, fashionable and decorative art for the commercial and designer markets. Also seeking

Americana art for our gallery clients. Considers oil, acrylic, watercolor, mixed media, pastel. Prefers landscapes, florals, still lifes. Art guidelines free for SASE with first-class postage. Artists represented include Christian Choisy, Benevolenza, Ona, Thiry, Magis, Marthe and Mansart. Editions created by working from an existing painting. Approached by 100-150 artists/year. Publishes the work of 10-20 emerging artists/year. Distributes the work of 10-20 emerging artists/year.

First Contact & Terms Send query letter with brochure, photocopies, photographs, photostats, résumé, slides, tearsheets. Accepts disk submissions in Mac or Windows. Samples are filed and returned. Responds in 2 months. Will contact artist for portfolio review if interested. Negotiates payment on basis of per-piece-sold arrangement. Offers advance when appropriate. Buys first rights. Provides advertising, promotion, shipping from our firm and contract. Also work with freelance designers. Prefers local designers only. Finds artists through exhibitions, word of mouth, submissions.

Tips "Pastel landscapes and still life pictures are good at the moment. Earthtones are popular—especially lighter shades. At the end of the day, we seek unusual, that has not yet been published."

ISLAND ART PUBLISHERS

6687 Mirah Rd., Saanichton BC V8M 1Z4 Canada. (250)652-5181. Fax: (250)652-2711. E-mail islandart@island-art.com. Web site: www.islandart.com. **President:** Myron D. Arndt. Estab. 1985. Art publisher and distributor. Publishes and distributes art cards, posters, open-edition prints, giclées and custom products. Clients: galleries, department stores, distributors, gift shops. Current clients include Public Galleries and Museums, Host-Marriott, HDS, etc.

Needs See Web site for current needs and requirements. Considers oil, watercolor and acrylic. Prefers lifestyle themes/Pacific Northwest. Art guidelines available on company's Web site. Over 50 artists represented. Editions created by working from an existing painting. Approached by 100 artists/year. Publishes the work of 2-8 emerging artists/year. Distributes the work of 4 emerging artists/year.

First Contact & Terms Send résumé, tearsheets, slides and photographs. Designers send photographs, slides or transparencies (do not send originals). Accepts submissions on disk compatible with Photoshop. Send EPS of TIFF files. Samples are not filed and are returned by SASE if requested by artist. Responds in 3 months. Publisher/distributor will contact artist for portfolio review if interested. Portfolio should include color roughs, final art, slides and 4×5 transparencies. Pays royalties of 5-10%. Licenses reproduction rights. Requires exclusive representation of artist for selected products only. Provides insurance while work is at firm, promotion, shipping from firm, written contract, trade fair representation and Internet service. Finds artists through art fairs, referrals and submissions.

Tips "Provide a body of work along a certain theme to show a fully developed style that can be built upon. We are influenced by our market demands. Please ask for our submission guidelines before sending work on spec."

JADEI GRAPHICS INC.

4943 McConnell Ave., Suite "W", Los Angeles CA 90066. (310)578-0082. Fax: (310)823-4399. Web site: www.jadeigraphics.com. **Contact:** Judy Smith, office manager. Licensing: Dennis Gaskin. Poster company. Publishes limited edition, unlimited edition and posters. Clients: galleries, framers. Licenses calendars, puzzles, etc.

Needs Seeking creative, decorative art for the commercial market. Considers oil, acrylic, watercolor and photographs. Editions created by collaborating with the artist or by working from an existing painting. Approached by 100 artists/year. Publishes work of 3-5 emerging artists each year. Also needs freelancers for design. Prefers local designers only.

First Contact & Terms Send query letter with brochure, photocopies, photographs and slides. Accepts disk submissions. Samples are returned by SASE. Responds only if interested. Company will contact artist for portfolio review of color, photographs, slides and transparencies. Negotiates payment. Offers advance. Rights purchased vary according to project. Provides advertising.

LESLI ART, INC.

Box 6693, Woodland Hills CA 91365. (818)999-9228. E-mail: lesliart@adelphia.net. Web site: www.lesliart.com. **President:** Stan Shevrin. Estab. 1965. Artist agent handling paintings for art galleries and the trade.

Needs Considers oil paintings and acrylic paintings. Prefers realism and impressionism—figures costumed with narrative content, landscapes, still lifes and florals. Works with 20 artists/year.

First Contact & Terms To show portfolio, mail slides or color photographs. Samples not filed are returned by SASE. Responds in 1 month. Payment method is negotiated. Offers an advance. Provides national distribution, promotion and written contract.

Tips "Considers only those artists who are serious about having their work exhibited in important galleries throughout the United States and Europe."

◾ LESLIE LEVY FINE ART PUBLISHING

7137 Main St., Scottsdale AZ 85251. (480)947-2925. Fax: (480)945-1518. E-mail: art@leslielevy.com. Web site: www.leslielevy.com. **President:** Leslie Levy. Estab. 1976. Art publisher of posters and open editions. "Our publishing customers are mainly frame shops, galleries, designers, framed art manufacturers, distributors and department stores. A division of the Bentley Publishing Group."

Needs Seeking creative and decorative art for the residential, hospitality, health care, commercial and designer markets. Artists represented include Steve Hanks, Terry Isaac, Stephen Morath, Kent Wallis, Cyrus Afsary, Raymond Knaub, and many others. Considers oil, acrylic, pastel, watercolor, tempera and mixed media. Prefers art depicting florals, landscapes, wildlife, semiabstract, nautical, figurative works and b&w photography. Approached by hundreds of artists/year.

First Contact & Terms Send query letter with résumé, slides or photos and SASE. Samples are returned by SASE. "Portfolio will not be seen unless interest is generated by the materials sent in advance." Please do not send limited editions, transparencies or original works. Pays royalties quarterly based on wholesale price. Insists on acquiring reprint rights for posters. Requires exclusive representation of the artist. Provides promotion and written contract. "Please, don't call us. After we review your materials, we will contact you or return materials within 1 month."

Tips "Please, if you are a beginner, do not go through the time and expense of sending materials."

LOLA LTD./LT'EE

1817 Egret St. SW, Shallotte NC 28470-5433. (910)754-8002. E-mail: lolaltd@yahoo.com. **Owner:** Lola Jackson. Distributor of limited editions, offset reproductions, unlimited editions, handpulled originals, antique prints and etchings. Clients: art galleries, architects, picture frame shops, interior designers, major furniture and department stores, industry and antique gallery dealers.

• This distributor also carries antique prints, etchings and original art on paper and is interested in buying/selling to trade.

Needs Seeking creative and decorative art for the commercial and designer markets. Also seeking landscapes. "Handpulled graphics are our main area." Also considers oil, acrylic, pastel, watercolor, tempera or mixed media. Prefers unframed series, up to 30×40 maximum. Artists represented include Buffet, White, Brent, Jackson, Mohn, Baily, Carlson, Coleman. Approached by 100 artists/year. Publishes the work of 5 emerging, 5 mid-career and 5 established artists/year. Distributes the work of 40 emerging, 40 mid-career and 5 established artists/year.

First Contact & Terms Send query letter with sample. Samples are filed or are returned only if requested. Responds in 2 weeks. Payment method is negotiated. "Our standard commission is 50% less 50% off retail." Offers an advance when appropriate. Provides insurance while work is at firm, shipping from firm and written contract.

Tips "We find we cannot sell b&w only. Best colors emerald, mauve, blues and gem tones. Leave wide margins on prints. Send all samples before end of May each year as our main sales are targeted for summer. We do a lot of business with birds, botanicals, boats and shells—anything nautical."

MACH 1, LLC

2415 Sagamore Pkwy. S., Lafayette IN 47905. (800)955-6224. Fax: (765)446-2144. E-mail: sales@mach1.com. Web site: www.mach1.com. **Vice President Marketing:** James Gordon. Estab. 1987. Art publisher. Publishes unlimited and limited editions and posters. Clients: museums, galleries, frame shops and mail order customers. Current clients include the Smithsonian Museum, the Intrepid Museum, Deck the Walls franchisers and Sky's The Limit.

Needs Seeking creative and decorative art for the commercial and designer markets. Considers mixed media. Prefers aviation related themes. Artists represented include Jarrett Holderby and Jay Haiden. Editions created by collaborating with the artist or by working from an existing painting. Publishes the work of 2-3 emerging, 2-3 mid-career and 2-3 established artists/year.

First Contact & Terms Send query letter with résumé, slides and photographs. Samples are not filed and are returned. Responds in 1 month. To show a portfolio, mail slides and photographs. Pays royalties. Offers an advance when appropriate. Requires exclusive representation of the artist. Provides promotion, shipping to and from firm and a written contract.

Tips "Find a good publisher."

MAIN FLOOR EDITIONS

4943 McConnell Ave., Suite Y, Los Angeles CA 90066. (310)823-5686. Fax: (310)823-4399. **Art Director:** Jim Ketterl. Estab. 1996. Poster company, art publisher and distributor. Publishes/distributes limited edition, unlimited edition and posters. Clients: distributors, retail chain stores, galleries, frame shops, O.E.M. framers.

Needs Seeking creative, fashionable and decorative art for the commercial and designer markets. Considers

oil, acrylic, watercolor, mixed media, pastel and photography. Artists represented include Allayn Stevens, Inka Zlin and Peter Colvin. Editions created by collaborating with the artist or by working from an existing painting. Approached by 100 artists/year. Publishes work of 30 emerging, 15 mid-career and 10 established artists/year. Distributes the work of 5 emerging, 3 mid-career and 2 established artists/year.

First Contact & Terms Send query letter with brochure, photocopies, photographs and tearsheets. Samples are filed and are not returned. Responds in 6 months only if interested. Company will contact artist for portfolio review if interested. Portfolio should include photographs, slides and tearsheets. Pays flat fee $300-700; royalties of 10%. Offers advance when appropriate. Negotiates rights purchased. Requires exclusive representation of artist. Finds artists through art fairs, sourcebooks and word of mouth.

Tips "Follow catalog companies—colors/motifs."

SEYMOUR MANN, INC.

230 Fifth Ave., Suite 910, New York NY 10001. (212)683-7262. Fax: (212)213-4920. E-mail: smanninc@aol.com. Web site: www.seymourmann.com. Manufacturer.

Needs Seeking fashionable and decorative art for the serious collector and the commercial and designer markets. Also needs freelancers for design. 15% of products require freelance design. Considers watercolor, mixed media, pastel, pen & ink and 3-D forms. Editions created by collaborating with the artist. Approached by "many" artists/year. Publishes the work of 2-3 emerging, 2-3 mid-career and 4-5 established artists/year.

Tips "Focus on commercial end purpose of art."

MAPLE LEAF PRODUCTIONS

391 Steelcase Rd. W, Unit 24, Markham ON L3R 3V9 Canada. (905)940-9229. Fax: (905)940-9761. E-mail: ssillcox@ca.inter.net. Web site: www.mapleleafproductions.com. **Contact:** Scott Sillcox, president. Estab. 1993. Art publisher. Publishes sports art (historical), limited edition, posters, unlimited edition. Clients distributors, frame shops, gift shops and museum shops.

Needs Considers watercolor. Please see our Web site for the theme and style. Artists represented include Tino Paolini, Nola McConnan, Bill Band. Editions created provide the artist with source material. Approached by 5 artists/year. Publishes/distributes 1 emerging artist/year.

First Contact & Terms Send e-mail. Accepts e-mail submissions with link to Web site. Prefers TIFF, JPEG, GIF, EPS. Responds in 1 week. Negotiates payment. Offers advance when appropriate. Buys all rights. Provides written contract. Finds artists through word of mouth.

Tips "We require highly detailed watercolor artists, especially those with an understanding of sports and the human body. Attention to small details is a must."

MARCO FINE ARTS

201 Nevada St., El Segundo CA 90245. (310)615-1818. Fax: (310)615-1850. E-mail: info@marcofinearts.com. Web site: www.marcofinearts.com. Publishes/distributes limited edition, fine art prints and posters. Clients: galleries, decorators and frame shops.

Needs Seeking creative and decorative art for the serious collector and design market. Considers oil, acrylic and mixed media. Prefers landscapes, florals, figurative, Southwest, contemporary, impressionist, antique posters. Accepts outside serigraph and digital printing (giclée) production work. Artists represented include Guy Buffet, Linda Kyser Smith and Nobu Haihara. Editions created by collaborating with the artist or working from an existing painting. Approached by 80-100 artists/year. Publishes the work of 3 emerging, 3 mid-career and 3-5 established artists/year.

First Contact & Terms Send query letter with brochure, photocopies, photographs, photostats, résumé, SASE, slides, tearsheets and transparencies. Accepts disk submissions. Samples are filed and are returned by SASE. Responds only if interested. Company will contact artist for portfolio review or original artwork (show range of ability) if interested. Payment to be discussed. Requires exclusive representation of artist.

BRUCE MCGAW GRAPHICS, INC.

389 W. Nyack Rd., West Nyack NY 10994. (845)353-8600. Fax: (845)353-8907. E-mail: acquisitions@bmcgaw.com. Web site: www.bmcgaw.com. **Product Development:** Katy Murphy. Clients: poster shops, galleries, I.D., frame shops.

● Bruce McGaw publishes nearly 300 images per year.

Needs Artists represented include Romero Britto, David Doss, Ray Hendershot, Jacques Lamy, Eve Shpritser, Beverly Jean, Peter Sculthorpe, Bob Timberlake, Robert Bateman, Michael Kahn, Albert Swayhoover, and P.G. Gravele. Other important fine art poster licenses include Disney, Andy Warhol, MOMA, New York and others. Publishes the work of 30 emerging and 30 established artists/year.

First Contact & Terms Send slides, disks (JPEGs), transparencies or any other visual material that shows the work in the best light. "We review all types of 2-dimensional art with no limitation on media or subject. Review

period is 1 month, after which time we will contact you with our decision. If you wish the material to be returned, enclose a SASE. If forwarding material electronically, send easily opened JPEG files for initial review consideration only. 10-15 JPEGs are preferred. Referrals to artists' Web sites will not be addressed.'' Contractual terms are discussed if work is accepted for publication.'' Forward 20-60 examples. We look for a body of work from which to publish.

Tips ''Simplicity is very important in today's market (yet there still needs to be 'a story' to the image). Form and palette are critical to our decision process. We have a tremendous need for decorative pieces, especially new abstracts, landscapes and florals. Decorative still life images are very popular, whether painted or photographed, and much needed as well. There are a lot of prints and posters being published into the marketplace these days. Market your best material! Review our catalog at your neighborhood gallery or poster shop or visit our Web site before submitting. Send your best.''

MILITARY GALLERY

(formerly Military Publishing), 821 E. Ojai Ave., Ojai CA 93023. (805)640-0057. Fax: (805)640-0059. E-mail: milgallery@aol.com. Web site: www.militarygallery.com. **President:** Rick Taylor. Estab. 1967. Art publisher and distributor. Publishes/distributes limited edition, unlimited edition, canvas transfers, fine art prints, offset reproduction and posters. Clients galleries and mail order. Current clients include The Soldier Factory and Virginia Bader Fine Art.

Needs Seeking creative, fashionable and decorative art. Considers oil, acrylic, watercolor and pen & ink. Prefers aviation and maritime. Artists represented includeGerald Coulson, Richard Taylor, Robert Taylor and Simon Atack. Editions created by collaborating with the artist or by working from an existing painting. Approached by 10 artists/year. Publishes and distributes work of 1 emerging, 1 mid-career and 1 established artist/year.

First Contact & Terms Send query letter with photographs, slides, tearsheets and transparencies. Samples are not filed and are returned with SASE. Prefers high resolution e-mail submissions.Responds in 1 month. Company will contact artist for portfolio review if interested. Portfolio should include photographs, tearsheets and transparencies. Payment negotiable. Buys all rights. Requires exclusive representation of artist. Provides advertising, promotion and written contract. Finds artists through word of mouth.

Tips ''Get to know us via our catalogs.''

MILL POND PRESS COMPANIES

310 Center Court, Venice FL 34285. (800)535-0331. Fax: (941)497-6026. E-mail: ellen@millpond.com. Web site: www.millpond.com. **Public Relations Director:** Ellen Collard. Licensing: Angela Sauro. Estab. 1973. Publishes limited editions, unlimited edition, offset reproduction and giclees. Divisions include Mill Pond Press, Visions of Faith, Mill Pond Art Licensing and NextMonet. Clients: galleries, frameshops and specialty shops, Christian book stores, licensees. Licenses various genres on a range of products.

Needs Seeking creative, decorative art. Open to all styles, primarily realism. Considers oil, acrylic, watercolor and mixed media. Prefers wildlife, spiritual, figurative, landscapes and nostalgic. Artists represented include Paul Calle, Kathy Lawrence, Jane Jones, John Seerey-Lester, Robert Bateman, Carl Brenders, Nita Engle, Luke Buck and Maynard Reece. Editions created by collaborating with the artist or by working from an existing painting. Approached by 400-500 artists/year. Publishes the work of 2-3 emerging, 2-3 mid-career and 8-10 established artists/year. The company has a program to assist independent artists who want to self publish.

First Contact & Terms Send query letter with photographs, résumé, SASE, slides, transparencies and description of artwork. Samples are not filed and are returned by SASE. Responds in 1 year. Company will contact artist for portfolio review if interested. Pays royalties. Rights purchased vary according to project. Requires exclusive representation of artist. Provides advertising, in-transit insurance, insurance while work is at firm, promotion, shipping to and from firm and written contract. Finds artists through art exhibitions, submissions and word of mouth.

Tips ''We continue to expand the genre published. Inspirational art has been part of expansion. Realism is our base but we are open to looking at all art.''

MODERNART EDITIONS

165 Chubb Ave., Lyndhurst NJ 07071. (201)842-8500. Fax: (201)842-8546. E-mail: submitart@theartpublishinggroup.com. Web site: www.modernarteditions.com. **Contact:** Artists Submissions. Estab. 1973. Art publisher and distributor of ''top of the line'' open edition posters and offset reproductions. Clients: galleries and custom frame shops worldwide.

Needs Seeking decorative art for the commercial and designer markets. Considers oil, watercolor, mixed media, pastel and acrylic. Prefers fine art abstract and contemporary, floral, representational, still life, decorative, collage, mixed media. Size 16×20. Artists represented include Carol Ann Curran, Diane Romanello, Pat Woodworth, Patrick Adam, Penny Feder, Kathryn Doherty, and Laura Duggan. Editions created by collaboration with

the artist or by working from an existing painting. Approached by 200 artists/year. Publishes the work of 10-15 emerging artists/year. Distributes the work of 100 emerging artists/year.
First Contact & Terms Submit low-res Jpegs to artists submissions at the Web site. Limit 4 files, no more than 300 KB each. Submissions via e-mail are accepted. Responds in 6 weeks. Publisher/distributor will contact artist for portfolio review if interested. Portfolio should include color photostats, photographs, slides and trasparencies. Pays flat fee of $200-300 or royalties of 10%. Offers advance against royalties. Provides insurance while work is at firm, shipping to firm and written contract.

MORIAH PUBLISHING, INC.
23500 Mercantile Rd., Unit B, Beechwood OH 44122. (216)595-3131. Fax: (216)595-3140. E-mail: rouven@moriahpublishing.com. Web site: www.moriahonline.com. **Contact:** Rouven R. Cyncynatus. Estab. 1989. Art publisher and distributor of limited editions. Licenses wildlife and nature on all formats. Clients wildlife art galleries.
Needs Seeking artwork for the serious collector. Editions created by working from an existing painting. Now printing Giclée. Approached by 100 artists/year. Publishes the work of 6 and distributes the work of 15 emerging artists/year. Publishes and distributes the work of 10 mid-career artists/year. Publishes the work of 30 and distributes the work of 10 established artists/year.
First Contact & Terms Send query letter with brochure showing art style, slides, photocopies, résumé, photostats, transparencies, tearsheets and photographs. Responds in 2 months. Write for appointment to show portfolio or mail appropriate materials rough, b&w, color photostats, slides, tearsheets, transparencies and photographs. Pays royalties. No advance. Buys reprint rights. Requires exclusive representation of artist. Provides in-transit insurance, promotion, shipping to and from firm, insurance while work is at firm and a written contract.
Tips "Artists should be honest, patient, courteous, be themselves, and make good art."

MUNSON GRAPHICS
1209 Parkway Dr., Suite A, Santa Fe NM 87507. (505)424-4112. Fax: (505)424-6338. E-mail: michael@munsongraphics.com. Web site: www.munsongraphics.com. **President:** Michael Munson. Estab. 1997. Poster company, art publisher and distributor. Publishes/distributes limited edition, fine art prints and posters. Clients: galleries, museum shops, gift shops and frame shops.
Needs Seeking creative art for the serious collector and commercial market. Considers oil, acrylic, watercolor and pastel. Artists represented include O'Keeffe, Baumann, Nieto, Abeyta. Editions created by working from an existing painting. Approached by 75 artists/year. Publishes work of 3-5 emerging, 3-5 mid-career and 3-5 established artists/year. Distributes the work of 5-10 emerging, 5-10 mid-career and 5-10 established artists/year.
First Contact & Terms Send query letter with slides, SASE and transparencies. Samples are not filed and are returned by SASE. Responds in 1 month. Company will contact artist for portfolio review if interested. Negotiates payment. Offers advance. Rights purchased vary according to project. Provides written contract. Finds artists through art exhibitions, art fairs, word of mouth and artists' submissions.

■ MUSEUM EDITIONS WEST
4130 Del Rey Ave., Marina Del Rey CA 90292. (310)822-2558. Fax: (310)822-3508. E-mail: sales@museumeditionswest.com. Web site: www.museumeditionswest.com. **Director:** Grace Yu. Poster company, distributor, gallery. Distributes unlimited editions, canvas transfers, posters. Clients: galleries, decorators, frame shops, distributors, architects, corporate curators, museum shops, giftshops. Current clients include San Francisco Modern Art Museum and The National Gallery, etc.
Needs Seeking creative, fashionable art for the commercial and designer markets. Considers oil, acrylic, watercolor, pastel. Prefers landscape, floral, abstract. Artists represented include John Botzy and Carson Gladson. Editions created by working from an existing painting. Approached by 150 artists/year. Publishes/distributes the work of 5 mid-career and 20 established artists/year. Also needs freelancers for design.
First Contact & Terms Send query letter with brochure, photocopies, photographs, résumé, SASE, slides, tearsheets, transparencies. May submit via e-mail with a link to artists' Web site. Samples are not filed and are returned by SASE. Responds in 3 months. Company will contact artist for portfolio review of photographs, slides, tearsheets and transparencies if interested. Pays royalties of 8-10%. Offers advance when appropriate. Rights purchased vary according to project. Provides advertising, insurance while work is at firm, promotion, shipping from firm, written contract. Finds artists through art exhibitions, art fairs, word of mouth, submissions.
Tips "Look at our existing catalog or Web site for samples."

NEW YORK GRAPHIC SOCIETY
129 Glover Ave., Norwalk CT 06850. (203)661-2400. Fax: (203)846-2105. Web site: www.nygs.com. **Publisher:** Richard Fleischmann. President: Owen Hickey. Estab. 1925. Publisher of offset reproductions, posters, unlimited

edition. Clients: galleries, frame shops and museums shops. Current clients include major retailers throughout the country.

Needs Considers oil, acrylic, pastel, watercolor, mixed media and colored pencil drawings. Publishes reproductions, posters. Artists represented include Dan Campanelli, Doug Rega. Publishes and distributes the work of numerous emerging artists/year. Art guidelines free with SASE. Response to submissions in 90 days.

First Contact & Terms Send query letter with transparencies or photographs. All submissions returned to artists by SASE after review. Pays royalties of 10%. Buys all print reproduction rights. Provides in-transit insurance from firm to artist, insurance while work is at firm, promotion, shipping from firm and a written contract; provides insurance for art if requested. Finds artists through submissions/self promotions, magazines, visiting art galleries, art fairs and shows.

Tips "We publish a broad variety of styles and themes. We actively seek all sorts of fine decorative art."

NEXTMONET

310 Center Ct., Venice FL 34285. (888)914-5050. Fax: (941)497-6026. E-mail: service@nextmonet.com. Web site: www.nextmonet.com. **Contact:** Artwork Submissions. Estab. 1998. Art publisher, distributor. Publishes/distributes limited edition and fine art prints as well as originals. Clients: decorators, corporate curators and private consumers.

Needs Seeking creative, temporary, and decorative art for the serious collector, commercial and designer markets. Considers oil, acrylic, watercolor, mixed media, pastel, pen & ink and photography. Prefers all styles. Artists represented include Tjasa Owen, Heli Hofmann, Carol Jessen, Tim Schaible, and Sarah Waldron. Editions created by collaborating with the artist and working from an existing painting. Approached by 500 artists/year.

First Contact & Terms Send query letter with résumé, SASE, slides and documentation for each work: title, date, media, dimension and edition number, if applicable. Include artist's statement. Do not send digital submissions in any format. Samples are filed, kept on disk or returned by SASE. Portfolio review not required. Finds artists through World Wide Web, sourcebooks, art exhibitions, art fairs, artists' submissions, publications and word of mouth.

NORTHLAND POSTER COLLECTIVE

1613 E. Lake St., Minneapolis MN 55407. (612)721-2273. E-mail: art@northlandposter.com. Web site: www.northlandposter.com. **Manager:** Ricardo Levins Morales. Estab. 1979. Art publisher and distributor of handpulled originals, unlimited editions, posters and offset reproductions. Clients: mail order customers, teachers, bookstores, galleries, unions.

Needs "Our posters reflect themes of social justice and cultural affirmation, history, peace." Artists represented include Christine Wong, Beatriz Aurora, Betty La Duke, Ricardo Levins Morales and Janna Schneider. Editions created by collaborating with the artist or by working from an existing painting.

First Contact & Terms Accepts digital files. Samples are filed or are returned by SASE. Responds in months; if does not report back, the artist should write or call to inquire. Write for appointment to show portfolio. Payment method is negotiated. Offers an advance when appropriate. Negotiates rights purchased. Contracts vary, but artist always retains ownership of artwork. Provides promotion and a written contract.

Tips "We distribute work that we publish as well as pieces already printed. We screenprint as well as produce digital prints."

OLD GRANGE GRAPHICS

40 Scitico Rd., Somersville CT 06072. (800)282-7776. Fax: (800)437-3329. E-mail: greg@denunzio.com. Web site: www.oldgrangegraphics.com. **CEO/President:** Gregory Panjian. Estab. 1976. Distributor/canvas transfer studio. Publishes/distributes canvas transfers, posters. Clients: galleries, frame shops, museum shops, publishers, artists.

Needs Seeking decorative art for the commercial and designer markets. Considers lithographs. Prefers prints of artworks that were originally oil paintings. Editions created by working from an existing painting. Approached by 100 artists/year.

First Contact & Terms Send query letter with brochure. Samples are not filed and are returned. Responds in 1 month. Will contact artist for portfolio review of tearsheets if interested. Negotiates payment. Rights purchased vary according to project. Provides promotion and shipping from firm. Finds artists through art publications.

Tips Recommends Galeria, Artorama and ArtExpo shows in New York and *Decor, Art Trends, Art Business News* and *Picture Framing* as tools for learning the current market.

OLD WORLD PRINTS, LTD.

8080 Villa Park Drive, Richmond VA 23228. (804)213-0600. Fax: (804)213-0700. E-mail: LLemco@oldworldprintsltd.com. Web site: www.oldworldprintsltd.com. **President:** Scott Ellis. Licensing: Lonnie Lemco. Estab. 1973. Art publisher and distributor of open-edition, hand-printed reproductions of antique engravings as well as all

subject matter of color printed art. Clients: retail galleries, frame shops and manufacturers, hotels and fund raisers.

- Old World Prints reports the top-selling art in their 10,000-piece collection includes botanical and decorative prints.

Needs Seeking traditional and decorative art for the commercial and designer markets. Specializes in handpainted prints. Considers "b&w (pen & ink or engraved) art which can stand by itself or be hand painted by our artists or originating artist." Prefers traditional, representational, decorative work. Editions created by collaborating with the artist. Distributes the work of more than 1,000 artists. "Also seeking golf, coffee, tea, and exotic floral images."

First Contact & Terms Send query letter with brochure showing art style or résumé and tearsheets and slides. Samples are filed. Responds in 6 weeks. Write for appointment to show portfolio of photographs, slides and transparencies. Pays flat fee of $100/piece and royalties of 10% of profit. Offers an advance when appropriate. Negotiates rights purchased. Provides in-transit insurance, insurance while work is at firm, promotion, shipping from firm and a written contract. Finds artists through word of mouth.

Tips "We are a specialty art publisher, the largest of our kind in the world. We are actively seeking artists to publish and will consider all forms of art."

PALOMA EDITIONS

2906 Morton Way, San Diego CA 92139. (619)434-8056. Fax: (619)434-8057. E-mail: customerservice@palomaeditions.com. Web site: www.palomaeditions.com. **Publisher:** Kim A. Butler. Art publisher/distributor of limited and unlimited editions, fine art prints, offset reproductions and posters. Specializes in African-American art. Clients include galleries, specialty shops, retail chains, framers, distributors, museum shops.

Needs Seeking creative and decorative art for the commercial and designer market. Considers all media. Prefers African-American art. Artists represented include Albert Fennell, Raven Williamson, Tod Haskin Fredericks. Editions created by working from existing painting. Approached by hundreds of artists/year. Publishes the work of 4 emerging artists/year. Distributes the work of 10 emerging artists/year.

First Contact & Terms Send query letter with brochure, photocopies, photographs, tearsheets and/or transparencies or JPEGs. Samples are returned by SASE, only if requested. Responds in 2 months, only if interested. Publisher will contact for portfolio review of color final art, photographs, tearsheets and transparencies if interested. Payment negotiable, royalties vary. Offers advance when appropriate. Negotiates rights purchased. Requires exclusive representation of artist. Provides advertising, promotion, shipping and written contract. Also needs designers. Prefers designers who own IBM PCs. Freelance designers should be experienced in QuarkXPress, Photoshop and FreeHand. Finds artists through art shows, magazines and referrals.

Tips "African-American art is hot! Read the trade magazines and watch the furniture and fashion industry. Keep in mind that your work must appeal to a wide audience. It is helpful if fine artists also have basic design skills so they can present their artwork complete with border treatments. We advertise in *Decor, Art Business News, Art Trends.* See ads for examples of what we choose to publish."

PENNY LANE PUBLISHING INC.

1791 Dalton Dr., New Carlisle OH 45344. (937)849-1101. Fax: (937)849-9666. E-mail: info@PennyLanePublishing.com. Web site: www.PennyLanePublishing.com. **Art Coordinators:** Kathy Benton and Stacey Bidlack. Licensing: Renee Franck and Beth Schenck. Estab. 1993. Art publisher. Publishes limited editions, unlimited editions, offset reproductions. Clients: galleries, frame shops, distributors, decorators.

Needs Seeking creative, decorative art for the commercial market. Considers oil, acrylic, watercolor, mixed media, pastel. Artists represented include Linda Spivey, Donna Aleins, Becca Barton, Pat Fischer, Annie LaPoint, Fiddlestix, Mary Ann June. Editions created by collaborating with the artist or working from an existing painting. Approached by 40 artists/year. Publishes the work of 3-4 emerging, 15 mid-career and 6 established artists/year.

First Contact & Terms Send query letter with brochure, résumé, photographs, slides, tearsheets. Samples are filed or returned by SASE. Responds in 2 months. Company will contact artist for portfolio review of color, final art, photographs, slides, tearsheets if interested. Pays royalties. Buys first rights. Requires exclusive representation of artist. Provides advertising, shipping from firm, promotion, written contract. Finds artists through art exhibitions, art fairs, submissions, decorating magazines.

Tips Advises artists to be aware of current color trends and work in a series. "Please review our Web site to see the style of artwork we publish."

🌐 PGM ART WORLD

Carl-von-Linde-Str. 33, Garching 85738 Germany. (01149)89-320-02-170. Fax: (01149)89-320-02-270. E-mail: info@pgm-art-world.com. Web site: www.pgm-art-world.de. **Contact:** Andrea Kuborn. Estab. 1969. International fine art publisher, distributor, gallery. Publishes/distributes limited and unlimited edition, offset reproduc-

tions, art prints, giclees, art cards. Worldwide supplier of galleries, framers, distributors, decorators.

- This publisher's main office is in Germany. PGM publishes around 180 images within one year and distributes more than 5,000 images. The company also operates three galleries in Munich.

Needs Seeking creative, fashionable and decorative art for the commercial and designer markets. Considers oil, acrylic, watercolor, mixed media, pastel, pen & ink, photography, and digital art. Considers any well accomplished work of any theme or style. Artists represented include Renato Casaro, Marianne Bernhardt, Ellen Filatov, Erika Heinemann, Vladimir Gorsky and others. Editions created by working from an existing painting. Approached by more than 350 artists/year.

First Contact & Terms Send query letter with photographs, résumé, SASE, slides, color copies, color prints or in digital (JPEG) format on CD-ROM. Samples are returned. Responds with-in 1-2 months. Will contact artist for portfolio review if interested. Pays royalties, negotiable. Does not require exclusive representation of artist. Provides promotion of prints in catalogs and promotional material, presentation of artists (biography & photo) on Web site.

Tips "Get as much exposure as possible on art shows and with own Web site."

PORTFOLIO GRAPHICS, INC.

P.O. Box 17437, Salt Lake City UT 84117. (801)424-2574. E-mail: info@portfoliographics.com. Web site: www.n ygs.com. **Creative Director:** Kent Barton. Estab. 1986. Publishes and distributes open edition prints and posters. Clients: galleries, designers, poster distributors (worldwide) and framers. Licensing: Most artwork is available for license for large variety of products. Portfolio Graphics works with a large licensing firm who represents all of their imagery.

Needs Seeking creative, fashionable and decorative art for commercial and designer markets. Considers oil, watercolor, acrylic, pastel, mixed media and photography. Publishes 100+ new works/year. Editions created by working from an existing painting, transparency or high-resolution digital file.

First Contact & Terms Send query letter with résumé, bio and the images you are submitting via photos, transparencies, tearsheets or gallery booklets. Please be sure to label each item. Please do no send original artwork. Make sure to include a SASE for any materials you would like returned. Samples are not filed. Responds in 3 months. Pays royalties of 10%. Provides promotion and a written contract.

Tips "We find artists through galleries, magazines, art exhibits, submissions. We're looking for a variety of artists and styles/subjects."

N POSNER FINE ART

13234 Fiji Way, Suite G, Marina Del Rey CA 90292. (310)318-8622. Fax: (310)578-8501. E-mail: posart1@aol.net. Web site: posnergallery.com. **Director:** Judith Posner and Wendy Posner. Estab. 1994. Art distributor and gallery. Distributes fine art prints, monoprints, sculpture and paintings. Clients galleries, frame shops, distributors, architects, corporate curators, museum shops. Current clients include Renaissance Hollywood Hotel, NWQ Co., Royal Specialty.

Needs Seeking creative art for the serious collector and commercial market. Considers oil, acrylic, watercolor, mixed media, sculpture. Prefers very contemporary style. Artists represented include Robert Indiana, Greg Gummersall and Michael Gallagher. Editions created by collaborating with the artist. Approached by hundreds of artists/year. Distributes the work of 5-10 emerging, 5 mid-career and 200 established artists/year. Art guidelines free for SASE with first-class postage.

First Contact & Terms Send slides. "Must enclose self-addressed stamped return envelope." Samples are filed or returned. Responds in a few weeks. Pays on consignment basis firm receives 50% commission. Buys one-time rights. Provides advertising, promotion, insurance while work is at firm. Finds artists through art fairs, word of mouth, submissions, attending exhibitions, art reps.

Tips "Know color trends of design market. Look for dealer with same style in gallery." Send consistent work.

POSTER PORTERS

P.O. Box 9241, Seattle WA 98109-9241. (800)531-0818. Fax: (206)286-0820. E-mail: markwithposterporters@ms n.com. Web site: www.posterporters.com. **Marketing Director:** Mark Simard. Art rep/publisher/distributor/gift wholesaler. Publishes/distributes limited and unlimited edition, posters and art T-shirts. Clients: galleries, decorators, frame shops, distributors, corporate curators, museum shops, giftshops.

Needs Publishes/distributes creative art for regional commercial and designer markets. Considers oil, watercolor, pastel. Prefers regional art. Artists represented include Beth Logan, Carolin Oltman, Rebecca Collins, Jean Casterline, M.J. Johnson. Art guidelines free for SASE with first-class postage. Editions created by collaborating with the artist or working from an existing painting. Approached by 144 artists/year. Publishes the work of 2 emerging, 2 mid-career and 1 established artist/year. Distributes the work of 50 emerging, 25 mid-career, 20 established artists/year.

First Contact & Terms Send photocopies, SASE, tearsheets. Accepts disk submissions. Samples are filed or

returned by SASE. Will contact artist for Friday portfolio drop off. Pays flat fee $225-500; royalties of 5%. Offers advance when appropriate. Buys all rights. Provides advertising, promotion, contract. Also works with freelance designers. Prefers local designers only. Finds artists through exhibition, art fairs, art reps, submissions.
Tips ''Be aware of what is going on in the interior design sector. Be able to take criticism. Be more flexible.''

⚡ POSTERS INTERNATIONAL
1180 Caledonia Rd. North York ON M6A 2W5 Canada. (416)789-7156. Fax: (416)789-7159. E-mail: art@postersi nternational.net. Web site: www.postersinternational.net. **President:** Esther Cohen-Bartfield. Licensing: Richie Cohen. Estab. 1976. Poster company, art publisher. Publishes fine art posters. Licenses for gift and stationery markets. Clients: galleries, decorators, distributors, hotels, restaurants etc., in U.S., Canada and international. Current clients include Holiday Inn and Bank of Nova Scotia.
Needs Seeking creative, fashionable art for the commercial market. Considers oil, acrylic, watercolor, mixed media, b&w and color photography. Prefers landscapes, florals, abstracts, photography, vintage, collage and tropical imagery. Editions created by collaborating with the artist or by working from an existing painting. Approached by 100 artists/year. Art guidelines free for SASE with first-class postage or IRC.
First Contact & Terms Send query letter with brochure, photographs, slides, transparencies to Esther Cohen-Bartfield. ''No originals please!'' Samples are filed or returned by SASE. Responds in 2 months. Company will contact artist for portfolio review of photographs, photostats, slides, tearsheets, thumbnails, transparencies if interested. Pays flat fee or royalties of 10%. Offers advance when appropriate. Rights purchased vary according to project. Provides advertising, promotion, shipping from firm, written contract. Finds artists through art fairs, art reps, submissions.
Tips ''Be aware of current color trends and always work in a series of two or more. Visit poster shops to see what's popular before submitting artwork.''

PRIME ART PRODUCTS
2800 S. Nova Rd., Bldg. A, South Daytona FL 32119. (800)749-7393. Fax: (386)788-6577 E-mail: tropicalframe@a ol.com. Web site: www.primeartproducts.com. **Owner:** Ken Kozimor. Estab. 1990. Art publisher, distributor. Publishes/distributes limited editions, unlimited editions, fine art prints, offset reproductions. Clients include galleries, specialty giftshops, interior design and home accessory stores.
Needs Seeking art for the commercial and designer markets. Considers oil, Gicleé acrylic, watercolor. Prefers realistic shore birds and beach scenes. Artists represented include Robert Binks, Keith Martin Johns, Christi Mathews, Art LaMay and Barbara Klein Craig. Editions created by collaborating with the artist or by working from an existing painting. Approached by 30 artists/year. Publishes the work of 1-2 emerging artists/year. Distributes the work of many emerging and 4 established artists/year.
First Contact & Terms Send photographs, SASE and tearsheets. Samples are filed or returned by SASE. Responds in 5 days. Company will contact artist for portfolio review if interested. Negotiates payment per signature. Offers advance when appropriate. Rights purchased vary according to project. Finds artists through submissions and small art shows.

⚡ PROGRESSIVE EDITIONS
37 Sherbourne St., Toronto ON M5A 2P6 Canada. (416)860-0983. Fax: (416)367-2724. E-mail: info@progressive editions.com. Web site: www.progressivefineart.com. **President:** Mike Havers. Estab. 1982. Art publisher. Publishes handpulled originals, limited edition fine art prints and monoprints. Clients galleries, decorators, frame shops, distributors.
Needs Seeking creative and decorative art for the serious collector and designer market. Considers oil, acrylic, watercolor, mixed media, pastel. Prefers figurative, abstract, landscape and still lifes. Artists represented include Emilija Pasagic, Doug Edwards, Marsha Hammel. Editions created by working from an existing painting. Approached by 100 artists/year. Publishes the work of 4 emerging artists/year. Distributes the work of 10 emerging artists/year.
First Contact & Terms Send query letter with photographs, slides. Samples are not filed and are returned. Responds in 1 month. Will contact artist for portfolio review if interested. Negotiates payment. Offers advance when appropriate. Negotiates rights purchased. Requires exclusive representation of artist. Provides advertising, in-transit insurance, insurance while work is at firm, promotion, shipping and contract. Finds artists through exhibition, art fairs, word of mouth, art reps, sourcebooks, submissions, competitions.
Tips ''Develop organizational skills.''

RIGHTS INTERNATIONAL GROUP, LLC
453 First St., Hoboken NJ 07030. (201)239-8118. Fax: (201)222-0694. E-mail: info@rightsinternational.com. Web site: www.rightsinternational.com. **Contact:** Robert Hazaga. Estab. 1996. Agency for cross licensing. Represents artists for licensing into publishing, stationery, posters, prints, calendars, giftware, home furnishing.

Clients: giftware, stationery, posters, prints, calendars, wallcoverings and home decor publishers.
 ● This company is also listed in the Greeting Card, Gifts & Products section.
Needs Seeking creative, decorative art for the commercial and designer markets. Also looking for country/
Americana with a new fresh interpretation of country with more of a cottage influence. Think Martha Stewart,
Country Living magazine; globally inspired artwork. Considers all media. Prefers commercial style. See Web
site for artist represented. Approached by 50 artists/year.
First Contact & Terms Send brochure, photocopies, photographs, SASE, slides, tearsheets, transparencies,
JPEGs, CD-ROM. Accepts disk submissions compatible with PC platform. Samples are not filed and are returned
by SASE. Responds in 8 weeks. Company will contact artist for portfolio review if interested. Negotiates pay-
ment.
Tips "Check our Web site for trend, color and style forecasts!"

RINEHART FINE ARTS

A division of Bentley Publishing Group, 250 W. 57th St., Suite 2202A, New York NY 10107. (212)399-8958.
Fax: (212)595-5837. E-mail: hwrinehart@aol.com. Web site: www.bentleypublishinggroup.com. Poster/open
edition print publisher and product licensing agent. **President:** Harriet Rinehart. Licenses 2D artwork for posters.
Clients include large change stores and wholesale framers, furniture stores, decorators, frame shops, museum
shops, gift shops and substantial overseas distribution.
 ● Harriet Rinehart does product development for all five divisions of Bentley Publishing Group. See also
 listing for Bentley Publishing Group for more information on this publisher.
Needs Seeking creative, fashionable and decorative art. Considers oil, acrylic, watercolor, mixed media, pastel.
Images created by collaborating with the artist or working from an existing painting. Approached by 200-300
artists/year. Publishes the work of 50 new artists/year.
First Contact & Terms Send query letter with photographs, SASE, slides, tearsheets, transparencies or "what-
ever the artist has that represents artwork best." Samples are not filed. Responds in 3 months. Portfolio review
not required. Pays royalties of 8-10%. Rights purchased vary according to project. Provides advertising, promo-
tion, written contract and substantial overseas exposure.
Tips "Submit work in pairs or groups of four. Work in standard sizes. Visit high-end furniture store chains for
color trends."

⊞ FELIX ROSENSTIEL'S WIDOW & SON LTD.

33-35 Markham St., London SW3 3NR United Kingdom. (44)207-352-3551. Fax: (44)207-351-5300. E-mail:
sales@felixr.com. Web site: www.felixr.com. **Contact:** Ms. Anna Smithson. Licensing: Mr. Francis Blake. Estab.
1880. Publishes art prints and posters, both limited and open edition. Licenses all subjects on any quality
product. Art guidelines on Web site.
Needs Seeking decorative art for the serious collector and the commercial market. Considers oil, acrylic, water-
color, mixed media and pastel. Prefers art suitable for homes or offices. 500 artists represented. Editions created
by collaborating with the artist or by working from an existing painting. Approached by 200-500 artists/year.
First Contact & Terms Send query letter with photographs. Samples are not filed and are returned by SAE.
Responds in 2 weeks. Company will contact artist for portfolio review of final art and transparencies if interested.
Negotiates payment. Offers advance when appropriate. Rights purchased vary according to project.
Tips "We publish decorative attractive contemporary art."

RUSHMORE HOUSE PUBLISHING

P.O. Box 1591, Sioux Falls SD 57101-1591. (800)456-1895. Estab. 1989. Art publisher and distributor of limited
editions. Clients: art galleries and picture framers.
Needs Seeking artwork for the serious collector and commercial market. Considers oil, watercolor, acrylic,
pastel and mixed media. Prefers realism, all genres. Artists represented include W.M. Dillard and Tom Phillips.
Editions created by collaborating with the artist.
First Contact & Terms Send query letter with résumé, tearsheets, photographs and transparencies. Samples
are filed or are returned by SASE if requested by artist. Responds in 1 month. Write for appointment to show
portfolio of original/final art, tearsheets, photographs and transparencies. Payment method is negotiated. Offers
an advance when appropriate. Negotiates rights purchased. Exclusive representation of artist is negotiable.
Provides in-transit insurance, insurance while work is at firm, promotion, shipping and written contract. "We
market the artist and their work."
Tips "Current interests include wildlife, Native American, Western."

SAGEBRUSH FINE ART

3065 South West Temple, Salt Lake City UT 84115. (801)466-5136. Fax: (801)466-5048. E-mail: chris@sagebrush
fineart.com. Web site: www.sagebrushfineart.com. **Art Review Coordinator:** Stephanie Marrott. Licensing

Director: Dena Peat. Co-Owner: Mike Singleton. Estab. 1991. Art publisher. Publishes and licenses fine art prints and offset reproductions. Clients: frame shops, distributors, corporate curators and chain stores.

Needs Seeking decorative art for the commercial and designer markets. Considers all media. Open to all themes and styles. Current clients include Anita Phillips, Kim Lewis, Stephanie Marrott, Michael Humphries and Jo Moulton. Editions created by collaborating with the artist or by working from an existing painting. Publishes the work of new and emerging artists.

First Contact & Terms Send SASE, slides and transparencies. Samples are not filed and are returned by SASE. Responds in 4 weeks. Company will contact artist for portfolio review if interested. Pays royalties of 10% or negotiates payment. Offers advance when appropriate. Rights purchased vary according to project. Provides advertising, promotion, shipping from firm and written contract.

SCAFA ART, ART PUBLISHING GROUP

165 Chubb Ave., Lyndhurst NJ 07071. (201)842-8500. Fax: (201)842-8546. E-mail: submitart@theartpublishgroup.com. Web site: www.scafa.com. **Art Coordinator and Licensing:** John Bridgewater. Produces open edition offset reproductions. Clients: framers, commercial art trade and manufacturers worldwide. Licenses florals, still lifes, landscapes, animals, religious, etc. for placemats, puzzles, textiles, furniture, cassette/CD covers.

Needs Seeking decorative art for the wall decor market. Considers unframed decorative paintings, posters, photos and drawings. Prefers pairs and series. Artists represented include T.C. Chiu, Jack Sorenson, Kay Lamb Shannon. Editions created by collaborating with the artist and by working from a pre-determined subject. Approached by 100 artists/year. Publishes and distributes the work of dozens of artists/year. "We work constantly with our established artists, but are always on the lookout for something new."

First Contact & Terms Please submit low res. j-pegs via e-mail with limit of 4 files of no more than 300KB each. Responds in about 1 month. Pays $200-350 flat fee for some accepted pieces. Royalty arrangements with advance against 5-10% royalty is standard. Buys only reproduction rights. Provides written contract. Artist maintains ownership of original art. Requires exclusive publication rights to all accepted work.

Tips "Do not limit your submission. We are interested in seeing your full potential. Please be patient. All inquiries will be answered."

SCHIFTAN INC.

1300 Steel Rd. W, Suite 4, Morrisville PA 19067. (215)428-2900 or (800)255-5004. Fax: (215)295-2345. E-mail: schiftan@erols.com. Web site: www.schiftan.com. **President:** Harvey S. Cohen. Estab. 1903. Art publisher, distributor. Publishes/distributes unlimited editions, fine art prints, offset reproductions, posters and hand-colored prints. Clients: galleries, decorators, frame shops, architects, wholesale framers to the furniture industry.

Needs Seeking fashionable, decorative art for the commercial market. Considers watercolor, mixed media. Editions created by collaborating with the artist. Approached by 15-20 artists/year. Also needs freelancers for design.

First Contact & Terms Send query letter with transparencies. Samples are not filed and are returned. Responds in 1 week. Company will contact artist for portfolio review of final art, roughs, transparencies if interested. Pays flat fee or royalties. Offers advance when appropriate. Negotiates rights purchased. Provides advertising, written contract. Finds artists through art exhibitions, art fairs, submissions.

SCHLUMBERGER GALLERY

P.O. Box 2864, Santa Rosa CA 95405. (707)544-8356. Fax: (707)538-1953. E-mail: sande@schlumberger.org. **Owner:** Sande Schlumberger. Estab. 1986. Private Art Dealer, art publisher, distributor and gallery. Publishes and distributes limited editions, posters, original paintings and sculpture. Specializes in decorative and museum-quality art and photographs. Clients: collectors, designers, distributors, museums, galleries, film and television set designers. Current clients include: Bank of America Collection, Fairmont Hotel, Editions Ltd., Sonoma Cutter Vineyards, Dr. Robert Jarvis Collection and Tom Sparks Collection.

Needs Seeking decorative art for the serious collector and the designer market. Prefers trompe l'oeil, realist, architectural, figure, portrait. Artists represented include Charles Giulioli, Deborah Deichler, Susan Van Camden, Aurore Carnero, Borislav Satijnac, Robert Hughes, Fletcher Smith, Jacques Henri Lartigue, Ruth Thorn Thompson, Ansel Adams and Tom Palmore. Editions created by collaborating with the artist or by working from an existing painting. Approached by 50 artists/year.

First Contact & Terms Send query letter with tearsheets and photographs. Samples are not filed and are returned by SASE if requested by artist. Publisher/distributor will contact artist for portfolio review if interested. Portfolio should include color photographs and transparencies. Negotiates payment. Offers advance when appropriate. Rights purchased vary according to project. Provides advertising, in-transit insurance, insurance while work is at firm, promotion, shipping to and from firm, written contract and shows. Finds artists through exhibits, referrals, submissions and "pure blind luck."

Tips "Strive for quality, clarity, clean lines and light, even if the style is impressionistic. Bring spirit into your images. It translates!"

SEGAL FINE ART

594 S. Arthur Ave., Louisville CO 80027. (800)999-1297 or (303)926-6800. Fax: (303)926-0340. E-mail: sfa@sega lfineart.com. Web site: www.segalfineart.com; www.motorcycleart.com. **Artist Liason:** Ron Segal. Estab. 1986. Art publisher. Publishes limited editions. Clients galleries and H-D dealerships.

Needs Seeking creative and fashionable art for the serious collector and commercial market. Considers oil, watercolor, mixed media and pastel. Artists represented include David Mann, Scott Jacobs and Motor Marc Lacourciere. Publishes limited edition serigraphs, mixed media pieces and posters.

First Contact & Terms Send query letter with slides or résumé, bio and photographs. Samples are not filed and are returned by SASE. Responds in 2 months. To show portfolio, mail slides, color photographs, bio and résumé. Offers advance when appropriate. Negotiates payment method and rights purchased. Requires exclusive representation of artist. Provides promotion.

Tips Advises artists to "remain connected to their source of inspiration."

ROSE SELAVY OF VERMONT

P.O. Box 1528, Manchester Center VT 05255. (802)362-0373. Fax: (802)362-1082. E-mail: michael@applejackart .com. Web site: www.applejackart.com. Publishes/distributes unlimited edition fine art prints. Clients: galleries, decorators, frame shops, distributors, architects, corporate curators, museum shops and giftshops.

Needs Seeking decorative art for the serious collector, commercial and designer markets. Considers oil, acrylic, watercolor, mixed media, pastel and pen & ink. Prefers folk art, antique, traditional and botanical. Artists represented include Lisa Audit, Susan Clickner and Valorie Evers Wenk. Editions created by collaborating with the artist or by working from an existing painting.

First Contact & Terms Send query letter (or e-mail) with brochure (or JPEGs), photocopies, photographs, slides and tearsheets. Samples are not filed and are returned by SASE. Responds only if interested. Company will contact artist for portfolio review if interested. Negotiates payment. Offers advance when appropriate. Rights purchased vary according to project. Usually requires exclusive representation of artist. Provides promotion and written contract. Also needs freelancers for design. Finds artists through art exhibitions and art fairs.

▣ SIERRA SUN EDITIONS

3430 Robin Lane, #3A, Cameron Park CA 95682. (530)672-9181. Fax: (530)672-9186. Web site: www.sierrasune ditions.com. **Art Director:** Ravel Buckley. Art publisher, distributor. Publishes/distributes handpulled originals, limited editions, unlimited editions, canvas transfers, fine art prints, offset reproductions. Clients galleries, decorators, frame shops, distributors, architects, corporate curators, museum shops, gift-shops, and sports memorabilia and collectibles stores. Current clients include Sports Legacy, Field of Dreams, Deck the Walls and Sports Forum.

Needs Seeking creative, realistic portrayal of professional sports athletes for the serious collector, commercial and memorabilia markets. "We publish/distribute primarily professional team sports art, i.e., celebrity athletes of major leagues, National Football League, Major League Baseball. Considers oil, acrylic, watercolor, mixed media, pastel. Artists represented include Daniel M. Smith, Stephen Holland, Eric Franchimon. Rick Rush, Ryan Fritz, Samantha Wendell, Ben Teeter, Robert Revels, Eric Cash, Terry Crews. Editions created by collaborating with the artist or by working from an existing painting. Approached by 60 artists/year. Publishes the work of 1-2 emerging, 2-3 mid-career and 7 established artists/year. Distributes the work of 3-8 emerging, 3-8 mid-career and 4-8 established artists/year.

First Contact & Terms Send query letter with brochure, résumé, SASE, slides, tearsheets, photographs. Samples are filed or returned by SASE. Responds in 3 months. Company will contact artist for portfolio review of color, final art, thumbnails, transparencies if interested. Pays royalties of 10-20%; or on a consignment basis firm receives 20-40% commission for sale of originals. Negotiates payment regarding licensing of works. Offers advance when appropriate. May require exclusive representation of artist. Provides advertising, promotion, shipping from firm, written contract, trade shows, gallery shows. Finds artists through word of mouth, art trade shows, gallery owners.

Tips "Painting likenesses of celebrity athletes and the human body in action must be accurate. We seek strong concepts that can continue in repetitive series. Freedom of expression, artistic creativity and painterly techniques are acceptable and sought after in sports art. Any published sports art including athlete likeness and team marks must be licensed by the appropriate entities. Sierra Sun Editions is officially licensed by MLBP and NFLP."

▣ SOMERSET FINE ART

29366 McKinnon Road, P.O. Box 869, Fulshear, TX 77441. (800)444-2540. Fax: (713)465-6062. E-mail: sallen@s omersethouse.com. Web site: www.somersethouse.com. **Executive Vice President:** Stephanie Allen. Licensing: Daniel Klepper. Estab. 1972. Art publisher of fine art limited editions: giclees, canvas transfers and reproductions on paper. Clients include independent galleries in U.S. and Canada.

Needs Seeking fine art for the serious collector. Considers oil, acrylic, watercolor, mixed media, pastel. Also has a line of religious art. Artists represented include G. Harvey, Larry Dyke, Rod Chase, Nancy Glazier, Martin Grelle, James E. Seward, Bruce Greene, Bill Anton, Kathryn Fincher, Deborah Bays, David Mann, Ragan Gennusa and Andy Thomas. Editions created by collaborating with the artist or by working from an existing painting. Approached by 1,500 artists/year. Publishes the work of 4 emerging, 4 mid-career and 7 established artists/year.

First Contact & Terms Send query letter accompanied by 10-12 slides or photos representative of work with SASE. Do not send transparencies until requested. Will review art on Web site or submitted digital files in jpg format. Samples are filed for future projects unless return is requested. Responds in 1 month. Publisher will contact artist for portfolio review if interested. Pays royalties. Rights purchased vary according to project. Artist retains painting. Company provides advertising and promotion, insurance in-transit, shipping and written contract.

Tips "Considers mature, full-time artists. Special consideration given to artists with originals selling above $10,000. Be open to direction."

JACQUES SOUSSANA GRAPHICS

37 Pierre Koenig St., Jerusalem 91041 Israel. 972-2-6782678. Fax: 972-2-6782426. E-mail: jsgraphics@soussanart .com. Web site: www.soussanart.com. Estab. 1973. Art publisher. Publishes handpulled originals, limited editions, sculpture. Clients galleries, decorators, frame shops, distributors, architects. Current clients include Royal Beach Hotel, Moriah Gallery, London Contemporary Art.

Needs Seeking decorative art for the serious collector and designer market. Considers oil, watercolor and sculpture. Artists represented include Zina Roitman, Nachum Gutman and Moshe Castel. Editions created by collaborating with the artist. Approached by 20 artists/year. Publishes/distributes the work of 5 emerging artists/year.

First Contact & Terms Send query letter with brochure, slides. To show portfolio, artist should follow up with letter after initial query. Portfolio should include color photographs.

SPORTS ART INC

1675 Powers Lake Rd., Powers Lake WI 53159. (800)552-4430. Fax: (262)279-9830. **President:** Dean Chudy. Estab. 1989. Art publisher and distributor of limited and unlimited editions, offset reproductions and posters. Clients: over 2,000 active art galleries, frame shops and specialty markets.

Needs Seeking artwork with creative artistic expression for the serious collector and the designer market. Considers oil, watercolor, acrylic, pastel, pen & ink and mixed media. Prefers sports themes. Artists represented include Ken Call and Brent Hayes. Editions created by collaborating with the artist or working from an existing painting. Approached by 150 artists/year. Distributes the work of 30 emerging, 60 mid-career and 30 established artists/year.

First Contact & Terms Send query letter with brochure showing art style or résumé, tearsheets, SASE, slides and photographs. Accepts submissions on disk. Samples are filed or returned by SASE if requested by artist. To show a portfolio, mail thumbnails, slides and photographs. Pays royalties of 10%. Offers an advance when appropriate. Negotiates rights purchased. Sometimes requires exclusive representation of the artist. Provides promotion and shipping from firm.

Tips "We are interested in generic sports art that captures the essence of the sport as opposed to specific personalities."

SULIER ART PUBLISHING

PMB 55, 3735 Palomar Blvd., Suite 150, Lexington KY 40513. (859)621-5511. Fax: (859)296-0650. E-mail: info@NeilSulier.com. **Art Director:** Neil Sulier. Art publisher and distributor. Publishes and distributes hand-pulled originals, limited and unlimited editions, posters, offset reproductions and originals. Clients: designers.

Needs Seeking creative, fashionable and decorative art for the serious collector and the commercial and designer markets. Considers oil, watercolor, mixed media, pastel and acrylic. Prefers impressionist. Artists represented include Judith Webb, Neil Sulier, Eva Macie, Neil Davidson, William Zappone, Zoltan Szabo, Henry Faulconer, Mariana McDonald. Editions created by collaborating with the artist or by working from an existing painting. Approached by 20 artists/year. Publishes the work of 5 emerging, 30 mid-career and 6 established artists/year. Distributes the work of 5 emerging artists/year.

First Contact & Terms Send query letter with brochure, slides, photocopies, résumé, photostats, transparencies, tearsheets and photographs. Samples are filed or are returned. Responds only if interested. Request portfolio review in original query. Artist should follow up with call. Publisher will contact artist for portfolio review if interested. Portfolio should include slides, tearsheets, final art and photographs. Pays royalties of 10%, on consignment basis or negotiates payment. Offers advance when appropriate. Negotiates rights purchased (usually one-time or all rights). Provides in-transit insurance, promotion, shipping to and from firm, insurance while work is at firm and written contract.

SUMMIT PUBLISHING

746 Higuera, Suite 1, San Luis Obispo CA 93401. (805)549-9700. Fax: (805)549-9710. E-mail: pq444@aol.com. Web site: www.summitpublishingart.com. **Owner:** Ralph Gorton. Estab. 1987. Art publisher, distributor and gallery. Publishes and distributes handpulled originals and limited editions.

Needs Seeking creative, fashionable and decorative art for the serious collector. Considers oil, watercolor, mixed media and acrylic. Prefers fashion, contemporary work. Artists represented include Manuel Nunez, and Tim Huhn. Editions created by collaborating with the artist or by working from an existing painting. Approached by 20 artists/year. Publishes and distributes the work of emerging, mid-career and established artists.

First Contact & Terms Send j-pegs or postcard-size sample of work or send query letter with brochure, résumé, tearsheets, slides, photographs and transparencies. Samples are filed. Responds in 5 days. Artist should follow up with call. Publisher/distributor will contact artist for portfolio review if interested. Portfolio should include color thumbnails, roughs, final art, tearsheets and transparencies. Pays royalties of 10-15%, 60% commission or negotiates payment. Offers advance when appropriate. Buys first rights or all rights. Requires exclusive representation of artist. Provides advertising, in-transit insurance, insurance while work is at firm, promotion, shipping to and from firm and written contract. Finds artists through attending art exhibitions, art fairs, word of mouth and submissions. Looks for artists at Los Angeles Expo and New York Expo.

Tips Recommends artists attend New York Art Expo, ABC Shows.

SUN DANCE GRAPHICS & NORTHWEST PUBLISHING

9580 Delegates Dr., Orlando FL 32837. (407)240-1091. Fax: (407)240-1951. E-mail: sales@sundancegraphics. com or sales@northwestpublishing.com. Web site: www.sundancegraphics.com. **Art Director:** Kim Dooley. Estab. 1996. Publishers and printers of giclée prints, fine art prints, and posters. **Sun Dance Graphics** provides trend forward images to customers that manufacture for upscale Hospitality, Retail, and Home Furnishings markets. Primarily looking for images in sets/pairs with compelling color palette, subject, and style. **Northwest Publishing** provides fine art prints and posters in the following categories: Classics, Traditional, Inspirational, Contemporary, Home and Hearth, Photography, Motivationals, Wildlife, Landscapes and Ethnic Art.

Needs Approached by 300 freelancers/year. Works with 50 freelancers/year. Buys 200 freelance designs and illustrations/year. Art guidelines free for SASE with first-class postage. Works on assignment only. Looking for high-end art. 20% of freelance design work demands knowledge of Photoshop, Illustrator and QuarkXPress.

First Contact & Terms Art submissions may be electronic (e-mail low res image or Web site link) or via mail. Please do not send original art unless specifically requested. Artists will be contacted if there is interest in further review. All submissions are reviewed for potential inclusion in either line as well as for licensing potential, and are kept on file for up to six months. Art may be purchased or signed under royalty agreement. Royalty/licensing contracts will be signed before any images can be considered for inclusion in either line.

Tips "Focus on style. We tend to carve our own path with unique, compelling and high quality art, and as a result are not interested in 'me too' images."

SUNSET MARKETING

14301 Panama City Beach Pkwy., Panama City Beach FL 32413. (850)233-6261. Fax: (850)233-9169. E-mail: info@sunsetartprints.com. Web site: www.sunsetartprints.com. **Product Development:** Denise Patterson. Estab. 1986. Art publisher and distributor of open edition prints. Clients: galleries, decorators, frame shops, distributors and corporate curators. Current clients include Stylecraft Home Collection, Paragon Picture Gallery, Propac Images, Allposters.com, and Lieberman's Gallery.

Needs Seeking fashionable and decorative art for the commercial and designer market. Considers oil, acrylic and watercolor art and home decor furnishings. Artists represented include Steve Butler, Dianne Krumel, Van Martin, Linda Amundsen, Jane Segrest, Kimberly Hudson, Carol Flallock, Talis Jayme and Barbara Shipman. Editions created by collaborating with the artist.

First Contact & Terms Send query letter with brochure, photocopies and photographs. Samples are filed. Company will contact artist for portfolio review of color final art, roughs and photographs if interested. Requires exclusive representation of artist.

SYRACUSE CULTURAL WORKERS

P.O. Box 6367, Syracuse NY 13217. (315)474-1132. Fax: (877)265-5399. E-mail: scw@syrculturalworkers.com. Web site: www.syrculturalworkers.com. **Art Director:** Karen Kerney. Produces posters, notecards, postcards, greeting cards, T-shirts and calendars that are feminist, multicultural, lesbian/gay allied, racially inclusive and honor elders and children (environmental and social justice).

Needs Art guidelines free for SASE with first-class postage and also available on company's Web site. View our Web site to get an idea of appropriate artwork for our company.

First Contact & Terms Pays flat fee, $85-400; royalties of 6% of gross sales.

JOHN SZOKE EDITIONS

591 Broadway, 3rd Floor, New York NY 10012-3232. (212)219-8300. Fax: (212)966-3064. E-mail: info@johnszok eeditions.com. Web site: www.johnszokeeditions.com. **Director:** John Szoke. Estab. 1974. Located in Soho. Gallery hours: Monday-Friday 9 am-5:30 pm or by appointment. Exhibits unique and limited edition works on paper, rare prints, limited edition multiples. Contemporary artists include Christo, Robert Cottingham, Jim Dine, Janet Fish, Helen Frankenthaler, Richard Haas, Jasper Johns, Alex Katz, Ellsworth Kelly, Robert Mangold, Peter Milton, Vik Muniz, Robert Rauschenberg, Larry Rivers, Sean Scully, Richard Serra, Jock Sturges, Donald Sultan, and William Wegman. Modern Masters: Pablo Picasso and Henri Matisse. Clients include art dealers and collectors. 20% of sales to private collectors.

TAKU GRAPHICS

5763 Glacier Hwy., Juneau AK 99801. (907)780-6310. Fax: (907)780-6314. E-mail: info@takugraphics.com. Web site: www.takugraphics.com. **Owner:** Adele Hamey. Estab. 1991. Distributor. Distributes handpulled originals, limited edition, unlimited edition, fine art prints, offset reproduction, posters, paper cast, bead jewelry and note cards. Clients: galleries and gift shops.

Needs Seeking art from Alaska and the Pacific Northwest exclusively. Considers oil, acrylic, watercolor, mixed media, pastel and pen & ink. Prefers regional styles and themes. Artists represented include JoAnn George, Barbara Lavalle, Byron Birdsall, Brenda Schwartz and Barry Herem. Editions created by working from an existing painting. Approached by 30-50 artists/year. Distributes the work of 20 emerging, 6 mid-career and 6 established artists/year.

First Contact & Terms Send query letter with brochure, photographs and tearsheets. Samples are not filed and are returned. Responds in 1 month. Company will contact artist for portfolio review if interested. Pays on consignment basis. Firm receives 35% commission. No advance. Requires exclusive representation of artist. Provides advertising, insurance while work is at firm, promotion, sales reps, trade shows and mailings. Finds artists through word of mouth.

TELE GRAPHICS

153 E. Lake Brantley Dr., Longwood FL 32779. E-mail: RonRybak@TelegraphicsOnline.com. **President:** Ron Rybak. Art publisher/distributor handling original mixed media and handpulled originals. Clients: galleries, picture framers, interior designers and regional distributors.

Needs Seeking decorative art for the serious collector. Artists represented include Beverly Crawford, Diane Lacom, Joy Broe and Ursala Brenner. Editions created by collaborating with the artist or by working from an existing painting. Approached by 30-40 artists/year. Publishes the work of 1-3 emerging artists/year.

First Contact & Terms Send query letter with résumé and samples. Samples are not filed and are returned only if requested. Responds in 1 month. Call or write for appointment to show portfolio of original/final art. Pays by the project. Considers skill and experience of artist and rights purchased when establishing payment. Offers advance. Negotiates rights purchased. Requires exclusive representation. Provide promotions, shipping from firm and written contract.

Tips ''Be prepared to show as many varied examples of work as possible. Show transparencies or slides plus photographs in a consistent style. We are not interested in seeing only one or two pieces.''

BRUCE TELEKY INC.

87 35th St., 3rd Floor, Brooklyn, NY 11232. (718)965-9690. Fax: (718)832-8432. Web site: www.teleky.com. **President:** Bruce Teleky. Estab. 1975. Clients include galleries, manufacturers and other distributors.

Needs Works from existing art to create open edition posters or works with artist to create limited editions. Visit our Web site to view represented artists. Also likes coastal images, music themes and Latino images. Uses photographs. Likes to see artists who can draw. Prefers depictions of African-American, Carribean scenes or African themes.

First Contact & Terms Send query letter with slides, transparencies, postcard or other appropriate samples and SASE. Publisher will contact artist for portfolio review if interested. Payment negotiable. Samples returned by SASE only.

THINGS GRAPHICS & FINE ART

8791 D'Arcy Rd., Forestville MD 20747. (301)333-1632. Fax: (301)333-1824. E-mail: sales@thingsgraphics.com. Web site: www.thingsgraphics.com. **Special Assistant New Acquisitions:** Edward Robertson. Estab. 1984. Art publisher and distributor. Publishes/distributes limited and unlimited editions, offset reproductions and posters. Clients: gallery owners. Current clients include Savacou Gallery and Deck the Walls.

Needs Seeking artwork with creative expression for the commercial market. Considers oil, watercolor, acrylic, pen & ink, mixed media and serigraphs. Prefers Afro-American, Caribbean and ''positive themes.'' Artists represented include Charles Bibbs, John Holyfield, James Denmark and Leroy Campbell. Editions created by

working from an existing painting. Approached by 60-100 artists/year. Publishes the work of 1-5 emerging, 1-5 mid-career and 1-5 established artists/year. Distributes the work of 10-20 emerging, 10-20 mid-career and 60-100 established artists/year.

First Contact & Terms Send query letter with résumé, tearsheets, photostats, photocopies, slides, photographs, transparencies and full-size print samples. Samples are filed. Responds in 3-4 weeks. To show a portfolio, mail thumbnails, tearsheets, photographs, slides and transparencies. Payment method is negotiated. Does not offer an advance. Negotiates rights purchased. Provides promotion and a written contract.

Tips "Continue to create new works; if we don't use the art the first time, keep trying us."

ULTIMATE LITHO

116 Costa Road, Highland NY 12528. E-mail: info@ultimatelitho.com. Web site: www.ultimatelitho.com. **Contact:** Ray Greenberg, owner. Estab. 1995. Art publisher. Publishes and/or distributes fine art prints, offset reproduction, posters and unlimited edition. Clients distributors.

Needs Seeking black ethnic art and yoga and spiritual themes. Considers acrylic, mixed media, oil, pastel, watercolor. Artists represented include Jason DeLancey, Shelley Jackson, Laura Loturco. Approached by 20 artists/year. Publishes work of 1-2 emerging artists/year.

First Contact & Terms Send query letter with brochure, photocopies, photographs, résumé, SASE, slides, tearsheets, transparencies. Samples are returned by SASE. Responds only if interested. Company will contact artist for portfolio review if interested. Portfolio should include color photographs, slides, tearsheets, transparencies, any good representation of the broadest range of styles and subjects the artist has done. Pays flat fee or advance against royalties. Offers advance when appropriate. Rights purchased vary according to project. Provides advertising, insurance while work is at firm, promotion, shipping from our firm, written contract. Finds artists through art exhibits/fairs, art reps, artist's submissions, Internet, word of mouth.

VARGAS FINE ART PUBLISHING, INC.

Enterprise Office Park, 9470 Annapolis Rd. Suite 313, Lanham MD 20706. (301)731-5175. Fax: (301)731-5712. E-mail: vargasfineart@aol.com. Web site: www.vargasfineart.com. **President:** Elba Vargas-Colbert. Estab. 1987. Art publisher and worldwide distributor of serigraphs, limited and open edition offset reproductions, etchings, sculpture, music boxes, keepsake boxes, ceramic art tiles, art magnets, art mugs, collector plates, calendars, canvas transfers and figurines. Clients: galleries, frame shops, museums, decorators, movie sets and TV.

Needs Seeking creative art for the serious collector and commercial market. Considers oil, watercolor, acrylic, pastel pen & ink and mixed media. Prefers ethnic themes. Artists represented include Joseph Holston, Kenneth Gatewood, Tod Haskin Fredericks, Betty Biggs, Charles Bibbs, Sylvia Walker, Ted Ellis, Leroy Campbell, William Tolliver, Sylvia Walker, Paul Goodnight, Wayne Still and Paul Awuzie. Approached by 100 artists/year. Publishes/distributes the work of about 80 artists.

First Contact & Terms Send query letter with résumé, slides and/or photographs. Samples are filed. Responds only if interested. To show portfolio, mail photographs. Payment method is negotiated. Requires exclusive representation of the artist.

Tips "Continue to hone your craft with an eye towards being professional in your industry dealings."

VIBRANT FINE ART

3941 W. Jefferson Blvd., Los Angeles CA 90016. (323)766-0818. Fax: (323)737-3128. E-mail: vibrantfineart@hotmail.com. **Art Director:** Phylise Stevens. Licensing: Tom Nolen. Design Coordinator: Jackie Stevens. Estab. 1990. Art publisher and distributor. Publishes and distributes fine art prints, limited and unlimited editions and offset reproductions. Licenses ethnic art to appear on ceramics, gifts, textiles, miniature art, stationery and note cards. Clients: galleries, designers, giftshops, furniture stores and film production companies.

Needs Seeking decorative and ethnic art for the commercial and designer markets. Considers oil, watercolor, mixed media and acrylic. Prefers African-American, Native-American, Latino themes. Artists represented include Sonya A. Spears, Van Johnson, Momodou Ceesay, William Crite and Darryl Daniels. Editions created by collaborating with the artist or by working from an existing painting. Approached by 40 artists/year. Publishes the work of 5 emerging, 5 mid-career and 2 established artists/year. Distributes the work of 5 emerging, 5 mid-career and 2 established artists/year. Also needs freelancers for design. 20% of products require design work. Designers should be familiar with Illustrator and Mac applications. Prefers local designers only.

First Contact & Terms Send query letter with brochure, tearsheets and slides. Samples are filed or are returned by SASE. Publisher/distributor will contact artist for portfolio review if interested. Portfolio should include color tearsheets, photographs, slides and biographical sketch. Pays royalties of 10%. Rights purchased vary according to project. Provides advertising, insurance while work is at firm, promotion, written contract and shipping from firm. Finds artists through art exhibitions, referrals, sourcebooks, art reps, submissions.

Tips "Ethnic art is hot. The African-American art market is expanding. I would like to see more submissions

from artists that include slides of ethnic imagery, particularly African-American, Latino and Native American. We desire contemporary cutting edge, fresh and innovative art. Artists should familiarize themselves with the technology involved in the printing process. They should possess a commitment to excellence and understand how the business side of the art industry operates.''

VLADIMIR ARTS USA INC.

2504 Sprinkle Rd., Kalamazoo MI 49001. (269)383-0032. Fax: (269)383-1840. E-mail: vladimir@vladimirarts.c om. Web site: www.vladimirarts.com. **Contact:** Lew Iwlew. Art publisher, distributor and gallery. Publishes/ distributes handpulled originals, limited edition, unlimited edition, canvas transfers, fine art prints, monoprints, monotypes, offset reproduction, posters and giclée. Clients: galleries, decorators, frame shops, distributors, architects, corporate curators, museum shops, giftshops and West Point military market.

Needs Seeking creative, fashionable and decorative art for the serious collector, commercial market and designer market. Considers oil, acrylic, watercolor, mixed media, pastel, pen & ink and sculpture. Artists represented include Hongmin Zou, Ben Maile, Bev Doolittle and Charles Wysocki. Editions created by collaborating with the artist. Approached by 30 artists/year. Publishes work of 10 emerging, 10 mid-career and 10 established artists/year. Distributes work of 1-2 emerging, 1 mid-career and 1-2 established artists/year.

First Contact & Terms Send query letter with brochure, photocopies, photographs and tearsheets. Accepts disk submissions compatible with Illustrator 5.0 for Windows 95 and later. Samples are filed or returned with SASE. Responds only if interested. Company will contact artist for portfolio review if interested. Portfolio should include b&w, color, fine art, photographs and roughs. Negotiates payment. No advance. Provides advertising, promotion and shipping from our firm. Finds artists through attending art exhibitions, art fairs, word of mouth, World Wide Web, art reps, sourcebooks, artists' submissions and watching art competitions.

Tips ''The industry is growing in diversity of color. There are no limits.''

WEBSTER FINE ART LTD.

1003 High House Road, Suite 101, Cary NC 27513. (919)388-9370. Fax: (919)388-9377. E-mail: info@websterfine art.com. Web site: www.websterfineart.com. **Contact:** Brandin O'Neill. Art publisher/distributor. Estab. 1987. Publishes open editions and fine art prints. Clients: OEM framers, galleries, frame shops, distributors, giftshops.

Needs Considers oil, acrylic, watercolor, pastel, pen & ink, mixed media. ''Seeking creative artists that can take directions; decorative, classic, traditional, fashionable, realistic, impressionistic, landscape, artists who know the latest trends.'' Editions created by collaborating with the artist.

First Contact & Terms E-mail JPEGs of art to be submitted to artclub@weberfineart.com. Send query letter with brochure, photocopies, photographs, slides, tearsheets, transparencies and SASE. Samples are filed or returned by SASE. Responds in 1 month. Company will contact artist for portfolio review if interested. Negotiates payment. Offers advance when appropriate. Buys all or reprint rights. Finds artists by word of mouth, attending art exhibitions and fairs, submissions and watching art competitions.

Tips ''Check decorative home magazines *Southern Accents*, *Architectural Digest*, *House Beautiful*, etc. for trends. Understand the decorative art market.''

WILD APPLE GRAPHICS, LTD.

526 Woodstock Rd., Woodstock VT 05091. (802)457-3003. Fax: (802)457-5891. E-mail: artists@wildapple.com. Web site: www.wildapple.com. **Art Development Coordinator:** Maureen Dow. Estab. 1990. Wild Apple publishes, distributes and represents a diverse group of contemporary artists. Clients: manufacturers, galleries, designers, poster distributors (worldwide) and framers. Licensing: Acting as an artist's agent, we present your artwork to manufacturers for consideration.

Needs We are always looking for fresh talent and varied images to show. Considers oil, watercolor, acrylic, pastel, mixed media and photography. Publishes 400+ new works each year.

First Contact & Terms Send query letter with résumé, biography, slides and photographs. Samples are not filed. Responds in 2 months. To show portfolio, e-mail JPGs or mail slides, transparencies, tearsheets and photographs with SASE. (Material will not be returned without an enclosed SASE.)

Tips ''We would love to hear from you. Use the telephone, fax machine, e-mail, post office or carrier pigeon (you must supply your own) to contact us.''

WILD ART GROUP

31630 Sierra Verde Rd., Homeland CA 92548. (800)669-1368. Fax: (888)219-2710. E-mail: sales@WildArtGroup. com. Web site: www.WildArtGroup.com. Art Publisher/Distributor/Framer. Publishes lithographs, canvas transfers, serigraphs, giclee printing, digital photography and offset/digital printing.

Needs Seeking fine art for serious collectors and decorative art for the commercial market. Considers all media. Artists represented include GAMBOA, JD Wild, Annie Lee, Terry Wilson, Merryl Jaye, Bernice Kendrick, Marty Tobias, Yatzie ''Silver Eagle'' Dee, Kadir Nelson, Albert Fennell, Simon Fennell and Teddie Oatey.

First Contact & Terms Send query letter with slides, transparencies or other appropriate samples and SASE. Will accept submissions on disk or CD-ROM. Publisher will contact artist for portfolio review if interested.

WILD WINGS LLC
2101 S. Highway 61, Lake City MN 55041. (651)345-5355. Fax: (651)345-2981. E-mail: info@wildwings.com. Web site: www.wildwings.com. **Marketing & Artist Relation Manager:** Jennifer A. White. Estab. 1968. Art publisher, distributor and gallery. Publishes and distributes limited editions and offset reproductions. Clients: retail and wholesale.

Needs Seeking artwork for the commercial market. Considers oil, watercolor, mixed media, pastel and acrylic. Prefers wildlife. Artists represented include David Maass, Lee Kromschroeder, Ron Van Gilder, Robert Abbett, Michael Sieve and Persis Clayton Weirs. Editions created by working from an existing painting. Approached by 300 artists/year. Publishes the work of 36 artists/year. Distributes the work of numerous emerging artists/year.

First Contact & Terms Send query letter with digital files, color print outs or slides and résumé. Samples are filed and held for 6 months then returned. Responds in 3 weeks if uninterested or 6 months if interested. Publisher will contact artist for portfolio review if interested. Pays royalties for prints. Accepts original art on consignment and takes 40% commission. No advance. Buys first rights or reprint rights. Requires exclusive representation of artist. Provides in-transit insurance, promotion, shipping to and from firm, insurance while work is at firm and a written contract.

WINN DEVON ART GROUP
110-6311 Westminster Hwy., Richmond BC V7C 4V4 Canada. (604)276-4551. Fax: (604)276-4552. E-mail: artsub missions@encoreartgroup.com. Web site: www.winndevon.com. **Contact:** Aimee Clarke, vice president of product and marketing. Estab. 1976. Art publisher. Publishes open and limited editions, offset reproductions, giclees and serigraphs. Clients: mostly trade, designer, decorators, galleries, retail frame shops. Current clients include Pier 1, Z Gallerie, Intercontinental Art, Chamton International, Bombay Co.

Needs Seeking decorative art for the designer market. Considers oil, watercolor, mixed media, pastel, pen & ink and acrylic. Artists represented include Buffet, Lourenco, Jardine, Hall, Goerschner, Lovelace, Bohne, Romeu and Tomao. Editions created by working from an existing painting. Approached by 300-400 artists/year. Publishes and distributes the work of 0-3 emerging, 3-8 mid-career and 8-10 established artists/year.

First Contact & Terms Send query letter with brochure, slides, photocopies, résumé, photostats, transparencies, tearsheets or photographs. Samples are returned by SASE if requested by artist. Responds in 4-6 weeks. Publisher will contact artist for portfolio review if interested. Portfolio should include "whatever is appropriate to communicate the artist's talents." Payment varies. Rights purchased vary according to project. Provides written contract. Finds artists through attending art exhibitions, agents, sourcebooks, publications, submissions.

Tips Advises artists to attend Art Expo New York City, Decor Expo Atlanta. "I would advise artists to attend just to see what is selling and being shown, but keep in mind that this is not a good time to approach publishers/exhibitors with your artwork."

Book Publishers

Walk into any bookstore and start counting the number of images you see on books and calendars. Publishers don't have enough artists on staff to generate such a vast array of styles. The illustrations you see on covers and within the pages of books are, for the most part, created by freelance artists. If you like to read and work creatively to solve problems, the world of book publishing could be a great market for you.

The artwork appearing on a book cover must grab readers' attention and make them want to pick up the book. It must show at a glance what type of book it is and who it is meant to appeal to. In addition, the cover has to include basic information such as title, the author's name, the publisher's name, blurbs and price.

Most assignments for freelance work are for jackets/covers. The illustration on the cover, combined with typography and the layout choices of the designer, announce to the prospective readers at a glance the style and content of a book. If it is a romance novel, it will show a windswept couple and the title is usually done in calligraphy. Suspenseful spy novels tend to feature stark, dramatic lettering and symbolic covers. Covers for fantasy and science fiction novels, as well as murder mysteries and historical fiction, tend to show a scene from the story. Visit a bookstore and then decide which kind of books interest you and would be best for your illustration style.

Book interiors are also important. The page layouts and illustrations direct readers through the text and complement the story. This is particularly important in children's books and textbooks. Many publishing companies hire freelance designers with computer skills to design interiors on a contract basis. Look within each listing for the subheading Book Design to find the number of jobs assigned each year and how much is paid per project.

Finding your best markets

The first paragraph of each listing describes the types of books each publisher specializes in. This may seem obvious, but submit only to publishers who specialize in the type of book you want to illustrate or design. There's no use submitting to a publisher of literary fiction if you want to illustrate children's picture books.

The publishers in this section are just the tip of the iceberg. You can find additional publishers by visiting bookstores and libraries and looking at covers and interior art. When you find covers you admire, write down the name of the books' publishers in a notebook. If the publisher is not listed in *Artist's & Graphic Designer's Market*, go to your public library and ask to look at a copy of *Literary Market Place*, also called *LMP*, published annually by Information Today, Inc. The cost of this large directory is prohibitive to most freelancers, but you should become familiar with it if you plan to work in the industry. Though it won't tell

Publishing Terms to Know

Important

- **Mass market** paperbacks are sold in supermarkets, newsstands, drugstores, etc. They include romance novels, diet books, mysteries and paperbacks by popular authors like Stephen King.

- **Trade books** are the hardcovers and paperbacks found only in bookstores and libraries. The paperbacks are larger than those on the mass market racks. They are printed on higher quality paper and often feature matte-paper jackets.

- **Textbooks** feature plenty of illustrations, photographs and charts to explain their subjects.

- **Small press** books are produced by small, independent publishers. Many are literary or scholarly in theme and often feature fine art on the cover.

- **Backlist titles** or **reprints** refer to publishers' titles from past seasons that continue to sell year after year. These books are often updated and republished with freshly designed covers to keep them up to date and attractive to readers.

you how to submit to each publisher, it does give art directors' names. Also be sure to visit publishers' Web sites—many offer artist's guidelines online.

How to submit

Send one to five nonreturnable samples along with a brief letter. Never send originals. Most art directors prefer samples $8\frac{1}{2} \times 11$ or smaller that can fit in file drawers. Bulky submissions are considered a nuisance. After sending your initial introductory mailing, you should follow up with postcard samples every few months to keep your name in front of art directors. If you have an e-mail account and can send TIFF or JPEG files, check the publishers' preferences and see if they will accept submissions via e-mail.

Getting paid

Payment for design and illustration varies depending on the size of the publisher, the type of project and the rights purchased. Most publishers pay on a per-project basis, although some publishers of highly illustrated books (such as children's books) pay an advance plus royalties. A few very small presses may only pay in copies.

Children's book illustration

Working in children's books requires a specific set of skills. You must be able to draw the same characters in a variety of action poses and situations. Like other publishers, many children's publishers are expanding their product lines to include multimedia projects. While a number of children's publishers are listed in this book, *Children's Writer's & Illustrator's Market*, also published by Writer's Digest Books, is an invaluable resource if you enter this field. You can order this essential book on www.writersdigest.com/store/books.asp or by

Book Publishers

Helpful Resources

For More Info

If you decide to focus on book publishing, become familiar with *Publishers Weekly*, the trade magazine of the industry. Its Web site, www.publishers weekly.com, will keep you abreast of new imprints, publishers that plan to increase their title selection and the names of new art directors. You should also look for articles on book illustration and design in *HOW* (www. howdesign.com), *Print* (www.printmag.com) and other graphic design magazines. *Jackets Required: An Illustrated History of American Book Jacket Design, 1920-1950*, by Steven Heller and Seymour Chwast (Chronicle Books), offers nearly 300 examples of book jackets.

calling (800)448-0915. Those interested in children's book illustration should also consider joining the Society of Children's Book Writers and Illustrators (www.scbwi.org), an international organization offering support, information, and lots of networking opportunities.

A&B PUBLISHERS GROUP

223 Duffield St., Brooklyn NY 11238. (718)783-7808. Fax: (718)783-7267. Web site: www.anbdonline.com. **Production Manager:** Eric Gift. Estab. 1992. Publishes trade paperback originals, calendars and reprints. Types of books include comic books, cookbooks, history, juvenile, preschool, reference, self-help and young adult. Specializes in history. Publishes 12 titles/year. Recent titles include: *Nutrition Made Simple*; *What They Never Told You in History Class, Vol. I and II*. 70% require freelance illustration; 25% require freelance design. Catalog available.

Needs Approached by 60 illustrators and 32 designers/year. Works with 12 illustrators and 6 designers/year. Prefers local illustrators experienced in airbrush and computer graphics. Uses freelancers mainly for "book covers and insides." 85% of freelance design demands knowledge of Photoshop, Illustrator and QuarkXPress. 60% of freelance design demands knowledge of Photoshop, Illustrator, QuarkXPress and Painter. 20% of titles require freelance art direction.

First Contact & Terms Designers: Send query letter with photocopies. Illustrators: Send postcard sample, photocopies, printed samples or tearsheets. Send follow-up postcard sample every 4 months. Accepts disk submissions from designers compatible with QuarkXPress, Photoshop and Illustrator. Send EPS and TIFF files. Samples are filed. Portfolio review required. Portfolio should include artwork portraying children, animals, perspective, anatomy and transparencies. Rights purchased vary according to project.

Book Design Assigns 14 freelance design jobs/year. Pays by the hour, $15-65 and also a flat fee.

Jackets/Covers Assigns 14 freelance design jobs and 20 illustration jobs/year. Pays by the project, $250-1,200. Prefers "computer generated titles, pen & ink and watercolor or airbrush for finish."

Text Illustration Assigns 11 freelance illustration jobs/year. Pays by the hour, $8-25 or by the project, $800-2,400 maximum. Prefers "airbrush or watercolor that is realistic or childlike, appealing to young school-age children." Finds freelancers through word of mouth, submissions, NYC school of design.

Tips "I look for artists who are knowledgeable about press and printing systems—from how color reproduces to how best to utilize color for different presses."

AACE INTERNATIONAL

209 Prairie Ave., Suite 100, Morgantown WV 26501. (304)296-8444. Fax: (304)291-5728. E-mail: nkinderknecht @compuserve.com. Web site: aacei.org. **Contact:** Noah Kinderknecht, graphic designer/editor. Estab. 1958. Publishes trade paperback originals and reprints and textbooks. Specializes in engineering and project management books. Titles include *Cost Engineering* journal. Catalog available.

Needs 100% of freelance design demands knowledge of QuarkXPress. 100% of freelance illustration demands knowledge of Photoshop, Illustrator and QuarkXPress.

First Contact & Terms Designers send query letter with résumé and slides.

Book Design Assigns 1-2 freelance design jobs/year.
Text Illustration Assigns 1-2 freelance illustration jobs/year.

HARRY N. ABRAMS, INC.

100 Fifth Ave., New York NY 10011. (212)206-7715. Fax: (212) 645-8437. Web site: www.abramsbooks.com.
Contact: Mark LaRiviere, creative director. Estab. 1951. Company publishes hardcover originals, trade paper-
back originals and reprints. Types of books include fine art and illustrated books. Publishes 240 titles/year.
60% require freelance design. Visit Web site for art submission guidelines.
Needs Uses freelance designers to design complete books including jackets and sales materials. Uses illustrators
mainly for maps and occasional text illustration. 100% of freelance design and 50% of illustration demands
knowledge of Illustrator, InDesign or QuarkXPress and Photoshop. Works on assignment only.
First Contact & Terms Send query letter with résumé, tearsheets, photocopies. Accepts disk submissions or
supply Web address. Samples are filed "if work is appropriate." Samples are returned by SASE if requested by
artist. Portfolio should include printed samples, tearsheets and/or photocopies. Originals are returned at job's
completion, with published product. Finds artists through word of mouth, submissions, attending art exhibitions
and seeing published work.
Book Design Assigns several freelance design jobs/year. Pays by the project.

⊞ ACROPOLIS BOOKS, INC.

8601 Dunwoody Pl., Suite 303, Atlantic GA 30350. (770)643-1118. Fax: (770)643-1170. E-mail: acropolisbooks@
mindspring.com. Web site: www.acropolisbooks.com. **Vice President Operations:** Christine Lindsey. Imprints
include Awakening. Publishes hardcover originals and reprints, trade paperback originals and reprints. Types
of books include mysticism and spiritual. Specializes in books of higher consciousness. Publishes 4 titles/year.
Recent titles include: *The Journey Back to the Fathers Home*, by Joel S. Goldsmith; *Showing Forth the Presence
of God*, by Joel S. Goldsmith. 30% require freelance design. Catalog available.
Needs Approached by 7 illustrators and 5 designers/year. Works with 2-3 illustrators and 2-3 designers/year.
Knowledge of Photoshop and QuarkXPress useful in freelance illustration and design.
First Contact & Terms Designers: Send brochure and résumé. Illustrators: Send query letter with photocopies
and résumé. Samples are filed. Responds in 2 months. Will contact artist for portfolio review if interested. Buys
all rights.
Book Design Assigns 3-4 freelance design jobs/year. Pays by the project.
Jackets/Covers Assigns 3-4 freelance design jobs/year. Pays by the project.
Tips "We are looking for people who are familiar with our company and understand our focus."

ADAMS MEDIA CORPORATION

Imprint of F+W Publications, 57 Littlefield St., Avon MA 02322. (508)427-7100. Fax: (508)427-6790. E-mail:
pbeatrice@adamsmedia.com. Web site: www.adamsmedia.com. **Art Director:** Paul Beatrice. Estab. 1980. Com-
pany publishes hardcover originals, trade paperback originals and reprints. Types of books include biography,
business, gardening, pet care, cookbooks, history, humor, instructional, New Age, nonfiction, reference, self-
help and travel. Specializes in business and careers. Publishes 100 titles/year. 15% require freelance illustration.
Recent titles include: *101 Things You Didn't Know About Da Vinci*; *Tales from the Scales*; *The 10 Women You'll
Be Before You're 35*. Book catalog free by request.
Needs Works with 8 freelance illustrators and 7-10 designers/year. Buys less than 100 freelance illustrations/
year. Uses freelancers mainly for jacket/cover illustration, text illustration and jacket/cover design. 100% of
freelance work demands computer skills. Freelancers should be familiar with QuarkXPress 4.1 and Photoshop.
First Contact & Terms Send postcard sample of work. Samples are filed. Art director will contact artist for
portfolio review if interested. Portfolio should include tearsheets. Rights purchased vary according to project,
but usually buys all rights.
Jackets/Covers Assigns 50 freelance design jobs/year. Pays by the project, $700-1,500.
Text Illustration Assigns 30 freelance illustration jobs/year.

AFRICA WORLD PRESS, INC.

541 W. Ingham Ave., Suite B, Trenton NJ 08638. (609)695-3200. Fax: (609)695-6466. E-mail: africawpress@nyo.
com. Web site: www.africanworld.com. **President:** Checole Kassahun. Estab. 1983. Publishes hardcover and
trade paperback originals. Types of books include biography, preschool, juvenile, young adult and history.
Specializes in any and all subjects that appeal to an Afrocentric market. Publishes 124 titles/year. Titles include:
Blacks Before America, by Mark Hyman; and *Too Much Schooling Too Little Education*, by Mwalimu J. Shujaa.
60% require freelance illustration; 10% require freelance design. Book catalog available by request. Approached
by 50-100 freelancers/year. Works with 5-10 illustrators and 4 designers/year. Buys 50-75 illustrations/year.
Prefers artists with experience in 4-color separation and IBM-compatible PageMaker. Uses freelancers mainly

for book illustration. Also for jacket/cover design and illustration. Uses designers for typesetting and formatting.

Needs "We look for freelancers who have access to or own their own computer for design and illustration purposes but are still familiar and proficient in creating mechanicals, mock-ups and new ideas by hand." 50% of freelance work demands knowledge of PageMaker 5.0, CorelDraw 4.0 and Word Perfect 6.0. Works on assignment only.

First Contact & Terms Send query letter with brochure, tearsheets, photostats, bio, résumé, SASE, photocopies and transparencies. Samples are filed or are returned by SASE if requested by artist. Responds in 6 weeks. Write for appointment to show portfolio, or mail b&w and color photostats, tearsheets and 8½×11 transparencies. Rights purchased vary according to project. Originals are returned at job's completion if artist provides SASE and instructions.

Book Design Assigns 100 freelance design jobs/year. Pays by the project.

Jackets/Covers Assigns 100 freelance design and 50-75 illustration jobs/year. Prefers 2- or 4-color process covers. Pays by the project.

Text Illustration Assigns 25 illustration jobs/year. Prefers "boards and film with proper registration and color specification." Pays by the project.

Tips "Artists should have a working knowledge of the Windows 3.1 platform of the IBM computer; be familiar with the four-color process (CMYK) mixtures and changes (5-100%) and how to manipulate them mechanically as well as on the computer; have a working knowledge of typefaces and styles, the ability to design them in an appealing manner; swift turn around time on projects from preliminary through the manipulation of changes and a clear understanding of African-centered thinking, using it to promote and professionally market books and other cultural items creatively. Work should be colorful, eyecatching and controversial."

THE AMERICAN BIBLE SOCIETY

1865 Broadway, New York NY 10023-7505. (212)408-1200. Fax: (212)408-1259. E-mail: info@americanbible.o rg. Web site: www.americanbible.org. **Associate Director, Product Development:** Christina Murphy. Estab. 1816. Company publishes religious products including Bibles/New Testaments, portions, leaflets, calendars and bookmarks. Additional products include religious children's books, posters, seasonal items, teaching aids, audio casettes, videos and CD-ROMs. Specializes in contemporary applications to the Bible. Publishes 15 titles/year. Recent titles include: *Contemporary English Children's Illustrated Bible*. 25% requires freelance illustration; 90% requires freelance design. Book catalog on Web site.

Needs Approached by 50-100 freelancers/month. Works with 10 freelance illustrators and 20 designers/year. Uses freelancers for jacket/cover illustration and design, text illustration, book design and children's activity books. 90% of freelance work demands knowledge of Illustrator, QuarkXPress, Photoshop. Works on assignment only. 5% of titles require freelance art direction.

First Contact & Terms Send postcard samples of work or send query letter with brochure and tearsheets. Samples are filed and/or returned. **Please do not call.** Responds in 2 months. Product design department will contact artist for portfolio review if additional samples are needed. Portfolio should include final art and tearsheets. Buys all rights. Finds artists through artists' submissions, *The Workbook* (by Scott & Daughters Publishing) and *RSVP Illustrator*.

Book Design Assigns 3-5 freelance interior book design jobs/year. Pays by the project, $350-1,000 depending on work involved.

Jackets/Covers Assigns 60-80 freelance design and 20 freelance illustration jobs/year. Pays by the project, $350-2,000.

Text Illustration Assigns several freelance illustration jobs/year. Pays by the project.

Tips "Looking for contemporary, multicultural artwork/designs and good graphic designers familiar with commercial publishing standards and procedures. Have a polished and professional-looking portfolio or be prepared to show polished and professional-looking samples."

AMERICAN EAGLE PUBLICATIONS, INC.

P.O. Box 1507, Show Low AZ 85902-1507. (623)556-2925. Fax: (623)556-2926. E-mail: ameagle@ameaglepubs.c om. Web site: www.ameaglepubs.com. **President:** Mark Ludwig. Estab. 1988. Publishes hardcover originals and reprints and trade paperback originals and reprints. Types of books include historical fiction, history and computer books. Publishes 10 titles/year. Titles include: *The Little Black Book of E-mail Viruses*; *The Quest for Water Planets*. 100% require freelance illustration and design. Book catalog free for large SAE with 2 first-class stamps.

Needs Approached by 10 freelance artists/year. Works with 4 illustrators and 4 designers/year. Buys 20 illustrations/year. Uses freelancers mainly for covers. Also for text illustration. 100% of design and 25% of illustration demand knowledge of Ventura Publisher and CorelDraw. Works on assignment only.

First Contact & Terms Send query letter with résumé, SASE and photocopies. Accepts disk submissions compatible with CorelDraw or Ventura Publisher on PC. Send TIFF files. Samples are filed. Responds only if interested.

Call for appointment to show portfolio, which should include final art, b&w and color photostats, slides, tearsheets, transparencies and dummies. Buys all rights. Originals are returned at job's completion.
Jackets/Covers Assigns 10 design and 10 illustration jobs/year. Payment negotiable (roughly $20/hr minimum). "We generally do 2-color or 4-color covers composed on a computer."
Text Illustration Assigns 7 illustration jobs/year. Pays roughly $20/hr minumum. Prefers pen & ink.
Tips "Show us good work that demonstrates you're in touch with the kind of subject matter in our books. Show us you can do good, exciting work in two colors."

AMERICAN INSTITUTE OF CHEMICAL ENGINEERING
3 Park Ave., Lobby 2, New York NY 10016-5991. (212)591-7338. Fax: (212)591-8888. E-mail: xpress@aiche.org. Web site: www.aiche.org. **Contact:** Creative Director. Estab. 1925. Book and magazine publisher of hardcover originals and reprints, trade paperback originals and reprints and magazines. Specializes in chemical engineering.
Needs Approached by 30 freelancers/year. Works with 17-20 freelance illustrators/year. Prefers freelancers with experience in technical illustration. Macintosh experience a must. Uses freelancers for concept and technical illustration. Also for multimedia projects. 100% of design and 50% of illustration demand knowledge of all standard Mac programs.
First Contact & Terms Send query letter with tearsheets. Accepts disk submissions. Samples are filed. Responds only if interested. Call for appointment to show portfolio of color tearsheets and 3.5 Mac disk. Buys first rights or one-time rights. Originals are returned at job's completion.
Jackets/Covers Payment depends on experience, style.
Text Illustration Assigns 250 jobs/year. Pays by the hour, $15-40.

AMERICAN JUDICATURE SOCIETY
2700 University Ave., Des Moines IA 50311. (515)271-2281. Fax: (515)279-3090. E-mail: drichert@ajs.org. Web site: www.ajs.org. **Editor:** David Richert. Estab. 1913. Publishes journals and books. Specializes in courts, judges and administration of justice. Publishes 5 titles/year. 75% requires freelance illustration. Catalog available free for SASE.
Needs Approached by 20 illustrators and 6 designers/year. Works with 3-4 illustrators and 1 designer/year. Prefers local designers. Uses freelancers mainly for illustration. 100% of freelance design demands knowledge of PageMaker, FreeHand, Photoshop and Illustrator. 10% of freelance illustration demands knowledge of QuarkXPress, FreeHand, Photoshop and Illustrator.
First Contact & Terms Designers: Send query letter with photocopies. Illustrators: Send query letter with photocopies and tearsheets. Send follow-up postcard every 3 months. Samples are not filed and are returned by SASE. Responds in 1 month. Will contact artist for portfolio review of photocopies, roughs and tearsheets if interested. Buys one-time rights.
Book Design Assigns 1-2 freelance design jobs/year. Pays by the project, $500-1,000.
Text Illustration Assigns 10 freelance illustration jobs/year. Pays by the project, $75-375.

AMERICAN PSYCHIATRIC PRESS, INC.
1000 Wilson Blvd., Suite 1825, Arlington VA 22209-3901. (703)907-7322. Web site: www.appi.org. **Contact:** Production Manager. Estab. 1981. Imprint of American Psychiatric Association. Company publishes hardcover originals and textbooks. Specializes in psychiatry and its subspecialties. Publishes 60 titles/year. Recent titles include: *Coping With Trauma*; and *Fatal Flaws*. 10% require freelance illustration; 10% require freelance design. Book catalog free by request.
Needs Uses freelancers for jacket/cover design and illustration. Needs computer-literate freelancers for design. 100% of freelance work demands knowledge of QuarkXPress, Illustrator 3.0, PageMaker 5.0. Works on assignment only.
First Contact & Terms Designers: Send query letter with brochure, photocopies, photographs and/or tearsheets. Illustrators: Send postcard sample. Samples are filed. Promotions Coordinator will contact artist for portfolio review if interested. Portfolio should include final art, slides and tearsheets. Rights purchased vary according to project.
Book Design Pays by the project.
Jackets/Covers Assigns 10 freelance design and 10 illustation jobs/year. Pays by the project.
Tips Finds artists through sourcebooks. "Book covers are now being done in Corel Draw 5.0 but will work with Mac happily. Book covers are for professional books with clean designs. Type treatment design are done in-house."

AMHERST MEDIA, INC.
175 Rano St., Suite 200, Buffalo NY 14207. (716)874-4450. Fax: (716)874-4508. Web site: www.AmherstMedia.com. **Publisher:** Craig Alesse. Estab. 1974. Company publishes trade paperback originals. Types of books include

instructional and reference. Specializes in photography, how-to. Publishes 30 titles/year. Recent titles include: *Portrait Photographer's Handbook*; *Creating World Class Photography*. 20% require freelance illustration; 80% require freelance design.

Needs Approached by 12 freelancers/year. Works with 3 freelance illustrators and 3 designers/year. Uses freelance artists mainly for illustration and cover design. Also for jacket/cover illustration and design and book design. 80% of freelance work demands knowledge of QuarkXPress or Photoshop. Works on assignment only.

First Contact & Terms Send brochure, résumé and photographs. Samples are filed. Responds only if interested. Art director will contact artist for portfolio review if interested. Rights purchased vary according to project. Originals are returned at job's completion. Finds artists through word of mouth.

Book Design Assigns 12 freelance design jobs/year. Pays for design by the hour $25 minimum; by the project $2,000.

Jackets/Covers Assigns 12 freelance design and 4 illustration jobs/year. Pays $200-1200. Prefers computer illustration (QuarkXPress/Photoshop).

Text Illustration Assigns 12 freelance illustration jobs/year. Pays by the project. Only accepts computer illustration (QuarkXPress).

ANDREWS MCMEEL PUBLISHING

4520 Main, Kansas City MO 64111-7701. (816)932-6700. Fax: (816)932-6781. E-mail: tlynch@amuniversal.com. Web site: www.andrewsmcmeel.com. **Art Director:** Tim Lynch. Estab. 1972. Publishes hardcover originals and reprints; trade paperback originals and reprints. Types of books include humor, instructional, nonfiction, reference, self help. Specializes in calendars and cartoon/humor books. Publishes 200 titles/year. Recent titles include: *Hard Sell*; *Made You Laugh*; *The Blue Day Book*; *Complete Calvin and Hobbes*. 10% requires freelance illustration; 80% requires freelance design.

Needs Approached by 100 illustrators and 50 designers/year. Works with 15 illustrators and 25 designers/year. Prefers freelancers experienced in book jacket design. Freelance designers must have knowledge of Illustrator, Photoshop, QuarkXPress or InDesign.

First Contact & Terms Send sample sheets and Web address or contact through artists' rep. Samples are filed and not returned. Responds only if interested. Portfolio review not required. Rights purchased vary according to project.

Book Design Assigns 60 freelance design jobs and 20 illustration jobs/year. Pays for design $600-3,000.

Tips "We want designers who can read a manuscript and design a concept for the best possible cover. Communicate well and be flexible with design." Designer portfolio review once a year in New York City.

ANTARCTIC PRESS

7272 Wurzbach, Suite 204, San Antonio TX 78240. (210)614-0396. Fax: (210)614-5029. E-mail: rod_espinosa@antarctic-press.com or apcog@hotmail.com. Web site: www.antarctic-press.com. **Contact:** Rod Espinosa, submissions editor. Estab. 1985. Publishes CD ROMs, mass market paperback originals and reprints, trade paperback originals and reprints. Types of books include adventure, comic books, fantasy, humor, juvenile fiction. Specializes in comic books. Publishes 18 titles/year. Recent titles include: *Ninja High School*; *Gold Digger*; *Twilight X*. 50% requires freelance illustration. Book catalog free with 9×12 SASE ($3 postage). Submission guidelines on Web site.

Needs Approached by 60-80 illustrators/year. Works with 12 illustrators/year. Prefers local illustrators. 100% of freelance illustration demands knowledge of Photoshop.

First Contact & Terms Do not send originals. Send copies only. Accepts e-mail submissions from illustrators. Prefers Mac-compatible, Windows-compatible, TIFF, JPEG files. Samples are filed or returned by SASE. Portfolios may be dropped off every Monday-Friday. Portfolio should include b&w, color finished art. All submissions must include finished comic book art, 10 pages minimum. Buys first rights. Rights purchased vary according to project. Finds freelancers through anthologies published, artist's submissions, Internet, word of mouth. Payment is made on royalty basis after publication.

Text Illustration Negotiated.

Tips "You must love comics and be proficient in doing sequential art."

APPALACHIAN MOUNTAIN CLUB BOOKS

5 Joy St., Boston MA 02108. (617)523-0655. Fax: (617)523-0722. E-mail: amcbooks@amcinfo.org. Web site: www.outdoors.org. **Production:** Brian Davidson. Estab. 1876. Publishes trade paperback originals and reprints. Types of books include adventure, instructional, nonfiction, travel and children's nature books. Specializes in hiking guidebooks. Publishes 7-10 titles/year. Recent titles include: *Best Day Hikes*. 5% requires freelance illustration; 100% requires freelance design. Book catalog free for #10 SAE with 1 first-class stamp.

Needs Design and typesetting work for 7-10 books per year. Prefers local freelancers experienced in book

design. 100% of freelance design demands knowledge of FreeHand, Photoshop, QuarkXPress. 100% of freelance illustration demands knowledge of FreeHand, Illustrator.

First Contact & Terms Designers: Send postcard sample or query letter with photocopies. Illustrators: Send postcard sample. Accepts Mac-compatible disk submissions. Samples are not filed and are not returned. Will contact artist for portfolio review of book dummy, photocopies, photographs, tearsheets, thumbnails if interested. Negotiates rights purchased. Finds freelancers through professional recommendation (word of mouth).

Book Design Assigns 10-12 freelance design jobs/year. Pays for design by the project, $1,200-1,500.

Jackets/Covers Assigns 10-12 freelance design jobs and 1 illustration job/year. Pays for design by the project.

ART DIRECTION BOOK CO. INC.

456 Glenbrook Rd., Glenbrook CT 06906. (203)353-1441. Fax: (203)353-1371. **Contact:** Karyn Mugmon, production manager. Publishes hardcover and paperback originals on advertising design and photography. Publishes 10-12 titles/year. Titles include disks of *Scan This Book* and *Most Happy Clip Art*; book and disk of *101 Absolutely Superb Icons* and *American Corporate Identity #11*. Book catalog free on request.

Needs Works with 2-4 freelance designers/year. Uses freelancers mainly for graphic design.

First Contact & Terms Send query letter to be filed and arrange to show portfolio of 4-10 tearsheets. Portfolios may be dropped off Monday-Friday. Samples returned by SASE. Buys first rights. Originals are returned to artist at job's completion. Advertising design must be contemporary. Finds artists through word of mouth.

Book Design Assigns 8 freelance design jobs/year. Pays $350 maximum.

Jackets/Covers Assigns 8 freelance design jobs/year. Pays $350 maximum.

ARTIST'S & GRAPHIC DESIGNER'S MARKET

Writer's Digest Books, Cincinnati OH 45236. E-mail: artdesign@fwpubs.com. **Editor:** Mary Cox. Annual directory of markets for designers, illustrators and fine artists. Buys one-time rights.

Needs Buys 35-45 illustrations/year. "I need examples of art that have been sold to the listings in *Artist's & Graphic Designer's Market*. Look through this book for examples. The art must have been freelanced; it cannot have been done as staff work. Include the name of the listing that purchased or exhibited the work, what the art was used for and, if possible, the payment you received. Bear in mind that interior art is reproduced in black and white, so the higher the contrast, the better. I also need to see promo cards, business cards and tearsheets."

First Contact & Terms Send printed piece, photographs or tearsheets. "Since *Artist's & Graphic Designer's Market* is published only once a year, submissions are kept on file for the upcoming edition until selections are made. Material is then returned by SASE if requested." Pays $75 to holder of reproduction rights and free copy of *Artist's & Graphic Designer's Market* when published.

ATHENEUM BOOKS FOR YOUNG READERS

1230 Avenue of the Americas, New York NY 10020. (212)698-7000. Fax: (212)698-2798. Web site: www.simons ayskids.com. **Art Director:** Ann Bobco. Imprint of Simon & Schuster Children's Publishing Division. Imprint publishes hardcover originals, picture books for young kids, nonfiction for ages 8-12 and novels for middle-grade and young adults. Types of books include biography, historical fiction, history, nonfiction. Publishes 60 titles/year. Recent titles include *Olivia Saves the Circus*, by Ian Falconer; *Zeely*, by Virginia Hamilton. 100% requires freelance illustration. Book catalog free by request.

Needs Approached by hundreds of freelance artists/year. Works with 40-60 freelance illustrators/year. Buys 40 freelance illustrations/year. "We are interested in artists of varying media and are trying to cultivate those with a fresh look appropriate to each title."

First Contact & Terms Send postcard sample of work or send query letter with tearsheets, résumé and photocopies. Samples are filed. Portfolios may be dropped off every Tuesday between 9 a.m. and 4:30 p.m. Art Director will contact artist for portfolio review if interested. Portfolio should include final art if appropriate, tearsheets, and folded and gathered sheets from any picture books you've had published. Rights purchased vary according to project. Originals are returned at job's completion. Finds artists through submissions, magazines ("I look for interesting editorial illustrators"), word of mouth.

Jackets/Covers Assigns 20 freelance illustration jobs/year. Pays by the project, $1,200-1,800. "I am not interested in generic young adult illustrators."

Text Illustration Pays by the project, $500-2,000.

AUGSBURG FORTRESS PUBLISHERS

100 S. Fifth St., Suite 700, Minneapolis MN 55402-1222. (612)330-3300. Fax: (612)330-3455. Web site: www.aug sburgfortress.org. **Contact:** Director of Design, Marketing Services. Publishes hard cover and paperback Protestant/Lutheran books (90 titles/year), religious education materials, audiovisual resources, periodicals. Recent titles include: *Ecotheraphy*, by Howard Clinebell; *Thistle*, by Walter Wangerin.

Needs Uses freelancers for advertising layout, design, illustration and circulars and catalog cover design. Freelancers should be familiar with QuarkXPress 4.1, Photoshop 5.5 and Illustrator 8.01.

First Contact & Terms "Majority, but not all, of our freelancers are local." Works on assignment only. Responds on future assignment possibilities in 2 months. Call, write or send brochure, disk, flier, tearsheet, good photocopies and 35mm transparencies; if artist is not willing to have samples filed, they are returned by SASE. Buys all rights on a work-for-hire basis. May require designers to supply overlays on color work.

Jackets/Covers Uses designers primarily for cover design. Pays by the project, $600-900. Prefers covers on disk using QuarkXPress.

Text Illustration Negotiates pay for 1-, 2- and 4-color. Generally pays by the project, $25-500.

Tips Be knowledgeable "of company product and the somewhat conservative contemporary Christian market."

BAEN BOOKS

P.O. Box 1403, Riverdale NY 10471. (919)570-1640. Fax: (919)570-1644. E-mail: jim@baen.com. Web site: www.baen.com. **Publisher:** Jim Baen. Editor: Toni Weisskopf. Estab. 1983. Publishes science fiction and fantasy. Publishes 60-70 titles/year. Titles include: *Music to My Sorrow* and *At All Costs*. 90% requires freelance illustration; 90% requires freelance design. Book catalog free on request.

First Contact & Terms Approached by 500 freelancers/year. Works with 10 freelance illustrators and 3 designers/year. 50% of work demands computer skills. Designers: Send query letter with résumé, color photocopies, tearsheets (color only) and SASE. Illustrators: Send query letter with color photocopies, SASE, slides and tearsheets. Samples are filed. Originals are returned to artist at job's completion. Buys exclusive North American book rights.

Jackets/Covers Assigns 64 freelance design and 64 illustration jobs/year. Pays by the project. $200 minimum, design; $1,000 minimum, illustration.

Tips Wants to see samples within science fiction, fantasy genre only. "Do not send black & white illustrations or surreal art. Please do not waste our time and your postage with postcards. Serious submissions only."

BEHRMAN HOUSE, INC.

11 Edison Place, Springfield NJ 07081. (973)379-7200. Fax: (973)379-7280. Web site: www.behrmanhouse.com. **Executive Editor:** Gila Gevirtz. Vice President: Terry Kaye. Estab. 1921. Book and software publisher. Publishes textbooks. Types of books include preschool, juvenile, young adult, history (all of Jewish subject matter) and Jewish texts. Specializes in Jewish books for children and adults. Publishes 12 titles/year. Recent titles include: *Jewish History Observer*. "Books are contemporary with lots of photographs and artwork; colorful and lively. Design of textbooks is very complicated." 50% require freelance illustration; 100% require freelance design. Book catalog free by request.

Needs Approached by 50 freelancers/year. Works with 6 freelance illustrators and 6 designers/year. Prefers freelancers with experience in illustrating for children; "Jewish background helpful." Uses freelancers for textbook illustration and book design. Works on assignment only.

First Contact & Terms Send postcard samples or query letter with résumé and tearsheets. Samples are filed. Responds only if interested. Buys reprint rights. Sometimes requests work on spec before assigning a job.

Book Design Assigns 8 freelance design and 3 illustration jobs/year. Pays by project, $4,000-20,000.

Jackets/Covers Assigns 8 freelance design and 4 illustration jobs/year. Pays by the project, $500-1,000.

Text Illustration Assigns 6 freelance design and 4 illustration jobs/year. Pays by the project.

N̄ BLUE DOLPHIN PUBLISHING, INC.

P.O. Box 8, Nevada City CA 95959. (530)265-6925. Fax: (530)265-0787. E-mail: bdolphin@netshel.net. Web site: www.bluedolphinpublishing.com. **President:** Paul M. Clemens. Estab. 1985. Publishes hardcover and trade paperback originals. Types of books include biography, cookbooks, humor and self-help. Specializes in comparative spiritual traditions, lay psychology and health. Publishes 20 titles/year. Recent titles include *The Art of Energy Healing; Your Mind Knows More Than You Do*. Books are "high quality on good paper, with laminated dust jacket and color covers." 10% require freelance illustration; 30% require freelance design. Book catalog free upon request.

Needs Works with 5-6 freelance illustrators and designers/year. Uses freelancers mainly for book cover design. Also for jacket/cover and text illustration. More hardcovers and mixed media are requiring box design as well. 50% of freelance work demands knowledge of PageMaker, QuarkXPress, FreeHand, Illustrator, Photoshop, CorelDraw and other IBM compatible programs. Works on assignment only.

First Contact & Terms Send postcard sample or query letter with brochure and photocopies. Samples are filed or are returned by SASE if requested. Responds in 2 months. Originals are returned to artist at job's completion. Sometimes requests work on spec before assigning job. Considers project's budget when establishing payment. Negotiates rights purchased. Considers buying second rights (reprint rights) to previously published work.

Book Design Assigns 3-5 jobs/year. Pays by the hour, $10-15; or by the project, $300-900.

Jackets/Covers Assigns 5-6 design and 5-6 illustration jobs/year. Pays by the hour, $10-15; or by the project, $300-900.

Text Illustration Assigns 1-2 jobs/year. Pays by the hour, $10-15; or by the project, $300-900.

Tips ''Send query letter with brief sample of style of work. We usually use local people, but always looking for something special. Learning good design is more important than designing on the computer, but we are very computer-oriented.''

▣ BLUEWOOD BOOKS

38 South B St., Suite 202, San Mateo CA 94401. (650)548-0754. Fax: (650)548-0654. E-mail: bluewoodb@aol.com. **Director:** Richard Michaels. Estab. 1990. Publishes trade paperback originals. Types of books include biography, history, nonfiction and young adult. Publishes 4-10 titles/year. Titles include: *True Stories of Baseball's Hall of Famers*, *100 Scientists Who Shaped World History* and *American Politics in the 20th Century*. 100% require freelance illustration; 75% require freelance design. Catalog not available.

Needs Works with 5 illustrators and 3 designers/year. Prefers local freelancers experienced in realistic, b&w line illustration and book design. Uses freelancers mainly for illustration and design. 80-100% of freelance design demands knowledge of Photoshop, Illustrator and QuarkXPress. 80-100% of freelance illustration demands knowledge of FreeHand, Photoshop, Illustrator and QuarkXPress.

First Contact & Terms Designers: Send query letter with brochure, photocopies, résumé, SASE and tearsheets. Illustrators: Send query letter with photocopies, résumé, SASE and tearsheets. Samples are filed. Responds only if interested. Will contact artist for portfolio review of photocopies, photographs, roughs, slides, tearsheets, thumbnails and transparencies if interested. Buys all rights.

Book Design Assigns 4-10 freelance design jobs/year. Pays by the hour or project.

Jackets/Covers Pays by the project, $150-200 for color.

Text Illustration Assigns 4-10 freelance illustration jobs/year. Pays $15-30 for each b&w illustration. Finds freelancers through submissions.

◼ BOYDS MILLS PRESS

815 Church St., Honesdale PA 18431. (570)253-1164. Fax: (570)253-0179. Web site: www.boydsmillpress.com. **Art Director:** Tim Gillner. Estab. 1990. A division of Highlights for Children, Inc. Imprint publishes hardcover originals and reprints. Types of books include fiction, nonfiction, picture books and poetry. Publishes 50 titles/ year. Recent titles include *A Splendid Friend, Indeedt*, by Suzanne Bloom; *Wings of Light: The Migration of the Yellow Butterfly*, by Stephen R. Swinburne (illustrated by Bruce Hiscock; *All Aboard! Passenger Trains Around the World*, by Karl Zimmermann (photographs by the author).

Needs Works with 25-30 freelance illustrators and 5 designers/year. Prefers illustrators with book experiencebut also uses illustrators of all calibers of experience. Uses freelancers mainly for picture books, poetry books, and jacket art. Works on assignment only.

First Contact & Terms Send sample tear sheets, color photocopies, post cards, or electronic submissions. If electronic samples are submitted, low res JPEGs or links to Web sites are best. Samples are not returned. Samples should include color and b&w. Rights purchased vary according to project. Originals are returned at job's completion. Finds artists through submissions filed, sourcebooks, agents, internet, and other publications.

Book Design Assigns 2-3 design/illustrator jobs/year. Pays by the project.

Jackets/Covers Assigns 2-3 design/illustration jobs/year. Pays by the project.

Text Illustration Pays by the project.

Tips Please don't send samples that need to be returned.

BROADMAN & HOLMAN PUBLISHERS

127 Ninth Ave. N., Nashville TN 37234. (615)251-5715. Web site: www.broadmanholman.com. **Contact:** Greg Pope , creative director (Bibles); Diana Lawrence, art director (trade books) Estab. 1891. Religious publishing house. Publishes 104 titles/year. Types of books include children's picture books, mainstream fiction, reference, romance, self-help, young adult fiction; biography, coffee table books, history, instructional, preschool, religious, textbooks, home school educational curricula nonfiction. 20% of titles require freelance illustration. Recent titles include *The Jericho Sanction*, by Oliver North; *Against All Odds*, by Chuck Norris. Books have contemporary look. Book catalog free on request.

Needs Works with 10 freelance illustrators and 15 freelance designers/year. Artist must be experienced, professional. Works on assignment only. 100% of titles require freelance art direction.

First Contact & Terms Send query letter and samples to be kept on file. Bio is helpful. Call or write for appointment to show portfolio. Send links, slides, tearsheets, postcards or photocopies; ''samples *cannot* be returned.'' Responds only if interested. Pays for illustration by the project, $250-1,500. Negotiates rights purchased.

Book Design Pays by the project, $500-1,000.

Jackets/Covers "100% of our cover designs are now done on computer." Pays by the project, $1,500-5,000
Text Illustration Pays by the project, $150 and up.
Tips "We are looking for computer-literate experienced book designers with extensive knowledge of CBA Publishing."

[N] BROOKS/COLE PUBLISHING COMPANY

511 Forest Lodge Rd., Pacific Grove CA 93950. (408)373-0728. Web site: www.brookscole.com. **Art Director:** Vernon T. Boes. Art Editor Lisa Torri. Estab. 1967. Specializes in hardcover and paperback college textbooks on mathematics, chemistry, earth sciences, physics, computer science, engineering and statistics. Publishes 100 titles/year. 85% requires freelance illustration. Books are bold, contemporary textbooks for college level.
Needs Works with 25 freelance illustrators and 25 freelance designers/year. Uses freelance artists mainly for interior illustration. Uses illustrators for technical line art and covers. Uses designers for cover and book design and text illustration. Also uses freelance artists for jacket/cover illustration and design. Works on assignment only.
First Contact & Terms Send query letter with brochure, résumé, tearsheets and photographs. Samples are filed or are returned by SASE. Art Director will contact artist for portfolio review if interested. Portfolio should include roughs, tearsheets, final reproduction/product, photographs, slides and transparencies. Considers complexity of project, skill and experience of artist, project's budget and turnaround time in determining payment. Negotiates rights purchased. Not interested in second rights to previously published work unless first used in totally unrelated market. Finds illustrators and designers through word of mouth, magazines, submissions/self promotion, sourcebooks, and agents.
Book Design Assigns 70 design and many illustration jobs/year. Pays by the project, $500-2,000.
Jackets/Covers Assigns 90 design and many illustration jobs/year. Pays by the project, $500-1,500.
Text Illustration Assigns 85 freelance jobs/year. Prefers ink/Macintosh. Pays by the project, $20-2,000.
Tips "Provide excellent package in mailing of samples and cost estimates. Follow up with phone call. Don't be pushy. Would like to see abstract and applied photography/illustration; single strong, memorable bold images."

CACTUS GAME DESIGN, INC.

751 Tusquittee St., Hayesville, NC 28904. (828)389-1536. Fax: (828)389-1534. E-mail: rob@cactusgamedesign.com. Web site: www.cactusgamedesign.com. **Art Director:** Doug Gray. Estab. 1995. Publishes comic books, game/trading cards, posters/calendars, CD-ROM/online games and board games. Main style/genre of games science fiction, fantasy and Biblical. Uses freelance artists mainly for illustration. Publishes 2-3 titles or products/year. *Outburst Bible Edition*, *Redemption 2nd Edition*, *Gil's Bible Jumble*. 100% requires freelance illustration; 25% requires freelance design.
Needs Approached by 50 illustrators and 5 designers/year. Works with 10 illustrators and 1 designer/year. Prefers freelancers experienced in fantasy and Biblical art. 100% of freelance design demands knowledge of Corel Draw, Photoshop, QuarkXPress and Adobe Illustrator.
First Contact & Terms Send query letter with résumé and photocopies. Accepts disk submissions in Windows format. Send via CD, floppy disk, Zip as TIFF, GIF or JPEG files. Samples are filed. Responds only if interested. Portfolio review not required. Rights purchased vary according to project. Finds freelancers through submission packets and word of mouth.
Visual Design Assigns 30-75 freelance design jobs/year. Pays for design by the hour, $20.
Book Covers/Posters/Cards Pays for illustration by the project, $25-250. "Artist must be aware of special art needs associated with Christian retail environment."
Tips "We like colorful action shots."

CANDLEWICK PRESS

2067 Massachusetts Ave., Cambridge MA 02140. (617)661-3330. Fax: (617)661-0565. **Contact:** Anne Moore, art resource coordinator. Estab. 1992. Imprints include Walker Books, London. Publishes hardcover, trade paperback children's books. Publishes 200 titles/year. 100% requires freelance illustration. Book catalog not available.
Needs Works with 170 illustrators and 1-2 designers/year. 100% of freelance design demands knowledge of Photoshop, Illustrator or QuarkXPress.
First Contact & Terms Designers: Send query letter with résumé. Illustrators: Send query letter with photocopies. Accepts nonreturnable disk submissions from illustrators. Samples are filed and are not returned. Will contact artist for portfolio review of artwork and tearsheets if interested. Buys all rights or rights purchased vary according to project.
Text Illustration Finds illustrators through agents, sourcebooks, word of mouth, submissions, art schools.
Tips "We generally use illustrators with prior trade book experience."

CANDY CANE PRESS

Ideals Publications, a division of Guideposts, 535 Metroplex Dr., Suite 250, Nashville TN 37211. (615)333-0478. Fax: (615)781-1447. Web site: www.idealspublications.com. **Art Director:** Eve DeGrie. Publisher: Patricia Pingry. Publishes hardcover and trade paperback originals. Types of books include children's picture books, juvenile and preschool. Publishes 10 titles/year.
 • See listing for Ideals Publications.

CENTERSTREAM PUBLISHING

P.O. Box 17878, Anaheim Hills CA 92817-7878. (714)779-9390. Fax: (714)779-9390. E-mail: centerstrm@aol.com. Web site: www.centerstream-usa.com. **Production:** Ron Middlebrook. Estab. 1978. Publishes DVDs, audio tapes, and hardcover and softcover originals. Types of books include music reference, biography, music history and music instruction. Publishes 10-20 titles/year. Recent titles include: *On Wings of Music Jerry Byrd Bio*; *Melodic Lines for the Intermediate Guitarist*; *Tony Ellis*; *Banjo*; *The Early Minstrel Banjo*; ''More Dobro'' DVD. 100% requires freelance illustration. Book catalog free for 6×9 SAE with 2 first-class stamps.
Needs Approached by 12 illustrators/year. Works with 3 illustrators/year.
First Contact & Terms Illustrators: Send postcard sample or tearsheets. Accepts Mac-compatible disk submissions. Samples are not filed and are returned by SASE. Responds only if interested. Buys all rights, or rights purchased vary according to project.
Tips ''Publishing is a quick way to make a slow buck.''

CHARLESBRIDGE PUBLISHING

85 Main St., Watertown MA 02472. E-mail: tradeart@charlesbridge.com. Phone/fax: (617)926-0329. Web site: www.charlesbridge.com. **Contact:** Art Director. Estab. 1980. Publishes hardcover and softcover children's trade picture books and transitional ''bridge books,'' books ranging from early readers to middle-grade chapter books. Publishes 35 titles/year, nonfiction and fiction. Recent titles include: *Amelia to Zora* and *Fluffy, Scourge of the Sea*. Books ''off accurate information, promote a positive worldview, and embrace a child's innate sense of wonder and fun.''
Needs Works with 15-20 freelance illustrators/year. Looks for illustrators who ''demonstrate strong originality, excellent conceptual abilities, and technical accomplishment in their chosen media.''
First Contact & Terms Send résumé, tearsheets and photocopies. Samples not filed are returned by SASE. Responds only if interested. Originals are not returned. Considers complexity of project and project's budget when establishing payment. Handles all rights. See Web site for submission guidelines.
Text Illustration Assigns 15-20 jobs/year. Pays royalty with advance.

CHELSEA HOUSE PUBLISHERS

1974 Sproul Rd., Suite 204, Broomall PA 19008-0914. (610)353-5166, ext. 188. Fax: (610)353-5191. **Contact:** Art Director. Estab. 1973. Publishes hardcover originals and reprints. Types of books include biography, history, juvenile, reference, young adult. Specializes in young adult literary books. Publishes 150 titles/year. Recent titles include: *Coretta Scott King*, by Lisa Renee Rhodes. 85% requires freelance illustration; 30% requires freelance design; 10% requires freelance art direction. Book catalog not available.
Needs Approached by 100 illustrators and 50 designers/year. Works with 25 illustrators, 10 designers, 5 art directors/year. Prefers freelancers experienced in Macintosh computer for design. 100% of freelance design demands knowledge of Photoshop, QuarkXPress. 20% of freelance illustration demands knowledge of Illustrator, Photoshop, QuarkXPress.
First Contact & Terms Designers: Send query letter with nonreturnable printed samples, photocopies. Illustrators: Send postcard sample and follow-up postcard every 3 months. Accepts Mac-compatible disk submissions. Samples are filed and are not returned. Will contact artist for portfolio review if interested. Buys first rights. Finds freelancers through networking, submissions, agents and *American Showcase*.
Book Design Assigns 25 freelance design and 5 art direction projects/year. Pays for design by the hour, $15-35; for art direction by the hour, $25-45.
Jackets/Covers Assigns 50 freelance design jobs and 150 illustration jobs/year. Prefers oil, acrylic. Pays for design by the hour, $25-35. Pays for illustration by the project, $650-850. Prefers portraits that capture close likeness of a person.
Tips ''Most of the illustrations we purchase involve capturing an exact likeness of a famous or historical person. Full color only, no black & white line art. Please send nonreturnable samples only.''

CLARION BOOKS

215 Park Ave. S., 10th Floor, New York NY 10003. (212)420-5800. Web site: www.hmco.com. **Art Director:** Joann Hill. Imprint of Houghton Mifflin Company. Imprint publishes hardcover originals and trade paperback reprints. Specializes in picture books, chapter books, middle grade novels and nonfiction, including historical

and animal behavior. Publishes 60 titles/year. 90% requires freelance illustration. Book catalog free for SASE.
- *The Three Pigs*, by David Weisner was awarded the 2002 Caldecott Medal. *A Single Shard*, by Linda Sue Park was awarded the 2002 Newbery Medal.

Needs Approached by "countless" freelancers. Works with 48 freelance illustrators/year. Uses freelancers mainly for picture books and novel jackets. Also for jacket/cover and text illustration.

First Contact & Terms Send query letter with tearsheets and photocopies. Samples are filed "if suitable to our needs." Responds only if interested. Portfolios may be dropped off every Monday. Art Director will contact artist for portfolio review if interested. Rights purchased vary according to project. Originals are returned at job's completion.

Text Illustration Assigns 48 freelance illustration jobs/year. Pays by the project.

Tips "Be familiar with the type of books we publish before submitting. Send a SASE for a catalog or look at our books in the bookstore. Send us children's book-related samples."

THE COUNTRYMAN PRESS

(Division of W.W. Norton & Co., Inc.), Box 748, Woodstock VT 05091. (802)457-4826. Fax: (802)457-1678. E-mail: countrymanpress@wwnorton.com. Web site: www.countrymanpress.com. **Contact:** Kelly Thompson. Estab. 1976. Book publisher. Publishes hardcover originals and reprints, and trade paperback originals and reprints. Types of books include history, cooking, travel, nature and recreational guides. Specializes in recreational (biking/hiking) guides. Publishes 60 titles/year. Titles include: *The King Arthur Flour Baker's Companion* and *Maine: An Explorer's Guide*. 10% require freelance illustration; 60% require freelance cover design. Book catalog free by request.

Needs Works with 4 freelance illustrators and 7 designers/year. Uses freelancers for jacket/cover and book design. Works on assignment only. Prefers working with computer-literate artists/designers with knowledge of Photoshop, Illustrator, QuarkXPress.

First Contact & Terms Send query letter with appropriate samples. Samples are filed. Responds to the artist only if interested. To show portfolio, mail best representations of style and subjects. Negotiates rights purchased.

Book Design Assigns 10 freelance design jobs/year. Pays for design by the project, $1,000-1,500.

Jackets/Covers Assigns 10 freelance design jobs/year. Pays for design $1,000-1,500.

CRC PRODUCT SERVICES

2850 Kalamazoo Ave. SE, Grand Rapids MI 49560. (616)224-0780. Fax: (616)224-0834. Web site: www.crcna.org. **Art Director:** Dean Heetderks. Estab. 1866. Publishes hardcover and trade paperback originals and magazines. Types of books include instructional, religious, young adult, reference, juvenile and preschool. Specializes in religious educational materials. Publishes 8-12 titles/year. 85% requires freelance illustration.

Needs Approached by 30-45 freelancers/year. Works with 12-16 freelance illustrators/year. Prefers freelancers with religious education, cross-cultural sensitivities. Uses freelancers for jacket/cover and text illustration. Works on assignment only. 5% requires freelance art direction.

First Contact & Terms Send query letter with brochure, résumé, tearsheets, photographs, photocopies, slides and transparencies. Submissions will not be returned. Illustration guidelines are available on Web site. Samples are filed. Portfolio should include thumbnails, roughs, finished samples, color slides, tearsheets, transparencies and photographs. Buys one-time rights. Originals are returned at job's completion.

Jackets/Covers Assigns 2-3 freelance illustration jobs/year. Pays by the project, $200-1,000.

Text Illustration Assigns 50-100 freelance illustration jobs/year. Pays by the project, $75-100. "This is high-volume work. We publish many pieces by the same artist."

Tips "Be absolutely professional. Know how people learn and be able to communicate a concept clearly in your art."

CROSS CULTURAL PUBLICATIONS, INC.

P.O. Box 506, Notre Dame IN 46556. (574)273-6526. Fax: (574)273-5973. E-mail: crosscult@aol.com. Web site: www.crossculturalpub.com. **Marketing Manager:** Anand Pullapilly. Director of Graphic Art Christine English. Business Manager Kavita Pullapilly. Estab. 1980. Imprint is Cross Roads Books. Company publishes hardcover and trade paperback originals and textbooks. Types of books include biography, religious and history. Specializes in scholarly books on cross-cultural topics. Publishes 30 titles/year. Recent titles include *She is With the Angels*, by August Swanenberg; *I Became a Fly*, by Donald McKnight; *Human Consciousness*; *The Material Soul*, by John Dedek.

Needs Approached by 25 freelancers/year. Works with 2 freelance illustrators/year. Prefers local artists only. Uses freelance artists mainly for jacket/cover illustration.

First Contact & Terms Send query letter with résumé and photocopies. Samples are not filed and are not returned. Responds only if interested. Art director will contact artist for portfolio review if interested. Portfolio

should include b&w samples. Rights purchased vary according to project. Originals are not returned. Finds artists through word of mouth.

Jackets/Covers Assigns 4-5 freelance illustration jobs/year. Pays by the project.

Tips "First-time assignments are usually book jackets. We publish books that push the boundaries of knowledge."

THE CROSSING PRESS

P.O. Box 7123, Berkeley CA 94707. (510)559-1600. Fax: (510)524-1052. E-mail: crossing@crossingpress.com. Web site: www.crossingpress.com. **Art Director:** Nancy Austin. Estab. 1966. Publishes trade paperback originals and reprints. Types of books include nonfiction and self-help. Specializes in natural healing, New Age spirituality. Publishes 20 titles/year. Art guidelines on Web site.

● Part of Ten Speed Press.

Needs Freelance designers welcome to submit samples. Prefers designers experienced in Quark, InDesign, Photoshop and book text design.

First Contact & Terms Send e-mail with web portfolio or query letter with printed samples, or color copies, materials are to be returned. Samples are filed or returned by SASE. Will contact artist for portfolio review if interested. Rights purchased vary according to project. Finds freelancers through submissions, promo mailings.

Tips "We usually buy stock imagery for covers and sometimes work with freelance designers."

CROWN PUBLISHERS, INC.

1745 Broadway, Mail Drop 13-1, New York NY 10019. (212)572-2600. **Art Director:** Whitney Cookman. Art Director: Mary Sarah Quinn. Specializes in fiction, nonfiction and illustrated nonfiction. Publishes 250 titles/year. Titles include: *The Crazyladies of Pearl Street* and *The Bright Forever*.

● Crown is an imprint of Random House. Within that parent company, several imprints—including Clarkson Potter, Crown Arts & Letters, and Harmony—maintain separate art departments.

Needs Approached by several hundred freelancers/year. Works with 15-20 illustrators and 25 designers/year. Prefers local artists. 100% of design demands knowledge of QuarkXPress and Illustrator. Works on assignment only.

First Contact & Terms Send query letter with samples showing art style. Responds only if interested. Originals are not returned. Rights purchased vary according to project.

Jackets/Covers Assigns 15-20 design and/or illustration jobs/year. Pays by the project.

Tips "There is no single style. We use different styles depending on nature of the book and its perceived market. Become familiar with the types of books we publish. For example, don't send juvenile, sci-fi or romance. Book design has changed to Mac-generated layout."

CYCLE PUBLICATIONS, INC.

1282 Seventh Ave., San Francisco CA 94112-2526. (415)665-8214. Fax: (415)753-8572. E-mail: pubrel@cyclepublishing.com. Web site: www.cyclepublishing.com. **Editor:** Rob van der Plas. Estab. 1985. Book publisher. Publishes trade paperback originals. Types of books include instructional and travel. Specializes in subjects relating to cycling and bicycles. Publishes 6 titles/year. Recent titles include *Baseball's Hitting Secrets*; *Play Golf in the Zone*; *Bicycle Repair Step by Step*. 20% require freelance illustration. Book catalog for SASE with first-class postage.

Needs Approached by 5 freelance artists/year. Works with 2 freelance illustrators/year. Buys 100 freelance illustrations/year. Uses freelance artists mainly for technical (perspective) and instructions (anatomically correct hands, posture). Also uses freelance artists for text illustration; line drawings only. Also for design. 50% of freelance work demands knowledge of CorelDraw and FreeHand. Works on assignment only.

First Contact & Terms Send query letter with tearsheets. Accepts disk submissions. Please include print-out with EPS files. Samples are filed. Call "but only after we have responded to query." Portfolio should include photostats. Rights purchased vary according to project. Originals are not returned to the artist at the job's completion.

Book Design Pays by the project.

Text Illustration Assigns 5 freelance illustration jobs/year. Pays by the project.

Tips "Show competence in line drawings of technical subjects and 2-color maps."

DA CAPO PRESS

11 Cambridge Center, Cambridge MA 02142. (617)252-5241. E-mail: alex.camlin@perseusbooks.com. Web site: www.dacapopress.com. **Contact:** Alex Camlin, art director. Estab. 1975. Publishes hardcover originals, trade paperback originals, trade paperback reprints. Types of books include self-help, parenting, biography, memoir, coffee table books, history, travel, music, and film. Specializes in self-help, parenting, music and history (trade). Publishes 100 titles/year. 25% requires freelance design; 5% requires freelance illustration.

Needs Approached by 30+ designers and 30+ illustrators/year. Works with 10 designers and 1 illustrator/year.
First Contact & Terms Send query letter with résumé, URL, color prints/copies. Send follow-up postcard sample every 6 months. Prefers Mac-compatible, JPEG, and PDF files. Samples are filed. Responds only if interested. Portfolios may be dropped off every Wednesday, Thursday and Friday and should include finished, printed samples. Rights purchased vary according to project. Finds freelancers through art competitions, artists' submissions, Internet and word of mouth.
Jackets/Covers Assigns 20 freelance cover illustration jobs/year.
Text Illustration Does not assign freelance illustration jobs/year.
Tips "Visit our Web site (www.dacapopress.com) to view work produced/assigned by Da Capo."

DARK HORSE

10956 SE Main, Milwaukie OR 97222. E-mail: dhcomics@darkhorse.com. Web site: www.darkhorse.com. **Contact:** Submissions. Estab. 1986. Publishes mass market and trade paperback originals. Types of books include comic books and graphic novels. Specializes in comic books. Recent titles include: *B.P.R.D.: The Universal Machine #2*, by Mike Mignola; *Star Wars: Knights of the Old Republic #4*, by John Jackson Miller; *Usagi Yojimbo #93*, by Stan Sakai. Book catalog available on Web site.
First Contact & Terms Send photocopies (clean, sharp, with name, address and phone number written clearly on each page). Samples are not filed and not returned. Responds only if interested. Company will contact artist for portfolio review interested.
Tips "If you're looking for constructive criticism, show your work to industry professionals at conventions."

JONATHAN DAVID PUBLISHERS

68-22 Eliot Ave., Middle Village NY 11379. (718)456-8611. Fax: (718)894-2818. E-mail: info@jdbooks.com. Web site: www.jdbooks.com. **Contact:** Editorial Review. Estab. 1948. Company publishes hardcover and paperback originals. Types of books include biography, religious, young adult, reference, juvenile and cookbooks. Specializes in Judaica. Publishes 25 titles/year. Titles include: *Drawing a Crowd* and *The Presidents of the United States & the Jews*. 50% require freelance illustration; 75% require freelance design.
Needs Approached by numerous freelancers/year. Works with 5 freelance illustrators and 5 designers/year. Prefers freelancers with experience in book jacket design and jacket/cover illustration. 100% of design and 5% of illustration demand computer literacy. Works on assignment only.
First Contact & Terms Designers: Send query letter with résumé and photocopies. Illustrators: Send postcard sample and/or query letter with photocopies, résumé. Samples are filed. Production coordinator will contact artist for portfolio review if interested. Portfolio should include color final art and photographs. Buys all rights. Originals are not returned. Finds artists through submissions.
Book Design Assigns 15-20 freelance design jobs/year. Pays by the project.
Jackets/Covers Assigns 15-20 freelance design and 4-5 illustration jobs/year. Pays by the project.
Tips First-time assignments are usually book jackets, mechanicals and artwork.

DAW BOOKS, INC.

375 Hudson St., 3rd Floor, New York NY 10014-3658. (212)366-2096. Fax: (212)366-2090. **Art Directors:** Elizabeth R. Wollheim and Sheila E. Gilbert. Estab. 1971. Publishes hardcover and mass market paperback originals and reprints. Specializes in science fiction and fantasy. Publishes 72 titles/year. Recent titles include: *The Wizard of London*, by Mercedes Lackey; *Pretender*, by C.J. Cherryh (science fiction). All require freelance illustration. Guidelines available on Web site.
Needs Works with numerous illustrators and 1 designer/year. Buys more than 36 illustrations/year. Works with illustrators for covers. Works on assignment only.
First Contact & Terms Send postcard sample or query letter with brochure, résumé, tearsheets, transparencies, photocopies, photographs and SASE. "Please don't send slides." Samples are filed or are returned by SASE only if requested. Responds in 3 days. Originals returned at job's completion. Call for appointment to show portfolio of original/final art, final reproduction/product and transparencies. Considers complexity of project, skill and experience of artist and project's budget when establishing payment. Buys first rights and reprint rights.
Jacket/Covers Pays by the project, $1,500-8,000. "Our covers illustrate the story."
Tips "We have a drop-off policy for portfolios. We accept them on Tuesdays, Wednesdays and Thursdays and report back within a day or so. Portfolios should contain science fiction and fantasy color illustrations *only*. We do not want to see anything else. Look at several dozen of our covers."

DC COMICS

Time Warner Entertainment, 1700 Broadway, 5th Floor, New York NY 10019. (212)636-5400. Fax: (212)636-5481. Web site: www.dccomics.com. **Vice President of Design and Retail Produce Development:** Georg

Brewer. Estab. 1948. Publishes hardcover originals and reprints, mass market paperback originals and reprints, trade paperback originals and reprints. Types of books include adventure, comic books, fantasy, horror, humor, juvenile, science fiction. Specializes in comic books. Publishes 1,000 titles/year.

- DC Comics does not accept unsolicited submissions.

DIAL BOOKS FOR YOUNG READERS

345 Hudson St., New York NY 10014. (212)414-3412. Fax: (212)414-3398. **Editors:** Nancy Mercado, Rebecca Waugh. Specializes in juvenile and young adult hardcovers. Publishes 50 titles/year. Recent titles include: *Snowmen at Night*, by Caralyn and Mark Buchner; *The Surprise Visitor*, by Juli Kangas. 100% require freelance illustration. Books are "distinguished children's books."

Needs Approached by 400 freelancers/year. Works with 40 freelance illustrators/year. Prefers freelancers with some book experience. Works on assignment only.

First Contact & Terms Send query letter with photocopies, tearsheets and SASE. Samples are filed and returned by SASE. Responds only if interested. Originals returned at job's completion. Send query letter with samples for appointment to show portfolio of original/final art and tearsheets. Considers complexity of project, skill and experience of artist and project's budget when establishing payment. Rights purchased vary.

Jackets/Covers Assigns 8 illustration jobs/year. Pays by the project.

Text Illustration Assigns 40 freelance illustration jobs/year. Pays by the project.

DUTTON CHILDREN'S BOOKS

Penguin Putnam Inc., 345 Hudson St., New York NY 10014. Web site: www.penguin.com. **Art Director:** Sara Reynolds. Publishes hardcover originals. Types of books include biography, children's picture books, fantasy, humor, juvenile, preschool, young adult. Publishes 100-120 titles/year. 75% require freelance illustration.

Needs Prefers local designers.

First Contact & Terms Send postcard sample, printed samples, tearsheets. Samples are filed or returned by SASE. Will contact artist for portfolio review if interested. Portfolios may be dropped off every Tuesday and picked up by end of the day. Do not send samples via e-mail.

Jackets/Covers Pays for illustration by the project $1,800-2,500.

EDUCATIONAL IMPRESSIONS, INC.

116 Washington Ave., Hawthorne NJ 07507. (973)423-4666. Fax: (973)423-5569. E-mail: awpeller@optionline.net. Web site: www.awpeller.com. **Art Director:** Karen Birchak. Estab. 1983. Publishes original workbooks with 2-4 color covers and b&w text. Types of books include instructional, juvenile, young adult, reference, history and educational. Specializes in all educational topics. Publishes 4-12 titles/year. Recent titles include: *September, October and November*, by Rebecca Stark; *Tuck Everlasting*; *Walk Two Moons Lit Guides*. Books are bright and bold with eye-catching, juvenile designs/illustrations.

Needs Works with 1-5 freelance illustrators/year. Prefers freelancers who specialize in children's book illustration. Uses freelancers for jacket/cover and text illustration. Also for jacket/cover design. 50% of illustration demands knowledge of QuarkXPress and Photoshop. Works on assignment only.

First Contact & Terms Send query letter with tearsheets, SASE, résumé and photocopies. Samples are filed. Art director will contact artist for portfolio review if interested. Buys all rights. Interested in buying second rights (reprint rights) to previously published work. Originals are not returned. Prefers line art for the juvenile market. Sometimes requests work on spec before assigning a job.

Book Design Pays by the project, $20 minimum.

Jackets/Covers Pays by the project, $20 minimum.

Text Illustration Pays by the project, $20 minimum.

Tips "Send juvenile-oriented illustrations as samples."

ELCOMP PUBLISHING, INC.

8780 19th St., #199, Alta Loma CA 91701. Phone/fax: (909)949-0262. E-mail: elcomp@csi.com. Web site: www.clipshop.com. **President:** Winifred Hofacker. Estab. 1979. Publishes mass market paperback originals and CD-ROMs. Types of books include reference, textbooks, travel and computer. Specializes in computer and software titles. Publishes 2-3 titles/year. Recent titles include: *Windows XP Pocket Reference*; *The World's Easiest Database*. 90% require freelance illustration; 90% require freelance design. Catalog free for 2 first-class stamps.

Needs Approached by 2 illustrators and 2 designers/year. Works with 1 illustrator and 1 designer/year. Prefers freelancers experienced in cartoon drawing and clip art drawing. Uses freelancers mainly for clip art drawing. 10% of freelance design demands knowledge of Photoshop. 10% of freelance illustration demands knowledge of Photoshop and Illustrator.

First Contact & Terms Designers: Send photocopies. Illustrators: Send photocopies, printed sample and follow-up postcard samples every 2 months. Accepts disk submissions compatible with EPS or WMF files for Windows.

Samples are returned. Responds in 6 weeks. Art director will contact artist for portfolio review if interested.
Book Design Pays for design by the project, $20-50.
Jackets/Covers Pays for design by the project, $10-50. Pays for illustration by the project, $10-20.
Text Illustration Pays by the project, $10-20.

EDWARD ELGAR PUBLISHING INC.

136 West St., Suite 202, Northampton MA 01060. (413)584-5551. Fax: (413)584-9933. E-mail: elgarinfo@e-elgar.com. Web site: www.e-elgar.com. **Marketing Manager:** Katy Wight. Estab. 1986. Publishes hardcover originals and textbooks. Types of books include instructional, nonfiction, reference, textbooks, academic monographs, references in economics and business and law. Publishes 200 titles/year. Recent titles include: *Who's Who in Economics, Fourth Edition*; *The IPO Decision*.

• This publisher uses only freelance designers. Its academic books are produced in the United Kingdom. Direct Marketing material is done in U.S. There is no call for illustration.

Needs Approached by 2-4 designers/year. Works with 2 designers/year. Prefers local designers. Prefers freelancers experienced in direct mail and academic publishing. 100% of freelance design demands knowledge of Photoshop, InDesign.
First Contact & Terms Designers: Send query letter with printed samples. Accepts Mac-compatible disk submissions. Samples are filed. Will contact artist for portfolio review if interested. Buys one-time rights or rights purchased vary according to project. Finds freelancers through word of mouth, local sources i.e. phone book, newspaper, etc.

M. EVANS AND COMPANY, INC.

216 E. 49th St., New York NY 10017. (212)688-2810. Fax: (212)486-4544. E-mail: editorial@mevans.com. Web site: www.mevans.com. **Contact:** Rik Lain Schell. Estab. 1956. Publishes hardcover and trade paperback originals. Types of books include adventure, humor (fiction); biography, cookbooks, history, instructional, self-help (nonfiction). Specializes in general nonfiction. Publishes 40 titles/year. Recent titles include *Dr. Atkins' New Diet Revolution*, by Robert C. Atkins; *Women, Weight and Hormones*, by Elizabeth Lee Vliet, M.D.; *Unbelievable Desserts with Splenda*, by Marlene Koch. 5% requires freelance illustration and design.
Needs Approached by hundreds of freelancers/year. Works with approximately 10 freelance illustrators and 5 designers/year. Prefers local artists. Uses freelance artists mainly for jacket/cover illustration. Also for text illustration and jacket/cover design. Works on assignment only.
First Contact & Terms Send query letter with brochure and résumé. Samples are filed. Art Director will contact artist for portfolio review if interested. Portfolio should include original/final art and photographs. Rights purchased vary according to project. Originals are returned at job's completion upon request.
Book Design Assigns 10 freelance jobs/year. Pays by project, $200-500.
Jackets/Covers Assigns 40 freelance design jobs/year. Pays by the project, $600-1,200.
Text Illustration Assigns 2-5 freelance text illustration jobs/year. Pays by the project, $50-500.

EXCELSIOR CEE PUBLISHING

P.O. Box 5861, Norman OK 73070. (405)329-3909. Fax: (405)329-6886. E-mail: ecp@oecadvantage.net. Web site: excelsiorcee.com. Estab. 1989. Publishes trade paperback originals. Types of books include how-to, instruction, nonfiction and self help. Specializes in how-to and writing. Publishes 6 titles/year. Titles include: *When I Want Your Opinion I'll Tell it to You*.
Needs Uses freelancers mainly for jacket and cover design.
First Contact & Terms Designers: Send query letter with SASE. Illustrators: Send query letter with résumé and SASE. Accepts disk submissions from designers. Samples returned by SASE. Negotiates rights purchased.
Book Design Assigns 2 freelance design jobs/year. Pays by the project.
Jackets/Covers Assigns 6 freelance illustration jobs/year. Pays by the project; negotiable.
Text Illustration Pays by the project. Finds freelancers through word of mouth and submissions.

F+W PUBLICATIONS INC.

4700 E. Galbraith Rd., Cincinnati OH 45236. Web site: www.fwpublications.com. **Art Director:** Clare Finney. Imprints: Writers Digest Books, North Light Books, Betterway Books, IMPACT Books, HOW Design Books, Adams Media, Krause. Publishes 120 books annually for writers, artists and photographers, plus selected trade (lifestyle, home improvement) titles. Recent titles include: *Quaint Birdhouses You Can Paint and Decorate*; *Colored Pencil Portraits Step by Step*; *Manga Madness*. Books are heavy on type-sensitive design.
Needs Works with 10-20 freelance illustrators and 5-10 designers/year. Uses freelancers for jacket/cover design and illustration, text illustration, direct mail and book design. Works on assignment only.
First Contact & Terms Send nonreturnable photocopies of printed work to be kept on file. Art director will contact artist for portfolio review if interested. Interested in buying second rights (reprint rights) to previously

published illustrations. "We like to know where art was previously published." Finds illustrators and designers through word of mouth and submissions/self promotions.

Book Design Pays by the project, $600-1,000.

Jackets/Covers Pays by the project, $750.

Text Illustration Pays by the project, $100 minimum.

Tips "Don't call. Send appropriate samples we can keep. Clearly indicate what type of work you are looking for."

FABER & FABER, INC.

Division of Farrar, Straus and Giroux, 19 Union Square W., New York NY 10003-3304. (212)741-6900. Fax: (212)633-9385. Web site: www.fsgbooks.com/faberandfaber.htm. **Senior Editor:** Denise Oswald. Estab. 1976. Publishes hardcover originals, trade paperback originals and reprints. Types of books include biography, cookbooks, history, mainstream fiction, nonfiction, self help and travel. Publishes 35 titles/year. 30% require freelance design.

Needs Approached by 60 illustrators and 40 designers/year. Works with 2 illustrators and 5 designers/year.

Illustration: Caitlin Kuhwald. Printed with permission of F+W Publications.

When Caitlin Kuhwald was given the assignment to illustrate the cover of *I'm an English Major—Now What?* for F+W Publications, she was asked simply to create a portrait of William Shakespeare. After delivering her illustration, the art director and editor felt it needed something more. Kuhwald came back with a second version, this time showing the Bard wearing an iPod and sharing the stage with typical English majors, and showing the book's title in Shakespeare's thought cloud. The art director found Kuhwald on www.theispot.com. Kuhwald's work has been featured in *Rolling Stone*, *Cosmo Girl*, *Spin* magazine and a long list of publications listed at www.caitlin kuhwald.com.

Uses freelancers mainly for book jacket design. 80% of freelance design demands knowledge of Photoshop and QuarkXPress.

First Contact & Terms Designers: Send query letter with photocopies. Illustrators: Send postcard sample or photocopies. Samples are filed or returned by SASE. Will contact artist for portfolio review if interested. Rights purchased vary according to project.

Jackets/Covers Assigns 20 freelance design and 4 illustration jobs/year. Pays by project.

FALCON PRESS PUBLISHING CO., INC.

Imprint of Globe Pequot Press, 246 Goose Lane, P.O. Box 480, Guilford CT 06437. (203)458-4500. Fax: (203)458-4601. E-mail: artwork@globepequot.com. Web site: www.globepequot.com. **Art/Production Director:** Michael Cirone. Estab. 1978. Book publisher. Publishes hardcover originals and reprints, trade paperback originals and reprints, and mass market paperback originals and reprints. Types of books include instruction, juvenile, travel and cookbooks. Specializes in recreational guidebooks and high-quality, four-color coffeetable photo books. Publishes 130 titles/year. Recent titles include: *Allen and Mike's Really Cool Telemark Tips*, by John Pukite; *Birder's Dictionary*, by Randall Cox. Book catalog free by request.

Needs Approached by 250 freelance artists/year. Works with 2-5 freelance illustrators/year. Buys 100 freelance illustrations/year. Uses freelance artists mainly for illustrating children's books, map making and technical drawing.

First Contact & Terms Send postcard sample or query letter with résumé, tearsheets, photographs, photocopies or photostats. Samples are filed if they fit our style. Accepts disk submissions compatible with PageMaker, QuarkXPress or Illustrator. Responds to the artist only if interested. Do not send anything you need returned. Originals are returned at job's completion.

Book Production Assigns 30-40 freelance production jobs and 1-2 design projects/year. Pays by the project.

Jackets/Covers Assigns 1-4 freelance design and 1-4 illustration jobs/year.

Text Illustration Assigns approximately 10 freelance illustration jobs/year. Pays by the project. No preferred media or style.

Tips "If we use freelancers, it's usually to illustrate nature-oriented titles. These can be for various children's titles or adult titles. We tend to look for a more 'realistic' style of rendering but with some interest."

FANTAGRAPHICS BOOKS, INC.

7563 Lake City Way, Seattle WA 98115. (206)524-1967. Fax: (206)524-2104. E-mail: fbicomix@fantagraphics.com. Web site: www.fantagraphics.com. **Contact:** Submissions Editor. Estab. 1976. Publishes hardcover and trade paperback originals and reprints. Types of books include contemporary, experimental, mainstream, historical, humor and erotic. "All our books are comic books or graphic stories." Publishes 100 titles/year. Recent titles include: *Love & Rockets*; *Hate*; *Eightball*; *Acme Novelty Library*; *JIM*; *Naughty Bits*. 10% requires freelance illustration. Book catalog free by request.

Needs Approached by 500 freelancers/year. Works with 25 freelance illustrators/year. Must be interested in and willing to do comics. Uses freelancers for comic book interiors and covers.

First Contact & Terms Send query letter addressed to submissions editor with résumé, SASE, photocopies and finished comics work. Samples are not filed and are returned by SASE. Responds to the artist only if interested. Call or write for appointment to show portfolio of original/final art and b&w samples. Buys one-time rights or negotiates rights purchased. Originals are returned at job's completion. Pays royalties.

Tips "We want to see completed comics stories. We don't make assignments, but instead look for interesting material to publish that is pre-existing. We want cartoonists who have an individual style, who create stories that are personal expressions."

FARRAR, STRAUS & GIROUX, INC.

19 Union Square W., New York NY 10003. (212)741-6900. Fax: (212)741-6973. **Art Director:** Susan Mitchell. Book publisher. Estab. 1946. Publishes hardcover and trade paperback originals and trade paperback reprints. Publishes nonfiction and juvenile fiction. Publishes 200 titles/year. 20% require freelance illustration; 40% freelance design.

Needs Works with 12 freelance designers and 3-5 illustrators/year. Uses artists for jacket/cover and book design.

First Contact & Terms Send postcards, tearsheets, photocopies or other nonreturnable samples. Samples are filed and are not returned. Responds only if interested. Originals are returned at job's completion. Call or write for appointment to show portfolio of photostats and final reproduction/product. Portfolios may be dropped off every Wednesday before 2 p.m. Considers complexity of project and budget when establishing payment. Buys one-time rights.

Book Design Assigns 40 freelance design jobs/year. Pays by the project, $300-450.

Jackets/Covers Assigns 20 freelance design jobs/year and 10-15 freelance illustration jobs/year. Pays by the project, $750-1,500.
Tips The best way for a freelance illustrator to get an assignment is "to have a great portfolio."

FILMS FOR CHRIST

P.O. Box 200, Gilbert AZ 85299. E-mail: mail@eden.org. Web site: www.eden.org. **Contact:** Paul S. Taylor. Number of employees 5. Motion picture producer, Web and book publisher. Audience educational, religious and secular. Produces and distributes motion pictures, videos and books.
• Design and computer work are done inhouse. Will work with out-of-town illustrators.
Needs Works with 1-5 freelance illustrators/year. Works on assignment only. Uses illustrators for books, catalogs and motion pictures. Also for storyboards, animation, cartoons, slide illustration and ads.
First Contact & Terms Send query letter with résumé, photocopies, slides, tearsheets or snapshots. Samples are filed or are returned by SASE. Responds in 1 month. All assignments are on a work-for-hire basis. Originals are not returned. Considers complexity of project and skill and experience of artist when establishing payment.

FIRST BOOKS

6750 SW Franklin St., Suite A, Portland OR 97223. (503)968-6777. Fax: (503)968-6779. Web site: www.firstbooks.com. **President:** Jeremy Solomon. Estab. 1988. Publishes trade paperback originals. Publishes 50 titles/year. Recent titles include: *Devine Color*, by Gretchen Schaufaer. 100% require freelance illustration.
Needs Works with 5 designers and 5 illustrators/year. Uses freelance designers not illustrators mainly for interiors and covers.
First Contact & Terms Designers: Send "any samples you want to send and SASE but no original art, please!" Illustrators: Send query letter with a few photocopies or slides. Samples are filed or returned by SASE. Responds in 1 month. Rights purchased vary according to project.
Book Design Payment varies per assignment.
Tips "Small samples get looked at more than anything bulky and confusing. Little samples are better than large packets and binders. Postcards are easy. Save a tree!"

FORT ROSS INC.

26 Arthur Place, Yonkers NY 10701. (914)375-6448. Fax: (914)375-6439. E-mail: fort.ross@verizon.net or vkartsev2000@yahoo.com. Web site: www.fortrossinc.com. **Executive Director:** Dr. Vladimir P. Kartsev. Represents leading Russian, Polish, Spanish, etc., publishing companies in the US and Canada. Estab. 1992. Specializes in books in Russian and Russian-related books in English. Hardcover originals, mass market paperback originals and reprints, and trade paperback reprints. Works with adventure, fantasy, horror, romance, science fiction. Specializes in romance, science fiction, fantasy, mystery. Publishes 5 titles/year. Represents 500 titles/year. Recent titles include: translations of *Judo*, by Vladamir Putin; *The Redemption*, by Howard Fast. 100% requires freelance illustration. Book catalog not available.
• "We have drastically changed the exterior of books published in Europe using classical American illustrations and covers."
Needs Approached by 100 illustrators/year. Works with 40 illustrators/year. Prefers freelancers experienced in romance, science fiction, fantasy, mystery cover art.
First Contact & Terms Illustrators: Send query letter with printed samples, photocopies, SASE, tearsheets. Accepts Windows-compatible disk submissions. Send EPS files. Samples are filed. Will contact artist for portfolio review if interested. Buys secondary rights. Finds freelancers through agents, networking events, sourcebooks, *Black Book*; *RSVP*; *Spectrum*.
Jackets/Covers Buys up to 1,000 illustrations/year. Pays for illustration by the project, $50-150 for secondary rights (for each country). Prefers experienced romance, mystery, science fiction, fantasy cover illustrators.
Tips "Fort Ross is the best place for experienced cover artists to sell secondary rights for their images in Russia, Poland, Czech Republic, countries of the former USSR, Western, Central and Eastern Europe. We prefer realistic, thoroughly executed expressive images on our covers."

FRANKLIN WATTS

90 Old Sherman Turnpike, Danbury CT 06816. (203)797-3500. Fax: (203)797-3657. Web site: www.scholasticlibrary.com. **Contact:** Art Director. Estab. 1942. Imprint of Scholastic Library Publishing. Publishes juvenile nonfiction and specialty reference sets.
• See listing for Scholastic Library Publishing. Its imprints include Children's Press and Grolier, in addition to Franklin Watts.

FULCRUM PUBLISHING

16100 Table Mountain Parkway #300, Golden CO 80403. (303)277-1623. Fax: (303)279-7111. Web site: www.fulcrum-books.com. **Contact:** Art Director. Estab. 1984. Book publisher. Publishes hardcover originals and trade

paperback originals and reprints. Types of books include biography, Native American, reference, history, self help, children's, teacher resource books, travel, humor, gardening and nature. Specializes in history, nature, teacher resource books, travel, Native American, environmental and gardening. Publishes 50 titles/year. Recent titles include: *Broken Trail*, by Alan Geaffrion; *Anton Wood: The Boy Murderer*, by Dick Kreck. 15% requires freelance illustration; 15% requires freelance design. Book catalog free by request.

Needs Uses freelancers mainly for cover and interior illustrations for gardening books. Also for other jacket/covers, text illustration and book design. Works on assignment only.

First Contact & Terms Send query letter with tearsheets, photographs, photocopies and photostats. Samples are filed. Responds to artist only if interested. To show portfolio, mail b&w photostats. Buys one-time rights. Originals are returned at job's completion.

Book Design Pays by the project.

Jackets/Covers Pays by the project.

Text Illustration Pays by the project.

Tips Previous book design experience a plus.

GALLAUDET UNIVERSITY PRESS

800 Florida Ave. NE, Washington DC 20002-3695. (202)651-5488. Fax: (202)651-5489. E-mail: jill.porco@gallaudet.edu. Web site: gupress.gallaudet.edu. **Contact:** Jill Porco, production coordinator. Estab. 1980. Publishes hardcover and trade paperback originals, hardcover and trade paperback reprints, DVDs, videotapes and textbooks. Types of books include reference, biography, coffee table books, history, instructional and textbook nonfiction. Specializes in books related to deafness. Publishes 12-15 new titles/year. Recent titles include: *Deaf People in Hitler's Europe*; *The Parents' Guide to Cochlear Inplants*. 90% requires freelance design; 2% requires freelance illustration. Book catalog free on request.

Needs Approached by 10-20 designers and 30 illustrators/year. Works with 15 designers/year. 100% of freelance design work demands knowledge of Illustrator, PageMaker, Photoshop and QuarkXPress.

First Contact & Terms Send query letter with postcard sample with résumé, sample of work and URL. After introductory mailing, send follow-up postcard sample every 6 months. Accepts disk submissions. Prefers Windows-compatible, PDF files. Samples are filed. Responds only if interested. Company will contact artist for portfolio review if interested. Portfolio should include color finished art. Rights purchased vary according to project. Finds freelancers through Internet and word of mouth.

Tips "Do not call us."

GAUNTLET PRESS

5307 Arroyo St., Colorado Springs CO 80922. E-mail: info@gauntletpress.com. Web site: www.gauntletpress.com. **Contact:** Barry Hoffman, president. Estab. 1991. Publishes hardcover originals and reprints, trade paperback originals and reprints. Types of books include horror, science fiction and young adult. Specializes in signed limited collectibles. Publishes 4 titles/year. Recent titles include: *It Came From Outerspace*; *Gateways*; *Lost Souls*.

- Currently Gauntlet Press is not accepting submissions, as they are solidly booked for the next few years.

GEM GUIDES BOOK CO.

315 Cloverleaf Dr., Suite F, Baldwin Park CA 91706. (626)855-1611. Fax: (626)855-1610. E-mail: gembooks@aol.com. Web site: www.gemguidesbooks.com. **Editors:** Kathy Mayerski, Nancy Fox. Estab. 1964. Book publisher and wholesaler of trade paperback originals and reprints. Types of books include earth sciences, western, instructional, travel, history and regional (western US). Specializes in travel and local interest (western Americana). Publishes 7 titles/year. Recent titles include: *Geodes: Nature's Treasures*, by Brad L. Cross and June Culp Zeither; *Baby's Day Out in Southern California: Fun Places to Go with Babies and Toddlers*, by Jobea Holt; *The Nevada Trivia Book*, by Richard Moreno; *Free Mining and Mineral Adventures in the Eastern U.S.*, by James Martin and Jeannette Hathaway Monaco. 75% requires freelance cover design.

Needs Approached by 24 freelancers/year. Works with one designer/year. Uses freelancers mainly for covers. 100% of freelance work demands knowledge of Quark, Photoshop. Works on assignment only.

First Contact & Terms Send query letter with brochure, résumé and SASE. Samples are filed. Editor will contact artist for portfolio review if interested. Requests work on spec before assigning a job. Buys all rights. Originals are not returned. Finds artists through word of mouth and "our files."

Jackets/Covers Pays by the project.

GIBBS SMITH, PUBLISHER

P.O. Box 667, Layton UT 84041. (801)544-9800. Fax: (801)546-8853. E-mail: info@gibbs-smith.com. Web site: www.gibbs-smith.com. **Contact:** Kurt Wahlner, art director. Estab. 1969. Imprints include Sierra Book Club for Children. Company publishes hardcover and trade paperback originals and textbooks. Types of books include

children's picture books, coffee table books, cookbooks, humor, juvenile, nonfiction textbooks, western. Publishes 60 titles/year. Recent titles include *Batter Up Kids Delicious Desserts*; *Lost Coast Stories from the Surf*. 10% requires freelance illustration; 90% requires freelance design

roman Book catalog free for 8½×11 SASE with $1.24 postage.

Needs Approached by 250 freelance illustrators and 50 freelance designers/year. Works with 5 freelance illustrators and 15 designers/year. Designers may be located anywhere with Broadband service. Prefers freelancers experienced in layout of photographic nonfiction. Uses freelancers mainly for cover design and book layout, cartoon illustration, children's book illustration. 100% of freelance design demands knowledge of QuarkXPress. 70% of freelance illustration demands knowledge of Photoshop, Illustrator and FreeHand.

First Contact & Terms Designers: Send samples for file. Illustrators: Send printed samples and photocopies. Samples are filed. Responds only if interested. Finds freelancers through submission packets and illustration annuals.

Book Design Assigns 50 freelance design jobs/year. Pays by the project, $10-15/page.

Jackets/Covers Assigns 50-60 freelance design jobs and 5 illustration jobs/year. Pays for design by the project, $500-800. Pays for illustration by the project.

Text Illustration Assigns 1 freelance illustration job/year. Pays by the project.

GLENCOE/MCGRAW-HILL PUBLISHING COMPANY

21600 Oxnard St., 5th Floor, Woodland Hills CA 91367. (818)615-2600. Fax: (818)615-2699. Web site: www.glen coe.com. **Design Supervisor:** Margaret Sims. Estab. 1965. Book publisher. Publishes textbooks. Types of books include marketing and career education, art and music, health, computer technology. Specializes in most el-hi (grades 7-12) subject areas, as well as post-secondary career subjects. Publishes 350 titles/year.

• Glencoe also has divisions in Peoria, Illinois and Columbus, Ohio, with separate art departments.

Needs Approached by 50 freelancers/year. Works with 10-20 freelance illustrators and 10-20 designers/year. Prefers experienced artists. Uses freelance artists mainly for illustration and production. Also for jacket/cover design and illustration, text illustration and book design. 100% of design and 50% of illustration demand knowledge of Adobe, InDesign, or Illustrator on Mac. Works on assignment only.

First Contact & Terms Send nonreturnable samples. Accepts disk submissions compatible with above program. Samples are filed. Sometimes requests work on spec before assigning a job. Negotiates rights purchased. Originals are not returned.

Book Design Assigns 10-20 freelance design and many illustration jobs/year. Pays by the project.

Jackets/Covers Assigns 10-20 freelance design jobs/year. Pays by the project.

Text Illustration Assigns 20-30 freelance design jobs/year. Pays by the project.

GLOBE PEQUOT PRESS

246 Goose Lane, Guilford CT 06437. (203)458-4500. Fax: (203)458-4601. E-mail: info@globepequot.com. Web site: www.globepequot.com. **Production Director:** Kevin Lynch. Estab. 1947. Publishes hardcover and trade paperback originals and reprints. Types of books include (mostly) travel, kayak, outdoor, cookbooks, instruction, self-help and history. Specializes in regional subjects New England, Northwest, Southeast bed-and-board country inn guides. Publishes 600 titles/year. 20% require freelance illustration; 75% require freelance design. Titles include: *Lost Lighthouses*, by John Grant; *Michael Shapiro's Internet Travel Planner*. Design of books is "classic and traditional, but fun." Book catalog available.

Needs Works with 10-20 freelance illustrators and 15-20 designers/year. Uses freelancers mainly for cover and text design and production. Also for jacket/cover and text illustration and direct mail design. Needs computer-literate freelancers for production. 100% of design and 75% of illustration demand knowledge of QuarkXPress 3.32, Illustrator 7.0 or Photoshop 5. Works on assignment only.

First Contact & Terms Send query letter with résumé, photocopies and photographs. Accepts disk submissions compatible with QuarkXPress 3.32, Illustrator 7.0 or Photoshop 5. Samples are filed and not returned. Request portfolio review in original query. Artist should follow up with call after initial query. Art Director will contact artist for portfolio review if interested. Portfolio should include roughs, original/final art, photostats, tearsheets and dummies. Requests work on spec before assigning a job. Considers complexity of project, project's budget and turnaround time when establishing payment. Buys all rights. Originals are not returned. Finds artists through word of mouth, submissions, self promotion and sourcebooks.

Book Design Pays by the hour, $20-28 for production; or by the project, $400-600 for cover design.

Jackets/Covers Prefers realistic style. Pays by the hour, $20-35; or by the project, $500-1,000.

Text Illustration Pays by the project, $25-150. Mostly b&w illustration, preferably computer-generated.

Cover Illustration Pays by the project, $500-700 for color.

Tips "Our books are being produced on Macintosh computers. We like designers who can use the Mac competently enough that their design looks as if it *hasn't* been done on the Mac."

GOLDEN BOOKS

1745 Broadway, New York NY 10019. (212)782-9000. Fax: (212)782-9020. Web site: www.goldenbooks.com. **Contact:** Roberta Ludlow, Tracy Tyler and Liz Alexander, art directors. Publishing company. Imprint is Golden Books. Publishes preschool and juvenile. Specializes in picture books themed for infant to 8-year-olds. Publishes 250 titles/year. Titles include: *Pat the Bunny; Little Golden Books; Nickelodeon, Mattel.*

Needs Approached by several hundred artists/year. Works with approximately 100 illustrators/year. Very little freelance design work. Most design is done in-house. Buys enough illustration for over 200 new titles, approximately 70% being licensed character books. Artists must have picture book experience; illustrations are generally full color but b&w art is required for coloring and activity books. Uses freelancers for picture books, storybooks. Traditional illustration, as well as digital illustration is accepted, although digital is preferred.

First Contact & Terms Send query letter with SASE and tearsheets. Samples are filed or are returned by SASE if requested by artist. Art director will call for portfolio if interested. Will look at original artwork and/or color representations in portfolios, but please do not send original art through the mail. Royalties or work-for-hire limited according to project.

Jackets/Covers All design done in-house. Makes outright purchase on licensed character properties only.

Text Illustration Assigns approximately 250 freelance illustration jobs/year. Payment varies.

Tips "We are open to a wide variety of styles. Contemporary illustrations that have strong bright colors and mass market appeal featuring appealing multicultural children will get strongest consideration."

◪ GOOSE LANE EDITIONS LTD.

330-500 Beaverbrook Court, Fredericton NB E3B 5X4 Canada. (506)450-4251. Fax: (506)459-4991. E-mail: goosel ane@gooselane.com. Web site: www.gooselane.com. **Art Director:** Julie Scriver. Estab. 1954. Publishes trade paperback originals of poetry, fiction and nonfiction. Types of books include poetry, biography, cookbooks, fiction, reference and history. Publishes 10-20 titles/year. 0-5% requires freelance illustration. Books are "high quality, elegant, generally with full-color fine art reproduction on cover." Book catalog free for SAE with Canadian first-class stamp or IRC.

Needs Approached by 30 freelancers/year. Works with 0-1 illustrators/year. Only works with freelancers in the region. Works on assignment only.

First Contact & Terms Send Web portfolio address. Illustrators may send postcard samples. Samples are filed or are returned by SASE. Responds in 2 months.

Book Design Pays by the project, $400-1,200 CAN.

Jackets/Covers Assigns 0-1 freelance design job and 0-1 illustration jobs/year. Pays by the project, $200-500 CAN.

Text Illustration Assigns 0-1 freelance illustration job/year. Pays by the project, $300-1,500.

THE GRADUATE GROUP

P.O. Box 370351, W. Hartford CT 06137-0351. (860)233-2330. E-mail: graduategroup@hotmail.com. Web site: www.graduategroup.com. **President:** Mara Whitman. Estab. 1967. Publishes trade paperback originals. Types of books include instructional and reference. Specializes in internships and career planning. Publishes 35 titles/year. Recent titles include: *Create Your Ultimate Résumé, Portfolio and Writing Samples An Employment Guide for the Technical Communicator*, by Mara W. Cohen Ioannides. 10% require freelance illustration and design. Book catalog free by request.

Needs Approached by 20 freelancers/year. Works with 1 freelance illustrator and 1 designer/year. Prefers local freelancers only. Uses freelancers for jacket/cover illustration and design; direct mail, book and catalog design. 5% of freelance work demands computer skills. Works on assignment only.

First Contact & Terms Send query letter with brochure and résumé. Samples are not filed. Responds only if interested. Write for appointment to show portfolio.

GRAYWOLF PRESS

2402 University Ave., #203, St. Paul MN 55114. (651)641-0077. Fax: (651)641-0036. E-mail: czarniec@graywolf press.org. Web site: www.graywolfpress.org. **Executive Editor:** Anne Czarniecki. Estab. 1974. Publishes hardcover originals, trade paperback originals and reprints. Specializes in novels, nonfiction, memoir, poetry, essays and short stories. Publishes 25 titles/year. Recent titles include: *The Translation of Dr Apelles*, by David Treuer; *When All Is Said and Done*, by Robert Hill; *Dear Ghosts*, by Tess Gallagher. 100% require freelance cover design. Books use solid typography, strikingly beautiful and well-integrated artwork. Book catalog free by request.

• Graywolf is recognized as one of the finest small presses in the nation.

Needs Approached by 100 freelance artists/year. Works with 7 designers/year. Buys 25 illustrations/year (existing art only). Prefers artists with experience in literary titles. Uses freelancers mainly for cover design. Works on assignment only.

First Contact & Terms Send query letter with résumé and photocopies. Samples are returned by SASE if requested by artist. Executive editor will contact artist for portfolio review if interested. Portfolio should include b&w, color photostats and tearsheets. Negotiates rights purchased. Interested in buying second rights (reprint rights) to previously published work. Originals are returned at job's completion. Pays by the project. Finds artists through submissions and word of mouth.

Jackets/Covers Assigns 25 design jobs/year. Pays by the project, $800-1,200. "We use existing art both contemporary and classicaland emphasize fine typography."

Tips "Have a strong portfolio of literary (fine press) design."

GREAT QUOTATIONS PUBLISHING

8102 Lemont Rd., #300, Woodridge IL 60517. (630)390-3580. Fax: (630)390-3585. **Contact:** Tami K. Suits. Estab. 1985. Imprint of Greatime Offset Printing. Company publishes hardcover, trade paperback and mass market paperback originals. Types of books include humor, inspiration, motivation and books for children. Specializes in gift books. Publishes 50 titles/year. Recent titles include: *Only a Sister Could Be Such a Good Friend*; *Words From the Coach*. 50% requires freelance illustration and design. Book catalog available for $3 with SASE.

Needs Approached by 100 freelancers/year. Works with 20 designers and 20 illustrators/year. Uses freelancers to illustrate and/or design books and catalogs. 50% of freelance work demands knowledge of QuarkXPress and Photoshop. Works on assignment only.

First Contact & Terms Send letter of introduction and sample pages. Name, address and telephone number should be clearly displayed on the front of the sample. All appropriate samples will be placed in publisher's library. Design Editor will contact artist under consideration, as prospective projects become available. Rights purchased vary according to project.

Jackets/Covers Assigns 20 freelance cover illustration jobs/year. Pays by the project, $300-3,000.

Text Illustration Assigns 30 freelance text illustration jobs/year. Pays by the project, $100-1,000.

Tips "We're looking for bright, colorful cover design on a small size book cover (around 6×6). Outstanding humor or motivational titles will be most in demand."

GREAT SOURCE EDUCATION GROUP

181 Ballardvale St., Wilmington MA 01887. (978)661-1564. Fax: (978)661-1331. E-mail: richard_spencer@hmco .com. Web site: www.greatsource.com. **Contact:** Richard Spencer, design director. Specializes in supplemental educational materials. Publishes more than 25 titles/year. 90% requires freelance design; 80% requires freelance illustration. Book catalog free with 9×12 SASE or check Web site.

Needs Approached by more than 100 illustrators/year. Works with 25 illustrators/year. 50% of freelance illustration demands knowledge of Illustrator and Photoshop.

First Contact & Terms Send nonreturnable samples such as postcards, photocopies and/or tearsheets. After introductory mailing, send follow-up postcard sample every year. Accepts disk submissions from illustrators. Prefers Mac-compatible, JPEG files. Samples are filed or returned by SASE. Responds only if interested. Company will contact artist for portfolio review if interested. Portfolio should include b&w, color tearsheets. Rights purchased vary according to project. Finds freelancers through art reps, artist's submissions, Internet.

Jackets/Covers Assigns 10 freelance cover illustration jobs/year. Pays for illustration by the project, $500-3,000. Prefers kid-friendly styles.

Text Illustration Assigns 25 freelance illustration jobs/year. Pays by the project, $30-1,000. Prefers professional electronic submissions.

GREENWOOD PUBLISHING

(formerly Libraries Unlimited/Teacher Ideas Press), 88 Post Rd. W., Westport CT 06881. (203)226-3571. Fax: (203)454-8662. **Contact:** Publicity Department. Estab. 1964. Specializes in hardcover and paperback original reference books concerning library science and school media for librarians, educators and researchers. Also publishes in resource and activity books for teachers. Publishes more than 60 titles/year. Recent titles include *Best Books for Children*. Book catalog free by request.

Needs Works with 4-5 freelance artists/year.

First Contact & Terms Designers send query letter with résumé and photocopies. Illustrators send query letter with photocopies. Samples not filed are returned only if requested. Responds in 2 weeks. Considers complexity of project, skill and experience of artist, and project's budget when establishing payment. Buys all rights. Originals not returned.

Text Illustration Assigns 2-4 illustration jobs/year. Pays by the project.

Jackets/Covers Assigns 4-6 design jobs/year. Pays by the project, $500 minimum.

Tips "We look for the ability to draw or illustrate without overly loud cartoon techniques. Freelancers should have the ability to use two-color effectively, with screens and screen builds. We ignore anything sent to us that is in four-color. We also need freelancers with a good feel for typefaces."

GROSSET & DUNLAP

Penguin Group USA, 345 Hudson St., New York NY 10014-3657. (212)414-3610. Fax: (212)414-3396. Web site: www.penguinputnam.com. **Contact:** Rosanne S. Guararra, art director. Publishes hardcover, trade paperback and mass market paperback originals and board books for preschool and juvenile audience (ages 1-10). Specializes in "very young mass market children's books." Publishes over 200 titles/year. Recent titles include *Meet Strawberry Shortcake*; *Jay-Jay the Jet Plane*; *Hank Zipzer*; *L Is for Liberty*. 100% require freelance illustration; 10% require freelance design.

- Grosset & Dunlap publishes children's books that examine new ways of looking at the world of children. Many books by this publisher feature unique design components such as acetate overlays, 3-D pop-up pages, or actual projects/toys that can be cut out of the book.

Needs Works with 100 freelance illustrators and 10 freelance designers/year. Buys 80 books' worth of illustrations/year. "Be sure your work is appropriate for our list." Uses freelance artists mainly for book illustration. Also for jacket/cover and text illustration and design. 100% of design and 50% of illustration demand knowledge of Illustrator 5.5, QuarkXPress 3.3, and Photoshop 2.5.

First Contact & Terms Designers: Send query letter with Web site address and tearsheets. Illustrators: Send postcard sample and/or query letter with résumé, photocopies, SASE, and tearsheets. Samples are filed. Responds to the artist only if interested. Call for appointment to show portfolio, or mail slides, color tearsheets, transparencies and dummies. Rights purchased vary according to project. Originals are returned at job's completion.

Book Design Assigns 20 design jobs/year. Pays by the hour, $30-40 for digital files.

GROUP PUBLISHING BOOK PRODUCT

1515 Cascade Ave., Loveland CO 80539. (970)669-3836. Fax: (970)292-4391. Web site: www.group.com. **Art Directors (for interiors):** Jean Bruns, Kari Monson and Randy Kady. Company publishes books, Bible curriculum products (including puzzles, posters, etc.), clip art resources and audiovisual materials for use in Christian education for children, youth and adults. Publishes 35-40 titles/year. Recent titles include: *Group's Scripture Scrapbook Series*, *The Dirt on Learning*; *Group's Hands-On Bible Curriculum*; *Group's Treasure Serengeti Trek Vacation Bible School*; *Faith Weaver Bible Curriculum*.

- This company also produces magazines. See listing in Magazines section for more information.

Needs Uses freelancers for cover illustration and design. 100% of design and 50% of illustration demand knowledge of InDesign CS2, Photoshop 7.0, Illustrator 9.0. Occasionally uses cartoons in books and teacher's guides. Uses b&w and color illustration on covers and in product interiors.

First Contact & Terms Contact Jeff Storm, Marketing Art Director, if interested in cover design or illustration. Contact if interested in book and curriculum interior illustration and design and curriculum cover design. Send query letter with nonreturnable b&w or color photocopies, slides, tearsheets or other samples. Accepts disk submissions. Samples are filed, additional samples may be requested prior to assignment. Responds only if interested. Rights purchased vary according to project.

Jackets/Covers Assigns minimum 15 freelance design and 10 freelance illustration jobs/year. Pays for design, $250-1,200; pays for illustration, $250-1,200.

Text Illustration Assigns minimum 20 freelance illustration projects/year. **Pays on acceptance.** $40-200 for b&w (from small spot illustrations to full page). Fees for color illustration and design work vary and are negotiable. Prefers b&w line or line and wash illustrations to accompany lesson activities.

Tips "We prefer contemporary, nontraditional styles appropriate for our innovative and upbeat products and the creative Christian teachers and students who use them. We seek experienced designers and artists who can help us achieve our goal of presenting biblical material in fresh, new and engaging ways. Submit design/illustration on disk. Self promotion pieces help get you noticed. Have book covers/jackets, brochure design, newsletter or catalog design in your portfolio. Include samples of Bible or church-related illustration."

GRYPHON PUBLICATIONS

P.O. Box 209, Brooklyn NY 11228-0209. Web site: www.gryphonbooks.com. Estab. 1983. Book and magazine publisher of hardcover originals, trade paperback originals and reprints, reference and magazines. Types of books include science fiction, mystery and reference. Specializes in crime fiction and bibliography. Publishes 20 titles/year. Titles include: *Difficult Lives*, by James Salli; and *Vampire Junkies*, by Norman Spinrad. 40% require freelance illustration; 10% require freelance design. Book catalog free for #10 SASE.

- Also publishes *Hardboiled*, a quarterly magazine of noir fiction, and *Paperback Parade* on collectable paperbacks.

Needs Approached by 75-200 freelancers/year. Works with 10 freelance illustrators and 1 designer/year. Prefers freelancers with "professional attitude." Uses freelancers mainly for book and magazine cover and interior illustrations. Also for jacket/cover, book and catalog design. Works on assignment only.

First Contact & Terms Send query letter with résumé, SASE, tearsheets or photocopies. Samples are filed.

Responds in 2 weeks only if interested. Buys one-time rights. "I will look at reprints if they are of high quality and cost effective." Originals are returned at job's completion if requested. Send b&w samples only.

Jackets/Covers Assigns 2 freelance design and 5-6 illustration jobs/year. Pays by the project, $25-150.

Text Illustration Assigns 2 freelance jobs/year. Pays by the project, $10-100. Prefers b&w line drawings.

Tips "It is best to send photocopies of your work with an SASE and query letter. Then we will contact on a freelance basis."

GUERNICA EDITIONS

P.O. Box 117, Station P, Toronto ON M5S 2S6 Canada. (416)658-9888. Fax: (416)657-8885. E-mail: guernicaediti ons@cs.com. Web site: www.guernicaeditions.com. **Publisher/Editor:** Antonio D'Alfonso. Estab. 1978. Book publisher and literary press specializing in translation. Publishes trade paperback originals and reprints. Types of books include contemporary and experimental fiction, biography and history. Specializes in ethnic/multicultural writing and translation of European and Quebecois writers into English. Publishes 20-25 titles/year. Recent titles include: *Hard Edge*, by F.G. Paci (artist Normand Cousineau); *Unholy Stories*, by Carole David (artist Hono Lulu). 40-50% require freelance illustration. Book catalog available for SAE; nonresidents send IRC.

Needs Approached by 6 freelancers/year. Works with 6 freelance illustrators/year. Uses freelancers mainly for jacket/cover illustration.

First Contact & Terms Send query letter with résumé, SASE (or SAE with IRC), tearsheets, photographs and photocopies. Samples are filed or are returned by SASE if requested by artist. Responds only if interested. To show portfolio, mail photostats, tearsheets and dummies. Buys one-time rights. Originals are not returned at job completion.

Jackets/Covers Assigns 10 freelance illustration jobs/year. Pays by the project, $150-200.

Tips "We really believe that the author should be aware of the press they work with. Try to see what a press does and offer your own view of that look. We are looking for strong designers. We have three new series of books, so there is a lot of place for art work."

HARLAN DAVIDSON, INC.

773 Glenn Ave., Wheeling IL 60090-6000. (847)541-9720. Fax: (847)541-9830. E-mail: harlandavidson@harland avidson.com. Web site: www.harlandavidson.com. **Production Manager:** Lucy Herz. Imprints include Forum Press and Crofts Classics. Publishes textbooks. Types of books include biography, classics in literature, drama, political science and history. Specializes in US and European history. Publishes 6-15 titles/year. Titles include: *The History of Texas*. 20% requires freelance illustration; 20% requires freelance design. Catalog available.

Needs Approached by 2 designers/year. Works with 1-2 designers/year. 100% of freelance design demands knowledge of Photoshop.

First Contact & Terms Designers: Send query letter with brochure and résumé. Samples are filed or are returned by SASE. Responds in 2 weeks. Portfolio review required from designers. Will contact artist for portfolio review of book dummy if interested. Buys all rights.

Book Design Assigns 3 freelance design jobs/year. Pays by the project, $500-1,000.

Jackets/Covers Assigns 3 freelance design jobs/year. Pays by the project, $500-1,000. Finds freelancers through networking.

Tips "Have knowledge of file preparation for electronic prepress."

HARLEQUIN ENTERPRISES LTD.

225 Duncan Mill Rd., Toronto ON M3B 3K9 Canada. (416)445-5860. Fax: (416)445-8736. **Contact:** Vivian Ducas, Art Director. Publishes mass market paperbacks. Specializes in women's fiction. Publishes more than 100 titles/year. 15% requires freelance design; 100% requires freelance illustration. Book catalog not available.

Needs Approached by 1-3 designers and 20-50 illustrators/year. Works with 3 designers and 25 illustrators/year. 100% of freelance design work demands knowledge of Illustrator, Photoshop and InDesign.

First Contact & Terms Designers: Send postcard sample with brochure, photocopies, tearsheets and URL. Illustrators: Send postcard sample with brochure, photocopies, tearsheets and URL. After introductory mailing, send follow-up postcard sample every 6 months. Samples are filed and not returned. Does not reply. Company will contact artist for portfolio review if interested. Portfolio should include b&w and color tearsheets and color outputs. Buys all rights. Finds freelancers through art competitions, art exhibits/fairs, art reps, artist's submissions, competition/book credits, Internet, sourcebooks, word of mouth.

Jackets/Covers Assigns more than 50 freelance cover illustration jobs/year. Prefers variety of representational art—not just romance genre.

HARMONY HOUSE PUBLISHERS—LOUISVILLE

P.O. Box 90, Prospect KY 40059. (502)228-4446. Fax: (502)228-2010. **Art Director:** William Strode. Estab. 1980. Publishes hardcover "coffee table" books. Specializes in general books, photographic books and education.

Publishes 20 titles/year. Titles include: *Sojourn in the Wilderness* and *Christmas Collections*. 10% require free-lance illustration.

Needs Approached by 10 freelancers/year. Works with 2-3 freelance illustrators/year. Prefers freelancers with experience in each specific book's topic. Uses freelancers mainly for text illustration. Also for jacket/cover illustration. Usually works on assignment basis.

First Contact & Terms Send query letter with brochure, résumé, SASE and appropriate samples. Samples are filed or are returned. Responds only if interested. "We don't usually review portfolios, but we will contact the artist if the query interests us." Buys one-time rights. Returns originals at job's completion. Assigns several freelance design and 2 illustration jobs/year. Pays by the project.

HARPERCOLLINS PUBLISHERS, LTD. (CANADA)

55 Avenue Rd., Suite 2900, Hazelton Lanes, Toronto ON M5R 3L2 Canada. (416)975-9334. Fax: (416)975-9884. Web site: www.harpercanada.com. **Contact:** Vice President Production. Publishes hardcover, trade paperback and mass market paperback originals and reprints. Types of books include adventure, biography, coffee table books, fantasy, history, humor, juvenile, mainstream fiction, New Age, nonfiction, preschool, reference, religious, self-help, travel, true crime, western and young adult. Publishes 100 titles/year. 50% require freelance illustration; 25% require freelance design.

Needs Prefers freelancers experienced in mixed media. Uses freelancers mainly for illustration, maps, cover design. 100% of freelance design demands knowledge of Photoshop, Illustrator, QuarkXPress. 25% of freelance illustration demands knowledge of Photoshop and Illustrator.

First Contact & Terms Designers: Send query letter with brochure, photocopies, tearsheets. Illustrators: Send postcard sample and/or query letter with photocopies, tearsheets. Accepts disk submissions compatible with QuarkXPress. Send EPS or TIFF files. Samples are filed. Will contact artist for portfolio review "only after review of samples if I have a project they might be right for." Portfolio should include book dummy, photocopies, photographs, slides, tearsheets, transparencies. Rights purchased vary according to project.

Book Design Assigns 5 freelance design jobs/year. Pays by the project.

Jackets/Covers Assigns 20 freelance design and 50 illustration jobs/year. Pays by the project.

Text Illustration Assigns 10 freelance illustration jobs/year. Pays by the project.

HARVEST HOUSE PUBLISHERS

990 Owen Loop N., Eugene OR 97402. (541)343-0123. Fax: (541)242-8819. **Contact:** Cover Coordinator. Special-izes in hardcover and paperback editions of Christian evangelical adult fiction and nonfiction, children's books, gift books and youth material. Publishes 100-125 titles/year. Recent titles include: *Why is the Sky Blue?*; *Power of a Praying Teen*; *Discovering Your Divine Assignment*; *My Little Angel*. Books are of contemporary designs which compete with the current book market.

Needs Works with 1-2 freelance illustrators and 4-5 freelance designers/year. Uses freelance artists mainly for cover art. Also uses freelance artists for text illustration. Works on assignment only.

First Contact & Terms Send query letter with brochure, résumé, tearsheets and photographs. Art director will contact artist for portfolio review if interested. Requests work on spec before assigning a job. Originals may be returned at job's completion. Buys all rights. Finds artists through word of mouth and submissions/self-promotions.

Book Design Pays by the project.

Jackets/Covers Assigns 100-125 design and less than 5 illustration jobs/year. Pays by the project.

Text Illustration Assigns less than 5 jobs/year. Pays by the project.

THE HAWORTH PRESS, INC.

10 Alice St., Binghamton NY 13904-1580. (607)722-5857. Fax: (607)722-1424. E-mail: getinfo@haworth.com. Web site: www.haworthpress.com. **Cover Design Director:** Marylouise E. Doyle. Estab. 1979. Imprints include Harrington Park Press, Haworth Pastoral Press, International Business Press, Food Products Press, Haworth Medical Press, Haworth Maltreatment, The Haworth Hospitality/Tourism Press and Trauma Press. Publishes hardcover originals, trade paperback originals and reprints and textbooks. Types of books include biography, new age, nonfiction, reference, religious and textbooks. Specializes in social work, library science, gerontology, gay and lesbian studies, addictions, etc. Catalog available.

Needs Approached by 2 illustrators and 5 designers/year. 100% of freelance design and illustration demands knowledge of PageMaker, Photoshop and Illustrator.

First Contact & Terms Designers: Send photocopies, SASE and slides. Illustrators: Send postcard sample or query letter with photocopies. Accepts disk submissions compatible with Illustrator and Photoshop 3.0. Samples are filed. Responds only if interested. Will contact artist for portfolio review of slides if interested. Buys reprint rights. Rights purchased vary according to project. Finds freelancers through word of mouth.

Book Design Pay varies.
Jackets/Covers Pay varies. Prefers a variety as long as camera ready art can be supplied.

HAY HOUSE, INC.
P.O. Box 5100, Carlsbad CA 92018-5100. (760)431-7695 or (800)431-7695. Fax: (760)431-6948. E-mail: csalinas @hayhouse.com. Web site: www.hayhouse.com. **Art Director:** Christy Salinas. Publishes hardcover originals and reprints, trade paperback originals and reprints, CD's, DVD's and videocassettes. Types of books include: self-help, mind-body-spirit, psychology, finance, health and fitness, nutrition, astrology. Publishes 175 titles/ year. Recent titles include: *Inspiration, Your Ultimate Calling*, by Wayne Dyer; *If You Could See What I See*, by Sylvia Browne; *Left to Tell*, by Immaculee Illibagiza. 40% require freelance illustration; 30% require freelance design.
 ● Hay House is also looking for people who design for the gift market.
Needs Approached by 50 freelance illustrators and 5 freelance designers/year. Works with 20 freelance illustrators and 2-5 freelance designers/year. Uses freelancers mainly for cover design and illustration. 80% of freelance design demands knowledge of Photoshop, Illustrator, QuarkXPress. 20% of titles require freelance art direction.
First Contact & Terms Send e-mail to csalinas@hayhouse.com or send non-returnable samples to the address above. Art director will contact if interested. Buys all rights. Finds freelancers through word of mouth and submissions.
Illustrations Purchases 200+ illustrations per year. A project such as illustrated "card deck" with affirmations may have 50 original illustrations. Illustrators must have a strong ability to conceptualize.
Tips "We look for freelancers with experience in graphic design, desktop publishing, printing processes, production and illustrators with strong ability to conceptualize."

HEMKUNT PUBLISHERS PVT. LTD.
A-78 Naraina Indl. Area Ph.I, New Delhi 110028. 011-91-11 2579-2083, 2579-0032 or 2579-5079. E-mail: hemkun t@ndf.vsnl.net.in. Web site: www.hemkuntpublishers.com. **Chief Executive:** Mr. G.P. Singh. **Director Marketing:** Arvinder Singh. **Director Production:** Deepinder Singh. Specializes in educational text books, illustrated general books for children and also books for adults on different subjects. Subjects include religion, history, etc. Publishes 30-50 new titles/year. Recent titles include: *More Tales of Birbal and Akbar*; *Whiz Kid General Knowledge*; *Bedtime Stories from Around the World*; *Benaras—Visions of a Living Ancient Tradition*.
Needs Works with 30-40 freelance illustrators and 3-5 designers/year. Uses freelancers mainly for illustration and cover design. Also for jacket/cover illustration. Works on assignment only.
First Contact & Terms Send query letter with résumé and samples to be kept on file. Prefers photographs and tearsheets as samples. Samples not filed are not returned. Art director will contact artist for portfolio review if interested. Requests work on spec before assigning a job. Originals are not returned. Considers complexity of project, skill and experience of artist and project's budget when establishing payment. Buys all rights. Interested in buying second rights (reprint rights) to previously published artwork.
Book Design Assigns 40-50 freelance design jobs/year. Payment varies.
Jackets/Covers Assigns 30-40 freelance design jobs/year. Pays $20-50.
Text Illustration Assigns 30-40 freelance jobs/year. Pays by the project.

HIPPOCRENE BOOKS INC.
171 Madison Ave., Suite 1602, New York NY 10016. (212)685-4371. Fax: (212)779-9338. Web site: www.hippocr enebooks.com. **Editor:** Nicholas Williams. Estab. 1971. Publishes hardcover originals and trade paperback reprints. Types of books include biography, cookbooks, history, nonfiction, reference, travel, dictionaries, foreign language, bilingual. Specializes in dictionaries, cookbooks, love poetry. Publishes 60 titles/year. Recent titles include *Hippocrene Children's Illustrated Foreign Language Dictionaries*; *St. Patrick's Secrets*; *American Proverbs*. 10% requires freelance illustration. Book catalog free for 9×12 SAE with 4 first-class stamps.
Needs Approached by 150 illustrators and 50 designers/year. Works with 2 illustrators and 3 designers/year. Prefers local freelancers experienced in line drawings.
First Contact & Terms Designers: Send query letter with photocopies, SASE, tearsheets. Illustrators send postcard sample and follow-up postcard every 6 months. No disk submissions. Samples are filed. Will contact artist for portfolio review if interested. Portfolio should include photocopies of artwork portraying "love" poetry and food subjects. Buys one-time rights. Finds freelancers through promotional postcards and suggestion of authors.
Jackets/Covers Assigns 2 freelance design and 4 freelance illustration jobs/year. Pays by the project, $200-500.
Text Illustration Assigns 4 freelance illustration jobs/year. Pays by the project, $250-1,700. Prefers freelancers who create drawings/sketches for love or poetry books.
Tips "We prefer traditional illustrations appropriate for gift books and cookbooks."

HENRY HOLT BOOKS FOR YOUNG READERS
Imprint of Henry Holt and Company, 115 W. 18th St., 6th Floor, New York NY 10011. (212)886-9200. Fax:

Bob McLeod

*Renowned comic book artist
conquers picture books*

Although kids are excited about the cool characters in his book *SuperHero ABC*, when artist Bob McLeod gives a presentation to a group of school children, they show a lot of interest in his earlier work. *SuperHero ABC* is McLeod's his first picture book, but he's got a long history drawing comics for the likes of Marvel and DC, including Superman, Batman, Star Wars, and other household-name heroes. During school visits, he says, "everyone still wants to know about drawing Spider-man."

The world of children's picture books is a great place for comics artist McLeod: Kids love superheroes and silly stuff, and he's adept at delivering both. From Astro-Man (who "is always alert for an alien attack") to the Zinger (who "zanily zigzags through the zero zone"), his book offers an alphabet of amusing heroes helping those who need a hand—battling baddies with big bubbles, mighty muscles, gobs of goo, and voluminous vomit.

Here McLeod reflects on the past and future of the comics industry, shares his plans for penning picture books, and advises aspiring artists. To learn more about him and his work, visit www.bobmcleod.com.

What's the difference between the comics scene when you started in the '70s and today?

It's a very different business now. The differences are too vast to fully get into here, but I'll mention a few. When I started in 1973, comic books were still distributed on a returnable basis through mass-market newstands, and there was a variety of genres, such as sci-fi, westerns, romance, war, horror, humor, etc. There were black and white magazine format comics published by Marvel and Warren and others. The National Lampoon published a lot of comic artists. Marvel had a knockoff of *Mad* magazine called *Crazy*, which is where I was first published. There were so many comics being published every month that the major publishers were desperate for artists to illustrate them. Marvel had a very informal atmosphere and was a fun place to work.

Today, comics are distributed non-returnable to mostly just comic shops, and because they're therefore necessarily targeted to a select group of rabid fans, the different genres have slowly evaporated and we're left mostly with just superheroes. And where the target buyer used to be 12-18 years old, they're now 18-30 years old. So most comics are dark, violent, and sexy; totally inappropriate for kids. There is very little humor to be found, outside of Archie comics, which thankfully are still around. There is a lot of competition among artists for the few available titles, and many good artists have left the business, either by choice to seek more money, or by an inability to get work. Marvel has become very corporate. Freelancers used to be able to hang out at the office and schmooze, but

now you need an appointment to get in the door. I doubt I would have ever become a comic book artist if the business in 1973 had been the way it is now. I probably would have gone into animation or children's books instead.

What did you like most about working on your first children's picture book *SuperHero ABC* (HarperCollins)? How was the experience different from what you're used to?

I got so much satisfaction from doing it all myself. In comics, the monthly deadline requires most jobs to be split up among a writer, penciler, inker, letterer and colorist. There's so much compromise in story and art. With *SuperHero ABC*, I was able to make it totally the way I envisioned it, within the confines of the market. I loved being able to color it myself, after working almost exclusively in black and white for 30 years.

It was also nice to work with such a good editor, Margaret Anastas. She made very constructive comments and kept me focused on my target market of 5- to 7-year-olds. She

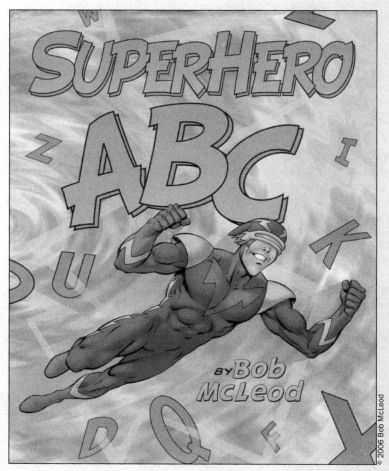

Bob McLeod's colorful cover for *Super-Hero ABC*, with its hovering hero, flying fists and astronomical alphabet, will engage superhero and comics fans of all ages. Reviews are smashing—*Booklist* raves, "This book's superpower? It will dazzle reluctant readers and disappear right off the shelves."

stood up for me, sometimes against the publisher, to maintain my vision of the book. I never had that from an editor in comic books. I also benefited from working with a wonderful designer, Meredith Pratt, who really helped shape the look of the book. I really felt like we were all working to create a great book, where in comics I often felt like I was battling everyone else to do good work.

Your wife came up with the idea for a superhero kids books. Why did that appeal to you?

Kids love superheroes. When my own boys were small, they wanted so much to just see superheroes in costume using their powers, but the comic books I was working on were too violent for them to read. I had to show them mostly old comics from the '60s. So there is a definite need for something like *SuperHero ABC*. I wasn't really looking to do superheroes in a children's book, though. I had wanted to do something different from what I'd been doing in comics. But I knew I could do a good superhero alphabet book, and I thought it was a very marketable idea. I was surprised no one had done it already, and I thought I should do it before someone beat me to it.

How did you hook up with HarperCollins for *SuperHero ABC*?

I did finished art and text for the first two letters, and wrote ideas for the rest of the book. I gave a link to my Web site so they could get a good idea of what I can do artistically, and I sent copies off to five different major publishers. Margaret from HarperCollins called about six weeks later and offered me a contract. I think it helped that she has a five-year-old son who she thought would love the book.

What are your upcoming projects for young readers?

I'd like to do a series of early readers using some of my *SuperHero ABC* characters. I think kids who read my alphabet book would then be excited to see the same characters in an early reader. I'd also like to do a picture storybook using one or two of my *ABC* characters, but I'm currently working on a picture book proposal with another writer.

In an interview, you said, "I love to draw but I don't care about storytelling." Has this changed at all since you've delved into children's books?

I was talking about the panel-to-panel story progression we do in comic books, as opposed to doing a single illustration. I'm a perfectionist, and I like to perfect an image rather than drawing a series of images quickly and emphasizing the story rather than the art. In comics, there's never enough time to polish the art. The panels are drawn just well enough to get the story across, due to the monthly deadline. The perspective is often off, the anatomy is often off, but the deadline has to be met regardless. It's frustrating to feel like you're never doing your best work.

In children's books, there's more time to devote to the art, so I don't feel like it's competing with the story for my time and attention. This was also the first time I've written anything, and I enjoyed the challenge of carefully choosing my words. Every single word in the book was very deliberately chosen. I had to try to be clever without being too clever for my young audience. I enjoyed it so much, I'd now like to try to write some stories as well. But my main love is still drawing.

You've also said you were never much of a superhero fan, and your real aspiration as a young artist was to work for *Mad* magazine. Is that part of what drew you to work on books for young readers—the possibility for silliness (which there is quite a bit of in *SuperHero ABC*)?

Definitely. There's a lot of *Mad* magazine in *SuperHero ABC*, in the writing and the art. My "Y" character, especially, the Yellow Yeller, reveals a lot of Mort Drucker influence. Mort

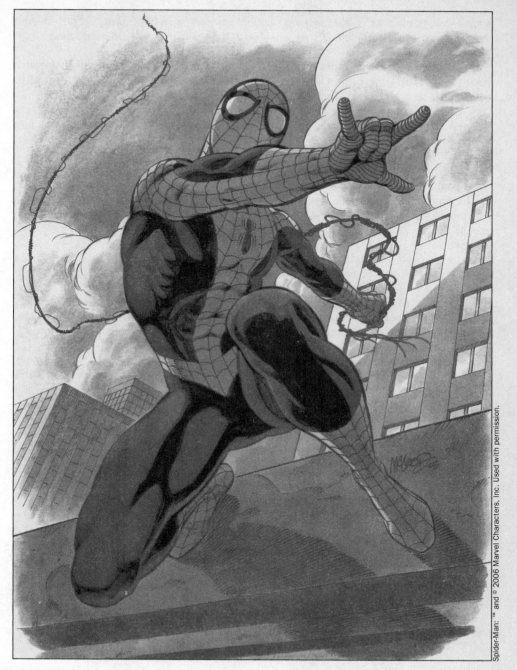

Rendering superheroes like Spider-Man offers a challenge to artists—how to portray familiar characters in equally familiar costumes, and yet make each picture your own. Visit Bob McLeod's Web site www.bobmcleod .com to see dozens more iages of Spider-Man and other beloved comic book heros.

was always the top artist at *Mad* in my opinion. I learned quite a bit studying his art. And the little side comments on every page are pure *Mad*. Silly humor is what I do best.

From your perspective, how has the popularity of the graphic novel in recent years impacted the comics industry? How is the process for creating a graphic novel different than creating a comic book?

They've had an impact in the sense that trade paperback collections of monthly comics sell better in bookstores now, but there's been little crossover from graphic novel readers to comic books, from what I've heard. Graphic novels are comic books. They've proven what I and many others have been saying for years—that there's a huge untapped audience for comic books if the major publishers would just get beyond superheroes and write stories that appeal to a broader audience, including girls!

The process is different in that graphic novels are usually over 100 pages, whereas comic books are typically 22 pages, so much more time is needed. Graphic novels are also usually written and drawn by the same person, so they have a more personal vision, as opposed to the assembly line feel of the average comic book. When the readers realize that graphic novels are indeed comic books, and the comics publishers realize that comics can be more like graphic novels, both will benefit.

You've done a lot of inking in your career and you've said, "Two artist working together can create art that neither one could create alone." On the flip side, what drawbacks are there to the collaborative process for creating comics?

I love inking. It's such a wonderful skill. It's seductive, because it's creative, but not demanding in the way that composing a drawing is. The drawback to splitting up the art chores is that each artist has his own style and vision, and it's difficult to let another artist mess with your art. The penciler often feels like the inker doesn't interpret his drawing well and is making too many changes. The inker often feels like the pencils are poorly drawn and need changing. Both often feel like the colorist is obscuring much of their work. Pencilers often think the writer has the characters standing around talking too much instead of moving, and is covering too much of the drawing with word balloons. Writers often feel the penciler doesn't draw the story the way they imagined it and didn't leave enough room for word balloons. Everyone has an ego and everyone is often pulling in opposite directions. But even with all of that, when things go well and the styles mesh, the results can be electrifying.

How long have you been doing commissioned pieces? How many do you create yearly?

I started doing commissions when my monthly comics work stopped coming in so regularly, in the late '90s. I discovered I preferred doing commissions to doing comics, because I got paid up front and there was more variety. I do everything from pencil character sketches to oil paintings and portraits. The number has increased every year, as I've spent less time pursuing regular comic book and commercial illustration work. In 2002, I did about 30. In 2005, I did over 50.

What's your advice for artists who want to break into comics? Into book publishing?

I seriously wouldn't recommend drawing comic books. There's no job security or benefits, and the money is better in other art fields. But for those who stubbornly insist, I recommend studying figure drawing extensively, as well as visual storytelling, perspective, and lighting. Learn how to draw guns, cars, boats, buildings, animals, etc. For style, study other comic

artists instead of trying to reinvent the wheel. When you think you can draw anything on demand, send 2-3 photocopied samples of panel pages to a specific editor at Marvel or DC.

For children's books, I'd say study more traditional illustration, and look at what other artists are doing. As in comics, study anatomy to be able to draw the same characters from page to page from various angles. Study camera angles to learn which viewpoint makes the best illustration.

The same advice really applies to both: Do your homework and learn the fundamentals. Learn to look at your art objectively with a critical eye. Breathe life into your figures.

I encourage people to take a look at comic art around the world. It's a wonderful art form, and if you don't respect it, you haven't really seen it. Follow your dreams, but work hard and pay your dues. Be ready when opportunity knocks!

—Alice Pope

(212)633-0748. Web site: www.henryholt.com. **Creative Director:** Raquel Jaramillo. Estab. 1833. Imprint publishes hardcover originals and reprints. Types of books include children's picture books, juvenile, preschool and young adult. Publishes 250 titles/year. Recent titles include: *Hondo & Fabian*, by Peter McCarty; *The House at Awful End*, by Philip Ardaugh. 100% requires freelance illustration. Book catalog free with 9×12 SASE.
Needs Approached by 2,500 freelancers/year.
First Contact & Terms Send query letter with photocopies and SASE. Samples are returned by SASE if requested by artist. Responds in 3 months if interested. Portfolios may be dropped off every Monday by 9 a.m. for 5 p.m. pickup. Art director will contact artist for portfolio review if interested. Portfolio should include tearsheets. "Anything artist feels represents style, ability and interests." Buys all rights. Finds artists through word of mouth, artists' submissions and attending art exhibitions.
Jackets/Covers Assigns 8-16 freelance illustration jobs/year. Pays by the project.

HONOR BOOKS

Imprint of Cook Communications, 4050 Lee Vance View, Colorado Springs CO 80918. (719)536-0100. Fax: (719)536-3269. E-mail: info@honorbooks.com. Web site: www.cookministries.com. **Creative Director:** Randy Maid. Estab. 1991. Publishes hardcover originals, trade paperback originals, mass market paperback originals and gift books. Types of books include biography, coffee table books, humor, juvenile, motivational, religious and self-help. Specializes in inspirational and motivational. Publishes 30 titles/year. Recent titles include: *God's Hands on my Shoulder*; *Breakfast for the Soul*. 40% require freelance illustration; 90% require freelance design.
Needs Works with 4 illustrators and 10 designers/year. Prefers illustrators experienced in line art; designers experienced in book design. Uses freelancers mainly for design and illustration. 100% of freelance design demands knowledge of FreeHand, Photoshop, Illustrator and QuarkXPress. 20% of freelance illustration demands knowledge of FreeHand, Photoshop and Illustrator. 15% of titles require freelance art direction.
First Contact & Terms Designers: Send query with photocopies and tearsheets. Illustrators: Send postcard, printed samples or tearsheets. Send follow-up postcard every 3 months. Accepts disk submissions compatible with QuarkXPress or EPS files. Samples are filed. Responds in 3 weeks. Request portfolio review in original query. Will contact artist for portfolio review of book dummy, photographs, roughs and tearsheets if interested. Rights purchased vary according to project.
Book Design Assigns 60 freelance design jobs/year. Pays by the project, $300-1,800.
Jackets/Covers Assigns 60 freelance design jobs and 30 illustration jobs/year. Pays for design by the project, $700-2,400. Pays for illustration by the project, $400-1,500.
Text Illustration Pays by the project. Finds freelancers through *Creative Black Book*, word of mouth, conventions and submissions.

HOUGHTON MIFFLIN COMPANY

Children's Book Department, 222 Berkeley St., Boston MA 02116. (617)351-3297. Fax: (617)351-1111. Web site: www.hmco.com. **Creative Director:** Sheila Smallwood. Estab. 1880. Company publishes hardcover originals. Types of books include juvenile, preschool and young adult. Publishes 60-70 titles/year. 100% requires freelance illustration; 10% requires freelance design. Recent titles include: *Song of the Water Boatman*, by Joyce Sidman (winner of the Caldecott Honor Medal); *Emmett Till*, by Marilyn Nelson (winner of the Coretta Scott King Award).

• Houghton Mifflin now has a new imprint, Graphia, a high-end paperback book series for teens.
Needs Approached by 6-10 freelancers/year. Works with 50 freelance illustrators and 10 designers/year. Prefers artists with interest in or experience with children's books. Uses freelance illustrators mainly for jackets, picture books. Uses freelance designers primarily for photo essay books. 100% of freelance design work demands knowledge of QuarkXPress, Photoshop and Illustrator.
First Contact & Terms Please send samples through artist rep only. Finds artists through artists' reps, sourcebooks, word of mouth.
Book Design Assigns 10-20 freelance design jobs/year. Pays by the project.
Jackets/Covers Assigns 5-10 freelance illustration jobs/year. Pays by the project.
Text Illustration Assigns up to 50 freelance illustration jobs/year. Pays by the project.

HOWELL PRESS, INC.

1713-2D Allied Lane, Charlottesville VA 22903. (434)977-4006. Fax: (434)971-7204. E-mail: editorial@howellpress.com. Web site: www.howellpress.com. **President:** Ross A. Howell Jr. Estab. 1985. Company publishes hardcover and trade paperback originals. Types of books include history, coffee table books, cookbooks, gardening, quilts and crafts, aviation, transportation and titles of regional interest. Publishes 6-8 titles/year. Recent titles include *Colonial Churches of Virginia*, by Don and Sue Massey; *The Nation's Hangar*; the *Aircraft Study Collection of the National Air and Space Museum*, by Robert vanderLinden; *Swear Like a Trooper*, by William Priest. 50% require freelance illustration and design. Book catalog free by request.
Needs Approached by 15-20 freelancers/year. Works with 0-1 freelance illustrator and 3-5 designers/year.''It's most convenient for us to work with local freelance designers.'' Uses freelancers overwhelmingly for graphic design. Also for jacket/cover, direct mail, book and catalog design. 100% of freelance work demands knowledge of PageMaker, Illustrator, Photoshop or QuarkXPress.
First Contact & Terms Designers send query letter with résumé, SASE and tearsheets. Illustrators send query letter with résumé, photocopies, SASE and tearsheets. Samples are filed and are returned by SASE if requested by artist. Production manager will contact artist for portfolio review if interested. Portfolio should include color tearsheets and slides. Negotiates rights purchased. Originals are returned at job's completion. Finds artists through submissions.
Book Design Assigns 9-10 freelance design jobs/year. Pays for design by the hour, $25-50; by the project, $500-5,000.

HUMANICS PUBLISHING GROUP

12 S. Dixie Hwy., Suite 203, Lake Worth FL 33460. (800)874-8844. Fax: (888)874-8844. E-mail: humanics@mindspring.com. Web site: www.humanicspub.com or www.humanicslearning.com. **Acquisitions Editor:** W. Arthur Bligh. Art Director: Hart Paul. Estab. 1976. Publishes college textbooks, paperback trade, New Age and educational activity books. Publishes 30 titles/year. Recent titles include *Learning Before and After School Activities*; *Homespun Curriculum*; *Learning Through Art*. Learning books are workbooks with 4-color covers and line art within; trade paperbacks are 6×9 with 4-color covers. Book catalog for 9×12 SASE. Specify which imprint when requesting catalog Learning or trade paperbacks.
• No longer publishes children's fiction or picture books.
First Contact & Terms Send query letter with résumé, SASE and photocopies. Samples are filed or are returned by SASE if requested by artist. Rights purchased vary according to project. Originals are not returned.
Book Design Pays by the project.
Jackets/Covers Pays by the project.
Text Illustration Pays by the project.
Tips ''We use 4-color covers, and our illustrations are line art with no halftones.''

IDEALS PUBLICATIONS INC.

A division of Guideposts, 535 Metroplex Dr., Suite 250, Nashville TN 37211. (615)333-0478. Fax: (615)781-1447. Web site: www.idealsbooks.com. **Publisher:** Patricia Pingry. Art Director: Eve DeGrie. Estab. 1944. Imprints include: Candy Cane Press, Williamson Books. Company publishes hardcover originals and *Ideals* magazine. Specializes in nostalgia and holiday themes. Publishes 100 book titles and 6 magazine issues/year. Recent titles include: *Blessings of a Husband's Love, Dear Santa*. 50% require freelance illustration. Guidelines free for #10 SASE with 1 first-class stamp or on Web site.
Needs Approached by 100 freelancers/year. Works with 10-12 freelance illustrators/year. Prefers freelancers with experience in illustrating people, nostalgia, botanical flowers. Uses freelancers mainly for flower borders (color), people and spot art. Also for text illustration, jacket/cover and book design. Works on assignment only.
First Contact & Terms Send tearsheets which are filed. Responds only if interested. Buys all rights. Finds artists through submissions.
Text Illustration Assigns 75 freelance illustration jobs/year. Pays by the project. Prefers watercolor or gouache.

Tips "Looking for illustrations with unique perspectives, perhaps some humor, that not only tells the story but draws the reader into the artist's world. We accept all styles."

IDW PUBLISHING
4411 Morena Blvd., Suite 106, San Diego CA 92117. Web site: www.idwpublishing.com. **Contact:** Editorial Offices. Publishes hardcover, mass market and trade paperback originals. Types of books include comic books, illustrated novel and art book nonfiction. Publishes 20 titles/year. Recent titles include: *Clive Barker's The Great and Secret Show #1*, *Spike vs. Dracula #1*, *The Transformers: Infiltration #3*. Submission guidelines available on Web site.
First Contact & Terms Send proposal with cover letter, photocopies (5 fully inked and lettered 8½×11 pages showing story and art), 1-page synopsis of overall story. Samples are not returned. Responds only if interested.
Tips "Do not send original art. Make sure photocopies are clean, sharp, and easy to read. Be sure that each page has your name, address, and phone number written clearly on it." Do not call.

IGNATIUS PRESS
Guadalupe Associates, 2515 McAllister St., San Francisco CA 94118. (415)387-2324. Fax: (415)387-0896. Web site: www.ignatius.com. **Production Editor:** Carolyn Lemon. Art Editor: Roxanne Lum. Estab. 1978. Company publishes Catholic theology and devotional books for lay people, priests and religious readers. Publishes 30 titles/year. Recent titles include *Father Elijah An Apocalypse*; *Tolkien A Celebration*.
Needs Works with 1-2 freelance illustrators/year. Works on assignment only.
First Contact & Terms Will send art guidelines "if we are interested in the artist's work." Accepts previously published material. Send brochure showing art style or résumé and photocopies. Samples not filed and not returned. Responds only if interested. To show a portfolio, mail appropriate materials; "we will contact you if interested." **Pays on acceptance.**
Jackets/Covers Buys cover art from freelance artists. Prefers Christian symbols/calligraphy and religious illustrations of Jesus, saints, etc. (used on cover or in text). "Simplicity, clarity, and elegance are the rule. We like calligraphy, occasionally incorporated with Christian symbols. We also do covers with type and photography." Pays by the project.
Text Illustration Pays by the project.
Tips "I do not want to see any schmaltzy religious art. Since we are a nonprofit Catholic press, we cannot always afford to pay the going rate for freelance art, so we are always appreciative when artists can give us a break on prices and work *ad maiorem Dei gloriam.*"

IMAGE COMICS
1942 University Ave., Suite 305, Berkeley CA 94704. E-mail: info@imagecomics.com. Web site: www.imagecomics.com. **Contact:** Erik Larsen. Estab. 1992. Publishes comic books, graphic novels. Recent titles include: *Athena Inc.*; *Noble Causes Family Secrets #2*; *Powers #25*. See this company's Web site for detailed guidelines.
Needs "We are looking for good, well-told stories and exceptional artwork that run the gamut in terms of both style and genre."
First Contact & Terms Send proposals only. See Web site for guidelines. No e-mail submissions. All comics are creator-owned. Image only wants proposals for comics, not "art submissions." Proposals/samples not returned. Do not include SASE. Responds as soon as possible.
Tips "Please do not try to 'impress' us with all the deals you've lined up or testimonials from your Aunt Matilda. We are only interested in the comic."

IMPACT BOOKS
4700 E. Galbraith Rd., Cincinnati OH 45236. (513)531-2690. Fax: (513)531-2686. E-mail: pam.wissman@fwpubs.com. Web site: www.impact-books.com. **Aquisitions Editor:** Pam Wissman. Publishes trade paperback originals. Specializes in illustrated instructional books. Publishes 8 titles/year. Recent titles include: *Dragonart*, by Jessica Peffer; *Fantastic Realms*, by V. Shane. Book catalog free with 9×12 SASE (6 first-class stamps).
- IMPACT Books publishes titles that emphasize illustrated how-to-draw-comics and fantasy art instruction. Currently emphasizing traditional superhero and American comics styles; Japanese-style (Manga and Anime), and fantasy art. This market is for experienced comic-book artists who are willing to work with an IMPACT editor to produce a step-by-step how-to book about the artists' creative process.
Needs Approached by 25 author-artists/year. Works with 8-10 author-artists/year.
First Contact & Terms Send query letter or e-mail; digital art, tearsheets, photocopies, photographs, transparencies or slides; résumé, SASE and URL. Accepts Mac-compatible e-mail submissions from artists (TIFF or JPEG). Samples may be filed but are usually returned. Responds only if interested. Company will contact artist for portfolio review of color finished art, digital art, roughs, photographs, slides, tearsheets and/or transparencies if interested. Buys all rights. Finds freelancers through artist's submissions, Internet, and word of mouth.

INCENTIVE PUBLICATIONS, INC.

3835 Cleghorn Ave., Nashville TN 37215. (615)385-2934. Fax: (615)385-2967. E-mail: info@incentivepublicatio ns.com. Web site: www.incentivepublications.com. **Contact:** Art Director. Specializes in supplemental teacher resource material, workbooks for middle shool and teaching strategy books for all levels. Publishes 15-30 titles/ year. Recent titles include: *If You Don't Feed the Teachers They Eat the Students*; *Basic Not Boring Book of Tests*; *Can We Eat the Art*. 40% require freelance illustration. Books are "cheerful, warm, uncomplicated and spontaneous."

Needs Works with 3-6 freelance illustrators/year. Uses freelancers for covers and text illustration. Also for promo items (occasionally). Works on assignment only, primarily with local artists.

First Contact & Terms Illustrators: Send query letter with photocopies, SASE and tearsheets. Samples are filed. Samples not filed are returned by SASE. Art director will contact artist for portfolio review if interested. Portfolio should include original/final art, photostats, tearsheets and final reproduction/product. Sometimes requests work on spec before assigning a job. Considers complexity of project, project's budget and rights purchased when establishing payment. Buys all rights. Originals are not returned.

Jackets/Covers Assigns 3-4 freelance illustration jobs/year. Prefers 4-color covers in any medium. Pays by the project, $350-450.

Text Illustration Assigns 3-4 freelance jobs/year. Black & white line art only. Pays by the project, $175-1,250.

Tips "We look for a warm and whimsical style of art that respects the integrity of the child. We sell to parents and teachers. Art needs to reflect specific age children/topics for immediate association of parents and teachers to appropriate books."

INNER TRADITIONS INTERNATIONAL/BEAR & COMPANY

One Park St., Rochester VT 05767. (802)767-3174. Fax: (802)767-3726. E-mail: peri@InnerTraditions.com. Web site: www.InnerTraditions.com. **Art Director:** Peri Champine. Estab. 1975. Publishes hardcover originals and trade paperback originals and reprints. Types of books include self-help, psychology, esoteric philosophy, alternative medicine, Eastern religion, teen self-help and art books. Publishes 60 titles/year. Recent titles include *The Virgin Mary Conspiracy*; *Strength Training on the Ball*; *The Discovery of the Nag Hammadi*. 25% requires freelance illustration; 25% requires freelance design. Book catalog free by request.

Needs Works with 8-9 freelance illustrators and 3-4 freelance designers/year. 100% of freelance design demands knowledge of QuarkXPress, InDesign, or Photoshop. Buys 10 illustrations/year. Uses freelancers for jacket/ cover illustration and design. Works on assignment only.

First Contact & Terms Send query letter with résumé, SASE, tearsheets, photocopies, photographs and slides. Accepts disk submissions. Samples filed if interested or are returned by SASE if requested by artist. Responds to the artist only if interested. To show portfolio, mail tearsheets, photographs, slides and transparencies. Rights purchased vary according to project. Originals returned at job's completion. Pays by the project.

Jackets/Covers Assigns approximately 25 design and illustration jobs/year. Pays by the project.

INTERCULTURAL PRESS, INC.

100 City Hall Plaza, Suite 501, Boston MA 02108. (617)523-3801. Fax: (617)523-3708. E-mail: books@intercultur alpress.com. Web site: www.interculturalpress.com. **Production Manager:** Erika Heilman. Estab. 1982. Company publishes paperback originals. Types of books include text and reference. Specializes in intercultural and multicultural. Publishes 12 titles/year. Recent titles include: *Kids Like Me*, by Judith Blohm and Terri Lapinski; *Islam & Muslims*, by Mark Sedgwick. 10% require freelance illustration. Book catalog free by request.

Needs Approached by 20 freelancers/year. Works with 2-3 freelance illustrators/year. Prefers freelancers with experience in trade books, multicultural field. Uses freelancers mainly for jacket/cover design and illustration. 80% of freelance work demands knowledge of PageMaker or Illustrator. "If a freelancer is conventional (i.e., not computer driven) they should understand production and pre-press."

First Contact & Terms Send query letter with brochure, tearsheets, résumé and photocopies. Samples are filed or are returned by SASE if requested by artist. Does not report back. Will contact artist for portfolio review if interested. Portfolio should include b&w final art. Buys all rights. Originals are not returned. Finds artists through submissions and word of mouth.

Jackets/Covers Assigns 6 freelance illustration jobs/year. Pays by the project, $300-500.

Text Illustration Assigns 1 freelance illustration job/year. Pays "by the piece depending on complexity." Prefers b&w line art.

Tips First-time assignments are usually book jackets only; book jackets with interiors (complete projects) are given to "proven" freelancers. "We look for artists who have flexibility with schedule and changes to artwork. We appreciate an artist who will provide artwork that doesn't need special attention by pre-press in order for it to print properly. For black & white illustrations keep your lines crisp and bold. For color illustrations keep your colors pure and saturated to keep them from reproducing 'muddy.'"

INTERNATIONAL MARINE/RAGGED MOUNTAIN PRESS

McGraw-Hill, Box 220, Camden ME 04843-0220. (207)236-4838. Fax: (207)236-6314. Web site: www.books.mcg raw-hill.com/im. **Director of Editing, Design and Production:** Molly Mulhern Gross. Estab. 1969. Imprint of McGraw-Hill. Specializes in hardcovers and paperbacks on marine (nautical) and outdoor recreation topics. Publishes 50 titles/year. 50% require freelance illustration. Book catalog free by request.

Needs Works with 20 freelance illustrators and 20 designers/year. Uses freelancers mainly for interior illustration. Prefers local freelancers. Works on assignment only.

First Contact & Terms Send résumé and tearsheets. Samples are filed. Responds in 1 month. Considers project's budget when establishing payment. Buys one-time rights. Originals are not returned.

Book Design Assigns 20 freelance design jobs/year. Pays by the project, $150-550; or by the hour, $12-30.

Jackets/Covers Assigns 20 freelance design and 3 illustration jobs/year. Pays by the project, $100-500; or by the hour, $12-30.

Text Illustration Assigns 20 jobs/year. Prefers technical drawings. Pays by the hour, $12-30; or by the project, $30-80/piece.

Tips "Do your research. See if your work fits with what we publish. Write with a résumé and sample; then follow with a call; then come by to visit."

JALMAR PRESS/INNERCHOICE PUBLISHING

P.O. Box 370, Fawnskin CA 92333. (909)866-2912. Fax: (909)866-2961. E-mail: jalmarpress@att.net. Web site: www.jalmarpress.com. **President:** Bradley L. Winch. Operations Manager: Cathy Winch. Estab. 1971. Publishes books emphasizing healthy self-esteem, character building, emotional intelligence, nonviolent communication, peaceful conflict resolution, stress management and whole brain learning. Publishes 12 titles/year. Recent titles include: *How to Handle a Bully*; *The Anger Workout for Teens*; *Positive Attitudes and Peacemaking*. Books are contemporary, yet simple and activity-driven.

●Jalmar has developed a line of books to help counselors, teachers and other caregivers deal with the 'tough stuff' including violence, abuse, divorce, AIDS, low self-esteem, the death of a loved one, etc.

Needs Works with 3-5 freelance illustrators and 3 designers/year. Uses freelancers mainly for cover design and illustration. Also for direct mail and book design. Works on assignment only.

First Contact & Terms Send query letter with brochure showing art style. Samples not filed are returned by SASE. 80% of freelance work demands knowledge of Photoshop, Illustrator, QuarkXPress and PDF. Buys all rights. Considers reprints but prefers original works. Considers complexity of project, budget and turnaround time when establishing payment.

Book Design Pays by the project, $200 minimum.

Jackets/Covers Pay by the project, $200 minimum.

Text Illustration Pays by the project, $15 minimum.

Tips "Portfolio should include samples that show experience. Don't include 27 pages of 'stuff.' Stay away from the 'cartoonish' look."

JEWISH LIGHTS PUBLISHING

Sunset Farm Offices, Rt. 4, P.O. Box 237, Woodstock VT 05091. (802)457-4000. Fax: (802)457-5032. E-mail: production@jewishlights.com. Web site: www.jewishlights.com. **Production Manager:** Tim Holtz. Estab. 1990. Publishes hardcover originals, trade paperback originals and reprints. Types of books include children's picture books, history, juvenile, nonfiction, reference, religious, self help, spirituality, life cycle, theology and philosophy, wellness. Specializes in adult nonfiction and children's picture books. Publishes 50 titles/year. Recent titles include: *I am Jewish*; *The Quotable Jewish Woman*; *The Jewish Journaling Book*. 10% requires freelance illustration; 50% requires freelance design. Book catalog free on request.

Needs Approached by 75 illustrators and 20 designers/year. Works with 3 illustrators and 10 designers/year. Prefers freelancers experienced in fine arts, children's book illustration, typesetting and design. 100% of freelance design demands knowledge of QuarkXPress. 50% of freelance design demands knowledge of Photoshop.

First Contact & Terms Designers: Send postcard sample, query letter with printed samples, tearsheets. Illustrators: Send postcard sample or other printed samples. Samples are filed and are not returned. Portfolio review not required. Buys all rights. Finds freelancers through submission packets, Web sites, searching local galleries and shows, Graphic Artists' Guild's *Directory of Illustrators* and *Picture Book*.

Book Design Assigns 40 freelance design jobs/year. Pays for design by the project.

Jackets/Covers Assigns 30 freelance design jobs and 5 illustration jobs/year. Pays for design by the project.

Tips "We prefer a painterly, fine-art approach to our children's book illustration to achieve a quality that would intrigue both kids and adults. We do not consider cartoonish, caricature-ish art for our children's book illustration."

◨ JIREH PUBLISHING COMPANY

P.O. Box 1911, Suisun City CA 94585-1911. (510)276-3322. E-mail: jaholman@jirehpublishing.com. Web site: www.jirehpublishing.com. **Contact:** J. Holman, editor. Publishes CD ROMs, hardcover and trade paperback originals. Types of books include adventure and religious fiction; instructional, religious and e-books nonfiction. Publishes 2 titles/year. Recent titles include: *Accessible Bathroom Design*; *The Art of Seeking God*. 85% requires freelance design; 50% requires freelance illustration. Book catalog not available. (See Web site for current titles.)

Needs Approached by 15 designers and 12 illustrators/year. Works with 2 designers and 1 illustrator/year. 85% of freelance design work and 75% of freelance illustration work demands knowledge of Corel Draw, Illustrator and Photoshop.

First Contact & Terms Designers/Illustrators: Send postcard samples with résumé, URL. Samples are filed. Responds only if interested. Company will contact artist for portfolio review if interested. Portfolio should include color finished art. Rights purchased vary according to project. Finds freelancers through art reps, artist's submissions and Internet.

Jackets/Covers Assigns 2 freelance cover illustration jobs/year. Pays for illustration by the project, $1,000 minimum. Prefers experienced Christian cover designer.

Text Illustration Assigns 1 freelance illustration job/year. $50 minimum/hour.

Tips "Be experienced in creating Christian cover designs for fiction and nonfiction titles."

KAEDEN BOOKS

P.O. Box 16190, Rocky River OH 44116. (440)617-1400. Fax: (440)617-1403. E-mail: curmston@kaeden.com. Web site: www.kaeden.com. **Publisher:** Craig Urmston. Estab. 1989. Publishes children's books and picture books. Types of books include picture books and early juvenile. Specializes in educational elementary content. Publishes 8-20 titles/year. 90% require freelance illustration. Book catalog available upon request. Recent new titles include: *Crow Said Noe*; *Ashley's Elephant*; and *Carla's New Glasses*.

● Kaeden Books is now providing content for Thinkbox.com and the TAE Kindlepark Electronic Book Program.

Needs Approached by 100-200 illustrators/year. Works with 5-10 illustrators/year. Prefers freelancers experienced in juvenile/humorous illustration and children's picture books. Uses freelancers mainly for story illustration.

First Contact & Terms Designers: Send query letter with brochure and résumé. Illustrators: Send postcard sample or query letter with photocopies, photographs, printed samples or tearsheets, no larger than 8½×11. Samples are filed and not returned. Responds only if interested. Art director will contact artist for portfolio review if interested. Buys all rights.

Text Illustration Assigns 8-20 jobs/year. Pays by the project. Looks for a variety of styles.

Tips "We look for professional-level drawing and rendering skills, plus the ability to interpret a juvenile story. There is a tight correlation between text and visual in our books, plus a need for attention to detail. Drawings of children are especially needed. Please send only samples that pertain to our market."

KALMBACH PUBLISHING CO.

21027 Crossroads Circle, P.O. Box 1612, Waukesha WI 53187. (262)796-8776. Fax: (262)796-1142. E-mail: tford@kalmbach.com. Web site: www.kalmbach.com. **Books Art Director:** Tom Ford. Estab. 1934. Types of books include reference and how-to books for serious hobbyists in the railfan, model railroading, plastic modeling, and toy train collecting/operating hobbies. Also publishes books and booklets on jewelry-making, beading and general crafts. Publishes 50+ new titles/year. Recent titles include: *Legendary Lionel Trains*, by John Grams and Terry Thompson; *The Model Railroader's Guide to Industries Along the Tracks*, by Jeff Wilson; *Tourist Trains 2005—The 40th Annual Guide to Tourist Railroads and Museums*; and *Chic&Easy Beading, 100 Fast and Fun Fashion Jewelry Projects*, edited by Alice Korach.

Needs 10-20% require freelance illustration; 10-20% require freelance design. Book catalog free upon request. Approached by 25 freelancers/year. Works with 2 freelance illustrators and 2 graphic designers/year. Prefers freelancers with experience in the hobby field. Uses freelance artists mainly for book layout/design and line art illustrations. Freelancers should have the most recent versions of Adobe InDesign, Photoshop and Illustrator. Projects by assignment only.

First Contact & Terms Send query letter with résumé, tearsheets and photocopies. No phone calls please. Samples are filed and will not be returned. Art Director will contact artist for portfolio review. Finds artists through word of mouth, submissions. Assigns 10-12 freelance design jobs/year. Pays by the project, $500-3,000. Assigns 3-5 freelance illustration jobs/year. Pays by the project, $250-2,000.

Tips First-time assignments are usually illustrations or book layouts. Complex projects (i.e., track plans, 100+ page books) are given to proven freelancers. Admires freelancers who present an organized and visually strong portfolio that meet deadlines and follow instructions carefully.

KIRKBRIDE BIBLE CO. INC.

Kirkbride Bible & Technology, 335 W. 9th St., Indianapolis IN 46202-0606. (317)633-1900. Fax: (317)633-1444. E-mail: sales@kirkbride.com. Web site: www.kirkbride.com. **Director of Production and Technical Services:** Michael B. Gage. Estab. 1915. Publishes hardcover originals, CD-ROM and many styles and translations of the Bible. Types of books include reference and religious. Specializes in reference and study material. Publishes 6 main titles/year. Recent titles include: *NIV Thompson Student Bible.* 5% require freelance illustration; 20% require freelance design. Catalog available.

Needs Approached by 1-2 designers/year. Works with 1-2 designers/year. Prefers freelancers experienced in layout and cover design. Uses freelancers mainly for artwork and design. 100% of freelance design and most illustration demands knowledge of PageMaker, FreeHand, Photoshop, Illustrator and QuarkXPress. 5-10% of titles require freelance art direction.

First Contact & Terms Designers: Send query letter with photostats, printed samples and résumé. Illustrators: Send query letter with photostats, printed samples and résumé. Accepts disk submissions compatible with QuarkXPress or Photoshop files4.0 or 3.1. Samples are filed. Responds only if interested. Rights purchased vary according to project.

Book Design Assigns 1 freelance design job/year. Pays by the hour $100 minimum.

Jackets/Covers Assigns 1-2 freelance design jobs and 1-2 illustration jobs/year. Pays for design by the project, $100-1,000. Pays for illustration by the project, $100-1,000. Prefers modern with traditional text.

Text Illustration Assigns 1 freelance illustration/year. Pays by the project, $100-1,000. Prefers traditional. Finds freelancers through sourcebooks and references.

Tips "Quality craftsmanship is our top concern, and it should be yours also!"

DENIS KITCHEN PUBLISHING CO., LLC

P.O. Box 2250, Amherst MA 01004-2250. (413)259-1627. Fax: (413)259-1812. E-mail: publishing@deniskitchen. com. Web site: www.deniskitchenpublishing.com. **Contact:** Denis Kitchen or Steven Krupp. Estab. 1999. Previously Kitchen Sink Press (1969-1999). Publishes hardcover originals and trade paperback originals. Types of books include art prints, coffee table books, graphic novels, illustrated books, postcard books, and boxed trading cards. Specializes in comix and graphic novels. Publishes 4-6 titles/year. Recent titles include: *Heroes of the Blues*, by R. Crumb; *Grasshopper & Ant*, by Harvey Kurtzman; *Mr. Natural Postcard Book*, by R. Crumb. 50% requires freelance design; 10% requires freelance illustration. Book catalog not available.

Needs Approached by 50 illustrators and 100 designers/year. Works with 6 designers and 2 illustrators/year. Prefers local designers. 90% of freelance design work demands knowledge of QuarkXPress and Photoshop. Freelance illustration demands QuarkXPress, Photoshop and sometimes old-fashioned brush and ink.

First Contact & Terms Send postcard sample with SASE, tearsheets, URL and other appropriate samples. After introductory mailing, send follow-up postcard sample every 6 months. Samples are filed or returned by SASE. Responds in 4-6 weeks. Portfolio not required. Finds freelancers through artist's submissions, art exhibits/fairs and word of mouth.

Jackets/Covers Assigns 2-3 freelance cover illustrations/year. Prefers "comic book" look where appropriate.

B. KLEIN PUBLICATIONS

P.O. Box 6578, Delray Beach FL 33482. (561)496-3316. Fax: (561)496-5546. **Editor:** Bernard Klein. Estab. 1955. Publishes reference books, such as the *Guide to American Directories*. Publishes approximately 15-20 titles/ year. 25% require freelance illustration. Book catalog free on request.

Needs Works with 1-3 freelance illustrators and 1-3 designers/year. Uses freelancers for jacket design and direct mail brochures. 25% of titles require freelance art direction.

First Contact & Terms Submit résumé and samples. Pays $50-300.

ALFRED A. KNOPF, INC.

Subsidiary of Random House Inc., 1745 Broadway, New York NY 10019-4305. (212)751-2600. Fax: (212)572-2593. Web site: www.randomhouse.com/knopf. **Art Director:** Carol Carson. Publishes hardcover originals for adult trade. Specializes in history, fiction, art and cookbooks. Publishes 200 titles/year. Recent titles include: *My Life*, by Bill Clinton; *A Good Year*, by Peter Mayle; *The Undressed Art Why We Draw*, by Peter Steinhart.

• Random House Inc. and its publishing entities are not accepting unsolicited submissions via e-mail at this time.

Needs Works with 3-5 freelance illustrators and 3-5 freelance designers/year. Prefers artists with experience in b&w. Uses freelancers mainly for cookbooks and biographies. Also for text illustration and book design.

First Contact & Terms Send query letter with SASE. Request portfolio review in original query. Artist should follow up. Sometimes requests work on spec before assigning a job. Originals are returned at job's completion.

Book Design Pays by the hour, $15-30; by the project, $450 minimum.

Text Illustration Pays by the project, $100-5,000; $50-150/illustration; $300-800/maps.

Tips Finds artists through submissions, agents and sourcebooks. "Freelancers should be aware that Macintosh/Quark is a must for design and becoming a must for maps and illustration."

HJ KRAMER/STARSEED PRESS

P.O. Box 1082, Tiburon CA 94920. (415)435-5367. Fax: (415)435-5364. E-mail: hjkramer@jps.net. **Contact:** Linda Kramer, vice president. Estab. 1987. Publishes children's hardcover and trade paperback originals. Types of books include children's picture books, personal growth, spiritual (nondenominational) fiction and nonfiction. Publishes 3-7 titles/year. Recent titles include: *Just for Today*; *Sudden Awakening*; *Saying What's Real*; *What All Children Want Their Parents to Know*. 20% requires freelance illustration. Book catalog free on request.
Needs Approached by 100 illustrators/year. Works with 1-2 illustrators/year.
First Contact & Terms Send query letter with brochure, photocopies, résumé, SASE, tearsheets. Samples are filed or returned by SASE. Responds only if interested. Company will contact artist for portfolio review if interested. Buys all rights. Finds freelancers through artist's submissions, Internet and word of mouth.
Text Illustration Assigns 1-2 freelance illustration jobs/year. Pays by the project. Prefers children's illustrators.

PETER LANG PUBLISHING, INC.

275 Seventh Ave., 28th Floor, New York NY 10001-6708. (212)647-7700. Fax: (212)647-7707. Web site: www.peterlangusa.com. **Production & Creative Director:** Lisa Dillon. Publishes humanities textbooks and monographs. Publishes 300 titles/year. Book catalog available on request and on Web site.
Needs Works with a small pool of designers/year. Prefers local freelance designers experienced in scholarly book covers. Most covers will be CMYK. 100% of freelance design demands knowledge of Illustrator, Photoshop and QuarkXPress.
First Contact & Terms Send query letter with printed samples, photocopies and SASE. Accepts Windows-compatible and Mac-compatible disk submissions. Samples are filed. Responds only if interested. Will contact artist for portfolio review if interested. Finds freelancers through referrals.
Jackets/Covers Assigns 100 freelance design jobs/year. Only accepts Quark electronic files. Pays for design by the project.

LAREDO PUBLISHING CO./RENAISSANCE HOUSE DBA

9400 Lloydcrest Dr., Beverly Hills CA 90210. (310)860-9930. Fax: (310)860-9902. E-mail: laredo@renaissancehouse.net. Web site: renaissancehouse.net. **Art Director:** Sam Laredo. Estab. 1991. Publishes juvenile, preschool textbooks. Specializes in Spanish texts, educational/readers. Publishes 16 titles/year. Recent titles include: *Legends of America* (series of 21 titles); *Extraordinary People* (series of 6 titles); *Breast Health with Nutribionics*.
Needs Approached by 10 freelance illustrators and 2 freelance designers/year. Works with 2 freelance designers/year. Uses freelancers mainly for book development. 100% of freelance design demands knowledge of Photoshop, Illustrator, QuarkXPress. 20% of titles require freelance art direction.
First Contact & Terms Designers: Send query letter with brochure, photocopies. Illustrators: Send photocopies, photographs, résumé, slides, tearsheets. Samples are not filed and are returned by SASE. Responds only if interested. Portfolio review required for illustrators. Art director will contact artist for portfolio review if interested. Portfolio should include book dummy, photocopies, photographs, tearsheets and artwork portraying children. Buys all rights or negotiates rights purchased.
Book Design Assigns 5 freelance design jobs/year. Pays for design by the project.
Jacket/Covers Pays for illustration by the project, page.
Text Illustration Pays by the project, page.

LEE & LOW BOOKS

95 Madison Ave., #1205, New York NY 10016-7801. (212)779-4400. Fax: (212)532-6035. E-mail: general@leeandlow.com. Web site: www.leeandlow.com. **Editor-in-Chief:** Louise May. Estab. 1991. Book publisher. Publishes hardcover originals and reprints for the juvenile market. Specializes in multicultural children's books. Publishes 12-15 titles/year. First list published in spring 1993. Titles include: *Rent Party Jazz*, by William Miller; *Where On Earth Is My Bagel?*, by Frances Park and Ginger Park; and *Love to Mama*, edited by Pat Mora. 100% requires freelance illustration and design. Book catalog available.
Needs Approached by 100 freelancers/year. Works with 12-15 freelance illustrators and 4-5 designers/year. Uses freelancers mainly for illustration of children's picture books. 100% of design work demands computer skills. Works on assignment only.
First Contact & Terms Contact through artist rep or send query letter with brochure, résumé, SASE, tearsheets or photocopies. Samples of interest are filed. Art director will contact artist for portfolio review if interested. Portfolio should include color tearsheets and dummies. Rights purchased vary according to project. Originals are returned at job's completion.
Book Design Pays by the project.

Text Illustration Pays by the project.

Tips "We want an artist who can tell a story through pictures and is familiar with the children's book genre. We are now also developing materials for older children, ages 8-12, so we are interested in seeing work for this age group, too. Lee & Low Books makes a special effort to work with writers and artists of color and encourages new talent. We prefer filing samples that feature children, particularly from diverse backgrounds."

LERNER PUBLISHING GROUP
241 First Ave. N., Minneapolis MN 55401. (612)332-3344. Fax: (612)332-7615. E-mail: info@lernerbooks.com. Web site: www.lernerbooks.com. **Art Director:** Zach Marell. Estab. 1975. Company publishes hardcovers and paperbacks. Publishes 200 titles/year. Recent titles include *Uncommon Revolutionary*; *Chocolate by Hershey*; *The Country Artist*. 100% require freelance illustration. Book catalog free on request.

Needs Uses 10-12 freelance illustrators/year. Uses freelancers mainly for book illustration. Also for jacket/cover design and illustration, book design and text illustration.

First Contact & Terms Send query letter with samples or tearsheets showing skill in children's book illustration to be kept on file. Samples not filed are returned by SASE. Responds in 2 weeks only if SASE included. Originals are returned at job's completion. Considers skill and experience of artist and turnaround time when establishing payment. Pays by the project, $500-3,000 average, or advance plus royalty. Considers buying second rights (reprint rights) to previously published artwork.

Tips Send samples showing active children, not animals or still life. Don't send original art. "Look at our books and see what we do."

LIPPINCOTT WILLIAMS & WILKINS
Parent company: Wolters Kluwer, 351 W. Camden St., Baltimore MD 21201-2436. (410)528-4000. Fax: (410)528-4414. E-mail: mfernand@lww.com. Web site: www.lww.com. **Senior Design Coordinator:** Mario Fernandez. Estab. 1890. Publishes audio tapes, CD-ROMs, hardcover originals and reprints, textbooks, trade paperbook originals and reprints. Types of books include instructional and textbooks. Specializes in medical publishing. Publishes 400 titles/year. Recent titles include: *Principles of Medical Genetics-2nd Edition*; *Communication Development Foundations Processes and Clinical Applications*. 100% requires freelance design.

Needs Approached by 20 illustrators and 20 designers/year. Works with 10 illustrators and 30 designers/year. Prefers freelancers experienced in medical publishing. 100% of freelance design demands knowledge of Illustrator, Photoshop, QuarkXPress.

First Contact & Terms Send query letter with printed samples and tearsheets. Accepts Mac-compatible disk submissions. Send EPS or TIFF files. Responds only if interested. Will contact artist for portfolio review if interested. Buys all rights. Finds freelancers through submission packets, word of mouth.

Book Design Assigns 150 freelance design jobs/year. Pays by the project, $350-5,000.

Jackets/Covers Assigns 150 freelance design jobs/year. Pays for design by the project, $350-5,000. Prefers medical publishing experience.

Text Illustration Assigns 150 freelance illustration jobs/year. Pays by the project, $350-500. Prefers freelancers with medical publishing experience.

Tips "We're looking for freelancers who are flexible and have extensive clinical and textbook medical publishing experience. Designers must be proficient in Quark, Illustrator and Photoshop and completely understand how design affects the printing (CMYK 4-color) process."

LITURGY TRAINING PUBLICATIONS
An agency of the Roman Catholic Archdiocese of Chicago, 1800 N. Hermitage, Chicago IL 60622. (773)486-8970. Fax: (773)486-7094. **Contact:** Design Manager. Estab. 1964. Publishes hardcover originals and trade paperback originals and reprints. Types of books include religious instructional books for adults and children. Publishes 50 titles/year. 60% require freelance illustration. Book catalog free by request.

Needs Approached by 30-50 illustrators/year. Works with 10-15 illustrators/year. 10% of freelance illustration demands knowledge of Photoshop.

First Contact & Terms Illustrators: Send postcard sample or send introductory letter with printed samples, photocopies and tearsheets. Accepts Mac-compatible disk submissions. Send EPS or TIFF files. Samples are filed and are not returned. Will contact artist for portfolio review if interested. Rights purchased vary according to project.

Text Illustration Assigns 15-20 freelance illustration jobs/year. Pays by the project. "There is more opportunity for illustrators who are good in b&w or 2-color, but illustrators who work exclusively in 4-color are also utilized."

Tips "Two of our books were in the AIGA 50 Best Books of the Year show in recent years and we win numerous awards. Sometimes illustrators who have done religious topics for others have a hard time working with us because we do not use sentimental or traditional religious art. We look for sophisticated, daring, fine art-

oriented illustrators and artists. Those who work in a more naturalistic manner need to be able to portray various nationalities well. We never use cartoons.''

LLEWELLYN PUBLICATIONS

2143 Wooddale Drive, Woodbury MN 55125. Web site: www.llewellyn.com. Estab. 1903. Book publisher. Publishes trade paperback and mass market books, calendars and Tarot decks. Llewllyn is not a distributor for fine art, cards or previously printed art works. Types of books include mystery/fiction, teens, New Age, reference, astrology, alternative religion, spanish language, metaphysical, occult, health, and women's spirituality. Publishes 135 titles/year. Books have photography, realistic painting and computer generated graphics. 60% require freelance illustration.

Needs Approached by 200 freelancers/year. Licenses 50-75 freelance illustrations/year. Prefers freelancers with experience in book covers, New Age material and realism. Uses freelancers mainly for realistic paintings and drawings. Works on assignment only. Sometimes requests work on spec before assigning job. Negotiates ''License for Use Only.''

Jackets/Covers Assigns 50+ freelance jobs/year. Pays by the illustration, $150-900. Realistic style preferred, may need to research for project, should know/have background in subject matter.

Text Illustration Assigns 40 freelance jobs/year. Pays by the project, or $30-150/illustration. Media and style preferred are pencil occasionally and pen & ink. Style should be realistic and anatomically accurate.

LUMEN EDITIONS/BROOKLINE BOOKS

P.O. Box 1209, Newton MA 02445. (617)734-6772. Fax: (617)734-3952. E-mail: milt@brooklinebooks.com. Web site: www.brooklinebooks.com. **Editor:** Milt Budoff. Estab. 1970. Publishes hardcover originals, textbooks, trade paperback originals and reprints. Types of books include biography, experimental and mainstream fiction, instructional, nonfiction, reference, self-help, textbooks, travel. Specializes in translations of literary works/ education books. Publishes 10 titles/year. Titles include: *Writing*, by Marguerite Duras; *Pursuit of a Woman*, by Hans Koning; *Study Power*; *The Well Adjusted Dog*. 100% requires freelance illustration; 70% requires freelance design. Book catalog free for 6×9 SAE with 2 first-class stamps.

Needs Approached by 20 illustrators and 50 designers/year. Works with 5 illustrators and 20 designers/year. Prefers freelancers experienced in book jacket design. 100% of freelance design demands knowledge of Photoshop, PageMaker, QuarkXPress.

First Contact & Terms Send query letter with printed samples, SASE. Samples are filed. Will contact artist for portfolio review of book dummy, photocopies, tearsheets if interested. Negotiates rights purchased. Finds freelancers through agents, networking, other publishers, Book Builders.

Book Design Assigns 30-40 freelance design/year. Pays for design by the project, varies.

Jackets/Covers Pays for design by the project, varies. Pays for illustration by the project, $200-2,500. Prefers innovative trade cover designs. Classic type focus.

Text Illustration Assigns 5 freelance illustration jobs/year. Pays by the project, $200-2,500.

Tips ''We have a house style, and we recommend that designers look at some of our books before approaching us. We like subdued colors—that still pop. Our covers tend to be very provocative, and we want to keep them that way. No 'mass market' looking books or display typefaces. All designers should be knowledgeable about the printing process and be able to see their work through production.''

THE LYONS PRESS

P.O. Box 480, 246 Goose Lane, Guilford CT 06437. (203)458-4660. Fax: (203)458-4604. E-mail: cmongilla@lyons press.com. Web site: www.lyonspress.com. **Art Director:** Liz Driesbach. Estab. 1980. Publishes hardcover and trade paperback originals and reprints. Types of books include adventure, humor, mainstream and western fiction, biography, coffee table books, cookbooks, history, instructional, reference, self-help, sporting (also hunting and fishing), and travel. Publishes 180 titles/year. Recent titles include *Quotable New York*; *The Way of the River*. 50% requires freelance illustration; 40% requires freelance design. Book catalog available.

Needs Approached by 20 illustrators and 10 designers/year. Works with 5-10 illustrators and 10-15 designers/ year. Prefers freelancers experienced in designing books and covers. 100% of freelance design and 20% of freelance illustration demands knowledge of Illustrator, Photoshop, QuarkXPress.

First Contact & Terms Designers: Send query letter with printed samples, photocopies, tearsheets. Illustrators: Send postcard sample or query letter with tearsheets. Accepts Mac-compatible disk submissions. Samples are filed and are not returned. Will contact artist for portfolio review if interested. Portfolio showing book dummy and tearsheets may be dropped off every Wednesday and can be picked up the following day. Rights purchased vary according to project. Finds freelancers through *Workbook*, *RSVP*.

Book Design Assigns 25 freelance design jobs/year. Pays by the project.

Text Illustration Assigns 60-70 freelance illustration jobs/year. Pays by the project, $200-700 depending on job.

MADISON HOUSE PUBLISHERS

4501 Forbes Blvd., Suite 200, Lanham MD 20706. (301)459-3366. Fax: (301)429-5748. Web site: www.rowmanli ttlefield.com. **Contact:** Vice President, Design. Estab. 1984. Publishes hardcover and trade paperback originals. Specializes in biography, history and popular culture. Publishes 10 titles/year. Titles include: *Connected Lives*; *Love and Limerence*; *Three Golden Ages*. 40% require freelance illustration; 100% require freelance jacket design. Book catalog free by request.

• Madison House is just one imprint of Rowman & Littlefield Publishing Group, which has eight imprints.
Needs Approached by 20 freelancers/year. Works with 4 freelance illustrators and 12 designers/year. Prefers freelancers with experience in book jacket design. Uses freelancers mainly for book jackets. Also for catalog design. 80% of freelance work demands knowledge of Illustrator, QuarkXPress, Photoshop or FreeHand. Works on assignment only.
First Contact & Terms Send query letter with tearsheets, photocopies and photostats. Samples are filed or are returned by SASE if requested by artist. Responds to the artist only if interested. Call for appointment to show portfolio of roughs, original/final art, tearsheets, photographs, slides and dummies. Buys all rights. Interested in buying second rights (reprint rights) to previously published work.
Jackets/Covers Assigns 16 freelance design and 2 illustration jobs/year. Pays by the project, $400-1,000. Prefers typographic design, photography and line art.
Text Illustration Pays by project, $100 minimum.
Tips "We are looking to produce trade-quality designs within a limited budget. Covers have large type, clean lines; they 'breathe.' If you have not designed jackets for a publishing house but want to break into that area, have at least five 'fake' titles designed to show ability. I would like to see more Eastern European style incorporated into American design. It seems that typography on jackets is becoming more assertive, as it competes for attention on bookstore shelf. Also, trends are richer colors, use of metallics."

MANDALA PUBLISHING

17 Paul Dr., San Rafael CA 94903. (415)883-4055. Fax: (415)884-0500. E-mail: mandala@mandala.org. Web site: www.mandala.org. **Contact:** Lisa Fitzpatrick, acquiring editor. Estab. 1987. Publishes art and photography books, calendars, journals, postcards and greeting card box sets. Types of books include New Age, spiritual, philosophy, art, biography, coffee table books, cookbooks, instructional, religious and travel nonfiction. Specializes in art books, spiritual. Publishes 12 titles/year. Recent titles include: *Ramayana A Tale of Gods & Demons*; *Prince of Dharma The Illustrated Life of the Buddha*. 100% requires freelance design and illustration. Book catalog free on request.
Needs Approached by 50 illustrators/year. Works with 12 designers and 12 illustrators/year. Location of designers/illustrators not a concern.
First Contact & Terms Send photographs and résumé. Accepts disk submissions from designers and illustrators. Prefers Mac-compatible, TIFF and JPEG files. Samples are filed. Responds only if interested. Company will contact artist for portfolio review if interested. Buys first, first North American serial, one-time and reprint rights. Rights purchased vary according to project. Finds freelancers through artist's submissions, word of mouth.
Jackets/Covers Assigns 24 freelance cover illustration jobs/year. Pays for illustration by the project. Prefers original "Indian" edge.
Text Illustration Assigns 24 freelance illustration jobs/year. Pays by the project.
Tips "Look at our published books and understand what we represent and how your work could fit."

MAPEASY, INC.

P.O. Box 80, 54 Industrial Rd., Wainscott NY 11975-0080. (631)537-6213. Fax: (631)537-4541. E-mail: info@map easy.com. Web site: www.mapeasy.com. **Production:** Chris Harris. Estab. 1990. Publishes maps. 100% requires freelance illustration; 25% requires freelance design. Book catalog not available.
Needs Approached by 15 illustrators and 10 designers/year. Works with 3 illustrators and 1 designer/year. Prefers local freelancers. 100% of freelance design and illustration demands knowledge of Illustrator, Photoshop, QuarkXPress and Painter.
First Contact & Terms Send query letter with photocopies. Accepts Mac-compatible disk submissions. Samples are filed. Responds only if interested. Will contact artist for portfolio review if interested. Portfolio should include photocopies. Finds freelancers through ads and referrals.
Text Illustration Pays by the hour, $45 maximum.

MCGRAW-HILL EDUCATION

148 Princeton-Hightstown Rd., Hightstown NJ 08520-1412. (609)426-5000. **Director of Design and Production:** Barbara Kopel. Estab. 1969. Independent book producer/packager of textbooks and reference books. Specializes

in social studies, history, geography, vocational, math, science, etc. Recent titles include: *The American Journey*; *The Middle Ages*. 80% require freelance design.

Needs Approached by 30 freelance artists/year. Works with 4-5 illustrators and 5-15 designers/year. Buys 5-10 illustrations/year. Prefers artists with experience in textbooks, especially health, medical, social studies. Works on assignment only.

First Contact & Terms Send query letter with tearsheets and résumé. Samples are filed. Responds to the artist only if interested. To show portfolio, mail roughs and tearsheets. Rights purchased vary according to project. Originals returned at job's completion.

Book Design Assigns 5-15 jobs/year. Pays by the project.

Jackets/Covers Assigns 1-2 design jobs/year. Pays by the project.

Tips "Designers, if you contact us with samples we will invite you to do a presentation and make assignments as suitable work arises. Graphic artists, when working assignments we review our files. Enclose typical rate structure with your samples."

MCGRAW-HILL HIGHER EDUCATION GROUP

2460 Kerper Blvd., Dubuque IA 52001. (563)588-1451. Fax: (563)589-2955. Web site: www.mhhe.com or www.mcgraw-hill.com. **Art Director:** Wayne Harris. Estab. 1944. Publishes hardbound and paperback college textbooks. Specializes in science, engineering and math. Produces more than 200 titles/year. 10% require freelance design; 70% require freelance illustration.

Needs Works with 15-25 freelance designers and 30-50 illustrators/year. Uses freelancers for advertising. 90% of freelance work demands knowledge of PageMaker, Illustrator, QuarkXPress, Photoshop or FreeHand. Works on assignment only.

First Contact & Terms Prefers color 35mm slides and color or b&w photocopies. Send query letter with brochure, résumé, slides and/or tearsheets. "Do not send samples that are not a true representation of your work quality." Responds in 1 month. Accepts disk submissions. Samples returned by SASE if requested. Responds on future assignment possibilities. Buys all rights. Pays $35-350 for b&w and color promotional artwork. Pays half contract for unused assigned work.

Book Design Assigns 100-140 freelance design jobs/year. Uses artists for all phases of process. Pays by the project. Payment varies widely according to complexity.

Jackets/Covers Assigns 100-140 freelance design jobs and 20-30 illustration jobs/year. Pays $1,700 for 4-color cover design and negotiates pay for special projects.

Text Illustration Assigns 75-100 freelance jobs/year. Considers b&w and color work. Prefers computer-generated, continuous tone, some mechanical line drawings; ink preferred for b&w. Pays $30-500.

Tips "In the McGraw-Hill field, there is more use of color. There is need for sophisticated color skills—the artist must be knowlegeable about the way color reproduces in the printing process. Be prepared to contribute to content as well as style. Tighter production schedules demand an awareness of overall schedules. *Must* be dependable."

MEADOWBROOK PRESS

5451 Smetana Dr., Minnetonka MN 55343. (952)930-1100. Fax: (952)930-1940. E-mail: artdirector@meadowbrookpress.com. Web site: www.meadowbrookpress.com and www.production.meadowbrookpress.com. Company publishes hardcover and trade paperback originals. Types of books include : pregnancy, c hildbirth and parenting instruction; baby names; preschool and children's poetry; party and humor. Publishes 20 titles/year. Titles include: *Pregnancy, Childbirth and the Newborn*; *Very Best Baby Name Book*; *Mary Had A Little Jam*; *Age Happens*; *Themed Baby Showers*. 80% require freelance illustration; 10% require freelance design.

Needs Uses freelancers mainly for humor, activity books, spot art. Also for jacket/cover and text illustration. 100% of design work demands knowledge of QuarkXPress, Photoshop or Illustrator. Works on assignment only.

First Contact & Terms Designers: Send query letter with résumé and photocopies. Illustrators: Send query letter with photocopies. Samples are filed and are not returned. Responds only if interested. Art director will contact artist if interested. Finds artists through agents, sourcebooks and submissions.

Book Design Assigns 2 freelance design jobs/year. "Pay varies with complexity of project."

Jackets/Covers Assigns 6 freelance jobs/year.

Tips "We want hardcopy samples to keep on file for review, not on disk or via e-mail, but do appreciate ability to illustrate digitally."

MENNONITE PUBLISHING HOUSE/HERALD PRESS

616 Walnut Ave., Scottdale PA 15683. (724)887-8500. Fax: (724)887-3111. E-mail: hp@mph.org. Web site: www.heraldpress.com. Estab. 1918. Publishes hardcover and paperback originals and reprints; textbooks and church curriculum. Specializes in religious, inspirational, historical, juvenile, theological, biographical, fiction

and nonfiction books. Publishes 17 titles/year. Recent titles include: *The Amish in Their Own Words*; *Yonie Wondernose*. Books are "fresh and well illustrated." 30% require freelance illustration. Catalog available free by request.

Needs Approached by 150 freelancers each year. Works with 8-10 illustrators/year. Prefers oil, pen & ink, colored pencil, watercolor, and acrylic in realistic style. "Prefer artists with experience in publishing guidelines who are able to draw faces and people well." Uses freelancers mainly for book covers. 10% of freelance work demands knowledge of Illustrator, QuarkXPress or CorelDraw. Works on assignment only.

First Contact & Terms Send query letter with résumé, tearsheets, photostats, slides, photocopies, photographs and SASE. Samples are filed ("if we feel freelancer is qualified") and are returned by SASE if requested by artist. Responds only if interested. Art director will contact artist for portfolio review of final art, photographs, roughs and tearsheets. Buys one-time or reprint rights. Originals are not returned at job's completion "except in special arrangements." To show portfolio, mail photostats, tearsheets, final reproduction/product, photographs and slides and also approximate time required for each project. Considers complexity of project, skill and experience of artist and project's budget when establishing payment. Buys all rights.

Jackets/Covers Assigns 8-10 illustration jobs/year. Pays by the project, $200 minimum. "Any medium except layered paper illustration will be considered."

Text Illustration Assigns 6 jobs/year. Pays by the project. Prefers b&w, pen & ink or pencil.

Tips "Design we use is colorful, realistic and religious. When sending samples, show a wide range of styles and subject matter—otherwise you limit yourself."

MITCHELL LANE PUBLISHERS, INC.

P.O. Box 196, Hockessin DE 19707. (302)234-9426. Fax: (302)234-4742. Web site: www.mitchelllane.com. **Publisher:** Barbara Mitchell. Estab. 1993. Publishes library bound originals. Types of books include biography. Specializes in multicultural biography for young adults. Publishes 85 titles/year. Recent titles include: *Disaster in the Indian Ocean, Tsunami 2004*. 50% requires freelance illustration; 50% requires freelance design.

Needs Approached by 20 illustrators and 5 designers/year. Works with 2 illustrators/year. Prefers freelancers experienced in illustrations of people. Looks for cover designers and interior book designers.

First Contact & Terms Send query letter with printed samples, photocopies. Interesting samples are filed and are not returned. Will contact artist for portfolio review if interested. Buys all rights.

Jackets/Covers Prefers realistic portrayal of people.

MODERN PUBLISHING

155 E. 55th St., New York NY 10022. (212)826-0850. Fax: (212)758-4166. E-mail: ntocco@modernpublishing.com. Web site: www.modernpublishing.com. **Executive Editor:** Nicole Tocco. Specializes in children's coloring and activity books, novelty books, hardcovers, paperbacks (both generic and based on licensed characters). Publishes approximately 200 titles/year. Recent titles include: Fisher Price books, Care Bears books, The Wiggles books, Bratz and Lil' Bratz books.

Needs Approached by 15-30 freelancers/year. Works with 25-30 freelancers/year. Works on assignment and royalty.

First Contact & Terms Send query letter with résumé and samples. Samples are not filed and are returned by SASE only if requested. Responds only if interested. Originals not returned. Considers turnaround time, complexity of work and rights purchased when establishing payment.

Jackets/Covers Pays by the project, $100-250/cover, usually 2-4 books/series.

Text Illustration Pays by the project, $35-75/page; line art, 24-384 pages per book, usually 2-4 books/series. Pays $50-125/page; full-color art.

Tips "Research our books at bookstores or on our Web site to get a good feel for our product line; do not submit samples that do not reflect the styles we use."

NBM PUBLISHING INC.

40 Exchange Pl., Ste. 1308, New York NY 10005. (212)643-5407. Fax: (212)643-1545. Web site: www.nbmpub.com. **Publisher:** Terry Nantier. Publishes graphic novels for an audience of 18-34 year olds. Types of books include fiction, fantasy, mystery, science fiction, horror and social parodies. Recent titles include: *A Treasury of Victorian Murder*; *Boneyard*. Circ. 5,000-10,000.

- Not accepting submissions unless for graphic novels. Publisher reports too many inappropriate submissions from artists who "don't pay attention." Check their Web site for instructions before submitting, so you're sure that your art is appropriate for them.

NORTH LIGHT BOOKS

4700 East Galbraith Rd., Cincinnati OH 45236. (513)531-2690. Fax: (513)531-2686. E-mail: jamie.markle@fwpubs.com. Web site: www.fwpublications.com. **Editorial Director:** Jamie Markle. Publishes trade paperback

originals. Specializes in fine art instruction books. Publishes 75 titles/year. Recent titles include: *Lifelike Drawing with Lee Hammond*; Creative *Watercolor Workshop*; *Color Harmony*; *Dragon Art*; *The Watercolor Bible*; *Secrets to Realistic Drawing*. Book catalog free with 9×12 SASE (6 first-class stamps).

• North Light Books publishes art, craft and design books, including watercolor, drawing, colored pencil and decorative painting titles that emphasize illustrated how-to art instruction. This market is for experienced fine artists who are willing to work with a North Light editor to produce a step-by-step how-to book about the artists' creative process.

Needs Approached by 100 author-artists/year. Works with 30 artists/year.

First Contact & Terms Send query letter with photographs, slides or transparencies. Accepts e-mail submissions with art. Samples are not filed and are returned. Responds only if interested. Company will contact artist for portfolio review of color slides if interested. Buys all rights. Finds freelancers through art competitions, art exhibits, artist's submissions, Internet and word of mouth.

Tips "Send 30 slides along with a possible book idea and outline and a sample step-by-step demonstration."

NORTHLAND PUBLISHING

2900 Fort Valley Rd., Flagstaff AZ 86001. (928)774-5251. Fax: (928)774-0592. E-mail: info@northlandpub.com. Web site: www.northlandbooks.com. **Publisher:** David Jenney. Estab. 1958. Company publishes hardcover and trade paperback originals. Types of books include Western and Southwestern, travel, Native American art, home design, cookbooks and children's picture books and activity books. Publishes 20 titles/year. Recent titles include: *Real Women Eat Chiles*; *Family Home of the New West*; *Do Princess Scrape Their Knees*. 50% requires freelance illustration. Art guidelines on Web site.

• Rising Moon and Luna Rising are Northland's children's imprint.

Needs Approached by 1,000 freelancers/year. Works with 5-12 freelance illustrators/year. Prefers freelancers with experience in illustrating children's titles. Uses freelancers mainly for children's books. Works on assignment only.

First Contact & Terms Send query letter and tearsheets. Will contact artist for portfolio review if interested. Rights purchased vary according to project. Originals are returned at job's completion. Finds artists mostly through Web sites and artist agents.

Jackets/Covers No jacket/cover art needed.

Text Illustration Assigns 5-12 freelance illustration jobs/year. Pays by the project, $1,000-10,000. Royalties are preferred—gives cash advances against royalties.

Tips "For Illustrators, send non-returnable samples to Theresa Howell, editor. For Photographers, send non-returnable samples to Claudine Randazzo, editor."

NORTHWORD BOOKS FOR YOUNG READERS

11571 K-Tel Drivem, Minnetonka, MN 55343. Web site: www.tnkidsbooks.com. **Contact:** Kristen McCurry, editorial director. Estab. 1984. Publishes children's nature nonfiction and picture book fiction with nature themes. Publishes 16-20 titles/year. Recent titles include *What Kinds of Seeds Are These?*, by Heidi be Roemer, illustrated by Olena Kassian; *Hungry Beasties*, by Neecy Twinem; and *Traveling Babies*, by Kathryn O. Galbraith, illustrated by Jane Dippold. 50% require illustration; 50% require photography.

Needs Works with 7-10 illustrators per year and 2-3 designers per year.

First Contact & Terms Send query letter and tear sheets to keep on file. Responds only if interested. No originals and please send samples no larger than 8 1/2 x 11. Negotiates rights purchased. Originals returned at job's completion. Editorial illustration: assigns 5 jobs/year. Pays by project.

Tips "Prefers artists with experience in wildlife art, but ability to render people is also key for some projects. Technical skill is important, but illustrations should also have character and dimension. No cartoons."

☢ NOVALIS PUBLISHING, INC.

10 Lower Spadina Avenue, Suite 400, Toronto ON M5V 2Z2 Canada. (416)363-3303. Fax: (416)363-9409. E-mail: novalis@interlog.com. Web site: www.novalis.ca. **Managing Editor:** Anne Louise Mahoney. Estab. 1936. Publishes hardcover, mass market and trade paperback originals and textbooks. Primarily religious. Publishes at least 30 titles/year. 100% requires freelance illustration; 25% requires freelance design; and 25% require freelance art direction. Free book catalog available.

Needs Approached by 4 illustrators and 4 designers/year. Works with 3-5 illustrators and 2-4 designers/year. Prefers local freelancers experienced in graphic design and production. 100% of freelance work demands knowledge of InDesign, Illustrator, Photoshop, PageMaker, QuarkXPress.

First Contact & Terms Send postcard sample or query letter with printed samples, photocopies, tearsheets. Samples are filed or returned on request. Will contact artist for portfolio review if interested. Rights purchased vary according to project; negotiable.

Book Design Assigns 10-20 freelance design and 2-5 art direction projects/year. Pays for design by the hour, $25-40.

Jackets/Covers Assigns 5-10 freelance design and 2-5 illustration jobs/year. Prefers b&w, ink, woodcuts, linocuts, varied styles. Pays for design by the project, $100-800, depending on project. Pays for illustration by the project, $100-600.

Text Illustration Assigns 2-10 freelance illustration jobs/year. Pays by the project, $100 minimum, depending on project.

Tips "We look for dynamic design incorporating art and traditional, non-traditional, folk etc. with spiritual, religious, Gospel, biblical themes—mostly Judeo-Christian."

ORCHARD BOOKS

Scholastic, 557 Broadway, New York NY 10012. (212)343-4490. Fax: (212)343-4890. Web site: www.scholastic.com. **Art Director:** David Saylor. Estab. 1987. Publishes hardcover children's books. Specializes in picture books and novels for children and young adults. Publishes 20 titles/year. Recent titles include: *Talkin About Bessi,* by Nikki Grimes, illustrated by E.B. Lewis. 100% require freelance illustration.

Needs Works with 20 illustrators/year. Works on assignment only. 5% of titles require freelance art direction.

First Contact & Terms Designers: Send brochure and/or photocopies. Illustrators: Send samples, photocopies and/or tearsheets. Samples are filed or are returned by SASE only if requested. Responds to queries/submissions only if interested. Portfolios may be dropped off on Mondays and are returned the same day. Originals returned to artist at job's completion. Considers complexity of project, skill and experience of artist and project's budget when establishing payment.

RICHARD C. OWEN PUBLICATIONS INC.

P.O. Box 585, Katonah NY 10536. (914)232-3903. Fax: (914)232-3977. Web site: www.rcowen.com. **Art Director:** Janice Boland. Estab. 1986. Company publishes children's books. Types of books include juvenile fiction and nonfiction. Specializes in books for 5-, 6- and 7-year-olds. Publishes 15-20 titles/year. Recent titles include: *I Went to the Beach*; *Cool*; *So Sleepy*; *Bedtime*; *Sea Lights*; *Mama Cut My Hair*; *The Author on My Street*; *My Little Brother Ben*. 100% require freelance illustration.

- "Focusing on adding nonfiction for young children on subjects such as history, biography, social studies, science and technology; with human characters, buildings, structures, machines. Realistic but appealing to a child."

Needs Approached by 200 freelancers/year. Works with 20-40 freelance illustrators/year. Prefers freelancers with focus on children's books who can create consistency of character from page to page in an appealing setting. Needs illustrators who can illustrate human characters, figures and architecture in an appropriate and appealing manner to young children. Uses freelancers for jacket/cover and text illustration. Works on assignment only.

First Contact & Terms Send samples of work (color brochure, tearsheets and photocopies). Samples are filed. Art director will contact artist if interested and has a suitable project available. Buys all rights. Original illustrations are returned at job's completion.

Text Illustration Assigns 20-40 freelance illustration jobs/year. Pays by the project, $1,000 for a full book; $25-100 for spot illustrations.

Tips "Show adequate number and only best samples of work. Send work in full color, but target the needs of the individual publisher. Send color copies of work—no slides. Be willing to work with the art director. All our books have a trade book look. No odd, distorted figures. Our readers are 5-8 years old. Try to create worlds that will captivate them."

OXFORD UNIVERSITY PRESS

English as a Second Language (ESL), New York NY 10016. E-mail: jun@oup-usa.org. Web site: www.oup.com/us. **Senior Art Editor:** Jodi Waxman. Chartered by Oxford University. Estab. 1478. Specializes in fully illustrated, not-for-profit, contemporary textbooks emphasizing English as a second language for children and adults. Also produces wall charts, picture cards, CDs and cassettes. Recent titles include: *Grammar Sense* and various Oxford Picture Dictionaries.

Needs Approached by 1,000 freelance artists/year. Works with 100 illustrators and 8 designers/year. Uses freelancers mainly for interior illustrations of exercises. Also uses freelance artists for jacket/cover illustration and design. Some need for computer-literate freelancers for illustration. 20% of freelance work demands knowledge of QuarkXPress or Illustrator. Works on assignment only.

First Contact & Terms Send query letter with brochure, tearsheets, photostats, slides or photographs. Samples are filed. Art Buyer will contact artist for portfolio review if interested. Artists work from detailed specs. Considers complexity of project, skill and experience of artist and project's budget when establishing payment. Artist retains copyright. Originals are returned at job's completion. Finds artists through submissions, artist catalogs

such as *Showcase, Guild Book*, etc. occasionally from work seen in magazines and newspapers, other illustrators.
Jackets/Covers Pays by the project.

Text Illustration Assigns 500 jobs/year. Uses black line, half-tone and 4-color work in styles ranging from cartoon to realistic. Greatest need is for natural, contemporary figures from all ethnic groups, in action and interaction. Pays for text illustration by the project, $45/spot, $2,500 maximum/full page.

Tips "Please wait for us to call you. You may send new samples to update your file at any time. We would like to see more natural, contemporary, nonwhite people from freelance artists. Art needs to be fairly realistic and cheerful."

PAPERCUTZ

555 8th Avenue, Ste. 1202, New York NY 10018. Fax: (212)643-1545. E-mail: salicrup@papercutz.com. Web site: www.papercutz.com. **Contact:** Jim Salicrup (material aimed at the tween and teen market). Estab. 2004. "Independent publisher of graphic novels based on popular existing properties aimed at the teen and tween market." Publishes hardcover originals, paperback originals. Format: glossy white 100 lb. paper; offset four-color printing; perfect bound; full-color comics illustrations. Publishes 10+ titles/year. Distributed by Holtz-brinck Publishers.

Publishes Licensenced characters/properties aimed at a tween and teen market. Not looking for original properties at this point. "Looking for professional comics writers able to write material for tweens and teens without dumbing down their work. Also looking for comic book artists able to work in animated or manga styles." Published *Nancy Drew, Girl Detective # 1* "The Demon of River Heights," by Stefan Petrucha (tween/teen mystery); *The Hardy Boys # 1* "The Ocean of Osyria," by Scott Lobdell (tween/teen mystery/adventure); *Zorro #1* "Scars!," by Don McGregor (tween/teen action/adventure). Series projects: Nancy Drew, Girl Detective; The Hardy Boys; Zorro; and more.

How to Contact Prefers submissions from writers, artists. Accepts unsolicited submissions. Send low res files of comic art samples or a link to samples on artist' s Web site. Attends New York comic book conventions, as well as the San Diego Comic-Con, and will review portfolios if time allows. Agented submissions: 0%. Responds to queries and ms/art packages in 1-2 weeks. Considers simultaneous submissions, e-mail submissions, submissions on disk. Never comments on rejected manuscripts.

Terms Pays an advance against royalties. Publishes ms 3-6 months after acceptance. Writer's and artist's guidelines not available. Book catalog free upon request.

Advice "Be familiar with our titles—that' s the best way to know what we' re interested in publishing. If you are somehow attached to a successful tween or teen property and would like to adapt it into a graphic novel, we may be interested."

PARENTING PRESS, INC.

11065 Fifth Ave. NE, #F, Seattle WA 98125. (206)364-2900. Fax: (206)364-0702. E-mail: office@parentingpress.com. Web site: www.parentingpress.com. **Contact:** Carolyn Threadgill, publisher. Estab. 1979. Publishes trade paperback originals and hardcover originals. Types of books include nonfiction; instruction and parenting. Specializes in parenting and social skill building books for children. Recent titles include: *The Way I Feel*; *Is This a Phase?*; *What About Me?* 100% requires freelance design; 100% requires freelance illustration. Book catalog free on request.

Needs Approached by 10 designers/year and 100 illustrators/year. Works with 2 designers/year. Prefers local designers. 100% of freelance design work demands knowledge of PageMaker, Photoshop and QuarkXPress.

First Contact & Terms Send query letter with brochure, SASE, postcard sample with photocopies, photographs and tearsheets. After introductory mailing, send follow-up postcard sample every 6 months. Accepts e-mail submissions. Prefers Windows-compatible, TIFF, JPEG files. Samples returned by SASE if not filed. Responds only if interested. Company will contact artist for portfolio review if interested. Portfolio should include b&w or color tearsheets. Rights purchased vary according to project.

Jackets/Covers Assigns 4 freelance cover illustrations/year. Pays for illustration by the project $300-1,000. Prefers appealing human characters, realistic or moderately stylized.

Text Illustration Assigns 3 freelance illustration jobs/year. Pays by the project or shared royalty with author.

Tips "Be willing to supply 2-4 roughs before finished art."

PATHWAY BOOK SERVICE

4 White Brook Rd., Gilsum NH 03448. (800)345-6665. Fax: (603)357-2073. E-mail: pbs@pathwaybook.com. Web site: www.stemmer.com. **President/Publisher:** Ernest Peter. Specializes in design resource originals, children's nonfiction and nature/environmental books in series format or as individual titles. Publishes 6-8 titles/year. Recent titles include: *Designs of Tonga, Art Deco Designs, Arts & Crafts Patters & Designs*, and *I Hear the Wind*. Books are "well illustrated." 10% requires freelance design; 75% requires freelance illustration.

• Pathway Book Service acquired Stemmer House Publishers as of July 1, 2003.
Needs Approached by more than 200 freelancers/year. Works with 4 freelance illustrators and 1 designer/year. Works on assignment only.
First Contact & Terms Designers: Send query letter with brochure, tearsheets, SASE, photocopies. Illustrators: Send postcard sample or query letter with brochure, photocopies, photographs, SASE, slides and tearsheets. Do not send original work. Material not filed is returned by SASE. Call or write for appointment to show portfolio. Responds in 6 weeks. Works on assignment only. Originals are returned to artist at job's completion on request. Negotiates rights purchased.
Book Design Assigns 1 freelance design and 2 illustration projects/year. Pays by the project.
Jackets/Covers Assigns 4 freelance design jobs/year. Prefers paintings. Pays by the project.
Text Illustration Assigns 3 freelance jobs/year. Prefers full-color artwork for text illustrations. Pays by the project.
Tips Looks for "draftmanship, flexibility, realism, understanding of the printing process." Books are "rich in design quality and color, stylized while retaining realism; not airbrushed. We prefer noncomputer. Review our books. No picture book illustrations considered currently."

PAULINE BOOKS & MEDIA

50 Saint Pauls Ave., Boston MA 02130-3491. (617)522-8911. Fax: (617)541-9805. E-mail: design@paulinemedia. com. Web site: www.pauline.org. **Art Director:** Sr. Mary Joseph Peterson. Estab. 1932. Book publisher. "We also publish a children's magazine and produce music and spoken recordings." Publishes hardcover and trade paperback originals. Types of books include instructional, biography, for children of all ages and adults, reference, history, self-help, prayer and religious. Specializes in religious topics. Publishes 30-40 titles/year. Art guidelines available. Send requests and art samples with SASE using first-class postage.
Needs Approached by 50 freelancers/year. Works with 10-20 freelance illustrators/year. Knowledge and use of QuarkXPress, InDesign, Illustrator, Photoshop, etc. is valued.
First Contact & Terms Send query letter with résumé, SASE, tearsheets and photocopies. Accepts disk submissions compatible with Mac. Send JPEG, EPS, TIFF or GIF files. Samples are filed or are returned by SASE. Responds in 3 months only if interested. Rights purchased vary according to project. Originals for magazine assignments are returned at job's completion.
Jackets/Covers Assigns 3-4 freelance illustration jobs/year. Pays by the project.
Text Illustration Assigns 6-10 freelance illustration jobs/year. Pays by the project.

PAULIST PRESS

997 Macarthur Blvd., Mahwah NJ 07430. (201)825-7300. Fax: (201)825-8345. E-mail: pmcmahon@paulistpress. com. Web site: www.paulistpress.com. **Managing Editor:** Paul McMahon. Estab. 1869. Company publishes hardcover and trade paperback originals, juvenile and textbooks. Types of books include: religion, theology, and spirituality including biography; speacializing in academic and pastoral theology. Publishes 90 titles/year. Recent titles include: *How to Read a Church*; *Traveling with the Saints in Italy*; *Child's Guide to the Seven Sacraments*. 5% requires freelance illustration; 5% requires freelance design.
• Paulist Press recently began to distribute a general trade imprint HiddenSpring.
Needs Works with 5 freelance illustrators and 10 designers/year. Prefers local freelancers particulary for juvenile titles, jacket/cover, and text illustration. Prefers knowledge of QuarkXPress. Works on assignment only.
First Contact & Terms Send query letter with brochure, résumé and tearsheets. Samples are filed. Portfolio review not required. Negotiates rights purchased. Originals are returned at job's completion if requested.
Book Design Assigns 8 freelance design jobs/year.
Jackets/Covers Assigns 30 freelance design jobs/year. Pays by the project, $400-800.
Text Illustration Assigns 5 freelance illustration jobs/year. Pays by the project.

PEACHTREE PUBLISHERS

1700 Chattahoochee Ave., Atlanta GA 30318. (404)876-8761. Fax: (404)875-2578. E-mail: hello@peachtree-online.c om. Web site: www.peachtree-online.com. **Art Director:** Loraine Joyner. Production Manager: Melanie McMahon Ives. Estab. 1977. Publishes hardcover and trade paperback originals. Types of books include children's picture books, young adult fiction, early reader fiction, juvenile fiction, parenting, regional. Specializes in children's and young adult titles. Publishes 24-30 titles/year. 100% requires freelance illustration. Call for catalog.
Needs Approached by 750 illustrators/year. Works with 15-20 illustrators. "If possible, send samples that show your ability to depict subjects or characters in a consistent manner. See our Web site to view styles of artwork we utilize."
First Contact & Terms Illustrators: Send query letter with photocopies, SASE, tearsheets. "Prefer not to receive samples from designers." Accepts Mac-compatible disk submissions but not preferred. Samples are returned by SASE. Responds only if interested. Will contact artist for portfolio review if interested. Rights purchased

vary according to project. Finds freelancers through submission packets, agents and sourcebooks, including *Directory of Illustration* and *Picturebook*.

Jackets/Covers Assigns 18-20 illustration jobs/year. Prefers acrylic, watercolor or a mixed media on flexible material. Pays for design by the project.

Text Illustration Assigns 4-6 freelance illustration jobs/year. Pays by the project.

Tips "We are an independent, high-quality house with a limited number of new titles per season, therefore each book must be a jewel. We expect the illustrator to bring creative insights which expand the readers' understanding of the storyline through visual clues not necessarily expressed within the text itself."

PELICAN PUBLISHING CO.

1000 Burmaster, Gretna LA 70053. (504)368-1175. Fax: (504)368-1195. E-mail: tcallaway@pelicanpub.com. Web site: www.pelicanpub.com. **Contact:** Production Manager. Publishes hardcover and paperback originals and reprints. Publishes 70 titles/year. Types of books include travel guides, cookbooks, business/motivational, architecture, golfing, history and children's books. Books have a "high-quality, conservative and detail-oriented" look. Recent titles include: *Brownies to Die For*; *Abraham Lincoln's Execution*; *Texas Zeke and the Longhorn*; *The Principal's Night Before Christmas*.

Needs Approached by 2000 freelancers/year. Works with 20 freelance illustrators/year. Uses freelancers for illustration and photo projects. Works on assignment only. 100% of design and 50% of illustration demand knowledge of QuarkXPress, Photoshop 4.0, Illustrator 4.0.

First Contact & Terms Designers: Send photocopies, photographs, SASE, slides and tearsheets. Illustrators: Send postcard sample or query letter with photocopies, SASE, slides and tearsheets. Samples are not returned. Responds on future assignment possibilities. Buys all rights. Originals are not returned.

Book Design Pays by the project, $500 minimum.

Jackets/Covers Pays by the project, $150-500.

Text Illustration Pays by the project, $50-250.

Tips "Show your versatility. We want to see realistic detail and color samples."

PENGUIN GROUP (USA) INC.

375 Hudson St., New York NY 10014. (212)366-2000. Fax: (212)366-2666. Web site: www.penguingroup.com. **Art Director:** Paul Buckley. Publishes hardcover and trade paperback originals.

Needs Works with 100-200 freelance illustrators and 100-200 freelance designers/year. Uses freelancers mainly for jackets, catalogs, etc.

First Contact & Terms Send query letter with tearsheets, photocopies and SASE. Rights purchased vary according to project.

Book Design Pays by the project; amount varies.

Jackets/Covers Pays by the project; amount varies.

◙ PEREGRINE

40 Seymour Ave., Toronto ON M4J 3T4 Canada. (416)461-9884. Fax: (416)461-4031. E-mail: peregrine@peregrine-net.com. Web site: www.peregrine-net.com. **Creative Director:** Kevin Davies. Estab. 1993. Publishes role-playing game books, audio music, and produces miniatures supplements. Main style/genre of games science fiction, cyberpunk, mythology, fantasy, military, horror and humor. Uses freelance artists mainly for interior art (b&w, greyscale) and covers (color). Publishes 1-2 titles or products/year. Game/product lines include: *Murphy's World* (role-playing game), *Bob, Lord of Evil* (role-playing game), *Adventure Areas* (miniatures supplements), *Grit Multi-Genre Miniatures Rules*, *Adventure Audio*, *Background Music*. 90% requires freelance illustration; 10% requires freelance design. Art guidelines available on Web site.

Needs Approached by 20 illustrators and 2 designers/year. Works with 2-5 illustrators/year. Prefers freelancers experienced in anatomy, structure, realism, cartoon and greyscale. 100% of freelance design demands knowledge of Illustrator, Photoshop, InDesign and QuarkXPress.

First Contact & Terms Send self-promotion photocopy and follow-up postcard every 9-12 months. Send query letter with résumé, business card. Illustrators: Send photocopies and/or tearsheets. Send 5-10 samples. Accepts digital submissions in Mac format via CD or e-mail attachment as EPS, TIFF or JPEG files at 72-150 ppi (for samples) and 300 ppi (for finished work). Paper and digital samples are filed and are not returned. Responds only if interested. Portfolio review not required. Rights purchased vary according to project. Finds freelancers through conventions, internet and word of mouth.

Book Covers/Posters/Cards Assigns 1-2 illustration jobs/year. Pays for illustration by the project.

Text Illustration Assigns 1-5 illustration jobs/year (greyscale/b&w). Pays by the full page, $50-100. Pays by the half page $10-25. "Price varies with detail of image required and artist's experience."

Tips "Check out our existing products at www.peregrine-net.com. Make sure at least half of the samples submitted reflect the art styles we're currently publishing. Other images can be provided to demonstrate your range of capability."

PERFECTION LEARNING CORPORATION

10520 New York Ave., Des Moines IA 50322-3775. (515)278-0133, ext. 209. Fax: (515)278-2980. E-mail: rmesser@pl conline.com. Web site: www.perfectionlearning.com. **Art Director:** Randy Messer. Senior Designer: Deb Bell. Estab. 1927. Publishes hardcover originals and reprints, mass market paperback originals and reprints, educational resources, trade paperback originals and reprints, high general interest/low reading level, multicultural, nature, science, social issues, sports. Specializes in high general interest/low reading level and Lit-based teacher resources. Publishes 30 titles/year. Recent titles: *American Justice II*; *The Secret Room, the Message, the Promise, and How Pigs Figure in*; *River of Ice*; *Orcas: High Seas Supermen*. All 5 titles have been nominated for ALA Quick Picks.

• Perfection Learning Corporation has had several books nominated for awards including *Iditarod*, nominated for a Golden Kite award and *Don't Bug Me*, nominated for an ALA-YALSA award.

Needs Approached by 70 illustrators and 10-20 designers/year. Works with 5-10 illustrators/year. Prefers local designers and art directors. Prefers freelancers experienced in cover illustration and interior spot—4-color and b&w. 100% of freelance design demands knowledge of InDesign.

First Contact & Terms Illustrators: Send postcard or query letter with printed samples, photocopies, SASE, tearsheets. Accepts Mac-compatible disk submissions. Send EPS. Samples are filed or returned by SASE. Responds only if interested. Portfolio review not required. Rights purchased vary according to project. Finds freelancers through tearsheet submissions, illustration annuals, phone calls, artists' reps.

Jackets/Covers Assigns 5-10 freelance illustration jobs/year. Pays for illustration by the project, $750-1,750, depending on project. Prefers illustrators with conceptual ability.

Text Illustration Assigns 5-10 freelance illustration jobs/year. Pays by the project. Prefers freelancers who are able to draw multicultural children and good human anatomy.

Tips "We look for good conceptual skills, good anatomy, good use of color. Our materials are sold through schools for classroom use—they need to meet educational standards. We're in a science mode right now with our current publishing schedule. We're using info-graphic/technical type of illustrations in the these books. With the science schedule, we're not using as much freelance work as in the past."

PLAYERS PRESS

P.O. Box 1132, Studio City CA 91614. (818)789-4980. E-mail: playerspress@att.net. **Associate Editor:** Jean Sommers. Specializes in plays and performing arts books. Recent titles include: *Costumes and Settings: v1, v2, & v3*; *Principles of Stage Combat*; *Theater Management*; *Scenery, Design and Fabrication*.

Needs Works with 3-15 freelance illustrators and 1-3 designers/year. Uses freelancers mainly for play covers. Also for text illustration. Works on assignment only.

First Contact & Terms Send query letter with brochure showing art style or résumé and samples. Samples are filed or are returned by SASE. Request portfolio review in original query. Art director will contact artist for portfolio review if interested. Portfolio should include thumbnails, final reproduction/product, tearsheets, photographs and "as much information as possible." Sometimes requests work on spec before assigning a job. Buys all rights. Considers buying second rights (reprint rights) to previously published work, depending on usage. "For costume books this is possible."

Book Design Pays by the project, rate varies.

Jackets/Covers Pays by the project, rate varies.

Text Illustration Pays by the project, rate varies.

Tips "Supply what is asked for in the listing and don't waste our time with calls and unnecessary cards. We usually select from those who submit samples of their work which we keep on file. Keep a permanent address so you can be reached."

CLARKSON N. POTTER, INC.

Imprint of Crown Publishers. Parent company: Crown Publishing Group, 1745 Broadway, New York NY 10019. (212)782-9000. Fax: (212)572-6181. Web site: www.clarksonpotter.com. **Art Director:** Marysarah Quinn. Publishes hardcover originals and reprints. Types of books include coffee table books, cookbooks, gardening, crafts, gift, style, decorating. Specializes in lifestyle (cookbooks, gardening, decorating). Publishes 50-60 titles/year. Recent titles include: *Barefoot in Paris*; *Moosewood Restaurant's Simple Suppers*. 20% requires freelance illustration; 25% requires freelance design.

Needs Works with 10-15 illustrators and 15 designers/year. Prefers freelancers experienced in illustrating food in traditional styles and mediums and designers with previous book design experience. 100% of freelance design demands knowledge of Illustrator, Photoshop, QuarkXPress, InDesign.

First Contact & Terms Send postcard sample or query letter with printed samples, photocopies, tearsheets. Samples are filed and are not returned. Will contact artist for portfolio review if interested or portfolios may be dropped off any day. Leave for 2-3 days. Negotiates rights purchased. Finds freelancers through submission packets, promotional postcards, Web sourcebooks and illustration annuals, previous books.

Book Design Assigns 20 freelance design jobs/year.

Jackets/Covers Assigns 20 freelance design and 15 illustration jobs/year. Pays for design by the project. Jackets are designed by book designer, i.e. the whole book and jacket are viewed as a package.

Text Illustration Assigns 15 freelance illustration jobs/year.

Tips "We no longer have a juvenile books department. We do not publish books of cartoons or humor. We look at a wide variety of design styles. We look at mainly traditional illustration styles and mediums and are always looking for unique food and garden illustrations."

PRAKKEN PUBLICATIONS, INC.

832 Phoenix Dr., Box 8623, Ann Arbor MI 48107. (734)975-2800. Fax: (734)975-2787. Web site: www.techdirecti ons.com or www.eddigest.com. **Production and Design Manager:** Sharon Miller. Estab. 1934. Imprints include The Education Digest, Tech Directions. Company publishes educator magazines, reference books and posters. Specializes in vocational, technical, technology and general education. Publishes 2 magazines. Titles include: *Technology's Past* and *More Technology Projects for the Classroom*. Book catalog free by request.

Needs Rarely uses freelancers. 50% of freelance work demands knowledge of PageMaker. Works on assignment only.

First Contact & Terms Send samples. Samples are filed or are returned by SASE if requested by artist. Responds only if interested. Art director will contact artist for portfolio review if interested. Portfolio should include b&w and color final art and tearsheets.

PRENTICE HALL COLLEGE DIVISION

Pearson Education, 445 Hutchinson Ave., 4th Floor, Columbus OH 43235. (614)841-3700. Fax: (614)841-3645. Web site: www.prenhall.com. **Design Coordinator:** Diane Lorenzo. Specializes in college textbooks in educa- tion and technology. Publishes 400 titles/year. Recent titles include *Through the Eyes of a Child*, by Norton; *Electronics Fundamentals*, by Floyd.

Needs Approached by 25-40 designers/freelancers/year. Works with 15 freelance designers/illustrators/year. Uses freelancers mainly for cover textbook design. 100% of freelance design and 70% of illustration demand knowledge of QuarkXPress 6.5, Illustrator and Photoshop CS.

First Contact & Terms Send query letter with résumé and tearsheets; sample text designs on CD in Mac format. Accepts submissions on CD in Mac files only (not PC) in software versions stated above. Samples are filed and portfolios are returned. Responds if job appropriate. Rights purchased vary according to project. Originals are returned at job's completion.

Book Design Pays by the project, $500-2,500.

Tips "Send a style that works well with our particular disciplines."

PROLINGUA ASSOCIATES

P.O. Box 1348, Brattleboro VT 05302-1348. (802)257-7779. Fax: (802)257-5117. E-mail: andy@ProlinguaAssocia tes.com. Web site: www.ProlinguaAssociates.com. **President:** Arthur A. Burrows. Estab. 1980. Company pub- lishes textbooks. Specializes in language textbooks. Publishes 3-8 titles/year. Recent titles include: *Writing Strategies*; *Dictations and Discussions*. Most require freelance illustration. Book catalog free by request.

Needs Approached by 10 freelance artists/year. Works with 2-3 freelance illustrators/year. Uses freelance artists mainly for pedagogical illustrations of various kinds. Also uses freelance artists for jacket/cover and text illustration. Works on assignment only.

First Contact & Terms Send postcard sample and/or query letter with brochure, photocopies and photographs. Samples are filed. Responds in 1 month. Portfolio review not required. Buys all rights. Originals are returned at job's completion if requested. Finds artists through word of mouth and submissions.

Text Illustration Assigns 5 freelance illustration jobs/year. Pays by the project, $200-1,200.

PUSSYWILLOW

1212 Punta Gorda St., #13, Santa Barbara CA 93103. (805)899-2145. E-mail: bandanna@cox.net. **Contact:** Briar Newborn, publisher. Estab. 2002. Publishes fiction and poetry trade paperback originals and reprints. Types of books include erotic classics mainly in translation for the connoisseur or collector. Recent titles include: *Wife of Bath*; *Aretino's Sonnetti Lussuriosi*. Target audience is mature adults of both sexes. No porn, yes erotica.

Needs Sensual suggestive art pieces in any genre.

First Contact & Terms Send samples for our files, not originals. Responds in 2 months only if interested.

Jackets/Covers Pays at least $200.

Text Illustration Pays by the project.

Tips "We're more likely to commission pieces than to buy originals. Show us what you can do. Send samples we can keep on file."

G.P. PUTNAM'S SONS, PHILOMEL BOOKS

345 Hudson St., 14th Floor, New York NY 10014-3657. (212)366-2000. Web site: www.penguin.com. **Art Director, Children's Books:** Cecilia Yung. Publishes hardcover juvenile books. Publishes 84 titles/year. Free catalog available.
Needs Illustration on assignment only.
First Contact & Terms Provide flier, tearsheet, brochure and photocopy to be kept on file for possible future assignments. Samples are returned by SASE only. "We take drop-offs on Tuesday mornings before noon and return them to the front desk after 4 p.m. the same day. Please call Katrina Damkoehler, (212)366-2000, in advance with the date you want to drop of your portfolio. Do not send samples via e-mail or CDs."
Jackets/Covers "Uses full-color paintings, realistic painterly style."
Text Illustration "Uses a wide cross section of styles for story and picture books."

QUITE SPECIFIC MEDIA GROUP LTD.

7373 Pyramid Place, Hollywood CA 90046. (323)851-5797. Fax: (323)851-5798. Web site: www.quitespecificmedia.com. **Contact:** Ralph Pine. Estab. 1967. Publishes hardcover originals and reprints, trade paperback reprints and textbooks. Specializes in costume, fashion, theater and performing arts books. Publishes 12 titles/year. Recent titles include: *The Medieval Tailor's Assistant.* 10% requires freelance illustration; 60% requires freelance design.
 • Imprints of Quite Specific Media Group Ltd. include Drama Publishers, Costume & Fashion Press, By Design Press, Entertainment Pro and Jade Rabbit.
Needs Works with 2-3 freelance designers/year. Uses freelancers mainly for jackets/covers. Also for book, direct mail and catalog design and text illustration. Works on assignment only.
First Contact & Terms Send query letter with brochure and tearsheets. Samples are filed. Responds to the artist only if interested. Rights purchased vary according to project. Originals not returned. Pays by the project.

RAINBOW PUBLISHERS

P.O. Box 70130, Richmond VA 23255. (804)273-0880. Fax: (804)273-0606. E-mail: rbpub@earthlink.net. **Creative Director:** Sue Miley. Estab. 1979. Publishes trade paperback originals. Types of books include religious books, reproducible Sunday School books for children ages 2-12 and Bible teaching books for children and adults. Publishes 20 titles/year. Titles include: *Favorite Bible Children*, *Make It Take It Crafts*, *Worship Bulletins for Kids*, *Cut, Color & Paste*, *God's Girls*, *Gotta Have God* and *God and Me*. Book catalog for SASE with 2 first-class stamps.
Needs Approached by hundreds of illustrators and 50 designers/year. Works with 5-10 illustrators and 5-10 designers/year. 100% of freelance design and illustration demands knowledge of Illustrator, Photoshop and QuarkXPress.
First Contact & Terms Send query letter with printed samples, SASE and tearsheets. Samples are filed or returned by SASE. Responds only if interested. Will contact artist for portfolio review if interested. Finds freelancers through samples sent and personal referrals.
Book Design Assigns 25 freelance design jobs/year. Pays for design by the project, $350 minimum. Pays for art direction by the project, $350 minimum.
Jackets/Covers Assigns 25 freelance design jobs and 25 illustration jobs/year. "Prefers computer generated-high energy style with bright colors appealing to kids." Pays for design and illustration by the project, $350 minimum. "Prefers designers/illustrators with some Biblical knowledge."
Text Illustration Assigns 20 freelance illustration jobs/year. Pays by the project, $500 minimum. "Prefers black & white line art, preferably computer generated with limited detail yet fun."
Tips "We look for illustrators and designers who have some Biblical knowledge and excel in working with a fun, colorful, high-energy style that will appeal to kids and parents alike. Designers must be well versed in Quark, Illustrator and Photoshop, know how to visually market to kids and have wonderful conceptual ideas!"

RANDOM HOUSE CHILDREN'S BOOK GROUP

1745 Broadway, New York NY 10019. (212)782-9000. Fax: (212)782-9452. Web site: www.randomhouse.com/kids. **Art Director:** Jan Gerardi. Specializes in hardcover and mass market paperback originals and reprints. Publishes 250 titles/year. Titles include: *Wiggle Waggle Fun* and *Junie B. First Grader (at last!)*. 100% require freelance illustration.
Needs Works with 100-150 freelancers/year. Works on assignment only.
First Contact & Terms Send query letter with résumé, tearsheets and printed samples, photostats; no originals. Samples are filed. Negotiates rights purchased.
Book Design Assigns 5 freelance design jobs/year. Pays by the project.
Text Illustration Assigns 150 illustration jobs/year. Pays by the project.

RANDOM HOUSE VALUE PUBLISHING

1745 Broadway, New York NY 10019. (212)782-9000. Fax: (212)572-2114. **Contact:** Art Director. Imprint of Random House, Inc. Other imprints include Wings, Testament, Gramercy and Crescent. Imprint publishes

hardcover, trade paperback and reprints, and trade paperback originals. Types of books include adventure, coffee table books, cookbooks, children's books, fantasy, historical fiction, history, horror, humor, instructional, mainstream fiction, New Age, nonfiction, reference, religious, romance, science fiction, self-help, travel and western. Specializes in contemporary authors' work. Recent titles include: work by John Saul, Mary Higgins Clark, Tom Wolfe, Dave Barry, Stephen King, Rita Mae Brown and Michael Crichton (all omnibuses). 80% requires freelance illustration; 50% requires freelance design.

Needs Approached by 50 freelancers/year. Works with 20 freelance illustrators and 20 designers/year. Uses freelancers mainly for jacket/cover illustration and design for fiction and romance titles. 100% of design and 50% of illustration demands knowledge of Illustrator, QuarkXPress, Photoshop and FreeHand. Works on assignment only.

First Contact & Terms Designers: Send résumé and tearsheets. Illustrators: Send postcard sample, brochure, résumé and tearsheets. Samples are filed. Request portfolio review in original query. Art Director will contact artist for portfolio review if interested. Portfolio should include tearsheets. Buys first rights. Originals are returned at job's completion. Finds artists through *American Showcase, Workbook, The Creative Illustration Book*, artist's reps.

Book Design Pays by the project.

Jackets/Covers Assigns 50 freelance design and 20 illustration jobs/year. Pays by the project, $500-1,500.

Tips "Study the product to make sure styles are similar to what we have done new, fresh, etc."

☑ RED DEER PRESS

1512-1800 4 Street SW, Calgary AB T2S 2S5 Canada. (403)220-4334. Fax: (403)210-8191. E-mail: rdp@reddeerpres s.com. **Managing Editor:** Dennis Johnson. Estab. 1975. Book publisher. Publishes hardcover and trade paperback originals. Types of books include contemporary and mainstream fiction, fantasy, biography, preschool, juvenile, young adult, humor and cookbooks. Specializes in contemporary adult and juvenile fiction, picture books and natural history for children. Recent titles include: *Hidden Buffalo*; *In Abby's Hands*. 100% require freelance illustration; 30% require freelance design. Book catalog available for SASE with Canadian postage.

Needs Approached by 50-75 freelance artists/year. Works with 10-12 freelance illustrators and 2-3 freelance designers/year. Buys 50 freelance illustrations/year. Prefers artists with experience in book and cover illustration. Also uses freelance artists for jacket/cover and book design and text illustration. Works on assignment only.

First Contact & Terms Send query letter with résumé to Erin Woodward, tearsheets, photographs and slides. Samples are filed. To show a portfolio, mail b&w slides and dummies. Rights purchased vary according to project. Originals returned at job's completion.

Book Design Assigns 3-4 design and 6-8 illustration jobs/year. Pays by the project.

Jackets/Covers Assigns 6-8 design and 10-12 illustration jobs/year. Pays by the project, $300-1,000 CDN.

Text Illustration Assigns 3-4 design and 4-6 illustration jobs/year. Pays by the project. May pay advance on royalties.

Tips Looks for freelancers with a proven track record and knowledge of Red Deer Press. "Send a quality portfolio, preferably with samples of book projects completed."

RED WHEEL/WEISER

500 Third Street, Suite 230, San Francisco CA 94107. (415)978-2665. Fax: (415)869-1022. E-mail: dlinden@redw heelweiser.com. Web site: www.redwheelweiser.com. **Contact:** Donna Linden, creative director. Specializes in hardcover and paperback originals, reprints and trade publications: Red Wheel: spunky self-help; Weiser Books: metaphysics/oriental mind-body-spirit/esoterica; Conari Press: self-help/inspirational. Publishes 50 titles/year.

Needs Freelancers for jacket/cover design and illustration.

First Contact & Terms Designers: Send résumé, photocopies and tearsheets. Illustrators: Send photocopies, photographs, SASE and tearsheets. "We can use art or photos. I want to see samples I can keep." Samples are filed or are returned by SASE only if requested by artist. Responds only if interested. Originals are returned to artist at job's completion. To show portfolio, mail tearsheets, color photocopies or slides. Considers complexity of project, skill and experience of artist, project's budget, turnaround time and rights purchased when establishing payment. Buys one-time nonexclusive rights. Finds most artists through references/word of mouth, portfolio reviews and samples received through the mail.

Jackets/Covers Assigns 20 design jobs/year. Prefers a variety of media—depends entirely on project. Pays by the project, $100-500.

Tips "Send samples by mail, preferably in color. We work electronically and prefer digital artwork or scans. Do not send drawings of witches, goblins, and demons for Weiser Books; we don't put those kinds of images on our covers. Please take a moment to look at our books before submitting anything; we have characteristic looks for all three imprints."

REGNERY PUBLISHING INC.

One Massachusetts Ave. NW, Washington DC 20001. (202)216-0601. Fax: (202)216-0612. E-mail: editorial@reg nery.com. Web site: www.regnery.com. **Contact:** Art Director. Estab. 1947. Publishes hardcover originals and

reprints, trade paperback originals and reprints. Types of books include biography, history, nonfiction. Specializes in nonfiction. Publishes 30 titles/year. Recent titles include: *God, Guns and Rock & Roll*, by Ted Nugent. 20-50% requires freelance design. Book catalog available for SASE.

Needs Approached by 20 illustrators and 20 designers/year. Works with 6 designers/year. Prefers local illustrators and designers. Prefers freelancers experienced in Mac, QuarkXPress and Photoshop. 100% of freelance design demands knowledge of QuarkXPress. 50% of freelance illustration demands knowledge of Photoshop, QuarkXPress.

First Contact & Terms Send postcard sample and follow-up postcard every 6 months. Accepts Mac-compatible disk submissions. Send TIFF files. Samples are filed. Will contact artist for portfolio review if interested. Finds freelancers through *Workbook*, networking and submissions.

Book Design Assigns 5-10 freelance design jobs/year. Pays for design by the project; negotiable.

Jackets/Covers Assigns 5-10 freelance design and 1-5 illustration jobs/year. Pays by the project; negotiable.

Tips "We welcome designers with knowledge of Mac platforms . . . and the ability to design 'bestsellers' under extremely tight guidelines and deadlines!"

SCHOLASTIC INC.

557 Broadway, New York NY 10012. Web site: www.scholastic.com. **Creative Director:** David Saylor. Specializes in hardcover and paperback originals of childen's picture books, young adult, biography, classics, historical and contemporary teen. Publishes 750 titles/year. Recent titles include: *The Three Questions*; *When Marian Sang*. 80% require freelance illustration.

• David Saylor is in charge of all imprints, from mass market to high end. Publisher uses digital work only for mass market titles. All other imprints usually prefer traditional media such as watercolors and pastels.

Needs Approached by thousands of freelancers/year. Works with 75 freelance illustrators and 2 designers/year. Prefers local freelancers with experience. Also for jacket/cover illustration and design and book design. 40% of illustration demands knowledge of QuarkXPress, Illustrator, Photoshop.

First Contact & Terms Illustrators: Send postcard sample or tearsheets. Samples are filed or are returned only if requested, with SASE. Art Director will contact artist for portfolio review if interested. Considers complexity of project and skill and experience of artist when establishing payment. Originals are returned at job's completion. Finds artists through word of mouth, *American Showcase*, *RSVP* and Society of Illustrators.

Book Design Pays by the project, $2,000 and up.

Jackets/Covers Assigns 200 freelance illustration jobs/year. Pays by the project, $2,000-5,000.

Text Illustration Pays by the project, $1,500 minimum.

Tips "Illustrators should research the publisher. Go into a bookstore and look at the books. Gear what you send according to what you see is being used. It is particularly helpful when illustrators include on their postcard a checklist of phrases, such as 'Please keep mailing samples' or 'No, your work is not for us.' That way, we can prevent the artists who we don't want from wasting postage and we can encourage those we'd like to work with."

SCHOOL GUIDE PUBLICATIONS

210 North Ave., New Rochelle NY 10801. (800)433-7771. Fax: (914)632-3412. E-mail: info@schoolguides.com. Web site: www.schoolguides.com. **Art Director:** Melvin Harris. Assistant Art Director: Tory Ridder. Estab. 1935. Types of books include reference and educational directories. Specializes in college recruiting publications. Recent titles include *School Guide*; *Graduate School Guide*; *College Transfer Guide*; *Armed Services Veterans Education Guide*; *College Conference Manual*. 25% requires freelance illustration; 75% requires freelance design.

Needs Approached by 10 illustrators and 10 designers/year. Prefers local freelancers. Prefers freelancers experienced in book cover and brochure design. 100% of freelance design and illustration demands knowledge of Illustrator, Photoshop, QuarkXPress.

First Contact & Terms Send query letter with printed samples. Accepts Mac-compatible disk submissions. Send EPS files. Samples are filed. Responds only if interested. Will contact artist for portfolio review if interested. Rights purchased vary according to project. Finds freelancers through word of mouth.

Book Design Assigns 4 freelance design and 4 art direction projects/year.

Jackets/Covers Assigns 8 freelance design jobs/year.

Tips "We look for an artist/designer to create a consistent look for our publications and marketing brochures."

SIMON & SCHUSTER

Division of Viacom, 1230 Avenue of the Americas, New York NY 10020. (212)698-7000. Fax: (212)698-7336. E-mail: michael.accordino@simonandschuster.com. Web site: www.simonsays.com. **Art Director:** Michael Accordino. Imprints include Pocket Books and Archway. Company publishes hardcover, trade paperback and mass market paperback originals, reprints and textbooks. Types of books include juvenile, preschool, romance, self-help, young adult and many others. Specializes in young adult, romance and self-help. Publishes 125 titles/year. Recent titles include *Plan of Attack*, by Bob Woodward; *The Price of Loyalty*, by Ron Suskind. 95% require freelance illustration; 80% require freelance design.

Needs Works with 50 freelance illustrators and 5 designers/year. Prefers freelancers with experience working with models and taking direction well. Uses freelancers for hand lettering, jacket/cover illustration and design and book design. 100% of design and 75% of illustration demand knowledge of Illustrator and Photoshop. Works on assignment only.

First Contact & Terms Send query letter with tearsheets. Accepts disk submissions. Samples are filed and are not returned. Responds only if interested. Portfolios may be dropped off every Monday and Wednesday and should include tearsheets. Buys all rights. Originals are returned at job's completion.

Text Illustration Assigns 50 freelance illustration jobs/year.

SIMON & SCHUSTER CHILDREN'S PUBLISHING

1230 Avenue of the Americas, 4th Floor, New York NY 10020. (212)698-7000. Web site: www.simonsays.com. **Vice President/Creative Director:** Lee Wade. Imprints include Alladin, Atheneum, McElderry, Simon & Schuster Books for Young Readers, Simon Pulse, Simon Spotlight. Imprint publishes hardcover originals and reprints. Types of books include picture books, nonfiction and young adult. Publishes 500 titles/year. 100% require freelance illustration; 1% require freelance design.

• Simon & Schuster's Children's Publishing division has many different imprints, each with a unique specialty and its own art director. Imprints include Simon Spotlight (Chani Yammer), Simon Pulse (Russell Gordon), Books for Young Readers (Dan Potash), Alladin (Debbie Sfetsios) and McElderry (Ann Bobco).

Needs Approached by 200 freelancers/year. Works with 40 freelance illustrators and 2-3 designers/year. Uses freelancers mainly for jackets and picture books. 100% of design work demands knowledge of Illustrator, QuarkXPress and Photoshop. Works on assignment only.

First Contact & Terms Designers: Send query letter with résumé and photocopies. Illustrators: Send postcard sample or other nonreturnable samples. Accepts disk submissions. Art Director will contact artist for portfolio review if interested. Portfolio should include original art, photographs and transparencies. Originals are returned at job's completion. Finds artists through submissions, agents, scouting in nontraditional juvenile areas such as painters, editorial artists.

Jackets/Covers Assigns 20 freelance illustration jobs/year. Pays by the project, $800-2,500. "We use full range of media collage, photo, oil, watercolor, etc."

Text Illustration Assigns 30 freelance illustration jobs/year. Pays by the project.

STAR PUBLISHING

940 Emmett Ave., Belmont CA 94002. (650)591-3505. Fax: (650)591-3898. E-mail: mail@starpublishing.com. Web site: www.starpublishing.com. **Publisher:** Stuart Hoffman. Estab. 1978. Specializes in original paperbacks and textbooks on science, art, business. Publishes 12 titles/year. 33% require freelance illustration. Titles include: *Microbiology Techniques*; *Interpersonal Communication*; *Geology*.

▣ TECHNICAL ANALYSIS, INC.

4757 California Ave. SW, Seattle WA 98116-4499. (206)938-0570. Fax: (206)938-1307. Web site: www.traders.com. **Art Director:** Christine Morrison. Estab. 1982. Magazine, books and software producer. Publishes trade paperback reprints and magazines. Types of books include instruction, reference, self-help and financial. Specializes in stocks, options, futures and mutual funds. Publishes 3 titles/year. Recent titles include: *Charting the Stock Market*. Books look "technical, but creative; original graphics are used to illustrate the main ideas." 100% requires freelance illustration; 10% requires freelance design.

Needs Approached by 100 freelance artists/year. Works with 20 freelance illustrators/year. Buys 100 freelance illustrations/year. Uses freelance artists for magazine illustration. Also uses freelance artists for text illustration and direct mail design. Works on assignment only.

First Contact & Terms Send query letter with nonreturnable tearsheets, photographs or photocopies. Samples are filed. Will contact for possible assignment if interested. Buys first rights or reprint rights. Most originals are returned to artist at job's completion.

Book Design Assigns 5 freelance design, 100 freelance illustration jobs/year. Pays by project, $30-230.

Jackets/Covers Assigns 1 freelance design, 15 freelance illustration jobs/year. Pays by project $30-230.

Text Illustration Assigns 5 freelance design and 100 freelance illustration jobs/year. Pays by the hour, $50-90; by the project, $100-140.

TORAH AURA PRODUCTIONS/ALEF DESIGN GROUP

4423 Fruitland Ave., Los Angeles CA 90058. (323)585-7312. Fax: (323)585-0327. E-mail: misrad@torahaura.com. Web site: www.torahaura.com. **Art Director:** Jane Golub. Estab. 1981. Publishes hardcover and trade paperback originals, textbooks. Types of books include children's picture books, cookbooks, juvenile, nonfiction and young adult. Specializes in Judaica titles. Publishes 15 titles/year. Recent titles include: *S'fatai Tiftan (Open*

My Lips); *I Have Some Questions About God*. 85% requires freelance illustration. Book catalog free for 9×12 SAE with 10 first-class stamps.

Needs Approached by 50 illustrators and 20 designers/year. Works with 5 illustrators/year.

First Contact & Terms Illustrators: Send postcard sample and follow-up postcard every 6 months, printed samples, photocopies. Accepts Windows-compatible disk submissions. Samples are filed. Will contact artist for portfolio review if interested. Rights purchased vary according to project. Finds freelancers through submission packets.

Jackets/Covers Assigns 6-24 illustration jobs/year. Pays by the project.

TREEHAUS COMMUNICATIONS, INC.

906 W. Loveland Ave., P.O. Box 249, Loveland OH 45140. (513)683-5716. Fax: (513)683-2882. E-mail: treehaus1 @earthlink.net. Web site: www.treehaus1.com. **President:** Gerard Pottebaum. Estab. 1973. Publisher. Specializes in books, periodicals, texts, TV productions. Product specialties are social studies and religious education. Recent titles include: *The Stray*; *Rosanna The Rainbow Angel* for children ages 4-8.

Needs Approached by 12-24 freelancers/year. Works with 2 or 3 freelance illustrators/year. Prefers freelancers with experience in illustrations for children. Works on assignment only. Uses freelancers for all work. Also for illustrations and designs for books and periodicals. 5% of work is with print ads. Needs computer-literate freelancers for illustration.

First Contact & Terms Send query letter with résumé, transparencies, photocopies and SASE. Samples sometimes filed or are returned by SASE if requested by artist. Responds in 1 month. Art director will contact artist for portfolio review if interested. Portfolio should include final art, tearsheets, slides, photostats and transparencies. Pays for design and illustration by the project. Rights purchased vary according to project. Finds artists through word of mouth, submissions and other publisher's materials.

Tips "We are looking for original style that is developed and refined. Whimsy helps."

TRIUMPH BOOKS

542 S. Dearborn St., Suite 750, Chicago IL 60605. (312)939-3330. Fax: (312)663-3557. Estab. 1990. Publishes hardcover originals and reprints, trade paperback originals and reprints. Types of books include biography, coffee table books, humor, instructional, reference, sports. Specializes in sports titles. Publishes 50 titles/year. 5% requires freelance illustration; 60% requires freelance design. Book catalog free for SAE with 2 first-class stamps.

Needs Approached by 5 illustrators and 5 designers/year. Works with 2 illustrators and 8 designers/year. Prefers freelancers experienced in book design. 100% of freelance design demands knowledge of Photoshop, InDesign, Illustrator, QuarkXPress.

First Contact & Terms Send query letter with printed samples, SASE. Accepts Mac-compatible disk submissions. Send TIFF files. Samples are filed or returned by SASE. Will contact artist for portfolio review if interested. Buys all rights. Finds freelancers through word of mouth, organizations (Chicago Women in Publishing), submission packets.

Book Design Assigns 20 freelance design jobs/year. Pays for design by the project.

Jackets/Covers Assigns 30 freelance design and 2 illustration jobs/year. Pays for design by the project. Prefers simple, easy-to-read, in-your-face cover treatment.

Tips "Most of our interior design requires a fast turnaround. We do mostly one-color work with occasional two-color and four-color jobs. We like a simple, professional design."

TYNDALE HOUSE PUBLISHERS, INC.

351 Executive Dr., Carol Stream IL 60188. (630)668-8300. E-mail: talindaiverson@tyndale.com. Web site: www. tyndale.com. **Art Buyer:** Talinda Iverson. Specializes in hardcover and paperback originals as well as children's books on "Christian beliefs and their effect on everyday life." Publishes 150 titles/year. 20% require freelance illustration. Books have "high quality innovative design and illustration." Recent titles include: *The Warrior—Sons of Encouragement*; and *Zion Covenant Series*.

Needs Approached by 200-250 freelance artists/year. Works with 5-10 illustrators.

First Contact & Terms Send query letter and tearsheets. Samples are filed or are returned by SASE. Responds only if interested. Considers complexity of project, skill and experience of artist, project's budget and rights purchased when establishing payment. Negotiates rights purchased. Originals are returned at job's completion except for series logos.

Jackets/Covers Assigns 5-10 illustration jobs/year. Prefers progressive but friendly style. Pays by the project.

Text Illustration Assigns 1-5 jobs/year. Prefers progressive but friendly style. Pays by the project.

Tips "Only show your best work. We are looking for illustrators who can tell a story with their work and who can draw the human figure in action when appropriate."

THE UNIVERSITY OF ALABAMA PRESS

P.O. Box 870380, Tuscaloosa AL 35487-0380. (205)348-5180 or (205)348-1571. Fax: (205)348-9201. E-mail: rcook@uapress.ua.edu. Web site: www.uapress.ua.edu. **Production Manager:** Rick Cook. Designer: Michele Myatt Quinn. Specializes in hardcover and paperback originals and reprints of academic titles. Publishes 60-70 titles/year. Recent titles include: *Satchel Paige's America*, by William Price Fox; *Alabama Folk Pottery*, by Brackner; *Spaces of Violence*, by Giles; and *Split-Gut Song*, by Karen Jackson Ford. 35% requires freelance design.

Needs Works with 5-6 freelancers/year. Requires book design experience, preferably with university press work. Works on assignment only. 100% of freelance design demands knowledge of PageMaker 6.5, Photoshop, QuarkXPress, InDesign.

First Contact & Terms Send query letter with résumé, tearsheets and slides. Accepts disk submissions if compatible with Macintosh versions of above programs, provided that a hard copy that is color accurate is also included. Samples not filed are returned only if requested. Responds in a few days. To show portfolio, mail tearsheets, final reproduction/product and slides. Considers project's budget when establishing payment. Buys all rights. Originals are not returned.

Book Design Assigns 4-5 freelance jobs/year. Pays by the project, $600 minimum.

Jackets/Covers Assigns about 50 freelance design jobs/year. Pays by the project, $600 minimum.

Tips Has a limited freelance budget. "We often need artwork that is abstract or vague rather than very pointed or focused on an obvious idea. For book design, our requirements are that they be classy."

THE UNIVERSITY OF NEBRASKA PRESS

1111 Lincoln Mall, Lincoln NE 68588-0630. (402)472-3581. Fax: (402)472-0308. Web site: www.unp.unl.edu. **Production Manager:** Alison Rold. Estab. 1941. Publishes hardcover originals and trade paperback originals and reprints. Types of books include history, translations. Specializes in Western history, American Indian ethnohistory, Judaica, nature, Civil War, sports history, women's studies. Publishes 180 titles/year. Recent titles include: *A World of Light*, by Floyd Skloot; *Algonquian Spirit*, by Bryan Swann. 5-10% require freelance illustration; 10% require freelance design. Book catalog free by request and available online.

Needs Approached by 10 freelancers/year. Works with 2-3 freelance illustrators/year. Prefers freelancers experienced in 4-color, action in Civil War, basketball or Western topics. "We must use Native American artists for books on that subject." Uses freelancers for jacket/cover illustration. Works on assignment only.

First Contact & Terms Send query letter with photocopies. Samples are filed. Responds to the artist only if interested. Buys one-time rights. Originals are returned at job's completion.

Jackets/Covers Assigns 2-3 illustration jobs/year. Usually prefers realistic, western, action styles. Pays by the project, $200-500.

UNIVERSITY OF OKLAHOMA PRESS

2800 Venture Dr., Norman OK 73069. (405)325-2000. Fax: (405)325-4000. E-mail: tonyroberts@ou.edu. Web site: www.oupress.com. **Art Director:** Tony Roberts. Estab. 1927. Company publishes hardcover and trade paperback originals, reprints and textbooks. Types of books include biography, coffee table books, history, nonfiction, reference, textbooks, western. Specializes in western/Indian nonfiction. Publishes 100 titles/year. 5% requires freelance design. Book catalog free by request.

Needs Approached by 50-100 freelancers/year. Works with 40-50 freelance illustrators and 10-15 designers/year. "We cannot commission work, must find existing art." Uses freelancers mainly for jacket/cover illustrations. Also for book design. 25% of freelance work demands knowledge of Illustrator, QuarkXPress, Photoshop, FreeHand, and InDesign.

First Contact & Terms Send query letter with brochure, résumé and photocopies. Samples are filed. Does not reply. Design Manager will contact artist for portfolio review if interested. Portfolio should include book dummy and photostats. Buys reprint rights. Originals are returned at job's completion. Finds artists through submissions, attending exhibits, art shows and word of mouth.

Book Design Assigns 5-10 freelance design jobs/year. Pays by the project.

UNIVERSITY OF PENNSYLVANIA PRESS

3905 Spruce St., Philadelphia PA 19104-4112. (215)898-6261. Fax: (215)898-0404. E-mail: wmj@pobox.upenn.edu. Web site: www.upenn.edu/pennpress/. **Design Director:** John Hubbard. Estab. 1920. Publishes hardcover originals. Types of books include biography, history, nonfiction, landscape architecture, art history, anthropology, literature and regional history. Publishes 80 titles/year. Recent titles include: *The Man Who Had Been King*. 10% requires freelance design.

Needs Works with 4 designers/year. 100% of freelance work demands knowledge of Illustrator, Photoshop and QuarkXPress.

First Contact & Terms Designers: Send query letter with photocopies. Illustrators: Send postcard sample.

Accepts Mac-compatible disk submissions. Samples are not filed or returned. Will contact artist for portfolio review if interested. Portfolio should include book dummy and photocopies. Rights purchased vary according to project. Finds freelancers through submission packets and word of mouth.

Book Design Assigns 2 freelance design jobs/year. Pays by the project, $600-1,000.

Jackets/Covers Assigns 6 freelance design jobs/year. Pays by the project, $600-1,000.

W PUBLISHING GROUP

A Division of Thomas Nelson Inc., P.O. Box 14100, Nashville TN 37214-1000. (615)889-9000. Fax: (615)902-2112. E-mail: gmaclachlan@thomasnelson.com. Web site: www.wpublishinggroup.com. **Packaging Manager:** Greg MacLachlan. Estab. 1951. Imprints include Word Bibles. Company publishes hardcover, trade paperback and mass market paperback originals and reprints; audio and video. Types of books include biography, fiction, nonfiction, religious, self-help and sports biography. "All books have a strong Christian content—including fiction." Publishes 50 titles/year. Recent titles include: *Stories of the Heart and Home*, by James Dobson; *He Chose the Nails*, by Max Lucado; *The Wounded Spirit*, by Frank Peretti. 30-35% require freelance illustration; 100% require freelance design.

Needs Approached by 700 freelancers/year. Works with 20 freelance illustrators and 30 designers/year. Buys 20-30 freelance illustrations/year. Uses freelancers mainly for book cover and packaging design. Also for jacket/cover illustration and design and text illustration. 100% of design and 10% of illustration demand knowledge of Illustrator, QuarkXPress and Photoshop. Works on assignment only.

First Contact & Terms Prefer e-mail with link to Web site. Send query letter with SASE, tearsheets, photographs, photocopies, photostats, "whatever shows artist's work best." Accepts disk submissions, but not preferred. Samples are returned by SASE. Art director will contact artist for portfolio review if interested. Portfolio should include tearsheets and transparencies. Purchases all rights. Originals are returned at job's completion. Finds artists through agents, *Creative Illustration Book, American Showcase, Workbook, Directory of Illustration.*

Jacket/Covers Assigns 65 freelance design and 20-30 freelance illustration jobs/year. Pays by the project $2,000-5,000. Considers all mediaoil, acrylic, pastel, watercolor, mixed.

Text Illustration Assigns 10 freelance illustration jobs/year. Pays by the project $75-250. Prefers line art.

Tips "Please do not phone. I'll choose artists who work with me easily and accept direction and changes gracefully. Meeting deadlines is also extremely important. I regret to say that we are not a good place for newcomers to start. Experience and success in jacket design is a must for our needs and expectations. I hate that. How does a newcomer start? Probably with smaller companies. Beauty is still a factor with us. Our books must not only have shelf-appeal in bookstores, but coffee-table appeal in homes."

WARNER BOOKS INC.

Imprint of AOL Time Warner Book Group, 1271 Avenue of the Americas, 9th Floor, New York NY 10020. (212)522-7200. Web site: www.twbookmark.com. **Vice President and Creative Director:** Anne Twomey. Publishes mass market paperbacks and adult trade hardcovers and paperbacks. Publishes 300 titles/year. Recent titles include: *Find Me*, by Rosie O'Donnell; *The Millionaires*, by Brad Meltzer; *Cancer Schmancer*, by Fran Drescher. 20% requires freelance design; 80% requires freelance illustration.

• Others in the department are Diane Luger and Flamur Tonuzi. Send them mailers for their files as well.

Needs Approached by 500 freelancers/year. Works with 75 freelance illustrators and photographers/year. Uses freelancers mainly for illustration and handlettering. Works on assignment only.

First Contact & Terms Do not call for appointment or portfolio review. Mail samples only. Send nonreturnable brochure or tearsheets and photocopies. Samples are filed. Art Director will contact artist for portfolio review if interested. Negotiates rights purchased. Considers buying second rights (reprint rights) to previously published work. Originals are returned at job's completion (artist must pick up). "Check for most recent titles in bookstores." Finds artists through books, mailers, parties, lectures, judging and colleagues.

Jackets/Covers Pays for design and illustration by the project. Uses all styles of jacket illustrations.

Tips Industry trends include "graphic photography and stylized art." Looks for "photorealistic style with imaginative and original design and use of eye-catching color variations. Artists shouldn't talk too much. Good design and art should speak for themselves."

WATERBROOK PRESS

Random House, 12265 Oracle Blvd., Suite 200, Colorado Springs CO 80921. (719)590-4999. Fax: (719)590-8977. E-mail: info@waterbrookpress.com. Web site: www.waterbrookpress.com. **Contact:** Mark Ford, art director. Estab. 1997. Publishes audio tapes, hardcover, mass market paperback and trade paperback originals. Types of books include romance, science fiction, western, young adult fiction; biography, coffee table books, religious, self-help nonfiction. Specializes in Christian titles. Publishes 60 titles/year. Recent titles include *Consider Lily, The Butterfly Farm*. 30% requires freelance design; 10% requires freelance illustration. Book catalog free on request.

Needs Approached by 10 designers and 100 illustrators/year. Works with 4 designers and 2 illustrators/year. 90% of freelance design work demands knowledge of Illustrator, QuarkXPress and Photoshop.

First Contact & Terms Designer/Illustrators: Send postcard sample with brochure, tearsheets. After introductory mailing, send follow-up postcard sample every 3 months. Samples are filed and not returned. Portfolio not required. Buys one-time rights, first North American serial rights. Finds freelancers through artist's submissions, Internet.

Jackets/Covers Assigns 2 freelance cover illustration jobs/year. Pays for illustration by the project $600-1,000.

Text Illustration Assigns 4 freelance illustration jobs/year. Pays by the project $200-3,000.

☒ WEIGL EDUCATIONAL PUBLISHERS LIMITED.

6325 Tenth St. SE, Calgary AB T2H 2Z9 Canada. (403)233-7747. Fax: (403)233-7769. E-mail: info@weigl.com. Web site: www.weigl.com. **Contact:** Managing Editor. Estab. 1979. Textbook and library series publisher catering to juvenile and young adult audience. Specializes in social studies, science-environmental, life skills, multi-cultural American and Canadian focus. Publishes over 100 titles/year. Titles include: *The Love of Sports*; *A Guide to American States*; *20th Century USA*. Book catalog free by request.

Needs Approached by 300 freelancers/year. Uses freelancers only during peak periods. Prefers freelancers with experience in children's text illustration in line art/watercolor. Uses freelancers mainly for text illustration or design. Also for direct mail design. Freelancers should be familiar with QuarkXPress 5.0, Illustrator 10.0 and Photoshop 7.0.

First Contact & Terms Send résumé for initial review prior to selection for interview. Limited freelance opportunities. Graphic designers required on site. Extremely limited need for illustrators. Samples are returned by SASE if requested by artist. Responds to the artist only if interested. Write for appointment to show portfolio of original/final art (small), b&w photostats, tearsheets and photographs. Rights purchased vary according to project.

Text Illustration Pays on project basis, depending on job. Prefers line art and watercolor appropriate for elementary and secondary school students.

WHALESBACK BOOKS

P.O. Box 9546, Washington DC 20016. (202)333-2182. Fax: (202)333-2184. E-mail: hhi@ix.netcom.com. **Publisher:** W. D. Howells. Estab. 1988. Imprint of Howells House. Company publishes hardcover and trade paperback originals and reprints. Types of books include biography, history, art, architecture, social and human sciences. Publishes 4 print, 2 online titles/year. 80% require freelance illustration; 80% require freelance design.

Needs Approached by 6-8 freelance artists/year. Works with 1-2 freelance illustrators and 1-3 freelance designers/year. Buys 10-20 freelance illustrations/job. Prefers local artists with experience in color and desktop. Uses freelance artists mainly for illustration and book/jacket designs. Also uses freelance artists for jacket/cover illustration and design; text, direct mail, book and catalog design. 20-40% of freelance work demands knowledge of PageMaker, Illustrator or QuarkXPress. Works on assignment only.

First Contact & Terms Send query letter with brochure, SASE and photocopies. Samples are not filed and are returned by SASE if requested by artist. Responds only if interested. Art Director will contact artist for portfolio review if interested. Portfolio should include b&w roughs and photostats. Rights purchased vary according to project.

Book Design Assigns 2-4 freelance design jobs/year. Pays by the project.

Jackets/Covers Assigns 2-4 freelance design jobs/year. Pays by the project.

Text Illustration Assigns 6-8 freelance illustration jobs/year. Pays by the project.

WHITE MANE PUBLISHING COMPANY, INC.

73 W. Burd St., P.O. Box 708, Shippensburg PA 17257. (717)532-2237. Fax: (717)532-6110. Web site: www.whitemane.com. **Vice President:** Harold Collier. Estab. 1987. Publishes hardcover originals and reprints, trade paperback originals and reprints. Types of books include biography, history, juvenile, nonfiction, religious, self-help and young adult. Publishes 70 titles/year. 10% requires freelance illustration. Book catalog free with SASE.

Needs Works with 2-3 illustrators and 2 designers/year.

First Contact & Terms Illustrators/Designers: send query letter with printed samples. Samples are filed. Interested only in historic artwork. Responds only if interested. Will contact artist for portfolio review if interested. Rights purchased vary according to project. Finds freelancers through submission packets and postcards.

Jackets/Covers Assigns 8 illustration jobs/year. Pays for design by the project.

Tips Uses art for covers only—primarily historical scenes.

ALBERT WHITMAN & COMPANY

6340 Oakton, Morton Grove IL 60053-2723. (847)581-0033. Fax: (847)581-0039. E-mail: mail@awhitmanco.com. Web site: www.albertwhitman.com. **Art Director:** Carol Gildar. Specializes in hardcover original juvenile

fiction and nonfiction—many picture books for young children. Publishes 35 titles/year. Recent titles include: *Mabella the Clever*, by Margaret Read MacDonal; *Bravery Soup*, by Maryann Cocca-Leffle. 100% requires freelance illustration. Books need "a young look—we market to preschoolers and children in grades 1-3."

Needs Prefers working with artists who have experience illustrating juvenile trade books. Works on assignment only.

First Contact & Terms Illustrators: Send postcard sample and tearsheets. "One sample is not enough. We need at least three. Do *not* send original art through the mail." Accepts disk submissions. Samples are not returned. Responds "if we have a project that seems right for the artist. We like to see evidence that an artist can show the same children and adults in a variety of moods, poses and environments." Rights purchased vary. Original work returned at job's completion.

Cover/Text Illustration Cover assignment is usually part of text illustration assignment. Assigns 2-3 covers per year. Prefers realistic and semi-realistic art. Pays by flat fee for covers; royalties for picture books.

Tips Especially looks for "an artist's ability to draw people, especially children and the ability to set an appropriate mood for the story. Please do NOT submit cartoon art samples or flat digital illustrations."

WILLIAMSON BOOKS

P.O. Box 185, Charlotte VT 05445. E-mail: susan@kidsbks.net. Web site: www.idealspublications.com/williamsonbooks.htm. **Editorial Director:** Susan Williamson. Estab. 1983. Publishes trade paperback originals/casebound. Types of books include children's nonfiction (science, history, the arts), creative play, early learning, preschool and educational. Specializes in children's active hands-on learning. Publishes 8 titles/year. Recent titles include: *Creating Clever Castle & Cars (from Boxes & Other Stuff)*, by Mari Mitchell; *Using Color in Your Art*, by Sandy Henry; and *Animal Habitats*, by Judy Press. Book catalog free for 8½×11 SASE with 6 first-class stamps.

• This publisher is an imprint of Ideals Publications, a division of Guideposts.

Needs Approached by 100 illustrators and 10 designers/year. Works with 7 illustrators and 6 designers/year. 100% of freelance design demands Quark computer skills. "We especially need illustrators whose art communicates with kids and has a vibrant style, as well as a sense of humor and quirky characterizations evident in illustrations. We are not looking for traditional or picture book styles." All illustrations must be provided in scanned, electronic form.

First Contact & Terms "Please do not e-mail large files to us. We prefer receiving postcards with references to your Web sites. We really will look if we are interested." Designers: Send query letter with with Web site or brochure, photocopies, résumé, SASE. Illustrators: Send postcard sample and/or query letter with Web site or photocopies, résumé and SASE. Samples are filed. Responds only if interested.

Book Design Pays for design by the project.

Tips "We are actively seeking freelance illustrators and book designers to support our growing team. We are looking for full color distinctive illustration, along with an "energized" view of how-to-do-it illustrations (always drawn with personality as opposed to technical drawings). Go to the library and look up several of our books in our four series. You'll immediately see what we're all about. Then do a few samples for us. If we're excited about your work, you'll definitely hear from us. We always need designers who are interested in a nontraditional approach to kids' book design. Our books are award-winners, and design and illustration are key elements to our books' phenomenal success."

WILSHIRE BOOK CO.

9731 Variel Avenue, Chatsworth CA 91311. E-mail: mpowers@mpowers.com. Web site: www.mpowers.com. **President:** Melvin Powers. Company publishes trade paperback originals and reprints. Types of books include Internet marketing, humor, instructional, New Age, psychology, self-help, inspirational and other types of nonfiction. Publishes 25 titles/year. Titles include: *Think Like a Winner!*; *The Dragon Slayer with a Heavy Heart*; *The Knight in Rusty Armor*. 100% require freelance design. Catalog for SASE with first-class stamps.

Needs Uses freelancers mainly for book covers.

First Contact & Terms Send query letter with fee schedule, tearsheets, photostats, photocopies (copies of previous book covers). Portfolio may be dropped off every Monday-Friday. Portfolio should include book dummy, slides, tearsheets, transparencies.

Book Design Assigns 25 freelance design jobs/year.

Jackets/Covers Assigns 25 cover jobs/year.

Galleries

Most artists dream of seeing their work in a gallery. It's the equivalent of "making it" in the art world. That dream can be closer than you realize. The majority of galleries are actually quite approachable and open to new artists. Though there will always be a few austere establishments manned by snooty clerks, most are friendly places where people come to browse and chat with the gallery staff.

So don't let galleries intimidate you. The majority of galleries will be happy to take a look at your slides if you make an appointment or mail your slides to them. If they feel your artwork doesn't fit their gallery, most will steer you toward a more appropriate one.

A few guidelines

- **Never walk into a gallery without an appointment,** expecting to show your work to the gallery director. When we ask gallery directors for pet peeves they always discuss the talented newcomer walking into the gallery with paintings in hand. Send a polished package of about eight to 12 neatly labeled, mounted duplicate slides of your work submitted in plastic slide sheet format. (Refer to the listings for more specific information on each gallery's preferred submission method.) Do not send original slides, as you will need them to reproduce later. Send a SASE, but realize you may not get your packet returned.
- **Seek out galleries that show the type of work you create.** Each gallery has a specific "slant" or mission.
- **Visit as many galleries as you can.** Browse for a while and see what type of work they sell. Do you like the work? Is it similar to yours in quality and style? What about the staff? Are they friendly and professional? Do they seem to know about the artists the gallery handles? Do they have convenient hours? If you are interested in galleries outside your city and you can't manage a personal visit before you submit, read the listing carefully to make sure you understand what type of work is shown in that gallery and get a feel for what the space is like. Ask a friend or relative who lives in that city to check out the gallery for you.
- **Attend openings.** You'll have a chance to network and observe how the best galleries promote their artists. Sign each gallery's guest book or ask to be placed on galleries' mailing lists. That's also one good way to make sure the gallery sends out professional mailings to prospective collectors.

Showing in multiple galleries

Most successful artists show in several galleries. Once you have achieved representation on a local level, you are ready to broaden your scope by querying galleries in other cities. You

Types of Galleries

As you search for the perfect gallery, it's important to understand the different types of spaces and how they operate. The route you choose depends on your needs, the type of work you do, your long term goals and the audience you're trying to reach.

Retail or commercial galleries. The goal of the retail gallery is to sell and promote artists while turning a profit. Retail galleries take a commission of 40 to 50 percent of all sales.

Co-op galleries. Co-ops exist to sell and promote artists' work, but they are run by artists. Members exhibit their own work in exchange for a fee, which covers the gallery's overhead. Some co-ops also take a small commission of 20 to 30 percent to cover expenses. Members share the responsibilities of gallery-sitting, sales, housekeeping and maintenance.

Rental galleries. The gallery makes its profit primarily through renting space to artists and consequently may not take a commission on sales (or will take only a very small commission). Some rental spaces provide publicity for artists, while others do not. Showing in this type of gallery is risky. Rental galleries are sometimes thought of as "vanity galleries" and, consequently, they do not have the credibility other galleries enjoy.

Nonprofit galleries. Nonprofit spaces will provide you with an opportunity to sell work and gain publicity but will not market your work aggressively, because their goals are not necessarily sales-oriented. Nonprofits normally take a small commission of 20 to 30 percent.

Museums. Though major museums generally show work by established artists, many small museums are open to emerging artists.

Art consultancies. Generally, art consultants act as liaisons between fine artists and buyers. Most take a commission on sales (as would a gallery). Some maintain small gallery spaces and show work to clients by appointment.

may decide to concentrate on galleries in surrounding states, becoming a "regional" artist. Some artists like to have an East Coast and a West Coast gallery.

If you plan to sell work from your studio, or from a Web site or other galleries, be up front with your gallery. Work out a commission arrangement you can all live with, and everybody wins.

Pricing your fine art

A common question of beginning artists is "What do I charge for my paintings?" There are no hard and fast rules. The better known you become, the more collectors will pay for your work. Though you should never underprice your work, you must take into consideration what people are willing to pay. Also keep in mind that you must charge the same amount for a painting sold in a gallery as you would for work sold from your studio.

Juried shows, competitions and other outlets

It may take months, maybe years, before you find a gallery to represent you. But don't worry; there are plenty of other venues to show in until you are accepted in a commercial gallery.

If you get involved with your local art community, attend openings and read the arts section of your local paper, you'll see there are hundreds of opportunities.

Enter group shows and competitions every chance you get. Go to the art department of your local library and check out the bulletin board, then ask the librarian to steer you to magazines like *Art Calendar* (www.artcalendar.com) that list "calls to artists" and other opportunities to exhibit your work. Subscribe to the *Art Deadlines List*, available in hard copy or online versions (www.artdeadlineslist.com). Join a co-op gallery and show your work in a space run by artists for artists.

Another opportunity to show your work is through local restaurants and retail shops that show the work of local artists. Ask the manager how you can show your work. Become an active member in an arts group. It's important to get to know your fellow artists. And since art groups often mount exhibitions of their members' work, you'll have a way to show your work until you find a gallery to represent you.

Helpful Resources

For More Info

To develop a sense of the various genres and how to approach them, look to the myriad art publications that contain reviews and articles:

- *Art in America* (www.artinamericamagazine.com)
- *ARTnews* (www.artnews.com)
- *Art New England* (www.artnewengland.com)
- *ARTweek* (West Coast; www.artweek.com)
- *Southwest Art* (www.southwestart.com)

Also look for lists of galleries and helpful information about dealing with galleries in the following publications:

- *Art in America*'s Guide to Galleries (www.artinamericamagazine.com)
- *Art Now* Galleries Guide (available on www.amazon.com)
- *The Artist's Magazine* (www.artistsmagazine.com)
- *Art Papers* (www.artpapers.org)
- *Art Calendar* (www.artcalendar.com)

ALABAMA

THE ATCHISON GALLERY
2847 Culver Rd., Birmingham AL 35223. (205)871-6233. **Director:** Larry Atchison. Retail gallery and art consultancy. Estab. 1974. Represents 35 emerging, mid-career and a few established artists/year. Exhibited artists include Bruno Zupan and Cynthia Knapp. Sponsors 12 shows/year. Average display time 1 month. Open all year; Monday-Friday, 9:30-5; Saturday, 10-2. Located in the Mountain Brook Village; 2,000 sq. ft.; open ceiling, large open spaces. 25-30% of space for special exhibitions; 75% of space for gallery artists. Clientele: upscale, residential and corporate. 70-75% private collectors, 25-30% corporate collectors. Overall price range $600-15,000; most work sold at $1,800-3,500 (except for exclusive pieces, Dine's, Warhols, etc.).
Media Considers all media except fiber, paper and pen & ink. Considers engravings, lithographs and etchings. Most frequently exhibits oil-acrylic, mixed media and pastel.
Style Exhibits expressionism, painterly abstraction, minimalism, impressionism, photorealism and realism. Genres include florals, landscapes and figurative work. Prefers painterly abstraction, impressionism and realism/figurative.
Terms Accepts work on consignment (50% commission). Retail price set by both the gallery and artist. Gallery provides insurance, promotion and contract; shipping costs are shared. Prefers artwork unframed.
Submissions Most artists are full-time professionals. Send query letter with résumé, bio and artist's statement with slides, brochure, photographs and/or reviews. Write for appointment to show portfolio of photographs, slides and transparencies. Responds in 1 month. Files résumé, slides, bio, photographs, artist statement and brochure. Finds artists through referrals by other artists, submissions, visiting exhibits, reviewing art journals/magazines.

CORPORATE ART SOURCE
2960-F Zelda Rd., Montgomery AL 36106. (334)271-3772. E-mail: casjb@mindspring.com. Web site: casgallery.com. For-profit gallery, art consultancy. Estab. 1985. Exhibits mid-career and established artists. Approached by 40 artists/year; exhibits 50 artists/year. Exhibited artists include George Taylor and Lawrence Mathis. Open Monday-Friday, 10-5:30; closed weekends. Located in an upscale shoppin center, small gallery walls but walls are filled, 50-85 pieces on display. Clients include corporate clients. Overall price range $200-40,000. Most work sold at $1,000.
Media Considers all media and all types of prints. Most frequently exhibited paintings, glass and watercolor.
Style Considers all styles and genres. Most frequently exhibits painterly abstraction, impressionism and realism.
Terms Artwork is accepted on consignment (50% commission). Retail price set by artist.
Submissions Call, e-mail, or write to arrange personal interview to show portfolio of photographs, slides, transparencies or CD, résumés, and reviews with SASE. Returns material with SASE.
Tips "Good photos of work, web sites with enough work to get a feel for the overall depth and quality."

EASTERN SHORE ART CENTER
401 Oak St., Fairhope AL 36532. (251)928-2228. E-mail: esac@mindspring.com. **Executive Director:** Robin Fitzhugh. Museum. Estab. 1957. Exhibits emerging, mid-career and established artists. Average display time 1 month. Open all year. Located downtown; 8,000 sq. ft. of galleries.
 • Artists applying to Eastern Shore should expect to wait at least a year for exhibits.
Media Considers all media and prints.
Style Exhibits all styles and genres.
Terms Accepts works on consignment (25% commission). Retail price set by artist. Gallery provides insurance, promotion and contract. Prefers artwork framed.
Submissions Send query letter with résumé and slides. Write for appointment to show portfolio of originals and slides.
Tips "Conservative, realistic art is appreciated more and sells better."

FAYETTE ART MUSEUM
530 N. Temple Ave., Fayette AL 35555. (205)932-8727. Fax: (205)932-8788. E-mail: fccfam@cyberjoes.com. **Director:** Jack Black. Museum. Estab. 1969. Exhibits the work of emerging, mid-career and established artists. Open all year; Monday-Friday, 9-4 and by appointment outside regular hours. Located downtown Fayette Civic Center; 16,500 sq. ft. Six galleries devoted to folk art.
Media Considers all media and all types of prints. Most frequently exhibits oil, watercolor and mixed media.
Style Exhibits expressionism, primitivism, painterly abstraction, minimalism, postmodern works, impressionism, realism and hard-edge geometric abstraction. Genres include landscapes, florals, Americana, wildlife, portraits and figurative work.
Terms Shipping costs negotiable. Prefers artwork framed.

Submissions Send query letter with résumé, brochure and photographs. Write for appointment to show portfolio of photographs. Files possible exhibit material.

Tips "Do not send expensive mailings (slides, etc.) before calling to find out if we are interested. We want to expand collection. Top priority is folk art from established artists."

GALLERY 54, INC.

54 Upham, Mobile AL 36607. (251)473-7995. E-mail: gallery54art1@aol.com. **Owner:** Leila Hollowell. Retail gallery. Estab. 1992. Represents 35 established artists/year. May be interested in seeing the work of emerging artists in the future. Exhibited artists inlcude Charles Smith and Lee Hoffman. Sponsors 5 shows/year. Average display time 1 month. Open all year; Tuesday-Saturday, 11-4:30. Located in midtown, about 560 sq. ft. Clientele local. 70% private collectors, 30% corporate collectors. Overall price range $20-6,000; most work sold at $200-1,500.

Media Considers oil, acrylic, watercolor, pastel, pen & ink, drawing, mixed media, collage, sculpture, ceramics, glass, photography, woodcuts, serigraphs and etchings. Most frequently exhibits acrylic/abstracts, watercolor and pottery.

Style Exhibits expressionism, painterly abstraction, impressionism and realism. Prefers realism, abstract and impressionism.

Terms Accepts work on consignment (40% commission) or buys outright for 50% of retail price (net 30 days). Retail price set by the artist. Gallery provides contract. Artist pays shipping costs. Prefers artwork framed.

Submissions Southern artists preferred (mostly Mobile area). It's easier to work with artist's work on consignment. Send query letter with slides and photographs. Write for appointment to show portfolio of photographs and slides. Responds in 2 weeks. Files information on artist. Finds artists through art fairs, referrals by other artists and information in mail.

Tips "Don't show up with work without calling and making an appointment."

THE KENTUCK ART CENTER

503 Main Ave., Northport AL 35476-4483. (205)758-1257. Fax: (205)758-1258. E-mail: Kentuck@dbtech.net. Web site: www.kentuck.org. **Executive Director:** Sara Anne Gibson. Nonprofit gallery. Estab. 1980. Exhibits emerging artists. Approached by 400 artists/year. Represents 100 artists/year. Sponsors 18 exhibits/year. Average display time 1 month. Open all year; Monday-Friday, 9-5; weekends 10-4:30. Closed major holidays. Clients include local community. 5% of sales are to corporate collectors. Overall price range $150-10,000; most work sold at $400.

Media Considers all media. Most frequently exhibits mixed media, oil and pastel. Considers all types of prints except posters.

Style Exhibits Considers all styles. Most frequently exhibits painterly abstraction, expressionism, conceptualalism.

Terms Artwork is accepted on consignment and there is a 40% commission. Artwork is bought outright for 50% of retail price; net 30 days. Retail price set by the artist. Gallery provides insurance, promotion and contract. Accepted work should be mounted. Requires exclusive representation locally.

Submissions Write to arrange a personal interview to show portfolio of slides. Mail portfolio for review. Returns material with SASE. Responds in 6 months. Finds artists through word of mouth, submissions, portfolio reviews, art exhibits and referrals by other artists.

Tips "Submit professional slides."

MAYOR'S OFFICE FOLK ART GALLERY

5735 Hwy. 431, P.O. Box 128, Pittsview AL 36871. (334)855-3568. E-mail: www.mayorsoffice@webtv.net. Web site: folkartisans.com/mayorsoffice. **Owner:** Frank Turner. Wholesale gallery. Estab. 1994. Represents 5-6 emerging, mid-career and established artists/year. Exhibited artists include Buddy Snipes, Butch Anthony, John Henry Toney, Ned Berry and Rocky Wade. Average display time 6 months. Open all year; by chance or appointment. Located in rural community on main highway; 800-1,000 sq. ft.; folk/outsider art only. 75% of space for gallery artists. Clientele tourists, upscale collectors, dealers. 50% private collectors (wholesale). Overall price range $60-1,000; most work sold at $60-150.

Media Considers oil, acrylic, watercolor, pastel, pen & ink, drawing, mixed media, collage, paper, sculpture, fiber and glass; considers all types of prints. Most frequently exhibits oil, house paint and wood.

Style Exhibits expressionism and primitivism. (It's folk art—you name it and they do it.)

Terms Buys outright. Retail price set by the gallery and the artist. Gallery provides promotion; shipping costs are shared.

Submissions Accepts only artists from east Alabama and west Georgia. Prefers folk/outsider only—must be "unique and true." Call to show portfolio of photographs and original art. Finds artists through word of mouth, referrals by other artists and submissions.

Tips "No craft items. Art must be truestraight from the heart and mind of the artist."

MOBILE MUSEUM OF ART

4850 Museum Dr., Mobile AL 36608-1917. (251)208-5200. E-mail: prichelson@mobilemuseumofart.com. Web site: www.MobileMuseumOfArt.com. **Director:** Tommy McPherson. Clientele tourists and general public. Sponsors 6 solo and 12 group shows/year. Average display time 6-8 weeks. Interested in emerging, mid-career and established artists. Overall price range $100-5,000; most artwork sold at $100-500.

Media Considers all media and all types of visual art.

Style Exhibits all styles and genres. "We are a general fine arts museum seeking a variety of styles, media and time periods." Looking for "historical significance."

Terms Accepts work on consignment (20% commission). Retail price set by artist. Exclusive area representation not required. Gallery provides insurance, promotion, contract; shipping costs are shared. Prefers framed artwork.

Submissions Send query letter with résumé, brochure, business card, slides, photographs, bio and SASE. Write to schedule an appointment to show a portfolio, which should include slides, transparencies and photographs. Replies only if interested within 3 months. Files résumés and slides. All material is returned with SASE if not accepted or under consideration.

Tips "Be persistent but friendly!"

RENAISSANCE GALLERY, INC.

431 Main Ave., Northport AL 35476. (205)752-4422. **Owners:** Anne Stickney and Kathy Groshong. Retail gallery. Estab. 1994. Represents 25 emerging, mid-career and established artists/year. Exhibited artists include Elayne Goodman and John Kelley. Sponsors 12 shows/year. Average display time 6 months. Open all year; Monday-Saturday, 11-4 :30. Located in downtown historical district; 1,000 sq. ft.; historic southern building. 25% of space for special exhibitions; 75% of space for gallery artists. Clientele tourists and local community. 95% private collectors; 5% corporate collectors. Overall price range $65-3,000; most work sold at $300-900.

Media Considers oil, acrylic, watercolor, pastel, pen & ink, mixed media, sculpture; types of prints include woodcuts and monoprints. No mass-produced reproductions. Most frequently exhibits oil, acrylic and watercolor.

Style Exhibits painterly abstraction, impressionism, photorealism, realism, imagism and folk-whimsical. Genres include florals, portraits, landscapes, Americana and figurative work. Prefers realism, imagism and abstract.

Terms Accepts work on consignment (50% commission). Retail price set by the artist. Gallery provides promotion; shipping costs are shared. Prefers artwork framed. "We are not a frame shop."

Submissions Prefers only painting, pottery and sculpture. Send query letter with slides or photographs. Write for appointment to show portfolio of photographs and sample work. Responds only if interested within 1 month. Files artists slides/photographs, returned if postage included. Finds artists through referrals by gallery artists.

Tips "Do your homework. See the gallery before approaching. Make an appointment to discuss your work. Be open to suggestions, not defensive. Send or bring decent photos. Have work that is actually available, not already given away or sold. Don't bring in your first three works. You should be comfortable with what you are doing, past the experimental stage. You should have already produced many works of art (zillions!) before approaching galleries."

UNIVERSITY OF ALABAMA AT BIRMINGHAM VISUAL ARTS GALLERY

1530 3rd Ave. South, HB 113, Birmingham AL 35294-1260. (205)934-4941. Fax: (205)975-2836. **Director and Curator:** Brett M. Levine. Nonprofit university gallery. Estab. 1972. Represents emerging, mid-career and established artists. Sponsors 10-12 exhibits/year. Average display time 3-4 weeks. Open Monday-Thursday, 11-6; Friday, 11-5; Saturday, 1-5. Closed Sundays and holidays. Located on first floor of Humanities Building, a classroom and office building, 2 rooms with a total of 2,000 sq. ft. and 222 running feet. Clients include local community, students and tourists.

Media Considers all media except craft. Considers all types of prints.

Style Considers all styles and genres.

Making Contact & Terms Gallery provides insurance and promotion. Accepted work should be framed.

Submissions Write to arrange a personal interview to show portfolio of slides. Send query letter with artist's statement, bio, brochure, photographs, résumé, reviews, SASE and slides. Returns material with SASE.

MARCIA WEBER/ART OBJECTS, INC.

1050 Woodley Rd., Montgomery AL 36106. (334)262-5349. Fax: (334)567-0060. E-mail: weberart@mindspring.com. Web site: www.marciaweberartobjects.com. **Owner:** Marcia Weber. Retail, wholesale gallery. Estab. 1991. Represents 21 emerging, mid-career and established artists/year. Exhibited artists include Woodie Long, Jimmie Lee Sudduth. Sponsors 6 shows/year. Open all year except July by appointment only. Located in Old Cloverdale near downtown in older building with hardwood floors in section of town with big trees and gardens. 100%

of space for gallery artists. Clientele tourists, upscale. 90% private collectors, 10% corporate collectors. Overall price range $300-20,000; most work sold at $300-4,000.

> • This gallery owner specializes in the work of self-taught, folk, or outsider artists. Many artists shown generally "live down dirt roads without phones," so a support person first contacts the gallery for them. Marcia Weber moves the gallery to New York's Soho district 3 weeks each winter and routinely shows in the Atlanta area.

Media Considers all media except prints. Must be original one-of-a-kind works of art. Most frequently exhibits acrylic, oil, found metals, found objects and enamel paint.

Style Exhibits genuine contemporary folk/outsider art, self-taught art and some Southern antique original works.

Terms Accepts work on consignment (variable commission) or buys outright. Gallery provides insurance, promotion and contract if consignment is involved. Prefers artwork unframed so the gallery can frame it.

Submissions Folk/outsider artists usually do not contact dealers. They have a support person or helper, who might write or call, send query letter with photographs, artist's statement. Call or write for appointment to show portfolio of photographs, original material. Finds artists through word of mouth, other artists and "serious collectors of folk art who want to help an artist get in touch with me." Gallery also accepts consignments from collectors.

Tips "An artist is not a folk artist or an outsider artist just because their work resembles folk art. They have to *be* folks who began creating art without exposure to fine art. Outsider artists live in their own world outside the mainstream and create art. Academic training in art excludes artists from this genre." Prefers artists committed to full-time creating.

ALASKA

ALASKA STATE MUSEUM

395 Whittier St., Juneau AK 99801-1718. (907)465-2901. Fax: (907)465-2976. E-mail: bruce_kato@eed.state.ak.us. Web site: www.museums.state.ak.us/asmhome.html. **Chief Curator:** Bruce Kato. Museum. Estab. 1900. Approached by 40 artists/year; exhibits 4 emerging, mid-career and established artists. Sponsors 10 exhibits/year. Average display time 6-10 weeks. Downtown location—3 galleries exhibiting temporary exhibitions.

Media Considers all media. Most frequently exhibits painting, photography and mixed media. Considers engravings, etchings, linocuts, lithographs, mezzotints, serigraphs and woodcuts.

Style Considers all styles.

Submissions Finds Alaskan artists through submissions and portfolio reviews every two years. Register for e-mail notification at: http://list.state.ak.us/guest/RemoteListSummary/Museum_Exhibits_Events_Calendar.

BUNNELL STREET GALLERY

106 W. Bunnell, Suite A, Homer AK 99603. (907)235-2662. Fax: (907)235-9427. E-mail: bunnell@xyz.net. Web site: www.bunnellstreetgallery.org. **Director:** Asia Freeman. Nonprofit gallery. Estab. 1990. Approached by 50 artists/year. Represents 35 emerging, mid-career and established artists. Sponsors 12 exhibits/year. Average display 1 month. Open Monday-Saturday, 10-6; Sunday, 12-4 (summer only). Closed January. Located on corner of Main and Bunnell Streets, Old Town, Homer; 30×25 exhibition space; good lighting, hardwood floors. Clients include local community and tourists. 10% of sales are to corporate collectors. Overall price range $50-2,500; most work sold at $500.

Media Considers all media. Most frequently exhibits painting, ceramics and installation. No prints; originals only.

Style Considers all styles and genres. Most frequently exhibits painterly abstraction, impressionism, conceptualism.

Terms Artwork is accepted on consignment and there is a 35% commission. A donation of time is requested. Gallery provides insurance, promotion and contract. Accepted work should be framed. Does not require exclusive representation locally.

Submissions Call or write to arrange a personal interview to show portfolio of slides or mail portfolio for review. Returns material with SASE. Responds in 1 month. Finds artists through word of mouth, submissions, art exhibits and referrals by other artists.

ARIZONA

ARIZONA STATE UNIVERSITY ART MUSEUM

Nelson Fine Arts Center and Ceramics Research Center, Tempe AZ 85287-2911. (480)965-2787. Fax: (480)965-5254. Web site: asuartmuseum.asu.edu. **Director:** Marilyn Zeitlin. Estab. 1950. Presents mid-career, established and emerging artists. Sponsors 12 shows/year. Average display time 2 months. Open all year; Tuesday, 10-9

(school year); Tuesday, 10-5 (summer); Wednesday-Saturday, 10-5; Closed Sunday, Monday and Holidays. Located downtown Tempe ASU campus. Nelson Fine Arts Center features award-winning architecture, designed by Antoine Predock. "The Ceramics Research Center, located just next to the main museum, features open storage of our 3,000 works plus collection and rotating exhibitions. The museum also presents an annual short film and video festival."

Media Considers all media. Greatest interests are contemporary art, crafts, video, and work by Latin American and Latin artists.

Submissions "Interested artists should submit slides to the director or curators."

Tips "With the University cutbacks, the museum has scaled back the number of exhibitions and extended the average show's length. We are always looking for exciting exhibitions that are also inexpensive to mount."

ARTISIMO ARTSPACE

Scottsdale AZ 85251. (480)949-0433. Fax: (480)994-0959. E-mail: artisimo@artisimogallery.com. Web site: www.artisimogallery.com. Contact: Amy Wenk, director. For-profit gallery. Estab. 1991. Approached by 30 artists/year. Represents 20 emerging, mid-career and established artists. Exhibited artists include Carolyn Gareis (mixed media), Korey Gulbrandson (mixed media). Sponsors 3 exhibits/year. Average display time 5 weeks. Clients include local community, upscale, designers, corporations, restaurants. Overall price range $200-4,000; most work sold at $1,500.

Media Considers all media and all types of prints.

Style Exhibits geometric abstraction and painterly abstraction. Genres include figurative work, florals, landscapes and abstract.

Terms "Available art is displayed on the Artisimo Web site. Artisimo will bring desired art to the client's home or business. If art is accepted, it will be placed on the Web site." There is a 50% commission upon sale of art. Retail price set by the artist. Gallery provides insurance and promotion. Requires exclusive representation locally.

Submissions Send query e-mail with artist's statement, bio, photographs, résumé or link to Web site. Responds in 3 weeks. Files photographs and bios. Finds artists through word of mouth, submissions, portfolio reviews, art exhibits, art fairs and referrals by other artists.

ASHLAND ARTS/ICON STUDIO

1205 W. Pierce, Phoenix AZ 85007. (602)257-8543. Fax: (602)257-8543. **Contact:** David Cook. Estab. 1986. Represents emerging, mid-career and established artists. Exhibited artists include David Cook, Frank Mell, Ron Crawford and Mark Dolce. Sponsors 2 invitationals: Fall—Best of the West—non-Cowboy Art Show; Spring—Adults Only—Open Invitational; 2 months each; group/solo shows. Located in "two-story old farm house in central Phoenix, off Central Ave." Overall price range $100-5,000; most artwork sold at $100-800.

Media Considers all media and all types of prints. Most frequently exhibits photography, painting, mixed media and sculpture.

Style Exhibits all styles, preferably conceptualism, minimalism and neo-expressionism.

Terms Accepts work on consignment (25% commission); rental fee for space covers 2 months. Retail price set by artist. Artist pays for shipping.

Submissions Accepts proposal in person or by mail to schedule shows 6 months in advance. Send query letter with résumé, brochure, business card, 3-5 slides, photographs, bio and SASE. Call or write for appointment to show portfolio of slides and photographs. Be sure to follow through with proposal format. Responds only if interested within 1 month. Samples are filed or returned if not accepted or under consideration.

Tips "Be active and enthusiastic."

JOAN CAWLEY GALLERY, LTD.

7135 E. Main St., Scottsdale AZ 85251. (602)947-3548. Fax: (602)947-7255. E-mail: karinc@jcgltd.com. Web site: www.jcgltd.com. **President:** Kevin P. Cawley. Director: Karin Cawley. Retail gallery and print publisher. Estab. 1974. Represents 20 emerging, mid-career and established artists/year. Exhibited artists include Carol Grigg, Adin Shade. Sponsors 5-10 shows/year. Average display time 2-3 weeks. Open all year; Monday-Saturday, 10-5; Thursday, 7-9. Located in art district, center of Scottsdale; 2,730 sq. ft. (about 2,000 for exhibiting); high ceilings, glass frontage and interesting areas divided by walls. 50% of space for special exhibitions; 75% of space for gallery artists. Clientele tourists, locals. 90% private collectors. Overall price range $100-12,000; most work sold at $3,500-5,000.

• Joan Cawley also runs an art licensing company. Joan Cawley Licensing, 1410 W. 14th St., Suite 101, Tempe AZ 85281. (800)835-0075. (602)858-0363.

Media Considers all media except fabric or cast paper; all graphics. Most frequently exhibits acrylic on canvas, watercolor, pastels and chine colle.

Style Exhibits expressionism, painterly abstraction, impressionism. Exhibits all genres. Prefers Southwestern and contemporary landscapes, figurative, wildlife.

Terms Accepts work on consignment (50% commission.) Gallery provides promotion and contract; shipping costs are shared. Prefers artwork framed.

Submissions Prefers artists from west of Mississippi. Send query letter with bio and at least 12 slides or photos. Call or write for appointment to show portfolio of photographs, slides or transparencies. Responds as soon as possible.

Tips "We are a contemporary gallery in the midst of traditional Western galleries. We are interested in seeing new work always." Advises artists approaching galleries to "check out the direction the gallery is going regarding subject matter and media. Also always make an appointment to meet with the gallery personnel. We always ask for a minimum of five to six paintings on hand. If the artist sells for the gallery, we want more, but a beginning is about six paintings."

ⓃⅢ DINNERWARE CONTEMPORARY ART GALLERY

101 W. 6th St., Tucson AZ 85701.(520)792-4503. Fax: (520)792-1282. E-mail: dinnerware@theriver.com. Web site: www.dinnerwareArts.com. Considers all media except craft. Most frequently exhibits painting and sculpture. Considers all types of prints.

Style Considers all styles. Most frequently exhibits painterly abstraction, expressionism and geometric abstraction. Genres include avant garde, figurative work and landscapes.

Terms There is a co-op membership fee plus a donation of time. There is a 15% commission. Retail price set by the artist. Gallery provides insurance. Accepted work should be framed and mounted. Requires exclusive representation locally. Exhibits member artists onlysometimes guest artists

Submissions Send query letter with résumé, SASE and slides. Returns material with SASE. Responds in 2 weeks. Files only materials for considered guest artists. Finds artists through word of mouth referrals by other artists and call for members.

Tips "Please submit great slides."

Ⓝ DULEY-JONES GALLERY

7160 Main St., Scottsdale AZ 85251. (480)945-8475. **Director:** Ms. Linda Corderman. Retail gallery and art consultancy. Estab. 1962. Interested in established artists. Represents 60 artists. Exhibited artists include Merrill Mahaffey, David Barba and Pat Bailey. Sponsors 6 solo and 2 group shows/year. Average display time 2 weeks. Open Monday-Saturday 10-5; Thursday 7-9. Located in downtown Scottsdale. Clientele valley collectors, tourists, international visitors. 80% private collectors; 20% corporate clients. Overall price range $500-30,000; most work sold at $1,000-10,000.

 ● Though focus is mainly on contemporary interpretations of Southwestern themes, gallery shows work of artists from all over the country. Director is very open to 3-dimensional work.

Media Considers oil, acrylic, watercolor, pastel, drawings, mixed media, collage, sculpture, ceramic, craft, glass, lithographs, monoprints and serigraphs. Most frequently exhibits oil, acrylic and watercolor.

Style Exhibits realism, painterly abstraction and postmodern works; will consider all styles. Genres include florals, watercolors, ceramic, whimsical figures, wood carvings and personal themes. Prefers contemporary realistic and abstract paintings, drawings and sculpture by American artists.

Terms Accepts work on consignment. Retail price set by the gallery and the artist. Exclusive area representation required. Gallery provides insurance, promotion and contract; gallery pays for shipping costs from gallery. Prefers framed artwork.

Submissions Send query letter with résumé, brochure, slides, photographs, bio and SASE. Responds in 2 weeks. All material is returned with SASE. No appointments are made.

Tips "Include a complete slide identification list, including availability of works and prices. The most common mistakes are presenting poor reproductions."

EL PRADO GALLERIES, INC.

Tlaquepaque Village, Sedona AZ 86339. (928)282-7390. E-mail: elprado@sedona.net. Web site: www.elpradogalleries.com. **President:** Joyce Gree. Estab. 1976. Represents 60 emerging, mid-career and established artists. Exhibited artists include Guy Manning and John Cogan. Open all year. Located in Sedona's Tlaquepaque Village 5,000 sq. ft. 95% private collectors, 5% corporate collectors. Accepts artists from all regions. Overall price range $75-125,000.

Media Considers oil, acrylic, watercolor, pastel, mixed media, collage, works on paper, sculpture, ceramic, craft, fiber and glass. Considers woodcuts, engravings, lithographs, wood engravings, mezzotints, serigraphs, linocuts and etchings. Most frequently exhibits oil, acrylic, watercolor and sculpture.

Style Exhibits all styles and genres. Prefers landscapes, Southwestern and Western styles. Does not want to see avant-garde.

Terms Accepts work on consignment (50% commission). Retail price set by the gallery and the artist. Gallery provides insurance and promotion; shipping costs are shared. Prefers framed work.

Submissions Send query letter with photographs. Call or write to schedule an appointment to show a portfolio which should include photographs. "A common mistake artists make is presenting work not up to our standards of quality." Responds in 3 weeks. Files material only if interested.

Tips "The artist's work must be original, not from copyrighted photos, and must include SASE. Our clients today are better art educated than before."

N EL PRESIDIO GALLERY

3001 E. Skyline Dr., Tucson AZ 85717. (520)299-1414. Web site: www.elpresidiogallery.com. **Owner:** Henry Rentschler. Retail gallery. Estab. 1981. Represents 30 artists; emerging, mid-career and established. Sponsors 5-6 group shows/year. Average display time 2 months. Located at upscale Santa Fe Square Shopping Plaza; 7,000 sq. ft. of exhibition space. Accepts mostly artists from the West and Southwest. Clientele locals and tourists. 80% private collectors, 20% corporate clients. Overall price range $500-20,000; most artwork sold at $1,000-5,000.

Media Considers oil, acrylic, watercolor, mixed media, works on paper, sculpture, ceramic, glass, egg tempera, pastel and original handpulled prints. Most frequently exhibits oil, watercolor and acrylic.

Style Exhibits impressionism, expressionism, realism, photorealism and painterly abstraction. Genres include landscapes, Southwestern, Western, wildlife and figurative work. Prefers realism, representational works and representational abstraction.

Terms Accepts work on consignment (50% commission). Retail price set by the gallery and the artist. Exclusive area representation required. Gallery provides insurance, promotion and contract; artist pays for shipping. Prefers framed artwork.

Submissions Send query letter with résumé, brochure, slides, photographs with sizes and retail prices, bio and SASE. Call or write to schedule an appointment to show a portfolio, which should include originals, slides, transparencies and photographs. A common mistake is artists overpricing their work. Responds in 2 weeks.

Tips "Work hard. Have a professional attitude. Be willing to spend money on good frames."

ETHERTON GALLERY

135 S. Sixth Ave., Tucson AZ 85701. (520)624-7370. Fax: (520)792-4569. E-mail: ethertongallery@mindspring.com. Web site: www.ethertongallery.com. **Contact:** Terry Etherton. Retail gallery and art consultancy. Specializes in vintage and contemporary photography. Estab. 1981. Represents 50+ emerging, mid-career and established artists. Exhibited artists include Holly Roberts, Rocky Schenck, Kate Breakey, James G. Davis and Mark Klett. Sponsors 4 shows/year. Average display time 8 weeks. Open year round. Located "downtown; 3,000 sq. ft.; in historic building—wood floors, 16 ft. ceilings." 75% of space for special exhibitions; 10% of space for gallery artists. Clientele: 50% private collectors, 25% corporate collectors, 25% museums. Overall price range $500-50,000; most work sold at $1,000-4,000.

Media Considers all types of photography, oil, acrylic, drawing, mixed media, collage, sculpture, ceramic, original handpulled prints, woodcuts, wood engravings, linocuts, engravings, mezzotints, etchings and lithographs. Most frequently exhibits photography and painting.

Style Exhibits expressionism, neo-expressionism, primitivism, postmodern works. Genres include landscapes, portraits and figurative work. Prefers expressionism, primitive/folk and post-modern. Interested in seeing work that is "cutting-edge, contemporary, issue-oriented, political."

Terms Accepts work on consignment (50% commission). Buys outright for 50% of retail price (net 30 days). Retail price set by gallery and artist. Gallery provides insurance and promotion; shipping costs are shared. Prefers framed artwork.

Submissions Only "cutting-edge contemporary—no decorator art." No "unprepared, incomplete works or too wide a range—not specific enough." Send résumé, brochure, disk, slides, photographs, reviews, bio and SASE. Call or write to schedule an appointment to show a portfolio, which should include disk. Responds in 6 weeks only if interested.

Tips "Become familiar with the style of our gallery and with contemporary art scene in general."

THE GALLOPING GOOSE

162 S. Montezuma, Prescott AZ 86303. (928)778-7600. Fax: (928)776-1806. E-mail: gallopgoose@aol.com. Web site: www.gallopinggoosegallery.com. **Owner:** Zack Batikh. Retail gallery. Estab. 1987. Represents 200 emerging, mid-career and established artists. Exhibited artists include Bev Doolittle and Maija. Average display time 2 weeks. Open all year. Located in the "SW corner of historic Whiskey Row across from the courthouse in downtown Prescott; newly remodeled with an additional 2,000 sq. ft. of gallery space." 10% of space for special exhibitions. Clients: established art collectors and tourists. 95% private collectors, 5% corporate collectors. Overall price range $20-5,000; most work sold at $150-1,000.

Media Considers oil, pen & ink, fiber, acrylic, drawing, sculpture, watercolor, mixed media, ceramic, pastel, original handpulled prints, reliefs, lithographs, offset reproductions and posters. Most frequently exhibits pastel, oil, tempera and watercolor.

Style Exhibits surrealism, imagism and realism. Genres accepted include landscapes, Americana, Southwestern, Western, wildlife and Indian themes only. Prefers wildlife, Southwestern cowboy art and landscapes.

Terms Buys outright for 50% of the retail price; net 30 days. Customer discounts and payment by installment are available. Retail price set by the gallery and the artist. Gallery pays for shipping costs to gallery. Prefers artwork unframed.

Submissions Send query letter with bio, brochure, photographs and business card. To show a portfolio, call for appointment. Gallery prefers written correspondence. Files photographs, brochures and biographies. Finds artists through visiting exhibitions, word of mouth and various art publications.

Tips "Stop by to see our gallery, determine if artwork would be appropriate for our clientele and meet the owner to see if an arrangement is possible."

THE LARSEN GALLERY

(formerly The Cultural Exchange Gallery), 3705 N. Bishop Lane, Scottsdale AZ 85251. (480)941-0900. Fax: (480)941-0814. Web site: www.larsengallery.com or www.culturalexchange.com. **Art Gallery Director**: Polly Larsen (plarsen@larsengallery.com). Retail gallery and art consultancy. Exhibits the work of 100s of mid-career and established artists/year. Exhibited artists include Christopher Pelley and Sandy Skoglund. Average display time 1 month. Open all year; Monday-Friday, 9-5; Thursday evenings, 7-9; Saturday, 10-5; Sunday, 12-4. Located downtown; 7,500 sq. ft. "Have vast array of artwork from the 1900s to contemporary." Clientele: upscale, local and tourists. 75% private collectors, 25% corporate collectors. Overall price range: $100-150,000; most work sold at $3,000-7,000.

Media Considers all media except weavings and tapestry. Considers all types of prints except posters. Most frequently exhibits oils/acrylics, bronze and pastels/lithos and photography.

Style Exhibits expressionism, neo-expressionism, painterly abstraction, conceptualism, minimalism, color field, postmodern works, photorealism, hard-edge geometric abstraction, realism and imagism. Exhibits all genres.

Terms Artwork is accepted on consignment and there is a 40% commission (from clients not artists). Retail price set by the gallery. Gallery provides insurance, promotion and contract; shipping costs are shared.

Submissions Accepts consignments from private and corporate clients. Represent contemporary artists.

MESA CONTEMPORARY ARTS

1 East Main St, Box 1466, Mesa AZ 85211-1466. (480)644-6501. Fax: (480)644-2901. E-mail: artscenterinfo@mesaartscenter.com. Web site: www.mesaartscenter.com. Owned and operated by the City of Mesa. Estab. 1981. Exhibits the work of emerging, mid-career and established artists. "We only do national juried shows and curated invitationals. We are an exhibition gallery, NOT a commercial sales gallery." Sponsors 6 shows/year. Average display time 4-6 weeks. Located downtown; 1,300 sq. ft., "wood floors, 14 ft. ceilings and monitored security." 100% of space for special exhibitions. Clientele "cross section of Phoenix metropolitan area." 95% private collectors, 5% gallery owners. "Artists selected only through national juried exhibitions." Overall price range $100-10,000; most artwork sold at $200-400.

Media Considers all media including sculpture, painting, printmaking, photography, fibers, glass, wood, metal, video, ceramics, installation and mixed.

Style Exhibits all styles and genres. Interested in seeing contemporary work.

Terms Charges 25% commission. Retail price set by artist. Gallery provides insurance, promotion and contract; pays for shipping costs from gallery. Requires framed artwork.

Submissions Send a query letter or postcard with a request for a prospectus. After you have reviewed prospectus, send slides of up to 4 works (may include details if appropriate). "We do not offer portfolio review. Artwork is selected through national juried exhibitions." Files slides and résumés. Finds artists through gallery's placement of classified ads in various art publications, mailing news releases and word of mouth.

Tips "Scout galleries to determine their preferences before you approach them. Have professional quality slides. Present only your very best work in a professional manner."

⃞Ｎ SCHERER GALLERY

Hillside, Sedona AZ 86336. (928)203-9000. Fax: (928)203-0643. **Owners:** Tess Scherer and Marty Scherer. Retail gallery. Estab. 1968. Represents over 30 mid-career and established artists. Interested in seeing the work of emerging artists. Exhibited artists include Tamayo, Hundertwasser, Friedlaender, Delaunay, Calder and Barnet. Sponsors 4 solo and 3 group shows/year. Average display time 2 months. Open daily 10-6. 3,000 sq. ft.; 25% of space for special exhibitions; 75% for gallery artists. Clientele upscale, local community and international collectors. 90% private collectors, 10% corporate clients. Overall price range $1,000-20,000; most artwork sold at $5,000-10,000.

Media Considers non-functional glass sculpture; paintings and other works on paper including hand-pulled prints in all mediums; and kaleidoscopes.

Style Exhibits color field, minimalism, surrealism, expressionism, modern and post modern works. Looking for artists "with a vision. Work that shows creative handling of the medium(s) and uniqueness to the style'innovation,' 'enthusiasm.''07'' Specializes in handpulled graphics, art-glass and kaleidoscopes.

Terms Accepts work on consignment (50% commission). Retail price set by artist. Exclusive area representation required. Gallery provides insurance, promotion and contract; shipping costs are shared.

Submissions Send query letter, résumé, bio, at least 12 slides (no more than 30), photographs and SASE. Follow up with a call for appointment to show portfolio. Responds in 1 month.

Tips "Persevere! Don't give up!" Considers "originality and quality of the work."

SCOTTSDALE MUSEUM OF CONTEMPORARY ART

7380 E. Second St., Scottsdale AZ 85251. (480)874-4630. Fax: (480)874-4655. Web site: www.smoca.org. **Contact:** Pat Evans, director. Museum. Approached by 30-50 artists/year. "Arizona's only museum devoted to the art, architecture and design of our time." Sponsors 12 exhibits/year. Average display time 10 weeks. Open Tuesday, Wednesday, Friday, Saturday, 10-5; Thursday, 10-8; Sunday, 12-5. Closed Monday. Located in downtown Scottsdale; more than 20,000 sq. ft. of exhibition space. Clients include local community, students and tourists.

Media Considers all media.

Style Considers works of contemporary art, architecture and design.

Submissions Send query letter with artist's statement, bio, photocopies, résumé, reviews and SASE. Returns material with SASE. Responds in 3 weeks.

Tips Make your submission clear and concise. Fully identify all slides. All submission material, such as artist's statement and slide labels should be typed, not handwritten.

VANIER FINE ART, LTD.

7106 E. Main St., Scottsdale AZ 85251. (480)946-7507. Fax: (602)945-2448. E-mail: RandolphRhoton@vanierart.com. Web site: www.vanier.roberts.com. **Contact:** Randolph or Jerre Lynn. Retail gallery. Estab. 1994. Represents 50 emerging, mid-career and established artists/year. Sponsors 7 shows/year. Average display time 1 month. Open all year; Monday-Saturday, 10 a.m.-5 p.m.; Thursday, 7-9 p.m. Located in Old Town (downtown) Scottsdale; 6,500 sq. ft.; multi-levels, multiple rooms, 25 foot ceilings. Clientele tourists, upscale, local. 90% private collectors, 10% corporate collectors. Overall price range $500-$295,000; most work sold at $2,000-$10,000.

Media Considers oil, pen & ink, drawing, sculpture, watercolor, mixed media, pastel, acrylic, paper, ceramics, glass, collage and photography. Most frequently exhibits oil.

Style Exhibits photorealism, color field, conceptualism, expressionism, geometric abstraction, surrealism and realism. Most frequently exhibits painterly abstraction, geometric and impressionism. Exhibits all genres. Prefers landscape, florals and portrait.

Terms Accepts work on consignment (50% commission). Retail price set by the artist in conjunction with gallery. Gallery provides insurance, promotion and contract; shipping costs are shared. Prefers artwork framed.

Submissions Send query letter with résumé, brochure, business card, slides, photographs, reviews, artist's statement, bio, SASE and price list. Write for appointment to show portfolio of photographs and slides. Responds in 3 weeks. Finds artists through out of town (state) shows, referrals by other artists, national publications.

Tips "Initial impressions are important. Don't waste my time until it is evident with an extensive CV and gallery exhibition record that your career is established."

RIVA YARES GALLERY

3625 Bishop Lane, Scottsdale AZ 85251. (480)947-3251. Fax: (480)947-4251. E-mail: art@rivayaresgallery.com. Web site: www.rivayaresgallery.com. Second gallery at 123 Grant Ave., Santa Fe NM 87501. (505)984-0330. Retail gallery. Estab. 1963. Represents 30-40 emerging, mid-career and established artists/year. Exhibited artists include Rodolfo Morales and Esteban Vicente. Sponsors 12-16 shows/year. Average display time 3-6 weeks. Open all year; Tuesday-Saturday, 10-5; Sunday by appointment. Located in downtown area; 8,000 sq. ft.; national design award architecture; international artists. 50% of space for special exhibitions; 50% of space for gallery artists. Clientele: collectors. 90% private collectors; 10% corporate collectors. Overall price range $1,000-1,000,000; most work sold at $20,000-50,000.

Media Considers all media except craft and fiber and all types of prints. Most frequently exhibits paintings (all media), sculpture and drawings.

Style Exhibits expressionism, photorealism, neo-expressionism, minimalism, pattern painting, color field, hard-edge geometric abstraction, painterly abstraction, realism, surrealism and imagism. Prefers abstract expressionistic painting and sculpture, surrealistic sculpture and modern schools' painting and sculpture.

Terms Accepts work on consignment (50% commission). Retail price set by the artist. Gallery provides insurance, promotion and contract; gallery pays for shipping from gallery; artist pays for shipping to gallery. Prefers artwork framed.
Submissions Not accepting new artists at this time.
Tips "Few artists take the time to understand the nature of a gallery and if their work even applies."

ARKANSAS

AMERICAN ART GALLERY

724 Central Ave., Hot Springs National Park AR 71901. (501)624-0550. E-mail: amerart@ipa.net. Web site: 411web.com/A/americanartgallery/. Retail gallery. Estab. 1990. Represents 22 emerging, mid-career and established artists. Exhibited artists include Jimmie Tucek and Jimmie Leach. Sponsors 12 shows/year. Average display time 1 month. Open all year. Located downtown; 4,000 sq. ft.; 40% of space for special exhibitions. Clientele: private, corporate and the general public. 85% private collectors, 15% corporate collectors. Overall price range $50-12,000; most work sold at $350-800.
Media Considers oil, acrylic, watercolor, pastel, pen & ink, sculpture, ceramic, photography, original handpulled prints, woodcuts, wood engravings, lithographs and offset reproductions. Most frequently exhibits oil, wood sculpture and watercolor.
Style Exhibits all styles and genres. Prefers realistic, abstract and impressionistic styles; wildlife, landscapes and floral subjects.
Terms Accepts work on consignment (40% commission). Retail price set by gallery and the artist. Gallery provides promotion and contract; artist pays for shipping. Offers customer discounts and payment by installments. Prefers artwork framed.
Submissions Prefers Arkansas artists, but shows 5-6 others yearly. Send query letter with résumé, 8-12 slides, bio and SASE. Call or write for appointment to show portfolio of originals and slides. Responds in 6 weeks. Files copy of résumé and bio. Finds artists through agents, by visiting exhibitions, word of mouth, various art publications and sourcebooks, submissions/self promotions and art collectors' referrals.
Tips "We have doubled our floor space and have two floors, which allows us to separate the feature artist from the regular artist. We have also upscaled the quality of artwork exhibited. Our new gallery is located between two other galleries. It's a growing art scene in Hot Springs. We prefer artists have an appointment, not just pop in."

N THE ARKANSAS ARTS CENTER

PBox 2137, Little Rock AR 72203. (501)372-4000. Fax: (501)375-8053. **Curator of Art:** Brian Young. Curator of Decorative Arts : Alan DuBois. Museum art school, children's theater and traveling exhibition service. Estab. 1930s. Exhibits the work of emerging, mid-career and established artists. Sponsors 25 shows/year. Average display time 6 weeks. Open all year. Located downtown; 10,000 sq. ft.; 60% of space for special exhibitions.
Media Most frequently exhibits drawings and crafts.
Style Exhibits all styles and all genres.
Terms Retail price set by the artist. "Work in the competitive exhibitions (open to artists in Arkansas and six surrounding states) is for sale; we usually charge 10% commission."
Submissions Send query letter with samples, such as photos or slides.
Tips "Write for information about exhibitions for emerging and regional artists, and various themed exhibitions."

ARKANSAS STATE UNIVERSITY FINE ARTS CENTER GALLERY

P.O. Drawer 1920, State University AR 72467. (870)972-3050. E-mail: csteele@astate.edu. Web site: www.clt.ast ate.edu/art/. **Chair, Department of Art:** Curtis Steele. University—Art Department Gallery. Estab. 1968. Represents/exhibits 3-4 emerging, mid-career and established artists/year. Sponsors 3-4 shows/year. Average display time 1 month. Open fall, winter and spring; Monday-Friday, 10-4. Located on university campus; 1,600 sq. ft.; 60% of time devoted to special exhibitions; 40% to faculty and student work. Clientele: students/community.
Media Considers all media. Considers all types of prints. Most frequently exhibits painting, sculpture and photography.
Style Exhibits conceptualism, photorealism, neo-expressionism, minimalism, hard-edge geometric abstraction, painterly abstraction, postmodern works, realism, impressionism and pop. "No preference except quality and creativity."
Terms Exhibition space only; artist responsible for sales. Retail price set by the artist. Gallery provides insurance, promotion and contract; shipping costs are shared. Prefers artwork framed.
Submissions Send query letter with résumé, slides and SASE. Portfolio should include photographs, transparen-

cies and slides. Responds only if interested within 2 months. Files résumé. Finds artists through call for artists published in regional and national art journals.

Tips "Show us 20 slides of your best work. Don't overload us with lots of collateral materials (reprints of reviews, articles, etc.). Make your vita as clear as possible."

ⓃCANTRELL GALLERY

8206 Cantrell Rd., Little Rock AR 72227. (501)224-1335. E-mail: cgallery@aristotle.net. Web site: www.cantrellgallery.com. **President:** Helen Scott. Director: Cindy Huisman. Wholesale/retail gallery. Estab. 1970. Represents/exhibits 120 emerging, mid-career and established artists/year. Exhibited artists include Boulanger, Dali, G. Harvey, Warren Criswell, N. Scott and Robin Morris. Sponsors 8-12 shows/year. Average display time 1 month. Open all year; Monday-Saturday, 10-5. Located in the strip center; 5,000 sq. ft.; "we have several rooms and different exhibits going at one time." Clientele collectors, retail, decorators, museums. Overall price range $100-10,000; most work sold at $250-3,000.

Media Considers oil, acrylic, watercolor, pastel, pen & ink, drawing, mixed media, collage, paper, sculpture, woodcut, engraving, lithograph, wood engraving, mezzotint, serigraphs, linocut, etching. Most frequently exhibits etchings, watercolor, mixed media, oils and acrylics. Looking for outsider art.

Style Exhibits eclectic work, all genres.

Terms Gallery provides insurance and promotion; shipping costs are shared. Prefers artwork unframed.

Submissions Send query letter with résumé, 5 photos and bio. Write for appointment to show portfolio of originals. Responds in 2 months. Files all material. Finds artists through agents, by visiting exhibitions, word of mouth, art publications and sourcebooks, artists' submissions.

Tips "Be professional. Be honest. Place a retail price on each piece, rather than only knowing what 'you need to get' for the piece. Don't spread yourself too thinin any particular area—only show in one gallery in any area."

ⓃDUCK CLUB GALLERY

2333 N. College, Fayetteville AR 72703. (479)443-7262. Web site: www.duckclubgallery.com. **President:** Charlie Sego. Vice President Ted B. Sego. Secretary-Treasurer Frances Sego. Retail gallery. Estab. 1980. Represents mid-career and established artists. May be interested in seeing the work of emerging artists in the future. Exhibited artists include Terry Redlin, Jane Garrison and Linda Cullers. Displays work "until it sells." Open all year; Monday-Friday, 10-5:30; Saturday, 10-4. Located midtown; 1,200 sq. ft. 100% of space for gallery artists. Clientele tourists, local community, students; "we are a university community." 80% private collectors, 20% corporate collectors. Overall price range $50-400; most work sold at $50-200.

Media Considers all media including wood carved decoys. Considers engravings, lithographs, serigraphs, etchings, posters. Most frequently exhibits limited edition and open edition prints and poster art.

Style Exhibits all styles and genres. Prefers wildlife, local art and landscapes.

Terms Buys outright for 50% of retail price (net 30 days). Retail price set by the artist. Gallery provides insurance and promotion; artist pays for shipping. Prefers artwork unframed.

Submissions Send query letter with brochure, photographs and business card. Write for appointment to show portfolio. Finds artists through word of mouth, referrals by other artists, visiting art fairs and exhibitions, submissions, referrals from customers.

Tips "Please call for an appointment. Don't just stop in. For a period of time, give exclusively to the gallery representing you. Permit a gallery to purchase one or two items, not large minimums."

ⓃGALLERY FOUR INC.

11330 Arcade Dr., Little Rock AR 72212-4085. (501)224-4090. E-mail: mmargo7421@aol.com. **Owner:** Michael Margolis. Retail gallery. Estab. 1985. Open all year; Tuesday-Friday, 10-5:30; Saturday, 10-5; also by appointment. Located in West Little Rock; 650 sq. ft. Clientele upscale-local. 100% private collectors. Overall price range $50-750; most work sold at $100-350.

Media Considers all media and all types of prints. Most frequently exhibits watercolor, pastel and oil-acrylic.

Style Exhibits all styles and all genres. Prefers impressionism, wildlife and portrait.

Terms Accepts work on consignment (40% commission). Retail price set by the gallery and the artist. Gallery provides insurance, promotion and contract. Artist pays shipping costs. Prefers artwork unframed.

Submissions Send query letter with brochure, business card and 2-3 slides. Call for appointment to show portfolio of slides. Responds in 1 week. Files name, address, phone and type of artwork and sizes. Finds artists through word of mouth and artist's submissions.

Tips "Ask! Don't be afraid to ask for gallery representation. We're all human. 'No' is just a word. It's a numbers game. Don't stop until you find a gallery that will give you a chance. We all started somewhere—didn't we?"

N SOUTH ARKANSAS ARTS CENTER

110 E. Fifth, El Dorado AR 71730. (870)862-5474. Fax: (870)862-4921. E-mail: saac@arkansas.net. Web site: www.saac-arts.org. **Executive Director:** Beth James. Nonprofit gallery. Estab. 1963. Exhibits the work of 50 emerging, mid-career and established artists. Exhibited artists include George Price and Dee Ludwig. Sponsors 15 shows/year. Average display time 1 month. Open all year. Located "in the middle of town; 3,200 sq. ft." 60% of space for special exhibitions. 100% private collectors. Overall price range $50-1,500; most work sold at $200-300.
Media Considers all media and prints. Most frequently exhibits watercolor, oil and mixed media.
Style Exhibits all styles.
Terms Accepts work on consignment (25% commission). Retail price set by the artist. Gallery provides insurance and promotion; contract and shipping may be negotiated. Prefers artwork framed.
Submissions Send query with slides, photographs, SASE and "any pertinent materials." Only after a query, call to schedule an appointment to show a portfolio. Portfolio should include originals and artist's choice of work. Responds in 2 weeks. Files materials unless artist requests return. "Keeping something on file helps us remember your style."
Tips "We exhibit a wide variety of works by local, regional and national artists. We have facilities for 3-D works."

N TAYLOR'S CONTEMPORANEA FINE ARTS

516 Central Ave., Hot Springs AR 71901. (501)624-0516. E-mail: taylors@direclynx.net. **Owner/Director:** Carolyn Taylor. Retail gallery. Estab. 1981. Represents emerging, mid-career and established artists/year. Exhibited artists include Warren Criswell, William Dunlap, Billy De Williams, Robert Evans and David Hostetler. Sponsors 12 shows/year. Average display time 1 month. Open all year, 11-6 daily (closed Monday). Located downtown Central Ave.; 3,000 sq. ft.; 18 ft. ceiling. Outdoor sculpture garden, restored building (circa 1890). 50% of space for special exhibitions; 50-75% of space for gallery artists. Clientele upscale, local, various. 90% private collectors, 10% corporate collectors. Overall price range $500-50,000; most work sold at $900-5,000.
Media Considers all media. Considers monoprint and serigraphs. Most frequently exhibits oil, bronze and clay.
Style Exhibits contemporary work of all genres. Prefers surrealism, primitivism and impressionism.
Terms Artwork is accepted on consignment and there is a 40% commission. Retail price set by gallery and artist. Gallery provides insurance, promotion and contract. Artist pays for shipping costs. Prefers artwork framed.
Submissions Send query letter with résumé, slides and SASE. Write for appointment to show portfolio of slides. Responds in 3 months. Files work of artists currently exhibited and future exhibitors.

WALTON ARTS CENTER

P.O. Box 3547, 495 N. Dickson St., Fayetteville AR 72702. (479)443-9216. Fax: (479)443-9784. Web site: www.waltonartscenter.org. **Contact:** Michele McGuire, curator of visual arts. Nonprofit gallery. Estab. 1990. Approached by 50 artists/year. Represents 10 emerging, mid-career and established artists. Exhibited artists include E. Fay Jones, Judith Leiber (handbags). Average display time 2 months. Open all year; Monday-Friday, 10-6; weekends 12-4. Closed Thanksgiving, Christmas, July 4. Joy Pratt Markham Gallery is 2,500 sq. ft. with approximately 200 running wall feet. McCoy Gallery also has 200 running wall feet in the Education Building. Clients include local community and upscale. Overall price range $100-10,000. "Walton Arts Center serves as a resource to showcase a variety of thought-provoking visual media that will challenge new and traditional insights and encourage new dialogue in a museum level environment."
Media Considers all media and all types of prints. Most frequently exhibits oil, installation, paper.
Style Considers all styles and genres.
Terms Artwork is accepted on consignment and there is a 30% commission. Retail price set by the artist. Gallery provides insurance and contract. Accepted work should be framed. Requires exclusive representation locally.
Submissions Mail portfolio for review. Send query letter with artist's statement, bio, business card, résumé, reviews, SASE and slides. Returns material with SASE. Responds in 3 months. Finds artists through submissions, art exhibits, referrals by other artists and travelling exhibition companies.

CALIFORNIA

THE ART COLLECTOR

4151 Taylor St., San Diego CA 92110. (800)987-4151. Fax: (619)299-8709. **Contact:** Janet Disraeli. Retail gallery and art consultancy. Estab. 1972. Represents emerging, mid-career and established artists. Exhibited artists include Susan Singleton and Reed Cardwell. Average display time 1 month. Open all year; Monday-Friday. 1,000 sq. ft.; 100% of space for gallery artists. Clientele: upscale, business, decorators, health facilities, hotels, resorts, liturgical and residential artwork with interior designers, architects, landscape architects, developers

and space planners. 50% private collectors, 50% corporate collectors. Overall price range $175-10,000; most work sold at $450-1,000. Other services include giclée printing, online artist resource (slide collection), custom commission work available and beginning to do governmental work.

Media Considers all media and all types of prints. Most frequently exhibits paintings, sculpture, monoprints.

Style Exhibits all styles. Genres include all genres, especially florals, landscapes and figurative work. Prefers abstract, semi-realistic and realistic.

Terms Artwork is accepted on consignment and there is a 50% commission. Retail price set by the artist. Gallery provides insurance. Gallery pays for shipping from gallery. Artist pays for shipping to gallery. Prefers artwork unframed.

Submissions Accepts artists from United States only. Send query letter with résumé and slides. Call for appointment to show portfolio of slides. Responds in 2 weeks. Files slides, biographies, information about artist's work.

Tips Finds artists through artist's submissions and referrals.

ART SOURCE LA INC.
Southern California Corporate Office, 2801 Ocean Park Blvd., #7, Santa Monica CA 90405. (310)452-4411. Fax: (310)452-0300. E-mail: info@artsourcela.com. Web site: www.artsourcela.com. **Contact:** Francine Ellman, president Southern California Corporate Office. Estab. 1980.

Media Considers fine art in all media, including works on canvas, paper, sculpture, giclée and a broad array of accessories handmade by American artists. Also sells photography, works on paper and sculpture. Considers all types of prints.

Terms Artwork is accepted on consignment, and there is a 50% commission. No geographic restrictions.

Submissions "Submit a minimum of 20 slides, photographs or inkjet prints (laser copies not acceptable), clearly labeled with name, date, title of work; plus résumé, catalogs, brochures, pricelist and SASE. E-mail submissions accepted; but not as good as slides, etc." Responds in 2 months.

Tips "Be professional when submitting visuals. Remember, first impressions can be critical! Submit a body of work that is consistent and of the highest quality. Work should be in excellent condition and already photographed for your records. Framing does not enhance presentation to the client."

ATHENAEUM MUSIC AND ARTS LIBRARY
1008 Wall St., La Jolla CA 92037-4418. (858)454-5872. Fax: (858)454-5835. **Director:** Erika Torri. Nonprofit gallery. Estab. 1899. Represents/exhibits emerging, mid-career and established artists. Exhibited artists include Ming Mur-Ray, Italo Scanga and Mauro Staccioli. Sponsors 8 exhibitions/year. Average display time 2 months. Open all year; Tuesday-Saturday, 10-5:30; Wednesday 10-8:30. Located downtown La Jolla. An original 1921 building designed by architect William Templeton Johnson 12-foot high wood beam ceilings, casement windows, Spanish-Italianate architecture. 100% of space for special exhibitions. Clientele tourists, upscale, local community, students and Athenaeum members. 100% private collectors. Overall price range $100-1,000; most work sold at $100-500.

Media Considers all media. Considers all types of prints. Most frequently exhibits painting, multi-media and book art.

Style Exhibits all styles. Genres include florals, portraits, landscapes and figurative work.

Terms Artwork is accepted on consignment, and there is a 25% commission. Retail price set by the artist. Gallery provides insurance and promotion; shipping costs are shared. Prefers artwork framed.

Submissions Artists must be considered and accepted by the art committee. Send query letter with slides, bio, SASE and reviews. Write for appointment to show portfolio of photographs, slides and transparencies. Responds in 2 months. Files slide and bio only if there is initial interest in artist's work.

Tips Finds artists through word of mouth and referrals.

TOM BINDER FINE ARTS
825 Wilshire Blvd., #708, Santa Monica CA 90401. (310)822-1080. Fax: (310)822-1580. E-mail: info@artman.net. Web site: www.artman.net. For profit gallery. Exhibits established artists. Also has location in Marina Del Rey. Clients include local community, tourists and upscale. Overall price range $200-2,000.

• Tom Binder Fine Arts also has a listing in the Poster & Prints section of this book.

Media Considers all media; types of prints include etchings, lithographs, posters and serigraphs.

Style Considers all styles and genres.

Making Contact & Terms Artwork accepted on consignment or bought outright. Retail price set by the gallery. Gallery provides insurance. Accepted work should be mounted.

Submissions Write to arrange a personal interview to show portfolio. Returns material with SASE. Responds in 2 weeks.

N BOEHM GALLERY

Palomar College, San Marcos CA 92069-1487. (760)744-1150, ext. 2304. Fax: (760)744-8123. **Gallery Director:** Harry E. Bliss. Nonprofit gallery. Estab. 1966. Represents/exhibits mid-career artists. May be interested in seeing the work of emerging artists in the future. Generally exhibits 30 or more artists/year in solo and group exhibitions, supplemented with faculty, student work. Exhibited artists include top illustrators, crafts people, painters and sculptors. Sponsors 6 shows/year. Average display time 4-5 weeks. Open fall and spring semester; Tuesday 10-4; Wednesday-Thursday 10-7; Friday-Saturday 10-2; closed Sunday, Monday and school holidays. Located on the Palomar College campus in San Marcos; 2,000 sq. ft.; 100% of space for special exhibitions. Clientele regional community, artists, collectors and students. "Prices range dramatically depending on exhibition type and artist . . . $25 for student works to $10,000 for paintings, drawings, oils and installational sculptural works."
Media Considers all media. Considers all types of prints. Most frequently exhibits installation art, painting, sculpture, glass, illustration, quilts, ceramics, furniture design and photography.
Style Exhibits all styles. Styles vary. Exhibits primarily group exhibits based on either a medium or theme or genre.
Terms If artwork is sold, gallery retains 10% gallery "donation." Gallery provides insurance and promotion.
Submissions Accepts primarily artists from Southern California. Send query letter with résumé, slides, reviews and bio. Call or write for appointment to show portfolio of photographs and slides. Responds in 2-3 months. Files artist bio and résumé. Finds artists through "artist network, other reviewed galleries, or university visits or following regional exhibitions, and referrals from other professional artists and crafts people."
Tips Advises artists to show "Clear focus for art exhibition and good slides. Lucid, direct artist statement. Be willing to take part in group exhibits—we have very few strictly 'solo' shows and then only for very prominent artists. Be professional in your contacts and presentations and prompt or meeting deadlines for response. Have a unified body of work which is identifiable as your expression."

CENTRAL CALIFORNIA ART ASSOCIATION/MISTLIN GALLERY

1015 J St., Modesto CA 95354. (209)529-3369. Fax: (209)529-9002. E-mail: artcenter@ccartassn.org. Web site: www.ccartassn.org. **Gallery Director:** Nancy Hawn. Cooperative, nonprofit sales, rental and exhibition gallery. Estab. 1951. Represents emerging, mid-career and established artists. Average display time 3 months. Open all year. Located downtown. Overall price range $50-3,000; most artwork sold at $300-800.
Media Considers oil, pen & ink, works on paper, fiber, acrylic, drawing, sculpture, watercolor, mixed media, ceramic, pastel, collage, photography and original handpulled prints. Most frequently exhibits watercolor, oil and acrylic.
Style Exhibits mostly impressionism, realism and abstract. Will consider all styles and genres.
Terms Artwork is accepted on consignment (40% commission). Price set by artist. Installment payment available. Prefers framed artwork.
Submissions Call for information. All works subject to jury process. Portfolio review not accepted. Finds artists primarily through referrals from other artists.

N CHOZEN GALLERY

276 E. Granvia Valmonte, Palm Springs CA 92262. (760)320-5707. Fax: (760)320-0288. E-mail: chozenpsca@aol. com. **Director:** David Smith. Alternative space, for profit gallery. Estab. 1998. Approached by 8-10 artists/year; represents 10-12 emerging artists. Exhibited artists include Downs, Benjamin, Figueredo, Moiseyev, Soto-Diaz, David Smith. Sponsors 10 exhibits/year. Average display time 3-4 weeks. Open by appointment. Clients include local community and upscale. 5% of sales are to corporate collectors.
Media Considers acrylic, oil, paper and sculpture. Most frequently exhibits oil, acrylic and metal. Considers lithographs, serigraphs and giclée.
Style Exhibits geometric abstraction, minimalism, postmodernism, surrealism and painterly abstraction. Most frequently exhibits minimalism, abstract and surrealism. Considers all genres.
Making Contact & Terms Artwork is accepted on consignment, and there is a 50% commission. Retail price set by the gallery and the artist (mutual agreement). Gallery provides insurance and promotion. Requires exclusive representation locally.
Submissions Call or e-mail to arrange a personal interview to show portfolio. Mail portfolio for review or send query letter with artist's statement, bio, photographs, résumé, reviews and SASE. Returns material with SASE. Responds in 2 months. Files entire packet if interested. Finds artists through word of mouth, submissions, portfolio reviews, art exhibits and referrals by other artists.

COAST GALLERIES

Big Sur, Carmel, Pebble Beach, CA; Hana, HI. Mailing address: P.O. Box 223519, Carmel CA 93922. (831)625-8688. Fax: (831)625-8699. E-mail: gary@coastgalleries.com. Web site: www.coastgalleries.com. **Owner:** Gary Koeppel. Retail gallery. Estab. 1958. Represents 300 emerging, mid-career and established artists. Sponsors 3-

4 shows/year. Open all year. Located in both rural and resort hotel locations; 4 separate galleries—square footage varies, from 1,500-3,000 sq. ft. "The Hawaii galleries feature Hawaiiana; our Big Sur gallery is constructed of redwood water tanks and features Central California Coast artists and imagery." 100% of space for special exhibitions. Clientele 90% private collectors, 10% corporate collectors. Overall price range $25-60,000; most work sold at $400-4,000.

• The new Carmel gallery features both fine art and master crafts.

Media Considers all media; engravings, lithographs, posters, etchings, wood engravings and serigraphs. Most frequently exhibits bronze sculpture, limited edition prints, watercolor and oil on canvas.

Style Exhibits impressionism and realism. Genres include landscapes, marine and wildlife.

Terms Accepts work on consignment (50% commission), or buys outright for 40% of retail price (net 30 days.) Retail price set by gallery. Gallery provides insurance, promotion and contract; artist pays for shipping. Requires artwork framed.

Submissions Accepts only artists from Hawaii for Maui gallery; coastal and wildlife imagery for California galleries; California painting and American crafts in Carmel gallery; interested in Central California Coast imagery for Pebble Beach gallery. Send query letter with résumé, slides, bio, brochure, photographs, SASE mandatory if presentation is to be returned, business card and reviews. Write for appointment to show portfolio of photographs, slides and transparencies. Responds in 2 weeks.

CONTEMPORARY CENTER

2630 W. Sepulveda Blvd., Torrance CA 90505. (310)539-1933. Fax: (310)539-0724. **Director:** Sharon Fowler. Retail gallery. Estab. 1953. Represents 150 emerging, mid-career and established artists. Exhibited artists include Steve Main, Cheryl Williams. Open all year; Tuesday-Saturday, 10-6; Sunday 12-5; closed Monday. Space is 5,000 sq. ft. "We sell contemporary American crafts along with contemporary production and handmade furniture." Clientele: private collectors, gift seekers, many repeat customers. Overall price range $20-800; most work sold at $20-200.

Media Considers paper, sculpture, ceramics, fiber and glass.

Terms Retail price set by the gallery and the artist.

Submissions Send query letter with brochure, slides and photographs. Call for appointment to show portfolio of photographs and slides. Responds in 2 weeks. Finds artists through word of mouth and attending craft shows.

Tips "Be organized with price, product and realistic ship dates."

PATRICIA CORREIA GALLERY

2525 Michigan Ave., Bergamot Station #E2, Santa Monica CA 90404. (310)264-1760. Fax: (310)264-1762. E-mail: correia@earthlink.net. Web site: www.correiagallery.com. **Director:** Patricia Correia. Associate Director: Rae Anne Robinett. Retail gallery. Estab. 1991. Represents 8 established artists only (at museum level). Exhibited artists include Patssi Valdez and Frank Romero. Sponsors 8 shows/year. Average display time 6 weeks. Open all year. 80% of space for special exhibitions; 20% of space for gallery artists. Clientele: upper middle class. 70% private collectors, 10% corporate collectors, 20% museum collection. Overall price range $500-100,000; most work sold at $10,000-20,000.

• Located in fashionable Bergamot Station, arts district surrounded by other interesting galleries.

Media Considers all media.

Style Exhibits contemporary art.

Terms Accepts work on consignment (50% commission). Retail price set by gallery and artist. Gallery provides insurance, promotion, contract and shipping costs from gallery.

Submissions Must be collected by museums.

Tips "The role as a dealer is different in contemporary time. It is as helpful for the artist to learn how to network with museums, press and the art world, as well as the gallery doing the same. It takes creative marketing on both parts. Please include your résumé, cover letter and slides with dimensions, median and retail price. Visit the gallery first and know their policies."

CREATIVE GROWTH ART CENTER GALLERY

355 24th St., Oakland CA 94612. (510)836-2340. Fax: (510)836-0769. E-mail: creativg@dnai-com. **Executive Director:** Irene Ward Brydon. Nonprofit gallery. Estab. 1978. Represents 100 emerging and established artists; 100 adults with disabilities work in our adjacent studio. Exhibited artists include Dwight Mackintosh, Nelson Tygart. Sponsors 10 shows/year. Average display time 5 weeks. Open all year; Monday-Friday, 10-4. Located downtown; 1,200 sq. ft.; classic large white room with movable walls, track lights; visible from the street. 25% of space for special exhibitions; 75% of space for gallery artists. Clientele private and corporate collectors. 90% private collectors, 10% corporate collectors. Overall price range $50-4,000; most work sold at $100-250.

● This gallery concentrates mainly on the artists who work in an adjacent studio, but work from other regional or national artists may be considered for group shows. Only outsider and brut art are shown. Brut art is like Brut champagneraw and undistilled. Most of the artists have not formally studied art, but have a raw talent that is honest and real with a strong narrative quality.

Media Considers oil, acrylic, watercolor, pastel, pen & ink, drawing, mixed media, collage, paper, sculpture, ceramics, fiber, woodcuts, engravings, lithographs, wood engravings, mezzotints, serigraphs, linocuts and etchings. Most frequently exhibits (2-D) drawing and painting, (3-D) sculpture, hooked rug/tapestries.

Style Exhibits expressionism, primitivism, color field, naive, folk art, brut. Genres include landscapes, florals and figurative work. Prefers brut/outsider, contemporary, expressionistic.

Terms Accepts work on consignment (40% commission). Retail price set by the gallery. Gallery provides insurance, promotion and contract; artist pays shipping costs to and from gallery. Prefers artwork framed.

Submissions Prefers only brut, naive, outsider; works by adult artists with disabilities. Send query letter with résumé, slides, bio. Write for appointment to show portfolio of photographs and slides. Responds only if interested. Files slides and printed material. Finds artists through agents, by visiting exhibitions, word of mouth, various art publications and sourcebooks, submissions and networking.

Tips "Peruse publications that feature brut and expressionistic art (example *Raw Vision*).'

CUESTA COLLEGE ART GALLERY

P.O. Box 8106, San Luis Obispo CA 93403-8106. (805)546-3202. Fax: (805)546-3904. E-mail: pmckenna@cuesta. edu. Web site: academic.cuesta.cc.ca.us/finearts/gallery.htm. **Contact:** Pamela McKenna, gallery assistant. Nonprofit gallery. Estab. 1965. Exhibits the work of emerging, mid-career and established artists. Exhibited artists include Italo Scanga and JoAnn Callis. Sponsors 5 shows/year. Average display time 4½ weeks. Open all year. Space is 1,300 sq. ft.; 100% of space for special exhibitions. Overall price range $250-5,000; most work sold at $400-1,200.

Media Considers all media and all types of prints. Most frequently exhibits painting, sculpture and photography.

Style Exhibits all styles, mostly contemporary.

Terms Accepts work on consignment (20% commission). Retail price set by artist. Customer payment by installment available. Gallery provides insurance, promotion and contract; shipping costs are shared. Prefers artwork framed.

Submissions Send query letter with résumé, slides, bio, brochure, SASE and reviews. Call for appointment to show portfolio. Responds in 6 months. Finds artists mostly by reputation and referrals, sometimes through slides.

Tips "We have a medium budget, thus cannot pay for extensive installations or shipping. Present your work legibly and simply. Include reviews and/or a coherent statement about the work. Don't be too slick or too sloppy."

D5 PROJECTS

2525 Michigan Ave., Santa Monica CA 90404. (310)315-1937. Fax: (310)315-9688. E-mail: berman@artnet.net. Web site: www.robertbermangallery.com. **Contact:** Manager. For profit gallery. Approached by 200 artists/ year; exhibits 25 mid-career artists. Sponsors 12 exhibits/year. Average display time 1 month. Open Tuesday-Saturday, 11-6. Closed December 24-January 1 and the last 2 weeks of August. Located in Bergamot Station Art Center in Santa Monica. Clients include local community, students, tourists, and upscale. Overall price range $600-30,000; most work sold at $4,000.

Media Considers all media. Most frequently exhibits oil on canvas.

Style Considers contemporary.

Making Contact & Terms Artwork is accepted on consignment. Retail price set by the gallery and the artist. Gallery provides insurance and promotion.

Submissions "We currently accept submissions via e-mail ONLY as URL address or no more than 3 images sent as attachments, JPEG or GIF. All three not to exceed 1.5 MB total. Images exceeding 1.5 MB will not be considered. If we receive slide submissions without a SASE, they will not be considered."

FALKIRK CULTURAL CENTER

1408 Mission Ave., P.O. Box 151560, San Rafael CA 94915-1560. (415)485-3328. Fax: (415)485-3404. Web site: www.falkirkculturalcenter.org. Nonprofit gallery. Estab. 1974. Approached by 500 artists/year. Exhibits 350 emerging, mid-career and established artists. Sponsors 8 exhibits/year. Average display time 2 months. Open Tuesday, Wednesday, Thursday, 1-5; Saturday, 10-1. Closed Sundays. Three galleries located on second floor with lots of natural light (UV filtered). National historic place (1888 Victorian) converted to multi-use cultural center. Clients include local community, students, tourists and upscale.

Media Considers all media and all types of prints. Most frequently exhibits painting, sculpture and works on paper.

Making Contact & Terms Artwork is accepted on consignment, and there is a 30% commission. Retail price set by the artist. Gallery provides insurance. Prefers only Marin County artists.

Submissions Marin County and San Francisco Bay Area artists only. Send artist's statement, bio, résumé and slides. Returns material with SASE. Responds within 3 months.

FRESNO ART MUSEUM

2233 N. First St., Fresno CA 93703. (559)441-4221. Fax: (559)441-4227. E-mail: info@fresnoartmuseum.org. Web site: www.fresnoartmuseum.org. **Executive Director:** Carlos Martinez. Associate Curator: Jacquelin Pilar. Estab. 1948. Exhibitions change approximately every 8 weeks. Exhibited artists for 2004/2005 include Olga Seem, Frank Lobdell, Hardy Hanson, Robert Cremean and Jusy Tuwaletstiwa. Open Tuesday-Sunday, 11-5; and until 8 on Thursdays. Accredited by AAM.

Media Considers acrylic, ceramics, collage, drawing, glass, installation, mixed media, oil, paper, pastel, pen & ink, sculpture and watercolor. Most frequently exhibits painting, sculpture and prints. Types of prints include engravings, etchings, linocuts, lithographs, serigraphs, woodcuts and fine books.

Style Exhibits contemporary and modernist art.

Making Contact & Terms Museum does not take commission. Retail price set by the artist. Gallery provides insurance.

Submissions Write to arrange a personal interview to show portfolio of transparencies and slides or mail portfolio for review. Send query letter with bio, résumé and slides. Files letters and bio/résumé. Finds artists through portfolio reviews and art exhibits.

SHERRY FRUMKIN/SHERRY DUVAL GALLERY

Bergamot Station T-1, Santa Monica CA 90404. (310)453-1850. Fax: (310)453-8370. E-mail: Frumkingal@aol.com. **Director:** Sherry Frumkin. Retail gallery. Estab. 1990. Represents 20 emerging, mid-career and established artists. Interested in seeing the work of emerging artists. Exhibited artists include Ron Pippin, Tanja Rector, Robert Russell. Sponsors 11 shows/year. Average display time 5 weeks. Open all year; Tuesday-Saturday, 1030-530. Located in the Bergamot Station Arts Center; 3,000 sq. ft. in converted warehouse with 16 ft. ceilings, skylights. 25% of space for special exhibitions; 75% of space for gallery artists. Clientele upscale, creative arts, i.e. directors, actors, producers. 80% private collectors, 20% corporate collectors. Overall price range $1,000-25,000; most work sold at $2,000-5,000.

Media Considers oil, acrylic, mixed media, collage, pen & ink, sculpture, ceramic and installation. Most frequently exhibits assemblage sculpture, paintings and photography.

Style Exhibits expressionism, neo-expressionism, conceptualism, painterly abstraction and postmodern works. Prefers expressionism, painterly abstraction and postmodern.

Terms Accepts work on consignment (50% commission). Retail price set by gallery and artist. Offers payment by installments. Gallery provides insurance and promotion. Prefers artwork framed.

Submissions Send query letter with résumé, slides, reviews and SASE. Portfolio review requested if interested in artist's work. Portfolio should include slides and transparencies. Responds in 1 month. Files résumé and slides.

Tips "Present a coherent body of work, neatly and professionally presented. Follow up, but do not become a nuisance."

GALLERY BERGELLI

483 Magnolia Ave., Larkspur CA 94939. (415)945-9454. Fax: (415)945-0311. E-mail: rcritelli@bergelli.com. Web site: www.gallerybergelli.com. **Contact:** Robin Critelli, owner. For-profit gallery. Estab. 2000. Approached by 200 artists/year; exhibits 15 emerging artists/year. Exhibited artists include Jeff Faust and James Leonard (acrylic painting). Sponsors 8-9 exhibits/year. Average display time 6 weeks. Open all year; Tuesday-Saturday, 10-5; Sunday, 12-5. "We're located in affluent Marin County, just across the Golden Gate Bridge from San Francisco. The Gallery is in the center of town, on the main street of Larkspur, a charming village known for its many fine restaurants. It is spacious and open with 2,500 square feet of exhibition space with large window across the front of the building. Moveable hanging walls (see the home page of our Web site) give us great flexibility to customize the space to best show the current exhibition." Clients include local community, upscale in the Marin County & Bay Area. Overall price range is $2,000-26,000; most work sold at $4,000-10,000.

Media Considers acrylic, collage, mixed media, oil, pastel, sculpture. Most frequently exhibits acrylic, oil and sculpture.

Style Exhibits geometric abstraction, imagism, new-expressionism, painterly abstraction, postmodernism, surrealism. Most frequently exhibits painterly abstraction, imagism and neo-expressionism.

Terms Artwork is accepted on consignment and there is a 50% commission. Retail price set by the artist with gallery input. Gallery provides insurance and promotion. Accepted work should be matted, stretched, unframed

and ready to hang. Requires exclusive representation locally. Artwork evidencing geographic and cultural differences is viewed favorably.

Submissions Mail portfolio for review or send query letter with artist's statement, bio, brochure, business card, photographs, résumé, reviews, SASE and slides. Returns material with SASE. Responds to queries in 1 month. Files material not valuable to the artist (returns slides) that displays artist's work. Finds artists through art exhibits, portfolio reviews, referrals by other artists, submissions and word of mouth.

Tips "Your submission should be about the artwork, the technique, the artist's accomplishments, and perhaps the artist's source of creativity. Many artist's statements are about the emotions of the artist, which is irrelevant when selling paintings."

GREENLEAF GALLERY

20315 Orchard Rd., Saratoga CA 95070. (408)867-3277. **Owner:** Janet Greenleaf. Director: Chris Douglas. Collection and art consultancy and advisory. Estab. 1979. Represents 45 to 60 emerging, mid-career and established artists. By appointment only. "Features a great variety of work in diverse styles and media. We have become a resource center for designers and architects, as we will search to find specific work for all clients." Clientele professionals, collectors and new collectors. 50% private collectors, 50% corporate clients. Prefers "very talented emerging or professional full-time artistsalready established." Overall price range $400-15,000; most artwork sold at $500-8,000.

Media Considers oil, acrylic, watercolor, pastel, mixed media, collage, works on paper, sculpture, glass, original handpulled prints, lithographs, serigraphs, etchings and monoprints.

Style Deals in expressionism, neo-expressionism, minimalism, impressionism, realism, abstract work or "whatever I think my clients want—it keeps changing." Traditional, landscapes, florals, wildlife, figurative and still lifes.

Terms Artwork is accepted on consignment. "The commission varies." Artist pays for shipping or shipping costs are shared.

Submissions Send query letter, résumé, 6-12 photographs (but slides OK), bio, SASE, reviews and "any other information you wish." Call or write to schedule an appointment for a portfolio review, which should include originals. If does not reply, the artist should call. Files "everything that is not returned. Usually throw out anything over two years old." Finds artists through visiting exhibits, referrals from clients, or artists, submissions and self promotions.

Tips "Send good photographs with résumé and ask for an appointment. Send to many galleries in different areas. It's not that important to have a large volume of work. I would prefer to know if you are full time working artist and have representation in other galleries."

JUDITH HALE GALLERY

2890 Grand Ave., P.O. Box 884, Los Olivos CA 93441-0884. (805)688-1222. Fax: (805)688-2342. E-mail: info@judithhalegallery.com. Web site: www.judithhalegallery.com. **Owner:** Judy Hale. Retail gallery. Estab. 1987. Represents 70 mid-career and established artists. Exhibited artists include Dirk Foslien, Howard Carr, Kelly Donovan and Mehl Lawson. Sponsors 4 shows/year. Average display time 6 months. Open all year. Located downtown; 2,100 sq. ft.; "the gallery is eclectic and inviting, an old building with six rooms." 20% of space for special exhibitions which are regularly rotated and rehung. Clientele: homeowners, tourists, decorators, collectors. Overall price range $500-15,000; most work sold at $500-5,000.

- This gallery opened a second location and connecting sculpture garden next door at 2884 Grand Ave. Representing nationally recognized artists, including Ted Goerschner, Marilyn Simandle, Dave DeMatteo, Dick Heichberger, this old building once housed the blacksmith's shop.

Media Considers oil, acrylic, watercolor, pastel, sculpture, engravings and etchings. Most frequently exhibits watercolor, oil, acrylic and sculpture.

Style Exhibits impressionism and realism. Genres include landscapes, florals, western and figurative work. Prefers figurative work, western, florals, landscapes, structure. No abstract or expressionistic.

Terms Accepts work on consignment (40% commission). Retail price set by artist. Offers payment by installments. Gallery arranges reception and promotion; artist pays for shipping. Prefers artwork framed.

Submissions Call ahead, or e -mail a link to your Web site, or a couple of representative images. This saves the mailing of slides, etc., and I don't have to return them. Send query letter with 10-12 slides, bio, brochure, photographs, business card and reviews. Call for appointment to show portfolio of photographs. Responds in 2 weeks. Files bio, brochure and business card.

Tips "Create a nice portfolio. See if your work is comparable to what the gallery exhibits. Do not plan your visit when a show is on; make an appointment for future time. I like 'genuine' people who present quality with fair pricing. Rotate artwork in a reasonable time, if unsold. Bring in your best work, not the 'seconds' after the show circuit."

HEARST ART GALLERY, SAINT MARY'S COLLEGE

P.O. Box 5110, St. Mary's College, Moraga CA 94575. (925)631-4379. Fax: (925)376-5128. E-mail: hdonner@stmarys-ca.edu. Web site: http//gallery.stmarys-ca.edu. **Contact**: Julie Armistead, Registrar/Collections Manager. Nonprofit gallery and museum. Estab. 1977. Exhibits mid-career and established artists. Approached by 100 artists/year. Most large exhibitions are either historic, invitational or ethnoraphic. Sponsors 5-6 exhibits/year. Average display time 8 weeks. Open Wednesday-Sunday, 11-4:30. Closed major holidays. Located on college campus, 1,650 square feet exhibition space. Clients include local community, students and tourists.
Media Considers all media. Considers engravings, etchings, lithographs, mezzotints, serigraphs, woodcuts.
Style Considers all styles and genres.
Terms Artwork is accepted on consignment and there is a 25% commision; 10% commission if artist has an area dealer or gallery taking a separate commission. Retail price set by the artist. Gallery provides insurance, promotion and contratct. Accepted work should be framed, mounted or matted as appropriate to media. Does not require exclusive representation locally.
Submissions Send query letter with bio, résumé, reviews, slides, or disks. Returns material with SASE. Responds to queries in 3 months. Finds artists through submissions, art exhibits, art fairs, and word-of-mouth.

JESSEL GALLERY

1019 Atlas Peak Rd., Napa CA 94558. (707)257-2350. E-mail: jessel@napanet.net. Web site: www.jesselgallery.com. **Owner:** Jessel Miller. Retail gallery. Represents 5 major artists. Exhibited artists include Clark Mitchell, Timothy Dixon and Jessel Miller. Sponsors 2-6 shows/year. Average display time 1 month. Open all year; 7 days/week 10:00-5:00. Located 1 mile out of town; 9,000 sq. ft. 20% of space for special exhibitions; 50% of space for gallery artists. Clientele upper income collectors. 95% private collectors, 5% corporate collectors. Overall price range $25-10,000; most work sold at $2,000-3,500.
Media Oil, acrylic, watercolor, pastel, collage, sculpture, ceramic and craft. Most frequently exhibits acrylic, watercolor and pastel.
Style Exhibits painterly abstraction, photorealism, realism and traditional. Genres include landscapes, florals and figurative work. Prefers figurative, landscape and abstract.
Terms Accepts work on consignment (50% commission). Retail price set by gallery. Gallery provides promotion; artist pays for shipping costs. Prefers artwork framed.
Submissions Send query letter with résumé, slides, bio, SASE and reviews. Call (after sending slides and background info) for appointment to show portfolio of photographs or slides. Responds in 1 month.

LA ARTISTS GALLERY

6650 Franklin Avenue, Hollywood CA 90028. (323)461-0047. Fax: (323)960-3357. E-mail: susan100art@yahoo.com. Web site: www.laartists.com. **Contact:** Susan Anderson, director. Alternative space. Estab. 2000. Approached by 25 artists/year. Represents 25 mid-career artists. Exhibited artists include Dan Shupe, Esau Andrade. Gallery not open to walk-ins. Open by appointment. Clients include upscale dealers, designers, private clients. 10% of sales are to corporate collectors. Overall price range $1,500-5,000.
Media Considers collage, oil, sculpture, watercolor. Most frequently exhibits oil on canvas. Considers all types of prints.
Style Exhibits neo-expressionism, postmodernism, figurative, contemporary, folk. Most frequently exhibits figurative/contemporary.
Terms Artwork is accepted on consignment and there is a 10-50% commission. Retail price set by the artist.
Submissions Write to arrange personal interview to show portfolio of photographs. Mail portfolio for review. Returns material with SASE. Does not reply to queries. File work I can sell.
Tips ''Keep submissions really short and enclose photographs, not slides.''

LIZARDI/HARP GALLERY

P.O. Box 91895, Pasadena CA 91109. (626)791-8123. Fax: (626)791-8887. E-mail: lizardiharp@earthlink.net. **Director:** Grady Harp. Retail gallery and art consultancy. Estab. 1981. Represents 15 emerging, mid-career and established artists/year. Exhibited artists include Wes Hempel, Gerard Huber, Wade Reynolds, Robert Peterson and William Fogg. Sponsors 4 shows/year. Average display time 2 months. Open all year; Tuesday-Saturday by appointment only. 80% private collectors, 20% corporate collectors. Overall price range $900-80,000; most work sold at $2,000-15,000.
Media Considers oil, acrylic, watercolor, pastel, pen & ink, drawing, mixed media, sculpture, installation, photography, lithographs, and etchings. Most frequently exhibits works on paper and canvas, sculpture, photography.
Style Exhibits representational art. Genres include landscapes, figurative work—both portraiture and narrative and still life. Prefers figurative, landscapes and experimental.

Galleries

Terms Accepts work on consignment (50% commission). Retail price set by the gallery and the artist. Gallery provides insurance, promotion, contract; artist pays shipping costs.

Submissions Send query letter with artist's statement, résumé, 20 slides, bio, photographs, SASE and reviews. Write for appointment to show portfolio of photographs, slides and transparencies. Responds in 1 month. Files "all interesting applications." Finds artists through studio visits, group shows, submissions.

Tips "Timelessness of message is a plus (rather than trendy). Our emphasis is on quality or craftsmanship, evidence of originality . . . and maturity of business relationship concept." Artists are encouraged to send an "artist's statement with application and at least one 4×5 or print along with 20 slides. Whenever possible, send images over the Internet via e-mail."

Ⓝ THE LOWE GALLERY

2030 Broadway, Santa Monica CA 90404.(310)449-0194. E-mail: info@lowegallery.com. Web site: www.lowegallery.com. For-profit gallery. Estab. 1989. Exhibits mid-career and established artists. Approached by 300 artists/year; represents 67 artists/year. Exhibited artists include Margarita Checa, Peruvian wood sculptress, working in olive wood and bronze; Thrush Holmes, Canadian painter, photocollage, mixed media including oil, acrylic, wax on wood. Sponsors 24 exhibits/year. Average display time 4-6 weeks. Open Tuesday - Friday, 10-5:30; Saturday, 11-5:30; closed Sunday & Mondays. Two galleries, one in Atlanta GA, 8,000 sq. ft.; Santa Monica CA, 6,000 sq. ft. Characterized by great architectural details including 22 ft. ceilings and exhibition spaces that rang from monumental to intimate. Clients include local community, tourists and upscale. 10% of sales are to corporate collectors. Overall price range: $1,000-$5,000,000; most work sold at $7,500-20,000.

Media Considers all medias excluding craft and installation. Most frequently exhibits oil, encaustic, bronze. Considers etchings, woodcuts.

Style Exhibits expressionism, geometric abstraction, postmodernism, primitivism realism, painterly abstractions. Scope ranges from complex, narratively-driven, figurative works to those which skew the extremes of meditative minimalism. Mostly frequently exhibits figurative work, landscapes and all forms of high-end contemporary.

Terms Artwork is accepted on consignment and there is a 50% commission. Retail price set by the gallery. Gallery provides insurance, promotion and contract. Accepted work must be framed, mounted or matted. Requires exclusive representation locally.

Submissions Send query letter with artist' s statement, bio, photographs, résumé, reviews and SASE. Returns material with SASE. Responds to queries in 6 months. Finds artists through art fairs, art exhibits, portfolio reviews, referrals by other artists, submissions and word-of-mouth.

Tips "Look at the type of work that the gallery already represents and make sure your work is on aesthetic fit first! Lots of great images of your work, dimensions and pricing."

ORANGE COUNTY CENTER FOR CONTEMPORARY ART

117 N. Sycamore St., Santa Ana CA 92701. (714)667-1517. E-mail: grau@prodigy.net. Web site: www.occca.org. **Exhibitions Director:** Pamela Grau Twena. Cooperative, nonprofit gallery. Exhibits emerging and mid-career artists. 26 members. Sponsors 12 shows/year. Average display time 1 month. Open all year; Thursday-Sunday 12-5 pm, and Friday and Saturday 12-8 pm. Opening receptions first Saturday of the months. Member participation is 5 hours per month gallery sitting + montly business meeting. $30 per membership fee. 5,500 sq. ft. 25% of time for special exhibitions; 75% of time for gallery artists.

Media Considers all media-contemporary work.

Terms Co-op membership fee plus a donation of time. Retail price set by artist.

Submissions Accepts artists generally in and within 50 miles of Orange County. Send query letter with SASE. Responds in 1 week.

Tips "This is an artist-run nonprofit. Send SASE for application prospectus. Membership means 20 hours monthly working in and for the gallery and programs; educational outreach; specific theme special exhibitions; hands-on gallery operations and professional career development."

ORLANDO GALLERY

18376 Ventura Blvd., Tarzana CA 91356. (818)705-5368. E-mail: orlando2@earthlink.com. Web site: www.empken.com/orlando.html. **Co-Directors:** Robert Gino and Don Grant. Retail gallery. Estab. 1958. Represents 30 emerging, mid-career and established artists. Sponsors 22 solo shows/year. Average display time is 1 month. Accepts only California artists. Overall price range up to $50,000; most artwork sold at $800. Open Tuesday-Saturday, 9:30-3:30.

Media Considers oil, acrylic, watercolor, pastel, pen & ink, drawings, mixed media, collage, works on paper, sculpture, ceramic and photography. Most frequently exhibits oil, watercolor and acrylic.

Style Exhibits painterly abstraction, conceptualism, primitivism, impressionism, photorealism, expressionism, neo-expressionism, realism and surrealism. Genres include landscapes, florals, Americana and figurative work.

Prefers impressionism, surrealism and realism. Interested in seeing work that is contemporary. Does not want to see decorative art. Also on exhibit is tribal African art.

Terms Accepts work on consignment. Retail price set by artist. Offers customer discounts and payment by installments. Exclusive area representation required. Gallery provides insurance and promotion; artist pays for shipping.

Submissions Send query letter, résumé and 12 or more slides. Portfolio should include slides and transparencies. Finds artists through submissions. Portfolio may be sent by e-mail.

Tips "Be inventive, creative and be yourself."

SAN DIEGO ART INSTITUTE (SDAI: Museum of the Living Artist)

House of Charm, Balboa Park, San Diego CA 92101-1617. (619)236-0011. Fax: (619)236-1974. E-mail: director@ sandiego-art.org. Web site: www.sandiego-art.org. **Executive Director:** Timothy J. Field. Membership Associate: Kerstin Robers. Art Director: K.D. Benton. Nonprofit gallery. Estab. 1941. Represents 600 emerging and mid-career member/artists. 2,400 artworks juried into shows each year. Sponsors 11 all-media exhibits/year. Average display time 4-6 weeks. Open Tuesday-Saturday, 10-4; Sunday 12-4. Closed major holidays—all Mondays. 10,000 sq. ft. located in the heart of Balboa Park. Clients include local community, students and tourists. 10% of sales are to corporate collectors. Overall price range $100-4,000. Most work sold at $800.

Media Considers all media and all types of prints. Most frequently exhibits oil, mixed media and pastel.

Style Considers all styles and genres. No craft or installations.

Making Contact & Terms Artwork is accepted on consignment, and there is a 40% commission. Membership fee $125. Retail price set by the artist. Accepted work should be framed. Work must be hand carried in for each monthly show except for annual international show juried by slides.

Submissions Request membership packet and information about juried shows. Membership not required for submittal in monthly juried shows, but fee required. Returns material with SASE. Finds artists through word of mouth and referrals by other artists.

Tips "All work submitted must go through jury process for each monthly exhibition. Work required to be framed in professional manner."

JILL THAYER GALLERIES AT THE FOX

1700 20th St., Bakersfield CA 93301-4329. (661)328-9880. E-mail: jill@jillthayer.com. Web site: www.jillthayer. com. **Director:** Jill Thayer. For profit gallery. Estab. 1994. Represents 25+ emerging, mid-career and established artists of regional and international recognition. Features 6-8 exhibits/year. Average display time 6 weeks. Open Friday-Saturday, 1 p.m.-4 p.m. or by appointment. Closed holidays. Located at the historic Fox Theater, built in 1930. Thayer renovated the 400 sq. ft. space in 1994. The space features large windows, high ceilings, wood floor and bare wire, SoLux halogen lighting system. Clients include regional southern California upscale. 25% of sales are to corporate collectors. Overall price range $250-10,000; most work sold at $2,500.

Media Considers all media, originals only. Exhibits painting, drawing, photography, sculpture, assemblage, glass.

Style Exhibits contemporary, abstract, and representational work.

Terms Artwork is accepted on consignment for duration of exhibit with 50% commission. Artist pays all shipping and must provide insurance. Retail price set by the gallery and the artist. Gallery provides marketing, mailer design, and partial printing. Artist shares cost of printing, mailings and receptions.

Submissions Send query letter with artist's statement bio, résumé, exhibition list, reviews, SASE and 12 slides. Responds in 1 month if interested. Finds artists through submissions and portfolio reviews.

Tips "When submitting to galleries, be concise, professional, send up-to-date package (art and info) and slide sheet of professionally documented work."

NATALIE AND JAMES THOMPSON ART GALLERY

School of Art Design, San Jose CA 95192-0089. (408)924-4723. Fax: (408)924-4326. E-mail: jfh@cruzio.com. Web site: www.sjsu.edu. **Contact:** Jo Farb Hernandez, director. Nonprofit gallery. Approached by 100 artists/ year. Sponsors 6 exhibits/year of emerging, mid-career and established artists. Average display time 1 month. Open during academic year; Tuesday, 11-4, 6-7:30; Wednesday-Friday, 11-4. Closed semester breaks, summer and weekends. Clients include local community, students and upscale.

Media Considers all media and all types of prints.

Style Considers all styles and genres.

Terms Retail price set by the artist. Gallery provides insurance, transportation and promotion. Accepted work should be framed and/or ready to display. Does not require exclusive representation locally.

Submissions Send query letter with artist's statement, bio, résumé, reviews, SASE and slides. Returns material with SASE.

THE WING GALLERY

13632 Ventura Blvd., Sherman Oaks CA 91423. (818)981-WING and (800)422-WING. Fax: (818)981-ARTS. E-mail: robin@winggallery.com. Web site: www.winggallery.com. **Director:** Robin Wing. Retail gallery. Estab. 1975. Represents 100+ emerging, mid-career and established artists. Exhibited artists include Doolittle and Wysocki. Sponsors 6 shows/year. Average display time 2 weeks-3 months. Open all year. Located on a main boulevard in a charming freestanding building, carpeted; separate frame design area. 60% of space for special exhibitions. Clientele 90% private collectors, 10% corporate collectors. Overall price range $50-$50,000; most work sold at $150-$5,000.

Media Considers oil, acrylic, watercolor, pen & ink, drawings, sculpture, ceramic, craft, glass, original hand-pulled prints, offset reproductions, engravings, lithographs, monoprints and serigraphs. Most frequently exhibits offset reproductions, watercolor and sculpture.

Style Exhibits primitivism, impressionism, realism and photorealism. Genres include landscapes, Americana, Southwestern, western, wildlife and fantasy.

Terms Accepts work on consignment (40-50% commission). Retail price set by gallery and artist. Sometimes offers customer discounts and payment by installments. Gallery provides insurance, promotion and contract; shipping costs are shared. Prefers unframed artwork.

Submissions Send query letter with résumé, slides, bio, brochure, photographs, SASE, reviews and price list. "Send complete information with your work regarding price, size, medium, etc., and make an appointment before dropping by." Portfolio reviews requested if interested in artist's work. Responds in 2 months. Files current information and slides. Finds artists through agents, by visiting exhibitions, word of mouth, various publications, submissions, and referrals.

Tips Artists should have a "professional presentation" and "consistent quality."

LOS ANGELES

ACADEMY GALLERY

8949 Wilshire Blvd., Beverly Hills CA 90211. (310)247-3000. Fax: (310)247-3610. E-mail: gallery@oscars.org. Web site: www.oscars.org. **Contact:** Ellen Harrington. Nonprofit gallery. Estab. 1992. Exhibitions focus on all aspects of the film industry and the filmmaking process. Sponsors 3-5 exhibitions/year. Average display time 3 months. Open all year; Tuesday-Friday, 10-5; weekends 12-6. Gallery begins in building's Grand Lobby and continues on the 4th floor. Total square footage is approx. 8,000. Clients include students, senior citizens, film aficionados and tourists.

Submissions Call or write to arrange a personal interview to show portfolio of photographs, slides and transparencies. Must be film process or history related.

CRAFT & FOLK ART MUSEUM (CAFAM)

5814 Wilshire Blvd., Los Angeles CA 90036. (323)937-4230. Fax: (323)937-5576. E-mail: info@cafam.org. **Director:** Maryna Hrushetska. Museum. Estab. 1973. Sponsors 3-4 shows/year. Average display time 2-3 months. Open all year; Tuesday-Sunday 11-5; closed Monday. Located on Miracle Mile; features design, contemporary crafts, international folk art.

Media Considers all media, woodcut and wood engraving. Most frequently exhibits ceramics, found objects, wood, fiber, glass, textiles.

Style Exhibits all styles, all genres. Prefers culturally specific, craft and folk art.

Submissions Send query letter with résumé, slides and bio. Write for information. Portfolio should include slides. Finds artists through written submissions, word of mouth and visiting exhibits.

DEL MANO GALLERY

11981 San Vicente Blvd., W. Los Angeles CA 90049. (310)476-8508. E-mail: gallery@delmano.com. Web site: www.delmano.com. **Contact:** Kirsten Muenster, director of exhibitions. Retail gallery. Estab. 1973. Represents more than 300 emerging, mid-career and established artists. Interested in seeing the work of emerging artists working in wood, glass, ceramics, fiber and metals. Gallery deals heavily in turned and sculpted wood, showing work by David Ellsworth, William Hunter and Ron Kent. Gallery hosts approximately 5 exhibitions per year. Average display time 2-6 months. Open Tuesday-Sunday. Gallery located in Brentwood (a scenic corridor). Space is 3,000 sq. ft. 25% of space for special exhibitions; 75% of space for gallery artists. Clientele professionals and affluent collectors. 20% private collectors, 5% corporate collectors. Overall price range $50-20,000; most work sold at $250-5,000.

Media Considers contemporary art in craft mediaceramics, glass, jewelry, wood, fiber. No prints. Most frequently exhibits wood, glass, ceramics, fiber, metal and jewelry.

Style Exhibits all styles and genres.

Terms Accepts work on consignment (50% commission) or 30 days net. Retail price set by gallery and artist. Customer discounts and payment by installment are available. 10-mile exclusive area representation required. Gallery provides insurance, promotion and shipping costs from gallery. Prefers artwork framed.
Submissions Send query letter with résumé, slides, bio and prices. Portfolio should include slides, price list, artist's statement and bio.

▤ GALLERY 825, LA Art Association

825 N. La Cienega Blvd., Los Angeles CA 90069. (310)652-8272. Fax: (310)652-9251. **ExecutiveDirector:** Peter Mays. Artistic Director: Sinead Finnerty. Nonprofit gallery. Estab. 1925. Exhibits emerging and established artists. "Artists must be Southern California-based." Interested in seeing the work of emerging artists. Approximately 200 members. Sponsors 11 juried shows/year. Average display time 3-4 weeks. Open all year; Tuesday-Saturday, 12-5. Located in Beverly Hills/West Hollywood. 25% of space for special exhibitions (2 rooms); 75% for gallery artists (2 large main galleries). Clientele set decorators, interior decorators, general public. 90% private collectors.
Media Considers all media and original handpulled prints. "Fine art only. No crafts." Most frequently exhibits mixed media, oil/acrylic and watercolor.
Style All styles.
Terms Requires $ 225 annual membership fee plus entry fees or 6 hours volunteer time for artists. Retail price set by artist (33% commission). Gallery provides promotion. "No shipping allowed." "Artists must apply via jury process held at the gallery 2 times per year in February and August." Phone for information.
Tips "No commercial work (i.e. portraits/advertisements)."

BEN MALTZ GALLERY AT OTIS COLLEGE OF ART & DESIGN

9045 Lincoln Blvd., Los Angeles CA 90045. (310)665-6905. Fax: (310)665-6908. E-mail: galleryinfo@otis.edu. Web site: www.otis.edu. **Gallery Director:** Meg Linton. Nonprofit gallery. Estab. 1957. Represents emerging and mid-career artists. Sponsors 4-6 exhibits/year. Average display time 1-2 months. Open Tuesday-Saturday, 10-5; Thursday, 10-7; closed major holidays. Located near Los Angeles International Airport (LAX). Approximately 3,520 sq. ft., wall height 14 ft. Clients include local community, students, tourists, upscale and artists.
Media Considers all media and all types of prints. Most frequently exhibits painting, mixed media. Finds artists through word of mouth, art exhibits, referrals by other artists.
Submissions Submit reproductions (slides, CD, DVD, video, photographs) with complete information, artist statement, and curriculum vitae, résumé or bio.
Tips Submit good quality 35mm slides of artwork—with information (name, title, date, media, dimensions) on slide—be patient. Submit reproductions (slides, CD, DVD, video, photographs) with complete information, artist statement, and curriculum vitae, résumé or bio.

SAN FRANCISCO

AUROBORA PRESS

147 Natoma St., San Francisco CA 94105. (415)546-7880. Fax: (415)546-7881. E-mail: monotype@aurobora.c om. Web site: www.aurobora.com. **Directors:** Michael Liener. Retail gallery and fine arts press. Invitational Press dedicated to the monoprint and monotype medium. Estab. 1993. Represents/exhibits emerging, mid-career and established artists. Exhibited artists include William T. Wiley, David Ireland, Stephan DeStaebler, Tony Delap. Sponsors 10 shows/year. Average display time 4-6 weeks. Open all year; Monday-Saturday, 11-5. Located south of MarketYerba Buena; 1,000 sq. ft.; turn of the century firehouseconverted into gallery and press area. Clientele collectors, tourists and consultants. Overall price range $1,200-6,000; most work sold at $1,500-4,000.

● Aurobora Press invites artists each year to spend a period of time in residency working with Master Printers.

Media Publishes monotypes.
Terms Retail price set by gallery and artist. Gallery provides promotion.
Submissions By invitation only.

CATHARINE CLARK GALLERY

49 Geary St., Second Floor, San Francisco CA 94108-5705. (415)399-1439. Fax: (415)399-0675. E-mail: morphos @cclarkgallery.com. Web site: www.cclarkgallery.com. **Owner/Director:** Catharine Clark. Retail gallery. Estab. 1991. Represents 25+ emerging and mid-career artists. Curates 8-12 shows/year. Average display time 4-6 weeks. Open all year. Located downtown San Francisco; 3,000 sq. ft., including video project room. 90% of

space for special exhibitions. Clientele 95% private collectors, 5% corporate collectors. Overall price range $200-$300,000; most work sold at $2,000-$5,000.

Media Considers painting, sculpture, installation, photography, printmaking, video and new genres. Most frequently exhibits painting, sculpture, installation and new genres.

Style Exhibits all styles and genres.

Terms Accepts work on consignment (50% commission). Retail price set by gallery and artist. Offers customer payment by installments. Gallery provides insurance, promotion and contract; shipping costs are shared. Prefers artwork framed.

Submissions Submission review is limited. Send query e-mail before sending submissions. Submissions will not be returned without SASE.

INTERSECTION FOR THE ARTS

446 Valencia, San Francisco CA 94103. (415)626-2787. Fax: (415)626-1636. E-mail: info@theintersection.org. Web site: www.theintersection.org. **Program Director:** Kevin B. Chen. Alternative space and nonprofit gallery. Estab. 1965. Exhibits the work of 10 emerging and mid-career artists/year. Sponsors 8 shows/year. Average display time 6 weeks. Open all year. Located in the Mission District of San Francisco; 1,000 sq. ft.; gallery has windows at one end and cement pillars betwen exhibition panels. 100% of space for special exhibitions. Clientele: 100% private collectors.

● This gallery supports emerging and mid-career artists who explore experimental ideas and processes. Interdisciplinary, new genre, video performance and installation are encouraged.

Media Considers oil, pen & ink, acrylic, drawings, watercolor, mixed media, installation, collage, photography, site-specific installation, video installation, original handpulled prints, woodcuts, lithographs, posters, wood engravings, mezzotints, linocuts and etchings.

Style Exhibits all styles and genres.

Terms Retail price set by artist. Customer discounts and payment by installment are available. Gallery provides promotion; shipping costs are shared.

Submissions Send query letter with résumé, 20 slides, reviews, bio, clippings and SASE. Portfolio review not required. Responds within 6 months only if interested and SASE has been included. Files slides.

Tips "Create proposals which consider the unique circumstances of this location, utilizing the availability of the theater and literary program/resources/audience."

THE LAB

2948 16th St., San Francisco CA 94103. (415)864-8855. Fax: (415)864-8860. Web site: www.thelab.org. **Co-directors:** Kristen Chappa and Sherry Koyama. Nonprofit gallery and alternative space. Estab. 1983. Exhibits numerous emerging, mid-career artists/year. Interested in seeing the work of emerging artists. Sponsors 5-7 shows/year. Average display time 1 month. Open all year; Wednesday-Saturday, 1-6. 40×55 ft.; 17 ft. height; 2,200 sq. ft.; white walls. Doubles as a performance and gallery space. Clientele: artists and Bay Area communities.

● The LAB often curates panel discussions, performances or other special events in conjunction with exhibitions. They also sponsor an annual conference and exhibition on feminist activism and art.

Media Considers all media with emphasis on interdisciplinary and experimental art. Most frequently exhibits installation art, interdisciplinary art, media art and group exhibitions.

Terms Artists receive honorarium from the art space. Work can be sold, but that is not the emphasis.

Submissions Submission guidelines online. Finds artists through word of mouth, submissions, calls for proposals.

Tips Ask to be put on their mailing list to get a sense of the LAB's curatorial approach and interests.

THE MEXICAN MUSEUM

Ft. Mason Center Bldg. D, San Francisco CA 94123. (415)202-9700. Fax: (415)441-7683. E-mail: curator@mexicanmuseum.org. Web site: www.mexicanmuseum.org. **Curator:** Tere Romo. Museum. Estab. 1975. Represents Mexican and Latino emerging, mid-career and established artists. Sponsors 3 exhibits/year. Average display time 3 months. Open Wednesday-Saturday, 11-5. Closed major holidays. Clients include local community, students, tourists and upscale.

Media Considers all media and all types of art.

Style Considers all styles. Most frequently exhibits modernist, popular and pre-conquest.

Submissions Send query letter with artist's statement, bio, brochure, business card, photocopies, photographs, résumé, reviews and slides. Responds only if interested and within 6 months.

MUSEO ITALOAMERICANO

Fort Mason Center Bldg. C, San Francisco CA 94123. (415)673-2200. Fax: (415)673-2292. E-mail: sfmuseo@sbcglobal.net. Web site: www.museoitaloamericano.org. Museum. Estab. 1978. Approached by 80 artists/year. Ex-

hibits 15 emerging, mid-career and established artists/year. Exhibited artists include Sam Provenzano. Sponsors 7 exhibits/year. Average display time 3-4 months. Open all year; Wednesday-Sunday, 12-4. Closed major holidays. Located in the San Francisco Marina District with beautiful view of the Golden Gate Bridge. 3,500 sq. ft. of exhibition space. Clients include local community, students, tourists, upscale and members.
Media Considers all media and all types of prints. Most frequently exhibits mixed media, paper, photography, oil, sculpture and glass.
Style Considers all styles and genres. Most frequently exhibits primitivism realism, geometric abstraction, figurative and conceptualism; 20th century and contemporary art.
Terms The museum sells pieces in agreement with the artist, and if it does, it takes 25% of the sale. Gallery provides insurance and promotion. Accepted work should be framed, mounted and matted. Accepts only Italian or Italian-American artists.
Submissions Submissions accepted with artist's statement, bio, brochure, photography, résumé, reviews, SASE and slides or CDs. Returns material with SASE. Responds in 2 months. Files 2 slides and biography and artist's statement for each artist. Finds artists through word of mouth and submissions.
Tips Looks for good quality slides and clarity in writing statements and résumés. "Be concise."

A NEW LEAF GALLERY/SCULPTURESITE.COM

SCULPTURESITE Gallery: 201 Third St., Suite 103, San Francisco CA 94103. (415)495-6400. E-mail: info@sculpt uresite.com. Hours: Tuesday-Saturday, 10-6; Thursday, 10-8. A NEW LEAF Gallery: Cornerstone Gardens, 23570 Arnold Drive (Hwy. 121), Sonoma CA 95476. (707)933-1300. info@sculpturesite.com. Hours: Thursday-Monday, 10-6; closed Tuesday and Wednesday. **Contact:** Brigitte Micmacker, curator. Retail gallery. Estab. 1990. Represents 100 emerging, mid-career and established artists. Sponsors 10 sculpture shows/year. Average display time 3-4 months. Clients include local community, USA and upscale. Overall price range $1,000-1,000,000; most work sold at $5,000-20,000.
Media Considers sculpture, mixed media, ceramic and glass. Most frequently exhibits sculpture. No crafts. "No paintings or works on paper, please."
Style Exhibits only contemporary abstract and abstract figurative.
Terms Accepts artwork on consignment (40-50% commission). Exclusive area representation required. Retail price set by artist in cooperation with gallery. Gallery provides insurance.
Submissions Check Web site for submission requirements; digital images best or send e-mail link to your site for review. Responds 2-3 times per year.
Tips "We suggest artists visit us if possible: these two galleries have unique settings. Sculpturesite is much more upscale. Sculpturesite.com, our extensive Web site, shows difference in the artwork shown at both galleries."

OCTAVIA'S HAZE GALLERY

498 Hayes St., San Francisco CA 94102. (415)255-6818. Fax: (415)255-6827. E-mail: octaviashaze@mindspring. com. Web site: www.octaviashaze.com. **Director:** Kelly Yount. For profit gallery. Estab. 1999. Approached by 60 artists/year. Represents 30 emerging and mid-career artists. Exhibited artists include Tsuchida Yasuhiko and James Michalopoulos. Sponsors 6 exhibits/year. Average display time 60 days. Open all year; Wednesday-Saturday, 12-6; Sunday, 12-5. Closed Christmas through New Years. Clients include local community, tourists and upscale. 13% of sales are to corporate collectors. Overall price range $200-6,000; most work sold at $600.
Media Most frequently exhibits glass, paintings (all media) and photography. Considers all types of prints.
Style Considers all styles. Most frequently exhibits abstract, surrealism and expressionism. Genres include figurative work and landscapes.
Terms Artwork is accepted on consignment and there is a 50% commission. Retail price set by the gallery. Gallery provides promotion and contract. Accepted work should be framed and matted.
Submissions Send query letter with artist's statement, résumé, SASE and slides. Returns material with SASE. Responds in 4 months. Finds artists through word of mouth, submissions and art exhibits.

COLORADO

THE BOULDER MUSEUM OF CONTEMPORARY ART

1750 13th St., Boulder CO 80302. (303)443-2122. Fax: (303)447-1633. E-mail: info@bmoca.org. Web site: www. bmoca.org. **Contact:** Exhibitions Committee. Nonprofit museum. Estab. 1972. Exhibits contemporary art and performance. Programs regional, national and international emerging and established artists. 10,000 sq. ft. of exhibition and performance spaces. "Located in a historically landmarked two-story, red-brick building in heart of downtown Boulder."
Media Considers all media.
Style Exhibits new art forms in the work of emerging and established artists.

Submissions Accepts work by invitation only, after materials have been reviewed by Exhibitions Committee. Send query letter, artist statement, résumé, approximately 20 high-quality slides or CD, outline of logistics if installation and SASE. Portfolio review requested if interested in artist's work. Submission review in January. Responds in 6 months. Submissions are filed. Additional materials appropriate to submission are accepted.

CORE NEW ART SPACE

900 Sante Fe Dr., Denver CO 80205. (303)297-8428. E-mail: art@corenewartspace.com. Web site: www.corenewartspace.com. **Directors:** M. Beneventi and Mark Monroe. Cooperative, alternative and nonprofit gallery. Estab. 1981. Exhibits 24 emerging and mid-career artists. Sponsors 10 solo and 6 group shows/year. Average display time 3 weeks. Open Thursday-Saturday. Open all year. Located Santa Fe Arts district. Accepts mostly artists from front range Colorado. Clientele 97% private collectors; 3% corporate clients. Overall price range $75-3,000; most work sold at $100-600.
Media Considers all media. Specializes in cutting edge work. Prefers quality rather than marketability.
Style Exhibits expressionism, neo-expressionism, painterly abstraction, conceptualism; considers all styles and genres, but especially contemporary and alternative (non-traditional media and approach), including installations.
Terms Co-op membership fee plus donation of time. Retail price set by artist. Exclusive area representation not required. Also rents annex space to non-members for $125-275/3 week run. Send slides for consideration to gallery attention Melissa Rackliff or contact her via e-amil: rackliff3@msn.com.
Submissions Send query letter with SASE. Quarterly auditions to show portfolio of originals, slides and photographs. Request membership application. "Our gallery gives an opportunity for emerging artists in the metro-Denver area to show their work. We run six open juried shows a year. There is an entry fee charged, and a 25% commission is taken on any work sold. The member artists exhibit in a two-person show once a year. Member artists generally work in more avant-garde formats, and the gallery encourages experimentation. Members are chosen by slide review and personal interviews. Due to time commitments we require that they live and work in the area." Finds artists through invitations, word of mouth, art publications.
Tips "We want to see challenging art. If your intention is to manufacture coffee-table and over-the-couch art for suburbia, we are not a good place to start."

N SUSAN DUVAL GALLERY

525 E. Cooper Ave., Aspen CO 81611. (970)925-9044. Fax: (970)925-9076. **Owner:** Susan Duval. Retail gallery. Estab. 1978. Represents 30 mid-career and established artists/year. Exhibited artists include Dale Chihuly and Theodore Waddell. Sponsors 5 shows/year. Average display time 3 weeks. Open all year; Monday-Saturday, 10-6. Located downtown; 2,500 sq. ft.; open plan, many windows. 60% of space for special exhibitions; 40% of space for gallery artists. Clientele tourists, upscale, local community. 90% private collectors, 10% corporate collectors. Overall price range $500-50,000; most work sold at $2,000-20,000.
Media Considers oil, paper, acrylic, sculpture, glass, mixed media, ceramics; types of prints include woodcuts and monoprints. Most frequently exhibits oil, acrylic and glass.
Style Exhibits expressionism, painterly abstraction and realism. Exhibits all genres.
Terms Accepts work on consignment (50% commission). Retail price set by the artist. Gallery provides promotion and pays for shipping from gallery; artist pays for shipping to gallery.
Submissions Send query letter with résumé, slides, photographs, reviews, bio and SASE. Write for appointment to show portfolio of photographs and slides. Finds artists through referrals by other artists and visiting art fairs and exhibitions.

GALLERY M

2830 E. Third Ave., Denver CO 80206. (303)331-8400. Fax: (303)331-8522. E-mail: newartists@gallerym.com. Web site: www.gallerym.com. **Contact:** Managing Partner. For-profit gallery. Estab. 1996. Represents emerging, mid-career and established artists. Exhibited artists include Alfred Elsenstaedt (photography). Average display time 6-12 weeks. Clients include local community, tourists and upscale. Overall price range $265 and up; most work sold at $1,000-5,000.
Media Considers acrylic, collage, drawing, glass, installation, mixed media, oil, paper, pastel, pen & ink, watercolor, engravings, etchings, linocuts, lithographs, mezzotints, serigraphs, woodcuts, photography and sculpture.
Style Exhibits color field, expressionism, geometric abstraction, neo-expressionism, postmodernism, primitivism, realism and surrealism. Considers all genres.
Terms Retail price set by the gallery and the artist. Gallery provides insurance and promotion. Requires exclusive local and regional representation.
Submissions Write to arrange a personal interview to show portfolio of photographs, slides and transparencies.

Mail portfolio for review. Returns materials with SASE. Finds artists through current artists represented, other gallery referral, museum referral and select art exhibits.

WILLIAM HAVU GALLERY

1040 Cherokee St., Denver CO 80204 (303)893-2360. Fax: (303)893-2813. E-mail: bhavu@mho.net. Web site: www.williamhavugallery.com. **Owner:** Bill Havu. Gallery Administrator: Nick Ryan. For-profit gallery. Estab. 1998. Approached by emerging, mid-career and established artists. Exhibits 50 artists. Exhibited artists include Emilio Lobato, painter and printmaker; Amy Metier, painter. Sponsors 7-8 exhibits/year. Average display time 6-8 weeks. Open all year; Tuesday-Friday, 10-6; Saturday, 11-5. Closed Sundays, Christmas and New Year's Day. Located in the Golden Triangle Arts District of downtown Denver. The only gallery in Denver designed as a gallery; 3,000 square feet, 18 foot high ceilings, 2 floors of exhibition space; sculpture garden. Clients include local community, students, tourists, upscale, interior designers and art consultants. Overall price range $250-18,000; most work sold at $1,000-4,000.
Media Considers acrylic, ceramics, collage, drawing, mixed media, oil, paper, pastel, pen & ink, sculpture and watercolor. Most frequently exhibits painting, prints. Considers etchings, linocuts, lithographs, mezzotints, woodcuts, monotypes, monoprints and silkscreens.
Style Exhibits expressionism, geometric abstraction, impressionism, minimalism, postmodernism, surrealism and painterly abstraction. Most frequently exhibits painterly abstraction and expressionism.
Terms Artwork is accepted on consignment and there is a 50% commission. Retail price set by the gallery and the artist. Gallery provides insurance, promotion and contract. Accepted work should be framed. Primarily accepts only artists from Rocky Mountain, Southwestern region.
Submissions Mail portfolio for review. Send query letter with artist's statement, bio, brochure, résumé, SASE and slides. Returns material with SASE. Responds only if interested within 1 month. Files slides and résumé, if we are interested in the artist. Finds artists through word of mouth, submissions and referrals by other artists.
Tips Always mail a portfolio packet. We do not accept walk-ins or phone calls to review work. Explore Web site or visit gallery to make sure work would fit with the gallery's objective. Archival-quality materials play a major role in selling fine art to collectors. We only frame work with archival-quality materials and feel its inclusion in work can "make" the sale.

PINE CREEK ART GALLERY

2419 W. Colorado Ave., Colorado Springs CO 80904. (719)633-6767. Web site: www.pinecreekgallery.com. **Owner:** Nancy Stovall. Retail gallery. Estab. 1991. Represents 10+ established artists. Exhibited artists include Lorene Lovell, Kirby Sattler, Karol Brown and Irene Braun. Average display time 4 months. Open all year Monday-Saturday, 10-6; Sunday, 11-5. 2,200 sq. ft.; in a National Historic District. 30% of space for special exhibitions. Clientele middle to upper income. Overall price range $30-5,000; most work sold at $100-500.
Media Considers most media, including bronze, pottery and all types of prints.
Style Exhibits all styles and genres.
Terms Accepts artwork on consignment (40% commission). Retail price set by gallery and artist. Gallery provides insurance, promotion and shipping costs from gallery. Prefers artwork "with quality frame only."
Submissions No fantasy or abstract art. Prefer experienced artists onlyno beginners. Send query letter with 6-12 slides and photographs. Call or write for appointment to show portfolio or originals, photographs, slides and tearsheets. Responds in 2 weeks.
Tips "Make sure your presentation is professional. We like to include a good variety of work, so show us more than one or two pieces."

SANGRE DE CRISTO ARTS CENTER AND BUELL CHILDREN'S MUSEUM

210 N. Santa Fe Ave., Pueblo CO 81003. (719)295-7200. Fax: (719)295-7230. E-mail: mail@sdc-arts.org. **Curator of Visual Arts:** Jina Pierce. Nonprofit gallery and museum. Estab. 1972. Exhibits emerging, mid-career and established artists. Sponsors 20 shows/year. Average display time 10 weeks. Open all year. Admission $4 adults; $3 children. Located "downtown, right off Interstate I-25"; 16,000 sq. ft.; six galleries, one showing a permanent collection of western art; changing exhibits in the other five. Also a new 12,000 sq. ft. children's museum with changing, interactive exhibits. Clientele: "We serve a 19-county region and attract 200,000 visitors yearly." Overall price range for artwork $50-100,000; most work sold at $50-2,500.
Media Considers all media.
Style Exhibits all styles. Genres include southwestern, regional and contemporary.
Terms Accepts work on consignment (40% commission). Retail price set by artist. Gallery provides insurance, promotion, contract and shipping costs. Prefers artwork framed.
Submissions "There are no restrictions, but our exhibits are booked into 2007 right now." Send query letter with portfolio of slides. Responds in 2 months.

PHILIP J. STEELE GALLERY AT ROCKY MOUNTAIN COLLEGE OF ART + DESIGN

1600 Pierce St., Lakewood CO 80214. (303)753-6046. Fax: (303)225-8610. E-mail: lspivak@rmcad.edu. Web site: www.rmcad.edu. **Gallery Director:** Lisa Spivak. For-profit college gallery. Estab. 1962. Represents emerging, mid-career and established artists. Sponsors 10-12 shows/year. Exhibited artists include Christo, Herbert Bayer, Andy Warhol and others. Average display time 1 month. Open all year; Monday-Friday, 12-5; Saturday, 12-5. Located between downtown Denver and the mountains; 1,700 sq. ft.; in very prominent location (art college with 450 students enrolled). 100% of space for gallery artists. Clientele: local community, students, faculty.

Media Considers all media and all types of prints.

Style Exhibits all styles.

Terms Artists sell directly to buyer; gallery takes no commission. Retail price set by the artist. Gallery provides insurance and promotion; artist pays shipping costs to and from gallery.

Submissions Send query letter with résumé, slides, bio, SASE and reviews by April 15 for review for exhibit the following year.

Tips Impressed by "professional presentation of materials, good-quality slides or catalog."

CONNECTICUT

ALVA GALLERY

54 State St., New London CT 06320. (860)437-8664. Fax: (860)437-8665. E-mail: Alva@Alvagallery.com. Web site: www.alvagallery.com. For-profit gallery. Estab. 1999. Approached by 50 artists/year. Represents 30 emerging, mid-career and established artists. Exhibited artists include Maureen McCabe (assemblage), Sol LeWitt (gouaches) and Judith Cotton (paintings). Average display time 6 weeks. Open all year; Tuesday-Saturday, 11-5. Closed between Christmas and New Year and last 2 weeks of August. Clients include local community, tourists and upscale. 5% of sales are to corporate collectors. Overall price range $250-10,000; most work sold at $1,500.

Media Considers acrylic, collage, drawing, fiber, glass, mixed media, oil, paper, pastel, pen & ink, sculpture and watercolor. Most frequently exhibits oil, photography and mixed media. Considers all types of prints.

Style Considers all styles and genres.

Terms Artwork is accepted on consignment and there is a 50% commission. Retail price set by the artist. Gallery provides insurance and promotion. Does not require exclusive representation locally.

Submissions Mail portfolio for review. Responds in 2 months. Finds artists through word of mouth, portfolio reviews and referrals by other artists.

ARTWORKS GALLERY

233 Pearl St., Hartford CT 06103. (860)247-3522. E-mail: artworks.gallery@snet.net. Web site: www.artworksgallery.org. **Executive Director:** Freddy McInerny. Cooperative nonprofit gallery. Estab. 1976. Exhibits 200 emerging, mid-career and established artists. Interested in seeing the work of emerging artists. 40 members. Sponsors 12 shows/year. Average display time 1 month. Open Wednesday-Friday, 11-5; Saturday, 12-3. Open all year. Located in downtown Hartford; 1,300 sq. ft.; large, first floor, store front space. 20% of space for special exhibitions; 80% of space for gallery artists. Clientele 80% private collectors, 20% corporate collectors. Overall price range $200-5,000; most work sold at $200-1,000.

Media Considers all media and all types of prints. Most frequently exhibits paintings, photography and sculpture. No crafts or jewelry.

Style Exhibits all styles and genres, especially contemporary.

Terms Co-op membership fee plus a donation of time. There is a 30% commission. Retail price set by artist. Offers customer discounts and payment by installments. Gallery provides insurance, promotion and contract. Artist pays for shipping costs. Accepts only artists from Connecticut for membership. Accepts artists from New England and New York for juried shows.

Submissions For membership, send query letter with résumé, slides, bio and $25 application fee. Call for appointment to show portfolio of slides. Responds in 1 month. Finds artists through visiting exhibitions, various art publications and sourcebooks, artists' submissions, art collectors' referrals, but mostly through word of mouth and 2 juried shows/year.

MONA BERMAN FINE ARTS

78 Lyon St., New Haven CT 06511. (203)562-4720. Fax: (203)787-6855. E-mail: info@monabermanfinearts.com. Web site: www.monabermanfinearts.com. **Director:** Mona Berman. Art consultant. Estab. 1979. Represents 100 emerging and mid-career artists. Exhibited artists include Tom Hricko, David Dunlop, Pierre Dardignac and S. Wind-Greenbaum. Sponsors 1 show/year. Open all year by appointment. Located near downtown; 1,400

sq. ft. Clientele 25% private collectors, 75% corporate collectors. Overall price range $200-20,000; most artwork sold at $500-5,000.

Media Considers all media except installation. Shows very little sculpture. Considers all limited edition prints except posters and photolithography. Also considers limited and carefully selected, well-priced, high-quality digital media. Most frequently exhibits works on paper, painting, relief and ethnographic arts.

Style Exhibits most styles. Prefers abstract, landscape and transitional. Little figurative, little still life.

Terms Accepts work on consignment (50% commission; net 30 days). Retail price is set by gallery and artist. Retail prices must be consistent regardless of venue. Customer discounts and payment by installment are available. Gallery provides insurance; artist pays for shipping. Prefers artwork unframed.

Submissions Accepts digital submissions by e-mail and links to Web sites or send query letter, résumé, CD, bio, SASE, reviews and "retail price list." Portfolios are reviewed only after images have been reviewed. Include e-mail address for faster response or responds in 1 month. CDs supporting material returned only if SASE is included. Finds artists through word of mouth, art publications and sourcebooks, submissions and self-promotions and other professionals' recommendations.

Tips "We will not carry artists who do not maintain consistent retail pricing. We are not a gallery, although we do a few exhibits so please do not submit if you are looking for an exhibition venue. We are primarily art consultants. We continue to be busy selling high-quality art and related services to the corporate, architectural, design and private sectors. A follow-up e-mail is preferable to a phone call."

[N] BROOKFIELD CRAFT CENTER

286 Whisconier Rd., Brookfield CT 06804-0122. E-mail: info@brookfieldcraftcenter.org. Web site: www.brookfieldcraftcenter.org. **Contact:** Gallery Director. Nonprofit gallery. Estab. 1954. Exhibits emerging, mid-career and established artists. Approached by 100 artists/year; represents 400+ artists.

Media Considers ceramics, craft, drawing, glass, mixed media and paper. Most frequently exhibits clay, glass, metal, wood. Considers all types of prints.

Style Exhibits color field and impressionism. Considers all genres.

Terms Artwork is accepted on consignment and there is a 40% commission or bought outright for 50% of retail price; net 30 days. Retail price of the art set by the artist. Gallery provides insurance, promotion and contract. Accepted work should be framed. Does not require exclusive representation locally.

Submissions Write to arrange personal interview to show portfolio of photographs and slides. Send query letter with brochure. Returns material with SASE. Responds to queries in 2 weeks-1 month. Finds artists through art fairs, art exhibits, portfolio reviews, referrals by other artist, submissions and word-of-mouth.

CONTRACT ART INTERNATIONAL, INC.

PBox 629, Old Lyme CT 06371-0629. (860)434-9799. Fax: (860)434-6240. E-mail: info@contractartinternational.com. Web site: www.contractartinternational.com. **President:** K. Mac Thames. In business approximately 36 years. "We contract artwork for hospitatlity and blue-chip businesses." Collaborates with emerging, mid-career and established artists. Assigns site-specific commissions to artists based on project design needs, theme and client preferences. Studio is open all year to corporate art directors, architects, designers, and faculty directors. 1,600 sq. ft. studio. Clientele 98% commercial. Overall price range $500-500,000.

Media Places all types of art mediums.

Terms Pays for design by the project, negotiable; 50% up front. Rights purchased vary according to project.

Submissions Send letter of introduction with résumé, slides, bio, brochure, photographs, DVD/video and SASE. If local, write for appointment to present portfolio; otherwise, mail appropriate materials, which should include slides and photographs. "Show us a good range of your talent. Also, we recommend you keep us updated if you've changed styles or media." Responds in 1 week. Files all samples and information in registry library.

Tips "We exist mainly to art direct commissioned artwork for specific projects."

FARMINGTON VALLEY ARTS CENTER'S FISHER GALLERY

25 Arts Center Lane, Avon CT 06001. (860)678-1867. Fax: (860)674-1877. E-mail: info@fvac.net. Web site: www.fvac.net. **Executive Director:** Marie Dalton-Meyer. Nonprofit gallery. Estab. 1972. Exhibits the work of 100 emerging, mid-career and established artists. Open all year; Wednesday-Saturday, 11 a.m.-5 p.m.; Sunday, 12 p.m.-5 p.m.; extended hours November-December. Located in Avon Park North just off Route 44; 600 sq. ft.; "in a beautiful 19th-century brownstone factory building once used for manufacturing." Clientele: upscale contemporary craft buyers. Overall price range $35-500; most work sold at $50-100.

Media Considers "primarily crafts," also considers some mixed media, works on paper, ceramic, fiber, glass and small size prints. Most frequently exhibits jewelry, ceramics and fiber.

Style Exhibits contemporary, handmade craft.

Terms Accepts artwork on consignment (50% commission). Retail price set by the artist. Gallery provides promotion and contract; shipping costs are shared. Requires artwork framed where applicable.

Submissions Send query letter with résumé, bio, slides, photographs, SASE. Responds only if interested. Files a slide or photo, résumé and brochure.

BILL GOFF, INC.

5 Bridge St., P.O. Box 977, Kent CT 06757-0977. (860)927-1411. Fax: (860)927-1987. Web site: goodsportsart.com. **President:** Bill Goff. Estab. 1977. Exhibits, publishes and markets baseball art. 95% private collectors, 5% corporate collectors.

Needs Baseball subjects for prints. Realism and photorealism. Represents 10 artists; emerging, mid-career and established. Exhibited artists include Andy Jurinko and William Feldman, Bill Purdom, Bill Williams.

First Contact & Terms Send query letter with bio and photographs. Write to schedule an appointment to show a portfolio, which should include photographs. Responds only if interested within 2 months. Files photos and bios. Accepts work on consignment (50% commission) or buys outright for 50% of retail price. Overall price range $95-30,000; most work sold at $125-220 (published lithographs). Retail price set by the gallery. Gallery provides insurance and promotion; shipping costs are shared. Prefers artwork unframed.

Tips "Do not waste our time or your own by sending non-baseball items."

GREAT HARBOR GALLERY OF FINE ART

63 Wall St., Madison CT 06443. (203)245-3327. Fax: (203)245-8012. E-mail: grharbartz@aol.com. **Director:** Robert A. Westerlund. For profit gallery. Estab. 1997. Exhibits antique American works of artists listed in *Who Was Who in American Art 1564-1975* and an occasional living local artist. Exhibited artists include Tina Waring, (oil, pastel, watercolor) contemporary artist. Sponsors 4 exhibits/year. Average display time 1 month. Open all year; Tuesday-Sunday, 10-5; weekends Saturday, 11-5; Sunday, 12-5. Located in a historic house in Madison. Clients include local community, upscale and Web.

Media Considers all media except ceramics, glass and craft. Most frequently exhibits oil, watercolor and pastel. Considers all types of prints, antique prints, mainly.

Style Most frequently exhibits impressionism. Considers all genres.

Terms Artwork is accepted on consignment or bought outright. Retail price set by the gallery. Accepts only artists from northeastern US.

Submissions Send query letter with bio, photographs and SASE. Responds in 6 months.

SILVERMINE GUILD GALLERY

1037 Silvermine Rd., New Canaan CT 06840. (203)966-5617. Fax: (203)972-7236. E-mail: gallery@silvermineart.org. Web site: www.silvermineart.org. **Director:** Helen Klisser During. Nonprofit gallery. Estab. 1922. Represents 300 emerging, mid-career and established artists/year. Sponsors 24 shows/year. Average display time 1 month. Open all year; Tuesday-Saturday, 11-5; Sunday, 1-5. 5,000 sq. ft. 95% of space for gallery artists. Clientele: private collectors, corporate collectors. Overall price range $250-10,000; most work sold at $1,000-2,000.

Media Considers all media and all types of prints. Most frequently exhibits paintings, sculpture and ceramics.

Style Exhibits all styles.

Terms Accepts guild member work on consignment (50% commission). Co-op membership fee plus donation of time (50% commission.) Retail price set by the gallery and the artist. Gallery provides insurance, promotion and contract. Prefers artwork framed.

Submissions Send query letter.

SMALL SPACE GALLERY

Arts Council of Greater New Haven, New Haven CT 06510. (203)772-2788. Fax: (203)772-2262. E-mail: dhesse.ac@snet.net. Web site: www.artscouncil-newhaven.org. **Director:** Debbie House. Alternative space. Estab. 1985. Interested in emerging artists. Sponsors 10 solo and group shows/year. Average display time 1-2 months. Open to Arts Council members only (Greater New Haven). Arts Council membership costs $35. Artwork price range $35-3,000.

Media Considers all media.

Style Exhibits all styles and genres. "The Small Space Gallery was established to provide our artist members with an opportunity to show their work. Particularly those who were just starting their careers. We're not a traditional gallery, but an alternative art space." Shows are promoted through greater New Haven's only comprehensive arts and entertainment events magazine.

Terms Arts Council requests 10% donation on sale of each piece. Retail price set by artist. Exclusive area representation not required. Gallery provides insurance (up to $10,000) and promotion.

Submissions Send query letter with résumé, brochure, slides, photographs and bio. Call or write for appointment to show portfolio of originals, slides, transparencies and photographs. Will reply to all mailings and phone calls.

DELAWARE

DELAWARE CENTER FOR THE CONTEMPORARY ARTS

200 S. Madison St., Wilmington DE 19801. (302)656-6466. Fax: (302)656-6944. E-mail: hbennett@thedcca.org. Web site: www.thedca.org. **Director:** Belena Chapp. Nonprofit gallery. Estab. 1979. Exhibits the work of emerging, mid-career and established artists. Sponsors 30 solo/group shows/year of both national and regional artists. Average display time is 1 month. 3,000 sq. ft. Overall price range $50-10,000; most artwork sold at $500-1,000.
Media Considers all media, including contemporary crafts.
Style Exhibits contemporary, abstract, figurative, conceptual, representational and nonrepresentational, painting, sculpture, installation and contemporary crafts.
Terms Accepts work on consignment (35% commission). Retail price is set by the gallery and the artist. Exclusive area representation not required. Gallery provides insurance and promotion; shipping costs are shared.
Submissions Send query letter, résumé, slides and/or photographs and SASE. Write for appointment to show portfolio. Seeking consistency within work as well as in presentation. Slides are filed. Submit up to 20 slides with a corresponding slide sheet describing the work (i.e. media, height by width by depth), artist's name and address on top of sheet and title of each piece in the order in which you would like them reviewed.
Tips "Before submitting slides, call and inquire about an organization's review schedule so your slides won't be tied up for an extended period. Submit at least ten slides that represent a cohesive body of work."

REHOBOTH ART LEAGUE, INC.

12 Dodds Lane, Henlopen Acres DE 19971. (302)227-8408. Nonprofit gallery; offers education in visual arts. Estab. 1938. Exhibits the work of 1,000 emerging, mid-career and established artists. Sponsors 8-10 shows/year. Average display time 3½ weeks. Open January through November. Located in a residential area just north of town; "3½ acres, rustic gardens, built in 1743; listed in the National Register of Historic Places; excellent exhibition and studio space. Regional setting attracts artists and arts advocates." 100% of space for special exhibitions. Clientele members, artists (all media), arts advocates.
Media Considers all media (except installation and photography) and all types of prints.
Style Exhibits all styles and all genres.
Terms Accepts artwork on consignment (30% commission). Retail price set by the artist. Gallery provides insurance and promotion. Artist pays for shipping. Prefers artwork framed for exhibition, unframed for browser sales.
Submissions Send query letter with résumé, slides and bio. Write to schedule an appointment to show a portfolio, which should include appropriate samples. Responds in 6 weeks. Files bios and slides in Member's Artist Registry.

DISTRICT OF COLUMBIA

ALEX GALLERY

2106 R St. NW, Washington DC 20008. (202)667-2599. E-mail: Alexartint@aol.com. Web site: www.alexgalleries.com. **Contact:** Victor Gaetan. Retail gallery and art consultancy. Estab. 1986. Represents 20 emerging and mid-career artists. Exhibited artists include Willem de Looper, Gunter Grass and Olivier Debre. Sponsors 8 shows/year. Average display time 1 month. Open all year. Located in the heart of a "gallery" neighborhood; "2 floors of beautiful turn-of-the-century townhouse; a lot of exhibit space." Clientele: diverse; international and local. 50% private collectors; 50% corporate collectors. Overall price range $1,500-60,000.
Media Considers oil, acrylic, watercolor, pastel, mixed media, collage, sculpture, photography, original hand-pulled prints, lithographs, linocuts and etchings. Most frequently exhibits painting, sculpture and works on paper.
Style Exhibits expressionism, abstraction, color field, impressionism and realism; all genres. Prefers abstract and figurative work.
Terms Accepts artwork on consignment. Retail price set by gallery and artist. Gallery provides insurance, promotion and contract; shipping costs are shared.
Submissions Send query letter with résumé, slides, bio, SASE and artist's statement. Write for appointment to show portfolio, which should include slides and transparencies. Responds in 2 months.

DADIAN GALLERY

4500 Massachusetts Ave. NW, Washington DC 20016. (202)885-8674. Fax: (202)885-8605. E-mail: dsokolove@ wesleysem.edu. Web site: www.luceartsandreligion.org/gallery. **Curator:** Deborah Sokolove. Nonprofit gallery. Estab. 1989. Approached by 50 artists a year. Exhibits 7-10 emerging, mid-career and established artists. Sponsors 7 exhibits/year. Average display time 2 months. Open Monday-Friday, 11-5. Closed August, December 24-

January 1. Gallery is within classroom building of Methodist seminary; 550 sq. ft.; glass front open to foyer, moveable walls for exhibition and design flexibility.

Media Considers all media and all types of prints. Most frequently exhibits painting, drawing and sculpture.

Style Considers all styles and genres.

Terms Artists are requested to make a donation to the Henry Luce III Center for the Arts and Religion at Wesley Theological Seminary from any sales. Gallery provides insurance. Accepted work should be framed. "We look for strong work with a spiritual or religious intention."

Submissions Send query letter with artist's statement, SASE and slides. Returns material with SASE. Responds only if interested within 1 year. Finds artists through word of mouth, submissions, art exhibits and referrals by other artists.

DISTRICT OF COLUMBIA ARTS CENTER (DCAC)

2438 18th St. NW, Washington DC 20009. (202)462-7833. Fax: (202)328-7099. E-mail: info@dcartscenter.org. Web site: dcartscenter.org. **Executive Director:** B. Stanley. Nonprofit gallery and performance space. Estab. 1989. Exhibits emerging and mid-career artists. Sponsors 7-8 shows/year. Average display time 1-2 months. Open Wednesday-Sunday, 2-7; Friday-Saturday, 2-10; and by appointment. Located "in Adams Morgan, a downtown neighborhood; 132 running exhibition feet in exhibition space and a 52-seat theater." Clientele: all types. Overall price range $200-10,000; most work sold at $600-1,400.

Media Considers all media including fine and plastic art. "No crafts." Most frequently exhibits painting, sculpture and photography.

Style Exhibits all styles. Prefers "innovative, mature and challenging styles."

Terms Accepts artwork on consignment (30% commission). Artwork only represented while on exhibit. Retail price set by the gallery and artist. Offers payment by installments. Gallery provides promotion and contract; artist pays for shipping. Prefers artwork framed.

Submissions Send query letter with résumé, slides, bio and SASE. Portfolio review not required. Responds in 4 months. More details are available on Web site.

Tips "We strongly suggest the artist be familiar with the gallery's exhibitions and the kind of work we show strong, challenging pieces that demonstrate technical expertise and exceptional vision. Include SASE if requesting reply and return of slides!"

FOXHALL GALLERY

3301 New Mexico Ave. NW, Washington DC 20016. (202)966-7144. Fax: (202)363-2345. E-mail: foxhallgallery@ foxhallgallery.com. Web site: www.foxhallgallery.com. **Director:** Jerry Eisley. Retail gallery. Represents emerging and established artists. Sponsors 6 solo and 6 group shows/year. Average display time 3 months. Overall price range $500-20,000; most artwork sold at $1,500-6,000.

Media Considers oil, acrylic, watercolor, pastel, sculpture, mixed media, collage and original handpulled prints (small editions).

Style Exhibits contemporary, abstract, impressionistic, figurative, photorealistic and realistic works and landscapes.

Terms Accepts work on consignment (50% commission). Retail price set by gallery and artist. Customer discounts and payment by installment are available. Exclusive area representation required. Gallery provides insurance.

Submissions Send résumé, brochure, slides, photographs and SASE. Call or write for appointment to show portfolio. Finds artists through agents, by visiting exhibitions, word of mouth, various art publications and sourcebooks, artists' submissions, self promotions and art collectors' referrals.

Tips To show in a gallery artists must have "a complete body of work—at least 30 pieces, participation in a juried show and commitment to their art as a profession."

THE FRASER GALLERY

1054 31st St., NW, Washington DC 20007. (202)298-6450. Fax: (202)298-6450. E-mail: info@frasergallery.com. Web site: www.thefrasergallery.com. **Director:** Catriona Fraser. For profit gallery. Estab. 1996. Approached by 400 artists/year. Represents 40 emerging, mid-career and established artists and sells the work of another 100 artists. Exhibited artists include David FeBland (oil painting) and Joyce Tenneson (photography). Sponsors 12 exhibits/year. Average display time 1 month. Open all year; Tuesday-Friday, 12-3; weekends, 12-6. 400 sq. ft. Located in the center of Georgetown, Ind.—inside courtyard with 3 other galleries. Clients include local community, tourists, Internet browsers and upscale. Overall price range $200-15,000; most work sold under $5,000. The Fraser Gallery is charter associate dealer for Southebys.com and member of Art Dealers Association of Greater Washington.

Media Considers acrylic, drawing, mixed media, oil, paper, pastel, pen & ink, sculpture and watercolor. Most

frequently exhibits oil, photography and drawing. Considers engravings, etchings, linocuts, mezzotints and woodcuts.

Style Most frequently exhibits contemporary realism. Genres include figurative work and surrealism.

Terms Artwork is accepted on consignment and there is a 50% commission. Retail price set by the artist. Gallery provides insurance, promotion and contract. Accepted work should be framed. Requires exclusive representation locally.

Submissions Write to arrange a personal interview to show portfolio of photographs and slides. Send query letter with bio, photographs, résumé, reviews, SASE and slides or CD-ROM with images and résumé. Returns material with SASE. Responds in 3 weeks. Finds artists through submissions, portfolio reviews, art exhibits and art fairs.

Tips "Research the background of the gallery and apply to galleries that show your style of work. All work should be framed or matted to full museum standards."

GALLERY K

2010 R St. NW, Washington DC 20009. (202)234-0339. Fax: (202)334-0605. E-mail: galleryk@ix.netcom.com. Web site: www.galleryk.com. **Director:** Komei Wachi. Retail gallery. Estab. 1975. Represents 47 emerging, mid-career and established artists. Interested in seeing the work of emerging artists. Exhibited artists include Jody Mussoff and Y. David Chung. Sponsors 10 shows/year. Average display time 1 month. Closed mid July through mid-September; Tuesday-Saturday 11-6. Located in DuPont Circle area; 2,500 sq. ft. Clientele local. 80% private collectors, 10% corporate collectors; 10% museums. Overall price range $100-250,000; most work sold at $200-2,000.

Media Considers oil, pen & ink, paper, acrylic, drawing, sculpture, watercolor, mixed media, ceramic, pastel, collage, photography, woodcuts, wood engravings, linocuts, engravings, mezzotints, etchings, lithographs and serigraphs. Most frequently exhibits oil, acrylic, drawing.

Style Exhibits realism, surrealism and abstract. Genres include landscapes and figurative work. Prefers surrealism, realism and postmodernism. Kindly look at our Web site home page.

Terms Accepts work on consignment (20-50% commission). Retail price set by gallery and artist. Gallery provides insurance, promotion and contract; artist pays for shipping costs. Prefers artwork framed and ready to display.

Submissions Accepts artists mainly from DC area. Send query letter with résumé, 1 sheet of 25 slides and SASE. Responds in 6 weeks only if SASE enclosed.

Tips You should have completed about 30-50 works of art before approaching galleries.

JANE HASLEM GALLERY

2025 Hillyer St. NW, Washington DC 20009-1005. (202)232-4644. Fax: (202)387-0679. E-mail: haslem@artline.com. Web site: www.JaneHaslemGallery.com. For-profit gallery. Estab. 1960. Approached by hundreds of artists/year; exhibits 75-100 emerging, mid-career and established artists/year. Exhibited artists include Garry Trudeau (cartoonist), Mark Adams (paintings, prints, tapestry), Nancy McIntyre (prints). Sponsors 6 exhibits/year. Average display time 7 weeks. Open by appointment. Located at DuPont Circle across from Phillips Museum; 2 floors of 1886 building; 3,000 square feet. Clients include local community, students, upscale and collectors worldwide. 5% of sales are to corporate collectors. Overall price range is $30-30,000; most work sold at $500-2,000.

Media Considers acrylic, collage, drawing, mixed media, oil, paper, pastel, pen & ink, watercolor. Most frequently exhibits prints and works on paper. Considers engravings, etchings, linocuts, lithographs, mezzotints, serigraphs, woodcuts and digital images.

Style Exhibits expressionism, geometric abstraction, neo-expressionism, pattern painting, painterly abstraction, postmodernism, surrealism. Most frequently exhibits abstraction, realism and geometric. Genres include figurative work, florals and landscapes.

Terms Artwork is accepted on consignment and there is a 50% commission. Retail price set by the artist and the gallery. Gallery provides promotion and contract. Accepts only artists from the US. Prefers only prints, works on paper and paintings.

Submissions Artists should contact via e-mail. Returns material with SASE. Responds to queries only if interested in 3 months. Finds artists through art fairs and exhibits, referrals by other artists and word of mouth.

Tips "100% of our sales are Internet generated. We prefer all submissions initially by e-mail."

TOUCHSTONE GALLERY

406 Seventh St. NW, Washington DC 20004-2217. (202)347-2787. Fax: (202)347-3339. E-mail: info@touchstonegallery.com. Web site: www.touchstonegallery.com. **Contact:** Sandy Rossi, Director. Rental and cooperative gallery. Estab. 1976. Interested in emerging, mid-career and established artists. Approached by 100+ artists a year; represents over 50 artists. Average display time 1 month. Open Wednesday-Saturday from 11-5; Sundays

from 12-5. Closed Christmas through New Years. Located downtown Washington, DC on Gallery Row. Large main gallery with several additional exhibition areas. High ceilings. Clients include local community, students, tourists, upscale. Overall price range $250-7,500.

Media/Style Considers all media. Considers engravings, etchings, linocuts, lithographs, mezzotints, serigraphs, woodcuts.

Terms There is a co-op membership fee plus a donation of time. There is a 40-60% commission. Rental fee covers 1 month. Retail fee for Annex A, $800/month; Annex B, $900/month. No commission taken on annex sales. Retail price set by artist. Gallery provides contract and promotion. Accepted work should be framed and matted. Exclusive area representation not required.

Submissions The gallery juries for new members meet the 4th Wednesday of each month. All interested artists may apply. No fee required. See gallery Web sites for details. Responds in 1 week. Find artists through art fairs, art exhibits, referrals by other artists, submissions and word-of-mouth.

Tips ''Visit Web site first. Read new members prospectus on the front page. Call with additional questions. Do not 'drop in' with slides or art. Do not show everything you do. Show 10-25 images that are cohesive in subject, style and presentation.''

FLORIDA

ALBERTSON-PETERSON GALLERY
329 Park Ave. S., Winter Park FL 32789. (407)628-1258. Fax: (407)647-6928. **Owner:** Judy Albertson. Retail gallery. Estab. 1984. Represents 10-25 emerging, mid-career and established artists/year. ''We no longer have a retail space—open by appointment only.''

Media Considers oil, acrylic, watercolor, pastel, mixed media, collage, paper, sculpture, ceramics, craft, fiber, glass, installation, photography, woodcut, engraving, lithograph, wood engraving, mezzotint, serigraphs, linocut and etching. Most frequently exhibits paintings, ceramic, sculpture.

Style Exhibits all styles. Prefers abstract, contemporary landscape and nonfunctional ceramics.

Terms Accepts work on consignment (varying commission). Retail price set by the gallery and the artist. Gallery provides insurance, promotion, contract and shipping costs from gallery; artist pays shipping costs to gallery. Prefers artwork unframed.

Submissions Accepts only artists ''exclusive to our area.'' Send query letter with résumé, slides, bio, photographs, SASE and reviews. Call or write for appointment to show portfolio of photographs, slides and transparencies. Responds within a month. Finds artists through exhibitions, art publications and artists' submissions.

ART CENTER/SOUTH FLORIDA
800 Lincoln Rd., Miami Beach FL 33139. (305)674-8278. Fax: (305)674-8772. E-mail: info@artcentersf.org. Web site: www.artcentersf.org. Nonprofit gallery. Estab. 1985. Exhibits group shows by emerging artists. Average display time 1 month. Open all year; Monday-Wednesday, 1-10; Thursday-Sunday, 1-11. Clients include local community, students, tourists and upscale. Overall price range $500-5,000.

Media Considers all media except craft. Most frequently exhibits painting, sculpture, drawings and installation.

Style Exhibits themed group shows, which challenge and advance the knowledge and practice of contemporary arts.

Terms Retail price set by the artist. Gallery provides insurance and promotion. Gallery receives 10% commission from sales. Accepted work should be ready to install. Does not require exclusive representation locally.

Submissions Artist sends SASE. We send application which will be reviewed by a panel. Send query letter with SASE. Returns material with SASE. Artists apply with a proposal for an exhibition. It is then reviewed by a panel.

ATLANTIC CENTER FOR THE ARTS, INC.
1414 Arts Center Ave., New Smyrna Beach FL 32168. (386)427-6975. Fax: (386)427-5669. Web site: www.atlanticcenterforthearts.org. Nonprofit interdisciplinary, international artists-in-residence program. Estab. 1977. Sponsors 5-6 residencies/year. Located on secluded bayfront 3½ miles from downtown.

- This location accepts applications for residencies only, but they also run Harris House of Atlantic Center for the Arts, which accepts Florida artists only for exhibition opportunities. Harris House is located at 214 S. Riverside Dr., New Smyrna Beach FL 32168. (386)423-1753.

Media Most frequently exhibits paintings/drawings/prints, video installations, sculpture, photographs.

Style Contemporary.

Terms Call Harris House for more information.

Submissions Call Harris House for more information.

BAKEHOUSE ART COMPLEX

561 N.W. 32 St., Miami FL 33127. (305)576-2828. E-mail: bakehouse@belsouth.net. Web site: www.bakehouse artcomplex.org. Alternative artist working space and exhibition galleries in not-for-profit complex. Estab. 1986. Represents moer than 100 emerging and mid-career artists. 65 tenants, more than 50 associate artists. Sponsors numerous shows and cultural events annually. Average display time 3-5 weeks. Open to public all year; daily, Noon-5. Office hours Monday-Friday, 9-5. Located in Wynwood Art District; 3,200 sq. ft. gallery; 33,000 sq. ft. retro fitted commercial bakery, 17 ft. ceilings. Clientele: 80% private collectors, 20% corporate collectors. Overall price range $500-10,000.
Media Considers all media.
Style Exhibits all styles, all genres.
Terms Co-op membership fee plus donation of time. Rental fee for studio space. Retail price of art set by the artist.
Submissions Accepts artists to juried membership. Send query letter for application.
Tips ''Don't stop painting, sculpting, etc. while you are seeking representation. Daily work (works-in-progress, studies) evidences a commitment to the profession. Speaking to someone about your work while you are working brings an energy and an urgency that moves the art and the gallery representation relationship forward.''

SETH JASON BEITLER FINE ARTS

520 SE Fifth Ave., Suite 2501, FtLauderdale FL 33301. (954)832-0414. Fax: (305)933-0939. E-mail: info@sethjaso n.com. Web site: www.sethjason.com. **Contact:** Seth Beitler, owner. For-profit gallery, art consultancy. Estab. 1997. Approached by 300 artists/year. Represents 40 mid-career, established artists. Exhibited artists include Florimond Dufoor, oil paintings; Terje Lundaas, glass sculpture. Sponsors 5 exhibits/year. Average display time 2-3 months. Open Tuesday through Saturday, 12-5. Closed June-August. Located in downtown Ft. Lauderdale, Florida in a 1,000 sq. ft. private showroom. Clients include local community and upscale. 5-10% of sales are to corporate collectors. Overall price range $2,000-300,000; most work sold at $5,000.
Media Considers acrylic, glass, mixed media, sculpture, drawing, oil. Most frequently exhibits sculpture, painting, photography. Considers etchings, linocuts, lithographs.
Style Exhibits color field, geometric abstraction and painterly abstraction. Most frequently exhibits geometric sculpture, abstract painting, photography. Genres include figurative work and landscapes.
Terms Artwork is accepted on consignment and there is a 50% commission. Retail price set by the gallery. Gallery provides insurance, promotion and contract. Accepted work should be mounted.
Submissions Write to arrange personal interview to show portfolio of photographs, slides, transparencies. Send query letter with artist's statement, bio, photographs, résumé, SASE. Returns material with SASE. Responds to queries in 2 months. Files photos, slides, transparencies. Finds artists through art fairs, portfolio reviews, referrals by other artists and word of mouth.
Tips Send ''easy to see photographs. E-mail submissions for quicker response.''

BETTCHER GALLERY—MIAMI

Soyka's 55th Street Station, 5582 NE Fourth Court, Miami FL 33137. (305)758-7556. Fax: (305)758-8297. E-mail: bettcher@aol.com. Web site: www.bettchergallery.com. **Contact:** Cora Bettcher, president/director. Art consultancy; for-profit gallery. Estab. 1995. Exhibits emerging, mid-career, established artists. Approached by 400-500 artists/year; represents 40-50 artists/year. In our cycle from 10/2004-6/2005, Bettcher Gallery exhibited (solo or curated small group) the following artists, more than two of whom are ''bestselling:'' Marc Dennis, Luis Sanchez, Ray Beldner, Jean Blackburn, Scott Cawood, Caui Lofgren, Lisa Bertnick, Jeff Schaller, Robin Koenig, R E Sanchez, Sinisa Kukec, Jon Peters. Sponsors 8 total exhibits/year. Average display time 6 weeks. Open Tuesday-Wednesday, 11-6; Thursday-Saturday, 1-11pm. Open all year. Clients include local community, students, tourists, upscale. 5-10% sales are to corporate collectors. Overall price range: $500-50,000; most work sold at $5,000-15,000.
Media Considers all media except giclées, similar mechanical prints. Original fine art or limited edition (i.e, photography/sculpture) only. Most frequently exhibits sculpture/multi-media installation (various), paintings (o/c, a/c, encaustic), works on paper (photography, drawings). Considers all types of prints except posters.
Style Exhibits realism/slight surreal (two dimensional). Most frequently exhibits realist work with a twist toward the surreal. ''Our curriculum is fairly content based, medium/process based, new use of medium, and use of new medium. In essence, we strive the unique, and that which is defines both 'exquisite' and 'provocative.' ''
Making Contact & Terms Retail price of the art set by the existing market (current, most recent exhibit or auction). Gallery provides contract.
Submissions Artist should contact by e-mail. Responds to queries only if interested within 6 months.
Tips ''Keep it clean and simple, and include retail prices.''

BOCA RATON MUSEUM OF ART

501 Plaza Real, Mizner Park, Boca Raton FL 33432. (561)392-2500. Fax: (561)391-6410. E-mail: info@bocamuse um.org. Web site: www.BocaMuseum.org. **Executive Director:** George S. Bolge. Museum. Estab. 1950. Represents established artists. 5,500 members. Exhibits change every 2 months. Open all year; Tuesday, Thursday and Friday, 10-5; Wednesday, 10-9; Saturday and Sunday, 12-5. Located one mile east of I-95 in Mizner Park in Boca Raton; 44,000 sq. ft.; national and international temporary exhibitions and impressive second-floor permanent collection galleries. Three galleries—one shows permanent collection, two are for changing exhibitions. 66% of space for special exhibitions.
Media Considers all media. Exhibits modern masters including Braque, Degas, Demuth, Glackens, Klee, Matisse, Picasso and Seurat; 19th and 20th century photographers; Pre-Columbian and African art, contemporary sculpture.
Submissions "Contact executive director, in writing."
Tips "Photographs of work of art should be professionally done if possible. Before approaching museums, an artist should be well-represented in solo exhibitions and museum collections. Their acceptance into a particular museum collection, however, still depends on how well their work fits into that collection's narrative and how well it fits with the goals and collecting policies of that museum."

ALEXANDER BREST MUSEUM/GALLERY

2800 University Blvd., Jacksonville University, Jacksonville FL 32211. (904)745-7371. Fax: (904)745-7375. E-mail: dlauder@ju.edu. Web site: www.dept.ju.edu/art/. **Director:** David Lauderdale. Museum. Estab. 1970. Sponsors group shows of various number of artists. Average display time 6 weeks. Open all year; Monday-Friday, 9-4:30; Saturday, 12-5. "We close 2 weeks at Christmas and University holidays." Located in Jacksonville University, near downtown; 1,600 sq. ft.; 11½ foot ceilings. 50% of space for special exhibitions. "As an educational museum we have few if any sales. We do not purchase work—our collection is through donations."
Media "We rotate style and media to reflect the curriculum offered at the institution. We only exhibit media that reflect and enhance our teaching curriculum. (As an example we do not teach bronze casting, so we do not seek such artists.)."
Style Exhibits expressionism, neo-expressionism, primitivism, painterly abstraction, surrealism, all styles, primarily contemporary.
Terms Retail price set by the artist. Gallery provides insurance and promotion; artist pays shipping costs to and from gallery. "The art work needs to be ready for exhibition in a professional manner."
Submissions Send query letter with résumé, slides, brochure, business card and reviews. Write for appointment to show portfolio of slides. "Responds fast when not interested. Yes takes longer." Finds artists through visiting exhibitions and submissions.
Tips "Being professional impresses us. But circumstances also prevent us from exhibiting all artists we are impressed with."

THE DELAND MUSEUM OF ART, INC.

600 N. Woodland Blvd., De Land FL 32720-3447. (386)734-4371. Fax: (386)734-7697. E-mail: info@delandmuse um.com. Web site: www.delandmuseum.com. **Contact:** Executive Director. Museum. Exhibits the work of established artists. Sponsors 8-10 shows/year. Open all year. Located near downtown; 5,300 sq. ft.; in The Cultural Arts Center; 18 ft. carpeted walls, two gallery areas, including a modern space. Clientele 85% private collectors, 15% corporate collectors. Overall price range $100-30,000; most work sold at $300-5,000.
Media Considers oil, acrylic, watercolor, pastel, works on paper, sculpture, ceramic, woodcuts, wood engravings, engravings and lithographs. Most frequently exhibits painting, sculpture, photographs and prints.
Style Exhibits contemporary art, the work of Florida artists, expressionism, surrealism, impressionism, realism and photorealism; all genres. Interested in seeing work that is finely crafted and expertly composed, with innovative concepts and professional execution and presentation. Looks for "quality, content, concept at the foundation—any style or content meeting these requirements considered."
Terms Accepts work on consignment for exhibition period only. Retail price set by artist. Gallery provides insurance, promotion and contract; shipping costs may be shared.
Submissions Send résumé, slides, bio, brochure, SASE and reviews. Files slides and résumé. Reviews slides twice a year.
Tips "Artists should have a developed body of artwork and an exhibition history that reflects the artist's commitment to the fine arts. Museum contracts 2-3 years in advance. Label each slide with name, medium, size and date of execution."

N DOT FIFTYONE GALLERY

51 NW 36 St. Wynwood Art District, Miami FL 33127.(305)573-3754. E-mail: dot@dotfiftyone.com. Web site: www.dotfiftyone.com. **Contact:** Isaac Perelman, Director; Alfredo Guzman, Director. For-profit gallery. Estab.

2004. Approached by 40+ artists/year. Represents 10 emerging, mid-career and established artists/year. Exhibited artists include Leonel Matheu, painting, video installations; Liliane Bouquet, photography. Sponsors 9 exhibits/year. Average display time 40 days. Open Monday-Friday, 12-7; Saturdays and private viewing by appointment. Located in Wynwood Art District approximately 7,000 sq. ft. Clients include local community, students, tourists and upscale. 10% of sales are to corporate collectors. Overall price range: $600-30,000; most work sold at $6,000.

Media Considers all media, serigraphs and woodcuts; most frequently exhibits acrylic, installation, mixed media and oil.

Style Exhibits color field, conceptualism, expression, geometric abstraction, minimalism. Exhibits all genres including figurative work.

Terms Artwork accepted on consignment and there is a 50% commission. Retail price set by the gallery and the artist. Gallery provides promotion and contract. Requires exclusive representation locally.

Submissions E-mail or mail query letter with artist's statement, bio, résumé, reviews and jpegs or CD or slides and SASE. Cannot return materials. Does not reply to queries unless interested. Artist should send e-mail. Files CD, catalogues, slides. Finds artists through portfolio reviews and referrals by other artists.

Tips Good presentation is essential. Contact first by gallery e-mail. Never try to show work during an opening. Do not show up at the gallery without a scheduled appointment.

FLORIDA ART CENTER & GALLERY

208 First St. NW, Havana FL 32333. (850)539-1770. E-mail: drdox@juno.com. **Executive Director:** Dr. Kim Doxey. Retail gallery, studio and art school. Estab. 1993. Represents 30 emerging, mid-career and established artists. Interested in seeing the work of emerging artists. Open all year. Located in a small but growing town just outside Tallahassee, Florida; 2,100 st. ft.; housed in a large renovated 50-year-old building with exposed rafters and beams. Clientele: private collectors. 100% private collectors.

Media Considers all media including original handpulled prints, sculpture, jewelry, and ceramics.

Style Exhibits all styles, tend toward traditional styles. Genres include landscapes and portraits.

Terms Accepts work on consignment (45% commission). Retail price set by gallery and artist. Gallery provides insurance, promotion and contract.

Submissions Send query letter with slides. Call or write for appointment.

Tips "Prepare a professional presentation for review, (i.e. quality work, good slides, clear, concise and informative backup materials). Include size, medium, price and framed condition of painting. In order to effectively express your creativity and talent, you must be a master of your craft, including finishing and presentation."

FLORIDA STATE UNIVERSITY MUSEUM OF FINE ARTS

250 Fab, corner of Copeland & W. Tennessee St., Tallahassee FL 32306-1140. (850)644-6836. Fax: (850)644-7229. E-mail: apcraig@mailer.fsu.edu. Web site: www.mofa.fsu.edu. **Director:** Allys Palladino-Craig. Estab. 1970. Shows work by over 100 artists/year; emerging, mid-career and established. Sponsors 12-22 shows/year. Average display time 3-4 weeks. Located on the university campus; 16,000 sq. ft. 50% of space for special exhibitions.

Media Considers all media, including electronic imaging and performance art. Most frequently exhibits painting, sculpture and photography.

Style Exhibits all styles. Prefers contemporary figurative and nonobjective painting, sculpture, printmaking, photography.

Terms "Sales are almost unheard of; the museum takes no commission." Retail price set by the artist. Museum provides insurance, promotion and shipping costs to and from the museum for invited artists.

Submissions Send query letter or call for Artist's Proposal Form.

Tips "The museum offers a yearly competition with an accompanying exhibit and catalog. Artists' slides are kept on file from this competition as a resource for possible inclusion in other shows. Write for prospectus, available late December through January."

BARBARA GILLMAN GALLERY

3814 NE Miami Court, Miami Beach FL 33137. (305)573-1920. Fax: (305)573-1940. E-mail: bggart@att.net. Web site: www.barbaragillman-gallery.com. **Director:** Barbara Gillman. For profit gallery. Estab. 1960. Approached by 20 artists/year. Represents 20 established artists. Exhibited artists include Herman Leonard and William Gettlieb. Sponsors 4 exhibits/year. Average display time 2 months. Open all year by appointment. Clients include local community, tourists and upscale. 30% of sales are to corporate collectors. Overall price range $1,000-20,000; most work sold at $10,000.

Media Considers painting, sculpture, prints, photography and mixed media. Most frequently exhibits photography, prints, paintings. Considers engravings, etchings, linocuts, lithographs, mezzotints and serigraphs.

Style See Web site. Considers all genres.

Terms Artwork is bought on consignment and there is a 50% commission. Gallery provides promotion. Accepted work should be framed, mounted and matted. Requires exclusive representation locally. Accepts only artists from Florida.

Submissions Please call for how and what to submit.

GLASS CANVAS GALLERY, INC.

146 Second St., N., St. Petersburg FL 33701. (727)821-6767. Fax: (727)821-1775. Web site: www.glasscanvasgallery.com. **President:** Dick Fortune. Retail gallery. Estab. 1992. Represents 350 emerging and established artists. Exhibited artists from US, Canada, Australia, England. Open all year; Monday-Friday, 10-6; Saturday, 10-5; Sunday, 12-5.

Media Considers glass only.

Style Exhibits color field. Prefers unique, imaginative, contemporary, colorful and unusual.

Terms Accepts work on consignment and buys at wholesale price (net 30 days). Retail price set by the gallery. Gallery provides insurance, promotion, contract and shipping costs from gallery; artist pays shipping costs to gallery. Prefers artwork framed.

Submissions Prefers only glass. Send query letter with résumé, brochure, photographs and business card. Call for appointment to show portfolio of photographs. Responds in 2 weeks. Files all material.

Tips ''We look at the pieces themselves (and not the slides) to evaluate the technical expertise prior to making the decision to represent an artist.''

A LAUREL ART GALLERY

2112 Crystal Dr., Ft. Myers FL 33907. (941)278-0489. Fax: (941)482-6879. E-mail: alaurelart@cyberstreet.com. Web site: www.alaurelart.com. Retail gallery. Estab. 1990. Represents 6 emerging artists/year. Exhibited artists include Ch. Vaurina and G. Valtier. Sponsors 2 shows/year. Average display time 6 weeks. Open all year; 11-4. 6,000 sq. ft. 75% of space for special exhibitions. Clientele: tourists and upscale. 10% private collectors. Overall price range $1,000-10,000; most work sold at $3,000.

Media Considers oil and acrylic.

Style Exhibits impressionism. Genres include landscapes and still lifes.

Terms Accepts work on consignment (50% commission). Retail price set by the gallery. Gallery provides promotion; artist pays for shipping.

Submissions Send résumé, brochure and 12 photographers. Call for appointment to show portfolio of photographs.

Tips ''You should have completed a body of work of approximately 200 works before approaching galleries.''

Ⓝ LEEPA-RATTNER MUSEUM OF ART

600 Klosterman Rd., Tarpon Springs FL 34689.(727)712-5223. E-mail: lrma@spcollege.edu. Web site: www.spcollege.edu/museum. **Contact:** Lynn Whitelaw, Director. Museum. Estab. 2002. Exhibits mid-career and established artists. We do not sell. We exhibit art from 20th century artists, alive and deceased. Average display time 8-10 weeks. Open Tuesday, Wednesday, Friday, 10-5; Thursday, 10-9; Sundays, 1-5; closed Mondays. Located on Tarpon Springs Campus of St. Petersburg College. Clients include local community, students, tourists and upscale.

Media Considers all types of media and prints. Mostly exhibits 20th century artwork.

Style Considers all genres.

LOCUST PROJECTS

105 NW 23rd St., Miami FL 33127. (305)576-8570. E-mail: locustprojects@yahoo.com. Web site: www.locustprojects.org. Alternative space and nonprofit gallery. 1,271 sq. ft. Estab. 1998. Exhibited artists include Randy Moore (video/drawing), David Rohn (installation) and Elizabeth Wild (installation). Sponsors 6 exhibits/year. Average display time 4-6 weeks. Open by appointment; weekends, 12-4. Closed summer.

Media Most frequently exhibits installation.

Style Exhibits postmodernism and contemporary.

Terms Retail price set by the artist. Gallery provides promotion. Does not require exclusive representation locally.

Submissions Send query letter with artist's statement, bio, résumé, reviews, slides and SASE. Returns material with SASE. Responds in 6 months. Finds artists through curated shows.

MICHAEL MURPHY GALLERY INC.

2722 S. MacDill Ave., Tampa FL 33629. (813)902-1414. Fax: (813)835-5526. E-mail: mmurphy@michaelmurphygallery.com. Web site: www.michaelmurphygallery.com. **Contact:** Michael Murphy, owner. For-profit gallery. Estab. 1988. Approached by 100 artists/year; exhibits 35 emerging and mid-career artists/year. Exhibited artists

include Marsha Hammel and Peter Pettegrew. Sponsors 6 exhibits/year. Average display time 1 month. Open all year; Monday-Saturday, 10-6. Clients include local community and upscale. 20% of sales are to corporate collectors. Overall price range is $500-15,000; most work sold at less than $1,000.

Media Considers all media. Most frequently exhibits acrylic, oil and watercolor. Considers all types of prints.

Style Considers all styles. Most frequently exhibits color field, impressionism and painterly abstraction. Considers all genres.

Terms Artwork is accepted on consignment and there is a 50% commission. Retail price set by the gallery. Accepted work should be framed. Requires exclusive representation locally.

Submissions Send query with artist's statement, bio, brochure, business card, photocopies, photographs, résumé, reviews, SASE and slides. Cannot return material. Responds to queries only if interested in 1 month. Files all materials. Finds artist's through art fairs and exhibits, portfolio reviews, referrals by other artists, submissions and word of mouth.

NUANCE GALLERIES

804 S. Dale Mabry, Tampa FL 33609. (813)875-0511. Fax: (813)849-1261. E-mail: art@nuancegalleries.com. Web site: www.nuancegalleries.com. **Owner:** Robert A. Rowen. Retail gallery. Estab. 1981. Represents 70 emerging, mid-career and established artists. Sponsors 3 shows/year. Open all year. 3,000 sq. ft. "We've reduced the size of our gallery to give the client a more personal touch. We have a large extensive front window area."

Media Specializing in watercolor, original mediums and oils.

Style "Majority of the work we like to see are realistic landscapes, escapism pieces, bold images, bright colors and semitropical subject matter. Our gallery handles quite a selection, and it's hard to put us into any one class."

Terms Accepts work on consignment (50% commission). Retail price set by gallery and artist. Offers customer discounts and payment by installments. Gallery provides insurance and contract; shipping costs are shared.

Submissions Send query letter with slides and bio, SASE if want slides/photos returned. Portfolio review requested if interested in artist's work.

Tips "Be professional; set prices (retail) and stick with them. There are still some artists out there that are not using conservation methods of framing. As far as submissions we would like local artists to come by to see our gallery and get the idea what we represent. Tampa has a healthy growing art scene, and the work has been getting better and better. But as this town gets more educated, it is going to be much harder for up-and-coming artists to emerge."

OPUS 71 FINE ARTS, HEADQUARTERS

(formerly Opus 71 Galleries, Headquarters), 4115 Carriage Dr., Villa P-2, Misty Oaks, Pompano Beach FL 33069. (954)974-4739. E-mail: lionxsx@aol.com. **Co-Directors:** Charles Z. Candler III and Gary R. Johnson. Retail and wholesale private gallery, alternative space, art consultancy and salon style organization. Estab. 1969. Represents 40 (15-20 on regular basis) emerging, mid-career and established artists/year. By appointment only. Clientele: upscale, local, international and regional. 75% private collectors; 25% corporate collectors. Overall price range $200-85,000; most work sold at $500-7,500.

- This gallery is a division of The Leandros Corporation. Other divisions include The Alexander Project and Opus 71 Art Bank.

Media Considers oil, acrylic, pastel, pen & ink, drawing, mixed media, collage, sculpture and ceramics; types of prints include woodcuts and wood engravings. Most frequently exhibits oils or acrylic, bronze and marble sculpture and pen & ink or pastel drawings.

Style Exhibits expressionism, neo-expressionism, primitivism, painterly abstraction, surrealism, conceptualism, minimalism, color field, postmodern works, impressionism, photorealism, hard-edge geometric abstraction (paintings), realism and imagism. Exhibits all genres. Prefers figural, objective and nonobjective abstraction and realistic bronzes (sculpture).

Terms Accepts work on consignment or buys outright. Retail price set by "consulting with the artist initially." Gallery provides insurance (with limitations), promotion and contract; artist pays for shipping to gallery and for any return of work. Prefers artwork framed, unless frame is not appropriate.

Submissions Telephone call is important. Call for appointment to show portfolio of photographs and actual samples. "We will not look at slides." Responds in 2 weeks. Files résumés, press clippings and some photographs. "Artists approach us from a far flung area. We currently have artists from about 12 states and 4 foreign countries. Most come to us. We approach only a handful of artists annually."

Tips "Know yourself . . . be yourself . . . ditch the jargon. Quantity of work available not as important as quality and the fact that the presenter is a working artist. We don't want hobbyists."

PALM AVENUE GALLERY

45 S. Palm Ave., Sarasota FL 34236. (941)953-5757. E-mail: info@palmavenuegallery.com. Web site: www.palm avenuegallery.com. **Owner/Director:** Mary Bates. Retail gallery. Represents 20 emerging and mid-career artists. Featuring one artist each month. Open all year; Tuesday-Saturday, 10-5. Located in arts and theater district downtown; 1,700 sq. ft.; "high tech, 10 ft. ceilings with street exposure in restored hotel." Clientele 75% private collectors, 25% corporate collectors. Overall price range $500-5,000; most artwork sold at $500-2,000.

Media Considers oil, acrylic, watercolor, mixed media, collage, works on paper, sculpture, glass and pottery. Most frequently exhibits painting, graphics and sculpture.

Style Exhibits expressionism, painterly abstraction, surrealism, impressionism, realism and hard-edge geometric abstraction. All genres. Prefers impressionism, surrealism.

Terms Accepts artwork on consignment (50% commission). Retail price set by artist. Sometimes offers customer discounts. Gallery provides insurance, promotion and contract. Prefers framed work. Exhibition costs shared 50/50.

Submissions Send résumé, brochure, slides, bio and SASE. Write for appointment to show portfolio of originals and photographs. "Be organized and professional. Come in with more than slides; bring P.R. materials, too!" Responds in 1 week.

SANTE FE TRAILS GALLERY

1429 Main St., Sarasota FL 34236. (813)954-1972. E-mail: sftgallery@aol.com. Web site: www.eltallerpublishing .com. **Owner:** Beth Segreti. Retail gallery. Emphasis is on Native American and contemporary Southwestern art. Estab. 1990. Represents/exhibits 25 emerging, mid-career and established artists/year. May be interested in seeing the work of emerging artists in the future. Exhibited artists include Amado Pena and R.C. Gorman. Sponsors 5-6 shows/year. Average display time 1 month. Open all year; Tuesday-Saturday, 10-5. Located downtown; 1,000 sq. ft.; 100% of space for special exhibitions featuring gallery artists. Clientele tourists, upscale and local community. 100% private collectors. Overall range $35-12,000; most work sold at $500-1,500.

Media Considers all media, etchings, lithographs, serigraphs and posters. Most frequently exhibits lithographs, mixed media and watercolor.

Style Prefers Southwestern. "Southwestern art has made a dramatic increase in the past few months. This could be the start of another seven-year cycle."

Terms Artwork is accepted on consignment (50% commission) or is bought outright for 50% of the retail price. Retail price set by the gallery and the artist. Gallery provides promotion. Shipping costs are shared. Artist pays for shipping costs to gallery. Prefers artwork unframed.

Submissions Send query letter with résumé, slides or photographs, bio and SASE. Write for appointment to show portfolio of photographs, slides and transparencies. Responds only if interested within 2 weeks. Finds artists through word of mouth, referrals by other artists and submissions.

Tips "Make an appointment. No walk-ins!!"

STETSON UNIVERSITY DUNCAN GALLERY OF ART

421 N. Woodland Blvd., Unit 8252, DeLand FL 32723-3756. (386)822-7266. E-mail: cnelson@stetson.edu. Web site: stetson.edu/departments/art. **Gallery Director:** Dan Gunderson. Nonprofit university gallery. Approached by 20 artists/year. Represents emerging and established artists. Sponsors 4-6 exhibits/year. Average display time 4-5 weeks. Open Sept.-April; Monday-Friday, 10-4; weekends 1-4. Approximately 2,400 sq. ft. gallery space at Stetson University. Clients include local community, students, tourists, school groups and elder hostelers.

Media Considers acrylic, ceramics, drawing, installation, mixed media, oil, acrylic, sculpture. Most frequently exhibits oil/acrylic, sculpture and ceramics.

Style Most frequently exhibits contemporary.

Terms 30% of price is returned to gallery. Retail price set by the artist. Gallery provides insurance. Accepted work should be framed, mounted and matted. Does not require exclusive representation locally.

Submissions Send query letter with artist's statement, bio, letter of proposal, résumé, reviews, SASE and 20 slides. Returns material with SASE. May respond, but artist should contact by phone. Files "whatever is found worthy of an exhibition—even if for future year." Finds artists through word of mouth, submissions, art exhibits, and referrals by other artists.

Tips Looks for "professional-quality slides. Good letter of proposal."

THE VON LIEBIG ART CENTER

585 Park St., Naples FL 34102. (239)262-6517. Fax: (239)262-5404. E-mail: info@naplesart.org. Web site: naples art.org. Full nonprofit contemporary visual arts center with galleries, professional studios, photography lab, resource library and outdoor festivals. Estab. 1954—new facility 1998. Represents 400 emerging, mid-career and established artists with membership of nearly 1,500. Exhibited artists include Clyde Butcher, Jim Rosenquist and Jonathan Green. Sponsors 14 exhibits/year. Average display time 6 weeks. Open all year; Monday-Saturday,

10 a.m.-4 p.m. Sundays 1 p.m.-4 p.m. Closed holidays. Located in downtown Naples; 16,000 sq. ft. visual arts facility. Audience includes local community, students, upscale.

Media Considers original works in all media.

Style Considers all styles. Most frequently exhibits contemporary American art in all media from 1950 forward.

Terms Artwork is accepted on consignment and there is a 30% commission. All members' exhibitions are juried. Must be a member to participate. Director selects artists for curated exhibitions. Retail price set by the artist. Gallery provides insurance. Accepted work should be framed. Requires exclusive representation locally. Prefers only Florida artists.

Submissions Finds artists through word of mouth, juried exhibits, and referrals by other artists and curators.

Tips "Must have had work exhibited in number of accredited fine art museums included in private, public and corporate collections. Must have received grant awards or fellowships."

GEORGIA

AMERICAN PRINT ALLIANCE

Office only: 302 Larkspur Turn, Peachtree City GA 30269-2210. E-mail: director@printalliance.org. Web site: www.printalliance.org. **Contact:** Carol Pulin, director. Nonprofit arts organization with on-line gallery and exhibitions, actual travelling exhibitions, and journal publication. Estab. 1992, first publications and exhibitions 1993. Gallery and some exhibitions are on-line, other exhibitions travel. Exhibits emerging, mid-career, established artists. Represents hundreds of artists/year. "We only exhibit original prints, artists' books and paperworks." Sponsors usually 2 travelling exhibits/year—all prints, paperworks and artists' books; photography within printmaking processes but not as a separate medium. Most exhibits travel for 2 years. Hours depend on the host gallery/museum/arts center. "We travel exhibits coast to coast and occasionally to Hawaii." Overall price range for Print Bin: $40-3,200; most work sold at $300-500.

Media Considers and exhibits original prints, paperworks, artists' books. Also all original prints including any combination of printmaking techniques, no reproductions/posters.

Style Considers all styles. Most frequently exhibits contemporary, but we accept all styles, genres and subjects; the decisions are made on quality of work.

Making Contact & Terms Print Bin is free with subscription, $30 members of Alliance councils, $37 other, $15 students; subscribers have free entry to jurying of travelling exhibitions but must pay for framing, shipping to and from our office. Gallery provides promotion. Accepted work should be submitted as slides for internet; specific instructions are given for frames for travelling exhibitions. Does not require exclusive representation locally. Most artists are in the U.S. and Canada, but there is no restriction.

Submissions Subscribe to our journal (see www.printalliance.org, direct page is www.printalliance.org/alliance/al_subform.html), send one slide and signed permission form (see www.printalliance.org/gallery/printbin_info.html). Returns slide if requested with SASE. Usually does not respond to queries from non-subscribers. Files slides and permission forms. Submissions to the print bin, and especially portfolio reviews at printmakers conferences (unfortunately, we don't have the staff for individual portfolio reviews though we may—and often do—request additional images after seeing one work, often for journal articles; generally about 100 images are reproduced per year in the journal).

Tips "See the Standard Forms area of our Web site (www.printalliance.org/library/li_forms.html) for correct labels on slides and much, much more about professional presentation."

BRENAU UNIVERSITY GALLERIES

One Centennial Circle, Gainesville GA 30501. (770)534-6263. Fax: (770)538-4599. E-mail: gallery@lib.brenau.edu. Web site: www.brenau.edu. **Gallery Director:** Jean Westmacott. Nonprofit gallery. Estab. 1980s. Exhibits emerging, mid-career and established artists. Sponsors 7-9 shows/year. Average display time 6-8 weeks. Open all year; Monday-Friday, 10-4; Sunday, 2-5 during exhibit dates. "Please call for Summer hours." Located near downtown; 3,958 sq. ft., 3 galleries—the main one in a renovated 1914 neoclassic building, the other in an adjacent renovated Victorian building dating from the 1890s, the third gallery is in the new center for performing arts. 100% of space for special exhibitions. Clientele tourists, upscale, local community, students. "Although sales do occur as a result of our exhibits, we do not currently take any percentage, except in our invitational exhibitions. Our purpose is primarily educational."

Media Considers all media.

Style Exhibits wide range of styles. "We intentionally try to plan a balanced variety of media and styles."

Terms Retail price set by the artist. Gallery provides insurance and promotion; shipping costs are shared, depending on funding for exhibits. Prefers artwork framed. "Artwork must be framed or otherwise ready to exhibit."

Submissions Send query letter with résumé, 10-20 slides, photographs and bio. Write for appointment to show

portfolio of slides and transparencies. Responds within months if possible. Artist should call to follow up. Files one or two slides or photos with a short résumé or bio if interested. Remaining material returned. Finds artists through referrals, direct viewing of work and inquiries.

Tips "Be persistent, keep working, be organized and patient. Take good slides and develop a body of work. Galleries are limited by a variety of constraints—time, budgets, location, taste—and rejection does not mean your work may not be good; it may not 'fit' for other reasons at the time of your inquiry."

SKOT FOREMAN FINE ART

315 Peters St. SW, Atlanta GA 30313. (404)222-0440. E-mail: info@skotforeman.com. Web site: www.skotforem an.com. **Contact:** Erica Stevens, assistant. For-profit gallery. Estab. 1994. Approached by 1,500-2,000 artists/ year; exhibits 30 mid-career and established artists/year. In-house exhibited artists include Purvis Young (house paint on wood), Chris Dolan (oil/acrylic on canvas). Also brokering works by Warhol, Haring, Finster, Escher, Dali, Wesselman and Matta. Sponsors 6-8 exhibits/year. Average display time 30-45 days. Open Wednesday-Saturday, 12-5:30 and by appointment. Located "in a downtown metropolitan loft district of Atlanta. The 100-year-old historical building features 2,000 sq. ft. of hardwood floors and 18 ft. ceilings." Clients include local community, tourists, upscale and art consultants. 25% of sales are to corporate collectors. Overall price range is $500-50,000; most work sold at $3,000-5,000.

Media Considers acrylic, collage, drawing, glass, installation, mixed media, oil, paper, pastel, pen & ink, sculpture, watercolor. Most frequently exhibits acrylic, oil and mixed media. Considers engravings, etchings, linocuts, lithographs, mezzotints, posters, serigraphs, woodcuts.

Style Exhibits expressionism, realism, neo-expressionism, painterly abstraction, postmodernism, surrealism. Most frequently exhibits painterly abstraction, neo-expressionism and realism. Genres include figurative work, landscapes, portraits and perspective.

Terms Artwork is accepted on consignment and there is a variable commission. Retail price set by the gallery. Gallery provides insurance, promotion and contract. Requires exclusive representation locally. No outdoor Fair self-representation.

Submissions Send e-mail with bio and digital photos. Returns material with SASE. Responds to queries only if interested in 3 weeks. Finds artist's through art fairs and exhibits, portfolio reviews, referrals by other artists, submissions and word of mouth.

Tips "Be concise. Not too much verbage—let the art speak on your behalf."

ℕ GERTRUDE HERBERT INSTITUTE OF ART

506 Telfair St., Augusta GA 30901-2310.(706)722-5495. Fax: (706)722-3670. E-mail: ghia@ghia.org. Web site: www.ghia.org. **Contact:** Kim Overstreet, Executive Director. Nonprofit gallery. Estab. 1937. Exhibits emerging, mid-career and established artists. Approached by 5 solo/group shows annually; approx. 40 artists. Exhibited artists include Andrew Crawford, sculpture; Susan Maakestad, oil, watercolor. Sponsors 5 exhibits/year. Average display time 6-8 weeks. Open Tuesday-Friday, 10-5; weekends by advanced appointment only; closed first week in August, December 20-31. Located in historic 1818 Ware' s Folly mansion. Clients include local community, tourists and upscale. Approx. 5% of sales are to corporate collectors. Overall price range: $100-5,000; most work sold at $500.

Media Considers all media except craft. Considers all types of prints.

Style Exhibits all styles.

Terms Artwork is accepted on consignment and there is a 35% commission. Retail price set by the artist. Gallery provides insurance and promotion. Accepted works on paper must be framed and under Plexiglas. Does not require exclusive representation locally.

Submissions Send query letter with artist statement, bio, brochure, résumé, reviews, SASE, slides or CD of current work. Returns material with SASE. Responds to queries quarterly after expeditions review committee meets. Finds artists through art exhibits, referrals by other artists and submissions.

THE LOWE GALLERY

75 Bennett St., Space A-2, Atlanta GA 30309. (404)352-8114. Fax: (404)352-0564. E-mail: info@lowegallery.c om. **Director:** Anne Archer Dennington. Retail gallery. Estab. 1989. Exhibits contemporary emerging, mid-career, and internationally recognized artists. Hosts 6-10 exhibits/year. Average display time 6-8 weeks. Open all year; Tuesday-Friday, 10:30-5:30; Saturday, 11-5 and Sunday by appointment. Located uptown (Buckhead); 12,000 sq. ft.; 4 exhibition rooms with a dramatic split level Grand Salon with 30 ft. ceilings and 18 ft. walls. 100% of space for gallery artists. 75% private collectors, 25% corporate collectors. Overall price range $700-150,000; most work sold at $2,000-15,000.

Media Considers any 2- or 3-dimensional medium. Most frequently exhibits painting, drawing and sculpture.

Style Exhibits a wide range of aesthetics from figurative realism to painterly abstraction. Prefers postmodern works with a humanistic/spiritual content.

Terms Artwork is accepted on consignment (50% commission). Retail price set by the gallery. Gallery provides promotion and contract; shipping costs are shared. Prefers artwork framed.

Submissions Send query letter with résumé, 10-20 slides and SASE. Responds only if interested within 6 weeks. Finds artists through submissions.

Tips "Put together an organized, logical submission. Do not bring actual pieces into the gallery. Be sure to include a SASE. Show galleries at least one cohesive body of work, could be anywhere between 10-40 pieces."

MARY PAULINE GALLERY

982 Broad St., Augusta GA 30901. E-mail: mmcdowel@mindspring.com. Web site: www.marypaulinegallery.com. **Contact:** Kathy Newton, gallery assistant. For-profit gallery. Estab. 1998. Approached by 10 artists/year; exhibits 20 established artists/year. Exhibited artists Benny Andrews (oil and collage on paper and canvas), Edward Rice (oil on paper, canvas, or board). Average display time 6-8 weeks. Closed Christmas-New Year. Located in downtown Augusta. Clients include local community, students, tourists and upscale. Overall price range $1,000-70,000; most work sold at $2,500.

Media Considers acrylic, ceramics, collage, drawing, glass, mixed media, oil, paper, pastel, pen & ink, sculpture, watercolor. Most frequently exhibits painting, drawing and collage.

Style Most frequently exhibits painterly abstraction, surrealism and expressionism. Genres include Americana, figurative work, florals and landscapes.

Terms Artwork is accepted on consignment and there is a 50% commission. Retail price of the art set by the gallery. Gallery provides insurance, promotion and contract. Accepted work should be framed. Requires exclusive representation locally. Prefers only Southern artists.

Submissions Send query letter with artist's statement, bio, brochure, business card, photocopies, photographs, résumé, reviews, SASE, slides. Returns material with SASE. Responds to queries in 6 months. Files résumé. Finds artist's through art fairs and exhibits, portfolio reviews, referrals by other artists, submissions and word of mouth.

Tips "Have a good body of work and a résumé that reflects that you are on a career track."

RAIFORD GALLERY

1169 Canton St., Roswell GA 30075. (770)645-2050. Fax: (770)992-6197. E-mail: raifordgallery@mindspring.com. Web site: www.raifordgallery.com. For profit gallery. Estab. 1996. Approached by many artists/year. Represents 400 mid-career and established artists. Exhibited artists include Cathryn Hayden (collage, painting and photography), Richard Jacobus (metal). Sponsors 4 exhibits/year. Average display time 4 weeks. Open all year; Tuesday-Friday, 10-6; Saturday, 10-5. Located in historic Roswell GA; 4,500 sq. ft. in an open 2-story timber frame space. Clients include local community, tourists and upscale. Overall price range $10-2,000; most work sold at $200-300.

Media Considers all media except installation. Most frequently exhibits painting, sculpture and glass.

Style Exhibits contemporary American art & craft.

Terms Artwork is accepted on consignment and there is a 50% commission. Retail price set by the artist. Gallery provides insurance, promotion and contract. Accepted work should be framed. Requires exclusive representation locally.

Submissions Call or write to arrange to show portfolio of photographs, slides and originals. Send query letter with artist's statement, bio, brochure, photocopies, photographs, SASE. Returns material with SASE. Finds artists through submissions, portfolio reviews, art exhibits and art fairs.

TEW GALLERIES INC.

The Galleries of Peachtree Hills, 425 Peachtree Hills Ave., Unit 24, Atlanta GA 30305. Phone: (404)869-0511. Fax: (404) 869-0512. E-mail: info@timothytew.com. Web site: www.timothytew.com. **Contact:** Jules Bekker, Director. For-profit gallery. Estab. 1989. Exhibits selected emerging and mid-career artists. Approached by 100 artists/year; represents or exhibits 27 artists/year. Exhibited artists include Deedra Ludwig, encaustic, mixed media, oil, pastel painting; Kimo Minton, polychrome on Cottonwood, bronze sculptures. Sponsors 8 exhibits/year. Average display time 28 days. Open Monday-Friday, 9-6; Saturdays, 11-5. Located in a prestigious arts and antiques complex. Total of 3,600 sq. ft. divided over three floors. Clients include upscale and corporate. 15% of sales are to corporate collectors. Overall price range: $1,800-20,000; most work sold at $4,500 or less.

Media Considers all media except craft and photography. Most frequently exhibits oil on canvas, works on paper and small to medium scale sculptures. Considers all types of prints. Small Limited editions only. Prints are a very minor aspect of our business.

Style Considers all styles.

Terms Artwork is accepted on consignment and there is a 50% commission. Retail price set by the gallery and the artist. Requires exclusive representation locally.

Submissions Send digital PDF by e-mail. Mail CD of portfolio with bio, artist statement and résumé for review.

Returns material with SASE. Responds to queries only if interested within 8 weeks. Files digital files only if interested. Finds artists through art exhibits, portfolio review, referrals by other artists and submissions.

Tips A minimum of 12 good quality images of recent work on digital media. Include all biographical material on the CD along with image.

TRINITY GALLERY

315 E. Paces Ferry Rd., Atlanta GA 30305. (404)237-0370. Fax: (404)240-0092. E-mail: info@trinitygallery.com. Web site: www.trinitygallery.com. **President:** Alan Avery. Retail gallery and corporate sales consultants. Estab. 1983. Represents/exhibits 67 mid-career and established artists and old masters/year. Exhibited artists include Roy Lichtenstein, Jim Dine, Robert Rauschenberg, Andy Warhol, Larry Gray, Ray Donley, Robert Marx, Lynn Davison and Russell Whiting. Sponsors 6-8 shows/year. Average display time 6 weeks. Open all year; Tuesday-Friday, 10-6; Saturday, 11-5 and by appointment. Located mid-city; 6,700 sq. ft.; 25-year-old converted restaurant. 50-60% of space for special exhibitions; 40-50% of space for gallery artists. Clientele: upscale, local, regional, national and international. 70% private collectors, 30% corporate collectors. Overall price range $2,500-100,000; most work sold at $2,500-5,000.

Media Considers all media and all types of prints. Most frequently exhibits painting, sculpture and work on paper.

Style Exhibits expressionism, conceptualism, color field, painterly abstraction, postmodern works, realism, impressionism and imagism. Genres include landscapes, Americana and figurative work. Prefers realism, abstract and figurative.

Terms Artwork is accepted on consignment (negotiable commission). Retail price set by gallery. Gallery pays promotion and contract. Shipping costs are shared. Prefers artwork framed.

Submissions Send query letter with résumé, at least 20 slides, bio, prices, medium, sizes and SASE. Reviews every 6 weeks. Finds artists through word of mouth, referrals by other artists and artists' submissions.

Tips "Be as complete and professional as possible in presentation. We provide submittal process sheets listing all items needed for review. Following this sheet is important."

HAWAII

DOLPHIN GALLERIES

230 Hana Highway, Suite 12, Kahalui HI 96732. (800)669-5051, ext. 207. Fax: (808)873-0820. E-mail: ChristianAdams@DolphinGalleries.com. **Contact:** Christian Adams, director of sales. For-profit gallery. Estab. 1976. Exhibits emerging, mid-career and established artists. Exhibited artists include Alexandra Nechita, Pino and Thomas Pradzynski. Sponsors numerous exhibitions/year; running at all times through 9 separate Fine Art or Fine Jewelry Gallery. Average display time varies from one-night events to a 30-day run. Open 7 days a week, 9 a.m.-10 p.m. Located in upscale, high traffic tourist locations throughout Hawaii. On Oahu, Dolphin has galleries at the Hilton Hawaiian Village. On Big Island they have galleries located at the Kings Shops at Waikoloa. Clients include local community and upscale tourists. Overall price range $100-100,000; most work sold at $1,000-5,000.

• The above address is for Dolphin Galleries' corporate offices. Dolphin Galleries has 9 locations throughout the Hawaiian islands.

Media Considers all media. Most frequently exhibits oil and acrylic paintings and limited edition works of art. Considers all types of prints.

Style Most frequently exhibits impressionism, figurative and abstract art. Considers American landscapes, portraits and florals.

Terms Artwork is accepted on consignment with negotiated commission, promotion and contract. Retail price set by the gallery. Gallery provides insurance, promotion and contract. Accepted work should be framed, mounted and matted. Requires exclusive representation locally.

Submissions E-mail submissions to ChristianAdams@DolphinGalleries.com. Finds artists mainly through referrals by other artists, art exhibits, submissions, portfolio reviews and word of mouth.

HANA COAST GALLERY

Hotel Hana-Maui, P.O. Box 565, Hana Maui HI 96713. (808)248-8636. Fax: (808)248-7332. E-mail: info@hanacoast.com. Web site: www.hanacoast.com. **Managing Director:** Patrick Robinson. Retail gallery and art consultancy. Estab. 1990. Represents 78 established artists. Sponsors 12 group shows/year. Average display time 1 month. Open all year. Located in the Hotel Hana-Maui at Hana Ranch; 3,000 sq. ft.; "an elegant ocean-view setting in one of the top small luxury resorts in the world." 20% of space for special exhibitions. Clientele ranges from very upscale to highway traffic walk-ins. 85% private collectors, 15% corporate collectors. Overall price range $150-50,000; most work sold at $1,000-6,500.

Media Considers oil, acrylic, watercolor, pastel, mixed media, collage, works on paper, sculpture, ceramic, craft, fiber, glass, photography, original handpulled prints, engravings, lithographs, pochoir, wood engravings, mezzotints, serigraphs and etchings. Most frequently exhibits oil, watercolor and original prints.
Style Exhibits expressionism, primitivism, impressionism and realism. Genres include landscapes, florals, portraits, figurative work and Hawaiiana. Prefers landscapes, florals and figurative work. "We also display decorative art and master-level craftwork, particularly turned-wood bowls, blown glass, fiber, bronze sculpture and studio furniture.
Terms Accepts artwork on consignment (60% commission). Retail price set by gallery and artist. Gallery provides insurance, promotion and shipping costs from gallery. Framed artwork only.
Submissions Accepts only full-time Hawaii resident artists. Send query letter with résumé, slides, bio, brochure, photographs, SASE and reviews. Write for appointment to show portfolio after query and samples submitted. Portfolio should include originals, photographs, slides and reviews. Responds only if interested within 1 week. If not accepted at time of submission, all materials returned.
Tips "Know the quality and price level of artwork in our gallery and know that your own art would be companionable with what's being currently shown. Be able to substantiate the prices you ask for your work. We do not offer discounts, so the mutually agreed upon price/value must stand the test of the market."

HONOLULU ACADEMY OF ARTS
900 S. Beretania St., Honolulu HI 96814. (808)532-8700. Fax: (808)532-8787. E-mail: academypr@honoluluacademy.org. Web site: www.honoluluacademy.org. **Director:** Stephen Little, Ph.D. Nonprofit museum. Estab. 1927. Exhibits emerging, mid-career and established Hawaiian artists. Interested in seeing the work of emerging artists. Sponsors 40-50 shows/year. Average display time 6-8 weeks. Open all year; Tuesday-Saturday 10-4:30, Sunday 1-5. Located just outside of downtown area; 40,489 sq. ft. 30% of space for special exhibition. Clientele general public and art community.
Media Considers all media. Most frequently exhibits painting, works on paper, sculpture.
Style Exhibits all styles and genres. Prefers traditional, contemporary and ethnic.
Terms "On occasion, artwork is for sale." Retail price set by artist. Museum provides insurance and promotion; museum pays for shipping costs. Prefers artwork framed.
Submissions Exhibits artists of Hawaii. Send query letter with résumé, slides and bio directly to curator(s) of Western and/or Asian art. Curators are Jennifer Saville, Western art; Julia White, Asian art. Write for appointment to show portfolio of slides, photographs and transparencies. Responds in 3-4 weeks. Files résumés, bio.
Tips "Be persistent but not obnoxious." Artists should have completed a body of work of 50-100 works before approaching galleries.

RAMSAY MUSEUM
1128 Smith St., Honolulu HI 96817. (808)537-ARTS. Fax: (808)531-MUSE. E-mail: ramsay@lava.net. Web site: www.ramsaymuseum.org. **CEO:** Ramsay. Gallery, museum shop, permanent exhibits and artists' archive documenting over 200 exhibitions including 500 artists of Hawaii. Estab. 1981. Open all year; Monday-Friday, 10-5; Saturday, 10-4. Located in downtown historic district; 5,000 sq. ft.; historic building with courtyard. Displaying permanent collection of Ramsay Quill and Ink originals spanning 50 years. Clientele 50% tourist, 50% local. 25% private collectors, 75% corporate collectors.
Media Especially interested in ink.
Style Currently focusing on the art of tattoo.
Terms Accepts work on consignment. Retail price set by the artist.
Submissions Send query letter with résumé, 20 slides, bio, SASE. Write for appointment to show portfolio of original art. Responds only if interested within 1 month. Files all material that may be of future interest.
Tips "Keep a record of all artistic endeavors for future use, and to show your range to prospective commissioners and galleries. Prepare your gallery presentation packet with the same care that you give to your art creations. Quality counts more than quantity. Show samples of current work with an exhibit concept in writing."

WAILOA CENTER
Division of State Parks, Department of Land & Natural Resources State of Hawaii, DLNR P.O. Box 936, Hilo HI 96721. (808)933-0416. Fax: (808)933-0417. E-mail: wailoa@yahoo.com. **Contact:** Codie M. King, director. Nonprofit gallery and museum. Focus is on propagation of the culture and arts of the Hawaiian Islands and their many ethnic backgrounds. Estab. 1968. Represents/exhibits 300 emerging, mid-career and established artists. Interested in seeing work of emerging artists. Sponsors 36 shows/year. Average display time 1 month. Open all year; Monday, Tuesday, Thursday, and Friday, 8:30-4:30; Wednesday, noon-4:30; closed weekends and state holidays. Located downtown; 10,000 sq. ft.; 4 exhibition areas Main Gallery, Fountain Gallery, Rotunda Gallery. Clientele: tourists, upscale, local community and students. Overall price range $25-25,000; most work sold at $1,500.

Media Considers all media and all types of prints. No giclée prints; original artwork only. Most frequently exhibits mixed media.

Style Exhibits all styles. "We cannot sell, but will refer buyer to seller." Gallery provides some promotion. Artist pays for shipping, invitation, and reception costs. Artwork must be framed.

Submissions Send query letter with résumé, slides, photographs and reviews. Call for appointment to show portfolio of photographs and slides. Responds in 3 weeks. Finds artists through word of mouth, referrals by other artists, visiting art fairs and exhibitions, submissions.

Tips "We welcome all artists, and try to place them in the best location for the type of art they have. Drop in and let us review what you have."

IDAHO

DEVIN GALLERIES

507 Sherman Ave., Coeur d'Alene ID 83814. (208)667-2898. E-mail: info@devingalleries.com. Web site: www.d evingalleries.com. **Owners** Skip and Debbie Peterson. Retail gallery. Estab. 1982. Represents 100 established and emerging artists. Exhibited artists include Chester Fields, Ovanes Berberian, J. Nelson, Dale Terbush, Pino, Yuri Gorbachev. Sponsors 9 shows/year. Open all year. Located "in main business district downtown;" 7,000 sq. ft.; historical building. 25% of space for special exhibitions. Clientele middle to upper income. 85% private collectors, 15% corporate collectors. Overall price range $500-75,000; most work sold at $1,500-7,500.

Media Considers all media.

Style Exhibits all styles from realism and impressionism to contemporary and abstract. Genres include landscapes, but are not limited to, Landscapes, Floral, Still Life, Western, and Wildlife.

Terms Accepts artwork on consignment. Retail price set by gallery and artist. Gallery provides promotion and contract; artist pays for shipping. Prefers artwork framed.

Submissions Submit portfolio with introduction letter, bio, photographs/slides, SASE (for return of materials if desired), Web site and other useful information. Gallery accepts "email" portfolio and/or Web site submissions via e-mail. Files all material for 6-12 months.

Tips "Devin Galleries now has a complete custom frame shop with 23 years experience in framing."

GALLERY DENOVO

P.O. Box 7214, Ketchum ID 83340-7214. (208)726-8180. Fax: (208)726-1007. E-mail: info@gallerydenovo.com. Web site: www.gallerydenovo.com. **Contact:** Robin Reiners, gallery director. For-profit gallery. Estab. 2002. Exhibits internationally exhibited mid-career and established artists. Represents approximately 25 artists/year. Exhibited artists include Andrew Lui, Ink and Acrylic on Rice Paper; Marta Moreu, Bronze. Sponsors 9 exhibits/ year. Average display time 1 month. Open Monday-Saturday, 10-6; Sunday, 12-5 (during winter and summer season); closed a week or two in late April, early May. Located Downtown Ketchum, ID (in Sun Valley Area) right along "gallery row." 1,000 sq. ft. of clean contemporary gallery with crisp white walls and stained concrete floor. Three galleries are housed in this same building. Clients include local community, tourists, upscale. Overall price range: $500-15,000; most work sold at $2,000-5,000.

Media Considers all media except craft. Most frequently exhibits oil, acrylic, mixed media. Considers all types of prints.

Style Contemporary. Considers all styles. Most frequently exhibits painterly abstraction, expressionism, conceptualism. Genres include figurative work, florals, landscapes, portraits.

Making Contact & Terms Artwork is accepted on consignment and there is a 50% commission. Artwork is bought outright for varying% of retail price. Retail price set by the artist. Requires exclusive representation locally. Accepts only artists from Internationally shown artists—many living outside the US.

Submissions E-mail with exhibition history, artist statement and 3-5 images attached. Send query letter with artist's statement, bio, slides or CD of works including SASE. Return of material not guaranteed without SASE. Responds to queries only if interested within 1 months. Try to respond to others, but receive so many that it is not guaranteed. Files interesting work that may fit in gallery at some other time. Finds artists mostly via art exhibits, but also by referrals by other artists and art fairs.

Tips "Spell check! Be concise and organized with information, and look at the type of gallery and type of work that is shown to see if new work would fit into that gallery and what they tend to represent."

POCATELLO ART CENTER GALLERY & SCHOOL

444 N. Main, Pocatello ID 83204. (208)232-0970. **President:** Jan Stanek. Nonprofit gallery featuring work of artist/members. Estab. 1970. Represents approximately 60 emerging, mid-career and established artists/year. Approximately 150 members. Exhibited artists include Barbara Ruffridge, Jerry Younkin, Onita Asbury and Barbara Swanson. Sponsors 10-12 shows/year. Average display time 2 months. Open all year; Monday-Friday,

10-4 (varies occasionally). Located downtown in "Old Town." "We sponsor the 'Sagebrush Arts Fes' each year, usually in September, on the Idaho State University Campus." We hold classes, feature all levels of artists and are a gathering place for artists. Clientele tourists, local community, students and artists. 100% private collectors. Overall price range $25-1,000; most work sold at $25-300.

Media Considers oil, acrylic, watercolor, pastel, pen & ink, drawing, mixed media, collage, paper, sculpture, ceramics, high-end craft, fiber, glass and photography; types of prints include woodcuts, engravings, wood engravings, serigraphs, linocuts and etchings. Most frequently exhibits watercolor, oil and pastel.

Style Exhibits Expressionism, neo-expressionism, primitivism, painterly abstraction, surrealism, minimalism, impressionism, photorealism, hard-edge geometric abstraction, realism and imagism. Exhibits all genres. Prefers impressionism, realism and painterly abstraction.

Terms Co-op membership fee plus donation of time. Donations-monetary. Retail price set by the artist. Gallery provides promotion; hand delivered works only. Prefers artwork framed.

Submissions Accepts only artists from Southeast Idaho. Memberships open to all artists and persons interested in the visual arts. Send query letter or visit gallery. Finds artists through word of mouth, referrals by other artists, visiting art fairs and exhibitions.

Tips "Have work ready to hang."

ILLINOIS

ARTCO, INCORPORATED

3148 RFD, Long Grove IL 60047. (847)438-8420. Fax: (847)438-6464. E-mail: sybiltillman@msn.com. Web site: www.e-Artco.com. **President:** Sybil Tillman. Retail and wholesale gallery, art consultancy and artists' agent. Estab. 1970. Represents 60 mid-career and established artists. Interested in seeing the work of emerging artists. Exhibited artists include Ed Paschke and Gary Grotey. Open all year; daily and by appointment. Located "2 blocks outside of downtown Long Grove; 7,200 sq. ft.; unique private setting in lovely estate and heavily wooded area." 50% of space for special exhibitions. Clientele upper middle income. 65% private collectors, 20% corporate collectors. Overall price range $500-20,000; most work sold at $2,000-5,000.

Media Considers paper, sculpture, fiber, glass, original handpulled prints, woodcuts, engravings, pochoir, wood engravings, mezzotints, linocuts, etchings and serigraphs. Most frequently exhibits originals and signed limited editions "with a small number of prints."

Style Exhibits all styles, including expressionism, abstraction, surrealism, conceptualism, postmodern works, impressionism, photorealism and hard-edge geometric abstraction. All genres. Likes American contemporary and Southwestern styles.

Terms Accepts artwork on consignment. Retail prices set by gallery. Customer discounts and payment by installment are available. Gallery provides promotion and contract; artist pays for shipping.

Submissions Send query letter with résumé, slides, transparencies, bio, brochure, photographs, SASE, business card and reviews. Responds in 1 month. Files materials sent. Portfolio review required. Finds artists through agents, by visiting exhibitions, word of mouth, various art publications and sourcebooks, submissions/self-promotions and art collectors' referrals.

Tips "We prefer established artists but will look at all new art."

CEDARHURST CENTER FOR THE ARTS

Richview Road, Mt. Vernon IL 62864. (618)242-1236. Fax: (618)242-9530. E-mail: mitchellmuseum@cedarhurst .org. Web site: www.cedarhurst.org. **Director of Visual Arts:** Kevin Sharp. Museum. Estab. 1973. Exhibits emerging, mid-career and established artists. Average display time six weeks. Open all year; Tuesday through Saturday, 10-5; Sunday 1-5; closed Mondays and federal holidays.

Submissions Call or send query letter with artist's statement, bio, résumé, SASE and slides.

FREEPORT ARTS CENTER

121 N. Harlem Ave., Freeport IL 61032. (815)235-9755. Fax: (815)235-6015. E-mail: artscenter@aeroinc.net. **Director:** Mary Fay Schoonover. Estab. 1975. Interested in emerging, mid-career and established artists. Sponsors 21 solo and group shows/year. Open all year; Tuesdays, 10-6; Wednesday-Friday, 10-5, Saturday and Sunday noon to 5 p.m. Clientele 30% tourists; 60% local; 10% students. Average display time 7 weeks.

Media Considers all media and prints.

Style Exhibits all styles and genres. "FAC is a regional museum serving Northwest Illinois, Southern Wisconsin and Eastern Iowa. There are extensive permanent collections and 8-9 special exhibits per year representing the broadest possible range of regional and national artistic trends. Some past exhibitions include 'Regional Juried Exhibition III,' 'Patterns of Life New Indonesian Textiles from the Collection,' and 'Through the Camera's Eye Lost Freeport Photographs and Works by David Anderson.' "

Terms Gallery provides insurance and promotion; artist pays shipping costs. Prefers artwork framed.
Submissions Send query letter with résumé, slides, SASE, brochure, photographs and bio. Responds in 4 months. Files résumés.
Tips "The Exhibition Committee meets quarterly each year to review the slides submitted."

ROBERT GALITZ FINE ART

166 Hilltop Court, Sleepy Hollow IL 60118. (847)426-8842. Fax: (847)426-8846. Web site: www.galitzfineart.com. **Owner:** Robert Galitz. Wholesale representation to the trade. Makes portfolio presentations to corporations. Estab. 1986. Represents 40 emerging, mid-career and established artists. Exhibited artists include Marko Spalatin and Jack Willis. Open by appointment. Located in far west suburban Chicago.
Media Considers oil, acrylic, watercolor, mixed media, collage, ceramic, fiber, original handpulled prints, engravings, lithographs, pochoir, wood engravings, mezzotints, serigraphs and etchings. "Interested in original works on paper."
Style Exhibits expressionism, painterly abstraction, surrealism, minimalism, impressionism and hard-edge geometric abstraction. Interested in all genres. Prefers landscapes and abstracts.
Terms Accepts artwork on consignment (variable commission) or artwork is bought outright (25% of retail price; net 30 days). Retail price set by artist. Customer discounts and payment by installment are available. Gallery provides promotion and shipping costs from gallery. Prefers artwork unframed only.
Submissions Send query letter with SASE and submission of art. Portfolio review requested if interested in artist's work. Files bio, address and phone.
Tips "Do your thing and seek representation—don't drop the ball! Keep going—don't give up!"

PRESTIGE ART GALLERIES

3909 W. Howard, Skokie IL 60076. (847)679-2555. E-mail: prestige@prestigeart.com. Web site: www.prestigeart.com. **President:** Louis Schutz. Retail gallery. Estab. 1960. Exhibits 100 mid-career and established artists/year. Interested in seeing the work of emerging artists. Exhibited artists include Jean Paul Avisse. Sponsors 4 shows/year. Average display time 4 months. Open all year; Saturday and Sunday, 11-5; Monday-Wednesday, 10-5. Located in a suburb of Chicago; 3,000 sq. ft. 20% of space for special exhibitions; 50% of space for gallery artists. Clientele professionals. 20% private collectors, 10% corporate collectors. Overall price range $100-100,000; most work sold at $1,500-2,000.
Media Considers oil, acrylic, mixed media, paper, sculpture, ceramics, craft, fiber, glass, lithographs and serigraphs. Most frequently exhibits paintings, glass and fiber.
Style Exhibits surrealism, New Age visionary, impressionism, photorealism and realism. Genres include landscapes, florals, portraits and figurative work. Prefers landscapes, figurative-romantic and floral.
Terms Accepts work on consignment (50% commission). Retail price set by the gallery and the artist. Gallery provides insurance, promotion and contract; shipping costs are shared. Prefers artwork framed.
Submissions Send query letter with résumé, slides, bio, SASE and prices/sizes. Call for appointment to show portfolio of photographs. Responds in 2 weeks. "Returns all material if SASE is included."

WILLIAM & FLORENCE SCHMIDT ART CENTER

Southwestern Illinois College, Belleville IL 62221. E-mail: libby.reuter@swic.edu. Web site: www.swicfoundation.com. **Contact:** Libby Reuter, executive director. Nonprofit gallery. Estab. 2001. Exhibits emerging, mid-career and established artists. Sponsors 10-12 exhibits/year. Average display time 6-8 weeks. Open Tuesday-Saturday, 11-5. Closed during college holidays. Clients include local community, students and tourists.
Media Considers all media. Most frequently exhibits oil, ceramics, photography. Considers all types of prints.
Style Considers all styles.
Submissions Mail portfolio for review. Send query letter with artist's statement, bio and slides. Returns material with SASE. Finds artists through art fairs and exhibits, portfolio reviews, referrals by other artists, submissions and word of mouth.

CHICAGO

A.R.C. GALLERY/EDUCATIONAL FOUNDATION

734 N. Milwaukee Ave., Chicago, IL 60622. (312)733-2787. E-mail: ARCgallery@yahoo.com. Web site: www.ARCgallery.org. **Executive Director:** Patricia Otto. Nonprofit gallery. Estab. 1973. Exhibits emerging, mid-career and established artists. Review work for solo and group shows on an ongoing basis. 21 members. (Visit Web site for prospectus.) Exhibited artists include Miriam Schapiro. Average display time 1 month. Closed August. Located in the River West area; 3,500 sq. ft. Clientele: 80% private collectors, 20% corporate collectors. Overall price range $50-40,000; most work sold at $200-4,000.

Media Considers oil, acrylic, drawings, mixed media, paper, sculpture, ceramics, installation, photography and original handpulled prints. Most frequently exhibits painting, sculpture (installation) and photography.
Style Exhibits all styles and genres. Prefers postmodern and contemporary work.
Terms Rental fee for space. Rental fee covers 1 month. Gallery provides promotion; artist pays shipping costs. Prefers work framed.
Submissions Send query letter with résumé, slides, bio and SASE. Call for deadlines for review. Portfolio should include slides.

JEAN ALBANO GALLERY

215 W. Superior St., Chicago IL 60610. (312)440-0770. E-mail: jeanalbano@aol.com. Web site: jeanalbano-artgallery.com. **Director:** Jean Albano Broday. Retail gallery. Estab. 1985. Represents 24 mid-career artists. Somewhat interested in seeing the work of emerging artists. Exhibited artists include Martin Facey and Jim Waid. Average display time 5 weeks. Open all year. Located downtown in River North gallery district; 1,600 sq. ft. 60% of space for special exhibitions; 40% of space for gallery artists. Clientele 80% private collectors, 20% corporate collectors. Overall price range $1,000-20,000; most work sold at $2,500-6,000.
Media Considers oil, acrylic, sculpture and mixed media. Most frequently exhibits mixed media, oil and acrylic. Prefers nonrepresentational, nonfigurative and abstract styles.
Terms Accepts artwork on consignment (50% commission). Retail price set by gallery and artist; shipping costs are shared.
Submissions Send query letter with résumé, bio, SASE and well-labeled slides "size, name, title, medium, top, etc." Write for appointment to show portfolio. Responds in 6 weeks. "If interested, gallery will file bio/résumé and selected slides."
Tips "We look for artists whose work has a special dimension in whatever medium. We are interested in unusual materials and unique techniques."

ARTEMISIA GALLERY

700 N. Carpenter, Chicago IL 60622. (312)226-7323. E-mail: info@artemisia.org. Web site: www.enteract.com/~artemisi. **Gallery Coordinator:** Tricia Alexander. Cooperative and nonprofit gallery/alternative space run by women artists. Estab. 1973. Sponsors 60 solo shows/year. Average display time 4 weeks. Interested in emerging and established artists. Overall price range $150-10,000; most work sold at $600-2,500.
Media Considers all traditional media including craft, installation, performance and new technologies.
Terms Rental fee for space; rental fee covers 1 month. Retail price set by artist. Exclusive area representation not required. Artist pays for shipping and announcement cards. Gallery does not take commission.
Submissions Send query letter with résumé, statement, 10 slides, slide sheet and SASE. Portfolios reviewed each month. Responds in 6 weeks. All material is returned if not accepted or under consideration if SASE is included.
Tips "Send clear, readable slides, labeled and marked 'top' or with red dot in lower left corner."

ATLAS GALLERIES, INC.

Two locations: 535 N. Michigan Ave.; 900 N. Michigan Ave., Level 6, Chicago IL 60611. (312)329-9330 (535 N.) and (312)649-0999 (900 N.). Fax: (312)329-9436. E-mail: cpagel@atlasgalleries.com. Web site: www.atlasgalleries.com. **President:** Susan Petle. For-profit gallery. Estab. 1967. Exhibits established artists. Sponsors 14 exhibits/year. Average display time 2 days solo/then permanently with collection. Open all year; Sunday through Saturday, 10-8. Located on Michigan Avenue's Magnificent Mile. Clients include local community, tourists, upscale. 5% of sales are to corporate collectors. Overall price range $200-100,000; most work sold at $2,000.
Media Considers acrylic, ceramics, collage, drawing, glass, mixed media, oil, paper, pastel, pen & ink, sculpture and watercolor. Most frequently exhibits oil, acrylic and sculpture. Considers prints of engravings, etchings, linocuts, lithographs, serigraphs, woodcuts and giclée.
Style Considers all styles and genres. Most frequently exhibits impressionism, surrealism/post modern. Exhibits all genres.
Terms Artwork is accepted on consignment. Artwork is bought outright. Retail price set by the gallery. Gallery provides insurance, promotion and contract. Requires exclusive representation locally.
Submissions Send query letter with artist's statement, bio, photocopies, photographs and slides. Returns material with SASE. Responds to queries if interested within 3 months. Does not file materials unless we are interested in artist. Finds artists through art exhibits, portfolio reviews, referrals by other artists, submissions and word of mouth.

BALZEKAS MUSEUM OF LITHUANIAN CULTURE ART GALLERY

6500 S. Pulaski Rd., Chicago IL 60629. (773)582-6500. Fax: (773)582-5133. Museum, museum retail shop, nonprofit gallery and rental gallery. Estab. 1966. Approached by 20 mid-career and established artists/year.

Sponsors 8 exhibits/year. Average display time 6 weeks. Open 7 days a week. Closed holidays. Clients include local community, tourists and upscale. 74% of sales are to corporate collectors. Overall price range $150-6,000; most work sold at $545.

Media Considers all media and all types of prints.

Style Considers all styles and genres.

Terms Artwork is accepted on consignment and there is a 33% commission. Retail price set by the gallery. Gallery provides promotion. Accepted work should be framed.

Submissions Write to arrange a personal interview to show portfolio. Cannot return material. Responds in 2 months. Finds artists through word of mouth, art exhibits, and referrals by other artists.

MARY BELL GALLERIES

740 N. Franklin, Chicago IL 60610. (312)642-0202. Fax: (312)642-6672. Web site: www.marybell.com. **President:** Mary Bell. Retail gallery. Estab. 1975. Represents mid-career artists. Interested in seeing the work of emerging artists. Exhibited artists include Mark Dickson. Sponsors 4 shows/year. Average display time 6 weeks. Open all year. Located downtown in gallery district; 5,000 sq. ft. 25% of space for special exhibitions. Clientele corporations, designers and individuals. 50% private collectors, 50% corporate collectors. Overall price range: $500-15,000.

Media Considers oil, acrylic, pastel, mixed media, collage, paper, sculpture, ceramic, fiber, glass, original handpulled prints, offset reproductions, woodcuts, engravings, lithographs, pochoir, posters, wood engravings, mezzotints, serigraphs, linocuts and etchings. Most frequently exhibits canvas, unique paper and sculpture.

Style Exhibits expressionism, painterly abstraction, impressionism, realism and photorealism. Genres include landscapes and florals. Prefers abstract, realistic and impressionistic styles. Does not want "figurative or bizarre work."

Terms Accepts artwork on consignment (50% commission). Retail price set by gallery and artist. Offers customer discounts and payment by installments. Gallery provides insurance and contract; shipping costs are shared. Prefers artwork unframed.

Submissions Send query letter with slides and SASE. Portfolio review requested if interested in artist's work. Portfolio should include slides or photos.

GALLERY 1633

1633 N. Damen Ave., Chicago IL 60647. (773)384-4441. E-mail: montanaart@att.net. Web site: home.att.net/~montanaart. **Director:** Montana Morrison. Consortium of contributing artists. Estab. 1986. Represents/exhibits a number of emerging, mid-career and established artists. Interested in seeing the work of emerging artists. Exhibited artists include painters, printmakers, sculptors, photographers. Sponsors 12 shows/year. Average display time 1 month. Open all year; Friday, 12-5 p.m.; Saturday and Sunday, 12-5. Opening reception first Friday of every month. Located in Bucktown; 900 sq. ft.; original tin ceiling, storefront charm. 35% of space for special exhibitions; 65% of space for gallery artists. Clientele tourists, local community, local artists, "suburban visitors to popular neighborhood." Sells to both private collectors and commercial businesses. Overall price range $50-5,000; most work sold at $250-500.

Media Considers all media and types of prints. Most frequently exhibits painting and drawing; ceramics, sculpture and photography.

Style Exhibits all styles including usable crafts (i.e. tableware). All genres. Montana Morrison shows neo-expressionism, activated minimalism and post modern works.

Terms Artwork is accepted on consignment, and there is a 25% commission. There is a rental fee for space. Available memberships include "gallery artists" who may show work every month for 1 year; associate gallery artists who show work for 6 months; and guest artists, who show for one month. Retail price set by the artist. Gallery provides promotion and contract. Artist pays for shipping costs. Call for appointment to show portfolio. Artist should call and visit gallery.

Tips "If you want to be somewhat independent and handle your own work under an 'umbrella' system where artists work together, in whatever way fits each individual—join us."

GALLERY 400, UNIVERSITY OF ILLINOIS AT CHICAGO

1240 W. Harrison (MC034), Chicago IL 60607. (312)996-6114. Fax: (312)355-3444. Web site: gallery400.aa.uic.edu. **Director:** Lorelei Stewart. Nonprofit gallery. Estab. 1983. Approached by 500 artists/year. Exhibits 80 emerging and mid-career artists. Exhibited artists include Ruben Ortiz Torres, Jenny Perlin and Scott Reeder. Sponsors 6 exhibits/year. Average display time 4-6 weeks. Open Tuesday-Friday, 10-6; Saturday, 12-6. Closed holiday season. Located in 2,400 sq. ft. former supermarket. Clients include local community, students, tourists and upscale.

Media Considers drawing, installation, mixed media and sculpture. Most frequently exhibits sculpture, drawing and installation.

Style Exhibits conceptualism, minimalism and postmodernism. Most frequently exhibits contemporary conceptually based artwork.

Terms Gallery provides insurance and promotion.

Submissions Send query letter with SASE. Returns material with SASE. Responds in 5 months. Files résumé only. Finds artists through word of mouth, art exhibits and referrals by other artists.

Tips Please check our Web site for guidelines for proposing an exhibition.

HYDE PARK ART CENTER

5307 S. Hyde Park Blvd., Chicago IL 60615. (773)324-5520. Fax: (773)324-6641. E-mail: info@hydeparkart.org. Web site: hydeparkart.org. **Executive Director:** Chuck Thurow. Nonprofit gallery. Estab. 1939. Exhibits emerging artists. Sponsors 8 group shows/year. Average display time is 4-6 weeks. Office-Gallery open Monday-Friday, 9-5; Saturday, 12-5. Located in the historic Del Prado building, in a former ballroom. "Primary focus on Chicago area artists not currently affiliated with a retail gallery." Clientele: general public. Overall price range $100-10,000.

Media Considers all media. Interested in seeing "innovative work by new artists; also interested in proposals from curators, groups of artists."

Terms Accepts work "for exhibition only." Retail price set by artist. Sometimes offers payment by installment. Exclusive area representation not required. Gallery provides insurance and contract.

Submissions Send query letter with résumé, no more than 10 slides and SASE. Will not consider poor slides. "A coherent artist's statement is helpful." Portfolio review not required. Send: Attn. Allison Peters, Exhibition Coordinator. Finds artists through open calls for slides, curators, visiting exhibitions (especially MFA programs) and artists' submissions. Prefers not to receive phone calls.

Tips "Do not bring work in person."

ILLINOIS ARTISANS PROGRAM

James R. Thompson Center, Chicago IL 60601. (312)814-5321. Fax: (312)814-3891. E-mail: cpatterson@museum.state.il.us. **Director:** Carolyn Patterson. Four retail shops operated by the nonprofit Illinois State Museum Society. Estab. 1985. Represents over 1,500 artists; emerging, mid-career and established. Average display time 6 months. "Accepts only juried artists living in Illinois." Clientele tourists, conventioneers, business people, Chicagoans. Overall price range $10-5,000; most artwork sold at $25-100.

Media Considers all media. "The finest examples in all media by Illinois artists."

Style Exhibits all styles. "Seeks contemporary, traditional, folk and ethnic arts from all regions of Illinois."

Terms Accepts work on consignment (50% commission). Retail price set by gallery and artist. Sometimes offers customer discounts. Exclusive area representation not required. Gallery provides promotion and contract.

Submissions Send résumé and slides. Accepted work is selected by a jury. Résumé and slides are filed. "The finest work can be rejected if slides are not good enough to assess." Portfolio review not required. Finds artists through word of mouth, requests by artists to be represented and by twice-yearly mailings to network of Illinois crafters announcing upcoming jury dates.

ILLINOIS STATE MUSEUM CHICAGO GALLERY

(formerly Illinois Art Gallery), Suite 2-100, 100 W. Randolph, Chicago IL 60601. (312)814-5322. Fax: (312)814-3471. E-mail: jstevens@museum.state.il.us. Web site: www.museum.state.il.us. **Assistant Administrator:** Jane Stevens. Museum. Estab. 1985. Exhibits emerging, mid-career and established artists. Sponsors 6-7 shows/year. Average display time 7-8 weeks. Open all year. Located "in the Chicago loop, in the James R. Thompson Center designed by Helmut Jahn." 100% of space for special exhibitions.

Media All media considered, including installations.

Style Exhibits all styles and genres, including contemporary and historical work.

Terms "We exhibit work, do not handle sales." Gallery provides insurance and promotion; artist pays for shipping. Prefers artwork framed.

Submissions Accepts only artists from Illinois. Send résumé, 10 high quality slides, bio and SASE.

DAVID LEONARDIS GALLERY

1346 N. Paulina St., Chicago IL 60622. (773)278-3058. Fax: (773)278-3068. E-mail: david@dlg-gallery.com. Web site: www.DLG-GALLERY.COM. **Owner:** David Leonardis. For-profit gallery. Estab. 1992. Approached by 100 artists/year. Represents 12 emerging, mid-career and established artists. Exhibited artists include Kristen Thiele and Christopher Makos. Average display time 30 days. Open all year; Tuesday-Saturday, 12-7; weekends from 12-6. Located in downtown Chicago. Clients include local community, tourists, upscale. 10% of sales are to corporate collectors. Overall price range $50-5,000; most work sold at $500.

Media Most frequently exhibits painting, photography and lithography. Considers lithographs and serigraphs.

Style Exhibits pop. Most frequently exhibits contemporary, pop, folk, photo. Genres include figurative work and portraits.

Terms Artwork is accepted on consignment and there is a 50% commission. Retail price set by the gallery and the artist. Gallery provides promotion. Accepted work should be framed. Does not require local representation. Prefers artists who are professional and easy to deal with.

Submissions E-mail. Responds only if interested. Files e-mail and JPEGs. Finds artists through word of mouth, art exhibits, and referrals by other artists.

LOYOLA UNIVERSITY CHICAGO

Crown Center Gallery, 6525 N. Sheridan Rd., Chicago IL 60626. (773)508-3811. Fax: (773)508-2282. **Contact:** Fine Arts Department. Nonprofit gallery. Estab. 1983. Approached by more than 100 artists/year. Sponsors 6 exhibits/year. Open all year; Monday-Friday, 10-3. Located on Chicago lakefront adjacent to glass wall overlooking lake and Michigan. Gallery is 85×19 with large lobby and auditorium. Clients include local community, students and upscale.

Media Considers all media except performance art.

Style Considers all styles and genres.

Terms We are nonprofit. Pass sales on to artists. Retail price set by the artist. Gallery provides insurance, promotion and contract. Accepted work should be framed, mounted and matted. Does not require exclusive representation locally. Prefer midwest and international artists.

Submissions Send query letter with artist's statement, bio, SASE and slides. Returns material with SASE. Responds in 3 months. Finds artists through word of mouth and portfolio reviews.

MASTERS' PORTFOLIO LTD

4075 S. Dearborn St., Suite 1030, Chicago IL 60605. (312)922-7594. Fax: (312)922-7291. **Contact:** Scott B. Johnson. Art consultancy and private dealer. Estab. 1984. Represents 20 established artists/year. Exhibiting artists from Manet through DeKooning. Sponsors 3 shows/year. Average display time 3 months. Open all year; Tuesday-Friday, 10:30-5:30; Saturday, 10:30-2:30. Located in the Central Business District; 1,400 sq. ft. Clientele museums, private and corporate collectors. 55% private collectors, 25% corporate collectors.

Media Considers oil, watercolor, pastel, pen & ink, drawing and sculpture. Most frequently exhibits oil, drawings, photography and watercolor.

Terms Retail price set by the gallery. Gallery provides promotion and contract. Prefers artwork framed.

Submissions Send query letter with résumé and slides. Write for appointment to show portfolio of originals and transparencies. Responds only if interested in 1 month.

Tips Finds artists through visiting exhibitions and word of mouth.

PETER MILLER GALLERY

118 N. Peoria St., Chicago IL 60607. (312)226-5291. Fax: (312)226-5441. E-mail: info@petermillergallery.com. Web site: petermillergallery.com. **Director:** Natalie R. Domchenko. Retail gallery. Estab. 1979. Represents 15 emerging, mid-career and established artists. Sponsors 9 solo and 3 group shows/year. Average display time is 1 month. Clientele: 80% private collectors, 20% corporate clients. Overall price range $500-30,000; most artwork sold at $5,000 and up.

Media Considers oil, acrylic, mixed media, collage, sculpture, installations and photography. Most frequently exhibits oil and acrylic on canvas and mixed media.

Style Exhibits abstraction, conceptual and realism.

Terms Accepts work on consignment (50% commission). Retail price set by gallery and artist. Exclusive area representation required. Insurance, promotion and contract negotiable.

Submissions Send a sheet of 20 slides of work done in the past 18 months with a SASE. Slides, show card are filed.

VALE CRAFT GALLERY

230 W. Superior St., Chicago IL 60610. (312)337-3525. Fax: (312)337-3530. E-mail: peter@valecraftgallery.com. Web site: www.valecraftgallery.com. **Owner:** Peter Vale. Retail gallery. Estab. 1992. Represents 100 emerging, mid-career artists/year. Exhibited artists include Tana Acton, Mark Brown, Tina Fung Holder, John Neering and Kathyanne White. Sponsors 4 shows/year. Average display time 3 months. Open all year; Tuesday-Friday, 10:30-5:30; Saturday, 11-5. Located in River North gallery district near downtown; 2,100 sq. ft.; lower level of prominent gallery building; corner location with street-level windows provides great visibility. Clientele: private collectors, tourists, people looking for gifts, interior designers and art consultants. Overall price range; $50-2,000; most work sold at $100-500.

Media Considers paper, sculpture, ceramics, craft, fiber, glass, metal, wood and jewelry. Most frequently exhibits fiber wall pieces, jewelry, glass, ceramic sculpture and mixed media.

Style Exhibits contemporary craft. Prefers decorative, sculptural, colorful, whimsical, figurative, and natural or organic.

Terms Accepts work on consignment (50% commission). Retail price set by the artist. Gallery provides insurance, promotion, contract and shipping costs from gallery; artist pays shipping costs to gallery.

Submissions Accepts only craft media. No paintings, prints, or photographs, please. By mail: Send query letter with résumé, bio or artist's statement, reviews if available, 10-20 slides, CD of images (in JPEG format) or photographs (including detail shots if possible), price list, record of previous sales, and SASE if you would like materials returned to you. By e-mail, please include a link to your Web site or send JPEG images, as well as any additional information listed above. Call for appointment to show portfolio of originals and photographs. Responds in 2 months. Files résumé (if interested). Finds artists through submissions, art and craft fairs, publishing a call for entries, artists' slide registry and word of mouth.

Tips "Call ahead to find out if the gallery is interested in showing the particular type of work that you make. Try to visit the gallery ahead of time or check out the gallery's Web site to find out if your work fits into the gallery's focus. I would suggest you have completed at least 20 pieces in a body of work before approaching galleries."

INDIANA

ARTLINK

437 E. Berry St., Suite 202, Fort Wayne IN 46802-2801. (219)424-7195. Fax: (219)424-8453. E-mail: artlinkfw@juno.com. Web site: www.artlinkfw.com. **Executive Director:** Betty Fishman. Nonprofit gallery. Estab. 1979. Exhibits emerging and mid-career artists. 620 members. Sponsors 18 shows/year, 2 galleries. Average display time 5-6 weeks. Open all year. Located 4 blocks from central downtown, 2 blocks from art museum and theater for performing arts; in same building as a cinema theater, dance group and historical preservation group; 1,600 sq. ft. 100% of space for special exhibitions. Overall price range $100-500; most artwork sold at $200.

- Publishes a quarterly newsletter, *Genre*, which is distributed to members. Includes features about upcoming shows, profiles of members and other news. Some artwork shown at gallery is reproduced in b&w in newsletter. Send SASE for sample and membership information.

Media Considers all media, including prints. Prefers work for annual print show and annual photo show, sculpture and painting.

Style Exhibits expressionism, neo-expressionism, painterly abstraction, conceptualism, color field, postmodern works, photorealism, hard-edge geometric abstraction; all styles and genres. Prefers imagism, abstraction and realism. "Interested in a merging of craft/fine arts resulting in art as fantasy in the form of bas relief, photo/books, all experimental media in nontraditional form."

Terms Accepts work on consignment only for exhibitions (35% commission). Retail price set by artist. Gallery provides insurance. Shipping costs are shared. Prefers framed artwork.

Submissions Send query letter with résumé, no more than 6 slides and SASE. Reviewed by 14-member panel. Responds in 1 month. "Jurying takes place three times per year unless it is for a specific call for entry. A telephone call will give the artist the next jurying date."

Tips "Call ahead to ask for possibilities for the future and an exhibition schedule for the next two years will be forwarded." Common mistakes artists make in presenting work are "bad slides and sending more than requested—large packages of printed material. Printed catalogues of artist's work without slides are useless." Sees trend of community-wide cooperation by organizations to present art to the community.

GREATER LAFAYETTE MUSEUM OF ART

102 S. Tenth St., Lafayette IN 47901. (765)742-1128. E-mail: glma@glmart.org. Web site: glma.org. **Executive Director:** Les Reker. Museum. Estab. 1909. Temporary exhibits of American and Indiana art as well as work by emerging, mid-career and established artists from Indiana and the midwest. 1,340 members. Sponsors 5-7 shows/year. Average display time 10 weeks. Located 6 blocks from city center; 3,318 sq. ft.; 4 galleries. Clientele includes Purdue University faculty, students and residents of Lafayette/West Lafayette and 14 county area.

Style Exhibits all styles. Genres include landscapes, still life, portraits, abstracts, non-objective and figurative work.

Terms Accepts some crafts for consignment in gift shop (35% mark-up).

Submissions Send query letter with résumé, slides, artist's statement and letter of intent.

Tips "Indiana artists specifically encouraged to apply."

HOOSIER SALON PATRONS ASSOCIATION & GALLERY

714 E. 65th St., Indianapolis IN 46220-1610. (317)253-5340. Fax: (317)259-1817. E-mail: hoosiersalon@iquest.net. Web site: www.hoosiersalon.org. Nonprofit fine art gallery. Estab. 1925. Membership of 500 emerging, mid-

career and established artists. Sponsors 7 exhibits/year (6 in gallery, 1 juried show each year at the Indiana State Museum). Average display time 5-6 weeks. Open Tuesday-Friday, 11-5; Saturday, 11-3. Closed over Christmas week. Gallery is in the Village of Broad Ripple, Indianapolis as part of a business building. Gallery occupies about 1,800 sq. ft. Clients include local community and tourists. 20% of sales are to corporate collectors. Overall price range $50-5,000; most work sold at $1,000.

• This gallery opened a new location in 2001 at 507 Church St., New Harmony IN 47631; (812)682-3970.

Media Considers acrylic, ceramics, collage, drawing, fiber, mixed media, oil, paper, pastel, pen & ink, sculpture, watercolor and hand-pulled prints. Most frequently exhibits oil, watercolor and pastel.

Style Exhibits traditional impressionism to abstract. Considers all genres.

Terms Artwork is accepted on consignment and there is a 33% commission. Retail price set by the artist. Gallery provides insurance and contract. Accepted work must be exhibit ready. Requires membership. Criteria for membership is 1 year's residence in Indiana. Accepts only artists from Indiana (1 year residency). Gallery only shows artists who have been in one Annual Exhibit (show of approx. 200 artists each year).

Submissions Call or e-mail for membership and Annual Exhibition information. Responds ASAP. We do not keep artists' materials unless they are members. Finds artists through word of mouth, art exhibits and art fairs.

Tips While not required, all mats, glass etc. need to be archival-quality. Because the Association is widely regarded as exhibiting quality art, artists are generally careful to present their work in the most professional way possible.

INDIANAPOLIS ART CENTER

820 E. 67th St., Indianapolis IN 46220. (317)255-2464. Fax: (317)254-0486. E-mail: exhibs@indplsartcenter.org. Web site: www.indplsartcenter.org. Director of Exhibitions and Artist Services: David Kwasigroh. Exhibitions Associate: Susan Grade. Nonprofit art center. Estab. 1934. Prefers emerging artists. Exhibits approximately 100 artists/year. 2,600 members. Sponsors 15-20 shows/year. Average display time 5 weeks. Open Monday-Friday, 9-10; Saturday, 9-3; Sunday, 12-3. Located in urban residential area; 2,560 sq. ft. in 3 galleries; "Progressive and challenging work is the norm!" 100% of space for special exhibitions. Clientele mostly private. 90% private collectors, 10% corporate collectors. Overall price range $50-15,000; most work sold at $100-5,000. Also sponsors annual Broad Ripple Art Fair in May.

Media Considers all media and all types of original prints. Most frequently exhibits painting, sculpture installations and fine crafts.

Style All styles. "In general, we do not exhibit genre works. We do maintain a referral list, though." Prefers postmodern works, installation works, conceptualism, large-scale outdoor projects.

Terms Accepts work on consignment (35% commission). Commission is in effect for 3 months after close of exhibition. Retail price set by artist. Gallery provides insurance, promotion, contract; artist pays for shipping. Prefers artwork framed.

Submissions "Special consideration for IN, OH, MI, IL, KY artists." Send query letter with résumé, minimum of 20 slides, SASE, reviews and artist's statement. Accepted July 1-December 31 each year. Season assembled in February.

Tips "Research galleries thoroughly; get on their mailing lists, and visit them in person at least twice before sending materials. Find out the 'power structure' of the targeted galleries and use it to your advantage. Most artists need to gain experience exhibiting in smaller or nonprofit spaces before approaching a gallery. Work needs to be of consistent, dependable quality. Have slides done by a professional if possible. Stick with one style—no scattershot approaches. Have a concrete proposal with installation sketches (if it's never been built). We book two years in advance—plan accordingly. Do not call. Put me on your mailing list one year before sending application so I can be familiar with your work and record. Ask to be put on my mailing list so you know the gallery's general approach. It works!"

NEW HARMONY GALLERY OF CONTEMPORARY ART

506 Main St., New Harmony IN 47631. (812)682-3156. Fax: (812)682-3870. E-mail: harmony@usi.edu. Web site: www.nhgallery.com. **Director:** April Vasher-Dean. Nonprofit gallery. Approached by 25 artists/year. Represents 8 emerging and mid-career artists. Exhibited artists include Patrick Dougherty, sculpture/installation. Sponsors 8 exhibits/year. Average display time 6 weeks. Open all year; Tuesday-Saturday, 10-5; Sundays, 12-4; closed Sundays, January-April. Clients include local community, students, tourists and upscale.

Media Considers all media and all types of prints. Most frequently exhibits sculpture and installation.

Style Exhibits Considers all styles including contemporary. No genre specified.

Terms Artwork is accepted on consignment and there is a 35% commission. Gallery provides insurance, promotion and contract. Accepted work should be framed, mounted and matted. Does not require exclusive representation locally. Prefers midwestern artists.

Submissions Send query letter with artist's statement, bio, résumé, SASE and slides. Returns material with SASE. Finds artists through art fairs, art exhibits, portfolio reviews and submissions.

IOWA

ARTS IOWA CITY

129 E. Washington St., Suite 1, Iowa City IA 52245-3925. (319)337-7447. E-mail: members@artsiowacity.com. Web site: www.artsiowacity.com. **Gallery director:** Elise Kendrot. Nonprofit gallery. Estab. 1975. Approached by 65± artists/year. Represents 30± emerging, mid-career and established artists. Sponsors 11 exhibits/year. Average display time 1 month. Open all year; Monday-Friday, 11 to 6; weekends, 12-4. Several locations include: AIC Center & Gallery—129 E. Washington St.; Starbucks Downtown Iowa City; Melrose Meadows Retirement Community in Iowa City; Englert Civic Theatre Gallery, Iowa City. Satellite Galleries: local storefronts, locations vary. Clients include local community, students and tourists. 10% of sales are to corporate collectors. Overall price range $200-6,000; most work sold at $500.

Media Considers all media, types of prints, and all genres. Most frequently exhibits painting, drawing and mixed media.

Terms Artwork is accepted on consignment and there is a 50% commission. Retail price set by the artist. Gallery provides insurance (in gallery, not during transit to/from gallery), promotion and contract. Accepted work should be framed, mounted and matted. Does not require exclusive representation locally.

Submissions "We represent artists who are members of Arts Iowa City; to be a member one must pay a membership fee. Most people are from Iowa and surrounding states." Call or write to arrange personal interview to show portfolio of photographs, slides and transparencies. Send query letter with artist's statement, bio, brochure, business card, photographs, résumé, reviews, SASE and slides. Returns material with SASE. Responds to queries in 1 month. Files printed material and CDs. Slides sent back to artist after review. Finds artists through referrals by other artists, submissions and word of mouth.

Tips "We are a nonprofit gallery with limited staff. Most work is done by volunteers. Artists interested in submitting work should visit our Web site at www.artsiowacity.com to gain a better understanding of the services we provide and to obtain membership and show proposal information. Please submit applications according to the guidelines on the Web site."

CORNERHOUSE GALLERY AND FRAME

2753 First Ave. SE, Cedar Rapids IA 52402. (319)365-4348. Fax: (319)365-1707. E-mail: info@cornerhousegallery.com. Web site: www.cornerhousegallery.com. For-profit gallery. Estab. 1976. Exhibits emerging, mid-career and established artists. Aproached by 75 artists/year. Sponsors 4 exhibits/year. Open Monday-Friday, 9:30-5:30; Saturday, 9:30-4:00; closed major holidaysa and annually December 25-January 2. Located on main street through Cedar Rapids in an original 1906 building expanded to cover 3,000 sq. ft. of gallery space. Outdoor sculpture garden. Clients include local community, students, tourists, upscale, and corporate. 20% of sales are to corporate collectors. Overall price range: $500-20,000; most work sold at $1,000.

Media Considers all media except craft and installation. Most frequently exhibits glass, oil and sculpture. Considers all prints except posters.

Style Considers all styles. Genres include figurative work, florals and landscapes.

Terms Artwork is accepted on consignment and there is a 45% commission. Retail price is set by the artist.

Submissions Call, e-mail or write to arrange personal interview to show portfolio of photographs, slides, transparencies or CD, résumés and reviews with SASE. Returns material with SASE.

Tips "Good photos of work, Web sites with enough work to get a feel for the overall depth and quality."

CSPS

1103 Third St. SE, Cedar Rapids IA 52401-2305. (319)364-1580. Fax: (319)362-9156. E-mail: legionarts.org. Web site: www.legionarts.org. **Artistic Director:** Mel Andringa. Alternative space, nonprofit gallery. Estab. 1991. Approached by 50 artists/year. Exhibits 15 emerging artists. Exhibited artists include Bill Jordan (photographs), Paco Rosic (spray can murals). Sponsors 15 exhibits/year. Average display time 2 months. Open Wednesday-Sunday, 11-6. Closed June, July and August. Located in south end Cedar Rapids; old Czech meeting hall, 2 large galleries and off-site exhibits; track lights, carpet, ornamental tin ceilings. (65 events a year). Clients include local community. Overall price range $50-500; most work sold at $200.

Media Considers all media and all types of prints. Most frequently exhibits painting, mixed media and installation.

Style Considers all styles. Most frequently exhibits postmodernism, conceptualism and surrealism.

Terms Artwork is accepted on consignment and there is a 30% commission. Retail price set by the artist. Gallery provides insurance and promotion. Accepted work should be framed. Requires exclusive representation locally.

Submissions Send query letter with artist's statement, bio, SASE and slides. Responds in 6 months. Files résumé, sample slide and statement. Finds artists through word of mouth, art exhibits and art trade magazines.

Galleries

KAVANAUGH ART GALLERY

131 Fifth St., W. Des Moines IA 50265. (515)279-8682. Fax: (515)279-7609. E-mail: kagallery@aol.com. Web site: www.kavanaughgallery.com. **Director:** Carole Kavanaugh. Retail gallery. Estab. 1990. Represents 25 mid-career and established artists/year. May be interested in seeing the work of emerging artists in the future. Exhibited artists include Kati Roberts, Don Hatfield, Dana Brown, Gregory Steele, August Holland, Ming Feng and Larry Guterson. Sponsors 3-4 shows/year. Averge display time 3 months. Open all year; Monday-Saturday, 10-5. Located in Old Town shopping area; 6,000 sq. ft. 70% private collectors, 30% corporate collectors. Overall price range $300-20,000; most work sold at $800-3,000.
Media Considers all media and all types of prints. Most frequently exhibits oil, acrylic and pastel.
Style Exhibits color field, impressionism, realism, florals, portraits, western, wildlife, southwestern, landscapes, Americana and figurative work. Prefers landscapes, florals and western.
Terms Accepts work on consignment (50% commission). Retail price set by the artist. Gallery provides insurance, promotion and contract. Shipping costs are shared. Prefers artwork unframed.
Submissions Send query letter with résumé, bio and photographs. Portfolio should include photographs. Responds in 3 weeks. Files bio and photos. Finds artists through word of mouth, referrals by other artists, visiting art fairs and exhibitions, artist's submissions.
Tips "Get a realistic understanding of the gallery/artist relationship by visiting with directors. Be professional and persistent."

MACNIDER ART MUSEUM

303 Second St. SE, Mason City IA 50401. (641)421-3666. E-mail: macnider@macniderart.org. Web site: www.macniderart.org. **Director:** Shelia Perry. Nonprofit gallery. Estab. 1966. Exhibits 1-10 emerging, mid-career and established artists. Sponsors 1 0- 15 exhibits/year. Average display time 3 months. Open all year; Tuesday and Thursday, 9-9; Wednesday, Friday and Saturday, 9-5; Sunday, 1-5. Closed Mondays. Large gallery space with track system which we hang works on monofiliment line. Smaller gallery items are hung or mounted on the wall. Clients include local community, students, tourists and upscale. Overall price range $50-2,500; most work sold at $200-$500.
Media Considers all media and all types of prints.
Style Considers all styles and genres.
Terms Artwork is accepted on consignment and there is a 40% commission. Retail price set by the artist. Gallery provides insurance, promotion and contract. Accepted work should be framed. Does not require exclusive representation locally.
Submissions For retail shop or exhibition: mail portfolio for review. Returns material with SASE. Responds only if interested within 3 months. Finds artists through word of mouth, submissions, portfolio reviews, art exhibits, art fairs and referrals by other artists.
Tips " Opportunities include exhibition in 2 different gallery spaces, entry into competitive exhibits (1 fine craft exhibit open to Iowa artists, 1 photography show open to artists living in Cerro Gordo County, 1 school art show, and 1 all media open to artists within 100 miles of Mason City Iowa), features in museum shop on consignment, booth space in Festival Art Market in June."

KANSAS

GALLERY XII

412 E. Douglas, Suite A, Wichita KS 67202. (316)267-5915. E-mail: galleryxii@aol.com. **President:** Rosemary Dugan. Consignment Committee: Judy Dove. Cooperative nonprofit gallery. Estab. 1977. Represents 50 mid-career and established artists/year and 20 members. Average display time 1 month. Open all year; Monday-Saturday, 10-5. Usually open with other galleries for "Final Fridays" gallery tour 7-10 p.m., final Friday of month. Located in historic Old Town which is in the downtown area; 1,300 sq. ft.; historic building. 20% of space for special exhibitions; 80% of space for gallery artists. Clientele private collectors, corporate collectors, people looking for gifts, tourists. Overall price range $10-2,000.
Terms Only accepts 3-D work on consignment (35% commission). Co-op membership screened and limited. Annual exhibition fee, 15% commission and time involved. Artist pays shipping costs to and from gallery.
Submissions Limited to local artists or those with ties to area. Work juroed from slides. "We are a co-op gallery whose members rigorously screen prospective new members."

PHOENIX GALLERY TOPEKA

2900-F Oakley Dr., Topeka KS 66614. (785)272-3999. E-mail: Phnx@aol.com. Web site: www.phnxgallery.com. **Contact:** Kyle Garcia. Retail gallery. Estab. 1990. Represents 60 emerging, mid-career and established artists/ year. Exhibited artists include Dave Archer, Louis Copt, Nagel, Phil Starke, Robert Berkeley Green and Raymond

Eastwood. Sponsors 6 shows/year. Average display time 6 weeks-3 months. Open Monday-Saturday, 10-6; closed most Sundays. Located downtown; 2,000 sq. ft. 100% of space for special exhibitions; 100% of space for gallery artists. Clientele: upscale. 75% private collectors, 25% corporate collectors. Overall price range $500-20,000.

Media Considers all media and engravings, lithographs, woodcuts, mezzotints, serigraphs, linocuts, etchings and collage. Most frequently exhibits oil, watercolor, ceramic and artglass.

Style Exhibits expressionism and impressionism, all genres. Prefers regional, abstract and 3-D type ceramic; national glass artists. "We find there is increased interest in original work and regional themes."

Terms Terms negotiable. Retail price set by the gallery and the artist. Prefers artwork framed.

Submissions Call for appointment to show portfolio of originals, photographs and slides.

Tips "We are scouting [for artists] constantly."

ALICE C. SABATINI GALLERY

1515 SW Tenth, Topeka KS 66604-1374. (785)580-4516. Fax: (785)580-4496. E-mail: sbest@mail.tscpl.org. Web site: www.tscpl.org. **Gallery Director:** Sherry Best. Nonprofit gallery. Estab. 1976. Exhibits emerging, mid-career and established artists. Sponsors 8-9 shows/year. Average display time 1 month. Open all year; Monday-Friday, 9-9; Saturday, 9-6; Sunday, 12-9. Located 1 mile west of downtown; 2,500 sq. ft.; security, track lighting, plex top cases; five moveable walls. 100% of space for special exhibitions and permanent collections. Overall price range $150-$5,000.

Media Considers oil, fiber, acrylic, sculpture, glass, watercolor, mixed media, ceramic, pastel, collage, metal work, woodcuts, wood engravings, linocuts, engravings, mezzotints, etchings, lithographs, photography, and installation. Most frequently exhibits ceramic, oil and watercolor.

Style Exhibits neo-expressionism, painterly abstraction, postmodern works and realism. Prefers painterly abstraction, realism and neo-expressionism.

Terms Artwork accepted or not accepted after presentation of portfolio/résumé. Retail price set by artist. Gallery provides insurance; artist pays for shipping costs. Prefers artwork framed.

Submissions Usually accepts regional artists. Send query letter with résumé and 12-24 slides. Call or write for appointment to show portfolio of slides. Responds in 2 months. Files résumé. Finds artists through visiting exhibitions, word of mouth and submissions.

Tips "Find out what each gallery requires from you and what their schedule for reviewing artists' work is. Do not go in unannounced. Have good quality slides. If slides are bad they probably will not be looked at. Have a dozen or more to show continuity within a body of work. Your entire body of work should be at least 50-100 pieces. Competition gets heavier each year. We look for originality."

EDWIN A. ULRICH MUSEUM OF ART

Wichita State University, Wichita KS 67260-0046. (316)978-3664. Fax: (316)978-3898. E-mail: ulrich@wichita.edu. Web site: www.ulrich.wichita.edu. **Director:** Dr. David Butler. Museum. Estab. 1974. Wichita's premier venue for modern and contemporary art. Sponsors 7 shows/year. Average display time 6-8 weeks. Open Tuesday-Friday, 11-5; Saturday and Sunday, 1-5; closed Mondays and major holidays. Free admission. Located on campus; 6,732 sq. ft.; high ceilings, neutral space. 75% of space for special exhibitions.

Media Considers sculpture, installation, new media.

Style Exhibits conceptualism and new media.

Submissions Currently not accepting submissions.

KENTUCKY

KENTUCKY MUSEUM OF ART AND CRAFT

715 West Main, Louisville KY 40202. (502)589-0102. Fax: (502)589-0154. Web site: www.kentuckyarts.org. **Contact:** Brion Clinkingbeard, deputy director of programming/curator. Nonprofit gallery, museum. Estab. 1981. Approached by 300 artists/year. Represents 100 emerging, mid-career and established artists. Sponsors 20 exhibits/year. Average display time 4-6 weeks. Open all year; Monday-Friday, 10-5; Saturday, 11-5. Located in downtown Louisville, one block from the river; 3 galleries, one on each floor. Clients include local community, students, tourists, upscale. 10% of sales are to corporate collectors. Overall price range $50-40,000; most work sold at $200.

Media Considers all media and all types of prints. Most frequently exhibits ceramics, glass, craft.

Style Exhibits primitivism realism.

Terms Artwork is accepted on consignment and there is a 50% commission. Retail price set by the artist. Gallery provides insurance, promotion and contract. Accepted work should be framed and matted. Does not require exclusive representation locally.

Submissions Send query letter with artist's statement, bio, photocopies, photographs, SASE and slides. Returns material with SASE. Responds to queries in 1 month. Files bio, artist's statement and copy of images. Finds artists through art fairs, art exhibits, portfolio reviews, referrals by other artists and submissions.

Tips "Clearly identify reason for wanting to work with KMAC. Show a level of professionalism and a proven track record of exhibitions."

LOUISIANA

BATON ROUGE GALLERY, INC.

1442 City Park Ave., Baton Rouge LA 70808-1037. (225)383-1470. Fax: (225)336-0943. E-mail: brgallery@brec.o rg. **Director:** Amelia Cox. Cooperative gallery. Estab. 1966. Exhibits the work of 50 professional artists. 300 members. Sponsors 12 shows/year. Average display time 1 month. Open all year. Located in the City Park Pavilion. Overall price range $100-10,000; most work sold at $200-600.

- The gallery hosts a spoken word series featuring literary readings of all genres. We also present special performances including dance, theater and music, including movies and music on the lawn and Flatscape Video Series.

Media Considers all media. Most frequently exhibits painting, sculpture and glass.

Style Exhibits all styles and genres.

Terms Co-op membership fee plus donation of time. Gallery takes 40% commission. Retail price set by artist. Artist pays for shipping. Artwork must be framed.

Submissions Membership and guest exhibitions are selected by screening committee. Send query letter for application.

Tips "The screening committee screens applicants in October each year. Call for application to be submitted with portfolio and résumé."

CONTEMPORARY ARTS CENTER

900 Camp St., New Orleans LA 70130. (504)528-3805. Fax: (504)528-3828. E-mail: info@cacno.org. Web site: cacno.org. **Curator of Visual Arts:** David S. Rubin. Alternative space, nonprofit gallery. Estab. 1976. Exhibits emerging, mid-career and established artists. Open all year; Tuesday-Sunday, 11-5; weekends 11-5. Closed Mardi Gras, Christmas and New Year's Day. Located in Central Business District of New Orleans; renovated/converted warehouse. Clients include local community, students, tourists and upscale.

Media Considers all media and all types of prints. Most frequently exhibits painting, sculpture, installation and photography.

Style Considers all styles. Exhibits anything contemporary.

Terms Artwork is accepted on loan for curated exhibitions. Retail price set by the artist. CAC provides insurance and promotion. Accepted work should be framed. Does not require exclusive representation locally. The CAC is not a sales venue, but will refer inquiries. CAC receives 20% on items sold as a result of an exhibition.

Submissions Send query letter with bio, SASE and slides or CDs. Responds in 4 months. Files letter and bio—slides when appropriate. Finds artists through word of mouth, submissions, art exhibits, art fairs, referrals by other artists, professional contacts and periodicals.

Tips "Use only one slide sheet with proper labels (title, date, medium and dimensions)."

HANSON GALLERY

229 Royal, New Orleans LA 70130-2226. (504)524-8211. Fax: (504)524-8420. E-mail: info@hansongallery-nola.c om. Web site: www.hansongallery-nola.com. **Director:** Angela King. For profit gallery. Estab. 1977. Represents 22 emerging, mid-career and established artists. Exhibited artists include Frederick Hart (sculptor) and Leroy Neiman (all mediums). Sponsors 6 exhibits/year. Average display time ongoing to 3 weeks. Open all year; Monday-Saturday, 10-6; Sunday, 11-5. Closed 3 days for Mardi Gras. Clients include local community, tourists and upscale. Overall price range $650-100,000; most work sold at $4,000.

Media Considers acrylic, drawing, oil, pastel, sculpture and watercolor. Most frequently exhibits oil, pastel and acrylic. Considers etchings, lithographs and serigraphs.

Style Exhibits impressionism, neo-expressionism and surrealism. Considers all styles. Genres include figurative work and landscapes.

Terms Retail price set by the gallery and the artist. Gallery provides insurance. Requires exclusive representation locally.

Submissions Write to arrange a personal interview to show portfolio of photographs and slides. Mail portfolio for review. Send query letter with artist's statement, bio, brochure, photographs, résumé, reviews, SASE and slides. Responds in 6 weeks. Finds artists through word of mouth, submissions, art exhibits and art fairs.

Tips "Archival-quality materials play a major role in selling fine art to collectors."

INSLEY ART GALLERY

427 Esplanade Ave., New Orleans LA 70116. (504)949-3512. Fax: (504)949-1909. E-mail: insleyartgallery@aol.com. Web site: www.insleyart.com. **Contact:** Charlene Insley, Director/Artist. For-profit gallery. Estab. 2004. Exhibits mid-career, established artists. Approached by 40 artists/year; represents 7 artists/year. Exhibited artists include Dr. Gerald Domingue, abstract naturalism, oil on canvas; Charles Foster, surrealist, oil on canvas. Sponsors 5-7 exhibits/year. Average display time 1 month. Open Tuesday-Saturday, 12-5; weekends, 10-3; closed most holidays. Located on the edge of the French Quarter, Insley Art Gallery is an eclectic gallery with a low key, welcoming attitude. A new participant in the rich and bountiful art tradition of New Orleans—a rustic yet contemporary space of approximately 6,000 sq. ft. in a convenient, historic, part of the city. Clients include local community, tourists, upscale. Overall price range: $350-6,000; most work sold at $3,000.
Media Considers acrylic, ceramics, collage, drawing, glass, mixed media, oil, sculpture. Considers giclées.
Style Exhibits conceptualism, surrealism, painterly abstraction.
Making Contact & Terms Artwork is accepted on consignment and there is a 30-50% commission. Retail price set by the artist. Gallery provides insurance, promotion, contract. Accepted work should be framed. Requires exclusive representation locally.
Submissions Call. Write to arrange personal interview to show portfolio. Send query letter with bio, photocopies, SASE. Returns material with SASE. Responds to queries in 3 months. Finds artists through art exhibits, portfolio reviews, referrals by other artists.

LE MIEUX GALLERIES

332 Julia St., New Orleans LA 70130. (504)522-5988. Fax: (504)522-5682. E-mail: mail@lemieuxgalleries.com. Web site: www.lemieuxgalleries.com. **Contact:** Christy Wood, Denise Berthiaume. Retail gallery and art consultancy. Estab. 1983. Represents 30 mid-career artists. Exhibited artists include Shirley Rabe Masinter and Alan Gerson. Sponsors 10 shows/year. Average display time 6 months. Open all year. Located in the warehouse district/downtown; 1,400 sq. ft. 20-75% of space for special exhibitions. Clientele 75% private collectors; 25% corporate clients.
Media Considers all media; engravings, etchings, linocuts, lithographs, mezzotints, serigraphs, woodcuts. Most frequently exhibits oil, watercolor and drawing.
Style Exhibits impressionism, neo-expressionism, realism and hard-edge geometric abstraction. Genres include landscapes, florals, wildlife and figurative work. Prefers landscapes, florals and figural/narrative.
Terms Accepts work on consignment (50% commission). Retail price set by artist. Exclusive area representation required. Gallery provides promotion and contract; artist pays for shipping.
Submissions Accepts only artists from the Southeast. Send query letter with SASE, bio, brochure, résumé, CD-ROM, slides and photographs. Will not schedule an in person meeting without seeing the work first. Will respond within 4-6 weeks. All material is returned if not accepted or under consideration as long as a SASE is provided, otherwise it is discarded within 2 weeks of review.
Tips "Send information before calling. Give me the time and space I need to view your work and make a decision; you cannot sell me on liking or accepting it; that I decide on my own."

MAINE

DUCKTRAP BAY TRADING COMPANY

37 Bayview St., Camden ME 04843. (207)236-9568. Fax: (207)236-0950. E-mail: info@ducktrapbay.com. Web site: www.ducktrapbay.com. **Owners:** Tim and Joyce Lawrence. Retail gallery. Estab. 1983. Represents 200 emerging, mid-career and established artists/year. Exhibited artists include Sandy Scott, Stefane Bougie, Yvonne Davis, Beki Killorin, Jim O'Reilly and Gary Eigenberger. Open all year; Monday-Saturday, 9-5, Sunday, 11-4. Located downtown waterfront; 2 floors 3,000 sq. ft. 100% of space for gallery artists. Clientele: tourists, upscale. 70% private collectors, 30% corporate collectors. Overall price range $250-120,000; most work sold at $250-2,500.
Media Considers watercolors, oil, acrylic, pastel, pen & ink, drawing, paper, sculpture, bronze and carvings. Types of prints include lithographs. Most frequently exhibits woodcarvings, watercolor, acrylic and bronze.
Style Exhibits realism. Genres include nautical, wildlife and landscapes. Prefers marine and wildlife.
Terms Accepts work on consignment (40% commission) or buys outright for 50% of the retail price (net 30 days). Retail price set by the artist. Gallery provides insurance and minimal promotion; artist pays for shipping. Prefers artwork framed.
Submissions Send query letter with 10-20 slides or photographs. Call or write for appointment to show portfolio of photographs. Files all material. Finds artists through word of mouth, referrals by other artists and submissions.
Tips "Find the right gallery and location for your subject matter. Have at least eight to ten pieces or carvings or three to four bronzes."

Galleries

GOLD/SMITH GALLERY

41 Commercial St., BoothBay Harbor ME 04538. (207)633-6252. Fax: (207)633-6252. **Contact:** Karen Swartsberg. Retail gallery. Estab. 1974. Represents 30 emerging, mid-career and established artists. Exhibited artists include John Vander and John Wissemann. Sponsors 6 shows/year. Average display time 6 weeks. Open May-October; Monday-Saturday, 10-6. Located downtown across from the harbor. 1,500 sq. ft.; traditional 19th century house converted to contemporary gallery. 75% of space for special exhibitions; 25% of space for gallery artists. Clientele residents and visitors. 90% private collectors, 10% corporate collectors. Overall price range $350-5,000; most work sold at $1,000-2,500.

- One of 2 Gold/Smith Galleries. The other is in Sugar Loaf; the 2 are not affiliated with each other. Artists creating traditional and representational work should try another gallery. The work shown here is strong, self-assured and abstract.

Media Considers oil, acrylic, watercolor, pastel, pen & ink, drawing, mixed media, collage, paper, sculpture, photography, woodcuts, engravings, wood engravings and etchings. Most frequently exhibits acrylic and watercolor.

Style Exhibits expressionism, painterly abstraction "emphasis on nontraditional work." Prefers expressionist and abstract landscape.

Terms Commission 50%. Retail price set by the artist. Gallery provides insurance and promotion; artist pays shipping costs to and from gallery. Prefers artwork framed.

Submissions No restrictions—emphasis on artists from Maine. Send query letter with slides, bio, photographs, SASE, reviews and retail price. Write for appointment to show portfolio of originals. Responds in 2 weeks. Artist should write the gallery.

Tips "Present a consistent body of mature work. We need 12 to 20 works of moderate size. The sureness of the hand and the maturity interest of the vision are most important."

GREENHUT GALLERIES

146 Middle St., Portland ME 04101. (207)772-2693. E-mail: greenhut@maine.com. Web site: www.greenhutgalleries.com. **Contact:** Peggy Greenhut Golden. Retail gallery. Estab. 1990. Represents/exhibits 20 emerging and mid-career artists/year. Sponsors 12 shows/year. Exhibited artists include Connie Hayes (oil/canvas), Sarah Knock (oil/canvas). Average display time 3 weeks. Open all year; Monday-Friday, 10-5:30; Saturday, 10-5. Located in downtown-Old Port; 3,000 sq. ft. with neon accents in interior space. 60% of space for special exhibitions. Clientele tourists and upscale. 55% private collectors, 10% corporate collectors. Overall price range $500-12,000; most work sold at $600-3,000.

Media Considers acrylic, paper, pastel, sculpture, drawing, oil, watercolor. Most frequently exhibits oil, watercolor, pastel.

Style Considers all styles; etchings, lithographs, mezzotints. Genres include figurative work, landscapes, still life, seascape. Prefers landscape, seascape and abstract.

Terms Artwork is accepted on consignment (50% commission). Retail price set by the gallery and artist. Gallery provides insurance and promotion. Artists pays for shipping costs. Prefers artwork framed (museum quality framing).

Submissions Accepts only artists from Maine or New England area with Maine connection. Send query letter with slides, reviews, bio and SASE. Call for appointment to show portfolio of slides. Responds in 1 month. Finds artists through word of mouth, referrals by other artists, visiting art shows and exhibitions, and submissions.

Tips "Visit the gallery and see if you feel your work fits in."

THE LIBRARY ART STUDIO

1467 State Rt. 32 at Munro Brook, Round Pond ME 04564. (207)529-4210. **Contact:** Sally DeLorme Pedrick, owner/director. Art consultancy and gallery. Estab. 1989. Exhibits established artists. Number of exhibits varies each year. Average display time 6 weeks. Open year round by appointment or chance. Located in a small coastal village (Round Pond) on the Pemaquid Peninsula, midcoast Maine. Clients include local community, tourists and upscale. Overall price range $50-7,500; most work sold at $350.

Media Considers all media. Most frequently exhibits oil, woodcuts, and mixed media with glass.

Style Considers all styles. Most frequently exhibits painterly abstraction, expressionism, conceptualism. "Most art is associated with literature, thus *The Library Art Studio*."

Terms Artwork is accepted on consignment and there is a 30% commission. Retail price set by the artist. Gallery provides promotion. Accepted work should be framed. Does not require exclusive representation locally.

Submissions Send query letter with SASE and slides. Returns material with SASE. Responds in 1 month.

MATHIAS FINE ART

10 Mathias Dr., Trevett ME 04571. (207)633-7404. **President:** Cordula Mathias. For profit gallery. Estab. 1992. Approached by 20-30 artists/year. Represents 15-20 emerging, mid-career and established artists. Exhibited

artists include Brenda Bettinson and Mike Culver. Sponsors 6 exhibits/year. Average display time 2 months. Open all year; Wednesday-Sunday, 12-5; and by appointment. Mid-November through mid-May by appointment only. Located in Mid-Coast area of Maine; 400 sq. ft. combination of natural and artificial lighting. Clients include local community, tourists and upscale. Percentage of sales to corporate collectors varies. Overall price range $50-25,000; most work sold at $1,200.

Media Considers acrylic, collage, drawing, original prints, mixed media, oil, paper and pen & ink. Most frequently exhibits painting, drawing and photography. Considers all types of prints except posters.

Style Considers all styles and genres.

Terms Artwork is accepted on consignment and there is a 50% commission. Retail price set by the gallery and the artist. Gallery provides promotion and contract. Accepted work should be framed and matted. Requires exclusive representation locally. Prefers paintings or works on paper. Prefers artists who can deliver and pick up.

Submissions Send query letter with bio, photographs, résumé, reviews, SASE and slides. Returns material with SASE. Responds in 6 weeks. Files CV, artist's statement, visuals if of interest within 6-18 months. Finds artists through word of mouth, submissions, portfolio reviews, art exhibits, and referrals by other artists.

Tips "Clearly labeled slides or photographs, well organized vita, informative artist's statement. Archival-quality materials are 100% essential in selling fine art to collectors."

MARYLAND

ARTEMIS, INC.
4715 Crescent St., Bethesda MD 20816. (301)229-2058. Fax: (301)229-2186. E-mail: sjtropper@aol.com. **Owner:** Sandra Tropper. Retail and wholesale dealership and art consultancy. Represents more than 100 emerging and mid-career artists. Does not sponsor specific shows. Clientele 40% private collectors, 60% corporate clients. Overall price range $100-10,000; most artwork sold at $1,000-3,000.

Media Considers oil, acrylic, watercolor, mixed media, collage, works on paper, sculpture, ceramic, craft, fiber, glass, installations, woodcuts, engravings, mezzotints, etchings, lithographs, pochoir, serigraphs and offset reproductions. Most frequently exhibits prints, contemporary canvases and paper/collage.

Style Exhibits impressionism, expressionism, realism, minimalism, color field, painterly abstraction, conceptualism and imagism. Genres include landscapes, florals and figurative work. "My goal is to bring together clients (buyers) with artwork they appreciate and can afford. For this reason I am interested in working with many, many artists." Interested in seeing works with a "finished" quality.

Terms Accepts work on consignment (50% commission). Retail price set by dealer and artist. Exclusive area representation not required. Gallery provides insurance and contract; shipping costs are shared. Prefers unframed artwork.

Submissions Send query letter with résumé, slides, photographs and SASE. Write to schedule an appointment to show a portfolio, which should include originals, slides, transparencies and photographs. Indicate net and retail prices. Responds only if interested within 1 month. Files slides, photos, résumé and promo material. All material is returned if not accepted or under consideration.

Tips "Many artists have overestimated the value of their work. Look at your competition's prices."

GOMEZ GALLERY
3600 Clipper Mill Rd., Suite 100, Baltimore MD 21211. (410)662-9510. Fax: (410)662-9496. E-mail: walter@gomez.com. Web site: www.gomezgallery.com. **Director:** Walter Gomez. Contemporary art and photography gallery. Estab. 1988. Sponsors 8 shows/year. Average display time 4-5 weeks. Open all year. Located in Baltimore City; 7,000 sq. ft. 80% private collectors, 20% corporate collectors. Overall price range $500-50,000.

Media Considers painting, sculpture and photography in all media.

Style Interested in all genres. Prefers figurative, abstract and landscapes with an experimental edge.

Terms Accepts artwork on consignment. Retail price set by the gallery and the artist. Gallery provides insurance and promotion. Artist pays for shipping.

Submissions Send query letter with résumé, slides, bio, brochure, SASE and reviews.

Tips "Find out a little bit about this gallery first; if work seems comparable, send a slide package."

MARIN-PRICE GALLERIES
7022 Wisconsin Ave., Chevy Chase MD 20815. (301)718-0622. E-mail: fmp@marin-price.com. Web site: www.marin-pricegalleries.com. **President:** F. Marin-Price. Retail/wholesale gallery. Estab. 1992. Represents/exhibits 25 established painters and 4 sculptors/year. Exhibited artists include Joseph Sheppard. Sponsors 24 shows/year. Average display time 3 weeks. Open Monday-Saturday, 10:30-7; Sunday, 12-5. 1,500 sq. ft. 50% of space

for special exhibitions. Clientele: upscale. 90% private collectors, 10% corporate collectors. Overall price range $3,000-25,000; most work sold at 6,000-12,000.

Media Considers oil, drawing, watercolor and pastel. Most frequently exhibits oil, watercolor and pastels.

Style Exhibits expressionism, photorealism, neo-expressionism, primitivism, realism and impressionism. Genres include landscapes, florals, Americana and figurative work.

Terms Retail price set by the gallery and the artist. Gallery provides insurance, promotion and contract. Artist pays for shipping costs. Prefers artwork framed.

Submissions Prefers only oils. Send query letter with résumé, slides, bio and SASE. Responds in 6 weeks.

RESURGAM GALLERY

910 S. Charles St., Baltimore MD 21230. (410)962-0513. **Office Manager:** P. Randall Whitlock. Cooperative gallery. Estab. 1990. Represents 34 emerging, mid-career and established artists/year. 34 members. Exhibited artists include Ruth Pettus and Beth Wittenberg. Sponsors 14 shows/year. Average display time 3 weeks. Open all year; Wednesday-Saturday, noon-6; closed in August. Located downtown; 600 sq. ft.; in Baltimore's historic Federal Hill district. 100% of space for gallery artists. Clientele urban professionals. 100% private collectors. Overall price range $100-1,800; most work sold at $200-800.

Media Considers oil, acrylic, watercolor, pastel, pen & ink, drawing, mixed media, collage, paper, sculpture, ceramics, craft, fiber, glass, photography and all types of prints. Most frequently exhibits painting, sculpture (mid-sized) and fine crafts.

Style Exhibits all styles, all genres.

Terms Co-op membership fee plus donation of time. Retail prices set by the artist. Gallery provides insurance. "Artists are responsible for their own promotion." Artist pays shipping costs to and from gallery. Prefers artwork framed.

Submissions "Artists must be available to sit in galleryor pay a sitterfive days each year." Memberships for calendar year decided in June. Rolling-basis jurying throughout the year. Send query letter with SASE to receive application form. Portfolio should include slides.

WASHINGTON COUNTY MUSEUM OF FINE ARTS

91 Key St., P.O. Box 423, Hagerstown MD 21741. (301)739-5727. Fax: (301)745-3741. E-mail: WCMFA@myactv. net. Web site: www.washcomuseum.org. **Curator:** Amy Hunt. Museum. Estab. 1929. Approached by 30 established artists/year. Open all year; Tuesday-Saturday, 10-5; Sunday, 1-5. Closed holidays. Located in western Maryland; facility includes 12 galleries. Overall price range $300-1,500; most work sold at $800-900.

Media Considers all media except installation and craft. Most frequently exhibits oil, watercolor and ceramics. Considers all types of prints except posters.

Style Exhibits impressionism. Genres include florals, landscapes, portraits and wildlife.

Terms Sales from exhibits only30% commission. Retail price set by the artist. Gallery provides insurance. Accepted work should be framed. Does not require exclusive representation locally.

Submissions Write to arrange a personal interview to show portfolio of photographs and slides. Mail portfolio for review. Returns material with SASE. Responds in 1 month. Finds artists through word of mouth, portfolio reviews, art exhibits, and referrals by other artists.

MASSACHUSETTS

DEPOT SQUARE GALLERY

1837 Massachusetts Ave., Lexington MA 02420. (781)863-1597. E-mail: depotsquaregallery@aol.com. Web site: www.depotsquaregallery.com. **Treasurer:** Natalie Warshawer. Cooperative gallery. Estab. 1981. Represents emerging, mid-career and established artists. 25 members. Exhibited artists include Gracia Dayton, Natalie Warshawer, Carolyn Latanision, Dora Hsiung and Joan Carcia. Sponsors 10 shows/year. Average display time 1 month. Open all year; Tuesday-Saturday, 10-5:30; open Sunday, 12-4, (September-June only). Located downtown; 2,000 sq. ft.; 2 floors—street level and downstairs. 100% of space for gallery artists. 10% private collectors, 10% corporate collectors. Overall price range $100-3,000; most work sold at $100-500.

Media Considers oil, acrylic, watercolor, pastel, pen & ink, drawing, mixed media, collage, paper, sculpture, ceramics, fiber, glass, woodcuts, engravings, wood engravings, mezzotints, serigraphs, linocuts and etchings. Most frequently exhibits watercolor, oil and prints.

Style Exhibits all styles, all genres. Prefers realism, impressionism (depends on makeup of current membership).

Terms Co-op membership fee plus donation of time (40% commission). Retail price set by the artist. Prefers artwork framed. Do have print bins for works on paper.

Submissions Accepts only local artists who must attend meetings, help hang shows and work in the gallery. Send query letter with résumé, slides, bio, SASE and reviews. Call for information. Responds in 6 weeks. Files

bio and one slide—"if we want to consider artist for future membership." Finds artists through advertising for new members and referrals.

Tips "The work needs to show a current direction with potential, and it must be professionally presented."

GALLERY NAGA

67 Newbury St., Boston MA 02116. (617)267-9060. Fax: (617)267-9040. E-mail: mail@gallerynaga.com. Web site: www.gallerynaga.com. **Director:** Arthur Dion. Retail gallery. Estab. 1977. Represents 30 emerging, mid-career and established artists. Exhibited artists include Robert Ferrandini and George Nick. Sponsors 9 shows/year. Average display time 1 month. Open Tuesday-Saturday 10-530. Closed August. Located on "the primary street for Boston galleries; 1,500 sq. ft.; housed in an historic neo-gothic church." Clientele 90% private collectors, 10% corporate collectors. Overall price range $850-35,000; most work sold at $2,000-3,000.

Media Considers oil, acrylic, mixed media, sculpture, photography, studio furniture and monotypes. Most frequently exhibits painting and furniture.

Style Exhibits expressionism, painterly abstraction, postmodern works and realism. Genres include landscapes, portraits and figurative work. Prefers expressionism, painterly abstraction and realism.

Terms Accepts work on consignment (50% commission). Retail price set by gallery and artist. Gallery provides insurance and promotion; artist pays for shipping. Prefers artwork framed.

Submissions "Not seeking submissions of new work at this time."

Tips "We focus on Boston and New England artists. We exhibit the most significant studio furnituremakers in the country. Become familiar with any gallery to see if your work is appropriate before you make contact."

KAJI ASO STUDIO/GALLERY NATURE AND TEMPTATION

40 St. Stephen St., Boston MA 02115. (617)247-1719. Fax: (617)247-7564. E-mail: mail@gallerynaga.com. Web site: www.gallerynaga.com. **Administrator:** Kate Finnegan. Nonprofit gallery. Estab. 1975. Represents 40-50 emerging, mid-career and established artists. 35-45 members. Exhibited artists include Kaji Aso and Katie Sloss. Sponsors 10 shows/year. Average display time 3 weeks. Open all year by appointment. Located in city's cultural area (near Symphony Hall and Museum of Fine Arts); "intimate and friendly." 30% of space for special exhibitions; 70% of space for gallery artists. Clientele: urban professionals and fellow artists. 80% private collectors, 20% corporate collectors. Overall price range $150-8,000; most work sold at $150-1,000.

Media Considers oil, acrylic, watercolor, pastel, pen & ink, drawing, ceramics and etchings. Most frequently exhibits watercolor, oil or acrylic and ceramics.

Style Exhibits painterly abstraction, impressionism and realism.

Terms Co-op membership fee plus donation of time (35% commission). Retail price set by the artist. Gallery provides promotion; artist pays shipping costs to and from gallery. Prefers artwork framed.

Submissions Send query letter with résumé, slides, bio, photographs and SASE. Write for appointment to show portfolio of originals, photographs, slides or transparencies. Does not reply; artist should contact. Files résumé. Finds artists through advertisements in art publications, word of mouth, submissions.

KINGSTON GALLERY

450 Harrison Ave. #43, Boston MA 02118. (617)423-4113. E-mail: director@hingstongallery.com. Web site: www.kingstongallery.com. **Director:** Janet Hansen Kawada. Cooperative gallery. Estab. 1982. Exhibits the work of 19 emerging, mid-career and established artists. Sponsors 11 shows/year. Average display time 1 month. Open Tuesday-Saturday, 12-5. Closed August. Located "in downtown Boston (South End); 1,300 sq. ft.; large, open room with 12 ft. ceiling and smaller center gallery—can accomodate large installation." Overall price range $100-7,000; most work sold at $600-1,000.

Media Considers all media. 20% of space for special exhibitions.

Style Exhibits all styles.

Terms Co-op membership requires dues plus donation of time. 25% commission charged on sales by members. Retail price set by the artist. Sometimes offers payment by installments. Gallery provides insurance, some promotion and contract. Rental of center gallery by arrangement.

Submissions Accepts only artists from New England for membership. Artist must fulfill monthly co-op responsibilities. Send query letter with résumé, slides, SASE and "any pertinent information. Slides are reviewed every other month. Gallery will contact artist within 1 month." Does not file material but may ask artist to re-apply in future.

Tips "Please include thorough, specific information on slides size, price, etc."

R. MICHELSON GALLERIES

132 Main St., Northampton MA 01060. (413)586-3964. E-mail: rm@rmichelson.com. Web site: www.rmichelson.com. **Owner:** RMichelson. Retail gallery. Estab. 1976. Represents 30 emerging, mid-career and established artists/year. Exhibited artists include Barry Moser and Leonard Baskin. Sponsors 6 shows/year. Average display

time 1 month. Open all year; Monday-Saturday, 10-6; Sunday, 12-5. Located downtown; Northampton gallery has 3,500 sq. ft.; Amherst gallery has 1,800 sq. ft. 50% of space for special exhibitions. Clientele 80% private collectors, 20% corporate collectors. Overall price range $100-75,000; most artwork sold at $1,000-25,000.
Media Considers all media and all types of prints. Most frequently exhibits oil, egg tempera, watercolor and lithography.
Style Exhibits impressionism, realism and photorealism. Genres include florals, portraits, wildlife, landscapes, Americana and figurative work.
Terms Accepts work on consignment (commission varies). Retail price set by gallery and artist. Customer discounts and payment by installment are available. Gallery provides promotion; shipping costs are shared.
Submissions Prefers Pioneer Valley artists. Send query letter with résumé, slides, bio, brochure and SASE. Write for appointment to show portfolio. Responds in 3 weeks. Files slides.

NIELSEN GALLERY
179 Newbury St., Boston MA 02116. (617)266-4835. Fax: (617)266-0480. E-mail: contact@nielsengallery.com. Web site: www.nielsengallery.com. **Owner/Director:** Nina Nielsen. Retail gallery. Estab. 1963. Represents 25 emerging, mid-career and established artists/year. Exhibited artists include Joan Snyder and John Walker. Sponsors 8 shows/year. Average display time 3-5 weeks. Closed in August. Located downtown; 2,500 sq. ft.; brownstone with 2 floors. 100% of space for gallery artists. 80% private collectors, 20% corporate collectors. Overall price range $1,000-100,000; most work sold at $5,000-20,000.
Media Considers contemporary painting, sculptures, prints, drawings and mixed media.
Style Exhibits all styles.
Terms Retail price set by the gallery and the artist. Gallery provides insurance and promotion.
Submissions Send query letter with slides and SASE. Responds in 2 months. Finds artists through word of mouth, referrals by other artists, visiting art fairs and exhibitions, submissions.

PEPPER GALLERY
38 Newbury St., Boston MA 02116. (617)236-4497. Fax: (617)236-4497. **Director:** Audrey Pepper. Retail gallery. Estab. 1993. Represents 20 emerging, mid-career and established artists/year. Exhibited artists include Marja Llanko, Daphne Confar, Judith Belzer, Andrew Nixon, Katy Schneider, Pamela Ellis Hawkes. Sponsors 9 shows/year. Average display time 6 weeks. Open all year; Tuesday-Saturday, 10-5. Located downtown, Back Bay; 700 sq. ft. 80% of space for special exhibitions. Clientele private collectors, museums, corporate. 70% private collectors, 15% corporate collectors, 15% museum collectors. Overall price range $600-25,000; most work sold at $1,000-7,000.
Media Considers oil, watercolor, pastel, drawing, mixed media, glass, woodcuts, engravings, lithographs, mezzotints, etchings and photographs. Most frequently exhibits oil on canvas, lithos/etchings and photographs.
Style Exhibits contemporary representational paintings, prints, drawings and photographs.
Terms Accepts work on consignment (50% commission). Retail price set by the gallery and the artist. Gallery provides insurance and contract.
Submissions Send query letter with résumé, slides, bio, SASE and reviews. Call for appointment to show portfolio of originals, photographs, slides and transparencies. Responds in 2 months. Finds artists through exhibitions, word of mouth, open studios and submissions.

SPAIGHTWOOD GALLERIES, INC.
P.O. Box 1193, Upton MA 01568-6193. (508)529-2511. E-mail: sptwd@verizon.net. Web site: www.spaightwoodgalleries.com. **Contact:** Sonja Hansard-Weiner, President. Vice President: Andy Weiner. For-profit gallery. Estab. 1980. Exhibits mostly established artists. See artists page on our Web site http://spaightwoodgalleries.com/Pages/Artists.html (9000 works from late 15th century to present in inventory). Exhibited artists include Marc Chagal, original lithographs and etchings; Claude Garache, original aquatints and lithographs. Sponsors 6 exhibits/year. Average display time 2 months. Open by appointment. ''We are located in a renovated ex-Unitarian Church; basic space is 90×46 ft; ceilings 25 ft. high at center, 13 ft. at walls. See http://spaightwoodgalleries.com/Pages/Upton.html for views of the gallery.''Clients include mostly internet and visitors drawn by internet; we are currently trying to attract visitors from Boston and vicinity via advertising and press releases. 2% sales are to corporate collectors. Overall price range: $175-125,000; most work sold at $1,000-4,000.
Media Considers all media except installations, photography, glass, craft, fiber. Most frequently exhibits oil, drawing and ceramic sculpture. Considers all types of prints.
Style Exhibits old master to contemporary; most frequently impressionist and post-impressionist (Cassatt, Renoir, Cezanne, Signac, Gauguin, Bonnard), Fauve (Matisse, Rouault, Vlaminck, Derain) modern (Picasso, Matisse, Chagall, Miró, Giacometti), German Expressionist (Heckel, Kollwitz, Kandinsky, Schmidt-Rottluff), Surrealist (Miró, Fini, Tanning, Ernst, Lam, Matta); COBRA (Alechinsky, Appel, Jorn), Abstract Expressionist (Tàpies, Tal-Coat, Saura, Llèdos, Bird, Mitchell, Frankenthaler, Olitski), Contemporary (Claude Garache, Titus-Carmel,

Joan Snyder, John Himmelfarb, Manel Llèdos, Jonna Rae Brinkman). Most frequently exhibits modern, contemporary, impressionist and post-impressionist. Most work shown is part of our inventory; we buy mostly at auction. In the case of some artists, we buy directly from the artist or the publisher; in others we have works on consignment.

Making Contact & Terms Retail price set by both artist and gallery. Accepted work should be unmatted and unframed. Requires exclusive representation locally.

Submissions Prefers link to Web site with bio, exhibition history and images. Returns material with SASE. Responds to queries only if interested. Finds artists through art exhibits (particularly museum shows), referrals by other artists, books.

Tips "Make high quality art."

WORCESTER CENTER FOR CRAFTS GALLERIES

25 Sagamore Rd., Worcester MA 01605. (508)753-8183. Fax: (508)797-5626. E-mail: wcc@worcestercraftcenter. org. Web site: www.worcestercraftcenter.org. **Executive Director:** David Leach. Nonprofit rental gallery. Dedicated to promoting artisans and American crafts. Estab. 1856. Has several exhibits throughout the year, including 1 juried, catalogue show and 2 juried craft fairs in May and November. Exhibits student, faculty, visiting artists, regional, national and international artists. Open all year; Monday-Saturday, 10-5. Located at edge of downtown; 2,205 sq. ft. (main gallery); track lighting, security. Overall price range $20-400; most work sold at $65-100.

Media Considers all media except paintings and drawings. Most frequently exhibits wood, metal, fiber, ceramics, glass and photography.

Style Exhibits all styles.

Terms Artwork is accepted on consignment (40% commission). Retail price set by the artist. Gallery provides insurance, promotion and contract. Shipping costs are shared.

Submissions Call for appointment to show portfolio of photographs and slides. Responds in 1 month.

MICHIGAN

THE ANN ARBOR CENTER/GALLERY SHOP

117 W. Liberty, Ann Arbor MI 48104. (734)994-8004. Fax: (734)994-3610. E-mail: info@annarborartcenter.org. Web site: www.annarborartcenter.org. **Gallery Shop Director:** Millie Rae Webster. Gallery Shop Assistant Director: Cindy Marr. Estab. 1978. Represents over 350 artists, primarily Michigan and regional. Gallery Shop purchases support the Art Center's community outreach programs.

- The Ann Arbor Art Center also has exhibition opportunities for Michigan artists in its Exhibition Gallery and Art Consulting Program.

Media Considers original work in virtually all 2- and 3-dimensional media, including jewelry, prints and etchings, ceramics, glass, fiber, wood, photography and painting.

Style The gallery specializes in well-crafted and accessible artwork. Many different styles are represented, including innovative contemporary.

Terms Accepts work on consignment. Retail price set by artist. Offers member discounts and payment by installments. Exclusive area representation not required. Gallery provides contract; artist pays for shipping.

Submissions "The Art Center seeks out artists through the exhibition visitation, wholesale and retail craft shows, networking with graduate and undergraduate schools, word of mouth, in addition to artist referral and submissions."

ART CENTER OF BATTLE CREEK

265 E. Emmett St., Battle Creek MI 49017. (269)962-9511. Fax: (269)969-3838. **Acting Director:** Linda Holberbaum. Estab. 1948. Represents 150 emerging, mid-career and established artists. 90% private collectors, 10% corporate clients. Exhibition program offered in galleries, usually 3-4 solo shows each year, two artists' competitions, and a number of theme shows. Also offers Michigan Artworks Shop featuring work for sale or rent. Average display time 1-2 months. "Three galleries, converted from church—handsome high-vaulted ceiling, arches lead into galleries on either side. Welcoming, open atmosphere." Overall price range $20-1,000; most work sold at $20-300. Hours: Tuesday-Friday 10-5 p.m. Saturdays: 11-3 p.m. Closed Sundays, Mondays and major holidays.

Media Considers oil, acrylic, watercolor, pastel, pen & ink, drawings, mixed media, collage, works on paper, sculpture, ceramic, craft, fiber, glass, photography and original handpulled prints.

Style Exhibits painterly abstraction, minimalism, impressionism, photorealism, expressionism, neo-expressionism and realism. Genres include landscapes, florals, Americana, portraits and figurative work. Prefers Michigan artists.

Terms Accepts work on consignment (40% commission). Retail price set by artist. Exclusive area representation not required. Gallery provides insurance, promotion and contract; artist pays for shipping.

Submissions Michigan artists receive preference. Send query letter, résumé, brochure, slides and SASE. Slides returned; all other material is filed.

Tips "Contact Art Center before mailing materials. We are working on several theme shows with groupings of artists."

THE ART CENTER

125 Macomb Place, Mount Clemens MI 48043. (586)469-8666. Fax: (586)469-4529. **Executive Director:** Jo-Anne Wilkie. Nonprofit gallery. Estab. 1969. Represents emerging, mid-career and established artists. 500 members. Sponsors 10 shows/year. Average display time 1 month. Open all year except July and August; Tuesday-Friday, 11-5; Saturday, 9-2. Located in downtown Mount Clemens; 1,300 sq. ft. The Art Center is housed in the historic Carnegie Library Building, listed in the State of Michigan Historical Register. 100% of space for special exhibitions. Clients include private and corporate collectors. Overall price range $5-1,000; most work sold at $50-500.

Media Considers oil, acrylic, watercolor, pastel, pen & ink, drawing, mixed media, collage, paper, sculpture, ceramics, photography, jewelry, metals, craft, fiber, glass, all types of printmaking. Most frequently exhibits oils/acrylics, watercolor, ceramics and mixed media.

Style Exhibits all styles, all genres.

Terms The Art Center receives a 30% commission on sales of original works; 50% commission on prints.

Submissions Send query with good reviews, 12 or more professional slides and a professional artist biography. Send photographs or slides and résumé with SASE for return. Finds artists through submissions, queries, exhibit announcements, word of mouth and membership.

Tips "Join The Art Center as a member, call for placement on our mailing list, enter the Michigan Annual Exhibition."

ARTQUOTE INTERNATIONAL, LLC

6364 Ramwyck Court, West Bloomfield MI 48322. (248)851-6091. Fax: (248)851-6090. E-mail: artquote@BigFoot.com. **Contact:** M. Burnstein. Art consultancy, for-profit, wholesale gallery, corporate art and identity programs. Estab. 1985. Exhibits established artists. Exhibited artists include Warhol, serigraph; and Bill Mack, sculpture. Clients include local community. 99% of sales are to corporate collectors. Does not sell art at retail prices.

Submissions Depends on corporate client. Finds artists through word of mouth, art exhibits and art fairs.

ARTS EXTENDED GALLERY, INC.

2966 Woodward Ave., The Art Bldg., Detroit MI 48201. (313)831-0321. Fax: (313)831-0415. E-mail: cctart@comcast.net. **Director:** Dr. C.C. Taylor. Retail, nonprofit gallery, educational 501C3 space art consultancy and appraisals. Estab. 1959. Represents/exhibits many emerging, mid-career and established artists. Exhibited artists include Michael Kelly Williams, Samuel Hodge, Marie-Helene Cauvin and Charles McGee. Sponsors 6 shows/year. Average display time 8-10 weeks. Open all year; Wednesday-Saturday, 11-5. Located near Wayne State University; 1,000 sq. ft. Clients include tourists, upscale, local community. 80% of sales are to private collectors, 20% corporate collectors. Overall price range $150-4,000 up; most work sold at $200-500 (craft items are considerably less).

• Gallery also sponsors art classes and exhibits outstanding work produced there.

Media Considers all media, woodcuts, engravings, linocuts, etchings and monoprints. Most frequently exhibits painting, fibers, photographs and antique African art.

Style "The work which comes out of the community we serve is varied but rooted in realism, ethnic symbols and traditional designs/patterns with some exceptions."

Terms Artwork is accepted on consignment, and there is a 45% commission, or artwork is bought outright for 55% of the retail price. Retail price set by the gallery and the artist. Gallery provides insurance, promotion and contract; shipping costs are shared. Prefers artwork framed or ready to install.

Submissions Send query letter with résumé, slides, photographs and reviews. Call for appointment to show a portfolio of photographs, slides and bio. Responds in 3 weeks. Files biographical materials sent with announcements, catalogs, résumés, visual materials to add to knowledge of local artists, letters, etc.

Tips "Our work of recruiting local artists is known, and consequently artists beginning to exhibit or seeking to expand are sent to us. Many are sent by relatives and friends who believe that ours would be a logical place to inquire. Study sound technique—there is no easy way or scheme to be successful. Work up to a standard of good craftsmanship and honest vision. Come prepared to show a group of artifacts. Have clearly in mind a willingness to part with work and understand that market moves fairly slowly."

CENTRAL MICHIGAN UNIVERSITY ART GALLERY

Wightman 132, Art Department, Mt. Pleasant MI 48859. (989)774-3800. Fax: (989)774-2278. E-mail: julia.morris roe@cmich.edu. Web site: www.uag.cmich.edu. **Director:** Julia Morrisroe. Nonprofit gallery. Estab. 1970. Approached by 250 artists/year. Represents 40 emerging, mid-career and established artists. Exhibited artists include Ken Fandell, Jan Estep, Sang-Ah-Choi, Amy Yoes, Scott Anderson, Richard Shaw. Sponsors 7 exhibits/year. Average display time 1 month. Open all year; Monday, Tuesday, Thursday and Friday, 10-5; Wednesday, 12-8; Saturday, 12-5. Clients include local community, students and tourists. Overall price range $200-5,000.
Media Considers all media and all types of prints. Most frequently exhibits sculpture, painting and photography.
Style Considers all styles.
Terms Buyers are referred to the artist. Gallery provides insurance, promotion and contract. Accepted work should be framed. Does not require exclusive representation locally.
Submissions Write to arrange a personal interview to show portfolio of slides. Mail portfolio for review. Send query letter with artist's statement, bio, résumé, reviews, SASE and slides. Returns material with SASE. Responds only if interested within 2 months. Files résumé, reviews, photocopies and brochure. Finds artists through word of mouth, submissions, portfolio reviews, art exhibits, and referrals by other artists.

DETROIT ARTISTS MARKET

4719 Woodward Ave., Detroit MI 48201. (313)832-8540. Fax: (313)832-8543. E-mail: info@detroitartistsmarket. org. Web site: www.detroitartistmarket.org. **Interim Director:** Mary Harrison. Gallery Manager: Jessica Dawson. Nonprofit gallery. Estab. 1932. Exhibits the work of emerging, mid-career and established artists/year; 1,000 members. Sponsors 8-10 shows/year. Average display time 6 weeks. Open Wednesday-Sunday, 11 a.m.-6 p.m. Located in downtown Detroit; 2,600 sq. ft. 85% of space for special exhibitions. Clientele "extremely diverse client basevaries from individuals to the Detroit Institute of Arts." 95% private collectors; 5% corporate collectors. Overall price range $200-$75,000; most work sold at $100-$500.
Media Considers all media. No posters. Most frequently exhibits paintings, glass and multimedia.
Style All contemporary styles and genres.
Terms Accepts artwork on consignment (33% commission). Retail price set by the artist. Gallery provides insurance; artist pays for partial shipping.
Tips "Detroit Artists Market educates the Detroit metropolitan community about the work of emerging and established Detroit and Michigan artists through exhibitions, sales and related programs."

GALLERY SHOP AND GALLERIES: BIRMINGHAM BLOOMFIELD ART CENTER

1516 S. Cranbrook Rd., Birmingham MI 48009. (248)644-0866. Fax: (248)644-7904. Web site: www.bbartcenter. org. Nonprofit gallery shop. Estab. 1962. Represents emerging, mid-career and established artists. Sponsors ongoing exhibition. Open all year; Monday-Saturday, 9-5. Suburban location. 100% of space for gallery artists. Clientele upscale, local. 100% private collectors. Overall price range $50-2,000.
Media Considers all media. Most frequently exhibits glass, jewelry, ceramics and 2D work.
Style Exhibits all styles.
Terms Accepts work on consignment (40% commission). Retail price set by the artist. Gallery provides promotion and contract; artist pays for shipping costs to gallery.
Submissions Send query letter with résumé, brochure, slides, photographs, reviews, artist's statement, bio, SASE; "as much information as possible." Files résumé, bio, brochure, photos.
Tips "We consider the presentation of the work (framing, matting, condition) and the professionalism of the artist."

GRAND RAPIDS ART MUSEUM

155 Division N, Grand Rapids MI 49503-3154. (616)831-1000. Fax: (616)559-0422. E-mail: pr@gr-artmuseum.o rg. Web site: www.gramonline.org. Museum. Estab. 1910. Exhibits established artists. Sponsors 3 exhibits/year. Average display time 4 months. Open all year; Tuesday-Thursday, 10-5; Friday, 10-8:30; Sunday, 12-5. Closed Mondays and major holidays. Located in the heart of downtown Grand Rapids, the Grand Rapids Art Museum presents exhibitions of national caliber and regional distinction. The museum collection spans Renaissance to modern art, with particular strength in 19th and 20th century paintings, prints and drawings. Clients include local community, students, tourists, upscale.
Media Considers all media and all types of prints. Most frequently exhibits paintings, prints and drawings.
Style Considers all styles and genres. Most frequently exhibits impressionist, modern and Renaissance.

RUSSELL KLATT GALLERY

33644 Woodward, Birmingham MI 48009. (248)647-1120. Fax: (248)644-5541. **Director:** Sharon Crane. Retail gallery. Estab. 1987. Represents 100 established artists/year. Interested in seeing the work of emerging artists. Exhibited artists include Henri Plisson, Roy Fairchild, Don Hatfield, Mary Mark, Eng Tay. Open all year; Monday-

Friday, 10-6; Saturday, 10-5. Located on Woodward, 4 blocks north of 14 mile on the east side; 800 sq. ft. 100% private collectors. Overall price range $800-1,500; most work sold at $1,000.

Media Considers oil, acrylic, watercolor, pastel, ceramics, lithograph, mezzotint, serigraphs, etching and posters. Most frequently exhibits serigraphs, acrylics and oil pastels.

Style Exhibits painterly abstraction, impressionism and realism. Genres include landscapes, florals and figurative work. Prefers traditional European style oil paintings on canvas.

Terms Accepts work on consignment (60% commission) or buys outright for 50% of retail price (net 30-60 days). Retail price set by the gallery and the artist. Gallery provides insurance and shipping to gallery; artist pays shipping costs from gallery. Prefers artwork unframed.

Submissions Send query letter with brochure and photographs. Write for appointment to show portfolio of photographs. Finds artists through visiting exhibitions.

SAPER GALLERIES

433 Albert Ave., East Lansing MI 48823. (517)351-0815. E-mail: roy@sapergalleries.com. Web site: www.saperg alleries.com. **Director:** Roy C. Saper. Retail gallery. Estab. in 1978; in 1986 designed and built new location. Displays the work of 150 artists; mostly mid-career, and artists of significant national prominence. Exhibited artists include Picasso, Peter Max, Rembrandt. Sponsors 2 shows/year. Average display time 2 months. Open all year. Located downtown; 5,700 sq. ft.; "We were awarded *Decor* magazine's Award of Excellence for gallery design." 50% of space for special exhibitions. Clients include students, professionals, experienced and new collectors. 80% of sales are to private collectors, 20% corporate collectors. Overall price range $100-100,000; most work sold at $1,000.

Media Considers oil, acrylic, watercolor, pastel, drawings, mixed media, collage, paper, sculpture, ceramic, craft, glass and original handpulled prints. Considers all types of prints except offset reproductions. Most frequently exhibits intaglio, serigraphy and sculpture. "Must be of highest professional quality."

Style Exhibits expressionism, painterly abstraction, surrealism, postmodern works, impressionism, realism, photorealism and hard-edge geometric abstraction. Genres include landscapes, florals, southwestern and figurative work. Prefers abstract, landscapes and figurative. Seeking extraordinarily talented, outstanding artists who will continue to produce exceptional work.

Terms Accepts work on consignment (negotiable commission); or buys outright for negotiated percentage of retail price. Retail price set by the artist. Offers payment by installments. Gallery provides insurance, promotion and contract; shipping costs are shared. Prefers artwork unframed (gallery frames).

Submissions Prefers digital pictures e-mailed to roy@sapergalleries.com. Call for appointment to show portfolio of originals or photos of any type. Responds in 1 week. Files any material the artist does not need returned. Finds artists mostly through NY Art Expo.

Tips "Present your very best work to galleries which display works of similar style, quality and media. Must be outstanding, professional quality. Student quality doesn't cut it. Must be great. Be sure to include prices and SASE."

SWORDS INTO PLOWSHARES

Peace Center and Gallery, 33 E. Adams, Detroit MI 48226. (313)963-7575. Fax: (313)963-2569. E-mail: swordsint oplowshares@prodigy.net. Web site: www.swordsintoplowshares.org. **Contact:** Tina Mangum, administrative assistant. Nonprofit gallery. "Our theme is 'World Peace.' " Estab. 1985. Represents 3-4 emerging, mid-career and established artists/year. Sponsors 4-6 shows/year. Average display time 2½ months. Open all year; Tuesday, Thursday, Saturday, 11-3. Located in downtown Detroit in the Theater District; 2,881 sq. ft.; 1 large gallery, 3 small galleries. 100% of space for special exhibitions. Clients include walk-in, church, school and community groups. 100% of sales are to private collectors. Overall price range $75-6,000; most work sold at $75-700.

Media Considers all media. Considers all types of prints. "We have a juried show every two years for Ontario and Michigan artists about our theme. The juries make the selection of 2- and 3-dimensional work."

Terms Accepts work on consignment (35% commission). Retail price set by the artist. Gallery provides insurance and promotion; shipping costs from gallery.

Submissions Accepts artists primarily from Michigan and Ontario. Send query letter with statement on how other work relates to our theme. Responds in 2 months. Finds artists through lists of Michigan Council of the Arts, Windsor Council of the Arts.

URBAN INSTITUTE FOR CONTEMPORARY ARTS

41 Sheldon Blvd. Grand Rapids MI 49503. (616)459-5994. Fax: (616)459-9395. E-mail: jteunis@uica.org. Web site: www.uica.org. **Managing Director:** Janet Teunis. Alternative space, nonprofit gallery. Estab. 1977. Approached by 250 artists/year. Exhibits 50 emerging, mid-career and established artists. "We have five galleries and places for site-specific work." Sponsors 20 exhibits/year. Average display time 6 weeks. Open Tuesday-Saturday, 12-10; Sunday, 12-7.

Media Considers all media. Most frequently exhibits mixed media, avant garde and nontraditional.
Style Exhibits conceptualism and postmodernism.
Terms Gallery provides insurance, promotion and contract.
Submissions Check Web site for gallery descriptions and how to apply. Send query letter with artist's statement, bio, résumé, reviews, SASE, application fee, and slides. Returns material with SASE. Does not reply. Artist should see Web site, inquire about specific calls for submissions. Finds artists through submissions.
Tips "Get submission requirements before sending materials."

MINNESOTA

ART OPTIONS GALLERY
132 E. Superior St., Duluth MN 55802. (218)727-8723. E-mail: artoptions@netzero.net. Web site: www.artoptions.com. **President:** Sue Pavlatos. Retail gallery. Estab. 1988. Represents 35 mid-career artists/year. Sponsors 4 shows/year. Average display time 1 month. Open all year; Tuesday-Friday, 10:30-5; Monday and Saturday, 10:30-2. Located downtown. Clients include tourists and local community. 70% of sales are to private collectors, 30% corporate collectors. Overall price range $50-1,000; most work sold at $300.
Media Considers all media and all types of prints. Most frequently exhibits watercolor, mixed media and oil.
Style Exhibits all styles and genres. Prefers landscape, florals and Americana.
Terms Accepts work on consignment (40% commission). Retail price set by the artist. Gallery provides insurance and promotion; artist pays for shipping. Prefers artwork framed.
Submissions Send query letter with résumé, slides and bio. Write for appointment to show portfolio of slides. Responds in 2 weeks. Files bio and résumé. Finds artists through word of mouth.
Tips "Paint or sculpt as much as you can. Work, work, work. You should have at least 50-100 pieces in your body of work before approaching galleries."

FARIBAULT ART CENTER, INC.
212 Central Ave., Suite A, Faribault MN 55021. (507)332-7372. E-mail: fac@deskmedia.com. Web site: www.faribaultart.org. **Contact:** Executive Director. Nonprofit gallery. Represents 10-12 emerging and mid-career artists/year. 200 members. Sponsors 8 shows/year. Average display time 1 month. Open all year; Monday-Saturday, 9:30-5. Located downtown; 1,600 sq. ft. 50% of space for special exhibitions; 50% of space for gallery artists. Clientele local and tourists. 90% private collectors.
Media Considers all media and all types of prints.
Style Open.
Terms Accepts work on consignment (30% commission for nonmembers). Retail price set by the artist. Artist pays for shipping. Prefers artwork framed.
Submissions Accepts local and regional artists. Send query letter with slides, bio, photographs, SASE and artist's statement. Call or write for appointment to show portfolio of photographs or slides. Responds only if interested within 2 weeks. Artist should call. Finds artists through word of mouth, referrals by other artists, visiting art fairs and exhibitions and submissions.
Tips "Artists should respond quickly upon receiving reply."

FLANDERS CONTEMPORARY ART
3012 Lyndale Ave. South, Minneapolis MN 55408. (612)344-1700. Fax: (612)344-1643. **Director:** Douglas Flanders. Retail gallery. Estab. 1972. Represents emerging, mid-career and established artists. Exhibited artists include Jim Dine and David Hockney. Sponsors 8 shows/year. Average display time 6 weeks. Open all year; Tuesday-Saturday 10-5. Located uptown, over 5,000 sq. ft. exhibition space with 13' ceiling. Clients include private, public institutions, corporations, museums. Price range starts as low as $85. Most work sold at $9,500-55,000.
Media Considers all media and original handpulled prints. Most frequently exhibits sculpture, paintings and various prints; some photography.
Style Exhibits all styles and genres. Prefers abstract expressionism, impressionism and post-impressionism.
Terms Accepts work on consignment (50% commission). Gallery provides insurance, promotion and contract; shipping costs are shared. Prefers artwork framed.
Submissions Send query letter with résumé, 20 slides, bio and SASE. Write for appointment to show portfolio of slides. Responds in 1 week.
Tips "Include a statement about your ideas and artwork."

ICEBOX QUALITY FRAMING & GALLERY
1500 Jackson St. NE, Suite 443, Minneapolis MN 55413. (612)788-1790. Fax: (612)788-6947. E-mail: icebox@bitstream.net. Web site: http://iceboxminnesota.com. **Fine Art Representative:** Howard Christopherson. Retail

gallery and alternative space. Estab. 1988. Represents photographers and fine artists in all media, predominantly photography. Overall price range $400-1,500. Most work sold at $200-800.

Media Considers photography and all fine art with some size limitations.

Style Exhibits photos of multicultural, enviromental, landscapes/scenics, rural, adventure, travel and fine art photographs from artists with serious, thought-provoking work. Interested in alternative process, documentary, erotic, historical/vintage. A sole proprietorship gallery, Icebox sponsors installations and exhibits in the gallery's space in the Minneapolis Arts District.

Terms "Exhibit expenses and promotional material paid by the artist along with a sliding scale commission." Gallery provides great exposure, mailing list of 2,000 and good promotion.

Submissions Send letter of interest telling why and what you would like to exhibit at Icebox. Include only materials that can be kept at the gallery and updated as needed. Check Web site for more details about entry and gallery history.

Tips "Be more interested in the quality and meaning in your artwork than in a way of making money."

MIKOLS RIVER STUDIO INC.

717 Main St. NW, Elk River MN 55330. (763)441-6385. **President:** Anthony Mikols. Retail gallery. Estab. 1985. Represents 12 established artists/year. Exhibited artists include Steve Hanks. Sponsors 2 shows/year. Open all year; Mon.-Fri., 9-6 and Sat. from 9-12. Located in downtown; 2,200 sq. ft. 10% of space for special exhibitions; 50% of space for gallery artists. Overall price range $150-500.

Media Considers watercolor, sculpture, acrylic, paper and oil; types of prints include lithographs, posters and seriographs.

Style Genres include florals, portraits, wildlife, landscapes and western. Prefers wildlife, florals and portraits.

Terms Buys outright for 50% of retail price (net on receipt). Retail price set by the gallery. Gallery provides insurance; gallery pays for shipping.

Submissions Send photographs. Artist's portfolio should include photographs. Responds only if interested within 2 weeks. Files artist's material. Finds artists through word of mouth.

THE CATHERINE G. MURPHY GALLERY

The College of St. Catherine, 2004 Randolph Ave. St. Paul MN 55105. (612)690-6637. Fax: (612)690-6024. E-mail: kmdaniels@stkate.edu. Web site: www.stkate.edu. **Director:** Kathleen M. Daniels. Nonprofit gallery. Estab. 1973. Represents emerging, mid-career and nationally and regionally established artists. "We have a mailing list of 1,000." Sponsors 5 shows/year. Average display time 4-5 weeks. Open September-June; Monday-Friday, 8-8; Saturday, 12-6; Sunday, 12-6. Located in the Visual Arts Building on the college campus of the College of St. Catherines; 1,480 sq. ft.

- This gallery also exhibits historical art and didactic shows of visual significance. Gallery shows 75% women's art since it is an all-women's undergraduate program.

Media Considers a wide range of media for exhibition.

Style Considers a wide range of styles.

Terms Artwork is loaned for the period of the exhibition. Gallery provides insurance. Shipping costs are shared. Prefers artwork framed.

Submissions Send query letter with artist statement and checklist of slides (title, size, medium, etc.), résumé, slides, bio and SASE. Responds in 6 weeks. Files résumé and cover letters. Serious consideration is given to artists who do group proposals under one inclusive theme.

NORMANDALE COLLEGE CENTER GALLERY

9700 France Ave., So., Bloomington MN 55431. (952)481-8121. Fax: (952)487-8130. E-mail: cikkelsen.n.cc.us. mn. **Contact:** Chris Mikkelsen. College gallery. Estab. 1975. Exhibits 6 emerging, mid-career and established artists/year. Sponsors 6 shows/year. Average display time 2 months. Open all year. Suburban location; 30 running feet of exhibition space. 100% of space for special exhibitions. Clientele students, staff and community. Overall price range $25-750; most artwork sold at $100-200.

Media Considers all media and all types of prints. Most frequently exhibits watercolor, photography and prints.

Style Exhibits all styles and genres.

Terms "We collect 10% as donation to our foundation." Retail price set by artist. Gallery provides insurance, promotion and contract; artist pays for shipping. Prefers framed artwork.

Submissions "Send query letter; we will send application and info." Portfolio should include slides. Responds in 2 months. Files "our application/résumé."

OPENING NIGHT FRAMING SERVICES & GALLERY

(formerly Opening Night Gallery), 2836 Lyndale Ave. S., Minneapolis MN 55408-2108. (612)872-2325. Fax: (612)872-2385. E-mail: deen@onframe-art.com. Web site: www.onframe-art.com. Rental gallery. Estab. 1974.

Approached by 40 artists/year. Exhibits 15 emerging and mid-career artists. Sponsors 4 exhibits/year. Average display time 6-10 weeks. Open all year; Monday-Friday, 8:30-5; Saturday, 10:30-4. Located on a main street the space is approximately 2,500 sq. ft. Clients include local community, tourists and upscale. 50% of sales are to corporate collectors. Overall price range $300-15,000; most work sold at $2,500.

Media Considers acrylic, ceramics, collage, drawing, fiber, glass, oil, paper, sculpture and watercolor. Most frequently exhibits paintings, drawings and pastels. Considers engravings, etchings, linocuts, lithographs, mezzotints, posters and serigraphs.

Style Exhibits impressionism and painterly abstraction. Genres include Americana, florals and landscapes.

Terms Artwork is accepted on consignment and there is a 50% commission. Retail price set by the gallery. Gallery provides insurance, promotion and contract. Accepted work should be framed. Requires exclusive representation locally.

Submissions Write to arrange a personal interview to show portfolio of photographs or slides. Mail portfolio for review. Send query letter with artist's statement, bio, résumé, SASE and slides. Responds in 2 months. Files slides and bio. Finds artists through word of mouth, submissions and portfolio reviews.

Tips "Please include a cover letter, along with your most appealing creations. Archival-quality materials are everything—we are also a framing service whom museums use for framing."

MISSISSIPPI

CHIMNEYVILLE CRAFTS GALLERY

Agricultural & Forestry Museum, Jackson MS 39216. (601)981-2499. Fax: (601)981-0488. **Director:** Kit Barksdale. Retail and nonprofit gallery. Estab. 1985. Represents all 400 members of Craftsmen Guild Mission. Exhibited artists include George Berry and Ann Baker. Open all year; Monday-Saturday, 9-5; closed some holidays. Located on the grounds of the State Agricultural & Forestry Museum; 2,000 sq. ft.; in a traditional log cabin. Clientele travelers and local patrons. 99% private collectors. Overall price range $250-900; most work sold at $10-60. Also sponsors Chimneyville Crafts Festival first weekend of December.

Media Considers paper, sculpture, ceramic, craft, fiber and glass. Most frequently exhibits clay, basketry and metals.

Style Exhibits all styles. Crafts media only. Interested in seeing a "full range of craftworkNative American, folk art, production crafts, crafts as art, traditional and contemporary. Work must be small enough to fit our limited space."

Terms Accepts work on consignment (40% commission), and purchases 50% of based on retail price (net 30 days), subsequent orders. Retail price set by the gallery and the artist. Gallery provides promotion and shipping costs to gallery.

Submissions Out of state submissions accepted. Out of state members have all privileges of members, but cannot vote. Artists must be juried members of the Craftsmen's Guild of Mississippi. Ask for standards review application form. Standards Review 1st Saturday in March and September.

Tips "All emerging craftsmen should read *Crafts Report* regularly and know basic business procedures. Read books on the business of art like *Crafting as a Business* by Wendy Rosen, distributed by Chilton—available by mail order through our crafts center or the *Crafts Report*. An artist should have mastered the full range of his medium.

MERIDIAN MUSEUM OF ART

628 25th Ave., Meridian MS 39302. (601)693-1501. E-mail: MeridianMuseum@aol.com. **Director:** Terence Heder. Museum. Estab. 1970. Represents emerging, mid-career and established artists. Interested in seeing the work of emerging artists. Exhibited artists include Jere Allen, Patt Odom, James Conner, Bonnie Busbee, Charlie Busler, Terry Cherry, Alex Loeb, and Hugh Williams. Sponsors 15 shows/year. Average display time 5 weeks. Open all year; Tuesday-Sunday, 1-5. Located downtown; 1,750 sq. ft.; housed in renovated Carnegie Library building, originally constructed 1912-13. 50% of space for special exhibitions. Clientele general public. Overall price range $150-2,500; most work sold at $300-1,000.

• Sponsors annual Bi-State Art Competition for Mississippi and Alabama artists.

Media Considers all media. Most frequently exhibits oils, watercolors and sculpture.

Style Exhibits all styles, all genres.

Terms Work available for sale during exhibitions (25% commission). Retail price set by the artist. Gallery provides insurance and promotion; shipping costs are shared. Prefers artwork framed.

Submissions Prefers artists from Mississippi, Alabama and the Southeast. Send query letter with résumé, slides, bio and SASE. Responds in 3 months. Finds artists through submissions, referrals, work included in competitions and visiting exhibitions.

MISSOURI

THE ASHBY-HODGE GALLERY OF AMERICAN ART

Central Methodist University, Fayette MO 65248. (660)248-6324 or (660)248-6304. Fax: (660)248-2622. E-mail: jgeistecoin.org. Web site: www.centralmethodist.edu. **Curator:** Joseph E. Geist. Nonprofit gallery, "Not primarily a sales galleryonly with special exhibits." Estab. 1993. Exhibits the work of 50 artists in permanent collection. Exhibited artists include Robert MacDonald Graham, Jr. and Birger Sandzen. Sponsors 5 shows/year. Average display time 2 months. Open all year; Tuesday-Thursday, 1:30-4:30. Located on campus of Central Methodist college. 1,400 sq. ft.; on lower level of campus library. 100% of gallery artists for special exhibitions. Clientele local community and surrounding areas of Mid-America. Physically impaired accessible. Tours by reservation.
Media Considers all media. Most frequently exhibits acrylic, lithographs, oil and fibers.
Style Exhibits Midwestern regionalists. Genres include portraits and landscapes. Prefers realism.
Terms Accepts work on consignment (30% commission.) Retail price set by the gallery. Gallery provides insurance and promotion; shipping costs are shared. Prefers artwork framed.
Submissions Accepts primarily Midwestern artists. Send query letter with résumé, slides, photographs and bio. Call for appointment to show portfolio of photographs, transparencies and slides. Finds artists through recommendations and submissions.

BARUCCI'S ORIGINAL GALLERIES

8101 Maryland Ave., St. Louis MO 63105. (314)727-2020. E-mail: baruccigallery@dellmail.com. Web site: baruc cigallery.com. **President:** Shirley Taxman Schwartz. Retail gallery and art consultancy specializing in hand-blown glass by national juried artists. Estab. 1977. Represents 40 artists. Interested in emerging and established artists. Sponsors 3-4 solo and 4 group shows/year. Average display time is 6 weeks. Located in "affluent county, a charming area." Clientele: affluent young area. 70% private collectors, 30% corporate clients. Overall price range $100-10,000; most work sold at $1,000.
 • This gallery has moved into a corner location featuring three large display windows. They specialize in hand blown glass by national juried artists.
Media Considers oil, acrylic, watercolor, pastel, collage and works on paper. Most frequently exhibits watercolor, oil, acrylic and hand blown glass.
Style Exhibits painterly abstraction and impressionism. Currently seeking contemporary works abstracts in acrylic and fiber and some limited edition serigraphs.
Terms Accepts work on consignment (50% commission). Retail price set by gallery or artist. Sometimes offers payment by installment. Gallery provides contract.
Submissions Send query letter with résumé, slides and SASE. Portfolio review requested if interested in artist's work. Slides, bios and brochures are filed.
Tips "More clients are requesting discounts or longer pay periods."

BOODY FINE ARTS, INC.

10706 Trenton Ave., St. Louis MO 63132. (314)423-2255. E-mail: bfa@boodyfinearts.com. Web site: www.bood yfinearts.com. Retail gallery and art consultancy. "Clientele is nationwide. Staff travels on a continual basis to develop collections within the region." Estab. 1978. Represents 200 mid-career and established artists. Clientele: 20% private collectors, 30% public and 50% corporate clients. Overall price range $1,000-$2,000,000.
Media Considers oil, acrylic, watercolor, pastel, drawings, mixed media, collage, sculpture, ceramic, fiber, metalworking, glass, works on handmade paper, neon and original handpulled prints, stainless steel, bronze, aluminum, corten, stone, etc.
Style Exhibits color field, painterly abstraction, minimalism, impressionism and photorealism. Prefers nonobjective, figurative work and landscapes.
Terms Accepts work on consignment. Retail price is set by artist and staff. Customer discounts and payment by installments available. Gallery provides insurance, promotion and contract; shipping costs are shared.
Submissions Send query letter, résumé and slides. "Accepts e-mail introductions with referrals or invitations to Web sites; no attachments. Write to schedule an appointment to show a portfolio, which should include originals, slides and transparencies. All material is filed. Finds artists by visiting exhibitions, word of mouth, artists' submissions, Internet and art collectors' referrals.
Tips "I very seldom work with an artist until they have been out of college about ten years."

CONTEMPORARY ART MUSEUM OF ST. LOUIS

3750 Washington Blvd., St. Louis MO 63108. (314)535-4660. Fax: (314)535-1226. E-mail: info@contemporarystl .org. Web site: www.contemporarystl.org. **Contact:** Paul Ha. Nonprofit museum. Estab. 1980. Is a noncollecting museum dedicated to exhibiting contemporary art from international, national and local established and emerg-

ing artists. Open Tuesday-Saturday, 10-5; Thursday, 10-7; Sunday, 11-4. Located mid-town, Grand Center; 27,200 sq. ft. building designed by Brad Cloepfil, Allied Works.

MILDRED COX GALLERY AT WILLIAM WOODS UNIVERSITY
One University Dr., Fulton MO 65251. (573)642-2251. Web site: www.williamwoods.edu. **Contact:** Julie Gaddy , gallery coordinator. Nonprofit gallery. Estab. 1970. Approached by 20 artist/year; exhibits 8 emerging, mid-career and established artists/year. Exhibited artists include Elizabeth Ginsberg and Terry Martin. Average display time 2 months. Open Monday-Friday, 8-4:30; Saturday-Sunday, 1-4. Closed Christmas-January 20. Located within large moveable walls; 300 running feet. Clients include local community, students, upscale and foreign visitors. Overall price range $1,000-10,000; most work sold at $800-1,000. Gallery takes no commission. "Our mission is education."
Media Considers all media except installation. Most frequently exhibits drawing, painting and sculpture. Considers all prints except commercial off-set.
Style Exhibits expressionism, geometric abstraction, impressionism, surrealism, painterly abstraction and realism. Most frequently exhibits figurative and academic. Genres include Americana, figurative work, florals, landscapes and portraits.
Terms Artists work directly with person interested in purchase. Retail price of the art set by the artist. Gallery provides insurance and contract. Accepted work should be framed and matted. Does not require exclusive representation locally. Artists are selected by a committee from slides or original presentation to faculty committee.
Submissions Write to arrange a personal interview to show portfolio of slides or send query letter with artist's statement, résumé and slides. Returns material with SASE. Does not reply to queries. Artist should call. Files slides, statement and résumé until exhibit concludes. Finds artists through word of mouth.
Tips To make your gallery submissions professional you should send "good quality slides! Masked with sliver opaque tapeno distracting backgrounds."

CRAFT ALLIANCE GALLERY
6640 Delmar, StLouis MO 63130. (314)725-1177, ext. 322. Fax: (314)725-2068. E-mail: gallery@craftalliance.org. Web site: www.craftalliance.org. **Contact:** Gregory Wilkerson, gallery director. Nonprofit gallery with exhibition and retail galleries. Estab. 1964. Represents 500 emerging, mid-career and established artists. Exhibited artists include Thomas Mann, Ellen Shankin and Randall Darwall. Exhibition space sponsors 10-12 exhibits/year. Average display time 4-6 weeks. Open all year. Located in the university area; storefront; adjacent to education center. Clients include local community, students, tourists and upscale. Retail gallery price range $20 and up. Most work sold at $100.
Media Considers ceramics, metal, fiber and glass. Most frequently exhibits jewelry, glass and clay. Doesn't consider prints.
Style Exhibits contemporary craft.
Terms Exhibition artwork is sold on consignment and there is a 50% commission. Artwork is bought outright. Retail price set by the gallery and the artist. Gallery provides insurance and promotion. Requires exclusive representation locally.
Submissions Call or write to arrange a personal interview to show portfolio of slides or call first, then send slides or photographs. Returns material with SASE.
Tips "Call and talk. Have professional slides and attitude."

HAL DAVID FINE ART
P.O. Box 411213, St. Louis MO 63141. (314)409-7884. E-mail: mscharf@sbcglobal.net. Web site: www.maxrscharf.net or www.maxrscharf.com. **Contact:** Max Scharf, Director. For-profit gallery. Estab. 1991. Exhibits established artists. Approached by 30 artists/year; represents 3 artists/year. Exhibited artists include Max R. Scharf (acrylic on canvas) and Sandy Kaplan (terra cotta sculpture). Sponsors 3 exhibits/year. Average display time 2 months. Open Monday through Friday from 10-4; weekends by appointment. Open all year. Located in historical central west end of St. Louis MO. Clients include upscale. 30% sales are to corporate collectors. Overall price range: $2,000-30,000; most work sold at $10,000.
Style Exhibits expressionism, impressionism, painterly abstraction. Most frequently exhibits impressionism and expressionism.
Making Contact & Terms Artwork is accepted on consignment and there is a 50% commission. Retail price set by the artist. Accepted work should be framed. Does not require exclusive representation locally.
Submissions Returns material with SASE. Responds to queries in 3 weeks. Finds artists through referrals by other artists.
Tips "Have a good Web site to look at."

GALERIE BONHEUR

10046 Conway Rd., St. Louis MO 63124. (314)993-9851. Fax: (314)993-9260. E-mail: gbonheur@aol.com. Web site: www.galeriebonheur.com. **Owner:** Laurie Griesedieck Carmody. Gallery Assistant: Sharon Ross. Private retail and wholesale gallery. Focus is on international folk art. Estab. 1980. Represents 60 emerging, mid-career and established artists/year. Exhibited artists include Milton Bond and Justin McCarthy. Sponsors 6 shows/year. Average display time 1 year. Open all year; by appointment. Located in Ladue (a suburb of St. Louis); 3,000 sq. ft.; art is displayed all over very large private home. 75% of sales to private collectors. Overall price range $25-25,000; most work sold at $50-1,000.

• Galerie Bonheur also has a location at 9243 Clayton Rd., Ladue MO.

Media Considers oil, acrylic, watercolor, pastel, pen & ink, drawing, mixed media, collage, paper, sculpture, ceramics and craft. Most frequently exhibits oil, acrylic and metal sculpture.

Style Exhibits expressionism, primitivism, impressionism, folk art, self-taught, outsider art. Genres include landscapes, florals, Americana and figurative work. Prefers genre scenes and figurative.

Terms Accepts work on consignment (50% commission) or buys outright for 50% of retail price. Retail price set by the gallery and the artist. Gallery provides promotion; artist pays shipping costs to and from gallery. Prefers artwork framed.

Submissions Prefers only self-taught artists. Send query letter with bio, photographs and business card. Write for appointment to show portfolio of photographs. Responds only if interested within 6 weeks. Finds artists through agents, visiting exhibitions, word of mouth, art publications and sourcebooks and submissions.

Tips "Be true to your inspirations. Create from the heart and soul. Don't be influenced by what others are doing; do art that you believe in and love and are proud to say is an expression of yourself. Don't copy; don't get too sophisticated or you will lose your individuality!"

DANA GRAY & ASSOCIATES

P.O. Box 9244, St. Louis MO 63117. (314)589-4541. E-mail: info@danagray.com. Web site: www.danagray.com. **Contact:** Dana Gray, president. Art consultancy. Estab. 2000. Represents over 12 mid-career and established artists/year. Exhibited artists include Miquel Berrocal (sculpture) and Salvador Dali (prints). Sponsors 1 exhibit/year. Average display time 3-6 weeks. Open by appointment only. Consultant works from home office and travels to client's location or does negotiations by phone, e-mail and mail. Clients include local community and upscale. 5% of sales are to corporate collectors. Overall price range $1,000-10,000; most work sold at $2,500.

Media Considers collage, drawing, glass, mixed media, oil, paper, pastel, pen & ink, sculpture, watercolor. Most frequently exhibits paintings, prints and sculpture. Considers all types of prints except giclee.

Style Exhibits impressionism, realism and surrealism. Considers all genres.

Terms "Generally, I broker artworks and the percentage is agreed in advance between the artist/owner and the broker." Retail price of the art set by the artist/owner. Does not require exclusive representation locally.

Submissions; Responds to queries only if interested. Finds artists through art fairs and exhibits, referrals by other artists, word of mouth and periodicals.

SHERRY LEEDY CONTEMPORARY ART

2004 Baltimore Ave., Kansas City MO 64108. (816)474-1919. Fax: (816)221-8689. E-mail: sherryleedy@sherrylee dy.com. **Director:** Sherry Leedy. Retail gallery. Estab. 1985. Represents 50 mid-career and established artists. Exhibited artists include Jun Kancke, Michael Eastman. Sponsors 6 shows/year. Average display time 6 weeks. 5,000 sq. ft. of exhibit area in 3 galleries. Clients include established and beginning collectors. 80% of sales are to private collectors, 20% corporate clients. Price range $50-100,000; most work sold at $3,500-35,000.

Media Considers all media and one-of-a-kind or limited-edition prints; no posters. Most frequently exhibits painting, photography, ceramic sculpture and glass.

Style Exhibits Considers all styles.

Terms Accepts work on consignment (50% commission). Retail price set by gallery. Sometimes offers customer discounts and payment by installment. Exclusive area representation required. Gallery provides insurance, promotion; shipping costs are shared. Prefers artwork framed.

Submissions Send query letter, résumé, good slides, prices and SASE. Write for appointment to show portfolio of originals, slides and transparencies. Bio, vita, slides, articles, etc. are filed if they are of potential interest.

Tips "Please allow three months for gallery to review slides."

MONTANA

ARTISTS' GALLERY

111 S. Grand, #106, Bozeman MT 59715. (406)587-2127. **Chairperson:** Justine Heisel. Retail and cooperative gallery. Estab. 1992. Represents the work of 20 local emerging and mid-career artists, 20 members. Sponsors

12 shows/year. Average display time 3 months. Open all year; Monday-Saturday, 10-5. Located near downtown; 900 sq. ft.; located in Emerson Cultural Center with other galleries, studios, etc. Clients include tourists, upscale and local community. 100% of sales are to private collectors. Overall price range $55-700.

Media Considers oil, acrylic, watercolor, pastel, pen & ink, drawing, mixed media, collage, paper, sculpture, ceramics and glass, woodcuts, engravings, linocuts and etchings. Most frequently exhibits oil, watercolor and ceramics.

Style Exhibits painterly abstraction, impressionism, photorealism and realism. Exhibits all genres. Prefers realism, impressionism and western.

Terms Co-op membership fee plus donation of time (20% commission). Rental fee for space; covers 1 month. Retail price set by the artist. Gallery provides promotion; artist pays for shipping costs to gallery. Prefers artwork framed.

Submissions Artists must be able to fulfill "sitting" time or pay someone to sit. Send query letter with résumé, slides, photographs, artist's statement or actual work. Write for appointment to show portfolio of photographs and slides. Responds in 2 weeks.

CORBETT GALLERY

Box 339, 459 Electric Ave. B, Bigfork MT 59911. (406)837-2400. E-mail: corbett@digisys.net. Web site: www.cor bettgallery.com. **Director:** Jean Moore. Retail gallery. Estab. 1993. Represents 20 mid-career and established artists. Exhibited artists include Cynthia Fisher. Sponsors 2 shows/year. Average display time 3 weeks. Open all year; Sunday-Friday, 10-7 summer, 10-5 winter. Located downtown; 2,800 sq. ft. Clients include tourists and upscale. 90% of sales are to private collectors. Overall price range $250-10,000; most work sold at $2,400.

Media Considers all media; types of prints include engravings, lithographs, serigraphs and etchings. Most frequently exhibits oil, watercolor, acrylic and pastels.

Style Exhibits photorealism. Genres include western, wildlife, southwestern and landscapes. Prefers wildlife, landscape and western.

Terms Accepts work on consignment (40% commission). Retail price set by the artist. Gallery provides insurance, promotion and contract. Shipping costs are shared. Prefers artwork framed.

Submissions Send query letter with slides, brochure and SASE. Call for appointment to show portfolio of photographs or slides. Responds in 1 week. Files brochures and bios. Finds artists through art exhibitions and referrals.

Tips "Don't show us only the best work, then send mediocre paintings that do not equal the same standard."

FAR WEST GALLERY

2817 Montana Ave., Billings MT 59101. (406)245-2334. Fax: (406)245-0935. E-mail: farwest@180com.net. Web site: www.farwestgallery.com. **Manager:** Sondra Daly. Retail gallery. Estab. 1994. Represents emerging, mid-career and established artists. Exhibited artists include Joe Beeler, Dave Powell, Kevin Red Star and Stan Natchez. Sponsors 4 shows/year. Average display time 6-12 months. Open all year; 9-6. Located in downtown historic district in a building built in 1910. Clientele tourists. Overall price range $1-9,500; most work sold at $300-700.

Media Considers all media and all types of prints. Most frequently exhibits Native American beadwork, oil and craft/handbuilt furniture.

Style Exhibits all styles. Genres include western and Americana. Prefers Native American beadwork, western bits, spurs, memorabilia, oil, watercolor and pen & ink.

Terms Buys outright for 50% of retail price. Retail price set by the gallery and the artist. Gallery provides insurance and promotion.

HOCKADAY MUSEUM OF ART

302 Second Ave. E., Kalispell MT 59901. (406)755-5268. Fax: (406)755-2023. E-mail: hockaday@aboutmontana.net. Web site: www.hockadayartmuseum.org. **Executive Director:** Linda Engh-Grady. Museum. Estab. 1968. Exhibits emerging, mid-career and established artists. Interested in seeing the work of emerging artists. 500 members. Exhibited artists include Jeannie Hamilton, Russell Chatham, Ace Powell, Bud Helbig and David Shaner. Sponsors approximately 15 shows/year. Average display time 2 months. Open year round. Located 2 blocks from downtown retail area; 2,650 sq. ft.; historic 1906 Carnegie Library Building with new (1989) addition; wheelchair access to all of building. 50% of space for special exhibitions. Overall price range $500-35,000.

Media Considers all media, plus woodcuts, wood engravings, linocuts, engravings, mezzotints, etchings, lithographs and serigraphs. Most frequently exhibits painting (all media), sculpture/installations (all media), photography and original prints.

Style Exhibits all styles and genres. Prefers art of Montana and Montana artists, historical art with special focus on the art of Glacier National Park and photographs and traveling exhibits.

Terms Accepts work on consignment (33⅓% commission). Also houses permanent collection Montana and

regional artists acquired through donations. Sometimes offers customer discounts and payment by installment to museum members. Gallery provides insurance, promotion and contract; shipping costs are shared. Artwork must be framed and ready to hang. Featured artists in Off the Wall Gallery and other exhibits must be members of the museum.

Submissions Send query letter with résumé, slides, bio, reviews and SASE. Portfolio should include b&w photographs and slides (20 maximum). "We review *all* submitted portfolios once a year, in spring." Finds artists through submissions and self-promotions.

Tips "Present yourself and your work in the best possible professional manner. Art is a business. Make personal contact with the director, by phone or in person. You have to have enough work of a style or theme to carry the space. This will vary from place to place. You must plan for the space. A good rule to follow is to present 20 completed works that are relative to the size of space you are submitting to. As a museum whose mission is education we choose artists whose work brings a learning experience to the community."

JAILHOUSE GALLERY

218 Center Ave., Hardin MT 59034. (406)665-3239. Fax: (406)665-3220. Web site: www.forevermontana.com. **Director:** Terry Jeffers. Nonprofit gallery. Estab. 1978. Represents 25 emerging, mid-career and established artists/year. Exhibited artists include Gale Running Wolf, Sr. and Mary Blain. Sponsors 9 shows/year. Average display time 6 weeks. Open all year; January-April; Tuesday-Friday, 10-5 (winter); May-December; Monday-Saturday, 9:30-5:30. Located downtown; 1,440 sq. ft. 75% space for special exhibitions; 25% of space for gallery artists. Clientele: all types. 95% private collectors, 5% corporate collectors. Overall price range $20-2,000; most work sold at $20-500.

Media Considers all media and all types of prints. Most frequently exhibits mixed media, watercolor and pen & ink.

Style Exhibits all styles and all genres. Prefers western, Native American and landscapes.

Terms Accepts work on consignment (30% commission). Retail price set by the gallery. Gallery provides insurance, promotion and contract. Artist pays shipping costs.

Submissions Send query letter with résumé, business card, artist's statement and bio. Call for appointment to show portfolio of photographs. Responds in 3 weeks. Finds artists through word of mouth, referrals by other artists, visiting art fairs and exhibitions and artists' submissions.

LIBERTY VILLAGE ARTS CENTER

400 S. Main, Chester MT 59522. (406)759-5652. **Contact:** Director. Nonprofit gallery. Estab. 1976. Represents 12-20 emerging, mid-career and established artists/year. Sponsors 6-12 shows/year. Average display time 6-8 weeks. Open all year; Tuesday-Friday, 12:30-4:30. Located near a school; 1,000 sq. ft.; former Catholic Church. Clients include tourists and local community. 100% of sales are to private collectors. Overall price range $100-2,500; most work sold at $250-500

Media Considers all media; types of prints include woodcuts, lithographs, mezzotints, serigraphs, linocuts and pottery. Most frequently exhibits paintings in oil, water, acrylic, b&w photos and sculpture assemblages.

Style Exhibits Considers all styles. Prefers contemporary and historic.

Terms Accepts work on consignment (30% commission) or buys outright for 40% of retail price. Retail price set by the gallery. Gallery provides insurance and promotion; shipping costs are shared. Prefers artwork framed or unframed.

Submissions Send query letter with slides, bio and brochure. Portfolio should include slides. Responds only if interested within 1 year. Artists should cross us off their list. Files everything. Finds artists through word of mouth and seeing work at shows.

Tips "Artists make the mistake of not giving us enough information and permission to pass information on to other galleries."

YELLOWSTONE GALLERY

216 W. Park St., P.O. Box 472, Gardiner MT 59030. (406)848-7306. E-mail: jckahrs@aol.com. Web site: yellowstonegallery.com. **Owner:** Jerry Kahrs. Retail gallery. Estab. 1985. Represents 20 emerging and mid-career artists/year. Exhibited artists include Mary Blain and Nancy Glazier. Sponsors 2 shows/year. Average display time 2 months. Open all year; seasonal 7 days; winter, Tuesday-Saturday, 10-6. Located downtown; 3,000 sq. ft. new building. 25% of space for special exhibitions; 50% of space for gallery artists. Clientele tourist and regional. 90% private collectors, 10% corporate collectors. Overall price range $25-8,000; most work sold at $75-600.

Media Considers oil, acrylic, watercolor, ceramics, craft and photography; types of prints include wood engravings, serigraphs, etchings and posters. Most frequently exhibits watercolors, oils and limited edition, signed and numbered reproductions.

Style Exhibits impressionism, photorealism and realism. Genres include western, wildlife and landscapes. Prefers wildlife realism, western and watercolor impressionism.

Terms Accepts work on consignment (45% commission). Retail price set by the artist. Gallery provides contract; artist pays for shipping. Prefers artwork framed.

Submissions Send query letter with brochure or 10 slides. Write for appointment to show portfolio of photographs. Responds in 1 month. Files brochure and biography. Finds artists through word of mouth, regional fairs and exhibits, mail and periodicals.

Tips "Don't show up unannounced without an appointment."

NEBRASKA

ARTISTS' COOPERATIVE GALLERY

405 S. 11th St., Omaha NE 68102. (402)342-9617. Web site: www.artistsco-opgallery.com. **President:** Susan Barnes. Cooperative and nonprofit gallery. Estab. 1974. Exhibits the work of 30-35 emerging, mid-career and established artists. 35 members. Exhibited artists include Mary Kolar and Jerry Jacoby. Sponsors 14 shows/year. Average display time 1 month. Open all year; Wednesday and Thursday, 11-5; Friday and Saturday, 11-10; Sunday, 12-5; closed Monday and Tuesday. Located in historic Old Market area; 5,000 sq. ft.; "large open area for display with 25' high ceiling." 20% of space for special exhibitions. Clientele: 85% private collectors, 15% corporate collectors. Overall price range $20-2,000; most work sold at $20-1,000.

Media Considers oil, acrylic, watercolor, pastel, drawings, mixed media, collage, paper, sculpture, ceramic, fiber, glass, photography, woodcuts, serigraphs. Most frequently exhibits sculpture, acrylic, oil and ceramic.

Style Exhibits all styles and genres.

Terms Co-op membership fee plus donation of time. Retail price set by artist. Sometimes offers payment by installment. Artist provides insurance; artist pays for shipping. Prefers artwork framed. No commission charged by gallery.

Submissions Accepts only artists from the immediate area. "We each work one day a month." Send query letter with résumé, slides and bio. Write for appointment to show portfolio of originals and slides. "Applications are reviewed and new members accepted and notified in August if any openings are available." Files applications.

Tips "Fill out application and touch base with gallery in July."

CARNEGIE ARTS CENTER

P.O. Box 375, 204 W. Fourth St., Alliance NE 69301. (308)762-4571. Fax: (308)762-4571. E-mail: carnegieartscenter@bbc.net. Web site: www.carnegieartscenter.com. **Contact:** Peggy Weber, gallery director. Nonprofit gallery. Estab. 1993. Represents 300 emerging, mid-career and established artists/year. 350 members. Exhibited artists include Liz Enyeart (functional pottery), Silas Kern (handblown glass). Sponsors 12 shows/year. Average display time 6 weeks. Open all year; Tuesday-Saturday, 10-4; Sunday, 1-4. Located downtown; 2,346 sq. ft.; renovated Carnegie library built in 1911. Clients include tourists, upscale, local community and students. 90% of sales are to private collectors, 10% corporate collectors. Overall price range $10-2,000; most work sold at $10-300.

Media Considers all media and all types of prints. Most frequently exhibits pottery, blown glass, 2-dimensional, acrylics, bronze sculpture, watercolor, oil and silver jewelry.

Style Exhibits all styles and genres. Most frequently exhibits realism, modern realism, geometric, abstraction.

Terms Accepts work on consignment (35% commission). Retail price set by the artist. Gallery provides promotion. Shipping costs negotiated. Prefers artwork framed.

Submissions Accepts only quality work. Send query. Write for appointment to show portfolio review of photographs, slides or transparencies. Responds only if interested within 1 month. Files résumé and contracts. Finds artists through word of mouth, referrals by other artists, visiting art fairs and exhibitions and artist's submissions.

Tips "Presentations must be clean, "new" quality, that is, ready to meet the public. Two-dimensional artwork must be nicely framed with wire attached for hanging. Unframed prints need protective wrapping in place."

GALLERY 72

2709 Leavenworth, Omaha NE 68105-2399. (402)345-3347. Fax: (402)348-1203. Web site: gallery72@novia.net. **Director:** Robert D. Rogers. Retail gallery and art consultancy. Estab. 1972. Interested in emerging, mid-career and established artists. Represents 10 artists. Sponsors 4 solo and 4 group shows/year. Average display time is 3 weeks. Clients include individuals, museums and corporations. 75% of sales are to private collectors, 25% corporate clients. Overall price range $750 and up.

Media Considers oil, acrylic, digital, watercolor, pastel, pen & ink, drawings, mixed media, collage, sculpture, ceramic, installation, photography, original handpulled prints and posters. Most frequently exhibits paintings, prints and sculpture.

Style Exhibits hard-edge geometric abstraction, color field, minimalism, impressionism and realism. Genres include landscapes and figurative work. Most frequently exhibits color field/geometric, impressionism and realism.
Terms Accepts work on consignment (commission varies), or buys outright. Retail price is set by gallery or artist. Gallery provides insurance; shipping costs and promotion are shared.
Submissions Send query letter with résumé, slides and photographs. Call to schedule an appointment to show a portfolio, which should include originals, slides and transparencies. Vitae and slides are filed.
Tips ''It is best to call ahead and discuss whether there is any point in sending your material.''

GERI'S ART AND SCULPTURE GALLERY

Omaha NE 68132. (402)556-4311. **President:** Geri. Retail gallery and art consultancy featuring restrike etchings and tapestry. Open by appointment only. Estab. 1975. Exhibited artists include Agam, Alvar, Ting and Calder. Open all year. Located in midtown Omaha. Clientele collectors, designers, residential and corporate. 50% private collectors, 50% corporate collectors. Overall price range $35-10,000; most work sold at $500-1,000.
Media Considers watercolor, mixed media, collage, paper, sculpture, ceramic and tapestry. Considers all types of prints, especially lithographs, serigraphs and monoprints.
Style Considers all styles and genres. ''We carry mostly original limited editions.''
Terms Artwork is bought outright or leased. Sometimes offers discounts to gallery customers.
Submissions Portfolio review not required. Finds artists through agents, visiting exhibitions, word of mouth, art publications and sourcebooks, artists' submissions, self-promotions and art collectors' referrals.

NOYES ART GALLERY

119 S. 9th St., Lincoln NE 68508. (402)475-1061. E-mail: julianoyes@aol.com. Web site: www.noyesartgallery.com. **Director:** Julia Noyes. For profit gallery. Estab. 1992. Exhibits 150 emerging artists. 25 members. Average display time 1 month minimum. (If mutually agreeable this may be extended or work exchanged.) Open all year. Located downtown, ''near historic Haymarket District; 3093 sq. ft.; renovated 128-year-old building.'' 25% of space for special exhibitions. Clientele private collectors, interior designers and decorators. 90% private collectors, 10% corporate collectors. Overall price range $100-5,000; most work sold at $200-750.
Media Considers oil, acrylic, watercolor, pastel, pen & ink, drawings, mixed media, collage, paper, sculpture, ceramic, fiber, glass and photography; original handpulled prints, woodcuts, wood engravings, linocuts, engravings, mezzotints, etchings, lithographs and serigraphs. Most frequently exhibits oil, watercolor and mixed media.
Style Exhibits expressionism, neo-expressionism, impressionism, realism, photorealism. Genres include landscapes, florals, Americana, wildlife, figurative work. Prefers realism, expressionism, photorealism.
Terms Accepts work on consignment (10-35% commission). Retail price set by artist (sometimes in conference with director). Gallery provides promotion and contract; artist pays for shipping. Prefers artwork framed.
Submissions Send query letter with résumé, slides, bio, SASE; label slides concerning size, medium, price, top, etc. Submit at least 6-8 slides. Reviews submissions monthly. Responds in 1 month. Files résumé, bio and slides of work by accepted artists (unless artist requests return of slides). All materials are returned to artists whose work is declined.

ADAM WHITNEY GALLERY

8725 Shamrock Rd., Omaha NE 68114. (402)393-1051. Fax: (402)390-8643. E-mail: gallery@adamwhitney.com. **Director:** Carol Copple. Retail gallery. Estab. 1986. Represents 350 emerging, mid-career and established artists. Exhibited artists include Richard Murray, Debra May, Dan Boylan, Ken and Kate Andersen, Scott Potter, Phil Hershberger and Brian Hirst. Average display time 3 months. Open all year; Monday-Saturday, 10-5. Located in countryside village; 5,500 sq. ft. 40% of space for special exhibitions. Overall price range $150-10,000.
Media Considers oil, paper, fiber, acrylic, sculpture, glass, watercolor, mixed media, ceramic, installation, pastel, collage, craft, jewelry. Most frequently exhibits glass, jewelry, 2-dimensional works.
Style Exhibits all styles and genres.
Terms Accepts work on consignment (50% commission). Retail price set by gallery and artist. Gallery provides insurance, promotion and contract; shipping costs are shared. Prefers artwork framed.
Submissions Send query letter with résumé, slides, photographs and reviews. Call or write for appointment to show portfolio of originals, photographs and slides. Files résumé, slides, reviews.

NEVADA

ART ENCOUNTER

3979 Spring Mountain Rd., Las Vegas NV 89102. (702)227-0220. Fax: (702)227-3353. E-mail: rod@artencounter.com. Web site: www.artencounter.com. **Director:** Rod Maly. Retail gallery. Estab. 1992. Represents 100 emerg-

ing and established artists/year. Exhibited artists include Jennifer Main, Jan Harrison and Vance Larson. Sponsors 4 shows/year. Open all year; Tuesday-Friday, 10-6; Saturday and Monday, 12-5. Located near the famous Las Vegas strip; 8,000 sq. ft. 20% of space for special exhibitions; 80% of space for gallery artists. Clients include upscale tourists and locals. 95% of sales are to private collectors, 5% corporate collectors. Overall price range $200-20,000; most work sold at $500-2,500.
Media Considers all media and all types of prints. Most frequently exhibits watercolor, oil, acrylic, and sculpture.
Style Exhibits all styles and genres.
Terms Rental fee for space; covers 6 months. Retail price set by the gallery and artist. Gallery provides promotion and contract; artist pays for shipping. Prefers artwork framed.
Submissions E-mail JPGS to rod@artencounter.com, photographs and SASE. Appointments will be scheduled according to selection of juried artists. Responds only if interested within 2 weeks. Files artist bio and résumé. Finds artists by advertising in the *Artist's Magazine, American Artist*, art shows and word of mouth.
Tips "Poor visuals and no SASE are common mistakes."

ARTIST'S CO-OP OF RENO
627 Mill St., Reno NV 89502. (775)322-8896. Web site: www.eldoradoreno.com. **President:** Mahree Roberts. Cooperative nonprofit gallery. Estab. 1966. Exhibits 12 feature shows/year and quarterly all-gallery change of show. Open all year; Monday-Sunday, 11-4. Located downtown; 1,000 sq. ft. in historic, turn of century "French laundry" building. Clients include tourists, upscale and local community.
Media Considers all media. Most frequently exhibits watercolor, oil, mixed media, pottery and photography.
Style Genres include western, landscapes, florals, wildlife, Americana, portraits, southwestern and figurative work. Prefers Nevada landscapes.
Terms There is co-op membership fee plus a donation of time. Retail price set by the artist. Gallery provides promotion. Artist pays for shipping costs from gallery. Prefers art framed.
Submissions Accepts only artists from northern Nevada. Send query letter with résumé, slides, photographs, reviews and bio. Call for appointment to show portfolio. Finds artists through word of mouth and artists' visits.
Tips "We limit our membership to 20 local artists so that each artist has ample display space."

CONTEMPORARY ARTS COLLECTIVE
101 E. Charlesten Blvd., Suite 101, Las Vegas NV 89104. (702)382-3886. Web site: www.cac-lasvegas.org. **Acting President:** Jacie Maynard. Alternative space, nonprofit gallery. Estab. 1989. Represents emerging and mid-career artists, 250 members. Exhibited artists include Mary Warner, Eric Murphy, Wendy Kveck and Daryl DePry. Sponsors 9 shows/year. Average display time 5 weeks. Open all year; Tuesday-Saturday, 12-4; 1st Friday of each month 6-10 p.m.; 1st Sunday following 1st Friday, 12-2 p.m. Located downtown; 800 sq. ft. Clients include tourists, local community and students. 75% of sales are to private collectors, 25% corporate collectors. Overall price range $250-2,000; most work sold at $400.
Media Considers all media and all types of prints. Most frequently exhibits painting, photography and mixed media.
Style Exhibits conceptualism, group shows of contemporary fine art. Genres include all contemporary art/all media. Artist pays shipping costs. Prefers artwork ready for display. Finds artists through entries.
Tips "We prioritize group shows that are self curated, or curated by outside curators. Groups need to be three to four artists or more. Annual guidelines are sent out in January for next coming year. We are looking for experimental and innovative work."

RED MOUNTAIN GALLERY AND STURM GALLERY
(Truckee Meadows Community College), 7000 Dandini Blvd., Reno NV 89512. (775)674-7698. E-mail: eml@scs. unr.cdu. **Curator:** Noland Preece. Nonprofit and college gallery. Estab. 1991. Represents emerging and mid-career artists. Sponsors 7 shows/year. Average display time 1 month. Located north of downtown Reno; 1,200 sq. ft.; "maximum access to entire college communitycentrally located." 100% of space for special exhibitions. Clientele corporate art community and students/faculty. 95% private collectors, 5% corporate collectors. Overall price range $150-1,500; most work sold at $300-800.
Media Considers oil, acrylic, watercolor, pastel, pen & ink, drawings, mixed media, collage, paper, sculpture, ceramic, fiber and photography. "Video is a new addition." Considers original handpulled prints, woodcuts, engravings, lithographs, wood engravings, mezzotints, serigraphs, linocuts and etchings. Most frequently exhibits painting, photography, sculpture and printmaking.
Style Exhibits all styles and genres. Prefers primitivism and socio-political works. Looks for "more contemporary concerns—less traditional/classical approaches. Subject matter is not the basis of the work—innovation and aesthetic exploration are primary."
Terms Accepts work on consignment (20% commission). Retail price set by gallery and artist. Gallery provides insurance, full color announcements, promotion, contract and shipping from gallery. Prefers artwork unframed.

Submissions Accepts artists from the U.S.A. Send query letter with résumé, 15 slides, SASE, reviews and artist's statement. Deadline for submissions February 15 of each year. Responds in 2 months. Files résumé. Submission fee $15.

NEW HAMPSHIRE

MILL BROOK GALLERY & SCULPTURE GARDEN

236 Hopkinton Rd., Concord NH 03301. (603)226-2046. E-mail: artsculpt@mindspring.com. Web site: www.the millbrookgallery.com. For-profit gallery. Estab. 1996. Exhibits over 70 emerging, mid-career and established artists. Exhibited artists include John Bott (painter), Laurence Young (painter), John Lee (sculptor) and Wendy Klemperer (sculptor). Sponsors 7 exhibits/year. Average display time 6 weeks. Open Tuesday-Saturday, 11-5; April 1-December 24th. Otherwise, by appointment. Located 3 miles west of The Concord NH Center; surrounding gardens, field and pond; outdoor juried sculpture exhibit. Three rooms inside for exhibitions, 1,800 sq. ft. Clients include local community, tourists and upscale, 10% of sales are to corporate collectors. Overall price range $80-30,000; most work sold at $500-1,000.
Media Considers acrylic, ceramics, collage, drawing, glass, mixed media, oil, pastel, sculpture, watercolor, etchings, mezzotints, serigraphs and woodcuts. Most frequently exhibits oil, acrylic and pastel.
Style Considers all styles. Most frequently exhibits color field/conceptualism, expressionism. Genres include landscapes. Prefers more contemporary art.
Terms Artwork is accepted on consignment and there is a 50% commission. Retail price set by the artist. Gallery provides insurance, promotion and contract. Accepted work should be framed and matted.
Submissions Call or write to show portfolio of photographs and slides. Send query letter with artist's statement, bio, photocopies, photographs, résumé, SASE and slides. Returns material with SASE. Responds in 1 month. Finds artists through word of mouth, submissions, art exhibits and referrals by other artists.

THE OLD PRINT BARN—ART GALLERY

P.O. Box 978, Winona Rd., Meredith NH 03253-0978. (603)279-6479. Fax: (603)279-1337. **Director:** Sophia Lane. Retail gallery. Estab. 1976. Represents 100-200 mid-career and established artists/year. May be interested in seeing the work of emerging artists in the future. Exhibited artists include Michael McCurdy, Ryland Loos and Joop Vegter. Sponsors 3-4 shows/year. Average display time 3-4 months. Open daily 10-5 (except Thanksgiving and Christmas Day). Located in the country; over 4,000 sq. ft.; remodeled antique 18th century barn. 30% of space for special exhibitions; 70% of space for gallery artists. Clients include tourists and local. 99% of sales are to private collectors. Overall price range $10-30,000; most work sold at $200-900.
Media Considers watercolor, pastel and drawing; types of prints include woodcuts, engravings, lithographs, mezzotints, serigraphs, linocuts and etchings. Most frequently exhibits etchings, engravings (antique), watercolors.
Style Exhibits color field, expressionism, postmodernism, realism. Most frequently exhibits color field, realism, postmodernism. Genres include florals, wildlife, landscapes and Americana.
Terms Accepts work on consignment. Retail price set by the gallery and artist. Gallery provides promotion; shipping costs are shared.
 ● Artist is responsible for insurance. Prefers artwork unframed but shrink-wrapped with 1 inch on top for clips so work can hang without damage to image or mat.
Submissions Prefers only works of art on paper. No abstract art. Send query letter with résumé, brochure, 10-12 slides and artist's statement. Title, medium and size of artwork must be indicated clearly on slide label. Call or write for appointment to show portfolio or photographs. Responds in a few weeks. Files query letter, statements, etc. Finds artists through word of mouth, referrals of other artists, visiting art fairs and exhibitions and submissions.
Tips "Show your work to gallery owners in as many different regions as possible. Most gallery owners have a feeling of what will sell in their area. I certainly let artists know if I feel their images are not what will move in this area."

NEW JERSEY

BARRON ARTS CENTER

582 Rahway Ave., Woodbridge NJ 07095. (732)634-0413. Fax: (732)634-8633. E-mail: barronarts@twp.woodbri dge.nj.us. Web site: www.twp.woodbridge.nj.us. **Director:** Cynthia Knight. Nonprofit gallery. Estab. 1977. Interested in emerging, mid-career and established artists. Sponsors several solo and group shows/year. Average display time is 1 month. Clients include culturally minded individuals mainly from the central New Jersey

region. 80% of sales are to private collectors, 20% corporate clients. Overall price range $200-5,000. Gallery hours during exhibits: Monday-Friday 11-4; Sunday 2-4; Closed holidays.

Media Considers oil, acrylic, watercolor, pastel, pen & ink, drawings, mixed media, collage, works on paper, sculpture, ceramic, craft, fiber, glass, installation, photography, performance and original handpulled prints. Most frequently exhibits water color, oils, photography and mixed media.

Style Exhibits painterly abstraction, impressionism, photorealism, realism and surrealism. Genres include landscapes and figurative work. Prefers painterly abstraction, photorealism and realism.

Terms Accepts work on consignment. Retail price set by artist. Exclusive area representation not required. Gallery provides insurance, promotion and contract; artist pays for shipping.

Submissions Send query letter, résumé and slides. Call for appointment to show portfolio. Résumés and slides are filed.

Tips Most common mistakes artists make in presenting their work are "improper matting and framing and poor quality slides. There's a trend toward exhibition of more affordable pieces—pieces in the lower end of price range."

BLACKWELL ST. CENTER FOR THE ARTS

PBox 808, Denville NJ 07834. (973)316-0857. E-mail: wblakeart2004@yahoo.com. Web site: www.blackwell-st-artists.org. **Director:** Annette Hanna. Nonprofit group. Estab. 1983. Exhibits the work of approximately 15 or more emerging and established artists. Sponsors 3-4 group shows/year. Average display time 1 month. Overall price range $100-5,000; most work sold at $150-350.

Media Considers oil, acrylic, watercolor, pastel, pen & ink, drawings, mixed media, collage, paper, sculpture, ceramics, photography, egg tempera, woodcuts, wood engravings, linocuts, engravings, mezzotints, etchings, lithographs and serigraphs. Most frequently exhibits oil, photography and pastel.

Style Exhibits all styles and genres. Prefers painterly abstraction, realism and photorealism.

Terms Membership fee plus donation of time; 20% commission. Retail price set by artist. Sometimes offers payment by installments. Exclusive area representation not required. Artist pays for shipping. Prefers artwork framed.

Submissions Send query letter with résumé, brochure, slides, photographs, bio and SASE. Call or write for appointment to show portfolio of originals and slides. Responds in 1 month. Files slides of accepted artists. All material returned if not accepted or under consideration.

Tips "Show one style of work and pick the bestless is more. Slides and/or photos should be current work. Enthusiasm and organization are big pluses!"

MARY H. DANA WOMEN ARTISTS SERIES

Mabel Smith Douglass Library, Douglass College, New Brunswick NJ 08901-8527. (732)932-9407, ext. 26. Fax: (732)932-6667. E-mail: olin@rci.rutgers.edu. Web site: www.libraries.rutgers.edu/rulib/abtlib/dglsslib/gen/events/was.htm. **Contact:** Dr. Ferris OlinAlternative exhibition space for juried exhibitions of works by women artists. Estab. 1971. Represents/exhibits 4 emerging, mid-career and established artists/year. Interested in seeing the work of emerging artists. Sponsors 4 shows/year. Average display time 5-6 weeks. Open September-June; Monday-Sunday approximately 12 hours a day. Located on college campus in urban area; lobby-area of library. Clients include students, faculty and community.

Media Considers all media.

Style Exhibits all styles and genres.

Terms Retail price by the artist. Gallery provides insurance, promotion and arranges transportation. Prefers artwork framed.

Submissions Exhibitions are curated by invitation. Portfolio should include 5 slides. Finds artists through referrals.

EXTENSION GALLERY

60 Sculptors Way Extension, Mercerville NJ 08619. (609)890-7777. Fax: (609) 890-1816. **Gallery Director:** Gyuri Hollosy. Nonprofit gallery/alternative space. Estab. 1984. Represents 60 emerging, mid-career, established artists/year. Sponsors 11 exhibitions/year. Average display time 1 month. Open all year; Monday-Thursday 10-4 p.m. 1,400 sq. ft.; attached to the Johnson Atelier Technical Institute of Sculpture. 90% of space devoted to showing the work of gallery artists.

- Extension Gallery is a service-oriented space for Johnson Atelier members; all work is done inhouse by Atelier members, apprentices and staff.

Media Considers oils, acrylics, watercolor, pastels, drawings, mixed media, sculpture and all types of prints. Most frequently exhibits sculpture and drawing.

Style Considers all styles. Prefers contemporary sculpture. Most frequently exhibits realism, expressionism, conceptualism.

GALMAN LEPOW ASSOCIATES, INC.

1879 Old Cuthbert Rd., #12, Cherry Hill NJ 08034. (856)354-0771. Fax: (856) 428-7559. **Contact:** Judith Lepow. Art consultancy. Estab. 1979. Represents emerging, mid-career and established artists. Open all year. 1% of sales are to private collectors, 99% corporate collectors. Overall price range $300-20,000; most work sold at $500-5,000.

Media Considers oil, acrylic, watercolor, pastel, mixed media, collage, paper, sculpture, ceramic, craft, fiber, glass, photography, original handpulled prints, woodcuts, engravings, lithographs, pochoir, wood engravings, mezzotints, linocuts, etchings, and serigraphs.

Style Exhibits painterly abstraction, impressionism, realism, photorealism, pattern painting and hard-edge geometric abstraction. Genres include landscapes, florals and figurative work.

Terms Accepts artwork on consignment (40-50% commission). Retail price set by artist. Gallery provides insurance; shipping costs are shared. Prefers artwork unframed.

Submissions Send query letter with résumé, slides and SASE. Call for appointment to show portfolio of originals, slides and transparencies. Responds in 3 weeks. Files "anything we feel we might ultimately show to a client."

DAVID GARY LTD. FINE ART

158 Spring St., Millburn NJ 07041. (973)467-9240. Fax: (973)467-2435. **Director:** Steve Suskauer. Retail and wholesale gallery. Estab. 1971. Represents 17-20 mid-career and established artists. Exhibited artists include John Talbot and Theo Raucher. Sponsors 3 shows/year. Average display time 3 weeks. Open all year. Located in the suburbs; 2,000 sq. ft.; high ceilings with sky lights. Clients include "upper income." 70% of sales are to private collectors, 30% corporate collectors. Overall price range $250-25,000; most work sold at $1,000-15,000.

Media Considers oil, acrylic, watercolor, drawings, sculpture, pastel, woodcuts, engravings, lithographs, wood engravings, mezzotints, linocuts, etchings and serigraphs. Most frequently exhibits oil, original graphics and sculpture.

Style Exhibits primitivism, painterly abstraction, surrealism, impressionism, realism and collage. All genres. Prefers impressionism, painterly abstraction and realism.

Terms Accepts artwork on consignment (50% commission). Retail price set by gallery and artist. Gallery services vary; artist pays for shipping. Prefers artwork unframed.

Submissions Send query letter with résumé, photographs and reviews. Call for appointment to show portfolio of originals, photographs and transparencies. Responds in 2 weeks. Files "what is interesting to gallery."

Tips "Have a basic knowledge of how a gallery works, and understand that the gallery is a business."

GROUNDS FOR SCULPTURE

18 Fairgrounds Rd., Hamilton NJ 08619. (609)586-0616. E-mail: info@groundsforsculpture.org. Web site: www. groundsforsculpture.com. **Contact:** Brooke Barrie, director/curator. Museum. Estab. 1992. Exhibits emerging, mid-career and established artists. Exhibited artists in the museum include Dale Chihuly (glass) and Beverly Pepper (cast iron, stone). Exhibited artists in the sculpture park include George Segal and Isaac Witkin (bronze). Sponsors 5-8 exhibits/year. Average display time 2-7 months. Open all year; Tuesday-Sunday, 10-9. Located in an industrial area in Hamilton, New Jersey—centrally located between New York City and Philadelphia. 2-10,000 square feet museum buildings and 35 acre sculpture park.

Media Considers sculpture. Most frequently exhibits stone, bronze, metals and mixed media.

Style Most frequently exhibits all styles of contemporary sculpture.

Submissions Only sculpture is considered/reviewed. Send query letter with artist's statement, bio, reviews, slides and exhibition catalogues. Does not return material. Keeps materials in artist registry. Responds to queries in 2 months. Files all materials in artist registry unless artist requests their return. Finds artists through art exhibits, portfolio reviews and referrals by other artists and art reps.

KEARON-HEMPENSTALL GALLERY

536 Bergen Ave., Jersey City NJ 07304. (201)333-8855. Fax: (201)333-8488. E-mail: suzann@khgallery.com. Web site: www.khgallery.com. **Director:** Suzann Anderson. Retail gallery. Estab. 1981. Represents emerging, mid-career and established artists. Exhibited artists include Dong Sik-Lee, Mary Buondies, Jesus Rivera, Stan Mullins, Linda Marchand, Stephen McKenzie, Elizabeth Bisbing and Kamil Kubik. Sponsors 3 shows/year. Average display time 2 months. Open Monday-Friday, 10-3; closed July and August. Located on a major commercial street; 150 sq. ft.; brownstone main floor, ribbon parquet floors, 14 ft. ceilings, ornate moldings, traditional. 100% of space for special exhibitions. Clients include local community and corporate. 60% of sales are to private collectors, 40% corporate collectors. Overall price range $200-8,000; most work sold at $1,500-2,500.

Media Considers oil, acrylic, watercolor, pastel, drawing, mixed media, collage, paper, sculpture, fiber, glass, installation, photography, engravings, lithographs, serigraphs, etchings and posters. Most frequently exhibits mixed media painting, photography and sculpture.

Style Prefers figurative expressionism and realism.

Terms Accepts work on consignment (50% commission). Retail price set by the gallery. Gallery provides promotion; artist pays for shipping. Prefers artwork framed.

Submissions Send query letter with résumé, slides, bio, brochure, SASE, reviews, artist's statement, price list of sold work. Write for appointment to show portfolio of photographs and slides. Responds in 6 weeks. Files slides and résumés. Finds artists through art exhibitions, magazines (trade), submissions.

Tips "View gallery Web site for artist requirements."

KERYGMA GALLERY

38 Oak St., Ridgewood NJ 07450. (201)444-5510. E-mail: vihuse@aol.com. Web site: www.kerygmagallery.com. **Contact:** Vi Huse. Retail gallery. Estab. 1988. Represents 30 mid-career artists. Sponsors 9 shows/year. Average display time 4-6 weeks. Open all year. Located in downtown business district; 2,000 sq. ft.; "professionally designed contemporary interior with classical Greek motif accents." Clientele: primarily residential, some corporate. 80-85% private collectors, 15-20% corporate collectors. Most work sold at $2,000-5,000.

Media Considers oil, acrylic, watercolor, pastel, mixed media, sculpture. Prefers oil or acrylic on canvas.

Style Exhibits painterly abstraction, impressionism and realism. Genres include landscapes, florals, still life and figurative work. Prefers impressionism and realism.

Terms Accepts artwork on consignment (50% commission). Retail price set by gallery and artist. Gallery provides insurance, promotion and in some cases, a contract; shipping costs are shared.

Submissions Send query letter with résumé, slides, bio, photographs, reviews and SASE. Call for appointment to show portfolio originals, photographs and slides "only after interest is expressed by slide/photo review." Responds in 1 month. Files all written information, returns slides/photos.

Tips "An appointment is essential—as is a slide register."

LIMITED EDITIONS & COLLECTIBLES

697 Haddon, Collingswood NJ 08108. (856)869-5228. Fax: (856)869-5228. E-mail: JDL697ltd@juno.com. Web site: www.LTDeditions.net. **Owner:** John Daniel Lynch, Sr. For profit gallery. Estab. 1997. Approached by 24 artists/year. Exhibited artists include Richard Montmurro, James Allen Flood and Gino Hollander. Open all year. Located in downtown Collingswood; 700 sq. ft. Overall price range $190-20,000; most work sold at $450.

Media Considers all media and all types of prints. Most frequently exhibits acrylic, watercolors and oil.

Style Considers all styles and genres.

Terms Artwork is accepted on consignment and there is a 30% commission. Retail price set by the artist. Gallery provides insurance, promotion and contract. Accepted work should be framed, mounted and matted. Does not require exclusive representation locally.

Submissions Call or write to arrange a personal interview to show portfolio. Send query letter with bio, business card and résumé. Responds in 1 month. Finds artists through word of mouth, portfolio reviews, art exhibits, and referrals by other artists.

PETERS VALLEY CRAFT EDUCATION CENTER

19 Kuhn Rd., Layton NJ 07851. (973)948-5200. Fax: (973)948-0011. E-mail: pvstore@warwick.net. Web site: www.petersvalley.org. **Gallery Manager:** Mikal Brutzman. Nonprofit gallery and store. Estab. 1970. Approached by about 100 artists/year. Represents about 350 emerging, mid-career and established artists. Exhibited artists include William Abranowitz and Ann Baver. Average display time for store items varies. Gallery exhibitions approx. one month duration. Open year round, call for hours. Located in northwestern New Jersey in Delaware Water Gap National Recreation Area; 2 floors; approximately 3,000 sq. ft. Clients include local community, students, tourists and upscale. 5% of sales are to corporate collectors. Overall price range $5-3,000; most work sold at $100-300.

Media Considers all media and all types of prints. Also exhibits non-referential, mixed media, collage and sculpture.

Style Considers all styles. Most frequently exhibits contemporary fine art and craft.

Terms Artwork is accepted on consignment and there is a 60% commission. Retail price set by the gallery in conjunction with artist. Gallery provides insurance and promotion. Accepted work should be framed, mounted and matted. Does not require exclusive representation locally. Accepts only artists from North America.

Submissions Call or write to arrange a personal interview to show portfolio. Send query letter with artist's statement, bio, résumé and images. Returns material with SASE. Responds in 2 months. Files résumé and bio. Finds artists through submissions, art exhibits, art fairs, and referrals by other artists.

Tips "Send images and artist's info first and follow up with an e-mail."

SERAPHIM FINE ARTS GALLERY

Dept. AM, 19 Engle St., Tenafly NJ 07670. (201)568-4432. **Directors:** E. Bruck and M. Lipton. Retail gallery. Represents 150 emerging, mid-career and established artists. 90% of sales are to private collectors, 10% corporate clients. Overall price range $700-20,000; most work sold at $2,000-5,000.

Media Considers oil, acrylic, watercolor, drawings, collage, sculpture and ceramic. Most frequently exhibits oil, acrylic and sculpture.

Style Exhibits impressionism, realism, painterly abstraction and conceptualism. Considers all genres. Prefers impressionism, realism and figure painting. "We are located in New Jersey, but we function as a New York gallery. We put together shows of artists who are unique. We represent fine contemporary artists and sculptors."

Terms Accepts work on consignment. Retail price set by gallery and artist. Exclusive area representation required. Gallery provides insurance and promotion. Prefers framed artwork.

Submissions Send query letter with résumé, slides and photographs. Portfolio should include originals, slides and photographs. Responds in 1 month. Files slides and bios.

Tips Looking for "artistic integrity, creativity and an artistic ability to express self." Notices a "return to interest in figurative work."

A SWITCH IN ART, GERALD F. PRENDERVILLE, INC.

P.O. Box 246, Monmouth Beach NJ 07750. (732)389-4912. Fax (732)389-4913. E-mail: aswitchinart@aol.com. **President:** G. Prenderville. Estab. 1979. Produces decorative switch plates. "We produce decorative switch plates featuring all types of designs including cats, animals, flowers, kiddies/baby designs, birds, etc. We sell to better gift shops, museums, hospitals, specialty stores, with large following in mail order catalogs."

Needs Approached by 4-5 freelancers/year. Works with 2-3 freelancers/year. Buys 10-20 designs and illustrations/year. Prefers artists with experience in card industry and cat rendering. Seeks cats and wildlife art. Prefers 8×10 or 10×12. Submit seasonal material 6 months in advance.

First Contact & Terms Send query letter with brochure, tearsheets and photostats. Samples are filed and are returned. Responds in 3-5 weeks. Pays by the project, $75-150. Interested in buying second rights (reprint rights) to previously published artwork. Finds artists mostly through word of mouth.

Tips "Be willing to accept your work in a different and creative form that has been very successful. We seek to go vertical in our design offering to insure continuity. We are very easy to work with and flexible. Cats have a huge following among consumers, but designs must be realistic."

NEW MEXICO

516 MAGNIFICO ARTSPACE

516 Central SW, Albuquerque NM 87102. (505)242-8244. Fax: (505)242-0174. E-mail: melody@magnifico.org. Web site: www.magnifico.org. **Executive Director:** Suzanne Sbarge. Associate Director: Melody Mock. Alternative space, nonprofit. Estab. 1999. Approached by 100 artists/year. Sponsors 10 exhibits/year. Average display time 1 month. Open all year; Tuesday-Saturday, 12-5. Closed between exhibitions. Located in downtown Albuquerque; features track lighting, cement floors and is 3,000 sq. ft. total; handicap accessible; approximately 90 ft. deep and 22 ft. wide, the east wall has 3 divider panels which divide the space into 4 areas; the front section is 2 stories high and lit by north facing glass wall. Overall price range $300-10,000.

Media Considers contemporary works in all media. Most frequently exhibits painting, photography and sculpture. Considers all types of prints except posters.

Style Considers all styles particularly contemporary works.

Terms Retail price set by the artist. Gallery provides insurance and contract. Requests 50% commission of works sold.

Submissions Call or visit Web site for proposal information and entry form. Exhibition proposals are reviewed by committee. Returns material with SASE. Responds in 3 months after the visual arts advisory committee meets. Files all selected materials; if not selected we will file the proposal and résumé. Finds artists through submissions, and proposals to gallery and referrals from our committee.

Tips "Call for submission information and send only the required information. Write a specific and detailed proposal for the exhibition space. Do not send unsolicited materials, or portfolio, without the application materials from the gallery. Please call if you have questions about the application or your proposal."

THE ALBUQUERQUE MUSEUM OF ART & HISTORY

2000 Mountain Rd. NW, Albuquerque NM 87104. (505)243-7255. Fax: (505)764-6546. Web site: www.cabq. gov/museum. **Curator of Art:** Douglas A. Fairfield. Curator of History: Deb Slaney. Nonprofit museum. Estab. 1967. Located in Old Town, west of downtown.

Style Mission is to collect, promote, and showcase art and artifacts from Albuquerque, the state of New Mexico, and the Southwest. Sponsors mainly group shows and work from the permanent collection. Exhibits run 3-4 months.

Submissions Artists may send portfolio for exhibition consideration: slides, photos, disk, artist statement, résumé, SASE.

ART CENTER AT FULLER LODGE

2132 Central Ave., Los Alamos NM 87544. (505)662-9331. Fax: (505)662-9334. E-mail: artful@losalamos.com. Web site: www.artfulnm.org. **ExecutiveDirector:** John Werenko. Nonprofit gallery, education facility and retail shop for members. Estab. 1977. 388 members. Sponsors 9 shows/year. Average display time 5 weeks. Sponsors 2 fairs/year. One one-day fair in August, and one two-day fair during early November. Open all year; Monday-Saturday, 10-4. Located downtown; 3,400 sq. ft. 90% of space for special exhibitions. Clients include local, regional and international visitors. 99% of sales are to private collectors, 1% corporate collectors. Overall price range $50-1,200; most artwork sold at $30-300.

Media Considers all media.

Style Exhibits all styles and genres.

Terms Accepts work by member artists on consignment (30% commission). Retail price set by the artist. Gallery provides insurance and promotion; artist pays for shipping. "Work should be in exhibition form (ready to hang)."

Submissions "Prefer the unique." Send query letter with résumé, slides, bio, brochure, photographs, SASE and reviews. Files "résumés, etc.; slides returned only by SASE." Applications for fairs, shows, teaching, and membership are on the Web site.

Tips "We put on juried competitions, guild exhibitions and special shows throughout the year. Send SASE for prospectus and entry forms."

BENT GALLERY AND MUSEUM

117 Bent St., Box 153, Taos NM 87571. (505)758-2376. Web site: www.laplaza.org/art/museums_bent.php3. **Owner:** Tom Noeding. Retail gallery and museum. Estab. 1961. Represents 15 emerging, mid-career and established artists. Exhibited artists include E. Martin Hennings, Charles Berninghaus, C.J. Chadwell and Leal Mack. Open all year; 9-5 (summer); 10-4 (winter). Located 1 block off of the Plaza, "in the home of Charles Bent, the first territorial governor of New Mexico." 95% of sales are to private collectors, 5% corporate collectors. Overall price range $100-10,000; most work sold at $500-1,000.

Media Considers oil, acrylic, watercolor, pastel, pen & ink, drawings, sculpture, original handpulled prints, woodcuts, engravings and lithographs.

Style Exhibits impressionism and realism. Genres include traditional, landscapes, florals, southwestern and western. Prefers impressionism, landscapes and western works. "We continue to be interested in collectors' art deceased Taos artists and founders' works."

Terms Accepts work on consignment (33⅓-50% commission). Retail price set by gallery and artist. Artist pays for shipping. Prefers artwork framed.

Submissions Send query letter with brochure and photographs. Write for appointment to show portfolio of originals and photographs. Responds if applicable.

Tips "It is best if the artist comes in person with examples of his or her work."

PETER ELLER GALLERY & APPRAISERS

206 Dartmouth NE, Albuquerque NM 87106. (505)268-7437. Fax: (505)268-6442. E-mail: pelgal@nmia.com. For-profit gallery. Estab. 1981. Approached by 20 artists a year. Exhibits established artists. Sponsors 2-3 exhibits/year. Average display time 4-5 weeks. Open all year; Wednesday-Friday, 1-5; weekends, 11-4. A small gallery in Albuquerque's historic Nob Hill, specializing in Albuquerque artists and minor New Mexico masters, 1925-1985. Overall price range $1,000-75,000.

Media Considers acrylic, ceramics, drawing, mixed media, oil, pastel, pen & ink, sculpture, watercolor, engravings, etchings, linocuts, lithographs, mezzotints, serigraphs and woodcuts. Most frequently exhibits oil, sculpture and acrylic.

Style Considers all styles and genres. Most frequently exhibits Southwestern realism and geometric abstraction.

Terms Primarily accepts resale works. Holds shows for contemporary artists occasionally.

Submissions Call or write to arrange a personal interview to show portfolio or photographs. Finds artists through word of mouth and art exhibits.

FENIX GALLERY

208A Ranchitos Road, Taos NM 87571. (505)758-9120. E-mail: jkendall@fenixgallery.com. Web site: www.fenixgallery.com. **Director/Owner:** Judith B. Kendall. Retail gallery. Estab. 1989. Represents 18 emerging, mid-career and established artists/year. Exhibited artists include Alyce Frank and Earl Stroh. Sponsors 4 shows/year. Average display time 4-6 weeks. Open all year; daily, 10-5; Sunday, 12-5; closed Wednesday; by appointment only during winter months. Located on the main road through Taos; 2,000 sq. ft.; minimal hangings; clean, open space. 100% of space for special exhibitions during one-person shows; 50% of space for gallery artists during group exhibitions. Clientele experienced and new collectors. 90% private collectors, 10% corporate collectors. Overall price range $100-25,000; most work sold at $1,000-2,500.

Media Considers all media; primarily non-representational, all types of prints except posters. Most frequently exhibits oil, sculpture and paper work/ceramics.

Style Exhibits expressionism, painterly abstraction, conceptualism, minimalism and postmodern works. Prefers conceptualism, expressionism and abstraction.

Terms Accepts work on consignment (50% commission). Retail price set by the artist or a collaboration. Gallery provides insurance, promotion and contract; artist pays shipping costs to and from gallery. Prefers artwork framed.

Submissions Prefers artists from area; "we do very little shipping of artist works." Send query letter with résumé, slides, bio, brochure, photographs, SASE, business card and reviews. Call for appointment to show portfolio of photographs. Responds in 3 weeks. Files "material I may wish to consider later—otherwise it is returned." Finds artists through personal contacts, exhibitions, studio visits, reputation regionally or nationally.

Tips "I rely on my experience and whether I feel conviction for the art and whether sincerity is present."

GIACOBBE-FRITZ FINE ART

702 Canyon Rd., Santa Fe NM 87501. (505)986-1156. Fax: (505)986-1158. E-mail: art@giacobbefritz.com. Web site: www.giacobbefritz.com. **Contact:** Artist Submissions. For-profit gallery. Estab. 2000. Approached by 300+ artists/year. Represents 12 emerging, mid-career and established artists. Exhibited artists include Connie Dillman (painting) and Tom Corbin (sculpture). Sponsors 12-20 exhibits/year. Average display time 2 weeks. Open all year; Monday-Saturday, 10-5; Sunday from 12-4. Located on prestigious Canyon Rd. in top Santa Fe art market. Classic adobe with 5 exhibit rooms. Clients include local community, tourists and upscale.

Media Considers acrylic, collage, mixed media, oil, pastel, sculpture, watercolor and etchings. Prints include etchings and mezzotints. Most frequently exhibits oil, sculpture and acrylic.

Style Exhibits impressionism, abstract and realism. Considers all styles including expressionism, impressionism, surrealism and patinerly abstraction. Genres include figurative work, landscapes and figures.

Terms Artwork is accepted on consignment and there is a 50% commission. Retail price set by the gallery. Gallery provides insurance, promotion and contract. Accepted work should be framed. Requires exclusive representation locally. No agents.

Submissions Call, write, or e-mail to arange personal interview to show portfolio of photographs, transparencies and slides. Prefers to receive e-mailed portfolios. Send query letter with artist's statement, bio, photocopies, photographs, SASE, slides and CD. Returns material with SASE only. Responds to queries in 2 weeks. Finds artists through art fairs, art exhibits, portfolio reviews, referrals by other artists, submissions, word of mouth.

Tips "Enclose SASE, brief query letter, and a few samples of your best work."

JONSON GALLERY, UNIVERSITY OF NEW MEXICO

1909 Las Lomas NE, Albuquerque NM 87131-1416. (505)277-4967. Fax: (505)277-3188. E-mail: jonsong@unm.edu. Web site: www.unm.edu/~jonsong/. **Contact:** Robert Ware, curator. Alternative space, museum and non-profit gallery. Estab. 1950. Approached by 20-30 artists/year. Represents emerging and mid-career artists. Exhibited artists include Raymond Jonson (oil/acrylic on canvas/masonite). Sponsors 6-8 exhibits/year. Average display time 6 weeks. Open Tuesday-Friday, 9-4. Closed Christmas through New Years. Clients include local community, students and tourists. Overall price range $150-15,000; most work sold at $3,000-4,000.

Media Considers all media.

Style Exhibits conceptualism, geometric abstraction, minimalism and postmodernism. Most frequently exhibits conceptual, postmodernism and geometric abstraction.

Terms Artwork is accepted on consignment and there is a 25% commission. Retail price set by dealer. Gallery provides insurance and promotion. Accepted work should be ready for display. Does not require exclusive representation locally.

Submissions Write to arrange a personal interview to show portfolio of photographs, slides, transparencies and originals. Send query letter with artist's statement, bio, brochure, business card, photocopies, photographs, résumé, reviews, SASE and slides. Responds in 1 week. Files slides, bios, CVs, reviews of artists' works in exhibitions. Finds artists through word of mouth, submissions, art exhibits and referrals by other artists.

Tips Submit a viable exhibition proposal.

MARGEAUX KURTIE MODERN ART

39 Yerba Buena, P.O. Box 39, Cerrillos NM 87010. (505)473-2250. E-mail: mkma@att.net. Web site: www.mkma madrid.com. **Contact:** Jill Alikas St. Thomas, director. Art consultancy. Estab. 1996. Approached by 200 artists/year. Represents 13 emerging, mid-career and established artists. Exhibited artists include Thomas St. Thomas, mixed media painting and sculpture; Gary Groves, color infrared film photography. Sponsors 8 exhibits/year. Average display time 5 weeks. Open January-April 1 a.m.-5, Friday-Sunday or by appointment; April-December, 11-5, except Tuesday and Wednesday or by appointment. Located within an historic adobe home, 18 miles S.E.

of Santa Fe; 5,000 sq. ft. Clients include local community, students and tourists. 5% of sales are to corporate collectors. Overall price range $500-15,000; most work sold at $2,800.
Media Considers acrylic, glass, mixed media, paper, sculpture. Most frequently exhibits acrylic on canvas, oil on canvas, photography.
Style Exhibits conceptualism, pattern painting. Most frequently exhibits narrative/whimsical, pattern painting, illussionistic. Genres include figurative work, florals.
Terms Artwork is accepted on consignment and there is a 50% commission. Retail price set by the gallery. Gallery provides insurance. Accepted work should be framed, mounted or matted. Requires exclusive representation locally.
Submissions Web site lists criteria for review process. Send query letter with artist's statement, bio, résumé, reviews, SASE, slides, $25 review fee, check payable to gallery. Returns material with SASE. Responds to queries in 1 month. Finds artists through art fairs, art exhibits, portfolio reviews, referrals by other artists, submissions, word of mouth.
Tips "Label all slides, medium, size, title and retail price, send only works that are available."

RICHARD LEVY GALLERY

514 Central Ave. SW, Albuquerque NM 87102. (505)766-9888. E-mail: info@levygallery.com. Web site: www.levygallery.com. **Contact:** Viviette Hunt, director. Estab. 1992. Open Tuesday-Saturday, 11 a.m.-4 p.m. Closed during art fairs (always noted on voice message). Located on Central Ave. between 5th and 6th. Clients include upscale.
Media Considers all media. Most frequently exhibits paintings, prints and photography.
Style Contemporary art.
Submissions Submissions by e-mail preferred. Please include images and any other pertinent information (artist's statment, bio, etc.). When sending submissions by post, please include slides or photographs and SASE for return of materials.
Tips "Portfolios are reviewed at the gallery by invitation or appointment only."

NEDRA MATTEUCCI GALLERIES

1075 Paseo De Peralta, Santa Fe NM 87501. (505)982-4631. Fax: (505)984-0199. E-mail: inquiry@matteucci.com. Web site: www.matteucci.com. **Director of Advertising/Public Relations:** Alex Hanna. For-profit gallery. Estab. 1972. Main focus of gallery is on deceased artists of Taos, Sante Fe and the West. Approached by 20 artists/year. Represents 100 established artists. Exhibited artists include Dan Ostermiller and Glenna Goodacre. Sponsors 3-5 exhibits/year. Average display time 1 month. Open all year; Monday-Saturday, 830-5. Clients include upscale.
Media Considers ceramics, drawing, oil, pen & ink, sculpture and watercolor. Most frequently exhibits oil, watercolor and bronze sculpture.
Style Exhibits impressionism. Most frequently exhibits impressionism, modernism and realism. Genres include Americana, figurative work, landscapes, portraits, Southwestern, Western and wildlife.
Terms Artwork is accepted on consignment. Retail price set by the gallery and the artist. Requires exclusive representation within New Mexico.
Submissions Write to arrange a personal interview to show portfolio of transparencies. Send query letter with bio, photographs, résumé and SASE.

MAYANS GALLERIES, LTD.

601 Canyon Rd., Santa Fe NM 87501 Fax: (505)982-1999. E-mail: arte4@aol.com. Web site: www.artnet.com/mayans.html. **Contact:** Ernesto Mayans. Retail gallery and art consultancy. Estab. 1977. Represents 10 emerging, mid-career and established artists. Sponsors 2 solo and 2 group shows/year. Average display time 1 month. Clientele 80% private collectors, 20% corporate clients. Overall price range $350 and up; most work sold at $500-7,500.
Media Considers oil, acrylic, watercolor, pastel, pen & ink, drawings, mixed media, sculpture, photography and original handpulled prints. Most frequently exhibits oil, photography, and lithographs.
Style Exhibits 20th century American and Latin American art. Genres include landscapes and figurative work.
Terms Accepts work on consignment. Retail price set by gallery and artist. Exclusive area representation required.
Submissions Send query letter (or e-mail first), résumé, business card and SASE. Discourages the use of slides. Prefers 2 or 3 snapshots or color photocopies which are representative of body of work. Files résumé and business card.
Tips "Currently seeking contemporary figurative work and still life with strong color and technique. Gallery space can accomodate small-scale work comfortably."

MICHAEL MCCORMICK GALLERIES

106-C Paseo del Pueblo Norte, Taos NM 87571. (505)758-1372 or (800)279-6879. Fax: (505)751-0090. E-mail: mail@mccormickgallery.com. Web site: McCormickgallery.com. Retail gallery. Estab. 1983. Represents 10 emerging and established artists. Provides 3 solo and 1 group show/year. Average display time 6 weeks. 90% of sales are to private collectors, 10% corporate clients. Overall price range $1,500-85,000; most work sold at $3,500-10,000.

Media Considers oil, acrylic, watercolor, pastel, pen & ink, drawings, mixed media, collage, works on paper, sculpture, ceramic, photography, wood engravings, linocuts, engravings, mezzotints, etchings, lithographs, pochoir, serigraphs and posters. Most frequently exhibits oil, pottery and sculpture/stone.

Style Exhibits impressionism, neo-expressionism, surrealism, primitivism, painterly abstraction, conceptualism and postmodern works. Genres include landscapes and figurative work. Interested in work that is "classically, romantically, poetically, musically modern." Prefers figurative work, lyrical impressionism and abstraction.

Terms Accepts work on adjusted consignment (approximately 50% commission). Retail price set by gallery and artist. Customer discounts and payment by installment are available. Exclusive area representation required. Gallery provides promotion and contract; artist pays for shipping. Prefers artwork framed.

Submissions Send query letter with résumé, brochure, slides, photographs, bio and SASE. Portfolio review requested if interested in artist's work. Responds in 7 weeks. Finds artists usually through word of mouth and artists traveling through town.

Tips "Send a brief, concise introduction with several color photos. During this last year there seem to be more art and more artists but fewer sales. The quality is declining based on a mad, frantic scramble to find something that will sell. Take some business courses. Try to be objective within your goals. If you want something you've never had, you have to do something you've never done."

THE MUNSON GALLERY

225 Canyon Rd., Santa Fe NM 87501. (505)983-1657. Fax: (505)988-9867. E-mail: art@munsongallery.com. Web site: www.munsongallery.com. **Contact:** Brendan Bullock, media coordinator. Retail gallery. Estab. 1860. Approached by 400 artists/year; exhibits 50 emerging, mid-career and established artists/year. Exhibited artists include Elmer Schooley (oils on canvas) and Richard Segalman (oils, watercolors and monoprints). Sponsors 9 shows/year. Average display time 3 weeks. Open all year; Monday-Friday, 9:30-5; weekends, 10-5. Located in a complex that houses about 10 contemporary art galleries. 100% of space for gallery artists. Clientele upscale locals and tourists. Overall price range $450-150,000; most work sold at $2,000.

Media Considers all media. Considers engravings, etchings, linocuts, lithographs, monotypes, woodcuts and aquatints. Most frequently exhibits oils watercolor, pastel.

Style Exhibits "contemporary representational, not too much abstract, except in sculpture." Genres include florals, southwestern, landscapes.

Terms Accepts work on consignment (50% commission). Retail price set by the artist. Gallery provides promotion. Accepted work should be framed.

Submissions Send query letter with artist's statement, bio, photographs, résumé, SASE and slides. Call or write for appointment to show portfolio of photographs, slides and transparencies. Responds as soon as possible. Finds artists through portfolio reviews, referrals by other artists, submissions and word of mouth. Files bios occasionally, announcements.

Tips "At the moment, the gallery is not taking on any new artists, though portfolios will be reviewed. We will not actually be adding any new artists to our roster for at least a year. Submissions welcome, but with the understanding that this is the case."

RUNNING RIDGE GALLERY

640 Canyon Rd., Santa Fe NM 87501. **Contact:** Patt Abbott, director. For-profit gallery. Estab. 1979. Approached by 25 artists/year; exhibits 50 emerging, mid-career and established artists/year. Exhibited artists include Hiroshi Yamano (glass) and Peter Hayes (ceramics). Sponsors 6 exhibits/year. Average display time 3 weeks. Open all year; Monday-Friday, 10-5; Saturday-Sunday, 11-5. Located midway on historic Canyon Rd. 5 rooms (1,500 square feet) in an old house-lots of light. Clients include local community and tourists. 10% of sales are to corporate collectors. Overall price range $55-12,000; most work sold at $1,000.

Media Considers acrylic, ceramics, fiber, glass, oil, paper, watercolor. Most frequently exhibits glass, ceramics, jewelry. Considers engravings, etchings, linocuts, lithographs, mezzotints, serigraphs and woodcuts.

Style Considers all styles.

Terms Artwork is accepted on consignment and there is a 50% commission. Retail price of the art set by the artist. Gallery provides insurance, promotion and contract. Accepted work should be framed. Requires exclusive representation locally.

Submissions Send e-mail images; then mail portfolio for review; then send query letter with artist's statement, bio, SASE and slides. Returns material with SASE. Responds to queries in 1 month. Finds artists through art

fairs and exhibits, portfolio reviews, referrals by other artists, submissions and word of mouth.
Tips "Have good quality slides."

NEW YORK

ART WITHOUT WALLS, INC.
P.O. Box 341, Sayville NY 11782. (631)567-9418. Fax: (63)567-9418. E-mail: artwithoutwalls@webtv.net. **Contact:** Sharon Lippman, executive director. Nonprofit gallery. Estab. 1985. Approached by 300 artists/year. Represents 100 emerging, mid-career and established artists. Exhibited artists include Tone Aanderaa (painting), Yanka Cantor (sculpture) and Stephanie Isles (photography). Sponsors 10 exhibits/year. Average display time 1 month. Open all year; Sunday-Monday, 9-5. Closed December 22-January 5 and Easter week. Clients include students, upscale and emerging artists. Overall price range $1,000-25,000; most work sold at $3,000-5,000.
Media Considers all media and all types of prints. Most frequently exhibits painting, sculpture and drawing.
Style Considers all styles and genres. Most frequently exhibits impressionism, expressionism, postmodernism.
Terms Artwork is accepted on consignment and there is 20% commission. Retail price set by the artist. Gallery provides promotion and contract. Accepted work should be framed, mounted and matted.
Submissions Mail portfolio for review. Send query letter with artist's statement, brochure, photographs, résumé, reviews, SASE and slides. Returns material with SASE. Responds in 1 month. Files artist résumé, slides, photos and artist's statement. Finds artists through submissions, portfolio reviews and art exhibits.
Tips Work should be properly framed with name, year, medium, title and size.

KENISE BARNES FINE ART
1955 Palmer Ave., Larchmont NY 10538. (914)834-8077. Fax: (914)833-7379. E-mail: Kenise@KBFA.com. Web site: www.ArtNet.com. **Contact:** Kenise Barnes, director. For-profit gallery. Estab. 1995. Approached by 300 artists/year; exhibits 30 emerging and mid-career artists/year. Exhibited artists include David Collins (paintings and monotypes) and Henry Mandell (paintings and drawings). Sponsors 6 exhibits/year. Average display time 5-6 weeks. Open Wednesday-Saturday, 10-6. Closed for two weeks in August. Clients include local community and upscale. 10% of sales are to corporate collectors. Overall price range $500-5,000; most work sold at $3,000.
Media Considers acrylic, drawing, oil and paper. Also considers etchings.
Style Exhibits color field and painterly abstraction.
Terms Artwork is accepted on consignment and there is a 50% commission. Retail price of the art set by the gallery. Gallery provides insurance and promotion. Requires exclusive representation locally.
Submissions Send query letter with artist's statement, bio, photocopies, résumé, reviews, SASE and slides. Returns material with SASE. Responds to queries in 1 month. Files letter and 1 image. Finds artists through referrals from other artists.

BROOKLYN BOTANIC GARDEN—STEINHARDT CONSERVATORY GALLERY
1000 Washington Ave., Brooklyn NY 11225. (718)623-7200. Fax: (718)622-7839. E-mail: emilycarson@bbg.org. Web site: www.bbg.org. **Contact:** Emily Carson, public programs associate. Nonprofit botanic garden gallery. Estab. 1988. Represents emerging, mid-career and established artists. 20,000 members. Sponsors 10-12 shows/year. Average display time 4-6 weeks. Open all year; Tuesday-Sunday, 10-4. Located near Prospect Park and Brooklyn Museum; 1,200 sq. ft.; part of a botanic garden, gallery adjacent to the tropical, desert and temperate houses. Clients include BBG members, tourists, collectors. 100% of sales are to private collectors. Overall price range $75-7,500; most work sold at $75-500.
Media Considers all media and all types of prints. Most frequently exhibits watercolor, oil and photography.
Style Exhibits all styles. Genres include landscapes, florals and wildlife.
Terms Accepts work on consignment (20% commission). Retail price set by the artist. Gallery provides insurance, promotion and contract; artist pays shipping costs to and from gallery. Artwork must be framed or ready to display unless otherwise arranged. Artists hang and remove their own shows.
Submissions Work must reflect the natural world. Send query letter with résumé, slides, bio, brochure, photographs, SASE, business card and reviews for review.
Tips "Artists' groups contact me by submitting résumé and slides of artists in their group. We favor seasonal art which echoes the natural events going on in the garden. Large format, colorful works show best in our multi-use space."

COURTHOUSE GALLERY, LAKE GEORGE ARTS PROJECT
1 Amherst St., Lake George NY 12845. (518)668-2616. Fax: (518)668-3050. E-mail: mail@lakegeorgearts.org. **Gallery Director:** Laura Von Rosk. Nonprofit gallery. Estab. 1986. Approached by 200 artists/year. Exhibits 10-15 emerging, mid-career and established artists. Sponsors 5-8 exhibits/year. Average display time 5-6 weeks.

Open all year; Tuesday-Friday, 12-5; Saturday, 12-4. Closed mid-December to mid-January. Clients include local community, tourists and upscale. Overall price range $100-5,000; most work sold at $500.

Media Considers all media and all types of prints. Most frequently exhibits painting, mixed media and sculpture.

Style Considers all styles and genres.

Terms Artwork is accepted on consignment and there is a 25% commission. Retail price set by the artist. Gallery provides insurance, promotion and contract. Accepted work should be framed, mounted and matted.

Submissions Mail portfolio for review. Deadline always January 31st. Send query letter with artist's statement, bio, résumé, SASE and slides. Returns material with SASE. Responds in 2 months. Finds artists through word of mouth, submissions, portfolio reviews, art exhibits, art fairs and referrals by other artists.

JAMES COX GALLERY AT WOODSTOCK

4666 Rt. 212, Willow NY 12495. (845)679-7608. Fax: (845)679-7627. E-mail: jcoxgal@ulster.net. Web site: www.jamescoxgallery.com. Retail gallery. Estab. 1990. Represents 30 mid-career and established artists. Exhibited artists include Richard Segalman, Bruce North, Christie Scheele and Mary Anna Goetz. Represents estates of 7 artists including James Chapin, Margery Ryerson and Winold Reiss. Sponsors 5 shows/year. Average display time 1 month. Open all year; Monday-Friday, 10-5; weekends, by appointment. Elegantly restored Dutch barn. 50% of space for special exhibitions. Clients include New York City and tourists, residents of 50-mile radius. 95% of sales are to private collectors. Overall price range $500-50,000; most work sold at $3,000-10,000.

Media Considers oil, watercolor, pastel, drawing and sculpture. Considers "historic Woodstock, fine prints." Most frequently exhibits oil paintings, watercolors, sculpture.

Style Exhibits impressionism, realism. Genres include landscapes and figurative work. Prefers expressive or evocative realism, painterly landscapes and stylized figurative work.

Terms Accepts work on consignment (40% commission). Retail price set by the artist. Gallery provides promotion; artist pays shipping costs to and from gallery. Prefers artwork framed.

Submissions Prefers only artists from New York region. Send query letter with résumé, slides, bio, brochure, photographs, SASE and business card. Responds in 3 months. Files material on artists for special, theme or group shows.

Tips "Be sure to enclose SASE and be patient for response. Also, please include information on present pricing structure."

EAST END ARTS COUNCIL

133 E. Main St., Riverhead NY 11901. (631)727-0900. Fax: (631)727-0966. E-mail: gallery@eastendarts.org. Web site: www.eastendarts.org. **Gallery Director:** Jane Kirkwood. Nonprofit gallery. Estab. 1971. Exhibits the work of artists of all media. Presents 9 shows annuallymost of which are juried group exhibitions. Exhibits include approximately 300 artists/year, ranging from emerging to mid-career exhibitors of all ages. Average display time 4-5 weeks. Prefers regional artists. Clientele small business and private collectors. Overall price range $100-7,500; most work sold at $100-500.

Media Considers all media including sculptures and installations. Considers matted but not framed giclees and serigraphs for gift shop but not shows.

Style Exhibits contemporary, abstract, naive, non-representational, photorealism, realism, post-pop works, projected installations and assemblages. "Being an organization relying strongly on community support, we aim to serve the artistic needs of our constituency and also expose them to current innovative trends within the art world. Therefore, there is not a particular genre bias, we are open to all art media."

Terms Accepts work on consignment (30% commission). Retail price for art sold through our juried exhibits is set by the artist. Exclusive area representation not required.

Submissions Work is dropped off at gallery for open calls, no slides are accepted.

Tips "Visit, become a member ($45/year individual) and you'll be sent all the mailings that inform you of shows, lectures, workshops, grants and more! All work must be framed with clean mats and glass/plexi and wired (or hooks) for hanging. Presentation of artwork is considered when selecting work for shows."

EVERSON MUSEUM OF ART

401 Harrison St., Syracuse NY 13202. (315)474-6064. Fax: (315)474-6943. E-mail: everson@everson.org. Web site: www.everson.org. **Contact:** Debora Ryan, curator. Museum. Estab. 1897. Approached by many artists/year. Exhibited artists include Adelaide Alsop Robineau (ceramics), Lynn Underhill, Ron Jude (photography), Robyn Tomlin (video sculpture). Sponsors 22 exhibits/year. Average display time 3 months. Open all year; Tuesday-Friday, 12-5; Saturday, 10-5; Sunday, 12-5. Located in a distinctive I.M. Pei-designed building in downtown Syracuse NY. The museum features 4 large galleries with 24 ft. ceilings, back lighting and oak hardwood, a sculpture court, a children's gallery, a ceramic study center and 5 smaller gallery spaces.

Media Considers all media. Most frequently exhibits painting, ceramics, works on paper, photography and video.

Style Considers all styles and genres. Most frequently exhibits contemporary work, realism and abstraction.
Submissions Send query letter with artist's statement, bio, résumé, reviews, SASE and slides. Returns material with SASE. Responds in 3 months. If interested for future exhibition, files slides, résumé, bio, reviews and artist's statement. Finds artists through submissions, portfolio reviews and art exhibits.

FOCAL POINT GALLERY

321 City Island Ave., City Island NY 10464. (718)885-1403. Fax: (718)885-1451. E-mail: RonTerner@aol.com. Web site: www.FocalPointGallery.com. **Contact:** Ron Terner. Retail gallery and alternative space. Estab. 1974. Interested in emerging and mid-career artists. Exhibited artists include Marguerite Chadwick-Juner (watercolor). Sponsors 2 solo and 6 group shows/year. Average display time 3-4 weeks. Open Tuesday-Sunday, 12-7 with additional evening hours; Friday and Saturday, 7:30-9. Clients include locals and tourists. Overall price range $175-750; most work sold at $300-500.
Media Considers all media. Most frequently exhibits photography, watercolor, oil. Also considers etchings, giclée, color prints, silver prints.
Style Exhibits all styles. Most frequently exhibits painterly abstraction, conceptualism, expressionism. Genres include figurative work, florals, landscapes, portraits. Open to any use of photography.
Terms Accepts work on consignment (40% commission). Exclusive area representation required. Customer discounts and payment by installment are available. Gallery provides promotion. Prefers artwork framed.
Submissions "Please call for submission information. Do not include résumés. The work should stand by itself. Slides should be of high quality."
Tips "Care about your work."

GALLERY NORTH

90 N. Country Rd., Setauket NY 11733. (516)751-2676. Fax: (516)751-0180. E-mail: gallerynorth@aol.com. Web site: www.gallerynorth.org. **Director:** Colleen W. Hanson. Not-for-profit gallery. Estab. 1965. Exhibits the work of emerging, mid-career and established artists from Long Island. Sponsors 9 shows annually. Average display time 4-5 weeks. Open all year. Located 1 mile from the State University at Stony Brook; approximately 1,600 sq. ft.; "in a renovated Victorian house." 85% of space for special exhibitions. Clients include university faculty and staff, Long Island collectors and tourists. Overall price range $100-25,000; most work sold at $1,500-2,500.
Media Considers all media and original handpulled prints, frequent exhibits of paintings, prints and fine crafts, especially jewelry and ceramics.
Style Prefers abstract and representational contemporary artists.
Terms Accepts work on consignment (50% commission). Retail price set by gallery and artist. Gallery provides insurance, promotion and contract. Requires well-framed artwork.
Submissions Send query letter with résumé, slides, bio, SASE and reviews. Portfolio review requested if interested in artist's work. Portfolio should include framed originals. Responds in 2 months. Files slides and résumés when considering work for exhibition. Finds artists from other exhibitions, slides and referrals.
Tips "If possible artists should visit to determine whether their work is compatible with overall direction of the gallery. A common mistake artists make is that slides are not fully labeled as to size medium, top and price."

THE GRAPHIC EYE GALLERY OF LONG ISLAND

402 Main St., Port Washington NY 11050. (516)883-9668. Cooperative gallery. Estab. 1974. Represents 25 artists. Sponsors solo, 2-3 person and 4 group shows/year. Average display time 1 month. Interested in emerging and established artists. Overall price range $35-7,500; most artwork sold at $500-800.
Media Considers mixed media, collage, works on paper, pastels, photography, paint on paper, woodcuts, wood engravings, linocuts, engravings, mezzotints, etchings, lithographs, serigraphs, and monoprints.
Style Exhibits impressionism, expressionism, realism, primitivism and painterly abstraction. Considers all genres.
Terms Co-op membership fee plus donation of time. Retail price set by artist. Offers payment by installments. Exclusive area representation not required. Prefers framed artwork.
Submissions Send query letter with résumé, SASE, slides and bio. Portfolio should include originals and slides. "When submitting a portfolio, the artist should have a body of work, not a 'little of this, little of that.''07'' Files historical material. Finds artists through visiting exhibitions, word of mouth, artist's submissions and self-promotions.
Tips "Artists must produce their *own* work and be actively involved. We have a competitive juried art exhibit annually. Open to all artists who work on paper."

CARRIE HADDAD GALLERY

622 Warren St., Hudson NY 12534. (518)828-1915. Fax: (518)828-3341. E-mail: art@valstar.net. Web site: www.carriehaddadgallery.com. **Owner:** Carrie Haddad. Art consultancy, nonprofit gallery. Estab. 1990. Ap-

proached by 50 artists/year. Exhibits 60 emerging, mid-career and established artists. Exhibited artists include Jane Bloodgood-Abrams, oil; David Halliday, photography. Sponsors 8 exhibits/year. Average display time 5½ weeks. Open all year; Monday-Thursday, 11-5. Located on main street of Hudson; large, rambling space. Clients include local community, tourists and upscale. 10% of sales are to corporate collectors. Overall price range $350-6,000; most work sold at $1,000.

Media Considers all media except acrylic, oil and paper. Considers all types of prints except posters.

Style Exhibits expressionism, impressionism and postmodernism. Most frequently exhibits representational landscapes. Genres include figurative work, landscapes and abstract.

Terms Artwork is accepted on consignment and there is a 50% commission. Retail price set by the artist. Gallery provides insurance and promotion. Requires exclusive representation locally.

Submissions Send query letter with bio, photocopies, photographs, SASE and price list. Returns material with SASE. Responds in 2 months. Files all materials if interested. Finds artists through word of mouth, submissions, art exhibits and referrals by other artists.

IMPACT ARTIST GALLERY, INC.

2495 Main St., Suite 545, Buffalo NY 14214. (716)835-6817. E-mail: impact@buffalo.com. Web site: www.buffalo.com/impact. Cooperative gallery, nonprofit gallery and rental gallery. Estab. 1993. Approached by 500 artists/year. Represents 310 emerging, mid-career and established artists. Sponsors 12 exhibits/year. Open all year; Tuesday-Friday, 11-4. Clients include local community, tourists and upscale.

Media Considers all media except glass, installation and craft. Considers engravings, etchings, lithographs, serigraphs and woodcuts.

Style Considers all styles. Most frequently exhibits expressionism, painterly abstraction, surrealism. Considers all genres.

Terms Artwork is accepted on consignment and there is a 25% commission. Retail price set by the artist. Gallery provides promotion. Accepted work should be framed, matted and ready for hanging. Does not require exclusive representation locally. Women's art except for Fall National Show and Summer Statewide Show.

Submissions Write to arrange a personal interview to show portfolio of slides. Mail portfolio for review. Send query letter with SASE and slides. Responds in 2 months. Files artist statement and résumé.

MADELYN JORDON FINE ART

14 Chase Rd., Scarsdale NY 10583. (914)472-4748. E-mail: mrjart@aol.com. Web site: www.madelynjordanfineart.com. **Contact:** Madelyn Jordon. Art consultancy, for-profit gallery. Estab. 1991. Approached by 50 artists/year. Exhibits 40 mid-career and established artists. Exhibited artists include Ted Larsen and Lawrence Kelsey. Clients include local community and upscale. 10% of sales are to corporate collectors. Overall price range $500-30,000; most work sold at $3,000-10,000.

Media Considers all media and all types of prints. Most frequently exhibits paintings, works on paper and sculpture.

Style Considers all styles and genres.

Terms Gallery provides insurance and promotion. Requires exclusive representation locally.

Submissions Send artist's statement, bio, photographs, SASE or slides. Returns material with SASE.

LEATHERSTOCKING GALLERY

52 Pioneer St., P.O. Box 446, Cooperstown NY 13326. (607)547-5942. E-mail: drwells@hdpteam.com. **Publicity:** Dorothy V. Smith. Retail nonprofit cooperative gallery. Estab. 1968. Represents emerging, mid-career and established artists. 45 members. Sponsors 1 show/year. Average display time 3 months. Open in the summer (mid-June to Labor Day); daily 11-5. Located downtown Cooperstown; 300-400 sq. ft. 100% of space for gallery artists. Clients include varied locals and tourists. 100% of sales are to private collectors. Overall price range $25-500; most work sold at $25-100.

Media Considers oil, acrylic, watercolor, pastel, pen & ink, drawing, mixed media, collage, paper, sculpture, ceramics, craft, photography, handmade jewelry, woodcuts, engravings, lithographs, wood engravings, mezzotints, serigraphs, linocuts and etchings. Most frequently exhibits watercolor, oil and crafts.

Style Exhibits impressionism and realism, all genres. Prefers landscapes, florals and American decorative.

Terms Co-op membership fee, a donation of time plus 10% commission. Retail price set by the artist. Gallery provides insurance, promotion and contract; artist pays shipping costs from gallery if sent to buyer. Prefers artwork framed.

Submissions Accepts only artists from Otsego County; over 18 years of age; member of Leatherstocking Brush & Palette Club. Responds in 2 weeks. Finds artists through word of mouth locally; articles in local newspaper.

Tips "We are basically non-judgmental (unjuried). You just have to live in the area!"

LIMNER GALLERY

59 Main St., Phoenicia NY 12464. (845)688-7129. E-mail: slowart@aol.com. Web site: www.slowart.com. **Director:** Tim Slowinski. Limner Gallery is an artist-owned alternative retail (consignment) gallery. Estab. 1987. Represents emerging and mid-career artists. Hosts periodic thematic exhibitions of emerging artists selected by competition, cash awards up to $1,000. Entry available for SASE or from Web site. Sponsors 6-8 shows/year. Average display time one month. Open Thursday-Sunday, 12-6; year round, by appointment. Located in storefront 400 sq. ft. 60-80% of space for special exhibitions; 20-40% of space for gallery artists. Clients include lawyers, real estate developers, doctors, architects. 95% of sales are to private collectors, 5% corporate collectors. Overall price range $300-10,000.

Media Considers all media, all types of prints except posters. Most frequently exhibits painting, sculpture and works on paper.

Style Exhibits primitivism, surrealism, political commentary, satire, all styles, postmodern works, all genres. ''Gallery exhibits all styles but emphasis is on non-traditional figurative work.''

Terms Accepts work on consignment (50% commission). Retail price set by the gallery and the artist. Gallery provides promotion and contract; artist pays shipping costs to and from gallery. Prefers artwork framed.

Submissions Send query letter with résumé, slides, bio and SASE. Call for appointment to show portfolio of originals, photographs, slides and transparencies. Responds in 3 weeks. Files slides, résumé. Finds artists through word of mouth, art publications and sourcebooks, submissions.

MAIN STREET GALLERY

105 Main Street, P.O. Box 161, Groton NY 13073. (607)898-9010. E-mail: maingal@localnet.com. Web site: www.mainstreetgal.com. **Director:** Adrienne Smith. For-profit gallery, art consultancy. Estab. 2003. Exhibits 15 emerging, mid-career and established artists. Sponsors 8 exhibits/year. Average display time 5-6 weeks. Open all year; Thursday/Friday 12-7p.m.; Saturday from 11 to 7 p.m.; Sunday 1-5 p.m; closed January and February. Located in the village of Groton in the Finger Lakes Region of New York, 20 minutes to Ithaca; 900 sq. ft. space. Clients include local community, tourists, upscale. Overall price range $120-5,000.

Media Considers all media. Considers prints, including engravings, etchings, linocuts, lithographs, mezzotints and woodcuts. Most frequently exhibits painting, sculpture, ceramics, prints.

Style Considers all styles and genres.

Terms Artwork is accepted on consignment and there is a 40% commission. Retail price set by the artist. Gallery provides insurance, promotion and contract. Accepted work should be framed, mounted and matted. Requires exclusive representation locally.

Submissions Write to arrange personal interview to show portfolio of photographs and slides. Send query letter with artist's statement, bio, brochure, photographs, résumé, reviews, SASE and slides. Returns material with SASE. Responds to queries only if interested in 4 weeks. Finds artists through art exhibits, portfolio reviews, referrals by other artists, submissions and word of mouth.

Tips 1. After initial submitting of materials, the artist will be set an appointment to talk over work. 2. Slides should be subject matter without background. 3. Artists should send up-to-date résumé and artist's statement.

OXFORD GALLERY

267 Oxford St., Rochester NY 14607. (585)271-5885. Fax: (585)271-2570. E-mail: info@oxfordgallery.com. Web site: www.oxfordgallery.com. **Director:** Erin Tobin. Retail gallery. Estab. 1961. Represents 70 emerging, mid-career and established artists. Sponsors 10 shows/year. Average display time 1 month. Open all year; Tuesday-Friday, 12-5; Saturday, 10-5; and by appointment. Located ''on the edge of downtown; 1,000 sq. ft.; large gallery in a beautiful 1910 building.'' Overall price range $100-30,000; most work sold at $1,000-2,000.

Media Considers oil, acrylic, watercolor, pastel, pen & ink, drawings, mixed media, collage, paper, sculpture, ceramic, fiber, original handpulled prints, woodcuts, engravings, lithographs, wood engravings, mezzotints, serigraphs, linocuts and etchings.

Styles All styles.

Terms Accepts artwork on consignment (50% commission). Retail price set by gallery and artist. Gallery provides promotion and contract.

Submissions Send query letter with résumé, slides, bio and SASE. Responds in 3 months. Files résumés, bios and brochures.

Tips ''Have professional slides done of your artwork. Have a professional résumé and portfolio. Do not show up unannounced and expect to show your slides. Either send in your information or call to make an appointment. An artist should have enough work to have a one-person show (20-30 pieces). This allows an artist to be able to supply more than one gallery at a time, if necessary. It is important to maintain a strong body of available work.''

PORT WASHINGTON PUBLIC LIBRARY

One Library Dr., Port Washington NY 11050. (516)883-4400. Fax: (516)883-7927. **Chair, Art Advisory Council:** Eric Pick. Nonprofit gallery. Estab. 1970. Represents 10-12 emerging, mid-career and established artists/year. 23 members. Exhibited artists include Frank Stella, Robert Dash. Sponsors 10-12 shows/year. Average display time 1 month. Open all year; Monday-Friday, 9-9; Saturday, 9-5; Sunday, 1-5. Located midtown, 972 sq. ft. Overall price range up to $100,000.

Media Considers all media and all types of prints.

Style Exhibits all styles.

Terms Price set by the artist. Gallery provides insurance and promotion.

Submissions Send query letter with résumé, slides, bio, SASE. Responds in 1 month. Artist should call library. Finds artists through word of mouth, referrals by other artists, visiting art fairs and exhibitions and submissions.

PRAKAPAS GALLERY

One Northgate 6B, Bronxville NY 10708. (914)961-5091. Fax: (914)961-5192. E-mail: eugeneprakapas@earthlink.net. Private dealers. Estab. 1976. Represents 50-100 established artists/year. Exhibited artists include Leger and Hodgkin. Located in suburbs. Clients include institutions and private collectors. Overall price range $500-500,000.

Media Considers all media with special emphasis on photography.

Style Exhibits all styles. "Emphasis is on classical modernism."

Submissions Finds artists through word of mouth, visiting art fairs and exhibitions. Does not consider unsolicited material.

SCULPTURECENTER

44-19 Purves St., Long Island City NY 11101. (718)361-1750. Fax: (718)786-9336. E-mail: info@sculpture-center.org. Web site: www.sculpture-center.org. **Executive Director:** Mary Ceruti. Alternative space, nonprofit gallery. Estab. 1928. Exhibits emerging and mid-career artists. Sponsors 8-10 shows/year. Average display time 2-4 months. Open all year; Thursday-Monday, 11-6. Does not actively sell work.

Media Considers drawing, mixed media, sculpture and installation. Most frequently exhibits sculpture, installations and video installations.

Terms Accepts work on consignment (25% commission). Retail price set by the gallery and the artist. Gallery provides promotion; artist pays shipping costs.

Submissions Send query letter with résumé, 10-20 slides, bio and SASE. See Web site.

WINDHAM FINE ARTS

5380 Main Street, Windham NY 12496. (518)734-6850. E-mail: info@windhamfinearts.com. Web site: www.windhamfinearts.com. **Director:** Victoria Alten. For-profit gallery, art consultancy. Estab. 2001. Exhibits around 40 emerging, mid-career and established artists. Exhibited artists include John Greene (modern) and Kevin Cook (Hudson River School). Sponsors 12 exhibits/year. Average display time 1 month. Open all year; Friday-Monday from 11-5; weekends from 11-5. Clients include local community, tourists and upscale. 5% of sales are to corporate collectors. Most work sold at $2,000-10,000.

Media Considers all media. Considers print types including etchings and woodcuts.

Style Exhibits expressionism, impressionism, postmodernism and painterly abstraction. Genres include Americana, figurative work, florals and landscapes.

Terms Artwork is accepted on consignment and there is a 50% commission. Gallery provides insurance, promotion and contract. Accepted work should be framed, mounted and matted. Requires exclusive representation locally.

Submissions Call or write to arrange personal interview to show portfolio of photographs and CDs. Send query letter with artist's statement, bio, photocopies, photographs, résumé, reviews and CD. Responds to queries in 2 weeks. Files name, contact information and images. Finds artists through art exhibits, portfolio reviews, referrals by other artists, submissions and word of mouth.

NEW YORK CITY

AGORA GALLERY

530 West 25th Street, New York NY 10001. (212)226-4151, ext. 206. Fax: (212)966-4380. E-mail: Angela@Agora-Gallery.com. Web site: www.Agora-Gallery.com. **Director:** Angela DiBello. For-profit gallery. Estab. 1984. Approached by 1,500 artists/year. Exhibits 100 emerging, mid-career and established artists. Sponsors 10 exhibits/year. Average display time 3 weeks. Open all year; Tuesday-Saturday, 12-6; weekends, 12-6. Closed national holidays. Located in Soho between Prince and Spring; 2,000 sq. ft. of exhibition space, landmark building;

elevator to gallery, exclusive gallery block. Clients include upscale. 10% of sales are to corporate collectors. Overall price range $550-10,000; most work sold at $3,500-6,500.

Media Considers acrylic, collage, digital, drawing, mixed media, oil, pastel, photography, sculpture, watercolor.

Style Considers all styles.

Terms There is a representation fee. There is a 35% commission to the gallery; 65% to the artist. Retail price set by the gallery and the artist. Gallery provides insurance and promotion. Does not require exclusive representation locally.

Submissions Mail portfolio for review or upload to our Web site. Send artist's statement, bio, brochure, photographs, reviews if available, SASE. Responds in 3 weeks. Files bio, slides/photos and artist statement. Finds artists through word of mouth, submissions, portfolio reviews, art exhibits, referrals by other artists and Web site links.

Tips "Follow instructions!"

THE ARSENAL GALLERY

The Arsenal Bldg., Central Park, New York NY 10021. (212)360-8163. Fax: (212)360-1329. E-mail: adrian.sas@ parks.nyc.gov. Web site: www.nyc.gov/parks. **Public Art Curator:** Adrian Sas. Nonprofit gallery. Estab. 1971. Approached by 100 artists/year. Exhibits 8 emerging, mid-career and established artists. Sponsors 10 exhibits/ year. Average display time 1 month. Open all year; Monday-Friday, 9-5. Closed holidays and weekends. 100 linear feet of wall space on the 3rd floor of the Administrative Headquarters of the Parks Department located in Central Park. Clients include local community, students, tourists and upscale. Overall price range $100-1,000.

Media Considers all media and all types of prints except 3-dimensional work.

Style Considers all styles. Genres include florals, landscapes and wildlife.

Terms Artwork is accepted on consignment and there is a 15% commission. Retail price set by the artist. Gallery provides promotion. Does not require exclusive representation locally.

Submissions Mail portfolio for review. Send query letter with artist's statement, bio, brochure, business card, photocopies, résumé, reviews and SASE. Returns material with SASE. Responds only if interested within 6 months. Files résumé and photocopies. Finds artists through word of mouth, portfolio reviews, art exhibits and referrals by other artists.

Tips Appear organized and professional.

ASIAN AMERICAN ARTS CENTRE

26 Bowery, New York NY 10013. (212)233-2154. Fax: (212)766-1287. E-mail: aaartsctr@aol.com. **Executive Director:** Robert Lee. Nonprofit gallery. Estab. 1974. Exhibits the work of emerging and mid-career artists; 1,100 artists in archives file. Sponsors 5 shows/year. Average display time 5-6 weeks. Open September through June. Located in Chinatown; 1,800 sq. ft.; "a gallery and a research facility." 100% of space for special exhibitions. Overall price range $500-10,000; most work sold at $500-3,000.

Media Considers all media and all types of prints. Prefers paintings, installation and mixed media.

Style Exhibits all styles and genres. Focuses on contemporary Asian, Asian American and American artists with strong Asian influences. Has a permanent historical archive of such.

Terms Suggests a donation of 30% of the selling price. Retail price set by the artist. Gallery provides insurance and promotion. Shipping costs are shared. Prefers artwork framed.

Submissions Send query letter with résumé and slides for permanent Asian American Artists Archive. Do not send original slides. Will call artists in summer if selected for Annual Show. Portfolio should include slides. Files slides.

ATLANTIC GALLERY

40 Wooster St., 4th Floor, New York NY 10013. (212)219-3183. Web site: www.atlanticgallery.org. Cooperative gallery. **President:** Pamela Talese. Estab. 1974. Approached by 50 artists/year. Represents 40 emerging, mid-career and established artists. Exhibited artists include Carol Hamann (watercolor); Sally Brody (oil, acrylic); Richard Lincoln (oil). Average display time 3 weeks. Open Tuesday-Saturday, 12-6. Closed August. Located in Soho. Has kitchenette. Clients include local community, tourists and upscale. 2% of sales are to corporate collectors. Overall price range $100-13,000; most work sold at $1,500-5,000.

Media Considers all media. Considers all types of prints. Most frequently exhibits watercolor, acrylic and oil.

Style Considers all styles and genres. Most frequently exhibits impressionism, realism, imagism.

Terms Artwork is accepted on consignment and there is a 20% commission. There is a co-op membership fee plus a donation of time. There is a 10% commission. Rental fee for space covers 3 weeks. Retail price set by the artist. Gallery provides promotion and contract. Accepted work should be framed. Does not require exclusive representation locally. Prefers only East Coast artists.

Submissions Call or write to arrange a personal interview to show portfolio of slides. Send query letter with artist's statement, bio, brochure, SASE and slides. Returns material with SASE. Responds in 2 weeks. Files only

Steve Diamant

Welcome to my gallery

Galleries

L ocated in Soho in New York, nationally renowned art gallery, Arcadia, is the brainchild of Steve Diamant, a creative visionary who has an unerring eye for picking winners and a reputation for staging exciting events featuring extraordinary artwork, where you might spot celebrities such as Brooke Shields or RuPaul.

After graduating with an advertising degree from Syracuse University, Diamant immediately started working for an arts and entertainment public relations firm. "One of the clients I worked with happened to be the famous printer, Eleanor Ettinger, a brilliant, classy woman with a great eye for art," he says. "At some point, I persuaded her to open a street level art gallery and focus on the retail aspect of the business—selling art."

The gallery became a tremendous success. Ettinger appreciated Diamant's enthusiam and the fact that he brought high profile artists into her gallery. "She was a terrific mentor who taught me how to work with artists and collectors and helped me realize that how you treat people is how you will be treated."

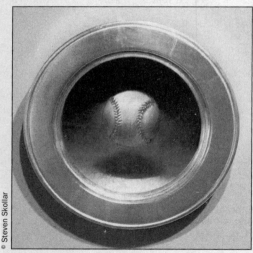

© Steven Skollar

Arcadia Gallery is known for showing unusual paintings. The baseball in Steven Skollar's oil on panel, "American Icon," appears to be headed straight toward the viewer.

Why did you decide to open your own gallery, Arcadia?

It seems that I've always had an appreciation for art and artists, mostly because my mother took me to museums when I was a child. A former art student, she wanted to instill a love of art in her children.

My association with Eleanor Ettinger lasted a wonderful 14 years, but it was time to move on and take control of my own destiny. In the autumn of 2000, I started to look for a gallery space of my own and had started to talk to many painters who had never shown in New York before and told them of my plans to open my own gallery. I wanted the gallery to be a place that wasn't subjected to whims or trends in the art world. Five years later, I hope that is what we have achieved. I would like to think that the works by the artists we represent will still be valid 10, 20, 30 or more years from now.

Steve Diamant's gallery, Arcadia, often attracts art lovers with familiar faces who feel very much at home there—possibly because everyone's looking at the artwork and not at them for a change. Here Diamant poses with Sarah Jessica Parker and Kristen Davis at an opening at his Soho Gallery.

What's your overview of the market for contemporary art?

The artworld in general never ceases to amaze me. When I look at the work that sells in galleries, from the fun and commercial works to the unbelievably avant-garde, I can't help but be amazed. What people buy, why they buy it, what it is about certain works that, move them. It's infinitely fascinating.

Many people get upset when they see a pile of paper cups sell for tens of thousands of dollars, but I try to see beyond that and understand why someone bought it, what the gallery owner could have said or what the artist's statement was. There's room for everyone and not one is better than another.

What is the best way to approach a gallery?

The first bit of advice is to find out what the submission policy is for the gallery. Call and politely ask if the gallery is accepting submissions and what is the policy and/or procedure. Nothing is more annoying than someone sending an elaborate presentation and not including a SASE for the return of the materials. If I did not ask to see their work, what makes someone think that I'm going to pay to return it to them?

If you're going to be working with a gallery, speak with the other artists who are represented by the gallery. Find out what it's like working with the gallery. Do the artists feel that they are being properly represented? Are they paid on time? Like any relationship, you should know what you are getting into. In addition, get everything in writing. Does the gallery give you a receipt for works you provided to them? Would you just hand over works to a stranger without having a list of everything you are giving them? It may be the art world, but it's still a business. Act like a business person *and* an artist. One is not mutually exclusive of the other.

Hypothetically speaking, how do you decide?

I get asked that question a lot. My answer is that I am looking for *what I don't have.* Hypothetically, if I already have a terrific artist who creates Dutch inspired still-lifes, why would I want another? I'm looking to provide as wide a range as possible within the genre I have decided to focus on. Remember, this is a business and decisions on what gets represented by a gallery are, hopefully, made for business reasons rather than personal

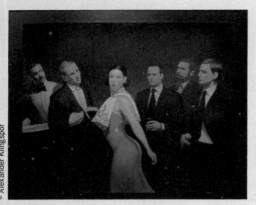

© Alexander Klingspor

Alexander Klingspor's work is so collectible, his shows sell-out before the opening according to Arcadia's Steve Diamant. Collectors cannot wait for him to come out with a new painting. His work often features demanding divas and fascinated admirers, as is evident in the above painting entitled, "Diva."

ones. Look at who the gallery exhibits. Are you as skilled as those artists? Do you have your own "signature style," that will set you apart from all of the other artists who are being shown there? It's a little bit of tough love, but grow up and really try to look at your work objectively.

Could you give us more straightforward advice and practical tips concerning conduct, slides and contracts?

Know what the focus of the gallery is. Do you fit in? Make your presentation professional. Nothing is more amateurish than a bunch of unlabeled photos thrown into an envelope and a note that says, "Call me if you're interested." That's lame and unprofessional. Call the gallery and find out how they look at works. We do not review CDs (why would I put a CD in my computer if I don't know what's on it?) I cannot tell you how many CDs we've received and never looked at. Contracts are great, but many galleries don't use them. I suggest that artists provide one if the gallery doesn't. It should state the agreed upon prices, how long the work is placed with the gallery, how long after the sale of the work is the artist to be paid, etc. This is a business—treat it that way. Make sure everything is spelled out, so it's all there in writing and nothing can be misinterpreted.

—*Elizabeth Exler*

accepted work. Finds artists through word of mouth, submissions, art exhibits and referrals by other artists.
Tips Submit an organized folder with slides, bio, and 3 pieces of actual work; if we respond with interest, we then review again.

BLUE MOUNTAIN GALLERY
530 W. 25th St., New York NY 10001. (646)486-4730. Fax: (646)486-4345. Web site: www.artincontext.org/new_york/blue_mountain_gallery/. **Contact:** Marcia Clark. Artist-run cooperative gallery. Estab. 1980. Exhibits 32 mid-career artists. Sponsors 13 solo and 1 group shows/year. Display time is 3 weeks. "We are located on the 4th floor of a building in Chelsea. We share our floor with two other well-established cooperative galleries. Each space has white partitioning walls and an individual floor-plan." Clients include art lovers, collectors and artists. 90% of sales are to private collectors, 10% corporate clients. Overall price range: $100-8,000; most work sold at $100-4,000.
Media Considers painting, drawing and sculpture.
Style "The base of the gallery is figurative but we show work that shows individuality, commitment and involvement with the medium."
Terms Co-op membership fee plus donation of time. Retail price set by artist. Exclusive area representation not required. Gallery provides insurance, some promotion and contract; artist pays for shipping.
Submissions Send name and address with intent of interest and sheet of 20 good slides. "We cannot be responsible for material return without SASE." Finds artists through artists' submissions and referrals.
Tips "This is a cooperative gallery it is important to represent artists who can contribute actively to the gallery. We look at artists who can be termed local or in-town more than out-of-town artists and would choose the former over the latter. The work should present a consistent point of view that shows individuality. Expressive use of the medium used is important also."

CITYARTS, INC.
525 Broadway, Suite 700, New York NY 10012. (212)966-0377. Fax: (212)966-0551. E-mail: tsipi@cityarts.org. Web site: www.cityarts.org. **Executive and Artistic Director:** Tsipi Ben-Haim. Art consultancy, nonprofit public

art organization. Estab. 1968. Represents 1,000 emerging, mid-career and established artists. Produces 4-8 projects/year. Average display time varies."A mural or public sculpture will last up to 15 years." Open all year; Monday-Friday, 10-5. Located in Soho; "the city is our gallery. CityArts's 200 murals are located in all 5 boroughs on NYC. We are funded by foundations, corporations, government and membership ('Friends of CityArts')."

Media Considers oil, acrylic, drawing, sculpture, mosaic and installation. Most frequently exhibits murals (acrylic), mosaics and sculpture.

Style Produces all styles and all genres depending on the site.

Terms Artist receives a flat commission for producing the mural or public art work. Retail price set by the gallery. Gallery provides insurance, promotion, contract, shipping costs.

Submissions "We prefer New York artists due to constant needs of a public art work created in the city." Send query letter with SASE. Call for appointment to show portfolio of originals, photographs and slides. Responds in 1 month. "We reply to original query with an artist application. Then it depends on commissions." Files application form, résumé, slides, photos, reviews. Finds artists through recommendations from other art professionals.

Tips "We look for artists who are dedicated to making a difference in people's lives through art, working in collaboration with schools and community members."

CLAMPART

531 W. 25th Street, New York NY 10001. E-mail: info@clampart.com. Web site: www.clampart.com. **Director:** Brian Paul Clamp. For-profit gallery. Estab. 2000. Approached by 1200 artists/year. Represents 15 emerging, mid-career and established artists. Exhibited artists include Arthur Tress (photography), and John Dugdale (photography). Sponsors 6-8 exhibits/year. Average display time 5 weeks. Open Tuesday-Saturday from 11 to 6; closed last two weeks of August. Located on the ground floor on Main Street in Chelsea. Small exhibition space. Clients include local community, tourists and upscale. 5% of sales are to corporate collectors. Overall price range $300-50,000; most work sold at $2,000.

Media Considers acrylic, collage, drawing, mixed media, oil, paper, pastel, pen & ink and watercolor. Considers all types of prints. Most frequently exhibits photo, oil and paper.

Style Exhibits conceptualism, geometric abstraction, minimalism and postmodernism. Considers genres including figurative work, florals, landscapes and portraits. Most frequently exhibits postmodernism, conceptualism and minimalism.

Terms Artwork is accepted on consignment and there is a 50% commission. Retail price set by the gallery. Gallery provides insurance, promotion and contract. Accepted work should be framed, mounted and matted. Does not require exclusive representation locally.

Submissions E-mail query letter with artist's statement, bio and JPGS. Cannot return material. Responds to queries in 2 weeks. Files JPGS. Finds artists through portfolio reviews, referrals by other artists and submissions.

Tips "Include a bio and well-written artist statement. Do not submit work to a gallery that does not handle the general kind of work you produce."

THOMAS ERBEN GALLERY

516 W. 20th St., New York NY 10011. (212)645-8701. Fax: (212)941-4158. E-mail: info@thomaserben.com. Web site: www.thomaserben.com. For-profit gallery. Estab. 1996. Approached by 100 artists/year. Represents 15 emerging, mid-career and established artists. Exhibited artists include Preston Scott Cohen (architecture) and Tom Wood (photography). Average display time 5-6 weeks. Open all year; Tuesday-Saturday, 10-6. Closed Christmas/New Year's and August. Clients include local community, tourists and upscale.

Media Considers all media. Most frequently exhibits photography, paintings and installation.

Style Exhibits contemporary art.

Submissions Mail portfolio for review. Returns material with SASE. Responds in 1 month.

GALE-MARTIN FINE ART

134 Tenth Ave., New York NY 10011. (646)638-2525. Fax: (646)486-7457. Web site: www.gale-martinfineart.com. For-profit gallery. Estab. 1993. Exhibits mid-career and established artists. Exhibited artists include D. Hamilton, Caranda-Martin and Francine Tint. Average display time 5 weeks. Open all year; Tuesday-Saturday, 11-6. Closed August and Christmas week. Located on ground floor space on Tenth Ave. in the Chelsea art district of Manhattan; 2,200 sq. ft./sky lights. Clients include upscale. Overall price range $2,500-150,000; most work sold at $15,000.

Media Considers acrylic, drawing, oil and paper. Most frequently exhibits paintings of all types.

Style Exhibits neo-expressionism and painterly abstraction.

Terms Artwork is accepted on consignment and there is a 50% commission. Retail price set by the gallery and the artist. Gallery provides insurance. Accepted work should be framed according to our specifications. Requires

exclusive representation locally. "We do not accept emerging artists, will consider artists with a strong following only."

Submissions Cannot return material. Responds only if interested within 3 months. Finds artists through word of mouth and referrals by other artists.

GALLERY 10

7 Greenwich Ave., New York NY 10014. (212)206-1058. E-mail: marcia@gallery10.com. Web site: www.gallery 10.com. **Director:** Marcia Lee Smith. Retail gallery. Estab. 1972. Open all year. Represents approximately 150 emerging and established artists. 100% of sales are to private collectors. Overall price range $24-1,000; most work sold at $50-300.

Media Considers ceramic, craft, glass, wood, metal and jewelry.

Style "The gallery specializes in contemporary American crafts."

Terms Accepts work on consignment (50% commission); or buys outright for 50% of retail price (net 30 days). Retail price set by gallery and artist.

Submissions Call or write for appointment to show portfolio of originals, slides, transparencies or photographs.

SANDRA GERING GALLERY

534 W. 22nd St., New York NY 10011. (646)336-7183. Fax: (646)336-7185. E-mail: sandra@geringgallery.com. Web site: www.geringgallery.com. **Director:** Marianna Baer. For-profit gallery. Estab. 1991. Approached by 240 artists/year. Exhibits 12 emerging, mid-career and established artists. Exhibited artists include John F. Simon, Jr., computer software panels; Xavier Veilhan, electronic sculpture and digital photography. Sponsors 9 exhibits/year. Average display time 5 weeks. Open all year; Tuesday-Saturday, 10-6; weekends, 10-6. Located on ground floor; 600 sq. ft. of storefront space.

Media Considers mixed media, oil, sculpture and hightech/digital. Most frequently exhibits computer-based work, electric (light) sculpture and video/DVD.

Style Exhibits geometric abstraction. Most frequently exhibits cutting edge.

Terms Artwork is accepted on consignment.

Submissions Send e-mail query with link to Web site and JPEGs. Cannot return material. Responds only if interested within 6 months. Finds artists through word of mouth, art exhibits, art fairs and referrals by other artists.

Tips Most important is to research the galleries and only submit to those that are appropriate. Visit Web sites if you don't have access to galleries. "We don't exhibit traditional, figurative painting or sculpture."

O.K. HARRIS WORKS OF ART

383 W. Broadway, New York NY 10012. (212)431-3600. Fax: (212)925-4797. E-mail: okharris@okharris.com. Web site: www.okharris.com. **Director:** Ivan C. Karp. Commercial exhibition gallery. Estab. 1969. Represents 55 emerging, mid-career and established artists. Sponsors 50 solo shows/year. Average display time 1 month. Open Tuesday-Saturday, 10-6; in June, Tuesday-Friday 10-6; Saturday by appointment; in July, Tuesday-Friday, 12-5; closed all of August and December 24th-January 3rd. "Four separate galleries for four separate one-person exhibitions. The back room features selected gallery artists which also change each month." 90% of sales are to private collectors, 10% corporate clients. Overall price range $50-250,000; most work sold at $12,500-100,000.

Media Considers all media. Most frequently exhibits painting, sculpture and photography.

Style Exhibits realism, photorealism, minimalism, abstraction, conceptualism, photography and collectibles. Genres include landscapes, Americana but little figurative work. "The gallery's main concern is to show the most significant artwork of our time. In its choice of works to exhibit, it demonstrates no prejudice as to style or materials employed. Its criteria demands originality of concept and maturity of technique. It believes that its exhibitions have proven the soundness of its judgment in identifying important artists and its pertinent contribution to the visual arts culture."

Terms Accepts work on consignment (50% commission). Retail price set by gallery. Customer discounts and payment by installment are available. Exclusive area representation required. Gallery provides insurance and limited promotion. Prefers artwork ready to exhibit.

Submissions Send query letter with 1 sheet of slides (20 slides) "labeled with size, medium, etc." and SASE. Responds in 1 week.

Tips "We suggest the artist be familiar with the gallery's exhibitions and the kind of work we prefer to show. Visit us either in person or online at www.okharris.com. Always include SASE." Common mistakes artists make in presenting their work are "poor, unmarked photos (size, material, etc.), submissions without return envelope, inappropriate work. We affiliate about one out of 10,000 applicants."

JEANETTE HENDLER

55 E. 87th St., Suite 15E, New York NY 10128. (212)860-2555. Fax: (212)360-6492. Art consultancy. Exhibits established artists. Exhibited artists include Warhol, DeKooning and Haring. Open all year by appointment. Located uptown. 50% of sales are to private collectors, 50% corporate collectors.

Media Considers oil and acrylic. Most frequently exhibits oils, acrylics and mixed media.

Style Exhibits Considers all styles. Genres include landscapes, florals, figurative and Latin. Prefers realism, classical, neo classical, pre-Raphaelite, still lifes and florals.

Terms Artwork is accepted on consignment and there is a commission. Retail price set by the gallery and the artist. Gallery provides insurance, promotion and contract.

Submissions Finds artists through word of mouth, referrals by other artists, visiting art fairs and exhibitions.

HOORN-ASHBY GALLERY

766 Madison Avenue, New York NY 10021. (212)628-3199. Fax: (212)861-8162. E-mail: info@hoornashby.com. Web site: www.hoornashby.com. For-profit gallery. Estab. 1990. Approached by 100 artists/year. Exhibits 25 emerging, mid-career and established artists. Exhibited artists include Donald Jurney (oil/canvas) and Janet Rickus (oil/panel). Sponsors 8 exhibits/year. Average display time for solo shows is 3 weeks. Open September-July, Monday-Saturday 10-6. Closed August and all Sundays, and reduced hours in July. Located on 2nd floor, 766 Madison, Brownstone width and length. Clients include local community, tourists and upscale. 5% of sales are to corporate collectors. Overall price range $3,000-80,000; most work sold at $10,000.

Media Considers drawing, oil, sculpture, watercolor and tempera. Types of prints include etchings, lithographs and mezzotints. Most frequently exhibits tempera and oil.

Style Exhibits impressionism and realism. Genres include figurative work, florals, landscapes, wildlife and still life.

Terms Artwork is accepted on consignment. Retail price set by the artist. Gallery provides insurance and promotion. Accepted work should be framed. Requires exclusive representation locally.

Submissions Mail portfolio for review with artist's statement, bio, brochure, photocopies, photographs, résumé, reviews, SASE, slides and retail prices. Responds to queries in 6 weeks to 3 months. Files copies of bio and show invites only if interested for feature. Finds artists through art fairs, art exhibits, portfolio reviews, referrals by other artists, submissions and word of mouth.

Tips "Include return envelope, other show invitations and retail prices of work."

HAL KATZEN GALLERY

459 Washington Street, New York NY 10013. (212)925-9777. E-mail: hkatzen916@aol.com. For-profit gallery. Estab. 1984. Exhibits established artists. Open Monday-Friday from 10-6, closed August. Clients include local community, tourists and upscale. 10-20% of sales are to corporate collectors. Overall price range $2,000-20,000; most work sold at $5,000.

Media Considers acrylic, collage, drawing, oil, paper, pen & ink, sculpture and watercolor. Most frequently exhibits paintings, works on paper and sculpture. Considers all types of prints.

Style Considers all styles and genres.

Terms Artwork is accepted on consignment or is bought outright. Accepts only established artists.

THE JOE & EMILY LOWE ART GALLERY AT HUDSON GUILD

441 W. 26th St., New York NY 10001. (212)760-9837. E-mail: jfurlong@hudsonguild.org. **Director:** Jim Furlong. Nonprofit gallery. Estab. 1948. Represents emerging, mid-career, community-based and established artists. Sponsors 8 shows/year. Average display time 6 weeks. Open all year. Located in West Chelsea; 1,200 sq. ft.; a community center gallery in a New York City neighborhood. 100% of space for special exhibitions. 100% of sales are to private collectors.

Media Considers oil, acrylic, watercolor, pastel, pen & ink, drawings, mixed media, collage, paper, sculpture, original handpulled prints, woodcuts, wood engravings, linocuts, engravings, mezzotints, etchings, lithographs, pochoir and serigraphs. Most frequently exhibits paintings, sculpture and graphics. Looking for artist to do an environmental "installation."

Style Exhibits all styles and genres.

Terms Accepts work on consignment (20% commission). Retail price set by artist. Gallery provides insurance; artist pays for shipping. Prefers artwork framed.

Submissions Send query letter, résumé, slides, bio and SASE. Portfolio should include photographs and slides. Responds in 1 month. Finds artists through visiting exhibitions, word of mouth, various art publications and sourcebooks, artists' submissions/self-promotions, art collectors' referrals.

Tips "Medium or small works by emerging artists are more likely to be shown in group shows than large work."

THE MARBELLA GALLERY, INC.

28 E. 72nd St., New York NY 10021. (212)288-7809. Fax: (212)288-7810. **President:** Mildred Thaler Cohen. Retail gallery. Estab. 1971. Represents/exhibits established artists of the nineteenth century. Exhibited artists include The Ten and The Eight. Sponsors 1 show/year. Average display time 6 weeks. Open all year; Tuesday-Saturday, 11-5:30. Located uptown; 750 sq. ft. 100% of space for special exhibitions. Clients include tourists and upscale. 50% of sales are to private collectors, 10% corporate collectors, 40% dealers. Overall price range $1,000-60,000; most work sold at $2,000-4,000.
Style Exhibits expressionism, realism and impressionism. Genres include landscapes, florals, Americana and figurative work. Prefers Hudson River, ''The Eight'' and genre.
Terms Artwork is bought outright. Retail price set by the gallery. Gallery provides insurance.

JAIN MARUNOUCHI GALLERY

24 W. 57th St., New York NY 10019. (212)969-9660. Fax: (212)969-9715. E-mail: jainmar@aol.com. Web site: www.jainmargallery.com. **President:** Ashok Jain. Retail gallery. Estab. 1991. Represents 30 emerging artists. Exhibited artists include Fernando Pomalaza and Pauline Gagnon. Open all year; Tuesday-Saturday, 11-5:30. Located in New York Gallery Bldg., 800 sq. ft. 100% of space for special exhibitions. Clients include corporate and designer. 50% of sales are to private collectors, 50% corporate collectors. Overall price range $1,000-20,000; most work sold at $5,000-10,000.
Media Considers oil, acrylic and mixed media. Most frequently exhibits oil, acrylic and collage.
Style Exhibits painterly abstraction. Prefers abstract and landscapes.
Terms Accepts work on consignment (50% commission). Retail price set by artist. Offers customer discount. Gallery provides contract; artist pays for shipping costs. Prefers artwork framed.
Submissions Send query letter with résumé, brochure, slides, reviews and SASE. Portfolio review requested if interested in artist's work. Portfolio should include originals, photographs, slides, transparencies and reviews. Responds in 1 week. Finds artists through referrals and promotions.

MULTIPLE IMPRESSIONS, LTD.

41 Wooster St., New York NY 10013. (212)925-1313. Fax: (212)431-7146. E-mail: info@multipleimpressions.com. Web site: www.multipleimpressions.com. **Contact:** Director. Estab. 1972. For-profit gallery. Approached by 100 artists/year. Represents 50 emerging, mid-career and established artists. Sponsors 5 exhibits/year. Average display time is 2 weeks. Open Tuesday-Saturday from 11 to 6:30; Sundays from 12 to 6:30; Monday 11-5:30; closed December 29-January 5. Located in the center of Soho, street level, 1,400 sq. ft. mezzanine and full basement. Clients: local community, tourists and upscale. 10% of sales are to corporate collectors. Overall price range $500-40,000; most work sold at $1,500.
Media Considers oil and pastel and prints of engravings, etchings, lithographs and mezzotints. Most frequently exhibits etchings, oils and pastels.
Styles Exhibits imagism and painterly abstraction. Genres include figurative work, landscapes and abstract.
Terms Artwork is accepted on consignment and there is a 50% commission. Retail price set by the gallery and the artist. Requires exclusive representation locally.
Submissions Send query letter with artist's statement, bio, photocopies, photographs, résumé, SASE, slide and price list. Returns material with SASE. Responds to queries in 1 week. Finds artists through art fairs, portfolio reviews, referrals by other artists, submissions, word of mouth and travel.

ANNINA NOSEI GALLERY

530 W. 22nd St., 2nd Floor, New York NY 10011. (212)741-8695. Fax: (212)741-2379. Estab. 1980. Exhibits emerging artists. Exhibited artists include Federico Uribe, sculptor; and Heidi McFall, works on paper. Open all year; Tuesday-Saturday, 11-6. Closed Christmas week and August. Located in Chelsea; includes 2 exhibition spaces. Clients include local community and upscale. Overall price range $5,000-15,000; most work sold at $10,000.
Media Considers all media. Most frequently exhibits paintings.
Style Considers all styles and genres.
Submissions Mail portfolio for review. Send query letter with artist's statement, reviews, SASE and images.

THE PAINTING CENTER

52 Greene St., New York NY 10013. (212)343-1060. E-mail: paintingcenter@aol.com. Web site: www.thepaintingcenter.com. **Contact:** Christina Chow, administrative director. Nonprofit, cooperative gallery. Estab. 1993. Exhibits emerging mid-career and established artists. Open all year; Tuesday-Saturday, 11-6; weekends, 11-6. Closed Thanksgiving, Christmas/New Year's Day. Clients include artists, local community, students, tourists and upscale businessmen.

Media Considers all media except sculpture, photographs and some installations. Most frequently exhibits paintings in oil, acrylic and drawings.
Style Considers all styles and genres.
Terms There is a 20% commission. Retail price set by the artist. Accepted work should be framed and mounted. Does not require exclusive representation locally.
Submissions Mail portfolio for review. Send artist's statement, bio, résumé, SASE and slides. Returns material with SASE. responds in 8 months. Finds artists through word of mouth, submissions, art exhibits and referrals by other artists and curators.
Tips "Submit a letter addressed to the 'review committee,' a sheet of slides of your work, SASE, résumé, and publications/reviews about your work if you have any."

SCOTT PFAFFMAN GALLERY
35 E. First St., New York NY 10003. **Contact:** Scott Pfaffman, director. Estab. 1996. Exhibits emerging, mid-career and established artists. Approached by 20 artists/year. Very small exhibition space. Clients include local community, collectors and artists. Overall price range $100-5,000; most work sold at $300-500.
Media Considers installation art, film, video, photography.
Style Considers all styles.
Terms Artwork is accepted on consignment and there is a 40% commission. Retail price of the art set by the the artist. Gallery provides promotion and contract. Does not require exclusive representation locally.
Submissions Write to arrange a personal interview to show portfolio of photographs, slides and transparencies or send query letter with photographs, reviews and SASE. Returns material with SASE. Responds to queries only if interested within 2 months. Finds artists through referrals by other artists.

THE PHOENIX GALLERY
210 11th Ave. at 25th St., Suite 902, New York NY 10001. (212)226-8711. E-mail: info@phoenix-gallery.com. Web site: www.phoenix-gallery.com. **Director:** Linda Handler. Nonprofit gallery. Estab. 1958. Exhibits the work of emerging, mid-career and established artists. 32 members. Exhibited artists include Gretl Bauer and Jae Hi Ahn. Sponsors 10-12 shows/year. Average display time 1 month. Open fall, winter and spring. Located in Chelsea; 180 linear ft. "We are in a landmark building in Soho, the oldest co-op in New York. We have a movable wall which can divide the gallery into two large spaces." 100% of space for special exhibitions. 75% of sales are to private collectors, 25% corporate clients, also art consultants. Overall price range $50-20,000; most work sold at $300-10,000.
 • The Phoenix Gallery actively reaches out to the members of the local community, scheduling juried competitions, dance programs, poetry readings, book signings, plays, artists speaking on art panels and lectures. A special exhibition space, The Project Room, has been established for guest-artist exhibits.
Media Considers oil, acrylic, watercolor, pastel, pen & ink, drawings, mixed media, collage, works on paper, sculpture, ceramic, photography, original handpulled prints, woodcuts, engravings, wood engravings, linocuts, etchings and photographs. Most frequently exhibits oil, acrylic and watercolor.
Style Exhibits painterly abstraction, minimalism, realism, photorealism, hard-edge geometric abstraction and all styles.
Terms Co-op membership fee plus donation of time for active members, not for in-active or associate members, (25% commission). Retail price set by gallery. Offers customer discounts and payment by installment. Gallery provides promotion and contract; artist pays for shipping. Prefers artwork framed.
Submissions Send query letter with résumé, slides and SASE. Call for appointment to show portfolio of slides. Responds in 1 month. Only files material of accepted artists. The most common mistakes artists make in presenting their work are "incomplete résumés, unlabeled slides and an application that is not filled out properly. We find new artists by advertising in art magazines and art newspapers, word of mouth, and inviting artists from our juried competition to be reviewed for membership." All information about the gallery can be downloaded from the gallery's www.phoenix-gallery.com.
Tips "Come and see the gallery—meet the director."

RAYDON GALLERY
1091 Madison Ave., New York NY 10028. (212)288-3555. **Director:** Alexander R. Raydon. Retail gallery. Estab. 1962. Represents established artists. Sponsors 12 group shows/year. Clientele tri-state collectors and institutions (museums). Overall price range $100-100,000; most work sold at $1,800-4,800.
Media Considers all media. Most frequently exhibits oil, prints and watercolor.
Style Exhibits all styles and genres. "We show fine works of arts in all media, periods and schools from the Renaissance to the present with emphasis on American paintings, prints and sculpture." Interested in seeing mature works of art of established artists or artist's estates.
Terms Accepts work on consignment or buys outright.

Tips "Artists should present themselves in person with background back-up material (bios, catalogs, exhibit records and original work, slides or photos). Join local, regional and national art groups and associations for grants exposure, review, criticism and development of peers and collectors."

ANITA SHAPOLSKY GALLERY

152 E. 65th St., (patio entrance), New York NY 10021. (212)452-1094. Fax: (212)452-1096. E-mail: ashapolsky@ nyc.rr.com. Web site: www.anitashapolskygallery.com. For-profit gallery. Estab. 1982. Exhibits established artists. Exhibited artists include Ernest Briggs, painting; Michael Loew, painting ; Buffie Johnson, painting; William Manning, painting; Clement Meadmore, sculpture; Betty Parsons, painting and sculpture and others. Open all year; Wednesday-Saturday, 11-6. Call for summer hours. Clients include local community and upscale.
Media Considers acrylic, collage, drawing, mosaic, mixed media, oil, paper, sculpture, etchings, lithographs, serigraphs. Most frequently exhibits oil, acrylic and sculpture.
Style Exhibits expressionism and geometric abstraction and painterly abstraction.
Terms Prefers only 1950s and 1960s abstract expressionism.
Submissions Mail portfolio for review in May and October only. Send query letter with artist's statement, bio, SASE and slides. Returns material with SASE.

ST. MARK'S CHURCH

Kiboko Projects, 131 E. Tenth St., New York NY 10003. (212)674-6377. Fax: (212)219-3588. E-mail: kibokoprojec ts@msn.com. Web site: www.kiboko.org. **Director:** Mark Scheflen. Alternative space, nonprofit gallery specializing in cultural exchange projects involving youth, adults and intergeneration between Africa, Russia and the USA; projects consist of multimedia, photography, video and film, sculpture and other forms of visual arts. Estab. 1994. Approached by 100 artists/year. Represents 10-50 established artists. Sponsors 1 exhibit/year. Average display time 1-2 months. Open all year; Saturday-Sunday, 3:30-6:30. Closed Easter and Christmas. Located in downtown New York City; 40×60 wood floors; ideal lighting. Clients include local community and students.
Media Considers all media. Most frequently exhibits multimedia exhibits. Considers engravings, etchings, linocuts, lithographs, mezzotints and woodcuts.
Style Considers all styles and genres.
Terms Artwork is accepted on consignment. Retail price set by the artist. Gallery provides insurance, promotion and contract. Accepted work should be framed and matted. Does not require exclusive representation locally. Professionals only.
Submissions Write to arrange a personal interview to show portfolio. Send query letter with artist's statement, bio, photographs, résumé and slides. Returns material with SASE. Reponds only if interested within 2 months. Files résumé and statement. Finds artists through word of mouth, art exhibits, and referrals by other artists.
Tips "Submit clear, concise artist and project statements."

JOHN SZOKE EDITIONS

591 Broadway, 3rd Floor, New York NY 10012. (212)219-8300. Fax: (212)219-0864. E-mail: info@johnszokeediti ons.com. Web site: www.johnszokeeditions.com. **President:** John Szoke. Retail gallery and art dealer/publisher. Estab. 1974. Contemporary artists include: Christo, Jim Dine, Janet Fish, Helen Frankenthaler, Richard Haas, Jasper Johns, Alex Katz, Ellsworth Kelly, Jeff Koons, Peter Milton, Robert Rauschenberg, Larry Rivers, Frank Stella and Donald Sultan. Modern Masters include: Picasso, Jean Cocteau and Matisse. Catalogues Raisonne Published: Janet Fish, Richard Haas and Jeannette Pasin Sloan. Open all year. Located downtown in Soho. Clients include other dealers and collectors. 20% of sales are to private collectors.

TIBOR DE NAGY GALLERY

724 Fifth Ave., New York NY 10019. (212)262-5050. Fax: (212)262-1841. **Owners:** Andrew H. Arnot and Eric Brown. Retail gallery. Estab. 1950. Represents emerging and mid-career artists. Exhibited artists include Jane Freilicher, Estate of Nell Blaine, Robert Berlind, George Nick, David Kapp and Estate of Rudy Burckhardt. Sponsors 12 shows/year. Average display time 1 month. Closed August. Located midtown; 3,500 sq. ft. 100% of space for work of gallery artists. 60% private collectors, 40% corporate collectors. Overall price range $1,000-100,000; most work sold at $5,000-20,000.
 • The gallery focus is on painting within the New York school traditions and photography.
Media Considers oil, pen & ink, paper, acrylic, drawings, sculpture, watercolor, mixed media, pastel, collage, etchings, and lithographs. Most frequently exhibits oil/acrylic, watercolor and sculpture.
Style Exhibits representational work as well as abstract painting and sculpture. Genres include landscapes and figurative work. Prefers abstract, painterly realism and realism.
Submissions Gallery is not looking for submissions at this time.

VIRIDIAN ARTISTS INC.
530 W. 25th St., Suite 407, New York NY 10001-5546. (212)245-2882. E-mail: info@viridianartists.com. Web site: www.viridianartists.com. **Director:** Vernita Nemec. Unique gallery. Estab. 1970. Exhibits the work of 35 emerging, mid-career and established artists. Sponsors 13 solo and 2 group shows/year. Average display time 3 weeks. Clients include consultants, corporations, private collectors. 50% of sales are to private collectors, 50% corporate clients. Overall price range $500-20,000; most work sold at $1,000-8,000.
Media Considers oil, acrylic, watercolor, pastel, pen & ink, drawings, mixed media, collage, works on paper, sculpture, installation, photography and limited edition prints. Most frequently exhibits works on canvas, sculpture, mixed media, works on paper and photography.
Style Exhibits hard-edge geometric abstraction, color field, painterly abstraction, conceptualism, postmodern works, primitivism, photorealism, abstract, expressionism, and realism. Eclecticism is Viridian's policy. The only unifying factor is quality. Work must be of the highest technical and aesthetic standards.
Terms Accepts work on consignment (30% commission). Retail price set by gallery and artist. Sometimes offers customer discounts and payment by installment. Exclusive area representation not required. Gallery provides promotion, contract and representation.
Submissions Send query letter, slides or call ahead for information on procedure. Portfolio review requested if interested in artist's work.
Tips "Artists often don't realize that they are presenting their work to an artist-owned, professionally run gallery. They must pay each month to maintain their representation. We feel a need to demand more of artists who submit work. Because of the number of artists who submit work, our criteria for approval has increased as we receive stronger work than in past years, due to commercial gallery closings."

WORLD FINE ART GALLERY
511 West 25th Street #803, New York NY 10001-5501. (646)336-1677. Fax: (646)336-8644. E-mail: info@worldfineart.com. Web site: www.worldfineart.com. **Director:** O'Delle Abney. Cooperative gallery. Estab. 1992. Approached by 1,500 artists/year. Represents 50 mid-career artists. Exhibited artists include James Eugene Albert (prints); Sandra Gottlieb (photography). Average display time 1 month. Open Tuesday-Saturday, 12-6; closed August. Located in Chelsea, NY, 1,000 sq. ft. Clients include local community and tourists. 10% of sales are to corporate collectors. Overall price range $500-5,000; most work sold at $1,500.
Media Considers all media; types of prints include lithographs, serigraphs and woodcuts. Most frequently exhibits acrylic, oil and mixed media.
Style Exhibits color field. Considers all styles and genres. Most frequently exhibits painterly abstraction, color field and surrealism.
Terms There is a rental fee for space. The rental fee covers 1 month or 1 year. Retail price set by the artist. Gallery provides insurance, promotion and contract. Accepted work should be framed. Does not require exclusive representation locally. Must be considered suitable for exhibition.
Submissions Write or e-mail (www.worldfineart.com/inforequest.html) JPG images. Responds to queries in 1 week. Files JPG images. Finds artists through the Internet.
Tips "Have Web site available for review."

NORTH CAROLINA

ARTS UNITED FOR DAVIDSON COUNTY
220 S. Main St., Lexington NC 27292. (336)249-7862. Web site: www.co.davidson.nc.us/arts. **Executive Director:** Erik Salzwedel. Nonprofit gallery. Estab. 1968. Exhibits 30 emerging, mid-career and established artists. Interested in seeing the work of emerging artists. 400 members. Exhibited artists include Bob Timberlake and Zoltan Szabo. Disney Animation Archives (1993), Ansel Adams (1994), P. Buckley Moss (1996). Sponsors 11 shows/year. Average display time 1 month. Open all year. 6,000 sq. ft; historic building, good location, marble foyer. 80% of space for special exhibitions; 10% of space for gallery artists. Clientele: 98% private collectors, 2% corporate collectors. Overall price range $50-20,000; most work sold at $50-4,000.
Media Considers all media and all types of prints. "Originals only for exhibition. Most frequently exhibits painting, photography and mixed media. "We try to provide diversity."
Style Exhibits expressionism, painterly abstraction, postmodern works, expressionism, photorealism and realism. Genres include landscapes and Southern artists.
Terms Accepts work on consignment (30% commission). Members can exhibit art for 2 months maximum per piece in our members gallery. 30% commission goes to Guild. Retail price set by gallery and artist. Gallery provides insurance, promotion and contract; artist pays for shipping. Prefers artwork framed for exhibition and unframed for sales of reproductions.
Submissions Send query letter with résumé, slides, bio, brochure, photographs, business card, reviews and

SASE. Write for appointment to show portfolio of originals, photographs and slides. Entries reviewed every May for following exhibition year.

BLOUNT BRIDGERS HOUSE/HOBSON PITTMAN MEMORIAL GALLERY

130 Bridgers St., Tarboro NC 27886. (252)823-4159. Fax: (252)823-6190. E-mail: edgecombearts@earthlink.net. Web site: www.edgecombearts.org. Museum. Estab. 1982. Approached by 20 artists/year. Exhibits 6 emerging, mid-career and established artists. Sponsors 8 exhibits/year. Average display time 6 weeks. Open Monday-Friday, 10-4; weekends 2-4. Closed major holidays, Christmas-New Year. Located in historic house in residential area of small town; gallery on 2nd floor is accessible by passenger elevator. Room is approximately 48' × 20'. Clients include local community, students and tourists. Overall price range $250-5,000; most work sold at $500.
Media Considers acrylic, ceramics, collage, craft, drawing, fiber, glass, mixed media, oil, paper, pstel, pen & ink and watercolor. Most frequently exhibits oil, watercolor and ceramic. Considers all types of prints.
Style Considers all styles and genres.
Terms Artwork is accepted on consignment and there is a 30% commission. Retail price set by the artist. Gallery provides insurance and limited promotion. Accepted work should be framed. Does not require exclusive representation locally. Accepts artists from southeast and Pennsylvania.
Submissions Send portfolio of photographs, slides or transparencies. Send query letter with artist's statement, bio, SASE and slides. Returns material with SASE. Responds in 3 months. Finds artists through word of mouth, submissions, art exhibits and referrals by other artists.

BLUE SPIRAL 1

38 Biltmore Ave., Asheville NC 28801. (828)251-0202. Fax: (828)251-0884. E-mail: info@bluespiral1.com. Web site: www.bluespiral1.com. **Director:** John Cram. Retail gallery. Estab. 1991. Represents emerging, mid-career and established artists living in the Southeast. Over 100 exhibited artists including Julyan Davis, Gary Beecham, Suzanne Stryk, Tommie Rush and Will Henry Stephens. Sponsors 15-20 shows/year. Average display time 6-8 weeks. Open all year; Monday-Saturday, 10-6; Sundays (May-October), 12-5. Located downtown; 15,000 sq. ft.; historic building. 50% of space for special exhibitions; 50% of space for gallery artists. Clientele "across the range." 90% private collectors, 10% corporate collectors. Overall price range less than $100-50,000; most work sold at $100-2,500.
Media Considers all media. Most frequently exhibits painting, clay, sculpture and glass.
Style Exhibits all styles, all genres.
Terms Accepts work on consignment (50% commission). Retail price set by the artist. Gallery provides insurance, promotion and contract; artist pays shipping costs to and from gallery. Prefers artwork framed.
Submissions Accepts only artists from Southeast. Send query letter with résumé, slides, prices, statement and SASE. Responds in 3 months. Files slides, name and address. Finds artists through word of mouth, referrals and travel.
Tips "Work must be technically well executed and properly presented."

Ⓝ BROADHURST GALLERY

2212 Midland Rd., Pinehurst NC 28374. (910)295-4817. E-mail: Judy@broadhurst.com. Web site: Broadhurstgallery.com. **Owner:** Judy Broadhurst. Retail gallery. Estab. 1990. Represents/exhibits 25 established artists/year. Sponsors about 4 large shows and lunch and Artist Gallery Talks on most Fridays. Average display time 1-3 months. Open all year; Tuesday-Friday, 11-5; Saturday, 1-4; and by appointment. Located on the main road between Pinehurst and Southern Pines; 3,000 sq. ft.; lots of space, ample light, large outdoor sculpture garden. 50% of space for special exhibitions; 50% of space for gallery artists. Clientele people building homes and remodeling, also collectors. 80% private collectors, 20% corporate collectors. Overall price range $5,000-40,000; most work sold at $5,000 and up.
Media Considers oil, acrylic, watercolor, pastel, mixed media and collage. Most frequently exhibits oil and sculpture (stone and bronze).
Style Exhibits all styles, all genres.
Terms Retail price set by the artist. Gallery provides insurance, promotion and contract; shipping costs are shared. Prefers artwork framed.
Submissions Send query letter with résumé, slides and/or photographs, and bio. Write for appointment to show portfolio of originals and slides. Responds only if interested within 3 weeks. Files résumé, bio, slides and/or photographs. Finds artists through agents, by visiting exhibitions, word of mouth, various art publications and sourcebooks and artists' submissions.
Tips "Talent is always the most important factor, but professionalism is very helpful."

CHAPELLIER FINE ART

128 Cabernet Drive, Chapel Hill NC 27516. (919)656-5258. E-mail: chapellier@earthlink.net. Web site: www.chapellier.com. **Director:** Shirley C. Lally. Retail gallery. Estab. 1916. Represents 3 established artists/year. Exhib-

ited artists include Mary Louise Boehm, Elsie Dinsmore Popkin. Sponsors 3-4 shows/year. Average display time 6-8 weeks. Open all year; Monday-Saturday by appointment. 1,000 sq. ft. 75% of space for special exhibitions; 25% of space for gallery artists. Clientele upscale. 90% private collectors, 10% corporate collectors. Overall price range $500-90,000; most work sold at $3,000-10,000.

Media Considers oil, acrylic, watercolor, pastel, pen & ink, drawing, mixed media, paper, sculpture (limited to small pieces) and all types of prints. Most frequently exhibits oil, watercolor, pastel.

Style Exhibits impressionism and realism. Exhibits all genres. Prefers realism and impressionism. Inventory is primarily 19th and early 20th century American art.

Terms Accepts work on consignment (50% commission). Retail price set by the gallery. Gallery provides insurance, promotion and contract; shipping costs are shared. Prefers artwork framed.

Submissions Accepts only artists from America. Send query letter with résumé, slides, bio or photographs, price list and description of works offered, exhibition record. Write for appointment to show portfolio of photographs, transparencies or slides. Responds in 1 month. Files material only if interested. Finds artists through word of mouth, visiting art fairs and exhibitions.

Tips "Gallery owner and artist must be compatible and agree on terms of representation."

DURHAM ART GUILD, INC.

120 Morris St., Durham NC 27701. (919)560-2713. E-mail: artguild1@yahoo.com. Web site: www.durhamartguild.org. **Gallery Director:** Lisa Morton. Gallery Assistant: Diane Amato. Nonprofit gallery. Estab. 1948. Represents/exhibits 500 emerging, mid-career and established artists/year. Sponsors more than 20 shows/year including an annual juried art exhibit. Average display time 5 weeks. Open all year; Monday-Saturday, 9-9; Sunday, 1-6. Free and open to the public. Located in center of downtown Durham in the Arts Council Building; 3,600 sq. ft.; large, open, movable walls. 100% of space for special exhibitions. Clientele: general public. 80% private collectors, 20% corporate collectors. Overall price range $100-14,000; most work sold at $200-1,200.

Media Considers all media. Most frequently exhibits painting, sculpture and photography.

Style Exhibits all styles, all genres.

Terms Artwork is accepted on consignment (30-40% commission). Retail price set by the artist. Gallery provides insurance and promotion. Artist installs show. Prefers artwork framed.

Submissions Artists 18 years or older. Send query letter with résumé, slides and SASE. We accept slides for review by February 1 for consideration of a solo exhibit or special projects group show. Artist should include SASE. Finds artists through word of mouth, referral by other artists, call for slides.

Tips "Before submitting slides for consideration, be familiar with the exhibition space to make sure it can accommodate any special needs your work may require."

WELLINGTON B. GRAY GALLERY, EAST CAROLINA UNIVERSITY

Jenkins Fine Art Center, Greenville NC 27858. (919)757-6336. Fax: (919)757-6441. Web site: ecuuax.cis.@cu.edu/academics/schdept/art/art.htm. **Director:** Gilbert W. Leebrick. Nonprofit university gallery. Estab. 1977. Represents emerging, mid-career and established artists. Sponsors 12 shows/year. Average display time 5-6 weeks. Open all year. Located downtown, in the university; 5,500 sq. ft.; "auditorium for lectures, sculpture garden." 100% of space for special exhibitions. Clientele 25% private collectors, 10% corporate clients, 50% students, 15% general public. Overall price range $1,000-10,000.

Media Considers all media plus environmental design, architecture, crafts and commercial art, original prints, relief, intaglio, planography, stencil and offset reproductions. Most frequently exhibits paintings, printmaking and sculpture.

Style Exhibits all styles and genres. Interested in seeing contemporary art in a variety of media.

Terms 30% suggested donation on sales. Retail price set by artist. Gallery provides insurance and promotion; shipping costs are shared. Prefers artwork framed.

Submissions Send query letter with résumé, slides, brochure and SASE. Write for appointment to show portfolio of originals, slides, photographs and transparencies. Responds in 6 months. Files "all mailed information for interesting artists. The rest is returned."

GREEN TARA GALLERY

18 E. Franklin St., Chapel Hill NC 27514. (919)932-6400. Fax: (919)918-7542. E-mail: greentaragallery@mindspring.com. Web site: www.greentaragallery.com. Retail gallery. Estab. 1998. Approached by 150 artists/year. Exhibits 150 established artists. Exhibited artists include Scott Gibbs and Pam Calore. Sponsors 12 exhibits/year. Average display time 7-8 weeks. Open all year; Monday-Saturday, 10-6. Closed July 4th and New Years. 3,000 sq. ft. fine art and fine craft gallery located in the heart of Chapel Hill, NC featuring one of a kind art and art objects for your home, office and body. Clients include local community, tourists and upscale. 10% of sales are to corporate collectors. Overall price range $25-3,000; most work sold at $1,000.

Media Considers acrylic, ceramics, collage, drawing, glass, mixed media, oil, pastel, sculpture, watercolor and woodcuts. Most frequently exhibits oil, acrylic, mixed media. Considers only original art.

Style Exhibits conceptualism, expressionism, geometric abstraction, impressionism, minimalism, neo-expressionism, postmodernism, primitivism realism, surrealism and painterly abstraction. Most frequently exhibits impressionism, abstract expressionism and conceptualism. Genres include figurative work and landscapes.

Terms Artwork is accepted on consignment and there is a 50% commission; or is bought outright for 40% of retail price. Retail price set by the gallery and the artist. Gallery provides insurance, promotion and contract. Accepted work should be framed, mounted and matted. Requires exclusive representation locally.

Submissions Mail portfolio for review. Send query letter with artist's statement, bio, brochure, business card, photocopies, photographs, résumé, reviews, pricing, SASE and slides. Returns material with SASE. Files business card. Finds artists through word of mouth, submissions, portfolio reviews, art exhibits, art fairs, referrals by other artists and through other galleries.

Tips "Include all the required information, and be reasonable in pricing and flexible. Act/behavior should be as if for any other job interview."

JERALD MELBERG GALLERY INC.

625 S. Sharon Amity Rd., Charlotte NC 28211. (704)365-3000. Fax: (704)365-3016. E-mail: gallery@jeraldmelber g.com. Web site: jeraldmelberg.com. **President:** Jerald Melberg. Retail gallery. Estab. 1983. Represents 35 emerging, mid-career and established artists/year. Exhibited artists include Robert Motherwell and Wolf Kahn. Sponsors 15-16 shows/year. Average display time 6 weeks. Open all year; Monday-Saturday, 10-6. 4,000 sq. ft. 100% of space for gallery artists. Clientele national. 70-75% private collectors, 25-30% corporate collectors. Overall price range $1,000-80,000; most work sold at $2,000-15,000.

Media Considers all media except photography. Considers all types of prints. Most frequently exhibits pastel, oil/acrylic and monotypes.

Style Genres include painterly abstraction, color field, impressionism and realism. Genres include florals and landscapes. Prefers landscapes, abstraction and still life.

Terms Artwork is accepted on consignment (50% commission). Retail price set by the gallery and the artist. Gallery provides insurance, promotion. Gallery pays for shipping costs from gallery. Artists pays for shipping costs to gallery. Prefers artwork unframed.

Submissions Send query letter with résumé, slides, reviews, bio, SASE and price structure. Responds in 2-3 weeks. Finds artists through art fairs, other artists, travel.

Tips "The common mistake artists make is not finding out what I handle and not sending professional quality materials."

RALEIGH CONTEMPORARY GALLERY

323 Blake St., Raleigh NC 27601. (919)828-6500. E-mail: RCGallery@mindspring.com. Web site: www.rcgallery. com. **Director:** Rory Parnell. Retail gallery. Estab. 1984. Represents 20-25 emerging and mid-career artists/ year. Sponsors 6 shows/year. Average display time 1 month. Open all year; Monday-Saturday, 11-4. Located downtown; 1,300 sq. ft.; architect-designed; located in historic property in a revitalized downtown area. 30% of space for special exhibitions; 70% of space for gallery artists. Clients include corporate and private. 35% of sales are to private collectors, 65% corporate collectors. Overall price range $500-5,000; most work sold at $1,200-2,500.

Media Considers oil, acrylic, watercolor, pastel, pen & ink, drawing, woodcut, engraving and lithograph. Most frequently exhibits oil/acrylic paintings, drawings and lithograph.

Style Exhibits all styles. Genres include landscapes and florals. Prefers landscapes, realistic and impressionistic; abstracts.

Terms Accepts work on consignment (50% commission). Retail price set by the gallery and the artist. Gallery provides insurance, promotion and contract; shipping costs are shared.

Submissions Send query letter with résumé, slides, bio, SASE and reviews. Call or write for appointment to show portfolio of slides. Responds in 1 month. Finds artists through exhibitions, word of mouth, referrals.

SOMERHILL GALLERY

3 Eastgate E. Franklin St., Chapel Hill NC 27514. (919)968-8868. Fax: (919)967-1879. **Director:** Joseph Rowand. Retail gallery. Estab. 1972. Represents emerging, mid-career and established artists. Sponsors 10 major shows/ year, plus a varied number of smaller shows. Open all year. 10,000 sq. ft.; gallery features "architecturally significant spaces, pine floor, 18' ceiling, 6 separate gallery areas, stable, photo, glass." 50% of space for special exhibitions.

Media Considers all media, woodcuts, wood engravings, linocuts, engravings, mezzotints, etchings, lithographs and serigraphs. Does not consider installation. Most frequently exhibits painting, sculpture and glass.

Style Exhibits all styles and genres.

Submissions Focus is on contemporary art of the United States; however artists from all over the world are exhibited. Send query letter with résumé, slides, bio, SASE and any relevant materials. Responds in 2 months. Files slides and biographical information of artists.

NORTH DAKOTA

THE ARTS CENTER
115 Second St. SW, Box 363, Jamestown ND 58402. (701)251-2496. Fax: (701)251-1749. E-mail: artscenter@csic able.net. Web site: www.jamestownartscenter.org. **Director:** Taylor Barnes. Nonprofit gallery. Estab. 1981. Sponsors 8 solo and 4 group shows/year. Average display time 6 weeks. Interested in emerging artists. Overall price range $50-600; most work sold at $50-350.
Style Exhibits contemporary, abstraction, impressionism, primitivism, photorealism and realism. Genres include Americana, figurative and 3-dimensional work.
Terms 20% commission on sales from regularly scheduled exhibitions. Retail price set by artist. Gallery provides insurance, promotion and contract; shipping costs are shared.
Submissions Send query letter, résumé, brochure, slides, photograph and SASE. Write for appointment to show portfolio. Invitation to have an exhibition is extended by Arts Center gallery manager.
Tips ''We are interested in work of at least 20-30 pieces, depending on the size.''

GANNON & ELSA FORDE GALLERIES
1500 Edwards Ave., Bismarck ND 58501. (701)224-5520. Fax: (701)224-5550. E-mail: Michelle_Lindblom@bsc. nodak.com. Web site: www.bismarckstate.com. **Gallery Director:** Michelle Lindblom. College gallery. Represents emerging, mid-career and established art exhibitions. Sponsors 6 shows/year. Average display time 6 weeks. Open all year; Monday-Thursday, 9-9; Friday, 9-4; Sunday, 6-9. Summer exhibit is college student work (May-August). Located on Bismarck State College campus; high traffic areas on campus. Clientele all. 80% private collectors, 20% corporate collectors. Overall price range $50-10,000; most work sold at $50-3,000.
Media Considers oil, acrylic, watercolor, pastel, drawing, mixed media, collage, paper, sculpture, ceramics, fiber, photography, woodcut, engraving, lithograph, wood engraving, mezzotint, serigraphs, linocut and etching. Most frequently exhibits painting media (all), mixed media and sculpture.
Style Exhibits expressionism, neo-expressionism, painterly abstraction, surrealism, impressionism, photorealism, hard-edge geometric abstraction and realism, all genres.
Terms Accepts work on consignment (20% commission). Retail price set by the artist. Gallery provides insurance on premises, promotion, contract and shipping costs from gallery; artist pays shipping costs to gallery. Prefers artwork framed.
Submissions Send query letter with résumé, slides, bio and SASE. Call or write for appointment to show portfolio of photographs and slides. Responds in 2 months. Files résumé, bio, photos if sent. Finds artists through word of mouth, art publications, artists' submissions, visiting exhibitions.
Tips ''Because our gallery is a university gallery, the main focus is to expose the public to art of all genres. However, we do sell work, occasionally.''

OHIO

ACME ART COMPANY
At The Continent, Huntington Building, 6172 Busch Boulevard, Columbus OH 43229. (614)430-9450. **Contact:** Melesa A.C. Klosek, CEO/Artistic Director. Volunteer and artist run nonprofit gallery. Estab. 1987. Gives exhibiting opportunities to thousands of emerging and mid-career artists/year. 400 members. Sponsors 12 shows/year. Average display time 1 month. Open all year; Tuesday-Saturday, 11 a.m.-7 p.m.; Evening hours, Tuesdays until 9 p.m., Fridays and Saturdays until 1:30 a.m. Located in Worthington area; 13,000 sq. ft.; 4 gallery areas. 90% of space for special exhibitions; 50% of space for gallery artists. Clientele avant-garde collectors, private and professional. 85% private collectors, 15% corporate collectors. Overall price range $30-5,000; most work sold at $50-1,000.
Media All media is accepted; including performance, film, dance, music and installation.
Style Exhibits all styles. Most frequently exhibits contemporary art. Considers all genres.
Terms Accepts work on consignment (30% commission to Acme Art). Retail price set by the gallery and the artist. Gallery provides promotion and contract; shipping costs are shared. Prefers artwork framed or ready to hang.
Submissions Prefers ''artists who push the envelope, who explore new vision and materials of presentation.'' Send query letter with SASE for a call for entries prospectus. Call for following fiscal year line-up (''we work

one year in advance''). Members exhibit in the months of August and December. Files bio, slides, résumé and other support materials sent by artists. The Artistic Director selects the work to be exhibited with an Advisory Panel.

ALAN GALLERY

101 Front St., Berea OH 44017. (440)243-7794. Fax: (440)243-7772. Web site: www.alangalleryberea.com. **President:** Linda Roberts. Retail gallery and arts consultancy. Estab. 1983. Represents 25-30 emerging, mid-career and established artists. Sponsors 4 solo shows/year. Average display time 6-8 weeks. Clientele: 40% private collectors, 60% corporate clients. Overall price range $700-6,000; most work sold at $1,500-2,000.
Media Considers all media and limited edition prints. Most frequently exhibits watercolor, works on paper and mixed media.
Style Exhibits color field, painterly abstraction and surrealism. Genres include landscapes, florals, western and figurative work.
Terms Accepts work on consignment (40% commission). Retail price set by gallery and artist. Gallery provides insurance, promotion and contract; shipping costs are shared.
Submissions Send résumé, slides and SASE. Call or write for appointment to show portfolio of originals and slides. All material is filed.

THE ART EXCHANGE

539 E. Town St., Columbus OH 43215. (614)464-4611. Fax: (614)464-4619. E-mail: artexg@ix.netcom.com. Art consultancy. Estab. 1978. Represents 40 emerging, mid-career and established artists/year. Exhibited artists include Mary Beam, Carl Krabill. Open all year; Monday-Friday, 9-5. Located near downtown; historic neighborhood; 2,000 sq. ft.; showroom located in Victorian home. 100% of space for gallery artists. Clientele corporate leaders. 20% private collectors; 80% corporate collectors. Overall price range $150-6,000; most work sold at $1,000-1,500.
Media Considers oil, acrylic, watercolor, pastel, mixed media, collage, sculpture, ceramics, fiber, glass, photography and all types of prints. Most frequently exhibits oil, acrylic, watercolor.
Style Exhibits painterly abstraction, impressionism, realism, folk art. Genres include florals and landscapes. Prefers impressionism, painterly abstraction, realism.
Terms Accepts work on consignment. Retail price set by the gallery and the artist.
Submissions Send query letter with résumé and slides or photographs. Write for appointment to show portfolio. Responds in 2 weeks. Files slides or photos and artist information. Finds artists through word of mouth, referrals by other artists, visiting art fairs and exhibitions, submissions.
Tips ''Our focus is to provide high-quality artwork and consulting services to the corporate, design and architectural communities. Our works are represented in corporate offices, health care facilities, hotels, restaurants and private collections throughout the country.''

ARTSPACE/LIMA

65 Town Square, Lima OH 45801. (419)222-1721. Fax: (419)222-6587. E-mail: artspace@wcoil.com. Web site: www.artspacelima.com. **Gallery Director:** David Cottrell. Nonprofit gallery. Exhibits 50-70 emerging and mid-career artists/year. Interested in seeing the work of emerging artists. Sponsors 8-10 shows/year. Average display time 6-8 weeks. Open all year; Monday-Friday, 10-5; Saturday, 12-3; Sunday, 2-4. Located downtown; 286 running ft. 100% of space for special exhibitions. Clientele local community. 80% private collectors, 5% corporate collectors. Overall price range $300-6,000; most work sold at $500-1,000.
 ● Most shows are thematic and geared toward education. James H. Bassett landscape architect reviewed in *Dialogue Magazine*, January 2002.
Media Considers all media and all types of prints. Most frequently exhibits painting, sculpture, drawing.
Style Exhibits all styles of contemporary and traditional work.
Terms Accepts work on consignment (40% commission). Retail price set by the artist. Gallery provides insurance, promotion and contract. Artwork must be ready to hang.
Submissions Send query letter with résumé, slides, artist's statement and SASE. Portfolio should include slides. Responds only if interested within 6 weeks. Files résumé.

THE CANTON MUSEUM OF ART

1001 Market Ave. N., Canton OH 44702. (330)453-7666. Fax: (330)453-1034. E-mail: al@cantonart.org. Web site: www.cantonart.org. **Executive Director:** M. Joseph Albacete. Nonprofit gallery. Estab. 1935. Represents emerging, mid-career and established artists. ''Although primarily dedicated to large format touring and original exhibitions, the CMA occasionally sponsors solo shows by local and original artists, and one group show every 2 years featuring its own 'Artists League.' '' Average display time is 6 weeks. Overall price range $50-3,000; few sales above $300-500.

Media Considers all media. Most frequently exhibits oil, watercolor and photography.
Style Considers all styles. Most frequently exhibits painterly abstraction, post-modernism and realism.
Terms ''While every effort is made to publicize and promote works, we cannot guarantee sales, although from time to time sales are made, at which time a 25% charge is applied.'' One of the most common mistakes in presenting portfolios is ''sending too many materials. Send only a few slides or photos, a brief bio and a SASE.''
Tips There seems to be ''a move back to realism, conservatism and support of regional artists.''

CINCINNATI ART MUSEUM
953 Eden Park Dr., Cincinnati OH 45202. (513)639-2995. Fax: (513)639-2888. E-mail: information@cincyart.org. Web site: www.cincinnatiartmuseum.org. Museum. Estab. 1881. Exhibits 6-10 emerging, mid-career and established artists. Sponsors 20 exhibits/year. Average display time 3 months. Open all year; Tuesday-Sunday, 11-5; Wednesdays open until 9. General art museum with a collection spanning 6,000 years of world art. Over 100,000 objects in the collection with exhibitions on view annually. Clients include local community, students, tourists and upscale.
Media Considers all media and all types of prints. Most frequently exhibits paper, mixed media and oil.
Style Considers all styles and genres.
Submissions Send query letter with artist's statement, photographs, reviews, SASE and slides.

CLEVELAND STATE UNIVERSITY ART GALLERY
2121 Euclid Ave., AB 108, Cleveland OH 44115. (216)687-2103. Fax: (216)687-9340. E-mail: artgallery@csuohio. edu. Web site: www.csuohio.edu/art/gallery. **Director:** Robert Thurmer. Assistant Director: Tim Knapp. University gallery. Exhibits 50 emerging, mid-career and established artists. Exhibited artists include Joel Peter Witkin and Buzz Spector. Sponsors 6 shows/year. Average display time 6 weeks. Open Monday-Friday, 10-5; Saturday, 12-4. Closed Sunday and holidays. Located downtown 4,500 sq. ft. (250 running ft. of wall space). 100% of space for special exhibitions. Clientele students, faculty, general public. 85% private collectors, 15% corporate collectors. Overall price range $250-50,000; most work sold at $300-1,000.
 • This gallery's street address is 2307 Chester Ave., Cleveland OH 44114. Their mailing address is listed above.
Media Considers all media.
Style Exhibits all styles and genres. Prefers contemporary. Looks for challenging work.
Terms 25% commission. Sales are not a priority. Gallery provides insurance, promotion, shipping costs to and from gallery; artists handle crating. Prefers artwork framed.
Submissions By invitation. Unsolicited inquiries may not be reviewed.
Tips ''Submissions recommended by galleries or institutions are preferred.''

THE DAYTON ART INSTITUTE
456 Belmonte Park North, Dayton OH 45405-4700. (937)223-5277. Fax: (937)223-3140. E-mail: info@daytonartinstitute.org. Web site: www.daytonartinstitute.org. Museum. Estab. 1919. Open all year; Monday-Wednesday, 10-4; Thursday, 10-8; Friday-Sunday, 10-4. Open 365 days of the year! Clients include local community, students and tourists.
Media Considers all media.
Submissions Send query letter with artist's statement, reviews and slides.

HILLEL JEWISH STUDENT CENTER GALLERY
2615 Clifton Ave., Cincinnati OH 45220. (513)221-6728. Fax: (513)221-7134. E-mail: email@hillelcincinnati.org. Web site: www.hillelcincinnati.org. **Director:** Rabbi Abie Ingber. Gallery Curator: Daniela Yovel. Nonprofit gallery, museum. Estab. 1982. Represents 5 emerging artists/academic year. Exhibited artists include Gordon Baer, Irving Amen and Lois Cohen. Sponsors 5 shows/year. Average display time 5-6 weeks. Open fall, winter, spring; Monday-Thursday, 9-5; Friday, 9-3; other hours in conjunction with scheduled programming. Located uptown (next to University of Cincinnati); 1,056 sq. ft.; features the work of Jewish artists in all media; listed in AAA Tourbook; has permanent collection of architectural and historic Judaica from synagogues. 20% of space for special exhibitions; 80% of space for gallery artists. Clientele upscale, community, students. 90% private collectors, 10% corporate collectors. Overall price range $150-3,000; most work sold at $150-800.
Media Considers all media except installations. Considers all types of prints. Most frequently exhibits prints/mixed media, watercolor, photographs.
Style Exhibits all styles. Genres include landscapes, figurative work and Jewish themes. Avoids minimalism and hard-edge geometric abstraction.
Terms Artwork accepted for exhibit and there is a 30% commission. Retail price set by the artist. Gallery provides insurance, promotion, contract, opening reception; shipping costs are shared. Prefers artwork framed.

Submissions "With rare exceptions, we feature Jewish artists." Send query letter with slides, bio or photographs, SASE. Call or write for appointment to show portfolio. Responds in 1 week. Files bios/résumés, description of work.

MALTON GALLERY
2643 Erie Ave., Cincinnati OH 45208. (513)321-8614. Fax: (513)321-8716. E-mail: info@maltonartgallery.com. Web site: www.maltonartgallery.com. **Director:** Sylvia Rombis. Retail gallery. Estab. 1974. Represents about 100 emerging, mid-career and established artists. Exhibits 20 artists/year. Exhibited artists include Carol Henry, Mark Chatterley, Terri Hallman and Esther Levy. Sponsors 7 shows/year. Average display time 1 month. Open all year; Tuesday-Friday, 11-5; Saturday, 12-5. Located in high-income neighborhood shopping district. 2,500 sq. ft. "Friendly, non-intimidating environment." 2-person shows alternate with display of gallery artists. Clientele: private and corporate. Overall price range $250-10,000; most work sold at $400-2,500.
Media Considers oil, acrylic, drawing, sculpture, watercolor, mixed media, pastel, collage and original hand-pulled prints.
Style Exhibits all styles. Genres include contemporary landscapes, figurative and narrative and abstractions work.
Terms Accepts work on consignment (50% commission). Retail price set by artist (sometimes in consultation with gallery). Gallery provides insurance, promotion, contract and shipping costs from gallery; artist pays shipping costs to gallery. Prefers framed works for canvas; unframed works for paper.
Submissions Send query letter with résumé, slides or photographs, reviews, bio and SASE. Responds in 4 months. Files résumé, review or any printed material. Slides and photographs are returned.
Tips "Never drop in without an appointment. Be prepared and professional in presentation. This is a business. Artists themselves should be aware of what is going on, not just in the 'art world,' but with everything."

RUTLEDGE GALLERY
Kettering Tower Lobby, Dayton OH 45423. (937)226-7335. Web site: www.rutledge-art.com. **Director:** Jeff Rutledge. Retail gallery, art consultancy. Focus is on artists from the Midwest. Estab. 1991. Represents 45 emerging and mid-career artists/year. Sponsors 6 shows/year. Average display time 3 months. Exhibited artists include Natalya Romanovsky and Jeff Potter. Open all year; Tuesday-Friday, 11-6; Saturday, 11-5. "We specialize in sculpture and regional artists. We also offer commissioned work and custom framing." 70% of space for special exhibitions; 30% of space for gallery artists. Clientele residential, corporate, private collectors, institutions. 65% private collectors, 35% corporate collectors.
Media Considers oil, acrylic, watercolor, pastel, pen & ink, drawing, mixed media, paper, sculpture, ceramic, craft, glass, woodcuts, engravings, lithographs, linocuts, etchings and posters. Most frequently exhibits paintings, drawings, prints and sculpture.
Style Exhibits expressionism, painterly abstraction, surrealism, color field, impressionism and realism. Considers all genres. Prefers contemporary (modern), geometric and abstract.
Terms Accepts work on consignment (50% commission). Retail price set by gallery. Gallery provides insurance, promotion and contract; artists pays shipping costs. Prefers artwork framed.
Submissions Accepts mainly Midwest artists. Send query letter with résumé, brochure, 20 slides and 10 photographs. Call for appointment to show portfolio of originals, photographs, slides and transparencies. Responds only if interested within 1 month. Files "only material on artists we represent; others returned if SASE is sent or thrown away."
Tips "Be well prepared, be professional, be flexible on price and listen."

SPACES
2220 Superior Viaduct, Cleveland OH 44113. (216)621-2314. E-mail: info@spacesgallery.org. Web site: www.spacesgallery.org. Artist-run alternative space. Estab. 1978. Exhibitions feature artists who push boundaries by experimenting with new forms of expression and innovative uses of media, presenting work of emerging artists and established artists with new ideas. SPACELab offers the same opportunity for younger artists and college students. the SPACES World Artist Program gives visiting national and international resident artist the opportunity to create new work and interact with the Northeast Ohio community. Sponsors 5-6 shows/year. Average display time 6 weeks. Open all year; Tuesday-Sunday. Located downtown Cleveland; 6,000 sq. ft.; "warehouse space with row of columns."
Media Considers all media. Most frequently exhibits installation, painting, video and sculpture.
Style Style not relevant; presenting challenging new ideas is essential.
Terms Works in exhibitions can be sold, at artists' discretion. Artists are provided honoraria, and 20% commission is taken on work sold. Gallery provides insurance, promotion and contract.
Submissions 2007-2008 Season Artists' Application deadline May 2007; contact SPACES for specific date and application. Also seeking curators interested in pursuing exhibition idea.
Tips "Present yourself professionally and don't give up."

OKLAHOMA

BONE ART GALLERY
114 S. Broadway, Geary OK 73040. (405)884-2084. E-mail: jim@boneartgallery.com. Web site: www.boneartgallery.com. **Owner/Operator** Jim Ford. Retail and wholesale gallery. Estab. 1988. Represents 6 emerging, mid-career and established artists/year. Exhibited artists include Jim Ford and Jerome Bushyhead. Average display time 6 months. Open all year; Monday-Friday, 10-6; Saturday, 10-6; Sunday by appointment. Located downtown. ²/₃% of space for gallery artists. Clientele tourists, upscale. 50% private collectors; 50% corporate collectors. Overall price range $15-1,000; most work sold at $15-650.
Media Considers oil, acrylic, watercolor, pastel, drawing, mixed media, sculpture, ceramics, lithographs and posters. Most frequently exhibits watercolor, sculpture and carvings, pipe making.
Style Exhibits primitivism. Genres include Western, wildlife, Southwestern and landscapes. Prefers Southwestern, Western and landscapes.
Terms Accepts work on consignment (20% commission). Retail price set by the artist. Gallery provides insurance and promotion; shipping costs are shared. Prefers artwork framed.
Submissions Prefers only Southwestern, Western, landscapes and wildlife. Send query letter with résumé, brochure, photographs and business card. Write for appointment to show portfolio of photographs. Responds in 1 month. Files business cards, résumé, brochure and letter of introduction. Finds artists through referrals and visiting art exhibitions.
Tips "New artists should be familiar with the types of artwork each gallery they contact represents. If after contacting a gallery you haven't had a response after 2-3 months, make contact again. Be precise, but not overbearing with your presentations."

M.A. DORAN GALLERY
3509 S. Peoria, Tulsa OK 74105. (918)748-8700. Fax: (918)744-0501. E-mail: madgallery@aol.com. Retail gallery. Estab. 1979. Represents 45 emerging, mid-career and established artists/year. Exhibited artists include P.S. Gordon and Otto Duecker. Sponsors 10 shows/year. Average display time 1 month. Open all year; Tuesday-Saturday, 10:30-6. Located central retail Tulsa; 2,000 sq. ft.; up and downstairs, Soho like interior. 50% of space for special exhibitions; 50% of space for gallery artists. Clients include upscale. 65% of sales are to private collectors; 35% corporate collectors. Overall price range $500-40,000; most work sold at $5,000.
Media Considers all media except pen & ink, paper, fiber and installation; types of prints include woodcuts, engravings, lithographs, wood engravings, mezzotints, serigraphs, linocuts and etchings. Most frequently exhibits oil paintings, watercolor and crafts.
Style Exhibits painterly abstraction, impressionism, photorealism, realism and imagism. Exhibits all genres. Prefers landscapes, still life and fine American crafts.
Terms Accepts work on consignment (50% commission). Retail price set by the gallery and artist. Gallery provides insurance and promotion; shipping costs are shared. Prefers artwork framed.
Submissions Send query letter with résumé, bio, SASE and artist's statement. Call for appointment. Responds in 1 month. Files any potential corporate artists.

INDIVIDUAL ARTISTS OF OKLAHOMA
P.O. Box 60824, Oklahoma City OK 73146. (405)232-6060. Fax: (405)232-6061. E-mail: iao@telepath.com. Web site: www.IAOgallery.org. **Director:** Shirley Blaschke. Administrative Assistant: Bethani Baum. Art space located at One N. Hudson, Suite 150. Alternative space. Founding member of NAAO. Estab. 1979. Approached by 60 artists/year. Represents 30 emerging, mid-career and established artists/year. Sponsors 30 exhibits/year. Average display time 3-4 weeks. Open all year; Tuesday-Friday, 11-4; Saturday, 1-4. Located in downtown arts district; 2,300 sq. ft.; 10 foot ceilings; track lighting. Clients include local community, students, tourists and upscale. 33% of sales are to corporate collectors. Overall price range $100-1,000; most work sold at $400.
Media Considers all media. Most frequently exhibits photography, painting, installation.
Style Considers all styles. Most frequently exhibits "bodies of work with cohesive style and expressed in a contemporary viewpoint." Considers all genres.
Making Contact & Terms Artwork is accepted on consignment and there is a 20% commission. Retail price set by the artist. Gallery provides insurance, promotion and contract. Prefers artwork framed. Preference to Oklahoma artists.
Submissions Mail portfolio for review. Send artist's statement, bio, photocopies or slides, résumé and SASE. Returns material with SASE. Responds in 3 months. Finds artists through word of mouth, art exhibits and referrals by other artists.
Tips "Individual Artists of Oklahoma is committed to sustaining and encouraging emerging and established artists in all media who are intellectually and aesthetically provocative or experimental in subject matter or technique."

Galleries

LACHENMEYER ARTS CENTER

700 S. Little, Cushing OK 74023. (918)225-7525. Fax: (918)223-2919. E-mail: roblarts@brightok.net. **Director:** Rob Smith. Nonprofit. Estab. 1984. Exhibited artists include Darrell Maynard, Steve Childers and Dale Martin. Sponsors 3 shows/year. Average display time 2 weeks. Open in August, September, December; Monday, Wednesday, Friday, 9-5; Tuesday, Thursday, 6-9. Located inside the Cushing Youth and Community Center; 550 sq. ft. 80% of space for special exhibitions; 80% of space for gallery artists. 100% private collectors.

Media Considers oil, acrylic, watercolor, pastel, pen & ink, drawing, mixed media, collage, paper, sculpture, ceramics, fiber, photography, woodcuts, engravings, lithographs, wood engravings, mezzotints, serigraphs, linocuts and etchings. Most frequently exhibits oil, acrylic and works on paper.

Style Exhibits all styles. Prefers landscapes, portraits and Americana.

Terms Retail price set by the artist. Gallery provides promotion; shipping costs are shared. Prefers artwork framed.

Submissions Send query letter with résumé, professional quality slides, SASE and reviews. Call or write for appointment to show portfolio of originals. Responds in 1 month. Files résumés. Finds artists through visiting exhibits, word of mouth, other art organizations.

Tips ''We prefer local and regional artists.''

NO MAN'S LAND MUSEUM

P.O. Box 278, Goodwell OK 73939-0278. (580)349-2670. Fax: (580)349-2670. E-mail: nmlhs@ptsi.net. **Director:** Kenneth R. Turner. Museum. Estab. 1934. Represents emerging, mid-career and established artists. Sponsors 12 shows/year. Average display time 1 month. Open all year; Tuesday-Saturday, 9-12 and 1-5. Located adjacent to university campus. 10% of space for special exhibitions. Clientele general, tourist. 100% private collectors. Overall price range $20-1,500; most work sold at $20-500.

Media Considers all media and all types of prints. Most frequently exhibits oils, watercolors and pastels.

Style Exhibits primitivism, impressionism, photorealism and realism. Genres include landscapes, florals, Americana, southwestern, western and wildlife. Prefers realist, primitive and impressionist.

Terms ''Sales are between artist and buyer; museum does not act as middleman.'' Retail price set by the artist. Gallery provides promotion and shipping costs to and from gallery. Prefers artwork framed.

Submissions Send query letter with résumé, brochure, photographs and reviews. Call or write for appointment to show portfolio of photographs. Responds only if interested within 3 weeks. Files all material. Finds artists through art publications, exhibitions, news items, word of mouth.

OREGON

▓ BLACKFISH GALLERY

420 NW Ninth Ave., Portland OR 97209. (503)224-2634. E-mail: bfish@teleport.com. Web site: www.blackfish.com. **Director:** Gina Carrington. Retail cooperative gallery. Estab. 1979. Represents 26 emerging and mid-career artists. Exhibited artists include Michael Knutson (oil paintings). Sponsors 12 shows/year. Open all year; Tuesday-Saturday, 11-5 and by appointment. Located downtown, in the ''Northwest Pearl District; 2,500 sq. ft.; street-level, 'garage-type' overhead wide door, long, open space (100' deep).'' 70% of space for feature exhibits, 15-20% for gallery artists. 80% of sales are to private collectors, 20% corporate clients. Overall price range $250-12,000; most artwork sold at $500-2,000.

Media Considers oil, acrylic, watercolor, pastel, pen & ink, drawings, mixed media, collage, sculpture, ceramic, photography, woodcuts, wood engravings, linocuts, engravings, mezzotints, etchings, lithographs, pochoir and serigraphs. Most frequently exhibits paintings, sculpture and prints.

Style Exhibits expressionism, neo-expressionism, painterly abstraction, surrealism, conceptualism, minimalism, color field, postmodern works, impressionism and realism. Prefers neo-expressionism, conceptualism and painterly abstraction.

Terms Accepts work on consignment from invited artists (50% commission); co-op membership includes monthly dues plus donation of time (40% commission on sales). Retail price set by artist with assistance from gallery on request. Customer discounts and payment by installment are available. Gallery provides insurance, promotion and contract, and shipping costs from gallery. Prefers artwork framed.

Submissions Accepts only artists from northwest Oregon and southwest Washington (''unique exceptions possible''); ''must be willing to be an active cooperative memberwrite for details.'' Send query letter with résumé, slides, SASE, reviews and statement of intent. Write for appointment to show portfolio of photographs and slides. ''We review throughout the year.'' Responds in 1 month. Files material only if exhibit invitation extended. Finds artists through agents, visiting exhibitions, word of mouth, various art publications and sourcebooks, submissions/self-promotions and art collectors' referrals.

Tips "Understand—via research—what a cooperative gallery is. Call or write for information packet. Do not bring work or slides to us without first having contacted us by phone, mail, or e-mail."

COOS ART MUSEUM

235 Anderson Avenue, Coos Bay OR 97420. (541)267-3901. E-mail: info@coosart.org. Web site: www.coosart.o rg. 3rd oldest Art Museum in Oregon, nonprofit organization. Estab. 1950. 500+ Permanent Collection of mid 20th Century contemporary works (both 2 & 3 dimensional) by regional and national artists. Mounts 4 juried group exhibitions/year of 85-150+ artists, 20 curated single/solo exhibits established artists a year and 6 exhibits from the Permanent Collection per year. 5 galleries allows for multible exhibits mounted simultaneously averaging 6 openings a year. Average display time 6-9 weeks. Open Tuesday-Friday, 10 a.m.-4 p.m.; Saturday only, 1 p.m.-4 p.m.; free admission on 2nd Thursday (Art Walk) from 5pm-8pm. Located downtown Coos Bay. One large main gallery and 3 smaller gallery areas. Clients include local community, students, tourists and upscale.

Media For curated exhibition considers all media including print, engraving, litho, serigraph. Poster and giclee not considered. Most frequently exhibits paintings (oil, acrylic, watercolor, pastel), sculpture (glass, metal, ceramic), drawings, etchings and prints.

Style Considers all styles and genres. Most frequently exhibits primitivism, realism, postmodernism and expressionism.

Terms No gallery floor sales. All inquiries are referred directly to the artist. Artist handles the sale. Retail price set by the artist. Museum provides insurance, promotion and contract. Accepted work should be framed, mounted and matted. Does not require exclusive representation locally. Accepts only artists from Oregon or Western USA.

Submissions Send query letter with artist's statement, bio, résumé, SASE, slides or digital files on CD or links to Web address. Responds to queries in 6 months. Never send 'only copies' of slides, résumés or portfolios. Exhibition committee reviews 2 times a year—schedule exhibits 2 years in advance. Files proposals. Finds artists through portfolio reviews and submissions.

Tips "Have complete files electronically on a Web site or CD. Have a completely written positioning statement and proposal of their show and letter(s) of recommendation from a producer/curator/gallery of a previous curated exhibit. Do no expect the museum to produce or create their exhibition. They should have all costs figured ahead of time and submit only when they have their work completed and ready. We do not develop artists. They must be professional."

ROGUE GALLERY & ART CENTER

40 S. Bartlett, Medford OR 97501. (541)772-8118. Fax: (541)772-0294. E-mail: judy@roguegallery.org. Web site: www.roguegallery.org. **Executive Director:** Judy Barnes. Nonprofit sales rental gallery. Estab. 1961. Represents emerging, mid-career and established artists. Sponsors 8 shows/year. Average display time 6 weeks. Open all year; Tuesday-Friday, 10-5; Saturday, 11-3. Located downtown; main gallery 240 running ft. (2,000 sq. ft.); rental/sales and gallery shop, 1,800 sq. ft.; classroom facility, 1,700 sq. ft. "This is the only gallery/art center/ exhibit space of its kind in the region, excellent facility, good lighting." 33% of space for special exhibitions; 33% of space for gallery artists. 95% of sales are to private collectors. Overall price range $100-5,000; most work sold at $400-1,000.

Media Considers all media and all types of prints. Most frequently exhibits mixed media, drawing, installation, painting, sculpture, watercolor.

Style Exhibits all styles and genres. Prefers figurative work, collage, landscape, florals, handpulled prints.

Terms Accepts work on consignment (35% commission to members; 40% non-members). Retail price set by the artist. Gallery provides insurance, promotion and contract; in the case of main gallery exhibit.

Submissions Send query letter with résumé, 10 slides, bio and SASE. Call or write for appointment. Responds in 1 month.

Tips "The most important thing an artist needs to demonstrate to a prospective gallery is a cohesive, concise view of himself as a visual artist and as a person working with direction and passion."

PENNSYLVANIA

THE ART BANK

7825 Winston Rd., Philadelphia PA 19118. (215)753-0500. E-mail: theartbank@aol.com. **Director:** Phyllis Sunberg. Retail gallery, art consultancy, corporate art planning. Estab. 1985. Represents 40-50 emerging, mid-career and established artists/year. Exhibited artists include Lisa Fedon and John Spears. Average display time 3-6 months. Open all year; by appointment only. 1,000 sq. ft.; Clientele corporate executives and their corporations.

20% private collectors, 80% corporate collectors. Overall price range $300-35,000; most work sold at $500-1,000.

Media Considers oil, acrylic, watercolor, pastel, mixed media, collage, sculpture, glass, installation, holography, exotic material, lithography, serigraphs. Most frequently exhibits acrylics, serigraphs and sculpture.

Style Exhibits expressionism, painterly abstraction, color field and hard-edge geometric abstraction. Genres include landscapes. Prefers color field, hard edge abstract and impressionism.

Terms Accepts work on consignment (40% commission). Shipping costs are shared. Prefers artwork unframed.

Submissions Prefers artists from the region (PA, NJ, NY, DE). Send query letter with résumé, slides, brochure, SASE and prices. Write for appointment to show portfolio of originals (if appropriate), photographs and corporate installation photos. Responds only if interested within 2 weeks. Files "what I think I'll useafter talking to artist and seeing visuals." Finds artists through agents, by visiting exhibitions, word of mouth, art publications and sourcebooks, submissions.

ART FORMS

106 Levering St., Philadelphia PA 19127. (215)483-3030. Fax: (215)483-8308. E-mail: artformsgallery@mac.com. **Gallery Manager:** Erin Bettejewski. Gallery Director: Marjie Lewis Quint. Cooperative gallery, nonprofit gallery. Estab. 1993. Exhibits emerging, mid-career and established artists. Average display time 1 month. Open all year; Wednesday-Sunday, 12-5; weekends, 12-9. Closed from December 24-January 2. Located in a block of Main St., in Manayunk Philadelphia; features 1 large main gallery, which the solo show is held and a smaller back gallery where 3 artists are displayed; huge storefront window.

Media Considers all media and all types of prints. Most frequently exhibits paintings and sculpture.

Style Considers all styles and genres.

Terms There is a co-op membership fee plus a donation of time. There is a 30% commission. Retail price set by the artist. Accepted work should be framed, mounted and matted.

Submissions Call or write to arrange a personal interview to show portfolio of slides. Mail portfolio for review. Send query letter with artist's statement, bio, brochure, business card, résumé, reviews, SASE and slides. Responds in 2 months. Finds artists through word of mouth, submissions, portfolio reviews and referrals by other aritsts.

Tips "Type statement, and research who you're sending materials to. Know if the gallery is commercial/co-op."

THE BINNEY & SMITH GALLERY

25 W. Third St., Bethlehem PA 18015. (610)332-1300. Fax: (610)332-1312. E-mail: jlipzen@fest.org. Web site: www.bananafactory.org. **Director of Visual Arts and Education:** Janice Lipzin. Nonprofit gallery. Estab. 1997. Approached by 100 artists/year. Represents emerging, mid-career and established artists. Average display time 6 weeks. Open Wednesday-Sunday, 10-5. Closed the first week of August. Clients include local community, students, tourists, upscale. Overall price range $75-15,000; most work sold at $300.

Media Considers all media and all types of prints. Most frequently exhibits oil/acrylic paintings, sculpture, watercolor and photography.

Style Considers all styles and genres.

Terms Artwork is accepted on consignment and there is a 35% commission. Retail price set by the artist. Gallery provides insurance, promotion and contract. Accepted work should be framed. Does not require exclusive representation locally.

Submissions Mail portfolio for review. Send query letter with artist's statement, bio, brochure, photographs, résumé, reviews, SASE and slides. Responds only if interested within 6 months. Files artists approved by gallery committee. Finds artists through word of mouth, submissions, portfolio reviews, art exhibits, art fairs, and referrals by other artists.

Tips "Have good slides, computer résumé and artist statement."

THE CLAY PLACE

5416 Walnut St., Pittsburgh PA 15232. (412)682-3737. Fax: (412)682-3239. E-mail: clayplace1@aol.com. Web site: www.clayplace.com. **Director:** Elvira Peake. Retail gallery. Estab. 1973. Represents 50 emerging, mid-career and established artists. Exhibited artists include Jack Troy and Kirk Mangus. Sponsors 7 shows/year. Open all year. Located in small shopping area; "second level modern building with atrium." 1,200 sq. ft. 50% of space for special exhibition. Overall price range $10-2,000; most work sold at $40-100.

Media Considers ceramic, sculpture, glass and pottery. Most frequently exhibits clay, glass and enamel.

Terms Accepts artwork on consignment (50% commission) or buys outright for 50% of retail price (net 30 days). Retail price set by artist. Sometimes offers customer discounts and payment by installments. Gallery provides insurance, promotion and shipping costs from gallery.

Submissions Prefers only clay, some glass and enamel. Send query letter with résumé, slides, photographs, bio

and SASE. Write for appointment to show portfolio. Portfolio should include actual work rather than slides. Responds in 1 month. Does not reply when busy. Files résumé. Does not return slides. Finds artists through visiting exhibitions and art collectors' referrals.

Tips "Functional pottery sells well. Emphasis on form, surface decoration. Some clay artists have lowered quality in order to lower prices. Clientele look for quality, not price."

EVERHART MUSEUM

1901 Mulberry St., Scranton PA 18510-2390. (570)346-7186. Fax: (570)346-0652. E-mail: everhart@adelphia.n et. Web site: www.everhart-museum.org. **Curator:** Edward McMullen. Museum. Estab. 1908. Represents established artists. 2,400 members. Sponsors 2 shows/year. Average display time 2-3 months. Open all year; Wednesday-Sunday, 12-4; Thursday till 8; closed Monday and Tuesday. Closed in January. Located in urban park; 300 linear feet. 20% of space for special exhibitions.

Media Considers all media.

Style Prefers regional, Pennsylvania artists.

Terms Gallery provides insurance, promotion and shipping costs. 2-D artwork must be framed.

Submissions Send query letter with résumé, slides, bio, brochure and reviews. Write for appointment. Responds in 1-2 months. Files letter of query, selected slides or brochures, other information as warranted. Finds artists through agents, by visiting exhibitions, word of mouth, art publications and sourcebooks, artists' submissions.

Tips Sponsors regional juried exhibition in the summer. "Write for prospectus."

FLEISHER/OLLMAN GALLERY

1616 Walnut St., Suite 100, Philadelphia PA 19103. (215)545-7562. Fax: (215)545-6140. E-mail: info@fleisher-ollmangallery.com. Web site: www.fleisher-ollmangallery.com. **Director:** John Ollman. Retail gallery. Estab. 1952. Represents 12 emerging and established artists. Exhibited artists include James Castle and Bill Traylor. Sponsors 10 shows/year. Average display time 5 weeks. Closed August. Located downtown; 4,500 sq. ft. 75% of space for special exhibitions. Clientele primarily art collectors. 90% private collectors, 10% corporate collectors. Overall price range $2,500-100,000; most work sold at $2,500-30,000.

Media Considers oil, acrylic, watercolor, pastel, pen & ink, drawing, mixed media and collage. Most frequently exhibits drawing, painting and sculpture.

Style Exhibits self-taught and contemporary works.

Terms Accepts artwork on consignment (commission) or buys outright. Retail price set by the gallery. Gallery provides insurance and promotion; shipping costs are shared. Prefers artwork framed.

Submissions Send query letter with résumé, slides, bio and SASE; gallery will call if interested within 1 month.

Tips "Be familiar with our exhibitions and the artists we exhibit."

GALLERY JOE

302 Arch St., Philadelphia PA 19106. (215)592-7752. Fax: (215)238-6923. **Director:** Becky Kerlin. Retail and commercial exhibition gallery. Estab. 1993. Represents/exhibits 15-20 emerging, mid-career and established artists. Exhibited artists include Wes Mills and Astrid Bowlby. Sponsors 6 shows/year. Average display time 6 weeks. Open all year; Wednesday-Saturday, 12-5:30. Located in Old City; 1,400 sq. ft. 100% of space for gallery artists. 80% private collectors, 20% corporate collectors. Overall price range $500-25,000; most work sold at $2,000-10,000.

Media Only exhibits sculpture and drawing.

Style Exhibits representational/abstract.

Terms Artwork is accepted on consignment (50% commission). Retail price set by the gallery and the artist. Gallery provides insurance and promotion. Artist pays for shipping costs. Prefers artwork framed.

Submissions Send query letter with résumé, slides, reviews and SASE. Responds in 6 weeks. Finds artists mostly by visiting galleries and through artist referrals.

LANCASTER MUSEUM OF ART

135 N. Lime St., Lancaster PA 17602. (717)394-3497. Fax: (717)394-0101. E-mail: info@lmapa.org. Web site: www.lmapa.org. **Executive Director:** Cindi Morrison. Nonprofit organization. Estab. 1965. Represents over 100 emerging, mid-career and established artists/year. 900+ members. Sponsors 12 shows/year. Average display time 6 weeks. Open all year; Monday-Saturday, 10-4; Sunday, 12-4. Located downtown Lancaster; 4,000 sq. ft.; neoclassical architecture. 100% of space for special exhibitions. 100% of space for gallery artists. Overall price range $100-25,000; most work sold at $100-10,000.

Media Considers all media.

Terms Accepts work on consignment (30% commission). Retail price set by the artist. Gallery provides insurance; shipping costs are shared. Artwork must be ready for presentation.

Submissions Send query letter with résumé, slides, photographs or CDs, SASE, and artist's statement for review by exhibitions committee. Annual deadline February 1st.

Tips Advises artists to submit quality slides and well-presented proposal. "No phone calls."

MATTRESS FACTORY

500 Sampsonia Way, Pittsburgh PA 15212. (412)231-3169. Fax: (412)322-2231. E-mail: info@mattress.org. Web site: www.mattress.org. **Contact:** Curatorial Dept. Nonprofit contemporary arts museum. Estab. 1977. Represents 8-12 emerging, mid-career and established artists/year. Exhibited artists include James Turrell, Bill Woodrow, Ann Hamilton, Jessica Stockholder, John Cage, Allan Wexler, Winnifred Lutz and Christian Boltanski. Sponsors 8-12 shows/year. Average display time 6 months. Tuesday-Saturday, 10-5; Sunday 1-5; closed August. Located in Pittsburgh's historic Mexican War streets; 14,000 sq. ft.; a six-story warehouse and a turn-of-the century general store present exhibitions of temporary and permanent work.

Media Considers site-specific installations—completed in residency at the museum.

Submissions Send query letter with résumé, slides, bio. Responds in 1 year.

NEXUS/FOUNDATION FOR TODAYS ART

137 North Second Street, Philadelphia PA 19106. (215)629-1103. E-mail: info@nexusphiladelphia.org. Web site: www.nexusphiladelphia.org. **Executive Director:** Nick Cassway. Alternative space, cooperative gallery, nonprofit gallery. Estab. 1975. Approached by 40 artists/year. Represents 20 emerging and mid-career artists. Exhibited artists include Matt Pruden (illegal art extravaganza). Sponsors 10 exhibits/year. Average display time 1 month. Open Wednesday-Sunday from 12 to 6 p.m.; closed July and August. Located Old City, Philadelphia; 2 gallery spaces approx. 750 sq. ft. each. Clients include local community, students, tourists and upscale. Overall price range $75-1,200; most work sold at $200-400.

Media Considers acrylic, ceramics, collage, craft, drawing, fiber, glass, installation, mixed media, oil, paper, pen & ink and sculpture. Prints include etchings, linocuts, lithographs, posters, serigraphs and woodcuts. Most frequently exhibits installation, collage and mixed media.

Style Exhibits conceptualism, expressionism, neo-expressionism, postmodernism and surrealism. Most frequently exhibits conceptualism, expressionism and postmodernism.

Terms Artwork is accepted on consignment and there is a 50% commission. Retail price set by the artist. Gallery provides promotion. Accepted work should be framed. Does not require exclusive representation locally. Accepts only artists from Philadelphia for membership in organization.

Submissions Send query letter with artist's statement, bio, photocopies, photographs, SASE and slides. Returns material with SASE. Finds artists through portfolio reviews, referrals by other artists, submissions. Nexus juries artists 3 times a year. Please visit our Web site for submission dates.

Tips "Get great slides made by someone who knows how to take professional slides. Learn how to write a cohesive and understandable artist statement."

PENTIMENTI GALLERY

145 North Second St., Philadelphia PA 19106. (215)625-9990. Fax: (215)625-8488. E-mail: mail@pentimenti.com. Web site: www.pentimenti.com. **Contact:** Christine Pfister, director. Commercial gallery. Estab. 1992. Represents 20-30 emerging, mid-career and established artists. Sponsors 7-9 exhibits/year. Average display time 4-6 weeks. Open all year; Wednesday-Friday, 11 a.m.-5 p.m.; weekends 12 a.m.-5 p.m. Closed Sundays, August, Christmas and New Year. Located in the heart of Old City Cultural district in Philadelphia. Overall price range $250-12,000; most work sold at $1,500-7,000.

Media Considers all media. Most frequently exhibits paintings of all media.

Style Exhibits conceptualism, minimalism, postmodernism, painterly abstraction, and representational works. Most frequently exhibits postmodernism, minimalism and conceptualism.

Terms Artwork is accepted on consignment and there is a 50% commission. Retail price set by the gallery and the artist. Gallery provides insurance and promotion. Requires exclusive representation locally.

Submissions Send query letter with artist's statement, bio, brochure, photographs, résumé, SASE and slides. Returns material with SASE. Responds in 3 months. Finds artists through word of mouth, submissions, portfolio reviews, art exhibits, art fairs and referrals by other artists.

THE PRINT CENTER

1614 Latimer St., Philadelphia PA 19103. (215)735-6090. Fax: (215)735-5511. E-mail: info@printcenter.org. Web site: www.printcenter.org. Nonprofit gallery. Estab. 1915. Exhibits emerging, mid-career and established artists. Approached by 500 artists/year. Sponsors 11 exhibits/year. Average display time 2 months. Open all year; Tuesday-Saturday, 11-5:30. Closed December 21-January 3. Gallery houses 3 exhibit spaces as well as a separate Gallery Store. We are located in historic Rittenhouse area of Philadelphia. Clients include local commu-

nity, students, tourists and high end collectors. 30% of sales are to corporate collectors. Overall price range $15-15,000; most work sold at $200.

Media Considers all forms of printmaking, photography and digital printing. Send original artwork—no reproductions.

Style Considers all styles and genres.

Terms Artwork is accepted on consignment and there is a 50% commission. Retail price set by the artist. Gallery provides insurance, promotion and contract. Accepted work should be framed and matted for exhibitions; unframed for Gallery Store. Does not require exclusive representation locally. Only accepts prints and photos.

Submissions Membership based—slides of members reviewed by Curator and Gallery Store Manager. Send membership. Finds artists through submissions, art exhibits and membership.

Tips Be sure to send proper labeling and display of slides with attached slide sheet.

SAMEK ART GALLERY OF BUCKNELL UNIVERSITY

Elaine Langone Center, Lewisburg PA 17837. (570)577-3792. Fax: (570)577-3215. E-mail: peltier@bucknell.edu. Web site: www.departments.bucknell.edu/samek-artgallery/. **Director:** Dan Mills. Gallery Manager: Cynthia Peltier. Assistant Registrar: Jeffery Brunner. Nonprofit gallery. Estab. 1983. Exhibits emerging, mid-career and established international and national artists. Sponsors 6 shows/year. Average display time 6 weeks. Open all year; Monday-Friday, 11-5; Saturday-Sunday, 1-4. Located on campus; 3,500 sq. ft. including main gallery, project room and Kress Study Collection Gallery.

Media Considers all media, traditional and emerging media. Most frequently exhibits painting, sculpture, works on paper and video.

Style Exhibits all styles, genres and periods.

Terms Retail price set by the artist. Gallery provides insurance, promotion (local) and contract; artist pays shipping costs to and from gallery. Prefers artwork framed or prepared for exhibition.

Submissions Send query letter with résumé, slides and bio. Write for appointment to show portfolio of originals. Responds in 12 months. Files bio, résumé, slides. Finds artists through museum and gallery exhibits, and through studio visits.

Tips "Most exhibitions are curated by the director or by a guest curator."

THE WORKS GALLERY

Dept. AGDM, 303 Cherry St., Philadelphia PA 19106. (215)922-7775. Fax: (215)238-9351. E-mail: ruth@snyder man-works.com. Web site: www.snyderman-works.com. **Owner:** Ruth Snyderman. Retail gallery. Estab. 1965. Represents 200 emerging, mid-career and established artists. Exhibited artists include Eileen Sutton and Patricia Sannit. Sponsors 10 shows/year. Average display time 1 month. Open all year; Tuesday-Saturday, 10 a.m.-6 p.m. First Friday of each month hours extend to 9 p.m. as all galleries in this district have their openings together. Exhibitions usually change on a monthly basis except through the summer. Located downtown ("Old City"); 3,000 sq. ft. 65% of space for special exhibitions. Clientele designers, lawyers, businessmen and women, students. 90% private collectors, 10% corporate collectors. Overall price range $50-$10,000; most work sold at $200-$600.

Media Considers ceramic, fiber, glass, photography and metal jewelry. Most frequently exhibits jewelry, ceramic and fiber.

Style Exhibits all styles.

Terms Accepts artwork on consignment (50% commission); some work is bought outright. Gallery provides insurance, promotion and contract; shipping costs are shared.

Submissions Send query letter with résumé, 5-10 slides and SASE. Files résumé and slides, if interested.

Tips "Most work shown is one-of-a-kind. We change the gallery totally for our exhibitions. In our gallery, someone has to have a track record so that we can see the consistency of the work. We would not be pleased to see work of one quality once and have the quality differ in subsequent orders, unless it improved. Always submit slides with descriptions and prices instead of walking in cold. Enclose an self-addressed, stamped return envelope. Follow up with a phone call. Try to have a sense of what the gallery's focus is so your work is not out of place. It would save everyone some time."

RHODE ISLAND

ARTIST'S COOPERATIVE GALLERY OF WESTERLY

12 High St., Westerly RI 02891. (401)596-2020. E-mail: info@westerlyarts.com. Web site: www.westerlyarts.c om. Cooperative gallery and nonprofit corporation. Estab. 1992. Represents 45-50 emerging, mid-career and established artists/year. Sponsors 12 shows/year. Average display time 1 month. Offers spring and fall open juried shows. Open all year; Tuesday-Saturday, 10-5. Located downtown on a main street; 30'×80'; ground

level, store front, arcade entrance, easy parking. 80% of sales are to private collectors, 20% corporate collectors. Overall price range $20-3,000; most work sold at $20-300.

Media Considers all media and all types of prints. Most frequently exhibits oils, watercolors, ceramics, sculpture and jewelry.

Style Exhibits expressionism, primitivism, painterly abstraction, postmodern works, impressionism and realism.

Terms Co-op membership fee of $120/year, plus donation of time and hanging/jurying fee of $10. Gallery takes no percentage. Regional juried shows each year. Retail price set by the artist. Gallery provides promotion; artist pays for shipping. Prefers artwork framed.

Submissions Send query letter with 3-6 slides or photos and artist's statement. Call or write for appointment. Responds in 3 weeks. Membership flyer and application available on request.

Tips "Take some good quality pictures of your work in person, if possible, to galleries showing the kind of work you want to be associated with. If rejected, reassess your work, presentation and the galleries you have selected. Adjust what you are doing appropriately. Try again. Be upbeat and positive."

BANNISTER GALLERY/RHODE ISLAND COLLEGE ART CENTER

600 Mt. Pleasant Ave., Providence RI 02908. (401)456-9765 or 8054. E-mail: domalley@grog.ric.edu. Web site: www.ric.edu/bannister. **Gallery Director:** Dennis O'Malley. Nonprofit gallery. Estab. 1978. Represents emerging, mid-career and established artists. Sponsors 9 shows/year. Average display time 3 weeks. Open September-May. Located on college campus; 1,600 sq. ft.; features spacious, well-lit gallery space with off-white walls, gloss black tile floor; two sections with 9 foot and 12 foot ceilings. 100% of space for special exhibitions. Clientele students and public.

Media Considers all media and all types of original prints. Most frequently exhibits painting, photography and sculpture.

Style Exhibits all styles.

Terms Artwork is exhibited for educational purposes—gallery takes no commission. Retail price set by artist. Gallery provides insurance, promotion and limited shipping costs from gallery. Prefers artwork framed.

Submissions Send query letter with résumé, slides, bio, brochure, SASE and reviews. Files addresses, catalogs and résumés.

BANNISTER GALLERYRHODE ISLAND COLLEGE ART CENTER

600 Mt. Pleasant Ave., Providence RI 02908. (401)456-9765 or 8054. E-mail: domalley@grog.ric.edu. Web site: www.ric.edu/bannister. **Gallery Director:** Dennis O'Malley. Nonprofit gallery. Estab. 1978. Represents emerging, mid-career and established artists. Sponsors 9 shows/year. Average display time 3 weeks. Open September-May. Located on college campus; 1,600 sq. ft.; features spacious, well-lit gallery space with off-white walls, gloss black tile floor; two sections with 9 foot and 12 foot ceilings. 100% of space for special exhibitions. Clientele students and public.

Media Considers all media and all types of original prints. Most frequently exhibits painting, photography and sculpture.

Style Exhibits all styles.

Terms Artwork is exhibited for educational purposes—gallery takes no commission. Retail price set by artist. Gallery provides insurance, promotion and limited shipping costs from gallery. Prefers artwork framed.

Submissions Send query letter with résumé, slides, bio, brochure, SASE and reviews. Files addresses, catalogs and résumés.

COMPLEMENTS ART GALLERY

Fine Art Investments, Ltd., 50 Lambert Lind Hwy., Warwick RI 02886. (401)739-9300. Fax: (401)739-7905. E-mail: fineartinv@aol.com. Web site: www.complementsartgallery.com. **President:** Domenic B. Rignanese. Retail gallery. Estab. 1986. Represents hundreds of international and New England emerging, mid-career and established artists. Exhibited artists include Fairchild and Hatfield. Sponsors 6 shows/year. Average display time 2-3 weeks. Open all year; Monday-Friday, 8:30am-6pm; Saturday-Sunday, 9 a.m.-5 p.m. 3,500 sq. ft.; "we have a piano and beautiful hardwood floors, also a great fireplace." 20% of space for special exhibitions; 60% of space for gallery artists. Clientele upscale. 40% private collectors, 15% corporate collectors. Overall price range $25-$10,000; most work sold at $600-2,000.

Media Considers all media except offset prints. Types of prints include engravings, lithographs, wood engravings, mezzotints, serigraphs and etchings. Most frequently exhibits serigraphs, oils.

Style Exhibits expressionism, painterly abstraction, impressionism, photorealism, realism and imagism. Genres include florals, portraits and landscapes. Prefers realism, impressionism and abstract.

Terms Accepts work on consignment (30% commission) or bought outright for 50% of retail price (90 days).

Retail price set by the gallery. Gallery provides insurance, promotion and contract. Shipping costs are shared. Prefers artwork unframed.

Submissions Size limitation due to wall space. Paintings no larger than 40×60, sculpture not heavier than 150 pounds. Send query letter with résumé, bio, 6 slides or photographs. Call for appointment to show portfolio of photographs and slides. Responds in 1 month. Files all materials from artists. Finds artists through word of mouth, referrals by other artists, visiting art fairs and all exhibitions and artist's submissions.

Tips "Artists need to have an idea of the price range of their work and provide interesting information about themselves."

THE DONOVAN GALLERY

3895 Main Rd., Tiverton Four Corners RI 02878. (401)624-4000. E-mail: kris@donovangallery.com. Web site: www.donovangallery.com. **Owner:** Kris Donovan. Retail gallery. Estab. 1993. Represents 50 emerging, mid-career and established artists/year. Average display time 1 month. Open all year; Monday-Saturday, 10-5; Sunday, 12-5; shorter winter hours. Located in a rural shopping area; 2,000 sq. ft.; located in 1750s historical home. 100% of space for gallery artists. Clientele tourists, upscale, local community and students. 90% private collectors, 10% corporate collectors. Overall price range $80-6,500; most work sold at $250-800.

Media Considers oil, acrylic, watercolor, pastel, mixed media, collage, paper, sculpture, ceramics, some craft, fiber and glass; and all types of prints. Most frequently exhibits watercolors, oils and pastels.

Style Exhibits conceptualism, impressionism, photorealism and realism. Exhibits all genres. Prefers realism, impressionism and representational.

Terms Accepts work on consignment (45% commission). Retail price set by the artist. Gallery provides limited insurance, promotion and contract; artist pays for shipping. Prefers artwork framed.

Submissions Accepts only artists from New England. Send query letter with résumé, 6 slides, bio, brochure, photographs, SASE, business card, reviews and artist's statement. Call or write for appointment to show portfolio of photographs or slides or transparencies. Responds in 1 week. Files material for possible future exhibition. Finds artists through networking and submissions.

Tips "Do not appear without an appointment, especially on a weekend. Be professional, make appointments by telephone, be prepared with résumé, slides and (in my case) some originals to show. Don't give up. Join local art associations and take advantage of show opportunities there."

SOUTH CAROLINA

CECELIA COKER BELL GALLERY

Coker College, Hartsville, SC 29550. (843)383-8156. E-mail: lmerriman@pascal.coker.edu. Web site: www.coker.edu/art/gallery.html. **Director:** Larry Merriman. "A campus-located teaching gallery which exhibits a variety of media and style to expose students and the community to the breadth of possibility for expression in art. Exhibits include regional, national and international artists with an emphasis on quality and originality. Shows include work from emerging, mid, and late career artists." Sponsors 5 solo shows/year, with a 4 week run for each show. The gallery measures 23×33×1, has grey carpeted walls, track lighting and is located in the art department.

Media Considers all media including installation and graphic design. Most frequently exhibits painting, photography, sculpture/installation and mixed media.

Style Considers all styles. Not interested in conservative/commercial art.

Terms Retail price set by artist (sales are not common). Exclusive area representation not required. Gallery provides insurance, promotion and contract; shipping costs are shared.

Submissions Send résumé, 10 slides (or JPEGS on CD), and SASE by October 15. Visits by artists are welcome; however, the exhibition committee will review and select all shows from the slides and JPEGS submitted by the artists.

COLEMAN FINE ART

79 Church St., Charleston SC 29401. (843)853-7000. Fax: (843)722-2552. E-mail: info@colemanfineart.com. Web site: www.colemanfineart.com. **Gallery Director:** Katherine Wright. Retail gallery, gilding, frame making and restoration. Estab. 1974. Represents 8 emerging, mid-career and established artists/year. Exhibited artists include John Cosby, Marc Hanson, Glenna Hartmann, Joe Paquet, Jan Pawlowski, Don Stone, George Strickland, Mary Whyte. Hosts 2 shows/year. Average display time 1 month. Open all year; Monday, 10-4; Tuesday-Saturday, 10-6, and by appointment. "Both a fine art gallery and restoration studio, Coleman Fine Art has been representing regional and national artists for over 30 years. Located on the corner of Church and Tradd streets, the gallery reinvigorates one of the country's oldest art studios." Clientele tourists, upscale and locals. 95-98%

private collectors, 2-5% corporate collectors. Overall price range $1,000-50,000; most work sold at $3,000-8,000.

Media Considers oil, watercolor, pastel, pen & ink, drawing, mixed media, sculpture. Most frequently exhibits watercolor, oil and sculpture.

Style Exhibits expressionism, impressionism, photorealism and realism. Genres include portraits, landscapes, still lifes and figurative work. Prefers figurative work/expressionism, realism and impressionism.

Terms Accepts work on consignment (45% commission); net 30 days. Retail price set by the gallery and the artist. Gallery provides promotion and contract. Shipping costs are shared. Prefers artwork framed.

Submissions Send query letter with brochure, 20 slides/digital CD of most recent work, reviews, bio and SASE. Write for appointment to show portfolio of photographs, slides and transparencies. Responds only if interested within 1 month. Files slides. Finds artists through submissions.

Tips "Do not approach gallery without an appointment."

HAMPTON III GALLERY LTD.

3110 Wade Hampton Blvd., Taylors (Greenville) SC 29687. E-mail: hampton3gallery@mindspring.com. **Contact:** Sandra Rupp, director. Rental gallery. Estab. 1970. Approached by 20 artists/year; exhibits 25 mid-career and established artists/year. Exhibited artists include Carl Blair (oil paintings) and Darell Koons (acrylic paintings). Sponsors 8 exhibits/year. Average display time 4-6 weeks. Open all year; Tuesday-Friday, 1-5; Saturday and Sunday, 10-5. Located 3 miles outside of downtown Greenville, SC; one large exhibition room in center with 7 exhibition rooms around center gallery. Clients include local community and upscale. 5% of sales are to corporate collectors. Overall price range $200-15,000; most work sold at $2,500.

Media Considers acrylic, ceramics, collage, drawing, mixed media, oil, paper, pastel, pen & ink, sculpture and watercolor. Most frequently exhibits oil and watercolor. Also considers engravings, etchings, linocuts, lithographs, mezzotints, serigraphs and woodcuts.

Style Exhibits color field, expressionism, geometric abstraction, imagism, impressionism and painterly abstraction. Most frequently exhibits painterly abstration and realism. Considers all genres.

Terms Artwork is accepted on consignment and there is a 40% commission. Retail price of the art set by the artist. Gallery provides insurance, promotion and contract. Accepted work should be framed. Requires exclusive representation locally.

Submissions Send query letter with artist's statement, bio, reviews, SASE and slides. Returns material with SASE. Responds to queries in 3 months. Finds artists through art exhibits, referrals by other artists and word of mouth.

MCCALLS

111 W. Main, Union SC 29379. (864)427-8781. **Contact:** Bill McCall. Retail gallery. Estab. 1972. Represents 5-7 established artists/year. Open all year; Tuesday-Friday, 10-5 (10 months); Monday-Saturday, 10-6 (2 months). Located downtown; 900 sq. ft. 10% of space for special exhibitions; 90% of space for gallery artists. Clientele: upscale. 60% private collectors, 40% corporate collectors. Overall price range $150-2,500; most work sold at $150-850.

Media Considers oil, pen & ink, acrylic, glass, craft (jewelry), watercolor, mixed media, pastel, collage; considers all types of prints. Most frequently exhibits jewelry, collage and watercolor.

Style Exhibits painterly abstraction, primitivism, realism, geometric abstraction and impressionism. Genres include florals, western, southwestern, landscapes, wildlife and Americana. Prefers southwestern, florals and landscapes.

Terms Accepts work on consignment (negotiable commission). Retail price set by the gallery and the artist. Gallery provides insurance, promotion and contract.

Submissions "I prefer to see actual work by appointment only."

Tips "Present only professional quality slides and/or photographs."

PORTFOLIO ART GALLERY

2007 Devine St., Columbia SC 29205. (803)256-2434. E-mail: artgal@portfolioartgal.com. Web site: www.portfolioartgal.com. **Owner:** Judith Roberts. Retail gallery and art consultancy. Estab. 1980. Represents 40-50 emerging, mid-career and established artists. Exhibited artists include Juko Ono Rothwell, Sigmund Abeles and Shannon Bueker. Sponsors 3 shows/year. Average display time 3 months. Open all year. Located in a 1930s shopping village, 1 mile from downtown; 2,000 sq. ft.; features 12 foot ceilings. 100% of space for work of gallery artists. "A unique feature is glass shelves where matted and medium to small pieces can be displayed without hanging on the wall." Clientele: professionals, collectors, corporations. 70% professionals and collectors, 30% corporate. Overall price range $150-12,500; most work sold at $600-$3,000.

- Portfolio Art Gallery was honored as the only South Carolina gallery in 2005 as "Top 100" by vote of american and canadian artists, sponsored by The Rosen Group, American Style and niche magazines.

Media Considers oil, acrylic, watercolor, pastel, mixed media, collage, works on paper, sculpture, ceramic,

glass, original handpulled prints, woodcuts, wood engravings, linocuts, engravings, mezzotints, etchings, lithographs and serigraphs. Most frequently exhibits oils, acrylics, ceramics and sculpture and original jewelry.

Style Exhibits neo-expressionism, painterly abstraction, imagism, minimalism, color field, impressionism, and realism. Genres include landscapes and figurative work. Prefers landscapes/seascapes, painterly abstraction and figurative work. "I especially like mixed media pieces, original prints and oil paintings. Pastel medium and watercolors are also favorites. Kinetic sculpture and whimsical clay pieces."

Terms Accepts work on consignment (40% commission). Retail price set by gallery and artist. Offers payment by installments. Gallery provides insurance, promotion and contract; artist pays for shipping. Artwork may be framed or unframed.

Submissions Send query letter with bio and images via e-mail, cd or slides. Write for appointment to show portfolio of originals, slides, photographs and transparencies. Responds only if interested within 1 month. Files tearsheets, brochures and slides. Finds artists through visiting exhibitions and referrals.

Tips "The most common mistake beginning artists make is showing all the work they have ever done. I want to see only examples of recent best work—unframed, originals (no copies)—at portfolio reviews."

SOUTH DAKOTA

DAKOTA ART GALLERY

902 Mt. Rushmore Rd., Rapid City SD 57701. (605)394-4108. **Director:** Marie Bachmeier. Retail gallery. Estab. 1971. Represents approximately 200 emerging, mid-career and established artists, approximately 180 members. Exhibited artists include James Van Nuys and Russell Norberg. Sponsors 8 shows/year. Average display time 6 weeks. Also sponsors 6-week-long spotlight exhibits 8 times a year. Average display time 6 weeks. Open all year; Monday-Saturday, 10-5. Located in downtown Rapid City; 1,800 sq. ft. 40% of space for special exhibitions; 60% of space for gallery artists. 80% private collectors, 20% corporate collectors. Overall price range $25-7,500; most work sold at $25-400.

Media Considers all media and all types of prints. Most frequently exhibits oil, acrylics, watercolors, pastels, jewelry, stained glass and ceramics.

Style Exhibits expressionism, painterly abstraction and impressionism and all genres. Prefers landscapes, western, regional, still lifes and traditional.

Terms Accepts work on assignment (40% commission). Retail price set by the artist. Gallery provides insurance, promotion and contract. Artist pays shipping costs.

Submissions "Our main focus is on artists from SD, ND, MN, WY, CO, MT and IA. We also show artwork from any state that has been juried in." Must be juried in by committee. Send query letter with résumé, 15-20 slides, bio and photographs. Call for appointment to show portfolio of photographs, slides, bio and résumé. Responds in 1 month. Files résumés and photographs. Finds artists through word of mouth, referrals by other artists, visiting art fairs and exhibitions, artist's submissions.

Tips "Make a good presentation with professional résumé, biographical material, slides, etc. Know the gallery quality and direction in sales, including prices."

TENNESSEE

BENNETT GALLERIES

5308 Kingston Pike, Knoxville TN 37919. (865)584-6791. Fax: (865)588-6130. Web site: www.bennettgalleries.com. **Director:** Marga Hayes. Owner: Rick Bennett. Retail gallery. Represents emerging and established artists. Exhibited artists include Richard Jolley, Carl Sublett, Scott Duce, Andrew Saftel and Tommie Rush, Akira Blount, Scott Hill, Marga Hayes Ingram, John Boatright, Grace Ann Warn, Timothy Berry, Cheryl Warrick, Dion Zwirne. Sponsors 10 shows/year. Average display time 1 month. Open all year; Monday-Thursday, 10-6; Friday-Saturday, 10-5:30. Located in West Knoxville. Clientele 80% private collectors, 20% corporate collectors. Overall price range $200-20,000; most work sold at $2,000-8,000.

Media Considers oil, acrylic, watercolor, pastel, drawing, mixed media, works on paper, sculpture, ceramic, craft, photography, glass, original handpulled prints. Most frequently exhibits painting, ceramic/clay, wood, glass and sculpture.

Style Exhibits contemporary works in abstraction, figurative, narrative, realism, contemporary landscape and still life.

Terms Accepts artwork on consignment (50% commission). Retail price set by the gallery and the artist. Sometimes offers customer discounts and payment by installments. Gallery provides insurance on works at the gallery, promotion and contract. Prefers artwork framed. Shipping to gallery to be paid by the artist.

Submissions Send query letter with résumé, no more than 10 slides, bio, photographs, SASE and reviews. Finds

artists through agents, visiting exhibitions, word of mouth, various art publications, sourcebooks, submissions/ self-promotions and referrals.

EATON GALLERY

1401 Heistan Place, Memphis TN 38104. (901)274-0000. Fax: (901)274-4147. **Owner/Director:** Sandra Saunders. Retail gallery. Estab. 1984. Represents 25 emerging, mid-career and established artists. Exhibited artists include Marjorie Liebman, Jiaxian Hao, Taylor Lin, Weimin. 30% of space for special exhibitions. Clientele 60% private collectors, 40% corporate clients. Overall price range $350-10,000; most work sold at $700-4,500.
Media Considers oil, acrylic, watercolor, pastel, drawings, mixed media, works on paper, sculpture, original handpulled prints, woodcuts, engravings, lithographs, mezzotints, serigraphs and etchings. Most frequently exhibits oil, acrylic and watercolor.
Style Exhibits expressionism, painterly abstraction, color field, impressionism and realism. Genres include landscapes, florals, Americana, Southwestern, portraits and figurative work. Prefers impressionism, expressionism and realism.
Terms Accepts work on consignment (50% commission). Retail price set by artist or both gallery and artist. Gallery provides insurance, promotion and contract; artist pays for shipping. Prefers artwork framed.
Submissions Send query letter with résumé, bio, slides, photographs and reviews. Write for appointment to show portfolio of originals "so that we may see how the real work looks" and photographs. Responds in 1 week. Files photos and "anything else the artists will give us."
Tips "Just contact us—we are here for you."

LISA KURTS GALLERY

766 S. White Station Rd., Memphis TN 38117. (901)683-6200. Fax: (901)683-6265. E-mail: art@lisakurts.com. Web site: www.lisakurts.com. **Contact:** Stephen Barker, communications. For-profit gallery. Estab. 1979. Approached by 500 artists/year; exhibits 20 mid-career and established nationnally and internationally known aritsts. Exhibited artists include Marcia Myers and Anita Huffington. Sponsors 9 total exhibitions/year. Average display time 4-6 weeks. Open all year; Tuesday-Friday, 10-5; Saturday, 11-4. "Lisa Kurts Gallery is Memphis' oldest gallery and is known to be one of the leading galleries in the USA. Exhibits nationally in International Art Fairs and is regularly reviewed in the national press. Publishes catalogues and works closely with serious collectors and museums. This gallery's sister company, Lisa Kurts Ltd. specializes in blue chip Impressionist and Early Modern paintings and sculpture." Clients include national and international. Overall price range $5,000-100,000; most work sold at $7,500-15,000.
Media Exhibits "80% oil painting, 18% sculpture, 2% photography."
Style Most frequently exhibits "artists with individual vision and who create works of art that are well crafted or painted." Considers all genres.
Terms Artwork is accepted on consignment and there is a 50% commission. Retail price of the art set by the artist and the market if the artist's career is mature; set by the gallery if the artist's career is young. Gallery provides insurance, promotion and contract. Accepted work should be "professionally framed or archively mounted as approved by gallery's standards." Requires exclusive representation in the South.
Submissions Send query letter with artist's statement, résumé, reviews and slides. Returns materials with SASE. Responds to queries in 3 months. Files slides and complete information. Finds artists through art fairs and exhibits, portfolio reviews, referrals by other artists, submissions and word of mouth.
Tips To make their gallery submissions professional artists must send "clearly labeled slides and a minimum of 1 sheet, with the total résumé, artist's statement, letter why they contacted our gallery reviews, etc. Do not call. E-mail if you've not heard from us in 3 months."

THE PARTHENON

Centennial Park, Nashville TN 37201. (615)862-8431. Fax: (615)880-2265. E-mail: susan@parthenon.org. Web site: www.parthenon.org. **Curator:** Susan E. Shockley. Nonprofit gallery in a full-size replica of the Greek Parthenon. Estab. 1931. Exhibits the work of emerging to mid-career artists. Clientele general public, tourists. Sponsors 10-12 shows/year. Average display time 3 months. Overall price range $300-2,000. "We also house a permanent collection of American paintings (1765-1923)."
Media Considers "nearly all" media.
Style "Interested in both objective and non-objective work. Professional presentation is important."
Terms "Sale requires a 20% commission." Retail price set by artist. Gallery provides a contract and limited promotion. The Parthenon does not represent artists on a continuing basis.
Submissions Send 20 well-organized slides, résumé and artist's statement addressed to curator.
Tips "We plan our gallery calendar at least one year in advance."

RIVER GALLERY

400 E. Second St., Chattanooga TN 37403. (423)265-5033, ext. 5. Fax: (423)265-5944. E-mail: details@river-gallery.com. **Owner Director:** Mary R. Portera. Retail gallery. Estab. 1992. Represents 150 emerging, mid-career and established artists/year. Exhibited artists include Leonard Baskin and Scott E. Hill. Sponsors 12 shows/year. Display time 1 month. Open all year; Monday-Saturday, 10-5; Sunday, 1-5. Located in Bluff View Art District in downtown area; 2,500 sq. ft.; restored early New Orleans-style 1900s home; arched openings into rooms. 20% of space for special exhibitions; 80% of space for gallery artists. Clients include upscale tourists, local community. 95% of sales are to private collectors, 5% corporate collectors. Overall price range $5-5,000; most work sold at $200-1,000.
Media Considers all media. Most frequently exhibits oil, original prints, photography, watercolor, mixed media, clay, jewelry, wood, glass and sculpture.
Style Exhibits all styles and genres. Prefers painterly abstraction, impressionism, photorealism.
Terms Accepts work on consignment (50% commission). Retail price set by the gallery. Gallery provides insurance, promotion and contract; shipping costs are shared. Prefers artwork framed.
Submissions Send query letter with résumé, slides, bio, photographs, SASE, reviews and artist's statement. Call or e-mail for appointment to show portfolio of photographs and slides. Files all material "unless we are not interested then we return all information to artist." Finds artists through word of mouth, referrals by other artists, visiting art fairs and exhibitions, submissions, ads in art publications.

TEXAS

ART LEAGUE OF HOUSTON

1953 Montrose Blvd., Houston TX 77006. (713)523-9530. E-mail: artleagh@neosoft.com. **Interim Executive Director:** Diana Griffin Gregory. Nonprofit gallery. Estab. 1948. Represents emerging and mid-career artists. Sponsors 12 individual and group shows/year. Average display time 3-4 weeks. Located in a contemporary metal building; 1,300 sq. ft., specially lighted; smaller inner gallery/video room. Clientele general, artists and collectors. Overall price range $100-5,000; most artwork sold at $100-2,500.
Media Considers all media.
Style Exhibits contemporary avant-garde, socially aware work. Features "high-quality artwork reflecting serious aesthetic investigation and innovation. Additionally the work should have a sense of personal vision."
Terms 30% commission. Retail price set by artist. Exclusive area representation not required. Gallery provides insurance, promotion and contract; artist pays for shipping.
Submissions Must be a Houston-area resident. Send query letter, résumé and slides that accurately portray the work. Portfolio review not required. Submissions reviewed once a year in mid-June, and exhibition agenda determined for upcoming year.

AUSTIN MUSEUM OF ART

823 Congress Ave., Austin TX 78701 Fax: (512)495-9024. E-mail: krobertson@amoa.org. Web site: www.amoa.org. **Director:** Elizabeth Ferrer. Museum. Estab. 1961. Downtown and Laguna Gloria locations. Interested in emerging, mid-career and established artists. Sponsors 2-3 solo and 6 group shows/year. Average display time 1½ months. Clientele tourists and Austin and central Texas citizens.
Media Currently exhibits 20th-21st Century art of the Americas and the Caribbean with an emphasis on two-dimensional and three-dimensional contemporary artwork to include experimental video, mixed media and outdoor site-specific installations.
Style Exhibits all styles and genres. No commercial cliched art.
Terms Retail price set by artist. Gallery provides insurance and contract; shipping costs to be determined. Exhibitions booked 2 years in advance. "We are not a commercial gallery."
Submissions Send query letter with résumé, slides and SASE. Responds only if interested within 3 months. Files slides, résumé and bio. Material returned only when accompanied by SASE. Common mistakes artists make are "not enough information—poor slide quality, too much work covering too many changes in their development."

BARNARD'S MILL ART MUSEUM

307 SW. Barnard St., Glen Rose TX 76043. (254)897-2611. **Contact:** Richard H. Moore, president. Museum. Estab. 1989. Represents 30 mid-career and established artists/year. Interested in seeing the work of emerging artists. Sponsors 2 shows/year. Open all year; Saturday, 10-5; Sunday, 1-5. Located 2 blocks from the square. "Barnards Mill is the oldest structure (rock exterior) in Glen Rose. 20% of space for special exhibitions; 80% of space for gallery artists.
Media Considers oil, acrylic, watercolor, pastel, pen & ink, drawing, mixed media, collage, paper, sculpture,

ceramics, fiber, glass, installation, photography, woodcuts, engravings, lithographs, wood engravings, mezzotints, serigraphs, linocuts and etchings. Most frequently exhibits oil, pastel and watercolor.

Style Exhibits experssionism, postmodern works, impressionism and realism, all genres. Prefers realism, impressionism and Western.

Terms Gallery provides promotion. Prefers artwork framed.

Submissions Send query letter with résumé, slides or photographs, bio and SASE. Write for appointment to show portfolio of photographs or slides. Responds only if interested within 3 months. Files résumés, photos, slides.

BLOSSOM STREET GALLERY & SCULPTURE GARDEN

4809 Blossom, Houston TX 77007. (713)869-1921. E-mail: Director@blossomstreetGallery.com. Web site: www. blossomstreetgallery.com. **Contact:** Diane, director. For-profit gallery. Estab. 1997. Approached by 40 artists/ year. Represents 20 emerging, mid-career and established artists. Exhibited artists include Richard Roederer (painting and sculpture) and William Webman (photography). Average display time 1 month. Open all year; Tuesday-Sunday, 11-6. Located in inner city Houston; 3 exhibit spaces and 1 acre sculpture park and garden area. Clients include local community, tourists and upscale. 20% of sales are to corporate collectors. Overall price range $200-20,000; most work sold at $1,000.

Media Considers acrylic, collage, drawing, fiber, glass, installation, mixed media, oil, paper, pastel, pen & ink, sculpture, watercolor, etchings, linocuts, lithographs, mezzotints, serigraphs and woodcuts. Most frequently exhibits oil, collage and photography.

Style Considers all styles. Genres include Americana, figurative work and landscapes.

Terms Artwork is accepted on consignment and there is a 50% commission. Retail price set by the gallery and the artist. Gallery provides insurance, promotion and contract. Accepted work should be hangable. Requires exclusive representation locallyif a one-person exhibit.

Submissions Send query letter with artist's statement, bio, brochure, business card, photocopies, photographs, résumé, reviews, SASE, slides or send Web page. Returns material with SASE. Responds in 1 month. Finds artists through word of mouth, submissions, portfolio reviews, art exhibits and referrals by other artists.

CONTEMPORARY GALLERY

4152 Shady Bend Dr., Dallas TX 75244. (214)247-5246. **Director:** Patsy C. Kahn. Private dealer. Estab. 1964. Interested in established artists. Clients include collectors and retail.

Media Considers original handpulled prints.

Style Contemporary, 20th-century artgraphics.

Terms Accepts work on consignment or buys outright. Retail price set by gallery and artist; shipping costs are shared.

Submissions Send query letter, résumé, slides and photographs. Write for appointment to show portfolio.

DALLAS MUSEUM OF ART

1717 Harwood St., Dallas TX 75201. (214)922-1200. Fax: (214)922-1350. Web site: www.DallasMuseumofArt.o rg. Museum. Estab. 1903. Exhibits emerging, mid-career and established Exhibited artists include Thomas Struth. Average display time 3 months. Open all year; Tuesday-Sunday, 11-5; open until 9 on Thursday. Closed New Year's Day, Thanksgiving and Christmas. Clients include local community, students, tourists and upscale.

• Museum does not accept unsolicited submissions.

Media Exhibits all media and all types of prints.

Style Exhibits all styles and genres.

F8 FINE ART GALLERY

211 Earl Garrett, Kerrville TX 78028. (830)895-0646. Fax: (830)895-0680. E-mail: fineart@ktc.com. Web site: www.f8fineart.com. For-profit gallery. Estab. 2001. Approached by 200 artists/year. Exhibits 30 emerging and mid-career artists. Exhibited artists include Ray Donley, Jennifer Balkan, and Michael Klung. Sponsors 8 exhibits/year. Average display time 6 weeks. Open all year; Tuesday-Friday, 11-6 and Saturday, 10-5. Clients include local community and tourists. Overall price range $400-10,000; most work sold at $2,500.

• This gallery has a second location at 1137 W. Sixth St., Austin TX 78703. (512)480-0242. Fax: (572)480-0241.Open all year; Tuesday-Saturday, 10-6. "Both galleries are amont the premier galleries in their areas. Each has clean lines and is minimally decorated so that the focus is on the art."

Media Considers acrylic, oil, mixed media and photography. Does not consider digital or reproduction work.

Style Considers contemporary.

Terms Artwork is accepted on consignment and there is a 50% commission. Retail price set by the gallery. Gallery provides insurance, promotion and contract. Accepted work should be framed and matted. Require exclusive representation regionally.

Submissions Send query letter with artist's statement, bio, images of work, résumé, reviews. Returns material with SASE. Responds only if interested within 6 weeks. Files all information that doesn't need to be returned on artists we're interested in only. Finds artists through submissions, portfolio reviews and art exhibits.

Tips Give us all of the information you think we might need in a clean, well-organized form. Do not send original work. All art submissions should represent the original as closely as possible. Archival-quality is a must.

GREMILLION & CO. FINE ART, INC.
2501 Sunset Blvd., Houston TX 77005. (713)522-2701. E-mail: fineart@gremillion.com. Web site: www.gremilli on.com. **Director:** Christopher Skidmore. Sales/Marketing Bob Russell. Retail gallery. Estab. 1980. Represents more than 80 mid-career and established artists. May be interested in seeing the work of emerging artists in the future. Exhibited artists include John Pavlicek and Robert Rector. Sponsors 12 shows/year. Average display time 4-6 weeks. Open all year. Located ''West University'' area; 12,000 sq. ft. 50% of space for special exhibi- tions. 60% private collectors; 40% corporate collectors. Overall price range $500-300,000; most work sold at $3,000-10,000.

Media Considers oil, acrylic, watercolor, pastel, pen & ink, drawing, mixed media, collage, works on paper, sculpture, original handpulled prints, woodcuts, engravings, lithographs, wood engravings, mezzotints, lino- cuts, etchings and serigraphs.

Style Exhibits painterly abstraction, minimalism, color field and realism. Genres include landscapes and figura- tive work. Prefers abstraction, realism and color field.

Terms Accepts artwork on consignment (varying commission). Retail price set by the gallery and artist. Gallery provides insurance and promotion; shipping costs are shared. Prefers artwork unframed.

Submissions Call for appointment to show portfolio of slides, photographs and transparencies. Responds only if interested within 3 weeks. Files slides and bios. Finds artists through submissions and word of mouth.

IVANFFY & UHLER GALLERY
4623 W. Lovers Lane, Dallas TX 75209. (214)350-3500. E-mail: info@ivanffyuhler.com. Web site: www.ivanffyu hler.com. **Director:** Paul Uhler. Retail/wholesale gallery. Estab. 1990. Represents 20 mid-career and established artists/year. May be interested in seeing the work of emerging artists in the future. Sponsors 1-2 shows/year. Average display time 1 month. Open from October-June; Tuesday-Saturday, 10-6. Located near Love Field Airport. 4,000 sq. ft. 100% of space for gallery artists. Clientele: upscale, local community. 85% private collec- tors, 15% corporate collectors. Overall price range $1,000-20,000; most work sold at $1,500-4,000.

Media Considers oil, acrylic, watercolor, pastel, pen & ink, drawing, mixed media, collage, paper, sculpture, woodcuts, engravings, lithographs, wood engravings, mezzotints, serigraphs, linocuts and etchings. Most fre- quently exhibits oils, mixed media, sculpture.

Style Exhibits neo-expressionism, painterly abstraction, surrealism, postmodern works, impressionism, hard- edge geometric abstraction, postmodern European school. Genres include florals, landscapes, figurative work.

Terms Shipping costs are shared.

Submissions Send query letter with résumé, photographs, bio and SASE. Write for appointment to show portfo- lio of photographs. Responds only if interested within 1 month.

LONGVIEW MUSEUM OF FINE ARTS
215 E. Tyler St, P.O. Box 3484, Longview TX 75606. (903)753-8103. E-mail: foxhearne@kilgore.net. **Director:** Renee Hawkins. Museum. Estab. 1967. Represents 80 emerging, mid-career and established artists/year. 600 members. Sponsors 6-9 shows/year. Average display time 6 weeks. Open all year; Tuesday-Friday, 10-4; Satur- day, 12-4. Located downtown. 75% of space for special exhibitions. Clientele members, visitors (local and out- of-town) and private collectors. Overall price range $200-2,000; most work sold at $200-800.

Media Considers all media, all types of prints. Most frequently exhibits oil, acrylic and photography.

Style Exhibits all styles and genres. Prefers contemporary American art and photography.

Terms Accepts work on consignment (30% commission). Retail price set by the artist. Offers customer discounts to museum members. Gallery provides insurance and promotion. Prefers artwork framed.

Submissions Send query letter with résumé and slides. Portfolio review not required. Responds in 1 month. Files slides and résumés. Finds artists through art publications and shows in other areas.

MCMURTREY GALLERY
3508 Lake St., Houston TX 77098. (713)523-8238. Fax: (713)523-0932. E-mail: info@mcmurtreygallery.com. **Owner:** Eleanor McMurtrey. Retail gallery. Estab. 1981. Represents 20 emerging and mid-career artists. Exhib- ited artists include Robert Jessup and Jenn Wetta. Sponsors 10 shows/year. Average display time 1 month. Open all year. Located near downtown; 2,600 sq. ft. Clients include corporations. 75% of sales are to private collectors, 25% corporate collectors. Overall price range $400-17,000; most work sold at $1,800-6,000.

Media Considers oil, acrylic, pastel, drawings, mixed media, collage, works on paper, photography and sculpture. Most frequently exhibits mixed media, acrylic and oil.
Style Exhibits figurative, narrative, painterly abstraction and realism.
Terms Accepts work on consignment (50% commission). Retail price set by gallery and artist. Prefers artwork framed.
Submissions Send query letter with résumé, slides and SASE. Call for appointment to show portfolio of originals and slides.
Tips "Be aware of the work the gallery exhibits and act accordingly. Please make an appointment."

MONTICELLO FINE ARTS GALLERY

3700 W. Seventh, Fort Worth TX 76107. (817)731-6412. Fax: (817)731-6413 or (888)374-3435. E-mail: glenna@ monticellogallery.com. Web site: www.monticellofineartsgallery.com. **Owner:** Glenna Crocker. Retail gallery and art consultancy. Estab. 1983. Represents about 50 artists; emerging, mid-career and established. Interested in seeing the work of emerging artists. Exhibited artists include Carol Anthony, Patricia Nix and Alexandra Nechita. Sponsors 9 shows/year. Average display time 3 weeks. Open all year; Monday-Friday, 10-6; Saturday, 10-5. Located in museum area; 2500 sq. ft.; diversity of the material and artist mix. "The gallery is warm and inviting." 66% of space for special exhibitions. Clientele upscale, community, tourists. 90% private collectors. Overall price range $30-10,000.
Media Considers oil, acrylic, watercolor, pastel, mixed media, collage, sculpture, ceramic; original handpulled prints; woodcuts, wood engravings, linocuts, engravings, mezzotints, etchings, lithographs and serigraphs. Most frequently exhibits painting and sculpture.
Style Exhibits expressionism, neo-expressionism, painterly abstraction, color field, impressionism, realism and Western. Genres include landscapes, florals and figurative work. Prefers landscape, florals, interiors and still life.
Terms Accepts work on consignment (50% commission). Retail price set by gallery and artist. Gallery provides insurance, promotion and contract. Artist pays for shipping. Prefers artwork framed.
Submissions Send query letter with résumé, slides and bio. Call or write for appointment to show portfolio of two of the following originals, photographs, slides and transparencies, or e-mail digital images and bio.
Tips Artists must have an appointment.

DEBORAH PEACOCK GALLERY

1705 Guadalupe, #118, Austin TX 78701. (512)474-2235. Fax: (512)474-8188. E-mail: photo@art-n-music.com. Web site: www.art-n-music.com. **Proprietor/Photographer:** Deborah Peacock. Alternative space, for-profit gallery and art consultancy. Estab. 1997. Approached by 100 artists/year. Represents 15 emerging, mid-career and established artists. Exhibited artists include Nicolas Herrera and Ava Brooks. Sponsors 6-8 exhibits/year. Average display time 1 month. Open all year; first Thursday of the month and by appointment. Located in downtown Austin within The Art Guadalupe Arts Building. The studio/gallery photographs art, helps artists with promotional materials, portfolios, advertising and exhibits. Clients include local community and tourists. 20% of sales are to corporate collectors. Overall price range $150-6,000; most work sold at $300.
● Universal Photographics is also owned by Deborah Peacock. In addition to promoting artists, they also cater to businesses, actors and musicians; product photography and graphic/web design.
Media Considers all media and all types of prints. Most frequently exhibits oil, sculpture and photography.
Style Considers all styles and genres. Most frequently exhibits conceptualism, expressionism and surrealism.
Terms Artwork is accepted on consignment and there is a 50% commission. There is a rental fee for space. The rental fee covers 1 month. Retail price set by the artist. Gallery provides insurance, promotion and contract. Accepted work should be framed and mounted. Does not require exclusive representation locally.
Submissions Write to arrange a personal interview to show portfolio of photographs and slides; or mail portfolio for review; or send query letter with artist's statement, bio, photographs, résumé, SASE and slides. Returns material with SASE. Responds only if interested within 1 month. Files artists statements, bios, review, etc. Finds artists through portfolio reviews.
Tips "Use of archival-quality materials is very important to collectors."

✠ WEST END GALLERY

5425 Blossom, Houston TX 77007. (713)861-9544. E-mail: kpackl1346@aol.com. **Owner:** Kathleen Packlick. Retail gallery. Estab. 1991. Exhibits emerging and mid-career artists. Exhibited artists include Kathleen Packlick and Maria Merrill. Open all year. Located 5 mintues from downtown Houston; 800 sq. ft.; "The gallery shares the building (but not the space) with West End Bicycles." 75% of space for special exhibitions; 25% of space for gallery artists. Clientele: 100% private collectors. Overall price range $30-2,200; most work sold at $300-600.
Media Considers oil, pen & ink, acrylic, drawings, watercolor, mixed media, pastel, collage, woodcuts, wood engravings, linocuts, engravings, mezzotints, etchings, lithographs and serigraphs. Prefers collage, oil and mixed media.

Style Exhibits conceptualism, minimalism, primitivism, postmodern works, realism and imagism. Genres include landscapes, florals, wildlife, Americana, portraits and figurative work.

Terms Accepts work on consignment (40% commission). Retail price set by artist. Payment by installment is available. Gallery provides promotion; artist pays shipping costs. Prefers artwork framed.

Submissions Accepts only artists from Houston area. Send query letter with slides and SASE. Portfolio review requested if interested in artist's work.

WOMEN & THEIR WORK ART SPACE

1710 Lavaca St., Austin TX 78701. (512)477-1064. Fax: (512)477-1090. E-mail: wtw@texas.net. Web site: www. womenandtheirwork.org. **Associate Director:** Kathryn Davidson. Alternative space and nonprofit gallery. Estab. 1978. Approached by more than 200 artists/year. Represents 8-10 one person and seasonal juried shows of emerging and mid-career Texas women. Exhibited artists include Margarita Cabrera, Misty Keasler, Karyn Olivier, Angela Fraleigh, Liz Ward. Sponsors 10 exhibits/year. Average display time 5 weeks. Open Monday-Friday, 9-6; Saturday, 12-5. Closed Holidays. Located downtown; 2,000 sq. ft. Clients include local community, students, tourists and upscale. 10% of sales are to corporate collectors. Overall price range $500-5,000; most work sold at $800-1,000.

Media Considers all media. Most frequently exhibits photography, sculpture, installation and painting.

Style Exhibits contemporary. Most frequently exhibits minimalism, conceptualism and imagism.

Terms Selects artists through a Artist Advisory Panel and Curatorial/Jury process. Pays artists to exhibit. Takes 25% commission if something is sold. Retail price set by the gallery and the artist. Gallery provides insurance, promotion and contract. Accepted work should be framed, mounted and matted. Does not require exclusive representation locally. Accepts Texas women—all media—in one person shows only. All other artists, male or female in curated show—once a year. Check www.womenandtheirwork.org for more information.

Submissions Check Web site for (CFE) Calls For Entry. Returns materials with SASE. Filing of material depends on artist and if they are members. Online slide registry for members. Finds artists through submissions and annual juried process.

Tips Send quality slides, typed résumé, and clear statement with artistic intent. 100% archival material required for framed works.

UTAH

BINGHAM GALLERY

136 S. Main St., #210, Salt Lake City UT 84101. (801)832-9220 or (800)992-1066. Web site: www.binggallery.com. **Owners:** Susan and Paul Bingham. Retail and wholesale gallery. Also provides art by important living and deceased artists for collectors. Estab. 1970. Represents 8 established artists. Exhibited artists include Carolyn Ward, Patricia Smith, Kraig Kiedrowski and many others. "Nationally known for works by Maynard Dixon. Represents the Estate of John Stenvall and have exclusive representation of G. Russel Case. Gallery owns the Maynard Dixon home and studio in Mount Carmel, Utah and Founders of the Thunderbird Foundation for the Arts." Sponsors 4 shows/year. Average display time 5 weeks. Open all year. Located downtown; 2,500 sq. ft.; high ceiling/great lighting, open space. 60% of space for special exhibitions; 40% for gallery artists. Clientele: serious collectors. 100% private collectors. Overall price range $1,000-300,000; most work sold at $1,800-5,000.

Media Considers oil, acrylic, watercolor, pastel, pen & ink, drawing and sculpture; original handpulled prints and woodcut. Most frequently exhibits oil, acrylic and pencil.

Style Exhibits painterly abstraction, impressionism and realism. Genres include landscapes, florals, southwestern, western, figurative work and all genres. Prefers California landscapes, Southwestern and impressionism.

Terms Accepts work on consignment (50% commission), or buys outright for 30% of retail price (net 30 days). Retail price set by gallery and artist. Gallery provides insurance, promotion, contract and shipping costs from gallery. Prefers artwork unframed.

Submissions Prefers artists be referred or present work in person. Call for appointment to show portfolio of originals. Responds in 1 week or gives an immediate yes or no on sight of work.

Tips "Gallery has moved to downtown Salt Lake City." The most common mistake artists make in presenting their work is "failing to understand the market we are seeking."

PHILLIPS GALLERY

444 E. 200 S., Salt Lake City UT 84111. (801)364-8284. Fax: (801)364-8293. Web site: www.phillips-gallery.com. **Director:** Meri DeCaria. Retail gallery, art consultancy, rental gallery. Estab. 1965. Represents 80 emerging, mid-career and established artists/year. Exhibited artists include Tony Smith, Doug Snow, Lee Deffebach. Sponsors 8 shows/year. Average display time 1 month. Open all year; Tuesday-Friday, 10-6; Saturday, 10-4; closed August 1-20 and December 25-January 1. Located downtown; has 3 floors at 2,000 sq. ft. and a 2,400

sq. ft. sculpture deck on the roof. 40% private collectors, 60% corporate collectors. Overall price range $100-10,000; most work sold at $200-4,000.

Media Considers all media, woodcuts, engravings, lithographs, wood engravings, linocuts, etchings. Most frequently exhibits oil, acrylic, sculpture/steel.

Style Exhibits expressionism, conceptualism, neo-expressionism, minimalism, pattern painting, primitivism, color field, hard-edge geometric abstraction, painterly abstraction, postmodern works, realism, surrealism, impressionism. Genres include Western, Southwestern, landscapes, figurative work, contemporary. Prefers abstract, neo-expressionism, conceptualism.

Terms Accepts work on consignment (50% commission). Gallery provides insurance and promotion; shipping costs are shared. Prefers artwork framed.

Submissions Accepts only artists from western region/Utah. Send query letter with résumé, slides, reviews, artist's statement, bio and SASE. Finds artists through word of mouth, referrals.

VERMONT

CONE EDITIONS

Powder Spring Rd., East Topsham VT 05076. (802)439-5751. Fax: (802)439-6501. E-mail: jcone@aol.com. **Owner:** Jon Cone. Gallery workshop. Printmakers, publishers and distributors of computer and digitally made works of art. Estab. 1980. Represents/exhibits 12 emerging, mid-career and established artists/year. Exhibited artists include Norman Bluhm and Wolf Kahn. Sponsors 4 shows/year. Average display time 3 months. Open all year; Monday-Friday, 7:30-5. Located downtown; 1,000 sq. ft.; post and beam, high ceilings, natural light. 50% of space for special exhibitions; 50% of space for gallery artists. Clientele private, corporate. 40% private collectors, 60% corporate collectors. Overall price range $300-5,000; most work sold at $500-1,500.

Media Considers computer and digital art and computer prints. Most frequently exhibits iris ink jet print, digitial monoprint and digital gravure.

Style Exhibits expressionism, minimalism, color field, painterly abstraction and imagism.

Terms Artwork is accepted on consignment (50% commission). Retail price set by the artist. Gallery provides promotion; shipping costs are shared. Prefers artwork unframed.

Submissions Prefers computer and digital art. Contact through e-mail. Call for appointment to show portfolio of CD-ROM. Responds in 1-3 weeks. Files slides and CD-ROM.

Tips "We find most of the artists we represent by referrals of our other artists."

VIRGINIA

THE ART LEAGUE, INC.

105 N. Union St., Alexandria VA 22314. (703)683-1780. Web site: www.theartleague.org. **Gallery Director:** Madalina Diaconu. Cooperative gallery. Estab. 1954. Interested in emerging, mid-career and established artists. 1,200-1,400 members. Sponsors 7-8 solo and 14 group shows/year. Average display time 1 month. Located in The Torpedo Factory Art Center. Accepts artists from metropolitan Washington area, northern Virginia and Maryland. 75% of sales are to private collectors, 25% corporate clients. Overall price range $50-4,000; most work sold at $150-500.

Media Considers all media. Most frequently exhibits watercolor, oil and photographs. Considers all types of prints.

Style Exhibits all styles and genres. Prefers impressionism, painted abstraction and realism. "The Art League is a membership organization open to anyone interested."

Terms Accepts work by jury on consignment (40% commission) and co-op membership fee plus donation of time. Retail price set by artist. Offers customer discounts (designers only) and payment by installments (if requested on long term). Exclusive area representation not required.

Submissions Work juried monthly for each new show from actual work (not slides). Work received for jurying on first Monday evening/Tuesday morning of each month; pick-up non-selected work throughout rest of week.

Tips "Artists find us and join/exhibit as they wish within framework of our selections jurying process. It is more important that work is of artistic merit rather than 'saleable.' "

ARTSPACE

Zero East Fourth Street, Richmond VA 23224. (804)232-6464. Fax: (804)232-6465. E-mail: artspacegallery@att.net. Web site: www.artspacegallery.org. **Exhibition Committee:** Annette Norman or Chris Semtner. Nonprofit gallery. Estab. 1988. Approached by 100 artists/year. Represents approx. 50 emerging, mid-career artists. Sponsors approx. 2 exhibits/year. Average display time 1 month. Open all year; Wednesday-Sunday from 12-4. Located in the newly designated Arts District in Manchester, in Richmond VA. Brand new gallery facilities; 4

exhibition spaces; approx. 3,000 sq. ft. Clients include local community, students, tourists and upscale. 2% of sales are to corporate collectors. Overall price range $100-800; most work sold at $450.
Media Considers all media and all types of prints. Most frequently exhibits photography, painting and sculpture.
Style Considers all styles and genres.
Terms There are exhibition fees; work sold = 33% commission. Retail price set by the artist. Gallery provides insurance and contract. Accepted work should be framed, mounted and matted. Pedestals available for sculpture. Does not require exclusive representation locally.
Submissions Send query letter with artist's statement, bio, résumé, SASE, slides and proposal form. Returns material with SASE. Responds to queries in 3 weeks. If accepted, all materials submitted are filed. Finds artists through referrals by other artists, submissions and word of mouth.

GALLERY WEST

205 S. Union St., Alexandria VA 22314. (703)549-7359. Fax: (703)549-8355. E-mail: gallerywest@starpower.net. Web site: www.gallery-west.com. **President:** Mary Allen. Cooperative gallery and alternative space. Estab. 1979. Exhibits the work of 24 emerging, mid-career and established artists. Sponsors 12 shows/year. Average display time 1 month. Open all year. Located in Old Town; 1,000 sq. ft. 60% of space for special exhibitions. Clients include individual, corporate and decorators. 90% of sales are to private collectors, 10% corporate collectors. Overall price range $100-3,500; most work sold at $500-700.
Media Considers all media except video and film.
Style All styles and genres.
Terms Co-op membership fee plus a donation of time. (30% commission.) Retail price set by artist. Sometimes offers customer discounts and payment by installments. Gallery assists promotion; artist pays for shipping. Prefers artwork framed.
Submissions Send query letter with résumé, slides, bio and SASE. Call for appointment to show portfolio of slides. Responds in 1 month. Files résumés. Holds jury shows once/year open to all artists.
Tips "High-quality slides are imperative."

HAMPTON UNIVERSITY MUSEUM

Huntington Building on Ogden Circle, Hampton VA 23668. (757)727-5308. Fax: (757)727-5170. Web site: www. hamptonu.edu. **Director:** Mary Lou Hultgren. Museum. Estab. 1868. Represents/exhibits established artists. Exhibited artists include Elizabeth Catlett and Jacob Lawrence. Sponsors 3-4 shows/year. Average display time 12-18 weeks. Open all year; Monday-Friday, 8-5; Saturday, 12-4; closed on Sunday, major and campus holidays. Located on the campus of Hampton University.
Media Considers all media and all types of prints. Most frequently exhibits oil or acrylic paintings, ceramics and mixed media.
Style Exhibits African-American, African and/or Native American art.
Submissions Send query letter with résumé and a dozen or more slides. Portfolio should include photographs and slides.
Tips "Familiarize yourself with the type of exhibitions the Hampton University Museum typically mounts. Do not submit an exhibition request unless you have at least 35-45 pieces available for exhibition. Call and request to be placed on the Museum's mailing list so you will know what kind of exhibitions and special events we're planning for the upcoming year(s)."

HARNETT MUSEUM OF ART

University of Richmond Museums, Richmond VA 23173. (804)289-8276. Fax: (804)287-1894. E-mail: museums @richmond.edu. Web site: oncampus.richmond.edu/museums. **Executive Director:** Richard Waller. Museum. Estab. 1968. Represents emerging, mid-career and established artists. Sponsors 10 shows/year. Average display time 6 weeks. Open all year; with limited summer hours May-August. Located on University campus; 5,000 sq. ft. 100% of space for special exhibitions.
Media Considers all media and all types of prints. Most frequently exhibits painting, sculpture, photography and drawing.
Style Exhibits all styles and genres.
Terms Work accepted on loan for duration of special exhibition. Retail price set by the artist. Gallery provides insurance, promotion, contract and shipping costs. Prefers artwork framed.
Submissions Send query letter with résumé, 8-12 slides, brochure, SASE, reviews and printed material if available. Write for appointment to show portfolio of photographs, slides, transparencies or "whatever is appropriate to understanding the artist's work." Responds in 1 month. Files résumé and other materials the artist does not want returned (printed material, slides, reviews, etc.).

MCLEAN PROJECT FOR THE ARTS

1234 Ingleside Ave., McLean VA 22101. (703)790-1953. Fax: (703)790-1012. E-mail: mpaart@aol.com. Web site: www.mpaart.org. Alternative space. Estab. 1962. Exhibited artists include Yuriko Yamaguchi and Christopher French. Sponsors 12-15 shows/year. Average display time 5-6 weeks. Open Tuesday-Friday, 10-5; Saturday, 1-5. 3,000 sq. ft.; large luminous "white cube" type of gallery; moveable walls. 85% of space for special exhibitions. Clientele local community, students, artists' families. 100% private collectors. Overall price range $200-15,000; most work sold at $800-1,800.

Media Considers all media except graphic design and traditional crafts; all types of prints except posters. Most frequently exhibits painting, sculpture and installation.

Style Exhibits all styles, all genres.

Terms Artwork is accepted on consignment (25% commission). Retail price set by the artist. Gallery provides insurance and promotion. Artist pays for shipping costs. Prefers artwork framed (if works on paper).

Submissions Accepts only artists from Maryland, DC, Virginia and some regional Mid-Atlantic. Send query letter with résumé, slides, reviews and SASE. Responds within 4 months. Artists' slides, bios and written material kept on file for 2 years. Finds artists through referrals by other artists and curators; by visiting exhibitions and studios.

Tips Visit the gallery several times before submitting proposals, so that the work you submit fits the framework of art presented.

THE PRINCE ROYAL GALLERY

204 S. Royal St., Alexandria VA 22314. (703)548-5151. Fax: (703)548-5627. E-mail: princeroyal@earthlink.net. Web site: www.princeroyalgallery.com. **Director:** John Byers. Retail gallery. Estab. 1977. Interested in emerging, mid-career and established artists. Sponsors 6 shows/year. Average display time 3-4 weeks. Located in middle of Old Town Alexandria. "Gallery is the ballroom and adjacent rooms of historic hotel." Clientele: primarily Virginia, Maryland and Washington DC residents. 95% private collectors, 5% corporate clients. Overall price range $75-8,000; most artwork sold at $700-1,200.

Media Considers oil, acrylic, watercolor, mixed media, sculpture, egg tempera, engravings, etchings and lithographs. Most frequently exhibits oil, watercolor and sculptures in wood, stone, and bronze.

Style Exhibits impressionism, expressionism, realism, primitivism and painterly abstraction. Genres include landscapes, florals, portraits, still lifes, and figurative work. "The gallery deals primarily in original, representational art. Abstracts are occasionally accepted but are hard to sell in northern Virginia. Limited edition prints are accepted only if the gallery carries the artist's original work."

Terms Accepts work on consignment (40% commission). Retail price set by artist. Customer discounts and payment by installment are available, but only after checking with the artist involved and getting permission. Exclusive area representation required. Gallery provides insurance, promotion and contract. Requires framed artwork.

Submissions Send query letter with résumé, brochure, slides and SASE. Call or write to schedule an appointment to show a portfolio, which should include originals, slides and transparencies. Responds in 1 week. Files résumés and brochures. All other material is returned.

Tips "Write or call for an appointment before coming. Have at least six pieces framed and ready to consign if accepted. Can't speak for the world, but in northern Virginia collectors are slowing down. Lower-priced items continue okay, but sales over $3,000 are becoming rare. More people are buying representational rather than abstract art. Impressionist art is increasing. Get familiar with the type of art carried by the gallery and select a gallery that sells your style work. Study and practice until your work is as good as that in the gallery. Then call or write the gallery director to show photos or slides."

ELIZABETH STONE GALLERY

1127 King Street, Suite 201, Alexandria VA 22314. (703)706-0025. Fax: (703)706-0027. E-mail: elizabeth@elizabethstonegallery.com. Web site: www.elizabethstonegallery.com. **Contact:** Elizabeth Stone, owner. Art consultancy. Estab. 1989. Approached by more than 50 artists/year; represents 100 established artists/year. Exhibited artists include Wendell Minor (watercolor/acrylic) and Lynn Munsinger (watercolor). Sponsors 12 exhibits/year. Average display time 1 month. Open all year; Tuesday-Saturday, 11 a.m.-6 p.m.; Sunday, 12 p.m.-5 p.m. Showroom located at 2713 11th St., North Arlington, VA 22201. Clients include local community, tourists and upscale. 25% of sales are to corporate collectors. Overall price range $100-7,500; most work sold at $500-1,000.

Media Considers acrylic, ceramics, collage, fiber, mixed media, oil, paper, pastel, pen & ink, sculpture, watercolor. Most frequently exhibits watercolor, collage and mixed media. Considers limited edition prints by giclee reproduction and limited editions by off-set reproduction.

Style Exhibits children's book illustration; specialist and consultant. Most frequently exhibits watercolor, collage and mixed media. Considers all genres.

Terms Artwork is accepted on consignment and there is a 50% commission. Retail price of the art set by the

gallery and the artist. Gallery provides insurance, promotion and contract. Accepted work does not have to be framed or matted. Does not require exclusive representation locally. Accepts art only from children's book illustrators.

Submissions Call or e-mail request. Cannot return material. Responds to queries in 1 month. Files children's books. Finds artists through referrals by other artists, word of mouth, children's book submissions.

Tips "A phone call or e-mail with intent to me is enough. Provide quality book information of your published books."

WASHINGTON

THE AMERICAN ART COMPANY

1126 Broadway Plaza, Tacoma WA 98402. (253)272-4327. E-mail: craig@americanartco.com. Web site: www.a mericanartco.com. **Director:** Craig Radford. Retail gallery. Estab. 1889. Represents/exhibits 150 emerging, mid-career and established artists/year. Exhibited artists include Art Hansen, Michael Ferguson, Danielle Desplan, Doug Granum, Oleg Koulikov, Yoko Hara and Warren Pope. Sponsors 10 shows/year. Open all year; Tuesday-Friday, 10 a.m.-5:30 p.m.; Saturday, 10 a.m.-5 p.m. Located downtown; 3,500 sq. ft. 60% of space for special exhibitions; 40% of space for gallery artists. Clientele: local community. 90% private collectors, 10% corporate collectors. Overall price range $500-15,000; most work sold at $1,800.

Media Considers oil, fiber, acrylic, sculpture, glass, watercolor, mixed media, quilt art, pastel, collage, woodcuts, wood engravings, linocuts, engravings, mezzotints, etchings, lithographs, serigraphs, contemporary baskets, contemporary sculptural wood. Most frequently exhibits contemporary wood sculpture and original paintings.

Style Exhibits all styles. Genres include landscapes, Chinese and Japanese.

Terms Artwork is accepted on consignment (50% commission) or bought outright for 50% of retail price; net 30 days. Retail price set by the gallery and the artist. Gallery provides insurance and promotion; shipping costs are shared. Prefers artwork unframed.

Submissions Send query letter with résumé, slides, bio and SASE. Write for appointment to show portfolio of slides. Responds in 3 weeks. Finds artists through word of mouth, referrals by other artists, visiting art fairs and exhibitions, submissions.

ART SHOWS

P.O. Box 245, Spokane WA 99210-0245. (509)922-4545. E-mail: info@artshows.net. Web site: www.artshows.n et. **President:** Don Walsdorf. Major art show producer. Estab. 1988. Sponsors large group shows. Clientele: collectors, hotel guests and tourists. 70% private collectors, 30% corporate collectors. Overall price range $200-250,000; most work sold at $500-3,000.

Media Considers all media except craft.

Style Interested in all genres.

Submissions Send query letter with bio, brochure and photographs. Portfolio review requested if interested in artist's work. This information is retained in our permanent files.

Tips Selecting quality art shows is important. Read all the prospectus materials. Then re-read the information to make certain you completely understand the requirements, costs and the importance of early responses. Respond well in advance of any suggested deadline dates. Producers cannot wait until 60 days in advance of a show, due to contractual requirements for space, advertising, programming etc. If you intend to participate in a quality event, seek applications a year in advance for existing events. Professional show producers are always seeking to upgrade the quality of their shows. Seek new marketing venues to expand your horizons and garner new collectors. List your fine art show events with info@artshow.net by providing name, date, physical location, full contact information of sponsor or producer. This is a free database at www.artshows.net. Any time you update a brochure, biography or other related materials, be certain to date the material. Outdated material in the hands of collectors works to the detriment of the artist.

DAVIDSON GALLERIES

313 Occidental Ave. S., Seattle WA 98104. (206)624-1324. E-mail: info@davidsongalleries.com. Web site: www. davidsongalleries.com. **Owner:** Sam Davidson. Retail gallery. Estab. 1973. Represents 150 emerging, mid-career and established artists. Sponsors 36 shows/year. Average display time 3 weeks. Open all year; Tuesday-Saturday, 10 a.m.-5:30 p.m. Located in old, restored part of downtown 3,200 sq. ft.; "beautiful antique space with columns and high ceilings built in 1890." 50% of space for special antique print exhibitions; 50% of space for gallery artists. Clientele 90% private collectors, 10% corporate collectors. Overall price range $50-70,000; most work sold at $250-5,000.

Media Considers oil, drawing (all types), watercolor, mixed media, pastel, woodcuts, wood engravings, linocuts, engravings, mezzotints, etchings, lithographs, limited interest in photography, digital manipulation or collage.

Style Exhibits expressionism, neo-expressionism, primitivism, painterly abstraction, postmodern works, realism, surrealism, impressionism.

Terms Accepts work on consignment (50% commission). Retail price set by gallery and artist. Gallery provides insurance, promotion and contract; shipping costs are one way.

Submissions Send query letter with résumé, 20 slides, bio and SASE. Responds in 6 weeks.

Tips Impressed by "simple straight-forward presentation of properly labeled slides, résumé with SASE included. No videos."

FOSTER/WHITE GALLERY

220 Third Avenue South, Suite 100, Seattle WA 98104. (206)622-2833. Fax: (206)622-7606. E-mail: seattle@fosterwhite.com. Web site: www.fosterwhite.com. **Owner/Director:** Phen Huang. Retail gallery. Estab. 1973. Represents 60 emerging, mid-career and established artists. Interested in seeing the work of local emerging artists. Exhibited artists include Dale Chihuly, Mark Tobey, George Tsutakawa, Morris Graves, and William Morris. Average display time 1 month. Open all year; Tuesday-Saturday, 10am-6pm; closed Sunday. Located historic Pioneer Square; 7,500 sq. ft. Clientele private, corporate and public collectors. Overall price range $300-35,000; most work sold at $2,000-8,000.

• Gallery has additional spaces at Ranier Square, 1331 Fifth Ave., Seattle WA 98101, (206)583-0100. Fax: (206)583-7188.

Media Considers oil, acrylic, watercolor, pastel, pen & ink, drawing, mixed media, collage, paper, sculpture, ceramics, craft, fiber, glass and installation. Most frequently exhibits glass sculpture, works on paper and canvas and ceramic and metal sculptures.

Style Contemporary Northwest art. Prefers contemporary Northwest abstract, contemporary glass sculpture.

Terms Gallery provides insurance, promotion and contract.

Submissions Send query letter with résumé, slides, bio and reviews. Write for appointment to show portfolio of slides. Responds in 2 months.

MING'S ASIAN GALLERY

10217 Main St., Old Bellevue WA 98004-6121. (206)462-4008. Fax: (206)453-8067. E-mail: mingsgallery@quest.net. **Contact:** Doreen Russell. Retail gallery. Estab. 1964. Represents/exhibits 3-8 mid-career and established artists/year. Exhibited artists include Kim Man Hee, Kai Wang and Kaneko Jonkoh. Sponsors 8 shows/year. Average display time 1 month. Open all year; Monday-Saturday, 10-6. Located downtown; 6,000 sq. ft.; exterior is Shanghai architecture circa 1930. 20% of space for special exhibitions. 35% private collectors, 20% corporate collectors. Overall price range $350-10,000; most work sold at $1,500-3,500.

Media Considers oil, acrylic, watercolor, sumi paintings, Japanese woodblock. Most frequently exhibits sumi paintings with woodblock and oil.

Style Exhibits expressionism, primitivism, realism and imagism. Genres include Asian. Prefers antique, sumi, watercolors, temple paintings and folk paintings.

Terms Artwork is accepted on consignment (50% commission). Retail price set by the gallery and the artist. Gallery provides insurance, promotion and contract; shipping costs are shared. Prefers artwork framed.

Submissions Send query letter with résumé, brochure, slides, photographs, reviews, bio and SASE. Write for appointment to show portfolio of photographs, slides and transparencies. Responds in 2 weeks. Finds artists by traveling to Asia, visiting art fairs, and through submissions.

PAINTERS ART GALLERY

30517 S.R. 706 E., P.O. Box 106, Ashford WA 98304-0106. (360)569-2644. E-mail: mtwoman@mashell.com. Web site: www.mashell.com/~mtwoman/. **Owner:** Joan Painter. Retail gallery. Estab. 1972. Represents 20 emerging, mid-career and established artists. Open all year. Located 5 miles from the entrance to Mt. Rainier National Park; 1,200 sq. ft. 50% of space for work of gallery artists. Clientele collectors and tourists. Overall price range $10-7,500; most work sold at $300-2,500.

• The gallery has over 60 people on consignment. It is a very informal, outdoors atmosphere.

Media Considers oil, acrylic, watercolor, pastel, mixed media, stained glass, reliefs, offset reproductions, lithographs and serigraphs. "I am seriously looking for totem poles and outdoor carvings." Most frequently exhibits oil, pastel and acrylic.

Style Exhibits primitivism, surrealism, imagism, impressionism, realism and photorealism. All genres. Prefers Mt. Rainier themes and wildlife. "Indians and mountain men are a strong sell."

Terms Accepts artwork on consignment (30% commission on prints and sculpture; 40% on paintings). Retail price set by gallery and artist. Gallery provides promotion; artist pays for shipping. Prefers artwork framed.

Submissions Send query letter or call. "I can usually tell over the phone if artwork will fit in here." Portfolio review requested if interested in artist's work. Does not file materials.

Tips "Sell paintings and retail price items for the same price at mall and outdoor shows that you price them in

galleries. I have seen artists underprice the same paintings/items, etc. when they sell at shows. Do not copy the style of other artists. To stand out, have your own style."

WEST VIRGINIA

THE ART STORE

1013 Bridge Rd., Charleston WV 25314. (304)345-1038. Fax: (304)345-1858. E-mail: theartstore@aol.com. **Director:** E. Schaul. Retail gallery. Estab. 1974. Represents 16 mid-career and established artists. Sponsors 6 shows/year. Average display time 3 weeks. Open all year. Located in a suburban shopping center; 2,000 sq. ft. 50% of space for special exhibitions. Clientele: professionals, executives, decorators. 80% private collectors, 20% corporate collectors. Overall price range $200-8,000; most work sold at $2,000.
Media Considers oil, acrylic, watercolor, pastel, mixed media, works on paper, ceramics, wood and metal.
Style Exhibits expressionism, painterly abstraction, color field and impressionism.
Terms Accepts artwork on consignment (50% commission). Retail price set by gallery and artist. Gallery provides insurance, promotion and shipping costs from gallery. Prefers artwork unframed.
Submissions Send query letter with résumé, slides, SASE, announcements from other gallery shows and press coverage. Gallery makes the contact after review of these items; responds in 6 weeks.
Tips "Do not send slides of old work."

WISCONSIN

CHARLES ALLIS ART MUSEUM

1801 N. Prospect Ave., Milwaukee WI 53202. (414)278-8295. Fax: (414)278-0335. E-mail: shaberstroh@cavtmuseums.org. Web site: www.cavtmuseums.org. **Manager of Exhibitions & Collections:** Sarah Haberstroh. Museum. Estab. 1947. Approached by 20 artists/year. Represents 6 emerging, mid-career and established artists that have lived or studied in Wisconsin. Exhibited artists include Anne Miotke (watercolor); Evelyn Patricia Terry (pastel, acrylic, multi-media). Sponsors 6-8 exhibits/year. Average display time 2 months. Open all year; Wednesday-Sunday from 1-5. Located in an urban area, historical home, 3 galleries. Clients include local community, students and tourists. 10% of sales are to corporate collectors. Overall price range $200-6,000; most work sold at $300.
Media Considers acrylic, collage, drawing, installation, mixed media, oil, pastel, pen & ink, sculpture, watercolor and photography. Print types include engravings, etchings, linocuts, lithographs, serigraphs and woodcuts. Most frequently exhibits acrylic, oil and watercolor.
Style Considers all styles and genres. Most frequently exhibits realism, impressionism and minimalism.
Terms Artwork is accepted on consignment. Artwork can be purchased during a run of an exhibition. There is a 30% commission. Retail price set by the artist. Museum provides insurance, promotion and contract. Accepted work should be framed. Does not require exclusive representation locally. Accepts only artists from or with a connection to Wisconsin.
Submissions Send query letter with artist's statement, bio, business card, résumé, reviews, SASE and slides. Material is returned if the artist is not chosen for our exhibition. Responds to queries in 1 year. Finds artists through art exhibits, referrals by other artists, submissions and word of mouth.
Tips "All materials should be typed. Slides should be labeled and accompanied by a complete checklist."

DAVID BARNETT GALLERY

1024 E. State St., Milwaukee WI 53202. (414)271-5058. Fax: (414)271-9132. Retail and rental gallery and art consultancy. Estab. 1966. Represents 300-400 emerging, mid-career and established artists. Exhibited artists include Claude Weisbuch and Carol Summers. Sponsors 12 shows/year. Average display time 1 month. Open all year. Located downtown at the corner of State and Prospect; 6,500 sq. ft.; "Victorian-Italianate mansion built in 1875, three floors of artwork displayed." 25% of space for special exhibitions. Clientele: retail, corporations, interior decorators, private collectors, consultants, museums and architects. 20% private collectors, 10% corporate collectors. Overall price range $50-375,000; most work sold at $1,000-50,000.
Media Considers oil, acrylic, watercolor, pastel, pen & ink, drawings, mixed media, collage, sculpture, ceramic, fiber, glass, photography, bronzes, marble, woodcuts, engravings, lithographs, wood engravings, serigraphs, linocuts, etchings and posters. Most frequently exhibits prints, drawings and oils.
Style Exhibits expressionism, neo-expressionism, primitivism, painterly abstraction, surrealism, imagism, conceptualism, minimalism, postmodern works, impressionism, realism and photorealism. Genres include landscapes, florals, Southwestern, Western, wildlife, portraits and figurative work. Prefers old master graphics, contemporary and impressionistic.

Terms Accepts artwork on consignment (50% commission). Retail price set by gallery and artist. Sometimes offers customer discounts and payment by installment. Gallery provides insurance and promotion; artist pays for shipping. Prefers artwork framed.

Submissions Send query letter with slides, bio, brochure and SASE. "We return everything if we decide not to carry the artwork." Finds artists through agents, word of mouth, various art publications, sourcebooks, submissions and self-promotions.

THE FLYING PIG LLC

N6975 State Hwy. 42, Algoma WI 54201. (920)487-9902. Fax: (920)487-9904. E-mail: theflyingpig@charterinternet.com. Web site: www.theflyingpig.biz. **Contact:** Susan Connor, owner/member. For-profit gallery. Estab. 2002. Exhibits all media; approximately 150 artists. Open Thursday-Sunday, 10-5 (winter); May 1st-October 31st daily, 9-6. Clients include local community, tourists and upscale. Overall price range $5-3,000; most work sold at $300.

Media Considers all media.

Style Exhibits impressionism, minimalism, painterly abstraction and primitivism realism. Most frequently exhibits primitivism realism, impressionism and minimalism. Genres include outsider and visionary.

Terms Artwork is accepted on consignment and there is a 40% commission or artwork is bought outright for 50% of retail price; net 15 days. Retail price set by the artist. Gallery provides insurance, promotion and contract. Accepted work should be framed. Does not require exclusive representation locally.

Submissions Send query letter with artist's statement, bio and photographs. Returns material with SASE. Responds to queries in 3 weeks. Files artist's statement, bio and photographs if interested. Finds artist's through art fairs and exhibitions, referrals by other artsts, submissions, word of mouth and Online.

TORY FOLLIARD GALLERY

233 N. Milwaukee St., Milwaukee WI 53202. (414)273-7311. Fax: (414)273-7313. E-mail: info@toryfolliard.com. Web site: www.toryfolliard.com. **Contact:** Richard Knight. Retail gallery. Estab. 1988. Represents emerging and established artists. Exhibited artists include Tom Uttech and John Wilde. Sponsors 8-9 shows/year. Average display time 4-5 weeks. Open all year; Tuesday-Friday, 11-5; Saturday, 11-4. Located downtown in historic Third Ward; 3,000 sq. ft. 60% of space for special exhibitions; 40% of space for gallery artists. Clientele: tourists, upscale, local community and artists. 90% private collectors, 10% corporate collectors. Overall price range $500-25,000; most work sold at $1,500-8,000.

Media Considers all media except installation and craft. Most frequently exhibits painting, sculpture.

Style Exhibits expressionism, abstraction, realism, surrealism and imagism. Prefers realism.

Terms Accepts work on consignment. Retail price set by the gallery and the artist. Gallery provides insurance and promotion; artist pays shipping costs. Prefers artwork framed.

Submissions Prefers artists working in midwest regional art. Send query letter with résumé, slides, photographs, reviews, artist's statement and SASE. Portfolio should include photographs or slides. Responds in 2 weeks. Finds artists through referrals by other artists.

GALLERY 218

218 S. Second St., Milwaukee WI 53204. (414)643-1732. E-mail: info@gallery218.com or jhha23@usa.net. Web site: www.gallery218.com. **President:** Judith Hooks. Nonprofit gallery, cooperative gallery, alternative space. "Gallery 218 is committed to providing exhibition opportunities to area artists. 218 sponsors exhibits, poetry readings, performances, recitals and other cultural events. 'The audience is the juror.' " Estab. 1990. Represents over 200 emerging, mid-career and established artists/year. Exhibited artists include Cathy Jean Clark, Steven Bleicher, Fred Stein, Judith Hooks, George Jones, Paul Drewry. Sponsors 15 shows and 1 fair/year. Average display time 1 month. Open all year; Wednesday, 12-5; Friday, 12-5; Saturday and Sunday 11-5. Located just south of downtown; 1,500 sq. ft.; warehouse-type spacewooden floor, halogen lights; includes information area. 100% of space for gallery artists. 75% private collectors, 25% corporate collectors. Overall price range $100-1,000; most work sold at $100-600.

- Gallery 218 has a "bricks and mortar" gallery as well as a great Web site, which provides lots of links to helpful art resources.

Media Considers all media except crafts. Considers linocuts, monotypes, woodcuts, mezzotints, etchings, lithographs and serigraphs. Most frequently exhibits paintings/acrylic, photography, mixed media.

Style Exhibits expressionism, conceptualism, photorealism, neo-expressionism, minimalism, hard-edge geometric abstraction, painterly abstraction, postmodern works, realism, surrealism, imagism, fantasy, comic book art. Exhibits all genres, portraits, figurative work; "anything with an edge." Prefers abstract expressionism, fine art photography, personal visions.

Terms There is a yearly Co-op membership fee plus a monthly fee, and donation of time (25% commission.) Membership good 1 year. There is a rental fee for space; covers 1 month. Group shows at least 8 times a year (small entry fee). Retail price set by the artist. Gallery provides promotion; artist pays for shipping. Prefers artwork framed.

Submissions Prefers only adults (21 years plus), no students (grad students OK), serious artists pursuing their careers. E-mail query letter with résumé, business card, slides, photographs, bio, SASE or request for application with SASE. E-mail for appointment to show portfolio of photographs, slides, résumé, bio. Responds in 1 month. Files all. Finds artists through referrals, visiting art fairs, submissions. ''We advertise for new members on a regular basis.''

Tips ''Don't wait to be 'discovered'. Get your work out therenot just once, but over and over again. Don't get distracted by material things, like houses, cars and real jobs. Be prepared to accept suggestions and/or criticism. Read entry forms carefully.''

THE FANNY GARVER GALLERY

230 State St., Madison WI 53703. (608)256-6755. E-mail: art@fannygarvergallery.com. Web site: www.fannygarvergallery.com. **President:** Jack Garver. Retail Gallery. Estab. 1972. Represents 100 emerging, mid-career and established artists/year. Exhibited artists include Lee Weiss, Jaline Pol. Sponsors 11 shows/year. Average display time 1 month. Open all year; Monday-Thursday, 10-6; Friday-Saturday, 10-8, Sunday, 12-4. Located downtown; 3,000 sq. ft.; older refurbished building in unique downtown setting. 33% of space for special exhibitions; 95% of space for gallery artists. Clientele private collectors, gift-givers, tourists. 40% private collectors, 10% corporate collectors. Overall price range $100-10,000; most work sold at $100-1,000.

Media Considers oil, pen & ink, paper, fiber, acrylic, drawing, sculpture, glass, watercolor, mixed media, ceramics, pastel, collage, craft, woodcuts, wood engravings, linocuts, engravings, mezzotints, etchings, lithographs and serigraphs. Most frequently exhibits watercolor, oil and glass.

Style Exhibits all styles. Prefers landscapes, still lifes and abstraction.

Terms Accepts work on consignment (50% commission) or buys outright for 50% of retail price (net 30 days). Retail price set by gallery. Gallery provides promotion and contract, artist pays shipping costs both ways. Prefers artwork framed.

Submissions Send query letter with résumé, 8 slides, bio, brochure, photographs and SASE. Write for appointment to show portfolio, which should include originals, photographs and slides. Responds only if interested within 1 month. Files announcements and brochures.

Tips ''Don't take it personally if your work is not accepted in a gallery. Not all work is suitable for all venues.''

RAHR-WEST ART MUSEUM

610 N. Eighth St., Manitowoc WI 54220. (920)683-4501. Fax: (920)683-5047. E-mail: rahrwest@manitowoc.org. Web site: www.rahrwestartmuseum.org. **Contact:** Jan Smith. Museum. Estab. 1950. Five thematic exhibits, preferably groups of mid-career and established artists. Sponsors 8-10 shows/year. Average display time 6-8 weeks. Open all year; Monday-Friday, 10-4; Wednesday, 10-8; weekends, 11-4. Closed major holidays. Clients include local community and tourists. Overall price range $50-2,200; most work sold at $150-200.

Media Considers all media and all types of original prints except postersor glicee' prints. Most frequently exhibits painting, pastel and original prints.

Style Considers all styles. Most frequently exhibits impressionism, realism and various abstraction. Genres include figurative work, florals, landscapes and portraits.

Terms Artwork is accepted on consignment and there is a 30% commission. Retail price set by the artist. Gallery provides insurance. Accepted work should be framed with hanging devices attached.

Submissions Send query letter with artist's statement, bio, SASE and slides. Returns material only if requested with with SASE if not considered. Otherwise slides are filed with contact info and bio. Responds only if interested.

STATE STREET GALLERY

1804 State St., La Crosse, WI 54601. (608)782-0101. E-mail: ssg1804@yahoo.com. Web site: www.statestreetartgallery.com. **President:** Ellen Kallies. Retail gallery. Estab. 2000. Approached by 15 artists/year. Represents 40 emerging, mid-career and established artists. Exhibited artists include Diane French, Phyllis Martino, Michael Martino and Barbara Hart Decker. Sponsors 6 exhibits/year. Average display time 4-6 months. Open all year; Tuesday-Saturday, 10-3; weekends by appointment. Located across from the University of Wisconsin/La Crosse on one of the main east/west streets. ''We are next to a design studio, parking behind gallery.'' Clients include local community, tourists, upscale. 40% of sales are to corporate collectors, 60% to private collectors. Overall price range $150-25,000; most work sold at $500-5,000.

Media Considers acrylic, collage, drawing, glass, mixed media, oil, pastel, sculpture, watercolor and photography. Most frequently exhibits oil, dry pigment, drawing, watercolor and mixed media collage. Considers all types of prints.

Style Considers all styles and genres. Most frequently exhibits contemporary representational, realistic watercolor, collage.

Terms Artwork is accepted on consignment and there is a 40% commission. Retail price set by the gallery and the artist. Gallery provides insurance, promotion, contract. Accepted work should be framed and matted.

Submissions Call to arrange a personal interview or mail portfolio for review. Send query letter with artist's statement, photographs or slides. Returns material with SASE. Responds in 1 month. Finds artists through word of mouth, art exhibits, art fairs, and referrals by other artists.

Tips "Be organized, be professional in presentation, be flexible! Most collectors today are savvy enough to want recent works on archival quality papers/boards, mattes etc. Have a strong and consistant body of work to present."

WALKER'S POINT CENTER FOR THE ARTS

911 W. National Ave., Milwaukee WI 53204. (414)672-2787. E-mail: staff@wpca-milwaukee.org. Web site: www.wpca-milwaukee.org. **Executive Director:** Jessica St. John. Alternative space and nonprofit gallery. Estab. 1987. Represents emerging and established artists; 200+ members. Exhibited artists include Sheila Hicks and Carol Emmons. Sponsors 6-8 shows/year. Average display time 2 months. Open all year. Located in urban, multicultural area; gallery 23′6″×70.

Media Considers all media. Prefers installation, sculpture and video.

Style Considers all styles. Our gallery often presents work with Latino themes.

Terms We are nonprofit and do not provide honoria. Gallery assumes a 20% commission. Retail prices set by the artist. Gallery provides insurance, contract and shipping costs. Prefers artwork framed.

Submissions Send query letter with résumé, slides, bio, photographs, SASE and reviews. Call to schedule an appointment to show a portfolio, which should include slides, photographs and transparencies. Responds in 6-12 months. Files résumés and slides.

Tips "WPCA is an alternative space, showing work for which there are not many venues. Experimental work is encouraged. Suggesting an exhitib (rather than just trying to get your work shown) can work for a small, understaffed space like ours."

WYOMING

NICOLAYSEN ART MUSEUM

400 E. Collins Dr., Casper WY 82601. (307)235-5247. Fax: (307)235-0923. E-mail: info@thenic.org. Web site: www.thenic.org. **Director:** Holly Turner. Regional contemporary art museum. Estab. 1967. Average display time 3-4 months. Interested in emerging, mid-career and established artists. Sponsors 10 solo and 10 group shows/year. Open all year. Clientele 90% private collectors, 10% corporate clients.

Media Considers all media with special attention to regional art.

Style Exhibits all subjects.

Terms Accepts work on consignment (40% commission). Retail price set by artist. Exclusive area representation not required. Gallery provides insurance, promotion and shipping costs from gallery.

Submissions Send query letter with slides. Write to schedule an appointment to show a portfolio, which should include originals or slides. Responds in 2 months.

CANADA

⚡ GALERIE ART & CULTURE

227 St. Paul W., Old Montreal QB H2Y 2A2 Canada. (514)843-5980. **President:** Helen Doucet. Retail gallery. Estab. 1989. Approached by 55 artists/year; represents 30 mid-career and established artists/year. Exhibited artists include Louise Martineau and Pierre A. Raymond. Sponsors 6 exhibits/year. Average display time 13 days. Open all year; Tuesday-Friday, 10-6; weekends 10-5. Located in the historic area of Old Montreal. St. Paul is the oldest established commercial street in North America. Original brick work and high ceilings fit well for the exhibition of works of art. Clients include local community, tourists and upscale. 15% corporate collectors. Overall price range $700-2,500; most work sold at $1,200-1,500.

Media Considers acrylic, oil, sculpture, watercolor. Most frequently exhibits oil, acrylic, sculpture.

Style Exhibits impressionism and postmodernism. Most frequently exhibits figurative works, landscapes, still lifes. Genres include figurative work, florals, landscapes, portraits.

Terms Accepts work on consignment (50% commission). Retail price set by the gallery and the artist. Gallery provides promotion and contract. Accepted work should be unframed. Does not require exclusive representation locally. Accepts only artists from Canada, United States. Prefers only oils, acrylic.

Submissions Mail portfolio for review. Send bio, photographs, résumé, reviews. Returns material with SASE. Responds in 1-2 months. Files dossiers of artists, exhibitions, portfolio reviews. Finds artists through submissions, portfolio reviews, referrals by other artists.

Tips "Artists should present complete dossier of their works including photos of artworks, biographies, exposi-

tions, solo or group works, how they started, courses taken, number of years in the profession. As a gallery representative, it helps when selling a work of art that you have as much information on the artist, and when you present not just the work of art, but a complete dossier, it reassures the potential customer.''

HARRISON GALLERIES

901 Homer St., Vancouver V6H 3J7. (604)732-5217. Fax: (604)732-0911. Web site: www.tourtheworld.com/bc03/bc03008.htm. **Director:** Chris Harrison. Estab. 1958. Approached by 20 artists/year; represents 25 emerging, mid-career and established artists/year. Exhibited artists include George Bates, Jae Dougall and Jose Trinidad. Nicholas Bott, Kiff Holland, Francine Gravel and Ron Parker. Average display time 3 weeks. Open all year; Monday-Friday, 9:30-5:30; weekends 11-4. Clients include local community, students, tourists and upscale. 30% of sales are to corporate collectors. Overall price range $300-40,000; most work sold at $3,000-7,000.

Media Considers acrylic, glass, mixed media, oil, sculpture, watercolor. Most frequently exhibits oil, acrylic, watercolor. Considers engraving, etching, lithographs.

Style Exhibits conceptualism, imagism, impressionism, landscapes, painterly abstraction, realism. Most frequently exhibits realism, impressionis and painterly abstraction. Genres include figurative work, florals, landscapes, western, wildlife, street scenes, cityscapes, still lifes.

Terms Artwork is accepted on consignment (50% commission). Retail price set by the gallery. Gallery provides insurance, promotion and contract. Usually requires exclusive representation locally.

Submissions Write to arrange a personal interview to show portfolio of photographs or mail portfolio for review. Portfolio should include query letter with artist's statement, bio, brochure, business card, photographs, résumé, reviews, SASE. Responds only if interested. Finds artists through word of mouth, portfolio reviews, referrals by other artists.

Tips ''To make your gallery submissions professional include digital photos or labelled and backed photos, curriculum vitae and bio. Deliver or mail and retrieve your portfolio on your own volition.''

MARCIA RAFELMAN FINE ARTS

10 Clarendon Ave., Toronto ON M4V 1H9 Canada. (416)920-4468. Fax: (416)968-6715. E-mail: info@mrfinearts.com. Web site: www.mrfinearts.com. **President:** Marcia Rafelman. Semi-private gallery. Estab. 1984. Approached by 100s of artists/year. Represents emerging and mid-career artists. Average display time 1 month. Open by appointment except the first 2 days of art openings which is open full days. Centrally located in Toronto's mid-town, 2,000 sq. ft. on 2 floors. Clients include local community, tourists and upscale. 40% of sales are to corporate collectors. Overall price range $500-30,000; most work sold at $1,500-5,000.

Media Considers all media. Most frequently exhibits photography, painting and graphics. Considers all types of prints.

Style Exhibits geometric abstraction, minimalism, neo-expressionism, primitivism and painterly abstraction. Most frequently exhibits high realism paintings. Considers all genres except southwestern, western and wildlife.

Terms Artwork is accepted on consignment (50% commission); net 30 days. Retail price set by the gallery and the artist. Gallery provides insurance, promotion and contract. Requires exclusive representation locally.

Submissions Prefer artists to send images by e-mail. Otherwise, mail portfolio of photographs, bio and reviews for review. Returns material with SASE if in Canada. Responds only if interested within 2 weeks. Files bios and visuals. Finds artists through word of mouth, submissions, art fairs and referrals by other artists.

SAW GALLERY INC.

67 Nicholas St., Ottawa K1N 7B9 Canada. (613)236-6181. Fax: (613)238-4617. E-mail: saw@magi.com. **Visual Arts Coordinator:** Stefan St. Laurent. Alternative space. Estab. 1973. Approached by 100 artists/year. Represents 8-30 emerging and mid-career artists. Average display time 4-5 weeks. Open all year; Tuesday-Saturday, 11-5. Clients include local community, students, tourists and other members. Sales conducted with artist directly.

Media Considers all media. Most frequently exhibits installation, mixed media, media arts (video/film/computer). Considers all types of prints.

Style Exhibits cutting edge contemporary art. Most frequently exhibits art attuned to contemporary issues. Considers critical and contemporary (avant-garde art).

Terms All sales arranged between interested buyer and artist directly. Retail price set by the artist. Gallery provides insurance, promotion and contract. Does not require exclusive representation locally. Accepts only art attuned to contemporary issues.

Submissions Send artist's statement, bio, résumé, reviews (if applicable), SASE, 10 slides. Returns material with SASE. Responds in 1-6 months. Proposals are reviewed in June and December. Files curriculum vitae. Finds artists through word of mouth, submissions, referrals by other artists, calls for proposals, advertising in Canadian art magazines.

Tips ''Have another artist offer an opinion of the proposal and build on the suggestions before submitting.''

INTERNATIONAL

▦ ABEL JOSEPH GALLERY

Avenue Marechal Foch, 89 Bruxelles Belgique 1030. 32-2-2456773. E-mail: abeljoseph_brsls@hotmail.com. Web site: www.cardoeditions.com. **Directors:** Kevin and Christine Freitas. Commercial gallery and alternative space. Estab. 1989. Represents young and established national and international artists. Exhibited artists include Carrie Ungerman, Diane Cole, Regent Pellerin and Ron DeLegge. Sponsors 6-8 shows/year. Average display time 6 weeks. Open all year. Located in Brussels. 100% of space for work of gallery artists. Clientele varies from first time buyers to established collectors. 80% private collectors; 20% corporate collectors. Overall price range $500-15,000; most work sold at $1,000-8,000.

Media Considers most media except craft. Most frequently exhibits sculpture, painting/drawing and installation (including active-interactive work with audiencepoetry, music, etc.).

Style Exhibits painterly abstraction, conceptualism, minimalism, post-modern works and imagism. "Interested in seeing all styles and genres." Prefers abstract, figurative and mixed-media.

Terms Accepts artwork on consignment (50% commission). Retail price set by the gallery with input from the artist. Customer discounts and payment by installments are available. Gallery provides insurance, promotion and contract; shipping costs are shared.

Submissions Send query letter with résumé, 15-20 slides, bio, SASE and reviews. Portfolio review requested if interested in artist's work. Portfolio should include slides, photographs and transparencies. Responds in 1 month. Files résumé, bio and reviews.

Tips "Submitting work to a gallery is exactly the same as applying for a job in another field. The first impression counts. If you're prepared, interested, and have any initiative at all, you've got the job. Know what you want before you approach a gallery and what you need to be happy, whether its fame, glory or money, be capable to express your desires right away in a direct and honest manner. This way, the gallery will be able to determine whether or not it can assist you in your work."

▦ ART@NET INTERNATIONAL GALLERY

(617)495-7451 (++359)98448132. Fax: (617)495-7049 (++359)251-2838. E-mail: Artnetg@Yahoo.com. Web site: www.designbg.com. **Director:** Yavor Shopov-Bulgari. For profit gallery, Internet gallery. Estab. 1998. Approached by 150 artists/year. Represents 20 emerging, mid-career and established artists. Exhibited artists include Nicolas Roerich (paintings) and Yavor Shopov-Bulgari (photography). Sponsors 15 exhibits/year. Average display time permanent. Open all year; Monday-Sunday, 24 hours. "Internet galleries like ours have a number of advantages and are expanding rapidly and taking over many markets held by conventional galleries for many years. Our gallery exists only in Internet. Our expenses are reduced, so we charge our artists a lower commission (only 10%) and offer low prices for the same quality of work. We mount cohesive shows of our artists. Each artist has individual 'exhibition space' divided to separate thematic exhibitions along with bio and statement. We are just hosted in the Internet space, otherwise we are the same as a traditional gallery." Clients include collectors, business offices, and corporate collectors. Overall price range $150-50,000.

Media Considers ceramics, craft, drawing, oil, pastel, pen & ink, sculpture and watercolor. Most frequently exhibits photos, oil and drawing. Considers all types of prints.

Style Considers expressionism, geometric abstraction, impressionism and surrealism. Most frequently exhibits surrealism. Considers Americana, figurative work, florals, landscapes and wildlife.

Terms Artwork is accepted on consignment and there is a 10% commission and a rental fee for space of $1/ image per month or $5/images per year (first 6 images are displayed free of rental fee). Retail price set by the gallery or the artist. Gallery provides promotion. Does not require exclusive representation locally.

Submissions E-mail portfolio for review. E-mail attached scans 900×1200 px (300dpi for prints or 900 dpi for 36mm slides) as JPEG files for IBM computers. "We accept only computer scans, no slides please." E-mail artist's statement, bio, résumé, and scans of the work. Cannot return material. Responds in 6 weeks. Finds artists through submissions, portfolio reviews, art exhibits, art fairs, and referrals by other artists.

Tips "E-mail us or send a disk or CD with a tightly edited selection of less than 20 scans of your best work. All work must be very appealing and interesting. Main usage of all works exhibited in our gallery is for limited edition (photos) or original (paintings) wall decoration of offices and homes. Photos must have the quality of paintings. We like to see strong artistic sense of mood, composition, light and color and strong graphic impact or expression of emotions. We exhibit only artistically perfect work in which value will last for decades. We would like to see any quality work facing these requirements on any media, subject or style. For us only quality of work is important, so new artists are welcome. Before you send us your work, ask yourself, 'who and why will someone buy this work? Is it appropriate and good enough for this purpose?' During the exhibition all photos must be available in signed limited edition museum quality 8×10 or larger matted prints."

THE BRACKNELL GALLERY/THE MANSION SPACES

South Hill Park Arts Centre, Berkshire RG12-7PA. (44)(0)1344-484858. Fax: (44)(0)1344-411427. E-mail: enquiries@southhillpark.org.uk. Web site: www.southhillpark.org.uk. **Contact:** Elvned Myhre, head of visual arts. Alternative space/nonprofit gallery. Estab. 1991. Approached by at least 20 artists/year; exhibits 6-7 shows of emerging, mid-career and established artists. "For Mansion Spaces **very** many artists approach us. All applications are looked at." Exhibited artists include Anne-Marie Carroll (video) and Michael Porter (painting and photography). Average display time 1-2 months. Open all year; Wednesday-Friday, 7-9:30; Saturday and Sunday, 1-5. Located "within a large Arts centre, including theatre, studios, workshops, restaurants, etc.; one large room and one smaller with high ceilings, plus more exhibiting spaces around the centre." Clients include local community and students.
Media Considers all media. Most frequently exhibits craftwork (ceramics, glasswork, jewelry, installations, group shows, video-digital works). Considers all types of prints.
Style Considers all styles and genres.
Terms Artwork is accepted on consignment and there is a 20% commission. Retail price set by the artist. Gallery provides insurance, promotion and contract. Does not require exclusive representation locally.
Submissions Send query letter with artist's statement, bio, photographs and slides. Returns material with SASE. Responds to queries only if interested. Files all material "unless return of slides/photos is requested." Finds artists through art exhibits, referrals by other artists, submissions and word of mouth.
Tips "We have a great number of applications for exhibitions in The Mansion Spacesmake yours stand out! Exhibitions at The Bracknell Gallery are planned 2-3 years in advance."

GALERIA ATLAS ART INC.

208 Cristo St., Old San Juan 00901 Mexico. (787)723-9987. Fax: (787)724-6776. E-mail: atlasartos@yunque.net. Represents international and local artists. Sponsors several shows/year. Average display time 3 months. Clientele 60% tourist and 40% local. 75% private collectors, 30% corporate clients. Overall price range $500-30,000; most work sold at $1,000-5,000.
Media Considers oil, acrylic, watercolor, pastel, drawings, mixed media, collage, sculpture, ceramic, woodcuts, wood engravings, linocuts, engravings, mezzotints, etchings, lithographs and serigraphs. Most frequently exhibits oil on canvas, mixed media and bronze sculpture. "The Atlas Art Gallery exhibits major contemporary artists. We prefer working with original paintings and sculpture."
Style Exhibits expressionism, neo-expressionism and primitivism. Genres include Americana and figurative work. Prefers expressionism and figurative work.
Terms Accepts work on consignment or buys outright. Retail price set by artist. Exclusive area representation required. Gallery provides insurance and contract; artist pays for shipping. Prefers artwork framed.
Submissions Send query letter with résumé, brochure, slides and photographs. Call for appointment to show portfolio of originals. Responds in 2 weeks. Files résumés.

GALERÍA VÉRTICE

Lerdo De Tejada, Guadalajara Jalisco C.P. 44140 Mexico. (5233) 36160078. Fax: (5233) 33160079. E-mail: grjsls@mail.udg.mx. Web site: www.verticegaleria.com. **Contact:** Luis Garca Jasso, director. Estab. 1988. Approached by 20 artists/year; exhibits 12 emerging, mid-career and established artists/year. Sponsors 10 exhibitions/year. Average display time 20 days. Open all year. Clients include local community, students and tourists. Overall price range $5,000-100,000.
Media Considers all media except installation. Considers all types of prints.
Style Considers all styles. Most frequently exhibits abstraction, new-figurativism and realism. Considers all genres.
Terms Artwork is accepted on consignment and there is a 40% commission. Retail price set by the gallery. Gallery provides insurance, promotion and contract. Accepted work should be framed. Requires exclusive representation locally.
Submissions Mail portfolio for review or send artist's statement, bio, brochure, photocopies, photographs and résumé. Responds to queries in 3 weeks. Finds artists through art fairs, art exhibits and portfolio reviews.

GALERIAS PRINARDI

Condominio El Centro I 14-A Ave. Munoz Rivera #500, Hato Rey 00198 Mexico. (787)763-5727. Fax: (787)763-0643. E-mail: prinardi@prinardi.com. Web site: www.prinardi.com. **Contact:** Andres Marrero, director. Administrator: Judith Nieves. Art consultancy and for-profit gallery. Approached by many artists/year; represents with exclusivity 10 artists and exhibits many emerging, mid-career and established artists' works. Exhibited artists include Rafael Tufiño, Domingo Izquierdo and Carlos Santiago (oi painting). Sponsors 12 exhibits/year. Average display time 2-3 weeks. Open all year; Monday-Friday, 10-6; Saturday, 11-4. Or by appointment. Closed Sunday. Clients include upscale. 50% of sales are to corporate collectors. Overall price range $3,000-25,000; most work sold at $8,000. "We also have serigraphs from $500-$3,500 and other works of art at different prices."

Media Considers oil, acrylic, ceramics, drawing, glass, installation, mixed media, paper, pastel, pen & ink, sculpture and watercolor. Considers most media. Most frequently exhibits oil, sculpture and works of art on paper. Considers all types of prints, especially limited editions.

Style Exhibits color field, expressionism, imagism, minimalism, neo-expressionism, postmodernism, painterly abstraction and some traditional works of art.

Terms Artwork is accepted on consignment and there is a 40% or 50% commission, or artwork is bought outright for 100% of retail price; net 30 days. Retail price set by the gallery and the artist. Gallery provides promotion and contract. Sometimes requires exclusive representation locally. Accepts only fine artists.

Submissions Mail portfolio for review or send query letter with artist's statement, bio, brochure, business card, photocopies, photographs, résumé, reviews and e-mail letter with digital photos. Cannot return material. Responds to queries in 1 month. If interested, files artist's statement, bio, brochure, photographs, résumé and reviews. Finds artist's through portfolio reviews, referrals by other artists and submissions.

Tips ''Present an artist's portfolio which should include biography, artist's statement, curriculum and photos or slides of his/her work of art.''

⊕ GARDEN SUBURB GALLERY

16 Arcade House Hampstead Way, London NW11 7TL. +44 181 455 9132. Web site: www.hgs.org.uk. **Manager:** R. Wakefield. Nonprofit gallery. Estab. 1995. Approached by 5 artists/year. Represents 32 emerging, mid-career and established artists. Exhibited artists include Annie Walker, Judy Bermant and Jennie Dunn. Average display time 1 month. Open all year; Monday-Saturday, 10-5. Located in conservation area. Very small utyens summer house; 18×10'. Clientele local community, tourists. Overall price range $250. Most work sold at $250.

Media Considers all media and all types of prints.

Style Considers all styles. Genres include florals, landscapes, portraits.

Terms Artwork is accepted on consignment (40% commission). Retail price set by the gallery. Gallery provides insurance and promotion. Accepted work should be framed or mounted.

Submissions Write to arrange a personal interview to show portfolio. Returns material with SASE. Responds in 2 weeks. Finds artists through word of mouth, submissions, art exhibits and referrals by other artists.

⊕ HONOR OAK GALLERY

52 Honor Oak Park, London SE23 1DY United Kingdom. 020-8291-6094. **Contact:** John Broad. or Sanchia Lewis. Estab. 1986. Approached by 15 artists/year. Represents 40 emerging, mid-career and established artists. Exhibited artists include Jenny Devereux, Norman Ackroyd, Clare Leighton, Robin Tanner and Karolina Larusdottir. Sponsors 2 total exhibits/year. Average display time 6 weeks. Open all year; Tuesday-Friday, 930-6; Saturday, 930-5. Closed 2 weeks at Christmas, New Years and August. Located on a main thoroughfare in South London. Exhibition space of 1 room 12×17'. Clientele local community and upscale. 2% corporate collectors. Overall price range 18-2,000; most work sold at 150.

Media Considers collage, drawing, mixed media, pastel, pen & ink, watercolor, engravings, etchings, linocuts, lithographs, mezzotints, engravings, woodcuts, screenprints, wood engravings. Most frequently exhibits etchings, wood engravings, watercolor.

Style Exhibits postmodernism, primitivism, realism, 20th century works on paper. Considers all styles. Most frequently exhibits realism. Genres include figurative work, florals, landscapes, wildlife, botanical illustrations.

Terms Artwork is accepted on consignment (40% commission). Retail price set by the gallery and the artist. Gallery provides promotion. Does not require exclusive representation locally. Prefers only works on paper.

Submissions Write to arrange a personal interview to show portfolio of recent original artwork. Send query letter with bio, photographs. Responds in 1 month. Finds artists through word of mouth, submissions, art fairs.

Tips ''Show a varied, but not too large selection of recent work. Be prepared to discuss a pricing policy. Present work neatly and in good condition. As a gallery which also frames work, we always recommend conservation mounting and framing and expect our artists to use good quality materials and appropriate techniques.''

⊕ MARIA ELENA KRAVETZ ART GALLERY

(formerly Artempresa Gallery) San Jeronimo 448, 5000 Cordoba (54)351 4221290. Fax: (54)351 4271776. E-mail: mek@mariaelenakravetzgallery.com. Web site: www.mariaelenakravetzgallery.com. **Contact:** Maria Elena Kravetz, director. For-profit gallery. Estab. 1998. Approached by 30 artists/year; exhibits 16 emerging and mid-career artists/year. Exhibited artists include Silvia Parmentier (glass-casting) and Alejandra Tolosa (carved wood, Xilographies). Average display time 20 days. Open Monday-Friday, 4:30pm-8:30pm; Saturday, 10am-1pm. Closed Sunday. Closed January and February. Located in the main downtown of Cordoba city; 170 square meters, 50 spotlights and white walls. Clients include local community and tourists. Overall price range $500-10,000; most work sold at $1,500-5,000.

Media Considers all media. Most frequently exhibits glass sculpture and mixed media. Considers etchings, linocuts, lithographs and woodcuts.

Style Considers all styles. Most frequently exhibits new-expressionism and painterly abstraction. Considers all genres.

Terms Artwork is accepted on consignment and there is a 30% commission. Retail price set by the artist. Requires exclusive representation locally. Prefers only artists from South America and emphasizes sculptors.

Submissions Mail portfolio for review. Cannot return material. Responds to queries in 1 month. Finds artist's through art fairs and exhibits, portfolio reviews, referrals by other artists, submissions and word of mouth.

Tips Artists "must indicate a Web page to make the first review of their works, then give an e-mail address to contact them if the gallery is interested in their work."

Ⓝ 🌐 LE MUR VIVANT

(incorporating CORPORART), 30 Churton St., London SW1V 2LP United Kingdom. (0171)821 5555. Web site: www.corporart.co.uk. **Contact:** Caro Lyle Skyrme. Estab. 1996. Represents 15 established artists. Exhibited artists include Charles MacQueen, Ron Bolt, Angus McEwan. Sponsors 10 exhibits/year. Average display time 3 weeks. Open Tuesday-Friday, 10-5; and one Saturday/month. Closed Mondays and Friday from noon. Gallery space is 2 connected roomseach approximately 12 × 15'. Total 30' long space. 2 offices in central LondonWestminster. High ceilings, Victorian shop. Clientele local community, tourists, upscale media and theater people. 20% corporate collectors. Overall price range $500-10,000; most work sold at 1,000.

Media Considers all media. Most frequently exhibits oil on canvas or board, watercolor, mixed media.

Style Exhibits color field, expressionism, imagism, impressionism, neo-expressionism, painterly abstraction, postmodernism and surrealism. Most frequently exhibits abstract expressionism, impressionism, magic realism and surrealism. Considers all genres including Northern Romantic and photo realism.

Terms "We work on flexible percentages depending on standing of artist and potential following. We take smaller percentage from already established artists with excellent C.V. and good client list as we can rely on many sales." Retail price set with collaboration of the artist. Gallery provides contract. Accepted work should be framed or mounted. Requires exclusive representation locally. Prefers only fully professional artists with excellent curriculum vitae.

Submissions Write to arrange a personal interview to show portfolio of photographs, slides, transparencies. Send query letter with artist's statement, bio, photographs, résumé and SASE. Portfolio should include good photos or slides etc. Full curriculum vitae detailing college and professional experience. Returns material with SASE. Replies only if interested within 1 month. Finds artists through word of mouth, submissions, portfolio reviews, art exhibits, referrals by other artists, Royal Academy exhibitions, public shows and magazines.

Tips "Send neatly presented details of past work/exhibitions/galleries, good quality transparencies, photos and/or slides. Do not expect to walk in and have your work looked at by a staff member in the middle of a business day!"

🌐 NEVILL GALLERY

43 St. Peters St., Canterbury, Kent CT1 2BG. (0044)1227 765291. E-mail: chris@nevillgallery.com. Web site: www.nevillgallery.com. **Director:** Christopher Nevill. Rental gallery. Estab. 1970. Approached by 6 artists/year. Represents 30 emerging, mid-career and established artists. Exhibited artists include Matthew Alexander and David Napp. Average display time 3 weeks. Open all year; Monday-Saturday, 10-5. Located on High St. in the heart of Canterbury. Clientele local community, tourists and upscale. Overall price range 100-5,000.

Media Considers acrylic, collage, mixed media, oil, paper, pastel, pen & ink, watercolor, engravings, etchings, linocuts, mezzotints and woodcuts. Most frequently exhibits oils, watercolor and pastels.

Style Exhibits expressionism, impressionism and painterly abstraction. Genres include abstract, figurative work, florals and landscapes.

Terms Artwork is accepted on consignment (40% commission). Retail price set by the artist. Gallery provides insurance while on the premises. Accepted work should be framed. Does not require exclusive representation locally.

Submissions Call or write to arrange a personal interview to show portfolio of photographs, slides, transparencies. Send query letter with photographs and résumé. Return material with SASE. Responds in 2 weeks. Finds artists through word of mouth, submissions, portfolio reviews, art exhibits, art fairs and referrals by other artists.

Ⓝ 🌐 NORTHCOTE GALLERY

110 Northcote Rd., London SW11 6QP United Kingdom. (0171)926 6741. **Director:** Ali Pettit. Art consultancy, wholesale gallery. Estab. 1992. Approached by 100 artists/year. Represents 30 emerging, mid-career and established artists. Exhibited artists include Daisy Cook and Robert McKellar. Sponsors 16 exhibits/year. Average display time 3-4 weeks. Open all year; Tuesday-Saturday, 11-7; Sunday, 11-6. Located in southwest London. 1 large exhibition space, 1 smaller space; average of 35 paintings exhibited/time. Clientele local community and upscale. 50% corporate collectors. Overall price range 400-12,000; most work sold at 1,500.

Media Considers acrylic, ceramics, drawing, glass, mixed media, oil, paper, photography, sculpture, watercolor, engravings, etchings and lithographs.

Style Exhibits conceptualism, expressionism, impressionism, painterly abstraction and postmodernism. Considers all genres.

Terms Artwork is accepted on consignment (45% commission). Retail price set by the gallery. Gallery provides promotion. Accepted work should be framed.

Submissions Send query letter with artist's statement, bio, brochure, photograph, résumé, reviews and SASE. Returns material with SASE. Responds in 4-6 weeks. Finds artists through word of mouth, submissions, portfolio reviews and referrals by other artists.

⊕ THE OCTOBER GALLERY

24 Old Gloucester St., Bloomsbury, London WC1N 3AL United Kingdom. 44(0)20 7242 7367. Fax: 44(0)20 7405 1851. E-mail: octobergallery@compuserve.com. Web site: www.theoctobergallery.com. **Contact:** Elisabeth Lalouschek, artistic director. Nonprofit gallery. Estab. 1979. Approached by 60 artist/year; exhibits 20 established artists/year. Exhibited artists include Ablade Glover (oil on canvas) and El Anatsui (mixed media). Average display time 1 month. Open Tuesday-Saturday, 12:30-5:30. Closed Christmas, Easter and August. Gallery is centrally located near the British Museum. Clients include local community and upscale. Overall price range $80-18,000.

Media Considers acrylic, ceramics, collage, drawing, mixed media, oil, paper, pen & ink, sculpture and watercolor. Most frequently exhibits mixed media, acrylic and collage. Also considers posters and woodcuts.

Style Exhibits color field, conceptualism, expressionism, imagism, pattern painting, painterly abstraction, postmodernism and primitivism realism. Most frequently exhibits expressionism, painterly abstraction and primitivism realism. Genres include contemporary art from around the world.

Terms Artwork is accepted on consignment and there is a 50% commission. Retail price set by the gallery and the artist. Gallery provides insurance, promotion and contract. Accepted work should be mounted. Does not require exclusive representation locally.

Submissions Write to arrange a personal interview to show portfolio of photographs and slides. Send query letter with artist's statement, bio, brochure, business card, photocopies, photographs, résumé, SASE and slides. Returns material with SASE. Responds to queries in 3 months. Finds artists through referrals by other artists, submissions and word of mouth.

Tips "Ensure all personal details are labeled clearly and correctly."

⊕ PARK WALK GALLERY

20 Park Walk, London SW10 0AQ United Kingdom. (0207)351 0410. E-mail: mail@jonathancooper.co.uk. Web site: www.jonathancooper.co.uk. **Gallery Owner:** Jonathan Cooper. Gallery. Estab. 1988. Approached by 5 artists/year. Represents 16 mid-career and established artists. Exhibited artists include Kate Nessler. Sponsors 8 exhibits/year. Average display time 3 weeks. Open all year; Monday-Saturday, 10-630; Sunday, 11-4. Located in Park Walk which runs between Fulham Rd. to Kings Rd. Clientele upscale. 10% corporate collectors. Overall price range 500-50,000; most work sold at 4,500.

Media Considers drawing, mixed media, oil, paper, pastel, pen & ink, photography, sculpture, watercolor. Most frequently exhibits watercolor, oil and sculpture.

Style Exhibits conceptualism, impressionism. Genres include florals, landscapes, wildlife, equestrian.

Terms Artwork is accepted on consignment (50% commission). Retail price set by the gallery. Gallery provides promotion. Requires exclusive representation locally.

Submissions Call to arrange a personal interview to show portfolio. Returns material with SASE. Responds in 1 week. Finds artists through submissions, portfolio reviews, art exhibits, art fairs, referrals by other artists.

Tips "Include full curriculum vitae and photographs of work."

N ⊕ PEACOCK COLLECTION

The Smithy Old Warden, Biggleswade, Belfordshire SG18 9HQ United Kingdom. (01767)627711. Fax: (01767)627027.E-mail: peacockcol@aol.com. **Contact:** Elaine Baker. Retail gallery. Estab. 1997. Represents emerging artists. Exhibited artists include Gary Hodges, Walasse Ting and Adrian Rigby. Average display time 2 weeks. Open all year; Monday-Friday, 9-5:30; weekends 1-4:30. Located in the beautiful 18th century award winning village of Old Warden. The gallery has 2 rooms both spotlit. Room 1 is 30×20 ft. Room 2 is 15×10 ft. Clientele local community and tourists. 20% of sales are to corporate collectors. Overall price range 29-4,500; most work sold at 200.

Media Considers acrylic, ceramics, craft, drawing, glass, mixed media, oil, pastel, pen & ink, photography, sculpture, watercolor, etchings, linocuts, lithographs and posters. Most frequently exhibits watercolor, ceramics and sculptures.

Style Considers all styles. Genres include figurative work, florals, landscapes and wildlife.

Terms Artwork is accepted on consignment (30% commission). Retail price set by gallery. Gallery provides

insurance, promotion and contract. Accepted work should be framed or mounted. Requires exclusive representation locally.

Submissions Write with details and photographic samples. Send query letter with bio and photographs. Returns material with SASE. Responds in 2 weeks. "If we are allowed to keep artists photos we file in specific categories, i.e., sculpture work for future exhibitions, i.e., wildlife exhibition." Finds artists through word of mouth, submissions, art exhibits, referrals by other artists.

Tips "Good, clear photographs of work with contact details with indication of best times to phone, i.e., day/evening."

⊕ PRAXIS MEXICO

Arquimedes 175, Colonia Polanco C.P. 11570 Mexico. (5255)5254-8813. Fax: (5255)5255-5690. E-mail: info@praxismexico.com. Web site: www.praxismexico.com. For-profit gallery. Estab. 1998. Exhibits emerging, mid-career and established artists. Approached by 8 artists/year. Sponsors 4 exhibitions/year. Average display time 30 days. Open all year; Monday-Friday, 10-7:30, Saturday and Sunday, 10-3. Located in a basement with two separate rooms, a temporary room and the collective space. Clients include local community and tourists. 70% of sales are to corporate collectors. Overall price range $5,000-100,000.

Media Considers acrylic, craft, drawing, oil and sculpture. Also considers etchings, lithographs and serigraphs.

Style Exhibits postmodernism. Genres include figurative work.

Terms Artwork is accepted on consignment and there is a 50% commission or artwork is bought outright; net 30 days. There is a co-op membership fee plus a donation of time. There is a 10% commission. Retail price set by the gallery. Gallery provides promotion. Accepted work should be framed. Requires exclusive representation locally.

Submissions Send e-mail. Returns material with SASE. Responds to queries in 1 month. Finds artists through art fairs and exhibits, portfolio reviews and referrals by other artists.

⊕ THE STUDIO

20 High St., Otford, Stevenoaks, Kent TN14 5PQ United Kingdom. 01959 524784. Web site: www.yell.co.uk/sites/the-studio-oxford/. **Contact:** Wendy Peck. Estab. 1990. Exhibits established artists. Exhibited artists include Deborah Scaldwell, Abigail Mill. Average display time 1 year. Open Tuesday-Saturday, 10-5:30. High street in picturesque village. The shop is fairly narrow but longplenty of wall space—along shelving and alcoves for craftwork (16th century building with oak beams). Clientele local community, tourists and upscale. Overall price range 5-400; most work sold at 50.

Media Considers all media except installations. Most frequently exhibits watercolor, bronze resin, ceramics. Considers etchings, linocuts, lithographs, mezzotints, serigraphs, engravings, woodcuts.

Style Exhibits color field, conceptualism, expressionism, impressionism, minimalism, pattern painting, painterly abstraction. Most frequently exhibits impressionism, pattern painting, expressionism. Genres include figurative work, florals, portraits, western and wildlife.

Terms Artwork is accepted on consignment (40% commission) or bought outright for 50% of retail price; net 30 days. Retail price set by gallery. Gallery provides insurance, promotion. Accepted work should be framed or mounted. Does not require exclusive representation locally.

Submissions Call or write to arrange a personal interview to show portfolio of photographs, slides, transparencies. Send query letter with artist's statement, brochure, business card. Responds in 1 months. Finds artists through word of mouth, art exhibits, art fairs, referrals by other artists.

Tips "The work must beg a high standard. Framing must beg good qualitywith an attractive mounting (not a cheap frame)."

Ⓝ ⊕ OSTEN ZEKI GALLERY

174 Walton St., London SW3 2JL United Kingdom. (0171)225-1624 and 225-2899. **Contact:** Ozten Zeki. Estab. 1991. Approached by 30 artists/year. Represents emerging, mid-career and established artists. Sponsors 5-6 exhibits/year. Open Monday-Saturday, 11-6. Clientele local community, students, tourists, upscale and banks. 60-70% corporate collectors.

Media Considers acrylic, ceramics, craft, drawing, glass, mixed media, oil, paper, pastel, pen & ink, watercolor, engravings and etchings.

Style Styles and genres include abstract, figurative, florals, landscapes, western and wildlife.

Terms Artwork is accepted on consignment (50% commission). Retail price set by the gallery. Gallery provides insurance, promotion and contract. Accepted work should be framed. Requires exclusive representation locally.

Submissions Write to arrange a personal interview to show portfolio of photographs. Send artist's statement, brochure, photographs. Returns material with SASE. Replies only if interested within 2 months. Finds artists through word of mouth, submissions, portfolio reviews, art exhibits, art fairs and referrals by other artists.

Art Fairs

How would you like to sell your art from New York to California, showcasing it to thousands of eager art collectors? Art fairs (also called art festivals or art shows) are not only a good source of income for artists but an opportunity to see how people react to your work. If you like to travel, enjoy meeting people and can do your own matting and framing, this could be a great market for you.

Many outdoor fairs occur during the spring, summer and fall months to take advantage of warmer temperatures. However, depending on the region, temperatures could be hot and humid, and not all that pleasant! And, of course, there is always the chance of rain. Indoor art fairs held in November and December are popular because they capitalize on the holiday shopping season.

To start selling at art fairs, you will need an inventory of work; some framed, some unframed. Even if customers do not buy the framed paintings or prints, having some framed work displayed in your booth will give buyers an idea of how your work looks framed, which could spur sales of your unframed prints. The most successful art fair participants try to show a rage of sizes and prices for customers to choose from.

When considering the art fairs in this section, first consider local shows and shows in your neighboring cities and states. Once you find a show you'd like to enter, visit their Web site or contact them for a more detailed prospectus. A prospectus is an application that will offer additional information we didn't have room to print in the art fair's listing.

Ideally, most of your prints should be matted and stored in protective wraps or bags so that customers can look through your inventory without damaging prints and mats. You will also need a canopy or tent to protect yourself and your wares from the elements as well as some bins in which to store the prints. A display wall will allow you to show off your best framed prints. Generally, artists will have a 10 ft. by 10 ft. space in which to set up their tents and canopies. Most listings will specify the dimensions of the exhibition space for each artist.

If you see the ♥ icon before a listing in this section, it means that this art fair is a juried event. In other words, there is a selection process artists must go through to be admitted into the fair. Many art fairs have quotas for the categories of exhibitors. For example, one art fair may accept the mediums of photography, sculpture, painting, metal work and jewelry. Once each category fills with qualified exhibitors, no more will be admitted to the show that year. The jurying process also ensures that the artists who sell their work at the fair meet the sponsor's criteria for quality. So, overall, if an art fair is juried, that is a good thing for the artists because it signals that they will be exhibiting their work along with other artists of equal caliber.

Be aware there are fees associated with entering art fairs. Most fairs have an application fee or a space fee or sometimes both. The space fee is essentially a rental fee for the space your booth will occupy for the art fair's duration. These fees can vary greatly from show to show, so be sure to check this information in each listing before you apply to any art fair.

Most art fair sponsors want to exhibit only work that is handmade by the artist, no matter what medium. Unfortunately, some people try to sell work that they purchased elsewhere as their own original artwork. In the art fair trade, this is known as "buy/sell." It is an undesirable situation since it tends to bring down the quality of the whole show. Some listings will make a point to say "no buy/sell" or no "manufactured work."

For more information on art fairs pick up a copy of *Sunshine Artists* or *Art Calendar*, and consult online sources such as www.artfairsource.com, www.artcalendar.com, and www.festival.net.

NORTHEAST & MIDATLANTIC

ALLENTOWN ART FESTIVAL

P.O. Box 1566, Ellicott Station, Buffalo NY 14205-1566. (716)881-4269. E-mail: allentownartfestival@verizon.net. Web site: www.allentownartfestival.com. **Contact:** Mary Myszkiewicz, president. Estab. 1958. Fine arts & crafts show held annually 2nd full weekend in June. Outdoors. Accepts photography, painting, watercolor, drawing, graphics, sculpture, mixed media, clay, glass, acrylic, jewelry, creative craft (hard/soft). Slides juried by hired professionals that change yearly. Awards/prizes: $17,925 in 40 cash prizes; Best of Show. Number of exhibitors: 450. Public attendance: 300,000. Free to public. Artists should apply by downloading application from Web site. Deadline for entry: January 31. Application fee: $15. Space fee: $225. Exhibition space: 13 × 10 ft. For more information, artists should e-mail, visit Web site, call or send SASE.
Tips "Artists must be present, have attractive booth, and interact with public."

AMERICAN ARTS AND CRAFTS SHOW

56 Lexington St., New Britain CT 06052. (860)223-6867, ext. 23. Fax: (860)826-4683. E-mail: trutterb@nbmaa.org. Web site: www.nbmaa.org. **Contact:** Becky Trutter, manager of special events. Estab. 1998. Fine arts & crafts show held annually in September. Outdoors. Accepts photography, paintings, drawings, ceramics, fiber, furniture, glass, jewelry, leather, metal, mixed media, sculpture, wood. Juried by museum staff, artists and buyers following the deadline. Awards/prizes: $100 each for Best in Show, Best Single Work, Best Booth Presentation. Number of exhibitors: 75-100. Public attendance: 2,000. Public admission: $5. Artists should apply by completing application available on Web site or by contacting museum. Deadline for entry: March 31. Application fee: $10. Space fee: $150-300 prior to deadline; $175-325 after deadline. Exhibition space: 12 × 12 ft. For more information, artists should e-mail, visit Web site or call.
Tips "Design booth space so it is inviting to buyers. Present work in a professional manner."

ART IN THE HEART OF THE CITY

171 East State St., Ithaca NY 14850. (607)277-8679. Fax: (607)277-8691. E-mail: phil@downtownithaca.com. Web site: www.downtownithaca.com. **Contact:** Phil White, office manager/event coordinator. Estab. 1999. Sculpture exhibition held annually in early June. Indoors and outdoors. Accepts photography, wood, ceramic, metal, stone. Juried by Public Arts Commission. Number of exhibitors: 28-35. Public attendance: 1,000-2,000. Free to public. Artists should apply by submitting application, artist statement, slides/photos. Deadline for entry: May. Exhibition space depends on placement. For more information, artists should e-mail.
Tips "Be sure there is a market and interest for your work, and advertise early."

ART IN THE PARK FALL FOLIAGE FESTIVAL

Sponsored by the Chaffee Center for the Visual Arts. 16 S. Main St., Rutland VT 05701. (802)775-0356. Fax: (802)773-4401. E-mail: beyondmarketing@yahoo.com. Web site: www.chaffeeartcenter.org. **Contact:** Sherri Birkheimer, event coordinator. Estab. 1961. Fine arts & crafts show held biannually: Art in the Park Summer Festival held 2nd weekend in August (Saturday and Sunday); Art in the Park Fall Foliage Festival held on Columbus Day weekend (Saturday and Sunday). Outdoors. Accepts photography, clay, fiber, floral, glass, wood, jewelry, soaps and baskets. Juried by a panel of 10-15 judges. Submit 3 slides (2 of artwork and 1 of booth display). Number of exhibitors: 130. Public attendance: 7,000-9,000. Public admission: voluntary donation. Artists should apply by visiting Web site for application. Deadline for entry: "Ongoing jurying, but to receive

discount for doing both shows, March 31." Space fee: $135-310. Exhibition space: 10×12 ft. and 20×12 ft. For more information, artists should e-mail, visit Web site, call.

Tips "Have a good presentation and variety, if possible (in pricing also), to appeal to a large group of people."

ART'S ALIVE

200-125th St. & the Bay, Ocean City MD 21842-2247. (410)250-0125. Fax: (410)250-5409. E-mail: Bmoore@ococ ean.com. Web site: www.ococean.com. **Contact:** Brenda Moore, event coordinator. Estab. 2000. Fine arts show held annually in mid-June. Outdoors. Accepts photography, ceramics, drawing, fiber, furniture, glass, printmaking, jewelry, mixed media, painting, sculpture, fine wood. Juried. Awards/prizes: Best of show, $2,000; Blue ribbon, $2000; 6 Judge's Choices, $500 each; Mayor's Choice; People's Choice. Number of exhibitors: 110. Public attendance: 10,000. Free to pubic. Artists should apply by downloading application from Web site or call. Deadline for entry: February 28. Space fee: $75. Exhibition space: 12×12 ft. For more information, artists should e-mail, visit Web site, call or send SASE.

Tips "Apply early."

ARTS & CRAFTS FESTIVAL

P.O. Box 903, Simsbury Ct., Hartford CT 06070. (860)658-2909. E-mail: ztd65@aol.com. **Contact:** Zita Duffy, co-chairman. Estab. 1978. Arts & crafts show held annually 2nd weekend after Labor Day. Outdoors. Accepts photography, clothing & accessories, jewelry, toys, wood objects, floral arrangements. Juried. Applicants should submit slides. Number of exhibitors: 140. Public attendance: 15,000-20,000. Free to public. Artists should apply by submitting completed application, 3 labeled slides of work, 1 slide of display and SASE. Deadline for entry: June 25. Space fee: $115-145. Exhibition space: 11×15 ft. frontage. For more information, artists should e-mail or call.

Tips "Display the artwork in an attractive setting."

CHATSWORTH CRANBERRY FESTIVAL

P.O. Box 286, Chatsworth NJ 08019-0286. (609)726-9237. Fax: (609)726-1459. E-mail: lgiamalis@aol.com. Web site: www.cranfest.org. **Contact:** Lynn Giamalis, chairperson. Estab. 1983. Arts & crafts show held annually in October. Outdoors. Accepts photography. Juried. Number of exhibitors: 200. Public attendance: 75,000-100,000. Free to public. Artists should apply by sending SASE to above address. Deadline for entry: September 1. Space fee: $200. Exhibition space: 15×15 ft. For more information, artists should visit Web site.

CHRISTMAS CRAFT SHOW

5989 Susquehanna Plaza Dr., York PA 17406. (717)764-1155, ext.1243. Fax: (717)252-4708. E-mail: joe.alfano@cumulus.com. Web site: www.yorkcraftshows.com. **Contact:** Joe Alfano, marketing assistant. Estab. 1985. Arts & crafts show held annually in mid-December. Indoors. Accepts photography and all hand crafts. Number of exhibitors: 250. Public attendance: 3,000. Public admission: $3. Artists should apply by visiting Web site or calling or mailing for an entry form. Space fee: $95. Exhibition space: 10×10 ft. Average gross sales/exhibitor: $1,000-$2,000. For more information, artists should e-mail, visit Web site or call.

• York Craft Shows also sponsors Holiday Craft Show in late October, the Codorus Summer Blast in late June, and the Summer Craft Show in late July. See listings for these events in this section.

CODORUS SUMMER BLAST

Codorus State Park, Hanover PA 17313. (717)764-1155, ext.1243. Fax: (717)252-4708. E-mail: jalfano@radioyork.com. Web site: www.yorkcraftshows.com. **Contact:** Joe Alfano, marketing/promotions. Estab. 2000. Arts & crafts show held annually in late June. Accepts photography and all crafts. Number of exhibitors: 50. Public attendance: 15,000. Free to the public. Artists should apply on Web site or through the mail. Space fee: $85. Exhibition space: 20×20 ft. Average gross sales/exhibitor: $1,000-2,000. For more information, artists should e-mail, visit Web site or call.

• York Craft Shows also sponsors Holiday Craft Show in late October, Christmas Craft Show in mid-December and the Summer Craft Show in late July. See listings for these events in this section.

COLORSCAPE CHENANGO ARTS FESTIVAL

P.O. Box 624, Norwich NY 13815. (607)336-3378. E-mail: info@colorscape.org. Web site: www.colorscape.org. **Contact:** Peggy Finnegan, festival director. Estab. 1995. Fine arts & crafts show held annually the weekend after Labor Day. Outdoors. Accepts photography and all types of mediums. Juried. Awards/prizes: $5,000. Number of exhibitors: 80-85. Public attendance: 14,000-16,000. Free to public. Deadline for entry: March. Application fee: $15/jury fee. Space fee: $150. Exhibition space: 12×12 ft. For more information, artists should e-mail, visit Web site, call or send SASE.

Tips "Interact with your audience. Talk to them about your work and how it is created. Don't sit grumpily at the rear of your booth reading a book. People like to be involved in the art they buy and are more likely to buy if you involve them."

CRAFTS AT RHINEBECK

6550 Springbrook Ave., Rhinebeck NY 12572. (845)876-4001. Fax: (845)876-4003. E-mail: fairgrounds@citlink. net. Web site: www.dutchessfair.com. **Contact:** Vicki Imperati, event coordinator. Estab. 1981. Fine arts & crafts show held biannually in late June and early October. Indoors. Accepts photography, fine art, ceramics, wood, mixed media, leather, glass, metal, fiber, jewelry. Juried by 3 slides of work and 1 of booth display. Number of exhibitors: 350. Public attendance: 25,000. Public admission: $7. Artists should apply by calling for application or downloading application from Web site. Deadline for entry: February 1. Application fee: $15. Space fee: $300-730. Exhibition space: 10×10 ft. to 15×15 ft. For more information, artists should e-mail, visit Web site or call.

Tips ''Presentation of work within your booth is very important. Be approachable and inviting.''

A DAY IN TOWNE

Boalsburg Memorial Day Committee, 117 E. Boal Ave., Boalsburg PA 16827. (814)466-6311. **Contact:** Margaret Tennis, chairperson for vendors. Estab. May 1980. Arts & crafts show held annually the last Monday in May/ Memorial Day weekend. Outdoors. Accepts photography, country fabric, wood, wool knit, soap, jewelry, dried flowers, pottery, blown glass. Vendor must make own work. Number of exhibitors: 125-135. Public attendance: 20,000. Artists should apply by writing an inquiry letter and sending 2-3 photos; 1 of booth and 2 of the craft. Deadline for entry: January 1- February 1. Space fee: $60. Exhibition space: 10×15 ft.

Tips ''Please do not send fees until you receive an official contract. Have a neat booth, nice smile. Have fair prices—if too high, product will not sell here.''

A FAIR IN THE PARK

Box Heart Gallery, 4523 Liberty Ave., Pittsburgh PA 15224. (412)687-8858. Fax: (412)687-6338. E-mail: boxheart express@earthlink.net. Web site: www.craftsmensguild.org. **Contact:** Nicole Capozzi, director. Estab. 1969. Fine arts & crafts show held annually weekend after Labor Day. Outdoors. Accepts photography, clay, fiber, jewelry, metal, mixed media, wood, glass, 2D visual arts. Juried. Awards/prizes: 1 Best of Show and 3 Crafts-men's Guild Awards. Number of exhibitors: 115. Public attendance: 30,000+. Free to public. Artists should apply by sending application with jury fee, booth fee and 5 slides. Deadline for entry: May 1. Application fee: $20. Space fee: $250. Exhibition space: 10×10 ft. Average gross sales/exhibitor: $700-3,000. For more information, artists should e-mail, visit Web site or call.

Tips ''It is very important for you to present your artwork to the public, to concentrate on the business aspects of your career. You will find that you can build a strong customer/collector base by exhibiting your work and by educating the public about your artistic process and passion for creativity.''

FORD CITY HERITAGE DAYS

P.O. Box 205, Ford City PA 16226-0205. (724)763-1617. Fax: (724)763-1763. E-mail: pendletonhomer@hotmail. com. Estab. 1980. Arts & crafts show held annually on the Fourth of July. Outdoors. Accepts photography, any handmade craft. Juried by state. Awards/prizes: 1st & 2nd place plaques for best entries. Public attendance: 35,000-50,000. Free to public. Artists should apply by requesting an application by e-mail or telephone. Deadline for entry: April 15. Application fee: $200. Space fee included with application fee. Exhibition space: 12×17 ft. For more information, artists should e-mail, call or send SASE.

Tips ''Show runs for 6 days. Have quality product, be able to stay for length of show, and have enough product.''

FOREST HILLS FESTIVAL OF THE ARTS

P.O. Box 477, Smithtown NY 11787-0477. (631)724-5966. Fax: (631)724-5967. E-mail: showtiques@aol.com. Web site: www.showtiques.com. **Contact:** Eileen. Estab. 2001. Fine arts & crafts show held annually in May. Outdoors. Accepts photography, all arts & crafts made by the exhibitor. Juried. Number of exhibitors: 300. Public attendance: 175,000. Free to public. Deadline for entry: until full. Space fee: $150-175. Exhibition space: 10×10 ft. For more information, artists should visit Web site or call.

GARRISON ART CENTER FINE ART & CRAFT FAIR

P.O. Box 4, 23 Camison's Landing, Garrison NY 10524. (845)424-3960. Fax: (845)424-3960. E-mail: gac@highlan ds.com. Web site: www.garrisonartcenter.org. Estab. 1969. **Contact:** Libby Turnock, executive director. Fine arts & crafts show held annually the 3rd weekend in August. Outdoors. Accepts all mediums. Juried by a committee of artists and community members. Number of exhibitors: 75. Public attendance: 10,000. Public admission: suggested donation of $5. Artists should call for application form or download from Web site. Deadline for entry: April. Application fee: $10. Space fee: $240; covered booth: $265. Exhibition space: 10×10 ft. For more information, artists should e-mail, visit Web site, call, send SASE.

Tips ''Have an inviting booth and be pleasant and accessible. Don't hide behind your product—engage the audience.''

N ✪ GREAT NECK STREET FAIR

P.O. Box 477, Smithtown NY 11787-0477. (631)724-5966. Fax: (631)724-5967. E-mail: showtiques@aol.com. Web site: www.showtiques.com. **Contact:** Eileen. Estab. 1978. Fine arts & crafts show held annually in May. Outdoors. Accepts photography, all arts & crafts made by the exhibitor. Juried. Number of exhibitors: 250. Public attendance: 50,000. Free to public. Deadline for entry: until full. Space fee: $150-175. Exhibition space: 10×10 ft. For more information, artists should e-mail, visit Web site or call.

N HOLIDAY CRAFT SHOW

5989 Susquehanna Plaza Dr., York PA 17406. (717)764-1155, ext. 1243. Fax: (717)252-4708. E-mail: joe.alfano@ cumulus.com. Web site: www.yorkcraftshows.com. **Contact:** Joe Alfano, marketing/promotions. Estab. 1984. Arts & crafts show held annually in late October. Indoors. Accepts photography and all hand crafts. Number of exhibitors: 170. Public attendance: 3,000. Public admission: $3. Artists should apply by visiting Web site or calling or mailing for an entry form. Space fee: $95. Exhibition space: 10×10 ft. Average gross sales/exhibitor: $1,000-$2,000. For more information, artists should e-mail, visit Web site or call.
 • York Craft Shows also sponsors Christmas Craft Show in mid-December, the Codorus Summer Blast in late June, and the Summer Craft Show in late July. See listings for these events in this section.

N HOME, CONDO AND GARDEN ART & CRAFT FAIR

P.O. Box 486, Ocean City MD 21843. (410)524-7020. Fax: (410)524-0051. E-mail: oceanpromotions@beachin.n et. Web site: www.oceanpromotions.info. **Contact:** Mike, promoter; Starr, assistant. Estab. 1984. Fine arts & crafts show held annually in March. Indoors. Accepts photography, carvings, pottery, ceramics, glass work, floral, watercolor, sculpture, prints, oils, pen and ink. Number of exhibitors: 125. Public attendance: 18,000. Public admission: $7/adults; $6/seniors and students; 13 and under free. Artists should apply by downloading application from Web site or e-mailing request. Deadline for entry: until full. Space fee: $225. Exhibition space: 10×8 ft. For more information, artists should e-mail, visit Web site or call.

N ✪ JOHNS HOPKINS UNIVERSITY SPRING FAIR

3400 N. Charles St., Mattin Suite 210, Baltimore MD 21218. (410)513-7692. Fax: (410)516-6185. E-mail: springfai r@gmail.com. Web site: www.jhuspringfair.com. **Contact:** Catalina McCallum, arts & crafts chair. Estab. 1972. Fine arts & crafts, campus-wide festival held annually in April. Outdoors. Accepts photography and all mediums. Juried. Number of exhibitors: 80. Public attendance: 20,000+. Free to public. Artists should apply via Web site. Deadline for entry: March 1. Space fee: $200. Exhibition space: 10×10 ft. For more information, artists should e-mail, visit Web site or call.
Tips "Artists should have fun displays, good prices, good variety and quality pieces."

N ✪ LILAC FESTIVAL ARTS & CRAFTS SHOW

171 Reservoir Ave., Rochester NY 14620. (585)256-4960. Fax: (585)256-4968. E-mail: info@lilacfestival.com. Web site: www.lilacfestival.com. **Contact:** Sue LeBeau, art show coordinator. Estab. 1985. Arts & crafts show held annually in May. Outdoors. Accepts photography, painting, ceramics, woodworking, metal sculpture, fiber. Juried by a panel. Number of exhibitors: 150. Public attendance: 25,000. Free to public. Deadline for entry: March 1. Space fee: $190. Exhibition space: 10×10 ft. For more information, artists should visit Web site or send SASE.

N MONTAUK POINT LIONS CLUB

P.O. Box 683, Montauk NY 11954. (631)668-5300. Fax: (631)668-1214. **Contact:** John McDonald, chairman. Estab. 1970. Arts & crafts show held annually Labor Day weekend. Outdoors. Accepts photography, arts & crafts. Number of exhibitors: 100. Public attendance: 1,000. Free to public. Artists should apply by mail. Deadline for entry: Labor Day Saturday. Application fee: $125. Exhibition space: 100 sq. ft. For more information, artists should send SASE.

N NORTH CONGREGATIONAL PEACH FAIR

17 Church St., New Hartford CT 06057. (860)379-2466. Estab. 1996. Arts & crafts show held annually in mid-August. Outdoors. Accepts photography, most arts & crafts. Number of exhibitors: 50. Public attendance: 500-2,000. Free to public. Artists should call for application form. Deadline for entry: June 1, 2007. Application fee: $60. Exhibition space: 11×11 ft.
Tips "Be prepared for all kinds of weather."

N ✪ PARADISE CITY ARTS FESTIVALS

30 Industrial Dr. E., Northampton MA 01060-2351. (800)511-9725. Fax: (413)587-0966. E-mail: artist@paradisec ityarts.com. Web site: www.paradisecityarts.com. **Contact:** Katherine Sanderson. Estab. 1995. Five fine arts &

crafts shows held annually in March, April, May, October and November. Indoors. Accepts photography, all original art & fine craft media. Juried by 5 slides or digital images of work and an independent board of jury advisors. Number of exhibitors: 150-275. Public attendance: 5,000-20,000. Public admission: $12. Artists should apply by submitting name and address to be added to mailing list or print application from Web site. Deadline for entry: September 20th and April 1. Application fee: $30. Space fee: $650-1,500. Exhibition space: 10×10 ft. to 10×20 ft. For more information, artists should e-mail, visit Web site or call.

N ☑ PAWLING ARTS & CRAFTS FESTIVAL

115 Chas. Colman Blvd., Pawling NY 12564-1120. (845)855-5626. Fax: (845)855-1798. **Contact:** Verna Carey, chairman. Estab. 1991. Arts & crafts show held annually in late September. Accepts photography, handcrafts. No kit work. Juried.

N ☑ PETERS VALLEY CRAFT FAIR

19 Kuhn Rd., Layton NJ 07851. (973)948-5200. Fax: (973)948-0011. E-mail: pv@warwick.net. Web site: www.p vcrafts.org. **Contact:** Nancy Nolte, development director. Estab. 1970. Arts & crafts show held annually in late September. Indoors. Accepts photography, ceramics, fiber, glass, basketry, metal, jewelry, sculpture, printmaking, paper book art, drawing, painting. Juried. Awards/prizes: $1,300 in cash awards. Number of exhibitors: 200. Public attendance: 7,000-10,000. Public admission: $7. Artists should apply by downloading application from Web site. Deadline for entry: May 30. Jury fee: $25. Space fee: $350. Exhibition space: 10×10 ft. Average gross sales/exhibitor: $2,000-3,000. For more information, artists should e-mail, visit Web site, call or send SASE.

Tips "Have fun, have an attractive booth design, and a diverse price range."

N ☑ QUAKER ARTS FESTIVAL

P.O. Box 202, Orchard Park NY 14127. (716)677-2787. **Contact:** Randy Kroll, chairman. Estab. 1961. Fine arts & crafts show held annually in September. Outdoors. Accepts photography, painting, graphics, sculpture, crafts. Juried by 4 panelists during event. Awards/prizes: over $10,000 total cash prizes. Number of exhibitors: 330. Public attendance: 75,000. Free to the public. Artists should apply by sending SASE. Deadline for entry: August. Space fee: $175. Exhibition space: 10×12 ft. For more information, artists should call, send SASE.

Tips "Have an inviting booth and be pleasant and accessible. Don't hide behind your product—engage the audience."

N ☑ SACO SIDEWALK ART FESTIVAL

P.O. Box 336, 146 Main St., Saco ME 04072. (207)286-3546. E-mail: sacospirit@hotmail.com. Web site: www.sa cospirit.com. **Contact:** Ann-Marie Mariner, downtown director. Estab. 1970. Fine arts & crafts show held annually the last Saturday in June. Outdoors. Accepts photography, sculpture, mixed media, painting, silk screening, graphics. Juried by a committee of judges with an art/media background. Awards/prizes: Best of Show, First Runner-up, Merit Awards, People's Choice Award, Purchase Prizes. Number of exhibitors: 115-125. Public attendance: 5,000. Free to the public. Space fee: $50. Exhibition space: 10×10 ft. Artists should e-mail, call for more information.

Tips "Offer a variety of pieces priced at various levels."

N SPRINGFEST AND SEPTEMBERFEST

P.O. Box 677, Nyack NY 10960-0677. (845)353-2221. Fax: (845)353-4204. Web site: www.nyack-ny.com. **Contact:** Lorie Reynolds, executive director. Estab. 1980. Arts & crafts show held biannually in April and September. Outdoors. Accepts photography, pottery, jewelry, leather, clothing, etc. Number of exhibitors: 220. Public attendance: 30,000. Free to public. Artists should apply by submitting application, fees, permits, photos of product and display. Deadline for entry: 15 days before show. Space fee: $175. Exhibition space: 10×10 ft. For more information, artists should visit Web site, call or send SASE.

N SUMMER CRAFT SHOW

Memorial Hall York Expo Center, York PA 17402. (717)764-1155, ext. 1243. Fax: (717)252-4708. E-mail: jalfano @radioyork.com. Web site: www.yorkcraftshows.com. **Contact:** Joe Alfano, marketing/promotions. Estab. 1976. Arts & crafts show held annually in late July. Accepts photography and handmade crafts. Number of exhibitors: 100. Public attendance: 3,000. Public admission: $3. Artists should apply on the Web site or through the mail. Space fee: $95. Exhibition space: 10×10 ft. Average gross sales/exhibitor: $1,000-2,000.

• York Craft Shows also sponsors Holiday Craft Show in late October, the Codours Summer Blast in late June, and the Christmas Craft Show in mid-December. See listings for these events in this section.

N ☑ SYRACUSE ARTS & CRAFTS FESTIVAL

109 S. Warren St. #1900, Syracuse NY 13202. (315)422-8284. Fax: (315)471-4503. E-mail: mail@downtownsyrac use.com. Web site: www.syracuseartsandcraftsfestival.com. **Contact:** Laurie Reed, festival director. Estab. 1970.

Fine arts & crafts show held annually in July. Outdoors. Accepts photography, ceramics, fabric/fiber, glass, jewelry, leather, metal, wood, computer art, drawing, printmaking, painting. Juried by 4 independent jurors. Jurors review 4 slides of work and 1 slide of booth display. Awards/prizes: $5,000, Award of Distinction/Medium, Best of Show, Best of Display, and Honorable Mentions. Number of exhibitors: 170. Public attendance: 50,000. Free to public. Artists should apply by calling for application or downloading from Web site. Deadline for entry: March 16. Application fee: $225. Space fee: $15. Exhibition space: 10×10 ft. For more information, artists should e-mail, visit Web site or call.

N ☑ WASHINGTON SQUARE OUTDOOR ART EXHIBIT

115 East 9th St. #7C, New York NY 10003. (212)982-6255. Fax: (212)982-6256. Web site: www.washingtonsquareoutdoorartexhibit.org. **Contact:** Margot J. Lufitg, executive director. Estab. 1931. Fine arts & crafts show held semiannually: Memorial Day weekend and the following weekend in May/early June, and Labor Day weekend and following weekend in September. Outdoors. Accepts photography, oil, watercolor, graphics, mixed media, sculpture, crafts. Juried by submitting 5 slides of work and 1 of booth. Awards/prizes: certificates, ribbons and cash prizes. Number of exhibitors: 200. Public attendance: 200,000. Free to public. Artists should apply by sending a SASE or downloading application from Web site. Deadline for entry: March 3, Spring Show; July 7, Fall Show. Application fee: $20. Exhibition space: 10×5 ft. For more information, artists should call or send SASE.

Tips "Price work sensibly."

N ☑ WESTMORELAND ART NATIONALS

252 Twin Lakes Rd., Latrobe PA 15650-3554. (724)834-7474. E-mail: info@artsandheritage.com. Web site: www.artsandheritage.com. **Contact:** Donnie Gutherie, executive director. Estab. 1975. Fine arts & crafts show held annually in July. Indoors. Accepts photography, all mediums. Juried: 2 jurors review slides. Awards/prizes: $5,000 + in prizes. Number of exhibitors: 200. Public attendance: 100,000. Free to public. Artists should apply by downloading application from Web site. Application fee: $35/craft show; $25/fine art exhibit. Space fee: $325. Exhibition space: 10×10 ft. For more information, artists should visit Web site.

Tips "Sell the product; don't let the product sell itself."

N ☑ WILD WIND FOLK ART & CRAFT FESTIVAL

719 Long Lake, New York NY 12847. (814)723-0707 or (518)624-6404. E-mail: wildwindcraftshow@yahoo.com. Web site: www.wildwindfestival.com. **Contact:** Liz Allen or Carol Jilk, promoters. Estab. 1979. Fine arts & crafts show held annually weekend after Labor Day. Barn locations and outdoors. Accepts photography, paintings, pottery, jewelry, traditional crafts, prints, stained glass. Juried by promoters. Three photos or slides of work plus 1 of booth if available. Number of exhibitors: 140. Public attendance: 8,000. Public admission: $5/adult; $3/seniors; 12 & under free. Artists should apply by visiting Web site and filling out application request, calling or sending a written request.

MIDSOUTH & SOUTHEAST

N ☑ AFFAIR ON THE SQUARE

112 Lafayette Pkwy., LaGrange GA 30240. (706)882-3267. Fax: (706)882-2878. E-mail: cvam@charter.net. Web site: www.cvam-online.org. **Contact:** Owen Holleran, event registrar. Estab. 1963. Fine arts & crafts show held annually in late May. Outdoors. Accepts photography, painting, prints, drawings, ceramics, sculpture, fiber, jewelry, glass. Juried. Review of slides by juror to select participants then selects winners on the 1st day of exhibit. Awards/prizes: cash awards totaling $2,000. Number of exhibitors: 55. Public attendance: 8,000. Free to pubic. Artists should apply by submitting name and address to review prospectus, or download prospectus from Web site. Deadline for entry: May 1. Space fee: $75. Exhibition space: 12×12 ft. For more information, artists should e-mail, visit Web site, call or send SASE.

Tips "Well done, reasonably priced art sells; be yourself, sell yourself."

N ☑ ANNUAL VOLVO MAYFAIRE-BY-THE-LAKE

Polk Museum of Art, 800 E. Palmetto St., Lakeland FL 33801. (863)688-7743, ext. 237. Fax: (863)688-2611. E-mail: mayfaire@polkmuseumofart.org. Web site: www.PolkMuseumOfArt.org. Estab. 1971. Fine arts & crafts show held annually in May on Mother's Day weekend. Outdoors. Accepts photography, oil, acrylic, watercolor, drawing & graphics, sculpture, clay, jewelry, glass, wood, fiber, mixed media. Juried by a panel of jurors who will rank the artists' bodies of work based on 3 slides of works and 1 slide of booth setup. Awards/prizes: 2 Best of Show, 3 Awards of Excellence, 8 Merit Awards, 10 Honorable Mentions, Museum Purchase Awards, Collectors Club Purchase Awards, which equal over $25,000. Number of exhibitors: 185. Public attendance:

65,000. Free to public. Artists should download application from Web site to apply. Deadline for entry: March 1. Application fee: $25. Space fee: $145. Exhibition space: 10×10 ft. For more information, artists should visit Web site or call.

APPLE ANNIE CRAFTS & ARTS SHOW

4905 Roswell Rd. NE, Marietta GA 30062. (770)552-6400, ext. 6110. Fax: (770)552-6420. E-mail: appleanniesho w@st-ann.org. Web site: www.st-ann.org/appleannie. **Contact:** Show Manager. Estab.1981. Arts & crafts show held annually 1st weekend in December. Indoors. Accepts photography, woodworking, ceramics, pottery, painting, fabrics, glass. Juried. Number of exhibitors: 135. Public attendance: 5,000. Public admission: $2. Artists should apply by visiting Web site to print an application form, or call to have one sent to them. Deadline: May 1. Application fee: $130. Exhibition space: 72 sq. ft. For more information, artists should e-mail, visit Web site, call.

Tips "Have an open, welcoming booth and be accessible and friendly to customers."

APPLE CHILL & FESTIFALL

200 Plant Rd., Chapel Hill NC 27514. (919)968-2784. Fax: (919)932-2923. E-mail: lradson@townofchapelhill.o rg. Web sites: www.applechill.com and www.festifall.com. **Contact:** Lauren Rodson, lead event coordinator. Estab. 1972. Apple Chill street fair held annually 3rd full weekend in April; Festifall street fair held annually 1st weekend in October. Estab. 1972. Outdoors. Accepts photography, pottery, painting, fabric, woodwork, glass, jewelry, leather, sculpture, tile. Juried by application process; actual event is not juried.

ART FESTIVAL BETH-EL

400 S. Pasadena Ave., St. Petersburg FL 33707. (227)347-6136. Fax: (227)343-8982. **Contact:** Sonya Miller, chairwoman. Estab. 1972. Fine arts & crafts show held annually the last weekend in January. Indoors. Accepts photography, painting, jewelry, sculpture, woodworking. Juried by special committee on-site or through slides. Awards/prizes: $7,500 prize money; $100,000 Purchase Award. Number of exhibitors: 150-175. Public attendance: 8,000-10,000. Free to the public. Artists should apply by application with photos or slides; show is invitational. Deadline for entry: September. Space fee: $25. Exhibition space: 4×8 ft. panels or wall space. For more information, artists should call.

Tips "Don't crowd display panels with artwork. Make sure your prices are on your pictures. Speak to customers about your work."

ART IN THE PARK

1 Gypsy Hill Part, Staunton VA 24401. (540)885-2028. E-mail: info@saartcenter.org. Web site: www.saartcenter. org. **Contact:** Leah Dubinski, office manager; Beth Hodges, executive director. Estab. 1966. Fine arts & crafts show held annually 3rd Saturday in May. Outdoors. Accepts photography, oil, watercolor, pastel, acrylic, clay, porcelain, pottery, glass, wood, metal, almost anything as long as it is handmade fine art/craft. Juried by submitting 4 photos or slides that are representative of the work to be sold. Award/prizes: Grand Winner. Number of exhibitors: 100. Public attendance: 3,000-4,000. Free to public. Artists should apply by sending in application. Application fee: $15. Space fee: $75/members; $100/nonmembers. Exhibition space: 10×10 ft. For more information, artists should e-mail or call.

ART IN THE PARK

P.O. Box 1540, Thomasville GA 31799. (229)227-7020. Fax: (229)227-3320. E-mail: roseshowfest@thmoasville. org. Web site: www.downtownthomasville.com. **Contact:** Felicia Brannen, festival coordinator. Estab. 1998-1999. Arts & crafts show held annually in April. Outdoors. Accepts photography, handcrafted items, oils, acrylics, woodworking, stained glass, other varieties. Juried by a selection committee. Number of exhibitors: 60. Public attendance: 5,000. Free to public. Artists should apply by application. Deadline for entry: March 1. Space fee: $75, varies by year. Exhibition space: 20×20 ft. For more information, artists should e-mail or call.

Tips "Most important, be friendly to the public and have an attractive booth display."

BIG ARTS ART FAIR

900 Dunlop Rd., Sanibel FL 33957. (239)395-0900. Fax: (239)395-0330. E-mail: ncunnigham@bigarts.org. Web site: www.bigarts.org. **Contact:** Natalie Cunningham, programs assistant. Estab. 1979. Fine arts & crafts show held annually the Friday and Saturday after Thanksgiving. Outdoors. Accepts photography, ceramics, graphics, painting, original wearable art, glass, jewelry, fiber, mixed media, sculpture, garden art. Juried by 1 judge who changes annually. Awards/prizes: cash. Number of exhibitors: 80-90. Public attendance: 3,000-5,000. Public admission: $3. Artists should apply by visiting Web site or calling after June 1 for application. Deadline for entry: late September. Application/space fee: $150. Exhibition space: 10×10 ft. For more information, artists should e-mail, visit Web site or call.

N ☑ CHERRY BLOSSOM FESTIVAL OF CONYERS

1996 Centennial Olympic Parkway, Conyers GA 30013. (770)860-4190. Fax: (770)602-2500. E-mail: rebecca.hill @conyersga.com. **Contact:** Rebecca Hill, event manager. Estab. 1981. Arts & crafts show held annually in late March. Outdoors. Accepts photography, paintings. Juried. Number of exhibitors: 300. Public attendance: 40,000. Free to public; $5 parking fee. Deadline for entry: January. Space fee: $125/booth. Exhibition space: 10 × 10 ft. For more information, artists should e-mail, visit Web site or call.

N ☑ CHRISTMAS IN NOVEMBER

2-14th St., Wheeling WV 43971. (304)233-7000. E-mail: sfedorko@wesbancoarena.com. **Contact:** Sonya Fedorko, coordinator. Estab. 1990. Seasonal/holiday arts & crafts show held annually the weekend before Thanksgiving. Indoors. Accepts photography. Juried. Number of exhibitors: 200. Public attendance: 12,000. Public admission: $2. Deadline for entry: August. Exhibition space: 10 × 10 ft. For more information, artists should e-mail with Christmas-in-November in the subject line.

Tips "Know your market. Our market looks for great buys. If you are selling wreaths for $80, you can't sell in our market. Don't sit in the corner; talk with the customer."

N ☑ CHURCH STREET ART & CRAFT SHOW

P.O. Box 1409, Waynesville NC 28786. (828)456-3517. Fax: (828)456-2001. E-mail: downtownwaynesville@charter.net. Web site: www.downtownwaynesville.com. **Contact:** Ronald Huelster, executive director. Estab. 1983. Fine arts & crafts show held annually 2nd Saturday in October. Outdoors. Accepts photography, paintings, fiber, pottery, wood, jewelry. Juried by committee: submit 4 slides or photos of work and 1 of booth display. Awards/prizes: $1,000 cash prizes in 1st, 2nd, 3rd and Honorable Mentions. Number of exhibitors: 100. Public attendance: 15,000-18,000. Free to public. Deadline for entry: August 15. Application/space fee: $95-165. Exhibition space: 10 × 12 ft. to 12 × 20 ft. For more information, artists should e-mail, call or send SASE.

Tips Recommends "quality in work and display."

N ☑ ELIZABETHTOWN FESTIVAL

818 Jefferson, Moundsville WV 26041. (304)843-1170. Fax: (304)845-2355. E-mail: jvhblake@aol.com. Web site: www.wvpentours.com. **Contact:** Sue Riggs at (304)843-1170 or Hilda Blake at (304)845-2552, co-chairs. Estab. 1999. Arts & crafts show held annually the 3rd weekend in May (Saturday and Sunday). Sponsored by the Moundsville Economic Development Council. Also includes heritage exhibits of 1800s-era food and entertainment. Indoors and outdoors. Accepts photography, crafts, wood, pottery, quilts, jewelry. "All items must be made by the craftspeople selling them; no commercial items." Juried based on design, craftsmanship and creativity. Submit 5 photos: 3 of your medium; 2 of your booth set-up. Jury fee: $10. Number of exhibitors: 70-75. Public attendance: 3,000-5,000. Public admission: $3. Artists should apply by requesting an application form by phone. Deadline for entry: May 1, 2007. Space fee: $50. Exhibition space: 100 sq. ft. For more information, artists should e-mail, visit Web site, call, send SASE.

Tips "Be courteous. Strike up conversations—do not sit in your booth and read! Have an attractive display of wares."

N ☑ FALL ART FESTIVAL

825 E. New Haven Ave., Melbourne FL 32901. (321)777-2109. E-mail: betsy@brevardevents.com. Web site: www.downtownmelbourne.com. **Contact:** Betsy Vosburgh, event coordinator. Estab. 1992. Fine arts & crafts show, 2-day event held annually in mid-October. This event is to benefit the historic downtown area. Outdoors. Accepts photography, painting, graphic arts, sculpture, glass, jewelry. Juried by a panel; 2-3 judges determine 1st, 2nd and 3rd places in each area of 8 categories. Awards/prizes: 3 awards in 8 categories; $6,800 total. Number of exhibitors: 200. Public attendance: 10,000. Free to public. Artist should apply by requesting application and returning with 4 slides or photos; 3 of work and 1 of booth. Deadline for entry: July 31. Application fee: $15. Space fee: $132.50 ($125 + sales tax). Exhibition space: 10 × 10 ft. For more information, artists should send e-mail.

Tips "Have a creative display. Be outgoing but not pushy. Be flexible; stay in it for the long term. One show won't make or break your career. Suggestions: give them and take them."

N ☑ FOOTHILLS CRAFTS FAIR

2753 Lynn Rd. #A, Tryon NC 28782-7870. (828)859-7427. E-mail: bbqfestival@azztez.net. Web site: www.Blue RidgeBBQFestival.com. **Contact:** Julie McIntyre. Estab. 1993. Fine arts & crafts show and Blue Ridge BBQ Festival/Championship held annually 2nd Friday and Saturday in June. Outdoors. Accepts photography, handcrafts; nothing manufactured or imported. Juried. Number of exhibitors: 50. Public attendance: 25,000+. Public admission: $6; under 12 free. Artists should apply by downloading application from Web site or sending personal

information to e-mail or mailing address. Deadline for entry: March 30. Jury fee: $25. Space fee: $150. Exhibition space: 10×10 ft. For more information, artists should visit Web site.
Tips "Have an attractive booth, unique items, and reasonable prices."

N GERMANTOWN FESTIVAL
P.O. Box 381741, Germantown TN 38183. (901)757-9212. E-mail: gtownfestival@aol.com. **Contact:** Melba Fristick, coordinator. Estab. 1971. Arts & crafts show held annually weekend after Labor Day. Outdoors. Accepts photography, all arts & crafts mediums. Number of exhibitors: 400+. Public attendance: 65,000. Free to public. Artists should apply by sending applications by mail. Deadline for entry: until filled. Application/space fee: $190-240. Exhibition space: 10×10 ft. For more information, artists should e-mail, call or send SASE.
Tips "Display and promote to the public. Price attractively."

N GOLD RUSH DAYS
P.O. Box 774, Dahlonega GA 30533. (706)864-7247. Web site: dahlonegajaycees.com. **Contact:** Gold Rush Chairman. Arts & crafts show held annually the 3rd full week in October. Accepts photography, paintings and homemade, handcrafted items. No digitally originated art work. Outdoors. Number of exhibitors: 300. Public attendance: 200,000. Free to the public. Artists should apply online at www.dahlonegajaycees.com under "Gold Rush," or send SASE to request application. Deadline: March. Space fee: $225, "but we reserve the right to raise the fee to cover costs." Exhibition space: 10×10 ft. Artists should e-mail, visit Web site for more information.
Tips "Talk to other artists who have done other shows and festivals. Get tips and advice from those in the same line of work."

N ☑ HIGHLAND MAPLE FESTIVAL
P.O. Box 223, Monterey VA 24465-0223. (540)468-2550. Fax: (540)468-2551. E-mail: highcc@cfw.com. Web site: www.highlandcounty.org. **Contact:** Carolyn Pottowsky, executive director. Estab. 1958. Fine arts & crafts show held annually 2nd and 3rd weekends in March. Indoors and outdoors. Accepts photography, pottery, weaving, jewelry, painting, wood crafts, furniture. Juried by 3 photos or slides. Number of exhibitors: 150. Public attendance: 35,000-50,000. Public admission: $2. Deadline for entry: "There is a late fee after December 20, 2006. Vendors accepted until show is full." Space fee: $125-$150. Exhibition space: 10×10 ft. For more information, artists should e-mail, visit Web site, call.
Tips "Have quality work and good salesmanship."

N ☑ HIGHLANDS ART LEAGUE'S ANNUAL FINE ARTS & CRAFTS FESTIVAL
1989 Lakeview Dr., Sebring FL 33870. (863)385-5312. Fax: (863)385-5336. E-mail: info@highlandsartleague.com. Web site: www.highlandsartleague.com. **Contact:** Show Coordinator. Estab. 1966. Fine arts & crafts show held annually 2nd weekend of November. Outdoors. Accepts photography, pottery, painting, jewelery, fabric. Juried "based on quality of work." Awards/prizes: monetary awards up to $1,500 and Purchase Awards. Number of exhibitors: 100+. Public attendance: 15,000+. Free to the public. Artists should apply by calling or visiting Web site for application form after May 1. Deadline for entry: October. Application fee: $60 plus $15 jury fee. Exhibtion space: 10×14 ft. Artists should e-mail for more information.

N ☑ HOLIDAY ARTS & CRAFTS SHOW
60 Ida Lee Dr., Leesburg VA 20176. (703)777-1368. Fax: (703)737-7165. E-mail: lfountain@leesburgva.gov. Web site: www.idalee.org. **Contact:** Linda Fountain, program supervisor. Estab. 1990. Arts & crafts show held annually 1st weekend in December. Indoors. Accepts photography, jewelry, pottery, baskets, personal care, clothing, accessories. Juried. Number of exhibitors: 100. Public attendance: 4,000. Free to public. Artists should apply by downloading application from Web site. Deadline for entry: August 31. Space fee: $100-150. Exhibition space: 10×7 ft. For more information, artists should e-mail or visit Web site.

N ☑ HOLLY ARTS & CRAFTS FESTIVAL
P.O. Box 2122, Pinehurst NC 28370. (910)295-7462. E-mail: sbharrison@earthlink.net. Web site: www.pinehurstbusinessguild.com. **Contact:** Susan Harrison, Holly Arts & Crafts committee. Estab. 1978. Arts & crafts show held annually the 3rd Saturday in October. Outdoors. Accepts photography and crafts. Juried based on uniqueness, quality of product, and overall display. Awards/prizes: plaque given to Best in Show; 2 Honorable Mentions receive ribbons. Number of exhibitors: 200. Public attendance: 7,000. Free to the public. Artists should apply by filling out application form. Deadline for entry: March 15, 2007. Space fee: $60. Exhibition space: 10×10 ft. For more information, artists should e-mail, visit Web site, call, send SASE.

N ☑ HOT SPRINGS ARTS & CRAFTS FAIR

Garland County Fairgrounds, Higdon Ferry Rd., Hot Springs AR 71912. (501)767-0254. E-mail: klccroyboy@aol. com. **Contact:** Paula Chandler, public relations. Estab. 1968. Fine arts & crafts show held annually 1st full weekend in October. Indoors and outdoors. Accepts photography and varied mediums ranging from heritage, crafts, jewelry, furniture. Juried by a committee of 12 crafter and artist volunteers. Number of exhibitors: 350 + . Public attendance: 50,000 + . Free to public. Deadline for entry: August. Space fee: $100. Exhibition space: 10 × 8 ft. For more information, artists should e-mail or call.

N ☑ INTERNATIONAL FOLK FESTIVAL

201 Hay St., Fayetteville NC 28302. (910)323-1776. Fax: (910)323-1727. E-mail: jasonc@theartscouncil.com. Web site: www.theartscouncil.com. **Contact:** Jason Clough, special events manager. Estab. 1978. Fine arts & crafts show held annually in late September. Outdoors. Accepts photography, painting, pottery, wood work, sculpture. Juried. Awards/prizes: cash prizes in several categories. Number of exhibitors: 120 + . Public attendance: 70,000. Free to public. Artists should apply online. Deadline for entry: mid-September. Application fee: $60 for original arts & crafts; includes space fee. Exhibition space: 10 × 10 ft. Average gross sales/exhibitor: $500. For more information, artists should e-mail or visit Web site.

Tips "Have reasonable prices."

N ☑ ISLE OF EIGHT FLAGS SHRIMP FESTIVAL

18 N. Second St., Ferninda Beach FL 32034. (904)271-7020. Fax: (904)261-1074. E-mail: islandart@net-magic.n et. Web site: www.islandart.org. **Contact:** Shrimp Festival Committee Chairperson. Estab. 1963. Fine arts & crafts show and community celebration held annually 1st weekend in May. Outdoors. Accepts photography and all mediums. Juried. Awards/prizes: $9,700 in cash prizes. Number of exhibitors: 425. Public attendance: 150,000. Free to public. Artists should apply by downloading application from Web site. Deadline for entry: January 1. Application fee: $30. Space fee: $200. Exhibition space: 10 × 12 ft. Average gross sales/exhibitor: $1,500 + . For more information, artists should visit Web site.

Tips "Quality product and attractive display."

N ☑ KETNER'S MILL COUNTY ARTS FAIR

P.O. Box 322, Lookout Mountain TN 37350. (243)267-5702. Fax: (423)757-1343. **Contact:** Sally McDonald. Estab. 1977. Arts & crafts show held annually the 3rd weekend in October. Outdoors. Accepts photography, painting, prints, dolls, fiber arts, baskets, folk art, wood crafts, jewelry, musical instruments, sculpture, pottery, glass. Juried. Prizes: 1st: $75 and free booth for following year; 2nd: $50 and free booth for following year; 3rd: free booth for following year; People's Choice Award. Number of exhibitors: 150. Number of attendees: 10,000/ day, depending on weather. Public admission: $5. Artists should call or send SASE to request a prospectus/ application. Deadline for entry: August 1, 2007. Space fee: $125. Exhibition space: 15 × 15 ft. Average gross sales/exhibitor: $1,500.

Tips "Display your best and most expensive work, framed. But also have smaller unframed items to sell. Never underestimate a show: Someone may come forward and buy a large item."

N ☑ LAZY RIVER ARTS & CRAFT FESTIVAL

4310 Tillson Rd., Wilmington NC 28412. E-mail: wnypremier@ec.rr.com. Web site: www.wnypremierpromotions.c om. **Contact:** Ed Kaczynski, Premier Promotions Company. Estab. 1994. Fine arts & crafts show held annually in mid-September. Outdoors. Accepts photography. Everything must be created by the artists themselves. No buy/ sell. Juried by application and jury form along with slides or photos of work and biography. No fee for application or jury form. Awards/prizes: Best Art and Best Craft. Both winners receive free booth the following year. Number of exhibitors: 100. Public attendance: 5,000. Free to public. Artists should apply by calling or visiting Web site for application. Deadline for entry: until show is filled. Space fee: $200-225. Exhibition space: 10 × 10 ft. or 10 × 10-ft. corner. Average gross sales/exhibitor: $2,000. For more information, artists should e-mail, visit Web site or call.

N ☑ LEEPER PARK ART FAIR

22180 Sundance Court #504, Estero FL 33928. (970)259-2606. Fax: (970)259-6571. E-mail: brian@durangoarts.o rg. Web site: www.durangoarts.org. **Contact:** Judy Ladd, director. Estab. 1967. Fine arts & crafts show held annually in June. Indoors. Accepts photography and all areas of fine art. Juried by slides. Awards/prizes: $3,500. Number of exhibitors: 120. Public attendance: 10,000. Free to public. Artists should apply by submitting application along with fees. Deadline for entry: March 1. Application fee: $15. Space fee: $195. Exhibition space: 12 × 12 ft. Average gross sales/exhibitor: $5,000. For more information, artists should e-mail or send SASE.

Tips "Make sure your booth display is well presented and, when applying, slides are top notch!"

⬛ 🔲 LUTZ ARTS & CRAFTS FESTIVAL

P.O. Box 656, Lutz FL 33548-0656. (813)949-1937 or (813)949-7060. Fax: (813)949-7060. **Contact:** Phyllis Hoedt, co-director; Shirley Simmons, co-director. Estab. 1979. Fine arts & crafts show held annually in December. Outdoors. Accepts photography, sculpture. Juried. Directors make final decision. Awards/prizes: $2,000 plus other cash awards. Number of exhibitors: 250. Public attendance: 35,000. Free to public. Deadline for entry: September 1 of each year or until category is filled. Application fee: $100. Exhibition space: 12 × 12 ft. For more information, artists should call or send SASE.
Tips "Have varied price range."

⬛ MOUNTAIN STATE FOREST FESTIVAL

P.O. Box 388, 101 Lough St., Elkins WV 26241. (304)636-1824. Fax: (304)636-4020. E-mail: msff@forestfestival.com. **Contact:** Pam Keller, executive secretary. Estab. 1930. Arts, crafts & photography show held annually in early October. Accepts photography and homemade crafts. Awards/prizes: cash awards for photography only. Number of exhibitors: 50. Public attendance: 50,000. Free to the public. Artists should apply by requesting an application form. Application fee: $100. Exhibition space: 10 × 10 ft. For more information, artists should visit Web site, call.

⬛ NATIVE AMERICAN DANCE & CRAFTS FESTIVAL

5181 DeSoto Caverns Parkway, Childersburg AL 35044-5663. (256)378-7252. Fax: (256)378-3678. E-mail: fun@deso tocavernspark.com. Web site: www.DeSotoCavernsPark.com. **Contact:** Bonita Rouse, manager. Estab. 1975. Arts & crafts show held biannually in early April and late September. Number of exhibitors: 80. Public attendance: 10,000. Public admission: $10/adult; $8/children 4-6. Artists should apply by writing or downloading application from Web site. Deadline for entry: March 16 for festival April 7 & 8; September 7 for festival September 29 & 30. Space fee: $150. Exhibition space: 11 × 14 ft. For more information, artists should e-mail, visit Web site or call.

⬛ NEW SMYRNA BEACH FIESTA

210 Sams Ave., New Smyrna Beach FL 32168. (386)424-2175. Fax: (386)424-2177. Web site: www.cityofnsb.c om. **Contact:** Kimla Shelton, program coordinator. Estab. 1952. Arts & crafts show held annually last full weekend in February. Outdoors. Accepts photography, oil, acrylics, pastel, drawings, graphics, sculpture, crafts, watercolor. Awards/prizes: $10,800 prize money; $1,000/category; Honorable Mentions. Number of exhibitors: 250. Public attendance: 14,000. Free to public. Artists should apply by calling to get on mailing list. Applications are always mailed out the day before Thanksgiving. Deadline for entry: until full. Application/space fee: $106.50. Exhibition space: 10 × 10 ft. For more information, artists should send SASE.

⬛ 🔲 NEW WORLD FESTIVAL OF THE ARTS

P.O. Box 994, Manteo NC 27954. (252)473-2838. Fax: (252)473-6044. E-mail: Edward@outerbankschristmas.c om. **Contact:** Owen Holleran, event registrar. Estab. 1963. Fine arts & crafts show held annually in late May. Outdoors. Juried. Accepts photography, watercolor, oil, mixed media, drawing, printmaking, graphics, pastels, ceramics, sculpture, fiber, handwoven wearable art, wood, glass, hand-crafted jewelry, metalsmithing, leather. No commercial molds or kits will be accepted. All work must be signed by the artist. No millinery, knitting, crocheting, velvet painting, candles, carpentry, manufactured or kit jewelry, mass-produced jewelry, loose stones, china painting, caricature, plants, novelty crafts, decoupage, manufactured wearing apparel, or shell work. Review of slides by juror to select participants; winners are selected on the 1st day of exhibit. Awards/prizes: cash awards totaling $3,000. Number of exhibitors: 80. Public attendance: 4,500-5000. Free to pubic. Artists should apply by sending for application. Deadline for entry: June 10. Application fee: $10 jury fee. Space fee: $80. Exhibition space: 10 × 10 ft. For more information, artists should e-mail or call.

⬛ 🔲 PANOPLY ARTS FESTIVAL, PRESENTED BY THE ARTS COUNCIL, INC.

700 Monroe St., Suite 2, Huntsville AL 35801. (256)519-2787. Fax: (256)533-3811. Web site: www.panoply.org; www.artshuntsville.org. Estab. 1982. Fine arts show held annually the last weekend in April. Also features music and dance. Outdoors. Accepts photography, painting, sculpture, drawing, printmaking, mixed media, glass, fiber. Juried by a panel of judges chosen for their indepth knowledge and experience in multiple mediums. They jury from slides in January. During the festival 1 judge awards the various prizes. Awards/prizes: Best of Show: $1,000; Award of Distinction: $500; Merit Awards: 5 awards, $200 each. Number of exhibitors: 100. Public attendance: 90,000. Public admission: weekend pass: $15; 1-day pass: $8; children under 12, free. Artists should e-mail, call or write for an application form. Deadline for entry: January 2007. Application fee: $30. Space fee: $150 for space only; $350 for tent rental. Exhibition space: 10 × 10 ft. Average gross sales/exhibitor: $2,000. Artists should e-mail for more information.

⬛ PUNGO STRAWBERRY FESTIVAL

P.O. Box 6158, Virginia Beach VA 23456. (757)721-6001. Fax: (757)721-9335. E-mail: pungofestival@aol.com. Web site: www.PungoStrawberryFestival.com. **Contact:** Janet Dowdy, secretary of board. Estab. 1983. Arts &

crafts show held annually Memorial Day weekend. Outdoors. Accepts photography and all media. Number of exhibitors: 60. Public attendance: 120,000. Free to Public; $5 parking fee. Artists should apply by calling for application or downloading a copy from the Web site to mail in. Deadline for entry: March 1; applications accepted from that point until all spaces are full. Application fee: $50 refundable deposit. Space fee: $175. Exhibition space: 10×10 ft. For more information, artists should e-mail, visit Web site or call.

N RATTLESNAKE ROUNDUP

P.O. Box 292, Claxton GA 30417. (912)739-3820. Fax: (912)739-0507. E-mail: ecwc@claxtonrattlesnakeroundup.com. Web site: www.claxtonrattlesnakeroundup.com. **Contact:** Nickole L. Holland, event coordinator. Estab. 1968. Arts & crafts show held annually 2nd weekend in March. Outdoors. Accepts photography and various mediums. Number of exhibitors: 150-200. Public attendance: 15,000-20,000. Public admission: $5/age 6 and up. Artists should apply by filling out an application. Deadline for entry: March 1. Space fee: $90. Exhibition space: 10×16 ft. For more information, artists should e-mail, visit Web site or call.

Tips "Your display is a major factor in whether people will stop to browse when passing by. Offer a variety."

N RIVERFRONT MARKET

P.O. Box 565, Selma AL 36702-0565. (334)874-6683. **Contact:** Ed Greene, chairman. Estab. 1972. Arts & crafts show held annually the 2nd Saturday in October. Outdoors. Accepts photography, painting, sculpture. Number of exhibitors: 200. Public attendance: 8,000. Public admission: $2. Artists should apply by calling or mailing to request application. Deadline for entry: September 1. Space fee: $40; limited covered space available at $60. Exhibition space: 10×10 ft. For more information, artists should call.

N ▼ RIVERSIDE ART FESTIVAL

2623 Herschel St., Jacksonville FL 32204. (904)389-2449. Fax: (904)389-0431. E-mail: rap@fdn.com. Web site: www.Riverside-Avondale.com. **Contact:** Bonnie Grissett, executive director. Estab. 1963. Fine arts & crafts show held annually the weekend after Labor Day. Outdoors. Accepts photography and all fine art. Juried. Awards/prizes: $9,000 cash. Number of exhibitors: 150. Public attendance: 25,000. Free to public. Artists should apply by sending address and requesting application. Deadline for entry: July 15. Jury fee: $50. Space fee: $150. Exhibition space: 10×10 ft. For more information, artists should e-mail.

N ▼ SANDY SPRINGS FESTIVAL

135 Hilderbrand Dr., Sandy Springs GA 30328-3805. (404)851-9111. Fax: (404)851-9807. E-mail: info@sandyspringsfestival.com. Web site: www.sandyspringsfestival.com. **Contact:** Megan Webb, special events director. Estab. 1985. Fine arts & crafts show held annually in mid-September. Outdoors. Accepts photography, painting, sculpture, jewelry, furniture, clothing. Juried by area professionals and nonprofessionals who are passionate about art. Awards/prizes: change annually; usually cash with additional prizes. Number of exhibitors: 100. Public attendance: 20,000. Public admission: $5. Artists should apply via application on Web site. Application fee: $10 ($25 for late registration). Space fee: $125. Exhibition space: 12×12 ft. Average gross sales/exhibitor: $1,000. For more information, artists should visit Web site.

Tips "Most of the purchases made at Sandy Springs Festival are priced under $100. The look of the booth and its general attractiveness are very important, especially to those who might not 'know' art."

N SIDEWALK ART SHOW

One Market Square, Roanoke VA 24011-143. (540)342-5760. E-mail: info@artmuseumroanoke.org. Web site: www.artmuseumroanoke.org. **Contact:** Mickie Kagey, registration chair. Estab. 1958. Fine arts show held annually in early June. Outdoors. Accepts photography, watercolor, oils, acrylic, sculpture, prints. Awards/prizes: $6,500 total cash awards. Number of exhibitors: 175-200. Public attendance: 10,000. Free to public. Deadline for entry: April 15th. Application fee: $25. Space fee: $90-175. Exhibition space: 10×10 ft./tent; 8 ft./fence. For more information, artists should e-mail or visit Web site.

N ▼ SMITHVILLE FIDDLERS' JAMBOREE AND CRAFT FESTIVAL

P.O. Box 83, Smithville TN 37166. (615)597-8500. Fax: (615)697-7799. E-mail: edudney@dtdccom.net. Web site: www.dekalb.com/jamboree. **Contact:** Neil Dudney, president. Estab. 1971. Arts & crafts show held annually the weekend nearest the Fourth of July. Indoors. Juried by photos and personally talking with crafters. Awards/prizes: ribbons and free booth for following year for Best of Show, Best of Appalachian Craft, Best Display, Best Newcomer. Number of exhibitors: 235. Public attendance: 130,000. Free to public. Artists should apply by requesting application by phone or mail. Deadline for entry: March 31. Application/space fee: $100, electricity provided. Exhibition space: 12×12 ft. Average gross sales/exhibitor: $1,200+. For more information, artists should call.

Tips "Call the office and talk to the person in charge."

N SPRINGFEST

P.O. Box 831, Southern Pines NC 28387. (910)315-6508. E-mail: spba@earthlink.net. Web site: www.southernpines.biz. **Contact:** Susan Harrison, booth coordinator. Estab. 1979. Arts & crafts show held annually last Saturday in April. Outdoors. Accepts photography and crafts. Number of exhibitors: 200. Public attendance: 8,000. Free to the public. Artists should apply by filling out application form. Deadline for entry: March 15, 2007. Space fee: $60. Exhibition space: 10×12 ft. For more information, artists should e-mail, visit Web site, call, send SASE.

N STEPPIN' OUT

P.O. Box 233, Blacksburg VA 24063. (540)951-0454. E-mail: dmob@downtownblacksburg.com. Web site: www .downtownblacksburg.com. **Contact:** Gwynn Hamilton, director. Estab. 1981. Arts & crafts show held annually 1st Friday and Saturday in August. Outdoors. Accepts photography, pottery, painting, drawing, fiber arts, jewelry, general crafts. Number of exhibitors: 170. Public attendance: 30,000. Free to public. Artists should apply by e-mailing, calling or downloading application on Web site. Space fee: $135. For more information, artists should e-mail, visit Web site or call.

Tips "Visit shows and consider the booth aesthetic—what appeals to you. Put the time, thought, energy and money into your booth to draw people in to see your work."

N SUBIACO ABBEY ART FAIR

405 Subiaco Ave., Subiaco AR 72865. (479)934-1000. Fax: (479)934-1033. E-mail: aaronpirrera@yahoo.com. Web site: www.subi.org. **Contact:** Fr. Aaron Pirrera, director. Estab. 1998. Fine arts & crafts show held annually in early September. Indoors and outdoors. Accepts photography and all other mediums. Number of exhibitors: 25-30. Public attendance: 250-400. Free to the public. Artists should apply by calling Fr. Aaron or sending a letter with a photo of the art/craft. Deadline: June/July. Space fee: 10% of sales. Exhibition space: 10×10 ft. Artists should e-mail or call for more information

Tips "Keep prices low. Fine arts new to the area."

N ⚑ TARPON SPRINGS FINE ARTS FESTIVAL

11 E. Orange St., Tarpon Springs FL 34689. (727)937-6109. Fax: (727)937-2879. E-mail: chamber@tarponsprings .com. Web site: www.tarponsprings.com. **Contact:** T. Davis, president. Estab. 1974. Fine arts & crafts show held annually in April. Outdoors. Accepts photography, acrylic, oil, ceramics, fiber, glass, graphics, drawings, pastels, jewelry, leather, metal, mixed media, sculpture, watercolor, wood. Juried by 3 slides of work and 1 of display. Awards/prizes: cash and ribbons. Number of exhibitors: 250. Public attendance: 20,000. Public admission: $2; under 16 free. Artists should apply by submitting signed application, slides, fees and SASE. Deadline for entry: mid-December. Jury fee: $25 +. Space fee: $175 +. Exhibition space: 10×12 ft. For more information, artists should e-mail, call or send SASE.

Tips "Produce good slides for jurors."

N ⚑ THREEFOOT ART FESTIVAL & CHILI COOKOFF

P.O. Box 1405, Meridian MS 39302. (601)693-ARTS. E-mail: debbie0708@comcast.net. Web site: www.meridia narts.org. **Contact:** Debbie Martin, president. Estab. 2002. Fine arts & crafts show held annually 2nd Saturday in October. Outdoors. Accepts photography and all mediums. Juried by a panel of prominent members of the arts community the day of show. Awards/prizes: $1,000, Best in Show; $500, 2 Awards of Distinction; up to 10 Merit Awards. Number of exhibitors: 50-75. Public attendance: 5,000. Free to public. Artists should apply by downloading application from Web site or request to be added to mailing list. Deadline for entry: September 15. Application fee: $10. Space fee: $85. Exhibition space: 10×10 ft. Average gross sales/exhibitor: $1,000. For more information, artists should visit Web site or send SASE.

Tips "Price points are relative to the market. Booth should be attractive."

N ⚑ WELCOME TO MY WORLD PHOTOGRAPHY COMPETITION

319 Mallery St., St. Simons Island GA 31522. (912)638-8770. E-mail: glynnart@earthlink.net. Web site: www.gly nnart.org. **Contact:** Pat Weaver, executive director. Estab. 1991. Seasonal photography competition held annually in July. Indoors. Accepts only photography. Juried. Awards/prizes: 1st, 2nd, 3rd in each category. Number of exhibitors: 50. Artists should apply by visiting Web site. Deadline for entry: June. Application fee: $35. For more information, artists should e-mail, visit Web site or call.

N ⚑ WHITE OAK CRAFTS FAIR

The Arts Center, 1424 John Bragg, Woodbury TN. (625)563-2787. Fax: (615)563-2788. E-mail: carol@artcentero fcc.com. Web site: www.artscenterofcc.com. **Contact:** Carol Reed, publicity. Estab. 1985. Arts & crafts show held annually in September. Outdoors. Accepts photography, all handmade crafts, traditional and contempo-

rary. Must be handcrafted displaying "excellence in concept and technique." Juried by committee. Send 3 slides or photos. Awards/prizes: more than $1,000. Number of exhibitors: 80. Public attendance: 6,000. Free to public; $2 parking fee. Applications can be downloaded from Web site. Deadline for entry: June 1. Space fee: $60. Exhibition space: 15×15 ft. For more information, artists should e-mail mary@artscenterofcc.com.

MIDWEST & NORTH CENTRAL

N ☑ AKRON ARTS EXPO

220 S. Balch St., Akron OH 44302. (330)375-2835. Fax: (330)375-2883. E-mail: recreation@ci.akron.oh.us. Web site: www.ci.akron.oh.us. **Contact:** Yvette Davidson, community events coordinator. Estab. 1979. Fine arts & crafts show held annually in late July. Outdoors. Accepts photography, 2D art, functional craft, ornamental. Juried by 4 slides of work and 1 slide of display. Awards/prizes: $1,600 in cash awards and ribbons. Number of exhibitors: 165. Public attendance: 30,000+. Free to public. Deadline for entry: March 31. Space fee: $150-180. Exhibition space: 15×15 ft. For more information, artists should e-mail or call.

N ☑ ALLEN PARK ARTS & CRAFTS STREET FAIR

16850 Southfield, Allen Park MI 48101. (313)928-1400, ext. 206. Fax: (313)382-7946. **Contact:** Allen Park Festivities Commission. Estab. 1981. Arts & crafts show held annually the 1st Friday and Saturday in August. Outdoors. Accepts photography, sculpture, ceramics, jewelry, glass, wood, prints, drawings, paintings. Juried by 3 photos of work. Number of exhibitors: 400. Free to the public. Artists should apply by requesting an application form by December 31 of the previous year. Application fee: $5. Space fee: $100. Exhibition space: 10×10 ft. For more information, artists should call.

N ☑ AMISH ACRES ARTS & CRAFTS FESTIVAL

1600 W Market St., Nappanee IN 46550. (574)773-4188. Fax: (574)773-4180. E-mail: jenniwysong@amishacres. com. Web site: www.amishacres.com. **Contact:** Jenni Wysong, marketplace coordinator. Estab. 1962. Arts & crafts show held annually 2nd full weekend in August. Outdoors. Accepts photography, crafts, floral, folk, jewelry, oil, acrylic, sculpture, textiles, watercolors, wearable, wood. Juried. Five images, either 35mm slides or digital images e-mailed. Awards/prizes: $10,000 cash including 2 Best of Show and $1,500 Purchase Prizes. Number of exhibitors: 386. Public attendance: 70,000. Public admission: $6; children under 12 free. Artists should apply by sending SASE or printing application from Web site. Deadline for entry: April 1. Space fee: $130 plus 10% commission. Exhibition space: 180 sq. ft. Average gross sales/exhibitor: $7,000. For more information, artists should e-mail, visit Web site, call or send SASE.

Tips "Create a vibrant, open display that beckons to passing customers. Interact with potential buyers. Sell the romance of the purchase."

ANN ARBOR'S SOUTH UNIVERSITY ART FAIR

P.O. Box 4525, Ann Arbor MI 48106. (734)663-5300. Fax: (734)663-5303. Web site: www.a2southu.com. **Contact:** Maggie Ladd, director. Estab. 1960. Fine arts & crafts show held annually 3rd Wednesday through Saturday in July. Outdoors. Accepts photography, clay, drawing, digital, fiber, jewelry, metal, painting, sculpture, wood. Juried. Awards/prizes: $3,000. Number of exhibitors: 190. Public attendance: 750,000. Deadline for entry: January. Application fee: $25. Space fee: $700-1500. Exhibition space: 10×10 ft. to 20×10 ft. Average gross sales/exhibitor: $7,000. For more information, artists should e-mail, visit Web site or call.

Tips "Research the market, use a mailing list, advertise in *Art Fair Guide* (150,000 circulation)."

N ☑ ANNUAL ARTS & CRAFTS ADVENTURE AND ANNUAL ARTS & CRAFTS ADVENTURE II

P.O. Box 1326, Palatine IL 60078. (312)751-2500. Fax: (847)221-5853. E-mail: asoa@webtv.net. Web site: www.americansocietyofartists.org. **Contact:** American Society of Artists—"anyone in the office can help." Estab. 1991. Fine arts & crafts show held biannually in May and September. Outdoors. Accepts photography, pottery, paintings, sculpture, glass, wood, woodcarving. Juried. Send 4 slides or photos of your work and 1 slide or photo of your display; SASE (No. 10); a résumé or show listing is helpful. Number of exhibitors: 75. Free to the public. Artists should apply by submitting jury materials. If juried in, you will receive a jury/approval number. Deadline for entry: 2 months prior to show or earlier if spaces fill. Space fee: $80. Exhibition space: approximately 100 sq. ft. For more information, artists should send SASE, submit jury material.

 • Event held in Park Ridge, Illinois.

Tips "Remember that when you are at work in your studio, you are an artist. But when you are at a show, you are selling your work."

N ✦ ANNUAL ARTS & CRAFTS EXPRESSIONS

P.O. Box 1326, Palatine IL 60078. (312)751-2500. Fax: (847)221-5853. E-mail: asoa@webtv.net. Web site: www.asmericansocietyofartists.org. **Contact:** American Society of Artists—"anyone in the office can help." Estab. 1998. Fine arts & crafts show held annually in late July. Outdoors. Accepts photography, sculpture, jewelry, glass works, woodworking and more. Juried. Send 4 slides or photos of your work and 1 slide or photo of your display; SASE (No. 10); a résumé or show listing is helpful. Number of exhibitors: 50. Free to the public. Artists should apply by submitting jury materials. If juried in, you will receive a jury/approval number. Deadline for entry: 2 months prior to show or earlier if spaces fill. Space fee: $150. Exhibition space: approximately 100 sq. ft. For more information, artists should send SASE, submit jury material.

Tips "Remember that when you are at work in your studio, you are an artist. But when you are at a show, you are selling your work."

N ✦ ANNUAL ARTS ADVENTURE

P.O. Box 1326, Palatine IL 60078. (312)571-2500. Fax: (847)221-5853. E-mail: asoa@webtv.net. Web site: www.americansocietyofartists.org. **Contact:** American Society of Artists—"anyone in the office can help." Estab. 2001. Fine arts & crafts show held annually the end of July. Outdoors. Accepts photography, paintings, pottery, sculpture, jewelry and more. Juried. Send 4 slides or photos of your work and 1 slide or photo of your display; SASE (No. 10); a résumé or show listing is helpful. Number of exhibitors: 50. Free to the public. Artists should apply by submitting jury materials. If juried in, you will receive a jury/approval number. Deadline for entry: 2 months prior to show or earlier if spaces fill. Space fee: $125. Exhibition space: approximately 100 sq. ft. For more information, artists should send SASE, submit jury material.

• Event held in Chicago, Illinois.

Tips "Remember that when you are at work in your studio, you are an artist. But when you are at a show, you are selling your work."

N ✦ ANNUAL CRESTWOOD ARTS & CRAFTS ADVENTURE

P.O. Box 1326, Palatine IL 60078. (312)751-2500. Fax: (847)221-5853. E-mail: asoa@webtv.net. Web site: www.americansocietyofartists.com. **Contact:** American Society of Artists—"anyone in the office can help." Estab. 2000. Arts & crafts show held annually in early October. Indoors. Accepts photography, paintings, jewelry, glassworks, quilting, graphics, woodworking, paperworks and more. Juried. Send 4 slides or photos of your work and 1 slide or photo of your display; SASE (No. 10); a résumé or show listing is helpful. Number of exhibitors: 150. Free to the public. Artists should apply by submitting jury materials. If juried in, you will receive a jury/approval number. Deadline for entry: 2 months prior to show or earlier if spaces fill. Space fee: $160. Exhibition space: approximately 100 sq. ft. For more information, artists should send SASE, submit jury material.

• Event held in St. Louis, Missouri.

Tips "Remember that when you are at work in your studio, you are an artist. But when you are at a show, you are selling your work."

N ✦ ANNUAL EDENS ART FAIR

P.O. Box 1326, Palatine IL 60078. (312)2500. Fax: (847)5853. E-mail: asoa@webtv.net. Web site: www.america nsocietyofartists.com. **Contact:** American Society of Artists—"anyone in the office can help." Estab. 1995 (after renovation of location; held many years prior to renovation). Fine arts & crafts show held annually in mid-July. Outdoors. Accepts photography, paintings, sculpture, glass works, jewelry and more. Juried. Send 4 slides or photos of your work and 1 slide or photo of your display; SASE (No. 10); a résumé or show listing is helpful. Number of exhibitors: 50. Free to the public. Artists should apply by submitting jury materials. If juried in, you will receive a jury/approval number. Deadline for entry: 2 months prior to show or earlier if spaces fill. Space fee: $130. Exhibition space: approximately 100 sq. ft. For more information, artists should send SASE, submit jury material.

• Event held in Willamette, Illinois.

Tips "Remember that when you are at work in your studio, you are an artist. But when you are at a show, you are selling your work."

N ✦ ANNUAL NORTHWOODS ARTS & CRAFTS EXPRESSIONS

P.O. Box 1326, Palatine IL 60078. (312)751-2500. Fax: (847)221-5853. E-mail: asoa@webtv.net. Web site: www.americansocietyofartists.org. Estab. 2003. Arts & crafts show held biannually in mid-to-late March and late October. Indoors. Accepts photography, paintings, graphics, sculpture, quilting, woodworking, fiber art, hand-crafted candles, glass works, jewelry. Juried. Send 4 slides or photos representative of work being exhibited; 1 photo of display set-up, #10 SASE, résumé with 7 show listings helpful. Number of exhibitors: 50. Free to public. Artists should apply by submitting jury material and indicate you are interested in this particular

show. When you pass the jury, you will receive jury/approval number and application you requested. Deadline for entry: 2 months prior to show or earlier if space is filled. Space fee: $165. Exhibition space: 100 sq. ft. for single space. For more information, artists should send SASE to submit jury material.

Tips "Remember that at work in your studio, you are an artist. When you are at a show, you are selling your work."

ℕ ☑ ANNUAL OAK PARK AVENUE-LAKE ARTS & CRAFTS SHOW

P.O. Box 1326, Palatine IL 60078. (312)751-2500. Fax: (847)221-5853. E-mail: asoa@webtv.net. Web site: www.americansocietyofartists.org. **Contact:** American Society of Artists—"anyone in the office can help." Estab. 1974. Fine arts & crafts show held annually in mid-August. Outdoors. Accepts photography, paintings, graphics, sculpture, glass, wood, paper, fiber arts, mosaics. Juried. Send 4 slides or photos of your work and 1 slide or photo of your display; SASE (No. 10); a résumé or show listing is helpful. Number of exhibitors: 150. Free to the public. Artists should apply by submitting jury materials. If juried in, you will receive a jury/approval number. Deadline for entry: 2 months prior to show or earlier if spaces fill. Space fee: $160. Exhibition space: approximately 100 sq. ft. For more information, artists should send SASE, submit jury material.

• Event held in Oak Park, Illinois.

Tips "Remember that when you are at work in your studio, you are an artist. But when you are at a show, you are selling your work."

ℕ ☑ ANNUAL WHITE OAKS ARTS & CRAFTS ADVENTURE

P.O. Box 1326, Palatine IL 60078. (312)751-2500. Fax: (847)21-5853. E-mail: asoa@webtv.net. Web site: www.americansocietyofartists.org. **Contact:** American Society of Artists—"anyone in the office can help." Estab. 2001. Arts & crafts show held biannually in late May/early June and mid-October. Indoors. Accepts photography, paintings, glass, wood, fiber arts, hand-crafted candles, quilts and more. Juried. Send 4 slides or photos of your work and 1 slide or photo of your display; SASE (No. 10); a résumé or show listing is helpful. Number of exhibitors: 40. Free to the public. Artists should apply by submitting jury materials. If juried in, you will receive a jury/approval number. Deadline for entry: 2 months prior to show or earlier if spaces fill. Space fee: $175. Exhibition space: approximately 100 sq. ft. For more information, artists should send SASE, submit jury material.

• Event held in Springfield, Illinois.

Tips "Remember that when you are at work in your studio, you are an artist. But when you are at a show, you are selling your work."

ℕ ☑ ART FAIR ON THE COURTHOUSE LAWN

P.O. Box 795, Rhinelander WI 54501. (715)365-7464. Fax: (715)365-7467. E-mail: pzastrow@rhinelanderchamber.com. **Contact:** Patty Zastrow, events coordinator. Estab.1985. Arts & crafts show held annually in June. Outdoors. Accepts photography, handmade crafts. Number of exhibitors: 150. Public attendance: 3,000. Free to the public. Space fee: 10×10 ft.: $65; 10×20 ft.: $90; 10×30 ft.: $125. For more information, artists should e-mail, call.

Tips "We accept only items handmade by the exhibitor."

ART IN THE BARN

450 W. Hwy. 22, Barrington IL 60010. (847)381-0123, ext. 4496. Fax: (847)842-4898. E-mail: bonniebixby@advocatehealth.com. **Contact:** Artist Committee. Estab. 1976. Arts & crafts show held annually in late September. Estab. 1972. Outdoors and indoors. Accepts photography, acrylic, oil painting, ceramics, drawing, fiber, printmaking, watercolor, wood. Juried; 3 jurors. Awards/prizes: Top 10 Sales, Best of Show, Best of Medium. Number of exhibitors: 160. Public attendance: 5,000-8,000. Public admission: $6. Artists should apply by sending 4 color slides (35mm) of current work and SASE. Deadline for entry: April 1. Application fee: $10. Space fee: $80. Exhibition space: 10×10 ft. Average gross sales/exhibitor: $300-500. For more information, artists should e-mail, call or send SASE.

Tips "Mid-price range, nice booth layout."

ℕ ☑ ART IN THE PARK

8707 Forest Ct., Warren MI 48093. (586)795-5471. E-mail: wildart@wowway.com. Web site: www.warrenfinearts.org. **Contact:** Paula Wild, chairperson. Estab. 1990. Fine arts & crafts show held annually the weekend after the Fourth of July. Outdoors. Accepts photography, sculpture, basketry, pottery, stained glass. Juried. Awards/prizes: 2D and 3D monetary awards. Number of exhibitors: 115. Public attendance: 7,500. Free to public. Deadline for entry: May 16. Jury fee: $10. Space fee: $100. Exhibition space: 12×12 ft./tent; 10×12 ft./pavilion. For more information, artists should e-mail, visit Web site or send SASE.

▓ ⬚ AN ARTS & CRAFTS AFFAIR, AUTUMN AND SPRING TOURS

P.O. Box 184, Boys Town NE 68010. (402)331-2889. Fax: (402)445-9177. E-mail: hpifestivals@cox.net. Web site: www.hpifestivals.com. **Contact:** Huffman Productions. Estab. 1970. An arts & crafts show that tours to different cities and states. The Autumn Festival tours annually October-November; Spring Festival tours annually March-April. Artists should visit Web site to see list of states and schedule. Indoors and outdoors. Accepts photography, pottery, stained glass, jewelry, clothing, wood, baskets. All artwork must be handcrafted by the actual artist exhibiting at the show. Juried by sending in 2 photos of work and 1 of display. Awards/prizes: Show gift certificates for $30, $50 and $100; a certificate for $150 off future booth fees. Number of exhibitors: 200-430 depending on location. Public attendance: 12,000-40,000. Public admission: $6-7/adults; $5-6/seniors and children 6-12 years old; 5 and under, free. Artists should apply by calling to request an application. Deadline for entry: varies for date and location. Space fee: $350-550. Exhibition space: 8 × 11 ft. to 10 × 10 ft. For more information, artists should e-mail, visit Web site, call or send SASE.

Tips "Have a nice display; make sure business name is visible; dress professionally; have different price points; and be willing to talk to your customers."

▓ ⬚ ARTS ON THE GREEN

2603 Curry Dr., Crestwood KY 40014. (502)243-9879. E-mail: judyanded2@peoplepc.com. Web site: www.oldh amcountyarts.com. **Contact:** Judy Wegenast, show coordinator. Estab. 2001. Fine arts & crafts show held annually the 1st weekend in June. Outdoors. Accepts photography, painting, clay, sculpture, metal, wood, fabric, glass, jewelry. Juried by a panel. Awards/prizes: Best of Show and category awards. Number of exhibitors: 100. Public attendance: 7,500. Free to the public. Artists should apply online or call. Deadline for entry: March 15, 2007. Application and space fees to be determined. Exhibition space: 12 × 12 ft. For more information, artists should e-mail, visit Web site, call.

Tips "Make potential customers feel welcome in your space. Don't overcrowd your work. Smile!"

⬚ BLACK SWAMP ARTS FESTIVAL

P.O. Box 532, Bowling Green OH 43402. (419)354-2723. E-mail: info@blackswamparts.org. Web site: www.blac kswamparts.org. **Contact:** Tim White, visual arts committee. Estab. 1993. Fine arts & crafts show held annually the weekend after Labor Day. Outdoors. Accepts photography, ceramics, drawing, enamel, fiber, glass, jewelry, leather, metal, mixed media, painting, paper, prints, sculpture, wood. Juried by unaffiliated, hired jurors. Awards/prizes: Best in Show, 2nd Place, 3rd Place, Honorable Mention, Painting Prize. Number of exhibitors: Juried: 110; Invitational: 40. Public attendance: 60,000. Free to the public. Artists should apply by visiting Web site. Deadline for entry: Juried: April; Invitational: June or until filled. Application fee: Juried: $225; Invitational: $120. Exhibition space: 10 × 10 ft. For more information, artists should visit Web site, call (voice mail only) or e-mail.

Tips "Offer a range of prices, from $5 to $500."

▓ ⬚ CAIN PARK ARTS FESTIVAL

40 Severance Circle, Cleveland Heights OH 44118-9988. (216)291-3669. Fax: (216)3705. E-mail: jhoffman@clvht s.com. Web site: www.cainpark.com. **Contact:** Janet Hoffman, administrative assistant. Estab. 1976. Fine arts & crafts show held annually the 2nd full week in July. Outdoors. Accepts photography, painting, clay, sculpture, wood, jewelry, leather, glass, ceramics, clothes and other fiber, paper, block printing. Juried by a panel of professional artists; submit 5 slides. Awards/prizes: cash prizes of $750, $500 and $250; also Judges' Selection, Director's Choice and Artists' Award. Number of exhibitors: 155. Public attendance: 60,000. Free to the public. Artists should apply by requesting an application by mail, visiting Web site to download application, or by calling. Deadline for entry: March 1, 2007. Application fee: $25. Space fee: $300. Exhibition space: 10 × 10 ft. Average gross sales/exhibitor: $4,000. For more information, artists should e-mail, visit Web site, call.

Tips "Have an attractive booth to display your work. Have a variety of prices. Be available to answer questions about your work."

▓ CENTERVILLE/WASHINGTON TOWNSHIP AMERICANA FESTIVAL

P.O. Box 41794, Centerville OH 45441-0794. (937)433-5898. Fax: (937)433-5898. E-mail: americanafestival@sbc global.net. Web site: www.americanafestival.org. **Contact:** Patricia Fleissner, arts & crafts chair. Estab. 1972. Arts & crafts show held annually on the Fourth of July. Festival includes entertainment, parade, food, car show and other activities. Accepts photography and all mediums. "No factory-made items accepted." Awards/prizes: 1st Place; 2nd Place; 3rd Place; certificates and ribbons for most attractive displays. Number of exhibitors: 275-300. Public attendance: 70,000. Free to the public. Artists should send SASE for application form or apply online. Deadline for entry: June 27, 2007. "Main Street is full by early June." Space fee: $40. Exhibition space: 12 × 10 ft. For more information, artists should e-mail, visit Web site, call.

Tips "Artists should have moderately priced items; bring business cards; and have an eye-catching display."

Ⓝ ☑ CHARDON SQUARE ARTS FESTIVAL

115 Main St., Chardon OH 44024. (440)564-9096. **Contact:** Jan Gipson, chairman. Estab. 1980. Fine arts & crafts show held annually in August. Outdoors. Accepts photography, pottery, weaving, wood, painting, jewelry. Juried. Number of exhibitors: 105. Public attendance: 3,000. Free to public. Artists should apply by calling or writing for application. Deadline for entry: March 15. Application fee: $5/jury fee. Space fee: $75. Exhibition space: 10×10 ft. For more information, artists should call.

Tips "Make your booth attractive; be friendly and offer quality work."

Ⓝ COUNTRY ARTS & CRAFTS FAIR

N104 W14181 Donges Bay Rd., Germantown WI 53022. (262)251-0604. E-mail: stjohnucc53022@sbcglobal.net. **Contact:** Mary Ann Toth, booth chairperson. Estab. 1975. Arts & crafts show held annually in September. Indoors and outdoors. Limited indoor space; unlimited outdoor booths. Accepts photography, jewelry, clothing, country crafts. Number of exhibitors: 70. Public attendance: 500-600. Free to the public. Artists should e-mail for an application and state permit. Space fee: $10 for youth; $30 for outdoor; $40 for indoor. Exhibition space: 10×10 ft. and 15×15 ft. For more information, artists should e-mail or call Mary Ann Toth or Amy Green, or send SASE.

Ⓝ ☑ CUENO GARDENS ARTS FESTIVAL

3417 R.F.D., Long Grove IL 60047. (847)438-4517. Fax: (847)726-8669. E-mail: dwevents@comcast.net. Web site: www.dwevents.org. **Contact:** D & W Events, Inc. Estab. 2005. Fine arts & crafts show. Outdoors. Accepts photography, fiber, oil, acrylic, watercolor, mixed media, jewelry, sculpture, metal, paper, painting. Juried by 3 jurors. Awards/prizes: Best of Show, 1st and 2nd Places, and Honorable Mentions. Number of exhibitors: 100. Public attendance: 10,000. Free to public. Artists should apply by downloading application from Web site, e-mail or call. Deadline for entry: March 1. Application fee: $25. Space fee: $250. Exhibition space: 100 sq. ft. For more information, artists should e-mail, visit Web site, call or send SASE.

Tips "Artists should display professionally and attractively, and interact positively with everyone."

Ⓝ DEERFIELD FINE ARTS FESTIVAL

3417 R.F.D., Long Grove IL 60047. (847)438-4517. Fax: (847)726-8669. E-mail: dwevents@comcast.net. Web site: www.dwevents.org. **Contact:** D&W Events, Inc. Estab. 2000. Fine arts & crafts show held annually in early June. Outdoors. Accepts photography, fiber, oil, acrylic, watercolor, mixed media, jewelry, sculpture, metal, paper, painting. Juried by 3 jurors. Awards/prizes: Best of Show, 1st and 2nd Places, and Honorable Mentions. Number of exhibitors: 100. Public attendance: 15,000. Free to public. Artists should apply by downloading application from Web site, e-mail or call. Deadline for entry: March 1. Application fee: $25. Space fee: $250. Exhibition space: 100 sq. ft. For more information, artists should e-mail, visit Web site, call or send SASE.

Tips "Artists should display professionally and attractively, interact positively with everyone."

Ⓝ ☑ FARGO'S DOWNTOWN STREET FAIR

203 4th St., Fargo ND 58102. (701)241-1570. Fax: (701)241-8275. E-mail: steph@fmdowntown.com. Web site: www.fmdowntown.com. **Contact:** Stephanie, events and membership. Estab. 1975. Fine arts & crafts show held annually in July. Outdoors. Accepts photography, ceramics, glass, fiber, textile, jewelry, metal, painting, prints, drawing, sculpture, 3D mixed media, wood. Juried by a team of artists from the Fargo-Moorehead area. Awards/prizes: Best of Show and best in each medium. Number of exhibitors: 300. Public attendance: 130,000-150,000. Free to pubic. Artists should apply online or by mail. Deadline for entry: February 18. Space fee: $275/booth; $50/corner. Exhibition space: 10×10 ft. For more information, artists should e-mail, visit Web site or call.

Ⓝ ☑ FOUR RIVERS ARTS & CRAFTS HARVEST HOME FESTIVAL

112 S. Lakeview Dr., Petersburg IN 47567. (812)354-6808, ext. 112. Fax: (812)354-2785. E-mail: rivers4@sigeco m.net. **Contact:** Denise Tuggle, program assistant. Estab. 1976. Arts & crafts show held annually 3rd weekend in October. Indoors. Juried. Board of Directors are assigned certain buildings to check for any manufactured items. Crafts are not judged. Awards/prizes: $30-50; 3 display awards based on display uniqueness and the correlation of the harvest theme. Number of exhibitors: 200. Public attendance: 5,000. Free to public; $2 parking fee. Artists should apply by calling with information. Application will be mailed along with additional information. Deadline for entry: July 30. Space fee: $55, 2 per applicant. Exhibition space: 10×10 ft. For more information, artists should call.

Ⓝ ☑ FOURTH STREET FESTIVAL FOR THE ARTS & CRAFTS

P.O. Box 1257, Bloomington IN 47402. (812)335-3814. Web site: www.4thstreet.org. Estab. 1976. Fine arts & crafts show held annually Labor Day weekend. Outdoors. Accepts photography, clay, glass, fiber, jewelry,

painting, graphics, mixed media, wood. Juried by a 4-member panel. Awards/prizes: Best of Show; 1st, 2nd, 3rd Places in 2D and 3D. Number of exhibitors: 105. Public attendance: 25,000. Free to public. Artists should apply by sending requests by mail, e-mail or download application from Web site. Deadline for entry: April 1. Application fee: $15. Space fee: $175. Exhibition space: 10×10 ft. Average gross sales/exhibitor: $2,700. For more information, artists should e-mail, visit Web site, call or send for information with SASE.
Tips "Be professional."

N ☑ GOOD OLD SUMMERTIME ART FAIR
P.O. Box 1753, Kenosha WI 53141-1753. (262)654-0065. E-mail: kaaartfairs@yahoo.com. Web site: www.Kenos haArtAssoc.org. **Contact:** Karen Wollert, art fair coordinator. Estab. 1975. Fine arts show held annually 1st Sunday in June. Outdoors. Accepts photography, paintings, drawings, mosaics, ceramics, pottery, sculpture, wood, stained glass. Juried by a panel. Photos or slides required with application. Awards/prizes: Best of Show, 1st, 2nd, 3rd Places plus Purchase Awards. Number of exhibitors: 100. Public attendance: 3,000. Free to public. Artists should apply by sending application, fees and SASE. Deadline for entry: April 1. Application/space fee: $60-65. Exhibition space: 12×12 ft. For more information, artists should e-mail, visit Web site or send SASE.
Tips "Have a professional display, and be friendly."

N GRADD ARTS & CRAFTS FESTIVAL
3860 US Hwy. 60 W., Owensboro KY 42301. (270)926-4433. Fax: (270)684-0714. E-mail: bethgoetz@gradd.com. Web site: www.gradd.com. **Contact:** Beth Goetz, festival coordinator. Estab. 1972. Arts & crafts show held annually 1st full weekend in October. Outdoors. Accepts photography taken by artist only. Number of exhibitors: 180-200. Public attendance: 15,000 +. Free to public; $3 parking fee. Artists should apply by calling to be put on mailing list. Space fee: $100-150. Exhibition space: 10×12 ft. For more information, artists should e-mail, visit Web site or call.
Tips "Be sure that only hand-crafted items are sold. No buy/sell items will be allowed."

N ☑ GREENWICH VILLAGE ART FAIR
711 N. Main St., Rockford IL 61103. (815)968-2787. Fax: (815)316-2179. E-mail: gvaf@rockfordartmuseum.org. Web site: www.rockfordartmuseum.org. **Contact:** Scott Prine, chairman. Estab. 1948. Fine arts & crafts show held annually in September. Outdoors. Accepts photography and all mediums. Juried by a panel of artists and committee. Awards/prizes: Best of Show and Best of Categories. Number of exhibitors: 120. Public attendance: 7,000. Public admission: $4. Artists should apply by mail or downloading prospectus from the Web site. Deadline for entry: April 30. Application fee: $20. Space fee: $195. Exhibition space: 10×10 ft. For more information, artists should e-mail, visit Web site or call.

N ☑ HINSDALE FINE ARTS FESTIVAL
22 E. First St., Hinsdale IL 60521. (603)323-3952. Fax: (630)323-3952. E-mail: hindsdalechamber@earthlink.net. Web site: www.hinsdalechamber.com. **Contact:** Jan Anderson, executive director. Fine arts show held annually Father's Day weekend. Outdoors. Accepts photography, ceramics, painting, sculpture, fiber arts, mixed media, jewelry. Juried by 3 slides. Awards/prizes: Best in Show, President's Award and 1st, 2nd, 3rd Places in 7 categories. Number of exhibitors: 150. Public attendance: 2,000-3,000. Free to public. Artists should apply by mailing or downloading application from Web site. Deadline for entry: March 2. Application fee: $20. Space fee: $200. Exhibition space: 10×10 ft. For more information, artists should e-mail or visit Web site.
Tips "Original artwork sold by artist. Artwork should be appropriately and reasonably priced."

N ☑ STAN HYWET HALL & GARDENS WONDERFUL WORLD OF OHIO MART
714 N. Portage Path, Akron OH 44303-1399. (330)836-5533. Web site: www.stanhywet.org. **Contact:** Lynda Grieves, exhibitor chair. Estab. 1966. Arts & crafts show held annually 1st full weekend in October. Outdoors. Accepts photography and all mediums. Juried 2 Saturdays in January and via mail application. Awards/prizes: Best Booth Display. Number of exhibitors: 115. Public attendance: 15,000-20,000. Public admission: $7. Deadline for entry: mid-February. Space fee: $450. Exhibition space: 10×10 ft. For more information, artists should visit Web site or call.

N ☑ KIA ART FAIR (KALAMAZOO INSTITUTE OF ARTS)
314 S. Park St., Kalamazoo MI 49007-5102. (269)349-7775. Fax: (269)349-9313. E-mail: srodia@chartermi.net. Web site: www.kiarts.org. **Contact:** Steve Rodia, artist coordinator. Estab. 1951. Fine arts & crafts show held annually 1st Saturday in June. Outdoors. Accepts photography, prints, pastels, drawings, paintings, mixed media, ceramics (functional and nonfunctional), sculpture/metalsmithing, wood, fiber, jewelry, glass, leather. Juried by no fewer than 3 and no more than 5 art professionals chosen for their experience and expertise. See prospectus for more details. Awards/prizes: 1st prize: $500; 2nd prize: 2 at $300 each; 3rd prize: 3 at $200

each. Number of exhibitors: 200. Public attendance: 40,000-50,000. Free to the public. Artists should apply by filling out application form and submitting 4 35mm color slides of their art and 1 color slide of their booth display. Deadline for entry: March 1. Application fee: $20, nonrefundable. Space fee: $110. Exhibition space: 10×12 ft. Height should not exceed 10 ft. in order to clear the trees in the park. For more information, artists should e-mail, visit Web site, call.

KRASL ART FAIR ON THE BLUFF

707 Lake Blvd., St. Joseph MI 49085. (269)983-0271. Fax: (269)983-0275. E-mail: sara@krasl.org. Web site: www.krasl.org. **Contact:** Sara Shambarger, art fair director. Estab. 1962. Fine arts & crafts show held annually in July. Outdoors. Accepts photogaphy, painting, digital art, drawing, pastels, wearable and nonwearable fiber art, glass, jewelry. Juried. (Returning artists do not have to re-jury or pay the $25 application fee.) Number of exhibitors: 216. Number of attendees: more than 70,000. Free to public. Artists should apply by completing an application form, which is sent out in December. Deadline for entry: approximately February 9. Application fee: $25. Space fee: $225. Exhibition space: 15×15 ft. or larger. Average gross sales/exhibitor: $3,000. For more information, artists should e-mail or visit Web site.

Tips "Be willing to talk to people in your booth. You are your own best asset!"

LAGRANGE ART-CRAFT FAIR

P.O. Box 455, Lemont IL 60439. (630)739-1071. **Contact:** Midwest Art-Craft Fairs. Estab. 1974. Arts & crafts show held annually 2nd weekend in July. Fair held in downtown LaGrange, Illinois. Outdoors. Accepts photography and all other original media. Juried by photos of the art and the display. Average number of exhibitors: 250. Public attendance: 15,000. Free to the public. Artists should apply by calling or writing for an application form. Deadline for entry: April. Space fee: $190. Exhibition space: 10×10 ft. For more information, artists should call.

LES CHENEAUX FESTIVAL OF ARTS

P.O. Box 30, Cedarville MI 49719. (906)484-2821. Fax: (906)484-6107. E-mail: lcha@cedarville.net. **Contact:** A. Goehring, curator. Estab. 1976. Fine arts & crafts show held annually 2nd Saturday in August. Outdoors. Accepts photography and all other media; original work and design only; no kits or commercially manufactured goods. Juried by a committee of 10. Submit 4 slides (3 of the artwork; 1 of booth display). Awards/prizes: Monetary prizes for excellent and original work. Number of exhibitors: 70. Public attendance: 8,000. Public admission: $7. Artists should fill out application form to apply. Deadline for entry: April 1. Application fee: $60. Space fee: $60. Exhibition space: 10×10 ft. Average gross sales/exhibitor: $5-$500. For more information, artists should call, send SASE.

MICHIGAN STATE UNIVERSITY HOLIDAY ARTS & CRAFTS SHOW

322 MSU Union, East Lansing MI 48824. (517)355-3354. Fax: (517)432-2448. E-mail: uab@hfs.msu.edu. Web site: www.uabevents.com. **Contact:** Janelle Jacobs, assistant manager. Estab. 1963. Arts & crafts show held annually 1st weekend in December. Indoors. Accepts photography, basketry, candles, ceramics, clothing, sculpture, soaps, drawings, floral, fibers, glass, jewelry, metals, painting, graphics, pottery, wood. Juried by a panel of judges using the photographs submitted by each vendor to eliminate commercial products. They will evaluate on quality, creativity and crowd appeal. Number of exhibitors: 220. Public attendance: 15,000. Free to public. Artists should apply by downloading application and instructions on Web site. Deadline for entry: August 7. Application fee: $10. Space fee: $225. Exhibition space: 8×5 ft. For more information, artists should visit Web site or call.

RILEY FESTIVAL

312 E. Main St. #C, Greenfield IN 46140. (317)462-2141. Fax: (317)467-1449. E-mail: info@rileyfestival.com. Web site: www.rileyfestival.com. **Contact:** Sarah Kesterson, secretary. Estab. 1975. Fine arts & crafts show held annually in October. Outdoors. Accepts photography, fine arts, home arts, quilts. Juried. Awards/prizes: small monetary awards and ribbons. Number of exhibitors: 450. Public attendance: 75,000. Free to public. Artists should apply by downloading application on Web site. Deadline for entry: September 15. Space fee: $120-145. Exhibition space: 10×10 ft. For more information, artists should visit Web site.

Tips "Keep art priced for middle-class viewers."

ROYAL OAK OUTDOOR ART FAIR

P.O. Box 64, Royal Oak MI 48068-0064. (248)246-3180. Fax: (248)246-3007. E-mail: artfaire@ci.royal-oak.mi.us. **Contact:** Recreation Office Staff, Events and Membership. Estab. 1970. Fine arts & crafts show held annually in July. Outdoors. Accepts photography, collage, jewelry, clay, drawing, painting, glass, wood, metal, leather, soft sculpture. Juried. Number of exhibitors: 110. Public attendance: 25,000. Free to pubic. Artists should apply

with application form and 3 slides of current work. Deadline for entry: March 1. Application fee: $20. Space fee: $300. Exhibition space: 15 × 15 ft. For more information, artists should e-mail or call.
Tips "Be sure to label your slides on the front with name, size of work and 'top.' "

[N] [✓] ST. JAMES COURT ART SHOW

P.O. Box 3804, Louisville KY 40201. (502)635-1842. Fax: (502)635-1296. E-mail: mesrock@stjamescourtartshow .com. Web site: www.stjamesartshow.com. **Contact:** Marguerite Esrock, executive director. Estab. 1957. Annual fine arts & crafts show held 1st full weekend in October. Accepts photography; has 16 medium categories. Juried in February; there is also a street jury held during the art show. Awards/prizes: Best of Show—3 places; $7,500 total prize money. Number of exhibitors: 340. Public attendance: 275,000. Free to the public. Artists should apply by visiting Web site and printing out an application or via www.zapplication.org. Deadline for entry: March 1, 2007. Application fee: $30. Space fee: $400-500. Exhibition space: 10 × 12 ft. For more information, artists should e-mail or visit Web site.
Tips "Have a variety of price points. Don't sit in the back of the booth and expect sales."

[N] ST. PATRICK'S DAY CRAFT SALE AND FALL CRAFT SALE

6370 102nd St. NW, Maple Lake MN 55358-2331. (320)963-5351. **Contact:** Betty Gordon, chairperson. Estab. 1988. Arts & crafts show held biannually in March and early November. Indoors. Number of exhibitors: 40-50. Public attendance: 300-600. Free to public. Artists should apply by requesting an application. Deadline for entry: 1 month-2 weeks before the event. Space fee: $18-22. Exhibition space: 10 × 10 ft. For more information, artists should send SASE.
Tips "Don't charge an arm and a leg for the items. Don't overcrowd your items. Be helpful but not pushy."

[N] [✓] STONE ARCH FESTIVAL OF THE ARTS

219 Main St. SE, Suite 304, Minneapolis MN 55414. (612)378-1226. E-mail: info@minneapolisriverfrontevents.c om. Web site: www.stonearchfestival.com. **Contact:** Sara Collins, manager. Estab. 1994. Fine arts & crafts show/culinary arts show held annually Father's Day weekend. Outdoors. Accepts photography, painting, ceramics, jewelry, fiber, printmaking, wood, metal. Juried by committee. Awards/prizes: free booth the following year; $100 cash prize. Number of exhibitors: 230. Public attendance: 80,000. Free to public. Artists should apply by application found on Web site. Deadline for entry: March 15. Application fee: $20. Space fee: $250-300. Exhibition space: 10 × 10 ft. For more information, artists should e-mail, visit Web site, call or send SASE.
Tips "Have an attractive display and variety of prices."

[N] [✓] STREET FAIRE AT THE LAKES

P.O. Box 348, Detroit Lakes MN 56502. (800)542-3992. Fax: (218)847-9082. E-mail: jan@visitdetroitlakes.com. Web site: www.visitdetroitlakes.com. **Contact:** Sue Brown, artist coordinator. Estab. 2001. Fine arts & crafts show held annually 1st weekend after Memorial Day, early June. Outdoors. Accepts photography, handmade/ original artwork, wood, metal, glass, painting, fiber. Juried by anonymous scoring. Submit 5 slides, 4 of work and 1 of booth display. Top scores are accepted. Number of exhibitors: 125. Public attendance: 15,000. Free to public. Artists should apply by downloading application from Web site. Deadline for entry: January 15. Application fee: $150-175. Exhibition space: 11 × 11 ft. For more information, artists should e-mail or call.

[N] SUMMER ARTS AND CRAFTS FESTIVAL

UW-Parkside, 900 Wood Rd., Box 2000, Kenosha WI 53141. (262)595-2457. E-mail: odegaard@uwp.edu. **Contact:** Roberta Odegaard, coordinator. Estab. 1990. Arts & crafts show held annually 3rd week in June. Outdoors. Accepts photography, painting, glass, sculpture, woodwork, metal, jewelry, leather, quilts. Number of exhibitors: 200. Public attendance: 4,000. Free to the public. Artists should apply by calling or e-mailing for an application form. Deadline for entry: May. Space fee: $100. Exhibition space: 10 × 10 ft. For more information, artists should e-mail, call.
Tips "Items priced less than $100 are excellent sellers."

SUMMERFAIR

2515 Essex Place, Cincinnati OH 45206. (513)531-0050. Fax: (513)531-0377. E-mail: info@summerfair.org. Web site: www.summerfair.org. **Contact:** Christina Waddle. Estab. 1968. Fine arts & crafts show held annually the weekend after Memorial Day. Outdoors. Accepts photography, ceramics, drawing, printmaking, fiber, leather, glass, jewelry, painting, metal work. Juried. Awards/prizes: $10,000 in cash awards and Purchase Award. Number of exhibitors: 300. Public attendance: 35,000. Public admission: $9. Artists should apply by downloading application from Web site (available in December) or by e-mailing for an application. Deadline: February. Application fee: $25. Space fee: $325 (single booth). Exhibition space: 10 × 10 ft. For more information, artists should e-mail, visit Web site, call.

N ☑ A VICTORIAN CHAUTAUQUA

1101 E Market St., P.O. Box 606, Jeffersonville IN 47131-0606. (812)283-3728. Fax: (812)283-6049. E-mail: hsmsteam@aol.com. Web site: www.steamboatmuseum.org. **Contact:** Yvonne Knight, administrator. Estab. 1993. Fine arts & crafts show held annually 3rd weekend in May. Outdoors. Accepts photography, all mediums. Juried by a committee of 5. Awards/prizes: $100, 1st Place; $75, 2nd Place; $50, 3rd Place. Number of exhibitors: 80. Public attendance: 3,000. Public admission: $3. Deadline for entry: March 31. Space fee: $40-60. Exhibition space: 12×12 ft. For more information, artists should e-mail or call.

N ☑ WINNEBAGOLAND ART FAIR

South Park Avenue/South Park, Oshkosh WI 54902. (920)303-1503. E-mail: shelling1230@charter.net. Estab. 1957. Fine arts show held annually. Outdoors. Accepts photography, watercolor, oils, acrylics, 3D large, 3D small, drawing, pastels. Juried. Applicants send in slides to be reviewed. Awards/prizes: monetary awards; Purchase and Merit Awards and Best of Show Award. Number of exhibitors: 125-160. Public attendance: 5,000-7,000. Free to public. Deadline for entry: April 30. Application fee: $60, but may increase next year. Exhibition space: 20×20 ft. For more information, artists should e-mail or call.
Tips "Have a nice-looking exhibit booth."

N ☑ ZIONSVILLE COUNTY MARKET

135 S. Elm St., Zionsville IN 46077. (317)873-3836. **Contact:** Debbie Cronfill, executive director. Estab. 1975. Fine arts & crafts show held annually Saturday after Mother's Day. Outdoors. Accepts photography, arts, crafts, antiques, apparel. Juried by sending 5 pictures. Number of exhibitors: 150-160. Public attendance: 8,000-10,000. Free to public. Artists should apply by requesting application. Deadline for entry: March 29. Space fee: $145. Exhibition space: 10×8 ft. For more information, artists should call.
Tips "Display is very important; make it look good."

SOUTH CENTRAL & WEST

N ☑ FOURTH OF JULY STREET FAIR, AUTUMN FEST IN THE PARK AND HOLIDAY STREET FESTIVAL

501 Poli St. #226, Ventura CA 93002. (805)654-7830. Fax: (805)648-1030. E-mail: mgoody@ci.ventura.ca.us. Web site: www.venturastreetfair.com. **Contact:** Michelle Goody, cultural affairs coordinator. Estab. 1976. Fine arts & crafts show held annually in July, September and December. Outdoors. Accepts photography. Juried by a panel of 3 artists that specialize in various mediums; photos of work required. Number of exhibitors: 75-300. Public attendance: 1,000-50,000. Free to public. Artists should apply by downloading application from Web site or call to request application. Space fee: $100-175. Exhibition space: 10×10 ft. For more information, artists should e-mail, visit Web site or call.
Tips "Be friendly, outgoing; know the area for pricing."

N ☑ AFFAIRE IN THE GARDENS ART SHOW

Greystone Park, 501 Doheny Rd., Beverly Hills CA 90210-2921. (310)550-4796. Fax: (310)858-9238. E-mail: kmclean@beverlyhills.org. Web site: www.beverlyhills.org. **Contact:** Karen Fitch McLean, art show coordinator. Estab. 1973. Fine arts & crafts show held biannually 3rd weekend in May and 3rd weekend in October. Outdoors. Accepts photography, painting, sculpture, ceramics, jewelry, digital media. Juried. Awards/prizes: 1st Place in Category, cash awards; Best in Show, cash award; Mayor's Purchase Award in October show. Number of exhibitors: 225. Public attendance: 30,000-40,000. Free to public. Deadline for entry: May show: end of February; October show: end of July. Application fee: $25. Space fee: $300. Exhibition space: 10×12 ft. For more information, artists should e-mail, visit Web site, call or send SASE.
Tips "Art fairs tend to be commercially oriented. It usually pays off to think in somewhat commercial terms—what does the public usually buy? Personally, I like risky and unusual art, but the artists who produce esoteric art sometimes go hungry! Be nice and have a clean presentation."

N ☑ ART IN THE PARK

P.O. Box 247, Sierra Vista AZ 85636-0247. (520)378-1763. E-mail: artinthepark@cox.net. Web site: www.huachuco-art.com. **Contact:** Wendy Breen, co-chair. Estab. 1972. Fine arts & crafts show held annually 1st full weekend in October. Outdoors. Accepts photography, all fine arts and crafts created by vendor. Juried by 3-6 typical customers. Artists submit 6 photos. Number of exhibitors: 222. Public attendance: 20,000. Free to public. Artists should apply by calling, e-mailing or sending SASE between February and May. Deadline for entry: postmarked by May 30. Application fee: $10 included in space fee. Space fee: $175, includes jury fee. Exhibition space: 15×35 ft. For more information, artists should e-mail, call or send SASE.

N ☑ AVON FINE ART & WINE AFFAIRE

15648 N. Eagles Nest Dr., Fountain Hills AZ 85268-1418. (480)837-5637. Fax: (480)837-2355. E-mail: info@thun derbirdartists.com. Web site: www.thunderbirdsartists.com. **Contact:** Denise Colter, vice president. Estab. 1993. Fine arts & crafts show and wine tasting held annually mid-July. Outdoors. Accepts photography, painting, mixed media, bronze, metal, copper, stone, stained glass, clay, wood, paper, baskets, jewelry, scratchboard. Juried by 4 slides of work and 1 slide of booth. Number of exhibitors: 150. Public attendance: 3,000-6,000. Free to public. Artists should apply by sending application, fees, 4 slides of work, 1 slide of booth, and 2 SASEs. Deadline for entry: March 27. Application fee: $20. Space fee: $360-1,080. Exhibition space: 10×10 ft.-10×30 ft. For more information, artists should visit Web site.

N CALABASAS FINE ARTS FESTIVAL

26135 Mureau Rd., Calabasas CA 91302. (818)878-4225. E-mail: artcouncil@cityofcalabasas.com. Web site: www.cityofcalabasas.com. Estab. 1997. Fine arts & crafts show held annually in late April/early May. Outdoors. Accepts photography, painting, sculpture, jewelry, mixed media. Juried. Number of exhibitors: 250. Public attendance: 10,000+. Free to public. Artists should visit Web site or e-mail for more information.

N ☑ CHUN CAPITOL HILL PEOPLE'S FAIR

1290 Williams St., Denver CO 80218. (303)830-1651. Fax: (303)830-1782. E-mail: info@peoplesfair.com; chun@chundenver.org. Web site: www.peoplesfair.com; www.chundenver.org. Estab. 1971. Arts & crafts show held annually 1st weekend in June. Outdoors. Accepts photography, ceramics, jewelry, paintings, wearable art, glass, sculpture, wood, paper, fiber. Juried by professional artisans representing a variety of mediums and selected members of Fair Management. The jury process is based on originality, quality and expression. Awards/prizes: Best of Show. Number of exhibitors: 300. Public attendance: 250,000. Free to public. Artists should apply by downloading application from Web site. Deadline for entry: March. Application fee: $35. Space fee: $290. Exhibition space: 10×10 ft. For more information, artists should e-mail, visit Web site or call.

N ☑ EDWARDS FINE ART & SCULPTURE FESTIVAL

15648 N. Eagles Nest Dr., Fountain Hills AZ 85268-1418. (480)837-5637. Fax: (480)837-2355. E-mail: info@thun derbirdartists.com. Web site: www.thunderbirdsartists.com. **Contact:** Denise Colter, vice president. Estab. 1999. Fine arts & crafts show held annually in late July. Outdoors. Accepts photography, painting, drawing, graphics, fiber, sculpture, mixed media, bronze, metal, copper, stone, stained glass, clay, wood, baskets, jewelry. Juried by 4 slides of work and 1 slide of booth presentation. Number of exhibitors: 150. Public attendance: 3,000-6,000. Free to public. Artists should apply by completing application, fees, 4 slides of work, 1 slide of booth, and 2 SASEs. Deadline for entry: March 29. Application fee: $20. Space fee: $360-1,080. Exhibition space: 10×10 ft.-10×30 ft. For more information, artists should visit Web site.

N ☑ EVERGREEN ARTS FESTIVAL

P.O. Box 3931, Evergreen CO 80437-3931. (303)679-1609, opt. 1. E-mail: info@evergreenartists.org. Web site: http://www.evergreenartists.org/Shows_Festivals.htm. **Contact:** EAA Arts Festival Coordinator. Estab. 1966. Fine arts & crafts show held annually last weekend in August. Outdoors. Accepts photography, fiber, oil, acrylic, pottery, jewelry, mixed media, ceramic, wood, watercolor. Juried by 5 jurors that change yearly. Artists should submit 4 slides of work and 1 of booth display. Awards/prizes: Best of Show; 1st, 2nd, 3rd Places in each category. Number of exhibitors: 96. Public attendance: 3,000-6,000. Free to public. Deadline for entry: April 15. Application fee: $25. Space fee: $275-325. Exhibition space: 10×10 ft. For more information, artists should call or send SASE.
Tips ''Have a variety of work. It is difficult to sell only high-ticketed items.''

FAIRE ON THE SQUARE

117 W. Goodwin St., Prescott AZ 86301-1147. (928)445-2000, ext. 12. Fax: (928)445-0068. E-mail: scott@prescot t.org. Web site: www.prescott.org. **Contact:** Scott or Jill Currey (Special Events—Prescott Chamber of Commerce). Estab. 1985. Arts & crafts show held annually Labor Day weekend. Outdoors. Accepts photography, ceramics, painting, sculpture, clothing, woodworking, metal art, glass, floral, home décor. ''No resale.'' Juried. ''Photos of work and artist creating work are required.'' Number of exhibitors: 170. Public attendance: 10,000-12,000. Free to public. Application can be printed from Web site or obtained by phone request. Deadline: spaces are sold until show is full. Application fee: $50 deposit. Space fee: $400. Exhibition space; 10×15 ft. For more information, artists should e-mail, visit Web site or call.

FALL FEST IN THE PARK

117 W. Goodwin St., Prescott AZ 86301-1147. (928)445-2000, ext. 12. Fax: (928)445-0068. E-mail: scott@prescot t.org. Web site: www.prescott.org. **Contact:** Scott or Jill Currey (Special Events—- Prescott Chamber of Com-

merce) Estab. 1981. Arts & crafts show held annually in mid-October. Outdoors. Accepts photography, ceramics, painting, sculpture, clothing, woodworking, metal art, glass, floral, home décor. "No resale." Juried. "Photos of work and artist creating work are required." Number of exhibitors: 150. Public attendance: 6,000-7,000. Free to public. Application can be printed from Web site or obtained by phone request. Deadline: spaces are sold until show is full. Application fee: $50 deposit. Space fee: $225. Exhibition space; 10×15 ft. For more information, artists should e-mail, visit Web site or call.

N ☑ FALL FESTIVAL OF ART AT QUEENY PARK
P.O. Box 190846, St. Louis MO 63119-6846. (314)889-0433. E-mail: info@gshaa.com. Web site: www.gslaa.com. **Contact:** Camille Latzer, show chair. Estab. 1976. Fine arts & crafts show held annually Labor Day weekend at Queeny Park. Indoors. Accepts photography, all fine art and fine craft categories. Juried by 5 jurors; 5 slides shown simultaneously. Awards/prizes: $4,000+ total prizes. Number of exhibitors: 130. Public attendance: 2,000-4,000. Public admission: $5 with free return. Deadline for entry: late May; see Web site for specific date. Application fee: $15. Space fee: $175. Exhibition space: 80 sq. ft. For more information, artists should e-mail or visit Web site.
Tips "Excellent, professional slides; neat, interesting booth. But most importantly—exciting, vibrant, eye-catching art work."

N ☑ FILLMORE JAZZ FESTIVAL
Fillmore St., between Jackson & Eddy, San Francisco CA 94115. (800)731-0003. Fax: (510)236-1691. E-mail: art@fillmorejazzfestival.com. Web site: www.fillmorejazzfestival.com. **Contact:** Sarah Myers, project manager. Estab. 1984. Fine arts & crafts show and jazz festival held annually 1st weekend of July. Outdoors. Accepts photography, ceramics, glass, paintings, jewelry, sculpture, metal, clay, wood, clothing. Juried by prescreened panel. Number of exhibitors: 250. Public attendance: 90,000. Free to public. Deadline for entry: ongoing. Space fee: $350-600. Exhibition space: 8×10 ft. or 10×10 ft. Average gross sales/exhibitor: $800-11,000. For more information, artists should e-mail, visit Web site or call.

N ☑ GRAND FESTIVAL OF THE ARTS & CRAFTS
P.O. Box 429, Grand Lake CO 80447-0429. (970)627-3372. Fax: (970)627-8007. E-mail: glinfo@grandlakechamber.com. Web site: www.grandlakechamber.com. **Contact:** Cindy Cunningham, events coordinator; Elaine Arguien, office chamber. Fine arts & crafts show held annually 1st weekend in June. Outdoors. Accepts photography, jewelry, leather, mixed media, painting, paper, sculpture, wearable art. Juried by chamber committee. Awards/prizes: Best in Show and People's Choice. Number of exhibitors: 50-55. Public attendance: 1,000+. Free to public. Artists should apply by submitting slides or photos. Deadline for entry: May 1. Application fee: $125, includes space fee, security deposit and business license. Exhibition space: 10×10 ft. For more information, artists should e-mail or call.

N HOME DECORATING & REMODELING SHOW
P.O. Box 230699, Las Vegas NV 89105-0699. (702)450-7984; (800)343-8344. Fax: 702)451-7305. E-mail: spvandy@cox.net. Web site: www.nashvillehomeshow.com. **Contact:** Vandy Richards, manager member. Estab. 1983. Home show held annually in September. Indoors. Accepts photography, sculpture, watercolor, oils, mixed media, pottery. Awards/prizes: Outstanding Booth Award. Number of exhibitors: 300-350. Public attendance: 25,000. Public admission: $8. Artists should apply by calling. Marketing is directed to middle- and above-average income brackets. Deadline for entry: open until filled. Space fee: $790+. Exhibition space: 9×10 ft. or complement of 9×10 ft. For more information, artists should call.

N ☑ KINGS MOUNTAIN ART FAIR
13106 Skyline Blvd., Woodside CA 94062. (650)851-2710. E-mail: kmafsecty@aol.com. **Contact:** Carrie German, administrative assistant. Estab. 1963. Fine arts & crafts show held annually Labor Day weekend. Accepts photography, ceramics, clothing, 2D painting, glass, jewelry, leather, sculpture, textile/fiber, wood. Juried. Number of exhibitors: 135. Public attendance: 10,000. Free to public. Deadline for entry: January 30. Application fee: $10. Space fee: $100 plus 15% commission. Exhibition space: 10×10 ft. Average gross sales/exhibitor: $3,000. For more information, artists should e-mail, visit Web site, call or send SASE.

N ☑ LAKE CITY ARTS & CRAFTS FESTIVAL
P.O.Box 1147, Lake City, CO 81235. (970)944-2706. E-mail: jlsharpe@centurytel.net. Web site: www.lakecityarts.org. **Contact:** Laura Sharpe, festival director. Estab. 1975. Fine arts/arts & craft show held annually in mid-July. One-day event. Outdoors. Accepts photography, jewelry, metal work, woodworking, painting, handmade items. Juried by an undisclosed 4-member jury. Prize: Winners are entered in a drawing for a free booth space in the following year's show. Number of exhibitors: 85. Public attendance: 500. Free to the public. Deadline

for entry: May 1, 2007. Application fee: $75. Exhibition space: 12×12 ft. Average gross sales/exhibitor: $500-$1,000. For more information, artists should visit Web site.

Tips "Repeat vendors draw repeat customers. People like to see their favorite vendors each year or every other year. If you come every year, have new things as well as your best-selling products."

N ♥ LITCHFIELD LIBRARY ARTS & CRAFTS FESTIVAL

101 W Wigwam Blvd., Litchfield Pk AZ 85340. (623)935-5053. E-mail: tinalibrary@qwest.net. **Contact:** Tina Norwalk, administrator. Estab. 1970. Fine arts & crafts show held annually 1st weekend in November. Outdoors. Accepts photography and all mediums. Juried. Number of exhibitors: 300. Public attendance: 125,000. Free to public. Artists should apply by calling for application. Deadline for entry: July 15. Space fee: $300. Exhibition space: 10×15 ft. For more information, artists should call.

Tips "Professional display and original art."

N ♥ LOMPOC FLOWER FESTIVAL

P.O. Box 723, Lompoc CA 93438. (805)735-9501. Web site: www.lompocvalleyartsassociation.com. **Contact:** Marie Naar, chairman. Estab. 1942. Fine arts & crafts show held annually last week in June. Event includes a parade, food booths, entertainment, beer garden and commercial center, which is not located near arts & crafts. Outdoors. Accepts photography, fine art, woodworking, pottery, stained glass, fine jewelry. Juried by 5 members of the Lompoc Valley Art Association. Vendor must submit 5 photos of their craft and a description on how to make the craft. Number of exhibitors: 95. Public attendance: 95,000+. Free to public. Artists should apply by calling the contact person for application or download application from Web site. Deadline for entry: April 1. Space fee: $173 plus insurance. Exhibition space: 16×16 ft. For more information, artists should visit Web site, call or send SASE.

Tips "Artists should have prices that are under $100 to succeed."

N ♥ MAIN AVENUE ARTS FESTIVAL

802 E. Second Ave., Durango CO 81301. (970)259-2606. Fax: (970)259-6571. E-mail: brian@durangoarts.org. Web site: www.durangoarts.org. **Contact:** Susan Anderson, ehibits director. Estab. 1993. Fine arts & crafts show held annually 2nd full weekend in August. Outdoors. Accepts photography and all mediums. Juried. Awards/prizes: Juror's Choice: $250; Best of Show, fine art: $250. Number of exhibitors: 100. Public attendance: 8,000. Free to public. Application fee: $25. Space fee: $230. Exhibition space: 10×10 ft. For more information, artists should e-mail, visit Web site or send SASE.

N ♥ MID-MISSOURI ARTISTS CHRISTMAS ARTS & CRAFTS SALE

P.O. Box 116, Warrensburg MO 64093. (660)747-6092. E-mail: bjsmith@iland.net or rlimback@iland.net. **Contact:** Beverly Smith. Estab. 1970. Holiday arts & crafts show held annually in November. Indoors. Accepts photography and all original arts and crafts. Juried by 3 good-quality color photos (2 of the artwork, 1 of the display). Number of exhibitors: 50. Public attendance: 1,000. Free to the public. Artists should apply by e-mailing or calling for an application form. Deadline for entry: November. Space fee: $50. Exhibition space: 10×10 ft. For more information, artists should e-mail or call.

Tips "Items under $100 are most popular."

N ♥ NAPA WINE & CRAFTS FAIRE

1556 First St., Suite 102, Napa CA 94559. (707)257-0322. Fax: (707)257-1821. E-mail: craig@napadowntown.com. Web site: www.napadowntown.com. **Contact:** Craig Smith, executive director. Wine & crafts show held annually in September. Outdoors. Accepts photography, jewelry, clothing, woodworking, glass, dolls, candles and soaps, garden art. Juried based on quality, uniqueness, and overall craft mix of applicants. Number of exhibitors: over 200. Public attendance: 20,000-30,000. Artists should apply by contacting the event coordinator, Marla Bird, at (707)299-0712 to obtain an application form. Application forms are also available on Web site. Application fee: $15. Space fee: $200. Exhibition space: 10×10 ft. For more information, artists should e-mail, visit Web site or call.

Tips "Electricity is available, but limited. There is a $40 processing fee for cancellations."

N ♥ PASEO ARTS FESTIVAL

3022 Paseo, Oklahoma City OK 73103. (405)525-2688. Web site: www.ThePaseo.com. **Contact:** Suzanne Owens, executive director. Estab. 1976. Fine arts & crafts show held annually Memorial Day weekend. Outdoors. Accepts photography and all fine art mediums. Juried by submitting 3 slides or CDs. Awards/prizes: $1,000, Best of Show. Number of exhibitors: 75. Public attendance: 40,000. Free to public. Artists should apply by calling for application form. Deadline for entry: March 1. Application fee: $25. Space fee: $250. Exhibition space: 10×10 ft. For more information, artists should visit Web site, call or send SASE.

N ☑ PATTERSON APRICOT FIESTA

P.O. Box 442, Patterson CA 95363. (209)892-3118. Fax: (209)892-3388. E-mail: patterson-apricot-fiesta@hotmail.com. Web site: www.patterson-ca.com. **Contact:** Chris Rodriguez, chairperson. Estab. 1984. Arts & crafts show held annually in June. Outdoors. Accepts photography, oils, leather, various handcrafts. Juried by type of product; number of artists already accepted; returning artists get priority. Number of exhibitors: 140-150. Public attendance: 25,000. Free to the public. Deadline for entry: approximately April 15. Application fee/space fee: $130. Exhibition space: 12 × 12 ft. For more information, artists should call, send SASE.

Tips "Please get your applications in early!"

N ☑ RIVERBANK CHEESE & WINE EXPOSITION

3300 Santa Fe St., Riverbank CA 95367-2317. (209)869-4541. Fax: (209)869-4639. E-mail: riverbankchamber@charter.net. Web site: www.riverbankchamber.net. **Contact:** Kim Velasquez, chamber manager. Estab. 1977. Arts & crafts show and commercial & food show held annually 2nd weekend in October. Outdoors. Accepts photography, other mediums—depends on the product. Juried by pictures and information about the artists. Number of exhibitors: 400. Public attendance: 70,000-80,000. Free to public. Artists should apply by calling and requesting an application. Deadline for entry: June 30th. Space fee: $260/arts & crafts; $380/commercial. Exhibition space: 10 × 12 ft. For more information, artists should e-mail, visit Web site, call or send SASE.

Tips "Make sure your display is pleasing to the eye."

N ☑ SANTA CALI GON DAYS FESTIVAL

P.O. Box 1077, Independence MO 64051. (816)252-4745. Fax: (816)252-4917. E-mail: tfreeland@independencechamber.org. Web site: www.santacaligon.com. **Contact:** Teresa Freeland, special projects assistant. Estab. 1940. Market vendors show held annually Labor Day weekend. Outdoors. Accepts photography, all other mediums. Juried by committee. Number of exhibitors: 240 market vendors. Public attendance: 225,000. Free to public. Artists should apply by requesting application. Application requirements include completed application, application fee, 4 photos of product/art and 1 photo of display. Deadline for entry: March 6-April 7. Application fee: $20. Space fee: $330-430. Exhibition space: 8 × 8 ft.-10 × 10 ft. For more information, artists should e-mail, visit Web site or call.

N ☑ SIERRA MADRE WISTORIA FESTIVAL

78 W. Sierra Madre Blvd., Sierra Madre CA 91024. (626)355-5111. Fax: (626)306-1150. E-mail: info@sierramadrechamber.com. Web site: www.SierraMadrechamber.com. Estab. 100 years ago. Fine arts, crafts and garden show held annually in March. Outdoors. Accepts photography, anything handcrafted. Juried based on appropriateness. Awards/prizes: Sometimes newspapers will do special coverage of a particular artist. Number of exhibitors: 175. Public attendance: 12,000. Free to public. Artists should apply by sending completed and signed application, 3-5 photographs of their work, application fee, license application, space fee and 2 SASEs. Deadline for entry: November 30. Application fee: $15. Space fee: $177. Exhibition space: 10 × 10 ft. For more information, artists should e-mail, visit Web site or call.

Tips "Have a clear and simple application. Be nice."

N ☑ SOLANO AVENUE STROLL

1563 Solano Ave. #PMB 101, Berkeley CA 94707. (510)527-5358. Fax: (510)548-5335. E-mail: saa@solanoave.org. Web site: www.solanoave.org. **Contact:** Lisa Bullwinkel, executive director. Estab. 1974. Fine arts & crafts show held 2nd Sunday in September. Outdoors. Accepts photography and all other mediums. Juried by board of directors. Jury fee: $10. Number of exhibitors: 140 spaces for crafts; 600 spaces total. Public attendance: 300,000. Free to the public. Artists should apply online after April 1, or send SASE. Deadline for entry: June 1. Space fee: $10. Exhibition space: 10 × 10 ft. For more information, artists should e-mail, visit Web site, send SASE.

Tips "Artists should have a clean presentation; small-ticket items as well as large-ticket items; great customer service; enjoy themselves."

N ☑ ST. GEORGE ART FESTIVAL

86 S. Main St., George UT 84770. (435)634-5850. Fax: (435)634-0709. E-mail: leisure@sgcity.org. Web site: www.sgcity.org. **Contact:** Carlene Garrick, administrator assistant. Estab. 1979. Fine arts & crafts show held annually Easter weekend in either March or April. Outdoors. Accepts photography, painting, wood, jewelry, ceramics, sculpture, drawing, 3D mixed media, glass. Juried from slides. Awards/prizes: $5,000 Purchase Awards. Art pieces selected will be placed in the city's permanent collections. Number of exhibitors: 110. Public attendance: 20,000/day. Free to public. Artists should apply by completing application form, nonrefundable application fee, slides or digital format of 4 current works in each category and 1 of booth, and SASE. Deadline

for entry: January 6. Application fee: $20. Space fee: $125. Exhibition space: 10×11 ft. For more information, artists should e-mail.

Tips "Artists should have more than 50% originals. Have quality booths and set-up to display art in best possible manner. Be outgoing and friendly with buyers."

STILLWATER ARTS & HERITAGE FESTIVAL

P.O. Box 1449, Stillwater OK 74074. (405)533-8541. Fax: (405)533-3097. **Contact:** Jessica Novak, festival director. Estab. 1977. Fine arts & crafts show held annually in April. Outdoors. Accepts photography, oil, acrylic, watercolor and multimedia paintings, pottery, pastel work, fiber arts, jewelry, sculpture, glass art. Juried by a committee of 3-5 jurors. Awards/prizes: Best of Show: $250; 1st Place: $100; 2nd Place: $75, and 3rd Place: $50. Number of exhibitors: 70. Public attendance: 7,500-10,000. Free to public. Artists should apply by calling for an application to be mailed or e-mailed. Deadline for entry: early February. Application fee: $65. Exhibition space: 11×11 ft. Average gross sales/exhibitor: $500. For more information, artists should call.

STRAWBERRY JUNCTION ARTS & CRAFTS SHOW

13858 N. Pumpkin Hollow, Proctoe OK 74457-3236. (918)456-0113. **Contact:** Cleva Smith, coordinator. Estab. 1985. Arts & crafts show held annually at various times throughout the year. Indoors. Accepts handmade arts and crafts and some photography. Juried by 3 photos. Number of exhibitors: 30-80. Free to public. Artists should apply by contacting the coordinator. Deadline for entry: until full. Application fee: $60. Space fee: $160 per 10×10 ft. Exhibition space: 10×10 ft.-10×20 ft. Average gross sales/exhibitor: $800-1,500. For more information, artists should call or send SASE.

SUN FEST, INC.

P.O. Box 2404, Bartlesville OK 74005. (918)914-2826. Fax: (918)331-3351. E-mail: lhigbee@tctc.org. **Contact:** Laura Higbee, chair of board. Estab. 1982. Fine arts & crafts show held annually in early June. Outdoors. Accepts photography, painting, other arts and crafts. Juried. Awards/prizes: $2,000; free booth rental for following year for 3 artists and 3 crafters. Number of exhibitors: 95-100. Number of attendees: 25,000-30,000. Free to the public. Artists should apply by e-mailing or calling for an entry form, or visit Web site. Application fee: $110 ($135 for late application). Exhibition space: 10×10 ft. For more information, artists should e-mail, call or visit Web site.

TILLES ARTS & CRAFT FESTIVAL

9551 Litzsinger Rd., St. Louis MO 63124. (636)391-0922, ext. 12. Fax: (636)527-2259. E-mail: toconnell@stlouisco.com. Web site: www.stlouisco.com/parks. **Contact:** Tonya O'Connell, recreation supervisor. Fine arts & crafts show held biannually in May and September. Outdoors. Accepts photography, oil, acrylic, clay, fiber, sculpture, watercolor, jewelry, wood, floral, basket, print, drawing, mixed media. Juried by a committee. Awards/prizes: $100. Number of exhibitors: 90-100. Public attendance: 5,000. Public admission: $1. Deadline for entry: March, spring show; May, fall show. Application fee: $15. Space fee: $75. Exhibition space: 10×10 ft. For more information, artists should call.

TULSA INTERNATIONAL MAYFEST

321 S. Boston #101, Tulsa OK 74103. (918)582-6435. Fax: (918)587-7721. E-mail: comments@tulsamayfest.org. Web site: www.tulsamayfest.org. Estab. 1972. Fine arts & crafts show held annually in May. Outdoors. Accepts photography, clay, leather/fiber, mixed media, drawing, pastel, graphics, printmaking, jewelry, glass, metal, wood, painting. Juried by a blind jurying process. Artists should submit 4 slides of work and 1 of booth set-up. Awards/prizes: Best in Category and Best in Show. Number of exhibitors: 120. Public attendance: 350,000. Free to public. Artists should apply by downloading application in late November. Deadline for entry: January 16. Application fee: $25. Space fee: $300. Exhibition space: 10×10 ft. For more information, artists should e-mail or visit Web site.

NORTHWEST

ANACORTES ARTS FESTIVAL

505 "O" St., Anacortes WA 98221. (360)293-6211. E-mail: info@anacortesartsfestival.com. Web site: www.anacortesartsfestival.com. **Contact:** Mary Leone. Fine arts & crafts show held annually 1st full weekend in August. Accepts photography, painting, drawings, prints, ceramics, fiber art, paper art, glass, jewelry, sculpture, yard art, woodworking. Juried by projecting 3 images on a large screen. Works are evaluated on originality, quality and marketability. Each applicant must provide 3 high-quality digital images or slides—2 of the product and 1 of the booth display. Awards/prizes: over $4,000 in prizes. Number of exhibitors: 250. Artists should apply by visiting Web site for

online submission or by mail (there is a $25 processing fee for application by mail). Deadline for entry: early March. Space fee: $300. For more information, artists should see Web site.

N ANNUAL ARTS & CRAFTS FAIR

Pend Oreille Arts Council, P.O. Box 1694, Sandpoint ID 83864. (208)263-6139. E-mail: art@sandpoint.net. Web site: www.ArtinSandpoint.org. Estab. 1962. Arts & crafts show held annually in August. Outdoors. Accepts photography and all handmade, noncommercial works. Juried by an 8-member jury. Number of exhibitors: 100. Public attendance: 5,000. Free to public. Artists should apply by sending in application. Deadline for entry: May 1. Application fee: $15. Space fee: $150-230. Exhibition space: 10×10 ft. or 10×15 ft. For more information, artists should e-mail, visit Web site, call or send SASE.

N 🖾 ART & JAZZ ON BROADWAY

P.O. Box 583, Philipsburg MT 59858. **Contact:** Sherry Armstrong at hitchinpost@blackfoot.net or (406)859-0366, or Liz Willett at kokopellilane@mac.com or (406)859-3189. Estab. 2000. Fine arts/jazz show held annually in August. Outdoors. Accepts photography and handcrafted, original, gallery-quality fine arts and crafts media made by selling artist. Juried by Flint Creek Valley Arts Council. Number of exhibitors: 75. Public attendance: 1,500-2,000. Admission fee: donation to Flint Creek Valley Arts Council. Artists should e-mail or call for an entry form. Application fee: $45. Exhibtion space: 10×10 ft. Artists should e-mail or call for more information.

Tips ''Be prepared for temperatures of 100 degrees or rain. Display in a professional manner. Friendliness is crucial; fair pricing is essential.''

N 🖾 ARTS IN THE PARK

302 2nd Ave. East, Kalispell MT 59901. (406)755-5268. Fax: (405)755-2023. E-mail: information@hackadaymuseum .org. Web site: www.hockadaymuseum/artpark.htm. Estab. 1968. Fine arts & crafts show held annually 4th weekend in July. Outdoors. Accepts photography, jewelry, clothing, paintings, pottery, glass, wood, furniture, baskets. Juried by a panel of 5 members. Artwork is evaluated for quality, creativity and originality. Jurors attempt to achieve a balance of mediums in the show. Awards/prizes: $100, Best Booth Award. Number of exhibitors: 100. Public attendance: 10,000. Public admission: $5/weekend pass; $3/day pass; under 12, free. Artists should apply by sending the application form, entry fee, a SASE and a CD containing 5 images in JPEG format; 4 images of work and 1 of booth. Deadline for entry: May 1. Application fee: $25. Space fee: $160-425. Exhibition space: 10×10 ft.-10×20 ft. For more information, artists should e-mail, visit Web site or call.

N 🖾 THE BIG ONE ARTS & CRAFTS SHOW

313-29th Ave. NE, Great Falls MT 59404-1005.E-mail: giskaasent@bresnan.net. **Contact:** Sue Giskaas, owner/promoter. Estab. 1990. Arts & crafts show held annually in mid-September. Indoors. Accepts photography, anything handmade, no resale. Juried by management selects. Number of exhibitors: 141. Public attendance: 5,000. Public admission: $2. Artists should apply by sending SASE to above address. Deadline for entry: August 15. Space fee: $125-195. Exhibition space: 10×10 ft.-10×15 ft. For more information, artists should e-mail, call or send SASE.

N 🖾 THE CRAFTSMEN'S CHRISTMAS ARTS & CRAFTS SHOW

313-29th Ave. NE, Great Falls MT 59404-1005. (406)453-3120. E-mail: giskaasent@bresnan.net. **Contact:** Sue Giskaas, owner/promoter. Estab. 2005. Arts & crafts show held annually in early November. Indoors. Accepts photography, anything handmade, no resale. Juried by management selects. Number of exhibitors: 85. Public attendance: 5,000. Public admission: $2. Artists should apply by sending SASE to above address. Deadline for entry: October 1. Space fee: $125. Exhibition space: 10×10 ft. For more information, artists should e-mail, call or send SASE.

N SIDEWALK ART MART

225 Cruse Ave. B, Helena MT 59601. (406)447-1535. Fax: (406)447-1533. E-mail: hlnabid@mt.net. Web site: www.downtownhelena.com. **Contact:** Joan More, programs and event manager. Estab. 1974. Arts, crafts & music festival held annually in July. Outdoors. Accepts photography. No restrictions except to display appropriate work for all ages. Number of exhibitors: 50+. Public attendance: 5,000. Free to public. Artists should apply by visiting Web site to download application. Space fee: $100-125. Exhibition space: 10×10 ft. For more information, artists should e-mail, visit Web site or call.

Tips ''Greet people walking by and have an eye-catching product in front of booth. We have found that high-end artists or expensively priced art booths that had business cards with e-mail or Web site information received many contacts after the festival.''

N ⚑ THE SPRING THING ARTS & CRAFTS SHOW

313 29th Ave. NE, Great Falls MT 59404-1005. (406)453-3120. E-mail: glskaasent@bresnan.net. **Contact:** Sue Giskass, owner/promoter. Estab. 2001. Arts & crafts show held annually in early May. Indoors. Accepts photography and any medium as long as it is handmade. No resale. Juried by management selections. Number of exhibitors: 85. Public attendance: 4,000. Public admission: $2. Artists should apply by sending SASE to above address. Deadline for entry: April 1. Space fee: $100-165. Exhibition space: 10×10 ft.-10×15 ft. For more information, artists should e-mail, call or send SASE.

Tips "Make your booth look professional."

N ⚑ STRAWBERRY FESTIVAL

2815 2nd Ave. N., Billings MT 59101. (406)259-5454. Fax: (406)294-5061. E-mail: lisaw@downtownbillings.com. Web site: www.strawberryfun.com. **Contact:** Lisa Woods, executive director. Estab. 1991. Fine arts & crafts show held annually 2nd Saturday in June. Outdoors. Accepts photography. Juried. Number of exhibitors: 76. Public attendance: 15,000. Free to public. Artists should apply by application available on the Web site. Deadline for entry: April 14. Exhibition space: 12×12 ft. For more information, artists should visit Web site.

N ⚑ TULIP FESTIVAL STREET FAIR

P.O. Box 1801, Mt. Vernon WA 98273. (360)226-9277. E-mail: dwntwnmv@cnw.com. Web site: www.downtownmountvernon.com. **Contact:** Executive Director. Estab. 1984. Arts & crafts show held annually 3rd weekend in April. Outdoors. Accepts photography and original artists' work only. No manufactured work. Juried by a board. Jury fee: $10 with application and prospectus. Number of exhibitors: 215-220. Public attendance: 20,000-25,000. Free to public. Artists should apply by calling or e-mailing request. Deadline for entry: January 30. Application fee: $10. Space fee: $80-160. Exhibition space: 10×10 ft. Average gross sales/exhibitor: $2,500-4,000. For more information, artists should e-mail, visit Web site, call or send SASE.

Tips "Keep records of your street fair attendance and sales for your résumé. Network with other artists about which street fairs are better to return to or apply for."

N ⚑ WHITEFISH ARTS FESTIVAL

P.O. Box 131, Whitefish MT 59937. (406)862-5875. Fax: (406)862-3515. Web site: www.whitefishartsfestival.org. **Contact:** Brenda deNeui, coordinator. Estab. 1979. Fine arts & crafts show held annually 1st weekend in July. Outdoors. Accepts photography, pottery, jewelry, sculpture, paintings, woodworking. Juried. Art must be original and handcrafted. Work is evaluated for creativity, quality and originality. Awards/prizes: Best of Show awarded half-price booth fee for the following year with no application fee. Number of exhibitors: 100. Public attendance: 3,000. Free to public. Deadline for entry: April 14. Application fee: $20. Space fee: $195. Exhibition space: 10×10 ft. For more information, artists should e-mail, visit Web site or call.

Tips Recommends "variety of price range, professional display, early application for special requests."

Syndicates & Cartoon Features

Syndicates are agents who sell comic strips, panels and editorial cartoons to newspapers and magazines. If you want to see your comic strip in the funny papers, you must first get the attention of a syndicate. They promote and distribute comic strips and other features in exchange for a cut of the profits.

The syndicate business is one of the hardest markets to break into. Newspapers are reluctant to drop long-established strips for new ones. Consequently, spaces for new strips do not open up often. When they do, syndicates look for a "sure thing," a feature they'll feel comfortable investing more than $25,000 in for promotion and marketing. Even after syndication, much of your promotion will be up to you.

To crack this market, you have to be more than a fabulous cartoonist—the art won't sell if the idea isn't there in the first place. Work worthy of syndication must be original, salable and timely, and characters must have universal appeal to attract a diverse audience. And you'll need lots of fortitude in the face of rejection along the way.

Although newspaper syndication is still the most popular and profitable method of getting your comic strip to a wide audience, the Internet has become an exciting new venue for comic strips. There are hundreds of strips available on the Web. With the click of your mouse, you can be introduced to *Bad Reporter*, by Don Asmussen; *The Fusco Brothers*, by J.C. Duffy; and *Nest Heads*, by John Allen. (UComics.com provides a great list of online comics.)

Such sites may not make much money for cartoonists, but it's clear they are a great promotional tool. It is rumored that scouts for the major syndicates have been known to surf the more popular comic strip sites in search of fresh voices.

HOW TO SUBMIT TO SYNDICATES

Each syndicate has a preferred method for submissions, and most have guidelines you can send for or access on the syndicate's Web site. Availability is indicated in the listings.

To submit a strip idea, send a brief cover letter (50 words or less is ideal) summarizing your idea, along with a character sheet (the names and descriptions of your major characters) and photocopies of 24 of your best strip samples on $8\frac{1}{2} \times 11$ paper, six daily strips per page. Sending at least one month of samples shows that you're capable of producing high-quality humor, consistent artwork and a long lasting idea. Never submit originals; always send photocopies of your work. Simultaneous submissions are acceptable. It is often possible to query syndicates online, attaching art files or links to your Web site. Response time can take several months. Syndicates understand it would be impractical for you to wait for replies before submitting your ideas to other syndicates.

Editorial cartoons

If you're an editorial cartoonist, you'll need to start out selling your cartoons to a base newspaper (probably in your hometown) and build up some clips before approaching a syndicate. Submitting published clips proves to the syndicate that you have a following and are able to produce cartoons on a regular basis. Once you've built up a good collection of clips, submit at least 12 photocopied samples of your published work along with a brief cover letter.

Payment and contracts

If you're one of the lucky few to be picked up by a syndicate, your earnings will depend on the number of publications in which your work appears. It takes a minimum of about 60 interested newspapers to make it profitable for a syndicate to distribute a strip. A top strip such as *Garfield* may be in as many as 2,000 papers worldwide.

Newspapers pay in the area of $10-15 a week for a daily feature. If that doesn't sound like much, multiply that figure by 100 or even 1,000 newspapers. Your payment will be a percentage of gross or net receipts. Contracts usually involve a 50/50 split between the syndicate and cartoonist. Check the listings for more specific payment information.

Before signing a contract, be sure you understand the terms and are comfortable with them.

Self-syndication

Self-syndicated cartoonists retain all rights to their work and keep all profits, but they also have to act as their own salespeople, sending packets to newspapers and other likely outlets. This requires developing a mailing list, promoting the strip (or panel) periodically, and developing a pricing, billing and collections structure. If you have a knack for business and the required time and energy, this might be the route for you. Weekly suburban or alternative newspapers are the best bet here. (Daily newspapers rarely buy from self-syndicated cartoonists.)

Helpful Resources

For More Info

You'll get an excellent overview of the field by reading *Your Career in Comics*, by Lee Nordling (Andrews McMeel), a comprehensive review of syndication from the viewpoints of the cartoonist, the newspaper editor and the syndicate. *Successful Syndication: A Guide for Writers and Cartoonists*, by Michael H. Sedge (Allworth Press), also offers concrete advice to aspiring cartoonists.

Another great source of information is Stu's Comic Strip Connection at www.stus.com/index2.htm. Here you'll find links to most syndicates and other essential sources, including helpful books, courtesy of Stu Rees.

ARTIZANS.COM

11149 65th St. NW, Edmonton AB T5W 4K2 Canada. e-mail submissions@artizans.com. Web site: www.artizan s.com. **Submission Editor:** Malcom Mayes. Estab. 1998. Artist agency and syndicate providing commissioned artwork, stock illustrations, political cartoons, gag cartoons, global caricatures, humorous illustrations to magazines, newspapers, Web sites, corporate and trade publications and ad agencies. Submission guidelines available on Web site. Artists represented include Jan Op De Beeck, Aaron Bacall and Dusan Petricic.

Needs Works with 30-40 artists/year. Buys 30-40 features/year. Needs single panel cartoons, caricatures, illustrations, graphic and clip art. Prefers professional artists with track records who create artwork regularly and artists who have archived work or a series of existing cartoons, caricatures and/or illustrations.

First Contact & Terms Send cover letter and copies of cartoons or illustrations. Send 6-20 examples if sending via e-mail; 24 if sending via snail mail. "In your cover letter, tell us briefly about your career. This should inform us about your training, what materials you use and where your work has been published." Resume and samples of published cartoons would be helpful but are not required. E-mail submission should include a link to other online examples of your work. Replies in 2 months. Artist receives 50-75%. Payment varies depending on artist's sales. Artists retain copyright. Our clients purchase a variety of rights from the artist.

Tips We are only interested in professional artists with a track record. See our Web site for guidelines.

" DOCTOR GORDON... THERE'S A DRUG DEALER HERE TO SEE YOU... "

Cartoonist Ron Coleman uses an e-mail campaign to woo potential markets for his cartoons. Coleman includes a link to his Web site www.coleman-cartoons.com and offers to deliver his cartoon digitally.

ATLANTIC SYNDICATION
4520 Main Street, Kansas City MO 64111. (816)360-6887. Fax: (816)932-6625. E-mail: kslagle@atlanticsyndicati on.com. Web site: www.atlanticsyndication.com. **President:** Mr. Kerry Slagle. Estab. 1933. Syndicate representative servicing 1,700 publications daily and weekly newspapers and magazines. International, US and Canadian sales. Recent introductions include *Pooch Cafe* and *Pepe*. Several of this syndicate's strips are offered in multiple languages. *Pepe* is offered in Spanish and English.
Needs Buys from 1-2 freelancers/year. Introduces 1-2 new strips/year. Considers comic strips, gag cartoons, caricatures, editorial/political cartoons and illustrations. Considers single, double and multiple panel, pen & ink. Prefers non-American themes. Maximum size of artwork 11×17. Does not accept unsolicited submissions.
First Contact & Terms Send cover letter, finished cartoons, tearsheets and photocopies. Include 24-48 strips/ panels. Does not want to see original artwork. Include SASE for return of materials. Pays 50% of gross income. Buys all rights. Minimum length of contract 2 years. Artist owns original art and characters.
Tips "Look for niches. Study, but do not copy the existing competition. Read the newspaper!" Looking for "well-written gags and strong character development."

CELEBRATION: AN ECUMENICAL WORSHIP RESOURCE
Box 419281, Kansas City MO 64141-6493. (800)444-8910. Fax: (816)968-2268. E-mail: patmarrin@aol.com. Web site: www.celebrationpubs.org. **Editor:** Patrick Marrin. Syndicate serving churches, clergy and worship committees.
Needs Buys 50 religious theme cartoons/year. Does not run an ongoing strip. Buys cartoons on church themes (worship, clergy, scripture, etc.) with a bit of the offbeat.
First Contact & Terms Originals returned to artist at job's completion. Payment upon use, others returned. Send copies. Simultaneous submissions OK. Pays $30/cartoon. "We grant reprint permission to subscribers to use cartoons in parish bulletins, but we request they send the artist an additional $5. Celebration is published both in print and online in pdf format.
Tips "We only use religious themes (black & white). The best cartoons tell the 'truth' —about human nature, organizations —by using humor."

CITY NEWS SERVICE, L.L.C.
Box 39, Willow Springs MO 65793. (417)469-2423. E-mail: cns@townsqr.com. **President:** Richard Weatherington. Estab. 1969. Editorial service providing editorial and graphic packages for magazines.
Needs Buys from 12 or more freelance artists/year. Considers caricature, editorial cartoons and tax and business subjects as themes; considers b&w line drawings and shading film.
First Contact & Terms Send query letter with résumé, tearsheets or photocopies. Samples should contain business subjects. "Send 5 or more b&w line drawings, color drawings, shading film or good line drawing editorial cartoons." Does not want to see comic strips. Samples not filed are returned by SASE. Responds in 4-6 weeks. To show a portfolio, mail tearsheets or photostats. Pays 50% of net proceeds; pays flat fee of $25 minimum. "We may buy art outright or split percentage of sales."
Tips "We have the markets for multiple sales of editorial support art. We need talented artists to supply specific projects. We will work with beginning artists. Be honest about talent and artistic ability. If it isn't there then don't beat your head against the wall."

CONTINENTAL FEATURES/CONTINENTAL NEWS SERVICE
501 W. Broadway, Plaza A, P.O. PMB 265, San Diego CA 92101. (858)492-8696. E-mail: continentalnewsservice @yahoo.com. Web site: www.continentalnewsservice.com. **Editor-in-Chief:** Gary P. Salamone. Parent firm established August, 1981. Syndicate serving 3 outlets house publication, publishing business and the general public through the *Continental Newstime* general interest news magazine. Features include *Portfolio*, a collection of cartoon and caricature art.
Needs Approached by up to 200 cartoonists/year. Number of new strips introduced each year varies. Considers comic strips and gag cartoons. Does not consider highly abstract, computer-produced or stick-figure art. Prefers single panel with gagline. Recent features include "King's Court" by Frank Hill, "Alice and Alana" by Sophia Chen. Guidelines available for #10 SASE with first-class postage. Maximum size of artwork 8½×11, must be reducible to 65% of original size.
First Contact & Terms Sample package should include cover letter, photocopies (10-15 samples). Samples are filed or are returned by SASE if requested by artist. Responds in 1 month only if interested or if SASE is received. To show portfolio, mail photocopies and cover letter. Pays 70% of gross income on publication. Rights purchased vary according to project. Minimum length of contract is 1 year. The artist owns the original art and the characters.
Tips "We need single-panel cartoons and comic strips appropriate for English-speaking, international audience including cartoons that communicate feelings or predicaments, without words. Do not send samples reflecting

the highs and lows and different stages of your artistic development. CF/CNS wants to see consistency and quality, so you'll need to send your best samples."

CREATORS SYNDICATE, INC.

5777 W. Century Blvd., Suite 700, Los Angeles CA 90045. (310)337-7003. Fax: (310)337-7625. E-mail: info@creators. Web site: www.creators.com. **President:** Richard S. Newcombe. Director of Operations Christina Lee. Estab. 1987. Serves 2,400 daily newspapers, weekly and monthly magazines worldwide. Guidelines on Web site.

Needs Syndicates 100 writers and artists/year. Considers comic strips, caricatures, editorial or political cartoons and "all types of newspaper columns." Recent introductions *Speedbump*, by Dave Coverly; *Strange Brew*, by John Deering.

First Contact & Terms Send query letter with brochure showing art style or résumé and "anything but originals." Samples are not filed and are returned by SASE. Responds in a minimum of 10 weeks. Considers salability of artwork and client's preferences when establishing payment. Negotiates rights purchased.

Tips "If you have a cartoon or comic strip you would like us to consider, we will need to see at least four weeks of samples, but not more than six weeks of dailies and two Sundays. If you are submitting a comic strip, you should include a note about the characters in it and how they relate to each other. As a general rule, drawings are most easily reproduced if clearly drawn in black ink on white paper, with shading executed in ink wash or Benday® or other dot-transfer. However, we welcome any creative approach to a new comic strip or cartoon idea. Your name(s) and the title of the comic or cartoon should appear on every piece of artwork. If you are already syndicated elsewhere, or if someone else owns the copyright to the work, please indicate this."

DRAWN & QUARTERED LTD.

Metahqua, Oak Lane, Sewickley PA 15143. (412)749-9427. E-mail: red@drawnandquartered.com. Web site: www.drawnandquartered.com. **Contact:** Robert Edwards, chief executive. Estab. 2000. Syndicate serving over 100 weekly and monthly Internet sites, magazines, newsletters, newspapers and tabloids. Guidelines available.
 • This company operates similarly to a stock agency. See their website for details.

Needs Considers celebrity caricatures, portraits, and single panel editorial/political cartoons only. Prefers topical, timely, as-the-news-happens images; newspaper emphasis (i.e. political, sports, entertainment figures). Maximum size of artwork 7" height; artwork must be reducible to 20% of original size. Prefers to receive CDs or Zips of work, JPEGs or PNGs; b&w or RGB color, resolution 250-350dpi.

First Contact & Terms Sample package should include cover letter, brochure, photocopies, résumé, contact information, tearsheets and self-caricature/portrait if possible. 5-10 samples should be included. Samples are filed. Samples are returned by SASE if requested by artist. Portfolio not required. Pays 50% of net proceeds or gross income. Established average amount of payment US $20 per download. Pays on publication or downloads by client. Responds to submissions in 1 week. Minimum length of contract is 1 year. Offers automatic renewal. Artist owns copyright, original art and original characters.

Tips "Identify and date" samples.

HISPANIC LINK NEWS SERVICE

1420 N St. NW, Washington DC 20005. (202)234-0280. Fax: (202)234-4090. E-mail: charlie@hispaniclink.org. Web site: www.hispaniclink.org. **Editor:** Charles Ericksen. Syndicated column service to 250 newspapers and a newsletter serving 2,000 subscribers "movers and shakers in the Hispanic community in U.S., plus others interested in Hispanics." Guidelines available.

Needs Buys from a few freelancers/year. Considers single panel cartoons; b&w, pen & ink line drawings. Work should have a Hispanic angle; "most are editorial cartoons, some straight humor."

First Contact & Terms Send query letter with résumé and photocopies to be kept on file. Samples not filed are returned by SASE. Responds in 3 weeks. Portfolio review not required. **Pays on acceptance**; $25 flat fee (average). Considers clients' preferences when establishing payment. Buys reprint rights and negotiates rights purchased. "While we ask for reprint rights, we also allow the artist to sell later."

Tips Interested in seeing more cultural humor. "While we accept work from all artists, we are particularly interested in helping Hispanic artists showcase their work. Cartoons should offer a Hispanic perspective on current events or a Hispanic view of life."

🌐 INTERPRESS OF LONDON AND NEW YORK

90 Riverside Dr., New York NY 10024. (212)873-0772. **Editor/Publisher:** Jeffrey Blyth. Syndicates to several dozen European magazines and newspapers.

Needs Buys from 4-5 freelancers and writers/year. Prefers material universal in appeal; no "American only."

First Contact & Terms Send query letter and photographs; write for artists' guidelines. Samples not kept on file are returned by SASE. Responds in 3 weeks. Purchases European rights. Pays 60% of net proceeds on publication.

PLAIN LABEL PRESS

P.O. Box 240331, Ballwin MO 63024. E-mail: mail@plainlabelpress.com. Web site: www.plainlabelpress.com. **Contact:** Laura Meyer, submissions editor. Estab. 1989. Syndicate serving over 100 weekly magazines, newspapers and Internet sites. Guidelines available on website.

Needs Approached by 500 cartoonists and 100 illustrators/year. Buys from 2-3 cartoonists/illustrators/year. Introduces 1-2 new strips/year. Strips introduced include *Barcley & Co.*, by Todd Schowalter and *The InterPETS!* Considers cartoons (single, double and multiple panel), comic strips, editorial/political cartoons and gag cartoons. Prefers comics with cutting edge humor, NOT mainstream. Maximum size of artwork 8½×11; artwork must be reducible to 25% of original size.

First Contact & Terms Sample package should include an intro letter, character descriptions, 3-4 weeks of material, photocopies or disk, no original art, SASE if you would like your materials returned. 18-24 samples should be included. Samples are not filed. If samples are not filed, samples are returned by SASE if requested by artist. Portfolio not required. Pays 60% net proceeds, upon publication. Pays on publication. Responds to submissions in 2 months. Contract is open and may be cancelled at any time by the creator and/or by Plain Label Press. Artist owns original art and original characters.

Tips "Be FUNNY! Remember readers read the comics as well as look at them. Don't be afraid to take risks. Plain Label Press does not wish to be the biggest syndicate, just the funniest. A large portion of our material is purchased for use online so a good knowledge of digital color and imaging puts a cartoonist at an advantage. Good luck!"

TRIBUNE MEDIA SERVICES, INC.

435 N. Michigan Ave., Suite 1400, Chicago IL 60611. (312)222-4444. e-mail submissions@tribune.com. Web site: www.comicspage.com. **Submissions Editor:** Tracy Clark. Managing Editor: Eve Becker. Syndicate serving daily domestic and international and Sunday newspapers as well as weeklies and new media services. Strips syndicated include *Broom-Hilda*, *Dick Tracy*, *Brenda Starr* and *Helen, Sweetheart of the Internet*. "All are original comic strips, visually appealing with excellent gags." Art guidelines available on Web site or for SASE with first-class postage or on Web site.

- Tribune Media Services is a leading provider of Internet and electronic publishing content, including the WebPoint Internet Service.

Needs Seeks comic strips and newspaper panels, puzzles and word games. Recent introductions include *Cats With Hands*, by Joe Martin; *Dunagin's People*, by Ralph Dunagin. Prefers original comic ideas, with excellent art and timely, funny gags; original art styles; inventive concepts; crisp, funny humor and dialogue.

First Contact & Terms Send query letter with résumé and photocopies. Sample package should include 4-6 weeks of daily strips or panels. Send 8½×11 copies of your material, not the original. "Interactive submissions invited." Samples not filed are returned only if SASE is enclosed. Responds in 2 months. Pays 50% of net proceeds.

Tips "Comics with recurring characters should include a character sheet and descriptions. If there are similar comics in the marketplace, acknowledge them and describe why yours is different."

UNITED FEATURE SYNDICATE/NEWSPAPER ENTERPRISE ASSOCIATION

200 Madison Ave., New York NY 10016. (212)293-8500. Web site: www.unitedfeatures.com. **Contact:** Comics Editor. Syndicate serving 2,500 daily/weekly newspapers. Guidelines available for #10 SASE and on Web site.

- This syndicate told *AGDM* they receive more than 4,000 submissions each year and only accept two or three new artists. Nevertheless, they are always interested in new ideas.

Needs Approached by 5,000 cartoonists/year. Buys 2-3 cartoons/year. Introduces 2-3 new strips/year. Strips introduced include *Dilbert*, *Luann*, *Over the Hedge*. Considers comic strips, editorial political cartoons and panel cartoons.

First Contact & Terms Sample package should include cover letter and nonreturnable photocopies of finished cartoons. 18-36 dailies. Color Sundays are not necessary with first submissions. Responds in 4 months. Does not purchase one shots. Does not accept submissions via fax or e-mail.

Tips "No oversize packages, please."

UNITED MEDIA

200 Madison Ave., New York NY 10016. (212)293-8500. Web site: www.unitedfeatures.com. **Contact:** Editorial Submissions Editor or Comic Art Submissions Editor. Estab. 1978. Syndicate servicing US and international newspapers. Guidelines for SASE. "United Media consists of United Feature Syndicate and Newspaper Enterprise Association. Submissions are considered for both syndicates. Duplicate submissions are not needed." Guidelines available on Web site.

Needs Introduces 2-4 new strips/year. Considers comic strips and single, double and multiple panels. Recent introductions include *Frazz*, by Jef Mallett. Prefers pen & ink.

First Contact & Terms Send cover letter, résumé, finished cartoons and photocopies. Include 36 dailies; "Sundays not needed in first submissions." Do not send "oversize submissions or concepts without strips." Samples are not filed and are returned by SASE. Responds in 3 months. "Does not view portfolios." Payment varies by contract. Buys all rights.

Tips "Send copies, but not originals. Do not send mocked-up licensing concepts." Looks for "originality, art and humor writing. Be aware of long odds; don't quit your day job. Work on developing your own style and humor writing. Worry less about 'marketability'—that's our job."

UNIVERSAL PRESS SYNDICATE

4520 Main St., Suite 700, Kansas City MO 64111. (816)932-6600. Web site: www.ucomics.com. **Editorial Director:** Lee Salem. Syndicate serving 2,750 daily and weekly newspapers.

Needs Considers single, double or multiple panel cartoons and strips; b&w and color. Requests photocopies of b&w, pen & ink, line drawings.

First Contact & Terms Responds in 6 weeks. To show a portfolio, mail photostats. Send query letter with photocopies.

Tips "Be original. Don't be afraid to try some new idea or technique. Don't be discouraged by rejection letters. Universal Press receives 100-150 comic submissions a week and only takes on two or three a year, so keep plugging away. Talent has a way of rising to the top."

Ⓝ WASHINGTON POST WRITERS GROUP

1150 15th St. NW, Washington DC 20071-9200. (202)334-6375. Fax: (202)334-5669. Web site: www.postwriters group.com. **Editorial Director:** Alan Shearer. Estab. 1973. Syndicate serving over 1,000 daily, Sunday and weekly newspapers in US and abroad. Art guidelines available for SASE and necessary postage.

Stock Illustration & Clip Art Firms

S tock illustration firms market images to book publishers, advertising agencies, magazines, corporations and other businesses through catalogs and Web sites. Art directors flip through stock illustration catalogs or browse the Web for artwork at reduced prices, while firms split fees with illustrators.

There are those who believe stock illustration hurts freelancers. They say it encourages art directors to choose ready-made artwork at reduced rates instead of assigning illustrators for standard industry rates. Others feel the practice gives freelancers a vehicle to resell their work. Marketing your work as stock allows you to sell an illustration again and again instead of filing it away in a drawer. That can mean extra income every time someone chooses the illustration from a stock catalog.

Stock vs. clip art

When most people think of clip art, they think of booklets of copyright-free graphics and cartoons, the kind used in church bulletins, high school newspapers, club newsletters and advertisements for small businesses. But these days, especially with some of the digital images available online, perceptions are changing. With the popularity of desktop publishing, newsletters that formerly looked homemade look more professional.

There is another crucial distinction between stock illustration and clip art. That distinction is copyright. Stock illustration firms do not sell illustrations. They license the right to reprint illustrations, working out a "pay-per-use" agreement. Fees charged depend on how many times and for what length of time their clients want to reproduce the artwork. Stock illustration firms generally split their fees 50-50 with artists and pay the artist every time his image is used. You should be aware that some agencies offer better terms than others. So weigh your options before signing any contracts.

Clip art, on the other hand, generally implies buyers are granted a license to use the image as many times as they want, and furthermore, they can alter it, crop it or retouch it to fit their purposes. Some clip art firms repackage artwork created many years ago because it is in the public domain, and therefore, they don't have to pay an artist for the use of the work. But in the case of clip art created by living artists, firms either pay the artists an agreed-upon fee for all rights to the work or negotiate a royalty agreement. Keep in mind that if you sell all rights to your work, you will not be compensated each time it is used unless you also negotiate a royalty agreement. Once your work is sold as clip art, the buyer of that clip art can alter your work and resell it without giving you credit or compensation.

How to submit artwork

Companies are identified as either stock illustration or clip art firms in the first paragraph of each listing. Some firms, such as Metro Creative Graphics and Dynamic Graphics, seem to

be hybrids of clip art firms and stock illustration agencies. Read the information under "Needs" to find out what type of artwork each firm needs. Then check "First Contact & Terms" to find out what type of samples you should send. Most firms accept samples in the form of slides, photocopies and tearsheets. Increasingly, disk and e-mail submissions are encouraged in this market.

AFROCENTREX

P.O. Box 4375, Chicago IL 60680. (708)386-6122. E-mail: info@afrocentrex-software.com. Web site: www.afroc entrex-.com. **Chief Executive Officer:** Keith Coleman. Estab. 1993. Clip art and digital media. Specializes in multicultural clip art, i.e. African-American and Hispanic-American, digital content, multicultural Web-sites and cultural specific mobile content (ringtones, videos and wallpapers). Distributes predominantly via internet and stores.

Needs Approached by 5-10 illustrators/year. Buys from 2 illustrators/year. Prefers realistic illustrations, b&w line drawings and digital art.

First Contact & Terms Send cover letter with résumé and photocopies or tearsheets and SASE. Include 3-5 samples. Samples are filed. Responds in 2 weeks. Write for appointment to show portfolio of final art. Pays flat fee; $25-150. **Pays on acceptance.** Negotiates rights purchased. Offers automatic renewal. Clip art firm owns original art and characters.

Tips Looks for "persistence, professionalism and humbleness."

AGFA MONOTYPE TYPOGRAPHY

200 Ballardvale St., Wilmington MA 01887. (978)284-5955. Fax: (978)657-8268. E-mail: allanhaley@agfamo notype.com. Web site: www.fonts.com. **Director of Words & Letters:** Allan Haley. Estab. 1897. Font foundry. Specializes in high-quality Postscript and Truetype fonts for graphic design professionals and personal use. Clients include advertising agencies, magazines and desktop publishers. Submission guidelines on Web site.

 • Does not want clip art or illustration—only fonts.

Needs Approached by 10 designers/year. Works with 5 typeface designers/year. Prefers typeface and font designs. Freelance work demands knowledge of Illustrator, Photoshop, QuarkXPress.

First Contact & Terms E-mail examples of font (PDF files or EPS or TIFF). Samples are not filed. Responds only if interested. Rights purchased vary according to project. Finds designers through word of mouth.

⊕ ARTBANK ILLUSTRATION LIBRARY

114 Clerkenwell Rd., London EC1M 5SA United Kingdom. (+44)020 7608 2288. Fax: (+44)020 8906 2289. E-mail: info@artbank.com. Web site: www.artbank.com. Estab. 1989. Picture library. Artists include Rafal Olbinski, Jane Spencer. Clients include advertising agencies, design groups, book publishers, calendar companies, greeting card companies and postcard publishers.

Needs Prefers 4×5 transparencies.

⊕ DRAWN & QUARTERED LTD.

4 Godmersham Park, Canterbury Kent CT4-7DT United Kingdom. (44)1227-730-565. E-mail: red@drawnandqua rtered.com. Web site: www.drawnandquartered.com. **Contact:** Robert Edwards, chief executive.

 • See listing in Syndicates & Cartoon Features section.

DYNAMIC GRAPHICS INC.

6000 N. Forest Park Dr., Peoria IL 61614-3592. (800)255-8800 or (309)688-8800. Fax: (309)688-8515. Web site: www.dgusa.com. **Art Director:** Mike Ulrich. Distributes clip art, stock images and animation to thousands of magazines, newspapers, agencies, industries and educational institutions.

 • Dynamic Graphics is a stock image firm and publisher of *Step into Design*, *Digital Design* newsletter and *Dynamic Graphics* Magazine. Uses illustrators from all over the world; 99% of all artwork sold as clip art is done by freelancers.

Needs Works with more than 50 freelancers/year. Prefers illustration, symbols and elements; buying color and b&w, traditional or electronic images. "We are currently seeking to contact established illustrators capable of handling b&w or color stylized and representational illustrations of contemporary subjects and situations."

First Contact & Terms Submit portfolio of at least 15 current samples with SASE. Responds in 2 weeks. **Pays on acceptance.** Negotiates payment. Buys all rights.

Tips "We are interested in quality, variety and consistency. Illustrators contacting us should have top-notch samples that show consistency of style (repeatability) over a range of subject matter. We often work with artists

who are getting started if their portfolios look promising. Because we publish a large volume of artwork monthly, deadlines are extremely important, but we do provide long lead time. (4-6 weeks is typical.) We are also interested in working with illustrators who would like an ongoing relationship. Not necessarily a guaranteed volume of work, but the potential exists for a considerable number of pieces each year for marketable styles.''

GETTY IMAGES

601 N. 34th St., Seattle WA 98103. (800)462-4379 or (206)925-5000. Fax: (206)925-5001. Web site: www.gettyim ages. Leading imagery company, creating and distributing the largest collection of images to communication professionals around the world. Getty Images products are found in newspapers, magazines, advertising, films, television, books and Web sites.Offering royalty-free and rights-managed images.
Needs Approached by 1,500 artists/year. Buys from 100 freelancers/year. Considers illustrations, photos, type-faces and spot drawings.
First Contact & Terms Visit www.gettyimages.com/contributors and select the link ''interested in marketing your imagery through Getty Images?''

IDEAS UNLIMITED FOR EDITORS

9700 Philadelphia Court, Lanham MD 20706. (301)731-5202. Fax: (301)731-5203. E-mail: editor@omniprint.n et. **Editorial Director:** Rachel Brown. Omni Print, Inc. provides editorial mateial to corporate newsletter editors via a monthly subscription newsletter, ideas unlimited for editors. The newsletter also supplies clip art both hard copy and CD formats.
 • Omni Print, Inc., is not open to submission at this time. In-house illustrators have provided all artwork for the past years.

INDEX STOCKWORKS

23 W. 18th St., 3rd Floor, New York NY 10011. (800)690-6979. Fax: (212)633-1914. E-mail: portfolio@indexstoc k.com. Web site: www.indexstock.com. **Contact:** Desmond Powell. Estab. 1992. Stock illustration firm. Special-izes in stock illustration for corporations, advertising agencies and design firms. Guidelines available on Web site.
Needs Approached by 300 new artists/year. Themes include animals, business, education, healthcare, holidays, lifestyles, technology and computers, travel locations.
First Contact & Terms Visit Web site. Click on link *For Artists Only*. Under **Submitting a Portfolio for review** click on link submitting a portfolio. Download and print the following documents Appropriate guidelines based on the type of media you wish to submit, Pre-Portfolio Questionnaire Form and 2002 or current year PORTFOLIO SUBMISSION FORM. As instructed in guidelines sign and return forms with your images for review. Samples are filed or are returned through pre-paid return shipping via Federal Express, UPS or US Postal Services at artist's expense, depending on the outcome of the portfolio review. Responds only if interested. E-mail for portfolio review of available stock images and leave behinds. Pays royalties of 40%. Negotiates rights purchased. Finds artists through *Workbook, Showcase, Creative Illustration*, magazines, submissions.
Tips ''Index Stock Imagery likes to work with artists to create images specifically for stock. We provide 'Want' lists and concepts to aid in the process. We like to work with illustrators who are motivated to explore an avenue other than just assignment to sell their work.''

METRO CREATIVE GRAPHICS, INC.

519 Eighth Ave., New York NY 10018. (212)947-5100. Fax: (212)714-9139. Web site: www.metrocreativegraphic s.com. **Senior Art Director:** Darrell Davis. Estab. 1910. Creative graphics/art firm. Distributes to 7,000 daily and weekly paid and free circulation newspapers, schools, graphics and ad agencies and retail chains. Guidelines available. (Send letter with SASE or e-mail art director on Web site.)
Needs Buys from 100 freelancers/year. Considers all styles of illustrations and spot drawings; b&w and color. Editorial style art, cartoons for syndication not considered. Special emphasis on computer-generated art for Macintosh. Send floppy disk samples using Illustrator 5.0 or Photoshop. Prefers all categories of themes associ-ated with newspaper advertising (retail promotional and classified). Also needs covers for special-interest newspaper, tabloid sections.
First Contact & Terms Send query letter with non-returnable samples, such as photostats, photocopies, slides, photographs or tearsheets to be kept on file. Accepts submissions on disk compatible with Illustrator 5.0 and Photoshop. Send EPS or TIFF files. Samples returned by SASE if requested. Responds only if interested. Works on assignment only. **Pays on acceptance**; flat fee of $25-1,500 (buy out). Considers skill and experience of artist, saleability of artwork and clients' preferences when establishing payment.
Tips This company is ''very impressed with illustrators who can show a variety of styles.'' When creating electronic art, make sure all parts of the illustration are drawn completely, and then put together. ''It makes the art more versatile to our customers.''

Sharon Dodge

Stock agency looks for fresh new talent

Although online image services offer many conveniences to designers and art directors, the process of locating appropriate, professional-quality illustration can sometimes be incredibly labor intensive. Doing a keyword search often yields pages and pages of far-ranging imagery, including vintage illustrations and fine art. Online niche marketers, such as Illustration Works (www.illustrationworks.com), have responded to the design industry's need to simplify the selection process by offering nothing but stock and royalty-free contemporary illustration from professional illustrators. As a supplier of illustration to Getty Images, the agency's artists can be accessed through Getty's search engine as well as through Illustration Works' own Web site.

Sharon Dodge, founder and CEO of Illustration Works, has many years of experience in the illustration industry and understands how artists can reap benefits from posting their work online as stock or royalty free imagery. Dodge worked as an illustrator's rep for several years before founding her Seattle-based service in 1996. "We were the first online stock illustration collection," says Dodge. "We haven't attempted to be the biggest, but we have attempted to maintain extremely high quality. That's brought us into relationships with companies like Getty and other major distributors who have selected us to represent a stock illustration offering."

The Illustration Works Web site features the work of close to 400 artists and allows users to access over 30,000 illustrations. The Web site's search engine is similar to those of other stock Web sites, allowing visitors to do keyword searches and narrow their selection to black-and-white or color as well as square, vertical, or horizontal orientation. Advance searches can also be done according to artist, style or medium.

Because Illustration Works specializes in professional-quality illustration, it's not a realistic venue for most beginners to consider as a place to market their work. "Most of the individuals we represent are life-time professionals," says Dodge. "They are people who have been doing this for 20 to 30 years." She says it's possible for gifted beginners to make money in stock if they're willing to do the work involved. Dodge notes that the agency represents a few illustrators who have less than five years of experience, individuals she describes as "brilliant talent." However, she cautions that even if the agency responds favorably to a new talent, there is a lot of work up front and the artist isn't compensated until an illustration is sold. This can be discouraging to young illustrators right out of school who are anxious to make money with their work.

Dodge also points out that experienced professionals are more likely to have accumulated work that offers some readily available imagery. "If there's a large body of illustration, we almost always find something we can post and sell on the day it goes up. That's obvi-

ously very efficient for the artist,'' she states. In the case of many illustrators, stock can represent new life for commissioned illustrations for which the artist has retained the rights. Illustration Works and similar online stock agencies offer an opportunity for marketing this existing work. ''A great deal of the imagery our company was built on is that sort of imagery,'' says Dodge. But she adds, ''You want to maintain a contemporary freshness.'' Work that has been around for several years starts to look stale.

Other advice Dodge offers to those who want to pursue marketing their work as online stock is to create and post lots of imagery. She notes that some of Illustration Works' illustrators have as many as 500 images on the Web site. This works to an artist's advantage when an art director or designer is seeking several images that are stylistically consistent for a brochure, annual report or other publication. ''The likelihood of your images being chosen increases exponentially with the breadth of the material you have,'' she explains.

The agency is always looking for fresh new talent to feature on its online library and welcomes submissions of about five low-res JPEGs attached to an e-mail sent to *submissions@illustrationworks.com*. If Dodge and her colleague, Loly Carrillo, see work with a stylistic approach they believe will sell as stock illustration, they will come back to the artist with suggestions for subject matter that they know will be most marketable. ''We look at rough sketches until we're all on the same page,'' says Dodge. When the artist delivers final illustrations, they're posted on the Illustration Works Web site. From there, users can download a watermarked version of an illustration to put in a working comp, and then return to purchase a high-res version of the same image.

When a stock or royalty-free illustration is sold, the agency's arrangement is standard for the industry. Fees range from 20-50% of the selling price to the artist. Illustration prices range from $100 up to as much as $50,000 per image for extensive usage, with an average price of $600 for a single-use situation. In addition to featuring stock and royalty-free images on its Web site, Illustration Works also hires artists to create royalty-free collections. ''In some cases we discover a unique talent who we want to develop material for a collection,'' says Dodge. The agency will pay an artist a one-time fee of up to $100 per

Whether the image needed is Albert Einstein or a piercing headache, Illustration Works delivers. The agency's Web site, www.illustrationworks.com, features the work of 400 artists and allows users to access over 30,000 illustrations.

illustration to develop royalty-free content, "This only works for illustrators who are very prolific and can deliver 50 illustrations at once," says Dodge.

The agency also works as a broker for commissioned illustration. Occasionally, a viewer will see an image by an artist and want something different than the subject matter that exists on the Web site. In these instances, Illustration Works serves as the artist's representative paying 65-75% of the commission fee to the artist.

—Poppy Evans

MILESTONE GRAPHICS
303B Anastasia Avenue, #140, St. Augustine FL 32080. (904)823-9962. E-mail: miles@aug.com. Web site: www.milestonegraphics.com. **Owner:** Jill O. Miles. Estab. 1993. Clip art firm providing targeted markets with electronic graphic images.
Needs Buys from 20 illustrators/year. 50% of illustration demands knowledge of Illustrator.
First Contact & Terms Sample package should include nonreturnable photocopies or samples on computer disk. Accepts submissions on disk compatible with Illustrator on the Macintosh. Send EPS files. Interested in b&w and some color illustrations. All styles and media are considered. Macintosh computer drawings accepted (Illustrator preferred). "Ability to draw people a plus, but many other subject matters needed as well. We currently have a need for golf and political illustrations." Reports back to the artist only if interested. Pays flat fee of $25 minimum/illustration, based on skill and experience. A series of illustrations is often needed.

ONE MILE UP, INC.
7011 Evergreen Court, Annandale VA 22003. (703)642-1177. Fax: (703)642-9088. E-mail: gene@onemileup.com. Web site: www.onemileup.com. **President:** Gene Velazquez. Estab. 1988.
● Gene Velazquez told *AGDM* he is looking for aviation graphics. He does not use cartoons.
Needs Approached by 10 illustrators and animators/year. Buys from 5 illustrators/year. Prefers illustration.
First Contact & Terms Send 3-5 samples via e-mail with résumé and/or link to your Web site. Pays flat fee; $30-120. **Pays on acceptance.** Negotiates rights purchased.

THE SPIRIT SOURCE.COM
1310 Pendleton St., Cincinnati OH 45202. (513)241-7473. Fax: (513)241-7505. E-mail: mpwiggins@thespiritsource.com. Web site: www.thespiritsource.com. **Owner:** Paula Wiggins. Estab. 2003. Stock illustration firm. Specializes in religious, spiritual and inspirational images for the print market. Distributes to book publishers, greeting card companies, magazine publishers, newspapers. Clients include *Sojourners* Magazine, St. Anthony Messenger Press, Gainey Conference Center, Liturgy Training Publications. Guidelines available on Web site.
Needs Approached by 25 illustrators/year. Works with 11 illustrators/year. Prefers digital art, b&w and color drawings with line, pen & ink, spot and any high-quality artwork in any medium that is inspirational in nature. Themes include education, families, fine art, holidays, landscapes/scenics, multicultural and religious. 100% of illusration demands skills in Photoshop.
First Contact & Terms Send brochure, photocopies, URL, images on a CD or E-mail low-res files. Samples are filed or returned by SASE. Accepts e-mail submissions with link to Web site and with image file. Prefers low-res JPEGs or images on a CD. Responds in 1 week. Portfolio should include at least 10 images, preferably in a digital format or b&w and color finished art. No originals. Pays for illustration 50% of negotiated fee. Buys one-time rights. Finds artists through artists' submissions and word of mouth.
Tips "Although we are a Web site that specializes in religious/spiritual/inspirational work, that can be interpreted broadly. Our categories include family life, human relationships, nature, virtues/vices and holidays. No overdone or cliched images. Artist should be prepared to submit digital images for the site according to our specifications."

STOCK ILLUSTRATION SOURCE
1140 Broadway, 4th Floor, New York NY 10011. (212)849-2900, (800)4-IMAGES. Fax: (212)691-6609. e-mail submissions@images.com. Web site: www.images.com. **Acquisitions Manager:** Margaret S. Zacharow. Estab. 1992. Stock illustration agency. Specializes in illustration for corporate, advertising, editorial, publishing industries. Guidelines available.
Needs "Prefers painterly, conceptual and lifestyle imagery. Themes include corporate, business, education, healthcare, law, and government, enviroment, family life and lifestyle.

First Contact & Terms Illustrators may send samples of work at any time by directing agency to personal Web site, sending an e-mail with compressed zip file or CD containing at least 20 low-resolution Jpeg images. Stock Illustrations Source offers exclusive representation on all accepted imagery along with competitive commission rates.

STOCKART.COM

155 N. College Ave., Suite 225, FtCollins CO 80524. (970)493-0087 or (800)297-7658. Fax: (970)493-6997. E-mail: art@stockart.com. Web site: www.stockart.com. **Art Manager:** Maile Fink. Estab. 1995. Stock illustration and representative. Specializes in b&w and color illustration for ad agencies, design firms and publishers. Clients include BBDO, Bozell, Pepsi, Chase, Saatchi & Saatchi.

Needs Approached by 250 illustrators/year. Works with 150 illustrators/year. Themes include business, family life, financial, healthcare, holidays, religion and many more.

First Contact & Terms Illustrators send at least 10 samples of work. Accepts hard copies, e-mail or disk submissions compatible with TIFF or EPS files less than 600K/image. Pays 50% stock royalty, 70% commission royalty (commissioned workartist retains rights) for illustration. Rights purchased vary according to project. Finds artists through sourcebooks, online, word of mouth. "Offers unprecedented easy-out policy. Not 100% satisfied, will return artwork within 60 days."

Tips "Stockart.com has many artists earning a substantial passive income from work that was otherwise in their file drawers collecting dust."

Advertising, Design & Related Markets

If you are an illustrator who can work in a consistent style or a designer with excellent skills, and you can take direction, this section offers a glimpse at one of the most lucrative markets for artists. Because of space constraints, the markets listed are just the tip of the proverbial iceberg. There are thousands of advertising agencies and public relations, design and marketing firms across the country and around the world. All rely on freelancers. Look for additional firms in industry directories, such as *Workbook* (Scott & Daughters Publishing), *Standard Directory of Advertisers* (National Register Publishing) and *The Adweek Directory*, available in the business section of most large public libraries. Find local firms in the yellow pages and your city's business-to-business directory. You can also pick up leads by reading *Adweek, HOW, Print, STEP inside design, Communication Arts* and other design and marketing publications.

Find your best clients

Read listings to identify firms whose clients and specialties are in line with the type of work you create. (You'll find clients and specialties in the first paragraph of each listing.) For example, if you create charts and graphs, contact firms whose clients include financial institutions. Fashion illustrators should approach firms whose clients include department stores and catalog publishers. Sculptors and modelmakers might find opportunities with firms specializing in exhibition design.

Payment and copyright

You will most likely be paid by the hour for work done on the firm's premises (in-house) and by the project if you take the assignment back to your studio. Most checks are issued 40-60 days after completion of assignments. Fees depend on the client's budget, but most companies are willing to negotiate, taking into consideration the experience of the freelancer, the lead time given and the complexity of the project. Be prepared to offer an estimate for your services and ask for a purchase order (P.O.) before you begin an assignment.

Some art directors will ask you to provide a preliminary sketch on speculation or "on spec," which, if approved by the client, can land you a plum assignment. If you are asked to create something "on spec," be aware that you may not receive payment beyond an hourly fee for your time if the project falls through. So be sure to ask upfront about payment policy before you start an assignment.

If you're hoping to retain usage rights to your work, you'll want to discuss this upfront, too. You can generally charge more if the client is requesting a buyout. If research and travel are required, make sure you find out ahead of time who will cover these expenses.

ALABAMA

COMPASS MARKETING, INC.
175 Northshore Place, Gulf Shores AL 36542. (251)968-4600. Fax: (251)968-5938. E-mail: awboone@compassbiz.com. Web site: www.compassbiz.com. **Editor:** Chad Kirtland. Estab. 1988. Number of employees 20-25. Approximate annual billing $4 million. Integrated marketing communications agency and publisher. Specializes in tourism products and programs. Product specialties are business and consumer tourism. Current clients include Alabama Bureau of Tourism and Alabama Gulf Coast CVB. Client list available upon request.
Needs Approached by 5-20 designers/year. Works with 4-6 designers/year. Prefers freelancers with experience in magazine work. Uses freelancers mainly for sales collateral, advertising collateral and illustration. 5% of work is with print ads. 100% of design demands skills in Photoshop 5.0 and QuarkXPress.
First Contact & Terms Designers: Send query letter with photocopies, résumé and tearsheets. Samples are filed and are not returned. Responds in 1 month. Art director will contact artist for portfolio review of slides and tearsheets if interested. Pays by the project, $100 minimum. Rights purchased vary according to project. Finds artists through sourcebooks, networking and print.
Tips "Be fast and flexible. Have magazine experience."

A. TOMLINSON/SIMS ADVERTISING, INC.
250 S. Poplar St., Florence AL 35630. (256)766-4222. Fax: (256)766-4106. E-mail: atsadv@hiwaay.net. Web site: ATSA-USA.com. **President:** Allen Tomlinson. Estab. 1990. Number of employees 9. Approximate annual billing $5.0 million. Ad agency. Specializes in magazine, collateral, catalog business-to-business. Product specialties are home building products. Client list available upon request.
Needs Approached by 20 illustrators and 20 designers/year. Works with 5 illustrators and 5 designers/year. Also for airbrushing, billboards, brochure and catalog design and illustration, logos and retouching. 35% of work is with print ads. 85% of design demands skills in PageMaker 6.5, Photoshop, Illustrator and QuarkXPress 4.1. 85% of illustration demands skills in PageMaker 6.5, Photoshop, Illustrator and QuarkXPress 4.1.
First Contact & Terms Designers: Send query letter with brochure and photocopies. Illustrators: Send samples of work, photocopies and résumé. Samples are filed and are not returned. Does not reply; artist should call. Artist should also call to arrange for portfolio review of color photographs, thumbnails and transparencies. Pays by the project. Rights purchased vary according to project.

ARIZONA

ARIZONA CINE EQUIPMENT, INC.
2125 E. 20th St., Tucson AZ 85719. (520)623-8268. Fax: (520)623-1092. Web site: www.arizonacine.com. **Vice President:** Linda A. Bierk. Estab. 1967. Number of employees 11. Approximate annual billing $850,000. AV firm. Full-service, multimedia firm. Specializes in video. Product specialty is industrial.
Needs Approached by 5 freelancers/year. Works with 5 illustrators and 5 freelance designers/year. Prefers local artists. Uses freelancers mainly for graphic design. Also for brochure and slide illustration, catalog design and illustration, print ad design, storyboards, animation and retouching. 20% of work is with print ads. Also for multimedia projects. 70% of design and 80% of illustration demand knowledge of PageMaker, QuarkXPress, FreeHand, Illustrator or Photoshop.
First Contact & Terms Send query letter with brochure, résumé, photocopies, tearsheets, transparencies, photographs, slides and SASE. Samples are filed. Responds only if interested. Will contact artist for portfolio review if interested. Portfolio should include color thumbnails, final art, tearsheets, slides, photostats, photographs and transparencies. Pays for design by the project, $100-5,000. Pays for illustration by the project, $25-5,000. Buys first rights or negotiates rights purchased.

BOELTS-STRATFORD ASSOCIATES
345 E. University Blvd., Tucson AZ 85705-7848. (520)792-1026. Fax: (520)792-9720. E-mail: bsa@boelts-stratford.com. Web site: www.boelts-stratford.com. **Principal:** Jackson Boelts. Estab. 1986. Specializes in annual reports, brand identity, corporate identity, display design, direct mail design, environmental graphics, package design, publication design and signage. Client list available upon request.
● This firm has won over 400 international, national and local awards.
Needs Approached by 100 freelance artists/year. Works with 10 freelance illustrators and 5-10 freelance designers/year. Works on assignment only. Uses designers and illustrators for brochure, poster, catalog, P-O-P and ad illustration, mechanicals, retouching, airbrushing, charts/graphs and audiovisual materials.
First Contact & Terms Send query letter with brochure, tearsheets and résumé. Samples are filed. Responds only if interested. Call to schedule an appointment to show portfolio. Portfolio should include roughs, original/

final art, slides and transparencies. Pays for design by the hour and by the project. Pays for illustration by the project. Negotiates rights purchased.

Tips When presenting samples or portfolios, artists "sometimes mistake quantity for quality. Keep it short and show your best work."

CRICKET CONTRAST GRAPHIC DESIGN

29505 North 146th Street, Scottsdale AZ 85262. (602)258-6149. Fax: (602)391-2199. E-mail: cricket@thecricketc ontrast.com. **Owner:** Kristie Bo. Estab. 1982. Number of employees 5. Specializes in providing solutions for branding, corporate identity, Web page design, advertising, package and publication design, and traditional online printing. Clients: corporations. Professional affiliations: AIGA, Scottsdale Chamber of Commerce, Phoenix Society of Communicating Arts, Phoenix Art Museum, Phoenix Zoo.

Needs Approached by 25-50 freelancers/year. Works with 5 freelance illustrators and 5 designers/year. Also uses freelancers for ad illustration, brochure design and illustration, lettering and logos. Needs computer-literate freelancers for design and production. 100% of freelance work demands knowledge of Illustrator, Photoshop and QuarkXPress.

First Contact & Terms Send photocopies, photographs and résumé via e-mail. Will contact artist for portfolio review if interested. Portfolio should include b&w photocopies. Pays for design and illustration by the project. Negotiates rights purchased. Finds artists through self-promotions and sourcebooks.

Tips "Beginning freelancers should send all info through e-mail."

CHARLES DUFF ADVERTISING

301 W. Osborn Rd., Suite 3600, Phoenix AZ 85013. (602)285-1660. Fax: (602)207-2193. E-mail: bdawes@mail.fa rnam.com. Web site: www.farnam.com. **Executive Art Director:** Brian Dawes. Estab. 1948. Number of employees 13. Approximate annual billing $1 million. Ad agency. Full-service multimedia firm. Specializes in agri-marketing promotional materialsliterature, audio, video, trade literature. Specializes in animal health.

● Charles Duff Advertising is the in-house ad agency for Farnam Companies, a multi-million dollar company specializing in horse care and agricultural products.

Needs Approached by 50 freelancers/year. Works with 10 freelance illustrators and 10 designers/year. Prefers

Maureen Erbe of Erbe Design created a series of brochures on various garden topics for the Monrovia Plant Information Center. Anne Smith's simple, yet joyful illustrations added fun to each topic. Erbe continued the playful attitude in the interior of each brochure.

Advertising & Design

freelancers with experience in animal illustration equine, pets and livestock. Uses freelancers mainly for brochure, catalog and print ad illustration and retouching, billboards and posters. 35% of work is with print ads. Needs computer-literate freelancers for design, illustration, production and presentation. 25% of freelance work demands knowledge of Photoshop, QuarkXPress and Illustrator.
First Contact & Terms Send query letter with brochure, photocopies, SASE, résumé, photographs, tearsheets, slides or transparencies. Samples are filed or are returned by SASE if requested by artist. Responds in 2 weeks. Reviews portfolios "only by our request." Pays by the project, $100-500 for design; $100-700 for illustration. Buys one-time rights.

GODAT DESIGN INC.
101 W. Simpson St., Tucson AZ 85701-2268. (520)620-6337. E-mail: ken@godatdesign.com. Web site: www.godatdesign.com. **Principal:** Ken Godat. Estab. 1983. Number of employees 10. Specializes in corporate identity, marketing communications, Web site and interactive design. Clients: corporate, retail, institutional, public service. Current clients include Long Reality, Tuscon, Tucson Airport Authority and University of Arizona. Professional affiliations AIGA, American Ad Federation.
Needs Works with 0-3 freelance illustrators and 0-3 designers/year. Freelancers should be familiar with InDesign, Photoshop and Illustrator.
First Contact & Terms Send query letter with samples or Web site address. Request portfolio review in original query. Will contact artist for portfolio review if interested. Pays for design by the hour. Pays for illustration by the project. Finds artists online and through sourcebooks.

THE M. GROUP GRAPHIC DESIGN
2512 East Thomas Road, Suite 12, Phoenix AZ 85016. (480)998-0600. Fax: (480)998-9833. E-mail: gary@themgroupinc.com. Web site: www.themgroupinc.com. **Head Designer:** Michael Carmagiano. Estab. 1987. Number of employees 7. Approximate annual billing 2.75 million. Specializes in annual reports, corporate identity, direct mail and package design, and advertising. Clients corporations and small business. Current clients include BankOne, Dole Foods, Giant Industries, Intel, Coleman Spas, Subway and Teksoft.
Needs Approached by 50 freelancers/year. Works with 5-10 freelance illustrators/year. Uses freelancers for ad, brochure, poster and P-O-P illustration. 95% of freelance work demands skills in Illustrator, Photoshop and QuarkXPress.
First Contact & Terms Send postcard sample or query letter with samples. Samples are filed or returned by SASE if requested by artist. Responds only if interested. Request portfolio review in original query. Artist should follow-up. Portfolio should include b&w and color final art, photographs and transparencies. Rights purchased vary according to project. Finds artists through publications (trade) and reps.
Tips Impressed by "good work, persistence, professionalism."

RIPE CREATIVE
1543 W. Apollo Road, Phoenix AZ 85041. (602)304-0703. Fax: (480)247-5339. E-mail: info@ripecreative.com. Web site: www.ripecreative.com. **Contact:** Mark Anthony Munoz, principal. Estab. 2005. Number of employees: 5. Approximate annual billing: $500,000. Design Firm. Specializes in branding, advertising, strategic marketing, publication, design, trade-show environments. Current clients include: Swing Development, Express Messenger, Aon Consulting, Satoru Data & Network Solutions, Hawk Hill Custom Hardware. Client list available on request. Professional affiliations: AIGA (Phoenix), NAPP, National Organization of Women Business Owners, Arizona Hispanic Chamber of Commerce.
Needs Approached by 100 illustrators and 10 designers/year. Works with 10 illustrators and 3 designers/year. Works on assignment only. Prefers designers, illustrators and Web designers with experience in tearsheets, computer graphics and Macintosh. Uses freelancers mainly for illustration, graphic design, Web site design. Also for brochure animation, brochure design, brochure illustration, direct mail, industrial/structural design, logos, posters, print ads, storyboards, brochure illustration, catalog design and technical illustration. 15% of work is assigned with print ads. 100% of design work demands skills in InDesign, Illustrator, QuarkXPress and Photoshop. 100% of illustration work demands skills in Illustrator, Photoshop and traditional illustration media.
First Contact & Terms Designers: Send query letter with brochure, ré sumé, tearsheets, URL. Illustrators: Send tearsheets, URL. Samples are returned if requested and SASE is provided. Designers and illustrators should attach pdf files and/or URL. Samples are filed or returned by SASE. Responds in 2 weeks. Company will contact artist for portfolio review if interested. Portfolio should include color finished art, photographs and tearsheets. Pays for illustration. Set rate negotiated and agreed to between RIPE and talent. Pays for design by the hour $25-100. Rights purchased vary according to project. Finds artists through artists' submissions, word of mouth, *Workbook*, *Blackbook*.
Tips "Cold calls are discouraged. When making first contact attempt, the preferred method is via mail or

electronically. If interested, RIPE will follow up witih talent electronically or by telephone. When providing samples, please ensure talent/rep contact is listed on all samples."

ARKANSAS

TAYLOR MACK ADVERTISING
509 W. Spring #450, Fayetteville AR 72071. (479)444-7770. Fax: (479)444-7977. E-mail: Greg@TaylorMack.com. Web site: www.TaylorMack.com. **Managing Director:** Greg Mack. Estab. 1990. Number of employees 16. Approximate annual billing $3 million. Ad agency. Specializes in collateral. Current clients include Cobb, Colliers, Jose's, Honeysuckle White and Marathon. Client list available upon request.

Needs Approached by 12 illustrators and 20 designers/year. Works with 4 illustrators and 6 designers/year. Uses freelancers mainly for brochure, catalog and technical illustration, TV/film graphics and Web page design. 30% of work is with print ads. 50% of design and illustration demands skills in Photoshop, Illustrator and QuarkXPress.

First Contact & Terms Designers: Send query letter with brochure and photocopies. Illustrators: Send postcard sample of work. Samples are filed or are returned. Responds only if interested. Art director will contact artist for portfolio review of photographs if interested. Pays for design by the project or by the day; pays for illustration by the project, $10,000 maximum. Rights purchased vary according to project.

MANGAN/HOLCOMB RAINWATER/CULPEPPER & PARTNERS
2300 Cottondale Lane, Suite 300, Little Rock AR 72202. (501)376-0321. Fax: (501)376-6127. E-mail: chip@mang anholcomb.com. Web site: www.manganholcomb.com. **Vice President Creative Director:** Chip Culpepper. Number of employees 12. Marketing, advertising and public relations firm. Approximate annual billing $3 million. Ad agency. Clients recreation, financial, tourism, retail, agriculture.

Needs Approached by 50 freelancers/year. Works with 8 freelance illustrators and 20 designers/year. Uses freelancers for consumer magazines, stationery design, direct mail, brochures/flyers, trade magazines and newspapers. Also needs illustrations for print materials. Needs computer-literate freelancers for production and presentation. 30% of freelance work demands skills in Macintosh page layout and illustration software.

First Contact & Terms Query with samples, flier and business card to be kept on file. Include SASE. Responds in 2 weeks. Call or write for appointment to show portfolio of final reproduction/product. Pays by the project, $250 minimum.

CALIFORNIA

N ADVANCE ADVERTISING AGENCY
606 E. Belmont Ave., Suite 202, Fresno CA 93701. (209)445-0383. **Creative Director:** M. Nissen. Estab. 1950. Ad agency. Full-service, multimedia firm. Current clients include Sound Investment Recording Studio, Howard Leach Auctions, Mr. G's Carpets, Allied Floorcovering, Fresno Dixieland Society, R & R Creative Solutions, Towers Accounting Services. Client list not available.

Needs Approached by 2-5 freelancers/month. Prefers local freelancers with experience in all media graphics and techniques. Works on assignment only. Uses freelancers mainly for direct mail, cartoons, caricatures. Also for brochure design and illustration, catalog and print ad design, airbrushing, storyboards, mechanicals, retouching, billboards and logos. 75% of work is with print ads. 25% of freelance work demands computer skills.

First Contact & Terms Send query letter with résumé, photocopies and SASE. Samples are filed or returned by SASE. Responds in 2 weeks only if interested. Creative Director will contact artist for portfolio review if interested. Portfolio should include roughs, tearsheets and/or printed samples. Pays for design and illustration by the project, rate varies. Buys all rights. Finds artists through artists' submissions.

THE ADVERTISING CONSORTIUM
10536 Culver Blvd., Suite D, Culver City CA 90232. (310)287-2222. Fax: (310)287-2227. E-mail: theadco@pacbel l.net. **Contact:** Kim Miyade. Estab. 1985. Ad agency. Full-service, multimedia firm. Specializes in print, collateral, direct mail, outdoor, broadcast. Current clients include Bernini, Davante, Westime, Modular Communication Systems.

Needs Works with 1 illustrator and 2 art directors/month. Prefers local artists only. Works on assignment only. Uses freelance artists and art directors for everything (none on staff), including brochure, catalog and print ad design and illustration and mechanicals and logos. 80% of work is with print ads. Also for multimedia projects. 100% of freelance work demands knowledge of PageMaker, QuarkXPress, FreeHand, Illustrator and Photoshop.

First Contact & Terms Send postcard sample or query letter with brochure, tearsheets, photocopies, photographs and anything that does not have to be returned. Samples are filed. Write for appointment to show portfolio. "No phone calls, please." Portfolio should include original/final art, b&w and color photostats, tearsheets, photographs, slides and transparencies. Pays for design by the hour, $60-75. Pays for illustration by the project, based on budget and scope.
Tips Looks for "exceptional style."

ADVERTISING DESIGNERS, INC.
7087 Snyder Ridge Rd., Mariposa CA 95338-9029. (209)742-6704. E-mail: ad@yosemite.net. **President:** Tom Ohmer. Estab. 1947. Number of employees 2. Specializes in annual reports, corporate identity, ad campaigns, package and publication design and signage. Clients: corporations.
First Contact & Terms Send query letter with postcard sample. Samples are filed. Does not reply. Artist should call. Write for appointment to show portfolio.

B&A DESIGN GROUP
634-C W. Broadway, Glendale CA 91204-1008. (818)547-4080. Fax: (818)547-1629. **Owner/Creative Director:** Barry Anklam. Full-service advertising and design agency providing ads, brochures, P-O-P displays, packaging, corporate identity, posters and menus. Product specialties are food products, electronics, hi-tech, real estate and medical. Clients high-tech, electronic, financial institutions and restaurants. Current clients include Mixtec Group, Humanomics Inc., Teasdale Quality Foods, DMG Marketing, DocuMedia Group Inc.
Needs Works with 3 freelancers/year. Assigns 10-15 jobs/year. Uses freelancers mainly for brochure, editorial newspaper and magazine ad illustration, mechanicals, retouching, direct mail packages, lettering, charts/graphs. Needs editorial, technical and medical illustration, photography, production on collateral materials, lettering and editorial cartoons. Needs computer-literate freelancers for design, illustration and production. 95% of freelance work demands skills in QuarkXPress, Photoshop and FreeHand.
First Contact & Terms Contact through artist's agent or send query letter with brochure showing art style. Samples are filed. Responds only if interested. To show a portfolio, mail color and b&w tearsheets and photographs. Pays for production by the hour, $25-35. Pays for design by the hour, $75-150; or by the project, $500-2,000. Pays for illustration by the project, $250-3,000. Considers complexity of project, client's budget and turnaround time when establishing payment. Rights purchased vary according to project. Finds artists through agents, sourcebooks and sometimes by submissions.

BASIC/BEDELL ADVERTISING & PUBLISHING
P. O. Box 6068, Ventura CA 93006. (805)650-1565. E-mail: barriebedell@earthlink.net. **President:** Barrie Bedell. Specializes in advertisements, direct mail, how-to books, direct response Web sites and manuals. Clients publishers, direct response marketers, retail stores, software developers, Web entrepreneurs, plus extensive self-promotion of proprietary advertising how-to manuals.
- This company's president is seeing "a glut of 'graphic designers,' and an acute shortage of 'direct response' designers."
Needs Uses artists for publication and direct mail design, book covers and dust jackets, and camera-ready computer desktop production. Especially interested in hearing from professionals experienced in e-commerce and in converting printed training materials to electronic media, as well as designers of direct response Web sites.
First Contact & Terms Portfolio review not required. Pays for design by the project, $100-2,500 and up and/or royalties based on sales.
Tips "There has been a substantial increase in use of freelance talent and increasing need for true professionals with exceptional skills and responsible performance (delivery as promised and 'on target'). It is very difficult to locate freelance talent with expertise in design of advertising and direct mail with heavy use of type. Contact with personal letter and photocopy of one or more samples of work that needn't be returned."

THE BASS GROUP
Dept. AM, 102 Willow Ave., Fairfax CA 94930. (415)455-8090. **Producer:** Herbert Bass. Number of employees 2. Approximate annual billing $300,000. "A multimedia, full-service production company providing corporate communications to a wide range of clients. Specializes in multimedia presentations, video/film, and events productions for corporations."
Needs Approached by 30 freelancers/year. Works with a variety of freelance illustrators and designers/year. Prefers solid experience in multimedia and film/video production. Works on assignment only. Uses freelancers for logos, charts/graphs and multimedia designs. Needs graphics, meeting theme logos, electronic speaker support and slide design. Needs computer-literate freelancers for design, illustration and production. 90% of freelance work demands skills in QuarkXPress, FreeHand, Illustrator and Photoshop.

First Contact & Terms Send résumé and slides. Samples are filed and are not returned. Responds in 1 month if interested. Will contact artist for portfolio review if interested. Sometimes requests work on spec before assigning a job. Pays by the project. Considers turnaround time, skill and experience of artist and how work will be used when establishing payment. Rights purchased vary according to project. Finds illustrators and designers mainly through word of mouth recommendations.

Tips "Send résumé, samples, rates. Highlight examples in speaker support—both slide and electronic media—and include meeting logo design."

BERSON, DEAN, STEVENS

P.O. Box 3997, Thousand Oaks CA 91359. (818)713-0134. Fax: (818)713-0417. E-mail: info@bersondeanstevens .com. Web site: www.bersondeanstevens.com. **Owner:** Lori Berson. Estab. 1981. Specializes in annual reports, brand and corporate identity, collateral, direct mail, trade show booths, promotions, Web sites, packaging, and publication design. Clients: manufacturers, professional and financial service firms, ad agencies, corporations and movie studios. Professional affiliation L.A. Ad Club.

Needs Approached by 50 freelancers/year. Works with 10-20 illustrators and 10 designers/year. Works on assignment only. Uses illustrators mainly for brochures, packaging, and comps. Also for catalog, P-O-P, ad and poster illustration, mechanicals retouching, airbrushing, lettering, logos and model-making. 90% of freelance work demands skills in Illustrator, QuarkXPress, Photoshop, as well as Web authoring Dreamweaver, Flash/HTML, CGI, Java, etc.

First Contact & Terms Send query letter with tearsheets and photocopies. Samples are filed. Will contact artist for portfolio review if interested. Pays for design and illustration by the project. Rights purchased vary according to project. Considers buying second rights (reprint rights) to previously published work. Finds artists through word of mouth, submissions/self-promotions, sourcebooks and agents.

BRAINWORKS DESIGN GROUP, INC.

5 Harris Court, Building T, Monterey CA 93940. (831)657-0650. Fax: (831)657-0750. E-mail: mail@brainwks.c om. Web site: www.brainwks.com. **Contact:** Alfred Kahn, president. Marketing Director: Stephanie Hickey. Estab. 1970. Number of employees 8. Specializes in ERC (Emotional Response Communications), graphic design, corporate identity, direct mail and publication. Clients colleges, universities, nonprofit organizations; majority are colleges and universities. Current clients include City College of New York, Manhattanville, University of South Carolina-Spartanburg, Queens College, Manhattan College, Nova University, American International College, Teachers College Columbia, University of Rochester.

Needs Approached by 100 freelancers/year. Works with 4 freelance illustrators and 10 designers/year. Prefers freelancers with experience in type, layout, grids, mechanicals, comps and creative visual thinking. Works on assignment only. Uses freelancers mainly for mechanicals and calligraphy. Also for brochure, direct mail and poster design; mechanicals; lettering; and logos. 100% of design work demands knowledge of QuarkXPress, Illustrator, Photoshop and InDesign.

First Contact & Terms Send brochure or résumé, photocopies, photographs, tearsheets and transparencies. Samples are filed. Artist should follow up with call and/or letter after initial query. Will contact artist for portfolio review if interested. Portfolio should include thumbnails, roughs, final reproduction/product and b&w and color tearsheets, photostats, photographs and transparencies. Pays for design by the project, $200-2,000. Considers complexity of project and client's budget when establishing payment. Rights purchased vary according to project. Finds artists through sourcebooks and self-promotions.

Tips "Creative thinking and a positive attitude are a plus." The most common mistake freelancers make in presenting samples or portfolios is that the "work does not match up to the samples they show." Would like to see more roughs and thumbnails.

JANN CHURCH PARTNERS, INC./PHILANTHROPY CONSULTANTS GROUP, INC.

P.O. Box 9527, Newport Beach CA 92660. (949)640-6224. Fax: (949)640-1706. **President:** Jann Church. Estab. 1970. Specializes in annual reports, brand and corporate identity, display, interior, direct mail, package and publication design, and signage. Clients real estate developers, medical/high technology corporations, private and public companies. Current clients include The Nichols Institute, The Anden Group, Institute for Biological Research & Development. Client list available upon request.

Needs Approached by 100 freelance artists/year. Works with 3 illustrators and 5 designers/year. Works on assignment only. Needs technical illustration. 10% of freelance work demands computer literacy.

First Contact & Terms Send query letter with résumé, photographs and photocopies. Samples are filed. Responds only if interested. To show a portfolio, mail appropriate materials. Portfolio should be "as complete as possible." Pays for design and illustration by the project. Rights purchased vary according to project.

CLIFF & ASSOCIATES

10061 Riverside Dr. #808, Toluca Lake CA 91602. (626)799-5906. Fax: (626)799-9809. E-mail: design@cliffassoc .com. **Owner:** Greg Cliff. Estab. 1984. Number of employees 10. Approximate annual billing $1 million. Specializes in annual reports, corporate identity, direct mail and publication design and signage. Clients: Fortune 500 corporations and performing arts companies. Current clients include BP, IXIA, WSPA, IABC, Capital Research and ING.

Needs Approached by 50 freelancers/year. Works with 30 freelance illustrators and 10 designers/year. Prefers local freelancers and Art Center graduates. Uses freelancers mainly for brochures. Also for technical, "fresh" editorial and medical illustration; mechanicals; lettering; logos; catalog, book and magazine design; P-O-P and poster design and illustration; and model making. Needs computer-literate freelancers for design and production. 90% of freelance work demands knowledge of QuarkXPress, FreeHand, Illustrator, Photoshop, etc.

First Contact & Terms Send query letter with résumé and a nonreturnable sample of work. Samples are filed. Art director will contact artist for portfolio review if interested. Portfolio should include thumbnails, b&w photostats and printed samples. Pays for design by the hour, $25-35. Pays for illustration by the project, $50-3,000. Buys one-time rights. Finds artists through sourcebooks.

COAKLEY HEAGERTY ADVERTISING & PUBLIC RELATIONS

1155 N. First St., Suite 201, San Jose CA 95112-4925. (408)275-9400. Fax: (408)995-0600. E-mail: info@coakley-heagerty.com. Web site: www.coakley-heagerty.com. **Creative Director:** Bob Meyerson. Estab. 1961. Number of employees 25. Full-service ad agency and PR firm. Clients real estate, consumer, senior care, banking/financial, insurance, automotive, tel com, public service. Client list available upon request. Professional affiliation MAGNET (Marketing and Advertising Global Network).

Needs Approached by 50 freelancers/year. Works with 50 freelance illustrators and 3 designers/year. Works on assignment only. Uses freelancers for illustration, retouching, animation, lettering, logos and charts/graphs. Freelance work demands skills in InDesign, Illustrator, Photoshop or QuarkXPress.

First Contact & Terms E-mail PDF files showing art style, or e-mail link to Web site. Does not report back. Call for an appointment to show portfolio. Pays for design and illustration by the project, $600-5,000.

DENTON DESIGN ASSOCIATES

491 Arbor St., Pasadena CA 91105. (626)792-7141. **President:** Margi Denton. Estab. 1975. Specializes in annual reports, corporate identity and publication design. Clients nonprofit organizations and corporations. Recent clients include California Institute of Technology, University of Southern California, Yellowjackets and SETI Institute.

Needs Approached by 12 freelance graphic artists/year. Works with roughly 5 freelance illustrators and 2 freelance designers/year. Prefers local designers only. "We work with illustrators from anywhere." Works with designers and illustrators for brochure design and illustration, lettering, logos and charts/graphs. Demands knowledge of QuarkXPress, Photoshop and Illustrator.

First Contact & Terms Send résumé, tearsheets and samples (illustrators just send samples). Samples are filed and are not returned. Responds only if interested. Art director will contact artist for portfolio review if interested. Portfolio should include color samples "doesn't matter what form." Pays for design by the hour. Pays for illustration by the project. Rights purchased vary according to project. Finds artists through sourcebooks, AIGA, *Print*, *CA*, *Folio Planet* and other Internet sources.

DESIGN 2 MARKET

(formerly Yamaguma & Associates), 909 Weddell Ct., Sunnyvale CA 94089. (408)744-6671. Fax: (408)744-6686. E-mail: info@design2marketinc.com. Web site: www.design2marketinc.com. **Production Manager:** Jean Philavong. Estab. 1980. Specializes in corporate identity, trade show exhibit design and coordination, displays, direct mail, print advertising, publication design, Web design, signage and marketing. Clients high technology, government and business-to-business. Clients include NEC, OKI Semiconductor, IDEC, Saver Glass and City College of San Francisco. Client list available upon request.

Needs Approached by 6 freelancers/year. Works with 3 freelance illustrators and 2 designers/year. Works on assignment only. Uses illustrators mainly for 4-color, airbrush and technical work. Uses designers mainly for logos, layout and production. Also uses freelancers for brochure, catalog, ad, P-O-P and poster design and illustration; mechanicals; retouching; lettering; book, magazine, model-making; direct mail design; charts/graphs; and AV materials. Also for multimedia projects (Director SuperCard). Needs editorial and technical illustration. 100% of design and 75% of illustration demand knowledge of InDesign, QuarkXPress, Dreamweaver, Illustrator, Model Shop, Strata, Sketchup, Flash, MMDir. or Photoshop.

First Contact & Terms Send postcard sample or query letter with brochure and tearsheets. Accepts disk submissions compatible with Illustrator, QuarkXPress, Photoshop, Sketchup, Flash and Strata. Samples are filed. Will contact artist for portfolio review if interested. Portfolio should include thumbnails, roughs, b&w and color

photostats, tearsheets, photographs, slides and transparencies. Sometimes requests work on spec before assigning a job. Pays for design by the hour, $25-50. Pays for illustration by the project, $300-3,000. Rights purchased vary according to project. Finds artists through self-promotions.
Tips Would like to see more images for advertising purposes as well as the ability to reproduce in all media.

DESIGN AXIOM
50 B Peninsula Center Dr., Suite 156, Rolling Hills Estates CA 90274. (310)377-0207. E-mail: tschorer@aol.com.
President: Thomas Schorer. Estab. 1973. Specializes in graphic, environmental and architectural design, product development and signage.
Needs Approached by 100 freelancers/year. Works with 3 freelance illustrators and 5 designers/year. Works on assignment only. Uses designers for all types of design. Uses illustrators for editorial and technical illustration. 50% of freelance work demands knowledge of PageMaker or QuarkXPress.
First Contact & Terms Send query letter with appropriate samples. Will contact artist for portfolio review if interested. Portfolio should include appropriate samples. Pays for design and illustration by the project. Finds artists through word of mouth, self-promotions, sourcebooks and colleges.

Ⓝ DESIGN COLLABORATIVE
1617 Lincoln Ave., San Rafael CA 94901-5400. (415)456-0252. Fax: (415)479-2001. E-mail: mail@designco.com.
Web site: www.designco.com. **Creative Director:** Bob Ford. Estab. 1987. Number of employees 7. Approximate annual billing $350,000. Ad agency/design firm. Specializes in publication design, package design, environmental graphics. Product specialty is consumer. Current clients include B of A, Lucas Film Ltd., Broderbund Software. Client list available upon request. Professional affiliations AAGD, PINC, AAD.
Needs Approached by 20 freelance illustrators and 60 designers/year. Works with 15 freelance illustrators and 20 designers/year. Prefers local designers with experience in package design. Uses freelancers mainly for art direction production. Also for brochure design and illustration, mechanicals, multimedia projects, signage, web page design. 25% of work is with print ads. 80% of design and 85% of illustration demand skills in PageMaker, FreeHand, Photoshop, QuarkXPress, Illustrator, PageMill.
First Contact & Terms Designers: Send query letter with photocopies, résumé, color copies. Illustrators: Send postcard sample and/or query letter with photocopies and color copies. After introductory mailing send follow-up postcard samples. Accepts disk submissions. Send EPS files. Samples are filed or returned. Responds in 1 week. Artist should call. Portfolio review required if interested in artist's work. Portfolios of final art and transparencies may be dropped off every Monday. Pays for design by the hour, $40-80. Pays for illustration by the hour, $40-100. Buys first rights. Rights purchased vary according to project. Finds artists through creative sourcebooks.
Tips "Listen carefully and execute well."

ERVIN/BELL ADVERTISING
2134 Michelson Dr., Irvine CA 92612. (949)251-1166. Fax: (949)417-2239. E-mail: mervin@ervinbell.com. Web site: www.ervinbell.com. Estab. 1981. Specializes in annual reports, branding and brand management, corporate identity, retail, direct mail, package and publication design. Clients corporations, malls, financial firms, industrial firms and software publishers. Current clients include First American Financial, Nutro Products, Toyota Certified, Ropak Corporation. Client list available upon request.
Needs Approached by 100 freelancers/year. Works with 10 freelance illustrators and 6 designers/year. Works on assignment only. Uses illustrators mainly for package designs, annual reports. Uses designers mainly for annual reports, special projects. Also uses freelancers for brochure design and illustration, P-O-P and ad illustration, mechanicals, audiovisual materials, lettering and charts/graphs. Needs computer-literate freelancers for production. 100% of freelance work demands knowledge of QuarkXPress or Photoshop.
First Contact & Terms Send résumé and photocopies. Samples are filed and are not returned. Responds only if interested. Request portfolio review in original query. Portfolio should include color roughs, tearsheets and transparencies. Pays for design by the hour, $15-30; by the project (rate varies); by the day, $120-240. Pays for illustration by the project (rate varies). Buys all rights.
Tips Finds artists through sourcebooks, submitted résumés, mailings.

ESSANEE UNLIMITED, INC.
P.O. Box 5168, Santa Monica CA 90409-5168. (310)396-0192. E-mail: essanee@earthlink.net. **Art Director:** Sharon Rubin. Estab. 1982. Integrated marketing communications agency/design firm. Specializes in packaging and promotion. Product specialties are travel and entertainment marketing.
Needs Works with 3-5 freelance illustrators and 3-5 designers/year. Prefers local freelancers with experience in graphic design. Also for Web design and multimedia projects.
First Contact & Terms Send nonreturnable samples. Accepts disk submissions. Samples are reviewed, filed or

returned by SASE. Portfolio review required only if interested in artist's work. Artist should follow-up with call. Finds artists through word of mouth, submissions.

EVENSON DESIGN GROUP

4445 Overland Ave., Culver City CA 90230. (310)204-1995. Fax: (310)204-4879. E-mail: edgmail@evensondesig n.com. Web site: evensondesign.com. **Principal:** Stan Evenson. Estab. 1976. Specializes in annual reports, brand and corporate identity, display design, direct mail, package design and signage. Clients ad agencies, hospitals, corporations, law firms, entertainment companies, record companies, publications, PR firms. Current clients include MGM, Pepsi Cola Company, Columbia Tri-Star, Sony Pictures Entertainment.

Needs Approached by 75-100 freelance artists/year. Works with 10 illustrators and 15 designers/year. Prefers artists with production experience as well as strong design capabilities. Works on assignment only. Uses illustrators mainly for covers for corporate brochures. Uses designers mainly for logo design, page layouts, all overflow work. Also for brochure, catalog, direct mail, ad, P-O-P and poster design and illustration, mechanicals, lettering, logos and charts/graphs. 100% of design work demands skills in QuarkXPress, FreeHand, Photoshop or Illustrator.

First Contact & Terms Send query letter with résumé and samples or send samples via e-mail. Responds only if interested. Portfolio should include b&w and color photostats and tearsheets and 4×5 or larger transparencies.

Tips "Be efficient in the execution of design work, producing quality designs over the quantity of designs. Professionalism, as well as a good sense of humor, will prove you to be a favorable addition to any design team."

FOOTE, CONE & BELDING

17600 Gillette Ave., Irvine CA 92614. (949)851-3050. Fax: (949)567-9465. Web site: www.fcb.com. **Art Buyer:** Connie Mangam. Estab. 1950. Ad agency. Full-service, multimedia firm. Product specialties are package goods, toys, entertainment and retail.

- This is the Southern California office of FCB, a global agency with offices all over the world. FCB is one of the top 3 agencies in the United States, with 188 offices in 102 countries. Main offices are in New York. Other offices are located in Chicago and San Francisco.

Needs Approached by 15-20 freelance artists/month. Works with 3-4 freelance illustrators and 2-3 freelance designers/month. Prefers local artists only with experience in design and sales promotion. Designers must be able to work in-house and have Mac experience. Uses freelance artists for brochure, catalog and print ad design and illustration, storyboards, mechanicals, retouching, lettering, logos and computer (Mac). 30% of work is with print ads.

First Contact & Terms Designers: Send query letter with résumé, photocopies and tearsheets. Illustrators: Send postcard, color photocopies, tearsheets or other nonreturnable samples. Samples are filed. Responds only if interested. Write to schedule an appointment to show a portfolio. Portfolio should include roughs and color. Pays for design based on estimate on project from concept to mechanical supervision. Pays for illustration per project. Rights purchased vary according to project.

GRAPHIC DESIGN CONCEPTS

15329 Yukon Ave., El Camino Village CA 90260-2452. (310)978-8922. **President:** C. Weinstein. Estab. 1980. Specializes in package, publication and industrial design, annual reports, corporate identity, displays and direct mail. Current clients include Trust Financial Financial Services (marketing materials). Current projects include new product development for electronic, hardware, cosmetic, toy and novelty companies.

Needs Works with 15 illustrators and 25 designers/year. "Looking for highly creative idea people, all levels of experience." All styles considered. Uses illustrators mainly for commercial illustration. Uses designers mainly for product and graphic design. Also uses freelancers for brochure, P-O-P, poster and catalog design and illustration; book, magazine, direct mail and newspaper design; mechanicals; retouching; airbrushing; model-making; charts/graphs; lettering; logos. Also for multimedia design, program and content development. 50% of freelance work demands knowledge of PageMaker, Illustrator, QuarkXPress, Photoshop or FreeHand.

First Contact & Terms Send query letter with brochure, résumé, tearsheets, photostats, photocopies, slides, photographs and/or transparencies. Accepts disk submissions compatible with Windows on the IBM. Samples are filed or are returned if accompanied by SASE. Responds in 10 days with SASE. Portfolio should include thumbnails, roughs, original/final art, final reproduction/product, tearsheets, transparencies and references from employers. Pays by the hour, $15-50. Considers complexity of project, client's budget, skill and experience of artist, how work will be used, turnaround time and rights purchased when establishing payment.

Tips "Send a résumé if available. Send samples of recent work or *high quality* copies. Everything sent to us should have a professional look. After all, it is the first impression we will have of you. Selling artwork is a business. Conduct yourself in a business-like manner."

HARTUNG & ASSOCIATES, LTD.

10279 Field Lane, Forestville CA 95436. (707)887-2825. Fax: (707)887-1214. Web site: www.grafted1@sonic.n et. **President:** Tim Hartung. Estab. 1976. Specializes in display, marketing and consulting, direct mail, package and publication design and corporate identity, Web design and signage. Clients corporations. Current clients include Marina Cove, Crown Transportation, Exigent. Client list available upon request.

Needs Approached by 20 freelance graphic artists/year. Works with 5 freelance illustrators and 1 freelance designer/year. Prefers local artists "if possible." Works on assignment only. Uses illustrators and designers mainly for brochures. Also uses freelance artists for brochure and package design and illustration, direct mail design, Web design, P-O-P illustration and design, mechanicals, retouching, airbrushing, audiovisual materials, lettering, logos and charts/graphs. 50% of freelance work demands skills in QuarkXPress or Illustrator.

First Contact & Terms Send query letter with brochure, tearsheets and résumé. Samples are filed. Does not reply. Artist should follow up with call. Portfolio should include b&w and color thumbnails, roughs, final art, photostats and tearsheets. Pays for design by the hour or by the project. Pays for illustration by the project. "Rate depends on size, detail, etc. of project." Buys all rights. Finds artists through sourcebooks and artists' submissions.

THE HITCHINS COMPANY

22756 Hartland St., Canoga Park CA 91307. (818)715-0150. Fax: (775)806-2687. E-mail: whitchins@socal.rr.c om. **President:** W. Hitchins. Estab. 1985. Advertising agency. Full-service, multimedia firm.

Needs Works with 1-2 illustrators and 3-4 designers/year. Works on assignment only. Uses freelance artists for brochure and print ad design and illustration, storyboards, mechanicals, retouching, TV/film graphics, lettering and logo. Needs editorial and technical illustration and animation. 60% of work is with print ads. 90% of design and 50% of illustration demand knowledge of PageMaker, Illustrator, QuarkXPress or FreeHand.

First Contact & Terms Send postcard sample. Samples are filed if interested and are not returned. Responds only if interested. Call for appointment to show portfolio. Portfolio should include tearsheets. Pays for design and illustration by the project, according to project and client. Rights purchased vary according to project.

IMPACT COMMUNICATIONS GROUP

18627 Brookhurst St., #4200, Fountain Valley CA 92708. (714)963-0080. E-mail: info@impactgroup.com. Web site: www.impactgroup.com. **Creative Director:** Brad Vinikow. Estab. 1983. Number of employees 15. Marketing communications firm. Full-service, multimedia firm. Specializes in electronic media, business-to-business and print design. Current clients include Yamaha Corporation, Prudential, Isuzu. Professional affiliations IICS, NCCC and ITVA.

Needs Approached by 12 freelancers/year. Works with 12 freelance illustrators and 12 designers/year. Uses freelancers mainly for illustration, design and computer production. Also for brochure and catalog design and illustration, multimedia and logos. 10% of work is with print ads. 90% of design and 50% of illustration demands knowledge of Photoshop, QuarkXPress, Illustrator and Macro Mind Director.

First Contact & Terms Designers: Send query letter with photocopies, photographs, résumé and tearsheets. Illustrators: Send postcard sample. Samples are filed and are not returned. Will contact artist for portfolio review if interested. Portfolio should include b&w and color final art, photographs, photostats, roughs, slides, tearsheets and thumbnails. Pays for design and illustration by the project, depending on budget. Rights purchased vary according to project. Finds artists through sourcebooks and self-promotion pieces received in mail.

Tips "Be flexible."

LINEAR CYCLE PRODUCTIONS

P.O. Box 2608, North Hills CA 91393-0608. Phone/fax: (818)347-9880. E-mail: lcp@wgn.net. Web site: www.lin earproductions.com. **Producer:** Rich Brown. Production Manager: R. Borowy. Estab. 1980. Number of employees 30. Approximate annual billing $200,000. AV firm. Specializes in audiovisual sales and marketing programs and also in teleproduction for CATV. Current clients include Katz, Inc. and McDave and Associates.

Needs Works with 7-10 freelance illustrators and 7-10 designers/year. Prefers freelancers with experience in teleproductions (broadcast/CATV/non-broadcast). Works on assignment only. Uses freelancers for storyboards, animation, TV/film graphics, editorial illustration, lettering and logos. 10% of work is with print ads. 25% of freelance work demands knowledge of FreeHand, Photoshop or Tobis IV.

First Contact & Terms Send query letter with résumé, photocopies, photographs, slides, transparencies, video demo reel and SASE. Samples are filed or are returned by SASE if requested by artist. Responds only if interested. To show portfolio, mail audio/videotapes, photographs and slides; include color and b&w samples. Pays for design and illustration by the project, $100 minimum. Considers skill and experience of artist, how work will be used and rights purchased when establishing payment. Negotiates rights purchased. Finds artists through reviewing portfolios and published material.

Tips "We see a lot of sloppy work and samples, portfolios in fields not requested or wanted, poor photos, photocopies, graphics, etc. Make sure your materials are presentable."

Ⓝ MOLLY DESIGNS
729 W. 16th. Street, A-3, Costa Mesa CA 92627. E-mail: info@mollydesigns.com. **Owner:** Molly. Estab. 1972. Number of employees 12. Approximate annual billing $1 million. Specializes in corporate identity, signage and automotive graphics. Clients corporations, ad agencies, PR firms, small companies. Current clients include Toyota Motor Sales, Lexus, Land Rover, Buick, Chevy, TRD, Yamaha, Kawasaki.
Needs Approached by 6-8 freelancers/year. Works with 3-4 freelance illustrators and 3-4 designers/year. Prefers freelancers with experience in the automotive field. Works on assignment only. Uses freelance illustrators mainly for presentations. Uses freelance designers mainly for graphic design. Also uses freelancers for brochure design, mechanicals, lettering, logos, P-O-P design and illustration and direct mail design. Needs computer-literate freelancers for illustration and presentation. 60% of freelance work demands knowledge of Illustrator and Photoshop.
First Contact & Terms Send query letter with photographs. Samples are filed. Responds in 2 weeks. Call for appointment to show portfolio of thumbnails, roughs, original/final art and photographs. Pays for design and illustration by the project, $100 minimum. Rights purchased vary according to project.

SOFTMIRAGE
2900 Bristol St., Suite J103, Costa Mesa CA 92626. (714)546-7030 ext. 102 (Steve Pollack). Fax: (714)546-3565. E-mail: steve@softmirage.com. Web site: www.softmirage.com. **Design Director:** Steve Pollack. Estab. 1995. Number of employees 12. Approximate annual billing $2 million. Visual communications agency. Specializes in architecture, real estate and entertainment. Needs people with strong spatial design skills, modeling and ability to work with computer graphics. Current clients include Four Seasons Hotels, Ford, Richard Meier & Partners and various real esate companies.
Needs Approached by 15 computer freelance illustrators and 5 designers/year. Works with 6 freelance 3D modelers, and 10 graphic designers/year. Prefers West coast designers with experience in architecture, engineering, technology. Uses freelancers mainly for concept, work in process computer modeling. Also for animation, brochure design, mechanicals, multimedia projects, retouching, technical illustration, TV/film graphics. 50% of work is renderings. 100% of design and 30% of illustration demand skills in Photoshop, 3-D Studio Max, Flash and Director. Need Macromedia Flash developers.
First Contact & Terms Designers: Send e-mail query letter with samples. 3-D modelers: Send e-mail query letter with photocopies or link to Web site. Accepts digital and video submissions. Samples are filed or returned by SASE. Will contact for portfolio review if interested. Pays for design by the hour, $15-85. Pays for modeling by the project, $100-2,500. Rights purchased vary according to project. Finds artists through Internet, AIGA and referrals.
Tips "Be innovative, push the creativity, understand the business rationale and accept technology. Check our Web site, as we do not use traditional illustrators, all our work is now digital. Send information electronically, making sure work is progressive and emphasizing types of projects you can assist with."

SPLANE DESIGN ASSOCIATES
30634 Persimmon Lane, Valley Center CA 90282. (760)749-6018. E-mail: splane@pacificnet.net. Web site: www.splanedesign.com. **President:** Robson Splane. Specializes in product design. Clients small, medium and large companies. Current clients include Hanson Research, Accuride Corp., Hewlett Packard, Sunrise Corp. Client list available upon request.
Needs Approached by 25-30 freelancers/year. Works with 1-2 freelance illustrators and 6-12 designers/year. Works on assignment only. Uses illustrators mainly for logos, mailings to clients, renderings. Uses designers mainly for sourcing, drawings, prototyping, modeling. Also uses freelancers for brochure design and illustration, ad design, mechanicals, retouching, airbrushing, model making, lettering and logos. 75% of freelance work demands skills in FreeHand, Ashlar Vellum, Solidworks and Excel.
First Contact & Terms Send query letter with résumé and photocopies. Samples are filed or are returned. Responds only if interested. Will contact artist for portfolio review if interested. Portfolio should include color roughs, final art, photostats, slides and photographs. Pays for design and illustration by the hour, $7-25. Rights purchased vary according to project. Finds artists through submissions and contacts.

JULIA TAM DESIGN
2216 Via La Brea, Palos Verdes CA 90274. (310)378-7583. Fax: (310)378-4589. E-mail: julia.tam@verizon.net. **Contact:** Julia Tam. Estab. 1986. Specializes in annual reports, corporate identity, brochures, promotional material, packaging and design. Clients: corporations. Current clients include Southern California Gas Co., *Los Angeles Times*, UCLA. Client list available upon request. Professional affiliations: AIGA.

● Julia Tam Design won numerous awards including American Graphic Design Award, Premier Print Award, *Creativity*, *American Corporate Identity* and work showcased in Rockport Madison Square Press and Northlight graphic books.

Needs Approached by 10 freelancers/year. Works with 6-12 freelance illustrators and 2 designers/year. "We look for special styles." Works on assignment only. Uses illustrators mainly for brochures. Also uses freelancers for catalog and ad illustration; retouching; and lettering. 50-100% of freelance work demands knowledge of QuarkXPress, Illustrator or Photoshop.

First Contact & Terms Designers: Send query letter with brochure and résumé. Illustrators: Send query letter with résumé and tearsheets. Samples are filed. Responds only if interested. Artist should follow up. Portfolio should include b&w and color final art, tearsheets and transparencies. Pays for design by the hour, $10-20. Pays for illustration by the project. Negotiates rights purchased. Finds artists through *LA Workbook*.

THE VAN NOY GROUP

3315 Westside Rd., Healdsburg CA 95448-9453. (707)433-3944. Fax: (707)433-0375. E-mail: jim@vannoygroup. com. Web site: www.vannoygroup.com. **Vice President:** Ann Van Noy. Estab. 1972. Specializes in brand and corporate identity, displays and package design. Clients corporations. Current clients include Waterford, Wedgewood USA, Leiner Health Products, Pentel of America. Client list available upon request.

Needs Approached by 1-10 freelance artists/year. Works with 2 illustrators and 3 designers/year. Prefers artists with experience in Macintosh design. Works on assignment only. Uses freelancers for packaging design and illustration, Quark and Photoshop production and lettering.

First Contact & Terms Send query letter with résumé and photographs. Samples are filed. Will contact artist for portfolio review if interested. If no reply, artist should follow up. Pays for design by the hour, $35-100. Pays for illustration by the hour or by the project at a TBD fee. Finds artists through sourcebooks, self-promotions and primarily agents. Also have permanent positions available.

Tips "I think more and more clients will be setting up internal art departments and relying less and less on outside designers and talent. The computer has made design accessible to the user who is not design-trained."

VIDEO RESOURCES

1809 E. Dyer Road, #307, Santa Ana CA 92705. (949)261-7266. Fax: (949)261-5908. Web site: www.videoresourc es.com. E-mail: brad@videoresouces.com. **Producer:** Brad Hagen. Number of employees 10. Video and multimedia firm. Specializes in automotive, banks, restaurants, computer, health care, transportation and energy.

Needs Approached by 10-20 freelancers/year. Works with 5-10 freelance illustrators and 5-10 designers/year. Works on assignment only. Uses freelancers for graphics, multimedia, animation, etc.

First Contact & Terms Send query letter with brochure showing art style or résumé, business card, photostats and tearsheets to be kept on file. Samples not filed are returned by SASE. Considers complexity of the project and client's budget when establishing payment. Buys all rights.

WESCO GRAPHICS, INC.

410 E. Grant Line Rd., #B, Tracy CA 95376. (209)832-1000. Fax: (209)832-7800. E-mail: joy@wescographics.com or graphics@wescographics.com. **Art Director:** Dawn Hill. Estab. 1977. Number of employees 20. Service-related firm. Specializes in design, layout, typesetting, paste-up, ads and brochures. Clients retailers. Current clients include Ben Franklin Crafts, Food 4 Less, Auto Deals.

Needs Approached by 10 freelancers/year. Works with 2 freelance illustrators and 2 designers/year. Prefers local freelancers with experience in paste-up and color. Works on assignment only. Uses freelancers mainly for overload. Also for ad and brochure layout. Needs computer-literate freelancers for production. 90% of freelance work demands skills in Illustrator, QuarkXPress, Photoshop and Multi Ad Creator.

First Contact & Terms Send query letter with résumé. Samples are filed. Will contact artist for portfolio review if interested. Artist should follow up with call. Portfolio should include b&w thumbnails, roughs, photostats and tearsheets. Sometimes requests work on spec before assigning a job. Pays for design and illustration by the hour, $10-15. Buys all rights. Finds artists through word of mouth.

Tips "Combine computer knowledge with traditional graphic skills."

DANA WHITE PRODUCTIONS, INC.

2623 29th St., Santa Monica CA 90405. (310)450-9101. E-mail: dwprods@aol.com. **Owner/Producer:** Dana C. White. AV firm. "We are a full-service audiovisual design and production company, providing video and audio presentations for training, marketing, awards, historical and public relations uses. We have complete inhouse production resources, including computer multimedia, photo digitizing, image manipulation, program assembly, slidemaking, soundtrack production, photography and AV multi-image programming. We serve major industries such as US Forest Services, medical, such as Whittier Hospital, Florida Hospital; schools, such as

University of Southern California, Pepperdine University; publishers, such as McGraw-Hill, West Publishing; and public service efforts, including fundraising.''

Needs Works with 8-10 freelancers/year. Prefers freelancers local to greater Los Angeles, "with timely turn-around, ability to keep elements in accurate registration, neatness, design quality, imagination and price.'' Uses freelancers for design, illustration, retouching, characterization/animation, lettering and charts. 50% of freelance work demands knowledge of Illustrator, FreeHand, Photoshop, Quark and Premier.

First Contact & Terms Send query letter with brochure or tearsheets, photostats, photocopies, slides and photographs. Samples are filed or are returned only if requested. Responds in 2 weeks only if interested. Call or write for appointment to show portfolio. Pays by the project. Payment negotiable by job.

Tips "These are tough times. Be flexible. Negotiate. Your work should show that you have spirit, enjoy what you do and that you can deliver high quality work on time.''

LOS ANGELES

ASHCRAFT DESIGN
11832 W. Pico Blvd., Los Angeles CA 90064. (310)479-8330. Fax: (310)473-7051. E-mail: information@ashcraftdesign.com. Web site: www.ashcraftdesign.com. Estab. 1986. Specializes in corporate identity, display and package design and signage. Client list available upon request.

Needs Approached by 2 freelance artists/year. Works with 1 freelance illustrator and 2 freelance designers/year. Works on assignment only. Uses freelance illustrators mainly for technical illustration. Uses freelance designers mainly for packaging and production. Also uses freelance artists for mechanicals and model making.

First Contact & Terms Send query letter with tearsheets, résumé and photographs. Samples are filed and are not returned. Responds only if interested. To show a portfolio, e-mail samples or mail color copies. Pays for design and illustration by the project. Rights purchased vary according to project.

BRAMSON + ASSOCIATES
7400 Beverly Blvd., Los Angeles CA 90036. (323)938-3595. Fax: (323)938-0852. E-mail: gbramson@aol.com. **Principal/Senior Creative Director:** Gene Bramson. Estab. 1970. Number of employees 15. Approximate annual billing more than $2 million. Advertising agency. Specializes in magazine ads, collateral, ID, signage, graphic design, imaging, campaigns. Product specialties are healthcare, consumer, business to business. Current clients include Johnson & Johnson, Chiron Vision, Lawry's and Isuzu Motors of America.

Needs Approached by 150 freelancers/year. Works with 10 freelance illustrators, 2 animators and 5 designers/year. Prefers local freelancers. Works on assignment only. Uses freelancers for brochure and print ad design; brochure, technical, medical and print ad illustration, storyboards, mechanicals, retouching, lettering, logos. 30% of work is with print ads. 50% of freelance work "prefers" knowledge of Pagemaker, Illustrator, QuarkX-Press, Photoshop, Freehand or 3-D Studio.

First Contact & Terms Send query letter with brochure, photocopies, résumé, photographs, tearsheets, SASE. Samples are filed. Will contact artist for portfolio review if interested. Portfolio should include roughs, color tearsheets. Sometimes requests work on spec before assigning job. Pays for design by the hour, $15-25. Pays for illustration by the project, $250-2,000. Buys all rights or negotiates rights purchased. Finds artists through sourcebooks.

Tips Looks for "very unique talent only." Price and availability are also important.

FREEASSOCIATES
2300 Westwood Blvd., Suite 105, Los Angeles CA 90064. (310)441-9950. Fax: (310)441-9949. E-mail: jfreeman@freeassoc.com. Web site: www.freeassoc.com. **President:** Josh Freeman. Estab. 1974. Number of employees 4. Design firm. Specializes in marketing materials for corporate clients. Client list available upon request. Professional affiliations AIGA.

Needs Approached by 60 illustrators and 30 designers/year. Works with 3 illustrators and 3 designers/year. Prefers freelancers with experience in top level design and advertising. Uses freelancers mainly for design, production, illustration. Also for airbrushing, brochure design and illustration, catalog design and illustration, lettering, logos, mechanicals, multimedia projects, posters, retouching, signage, storyboards, technical illustration and Web page design. 30% of work is with print ads. 90% of design and 50% of illustration demand skills in Photoshop, InDesign CS, Illustrator.

First Contact & Terms Designers: Send query letter with photocopies, photographs, résumé, tearsheets and transparencies. Illustrators send postcard sample of work and/or photographs and tearsheets. Accepts Mac-compatible disk submissions to view in current version of major software or self-running presentations. CD-ROM OK. Samples are filed or returned by SASE. Will contact for portfolio review if interested. Pays for design and illustration by the project; negotiable. Rights purchased vary according to project. Finds artists through

iSpot and other online resources, *LA Workbook, CA, Print, Graphis*, submissions and samples.
Tips "Designers should have their own computer and high speed Internet connection. Must have sensitivity to marketing requirements of projects they work on. Deadline commitments are critical."

STUDIO WILKS

2148-A Federal Ave., Los Angeles CA 90025. (310)478-4442. Fax: (310)478-0013. E-mail: richard@studiowilks.com. Web site: www.studiowilks.com. **Executive Creative Dirctor**: Richard Wilks. Estab. 1990. Specializes in print, collateral, packaging, editorial and environmental work. Clients ad agencies, architects, corporations and small business owners. Current clients include Walt Disney Co., Major League Soccer and Yoga Works.
Needs Works with 6-10 freelance illustrators and 10-20 designers/year. Uses illustrators mainly for packaging illustration. Also for brochures, print ads, collateral, direct mail and promotions.
First Contact & Terms Designers: Send query letter with brochure, résumé, photocopies and tearsheets. Illustrators: Send postcard sample or query letter with tearsheets. Samples are returned by SASE if requested by artist. Will contact artist for portfolio review if interested. Pays for design by the project. Buys all rights. Considers buying second rights (reprint rights) to previously published work. Finds artists through *The Workbook* and word of mouth.

SAN FRANCISCO

THE AD AGENCY

P.O. Box 470572, San Francisco CA 94147. **Creative Director:** Michael Carden. Estab. 1972. Ad agency. Full-service multimedia firm. Specializes in print, collateral, magazine ads. Client list available upon request.
Needs Approached by 120 freelancers/year. Works with 120 freelance illustrators and designers/year. Uses freelancers mainly for collateral, magazine ads, print ads. Also for brochure, catalog and print ad design and illustration, mechanicals, billboards, posters, TV/film graphics, multimedia, lettering and logos. 60% of freelance work is with print ads. 50% of freelance design and 45% of illustration demand computer skills.
First Contact & Terms Send query letter with brochure, photocopies and SASE. Samples are filed or returned by SASE. Responds in 1 month. Portfolio should include color final art, photostats and photographs. Buys first rights or negotiates rights purchased. Finds artists through word of mouth, referrals and submissions.
Tips "We are an eclectic agency with a variety of artistic needs."

CAHAN & ASSOCIATES

171 Second St., 5th Floor, San Francisco CA 94105. (415)621-0915. Fax: (415)621-7642. E-mail: info@cahan.com. Web site: www.cahanassociates.com. **President:** Bill Cahan. Estab. 1984. Specializes in annual reports, corporate identity, package design, signage, business and business collateral. Clients public and private companies real estate, finance and biotechnology. Client list available upon request.
Needs Approached by 50 freelance artists/year. Works with 5-10 freelance illustrators and 3-5 freelance designers/year. Works on assignment only. Uses freelance illustrators mainly for annual reports. Uses freelance designers mainly for overload cases. Also uses freelance artists for brochure design.
First Contact & Terms Send query letter with brochure, tearsheets, photostats, résumé, photographs, and photocopies. Samples are filed and are not returned. Responds only if interested. To show a portfolio, mail thumbnails, roughs, tearsheets, and transparencies. Pays for design or illustration by the hour or by the project. Negotiates rights purchased.

HOWRY DESIGN ASSOCIATES

354 Pine St., Suite 600, San Francisco CA 94104. (415)433-2035. Fax: (415)433-0816. E-mail: info@howry.com. Web site: www.howry.com. **Principal/Creative Director:** Jill Howry. Estab. 1988. Full service design studio. Number of employees 12. Specializes in annual reports, corporate identity, print, advertising and multimedia. Clients startups to Fortune 100 companies. Current clients include Del Monte, Affymetrix, Geron Corporation, McKesson Corp., First Republic Bank, View our Web site for current information and portfolio viewing. Professional affiliations AIGA.
Needs Works with 30 freelance illustrators, photographers and Web and print designers/year. Works on assignment only. Uses illustrators for "anything that applies." Uses designers mainly for newsletters, brochures, corporate identity. Also uses freelancers for production, programming, retouching, photography/illustration, logos and charts/graphs. 100% of design work, 10% of illustration work demands knowledge of QuarkXPress, Illustrator or Photoshop.
First Contact & Terms Samples are filed. Responds only if interested. Portfolios may be dropped off every Thursday. Pays for design/production by the hour, or by the job, $25-60. Pays for photography and illustration on a per-job basis. Rights purchased vary according to project.
Tips Finds artists through sourcebooks, samples, representatives.

TOKYO DESIGN CENTER

703 Market St., Suite 252, San Francisco CA 94103. (415)543-4886. **Creative Director:** Kaoru Matsuda. Specializes in annual reports, brand identity, corporate identity, packaging and publications. Clients consumer products, travel agencies and retailers.

Needs Uses artists for design and editorial illustration.

First Contact & Terms Send business card, slides, tearsheets and printed material to be kept on file. Samples not kept on file are returned by SASE only if requested. Will contact artist for portfolio review if interested. Pays for design and illustration by the project, $100-1,500 average. Sometimes requests work on spec before assigning job. Considers client's budget, skill and experience of artist, turnaround time and rights purchased when establishing payment. Interested in buying second rights (reprint rights) to previously published work. Finds artists through self-promotions and sourcebooks.

COLORADO

BARNSTORM VISUAL COMMUNICATIONS, INC.

530 E. Colorado Ave., Colorado Springs CO 80903. (719)630-7200. Fax: (719)630-3280. Web site: www.barnstor mcreative.biz. **Owner:** Becky Houston. Estab. 1975. Specializes in corporate identity, brochure design, publications, Web design and Internet marketing. Clients high-tech corporations, nonprofit fundraising, business-to-business and restaurants. Current clients include Liberty Wire and Cable, Colorado Springs Visitors Bureau and Billiard Congress of America.

Needs Works with 2-4 freelance artists/year. Prefers local, experienced (clean, fast and accurate) artists with experience in TV/film graphics and multimedia. Works on assignment only. Uses freelancers mainly for editorial and technical illustration and production. Needs computer-literate freelancers for production. 90% of freelance work demands knowledge of Illustrator, QuarkXPress, Photoshop, Macromedia FreeHand, InDesign and Flash.

First Contact & Terms Send query letter with résumé and samples to be kept on file. Prefers "good originals or reproductions, professionally presented in any form" as samples. Samples not filed are returned by SASE. Responds only if interested. Call or write for appointment to show portfolio. Pays for design by the hour/$15-40. Pays for illustration by the project, $500 minimum for b&w. Considers client's budget, skill and experience of artist, and turnaround time when establishing payment.

Tips "Portfolios should reflect an awareness of current trends. We try to handle as much inhouse as we can, but we recognize our own limitations (particularly in illustration). Do not include too many samples in your portfolio."

CINE DESIGN FILMS

Box 6495, Denver CO 80206. (303)777-4222. E-mail: jghusband@aol.com. Web site: www.cinedesignfilms.com. **Producer/Director:** Jon Husband. AV firm. Clients automotive companies, banks, restaurants, etc.

Needs Works with 3-7 freelancers/year. Works on assignment only. Uses freelancers for layout, titles, animation and still photography. Clear concept ideas that relate to the client in question are important.

First Contact & Terms Send query letter to be kept on file. Responds only if interested. Write for appointment to show portfolio. Pays by the project. Considers complexity of project, client's budget and rights purchased when establishing payment. Rights purchased vary according to project.

🏆 JO CULBERTSON DESIGN, INC.

939 Pearl St., Denver CO 80203. (303)861-9046. E-mail: joculdes@aol.com. **President:** Jo Culbertson. Estab. 1976. Number of employees 1. Approximate annual billing $75,000. Specializes in direct mail, packaging, publication and marketing design, annual reports, corporate identity, and signage. Clients: corporations, not-for-profit organizations. Current clients include Love Publishing Company, E-Smart Services Inc., Jace Management Services, Vitamin Cottage, Sun Gard Insurance Systems. Client list available upon request.

Needs Approached by 10 freelancers/year. Works with 2 freelance illustrators/year. Prefers local freelancers only. Works on assignment only. Uses illustrators mainly for corporate collateral pieces, illustration and ad illustration. 50% of freelance work demands knowledge of QuarkXPress, Photoshop, CorelDraw.

First Contact & Terms Send query letter or e-mail with résumé, tearsheets and photocopies. Samples are filed. Reports back to the artist only if interested. Artist should follow up with call. Portfolio should include b&w and color thumbnails, roughs and final art. Pays for design by the project, $250 minimum. Pays for illustration by the project, $100 minimum. Finds artists through file of résumés, samples, interviews.

CONNECTICUT

BRANDLOGIC

(formerly JMK Corp.), 15 River Rd., Suite 310, Wilton CT 06897. (203)834-0087. Web site: www.brandlogic.c om. **Creative Director:** Karen Lukas-Hardy. Specializes in annual reports, corporate brand identity, Web site design, and publications. Clients IBM, GE, Texaco, Avon Products, Pepsi Cola.

Needs Works with 30 artists/year. Works on assignment only. Uses artists for editorial illustration. Needs computer-literate freelancers for illustration. 30% of freelance work demands knowledge of Illustrator.

First Contact & Terms *"No* phone calls!" Send query letter with tearsheets, slides, photostats or photocopies. Samples not kept on file are returned by SASE only. Responds only if interested. Pays for illustration by the project $300-3,500 average. Considers client's budget, skill and experience of artist and how work will be used when establishing payment.

COPLEY MEDIAWORKS

18 Reef Rd., Fairfield CT 06430. (203)259-0525. Fax: (203)259-3321. E-mail: acopley@snet.net. **Production Director:** Alyce Kavanagh. Estab. 1987. Number of employees 6. Approximate annual billing $2,600,000. Integrated marketing communications agency. Specializes in television, business-to-business print. Product specialties are sports, publishing.

Needs Approached by 12 freelance illustrators and 20 designers/year. Works with 2 freelance illustrators and 2 designers/year. Uses freelancers mainly for brochures and ads. Also for brochure illustration, catalog design, lettering, logos, mechanicals, storyboards, TV/film graphics. 25% of work is with print ads. 100% of freelance design demands skills in PageMaker, Photoshop, QuarkXPress, Illustrator. 50% of freelance illustration demands skills in Photoshop and Illustrator.

First Contact & Terms Send query letter with brochure and résumé. Accepts disk submissions compatible with QuarkXPress. Samples are filed. Will contact for portfolio review if interested. Pays by project. Buys all rights. Finds artists through word of mouth, magazines, submissions.

Tips "Bring overall business sense plus sense of humor. Must be punctual, trustworthy."

MACEY NOYES ASSOCIATES, INC.

93 Lake Avenue, Third Floor, Danbury CT 06810. (203)791-8856. Fax: (203)791-8876. E-mail: information@mac eynoyes.com. Web site: www.maceynoyes.com. **Designer:** Jason Arena. Structural Design Director: Tod Dawson. Estab. 1979. Specializes in corporate and brand identity systems, graphic and structural packaging design, retail merchandising systems, naming and nomenclature systems, Internet and digital media design. Clients corporations (marketing managers, product managers). Current clients include Duracell, Norelco, Motorola, Remington, Pitney Bowes, Altec Lansing, Philips, Iomega Corp. Majority of clients are retail suppliers of consumer goods.

Needs Approached by 25 artists/year. Works with 2-3 illustrators and 5 designers/year. Prefers local and international artists with experience in package comps, Macintosh and type design. Uses technical and product illustrators mainly for ad slick, in-use technical and front panel product. Uses designers for conceptual layouts and product design. Also uses freelancers for mechanicals, retouching, airbrushing, lettering, logos and industrial/structural design. Needs computer-literate freelancers for design, illustration and production. 40% of freelance work demands knowledge of QuarkXPress, Illustrator, Photoshop, Director, Flash and Shockwave.

First Contact & Terms Send query letter with résumé. Samples are filed or are returned by SASE if requested by artist. Responds only if interested. Will contact artist for portfolio review if interested. Portfolio should include thumbnails, roughs and transparencies. Pays for design by the hour, $25-50. Pays for illustration by the project, $100-2,500. Rights purchased vary according to project. Finds new artists through sourcebooks and agents.

▣ REALLY GOOD COPY CO.

92 Moseley Terrace, Glastonbury CT 06033. (860)659-9487. Fax: (860)633-3238. E-mail: copyqueen@aol.com. **President:** Donna Donovan. Estab. 1982. Number of employees 2. Ad agency. Full-service, multimedia firm. Specializes in direct response and catalogs. Product specialties are medical/health care, business services, consumer products and services. Current clients include The Globe-Pequot Press, Wellspring, Danbury Hospital. Professional affiliations Connecticut Art Directors Association, New England Mail Order Association.

Needs Approached by 40-50 freelancers/year. Works with 1-2 freelance illustrators and 6-8 designers/year. Prefers local freelancers whenever possible. Works on assignment only. Uses freelancers for all projects. "There are no on-staff artists." 50% print, 50% web. 100% of design and 50% of illustration demand knowledge of QuarkXPress, Illustrator or Photoshop and HTML.

First Contact & Terms Designers send query letter with résumé. Illustrators send postcard samples. Accepts CD submissions. Send EPS or JPEG files only. Samples are filed or are returned by SASE only if requested.

Responds only if interested. Portfolio review not required, but portfolio should include roughs and original/final art. Pays for design by the hour, $50-125. Pays by the project or by the hour.

Tips "Continue to depend upon word of mouth from other satisfied agencies and local talent. I'm fortunate to be in an area that's overflowing with good people. Send two or three good samples—not a bundle."

ULTITECH, INC.

Foot of Broad St., Stratford CT 06615. (203)375-7300. Fax: (203)375-6699. E-mail: comcowic@meds.com. Web site: www.meds.com. **President:** W. J. Comcowich. Estab. 1993. Number of employees 3. Approximate annual billing $1 million. Integrated marketing communications agency. Specializes in interactive multimedia, software, online services. Product specialties are medicine, science, technology. Current clients include large pharma companies.

Needs Approached by 10-20 freelance illustrators and 10-20 designers/year. Works with 2-3 freelance illustrators and 6-10 designers/year. Prefers freelancers with experience in interactive media design and online design. Uses freelancers mainly for design of Web sites and interactive CD-ROMS/DVDs. Also for animation, brochure design, medical illustration, multimedia projects, TV/film graphics. 10% of work is with print ads. 100% of freelance design demands skills in Photoshop, QuarkXPress, Illustrator, 3D packages.

First Contact & Terms E-mail submission is best. Include links to online "book". Responds only if interested. Pays for design by the project or by the day. Pays for illustration by the project. Buys all rights. Finds artists through sourcebooks, word of mouth, "cold" submissions.

Tips "Learn design principles for interactive media."

DELAWARE

ALOYSIUS BUTLER & CLARK (AB&C)

819 Washington St., Wilmington DE 19801. (302)655-1552. Fax: (302)655-3105. Web site: www.a-b-c.com. **Contact:** Tom Desanto. Ad agency. Clients healthcare, banks, industry, restaurants, hotels, businesses, government offices.

Needs Works with 12 or more illustrators and 3-4 designers/year. Uses artists for trade magazines, billboards, direct mail packages, brochures, newspapers, stationery, signage and posters. 95% of design and 15% of illustration demand skills in QuarkXPress, Illustrator or Photoshop.

First Contact & Terms Designers: Send query letter with résumé and photocopies. Illustrators: Send postcard samples. Samples are filed; except work that is returned only if requested. Responds only if interested. Works on assignment only. Pays for design by the hour, $20-50. Pays for illustration by the hour; or by the project, $250-1,000.

CUSTOM CRAFT STUDIO

310 Edgewood St., Bridgeville DE 19933. (302)337-3347. Fax: (302)337-3444. **Vice President:** Eleanor H. Bennett. AV producer.

Needs Works with 12 freelance illustrators and 12 designers/year. Works on assignment only. Uses freelancers mainly for work on filmstrips, slide sets, trade magazines and newspapers. Also for print finishing, color negative retouching and airbrush work. Prefers pen & ink, airbrush, watercolor and calligraphy. 10% of freelance work demands knowledge of Illustrator. Needs editorial and technical illustration.

First Contact & Terms Send query letter with résumé, slides or photographs, brochure/flyer and tearsheets to be kept on file. Samples returned by SASE. Responds in 2 weeks. Originals not returned. Pays by the project, $25 minimum.

GLYPHIX ADVERTISING

105 Second St., Lewes DE 19958. (302)645-0706. Fax: (302)645-2726. E-mail: rjundt@intercom.net. Web site: www.glyphixadv.com. **Creative Director:** Richard Jundt. Estab. 1981. Number of employees 2. Approximate annual billing $200,000. Ad agency. Specializes in collateral and advertising. Current clients include local colleges, ATR Galleries locally and New York City and Cytec Industries. Client list available upon request.

Needs Approached by 10-20 freelancers/year. Works with 2-3 freelance illustrators and 2-3 designers/year. Prefers local artists only. Uses freelancers mainly for "work I can't do." Also for brochure and catalog design and illustration and logos. 20% of work is with print ads. 100% of freelance work demands knowledge of Photoshop, QuarkXPress, Illustrator and Delta Graph.

First Contact & Terms Send query letter with samples. Responds in 10 days if interested. Artist should follow-up with call. Portfolio should include b&w and color final art, photographs and roughs. Buys all rights. Finds artists through word of mouth and submissions.

WASHINGTON DC

ARNOLD & ASSOCIATES
1834 Jefferson Pl. N.W., Washington DC 20036. (703)837-8850. Fax: (703)838-3626. Web site: www.arnold.tv. **President:** John Arnold. AV/video firm. Clients include United Airlines, Colt 45, Amtrak, US Postal Service, Edison Electric Institute, Nescafe.

Needs Works with 30 artists/year. Prefers local artists, award-winning and experienced. "We're an established, national firm." Works on assignment only. Uses freelancers for multimedia, slide show and staging production.

First Contact & Terms Send query letter with brochure, tearsheets, slides and photographs to be kept on file. Call for appointment to show portfolio, which should include final reproduction/product and color photographs. Pays for design by the hour, $50-100 or by the project, $500-3,500. Pays for illustration by the project, $500-4,000. Considers complexity of the project, client's budget and skill and experience of artist when establishing payment.

▣ LOMANGINO STUDIO INC.
1042 Wisconsin Ave., Washington DC 20007. (202)338-4110. E-mail: info@lomangino.com. Web site: www.lomangino.com. **President:** Donna Lomangino. Estab. 1987. Number of employees 6. Specializes in annual reports, corporate identity, Web site and publication design. Clients corporations, nonprofit organizations. Client list available upon request. Professional affiliations AIGA Washington DC.

Needs Approached by 25-50 freelancers/year. Works with 1 freelance illustrator/year. Uses illustrators and production designers occasionally for publication. Also for multimedia projects. Accepts disk submissions, but not preferable. 99% of design work demands skills in Illustrator, Photoshop and QuarkXPress.

First Contact & Terms Send postcard sample of work or URL. Samples are filed. Will contact artist for portfolio review if interested. Pays for design and illustration by the project. Finds artists through sourcebooks, word of mouth and studio files.

Tips "Please don't call. Send samples or URL for consideration."

FLORIDA

AURELIO & FRIENDS, INC.
14971 SW 43 Terrace, Miami FL 33185. (305)225-2434. Fax: (305)225-2121. E-mail: aurelio97@aol.com. **President:** Aurelio Sica. Vice President: Nancy Sica. Estab. 1973. Number of employees 3. Specializes in corporate advertising and graphic design. Clients: corporations, retailers, large companies, hotels and resorts.

Needs Approached by 4-5 freelancers/year. Works with 1-2 freelance illustrators and 3-5 designers/year. Also uses freelancers for ad design and illustration, brochure, catalog and direct mail design, and mechanicals. 50% of freelance work demands knowledge of Adobe Ilustrator, Photoshop and QuarkXPress.

First Contact & Terms Send brochure and tearsheets. Samples are filed. Will contact artist for portfolio review if interested. Portfolio should include b&w and color final art, photographs, roughs and transparencies. Pays for design and illustration by the project. Buys all rights.

BROMLEY COMMUNICATIONS
1799 Coral Way, Suite 510, Miami FL 33145. (305)442-1586. Fax: (305)442-2598. E-mail: orlando.sosa@publicis-sanlev.com. **Creative Director:** Orlando Sosa. Number of employees 80. Approximate annual billing $80 million. Estab. 1986. Full-service, multimedia ad agency and PR firm. Specializes in TV, radio and magazine ads, etc. Specializes in consumer service firms and Hispanic markets. Current clients include BellSouth Telecommunications, Metro-Dade, Coca-Cola, The House of Seagram, Procter & Gamble, BMW, Nestle.

- In February 2004 the Miami agency Publicis Sanchez & Levitan merged with Texas' Bromley Communications, becoming the top Hispanic advertising agency in the U.S.

Needs Approached by 1 artist/month. Prefers local artists only. Works on assignment only. Uses freelancers for storyboards, slide illustration, new business presentations and TV/film graphics and logos. 35% of work is with print ads. 25% of freelance work demands knowledge of PageMaker, QuarkXPress and Illustrator.

First Contact & Terms Send query letter with brochure and résumé. Samples are not filed and are returned by SASE only if requested by artist. Responds only if interested. Write for appointment to show portfolio.

EXHIBIT BUILDERS INC.
150 Wildwood Rd., Deland FL 32720. (386)734-3196. Fax: (386)734-9391. E-mail: art@exhibitbuilders.com. Web site: exhibitbuilders.com. **President:** Penny D. Morford. Produces themed custom trade show exhibits and distributes modular and portable displays, and sales centers. Clients museums, primarily manufacturers, government agencies, ad agencies, tourist attractions and trade show participants.

• Looking for freelance trade show designers.

Needs Works on assignment only. Uses artists for exhibit/display design murals.

First Contact & Terms Provide résumé, business card and brochure to be kept on file. Samples returned by SASE. Reports back for portfolio review. Considers complexity of project, skill and experience of artist, how work will be used, turnaround time and rights purchased when establishing payment.

Tips "Wants to see examples of previous design work for other clients; not interested in seeing school-developed portfolios."

GOLD & ASSOCIATES INC.

6000-C Sawgrass Village Circle, Ponte Vedra Beach FL 32082. (904)285-5669. Fax: (904)285-1579. E-mail: gold@strikegold.com. Web site: www.strikegold.com. **Creative Director/President:** Keith Gold. Incorporated in 1988. Full-service multimedia, marketing and communications firm. Specializes in graphic design and advertising. Product specialties are entertainment, medical, publishing, tourism and sports.

Needs Approached by over 100 freelancers/year. Works with approximately 25 freelance illustrators/year. Works primarily with artist reps. Uses illustrators for annual reports, books, brochures, editorial, technical, print ad illustration; storyboards, animatics, animation, music videos. 65% of work is in print. 50% of freelance work demands knowledge of Illustrator, QuarkXPress, Photoshop or InDesign.

First Contact & Terms Contact through artist rep or send query letter with photocopies or tearsheets. Samples are filed. Responds *only* if interested. Will contact artists for portfolio review if interested. Follow up with letter after initial query. Portfolio should include tearsheets. Pays for illustration by the project, $200-7,500. Buys all rights. Finds artists primarily through sourcebooks and reps. Does not use freelance designers.

TOM GRABOSKI ASSOCIATES, INC.

4649 Ponce de Leon Blvd., #401, Coral Gables FL 33146. (305)669-2550. Fax: (305)669-2539. E-mail: mail@tgadesign.com. **President:** Tom Graboski. Estab. 1980. Specializes in exterior/interior signage, environmental graphics, corporate identity, urban design and print graphics. Clients corporations, cities, museums, a few ad agencies. Current clients include Universal Studios, Florida; Royal Caribbean Cruise Line; The Equity Group; Disney Development; Celebrity Cruises; Baptist Health So. Florida; City of Miami; City of Coral Gables.

Needs Approached by 20-30 freelance artists/year. Works with approximately 4-8 designers/draftspersons/year. Prefers artists with a background in signage and knowledge of architecture and industrial design. Freelance artists used in conjunction with signage projects, occasionally miscellaneous print graphics. 100% of design and 10% of illustration demand knowledge of Illustrator, Photoshop and QuarkXPress.

First Contact & Terms Send query letter with brochure and résumé. "We will contact designer/artist to arrange appointment for portfolio review. Portfolio should be representative of artist's work and skills; presentation should be in a standard portfolio format." Pays by the project. Payment varies by experience and project. Rights purchased vary by project.

Tips "Look at what type of work the firm does. Tailor presentation to that type of work." For this firm "knowledge of environmental graphics, detailing, a plus."

VAN VECHTEN & COMPANY PUBLIC RELATIONS

P.O. Box 99, Boca Raton FL 33429. (561)620-2900. E-mail: lowell@vanvechtenpr.com. Web site: www.vanvechtenpr.com. **President:** Lowell Van Vechten. Number of employees 8. Approximate annual billing $1.5 million. PR firm. Clients medical, consumer products, industry. Client list available for SASE.

Needs Approached by 20 freelancers/year. Works with 4 freelance illustrators and 4 designers/year. Works on assignment only. Uses artists for editorial and medical illustration, consumer and trade magazines, brochures, newspapers, stationery, signage, AV presentations and press releases. 100% of freelance work demands computer skills.

First Contact & Terms Send query letter with brochure, résumé, business card, photocopies. Samples not returned. Responds only if interested. Pays for design and illustration by the project. Considers client's budget when establishing payment. Buys all rights.

Tips Advises freelancers starting out in the field to research agencies. "Find out what clients the agency has. Create a thumbnail sketch or original idea to get yourself in the door."

GEORGIA

CRITT GRAHAM & ASSOCIATES

2970 Clairmont Rd., Suite 850, Atlanta GA 30329. (404)320-1737. Fax: (404)320-1920. E-mail: cgaoffice@aol.com. Web site: www.crittgraham.com. **Creative Director:** Deborah Pinals. Estab. 1979. Specializes in design and production of annual reports, corporate magazines, capabilities brochures, identification systems and pack-

aging, product literature, multi-media/interactive presentations and Web sites. Clients primarily major corporations; "15 are members of the Fortune 1000." Current clients include Compaq Computer, Home Depot, IBM, Proctor & Gamble, Eastman Chemical, Harris, Royal Caribbean Cruises.

Needs Works with 5-10 freelance illustrators/year. Also needs photographers, illustrators, typesetters and computer production designers. Also for multimedia projects. 100% of design and 75% of illustration requires computer skills. All design work is done internally.

First Contact & Terms Designers: Send query letter with résumé and photocopies. Illustrators: Send postcard samples and tearsheets. Accepts submissions on disk compatible with FreeHand 5.5. Send EPS files. Samples are filed. Will contact artist for portfolio review if interested. Pays for illustration by the project, depending on style. Considers buying second rights (reprint rights) to previously published work. Finds artists through word of mouth, magazines, artists' submissions/self-promotions, sourcebooks and agents.

Tips "Price is always a consideration, also usage and sometimes buy-out. Try not to price yourself out of a job."

DAUER ASSOCIATES

1134 Warren Hall Lane, Atlanta GA 30319. (404)252-0248. Fax: (404)252-1018. **President/CEO:** Jacqueline M. Dauer. Estab. 1978. Number of employees 2. Specialist in researching, concept designing, producing custom, world-class museum quality, digital, full-color, back-lit indoor medal of honor displays. Specializes in annual reports, brand and corporate identity; display, direct mail, fashion, package and publication design; technical illustration and signage.

• Has 50 years experience in the business. Only wants seasoned professionals.

Needs Approached by hundreds of freelancers/year. Uses freelancers for ad, brochure, catalog, poster and P-O-P design and illustration; airbrushing; audiovisual materials; charts/graphs; direct mail and magazine design; lettering; logos; mechanicals; and model making. Freelancers should be familiar with Illustrator, Photoshop, FreeHand, PageMaker and QuarkXPress.

First Contact & Terms Send postcard sample of work or send brochure, photocopies, résumé, slides, tearsheets and transparencies. Samples are filed and are not returned. Request portfolio review in original query. Artist should follow up with call. Will contact artist for portfolio review if interested. Portfolio should include "work produced on a professional basis." Pays for design and illustration by the project. Rights purchased vary according to project, most of the time buys all rights.

Tips "Computer training isn't enough. The idea is the most important thing. Also, you must understand the basics of design. Be professional; be dedicated; be flexible. Learn how to make every art buyer who uses you once want to work with you again and again. Your reputation is at stake . Every job counts."

EJW ASSOCIATES, INC.

Crabapple Village Office Park, Alpharetta GA 30004. (770)664-9322. Fax: (770)664-9324. E-mail: advertise@ejw assoc.com. Web site: www.ejwassoc.com. **President:** Emil Walcek. Estab. 1982. Ad agency. Specializes in space ads, corporate ID, brochures, show graphics. Product specialty is business-to-business.

Needs Works with 2-4 freelance illustrators and designers/year. Prefers local freelancers with experience in Mac computer design and illustration and Photoshop expertise. Works on assignment only. Uses freelancers for brochure, Web site development, catalog and print ad design and illustration, editorial, technical illustration and logos. 50% of work is with print ads. 75% of freelance work demands skills in FreeHand, Photoshop, Web coding, FLASH.

First Contact & Terms Send query letter with résumé, photostats, slides and Web site. Samples are filed or are returned by SASE if requested by artist. Responds only if interested. Pays for design by the hour, $40-80; by the day, $300-600; or by the project. Buys all rights.

Tips Looks for "experience in non-consumer, industrial or technology account work. Visit our Web site first, then e-mail or call. Do not send e-mail attachments."

LORENC & YOO DESIGN, INC.

109 Vickery St., Roswell GA 30075. (770)645-2828. Fax: (770)998-2452. E-mail: jan@lorencyoodesign.com. Web site: www.lorencyoodesign.com. **President:** Mr. Jan Lorenc. Specializes in architectural signage design; environmental, exhibit, furniture and industrial design. Clients: corporate, developers, product manufacturers, architects, real estate and institutions. Current clients include Gerald D. Hines Interests, MCI, Georgia-Pacific, IBM, Simon Property Company, Mayo Clinic. Client list available upon request.

Needs Approached by 25 freelancers/year. Works with 5 illustrators and 10 designers/year. Local senior designers only. Uses freelancers for design, illustration, brochures, catalogs, books, P-O-P displays, mechanicals, retouching, airbrushing, posters, direct mail packages, model-making, charts/graphs, AV materials, lettering and logos. Needs editorial and technical illustration. Especially needs architectural signage and exhibit designers. 95% of freelance work demands knowledge of QuarkXPress, Illustrator or FreeHand.

First Contact & Terms Send brochure, Weblink, or CD, résumé and samples to be kept on file. Prefers digital files as samples. Samples are filed or are returned. Call or write for appointment to show portfolio of thumbnails, roughs, original/final art, final reproduction/product and color photostats and photographs. Pays for design by the hour, $40-100; by the project, $250-20,000; by the day, $80-400. Pays for illustration by the hour, $40-100; by the project, $100-2,000; by the day, $80-400. Considers complexity of project, client's budget, and skill and experience of artist when establishing payment.

Tips "Sometimes it's more cost-effective to use freelancers in this economy, so we have scaled down permanent staff."

T-P DESIGN INC.

7007 Eagle Watch Court, Stone Mountain GA 30087. (770)413-8276. Fax: (770)413-9856. Web site: www.tpdesig ninc.com. E-mail: tpdesign@mindspring.com. **Creative Director:** Charly Palmer. Estab. 1991. Number of employees 3. Approximate annual billing $500,000. Specializes in brand identity, display, package and publication design. Clients corporations. Current clients include Georgia Pacific, Cartoon Network, General Mills, KFC.

Needs Approached by 4 freelancers/year. Works with 2 freelance illustrators and 2 designers/year. Prefers local artists with Mac systems, traditional background. Uses illustrators and designers mainly for comps and illustration on Mac. Also uses freelancers for ad, brochure, poster and P-O-P design and illustration; book design, charts/graphs, lettering, logos, mechanicals (important) and page layout. Also for multimedia projects. 75% of freelance work demands skills in Illustrator, Photoshop, FreeHand and QuarkXPress. "Knowledge of multimedia programs such as Director and Premier would also be desirable."

First Contact & Terms Send query letter or photocopies, résumé and tearsheets. Accepts e-mail submissions to tpdesign@mindspring.com. Samples are filed. Will contact artist for portfolio review if interested. Portfolio should include b&w and color final art, roughs (important) and thumbnails (important). Pays for design and illustration by the project. Rights purchased vary according to project. Finds artists through submissions and word of mouth.

Tips "Be original, be creative and have a positive attitude. Need to show strength in illustration with a good design sense. A flair for typography would be desirable."

J. WALTER THOMPSON COMPANY

10 B Glenlake Pkwy NE North Tower 4th FL, Atlanta GA 30328. (404)365-7300. Fax: (404)365-7399. Web site: www.jwt.com. **Executive Creative Director:** Carl Warner. Ad agency. Clients mainly financial, industrial and consumer. "This office does creative work for Atlanta and the southeastern U.S."

Needs Works on assignment only. Uses freelancers for billboards, consumer and trade magazines and newspapers. Needs computer-literate freelancers for design, production and presentation. 60% of freelance work demands skills in Illustrator, Photoshop or QuarkXPress.

First Contact & Terms *Deals with artist reps only.* Send slides, original work, stats. Samples returned by SASE. Responds only if interested. Originals not returned. Call for appointment to show portfolio. Pays by the hour, $20-80; by the project, $100-6,000; by the day, $140-500.

Tips Wants to see samples of work done for different clients. Likes to see work done in different mediums, variety and versatility. Freelancers interested in working here should "be *professional* and do top-grade work."

HAWAII

ERIC WOO DESIGN, INC.

733 Bishop St., Suite 1280, Honolulu HI 96813. (808)545-7442. Fax: (808)545-7445. E-mail: info@ericwoodesign .com. Web site: www.ericwoodesign.com. **Principal:** Eric Woo. Estab. 1985. Number of employees 3. Approximate annual billing 500,000. Design firm. Specializes in identities and visual branding, product packaging, print & Web design, and environmental graphics & signage. Majority of clients are government, corporate and nonprofits. Current clients include State of Hawaii, Alexander & Baldwin Inc., Western Pacific Regional Fishery Management Council.

Needs Approached by 5-10 illustrators and 10 designers/year. Works with 1-2 illustrators/year. Prefers freelancers with experience in multimedia. Uses freelancers mainly for multimedia projects and lettering. 5% of work is with print ads. 90% of design demands skills in Photoshop, Illustrator, Quark, Flash, Go Live, Dreamweaver and Metropolis.

First Contact & Terms Designers: Send query letter with brochure, photocopies, photographs, résumé and tearsheets. Illustrators: Send postcard sample of work or query letter with brochure, photocopies, photographs, résumé, tearsheets. Send follow-up postcard samples every 1-2 months. Pays for design by the hour, $15-50. Pays for illustration by the project. Rights purchased vary according to project.

Tips "Design and draw constantly. Have a good sense of humor and enjoy life."

IDAHO

HNA IMPRESSION MANAGEMENT

1524 W. Hays St., Boise ID 83702. (208)344-4631. Fax: (208)344-2458. E-mail: tony@hedden-nicely.com. Web site: www.hedden-nicely.com. **Production Coordinator:** Tony Uria. Estab. 1986. Number of employees 7. Approximate annual billing $600,000. Ad agency. Specializes in print materials—collateral, display, direct mail. Product specialties are industrial, manufacturing.

Needs Approached by 5 illustrators and 10 designers/year. Works with 1 illustrator and 6 designers/year. Prefers local freelancers. Prefers that designers work electronically with own equipment. Uses freelancers mainly for logos, brochures. Also for airbrushing, animation, billboards, brochure, brochure illustration, lettering, model-making, posters, retouching, storyboards. 10% of work is with print ads. 90% of design demands knowledge of PageMaker, Photoshop, Illustrator 8.0. 40% of illustration demands knowledge of Photoshop, Illustrator, Quark.

First Contact & Terms Designers: Send query letter with brochure and résumé. Illustrators: Send postcard sample of work. Accepts any Mac-compatible Photoshop or Adobe file on CD or e-mail. Samples are filed. Responds only if interested when an appropriate project arises. Art director will contact artists for portfolio review of color, final art, tearsheets if interested. Pays by the project. Rights purchased vary according to project, all rights preferred. "All of our freelancers have approached us through query letters or cold calls."

ILLINOIS

ARTONWEB

508 Bluffs Edge Dr., McHenry IL 60185. (815)578-9171. E-mail: sbastian@artonweb.com. Web site: www.arton web.com. **Owner:** Thomas Sebastian. Estab. 1996. Number of employees 10. Integrated marketing communications agency and Internet service. Specializes in Web site design and marketing. Current clients include Design Strategies, Creative FX. Client list available upon request.

Needs Approached by 12 illustrators and 12 designers/year. Works with 2-3 illustrators and 1-2 designers/year. Uses freelancers mainly for design and computer illustration. Also for humorous illustration, lettering, logos and Web page design. 5% of work is with print ads. 90% of design and 70% of illustration demands knowledge of Photoshop, Illustrator, QuarkXPress.

First Contact & Terms Send e-mail and follow-up postcard samples every 6 months. Accepts Mac-compatible disk submissionsfloppy, Zip disk or CD-ROM. Samples are filed and are not returned. Does not reply. Artist should contact via e-mail. Will contact artist for portfolio review if interested. Pays by the project. Negotiates rights purchased. Finds freelancers through *Black Book*, creative sourcebooks, Web.

BEDA DESIGN

38663 Thorndale Place, Lake Villa IL 60046. Phone/fax (847)245-8939. **President:** Lynn Beda. Estab. 1971. Number of employees 2-3. Approximate annual billing $250,000. Design firm. Specializes in packaging, publishing, film and video documentaries. Current clients include business-to-business accounts, producers to writers, directors and artists.

Needs Approached by 6-12 illustrators and 6-12 designers/year. Works with 6 illustrators and 6 designers/year. Prefers local freelancers. Also for retouching, technical illustration and production. 50% of work is with print ads. 75% of design demands skills in Photoshop, QuarkXPress, Illustrator, Premiere, Go Live.

First Contact & Terms Designers: Send query letter with brochure, photocopies and résumé. Illustrators: Send postcard samples and/or photocopies. Samples are filed and are not returned. Will contact for portfolio review if interested. Payments are negotiable. Buys all rights. Finds artists through word of mouth.

BENTKOVER'S DESIGN & MORE

1222 Cavell, Suite 3C, Highland Park IL 60035. (847)831-4437. Fax: (847)831-4462. **Creative Director:** Burt Bentkover. Estab. 1989. Number of employees 2. Approximate annual billing $200,000. Specializes in annual reports, ads, package and brochure design. Clients business-to-business, foodservice.

Needs Works with 3 freelance illustrators/year. Works with artist reps. Prefers freelancers with experience in computer graphics, multimedia, Macintosh. Uses freelancers for direct mail and brochure illustration. 80% of freelance work demands computer skills.

First Contact & Terms Send brochure, photocopies and tearsheets. No original artonly disposable copies. Samples are filed. Responds in 1 week if interested. Request portfolio review in original query. Will contact artist for portfolio review if interested. Portfolio should include b&w and color photocopies. "No final art or photographs." Pays for design and illustration by the project. Rights purchased vary according to project. Finds artists through sourcebooks and agents.

BRAGAW PUBLIC RELATIONS SERVICES

800 E. Northwest Hwy., Palatine IL 60074. (847)934-5580. Fax: (847)934-5596. Web site: www.bragawpr.com. **President:** Richard S. Bragaw. Number of employees 3. PR firm. Specializes in newsletters and brochures. Clients professional service firms, associations and industry. Current clients include Kaiser Precision Tooling, Inc. and Nykiel-Carlin and Co., Ltd.

Needs Approached by 12 freelancers/year. Works with 2 freelance illustrators and 2 designers/year. Prefers local freelancers only. Works on assignment only. Uses freelancers for direct mail packages, brochures, signage, AV presentations and press releases. 90% of freelance work demands knowledge of PageMaker. Needs editorial and medical illustration.

First Contact & Terms Send query letter with brochure to be kept on file. Responds only if interested. Pays by the hour, $25-75 average. Considers complexity of project, skill and experience of artist and turnaround time when establishing payment. Buys all rights.

Tips "We do not spend much time with portfolios."

THE CHESTNUT HOUSE GROUP INC.

2121 St. Johns Ave., Highland Park IL 60035. (847)432-3273. Fax: (847)432-3229. E-mail: chestnut@comcast.n et. Web site: www.chestnuthousegroup.com. **Contact:** Miles Zimmerman. Clients major educational publishers, small publishers, and selected self-publishers.

Needs Illustration, layout and electronic page production. Needs computer-literate freelancers with educational publishing experience. Uses experienced freelancers only. Freelancers should be familiar with QuarkXPress and various drawing and painting programs for illustrators. Pays for production by the hour. Pays for illustration by the project.

First Contact & Terms Illustrators, submit samples.

CLEARVUE, INC.

6465 N. Avondale, Chicago IL 60631. (773)775-9433. E-mail: custserv@clearvue.com. Web site: www.clearvue. com. **President:** Mark Ventling. Director: Jeffrey Kytta. Educational publishing and distribution.

Needs Works with 1-2 freelance artists/year. Works on assignment only. Uses freelance artists mainly for catalog layout.

First Contact & Terms Send query letter with SASE to be kept on file. Responds in 10 days. Write for appointment to show portfolio.

Tips "Have previous layout skills."

DEFOREST CREATIVE

(formerly Lee DeForest Communications), 300 W. Lake St., Elmhurst IL 60126. (630)834-7200. Fax: (630)834-0908. E-mail: info@deforestgroup.com. **Art Director:** Wendy Engleking. Estab. 1965. Number of employees 15. Marketing solutions, graphic design and digital photography firm.

Needs Approached by 50 freelance artists/year. Works with 3-5 freelance designers/year. Prefers artists with experience in PhotoShop, Illustrator and Quark.

First Contact & Terms Send query letter with résumé and samples. Samples are filed or returned by SASE if requested by artist. To arrange for portfolio review artist should fax or e-mail. Pays for production by the hour, $25-75. Finds designers through word of mouth and artists' submissions.

Tips "Be hardworking, honest, and good at your craft."

DESIGN ASSOCIATES

1828 Asbury Ave., Evanston IL 60201-3504. (847)425-4800. E-mail: info@designassociatesinc.com. Web site: www.designassociatesinc.com. **Contact:** Paul Uhl. Estab. 1986. Number of employees 5. Specializes in text and trade book design, annual reports, corporate identity, Web site development. Clients corporations, publishers and museums. Client list available upon request.

Needs Approached by 10-20 freelancers/year. Works with 100 freelance illustrators and 2 designers/year. Uses freelancers for design and production. 100% of freelance work demands knowledge of Illustrator, Photoshop and InDesign.

First Contact & Terms Send query letter with samples that best represent work. Accepts disk submissions. Samples are filed. Will contact artist for portfolio review if interested. Portfolio should include b&w and color samples.

DESIGN MOVES, LTD.

660 LaSalle Place, Suite 202, Highland Park IL 60035. (847)433-4313. Fax: (847)433-4314. E-mail: laurie@design moves.com. Web site: www.designmoves.com. **Principal:** Laurie Medeiros Freed. Estab. 1988. Number of employees 4. Specializes in design for annual reports, corporate literature, corporate identity, packaging, adver-

tising and Web site design. Current clients include Baxter Healthcare, Microsoft Corp. and the Chicago Park District. Professional affiliations AIGA, ACD, NAWBO.

Needs Approached by 5-10 freelancers/year. Works with 3-5 freelance illustrators and 1-3 designers/year. Works on assignment only. Uses freelancers for lettering, Internet design and programming, poster illustration and design, direct mail design and charts/graphs. Freelance work requires knowledge of HTML and Director, Illustrator, QuarkXPress and Photoshop.

First Contact & Terms Send query letter with brochure, résumé and tearsheets. Samples are filed or are returned by SASE if requested. Request portfolio review in original query. Responds only if interested. Portfolio should include thumbnails, tearsheets, photographs and transparencies. Pays for design by the hour, $20-30. Pays for illustration by the project. Rights purchased vary according to project.

DESIGN RESOURCE CENTER

1548 Bond St., Suite 114, Naperville IL 60563. (630)357-6008. Fax: (630)357-6040. E-mail: info@drcchicago.com. Web site: www.drcchicago.com. **President:** John Norman. Estab. 1990. Number of employees 12. Approximate annual billing $850,000. Specializes in package design and display, brand and corporate identity. Clients corporations, manufacturers, private label.

Needs Approached by 5-10 freelancers/year. Works with 3-5 freelance designers and production artists and 3-5 designers/year. Uses designers mainly for Macintosh or concepts. Also uses freelancers for brochure, poster and P-O-P design and illustration, lettering, logos and package design. Needs computer-literate freelancers for design, illustration and production. 100% of freelance work demands knowledge of Illustrator 10, QuarkXPress and Photoshop.

First Contact & Terms Send query letter with brochure, photocopies, photographs and résumé. Samples are filed. Does not reply. Artist should follow up. Portfolio review sometimes required. Portfolio should include b&w and color final art, photocopies, photographs, photostats, roughs and thumbnails. Pays for design by the hour, $15-40. Pays for illustration by the project. Buys all rights. Finds artists through word of mouth, referrals.

GUERTIN ASSOCIATES

3703 W. Lake Ave., Glenview IL 60026. (847)729-2674. Fax: (847)729-5190. **Vice President Creative:** Fred Nelson. Estab. 1987. Number of employees 8. Approximate annual billing $3 million. Marketing service agency. Specializes in P.O.S. materials, magazine ads, direct mail and business-to-business communications. Product specialties are boating, gasolines, financial and pharmaceuticals. Current clients include Heinz Pet Foods, Firstar Bank, Unocal, Outboard Marine Corp. Effidac. Client list available upon request.

Needs Approached by 50 freelancers/year. Works with 10 freelance illustrators/year. Prefers freelancers with experience in Mac Quark, Illustrator, Freehand, Photoshop who can work off-site. Uses freelancers mainly for keyline and layout. Also for billboards, brochure design, catalog design and illustration, logos, mechanicals, posters and signage. 10% of work is with print ads. Needs computer-literate freelancers for illustration and production. 90% of freelance work demands skills in FreeHand, Photoshop, QuarkXPress and Illustrator.

First Contact & Terms Send query letter with photocopies and résumé. Samples are not returned. Will contact artist for portfolio review if interested. Pays for design by the project, $100-1,000. Pays for illustration by the project. Buys all rights.

INNOVATIVE DESIGN & GRAPHICS

1327 Greenleaf St., Evanston IL 60202-1375. (847)475-7772. Fax: (847)475-7784 E-mail: idgemail@sprintmail.com. **Contact:** Tim Sonder. Clients corporate communication and marketing departments.

Needs Works with 1-5 freelance artists/year. Prefers local artists only. Uses artists for editorial and technical illustration and desktop (CorelDraw, FreeHand, Illustrator).

First Contact & Terms Send query letter with résumé or brochure showing art style, tearsheets, photostats, slides and photographs. Will contact artist for portfolio review if interested. Pays for design by the hour, $20-45. Pays for illustration by the project, $200-1,000 average. Considers complexity of project, client's budget and turnaround time when establishing payment. Interested in buying second rights (reprint rights) to previously published work.

Tips ''Interested in meeting new illustrators, but have a tight schedule. Looking for people who can grasp complex ideas and turn them into high-quality illustrations. Ability to draw people well is a must. Do not call for an appointment to show your portfolio. Send nonreturnable tearsheets or self-promos, and we will call you when we have an appropriate project for you.''

JOHN STRIBIAK & ASSOCIATES, INC.

1266 Holiday Dr., Somonauk IL 60552. (815)498-4900. Fax: (815)498-4905. E-mail: jsa@stribiak.com. Web site: www.jsa@stribiak.com. **President:** John Stribiak. Estab. 1981. Number of employees 2. Approximate annual

billing $300,000. Specializes in corporate identity and package design. Clients corporations. Professional affiliations IOPP, PDC.

Needs Approached by 75-100 freelancers/year. Works with 20 freelance illustrators and 2 designers/year. Prefers artists with experience in illustration, design, retouching and packaging. Uses illustrators mainly for packaging and brochures. Uses designers mainly for new products. Also uses freelancers for ad and catalog illustration, airbrushing, brochure design and illustration, lettering, model-making and retouching. Needs computer-literate freelancers for production. 70% of freelance work demands skills in Illustrator, Photoshop and QuarkXPress.

First Contact & Terms Send postcard sample of work. Samples are filed. Will contact artist for portfolio review if interested. Portfolio should include b&w and color roughs and transparencies. Pays for design and illustration by the project. Rights purchased vary according to project. Finds artists through sourcebooks.

TEMKIN & TEMKIN, INC.

156 Barberry, Highland Park IL 60035. (847)831-0237. Fax: (847)831-0409. E-mail: steve@temkin.com. Web site: www.temkin.com. **President:** Steve Temkin. Estab. 1945. Number of employees 10. Ad agency. Specializes in business-to-business collateral, consumer direct mail. Product specialties are food, gifts, electronics and professional services. Current clients include Verilux, Office Max, Chase Bank cards.

Needs Approached by 100 freelancers/year. Works with 5-10 freelance illustrators and 10 designers/year. Prefers local artists only. Uses freelancers mainly for design, concept and comps. Also for brochure and catalog design, mechanicals and retouching. 95% of work is with print ads. Needs computer-literate freelancers for design and production. 75% of freelance work demands knowledge of Photoshop, QuarkXPress, InDesign, Draw and Illustrator.

First Contact & Terms Send query letter with photocopies and résumé. To arrange portfolio review artist should follow up with call or letter after initial query. Portfolio should include roughs, tearsheets and thumbnails. Pays for design by the project, $250-5,000. Rights purchased vary according to project.

Tips ''Present evidence of hands-on involvement with concept and project development.''

CHUCK THOMAS CREATIVE, INC.

214 West River Rd., St. Charles IL 60174. (630)587-6000. Fax: (630)587-6430. E-mail: branding@ctcreative.com. Web site: www.ctcreative.com. Estab. 1989. Integrated marketing communications agency. Specializes in consulting, creative branding, collateral. Product specialties healthcare, family. Current clients include Kidspeace, Cook Communications, Opportunity International.

Needs Works with 1-2 freelance illustrators and 2-3 designers/year. Needs freelancers for brochure design and illustration, logos, multimedia projects, posters, signage, storyboards, TV/film graphics. 20% of work is with print ads. 100% of freelance design demands skills in PageMaker, FreeHand.

First Contact & Terms Designers: Send query letter with brochure and photocopies. Illustrators: Send postcard sample of work. Samples are filed. Responds only if interested. Portfolio review not required. Pays by the project. Buys all rights.

CHICAGO

DEFOREST CREATIVE

(formerly Lee DeForest Communications), 300 W. Lake St., Elmhurst IL 60126. (630)834-7200. Fax: (630)834-0908. E-mail: info@deforestgroup.com. **Art Director:** Wendy Engleking. Estab. 1965. Number of employees 15. Marketing solutions, graphic design and digital photography firm.

Needs Approached by 50 freelance artists/year. Works with 3-5 freelance designers/year. Prefers artists with experience in PhotoShop, Illustrator and Quark.

First Contact & Terms Send query letter with résumé and samples. Samples are filed or returned by SASE if requested by artist. To arrange for portfolio review artist should fax or e-mail. Pays for production by the hour, $25-75. Finds designers through word of mouth and artists' submissions.

Tips ''Be hardworking, honest, and good at your craft.''

DAVE DILGER

1467 N. Elston, Suite 200, Chicago IL 60622. (773)772-3200. Fax: (773)772-3244. E-mail: paulsen@paulsenpartners.com. Web site: www.paulsenpartners.com. **Contact:** Dave Dilger. Estab. 1951. Number of employees 8. Ad agency. Full-service, multimedia firm. Specializes in print ads, collateral and other print material. Product specialty is industrial.

Needs Approached by 5-10 freelancers/year. Works with 3-4 freelance illustrators and 10 designers/year. Prefers local artists only. Uses freelancers mainly for design and illustration. Also for brochure and catalog design; and

retouching. 100% of work is with print ads. Needs computer-literate freelancers for design and production. 85% of freelance work demands knowledge of Photoshop 3.1, QuarkXPress 3.3 and Illustrator.

First Contact & Terms Send query letter with résumé. Samples are filed or returned. Request portfolio review in original query. Portfolio should include b&w and color final art and roughs. Pays for design and illustration by the hour or by the project. "We work with the artist." Buys all rights or negotiates rights purchased.

Ⓝ DOWLING & POPE ADVERTISING

311 W. Superior, Suite 308, Chicago IL 60610. (312)573-0600. Fax: (312)573-0071. E-mail: dpadvestarnetinc.com. Web site: www.career-net.com. **Executive Vice President:** Amy Witt. Estab. 1988. Number of employees 22. Approximate annual billing $17 million. Ad agency. Full-service multimedia firm. Specializes in magazine ads and collateral. Product specialty is recruitment.

Needs Approached by 6-12 freelance artists/year. Works with 6 freelance illustrators and 72 designers/year. Uses freelancers mainly for collateral. Also for annual reports, multimedia, brochure design and illustration, catalog illustration, lettering and posters. 80% of work is with print ads. 80% of design and 50% of illustration demand knowledge of FreeHand, Photoshop and Illustrator.

First Contact & Terms Designers: Send postcard sample with brochure, résumé, photocopies and photographs. Illustrators: Send postcard sample with brochure and résumé. Accepts submissions on disk. Samples are filed. Responds in 2 weeks. Portfolios may be dropped off every Monday. Will contact artist for portfolio review if interested. Portfolio should include b&w and color final art. Pays for design and illustration by the project. Negotiates rights purchased. Finds artists through *Black Book*, *Workbook* and *Chicago Source Book*.

HUTCHINSON ASSOCIATES, INC.

1147 W. Ohio, Suite 305, Chicago IL 60622. (312)455-9191. Fax: (312)455-9190. E-mail: hutch@hutchinson.com. Web site: www.hutchinson.com. **Contact:** Jerry Hutchinson. Estab. 1988. Number of employees 3. Specializes in annual reports, corporate identity, capability brochures, direct mail, publication design and Web site design and development. Clients corporations, associations and PR firms. Professional affiliations AIGA, ACD.

• Work from Hutchinson Associates has been published in the design books *Work With Computer Type*, Vols. 1-3 by Rob Carter (Rotovision) and *Graphic Design 97*.

Needs Approached by 5-10 freelancers/year. Works with 3-4 freelance illustrators and 5-15 designers/year. Uses freelancers mainly for brochure design, annual reports, multimedia and Web designs. Also uses freelancers for ad and direct mail design, catalog illustration, charts/graphs, logos, multimedia projects and mechanicals.

First Contact & Terms Send postcard sample of work or send query letter with résumé, brochure, photocopies and photographs. Accepts disk submissions. Samples are filed. Request portfolio review in original query. Artist should follow up with call. Will contact artist for portfolio review if interested. Portfolio should include transparencies and printed pieces. Pays by the project, $100-10,000. Rights purchased vary according to project. Finds artists through sourcebooks, Illinois reps, submissions.

Tips "Persistence pays off."

MSR ADVERTISING, INC.

P.O. Box 10214, Chicago IL 60610-0214. (312)573-0001. Fax: (312)573-1907. E-mail: info@msradv.com. Web site: msradv.com. **President:** Marc S. Rosenbaum. Vice President: Peter Miller. Art Director: Linda Gits. Office Manager: Danielle Davidson. Estab. 1983. Number of employees 6. Approximate annual billing $2.5 million. Ad agency. Full-service multimedia firm. Specializes in medical, food, industrial and biotechnology. Current clients include AGCO Parts N.A., American Hospital Association, Illinois Biotechnology Industries Association.

• MSR's Tampa, Florida office including similar SIC represented industries and professions, has added insurance agencies, law firms and engineering firms to their growing list of clients.

Needs Approached by 6-10 freelancers/year. Works with 5-10 freelance illustrators and 5-10 designers/year. Prefers local artists who are "innovative, resourceful and hungry." Works on assignment only. Uses freelancers mainly for creative thought boards. Also for brochure, catalog and print ad design and illustration, multimedia, storyboards, mechanicals, billboards, posters, lettering and logos. 30% of work is with print ads. 75% of design and 25% of illustration demand computer skills.

First Contact & Terms Send query letter with brochure, photographs, photocopies, slides, SASE and résumé. Accepts submissions on disk. Samples are filed or returned. Responds in 2 weeks. Write for appointment to show portfolio or mail appropriate materials thumbnails, roughs, finished samples. Artist should follow up with call. Pays for design by the hour, $45-95. Buys all rights. Finds artists through submissions and agents.

Tips "We maintain a relaxed environment designed to encourage creativity; however, work must be produced in a timely and accurate manner. Normally the best way for a freelancer to meet with us is through an introductory letter and a follow-up phone call a week later. Repeat contact every 2-4 months. Be persistent and provide outstanding representation of your work."

ZUNPARTNERS INCORPORATED

326 W. Chicago Ave., Chicago IL 60610. (312)951-5533. Fax: (312)951-5522. E-mail: request@zunpartners.com. Web site: www.zunpartners.com. **Partners:** William Ferdinand and David Philmlee. Estab. 1991. Number of employees 9. Specializes in annual reports, brand and corporate identity, capability brochures, package and publication design, electronic and interactive. Clients from Fortune 500 to Internet startup companies. Current clients include Arthur Andersen, Unicom, B.P. and Sears. Client list available upon request. Professional affiliations AIGA, ACD.

Needs Approached by 30 freelancers/year. Works with 10-15 freelance illustrators and 15-20 designers/year. Looks for strong personal style (local and national). Uses illustrators mainly for editorial. Uses designers mainly for design and layout. Also uses freelancers for collateral and identity design, illustration; web, video, audiovisual materials; direct mail, magazine design and lettering; logos; and retouching. Needs computer-literate freelancers for design, illustration, production and presentation. 90% of freelance work demands knowledge of Illustrator, Photoshop, QuarkXPress, Flash, Dreamweaver and Go Live.

First Contact & Terms Send postcard sample of work or send query letter with brochure or résumé. Samples are filed. Responds only if interested. Portfolios may be dropped off every Friday. Artist should follow up. Portfolio should include b&w and color samples. Pays for design by the hour and by the project. Pays for illustration by the project. Rights purchased vary according to project. Finds artists through reference books and submissions.

Tips Impressed by "to the point portfolios. Show me what you like to do and what you brought to the projects you worked on. Don't fill a book with extra items (samples) for sake of showing quantity."

INDIANA

ASHER AGENCY

535 W. Wayne, Fort Wayne IN 46802. (260)424-3373. Fax: (260)424-0848. E-mail: asherideas@centralnet.net.com. Web site: www.asheragency.com. **Contact:** Ringo Santiato, Senior Art Director. Estab. 1974. Number of employees 21. Approximate annual billing $12 million. Full service ad agency and PR firm. Clients automotive firms, financial/investment firms, area economic development agencies, health care providers, fast food companies, gaming companies and industrial.

Needs Works with 5-10 freelance artists/year. Assigns 25-50 freelance jobs/year. Prefers local artists. Works on assignment only. Uses freelance artists mainly for illustration. Also uses freelance artists for design, brochures, catalogs, consumer and trade magazines, retouching, billboards, posters, direct mail packages, logos and advertisements.

First Contact & Terms Send query letter with brochure showing art style or tearsheets and photocopies. Samples are filed or are returned by SASE. Responds only if interested. Will contact artist for portfolio review if interested. Portfolio should include roughs, original/final art, tearsheets and final reproduction/product. Pays for design by the hour, $40 minimum. Pays for illustration by the project, $40 minimum. Finds artists usually through word of mouth.

BOYDEN & YOUNGBLUTT ADVERTISING & MARKETING.

120 W. Superior St., Fort Wayne IN 46802. (260)422-4499. Fax: (260)422-4044. E-mail: info@b-y.net. Web site: www.b-y.net. **Vice President:** Jerry Youngblutt. Estab. 1990. Number of employees 20. Ad agency. Full-service, multimedia firm. Specializes in magazine ads, collateral, web, media, television.

Needs Approached by 10 freelancers/year. Works with 3-4 freelance illustrators and 5-6 designers/year. Uses freelancers mainly for collateral layout and Web. Also for annual reports, billboards, brochure design and illustration, logos and model-making. 40% of work is with print ads, 20% web, 20% media, and 10% TV. Needs computer-literate freelancers for design. 100% of freelance work demands knowledge of FreeHand, Photoshop, Adobe Ilustrator, Web Weaver and InDesign.

First Contact & Terms Send query letter with photostats and résumé. Samples are filed. Will contact artist for portfolio review if interested. Portfolio should include b&w and color final art. Pays for design and illustration by the project. Buys all rights.

Tips Finds artists through sourcebooks, word of mouth and artists' submissions. "Send a precise résumé with what you feel are your 'best' samples—less is more."

GRIFFIN MARKETING SERVICES, INC.

802 Wabash Ave., Chesterton IN 46304-2250. (219)929-1616. Fax: (219)921-0388. E-mail: rob@griffinmarketing services.com. Web site: www.griffinmarketingservices.com. **President:** Michael J. Griffin. Estab. 1974. Number of employees 20. Approximate annual billing $4 million. Integrated marketing firm. Specializes in collateral, direct mail, multimedia. Product specialty is industrial. Current clients include Hyatt, USX, McDonalds.

Needs Works with 20-30 freelance illustrators and 2-30 designers/year. Prefers artists with experience in computer graphics. Uses freelancers mainly for design and illustration. Also uses freelancers for animation, model making and TV/film graphics. 75% of work is with print ads. Needs computer-literate freelancers for design, illustration, production and presentation. 95% of freelance work demands knowledge of PageMaker, FreeHand, Photoshop, QuarkXPress and Illustrator.

First Contact & Terms Send query letter with SASE or e-mail. Samples are not filed and are returned by SASE if requested by artist. Responds in 1 month. Will contact artist for portfolio review if interested. Pays for design and illustration by the hour, $20-150; or by the project.

Tips Finds artists through *Creative Black Book*.

IOWA

F.A.C. MARKETING
P.O. Box 782, Burlington IA 52601. (319)752-9422. Fax: (319)752-7091. Web site: www.facmarketing.com. **President:** Roger Sheagren. Estab. 1952. Number of employees 8. Approximate annual billing $500,000. Ad agency. Full-service, multimedia firm. Specializes in newspaper, television, direct mail. Product specialty is funeral home to consumer.

Needs Approached by 30 freelancers/year. Works with 1-2 freelance illustrators and 4-6 designers/year. Prefers freelancers with experience in newspaper and direct mail. Uses freelancers mainly for newspaper design. Also for brochure design and illustration, logos, signage and TV/film graphics. Freelance work demands knowledge of PageMaker, Photoshop, CorelDraw and QuarkXPress.

First Contact & Terms Send query letter with brochure, SASE, tearsheets and photocopies. Samples are filed or returned by SASE if requested by artist. Request portfolio review in original query. Portfolio should include b&w photostats, tearsheets and thumbnails. Pays by the project, $100-500. Rights purchased vary according to project.

FLEXSTEEL INDUSTRIES INC.
3200 Jackson, Dubuque IA 52004-0877. (563)556-7730. Fax: (563)556-8345. Web site: www.flexsteel.com. **Advertising Manager:** Tom R. Baldwin or Lance Rygh. Estab. 1893. Full-service, multimedia firm, manufacturer with full-service in-house agency. Specializes in furniture advertising layouts, price lists, etc. Product specialty is consumer-upholstered furniture.

Needs Approached by 1 freelance artist/month. Works with 2-4 illustrators/month. Prefers artists who can do both wash and line illustration of upholstered furniture. Uses freelance artists for catalog and print ad illustration, retouching, billboards and posters. Works on assignment only. 25% of work is with print ads.

First Contact & Terms Send query letter with résumé, tearsheets and samples. Samples are filed or are returned by SASE if requested by artist. Responds only if interested. To show a portfolio, mail thumbnails, roughs and b&w tearsheets. Pays for design and illustration by the project. Buys all rights.

KANSAS

BRYANT, LAHEY & BARNES, INC.
5300 Foxridge Dr., Shawnee Mission KS 66202. (913)262-7075. **Contact:** Art Director. Ad agency. Clients agriculture and veterinary firms.

Needs Local freelancers only. Uses freelancers for illustration and production, via Mac format only; keyline and paste-up; consumer and trade magazines and brochures/flyers.

First Contact & Terms Query by phone. Send business card and résumé to be kept on file for future assignments. Originals not returned. Negotiates payment.

GRETEMAN GROUP
1425 E. Douglas Ave., Wichita KS 67211. (316)263-1004. Fax: (316)263-1060. E-mail: info@gretemangroup.com. Web site: www.gretemangroup.com. **Owner:** Sonia Greteman. Estab. 1989. Number of employees 19. Capitalized billing $20 million. Creative agency. Specializes in corporate identity, advertising, annual reports, signage, Web site design, interactive media, brochures, collateral. Professional affiliations AIGA.

Needs Approached by 2 illustrators and 10-20 designers/year. Works with 2 illustrators and 2 designers/year. Also for brochure illustration. 10% of work is with print ads. 100% of design demands skills in PageMaker, FreeHand, Photoshop, QuarkXPress, Illustrator. 30% of illustration demands computer skills.

First Contact & Terms Send query letter with brochure and résumé. Accepts disk submissions. Send EPS files.

Samples are filed. Will contact for portfolio review of b&w and color final art and photostats if interested. Pays for design by the hour. Pays for illustration by the project. Rights purchased vary according to project.

MARKETAIDE SERVICES, INC.
P.O. Box 500, Salina KS 67402-0500. (785)825-7161. Fax: (785)825-4697. Web site: www.marketaide.com. **Production Manager:** Dee Warren. Graphic Designer: Marla Kuiper Full-service ad/marketing/direct mail firm. Clients financial, industrial and educational.
Needs Prefers artists within one-state distance who possess professional expertise. Works on assignment only. Needs computer-literate freelancers for design, illustration and web design. 90% of freelance work demands knowledge of QuarkXPress, Illustrator and Photoshop.
First Contact & Terms Send query letter with résumé, business card and samples to be kept on file. Samples not filed are returned by SASE only if requested. Responds only if interested. Write for appointment to show portfolio. Pays for design by the hour, $15-75 average; "since projects vary in size, we are forced to estimate according to each job's parameters." Pays for illustration by the project.
Tips "Artists interested in working here should be highly polished in technical ability, have a good eye for design and be able to meet all deadline commitments."

TASTEFUL IDEAS, INC.
5822 Nall Ave., Mission KS 66202. (913)722-3769. Fax: (913)722-3967. E-mail: john@tastefulideas.com. Web site: www.tastefulideas.com. **President:** John Thomsen. Estab. 1986. Number of employees 4. Approximate annual billing $500,000. Design firm. Specializes in consumer packaging. Product specialties are largely, but not limited to, food and foodservice.
Needs Approached by 15 illustrators and 15 designers/year. Works with 3 illustrators and 3 designers/year. Prefers local freelancers. Uses freelancers mainly for specialized graphics. Also for airbrushing, animation, humorous and technical illustration. 10% of work is with print ads. 75% of design and illustration demand skills in Photoshop and Illustrator.
First Conact & Terms Designers: S end query letter with photocopies. Illustrators: S end non-returnable promotional sample. Accepts submissions from designers and illustrators compatible with Illustrator, PhotoshopMac based. Samples are filed. Responds only if interested. Art director will contact artist for portfolio review of final art if interested. Pays by the project. Finds artists through submissions.

WEST CREATIVE, INC.
9552 W. 116th Terrace, Overland Park KS 66210. (913)661-0561. Fax: (913)498-8627. E-mail: stan@westcreative.com. Web site: www.westcreative.com. **Creative Director:** Stan Chrzanowski. Estab. 1974. Number of employees 8. Approximate annual billing $600,000. Design firm and agency. Full-service, multimedia firm. Client list available upon request. Professional affiliation AIGA.
Needs Approached by 50 freelancers/year. Works with 4-6 freelance illustrators and 1-2 designers/year. Uses freelancers mainly for illustration. Also for animation, lettering, mechanicals, model-making, retouching and TV/film graphics. 20% of work is with print ads. Needs computer-literate freelancers for design, illustration and production. 95% of freelance work demands knowledge of FreeHand, Photoshop, QuarkXPress and Illustrator. Full service web design capabilities.
First Contact & Terms Send postcard-size sample of work or send query letter with brochure, photocopies, résumé, SASE, slides, tearsheets and transparencies. Samples are filed or returned by SASE if requested by artist. Responds only if interested. Portfolios may be dropped off every Monday-Thursday. Portfolios should include color photographs, roughs, slides and tearsheets. Pays for illustration by the project; pays for design by the hour, $25-60. "Each project is bid." Rights purchased vary according to project. Finds artists through *Creative Black Book* and *Workbook*.

WP POST & GRAPHICS
228 Pennsylvania, Wichita KS 67214-4149. (316)263-7212. Fax: (316)263-7539. E-mail: wppost@aol.com. Web site: www.wponline.com. **Art Director:** Kelly Flack. Estab. 1968. Number of employees 4. Ad agency, design firm, video production/animation. Specializes in TV commercials, print advertising, animation, Web design, packaging. Product specialties are automative, broadcast, furniture, restaurants. Current clients include Adventure RV and Truck Center, The Wichita Eagle, Dick Edwards Auto Plaza, Turner Tax Wise. Client list available upon request. Professional affiliations Advertising Federation of Wichita.
● Recognized by the American Advertising Federation of Wichita for excellence in advertising.
Needs Approached by 2 illustrators and 10 designers/year. Works with 1 illustrator and 2 designers/year. Prefers local designers with experience in Macintosh production, video and print. Uses freelancers mainly for overflow work. Also for animation, brochure design and illustration, catalog design and illustration, logos, TV/

film graphics, web page design and desktop production. 10% of work is with print ads. 100% of freelance work demands knowledge of Photoshop, FreeHand and QuarkXPress.

First Contact & Terms Designers: Send query letter with résumé and self-promotional sheet. Illustrators: Send postcard sample of work or query letter with résumé. Send follow-up postcard samples every 3 months. Samples are filed and are not returned. Responds only if interested. Art director will contact artist for portfolio review of b&w, color, final art, illustration if interested. Pays by the project. Rights purchased vary according to project and are negotiable. Finds artists through local friends and coworkers.

Tips ''Be creative, be original, and be able to work with different kinds of people.''

KENTUCKY

HAMMOND DESIGN ASSOCIATES, INC.

206 W. Main, Lexington KY 40507. (859)259-3639. Fax: (859)259-3697. Web site: www.hammonddesign.com. **Vice-President:** Grady Walter. Estab. 1986. Specializes in direct mail, package and publication design and annual reports, brand and corporate identity, display and signage. Clients corporations, universities and medical facilities.

Needs Approached by 35-50 freelance/year. Works with 5-7 illustrators and 5-7 designers/year. Works on assignment only. Uses freelancers mainly for brochures and ads. Also for editorial, technical and medical illustration, airbrushing, lettering, P-O-P and poster illustration; and charts/graphs. 100% of design and 50% of illustration require computer skills.

First Contact & Terms Send postcard sample or query letter with brochure or résumé. ''Sample in query letter a must.'' Samples are filed or returned by SASE if requested by artist. Responds only if interested. Will contact artist for portfolio review if interested. Pays by the project.

THE WILLIAMS MCBRIDE GROUP

344 E. Main St., Lexington KY 40507. (859)253-9319. Fax: (859)233-0180. E-mail: mail@williamsmcbride.com. Web site: www.williamsmcbride.com. **Partners:** Robin Williams Brohm and Kimberly McBride. Estab. 1988. Number of employees 7. Design firm specializing in brand management, corporate identity and business-to-business marketing.

Needs Approached by 10-20 freelance artists/year. Works with 4 illustrators and 3 designers/year. Prefers freelancers with experience in corporate design, branding. Works on assignment only. 100% of freelance design work demands knowledge of QuarkXPress, Photoshop and Illustrator. Will review résumés of Web designers with knowledge of Director and Flash.

First Contact & Terms Designers: Send query letter with résumé. Will review portfolios electronically or hard-copy samples. Illustrators: Send Web site or postcard sample of work. Samples are filed. Responds only if interested. Pays for design by the hour, $50-65. Pays for illustration by the project. Rights purchased vary according to project. Finds artists through submissions, word of mouth, *Creative Black Book*, *Workbook* and *American Showcase*, artist's representatives.

Tips ''Keep our company on your mailing list; remind us that you are out there.''

LOUISIANA

ANTHONY DI MARCO

301 Aris Ave., Metairie LA 70005. (504)833-3122. Fax: (504)833-3122. **Creative Director:** Anthony Di Marco. Estab. 1972. Number of employees 1. Specializes in illustration, sculpture, costume design, and art and photo restoration and retouching. Current clients include Audubon Institute, Louisiana Nature and Science Center, Fair Grounds Race Course. Client list available upon request. Professional affiliations Art Directors Designers Association, Entergy Arts Council, Louisiana Crafts Council, Louisiana Alliance for Conservation of Arts.

- Anthony DiMarco recently completed the re-creation of a 19th-century painting, *Life on the Metairie*, for the Fair Grounds racetrack. The original painting was destroyed by fire in 1993.

Needs Approached by 50 or more freelancers/year. Works with 5-10 freelance illustrators and 5-10 designers/year. Seeks ''local freelancers with ambition. Freelancers should have substantial portfolios and an understanding of business requirements.'' Uses freelancers mainly for fill-in and finish design, illustration, mechanicals, retouching, airbrushing, posters, model-making, charts/graphs. Prefers highly polished, finished art in pen & ink, airbrush, charcoal/pencil, colored pencil, watercolor, acrylic, oil, pastel, collage and marker. 25% of freelance work demands computer skills.

First Contact & Terms Send query letter with résumé, business card, slides, brochure, photocopies, photographs, transparencies and tearsheets to be kept on file. Samples not filed are returned by SASE. Responds in

1 week if interested. Call or write for appointment to show portfolio. Pays for illustration by the hour or by the project, $100 minimum.

Tips "Keep professionalism in mind at all times. Put forth your best effort. Apologizing for imperfect work is a common mistake freelancers make when presenting a portfolio. Include prices for completed works (avoid overpricing). Three-dimensional works comprise more of our total commissions than before."

FOCUS COMMUNICATIONS, INC.

5739 Lovers Ln., Shreveport LA 71105. (318)219-7688. Fax: (318)219-7689. **President:** Jim Huckabay. Estab. 1976. Number of employees 3. Specializes in corporate identity, direct mail design and full service advertising. Clients medical, financial and retail. Professional affiliations AAF.

Needs Approached by 5 freelancers/year. Works with 2 freelance illustrators and designers/year. Prefers local artists with experience in illustration, computer (Mac) design and composition. Uses illustrators mainly for custom projects; print ads. Uses designers mainly for custom projects; direct mail, logos. Also uses freelancers for ad and brochure design and illustration, audiovisual materials, charts/graphs, logos, mechanicals and retouching. Needs computer-literate freelancers for design, illustration and production. 85% of freelance work demands skills in Photoshop, FreeHand and QuarkXPress.

First Contact & Terms Send postcard sample of work or send query letter with brochure, photocopies, photostats, slides, tearsheets and transparencies. Samples are filed. Will contact artist for portfolio review if interested. Portfolio should include b&w and color final art and slides. Pays for design by the hour, $40-75; by the project. Pays for illustration by the project, $100-1,000. Negotiates rights purchased.

Tips Impressed by "turnkey capabilities in Macintosh design and finished film/proof composition."

MAINE

BACKBEAT ADVERTISING

428 Fore Street, Portland ME 04101. (207)775-5100. Fax: (207)775-5147. Web site: www.backbeatadvertising.com. **Creative Director:** Frank Laurino. Production Manager: Dana Williams. Estab. 1985. Number of employees 6. Full-service advertising agency.

Needs Works with freelancers for illustration, occasionally for design. Accepts work via disk in compatible Mac formats only. Samples are filed, responds only if interested.

First Contact & Terms Designers/Illustrators: Send samples for review. Pays for design by the hour or by the project, pays for illustration by the project.

MICHAEL MAHAN GRAPHICS

48 Front, P.O. Box 642, Bath ME 04530-0642. (207)443-6110. Fax: (207)443-6085. E-mail: ldelorme@mahangraphics.com. Web site: www.mahangraphics.com. **Contact:** Linda Delorme. Estab. 1986. Number of employees 5. Approximate annual billing $500,000. Design firm. Specializes in publication design—catalogs and direct mail. Product specialties are furniture, fine art and high tech. Current clients include Bowdoin College, Bath Iron Works and Bradco Chair. Client list available upon request. Professional affiliations G.A.G., AIGA and Art Director's Club-Portland, ME.

Needs Approached by 5-10 illustrators and 10-20 designers/year. Works with 2 illustrators and 2 designers/year. Uses freelancers mainly for production. Also for brochure, catalog and humorous illustration and lettering. 5% of work is with print ads. 100% of design demands skills in Photoshop and QuarkXPress.

First Contact & Terms Designers: Send query letter with photocopies and résumé. Illustrators: Send query letter with photocopies. Accepts disk submissions. Samples are filed and are not returned. Responds only if interested. Art director will contact artist for portfolio review of final art roughs and thumbnails if interested. Pays for design by the hour, $15-40. Pays for illustration by the hour, $18-60. Rights purchased vary according to project. Finds artists through word of mouth and submissions.

MARYLAND

🖫 SAM BLATE ASSOCIATES LLC

10331 Watkins Mill Dr., Montgomery Village MD 20886-3950. (301)840-2248. Fax: (301)990-0707. E-mail: info@writephotopro.com. Web site: www.writephotopro.com. **President:** Sam Blate. Number of employees 2. Approximate annual billing $120,000. AV and editorial services firm. Clients business/professional, US government, private.

Needs Approached by 6-10 freelancers/year. Works with 1-5 freelance illustrators and 1-2 designers/year. Prefers to work with freelancers in the Washington DC metropolitan area. Works on assignment only. Uses

freelancers for cartoons (especially for certain types of audiovisual presentations), editorial and technical illustrations (graphs, etc.) for 35mm and digital slides, pamphlet and book design. Especially important are "technical and aesthetic excellence and ability to meet deadlines." 80% of freelance work demands knowledge of PageMaker, Photoshop, and/or Powerpoint for Windows.

First Contact & Terms Send query letter with résumé and Web site, tearsheets, brochure, photocopies, slides, transparencies or photographs to be kept on file. Accepts disk submissions compatible with Photoshop and PageMaker. IBM format only. "No original art." Samples are returned only by SASE. Responds only if interested. Pays by the hour, $20-50. Rights purchased vary according to project, "but we prefer to purchase first rights only. This is sometimes not possible due to client demand, in which case we attempt to negotiate a financial adjustment for the artist."

Tips "The demand for technically-oriented artwork has increased."

DEVER DESIGNS

1056 West St., Laurel MD 20707. (301)776-2812. Fax: (301)953-1196. E-mail: info@deverdesigns.com. Web site: www.deverdesigns.com. **President:** Jeffrey Dever. Marketing Director: Holly Hagen. Estab. 1985. Number of employees 8. Specializes in annual reports, corporate identity and publication design. Clients: corporations, museums, government agencies, associations, nonprofit organizations.

Needs Approached by 100 freelance illustrators/year. Works with 30-50 freelance illustrators/year. Prefers artists with experience in editorial illustration. Uses illustrators mainly for publications.

First Contact & Terms Send postcard, samples or query letter with photocopies, résumé and tearsheets. Accepts PDFs and disk submissions compatible with Photoshop, Illustrator or InDesign, but prefers hard copy samples which are filed. Will contact artist for portfolio review if interested. Portfolio should include b&w and/or color photocopies for files. Pays for illustration by the project. Rights purchased vary according to project. Finds artists through referrals and sourcebooks.

Tips Impressed by "uniqueness and consistent quality."

SPIRIT CREATIVE SERVICES INC.

3157 Rolling Rd., Edgewater MD 21037. (410)956-1117. Fax: (410)956-1118. E-mail: alice@spiritcreativeservices. com. Web site: www.spiritcreativeservices.com. **President:** Alice Yeager. Estab. 1992. Number of employees 2. Approximate annual billing $90,000. Specializes in catalogs, signage, books, annual reports, brand and corporate identity, display, direct mail, package and publication design, Web page design, technical and general illustration, photography and marketing. Clients associations, corporations, government. Client list available upon request.

Needs Approached by 30 freelancers/year. Works with local designers only. Uses freelancers for ad, brochure, catalog, poster and P-O-P design and illustration, books, direct mail and magazine design, audiovisual materials, crafts/graphs, lettering, logos and mechanicals. Also for multimedia and Internet projects. 100% of design and 10% of illustration demands knowledge of Illustrator, Photoshop and PageMaker, A Type Manager and QuarkXPress. Also knowledge of Web design.

First Contact & Terms Send 2-3 samples of work with résumé. Accepts hardcopy submissions. Does not accept e-mail submissions. Samples are filed. Responds in 1-2 weeks if interested. Request portfolio review in original query. Portfolio should include b&w and color final art, tearsheets, sample of comping ability. Pays for design by the project, $50-6,000.

Tips "Paying attention to due dates, details, creativity, communication and intuition is vital."

MASSACHUSETTS

A.T. ASSOCIATES

63 Old Rutherford Ave., Charlestown MA 02129. (617)242-6004. **Partner:** Annette Tecce. Estab. 1976. Specializes in annual reports, industrial, interior, product and graphic design, model making, corporate identity, signage, display and packaging. Clients nonprofit companies, high tech, medical, corporate clients, small businesses and ad agencies. Client list available upon request.

Needs Approached by 20-25 freelance artists/year. Works with 3-4 freelance illustrators and 2-3 freelance designers/year. Prefers local artists; some experience necessary. Uses artists for posters, model making, mechanicals, logos, brochures, P-O-P display, charts/graphs and design.

First Contact & Terms Send résumé and nonreturnable samples. Samples are filed or are returned by SASE if requested by artist. Responds only if interested. Call to schedule an appointment to show a portfolio, which should include a "cross section of your work." Pays for design and illustration by the hour or by the project. Rights purchased vary according to project.

RICHARD BERTUCCI/GRAPHIC COMMUNICATIONS

3 Juniper Lane, Dover MA 02030-2146. (508)785-1301. Fax: (508)785-2072. E-mail: rich.bert@netzero.net. **Owner:** Richard Bertucci. Estab. 1970. Number of employees 1. Approximate annual billing $500,000. Specializes in annual reports, corporate identity, display, direct mail, package design, print advertising, collateral material. Clients companies and corporations. Professional affiliations AIGA.

Needs Approached by 12-24 freelancers/year. Works with 6 freelance illustrators and 3 designers/year. Prefers local artists with experience in business-to-business advertising. Uses illustrators mainly for feature products. Uses designers mainly for fill-in projects, new promotions. Also uses freelancers for ad, brochure and catalog design and illustration, direct mail, magazine and newspaper design and logos. 50% of design and 25% of illustration demand knowledge of Illustrator, Photoshop and QuarkXPress.

First Contact & Terms Send postcard sample of work or send query letter with brochure and résumé. Samples are filed. Will contact artist for portfolio review if interested. Portfolio should include b&w and color roughs. Pays for design by the project, $500-5,000. Pays for illustration by the project, $250-2,500. Rights purchased vary according to project.

Tips "Send more information, not just a postcard with no written information." Chooses freelancers based on "quality of samples, turn-around time, flexibility, price, location."

BODZIOCH DESIGN

30 Robbins Farm Rd., Dunstable MA 01827. (978)649-2949. E-mail: bodzioch@tiac.net. Web site: www.bodziochdesign.com. Estab. 1986. Number of employees 1. Specializes in annual reports, corporate identity and direct mail design. Clients corporations. Current clients include New England Business Service, Analog Devices, Inc., Centra Software, Simpley Grinell/Tyco and Hybercom Corporation, Codem Systems. Client list available upon request.

Needs Works with freelance illustrators and designers. Prefers local artists with experience in direct mail and corporate work. Uses illustrators mainly for charts, graphs and spot illustration. Uses designers mainly for concept, ad and logo design. Also uses freelancers for airbrushing, brochure and direct mail design, retouching. Needs computer-literate freelancers for design, illustration, production and presentation. 90% of freelance work demands knowledge of Illustrator, Photoshop, FreeHand and QuarkXPress.

First Contact & Terms Send postcard sample of work. Samples are filed. Will contact artist for portfolio review if interested. Portfolio should include b&w and color final art and roughs. Pays for design by the hour, or project. Pays for illustration by the project (supply quote). Rights purchased as dictated by client (usually all rights). Finds artists through *American Showcase, Communication Arts, Workbook, Direct Stock*, mailings from reps, and Web sites such as www.monster.com and www.guru.com.

FLAGLER ADVERTISING/GRAPHIC DESIGN

Box 280, Brookline MA 02446. (617)566-6971. Fax: (617)566-0073. E-mail: sflag@aol.com. **President/Creative Director:** Sheri Flagler. Specializes in corporate identity, brochure design, ad campaigns and package design. Clients: finance, real estate, high-tech and direct mail agencies, infant/toddler manufacturers.

Needs Works with 10-20 freelancers/year. Works on assignment only. Uses freelancers for illustration, photography, retouching, airbrushing, charts/graphs and lettering.

First Contact & Terms Send résumé, business card, brochures, photocopies or tearsheets to be kept on file. Call or write for appointment to show portfolio. Samples filed and are not returned. Responds only if interested. Pays for design and illustration by the project, $150-2,500. Considers complexity of project, client's budget and turnaround time when establishing payment.

Tips "Send a range and variety of styles showing clean, crisp and professional work."

G2 PARTNERS

209 W. Central St., Natick MA 01760. (508)651-8158. Fax: (508)655-1637. Web site: www.g2partners.com. Estab. 1975. Number of employees 2. Ad Agency. Specializes in advertising, direct mail, branding programs, literature, annual reports, corporate identity. Product specialty is business-to-business.

Needs Uses freelancers mainly for advertising, direct mail and literature. Also for brochure and print ad illustration.

First Contact & Terms Samples are filed or are returned by SASE if requested by artist. Does not reply. Portfolio review not required. Pays for illustration by the project, $500-3,500. Finds artists through annuals and sourcebooks.

MONDERER DESIGN, INC.

2067 Massachusetts Ave., 3rd Floor, Cambridge MA 02140. (617)661-6125. Fax: (617)661-6126. E-mail: stewart @monderer.com. Web site: www.monderer.com. **Creative Director:** Stewart Monderer. Estab. 1982. Specializes in annual reports, corporate identity, corporate communications, datasheets, and interactive solutions.

Clients corporations (technology, education, consulting, and life science). Current clients include Aspen Technology, Spotfire, eCredit.com, Fluent, Thermo Electron, Northeastern University, Dean College, Metamatrix. Client list on Web site.

Needs Approached by 40 freelancers/year. Works with 10-12 illustrators and photographers per year. Works on assignment only.

First Contact & Terms Send query letter with brochure, tearsheets, photographs, photocopies or nonreturnable postcards. Will look at links and PDF files. Samples are filed. Will contact artist for portfolio review if interested. Portfolio should include b&w and color-finished art samples. Sometimes requests work on spec before assigning a job. Pays for design by the hour, $15-25; by the project. Pays for illustration by the project, $250 minimum. Negotiates rights purchased. Finds artists through submissions/self-promotions and sourcebooks.

SPECTRUM BOSTON CONSULTING, INC.

9 Park St., Boston MA 02108. (617)367-1008. Fax: (617)367-5824. E-mail: gboesel@spectrumboston.com. **President:** George Boesel. Estab. 1985. Specializes in brand and corporate identity, display and package design and signage. Clients consumer, durable manufacturers.

Needs Approached by 30 freelance artists/year. Works with 5 illustrators and 3 designers/year. All artists employed on work-for-hire basis. Works on assignment only. Uses illustrators mainly for package and brochure work. Also for brochure design and illustration, mechanicals, logos, P-O-P design and illustration and model-making. 100% of design and 85% of illustration demand knowledge of Illustrator, QuarkXPress, Photoshop or FreeHand. Needs technical and instructional illustration.

First Contact & Terms Designers: Send query letter with résumé and photocopies. Illustrators: Send query letter with tearsheets, photographs and photocopies. Accepts any Mac-formatted disk submissions except for PageMaker. Samples are filed. Responds only if interested. Call or write for appointment to show portfolio of roughs, original/final art and color slides.

TR PRODUCTIONS

209 W. Central Street, Suite 108, Natick MA 01760. (508)650-3400. Fax: (508)650-3455. E-mail: info@tripod.com. Web site: www.trprod.com. **Creative Director:** Cary M. Benjamin. Estab. 1947. Number of employees 12. AV firm. Full-service multimedia firm. Specializes in FLASH, collateral, multimedia, web graphics and video.

Needs Approached by 15 freelancers/year. Works with 5 freelance illustrators and 5 designers/year. Prefers local freelancers with experience in slides, Web, multimedia, collateral and video graphics. Works on assignment only. Uses freelancers mainly for slides, Web, multimedia, collateral and video graphics. Also for brochure and print ad design and illustration, slide illustration, animation and mechanicals. 25% of work is with print ads. Needs computer-literate freelancers for design, production and presentation. 95% of work demands skills in FreeHand, Photoshop, Premier, After Effects, Powerpoint, QuarkXPress, Illustrator, Flash and Front Page.

First Contact & Terms Send query letter. Samples are filed. Does not reply. Artist should follow up with call. Will contact artist for portfolio review if interested. Rights purchased vary according to project.

TVN-THE VIDEO NETWORK

31 Cutler Dr., Ashland MA 01721-1210. (508)881-1800. Fax: (508)532-1129. E-mail: tvnvideo@aol.com. Web site: www.tvnvideo.com. **Producer:** Gregg McAllister. Estab. 1986. AV firm. Full-service multimedia firm. Specializes in video production for business, broadcast and special events. Product specialties "cover a broad range of categories." Current clients include Marriott, Digital, IBM, Waters Corp., National Park Service.

Needs Approached by 1 freelancer/month. Works with 1 illustrator/month. Prefers freelancers with experience in Mac/NT, Amiga PC, The Video Toaster, 2D and 3D programs. Works on assignment only. Uses freelancers mainly for video production, technical illustration, flying logos and 3-D work. Also for storyboards, animation, TV/film graphics and logos.

First Contact & Terms Send query letter with videotape or computer disk. Samples are filed or are returned. Responds in 2 weeks. Will contact artist for portfolio review if interested. Portfolio should include videotape and computer disk. Pays for design by the hour, $50; by the project, $1,000-5,000; by the day, $250-500. Buys all rights. Finds artists through word of mouth, magazines and submissions.

Tips Advises freelancers starting out in the field to find a company internship or mentor program.

WAVE DESIGN WORKS

P.O. Box 995, Norfolk MA 02056. (508)541-9171. Fax: (508)541-9172. Web site: www.wavedesignworks.com. E-mail: ideas@wavedesignworks.com. **Principal:** John Buchholz. Estab. 1986. Specializes in corporate identity and display, package and publication design. Clients corporations primarily biotech and software. Current clients include Genzyme, New England Biolabs, Siemens Medical, Neurometrix.

Needs Approached by 24 freelance graphic artists/year. Works with 1-5 freelance illustrators and 1-5 freelance designers/year. Works on assignment only. Uses freelancers for brochure, catalog, poster and ad illustration;

lettering; and charts/graphs. 100% of design and 50% of illustration demand knowledge of QuarkXPress, Illustrator or Photoshop, Indesign.

First Contact & Terms Designers send query letter with brochure, résumé, photocopies, photographs and tearsheets. Illustrators send postcard promo. Samples are filed. Responds only if interested. Artist should follow up with call and/or letter after initial query. Portfolio should include b&w and color thumbnails and final art. Pays for design by the hour, $12.50-25. Pays for illustration by the project. Rights purchased vary according to project. Finds artists through submissions and sourcebooks.

WEYMOUTH DESIGN, INC.

332 Congress St., Boston MA 02210-1217. (617)542-2647. Fax: (617)451-6233. E-mail: jlizardo@weymouthdesign.com. **Staff Assistant:** Johana Bodnyk. Estab. 1973. Number of employees 16. Specializes in annual reports, corporate collateral, designing Web sites and laptop presentations, CD-ROMs and miscellaneous multimedia. Clients corporations and small businesses. Client list not available. Professional affiliation AIGA.

Needs Works with 3-5 freelance illustrators and/or photographers. Needs editorial, medical and technical illustration mainly for annual reports. Also uses freelancers for multimedia projects.

First Contact & Terms Send query letter with résumé or illustration samples and/or tearsheets. Samples are filed or are returned by SASE if requested by artist. Will contact artist for portfolio review if interested.

MICHIGAN

BIGGS GILMORE COMMUNICATIONS

261 E. Kalamazoo Ave., Suite 300, Kalamazoo MI 49007-3990. (269)349-7711. Fax: (269)349-3051. Web site: www.biggs-gilmore.com. Estab. 1973. Ad agency. Full-service, multimedia firm. Specializes in traditional advertising (print, collateral, TV, radio, outdoor), branding, strategic planning, e-business development, and media planning and buying. Product specialties are consumer, business-to-business, marine and healthcare.

- This is one of the largest agencies in southwestern Michigan. Clients include DuPont, Kellogg Company, Zimmer Inc., Armstrong Machine Works, American Greetings, Forest Laboratories, Pfizer Animal Health and Wilmington Trust.

Needs Approached by 10 artists/month. Works with 1-3 illustrators and designers/month. Works both with artist reps and directly with artist. Prefers artists with experience with client needs. Works on assignment only. Uses freelancers mainly for completion of projects needing specialties. Also for brochure, catalog and print ad design and illustration, storyboards, mechanicals, retouching, billboards, posters, TV/film graphics, lettering and logos.

First Contact & Terms Send query letter with brochure, photocopies and résumé. Samples are filed. Responds only if interested. Call for appointment to show portfolio. Portfolio should include all samples the artist considers appropriate. Pays for design and illustration by the hour and by the project. Rights purchased vary according to project.

LEO J. BRENNAN, INC.

2359 Livernois, Troy MI 48083-1692. (248)524-3222. Fax: (248)362-2355. E-mail: lbrennan@ljbrennan.com. Web site: www.ljbrennan.com. **Vice President:** Virginia Janusis. Estab. 1969. Number of employees 11. Ad agency, PR and marketing firm. Clients: industrial, electronics, robotics, automotive, banks and CPAs.

Needs Works with 2 illustrators and 2 designers/year. Prefers experienced artists. Uses freelancers for design, technical illustration, brochures, catalogs, retouching, lettering, keylining and typesetting. Also for multimedia projects. 50% of work is with print ads. 100% of freelance work demands knowledge of IBM software graphics programs.

First Contact & Terms Send query letter with résumé and samples. Samples not filed are returned only if requested. Responds only if interested. Call for appointment to show portfolio of thumbnails, roughs, original/final art, final reproduction/product, color and b&w tearsheets, photostats and photographs. Payment for design and illustration varies. Buys all rights.

COMMUNICATIONS ELECTRONICS, INC.

Dept. AM, Box 2797, Ann Arbor MI 48106-2797. (734)996-8888. E-mail: cei@usascan.com. **Editor:** Ken Ascher. Estab. 1969. Number of employees 38. Approximate annual billing $5 million. Manufacturer, distributor and ad agency (13 company divisions). Specializes in marketing. Clients electronics, computers.

Needs Approached by 500 freelancers/year. Works with 40 freelance illustrators and 40 designers/year. Uses freelancers for brochure and catalog design, illustration and layout, advertising, product design, illustration on product, P-O-P displays, posters and renderings. Needs editorial and technical illustration. Prefers pen & ink,

airbrush, charcoal/pencil, watercolor, acrylic, marker and computer illustration. 30% of freelance work demands skills in PageMaker or QuarkXPress.

First Contact & Terms Send query letter with brochure, résumé, business card, samples and tearsheets to be kept on file. Samples not filed are returned by SASE. Responds in 1 month. Will contact artist for portfolio review if interested. Pays for design and illustration by the hour, $10-120; by the project, $10-15,000; by the day, $40-800.

CREATIVE HOUSE MARKETING

222 Main St., Suite 111, Rochester MI 48307. (248)601-5223. Fax: (248)928-0473. E-mail: results@creative-house.com. **Executive Vice President/Creative Director:** Don Anderson. Estab. 1964. Full service advertising/marketing firm. Clients home building products, sporting goods, automotive OEM, industrial manufacturing OEM, residential and commercial construction, land development, consumer, retail, finance, manufacturing, b to b and healthcare.

Needs Assigns 20-30 jobs; buys 10-20 illustrations/year. Works with 6 illustrators and 4 designers/year. Prefers local artists. Uses freelancers for work on filmstrips, consumer and trade magazines, multimedia kits, direct mail, television, brochures/flyers and newspapers. Most of work involves illustration, design and comp layouts of ads, brochures, catalogs, annual reports and displays. 25% of work is with print ads.

First Contact & Terms Query with résumé, business card and brochure/flier or postcard sample to be kept on file. Artist should follow up with call. Samples returned by SASE. Responds in 2 weeks. Originals not returned. Prefers to see online portfolios. Pays for design by the hour, $25-45; by the day, $240-400; or by the project. Pays for illustration by the project, $200-2,000. Considers complexity of project, client's budget and rights purchased when establishing payment. Reproduction rights are purchased as a buy-out.

MINNESOTA

BUTWIN & ASSOCIATES ADVERTISING

8700 Westmoreland Lane, Minneapolis MN 55426. (952)545-3886. **President:** Ron Butwin. Estab. 1977. Ad agency. "We are a full-line ad agency working with both consumer and industrial accounts on advertising, marketing, public relations and meeting planning." Clients banks, restaurants, clothing stores, food brokerage firms, corporations and a "full range of retail and service organizations."

• This agency offers some unique services to clients, including uniform design, interior design and display design.

Needs Works with 10-15 illustrators and 10-12 designers/year. Prefers local artists when possible. Uses freelancers for design and illustration of brochures, catalogs, newspapers, consumer and trade magazines, P-O-P displays, retouching, animation, direct mail packages, motion pictures and lettering. 20% of work is with print ads. Prefers realistic pen & ink, airbrush, watercolor, marker, calligraphy, computer, editorial and medical illustration. Needs computer-literate freelancers for design and illustration. 40% of freelance work demands computer skills.

First Contact & Terms Send brochure or résumé, tearsheets, photostats, photocopies, slides and photographs. Samples are filed or are returned only if SASE is enclosed. Responds only if interested. Call for appointment to show portfolio. Pays for design and illustration by the project; $25-3,000. Considers client's budget, skill and experience of artist and how work will be used when establishing payment. Buys all rights.

Tips "Portfolios should include layouts and finished project." A problem with portfolios is that "samples are often too weak to arouse enough interest."

TAKE 1 PRODUCTIONS

9969 Valley View Rd., Minneapolis MN 55344. (952)831-7757. Fax: (952)831-2193. Web site: www.take1produc tions.com. **Contact:** Art Director. Estab. 1985. Number of employees 10. Approximate annual billing $800,000. AV firm. Full-service multimedia firm. Specializes in video and multimedia production. Specialty is industrial. Current clients include 3M, NordicTrack and Kraft. Client list available upon request. Professional affiliations MCAI, SME, IICS.

Needs Approached by 100 freelancers/year. Works with 10 freelance illustrators/year. Prefers freelancers with experience in video production. Uses freelancers for graphics, sets. Also for animation, brochure design, logos, model making, signage and TV/film graphics. 2% of work is with print ads. 90% of freelance work demands knowledge of Photoshop and Lightwave.

First Contact & Terms Send query letter with video. Samples are filed. Will contact artist for portfolio review if interested. Pays for design and illustration by the hour or by the project. Rights purchased vary according to project. Finds artists through sourcebooks, word of mouth.

Tips "Tell me about work you have done with videos."

UNO HISPANIC ADVERTISING AND DESIGN
111 East Franklin Ave., Suite 101, Minneapolis MN 55404. (612)874-1920. Fax: (612)874-1912. E-mail: luis@uno online.com. Web site: www.unoonline.com. **Creative Director: Luis Fitch.** Marketing Director: Carolina Ornelas. Estab. 1990. Number of employees 6. Approximate annual billing $950,000. Specializes in brand and corporate identity, display, package and retail design and signage for the US Hispanic markets. Clients Latin American corporations, retail. Current clients include MTV Latino, Target, Mervyn's, 3M, Dayton's, SamGoody, Univision, Wilson's. Client list available upon request. Professional affiliations AIGA, GAG.
Needs Approached by 33 freelancers/year. Works with 40 freelance illustrators and 20 designers/year. Works only with artists' reps. Prefers local artists with experience in retail design, graphics. Uses illustrators mainly for packaging. Uses designers mainly for retail graphics. Also uses freelancers for ad and book design, brochure, catalog and P-O-P design and illustration, audiovisual materials, logos and model making. Also for multimedia projects (Interactive Kiosk, CD-Educational for Hispanic Market). 60% of design demands computer skills in Illustrator, Photoshop, FreeHand and QuarkXPress.
First Contact & Terms Designers: Send postcard sample, brochure, résumé, photographs, slides, or tearsheets. Illustrators: Send postcard sample, brochure, or tearsheets. Accepts disk submissions compatible with Illustrator, Photoshop, FreeHand. Send EPS files. Samples are filed. Will contact artist for portfolio review if interested. Portfolio should include color final art, photographs and slides. Pays for design by the project, $500-6,000. Pays for illustration by the project, $200-20,000. Rights purchased vary according to project. Finds artists through artist reps, *Creative Black Book* and *Workbook*.
Tips "It helps to be bilingual and to have an understanding of Hispanic cultures."

MISSOURI

PHOENIX LEARNING GROUP, INC.
2349 Chaffee Dr., St. Louis MO 63146. (314)569-0211. Fax: (314)569-2834. Web site: phoenixlearninggroup.com. **President: Heinz Gelles.** Executive Vice President: Barbara Bryant. Vice President, Market Development: Kathy Longsworth. Number of employees 50. Clients: libraries, museums, religious institutions, US government, schools, universities, film societies and businesses. Produces and distributes educational films.
Needs Works with 1-2 freelance illustrators and 2-3 designers/year. Prefers local freelancers only. Uses artists for motion picture catalog sheets, direct mail brochures, posters and study guides. Also for multimedia projects. 85% of freelance work demands knowledge of PageMaker, QuarkXPress and Illustrator.
First Contact & Terms Send postcard sample and query letter with brochure (if applicable). Send recent samples of artwork and rates to director of promotions. "No telephone calls please." Responds if need arises. Buys all rights. Keeps all original art "but will loan to artist for use as a sample." Pays for design and illustration by the hour or by the project. Rates negotiable. Free catalog upon written request.

THE ZIPATONI CO.
555 Washington Ave., St. Louis MO 63101-2019. (314)231-2400. Fax: (314)231-6622. E-mail: administrator@zipatoni.com. Web site: www.zipatoni.com. **Art Buyer: Chris Coffey.** Estab. 1984. Number of employees 235. Approximate annual billing $30 million. Sales promotion agency, creative/design service, event marketing agency. Specializes in new product development, brand extensions, promotional packaging and brand and corporate identity. Also maintains electronic design division which designs, develops and manages client Web sites, develops client intranets, extranets and CD-ROMs, and consults on Web marketing strategies, competitive analysis, and domain name research. Product specialties are food and beverage. Current clients include Miller Brewing Co., Energizer Battery, Chicken of the Sea, Bacardi, Ralston Purina, Campbell's Soup, Edy's/Dreyer's and the Coca-Cola Company. Client list available on Web site.
Needs Approached by 200 illustrators and 50 designers/year. Works with 35 illustrators/year. Uses freelancers mainly for point-of-purchase displays, brochures. Also for brochure design and illustration, model-making, posters and Web graphics.
First Contact & Terms Send query letter with brochure or photocopies and résumé. Send postcard sample of work with follow-up postcard samples every 3 months. Accepts disk submissions. Samples are filed. Pays by the project, $300-8,000. Negotiates rights purchased. Finds illustrators through *American Showcase, Black Book, Directory of Illustration* and submissions.

MONTANA

WALKER DESIGN GROUP
421 Central Ave., Great Falls MT 59401. (406)727-8115. Fax: (406)791-9655.Web site: www.walkerdesigngroup.com. E-mail: info@walkerdesigngroup.com. **President: Duane Walker.** Number of employees 6. Design firm.

Specializes in annual reports and corporate identity. Professional affiliations AIGA and Ad Federation.

Needs Uses freelancers for animation, annual reports, brochure, medical and technical illustration, catalog design, lettering, logos and TV/film graphics. 80% of design and 90% of illustration demand skills in PageMaker, Photoshop and Adobe Illustration.

First Contact & Terms Send query letter with brochure, photocopies, post cards, résumé, and/or tearsheets. Accepts digital submissions. Samples are filed and are not returned. Responds only if interested. To arrange portfolio review, artist should follow up with call or letter after initial query. Portfolio should include color photographs, photostats and tearsheets. Pays by the project; negotiable. Finds artists through *Workbook*.

Tips "Stress customer service and be very aware of deadlines."

NEBRASKA

BRIARDY DESIGN

5414 NW Radial Hwy., Suite 200, Omaha NE 68104. (402)561-1000. E-mail: mbriardy@briardydesign.com. Web site: www.briardydesign.com. **Creative Director/Owner:** Michael P. Briardy. Estab. 1995. Number of employees 1. Design firm. Specializes in packaging, P.O.P., corporate identity, environmental graphic design. Product specialties are food, financial, construction. Professional affiliations AIGA, Nebraska.

- Briardi Design also has an office in Denver.

Needs Approached by 5 illustrators and 5 designers/year. Uses freelancers for humorous, medical and technical illustration, model making and signage. 20% of work is with print ads. 90% of design demands knowledge of Photoshop 3.0, FreeHand 5.0, QuarkXPress 3.0. 50% of illustration demands knowledge of Photoshop 3.0, Illustrator 5.0, FreeHand 5.0, QuarkXPress 3.0.

First Contact & Terms Designers: Send query letter with brochure, photocopies and résumé. Illustrators: Send postcard sample of work, query letter with brochure, photocopies, résumé. Send follow-up postcard samples every 6 months. Accepts disk submissions. Send EPS, FreeHand, Illustrator, TIFF, BMP or Quark 3.0 files. Samples are not filed and are not returned. Does not report back. Artist should call. Will contact artist for portfolio review of color, final art and photographs if interested. Payment negotiable. Finds artists through both word of mouth and creative sourcebooks and trade journals.

Tips "Meet the objective on time."

IDEA BANK MARKETING

701 W. Second St., Hastings NE 68902-2117. (402)463-0588. Fax: (402)463-2187. E-mail: mail@ideabankmarketing.com. Web site: www.ideabankmarketing.com. **Creative Director:** Sherma Jones. Estab. 1982. Number of employees 7. Approximate annual billing $1,000,000. Ad agency. Specializes in print materials, direct mail. Product specialty is manufacturers. Client list available upon request. Professional affiliations Advertising Federation of Lincoln.

Needs Approached by 2 illustrators/year. Works with 2 illustrators and 2 designers/year. Prefers local designers only. Uses freelancers mainly for illustration. Also for airbrushing, catalog and humorous illustration, lettering. 30% of work is with print ads. 75% of design demands knowledge of Photoshop, Illustrator, FreeHand. 60% of illustration demands knowledge of FreeHand, Photoshop, Illustrator.

First Contact & Terms Designers/Illustrators: Send query letter with brochure. Send follow-up postcard samples every 6 months. Accepts disk submissions compatible with original illustration files or Photoshop files. Samples are filed or returned by SASE. Responds only if interested. Will contact artist for portfolio review of b&w, color, final art, tearsheets if interested. Pays by the project. Rights purchased vary according to project and are negotiable. Finds artists through word of mouth.

SWANSON RUSSELL ASSOCIATES

14301 FNB Parkway, Suite 312, Omaha NE 68154. (402)393-4940. Fax: (402)393-6926. E-mail: paulb@sramarketing.com. Web site: www.sramarketing.com. **Associate Creative Director:** Paul Berger. Estab. 1963. Number of employees 70. Approximate annual billing $40 million. Integrated marketing communications agency. Specializes in collateral, catalogs, magazine and newspaper ads, direct mail. Product specialties are healthcare, pharmaceuticals, agriculture. Current clients include Schering-Plough Animal Health, Alegent Health, AGP Inc. Professional affiliations 4A's, PRSA, AIGA, Ad Club.

Needs Approached by 12 illustrators and 3-4 designers/year. Works with 5 illustrators and 2 designers/year. Prefers freelancers with experience in agriculture, pharmaceuticals, human and animal health. Uses freelancers mainly for collateral, ads, direct mail, storyboards. Also for brochure design and illustration, humorous and technical illustration, lettering, logos, mechanicals, posters, storyboards. 10% of work is with print ads. 90% of design demands knowledge of Photoshop 7.0, FreeHand 5.0, QuarkXPress 3.3. 30% of illustration demands knowledge of Photoshop, Illustrator, FreeHand.

First Contact & Terms Designers: Send query letter with photocopies, photographs, photostats, SASE, slides, tearsheets, transparencies. Illustrators: Send query letter with SASE. Send follow-up postcard samples every 3 months. Accepts Mac compatible disk submissions. Send self expanding archives and player for multimedia, or JPEG, EPS and TIFFs. Software Quark, FreeHand or Adobe. Samples are filed or returned by SASE. Responds only if interested within 2 weeks. Art director will contact artist for portfolio review of final art, photographs, photostats, transparencies if interested. Pays for design by the hour, $50-65; pays for illustration by the project, $250-3,000. Rights purchased vary according to project. Finds artists through agents, submissions, word of mouth, *Laughing Stock*, *American Showcase*.

WEBSTER DESIGN ASSOCIATES, INC.
5060 Dodge St., Omaha NE 68132. (402)551-0503. Fax: (402)551-1410. **Contact:** Dave Webster. Estab. 1982. Number of employees 12. Approximate annual billing $16.3 million. Design firm specializing in 3 dimensional direct mail, corporate identity, human resources, print communications, web-interactive brochure/annual report design. Product specialites are telecommunications, Web design, corporate communications and human resources. Client list available upon request. Member of AIGA, Chamber of Commerce and Metro Advisory Council.
Needs Approached by 50 freelance illustrators and 50-75 freelance designers/year. Works with 12 freelance illustrators and 6 freelance designers/year. Prefers national and international artists with experience in QuarkXPress, Illustrator and Photoshop. Uses freelancers mainly for illustration, photography and annual reports. 15% of work is with print ads. 100% of freelance design and 70% of freelance illustration require knowledge of Aldus Freehand, Photoshop, Illustrator and QuarkXPress.
First Contact & Terms Designers: Send brochure, photographs and résumé. Illustrators: Send postcard sample of work. Send follow-up postcard every 3 months. Accepts submissions on disk, Photoshop and Illustrator. EPS preferred in most cases. Sample are filed or returned. Responds only if interested. To show portfolio, artist should follow-up with a call and/or letter after initial query. Portfolio should include b&w and color tearsheets, thumbnails and transparencies. Pays by the project. Rights purchased vary according to project. Finds artists through *Creative Black Book*, magazines and submissions.

NEW HAMPSHIRE

YASVIN DESIGNERS
45 Peterborough Rd., Box 116, Hancock NH 03449. (603)525-3000. Fax: (603)525-3300. **Contact:** Creative Director. Estab. 1990. Number of employees 3. Specializes in annual reports, brand and corporate identity, package design and advertising. Clients corporations, colleges and institutions.
Needs Approached by 10-15 freelancers/year. Works with 6 freelance illustrators and 2 designers/year. Uses freelancers for book production, brochure illustration, logos. 50% of freelance work demands knowledge of Illustrator, Photoshop, FreeHand and/or QuarkXPress.
First Contact & Terms Send postcard sample of work or send query letter with photocopies, SASE and tearsheets. Samples are filed. Responds only if interested. Request portfolio review in original query. Portfolio should include b&w and color photocopies, roughs and tearsheets. Pays for design by the project and by the day. Pays for illustration by the project. Rights purchased vary according to project. Finds artists through sourcebooks and artists' submissions.

NEW JERSEY

AM/PM ADVERTISING, INC.
345 Claremont Ave., Suite 26, Montclair NJ 07402. (973)824-8600. Fax: (973)824-6631. E-mail: mpt4220@aol.com. **President:** Bob Saks. Estab. 1962. Number of employees 130. Approximate annual billing $24 million. Ad agency. Full-service multimedia firm. Specializes in national TV commercials and print ads. Product specialties are health and beauty aids. Current clients include J&J, Bristol Myers, Colgate Palmolive. Client list available upon request. Professional affiliations AIGA, Art Directors Club, Illustration Club.
Needs Approached by 35 freelancers/year. Works with 3 freelance illustrators and designers/month. Agency prefers to work with local freelancers only with experience in animation, computer graphics, film/video production, multimedia, Macintosh. Works only with artist reps. Works on assignment only. Uses freelancers mainly for illustration and design. Also for brochure design and illustration, storyboards, slide illustration, animation, technical illustration, TV/film graphics, lettering and logos. 30% of work is with print ads. 50% of work demands knowledge of PageMaker, QuarkXPress, FreeHand, Illustrator or Photoshop.
First Contact & Terms Send postcard sample and/or query letter with brochure, résumé and photocopies. Samples are filed or returned. Responds in 10 days. Portfolios may be dropped off every Friday. Artist should

follow up after initial query. Portfolio should include b&w and color thumbnails, roughs, final art, tearsheets, photographs and transparencies. Pays by the hour, $35-100; by the project, $300-5,000; or with royalties (25%). Rights purchased vary according to project.

Tips "When showing work, give time it took to do job and costs."

BLOCK ADVERTISING & MARKETING, INC.

3 Clairidge Dr., Verona NJ 07044. (973)857-3900. Fax: (973)857-4041. E-mail: blockmark@aol.com. **Senior VP/Creative Director:** Karen DeLuca. Senior Art Director: Jay Baumann. Studio Manager: John Murray. Art Director: Evan Daly. Estab. 1939. Number of employees 25. Approximate annual billing $12 million. Product specialties are food and beverage, education, finance, home fashion, giftware, healthcare and industrial manufacturing. Professional affiliations Ad Club of North Jersey.

Needs Approached by 100 freelancers/year. Works with 25 freelance illustrators and 25 designers/year. Prefers to work with "freelancers with at least 3-5 years experience as Mac-compatible artists and 'on premises' work as Mac artists." Uses freelancers for "consumer friendly" technical illustration, layout, lettering, mechanicals and retouching for ads, annual reports, billboards, catalogs, letterhead, brochures and corporate identity. Needs computer-literate freelancers for design and presentation. 90% of freelance work demands knowledge of Quark-XPress, Illustrator, Type-Styler and Photoshop.

First Contact & Terms To show portfolio, mail appropriate samples and follow up with a phone call. E-mail résumé and samples of work or mail the same. Responds in 2 weeks. Pays for design by the hour, $20-60. Pays for illustration by the project, $250-5,000 or more.

Tips "We are fortunately busy—we use four to six freelancers daily. Be familiar with the latest versions of QuarkXpress, Illustrator and Photoshop. We like to see sketches of the first round of ideas. Make yourself available occasionally to work on premises. Be flexible in usage rights!"

CUTRO ASSOCIATES, INC.

47 Jewett Ave., Tenafly NJ 07670. (201)569-5548. Fax: (201)569-8987. E-mail: cutroassoc@optonline.net. **Manager:** Ronald Cutro. Estab. 1961. Number of employees 2. Specializes in annual reports, corporate identity, direct mail, fashion, package and publication design, technical illustration and signage. Clients corporations, business-to-business, consumer.

Needs Approached by 5-10 freelancers/year. Works with 2-3 freelance illustrators and 2-3 designers/year. Prefers local artists only. Uses illustrators mainly for wash drawings, fashion, specialty art. Uses designers for comp layout. Also uses freelancers for ad and brochure design and illustration, airbrushing, catalog and P-O-P illustration, direct mail design, lettering, mechanicals, and retouching. Needs computer-literate freelancers for design, illustration and production. 98% of freelance work demands knowledge of Illustrator, QuarkXPress and Photoshop.

First Contact & Terms Send postcard sample of work. Samples are filed. Will contact artist for portfolio review if interested. Portfolio should include final art and photocopies. Pays for design and illustration by the project. Buys all rights.

NORMAN DIEGNAN & ASSOCIATES

3 Martens Rd., Lebanon NJ 08833. (908)832-7951. Fax: (908)832-9650. Web site: www.diegnan-associates.com. **President:** N. Diegnan. Estab. 1977. Number of employees 5. Approximate annual billing $1 million. PR firm. Specializes in magazine ads. Product specialty is industrial.

Needs Approached by 10 freelancers/year. Works with 20 freelancers illustrators/year. Works on assignment only. Uses freelancers for brochure, catalog and print ad design and illustration, storyboards, slide illustration, animatics, animation, mechanicals, retouching and posters. 50% of work is with print ads. Needs editorial and technical illustration.

First Contact & Terms Send query letter with brochure and tearsheets. Samples are filed and not returned. Responds in 1 week. To show portfolio, mail roughs. Pays for design and illustration by the project. Rights purchased vary according to project.

HOWARD DESIGN GROUP, INC.

20 Nassau St., Suite 115, Princeton NJ 08542. (609)924-1106. Fax: (609)924-1165. E-mail: diane@howarddesign. com. **Partner:** Diane Savoy. Estab. 1980. Number of employees 9. Specializes in Web sites, corporate identity, college recruitment materials and publication design. Clients corporations, schools and colleges.

Needs Approached by 20 freelancers/year. Works with 10 freelance illustrators and 5 designers/year. Uses illustrators mainly for publication design. Also uses freelancers for brochure design and illustration; catalog, direct mail, magazine and poster design; logos. Needs computer-literate freelancers for design and production. 100% of freelance work demands knowlege of Illustrator, Photoshop, FreeHand and QuarkXPress.

First Contact & Terms Send résumé. Samples are filed. Will contact artist for portfolio review if interested.

Portfolio should include color final art, roughs and thumbnails. Pays for design and illustration by the project. Buys one-time rights. Finds artists through *Showcase.*
Tips Looks for "innovative design in portfolio."

JANUARY PRODUCTIONS, INC.

116 Washington Ave., Hawthorne NJ 07506. (201)423-4666. Fax: (973)423-5569. E-mail: awpeller@inetmail.att. net. Web site: www.awpeller.com. **Art Director:** Karen Birchak. Estab. 1973. Number of employees 12. AV producer. Serves clients in education. Produces children's educational materials—videos, sound filmstrips, read-along books, cassettes and CD-ROM.
Needs Works with 1-2 freelance illustrators/year. "While not a requirement, a freelancer living in the same geographic area is a plus." Works on assignment only, "although if someone had a project already put together, we would consider it." Uses freelancers mainly for illustrating children's books. Also for artwork for filmstrips, sketches for books and layout work. 50% of freelance work demands knowledge of QuarkXPress and Photoshop.
First Contact & Terms Send query letter with résumé, tearsheets, SASE, photocopies and photographs. Will contact artist for portfolio review if interested. "Include child-oriented drawings in your portfolio." Requests work on spec before assigning a job. Pays for design and illustration by the project, $20 minimum. Originals not returned. Buys all rights. Finds artists through submissions.

MIKE QUON/DESIGNATION INC.

543 River Rd., Fair Haven NJ 07704. (732)212-9200. Fax: (732)212-9217. E-mail: mike@quondesign.com. Web site: www.quondesign.com. **President:** Mike Quon. Estab. 1982. Number of employees 3. Specializes in corporate identity, displays, direct mail, packaging, publications and Web design. Clients corporations (financial, healthcare, high technology) and ad agencies. Current clients include Pfizer, Bristol-Myers Squibb, American Express, JP Morgan Chase, Hasbro, Verizon, AT&T. Client list available upon request. Professional affiliations AIGA, Society of Illustrators, Graphic Artists Guild.
Needs Approached by 20 illustrators and 20 designers/year. Works with 6 designers/year. Works on assignment only. Prefers graphic style. Uses artists for brochures, design and catalog illustration, P-O-P displays, logos, mechanicals, charts/graphs and lettering. Especially needs computer artists with skills in QuarkXPress, Illustrator, Photoshop and InDesign.
First Contact & Terms Send query letter with résumé and photocopies. Samples are filed or are returned if accompanied by SASE. Responds only if interested. No portfolio drop-offs. Mail only. Pays for design by the hour, depending on experience. Pays for illustration by the project, $100-500. Buys first rights.

SMITH DESIGN ASSSOCIATES

205 Thomas St., Box 8278, Glen Ridge NJ 07028. (973)429-2177. Fax: (973)429-7119. E-mail: laraine@smithdesi gn.com. Web site: www.smithdesign.com. **Vice President:** Laraine Blauvelt. Clients: grocery, mass market consumer brands, electronics, construction, automotive, toy manufacturers. Current clients Popsicle, Good Humor, Motts. Client list available upon request.
Needs Approached by more than 100 freelancers/year. Works with 10-20 freelance illustrators and 3-4 designers/year. Requires high level, experienced, talent, quality work and reliability. Uses freelancers for package design, concept boards, brochure design, print ads, newsletters illustration, POP display design, retail environments, web programming. 90% of freelance work demands knowledge of Illustrator, QuarkXPress, 3-D rendering programs. Design style must be current to trends. Our work ranges from "classic brands" to "of the moment/ cutting edge." Particularly when designing for KIDS and TEENS.
First Contact & Terms Send query letter with brochure/samples showing work, style and experience. Include contact information. Samples are filed or are returned only if requested by artist. Responds in 1 week. Call for appointment to show portfolio. Pays for design by the hour, $35-100; or by the project, $175-5,000. Pays for illustration by the project, $175-5,000. Considers complexity of project and client's budget when establishing payment. Buys all rights. (For illustration work, rights may be limited to a particular use TBD). Also buys rights for use of existing non-commissioned art. Finds artists through word of mouth, self-promotions/sourcebooks and agents.
Tips "Know who you're presenting to (visit our Web site to see our needs). Show work which is relevant to our business at the level and quality we require. We use more freelance designers and illustrators for diversity of style and talent."

NEW MEXICO

BOOKMAKERS LTD.

P.O. Box 1086, Taos NM 87571. (505)776-5435. Fax: (505)776-2762. E-mail: bookmakers@newmex.com. Web site: www.bookmakersltd.com. **President:** Gayle McNeil. "We are agents for professional, experienced chil-

dren's book illustrators and provide design and product in services to the publishing industry.''

First Contact & Terms Send query letter with samples and SASE if samples need returning. E-mail inquiries accepted.

Tips The most common mistake illustrators make in presenting samples or portfolios is ''too much variety, not enough focus.''

R H POWER AND ASSOCIATES, INC.

9621 Fourth St. NW, Albuquerque NM 87114-2128. (505)761-3150. Fax: (505)761-3153. E-mail: info@rhpower.c om. Web site: www.rhpower.com. **Art Director:** Bruce Yager. Creative Director: Roger L. Vergara. Estab. 1989. Number of employees 12. Ad agency. Full-service, multimedia firm. Specializes in TV, magazine, billboard, direct mail, newspaper, radio. Product specialties are recreational vehicles and automotive. Current clients include Kem Lite Corporation, RV Sales & Rentals of Albany, Ultra-Fab Products, Collier RV, Nichols RV, American RV and Marine. Client list available upon request.

Needs Approached by 10-50 freelancers/year. Works with 5-10 freelance illustrators and 5-10 designers/year. Prefers freelancers with experience in retail automotive layout and design. Uses freelancers mainly for work overload, special projects and illustrations. Also for annual reports, billboards, brochure and catalog design and illustration, logos, mechanicals, posters and TV/film graphics. 50% of work is with print ads. 100% of design demands knowledge of Photoshop 6.0, QuarkXPress and Illustrator 8.0.

First Contact & Terms Send query letter with photocopies or photographs and résumé. Accepts disk submissions in PC format compatible with CorelDraw, QuarkXPress or Illustrator 8.0. Send PC EPS files. Samples are filed and are not returned. Will contact artist for portfolio review if interested. Portfolio should include b&w and color final art, roughs and thumbnails. Pays for design and illustration by the hour, $12 minimum; by the project, $100 minimum. Buys all rights.

Tips Impressed by work ethic and quality of finished product. ''Deliver on time and within budget. Do it until it's right without charging for your own corrections.''

NEW YORK

BOXER DESIGN

548 State St., Brooklyn NY 11216-1619. (718)802-9212. Fax: (718)802-9213. E-mail: eileen@boxerdesign.com. Web site: www.boxerdesign.com. **Contact:** Eileen Boxer. Estab. 1986. Approximate annual billing $250,000. Design firm. Specializes in books and catalogs for art institutions, announcements, conceptual, primarily, but not exclusively for cultural institutions. Current clients include Ubu Gallery, Guggenheim Museum, The American Federation of Arts, The Menil Collection, Dallas Museum of Fine Arts. AIGA award of excellence (Graphic Design USA) 1997.

Needs 10% of work is with print ads. Design work demands intelligent and mature approach to design. Knowledge of Photoshop, Illustrator, QuarkXPress, InDesign.

First Contact & Terms Send e-mail with written and visual credentials. Accepts disk submissions compatible with Adobe PDFs, Quark 6, InDesign, Photoshop, Illustrator, all Mac, Zip. Samples are filed or returned on request. Responds in 3 weeks if interested in artist's work. Artist should follow-up with call after initial query. Pays by the project. Rights purchased vary according to project.

CARNASE, INC.

21 Dorset Rd., Scarsdale NY 10583. (212)777-1500. Fax: (914)725-9539. E-mail: carnase@carnase.com. Web site: www.carnase.com. **President:** Tom Carnase. Estab. 1978. Specializes in annual reports, brand and corporate identity, display, landscape, interior, direct mail, package and publication design, signage and technical illustration. Clients agencies, corporations, consultants. Current clients include Clairol, Shisheido Cosmetics, Times Mirror, Lintas New York. Client list not available.

• President Tom Carnase predicts ''very active'' years ahead for the design field.

Needs Approached by 60 freelance artists/year. Works with 2 illustrators and 1 designer/year. Prefers artists with 5 years experience. Works on assignment only. Uses artists for brochure, catalog, book, magazine and direct mail design and brochure and collateral illustration. Needs computer-literate freelancers. 50% of freelance work demands skills in QuarkXPress or Illustrator.

First Contact & Terms Send query letter with brochure, résumé and tearsheets. Samples are filed. Responds in 10 days. Will contact artist for portfolio review if interested. Portfolio should include photostats, slides and color tearsheets. Negotiates payment. Rights purchased vary according to project. Finds artists through word of mouth, magazines, artists' submissions/self-promotions, sourcebooks and agents.

DESIGN CONCEPTS

137 Main St., Unadilla NY 13849. (607)369-4709. **Owner:** Carla Schroeder Burchett. Estab. 1972. Specializes in annual reports, brand identity, design and package design. Clients corporations, individuals. Current clients include American White Cross and Private & Natural.

Needs Approached by 6 freelance graphic artists/year. Works with 2 freelance illustrators and designers/year. Prefers artists with experience in packaging, photography, interiors. Uses freelance artists for mechanicals, poster illustration, P-O-P design, lettering and logos.

First Contact & Terms Send query letter with tearsheets, brochure, photographs, résumé and slides. Samples are filed or are returned by SASE if requested by artist. Responds. Artists should follow up with letter after initial query. Portfolio should include thumbnails and b&w and color slides. Pays for design by the hour, $30 minimum. Negotiates rights purchased.

Tips "Artists and designers are used according to talent; team cooperation is very important. If a person is interested and has the professional qualification, he or she should never be afraid to approach us—small or large jobs."

GARRITY COMMUNICATIONS, INC.

217 N. Aurora St., Ithaca NY 14850. (607)272-1323. Web site: www.garrity.com. **Art Directors:** Allan Roe and Debra Martens. Estab. 1978. Ad agency, AV firm. Specializes in trade ads, newspaper ads, annual reports, video, etc. Product specialties are financial services, food, higher ed.

Needs Approached by 8 freelance artists/month. Works with 2 freelance illustrators and 1 freelance designer/month. Works on assignment only. Uses freelance artists mainly for work overflow situations; some logo specialization. Also uses freelance artists for brochure design and illustration, print ad illustration, TV/film graphics and logos. 40% of work is with print ads. 90% of freelance work demands knowledge of Photoshop, Illustrator, InDesign.

First Contact & Terms Send query letter with brochure and photocopies. Samples are filed and are not returned. Responds only if interested. Will contact artist for portfolio review if interested. Pays for design by the hour, $25-75. Pays for illustration by the project, $150-1,500. Rights purchased vary according to project. Finds artists through sourcebooks, submissions.

KERRY GAVIN STUDIOS

30 Brookwood Rd., Waterford NY 12188. (518)235-5630. Web site: www.kerrygavinsstudio.com. Specializes in publication design. Clients corporations, companies. Client list available upon request.

Needs Approached by 6-10 freelancers/year. Works with 6-8 freelance illustrators and 1-2 designers/year. Uses illustrators mainly for magazine covers. Uses designers mainly for production. Also uses freelancers for magazine design. Freelancers should be familiar with InDesign, Illustrator and Photoshop.

First Contact & Terms Send postcard sample of work or photocopies and tearsheets. Samples are filed or returned. Reports back to the artist only if interested. Portfolio review not required. Pays for design by the hour, $20-35. Pays for illustration by the project, $450 minimum. Buys one-time rights. Finds artists through sourcebooks, direct mailing, word of mouth and annuals.

Tips Impressed by "prompt response to query calls, good selection of samples, timely delivery."

LEONE DESIGN GROUP INC.

7 Woodland Ave., Larchmont NY 10538. (914)834-5700. E-mail: leonegroup@earthlink.net. Web site: www.leonedesign.com. **President:** Lucian J. Leone. Specializes in corporate identity, publications, signage and exhibition design. Clients nonprofit organizations, museums, corporations, government agencies. Client list not available. Professional affiliations AAM, SEGD, MAAM, AASLH, NAME.

Needs Approached by 30-40 freelancers/year. Works with 10-15 freelance designers/year. Uses freelancers for exhibition design, brochures, catalogs, mechanicals, model making, charts/graphs and AV materials. Needs computer-literate freelancers for design and presentation. 100% of freelance work demands knowledge of Adobe Indesign, Adobe Golive, Photoshop, Illustrator.

First Contact & Terms Send query letter with résumé, samples and photographs. Samples are filed unless otherwise stated. Samples not filed are returned only if requested. Responds in 2 weeks. Write for appointment to show portfolio of thumbnails, b&w and color original/final art, final reproduction/product and photographs. Pays for design by the hour, $20-45 or on a project basis. Considers client's budget and skill and experience of artist when establishing payment.

NOTOVITZ COMMUNICATIONS

15 Cutter Mill Road, Suite 212, Great Neck NY 11021. (212)677-9700. Fax: (649)349-3309. E-mail: joseph@notovitz.com. Web site: www.notovitz.com. **President:** Joseph Notovitz. Number of employees 4. Specializes in marketing communications (branding, annual reports, literature, publications, Web sites), corporate identity,

exhibit signage, event design and writing. Clients finance, real estate and industry. Professional affiliation: Specialty Graphic Imaging Association.

Needs Approached by 100 freelancers/year. Works with 10 freelance illustrators and 10 designers/year. Uses freelancers for brochure, poster, direct mail and booklet illustration; mechanicals; charts/graphs; and logo design. Needs computer-literate freelancers for design, illustration and production. 90% of freelance work demands expertise in InDesign, Illustrator and Photoshop. Needs pool of freelance Web developers with expertise in Flash, coding and design. Also collaborates on projects that writers and freelancers bring.

First Contact & Terms Send résumé, and links to online examples of work. Responds if there is fit and need. Pays for design and production work by the hour, $25-75. Pays for illustration by the project, $200-5,000.

Tips "Do a bit of research on the firm you are contacting. Send pieces which reflect our firm's style and needs. If we never produce book covers, book cover art does not interest us. Stress what you can do for the firm— not what the firm can do for you."

SMITH & DRESS

432 W. Main St., Huntington NY 11743. (631)427-9333. Web site: www.smithanddress.com. **Contact:** A. Dress. Specializes in annual reports, corporate identity, display, direct mail, packaging, publications and signage. Clients corporations.

Needs Works with 3-4 freelance artists/year. Prefers local artists only. Works on assignment only. Uses artists for illustration, retouching, airbrushing and lettering.

First Contact & Terms Send query letter with brochure showing art style or tearsheets to be kept on file (except for works larger than $8\frac{1}{2} \times 11$). Pays for illustration by the project. Considers client's budget and turnaround time when establishing payment.

TOBOL GROUP, INC.

14 Vanderventer Ave., Port Washington NY 11080. (516)767-8182. Fax: (516)767-8185. E-mail: mt@tobolgroup. com. Web site: www.tobolgroup.com. Estab. 1981. Ad agency. Product specialties are "50/50, business to business and business to consumer."

Needs Approached by 2 freelance artists/month. Works with 1 freelance illustrator and 1 designer/month. Works on assignment only. Uses freelancers for brochure, catalog and print ad design and technical illustration, mechanicals, retouching, billboards, posters, TV/film graphics, lettering and logos. 45% of work is with print ads. 75% of freelance work demands knowledge of QuarkXPress, Illustrator, Photoshop or GoLive.

First Contact & Terms Send query letter with SASE and tearsheets. Samples are filed or are returned by SASE. Responds in 1 month. Call for appointment to show portfolio or mail thumbnails, roughs, b&w and color tearsheets and transparencies. Pays for design by the hour, $25 minimum; by the project, $100-800; by the day, $200 minimum. Pays for illustration by the project, $300-1,500 ($50 for spot illustrations). Negotiates rights purchased.

VISUAL HORIZONS

180 Metro Park, Rochester NY 14623. (585)424-5300. Fax: (585)424-5313. E-mail: cs@visualhorizons.com. Web site: www.visualhorizons.com. Estab. 1971. AV firm. Full-service multimedia firm. Specializes in presentation products; digital imaging of 35mm slides. Current clients include US government agencies, corporations and universities.

Needs Works on assignment only. Uses freelancers mainly for catalog design. 10% of work is with print ads. 100% of freelance work demands skills in PageMaker and Photoshop.

First Contact & Terms Send query letter with tearsheets. Samples are not filed and are not returned. Responds if interested. Portfolio review not required. Pays for design and illustration by the hour or project, negotiated. Buys all rights.

NEW YORK CITY

AVANCE DESIGNS, INC.

1775 Broadway, Suite 419, New York NY 10019-1903. (212)876-4265. Fax: (212)876-3078. E-mail: info@avance-designs.com. Web site: www.avance-designs.com. Estab. 1986. "Avance Designs are specialists in visual communication. We maintain our role by managing multiple design disciplines from print and information design, to Web site design and interactive media." Clients include Fairchild Publications, Fashion Group International.

Needs Designers, Web designers, strong in Photoshop, Illustrator programmers in PHC, ASP, DHTML, JavaScript and Java.

First Contact & Terms Send query letter. Samples of interest are filed and are not returned. Responds only if interested.

BBDO NEW YORK

1285 Avenue of the Americas, New York NY 10019-6028. (212)459-5000. Fax: (212)459-6645. Web site: www.bb do.com. **Illustration Manager/Creative Project Coordinator:** Ron Williams. Estab. 1891. Number of employees 850. Annual billing $50,000,000. Specializes in business, consumer advertising, sports marketing and brand development. Clients include Texaco, Frito Lay, Bayer, Campbell Soup, FedEx, Pepsi, Visa and Pizza Hut. Ad agency. Full-service multimedia firm.

- BBDO Art Director told our editors he is always open to new ideas and maintains an open drop-off policy. If you call and arrange to drop off your portfolio, he'll review it, and you can pick it up in a couple days.

BARRY DAVID BERGER & ASSOCIATES, INC.

250 West 26th St., New York NY 10001. (212)255-4100. **Art Director:** Barry Berger. Number of employees 5. Approximate annual billing $500,000. Specializes in brand and corporate identity, P-O-P displays, product and interior design, exhibits and shows, corporate capability brochures, advertising graphics, packaging, publications and signage. Clients manufacturers and distributors of consumer products, office/stationery products, art materials, chemicals, healthcare, pharmaceuticals and cosmetics. Current clients include Dennison, Timex, Sheaffer, Bausch & Lomb and Kodak. Professional affiliations IDSA, AIGA, APDF.

Needs Approached by 12 freelancers/year. Works with 5 freelance illustrators and 7 designers/year. Uses artists for advertising, editorial, medical, technical and fashion illustration, mechanicals, retouching, direct mail and package design, model-making, charts/graphs, photography, AV presentations and lettering. Needs computer-literate freelancers for illustration and production. 50% of freelance work demands computer skills.

First Contact & Terms Send query letter, then call for appointment. Works on assignment only. Send "whatever samples are necessary to demonstrate competence" including multiple roughs for a few projects. Samples are filed or returned. Responds immediately. Provide brochure/flyer, résumé, business card, tearsheets and samples to be kept on file for possible future assignments. Pays for design by the project, $1,000-10,000. Pays for illustration by the project.

Tips Looks for creativity and confidence.

COUSINS DESIGN

330 E. 33rd St., New York NY 10016. (212)685-7190. Fax: (212)689-3369. E-mail: info@cousinsdesign.com. Web site: www.cousinsdesign.com. **President:** Michael Cousins. Number of employees 4. Specializes in packaging and product design. Clients: marketing and manufacturing companies. Professional affiliation: IDSA.

Needs Occassionally works with freelance designers. Prefers local designers. Works on assignment only.

First Contact & Terms Send nonreturnable postcard sample or e-mail your link. Samples are filed. Responds in 2 weeks only if interested. Write for appointment to show portfolio of roughs, final reproduction/product and photostats. Pays for design by the hour or flat fee. Considers skill and experience of artist when establishing payment. Buys all rights.

Tips "Send great work that fits our direction."

DLS DESIGN

156 Fifth Ave., New York NY 10010. (212)255-3464. E-mail: info@dlsdesign.com. Web site: www.dlsdesign.c om. **President:** David Schiffer. Estab. 1986. Number of employees 3. Web and graphic design firm. Specializes in implementation of graphically rich Web sites and other on-screen interfaces, especially software icons and high-end print work and logo design. Client sectors are corporate, law, publishing, nonprofit, enertainment, fashion, media and industrial companies. Current clients include Horizon Media, Telcordia Technologies, New-castle/Acoustone Fabrics and many others. Professional affiliation BNI (Business Network International).

- Awards include 2004-Two Communicator Awards for Best Web site:s and Graphics and over a dozen others dating back 10 years.

Needs "About 75% of our work is high-end corporate Web sites. Work is clean, but can also be high in the 'delight factor.' " Requires designers and illustrators fluent in Photoshop, Image Ready, Dreamweaver and Flash.

First Contact & Terms E-mail is acceptable, but unsolicited attached files will be rejected. "Please wait until we say we are interested, or direct us to your URL to show samples." Uses some hourly freelance help in Web site production; occasionally needs editorial illustrations in traditional media.

ERICKSEN ADVERTISING & DESIGN, INC.

12 W. 37th St., Ninth Floor, New York NY 10018. (212)239-3313. **Director:** Robert Ericksen. **Art Director:** Jin Lim. Full-service ad agency providing all promotional materials and commercial services for clients. Product specialties are promotional, commercial and advertising material for the entertainment industry. Current clients include BBC, National Geographic, Scripps Network.

Needs Works with several freelancers/year. Assigns several jobs/year. Works on assignment only. Uses free-

lancers mainly for advertising, packaging, brochures, catalogs, trade, P-O-P displays, posters, lettering and logos. Prefers composited and computer-generated artwork.

First Contact & Terms Contact through artist's agent or send query letter with brochure or tearsheets and slides. Samples are filed and are not returned unless requested with SASE; unsolicited samples are not returned. Responds in 1 week if interested or when artist is needed for a project. Does not respond to all unsolicited samples. "Only on request should a portfolio be sent." Pays for illustration by the project, $500-5,000. Buys all rights, and retains ownership of original in some situations. Finds artists through word of mouth, magazines, submissions and sourcebooks.

Tips "Advertising artwork is becoming increasingly 'commercial' in response to very tightly targeted marketing (i.e., the artist has to respond to increased creative team input versus the fine art approach."

GREY WORLDWIDE INC.

777 Third Ave., New York NY 10017. (212)546-2000. Fax: (212)546-2255. Web site: www.grey.com. **Vice President/Art Buying Manager:** Jayne Horowitz. Number of employees 1,800. Specializes in cosmetics, food and toys. Clients include BellSouth, Hasbro, Procter & Gamble, Volkswagen, Merck, Lilly. Professional affiliations 4A's Art Services Committee.

• This company has six art buyers, each of whom makes about 50 assignments per year. Freelancers are needed mostly for illustration and photography, but also for model-making, fashion styling and lettering.

Needs Approached by hundreds of freelancers/year. Works with some freelance illustrators and few designers/year.

First Contact & Terms Works on assignment only. Call at beginning of the month for appointment to show portfolio of original/final art. Pays by the project. Considers client's budget and rights purchased when establishing fees.

Tips "Be prepared and very professional when showing a portfolio. Show your work in a neat and organized manner. Have sample leave-behinds and do not expect to leave with a job. It takes time to plant your ideas and have them accepted."

LEO AND YOSSHI ATELIER

276 Fifth Ave., Suite 401, New York NY 10001. (212)685-3174. Fax: (212)685-3170. E-mail: leoart2765@aol.com. **President:** Leopold Schein. Studio Manager and Art Director: Robert Schein. Number of employees 3. Approximate annual billing $500,000. Specializes in textile design for home furnishings. Clients wallpaper manufacturers/stylists, glassware companies, furniture and upholstery manufacturers. Current clients include Eisenhart Wallcoverings, Town and Country, Culp, Inc. and Notra Trading. Client list available upon request.

Needs Approached by 25-30 freelancers/year. Works with 3-4 freelance illustrators and 20-25 textile designers/year. Prefers freelancers trained in textile field, not fine arts. Must have a portfolio of original art designs. Should be able to be in NYC on a fairly regular basis. Works both on assignment and speculation. Prefers realistic and traditional styles. Uses freelancers for design, airbrushing, coloring and repeats. "We will look at any freelance portfolio to add to our variety of hands. Our recent conversion to CAD system may require future freelance assistance. Knowledge of Coreldraw, Photoshop or others is a plus."

First Contact & Terms Send query letter with résumé. Do not send slides. Request portfolio review in original query. "We prefer to see portfolio in person. Contact via phone is OK—we can set up appointments with a day or two's notice." Samples are not filed and are returned. Responds in 5 days. Portfolio should include original/final art. Sometimes requests work on spec before assigning job. Pays for design by the project, $500-1,500. "Payment is generally a 60/40 split of what design sells forslightly less if reference material, art material, or studio space is requested." Considers complexity of project, skill and experience of artist and how work will be used when establishing payment. Buys all rights.

Tips "Stick to the field we are in (home furnishing textiles, upholstery, fabrics, wallcoverings). Understand manufacture and print methods. Walk the market; show that you are aware of current trends. Go to design shows before showing portfolio. We advise all potential textile designers and students to see the annual design show—Surtexat the Jacob Javitz Center in New York, usually in spring. Also attend High Point Design Show in North Carolina and Heimtex America in Florida."

LIEBER BREWSTER DESIGN, INC.

740 Broadway, Suite 1101, New York NY 10003. (212)614-1221. E-mail: anna@lieberbrewster.com. Web site: www.lieberbrewster.com. **Principal:** Anna Lieber. Estab. 1988. Specializes in strategic marketing. Clients small and midsize business, fortune 500s. Client list available upon request. Professional affiliations Toastmasters, Ad Club-NY.

Needs Approached by more than 100 freelancers/year. Works on assignment only. Uses freelancers for HTML programming, multimedia presentations, Web development, logos, marketing programs, audiovisual materials.

First Contact & Terms Send query letter with résumé, tearsheets and photocopies. Will contact artist for portfolio review if interested.

LUBELL BRODSKY INC.
286 Madison Ave., New York NY 10017. (212)684-2600. **Art Directors:** Ed Brodsky and Ruth Lubell. Number of employees 5. Specializes in corporate identity, direct mail, promotion, consumer education and packaging. Clients ad agencies and corporations. Professional affiliations ADC, TDC.
Needs Approached by 100 freelancers/year. Works with 10 freelance illustrators and photographers and 1-2 designers/year. Works on assignment only. Uses freelancers for illustration, retouching, charts/graphs, AV materials and lettering. 100% of design and 30% of illustration demands skills in Photoshop.
First Contact & Terms Send postcard sample, brochure or tearsheets to be kept on file. Responds only if interested.
Tips Looks for unique talent.

MARKEFXS
449 W. 44th St., Suite 4-C, New York NY 10036. (212)581-4827. Fax: (212)265-9255. E-mail: mark@mfxs.com. Web site: www.mfxs.com. **Creative Director/Owner:** Mark Tekushan. Estab. 1985. Full-service multimedia firm. Specializes in TV, video, advertising, design and production of promos, show openings and graphics. Current clients include ESPN and HBO.
Needs Prefers freelancers with experience in television or advertising production. Works on assignment only. Uses freelancers mainly for design production. Also for animation, TV/film graphics and logos. Needs computer-literate freelancers for design, production and presentation.
First Contact & Terms Send query letter with résumé and demo reels. Samples are filed. Coordinating Producer will contact artist for portfolio review if interested. Portfolio should include 3/4'' video or VHS. Pays for design by the hour, $25-50. Finds artists through word of mouth.
Tips Considers ''attitude (professional, aggressive and enthusiastic, not cocky), recommendations and demo sample.''

LOUIS NELSON ASSOCIATES INC.
P.O. Box 2021, New York NY 10013. (212)620-9191. Fax: (212)620-9194. E-mail: info@louisnelson.com. Web site: www.louisnelson.com. **President:** Louis Nelson. Estab. 1980. Number of employees 12. Approximate annual billing $1.2 million. Specializes in environmental, interior and product design and brand and corporate identity, displays, packaging, publications, signage and wayfinding, exhibitions and marketing. Clients non-profit organizations, corporations, associations and governments. Current clients include Stargazer Group, Rocky Mountain Productions, Wildflower Records, Port Authority of New York & New Jersey, Richter + Ratner Contracting Corporation, MTA and NYC Transit, Massachusetts Port Authority. Professional affiliations IDSA, AIGA, SEGD, APDF.
Needs Approached by 30-40 freelancers/year. Works with 30-40 designers/year. Works on assignment only. Uses freelancers mainly for specialty graphics and 3-dimensional design. Also for design, photo-retouching, model-making and charts/graphs. 100% of design demands knowledge of PageMaker, QuarkXPress, Photoshop, Velum, Autocad, Vectorworks, Alias, Solidworks or Illustrator. Needs editorial illustration.
First Contact & Terms Send postcard sample or query letter with résumé. Accepts disk submissions compatible with Illustrator 10.0 or Photoshop 7.0. Send EPS/PDF files. Samples are returned only if requested. Responds in 2 weeks. Write for appointment to show portfolio of roughs, color final reproduction/product and photographs. Pays for design by the hour, $15-25 or by the project, negotiable. Needs design more than illustration or photography.
Tips ''I want to see how the artist responded to the specific design problem and to see documentation of the process—the stages of development. The artist must be versatile and able to communicate a wide range of ideas. Mostly, I want to see the artist's integrity reflected in his/her work.'' -Louis Nelson

NICOSIA CREATIVE EXPRESSO, LTD.
355 W. 52nd St., 8th Floor, New York NY 10019. (212)515-6600. Fax: (212)265-5422. E-mail: info@niceltd.com. Web site: www.niceltd.com. **President/Creative Director:** Davide Nicosia. Estab. 1993. Number of employees 20. Specializes in graphic design, corporate/brand identity, brochures, promotional material, packaging, fragrance bottles and 3-D animations. As of 2005 welcomed Gaemer Gutierrez as head of ''Advertising/Brand Development'' division. Current clients include Estee Lauder Companies, Procter & Gamble, Escada, Montblanc, Old Spice, Loreal, and Wella.
- NICE is an innovative graphic design firm. Their team of multicultural designers deliver design solutions for the global marketplace.

Needs Approached by 70 freelancers/year. Works with 6 freelance illustrators and 8 designers/year. Works by

assignment only. Uses illustrators, designers, 3-D computer artists and computer artists familiar with Illustrator, Photoshop, After Effects, Premiere, QuarkXPress, Macromedia Director, Flash and Alias Wavefront.

First Contact & Terms Send query letter and résumé. Responds for portfolio review only if interested. Pays for design by the hour. Pays for illustration by the project. Rights purchased vary according to project.

Tips Looks for "promising talent and the right attitude."

SAATCHI & SAATCHI ADVERTISING WORLDWIDE

375 Hudson St., New York NY 10014-3620. (212)463-2000. Fax: (212)463-9855. Web site: www.saatchi-saatchi. com. **Contact:** Senior Art Buyer. Full-service advertising agency. Clients include Delta Airlines, Eastman Kodak, General Mills and Procter & Gamble.

Needs Approached by 50-100 freelancers/year. Works with 1-5 designers and 15-35 illustrators/year. Uses freelancers mainly for illustration and advertising graphics. Prefers freelancers with knowledge of electronic/ digital delivery of images.

First Contact & Terms Send query letter and nonreturnable samples or postcard sample. Prefers illustrators' sample postcards or promotional pieces to show "around a half a dozen illustrations," enough to help art buyer determine illustrator's style and visual vocabulary. Files interesting promo samples for possible future assignments. Pays for design and illustration by the project.

STRATEGIC COMMUNICATIONS

45 W. 21st St., New York NY 10010. (212)727-9909. Fax: (212)727-9908. E-mail: ideas@stracom.com. Web site: www.stracom.com. Estab. 1981. PR firm. Specializes in corporate and press materials, World Wide Web-based environments, VNRs, Quicktime and other DV, and presentation materials. Specializes in service businesses and online marketing.

Needs Approached by 3-4 freelancers/month. Works with 3 illustrators and 4 designers/month. Prefers local freelancers only. Works on assignment only. Uses freelancers for brochure design and illustration, slide illustration, mechanicals, posters, web-based design, lettering, logos, corporate ID programs, annual reports, collateral and press materials.

First Contact & Terms Send query letter with brochure, résumé, photographs and nonreturnable samples only. Include information about fee structure. Samples are filed. Does not reply, in which case the artist should send follow-up communication every 6-9 months to keep file active. Portfolio should include original, final art. Pays for design and illustration by the project. Rights purchased vary according to project.

Tips "Send relevant work samples and pricing information based on 'needs.' When I receive irrelevant samples, I immediately assume the sender does not understand my business and would not be someone we are likely to engage. We toss all extraneous material and don't have time to separate a portfolio. We expect the artist to have some judgment. Do not deluge me with periodic postcards."

STROMBERG CONSULTING

1285 Avenue of the Americas, 3rd floor, New York NY 10019. (646)935-4300. Fax: (646)935-4370. E-mail: clatz@stromberconsulting.com. Web site: www.strombergconsulting.com. **Creative Director:** Chad Latz. Number of employees 60. Product specialties are direct marketing, internal and corporate communication using traditional print base as well as Web and new media. Clients industrial and corporate. Produces multimedia, presentations, videotapes and print materials.

Needs Assigns 25-35 jobs/year. Prefers local designers only (Manhattan and its 5 burroughs) with experience in animation, computer graphics, multimedia and Macintosh. Uses freelancers for animation logos, posters, storyboards, training guides, Web Flash, application development, design catalogs, corporate brochures, presentations, annual reports, slide shows, layouts, mechanicals, illustrations, computer graphics and desk-top publishing web development, application development.

First Contact & Terms "Send note on availability and previous work." Responds only if interested. Provide materials to be kept on file for future assignments. Originals are not returned. Pays hourly or by the project.

Tips Finds designers through word of mouth and submissions.

TALCO PRODUCTIONS

279 E. 44th St., New York NY 10017. (212)697-4015. Fax: (212)697-4827. E-mail: alaw1@springmail.com. **President:** Alan Lawrence. Number of employees 5. TV/film producer. Specializes in nonprofit organizations, industry, associations and PR firms. Produces videotapes, motion pictures. Professional affiliation DGA.

Needs Works with 1-2 freelance illustrators and 1-2 designers/year. Prefers local freelancers with professional experience. 15% of freelance work demands skills in FreeHand or Illustrator.

First Contact & Terms Send query letter with résumé, brochure and SASE. Responds only if interested. Portfolio should include roughs, final reproduction/product, and color copies. Payment varies according to assignment.

Pays on production. Originals almost always returned at job's completion. Buys all rights. Considers complexity of project, client's budget and rights purchased when establishing payment.

NORTH CAROLINA

BOB BOEBERITZ DESIGN

247 Charlotte St., Asheville NC 28801. (828)258-0316. E-mail: bobb@main.nc.us. Web site: www.bobboeberitz design.com. **Owner:** Bob Boeberitz. Estab. 1984. Number of employees 1. Approximate annual billing $80,000. Specializes in graphic design, corporate identity and package design. Clients: retail outlets, hotels and restaurants, dot com companies, record companies, publishers, professional services. Majority of clients are business-to-business. Current clients include Para Research Software, SalesVantage.com, AvL Technologies, Southern Appalachian Repertory Theatre, Billy Edd Wheeler (Songwriter/Playwright), Shelby Stephenson (poet), and High Windy Audio. Professional affiliations AAF, NARAS, Asheville Freelance Network, Asheville Creative Services Group, Public Relations Association of WNC.
 • Owner Bob Boeberitz predicts "everything in art design will be done on computer; more electronic; more stock images; photo image editing and conversions will be used; there will be less commissioned artwork."
Needs Approached by 50 freelancers/year. Works with 2 freelance illustrators/year. Works on assignment only. Uses freelancers primarily for technical illustration and comps. Prefers pen & ink, airbrush and acrylic. 50% of freelance work demands knowledge of PageMaker, Illustrator, Photoshop or CorelDraw.
First Contact & Terms Send query letter with résumé, brochure, SASE, photographs, slides and tearsheets. "Anything too large to fit in file" is discarded. Accepts disk submissions compatible with IBM PCs. Send AI-EPS, PDF, JPEG, GIF, HTML and TIFF files. Samples are returned by SASE if requested. Responds only if interested. Will contact artist for portfolio review if interested. Portfolio should include thumbnails, roughs, final art, b&w and color slides and photographs. Sometimes requests work on spec before assigning a job. Pays for design and illustration, by the project, $50 minimum. Rights purchased vary according to project. Will consider buying second rights to previously published artwork. Finds artists through word of mouth, submissions/self-promotions, sourcebooks, agents.
Tips "Show sketches. Sketches help indicate how an artist thinks. The most common mistake freelancers make in presenting samples or portfolios is not showing how the concept was developed, what their role was in it. I always see the final solution, but never what went into it. In illustration, show both the art and how it was used. Portfolios should be neat, clean and flattering to your work. Show only the most memorable work, what you do best. Always have other stuff, but don't show everything. Be brief. Don't just toss a portfolio on my desk; guide me through it. A 'leave-behind' is helpful, along with a distinctive-looking résumé. Be persistent but polite. Call frequently. I don't recommend cold calls (you rarely ever get to see anyone) but it is an opportunity for a 'leave behind.' I recommend using the mail. E-mail is okay, but it isn't saved. Asking people to print out your samples to save in a file is asking too much. I like postcards. They get noticed, maybe even kept. They're economical. And they show off your work. And you can do them more frequently. Plus you'll have a better chance to get an appointment. After you've had an appointment, send a thank you note. Say you'll keep in touch and do it!"

IMAGE ASSOCIATES INC.

4909 Windy Hill Dr., Raleigh NC 27609. (919)876-6400. Fax: (919)876-7064. E-mail: carla@imageassociates.com. Web site: www.imageassociates.com. **President:** Carla Davenport. Estab. 1984. Number of employees 35. Marketing communications group offering advanced Web-based solutions, multimedia and print. Visual communications firm specializing in computer graphics and AV, multi-image, interactive multimedia, Internet development, print and photographic applications.
Needs Approached by 10 freelancers/year. Works with 4 freelance illustrators and 4 designers/year. Prefers freelancers with experience in Web, CD-ROM and print. Works on assignment only. Uses freelancers mainly for Web design and programming. Also for print ad design and illustration and animation. 90% of freelance work demands skills in Flash, HTML, DHTML, ASP, Photoshop and Macromind Director.
First Contact & Terms Send query letter with brochure, résumé and tearsheets. Samples are filed or are returned by SASE if requested by artist. Responds only if interested. To show portfolio, mail roughs, finished art samples, tearsheets, final reproduction/product and slides. Pays for assignments by the project, $100 minimum. Considers complexity of project, client's budget and how work will be used when establishing payment. Rights purchased vary according to project.

SMITH ADVERTISING & ASSOCIATES

321 Arch St., Drawer 2187, Fayetteville NC 28302. (910)222-5071. Fax: (910)486-8075. Web site: www.smithadv .com. **Contact:** Art director. Estab. 1974. Ad agency. Full-service, multimedia firm. Specializes in newspaper,

magazine, broadcast, collateral, PR, custom presentations and Web design. Product specialties are financial, healthcare, manufacturing, business-to-business, real estate, tourism. Current clients include Sarasota CVB, NC Ports, Southeastern Regional Medical Center, Standard Tobacco Corp. Client list available upon request.

Needs Approached by 0-5 freelance artists/month. Works with 5-10 freelance illustrators and designers/month. Prefers artists with experience in Macintosh. Works on assignment only. Uses freelance artists mainly for mechanicals and creative. Also uses freelance artists for brochure, catalog and print ad illustration and animation, mechanicals, retouching, model-making, TV/film graphics and lettering. 50% of work is with print ads. Needs computer-literate freelancers for design, illustration, production and presentation. 95% of freelance work demands knowledge of QuarkXPress, Illustrator or Photoshop.

First Contact & Terms Send query letter with résumé and copies of work. Samples are returned by SASE if requested by artist. Responds in 3 weeks. Artist should call. Will contact artist for portfolio review if interested. Portfolio should include b&w and color thumbnails, final art and tearsheets. Pays for design and illustration by the project, $100. Buys all rights.

NORTH DAKOTA

FLINT COMMUNICATIONS

101 Tenth St. N., Suite 300, Fargo ND 58102. (701)237-4850. Fax: (701)234-9680. Web site: www.flintcom.com. **Art Directors:** Gerri Lien, Dawn Koranda and Jeff Reed. Estab. 1947. Number of employees 40. Approximate annual billing $9 million. Ad agency. Full-service, multimedia firm. Product specialties are agriculture, manufacturing, healthcare, insurance and banking. Professional affiliations AIGA.

Needs Approached by 50 freelancers/year. Works with 6-10 freelance illustrators and 3-4 designers/year. Uses freelancers for annual reports, brochure design and illustration, lettering, logos and TV/film graphics. 40% of work is with print ads. 20% of freelance work demands knowledge of InDesign, Photoshop, QuarkXPress and Illustrator.

First Contact & Terms Send postcard-size or larger sample of work and query letter. Samples are filed. Will contact artist for portfolio review if interested. Pays for illustration by the project, $100-2,000. Rights purchased vary according to project.

SIMMONS/FLINT ADVERTISING

33 South 3rd Street, Suite D, Grand Forks ND 58201. (701)746-4573. Fax: (701)746-8067. E-mail: YvonneRW@simmonsflint.com. Web site: www.simmonsflint.com. **Contact:** Yvonne Westrum. Estab. 1947. Number of employees 90. Approximate annual billing $5.5 million. Ad agency. Specializes in magazine ads, collateral, documentaries, Web design etc. Product specialties are agriculture, gardening, fast food/restaurants, healthcare. Client list available upon request.

• A division of Flint Communications, Fargo ND, with 5 locations in North Dakota and Minnesota.

Needs Approached by 3-6 freelancers/year. Works with 3 freelance illustrators and 2 designer/year. Works on assignment only. Uses freelancers mainly for illustration. Also for brochure, catalog and print ad design and illustration; storyboards; billboards; and logos. 10% of work is with print ads. 10% of freelance work demands knowledge of QuarkXPress, Photoshop, Illustrator.

First Contact & Terms Send postcard, tearsheets or digital submission. Samples are filed or are returned. Will contact artist for portfolio review if interested. Portfolio should include color thumbnails, roughs, tearsheets, and photographs. Pays for design and illustration by the hour, by the project, or by the day. Rights purchased vary according to project.

OHIO

BFL MARKETING COMMUNICATIONS

2000 Sycamore St., 4th Floor, Cleveland OH 44113-2340. (216)875-8860. Fax: (216)875-8870. E-mail: dpavan@bflcom.com. Web site: www.bflcom.com. **President:** Dennis Pavan. Estab. 1955. Number of employees 12. Approximate annual billing $6.5 million. Marketing communications firm. Full-service, multimedia firm. Specializes in new product marketing, Internet Web site design, interactive media. Product specialty is consumer home products. Client list available upon request. Professional affiliations North American Advertising Agency Network, BPAA.

Needs Approached by 20 freelancers/year. Works with 5 freelance illustrators and 5 designers/year. Prefers freelancers with experience in advertising design. Uses freelancers mainly for graphic design, illustration. Also for brochure and catalog design and illustration, lettering, logos, model making, posters, retouching, TV/film graphics. 80% of work is with print ads. Needs computer-literate freelancers for design, illustration, production and presentation. 50% of freelance work demands knowledge of FreeHand, Photoshop, QuarkXPress, Illustrator.

First Contact & Terms Send postcard-size sample of work or send query letter with brochure, photostats,

tearsheets, photocopies, résumé, slides and photographs. Samples are filed or returned by SASE. Responds in 2 weeks. Artist should follow-up with call and/or letter after initial query. Will contact artist for portfolio review if interested. Portfolio should include b&w and color final art, photographs, photostats, roughs, slides and thumbnails. Pays by the project, $200 minimum.

Tips Finds artists through *Creative Black Book*, *Illustration Annual*, *Communication Arts*, local interviews. "Seeking specialist in Internet design, CD-ROM computer presentations and interactive media."

BRIGHT LIGHT PRODUCTIONS, INC.

602 Main St., Suite 810, Cincinnati OH 45202. (513)721-2574. Fax: (513)721-3329. **President:** Linda Spalazzi. Estab. 1976. AV firm. "We are a full-service film/video communications firm producing TV commercials and corporate communications."

Needs Works on assignment only. Uses artists for editorial, technical and medical illustration and brochure and print ad design, storyboards, slide illustration, animatics, animation, TV/film graphics and logos. Needs computer-literate freelancers for design and production. 50% of freelance work demands knowledge of Photoshop, Illustrator and After Effects.

First Contact & Terms Send query letter with brochure and résumé. Samples not filed are returned by SASE only if requested by artist. Request portfolio review in original query. Portfolio should include roughs and photographs. Pays for design and illustration by the project. Negotiates rights purchased. Finds artists through recommendations.

Tips "Our need for freelance artists is growing."

EVENTIV

10116 Blue Creek North, Whitehouse OH 43571. E-mail: jan@eventiv.com. Web site: www.eventiv.com. **President/Creative Director:** Janice Robie. Agency specializing in graphics, promotions and tradeshow marketing. Product specialties are industrial, consumer.

Needs Assigns 30 freelance jobs/year. Works with 5 illustrators/year and 20 designers/year. Works on assignment only. Uses freelancers for consumer and trade magazines, brochures, catalogs, P-O-P displays, AV presentations, posters and illustrations (technical and/or creative). 100% of design and 50% of illustration require computer skills. Also needs freelancers experienced in electronic authoring, animation, web design, programming and design.

First Contact & Terms Send query letter with résumé and slides, photographs, photostats or printed samples. Accepts disk submissions compatible with Mac or Windows. Samples returned by SASE if not filed. Responds only if interested. Write for appointment to show portfolio, which should include roughs, finished art, final reproduction/product and tearsheets. Pays by the hour, $25-80 or by the project, $100-2,500. Considers client's budget and skill and experience of artist when establishing payment. Negotiates rights purchased.

Tips "We are interested in knowing your specialty."

HOLLAND COMMUNICATIONS

700 Walnut St., Suite 300, Cincinnati OH 45202-2011. (513)721-1310. Fax: (513)721-1269. E-mail: holland@hollandroi.com. Web site: www.hollandROI.com. **Contact:** David Dreisbach. Estab. 1937. Number of employees 17. Approximate annual billing $12 million. Ad agency. Full-service, multimedia firm. Professional affiliation AAAA.

Needs Approached by 6-12 freelancers/year. Works with 5-10 freelance illustrators and 2-3 designers/year. Prefers artists with experience in Macintosh. Uses freelancers for brochure illustration, logos and TV/film graphics. 100% of freelance work demands knowledge of Photoshop, QuarkXPress and Illustrator.

First Contact & Terms Send query letter with photocopies and résumé. Accepts submissions on disk. Samples are filed and are not returned. Will contact artist for portfolio review if interested. Portfolio should include b&w and color final art, photographs, roughs, tearsheets and thumbnails. Pays for design by the hour, by the project and by the day. Pays for illustration by the project. Rights purchased vary according to project.

INNOVATIVE MULTIMEDIA

(formerly Instant Replay), 2515 Essex, Suite 164, Cincinnati OH 45206. (513)569-8600. Fax: (513)569-8608. **President:** Terry Hamad. Estab. 1977. AV/Post Production/Graphic Design firm. "We are a full-service film/video production and video post production house with our own sound stage. We also do traditional animation and 3-D computer animation for broadcast groups, corporate entities and ad agencies. We do many corporate identity pieces as well as network affiliate packages, car dealership spots and general regional and national advertising for TV market." Current clients include Procter and Gamble, General Electric and Western Southern.

Needs Works with 1 designer/month. Prefers freelancers with experience in video production. Works on assignment only. Uses freelancers mainly for production. Also uses freelancers for storyboards, animatics, animation and TV/film graphics.

First Contact & Terms Send query letter with résumé, photocopies, slides and videotape. "Interesting samples

are filed." Samples not filed are returned by SASE only if requested. Responds only if interested. Call for appointment to show slide portfolio. Pays by the hour, $25-50 or by the project and by the day (negotiated by number of days.) Pays for production by the day, $75-300. Considers complexity of project, client's budget and turnaround time when establishing payment. Buys all rights.

LOHRE & ASSOCIATES

2330 Victory Parkway, Suite 701, Cincinnati OH 45206. (513)961-1174. E-mail: chuck@lohre.com. Web site: www.lohre.com. **President:** Chuck Lohre. Number of employees 8. Approximate annual billing $1 million. Ad agency. Specializes in industrial firms. Professional affiliation BMA.

Needs Approached by 24 freelancers/year. Works with 10 freelance illustrators and 10 designers/year. Works on assignment only. Uses freelance artists for trade magazines, direct mail, P-O-P displays, multimedia, brochures and catalogs. 100% of freelance work demands knowledge of PageMaker, FreeHand, Photoshop and Illustrator.

First Contact & Terms Send postcard sample or e-mail. Accepts submissions on disk, any Mac application. Pays for design and illustration by the hour, $10 minimum.

Tips Looks for artists who "have experience in chemical and mining industry, can read blueprints and have worked with metal fabrication. Also needs Macintosh-literate artists who are willing to work at office, during day or evenings."

STEVENS BARON COMMUNICATIONS

Hanna Bldg., Suite 645, 1422 Euclid Ave., Cleveland OH 44115-1900. (216)621-6800. Fax: (216)621-6806. E-mail: estevens@stevensbaron.com. Web site: www.stevensbaron.com. **President:** Edward M. Stevens, Sr. Estab. 1956. Ad agency. Specializes in public relations, advertising, corporate communications, magazine ads and collateral. Product specialties are business-to-business, food, building products, technical products, industrial food service, healthcare, safety.

Needs Approached by 30-40 freelance artists/month. Prefers artists with experience in food and technical equipment. Works on assignment only. Uses freelance artists mainly for specialized projects. Also uses freelance artists for brochure, catalog and print ad illustration and retouching. Freelancers should be familiar with PageMaker, QuarkXPress, FreeHand, Illustrator and Photoshop.

First Contact & Terms Send query letter with résumé and photocopies. Samples are filed and are not returned. Does not reply back. "Artist should send only samples or copies that do not need to be returned." Will contact artist for portfolio review if interested. Portfolio should include final art and tearsheets. Pay for design depends on style. Pay for illustration depends on technique. Buys all rights. Finds artists through agents, sourcebooks, word of mouth and submissions.

OKLAHOMA

THE FORD AGENCY

P.O. Box 521180, Tulsa OK 74152-1180. (918)743-3673. Web site: www.thefordagency.com. **Creative Director:** CFord. Estab. 1985. Design firm specializing in corporate identity and positioning in the fields of business, financial, food and retail.

Needs Uses freelancers mainly for logo work, custom lettering, type design and technical illustration. Also for animation, medical and technical illustration, mechanicals, multimedia projects, retouching, storyboards, TV/film graphics and web page design.

First Contact & Terms Designers: Send query letter with résumé. Illustrators: Send sample. Accepts disk submissions compatible with Macintosh format only. Samples are filed. Responds only if interested. Will contact artist for portfolio review of final art, roughs, tearsheets, thumbnails if interested. Pays $50-1,000. Finds artists through sourcebooks, graphics magazines and networking at speakers events and affiliated peer organizations.

KIZER INCORPORATED ADVERTISING & COMMUNICATIONS

4513 Classen Blvd., Oklahoma City OK 73118. (405)858-4906. E-mail: bill@kizerincorporated.com. Web site: www.kizerincorporated.com. **Principal:** William Kizer. Estab. 1998. Number of employees 3. Ad agency. Specializing in magazine ads, print ads, copywriting, design/layout, collateral material. Professional affiliations OKC Ad Club, AMA, AIGA.

Needs Approached by 20 illustrators/year. Works with 3 illustrators and 3 designers/year. 50% of work is with print ads. 100% of design demands knowledge of InDesign, FreeHand, Photoshop. 50% of illustration demands knowledge of FreeHand, Photoshop.

First Contact & Terms Designers: Send or e-mail query letter with samples. Illustrators: Send or e-mail query letter with samples. Accepts disk submissions compatible with FreeHand or Photoshop file. Samples are filed and are not returned. Responds only if interested. To show portfolio, artist should follow up with call. Portfolio

Advertising & Design

should include "your best work." Pays by the project. Rights purchased vary according to project. Finds artists through agents, sourcebooks, online services, magazines, word of mouth, artist's submissions.

OREGON

COLOR PLAY STUDIO
P.O. Box 5855, Eugene OR 97405-0855. (541)687-8262. Fax: (541)687-8576. **President/Creative Director:** Gary Schubert. Media Director/VP: Gwen Schubert. Estab. 2005. Ad agency. "We provide full-service advertising to a wide variety of regional and national accounts. Our specialty is print media, serving predominantly industrial and business-to-business advertisers." Product specialties are forest products, heavy equipment, software, sporting equipment, food and medical.

Needs Works with approximately 4 freelance illustrators and 2 designers/year. Works on assignment only. Uses freelancers mainly for specialty styles. Also for brochure and magazine ad illustration (editorial, technical and medical), retouching, animation, films and lettering. 80% of work is with print ads. 80% of freelance work demands knowledge of Illustrator, QuarkXPress, FreeHand, Director, Photoshop, multimedia program/design.

First Contact & Terms Send query letter, brochure, résumé, slides and photographs. Samples are filed or are returned by SASE only if requested. Responds only if interested. Write for appointment to show portfolio. Pays for design and illustration and by the hour, $25-100. Rights purchased vary according to project.

Tips "We're busy. So follow up with reminders of your specialty, current samples of your work and the convenience of dealing with you. We are looking at more electronic illustration. Find out what the agency does most often and produce a relative example for indication that you are up for doing the real thing! Follow up after initial interview of samples. Do not send fine art, abstract subjects."

CREATIVE COMPANY, INC.
726 NE Fourth St., McMinnville OR 97128. Toll-free (866)363-4433. Fax: (503)883-6817. E-mail: jlmorrow@creative co.com. Web site: www.creativeco.com. **President/Owner:** Jennifer Larsen Morrow. Specializes in branding, marketing-driven corporate identity, collateral, direct mail, packaging and ongoing marketing campaigns. Product specialties are food, financial services, colleges, manufacturing, pharmaceutical, medical, agricultural products.

Needs Works with 6-10 freelance designers and 3-7 illustrators/year. Prefers local artists. Works on assignment only. Uses freelancers for design, illustration, computer production (Mac), retouching and lettering. "Looking for clean, fresh designs!" 100% of design and 60% of illustration demand skills in InDesign, FreeHand, Illustrator and Photoshop.

First Contact & Terms Send query letter with brochure, résumé, business card, photocopies and tearsheets to be kept on file. Samples returned by SASE only if requested. Will contact for portfolio review if interested. "We require a portfolio review. Years of experience not important if portfolio is good. We prefer one-on-one review to discuss individual projects/time/approach." Pays for design by the hour or project, $50-90. Pays for illustration by the project. Considers complexity of project and skill and experience of artist when establishing payment.

Tips Common mistakes freelancers make in presenting samples or portfolios are "1) poor presentation, samples not mounted or organized; 2) not knowing how long it took them to do a job to provide a budget figure; 3) not demonstrating an understanding of the audience, the problem or printing process and how their work will translate into a printed copy; 4) just dropping in without an appointment; 5) not following up periodically to update information or a résumé that might be on file."

WISNER CREATIVE
18200 NW Sauvie Island Rd., Portland OR 97231-1338. (503)282-3929. Fax: (503)282-0325. E-mail: wizbiz@wis nercreative.com. **Creative Director:** Linda Wisner. Estab. 1979. Number of employees 1. Specializes in brand and corporate identity, book design, publications and exhibit design. Clients small businesses, manufacturers, restaurants, service businesses and book publishers.

Needs Works with 3-5 freelance illustrators/year. Prefers experienced freelancers and "fast, accurate work." Works on assignment only. Uses freelancers for technical and fashion illustration and graphic production. Knowledge of QuarkXPress, Photoshop, Illustrator and other software required.

First Contact & Terms Send query letter or e-mail with résumé and samples. Prefers "examples of completed pieces which show the fullest abilities of the artist." Samples not kept on file are returned by SASE only if requested. Will contact artist for portfolio review if interested. Pays for illustration by the hour, $30-45 average or by the project, by bid. Pays for computer work by the hour, $25-35.

PENNSYLVANIA

BAILEY DESIGN GROUP, INC.
200 West Germantown Pike, Bldg. B, Plymouth Meeting PA 19462-1047. (610)940-9030. Fax: (610)940-2254. Web site: www.baileygp.com. **Owners/Partners:** Christopher Bailey, Russ Napolitano. Creative Director: Dave

Fiedler. Estab. 1985. Number of employees 38. Specializes in package design, brand and corporate identity, sales promotion materials, corporate communications and signage systems. Clients corporations (food, drug, health and beauty aids). Current clients include Johnson & Johnson Consumer Products Co., McNeil Consumer Specialty & Pharmaceutical, Welch's, Compass Group, Just Born Inc. and William Grant & Son. Professional affiliations AIGA, PDC, APP, AMA, ADC.

Needs Approached by 10 freelancers/year. Works with 3-6 freelance illustrators and 3-6 designers/year. Uses illustrators mainly for editorial, technical and medical illustration and final art, charts and airbrushing. Uses designers mainly for freelance production (*not* design), or computer only. Also uses freelancers for mechanicals, brochure and catalog design and illustration, P-O-P illustration and model-making.

First Contact & Terms Send query letter with brochure, résumé, tearsheets and photographs. Samples are filed. Responds only if interested. Will contact for portfolio review if interested. Portfolio should include finished art samples, color tearsheets, transparencies and artist's choice of other materials. May pay for illustration by the hour, inhouse $10-15; by the project, $300-3,000. Rights purchased vary according to project.

Tips Finds artists through word of mouth, self-promotions and sourcebooks.

DICCICCO BATTISTA COMMUNICATIONS

655 Business Center Dr., Suite 100, Horsham PA 19044. (215)957-0300 Fax (215) 672-9373. Web site: www.dbco mmunications.net. **Creative Director:** Carol Corbett. Estab. 1967. Full-service, multimedia, business-to-business ad agency. "High Creative." Specializes in food and business-to-business. Current clients include Hatfield Meats, Primavera, Hallowell and Caulk Dental Supplies.

Needs Works with 10 freelance illustrators and 25 freelance designers/month. Uses freelance artists mainly for paste-up and mechanicals, illustration, photography and copywriting. Also uses artists for brochure design, slides, print ads, animatics, animation, retouching, TV/film grapics, lettering and logos. 60% of work is with print ads.

First Contact & Terms Send query letter with brochure, résumé, tearsheets, photostats, photocopies, photographs, slides and SASE. Samples are filed or are returned by SASE only if requested by artist. Responds only if interested. Write to schedule an appointment to show a portfolio, which should include roughs, original/ final art, tearsheets, final reproduction/product, photographs, slides; include color and b&w samples. Pays for design by the hour, $15-50. Pays for illustration by the project. Rights purchased vary according to project.

Tips "Not everything they've had printed is worth showing—good ideas and good executions are worth more than mediocre work that got printed. Check on agency's client roster in the Red Book—that should tell you what style or look they'll be interested in."

DLD CREATIVE

620 E. Oregon Rd., Lititz PA 17543. (717)569-6568. Fax: (717)569-7410. E-mail: info@dldcreative.com. Web site: www.dldcreative.com. **President/Creative Director:** Dave Loose. Estab. 1986. Number of employees 12. Full-service design firm. Specializes in branding and corporate communications. Client list available upon request.

Needs Approached by 4 illustrators and 12 designers/year. Works with 4 illustrators/year. Uses freelancers mainly for illustration. Also for animation, catalog, humorous and technical illustration and TV/film graphics. 10% of work is with print ads. 50% of design demands skills in Photoshop, QuarkXPress, Illustrator.

First Contact & Terms Designers: Send query letter with photocopies, résumé and tearsheets. Illustrators: Send postcard sample of work. Accepts e-mail submissions. Samples are filed. Responds only if interested. No calls, please. Portfolio should include color final art and concept roughs. Pays for design and illustration by the project. Buys all rights. Finds artists through *American Showcase*, postcard mailings, word of mouth.

Tips "Be conscientious of deadlines, willing to work with hectic schedules. Must be top talent and produce highest quality work."

WARKULWIZ DESIGN ASSOCIATES INC.

2218 Race St. Suite 300, Philadelphia PA 19103. (215)988-1777. Fax: (215)988-1780. E-mail: wda@warkulwiz.c om. Web site: www.warkulwiz.com. **President:** Bob Warkulwiz. Estab. 1985. Number of employees 6. Approximate annual billing $1 million. Specializes in annual reports, publication design and corporate communications. Clients corporations and universities. Current clients include Firstrust Bank, Penn Law and Wharton School. Client list available upon request. Professional affiliations AIGA, 1ABC.

Needs Approached by 100 freelancers/year. Works with 10 freelance illustrators and 5-10 photographers/year. Works on assignment only. Uses freelance illustrators mainly for editorial and corporate work. Also uses freelance artists for brochure and poster illustration and mechanicals. Freelancers should be familiar with most recent versions of QuarkXPress, Illustrator, Photoshop, FreeHand and Director.

First Contact & Terms Send query letter with tearsheets and photostats. Samples are filed. Responds only if interested. Call for appointment to show portfolio of "best edited workpublished or unpublished." Pays for

illustration by the project, "depends upon usage and complexity." Rights purchased vary according to project.
Tips "Be creative and professional."

SPENCER ZAHN & ASSOCIATES
2015 Sansom St., Philadelphia PA 19103. (215)564-5979. Fax: (215)564-6285. E-mail: szahn@erols.com. **President:** Spencer Zahn. Business Manager Brian Zahn. Estab. 1970. Number of employees 10. Specializes in brand and corporate identity, direct mail design, marketing and retail advertising. Clients: corporations.
Needs Approached by 100 freelancers/year. Works with freelance illustrators and designers. Prefers artists with experience in Macintosh computers. Uses freelancers for ad, brochure and poster design and illustration; direct mail design; lettering; and mechanicals. Needs computer-literate freelancers for design, illustration and production. 80% of freelance work demands knowledge of Illustrator, Photoshop, FreeHand and QuarkXPress.
First Contact & Terms Send query letter with samples. Samples are not filed and are returned by SASE if requested by artist. Responds only if interested. Artist should follow up with call. Portfolio should include final art and printed samples. Buys all rights.

RHODE ISLAND

MARTIN THOMAS, INC.
42 Riverside Dr., Barrington RI 02806-2410. (401)245-8500. Fax: (866)899-2710. E-mail: contact@martinthomas.com. Web site: www.martinthomas.com. **Contact:** Martin K. Pottle. Estab. 1987. Number of employees 12. Approximate annual billing $7 million. Ad agency, PR firm. Specializes in industrial, business-to-business. Product specialties are plastics, medical and automotive. Professional affiliations American Association of Advertising Agencies, Boston Ad Club.
Needs Approached by 10-15 freelancers/year. Works with 6 freelance illustrators and 10-15 designers/year. Prefers freelancers with experience in business-to-business/industrial. Uses freelancers mainly for design of ads, literature and direct mail. Also for brochure and catalog design and illustration. 85% of work is print ads. 70% of design and 40% of illustration demands skills in QuarkXPress.
First Contact & Terms Send query letter with brochure and résumé. Samples are filed and are returned. Responds in 3 weeks. Will contact artist for portfolio review if interested. Portfolio should include b&w and color final art. Pays for design and illustration by the hour and by the project. Buys all rights. Finds artists through *Creative Black Book*.
Tips Impress agency by "knowing industries we serve."

TENNESSEE

ANDERSON STUDIO, INC.
2609 Grissom Dr., Nashville TN 37204. (615)255-4807. Fax: (615)255-4812. **Contact:** Andy Anderson. Estab. 1976. Specializes in T-shirts (designing and printing of art on T-shirts for retail/wholesale promotional market). Clients business, corporate retail, gift and specialty stores.
Needs Approached by 20 freelancers/year. Works with 1-2 freelance illustrators and 1-2 designers/year. "We use freelancers with realistic (photorealistic) style. Works on assignment only. We need artists for automotive-themed art. Also motorcycle designs as seen in the current line of shirts produced for Orange County Choppers of the Discovery Channel. We're also in need of Hot Rod art and designs for T-shirts along with graphic work and logo designs of the same."
First Contact & Terms Send postcard sample or query letter with color copies, brochure, photocopies, photographs, SASE, slides, tearsheets and transparencies. Samples are filed and are returned by SASE if requested by artist. Portfolio should include slides, color tearsheets, transparencies and color copies. Sometimes requests work on spec before assigning a job. Pays for design and illustration by the project, $300-1,000 or in royalties per piece of printed art. Negotiates rights purchased. Considers buying second rights (reprint rights) to previously published work.
Tips "Be flexible in financial/working arrangements. Most work is on a commission or flat buyout. We work on a tight budget until product is sold. Art-wise, the more professional the better." Advises freelancers entering the field to "show as much work as you can. Even comps or ideas for problem solving. Let art directors see how you think. Don't send disks. Takes too long to review. Most art directors like hard copy art."

HARMON GROUP
807 Third Ave. S., Nashville TN 37210. (615)256-3393. Fax: (615)256-3464. E-mail: abinfo@abstudios.com. Web site: www.harmongrp.com. **President:** Rick Arnemann. Estab. 1988. Number of employees 20. Approxi-

mate annual billing $3.7 million. Specializes in brand identity, display and direct mail design and signage. Clients ad agencies, corporations, mid-size businesses. Current clients include Best Products, Service Merchandise, WalMart, Hartmann Luggage. Client list available upon request. Professional affiliations Creative Forum.
Needs Approached by 20 freelancers/year. Works with 4-5 freelance illustrators and 5-6 designers/year. Uses illustrators mainly for P-O-P. Uses designers mainly for fliers and catalogs. Also uses freelancers for ad, brochure, catalog, poster and P-O-P design and illustration, logos, magazine design, mechanicals and retouching. 85% of freelance work demands skills in Illustrator 5.5, Photoshop 3.0 and QuarkXPress 3.31.
First Contact & Terms Send photographs, résumé, slides and transparencies. Samples are filed. Will contact artist for portfolio review if interested. Portfolio should include color final art, roughs, slides and thumbnails. Pays for design and illustration by the project. Rights purchased vary according to project. Finds artists through sourcebooks and portfolio reviews.

THE TOMBRAS GROUP

630 Concord St., Knoxville TN 37919. (865)524-5376. Fax: (865)524-5667. E-mail: mmccampbell@tombras.com. Web site: www.tombras.com. **Executive Creative Director:** Mitch McCampbell. Estab. 1946. Number of employees 60. Approximate annual billing $35 million. Ad agency. Full-service multimedia firm. Specializes in full media advertising, collateral, PR. Current clients include The State of Tennessee and Eastman Chemical. Client list available upon request. Professional affiliations AAAA, Worldwide Partners, PRSA.
Needs Approached by 20-25 freelancers/year. Works with 20-30 freelance illustrators and 10-15 designers/ year. Uses freelancers mainly for illustration and photography. Also for brochure design and illustration, model-making and retouching. 60% of work is with print ads. Needs computer-literate freelancers for design and presentation. 25% of freelance work demands skills in FreeHand, Photoshop and QuarkXPress.
First Contact & Terms Send query letter with photocopies and résumé. Samples are filed. Will contact artist for portfolio review if interested. Portfolio should include b&w and color samples. Pays for design by the hour, $25-75; by the project, $250-2,500. Pays for illustration by the project, $100-10,000. Rights purchased vary according to project.
Tips "Stay in touch with quality promotion. 'Service me to death' when you get a job."

TEXAS

DYKEMAN ASSOCIATES INC.

4115 Rawlins, Dallas TX 75219. (214)528-2991. Fax: (214)528-0241. E-mail: adykeman@airmail.net. Web site: www.dykemanassoc.com. **Contact:** Alice Dykeman. PR/marketing firm. Specializes in business, industry, hospitality, sports, environmental, energy, health.
Needs Works with 5 illustrators and designers/year. Local freelancers only. Uses freelancers for editorial and technical illustration, brochure design, exhibits, corporate identification, POS, signs, posters, ads and all design and finished artwork for graphics and printed materials. PC or Mac.
First Contact & Terms Request portfolio review in original query. Pays by the project, $250-3,000. "Artist makes an estimate; we approve or negotiate."
Tips "Be enthusiastic. Present an organized portfolio with a variety of work. Portfolio should reflect all that an artist can do. Don't include examples of projects for which you only did a small part of the creative work. Have a price structure but be willing to negotiate per project. We prefer to use artists/designers/illustrators who will work with barter (trade) dollars and join one of our trade exchanges. We see steady growth ahead."

EGAN DESIGN ASSOCIATES

18768 Wainsborough Lane, Dallas TX 75287. (972)931-7001. Fax: (972)931-7141. E-mail: abby-design@mindspring.com. **Art Director:** Abby Egan Smith. Estab. 1980. Number of employees 6. Specializes in brand and corporate identity; display, direct mail and package design. Clients corporations and manufacturers. Client list available upon request.
Needs Uses designers mainly for computer production. Also uses freelancers for brochure and catalog design and illustration, lettering, logos, mechanicals and poster and P-O-P illustration. Needs computer-literate freelancers for illustration and production. 100% of freelance work demands knowledge of Illustrator, Photoshop and QuarkXPress.
First Contact & Terms Send postcard sample of work, brochure, photocopies, photographs, photostats, résumé and tearsheets. Samples are filed. Will contact artist for portfolio review if interested. Rights purchased vary according to project.

THE EMERY GROUP

Dept. AM, 1519 Montana, El Paso TX 79902. (915)532-3636. Fax: (915)544-7789. E-mail: liza@emerygroup.com. **Contact:** Enrique Zarogoza, art director. Number of employees 18. Ad agency. Specializes in automotive

and retail firms, banks and restaurants. Current clients include Whataburger and Pepsi of El Paso.

Needs Approached by 3-4 freelancers/year. Works with 2-3 freelance illustrators and 4-5 designers/year. Uses freelancers mainly for design, illustration and production. Needs technical illustration and cartoons.

First Contact & Terms Works on assignment only. Send query letter with résumé and samples to be kept on file. Will contact artist for portfolio review if interested. Prefers tearsheets as samples. Samples not filed are returned by SASE. Replies. Sometimes requests work on spec before assigning a job. Pays for design by the hour, $15 minimum; by the project, $100 minimum; by the day, $300 minimum. Pays for illustration by the hour, $15 minimum; by the project, $100 minimum. Considers complexity of project, client's budget and turnaround time when establishing payment. Rights purchased vary according to project.

Tips Especially looks for "consistency and dependability; high creativity; familiarity with retail, Southwestern and Southern California look."

STEVEN SESSIONS INC.

5177 Richmond, Suite 500, Houston TX 77056. (713)850-8450. Fax: (713)850-9324. E-mail: Steven@Sessionsgroup.com. Web site: www.sessionsgroup.com. **President, Creative Director:** Steven Sessions. Estab. 1981. Number of employees 8. Approximate annual billing $2.5 million. Specializes in annual reports; brand and corporate identity; fashion, package and publication design. Clients corporations and ad agencies. Current clients are listed on Web site. Professional affiliations AIGA, Art Directors Club, American Ad Federation.

Needs Approached by 50 freelancers/year. Works with 10 illustrators and 2 designers/year. Uses freelancers for brochure, catalog and ad design and illustration; poster illustration; lettering; and logos. 100% of freelance work demands knowledge of Illustrator, QuarkXPress, Photoshop. Needs editorial, technical and medical illustration.

First Contact & Terms Designers: Send query letter with brochure, tearsheets, CD's, PDF files and SASE. Illustrators: Send postcard sample or other nonreturnable samples. Samples are filed. Responds only if interested. To show portfolio, mail slides. Payment depends on project, ranging from $1,000-30,000/illustration. Rights purchased vary according to project.

UTAH

BROWNING ADVERTISING

1 Browning Place, Morgan UT 84050. (801)876-2711. Fax: (801)876-3331. **Contact:** Senior Art Director. Estab. 1878. Distributor and marketer of outdoor sports products, particularly firearms. Inhouse agency for 3 main clients. Inhouse divisions include non-gun hunting products, firearms and accessories.

Needs Approached by 50 freelancers/year. Works with 20 freelance illustrators and 20 designers/year. Prefers freelancers with experience in outdoor sportshunting, shooting, fishing. Works on assignment only. Uses freelancers mainly for design, illustration and production. Also for advertising and brochure layout, catalogs, product rendering and design, signage, P-O-P displays, and posters.

First Contact & Terms Send query letter with résumé and tearsheets, slides, photographs and transparencies. Samples are not filed and are not returned. Responds only if interested. To show portfolio, mail photostats, slides, tearsheets, transparencies and photographs. Pays for design by the hour, $50-75. Pays for illustration by the project. Buys all rights or reprint rights.

VIRGINIA

BERMAN/KAPLER PROPERTIES L.L.C.

1600 Tysons Blvd., 8th Floor, McLean VA 22102. (703)556-3242. **Art Director:** Jeff Berman. Estab. 1974. Specializes in annual reports, corporate identity, signage, advertising and PR programs. Clients real estate developers, architects, high-technology corporations, financially-oriented firms (banks, investment firms, etc.) and associations.

Needs Works with 10 freelance artists/year. Mainly uses artists for architectural rendering and mechanical/production. Also uses artists for design and illustration of brochures, magazines, books, P-O-P displays, retouching, airbrushing, posters, model making, AV materials, lettering and advertisements. Needs computer-literate freelancers for design and production. 75% of freelance work demands computer literacy in Quark XPress.

First Contact & Terms "Artists should be highly professional, with at least 5 years of experience. Restricted to local artists for mechanicals only." Send query letter with brochure, résumé, business card and samples to be kept on file. Call or write for appointment to show portfolio or contact through agent. "Samples should be as compact as possible; slides not suggested." Samples not kept on file are returned by SASE. Responds only if interested. Pays for design by the hour, $20-50. Pays for illustration by the project, $200 minimum.

Tips Artists should have a "totally professional approach." The best way for illustrators or designers to

break into our field is a "phone call followed by a strong portfolio presentation" which should include "original completed pieces."

EDDINS MADISON CREATIVE

6487 Overlook Dr., Alexandria VA 22312. (703)750-2595. Fax: (703)750-3109. E-mail: steve@em-creative.com. Web site: www.em-creative.com. **Creative Director:** Marcia Eddins. Estab. 1983. Number of employees 5. Specializes in brand and corporate identity and publication design. Clients corporations, associations and non-profit organizations. Current clients include Reuters, ABC, National Fire Protection Assoc., Nextel. Client list available upon request.

Needs Approached by 20-25 freelancers/year. Works with 4-6 freelance illustrators and 2-4 designers/year. Uses only artists with experience in Macintosh. Uses illustrators mainly for publications and brochures. Uses designers mainly for simple design and Mac production. Also uses freelancers for airbrushing, brochure and poster design and illustration, catalog design, charts/graphs. Needs computer-literate freelancers for design, production and presentation. 100% of freelance work demands knowledge of Illustrator, Photoshop, and QuarkXPress.

First Contact & Terms Send postcard sample of work or send query letter with photocopies and résumé. Samples are filed. Will contact artist for portfolio review if interested. Rights purchased vary according to project. Finds artists through sourcebooks, design/illustration annuals and referrals.

Tips Impressed by "great technical skills, nice cover letter, good/clean résumé and good work samples."

BERNARD HODES ADVERTISING

8270 Greensboro Dr., Suite 600, McLean VA 22102. (703)848-0810. Fax: (703)848-0895. **Creative Director:** Gregg Petermann. Estab. 1970. Ad agency. Full-service, multimedia firm. Specializes in recruitment advertising and employment communications.

Needs Prefers artists with experience in graphic design and high-tech corporate identity. Works on assignment only. Uses freelancers for illustration. 90% of work is with print ads. 99% of freelance work demands knowledge of QuarkXPress, Illustrator, Photoshop or InDesign.

First Contact & Terms Send query letter with brochure, photocopies, résumé and tearsheets. Samples are filed. Write for an appointment to show a portfolio.

WORK, INC.

2019 Monument Ave., Richmond VA 23220. (804)358-9372. Fax: (804)355-2784. E-mail: cabel@worklabs.com. Web site: www.workadvertising.com. **Contact:** Cabell Harris, president, chief creative director. Estab. 1994. Number of employees 38. Approximate annual billing $44 million. Ad agency. Specializes in strategic council, account management, creative and production services. Current clients include Mercedes-Benz, Burger King, Hardee's, McDonald's, Office Depot, Virginia Tourism Corporation, Super 8. Client list available upon request. Professional affiliations Advertising Club of Richmond, AIGA.

Needs Approached by 25 illustrators and 35-40 designers/year. Works with 2-3 illustrators and 6-7 designers/year. Works on assignment only. Prefers freelancers with experience in animation, computer graphics, Macintosh. Uses freelancers mainly for new business pitches and specialty projects. Also for logos, mechanicals, TV/film graphics, posters, print ads and storyboards. 40% of work is with print ads. 95% of design work demands knowledge of FreeHand, Illustrator, Photoshop and QuarkXPress. 20% of illustration work demands knowledge of FreeHand, Illustrator, Photoshop and QuarkXPress.

First Contact & Terms Send query letter with photocopies, photographs, résumé, tearsheets, URL. Accepts e-mail submissions. Check Web site for formats. Samples are filed or returned. Responds only if interested. Request portfolio review in original query. Company will contact artist for portfolio review if interested. Portfolio should include b&w and color finished art, photographs, slides, tearsheets and transparencies. Pays freelancers usually a set budget with a buyout. Negotiates rights purchased. Finds freelancers through artists' submissions, sourcebooks and word of mouth.

Tips "Send nonreturnable samples (lasers) of work with résumé. Follow up by e-mail.

WASHINGTON

AUGUSTUS BARNETT ADVERTISING/DESIGN

P.O. Box 197, Fox Island WA 98333. (253)549-2396. Fax: (253)549-4707. E-mail: charlieb@augustusbarnett.com. **President/Creative Director:** Charlie Barnett. Estab. 1981. Approximate annual billing $1.2 million. Specializes in food, beverages, financial, agricultural, retail, corporate identity, package design. Clients: corporations, manufacturers. Current clients include Tree Top, Inc., Gilbert Global, Russell Investment Group, Nunhems USA, Tacoma Art Museum, Olympia Federal Savings, VOLTA, City of Tacoma. Client list available upon request. Professional affiliations.

Needs Approached by more than 50 freelancers/year. Works with 2-4 freelance illustrators and 2-3 designers/year. Prefers freelancers with experience in food/retail and Mac usage. Works on assignment and retainer. Uses illustrators for product, theme and food illustration, some identity and business-to-business. Also uses freelancers for illustration and multimedia projects. Send query letter with samples, résumé and photocopies. Samples are filed. Responds in 1 month. Pays for design by the hour, negotiable. Pays for illustration by project/use and buyouts. Rights purchased vary according to project.
Tips "Freelancers must understand design is a business."

BELYEA

1809 Seventh Ave., Suite 1250, Seattle WA 98101. (206)682-4895. Fax: (206)623-8912. Web site: www.belyea.com. Estab. 1988. Design firm. Specializes in brand and corporate identity, marketing collateral, in-store P-O-P, direct mail, packages and publication design. Clients: corporate, manufacturers, retail. Current clients include PEMCO Insurance, Genie Industries, and Weyerhaeuser. Client list available upon request.
Needs Approached by 20-30 freelancers/year. Works with 3 freelance illustrators/photographers and no designers/year. Prefers local design freelancers only. Works on assignment only. Uses illustrators for "any type of project." Also uses freelancers for brochure, catalog, poster and ad illustration; and lettering. 100% of design and 70% of illustration demands skills in Adobe CS.
First Contact & Terms Send postcard sample and résumé. Samples are filed. Responds only if interested. Pays for illustration by the project. Rights purchased vary according to project. Finds artists through submissions by mail and referral by other professionals.
Tips "Designers must be computer-skilled. Illustrators must develop some styles that make them unique in the marketplace. When pursuing potential clients, send something (one or more) distinctive. Follow up. Be persistent (it can take one or two years to get noticed) but not pesky. Get involved in local AIGA. Always do the best work you can—exceed everyone's expectations."

CREATIVE CONSULTANTS

2608 W. Dell Dr., Spokane WA 99208-4428. (509)326-3604. Fax: (509)327-3974. E-mail: ebruneau@creativeconsultants.com. Web site: www.creativeconsultants.com. **President:** Edmond A. Bruneau. Estab. 1980. Approximate annual billing $300,000. Ad agency and design firm. Specializes in collateral, logos, ads, annual reports, radio and TV spots. Product specialties are business and consumer. Client list available upon request.
Needs Approached by 20 illustrators and 25 designers/year. Works with 10 illustrators and 15 designers/year. Uses freelancers mainly for animation, brochure, catalog and technical illustration, model-making and TV/film graphics. 36% of work is with print ads. Designs and illustration demands skills in Photoshop and QuarkXPress.
First Contact & Terms Designers: Send query letter. Illustrators: Send postcard sample of work and e-mail. Accepts disk submissions if compatible with Photoshop, QuarkXPress, PageMaker and FreeHand. Samples are filed. Responds only if interested. Pays by the project. Buys all rights. Finds artists through Internet, word of mouth, reference books and agents.

DAIGLE DESIGN INC.

180 Olympic Dr. SE, Bainbridge Island WA 98110. (206)842-5356. Fax: (206)780-2526. E-mail: candace@daigle.com. Web site: www.daigledesign.com. **Creative Director:** Candace Daigle. Estab. 1987. Number of employees 6. Approximate annual billing $450,000. Design firm. Specializes in brochures, catalogs, logos, magazine ads, trade show display and Web sites. Product specialties are telecommunications, furniture, real estate development, aviation, yachts, restaurant equipment and automotive. Professional affiliations AIGA.
Needs Approached by 10 illustrators and 20 designers/year. Works with 5 illustrators and 5 designers/year. Prefers local designers with experience in Photoshop, Illustrator, DreamWeaver, Flash and FreeHand. Uses freelancers mainly for concept and production. Also for airbrushing, brochure design and illustration, lettering, logos, multimedia projects, signage, technical illustration and Web page design. 15% of work is with print. 90% of design demands skills in Photoshop, Illustrator and FreeHand. 50% of illustration demands skills in Photoshop, Illustrator, FreeHand and DreamWeaver.
First Contact & Terms Designers: Send query letter with résumé. Illustrators: Send query letter with photocopies. Accepts disk submissions compatible with Adobe pdf players. Send JPEG files. Samples are filed and are not returned. Responds only if interested. Will contact for portfolio review of b&w, color, final art, slides and tearsheets if interested. Pays for design by the hour, $15; pays for illustration by the project, $100-3,000. Buys all rights. Finds artists through submissions, reps, temp agencies and word of mouth.

DITTMANN DESIGN

P.O. Box 31387, Seattle WA 98103-1387. (206)523-4778. E-mail: dittdsgn@nwlink.com. **Owner/Designer:** Martha Dittmann. Estab. 1981. Number of employess 2. Specializes in brand and corporate identity, display and package design and signage. Clients corporations. Client list available upon request. Professional affiliations AIGA.

Needs Approached by 50 freelancers/year. Works with 5 freelance illustrators and 2 designers/year. Uses illustrators mainly for corporate collateral and packaging. Uses designers mainly for color brochure layout and production. Also uses freelancers for brochure and P-O-P illustration, charts/graphs and lettering. Needs computer-literate freelancers for design, illustration, production and presentation. 75% of freelance work demands knowledge of Illustrator, Photoshop, PageMaker, Persuasion, FreeHand and Painter.

First Contact & Terms Send postcard sample of work or brochure and photocopies. Samples are filed. Will contact artist for portfolio review if interested. Portfolio should include final art, roughs and thumbnails. Pays for design by the hour, $35-100. Pays for illustration by the project, $250-5,000. Rights purchased vary according to project. Finds artists through sourcebooks, agents and submissions.

Tips Looks for "enthusiasm and talent."

GIRVIN STRATEGIC BRANDING AND DESIGN

1601 Second Ave., 5th Floor, Seattle WA 98101-1575. (206)674-7808. Fax: (206)674-7909. Web site: www.girvin .com. Design Firm. Estab. 1977. Number of employees 34. Specializes in corporate identity and brand strategy, naming, Internet strategy, graphic design, signage, and packaging. Current clients include Warner Bros., Procter & Gamble, Paramount, Wells Fargo, Johnson & Johnson, and Kraft/Nabisco.

Needs Works with several freelance illustrators, production artists and designers/year.

First Contact & Terms Designers: Send query letter with appropriate samples. Illustrators: Send postcard sample or other nonreturnable samples. Will contact for portfolio review if interested. Payment negotiable.

HORNALL ANDERSON DESIGN WORKS, INC.

710 Second Avenue, Suite 1300, Seattle WA 98104. (206)467-5800. Fax: (206)467-6411. E-mail: info@hadw.c om. Web site: www.hadw.com. Estab. 1982. Number of employees 70. Design firm. Specializes in full range brand and marketing strategy consultation; corporate, integrated brand and product identity systems; new media; interactive media Web sites; packaging; collateral; signage; trade show exhibits; environmental graphics and annual reports. Product specialties are large corporations to smaller businesses. Current clients include Microsoft, K2 Corporation, Weyerhaeuser, Space Needle, CitationShares, Eos, Holland America, Widmer Brothers Brewery, Red Hook Brewery. Professional affiliations AIGA, Society for Typographic Arts, Seattle Design Association, Art Directors Club.

- This firm has received numerous awards and honors, including the International Mobius Awards, National Calendar Awards, London International Advertising Awards, Northwest and National ADDY Awards, Industrial Designers Society of America IDEA Awards, Communication Arts, Brand Design Association Gold Awards, AIGA, Clio Awards, Communicator Awards, Web by Awards.

Needs Interested in all levels, from senior design personnel to interns with design experience. Additional illustrators and freelancers are used on an as needed basis in design and online media projects.

First Contact & Terms Designers: S end query letter with photocopies and résumé. Illustrators: Send query letter with brochure and follow-up postcard. Accepts disk submissions compatible with FreeHand or Photoshop, "but the best is something that is platform/software independent (i.e., Director)." Samples are filed. Responds only if interested. Portfolios may be dropped off. Rights purchased vary according to project. Finds designers through word of mouth and submissions; illustrators through sourcebooks, reps and submissions.

HOWARD/FROST ADVERTISING COMMUNICATIONS

3131 Western Ave., #520, Seattle WA 98121. (206)378-1909. Fax: (206)378-1910. E-mail: bruce@hofro.com. Web site: www.hofro.com. **Creative Director:** Bruce Howard. Estab. 1994. Number of full-time employees 4. Ad agency. Specializes in media advertising, collateral and direct mail. Client list is available upon request.

Needs Approached by 20-30 illustrators and 10-15 designers/year. Works with 10 illustrators and 2 designers/year. Works only with artist reps. Uses freelancers mainly for illustration, design overload. Also for airbrushing, animation, billboards, brochure, humorous and technical illustration, lettering, logos, multimedia projects, retouching, storyboards, Web page design. 60% of work is with print ads. 60% of freelance design demands knowledge of PageMaker, FreeHand and Photoshop.

First Contact & Terms Designers: Send query letter with photocopies. Illustrators: Send postcard sample. Accepts disk submissions. Send files compatible with Acrobat, FreeHand, PageMaker or Photoshop. Samples are filed and not returned. Responds only if interested. Art director will contact artist for portfolio review if interested. Pays for design and illustration by the project. Negotiates rights purchased.

Tips "Be patient."

WISCONSIN

HANSON/DODGE DESIGN

220 E. Buffalo St., Milwaukee WI 53202-5704. (414)347-1266. Fax: (414)347-0493. Web site: www.hanson-dodge.c om. **CEO:** Ken Hanson. Estab. 1980. Number of employees 40. Approximate annual billing $4.6 million. Specializes

in integrated design, brand and corporate identity; catalog, display, direct mail and package design; signage; Web sites and digital publishing systems. Clients corporations, agencies. Current clients include Trek Bicycle, Timex, T-Fal, Hushpuppies. Client list available upon request. Professional affiliations AIGA, APDF, ACD.

Needs Approached by 30 freelancers/year. Works with 2-3 freelance illustrators, 2-3 designers and 5-8 production artists/year. Needs computer-literate freelancers for design, illustration and production. 90% of freelance work demands knowledge of Illustrator, Photoshop and QuarkXPress.

First Contact & Terms Send letter of introduction and position sought with résumé and nonreturnable samples to Hanson/Dodge Design, Attn: Claire Chin or e-mail postmaster@hanson-dodge.com. Résumés and samples are kept on file for 6 months. Responds in 2 weeks. Artist should follow-up with call. Pays for design and illustration by the hour. Finds artists through word of mouth, submissions.

IMAGINASIUM, INC.

321 St. George St., Green Bay WI 54302-1310. (920)431-7872. Fax: (920)431-7875. E-mail: joe@imaginasium.com. Web site: www.imaginasium.com. **Creative Director:** Joe Bergner. Estab. 1991. Number of employees 18. Approximate annual billing $2 million. Strategic marketing communications firm. Specializes in brand development, graphic design, advertising. Product specialties are business to business retail. Current clients include Wisconsin Public Service, Manitowoc Crane, Ansul. Client list available upon request. Professional affiliation Green Bay Advertising Federation, Second Wind Network.

Needs Approached by 50 illustrators and 25 designers/year. Works with 5 illustrators and 2 designers/year. Prefers local designers. Uses freelancers mainly for overflow. Also for brochure illustration and lettering. 15-20% of work is with print ads. 100% of design and 88% of illustration demands skills in Photoshop, QuarkXPress and Illustrator.

First Contact & Terms Designers: Send query letter with brochure, photographs and tearsheets. Illustrators: Send sample of work with follow-up every 6 months. Accepts Macintosh disk submissions of above programs. Samples are filed and are not returned. Will contact for portfolio review of color tearsheets, thumbnails and transparencies if interested. Pays for design by the hour, $50-75. Pays for illustration by the project. Rights purchased vary according to project. Finds artists through submissions, word of mouth, Internet.

UNICOM

9470 N. Broadmoor Rd., Bayside WI 53217. (414)352-5070. Fax: (414)352-4755. Web site: www.litteratibooks.com. **Senior Partner:** Ken Eichenbaum. Estab. 1974. Specializes in annual reports, brand and corporate identity; display, direct, package and publication design and signage. Clients corporations, business-to-business communications, and consumer goods. Client list available upon request.

Needs Approached by 5-10 freelancers/year. Works with 1-2 freelance illustrators/year. Works on assignment only. Uses freelancers for brochure, book and poster illustration, pre-press composition.

First Contact & Terms Send query letter with brochure. Samples not filed or returned. Does not reply; send nonreturnable samples. Write for appointment to show portfolio of thumbnails, photostats, slides and tearsheets. Pays by the project, $200-3,000. Rights purchased vary according to project.

WYOMING

BRIDGER PRODUCTIONS, INC.

P.O. Box 8131, Jackson WY 83001. (307)733-7871. Fax: (307)734-1947. E-mail: info@bridgerproductions.com. Web site: www.bridgerproductions.com. **Director/Cameraman:** Michael J. Emmer. Estab. 1990. AV firm. Full-service, multimedia firm. Specializes in national TV sports programming, national commercials, marketing videos, documentaries. Product specialties are skiing, mountain biking, mountain scenery. Current clients include Life Link International, Crombies, JH Ski Corp., State of Wyoming. Client list available upon request.

Needs Approached by 2 freelance artists/month. Works with 0-1 freelance illustrator and designer/month. Works on assignment only. Uses freelance artists for everything. Also uses freelance artists for storyboards, animation, model-making, billboards, TV/film graphics, lettering and logos. Needs computer-literate freelancers for design, illustration and production. 80% of freelance work demands knowledge of Amiga/Lightwave and other 3-D and paint programs.

First Contact & Terms Send query letter with film and video work—animations, etc. Samples are filed and are not returned. Responds only if interested. Will contact artist for portfolio review if interested. Portfolio should include 16mm, 35mm, motion picture and video work. Pays for design by the project, $150-20,000. Pays for illustration by the project, $150-1,500. Rights purchased vary according to project. Finds artists through word of mouth and submissions.

Advertising & Design

CANADA

⬛ WARNE MARKETING & COMMUNICATIONS

65 Overlea Blvd, Suite 112, Toronto ON M4H 1P1 Canada. (416)927-0881. Fax: (416)927-1676. E-mail: john@wa rne.com. Web site: www.warne.com. **Studio Manager:** John Coljee. Number of employees 10. Approximate annual billing $2.5 million. Specializes in business-to-business marketing and communications. Current clients include ACTRA Fraternal Benefits Society, Butler Buildings, Johnston Equipment, KWH Pipe, The Orthotic Group, Virtek Vision. Professional affiliations CIM, BMA, INBA.

Needs Works with 4-5 freelance illustrators and 1-3 designers/year. Works on assignment only. Uses freelancers for design and technical illustrations, advertisements, brochures, catalogs, P-O-P displays, retouching, posters, direct mail packages, logos and interactive. Artists should have ''creative concept thinking.''

First Contact & Terms Send query letter with résumé and photocopies. Samples are not returned. Responds only if interested. Pays for design by the hour, or by the project. Considers complexity of project, client's budget and skill and experience of artist when establishing payment. Buys all rights.

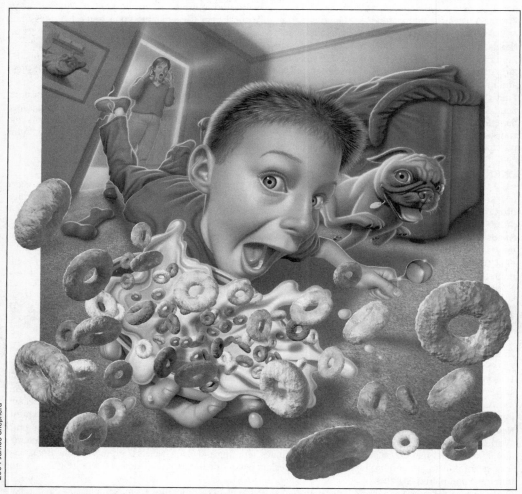

© 2004 James Shepherd

Advertising art should be memorable and this image fits the bill. The action-packed scene showcases the resiliency of Mohawk Carpeting in the face of little boys, cereal spills and puppy dogs. James Shepherd had fun with the assignment by adding a few personal touches. ''The woman in the image is my wife, Dawn, and the pug is my dog, Oswald,'' says Shepherd, whose online portfolio can be viewed at www.jamesshepherd.com.

Artists' Reps

Many artists find leaving promotion to a rep allows them more time for the creative process. In exchange for actively promoting an artist's career, the representative receives a percentage of sales (usually 25-30%). Reps focus either on the fine art or commercial markets, rarely both. Very few reps handle designers.

Fine art reps promote the work of fine artists, sculptors, craftspeople and fine art photographers to galleries, museums, corporate art collectors, interior designers and art publishers. Commercial reps help illustrators obtain assignments from advertising agencies, publishers, magazines and other art buyers. Some reps also act as licensing agents.

What reps do

Reps work with you to bring your portfolio up to speed and actively promote your work to clients. Usually a rep will recommend advertising in one of the many creative directories such as *Showcase* (www.showcase.com) or *Workbook* (www.workbook.com) so that your work will be seen by hundreds of art directors. (Expect to make an initial investment in costs for duplicate portfolios and mailings.) Reps also negotiate contracts, handle billing and collect payments.

Getting representation isn't as easy as you might think. Reps are choosy about who they represent, not just in terms of talent but also in terms of marketability and professionalism. Reps will only take on talent they know will sell.

What to send

Once you've gone through the listings here and compiled a list of art reps who handle your type and style of work, contact them with a brief query letter and nonreturnable copies of your work. Check each listing for specific information.

Learn About Reps

For More Info

The Society of Photographers and Artists Representatives (SPAR) is an organization for professional representatives. SPAR members are required to maintain certain standards and follow a code of ethics. For more information, write to SPAR, 60 E. 42nd St., Suite 1166, New York NY 10165, or visit their Web site www.spar.org.

FRANCE ALINE INC.

1637 N. Las Palmas Ave., Hollywood CA 90028. (323)467-0210. E-mail: france@francealine.com. **Owner:** France Aline. Commercial illustration, photography and digital artists representative. Specializes in logo design, advertising. Markets include advertising, corporations, design firms, movie studios, record companies. Artists include Jill Sabella, Craig Mullins, Ezra Tucker, Elisa Cohen, Justin Brandstater, Nora Feller, Peter Greco, Erica Lennand and Thomas Blacksedir.

Handles Illustration, photography.

Terms Rep receives 25% commission. Exclusive area representation is required. Advertises in *American Showcase*, *The Workbook* and *Blackbook.*.

How to Contact For first contact, send e-mail france@francealine.com. Responds in a few days.

ART LICENSING INTERNATIONAL INC.

7350 So. Tamiami Trail #227, Sarasota FL 34231. (941)966-8912. Fax: (941)966-8914. E-mail: artlicensing@comcast.net. Web site: www.artlicensinginc.com. **President:** Michael Woodward, author of *Art Licensing 101*. Licensing agent. Estab. 1986. Licensing agents for artists, illustrators, photographers, and concept designers. Handles collections of work submitted by artists for licensing across a range of product categories, such as greeting cards, calendars, stationery and gift products, jigsaw puzzles, partyware, textiles, housewares, etc.

Needs Prefers collections of art, illustrations or photography which have wide consumer appeal.

First Contact & Terms Send examples on CD (TIFF or JPEG files), color photocopies or slides/transparencies with SASE. Fine artists should send short bio. Terms are 50/50 with no expenses to artists "as long as artist can provide high resolution scans if we agree on representation. Our agency specializes in aiming to create a full licensing program so we can license art across a varied product range. We are therefore only interested in collections, or groups of artworks or concepts which have commercial appeal. Artists need to consider actual products when creating new art.

Tips "Look at actual products in retail outlets and get a feel for what is selling well. Ask store owners or sales assistants what's 'hot.' Get to know the markets you are actually trying to sell your work to."

ART SOURCE L.A., INC.

2801 Ocean Park Blvd., # 7, Santa Monica CA 90405. (310)452-4411. Fax: (310)452-0300. E-mail: info@artsourcela.com. Web site: www.artsourcela.com. **Contact:** Francine Ellman, president. Fine art representative. Estab. 1984. Represents artists in all media in fine art and accessories. Specializes in fine art consulting and curating worldwide. Markets include architects; corporate collections; developers; hospitality; health care; public space; interior designers; private collections and government projects.

• Art Source has an additional office in North Bethesda, MD.

Handles Fine art in all media, including works on paper/canvas, giclees, photography, sculpture, and other accessories handmade by American artists. Genres include figurative, florals, landscapes and many others. Artists represented include Boylan and Howe.

Terms Agent receives commission, amount varies; generally 50% commission. Exclusive area representation required in some cases. No geographic restrictions. "We request artists submit cd, JPEGS directly to info@artsourcela.com, minimum of 20 slides/visuals, résumé and SASE." Advertises in *Art in America*, *Gallery Guide*, *Art Diary*, *Art & Auction*, *Guild*, and *Internet.*.

How to Contact For first contact, send résumé, bio, slides or photographs and SASE. Responds in 2 months. After initial contact, "we will call to schedule an appointment" to show portfolio of original art, slides, photographs. Obtains new talent through recommendations, artists' submissions and exhibitions. Finds artists through art exhibitions, art fairs, submissions, referrals by other artists, portfolio reviews and word of mouth.

Tips "Be professional when submitting visuals. Remember—first impressions can be critical! Submit a body of work that is consistent and of the highest quality. Work should be in excellent condition and already photographed for your records. Framing does not enhance the presentation to the client. Please send all submissions to the Southern California Corporate Office."

ARTVISIONS

E-mail: see Web site. Web site: www.artvisions.com. Estab. 1993. Licenses fashionable, decorative fine art and high quality fantasy art to the commercial print, decor and puzzle/games markets.

Handles Fine art and fantasy art licensing only.

Terms Royalties are split 50/50. Exclusive worldwide representation for licensing is required (the artist is free to market original art). Written contract provided.

How to Contact See Web site. "Not currently seeking new talent. However, we are always willing to view the work of top-notch established artists. If you fit this category, please contact ArtVisions via e-mail and include

a link to a Web site where your art can be seen. Or, you may include a few small samples attached to your e-mail as JPEG files.''

Tips ''To gain an idea of the type of art we license, please view our Web site http://www.artvisions.com. The artist must be able to provide either 4×5 transparencies or high resolution, professionally made scans of your artwork on CD.''

ARTWORKS ILLUSTRATION

325 W. 38th St., New York NY 10018. (212)239-4946. Fax: (212)239-6106. E-mail: artworksillustration@earthlink.net. Web site: www.artworksillustration.com. **Contact:** Betty Krichman, owner. Commercial illustration representative. Estab. 1990. Member of Society of Illustrators. Represents 30 illustrators. Specializes in publishing. Markets include advertising agencies, design firms, paper products/greeting cards, movie studios, publishing/books, sales/promotion firms, corporations/client direct, editorial/magazines. Artists include Dan Brown, Dennis Lyall, Jerry Vanderstelt.

Handles Illustration. Looking for interesting juvenile.

Terms Rep receives 25% commission; 30% for out of town artists (outside tri-state area). Exclusive area representation required. Advertising costs are split 75% paid by artist; 25% paid by rep. Advertises in *American Showcase* and *ISPOT.*.

How to Contact For first contact, send e-mail samples. Responds only if interested. After initial contact, drop off or mail portfolio. Portfolio should include slides, tearsheets, transparencies.

ASCIUTTO ART REPS., INC.

1712 E. Butler Circle, Chandler AZ 85225. (480)899-0600. Fax: (480)899-3636. E-mail: aartreps@cox.net. **Contact:** Mary Anne Asciutto. Children's illustration representative. Estab. 1980. Specializes in children's illustration for books, magazines, posters, packaging, etc. Markets include publishing/packaging/advertising.

Handles Illustration only.

Terms Rep receives 25% commission. No national geographic restrictions. Advertising costs are split 75% paid by talent; 25% paid by representative. For promotional purposes, talent should provide ''prints (color) or originals within an 8×11 size format.''

How to Contact Send a direct mail flier/brochure, tearsheets, photocopies and SASE. Responds in 2 weeks. After initial contact, send appropriate materials if requested. Portfolio should include original art on paper, tearsheets, photocopies or color prints of most recent work. If accepted, materials will remain for scanning.

Tips In obtaining representation ''be sure to connect with an agent who handles the kind of accounts you *want*.' ''

CAROL BANCROFT & FRIENDS

4 Old Mill Plain Rd., Danbury CT 06811. (203)730-8270. Fax: (203)730-8275. E-mail: artists@carolbancroft.com. Web site: www.carolbancroft.com. **Owner:** Carol Bancroft & Associates. Illustration representative for children's publishing. Estab. 1972. Member of SPAR, Society of Illustrators, Graphic Artists Guild, SCBWI. Represents over 40 illustrators. Specializes in representing artists who illustrate for children's publishing—text, trade and any children's-related material. Clients include Scholastic, Harcourt, HarperCollins, Random House, Penguin USA, Simon & Schuster. Artist list available upon request.

Handles Illustration for children of all ages.

Terms Rep receives 25-30% commission. Advertising costs are split 75% paid by talent; 25% paid by representative. For promotional purposes, artist should provide ''Web address on an e-mail or samples via mail laser copies (not slides), tearsheets, promo pieces, books, good color photocopies, etc.; 6 pieces or more; narrative scenes with children and/or animals interacting.'' Advertises in *RSVP*, *Picture Book*, *Directory of Illustration*.

How to Contact Send samples and SASE. ''Artists must call no sooner than one month after sending samples.''

Tips ''We look for artists who can draw animals and people with imagination and energy, depicting engaging characters with action in situational settings.''

BERENDSEN & ASSOCIATES, INC.

2233 Kemper Lane, Cincinnati OH 45206. (513)861-1400. Fax: (513)861-6420. E-mail: bob@illustratorsrep.com. Web site: www.illustratorsrep.com and www.StockArtRep.com. **Contact:** Bob Berendsen, commercial illustration, photography, artists' representative. Incorporated 1986. Represents 50 illustrators, 15 photographers. Specializes in ''high-visibility consumer accounts.'' Markets include advertising agencies; corporations/client direct; design firms; editorial/magazines; paper products/greeting cards; publishing/books; sales/promotion firms. Clients include Disney, CNN, Pentagram, F+W Publications. Additional client list available upon request. Represents Jake Ellison, Bill Fox, Frank Ordaz, Wendy Ackison, Marcia Hartsock, Duff Orlemann, Jack Pennington, Dave Reed, Garry Richardson, Ursula Roma, Robert Schuster.

• This rep has four Web sites illustratorsrep.com, photographersrep.com, designersrep.com and stockartrep-.com. The fast-loading pages are easy for art directors to accessa great promotional tool for their talent.

Handles Illustration, photography. "We are always looking for illustrators who can draw people, product and action well. Also, we look for styles that are metaphoric in content, and it's a plus if the stock rights are available."

Terms Rep receives 30% commission. Charges "mostly for postage but figures not available." No geographic restrictions. Advertising costs are split 70% paid by talent; 30% paid by representative. For promotional purposes, "artist must co-op in our direct mail promotions, and sourcebooks are recommended. Portfolios are updated regularly." Advertises in *RSVP*, *Creative Illustration Book*, *Directory of Illustration* and *American Showcase*.

How to Contact For first contact, send an e-mail with no more than 6 JPEGs attached or send query letter, résumé, and any nonreturnable tearsheets, slides, photographs or photocopies.

Tips Artists should have a "proven style with at least ten samples of that style."

BERNSTEIN & ANDRIULLI INC.

58 W. 40th St., New York NY 10018. (212)682-1490. Fax: (212)286-1890. E-mail: artinfo@ba-reps.com or photoinfo@ba-reps.com. Web site: www.ba-reps.com. **Contact:** Louisa St. Pierre. Commercial illustration and photography representative. Estab. 1975. Member of SPAR. Represents 54 illustrators, 16 photographers. Staff includes Anthony Andriulli, Howard Bernstein, Gregg Lhotsky, Francine Rosenfeld. Markets include advertising agencies; corporations/client direct; design firms; editorial/magazines; paper products/greeting cards; publishing/books; sales/promotion firms.

Handles Illustration and photography.

Terms Rep receives a commission. Exclusive career representation is required. No geographic restrictions. Advertises in *American Showcase*, *Black Book*, *The Workbook*, *New York Gold*, *Bernstein & Andriulli International Illustration*, *CA Magazine*, *Archive*.

How to Contact For first contact, send query letter or e-mail with Web site or digital files. Call before dropping off portfolio to schedule an appointment.

☑ JOANIE BERNSTEIN, ART REP

756-8 Aves, Naples FL 34102. (239)403-4393. Fax: (239)403-0066. E-mail: joanie@joaniebrep.com. Web site: www.joaniebrep.com. **Contact:** Joanie. Commercial illustration representative. Estab. 1984.

Handles Illustration. Looking for an unusual, problem solving style. Clients include advertising, design, books, music, product merchandising, developers, movie studios, films, private collectors.

Terms Rep receives 25% commission. Exclusive representation required.

How to Contact E-mail samples.

Tips "Web sites a necessity."

BROWN INK ASSOCIATES

222 E. Brinkerhoff Ave., Palisades Park NJ 07650. (201)313-6081. Fax: (201)461-6571. E-mail: illobob@juno.com. Web site: www.browninkonline.com. **President/Owner:** Bob Brown, artists/illustrators representative. Digital fine art publisher and distributor. Estab. 1979. Represents 5 fine artists, 2 illustrators. Specializes in advertising, magazine editorials and book publishing, fine art. Markets also include advertising agencies, corporations/client direct, design firms, editorial/magazines, galleries, movie studios, paper products/greeting cards, publishing/books, record companies, sales/promotion firms.

Handles Fine art, illustration, digital fine art, digital fine art printing, licensing material. Looking for professional artiststhose who are interested in making a living with their art. Art samples and portfolio required.

Terms Rep receives 25% commission on illustration assignment; 50% on publishing (digital publishing) after expenses. "The only fee we charge is for services rendered (scanning, proofing, printing, etc.). We pay postage, labels and envelopes. Exclusive area representation required (only in the NY, NJ, CT region of the country). Advertising costs are paid by artist or split 75% paid by artist; 25% paid by rep. Artists must pay for their own promotional material. For promotional purposes, talent must provide a full color direct mail piece, an 11×14 flexible portfolio, digital files and CD. Advertises in *Workbook*.

How to Contact For first contact, send bio, direct mail flier/brochure, photocopies, photographs, résumé, SASE, tearsheets, slides, digital images/CD, query letter (optional). Responds only if interested. Visuals must be sentotherwise we will not respond. After initial contact, call to schedule an appointment, drop off or mail portfolio, or e-mail. Portfolio should include b&w and color finished art, original art, photographs, slides, tearsheets, transparencies (35mm, 4×5 and 8×10).

Tips "Be as professional as possible! Your presentation is paramount. The competition is fierce, therefore your presentation (portfolio) and art samples need to match or exceed that of the competition."

SID BUCK SYDRA TECHNIQUES CORP.

998C Old Country Rd., Plainview NY 11803. (516)496-0953. Fax: (516)682-8153. E-mail: sydra@optonline.com. **President:** Sid Buck. Commercial illustration representative. Estab. 1964. Markets include advertising agencies; corporations/client direct; design firms; editorial/magazines; paper products/greeting cards; publishing/books; fashion. Represents Jerry Schurr, Ken Call and Glenn Iunstull, Robert Melendez, Robert Passantino, Howard Rose, Dee Densmore D'Amico.
Handles Illustration, fashion and editorial.
Terms Rep receives 25% commission. Exclusive area represention is required. Advertising costs are split 75% paid by talent; 25% paid by representative.
How to Contact For first contact, send photocopies, photostats. Responds in 1 week. After initial contact, call to schedule an appointment for portfolio review. Portfolio should include photostats, photocopies.

BUZZ LICENSING

(800)975-2899. E-mail: rita.marie@mindspring.com. Web site: www.buzzlicensing.com. **President:** Rita Marie. Licensing artists and brands. Estab. 2000. Member of LIMA. Represents 1 fine artist, 5 illustrators. Specializes in artists and brands. Licenses illustrators. Markets include paper products/greeting cards, puzzles, home decor. Artists include Susan Martinelli, Joe Cepeda, Mary Faustine, David Willardson.
Handles Fine art, illustration, photography.
Terms Exclusive representation required.
How to Contact For first contact, send query letter with photocopies, photographs, SASE, tearsheets. Responds only if interested. After initial contact, call to schedule an appointment. Portfolio should include b&w and color finished art, tearsheets.

WOODY COLEMAN PRESENTS, INC.

490 Rockside Rd., Cleveland OH 44131. (216)661-4222. Fax: (216)661-2879. E-mail: woody@portsort.com. Web site: www.portsort.com. **Contact:** Laura Ray, CEO. Estab. 1978. Member of Graphic Artists Guild. Specializes in illustration. Markets include advertising agencies; corporations/client direct; design firms; editorial/magazines; paper products/greeting cards; publishing/books; sales/promotion firms; public relations firms.
Handles Illustration.
Terms Cooperative organization negotiates and invoices all projects and receives 25% commission. Member illustrators receive free placement of 12-image portfolios on Internet Database (see www.portsort.com). For project negotiator purposes, talent must provide "all 12 or more image portfolios in 4×5 transparencies or high-quality prints." Advertises in *American Showcase*, *Black Book*, *The Workbook*, other publications.
How to Contact For member consideration first contact, send query letter, as well as tearsheets, slides, or SASE. If accepted for membership, portfolio should include tearsheets, 4×5 transparencies.
Tips "Concentrate on developing 12 specific examples of a single style exhibiting work aimed at a particular specialty, such as fantasy, realism, Americana or a particular industry such as food, medical, architecture, transportation, film, etc. Multiple 12-image portfolios allowed."

CONTACT JUPITER

5 Laurier St., St. Eustache QB J7R 2E5 Canada. Phone/fax: (450)491-3883. E-mail: info@contactjupiter.com. Web site: www.contactjupiter.com. **Contact:** Oliver Mielenz, president. Commercial illustration representative. Estab. 1996. Represents 12 illustrators, 6 photographers. Specializes in publishing, children's books, magazine, advertising. Licenses illustrators, photographers. Markets include advertising agencies, paper products/greeting cards, record companies, publishing/books, corporations/client direct, editorial/magazines.
Handles Illustration, multimedia, music, photography, design.
Terms Reps receive 15-25% and rep fee. Promotion, sales services; $3,000-5,000. Advertising costs are split 50% paid by artist; 50% paid by rep. Exclusive representation required. For promotional purposes, talent must provide portfolio pieces (8×10) and electronic art samples. Advertises in *Illustrators Directory*.
How to Contact Send query by e-mail with a few JPEG samples. Responds only if interested. After initial contact, e-mail to set up an interview or portfolio review. Portfolio should include b&w and color tearsheets.
Tips "One specific style is easier to sell. Focus, focus, focus. Initiative, I find, is very important in an artist."

CORNELL & MCCARTHY, LLC

2-D Cross Hwy., Westport CT 06880. (203)454-4210. Fax: (203)454-4258. E-mail: contact@cmartreps.com. Web site: www.cornellandmccarthy.com. **Contact:** Merial Cornell. Children's book illustration representative. Estab. 1989. Member of SCBWI and Graphic Artists Guild. Represents 30 illustrators. Specializes in children's books trade, mass market, educational.
Handles Illustration.
Terms Agent receives 25% commission. Advertising costs are split 75% paid by talent; 25% paid by representa-

tive. For promotional purposes, talent must provide 10-12 strong portfolio pieces relating to children's publishing.

How to Contact For first contact, send query letter, direct mail flier/brochure, tearsheets, photocopies and SASE. Responds in 1 month. Obtains new talent through recommendations, solicitation, conferences.
Tips "Work hard on your portfolio."

CWC INTERNATIONAL, INC.

296 Elizabeth St., #1F, New York NY 10012. (646)486-6586. Fax: (646)486-7622. E-mail: contact@cwc-i.com. Web site: www.cwc-i.com. **Contact:** Koko Nakano, vp./executive creative agent. Commercial ilustration representative. Represents 21 illustrators. Specializes in advertising, fashion. Markets include advertising agencies, corporations/client direct, design firms, editorial/magazines, galleries, paper products/greeting cards, publishing/books, record companies. Artists include Jeffrey Fulimari, Stina Persson, Chris Long, Kenzo Minami.
Handles Fine art, illustration.
Terms Exclusive area representation required.
How to Contact For first contact, send query letter with direct mail flier/brochure, photocopies (3-4 images) and résumé via snail mail or e-mail. Please put "rep query" as the subject of the e-mail. Responds only if interested.
Tips "Please do not call. When sending any image samples by e-mail, be sure the entire file will not exceed 300K."

LINDA DE MORETA REPRESENTS

1839 Ninth St., Alameda CA 94501. (510)769-1421. Fax: (510)892-2955. E-mail: linda@lindareps.com. Web site: www.lindareps.com. **Contact:** Linda de Moreta. Commercial illustration and photography representative; also portfolio and career consultant. Estab. 1988. Represents 7 illustrators, 2 photographers. Markets include advertising agencies; design firms; corporations/client direct; editorial/magazines; paper products/greeting cards; publishing/books. Represents Chuck Pyle, Pete McDonnell, Tina Healey, Craig Hannah, Monica Dengo, Tina Rachelle, James Chiang, John Howell and Ron Miller.
Handles Photography, illustration, lettering/title design, storyboards/comps.
Terms Commission, exclusive representation requirements and advertising costs are according to individual agreements. Materials for promotional purposes vary with each artist. Advertises in *The Workbook, Directory of Illustration, the ispot.*
How to Contact For first contact, send direct mail flier/brochure, slides or photocopies and SASE. "Please do *not* send original art. SASE for any items you wish returned." Responds to any inquiry in which there is an interest. Portfolios are individually developed for each artist and may include transparencies, prints or tearsheets.
Tips Obtains new talent through client and artist referrals primarily, some solicitation. "I look for great creativity, a personal vision and style of photography or illustration combined with professionalism, and passion."

BARBARA GORDON

165 E. 32nd St., New York NY 10016. (212)686-3514. Fax: (212)532-4302. **Contact:** Barbara Gordon. Commercial illustration and photography representative. Estab. 1969. Member of SPAR, Society of Illustrators, Graphic Artists Guild. Represents 9 illustrators, 1 photographer. "I represent only a small, select group of people and therefore give a great deal of personal time and attention to the people I represent."
Terms No information provided. No geographic restrictions in continental US.
How to Contact For first contact, send direct mail flier/brochure. Responds in 2 weeks. After initial contact, drop off or mail appropriate materials for review. Portfolio should include tearsheets, slides, photographs; "if the talent wants materials or promotion piece returned, include SASE." Obtains new talent through recommendations from others, solicitation, conferences, etc.
Tips "I do not care if an artist or photographer has been published or is experienced. I am essentially interested in people with a good, commercial style. Don't send résumés and don't call to give me a verbal description of your work. Send promotion pieces. *Never* send original art. If you want something back, include a SASE. Always label your slides in case they get separated from your cover letter. And always include a phone number where you can be reached."

ANITA GRIEN REPRESENTING ARTISTS

155 E. 38th St., New York NY 10016. E-mail: anita@anitagrien.com. Representative not currently seeking new talent.

▣ CAROL GUENZI AGENTS, INC.

865 Delaware St., Denver CO 80204. (303)820-2599. E-mail: art@artagent.com. Web site: www.artagent.com. **Contact:** Carol Guenzi. Commercial illustration, photography, new media and film/animation representative.

Estab. 1984. Represents 25 illustrators, 6 photographers, 4 film/animation developers, and 3 multimedia developers. Specializes in a "wide selection of talent in all areas of visual communications." Markets include advertising agencies; corporations/client direct; design firms; editorial/magazine, paper products/greeting cards, sales/promotions firms. Clients include Integer, BBDO, DDB Needham, TLP. Partial client list available upon request. Represents Christer Eriksson, Juan Alvarez, Michael Fisher, Kelly Hume, Capstone Studios and more.
Handles Illustration, photography. Looking for "unique style application."
Terms Rep receives 25-30% commission. Exclusive area representative is required. Advertising costs are split 70-75% paid by talent; 25-30% paid by the representation. For promotional purposes, talent must provide "promotional material, some restrictions on portfolios." Advertises in *Black Book*, *Directory of Illustration*, *The Workbook*.
How to Contact For first contact, send PDF's or JPEGs or direct mail flier/brochure. Responds only if interested. E-mail or call for appointment to drop off or mail in appropriate materials for review, depending on artist's location. Portfolio should include tearsheets, CD/DVD, photographs. Obtains new talent through solicitation, art directors' referrals, and active pursuit by individual artist.
Tips "Show your strongest style and have at least 12 samples of that style before introducing all your capabilities. Be prepared to add additional work to your portfolio to help round out your style. Have a digital background."

GUIDED IMAGERY DESIGN & PRODUCTIONS
(formerly Guided Imagery Productions), 2995 Woodside Rd., #400, Woodside CA 94062. (650)324-0323. Fax: (650)324-9962. **Owner/Director:** Linda Hoffman. Fine art representative. Estab. 1978. Member of Hospitality Industry Association. Represents 3 illustrators, 12 fine artists. Specializes in large art production perspective murals (trompe l'oeil); unusual painted furniture/screens. Markets include design firms; interior decorators; hospitality industry.
Handles Looking for "mural artists (realistic or trompe l'oeil) with good understanding of perspectives."
Terms Rep receives 33-50% commission. 100% of advertising costs paid by representative. For promotional purposes, talent must provide a direct mail piece to preview work, along with color copies of work (SASE too). Advertises in *Hospitality Design*, *Traditional Building Magazine* and *Design Journal*.
How to Contact For first contact, send query letter, résumé, photographs, photocopies and SASE. Responds in 1 month. After initial contact, mail appropriate materials. Portfolio should include photographs.
Tips Wants artists with talent, references and follow-through. "Send color copies of original work that show your artistic style. Never send one-of-a-kind artwork. My focus is 3-D murals. References from previous clients very helpful." Please no cold calls.

PAT HACKETT/ARTIST REPRESENTATIVE
7014 N. Mercer Way, Mercer Island WA 98040. (206)447-1600. Fax: (206)447-0739. E-mail: pat.hackett@hotmail.com. Web site: www.pathackett.com. **Contact:** Pat Hackett. Commercial illustration and photography representative. Estab. 1979. Represents 12 illustrators, 1 photographer. Markets include advertising agencies; corporations/client direct; design firms; editorial/magazines.
Handles Illustration.
Terms Rep receives 25-33% commission. Advertising costs are split 75% paid by talent; 25% paid by representative. For promotional purposes, talent must provide "standardized portfolio, i.e., all pieces within the book are the same format. Reprints are nice, but not absolutely required." Advertises in *Showcase*, *The Workbook*.
How to Contact For first contact, send direct mail flier/brochure. Responds in 1 week, only if interested. After initial contact, drop off or mail in appropriate materials tearsheets, slides, photographs, photostats, photocopies. Obtains new talent through "recommendations and calls/letters."
Tips Looks for "experience in the *commercial* art world, professional presentation in both portfolio and person, cooperative attitude and enthusiasm."

HOLLY HAHN & CO.
837 W. Grand Ave., 3rd Floor, Chicago IL 60622. (312)633-0500. Fax: (312)633-0484. E-mail: holly@hollyhahn.com. Web site: www.hollyhahn.com. Commercial illustration and photography representative. Estab. 1988. Member of CAR (Chicago Artists Representatives). Represents 3 illustrators, 3 photographers. Markets include advertising agencies; corporations/client direct; design firms; editorial/magazines; publishing/books.
Handles Illustration, photography.
Terms Rep receives 30% commission. Advertises in *The Workbook*, *Black Book*, *Klik*, *Tilt* and *The Alternative Pick*.
How to Contact To contact, send direct mail flier/brochure and tearsheets.
Tips Wants artists with "professional attitudes and knowledge, unique abilities or application, interest and motivation and a strong commitment to the work and the imagery."

HANKINS & TEGENBORG, LTD.

11 E. 47th St., 6th Floor, New York NY 10017. (212)755-6070. Fax: (212)755-6075. E-mail: dhlt@aol.com. Web site: www.ht-ltd.com. Commercial illustration representative. Estab. 1980. Represents 50 illustrators. Specializes in realistic and digital illustration. Markets include advertising agencies; publishing/book covers/promotion.

Handles Illustration, computer illustration.

Terms Rep receives 25% commission. "All additional fees are charged per job if applicable." Exclusive area representation is required. Advertising costs are split 75% paid by talent; 25% paid by representative. For promotional purposes, talent must provide digital files. Advertises on Web site."

How to Handle For first contact, e-mail with jpegs attached or with Web site address to facilitate viewing work. Responds if interested.

BARB HAUSER, ANOTHER GIRL REP

P.O. Box 421443, San Francisco CA 94142-1443. (415)647-5660. E-mail: barb@girlrep.com. Web site: www.girlrep.com. Estab. 1980. Represents 8 illustrators. Markets include primarily advertising agencies and design firms; corporations/client direct.

Handles Illustration.

Terms Rep receives 25-30% commission. Exclusive representation in the San Francisco area is required.

How to Contact For first contact, please e-mail. If you wish to send samples, please send no more than 3 very small jpgs, but please note, I am not presently accepting new talent.

JOANNE HEDGE/ARTIST REPRESENTATIVE

1415 Garden St., Glendale CA 91201. (818)244-0110. Fax: (818)244-0136. E-mail: hedgegraphics@earthlink.com. Web site: www.hedgereps.com. **Contact:** J. Hedge. Commercial illustration representative. Estab. 1975. Represents 12 illustrators. Specializes in quality, painterly and realistic illustration, digital art and lettering, also vintage and period styles. Markets include packaging, especially food and beverage, advertising agencies, design firms, movie studios, package design firms and Web/interactive clients.

Handles Illustration. Seeks established artists compatible with Hedge Graphics Group.

Terms Rep receives 30% commission. Handles all negotiations and billing. Artist pays quarterly portfolio maintenance expenses. Advertising costs are split 75% paid by talent; 25% paid by representative. For promotional purposes, talent should provide reprint flyer, CD, 4×5 or 8×10 copy transparencies, matted on 11×14 laminate mattes. Advertises in *The Workbook*, *Directory of Illustration* and Web site.

How to Contact E-mail with samples attached or Web site address to view your work. Responds if interested.

Tips Obtains new talent after talent sees *Workbook* directory ad, or through referrals from art directors or other talent. "Have as much experience as possible and zero or one other rep. That, and a good looking 8½×11 flier!"

HK PORTFOLIO

10 E. 29th St., Suite 40G, New York NY 10016. (212)689-7830. Fax: (212)689-7829. E-mail: mela@hkportfolio.com. Web site: www.hkportfolio.com. **Contact:** Mela Bolinao. Commercial illustration representative. Estab. 1986. Member of SPAR, Society of Illustrators and Graphic Artists Guild. Represents 44 illustrators. Specializes in illustration for juvenile markets. Markets include advertising agencies; editorial/magazines; publishing/books.

Handles Illustration.

Terms Rep receives 25% commission. No geographic restrictions. Advertising costs are split 75% paid by talent; 25% paid by representative. Advertises in *Picture Book*, *Directory of Illustration*, *I-Spot* and *Workbook*.

How to Contact No geographic restrictions. E-mail query letter with Web site address or send portfolio with flier/brochure, tearsheets, published books if available, and SASE. Responds in 1 week. Portfolio should include at least 10-15 images exhibiting a consistent style.

Tips Leans toward "highly individual personal styles."

SCOTT HULL ASSOCIATES

4 West Franklin St., Suite 200, Dayton OH 45459. (937)433-8383. Fax: (937)433-0434. E-mail: scott@scotthull.com. Web site: www.scotthull.com. **Contact:** Scott Hull. Commercial illustration representative. Estab. 1981. Represents 30 plus illustrators.

How to Contact Contact by sending e-mail samples, tearsheets or appropriate materials for review. Follow up with phone call. Responds in 2 weeks.

Tips Looks for "an interesting style and a desire to grow, as well as a marketable portfolio."

INDUSTRY ARTS AGENCY

P.O. Box 1737 Beverly Hills, CA 90213. (310)663-1004. E-mail: iacreative@industryarts.com. Web site: www.industryarts.com. **Contact:** Marc Tocker. Commercial illustration, photography, graphic design representative and copywriters. Estab. 1997. Member of California Lawyers for the Arts. Represents 1 copywriter, 1 illustrator, 1 photographer, 1 designer. Specializes in clever cutting edge design. Markets include advertising agencies, corporations/client direct, design firms.

Handles Illustration, photography, design, Web design/programming. "We are looking for design mindful people who create cutting edge work that challenges dominant cultural paradigms."

Terms Rep receives 20-25% commission. Exclusive area representation is required. Advertising costs are paid by talent. For promotional purposes, portfolio should be adapted to digital format for Web site presentation. Advertises in *The Workbook*.

How to Contact For first contact, send e-mail, bio. Portfolio should include original art, tearsheets, slides, photographs.

Tips "Looks for artists with an awareness of the cutting edge in contemporary design."

THE INTERMARKETING GROUP

29 Holt Road, Amherst NH 03031. (603)672-0499. **President:** Linda Gerson. Art licensing agency. Estab. 1985. Represents 8 illustrators. Specializes in art licensing. Licenses fine artists, illustrators. Markets include paper products/greeting cards, publishing/books, all consumer product applications of art. Artists include Tracy Flickinger, Manlee Carroll, Kate Beetle, Janet Amendola, Cheryl Welch, Rebecca Beuker, Loren Guttormson, Natalie Samolb.

Handles Fine art, illustration.

Terms Will discuss terms of representation directly with the artists of interest. Advertising costs are paid by the artist. For promotional purposes, talent must provide color copies, biography.

How to Contact For first contact, send query letter with bio, direct mail flier/brochure, photocopies, SASE, tearsheets, a good representation of your work in color. Responds in 3 weeks. After initial contact, we will be in contact with you if interested. Portfolio should include color tearsheets.

Tips "Present your work in an organized way. Send the kind of work you enjoy doing and is the most representative of your style."

TANIA KIMCHE

111 Barrow St., Suite 8D, New York NY 10014. Phone/Fax: (212)242-6367. E-mail: tanikim@aol.com. **Contact:** Tania. Commercial illustration representative. Estab. 1981. Member of SPAR. Represents 9 illustrators. "We do everything, design firm, corporate/conceptual work." Markets include advertising agencies; corporations/client direct; design firms; editorial/magazines; publishing books; sales/promotion firms.

Handles Illustration. Looking for "conceptual/corporate work."

Terms Rep receives 25% commission if the artist is in town; 30% if the artist is out of town. Splits postage and envelope expense for mailings with artists. Advertising costs are split 75% paid by the talent; 25% paid by the representative. For promotional purposes, talent advertists both online and off.

How to Contact For first contact, send bio, tearsheets, slides. Responds in months, only if interested. After initial contact, drop off or mail in appropriate materials for review. Portfolio should include tearsheets, slides, photostats.

Tips Obtains new talent through recommendations from others or "they contact me. Do not call. Send promo material in the mail. Don't waste time with a résumé—let me see the work."

CLIFF KNECHT—ARTIST REPRESENTATIVE

309 Walnut Rd., Pittsburgh PA 15202. (412)761-5666. Fax: (412)761-4072. E-mail: cliff@artrep1.com. Web site: www.artrep1.com. **Contact:** Cliff Knecht. Commercial illustration representative. Estab. 1972. Represents 20 illustrators. Markets include advertising agencies; corporations/client direct; design firms; editorial/magazines; paper products/greeting cards; publishing/books; sales/promotion firms.

Handles Illustration.

Terms Rep receives 25% commission. No geographic restrictions. Advertising costs are split 75% paid by the talent; 25% paid by representative. For promotional purposes, talent must provide a direct mail piece. Advertises in *Graphic Artists Guild Directory of Illustration*.

How to Contact For first contact, send résumé, direct mail flier/brochure, tearsheets, slides. Responds in 1 week. After initial contact, call for appointment to show portfolio of original art, tearsheets, slides, photographs. Obtains new talent directly or through recommendations from others.

ANN KOEFFLER ARTIST REPRESENTATION

1020 W. Riverside Dr., #45, Burbank CA 91506. (818)260-8980. Fax: (818)260-8990. E-mail: annartrep@aol.com. Web site: www.annkoeffler.com. **Owner/Operator:** Ann Koeffler. Commercial illustration representative.

Estab. 1984. Represents 20 illustrators. Markets include advertising agencies, corporations/client direct, design firms, editorial/magazines, paper products/greeting cards, publishing/books, individual small business owners.
Will Handle Interested in reviewing illustration. Looking for artists who are digitally adept.
Terms Rep receives 25-30% commission. Advertising costs 100% paid by talent. For promotional purposes, talent must provide an initial supply of promotional pieces and a committment to advertise regularly. Advertises in *The Workbook* and *Folio Planet*.
How to Contact For first contact, send tearsheets or send images digitally. Responds in 1 week. Portfolio should include photocopies, 4×5 chromes.
Tips "I only carry artists who are able to communicate clearly and in an upbeat and professional manner."

LANGLEY CREATIVE
333 N. Michigan Ave., Suite 1322, Chicago IL 60601. (312)782-0244. Fax: (312)782-1535. E-mail: artrepsjl@aol.com and MeganJeanil@aol.com. Web site: www.sharonlangley.com and www.theispot.com. **Contact:** Sharon Langley and/or Megan Langley. Commercial illustration representative. Estab. 1988. Represents illustrators. Markets include advertising agencies; corporations; design firms; editorial/magazines; publishing/books; promotion. Clients include every major player in the United States.
Handles Illustration. "I am receptive to reviewing samples by enthusiastic up-and-coming artists. " E-mail samples and/ or your Web site address.
Terms Rep receives 25% commission. Exclusive area representation is preferred. Advertising costs are split 75% paid by talent; 25% paid by representative. For promotional purposes, talent must provide printed promotional pieces, a well organized, creative portfolio. Advertises in *The Workbook*. "If your book is not ready to show, be willing to invest in a 'zippy' new one."
How to Contact For first contact, send "samples via e-mail or printed materials that do not have to be returned." Responds only if interested. Obtains new talent through recommendations from art directors, referrals and submissions.
Tips "You need to be focused in your direction and style. Be willing to create new samples. Be a 'team player.' The agent and artist form a bond and the goal is success. Don't let your ego get in the way. Be open to constructive criticism and if one agent turns you down, quickly move to the next name on your list."

LESLI ART, INC.
Box 6693, Woodland Hills CA 91364. (818)999-9228. Fax: (818)999-0833. E-mail: lesliart@adelphia.com. Web site: www.LesliArt.com. **Contact:** Stan Shevrin. Fine art agent, publisher and advisor. Estab. 1965. Represents emerging, mid-career and established artists. Specializes in artists painting in oil or acrylic, in traditional subject matter in realistic or impressionist style. Also represents illustrators who want to establish themselves in the fine art market. Sells to leading art galleries throughout the US. Represents Tom Darro, Greg Harris, Christa Kieffer, Roger LaManna, Dick Pionk, Rick Peterson and John Stephens. Licenses period costumed figures and landscapes for prints, calendars and greeting cards.
Terms Receives 50% commission. Pays all expenses including advertising and promotion. Artist pays one-way shipping. All artwork accepted unframed. Exclusives preferred. Contract provided.
How to Contact For first contact, send either color prints or slides with short bio and SASE if material is to be returned. Material will be filed if SASE is not included. Responds in 1 month. Obtains new talent through "reviewing portfolios."
Tips "Artists should show their most current works and state a preference for subject matter and medium. Know what subject you're best at and focus on that."

LINDGREN & SMITH
630 Ninth Avenue, New York NY 10036. (212)397-7330. Fax: (212)397-7334. E-mail: inquiry@lindgrensmith.com. Web site: www.lindgrensmith.com. **Assistant:** Pamela Wilson. Commercial illustration representative. Estab. 1984. Member of SPAR. Markets include advertising agencies; corporations/client direct; design firms; editorial/magazines; paper products/greeting cards; publishing/books, children's books. Represents Francis Livingston, Doug Fraser, Kim Johnson, Lee Chapman, Regan Dunnick, Chris Lyons, Chris O'Leary, Dan Williams, Donna Racer, Jennifer Herbert, Lori Lohstoeter, Miles Hyman, Michael Paraskevas, Rob toth, Tricia Krauss, Yan Nascimbene and others.
Handles Illustration and picture books.
Terms Exclusive representation is required. Advertises in *Workbook*, *Black Book* and *Picture Book*.
How to Contact For first contact, send direct mail flier/brochure, tearsheets, photocopies. "We will respond by mail."
Tips "Check to see if your work seems appropriate for the group. We only represent experienced artists who have been professionals for some time."

MAGNET REPS

3450 Vinton Ave., Los Angeles CA 90034. (866)390-5656. E-mail: art@magnetreps.com. Web site: http://www. magnetreps.com. **Contact:** Paolo Rizzi, director. Commercial illustration representative. Estab. 1998. Represents 14 illustrators. Markets include advertising agencies, corporations/client direct, design firms, editorial/magazines, movie studios, paper products/greeting cards, publishing/books, record companies, character development. Artists include Ben Shannon, Red Nose Studio, Shawn Barber.

Handles Illustration. Looking for artists with the passion to illustrate every day, an awareness of cultural trends in the world we live in, and a basic understanding of the business of illustration.

Terms Exclusive representation required. Advertising costs are split. For promotional purposes, talent must provide a well-developed, consistent portfolio. Advertises in *Workbook* and others..

How to Contact For first contact, submit a Web link to portfolio, or 2 sample JPEGs for review via e-mail only. Responds in 1 month. We will contact artist via e-mail if we are interested. Portfolio should include color print outs, good quality.

Tips "Be realistic about how your style matches our agency. We do not represent scientific, technical, medical, sci-fi, hyper-realistic, story boarding, landscape, pin-up, cartoon or cutesy styles. We do not represent graphic designers. We will not represent artists that imitate the style of one of our existing artists."

MARLENA AGENCY

322 Ewing St., Princeton NJ 08540. (609)252-9405. Fax: (609)252-1949. E-mail: marlena@marlenaagency.com. Web site: www.marlenaagency.com. **Artist Reps:** Marlena Torzecka, Ella Lupo, Greta T'Jonck. Commercial illustration representative. Estab. 1990. Member of Art Directors Club of New York, Society of Illustrators. Represents 28 illustrators from France, Poland, Germany, Hungary, Italy, Spain, Canada and US. Specializes in conceptual illustration. Markets include advertising agencies; corporations/client direct; design firms; editorial/magazines; publishing/books; theaters. Represents Serge Bloch, Hadley Hooper, Linda Helton and Gerard DuBois.

● This agency produces promotional materials for artists such as wrapping paper, calendars, brochures.

Handles Illustration, fine art and prints.

Terms Rep receives 30% commission; 35% if translation needed. Costs are shared by all artists. Exclusive area representation is required. Advertising costs are split 70% paid by talent; 30% paid by representative. For promotional purposes, talent must provide slides (preferably 8×10 framed); direct mail pieces, 3-4 portfolios. Advertises in *American Showcase*, *Black Book*, *Illustrators 35* (New York City), *Workbook*, *Alternative Pick*. Many of the artists are regularly featured in CA Annuals, The Society of Illustrators Annuals, American Illustration Annuals.

How to Contact For first contact send tearsheets or e-mail low resolution images. Responds in 1 week only if interested. After initial contact, drop off or mail appropriate materials. Portfolio should include tearsheets.

Tips Wants artists with "talent, good concepts—intelligent illustration, promptness in keeping up with projects, deadlines, etc."

MARTHA PRODUCTIONS, INC.

7550 W. 82nd St., Playa Del Rey CA 90293. (310)670-5300. Fax: (310)670-3644. E-mail: marthaprod@earthlink. net. Web site: www.marthaproductions.com. **Contact:** Martha Spelman, president. Commercial illustration representative. Estab. 1978. Represents 40 illustrators. Licenses illustrators. Specializes in illustration in various styles and media. Markets include advertising agencies; corporations/client direct; design firms; developers; editorial/magazines; paper products/greeting cards; publishing/books; record companies; sales/promotion firms. Represents Steve Vance, Allen Garns, Bruce Sereta.

Handles Illustration, retro, infographics, character design.

Terms Rep receives 30% commission. Advertising costs are split 70% paid by talent; 30% paid by representative. For promotional purposes, talent must "have existing promotional pieces. Also need to be on our Web site." Advertises in *The Workbook*, *Blackbook*.

How to Contact For first contact, send query letter, direct mail flier/brochure and SASE. Can e-mail a few small JPEG files. Responds only if interested. After initial contact, drop off or mail portfolio. Portfolio should include b&w and color tearsheets. Obtains new talent through recommendations and solicitation.

Tips "An artist seeking representation should have a strong portfolio with pieces relevant to advertising, corporate collateral or publishing markets. Check the rep's Web site or ads to see the other talent they represent to determine whether the artist could be an asset to that rep's group or if there may be a conflict. Reps are looking for new talent that already has a portfolio of salable pieces, some existing promos and hopefully some experience."

MASLOV-WEINBERG

608 York St., San Francisco CA 94110. (415)641-1285. Fax: (415)641-5500. E-mail: larryuu@aol.com. Web site: www.maslov.com. **Partner:** Larry Weinberg. Commercial illustration representative. Estab. 1988. Represents

2 fine artists, 15 illustrators. Markets include advertising agencies, corporations/client direct, design firms, editorial/magazines, movie studios, paper products/greeting cards, publishing/books, record companies, sales/promotion firms. Artists include Mark Matcho, Mark Ulriksen, Pamela Hobbs.
Handles Illustration.
Terms Rep receives 25% commission. Exclusive representation required. Advertises in *American Showcase*, *Workbook*.
How to Contact For first contact, send query letter with direct mail flier/brochure. Responds only if interested. After initial contact, write to schedule an appointment.

MENDOLA ARTISTS

420 Lexington Ave., New York NY 10170. (212)986-5680. Fax: (212)818-1246. E-mail: mendolaart@aol.com. **Contact:** Tom Mendola. Commercial illustration representative. Estab. 1961. Member of Society of Illustrators, Graphic Artists Guild. Represents 60 or more illustrators. Markets include advertising agencies; corporations/client direct; design firms; editorial/magazines; sales/promotion firms.
Handles Illustration. "We work with the top agencies and publishers. The calibre of talent must be in the top 5%."
Terms Rep receives 25% commission. Exclusive area representation is sometimes required.
How to Contact "Send e-mail with link to Web site or JPEGs. Alternatively, send printed samples with SASE or items that you do not need returned. We will contact you if interested in seeing additional work."

MHS LICENSING

11100 Wayzata Blvd., Suite 550, Minneapolis MN 55305-5517. (952)544-1377. Fax: (952)544-8663. E-mail: artreviewcommittee@mhslicensing.com. Web site: www.mhslicensing.com. **President:** Marty H. Segelbaum. Licensing agency. Estab. 1995. Represents 18 fine artists, 1 photographer, and 4 illustrators or other artists and brands. Markets include paper products/greeting cards, publishing/books and other consumer products including giftware, stationery/paper, tabletop, apparel home fashions, textiles, etc. Artists include Hautman Brothers, Judy Buswell, Erika Oller, Kathy Hatch, Constance Coleman and many others.
• See Insider Report with pet portraitist Constance Coleman in the Gallery section of this book.
Handles Fine art, illustration, photography and brand concepts.
Terms Negotiable with firm.
How to Contact Send query letter with bio, tearsheets, approximately 10 low res JPEGs via e-mail to artreviewco mmittee@mhslicensing.com. See submission guidelines on Web site. "Keep your submission simple and affordable by leaving all the fancy packaging, wrapping and enclosures in your studio. $8^{1}/_{2} \times 11$ tearsheets (inkjet is fine), biography, and SASE are all that we need for review." Responds in 6 weeks. No appointments scheduled, please no calls. Portfolio should include color tearsheets. Send SASE for return of material.
Tips "Our mutual success is based on providing manufacturers with trend forward artwork. Please don't duplicate what is already on the market but think instead, 'What are consumers going to want to buy in nine months, one year, or two years?' We want to learn how you envision your artwork being applied to a variety of product types. Artists are encouraged to submit their artwork mocked-up into potential product collections ranging from stationery to tabletop to home fashion (kitchen, bed, and bath). Visit your local department store or mass retailer to learn more about the key items in these categories. And, if you have multiple artwork styles, include them with your submission."

MORGAN GAYNIN INC.

194 Third Ave., New York NY 10003. (212)475-0440. Fax: (212)353-8538. E-mail: info@morgangaynin.com. Web site: www.morgangaynin.com. **Partners:** Vicki Morgan and Gail Gaynin. Commercial illustration representative. Estab. 1974. Markets include advertising agencies; corporations/client direct; design firms; magazines; books; sales/promotion firms.
Handles Illustration.
Terms Rep receives 30% commission. Exclusive area representation is required. No geographic restrictions. Advertising costs are split 70% paid by talent; 30% paid by representative. Advertises in directories, on the Web, direct mail.
How to Contact For first contact, send "an e-mail with a URL. No drop-off policy."

MUNRO CAMPAGNA

630 N. State St., Chicago IL 60610. (312)321-1336. Fax: (312)321-1350. E-mail: steve@munrocampagna.com. Web site: www.munrocampagna.com. **President:** Steve Munro. Commercial illustration, photography representative. Estab. 1987. Member of SPAR, CAR (Chicago Artists Representatives). Represents 22 illustrators, 2 photographers. Markets include advertising agencies; corporations/client direct; design firms; publishing/books. Represents Pat Dypold and Douglas Klauba.

Handles Illustration.
Terms Rep receives 25-30% commission. Exclusive area representation is required. Advertising costs are split 75% paid by talent; 25% paid by representative. For promotional purposes, talent must provide 2 portfolios. Advertises in *Black Book*, *The Workbook*.
How to Contact For first contact, send query letter, bio, tearsheets and SASE. Responds in 2 weeks. After initial contact, write to schedule an appointment.

THE NEWBORN GROUP, INC.
115 W. 23rd St., Suite 43A, New York NY 10011. (212)989-4600. Fax: (212)989-8998. Web site: www.newborngroup.com. **Owner:** Joan Sigman. Commercial illustration representative. Estab. 1964. Member of SPAR, Society of Illustrators, Graphic Artists Guild. Represents 12 illustrators. Markets include advertising agencies; design firms; editorial/magazines; publishing/books. Clients include Leo Burnett, Penguin Putnam, Time Inc., Weschler Inc.
Handles Illustration.
Terms Rep receives 30% commission. Exclusive area representation is required. Advertising costs are split 70% paid by talent; 30% paid by representative. Advertises in *American Showcase*, *The Workbook*, *Directory of Illustration*.
How to Contact "Not reviewing new talent."
Tips Obtains new talent through recommendations from other talent or art directors.

PAINTED WORDS
(formerly Lori Nowicki and Associates) 310 W. 97th St., #24, New York NY 10025. E-mail: lori@painted-words.com. Web site: www.painted-words.com. Estab. 1993. Represents 20 illustrators. Markets include advertising agencies; design firms; editorial/magazines; publishing/books; children's publishing.
Handles Illustration and author/illustrators.
Terms Rep receives 25-30% commission. Cost for direct mail promotional pieces is paid by illustrator. Exclusive area representation is required. Advertising costs are split 75% paid by talent; 25% paid by representative. Advertises in *The Workbook*, *Black Book*, *Showcase*, *Directory of Illustration*.
How to Contact For first contact, send query letter, résumé, non-returnable tearsheets, or e-mail a link to your Web site. Samples are not returned. "Do not phone, do not e-mail attachments, will contact if interested." Wants artists with consistent style. "We are aspiring to build a larger children's publishing division and specifically looking for author/illustrators."

CAROLYN POTTS & ASSOC. INC.
848 Dodge Ave., #236, Evanston IL 60202. (847)864-7644. E-mail: carolyn@cpotts.com. **President:** Carolyn Potts. Commercial photography, illustration representative and marketing consultant for creative professionals. Estab. 1976. Member of SPAR, CAR (Chicago Artists Reps). Represents photographers and illustrators. Specializes in contemporary advertising and design. Markets include advertising agencies; corporations/client direct; design firms; publishing/books. Artists include Julia La Pine, John Craig, Rhonda Voo and Karen Bell.
Handles Illustration, photography. Looking for "artists able to work with new technologies (interactive, computer, etc.)."
Terms Rep receives 30-35% commission. Artists share cost of their direct mail postage and preparation. Exclusive area representation is required. Advertising costs are split 70% paid by the talent; 30% paid by the representative after initial trial period wherein artist pays 100%. For promotional purposes, talent must provide direct mail piece and multiple portfolios. Advertises in *American Showcase*, *Black Book*, *The Workbook*, *Single Image*.
How to Contact For first contact, send direct mail flier/brochure and SASE. Responds in 3 days. After initial contact, write to schedule an appointment. Portfolio should include tearsheets, slides, photographs.
Tips Looking for artists with high level of professionalism, awareness of current advertising market, professional presentation materials (that includes a digital portfolio) and positive attitude.

CHRISTINE PRAPAS/ARTIST REPRESENTATIVE
8402 SW Woods Creek Ct., Portland OR 97219. E-mail: cprapas@teleport.com. Web site: www.christineprapas.com. **Contact:** Christine Prapas. Commercial illustration and photography representative. Estab. 1978. Member of AIGA and Graphic Artists Guild. "Promotional material welcome."

PUBLISHERS' GRAPHICS
231 Judd Rd., Easton CT 06612. (203)445-1511. Fax: (203)445-1411. E-mail: paigeg@publishersgraphics.com. Web site: www.publishersgraphics.com. **Sales & Contract Manager:** Paige Gillies. Estab. 1970. Member of Society of Children's Book Writers and Illustrators, Author's Guild Inc. No longer reviewing artist or author

submissions. Specializes in children's book illustration. Markets include publishing/books. Represents Lisa McCue, Pam Paparone, SD Schindler, Robert Andrew Parker.
Handles Illustration.
Terms Rep receives 25% commission. Exclusive area representation is required. For promotional purposes, talent must provide original art, proofs, photocopies "to start. The assignments generate most sample/promotional material thereafter unless there is a stylistic change in the work."
How to Contact Portfolio is closed.
Tips "Show samples that relate to the market in which you wish to find representation."

GERALD & CULLEN RAPP, INC.

420 Lexington Ave., Penthouse, New York NY 10170. (212)889-3337. Fax: (212)889-3341. E-mail: lara@rappart. com. Web site: www.theispot.com/rep/rapp. **Contact:** Nancy Moore. Commercial illustration representative. Estab. 1944. Member of SPAR, Society of Illustrators, Graphic Artists Guild. Represents 50 illustrators. Markets include advertising agencies; corporations/client direct; design firms; editorial/magazines; paper products/ greeting cards; publishing/books; sales/promotion firms. Represents Jonathan Carlson, Mark Rosenthal, Seth and James Steinberg.
Handles Illustration.
Terms Rep receives 25-30% commission. Exclusive area representation is required. No geographic restrictions. Split of advertising costs is negotiated. Advertises in *American Showcase, The Workbook, Graphic Artists Guild Directory* and *CA, Print* magazines. "Conducts active direct mail program and advertises on the Internet."
How to Contact For first contact, send query letter, direct mail flier/brochure or e-mail with no more than 1 image attached. Responds in 1 week. Obtains new talent through recommendations from others, solicitations.

KERRY REILLY: REPS

1826 Asheville Place, Charlotte NC 28203. (704)372-6007. **Contact:** Kerry Reilly. Commercial illustration and photography representative. Estab. 1990. Represents 16 illustrators, 2 photographers and animatics. Markets include advertising agencies; corporations/client direct; design firms; editorial/magazines. Clients include GM, VW, Disney World, USPO.
• Kerry Reilly Reps is partnering with Steven Edsey & Sons.
Handles Illustration, photography. Looking for computer graphics Photoshop, Illustrator, FreeHand, etc.
Terms Rep receives 25% commission. Exclusive area representation is required. No geographic restrictions. Advertising costs are split 75% paid by talent; 25% paid by representative. For promotional purposes, talent must provide at least 2 pages printed leave-behind samples. Preferred format is 9×12 pages, portfolio work on 4×5 transparencies. Advertises in iSpot.
How to Contact For first contact, send direct mail flier/brochure or samples of work. Responds in 2 weeks. After initial contact, call for appointment to show portfolio or drop off or mail tearsheets, slides, 4×5 transparencies.
Tips "Have printed samples and electronic samples (in JPEG format)."

REMEN-WILLIS DESIGN GROUP

2964 Colton Rd., Pebble Beach CA 93953. (831)655-1407. Fax: (831)655-1408. E-mail: remenwillis@comcast.n et. Web site: www.annremenwillis.com. **Art Rep:** Ann Remen-Willis. Children's books only/no advertising. Estab. 1984. Member of SCBWI. Represents 15 illustrators. Specializes in children's books trade and text. Markets include design firms, editorial/magazines, paper products/greeting cards, publishing/books. Visit Web site for artist names.
Handles Illustration.
Terms Rep receives 25% commission. Advertising costs are split 50% paid by artist; 50% paid by rep. Advertises in *Picturebook* and postcard mailings.
How to Contact For first contact, send query letter with tearsheets. Responds in one week. After initial contact, call to schedule an appointment. Portfolio should include b&w and color tearsheets.
Tips "Fill portfolio with samples of art you want to continue receiving as commissions. Do not include that which is not a true representation of your style and capability."

REPFILE

837 E. 17th Ave., Suite 3C, Denver CO 80218. (303)504-0805. E-mail: michelle@repfile.com. Web site: www.rep file.com. **Contact:** Michelle Desloge, president/owner. Commercial/fine art talent rep. Estab. 1998. Member of ADCD/AIGA.
Handles Fine art, photography, illustration.
Terms Rep receives variable commission. Advertising costs and commisions are paid by artist. For promotional purposes, talent must provide portfolios, direct mail campaign (active), rational ad in sourcebooks, *Creative Black Book, Directory of Illustration.*

How to Contact Send query letter with bio, direct mail flier/brochure, e-mail portfolio. Responds only if interested. Portfolio should include slides (that do not need to be returned to talent), e-mail samples.

Tips "Do not approach a rep without first sending samples of work. My pet peeve is receiving a phone call/message wanting to set-up an appointment before I even know the caliber of work. Always send samples with introduction."

RETROREPS (A DIVISION OF MARTHA PRODUCTIONS)

7550 W. 82nd St., Playa Del Rey CA 90293. (310)670-5300. Fax: (310)670-3644. E-mail: martha@retroreps.com. Web site: www.retroreps.com. **Contact:** Martha Spelman. Commercial illustration representative. Estab. 1998. Represents 19 illustrators, 1 photographer. Specializes in artists and a photographer working in retro styles from the 1920s through 1970s. Licenses illustrators and photographers. Artists include Bruce Sereta, John Kachik, Tom Nikosey.

- See listing for Martha Productions.

Handles Interested in illustration and photography.

LILLA ROGERS STUDIO

E-mail: info@lillarogers.com. Web site: www.lillarogers.com. **Agent:** Lilla Rogers, Ashley Lorenz. Commercial illustration representative. Estab. 1984. Represents 20 illustrators. Markets include advertising agencies, corporations/client direct, design firms, editorial/magazines, paper products/greeting cards, publishing/books, prints and posters, must companies, sales/promotion firms, children's books, surface design. Artists include Bonnie Dain, Diane Bigda, Jon Cannell.

- Lilla provides mentoring and frequent events for our artists including classes and guest art director lunches.

Handles Illustration.

Terms Rep receives 30% commission. Exclusive representation required. Advertises in *Print Magazine*, *Workbook*, *Showcase*, and runs extensive postcard direct mail campaigns .

How to Contact For first contact, e-mail a link to your site, or 3-5 JPEGs. Responds only if interested.

Tips "It's good to check out the agency's Web site and see if you feel like it's a good fit. Explain in your e-mail why you want an agent and why you think we are a good match."

ROSENTHAL REPRESENTS

3850 Eddingham Ave., Calabasas CA 91302. (818)222-5445. Fax: (818)222-5650. E-mail: eliselicenses@hotmail.com. Commercial illustration representative and licensing agent for artists who do advertising, entertainment, action/sports, children's books, giftware, collectibles, figurines, children's humorous, storyboard, animal, graphic, floral, realistic, impressionistic and game packaging art. Estab. 1979. Member of SPAR, Society of Illustrators, Graphic Artists Guild, Women in Design and Art Directors Club. Represents 100 illustrators, 2 designers and 5 fine artists. Specializes in game packaging, personalities, licensing, merchandising art and storyboard artists. Markets include advertising agencies; corporations/client direct; paper products/greeting cards; sales/promotion firms; licensees and manufacturers.

Handles Illustration.

Terms Rep receives 30% as a rep; 50% as a licensing agent. Exclusive area representation is required. No geographic restrictions. Advertising costs are paid by talent. For promotion purposes, talent must provide 1-2 sets of transparencies (mounted and labeled). Also include 1-3 promos. Advertises in *American Showcase* and *The Workbook*.

How to Contact For first contact, send direct mail flier/brochure, tearsheets, slides, photocopies, photostats and SASE. Responds in 1 week. After initial contact, call for appointment to show portfolio of tearsheets, slides, photographs, photocopies.

Tips Obtains new talent through seeing their work in an advertising book or at award shows, *Art Decor*, *Art Business News* and by referrals.

S.I. INTERNATIONAL

43 E. 19th St., New York NY 10003. (212)254-4996. Fax: (212)995-0911. E-mail: hspiers@si-i.com. Web site: www.si-i.com. **Artists Relations:** Donald Bruckstein. Commercial illustration representative. Estab. 1983. Member of SPAR, Graphic Artists Guild. Represents 50 illustrators. Specializes in license characters, educational publishing and children's illustration, digital art and design, mass market paperbacks. Markets include design firms; publishing/books; sales/promotion firms; licensing firms; digital art and design firms.

Handles Illustration. Looking for artists "who have the ability to do children's illustration and to do license characters either digitally or reflectively."

Terms Rep receives 25-30% commission. Advertising costs are split 70% paid by talent; 30% paid by representative. "Contact agency for details. Must have mailer." Advertises in *Picture Book*.

How to Contact For first contact, send query letter, tearsheets. Responds in 3 weeks. After initial contact, write for appointment to show portfolio of tearsheets, slides.

LIZ SANDERS AGENCY

2415 E. Hangman Creek Lane, Spokane WA 99224. (509)993-6400. Fax: (509)466-5400. E-mail: liz@lizsanders.com. Web site: www.lizsanders.com. **Contact:** Liz Sanders, owner. Commercial illustration representative. Estab. 1985. Represents 10 illustrators. Specializes in marketing of individual artists within an ever-evolving illustration world. Markets include advertising agencies, corporations/client direct, design firms, editorial/magazines, juvenile markets, paper products/greeting cards, publishing/books, record companies, sales/promotion firms.
Handles Interested in illustration. Looking for fresh, unique talent committed to long-term careers whereby the agent/talent relationship is mutually respectful, responsive and measurably successful.
Terms Rep receives 25-30% commission. Exclusive representation required. Advertises in *Picturebook*, *American Showcase*, *Workbook*, *Directory of Illustration*, direct mail material, traditional/electronic portfolio for agent's personal presentations, means to advertise if not substantially, then consistently.
How to Contact For first contact, send nonreturnable printed pieces or e-mailed Web address. Responds only if interested. After initial contact, call to schedule an appointment, depending on geographic criteria. Portfolio should include tearsheets, photocopies and digital output.
Tips "Concisely present a single, focused style supported by 8-12 strong samples. Only send a true portfolio upon request."

THE SCHUNA GROUP INC.

1503 Briarknoll Dr., Arden Hills MN 55112. (651)631-8480. Fax: (651)631-8426. E-mail: joanne@schunagroup.com. Web site: www.schunagroup.com. **Contact:** JoAnne Schuna, owner. Commercial illustration representative. Represents 15 illustrators. Specializes in illustration. Markets include advertising agencies, corporations/client direct, design firms, editorial/magazines, paper products/greeting cards, publishing/books, record companies, sales/promotion firms. Artists include Cathy Gendron, Jim Dryden.
Handles Interesting in reviewing illustration samples.
Terms Rep receives 25% commission. Exclusive representation required. Advertising costs are split 75% paid by artist; 25% paid by rep. Advertises in various mediums.
How to Contact For first contact, send digital samples via e-mail. "2-3 samples to show style are adequate. I will respond via e-mail within a few weeks at most if interested."
Tips "Listing your Web site in your e-mail is helpful, so I can see more if interested."

THREE IN A BOX INC.

862 Richmond St. E, Suite 201, Toronto ON M6J 1C9 Canada. (416)367-2446. Fax: (416)367-3362. E-mail: info@threeinabox.com. Web site: www.threeinabox.com. **Contact:** Holly Venable, managing director. Commercial illustration representative. Estab. 1990. Member of Graphic Artists Guild. Represents 53 illustrators, 3 photographers. Specializes in illustration. Licenses illustrators and photographers. Markets include advertising agencies, corporations/client direct, design firms, editorial/magazines, paper products/greeting cards, publishing/books, record companies, sales/promotion firms. Artists include Otto Steininger, Martin O'Neill and Peter Ferguson.
How to Contact For first contact, send query letter and URL to info@threeinabox.com. Responds in 1 week. After initial contact, we'll call if interested. Portfolio should include digital.
Tips "Try to specialize; you can't do everything well."

CHRISTINA A. TUGEAU: ARTIST AGENT

3009 Margaret Jones Lane, Williamsburg VA 23185. E-mail: chris@catugeau.com. Web site: www.catugeau.com. **Owner:** Chris Tugeau. Children's publishing market illustration representative (K-12). Estab. 1994. Member of Graphic Artists Guild, SPAR, SCBWI. Represents 35 illustrators. Specializes in children's book publishing and educational market and related areas. Represents Stacey Schuett, Larry Day, Bill Farnsworth, Melissa Iwai, Margie Moore, Keiko Motoyama, Jason Wolff, Jeremy Tugeau, Priscilla Burris, John Kanzler, Ann Barrow, Martha Aviles, Ana Ochoa, Daniel J. Mahoney and others.
Handles Illustration. Must be proficient at illustrating children and animals in a variety of interactive situations, backgrounds, full color/b&w, and with a strong narrative sense.
Terms Rep receives 25% commission. Exclusive USA representation is required. For promotional purposes, talent must provide a direct mail promo piece(s), 8-10 good "back up" samples (multiples), 3 strong portfolio pieces. Advertises in *RSVP*, *GAG Directory of Illustration* and *Picturebook*.
How to Contact For first contact, e-mail a few JPEG samples or send direct mail flier/brochure, tearsheets, photocopies, books, SASE. "No slides or originals." Responds by 2 weeks.
Tips "You should have a style uniquely and comfortably your own. Cooperative team player and be great with

deadlines. Will consider young, new artists to the market with great potential and desire, and of course published, more experienced illustrators. Best to study and learn the market standards and expectations by representing yourself for a while when new to the market."

JAE WAGONER, ARTIST REPRESENTATIVE

P.O. Box 1259, Alta CA 95701. Web site: www.jaewagoner.com. **Contact:** Jae Wagoner. "By mail only—send copies or tear sheets only for us to keep—do not call!" Commercial illustration representative. Estab. 1975. Represents 20 illustrators. Markets include advertising agencies; corporations/client direct; design firms; editorial/magazines; paper products/greeting cards; publishing/books; sales/promotion firms.

- This rep's street address is 33885 Nary Red Rd., Alta CA 95701. However, all mail should go to the P.O. Box.

Handles Illustration.

Terms Agent receives 30% commission. Exclusive area representation required. Advertising costs depend. For promotional purposes talent must advertise once a year in major promotional book (ex Workbook) exclusively with us. "Specifications and details are handled privately." Advertises in *The Workbook*.

How to Contact When making first contact, send query letter (with other reps mentioned), photocopies ("examples to keep only. No unsolicited work returned.") Responds in weeks only if interested. After initial contact, talent should wait to hear from us.

Tips "We select first from submitted samples we can keep, that are mailed to us. The actual work determines our interest, not verbal recommendation or résumés. Sometimes we search for style we are lacking. It is *not* a good idea to call a rep out of the blue. You are just another voice on the phone. What is important is your work, *not* who you know, where you went to school, etc. Unsolicited work that needs to be returned creates a negative situation for the agent. It can get lost, and the volume can get horrendous. Also—do your homework—do not call and expect to be given the address by phone. It's a waste of the rep's time and shows a lack of effort. Be brief and professional." Sometimes, even if an artist can't be represented, Jae Wagoner provides portfolio reviews, career counseling and advice for an hourly fee (with a 5 hour minimum fee). If you are interested in this service, please request this in your cover letter.

GWEN WALTERS

1801 S. Flagler Dr. #1202, West Palm Beach FL 33401. (561)805-7739. Fax: (561)805-5931. E-mail: Artincgw@aol.com. Web site: www.GwenWaltersartrep.com. Commercial illustration representative. Estab. 1976. Represents 19 illustrators. "I lean more toward book publishing." Markets include advertising agencies; corporations/client direct; editorial/magazines; paper products/greeting cards; publishing/books; sales/promotion firms. Represents Gerardo Suzan, Fabricio Vanden Broeck, Resario Valderrama, Lave Gregory, Susan Spellman, Judith Pfeiffer, Yvonne Gilbert, Gary Torrisi, Larry Johnson, Pat Daris, Scott Wakefield, Tom Barrett, and Linda Pierce.

Handles Illustration.

Terms Rep receives 30% commission. Charges for color photocopies. Advertising costs are split; 50% paid by talent; 50% paid by representative. For promotional purposes, talent must provide direct mail pieces. Advertises in *RSVP*, *Directory of Illustration.*.

How to Contact For first contact, send résumé, bio, direct mail flier/brochure. After initial contact, representative will call. Portfolio should include "as much as possible."

Tips "You need to pound the pavement for a couple of years to get some experience under your belt. Don't forget to sign all artwork. So many artists forget to stamp their samples."

WATSON & SPIERMAN PRODUCTIONS

636 Broadway, Suite 708, New York NY 10012. (212)431-4480. Fax: (212)253-9996. E-mail: email@watsonspierman.com. Web site: www.watsonspierman.com. Commercial illustration/photography representative. Estab. 1992. Member of SPAR. Represents 9 fine artists, 8 illustrators, 10 photographers. Specializes in general illustration, photography. Markets include advertising agencies, design firms, galleries, paper products/greeting cards, record companies, publishing/books, sales/promotion firms, corporations/client direct, editorial/magazines. Artists include Kan, Monica Lind, Daniel Arsenault, Adam Brown, Bryan Helm, Paul Swen, Joseph Ilan, Frank Siteman, North Sullivan, Kim Harlow, Annabelle Verhoye, Pierre Chanteau, Kristofer Dan-Bergman, Lou Wallach, Eva Byrene, Dan Cotton, Glenn Hilario, Paula Romani, Dannielle Siegelbaum, Ty Wilson, Fulvia Zambon.

Handles Commercial, illustration, and photography.

Terms Rep receives 30% commission. Exclusive representation required. Advertising costs are paid by artist. Artist must publish every year in a sourcebook with all Watson & Spierman talent. Advertises in *Blackbook* and *Workbook*.

How to Contact For first contact, send link to Web site. Responds only if interested. After initial contact, drop off or mail portfolio. Portfolio should include b&w, color, finished art, original art, photographs, tearsheets.

Tips "We love to hear if an artist has an ad out or recently booked a job. Those are the updates that are most important to us."

WILEY ART GROUP

1535 Green St., Suite 301, San Francisco CA 94123. (415)441-3055. Fax: (415)441-6200. E-mail: david@wileyartg roup.com. Web site: www.wileyartgroup.com. **Contact:** David Wiley. Commercial and fine art illustration and photography representative. Estab. 1984. Member of AIP (Artists in Print). Society of Illustrators, Graphic Artists Guild, Bay Area Lawyers for the Arts. Represents 6 illustrators and 1 photographer. Specializes in "being different and effective!" Clients include Coke, Pepsi, Robert Mondavi. Client list available upon request.

Terms Agent receives 30% commission. No geographical restriction. Artist is responsible for all portfolio costs. Artist pays for sourcebook ads, postcard, tearsheet mailing. Agent will reimburse artist for 30% of page costs through commissioned jobs. Each year the artists are promoted in *American Showcase*, *Black Book* and *Workbook*, *Directory of Illustration*, and through direct mail (tearsheets and quarterly postcard mailings).

How to Contact For first contact, send tearsheets or copies of your work accompanied by SASE. If interested, agent will call back to review portfolio, which should include commissioned and non-commissioned work.

Tips "The bottom line is that a good agent will get you *more* work at *better rates* of pay. More work because clients come to us knowing that we only represent serious professionals. Better rates because our clients know that we have a keen understanding of what the market will bear and what the art is truly worth."

DEBORAH WOLFE LTD.

731 N. 24th St., Philadelphia PA 19130. (215)232-6666. Fax: (215)232-6585. E-mail: inquiry@illustrationOnLine. com. Web site: www.illustrationOnLine.com. **Contact:** Deborah Wolfe. Commercial illustration representative. Estab. 1978. Represents 25 illustrators. Markets include advertising agencies; corporations/client direct; design firms; editorial/magazines; publishing/books.

Handles Illustration.

Terms Rep receives 25% commission. Advertises in *Black Book*, *The Workbook*, *Directory of Illustration* and *Picturebook*.

How to Contact For first contact, send direct mail flier/brochure, tearsheets, slides or e-mail. Responds in 3 weeks.

Organizations, Publications & Web sites

T here are literally millions of artist- and designer-related websites out there. Here are just a few that we at *Artist's & Graphic Designer's Market* think are particularly useful.

BUSINESS

Arts Business Exchange: www.artsbusiness.com.
Sign up for the free e-mail newsletter and get updates on trends, Canadian art news, sales data and art law and policy.

Starving Artists Law: www.starvingartistslaw.com.
Start here for answers to your legal questions.

Tera's Wish: www.teras-wish.com/marketing.htm.
Tera Leigh, author of *How to Be Creative If You Never Thought You Could* (North Light Books), shares tips and ideas for marketing, promotion, P.R. and more.

ILLUSTRATORS

Altpick.com: The Source for Creative Talent & Imagination: www.altpick.com.
News, competition deadlines, artist listings and much more. Check out the wealth of information listed.

Association of Medical Illustrators: www.ami.org.
A must-visit for anyone interested in the highly specialized niche of medical illustration.

The Association of Science Fiction and Fantasy Artists: www.asfa-art.org.
Home of the Chesley Awards, this site is essential for anyone connected to the visual arts of science fiction, fantasy, mythology and related topics.

Canadian Association of Photographers and Illustrators in Communications (CAPIC): www.capic.org.
There's a ton of copyright and industry news and articles on this site, also help with insurance, lawyers, etc.

Canadian Society of Children's Authors, Illustrators and Performers: www.canscaip.org. This organization promotes all aspects of Children's writing, illustration and performance.

THE DRAWING BOARD: members.aol.com/thedrawing. Get everything here—from pricing guidelines to events, tips to technique.

Greeting Card Association: www.greetingcard.org. A great place for learning about and networking in the greeting card industry.

Magatopia: www.magatopia.com. Online magazine articles, Web searches for art jobs, weekly columns on freelancing. . . . there's a lot to explore at this site.

Magazines A-Z: www.magazinesatoz.com. This is a straightforward listing of a bunch of magazines.

The Medical Illustrators' Home Page: www.medartist.com. A site for medical illustrators who want to post their work for stock imagery or view others' work.

Society of Children's Book Writers and Illustrators: www.scbwi.org. With chapters all over the world, SCBWI is the premier organization for professionals in children's publishing.

The Society of Illustrators: www.societyillustrators.org. Since 1901, this organization has been working to promote the interest of professional illustrators. Information on exhibitions, career advice and many other links provided.

Theispot.com: www.theispot.com. An online "home for illustrators" developed by Gerald Rapp, which showcases illustrators' work and serves as a meeting place where illustrators can discuss their profession and share ideas.

Writers Write: Greeting Cards: www.writerswrite.com/greetingcards. This site has links to greeting card companies and their submission information.

FINE ART

American Artist Registry: www.artistregistry.com. A registry where you can post art, get updates on calls for entries throughout the United States and much more.

Art Deadlines List: www.artdeadlineslist.com. The e-mail version of this list is free. It's a great source for deadlines for calls for entries, competitions, scholarships, festivals and more.

Art Dealers Association of America: www.artdealers.org. Opportunities and information on marketing your work, galleries and dealers.

Artdeadline.com: artdeadline.com. Called the "Art Professional's Resource," this site lists information for funding, grants, commissions for art in public places, representation. . . . the list goes on and on.

Artist Help Network: www.artisthelpnetwork.com.
Find career, legal and financial advice along with multiple regional, national and international resources.

The Artist's Network: www.artistsnetwork.com.
Get articles, excerpts and tips from *The Artist Magazine, Watercolor Magic*, and *Decorative Artist's Workbook*. The Artists Network Forum hosts discussions on all art-related topics including art business and inspiration.

Artline: www.artline.com.
Artline is comprised of 7 dealer associations: Art Dealers Association of America, Art Dealers Association of Greater Washington, Association of International Photography Art Dealers, Chicago Art Dealers Association, International Fine Print Dealers Association, San Francisco Art Dealers Association, and Society of London Art Dealers. The website has information about exhibits and artists worldwide.

New York Foundation for the Arts: www.nyfa.org.
With news, a searchable database of opportunities for artists, links to other useful sites such as databases of galleries and the Artist's Community Federal Credit Union, this site is loaded!

CARTOONS & COMIC BOOK ART

The Comic Book Legal Defense Fund: www.cbldf.org.
"Defending the comic industry's first amendment rights since 1986."

Friends of Lulu: www.friends-lulu.org.
This national nonprofit organization's purpose is to "promote and encourage female readership and participation in the comic book industry."

National Cartoonists Society: www.reuben.org.
Home and birthplace of the famed Reuben Awards, this organization holds something for cartoonists interested in everything from caricature to animation.

TalkAboutComics.com: www.talkaboutcomics.com.
"Free community resource for small press and Web comics creators and fans."

The Nose: www.the-nose.com.
Online caricature artist index.

ADVERTISING, DESIGN & GRAPHIC ART

Advertising Age: www.adage.com.
This site is a database of advertising agencies.

American Institute of Graphic Arts: www.aiga.org.
Whether or not you join the organization, this site is a must for designers! From inspiration to insurance the AIGA is the designer's spot.

The Art Directors Club: www.adcny.org.
Founded in 1920, this international not-for-profit organization features job listings,

educational opportunities and annual awards in advertising, graphic design, new media and illustration.

Association Typographique Internationale (ATYPI): www.atypi.org.
Dedicated entirely to typography and type, if fonts are your specialty, make sure this site is on your favorites list.

Graphic Artists Guild: www.gag.org.
The art and design industry standard.

HOW **Magazine**: www.howdesign.com.
One of the premier publications dedicated to design, the website features jobs, business resources, inspiration and news, as well as conference information.

Society of Graphic Designers of Canada: www.gdc.net.
Great site for Canadian designers that offers industry news, job postings and forums.

Type Directors Club: www.tdc.org.
Events, news, awards and scholarships are all here for "those interested in excellence in typography."

OTHER USEFUL SITES

Animation World Network: www.awn.com.
Animation industry database, job postings, resume database, education resources, discussion forums, links, newsletters and a host of other resources cover everything animation.

Art Schools: www.artschools.com.
A free online directory with a searchable database of art schools all over the world. They also have information on financial aid, majors and lots more.

Artbusiness.com: www.artbusiness.com.
Contains art-business-related articles, reviews business-of-art books and sells classes on marketing for artists.

The Artist's Magazine: www.artistsmagazine.com.
Archives of articles covering everything from the newest type of colored pencil to techniques in waterolors.

Artlex Art Dictionary: www.artlex.com.
Art dictionary with more than 3,200 terms.

Communication Arts Magazine: www.commarts.com.
Publication and website covering all aspects of design from print to digital.

International Animation Association: asifa.net.
ASIFA or Association Internationale du Film d'Animation is an international group dedicated to the art of animation. They list worldwide news and information on chapters of the group, as well as conferences, contests and workshops.

Music Connection: www.musicconnection.com.

If you're working hard to get your art on CD covers, you'll want to keep up with the ever-changing world of the music industry.

Portfolios.com: www.portfolios.com.

Serving both artists and clients looking for artists, portfolios.com offers a variety of services for everyone. This is a really nice site; you can post up to a five-image portfolio for free.

Glossary

Acceptance (payment on). An artist is paid for his work as soon as a buyer decides to use it.

Adobe Illustrator®. Drawing and painting computer software.

Adobe InDesign. Revised, retooled version of Adobe Illustrator.

Adobe PageMaker®. Page-layout design software. Product relaunched as InDesign.

Adobe Photoshop®. Photo manipulation computer program.

Advance. Amount paid to an artist before beginning work on an assigned project. Often paid to cover preliminary expenses.

Airbrush. Small pencil-shaped pressure gun used to spray ink, paint or dye to obtain gradated tonal effects.

Anime. Japanese word for animation.

Art director. In commercial markets, the person responsible for choosing and purchasing artwork and supervising the design process.

Biannually. Occurring twice a year.

Biennially. Occurring once every two years.

Bimonthly. Occurring once every two months.

Biweekly. Occurring once every two weeks.

Book. Another term for a portfolio.

Buy-out. The sale of all reproduction rights (and sometimes the original work) by the artist; also subcontracted portions of a job resold at a cost or profit to the end client by the artist.

Calligraphy. The art of fine handwriting.

Camera-ready. Art that is completely prepared for copy camera platemaking.

Capabilities brochure. A brochure, similar to an annual report, outlining for prospective clients the nature of a company's business and the range of products or services it provides.

Caption. See gagline.

Carriage trade. Wealthy clients or customers of a business.

CD-ROM. Compact disc read-only memory; nonerasable electronic medium used for digitized image and document storage and retrieval on computers.

Collateral. Accompanying or auxiliary pieces, such as brochures, especially used in advertising.

Color separation. Photographic process of separating any multi-color image into its primary component parts (cyan, magenta, yellow and black) for printing.

Commission. 1) Percentage of retail price taken by a sponsor/salesman on artwork sold. 2) Assignment given to an artist.

Comprehensive. Complete sketch of layout showing how a finished illustration will look when printed; also called a comp.

Copyright. The exclusive legal right to reproduce, publish and sell the matter and form of a literary or artistic work.

Consignment. Arrangement by which items are sent by an artist to a sales agent (gallery, shop, sales rep, etc.) for sale with the understanding the artist will not receive payment until work is sold. A commission is almost always charged for this service.

Direct-mail package. Sales or promotional material that is distributed by mail. Usually consists of an outer envelope, a cover letter, brochure or flier, SASE, and postpaid reply card, or order form with business reply envelope.

Dummy. A rough model of a book or multi-page piece, created as a preliminary step in determining page layout and length. Also, a rough model of a card with an unusual fold or die cut.

Edition. The total number of prints published of one piece of art.

Elhi. Abbreviation for elementary/high school used by publishers to describe young audiences.

Environmental graphic design (EGD). The planning, designing and specifying of graphic elements in the built and natural environment; signage.

EPS files. Encapsulated PostScript—a computer format used for saving or creating graphics.

Estimate. A ballpark figure given to a client by a designer anticipating the final cost of a project.

Etching. A print made by the intaglio process, creating a design in the surface of a metal or other plate with a needle and using a mordant to bite out the design.

Exclusive area representation. Requirement that an artist's work appear in only one outlet within a defined geographical area.

Finished art. A completed illustration, mechanical, photo or combination of the three that is ready to go to the printer. Also called camera-ready art.

Gagline. The words printed with a cartoon (usually directly beneath); also called a caption.

Giclée Method of creating limited and unlimited edition prints using computer technology in place of traditional methods of reproducing artwork. Original artwork or transparency is digitally scanned and the stored information is manipulated on screen using computer software (usually Photoshop). Once the image is refined on screen, it is printed on an Iris printer, a specialized ink-jet printer designed for making giclée prints.

Gouache. Opaque watercolor with definite, appreciable film thickness and an actual paint layer.

Halftone. Reproduction of a continuous tone illustration with the image formed by dots produced by a camera lens screen.

Informational graphics. Information, especially numerical data, visually represented with illustration and text; charts/graphs.

IRC. International Reply Coupon; purchased at the post office to enclose with artwork sent to a foreign buyer to cover his postage cost when replying.

Iris print. Limited and unlimited edition print or giclée output on an Iris or ink-jet printer (named after Iris Graphics of Bedford, Massachusetts, a leading supplier of ink-jet printers).

JPEG files. Joint Photographic Experts Group—a computer format used for saving or creating graphics.

Keyline. Identification of the positions of illustrations and copy for the printer.

Kill fee. Portion of an agreed-upon payment an artist receives for a job that was assigned, started, but then canceled.

Layout. Arrangement of photographs, illustrations, text and headlines for printed material.

Licensing. The process whereby an artist who owns the rights to his or her artwork permits (through a written contract) another party to use the artwork for a specific purpose for a specified time in return for a fee and/or royalty.

Lithography. Printing process based on a design made with a greasy substance on a limestone slab or metal plate and chemically treated so image areas take ink and nonimage areas repel ink.

Logo. Name or design of a company or product used as a trademark on letterhead, direct mail packages, in advertising, etc., to establish visual identity.

Mechanicals. Preparation of work for printing.

Multimedia. A generic term used by advertising, public relations and audiovisual firms to describe productions involving animation, video, Web graphics or other visual effects. Also, a term used to reflect the varied in-house capabilities of an agency.

Naif. Native art of such cultures as African, Eskimo, Native American, etc., usually associated with daily life.

Offset. Printing process in which a flat printing plate is treated to be ink-receptive in image areas and ink-repellent in nonimage areas. Ink is transferred from the printing plate to a rubber plate, and then to the paper.

Overlay. Transparent cover over copy, on which instruction, corrections or color location directions are given.

Panel. In cartooning, the boxed-in illustration; can be single panel, double panel or multiple panel.

PMT. Photomechanical transfer; photostat produced without a negative.

P-O-P. Point-of-purchase; in-store marketing display that promotes a product.

Prima facie. Evidence based on the first impression.

Print. An impression pulled from an original plate, stone, block screen or negative; also a positive made from a photographic negative.

Production artist. In the final phases of the design process, the artist responsible for mechanicals and sometimes the overseeing of printing.

QuarkXPress. Page layout computer program.

Query. Letter to an art director or buyer eliciting interest in a work an artist wants to illustrate or sell.

Quotation. Set fee proposed to a client prior to commencing work on a project.

Rendering. A drawn representation of a building, interior, etc., in perspective.

Retail. The sale of goods in small quantities directly to the consumer.

Roughs. Preliminary sketches or drawings.

Royalty. An agreed percentage paid by a publisher to an artist for each copy of a work sold.

SASE. Self-addressed, stamped envelope.

Self-publishing. In this arrangement, an artist coordinates and pays for printing, distribution and marketing of his/her own artwork and in turn keeps all ensuing profits.

Semiannual. Occurring twice a year.

Semimonthly. Occurring twice a month.

Semiweekly. Occurring twice a week.

Serigraph. Silkscreen; method of printing in which a stencil is adhered to a fine mesh cloth stretched over a wooden frame. Paint is forced through the area not blocked by the stencil.

Speculation. Creating artwork with no assurance that a potential buyer will purchase it or reimburse expenses in any way; referred to as work "on spec."

Spot illustration. Small illustration used to decorate a page of type or to serve as a column ending.

Storyboard. Series of panels that illustrate a progressive sequence or graphics and story copy of a TV commercial, film or filmstrip. Serves as a guide for the eventual finished product.

Tabloid. Publication whose format is an ordinary newspaper page turned sideways.

Tearsheet. Page containing an artist's published illustration, cartoon, design or photograph.

Thumbnail. A rough layout in miniature.

TIFF files. Tagged Image File Format—a computer format used for saving or creating graphics.

Transparency. A photographic positive film such as a color slide.

Type spec. Type specification; determination of the size and style of type to be used in a layout.

Velox. Photoprint of a continuous tone subject that has been transformed into line art by means of a halftone screen.

VHS. Video Home System; a standard videotape format for recording consumer-quality videotape, most commonly used in home videocassette recording and portable camcorders.

Video. General category comprised of videocassettes and videotapes.

Wash. Thin application of transparent color or watercolor black for a pastel or gray tonal effect.

Wholesale. The sale of commodities in large quantities usually for resale (as by a retail merchant).

Enter our drawing for a
free copy of the next edition

Reader Survey:
Tell us about yourself!

1. How often do you purchase *Artist's & Graphic Designer's Market?*

- ○ every year
- ○ every other year
- ○ This is my first edition

2. Describe yourself and your artwork—and how you use *AGDM.*

3. What do you like best about *AGDM?*

4. Would you like to see an online version of *AGDM?*

- ○ Yes
- ○ No

Name: _____
Address: _____
City: _____ State: _____ Zip: _____
Phone: _____ e-mail _____
Web site: _____

Fax to Mary Cox, (513) 531-2686 or mail to Artist's & Graphic Designer's Market, 4700 East Galbraith Road, Cincinnati, OH 45236, or e-mail artdesign@fwpubs.com.

Niche Marketing Index

The following indexes can help you find the most apropriate listings for the kind of artwork you create. Check the individual listings for specific information about submission requirements.

Collectibles

Fashion

Horror

Humorous Illustration

Religious/Spiritual

Science Fiction/Fantasy

Sport Art

Textiles & Wallpaper

T-Shirts

General Index